Market Research Submissions Packaged & Mailed

Miscellaneous Markets

Stock Photo Agency

Stock agent evaluates images against existing file

Agency circulates photos to many buyers

Agency sends 50% of sales prices to photographer

Marketing & Usage elance Photography

1986 PHOTO GRAPHER'S MARKET®

WHERE TO SELL YOUR PHOTOGRAPHS

Edited by Robin Weinstein

Distributed in Canada by Prentice-Hall of Canada Ltd., 1870 Birchmount Road, Scarborough, Ontario M1P 2J7 and in Australia and New Zealand by Bookwise (Aust.) Pty. Ltd., Box 296, Welland S.A. 5007, Australia. Available in the U.K. from Henry Greenwood & Co. Ltd., 28 Great James Street, London WC1N 3HL.

Managing Editor, Market Books Department: Constance J. Achabal

Photographer's Market. Copyright © 1985 by Writer's Digest Books. Published by F&W Publications, 9933 Alliance Rd., Cincinnati, Ohio 45242. Printed and bound in the United States of America. All rights reserved. No part of this book may be reproduced in any manner whatsoever without written permission from the publisher, except by reviewers who may quote brief passages to be printed in a magazine or newspaper.

International Standard Serial Number 0147-247X International Standard Book Number 0-89879-199-5

Contents

The Profession

- 1 Introduction
- 3 Using Photographer's Market
- 5 The Best Way to Sell Editorial Photos, by Bob Grewell
- 9 Creating a Profitable Stock Photography Business, by Nadine Orabona

The Markets

- 13 Advertising, Public Relations & Audiovisual Firms 49 Close-up: Michael Knab, President, Multivision International, Inc.
- 111 Book Publishers
 129 Close-up: Bruce Johnson, Photo Manager, Charles E. Merrill
 Publishing Co.
- 142 Businesses and Organizations
 146 Close-up: Dennis Mansell, Freelance Photographer
- 164 Galleries
- 182 Paper Products
 184 Close-up: Charles Mauzy, Vice President, Arpel Graphics
- 195 Periodicals
 - 196 Association Publications
 - 238 Company Publications
 - 251 Consumer Magazines
 - 258 Close-up: Martha Hill, Picture Editor, Audubon
 - 361 Close-up: Pam Withers, Editor, Select Homes
 - 389 Newspapers and Newsletters
 - 409 Close-up: Laurie Kratochvil, Photo Editor, Rolling Stone
 - 416 Trade Journals

475 Record Companies
489 Close-up: Bill Comeau, President, Sine Qua Non Records

492 Stock Photo Agencies
521 Close-up: Mary Ann Platts, Director,
Third Coast Stock Source

Services & Opportunities

523 Contests

532 Workshops

533 Close-up: Tim Barnwell, Director, Appalachian Photographic Workshops

Appendix

539 The Business of Freelancing

539 Promotional Materials

540 The Portfolio

540 Business Forms

540 Model Releases

541 Copyright

542 Rights

543 Recordkeeping

543 Taxes

544 Insurance

Glossary

545

Index

549

The Profession

Introduction

This edition of *Photographer's Market* fulfills several goals—it provides you with the facts, the inside information and the tips you need to successfully market your freelance photos. It's all here in one volume recognized nationally as *THE DIRECTORY OF PHOTO BUYERS* for photographers. It tells you not only where you can sell your work, but also helps increase your professionalism and understanding of the business of freelancing.

The two articles in the front of the book, "The Best Way to Sell Editorial Photos" and "Creating a Profitable Stock Photography Business," explain step by step how to tap those lucrative periodicals markets and how to set up your own stock busi-

ness. Both articles are written by leading experts in their fields.

The introductions to the individual sections of the book discuss the nature of the market, review its buying potential and spell out any special needs or submission requirements it might have. Use them to your advantage as you consider the

listings.

The ten close-up interviews are with photo buyers from some of the leading photo marketplaces in the United States—Audobon, Rolling Stone, Sin Qua Non, Arpel Graphics, Charles E. Merrill Publishing Company, Third Coast Stock Source and Multivision International, Inc. Each interview reveals how these buyers handle their firm's photography needs. The remaining close-ups with Dennis Mansell, British freelance photographer, and Tim Barnwell, the director of Appalachian Photographic Workshops, repectively reveal how to successfully shoot and sell stock photography and how workshops can improve your technique to give you that creative edge.

Photos purchased by photo buyers listed in the book are shown so you can see what they are buying. The captions explain how the photographers approached the markets and sold their work, and why the photo buyers purchased it. And each photo caption also provides tips you can use to improve your marketing skills.

The section entitled "The Business of Freelancing" delves into the nitty gritty of business practices, giving details on promotional materials, preparing a portfolio, business forms, model releases, copyright, rights, recordkeeping, taxes and insurance. Finally, the glossary defines words and phrases photographers should know.

This expanded edition of *Photographer's Market* includes more than 400 new listings, each marked with an asterisk (*) for easy spotting. And changes have occurred in listings which have previously appeared in the book—new addresses and/or phone numbers, new contact names, company name changes, new pay rates, new photo needs—all in all, the most up-to-date information available to help photographers sell their photos.

The markets, the inside information, the tips, the facts, are all here in *Photogra-pher's Market*. Talent, know-how, skill and this book can lead to a very lucrative

freelance photography career. Good Luck!

A Very Important Note:

- The markets listed in this book are those which are actively seeking new freelance contributors. Those companies not interested in hearing from new photographers are not included. If a particular magazine or other market is missing, it is probably not listed for that reason, or because: 1) it has gone out of business; 2) it did not respond to our questionnaire requesting listing information; 3) it did not verify its listing from last year's edition; 4) it has failed to respond adequately to photographers' complaints against it; or 5) it requested that its listing be deleted.
- Market listings new to this edition are marked with an asterisk. These new markets are often the most receptive to new freelance talent.
- Although every buyer is given the opportunity to update his listing information prior to publication, the photography marketplace changes constantly throughout the year and between editions. Therefore it is possible that some of the market information will be out of date by the time you make use of it. The monthly *Photographer's Market Newsletter* updates these changes and reports on current market developments on an ongoing basis.
- Market listings are published free of charge to photography buyers and are not advertisements. While every measure is taken to ensure that the listing information is as accurate as possible, we cannot guarantee or endorse any listing.
- Photographer's Market reserves the right to exclude any listing which does not meet its requirements.

Using Photographer's Market

The listings in this book are more than names and addresses. Included is information on whom to contact, what kind of photos the listing needs, how they utilize photographers, and payment method and amount. Here are some tips to help you interpret these listings.

How To Read a Market Listing

•The asterisk (*) in front of a listing means that listing is new to this edition.

•The name and title of the person you should contact are given in most listings. If not, address your work to the editor or photo editor or the person most appropriate in that particular field.

•Established dates are listed only if they are 1984 or 1985. This is to indicate the firm or publication is new and possibly more open to freelance photographers.

•Be aware that reporting time and payment rates may vary from the listing in this directory. This may happen if a change in management occurs after our publication date and new policies are established.

•The number or percentage of jobs assigned to freelance photographers or the

number of photos bought gives you an idea of the size of the market.

•Editorial descriptions and client lists appear in listings to help you slant your

photography toward that specific business.

•Label each submission you send to a potential buyer with your name and address; tell whether you want your work returned; and enclose all transparencies

in slide sheets for easy mailing and review.

•If a market does not return unsolicited material, we have specified such. It is always professionally wise whenever corresponding, to include a self-addressed, stamped envelope (SASE) for a reply. If you are expecting the return of material, especially slides or a portfolio, be sure that sufficient postage and proper packaging are included. If you live in the United States and are soliciting foreign listings, purchase International Reply Coupons (IRC) at your local post office to cover your postage.

•When a market states that it requires model releases for identifiable people, get them. A photo may meet a photo editor's needs exactly, but if he doesn't have model releases the photo is useless to him. Even if a market states that model releases are optional or preferred, it's always a good idea to have them in hand when

you submit photos.

•Markets that accept previously published work (especially in publications) state it in their listings. Otherwise they do not accept these submissions.

•If a listing requests samples, we have tried to specify what types of samples it prefers. If the listing states it will keep material on file for possible future assign-

ments, make sure your material easily fits the average 81/2x11" file.

•If a listing instructs you to query, please query. Do not send samples unless that is what they want you to do. Some listings tell you to query and then list what type of samples they prefer. This does not mean to send samples. It is simply added information so that when you have further contact with them, you will have an idea of what type of samples to submit if they do ask to see them.

•Note what rights the listing prefers to purchase. If several types of rights are listed, it usually means the firm will negotiate. But not always. Be certain you and the

photo buyer understand exactly what rights you are selling.

•Many firms work on assignment only. Do not expect them to buy the photos you send as samples. When your photos fill a current need, they will contact you.

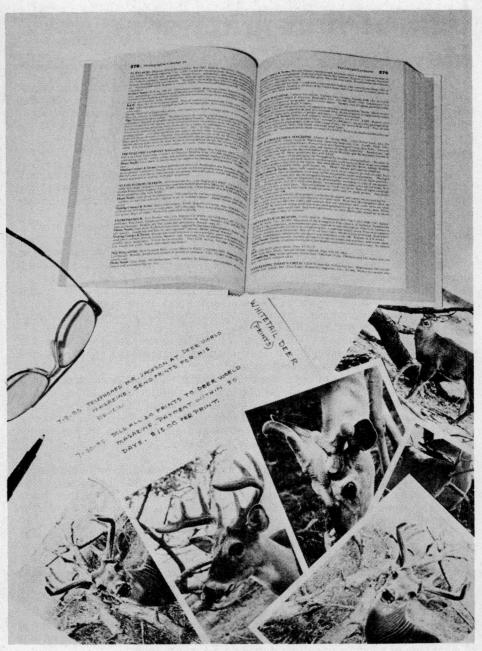

One secret to successfully marketing your photos is to submit a properly prepared photo package. Make sure your photos match the needs of your clients; label your photos with your name, address, and phone number; package them in material which will make viewing easier for the editor; provide detailed caption information and include a self-addressed, stamped envelope, says freelance photographer Bob Grewell.

The Best Way to Sell Editorial Photos_____

BY BOB GREWELL

Wouldn't you like to take advantage of the vast needs of today's photographic markets? Needs exist all around you—from the most casual rural town in any part of the country, to the hectic pace of our sprawling metropolitan cities. Remember those huge illustrated roadside billboards you read on your way to work? Or consider the uncountable picture-wrapped food containers in every grocery store. Don't forget the flood of daily newspapers and magazines that require photographic support. Even items as simple as greeting or birthday cards. Editorial photographs are a significant visual stimuli to everyone's lives, and there's no reason you shouldn't cash in on this diversified field of profit.

The Right Way

If you're at all interested in selling your photographs, the best way is the *right* way. The key to successfully selling hinges upon the proper technique of preparing the images, carefully selecting a market and submitting your material to a potential buyer in a professional manner. You might have a superb selection of prints or transparencies which could earn you big dollars, but if you assemble them improperly, choose the wrong market, or package them incorrectly and they are damaged in transit, you've earned nothing and instead, cost yourself a lot of time and money.

The Reality of Rejection

Freelance photography is a highly competitive field and you will have to accept the fact that throughout your career you will receive many rejections. Competition and rejection are ingredients to be dealt with in achieving your marketing success. They can be conquered by approaching them correctly. You can succeed if you are critical of your work and you develop a *never-give-up* attitude.

Five minutes of your time now can save you \$500 later. A cliche maybe, but by familiarizing yourself with each editorial market you submit to, you can minimize your rejections. Also, find out the buyers' submission procedures and adhere to them. Editors have guidelines for reasons. Buck their standards or requirements and you'll be cutting your own throat.

Target Your Markets

Target your markets carefully. Nothing irritates photo editors more than to receive photos which don't meet their needs. It wastes their time and money, as well as yours. If you're guilty of doing this with the same editor more than once, he isn't likely to forget your carelessness.

One way to keep in touch with current editorial photo trends is by reading several issues of each magazine. Study the photos in the ads, the various illustrated articles and all the pictures. Each issue will abound with photos. In fact, magazines constantly struggle to select the perfect eye-catching cover photo that will instantly

Freelance photographer **Bob Grewell** specializes in wildlife photography and has had his photos published by Field & Stream, Sports Afield, Modern Photography and Petersen's Photographic. He has written the book The Modern World of Raccoon Hunting. His second book, on whitetail deer, will be published by Prentice Hall in 1986.

grab the reader's attention. Exciting covers and lead photos increase potential reader interest in the magazine. If a magazine hooks readers during those first few seconds they're browsing at a newsstand, the chances are greater that they'll buy. Use the information in your *Photographer's Market* listings for specific editorial requirements. You'll want to know, for example, which editors only buy color slides and which editors will accept black and white prints.

Be absolutely certain to submit your work on a timely basis. In other words, if the images are seasonal or holiday related, your photos need to be in an editor's hands months before their potential use. Most photo editors require a 5- to 6-month lead time; send out your selection of Christmas photos in June. If an editor is interested,

he will have plenty of time for decision and use.

Are your pictures technically correct? In other words, do they match the format of the subject? You wouldn't want to stage a beautiful color slide of a desert cactus with a contrasting snowy background, unless you were doing it for creative reasons. Match the subject to its surroundings. The editor you're approaching will be pretty astute of his subject matter and he'll spot a falsity of this nature right away. If he doesn't, his readers will.

Editing Your Work

Each time you scrutinize photographs for possible sale, edit prudently. It's far better to send a smaller number of crisp, clear, sharp photos than a quantity of good

photos mixed with mediocre ones. Quality always overrides quantity.

Edit your work as if you were in the editor's seat and buying from someone else. Try to think like an editor. His job depends upon his careful selection of photos, just as your sales depend upon your careful selection of your own photos. Use your imagination; choose a selection that applies to the theme but which is unique or different. Don't send an editor a group of photos of practically all the same pose or composition. You can use the same subject but vary the angle, distance, background or lighting. The more critical you are of your work, the better your chances are of selling. The golden rule to use when editing your photos is: When in doubt—don't send.

Whether you're submitting one photo or a selection always send a cover letter explaining your intentions. Never handwrite an introductory letter, use a typewriter.

Keep copies of your correspondence for your files.

In a businesslike manner, describe what you've submitted, the quantity and whether you're submitting on request or speculation. Indicate whether you're selling your photos as a group or individually. Also, tell the editor that they should be returned to you if they aren't used. And don't forget to include a SASE. These points are important because they enable an editor to interpret your intentions, and leave no room for misunderstandings. Your submissions will be accepted more readily, too.

Whenever you submit your photos, keep records of all your mailings, correspondence or telephone calls in a single manila business folder, labeled for each submission. Record the date of the mailing, to whom you submitted, whether the photos were accepted or returned, and the income derived from any sales. These records don't need to be taken care of by a certified public accountant; you can keep accurate handwritten details and figures for your files.

Package Your Photos Correctly

I once hand-delivered an important selection of prints to a magazine editor. While discussing methods and requirements photographers must use to market their photos, he condemned a freelance submission scattered on his desk. The photographer had mailed loose slides in a plain envelope, and they could have been damaged in the mail. They were in no logical order for viewing—forty color slides of three different subjects were all intermingled. It was confusing to study them for

possible purchase, and it angered the editor. The photographer's failure to package his work properly cost him a sale.

Even though you're dealing with fewer pieces than in stock photo submissions, packaging is still very important and performs two distinct roles. The correct procedure protects your products and, when undertaken properly, gives initial visual appeal to the potential buyer. That first impression can often be the leverage you need to catch a busy editor's eye.

When mailing any photos take great care to protect them from loss or damage. Prints in quantities of 10 to 20 can be mailed in a 9x12 manila envelope, backed with a stiff piece of cardboard. The cardboard stiffener helps keep the mailer from being bent or folded in transit. Larger quantities of prints should be sent in a sturdy box.

Each photo should be permanently marked in ink with your name, address and telephone number. Have a rubber stamp made and stamp the back of each print, or the side of each cardboard slide holder. If you don't identify your photos, they can become just another photo slush pile casualty. You must send a self-addressed, stamped envelope (SASE) and indicate you want your work returned. A busy photo editor isn't going to waste time guessing if you want your work returned or ferreting out anonymous photographers, packaging their work and returning the photos at his company's expense.

An important step is to purchase clear plastic slide holders for mailing and filestoring your slides. These sleeves protect each slide, keep them in a logical order and make viewing easier for an editor. These relatively inexpensive sleeves can be purchased at any camera supply store and can accommodate all sizes of slides and

prints.

A recommended procedure when submitting color slides is to have copies made of each slide you will be circulating, especially valuable transparencies which would be difficult to reshoot. When you submit slides be sure to indicate that you have sent copies, and if the editor is interested in buying your work you can supply the originals. Unless, of course, the copies have been reproduced well enough that the quality satisfies your buyer. By keeping the originals and submitting copies with a clear understanding that the editor has received copies to review, you protect your product.

Don't Send Negatives

Minor initial safeguards can eliminate future problems. For instance, don't send your negatives to an editor. These are yours, your property, your protection against theft or loss. If your prints are misplaced or used by an editor and you're not paid or there's some question as to the ownership of the photographs, you'll have your negatives for proof or financial recourse. The only time your negatives should ever be released is when the buyer is willing to pay the price for them, or you have dealt with the editor on several occasions and you trust his integrity. Your negatives are your insurance policy.

When mailing your photos, write "PHOTOGRAPHS-DO NOT BEND" in red ink on the outside of the mailer. Or you can have a rubber stamp made and brand the envelope in red ink. Also, stamp the warning on the SASE you've included with your photos. Send your mailers either "first class," "certified," or by "registered" mail. First class assures quicker delivery. Certified costs a little more, but the receiver must sign for the package as proof of delivery. Registered mailing costs still more, but the parcel is signed for upon delivery and is insured against loss or damage. The decision is determined by your budget, but it never hurts to play it safe by insuring your photos.

Promote Yourself

"How do you sell photographs to numerous markets all over the country without an agent?" is frequently asked.

8 Photographer's Market '86

There's only one conceivable way to do it on your own. You have to promote yourself through constant exposure. An editor 400 miles away won't be aware of your photos unless you contact him by letter or telephone, or mail your work to him.

Make yourself known.

And what about stock photo agencies? By using these photo holding houses you could gain a greater range of potential exposure. After your work has been filed with an agency, however, the photos will sometimes leave visual circulation. This can especially be the case with agencies which handle more photos and photographers than they have time for. Stock agencies can work for you, but if you don't circulate large quantities of photos or you work on a limited budget, they'll not be to your best advantage. If you ever do agree to an arrangement with a photo agency, beware of those who want to hold your photographs on speculation for extended periods of time without any payment. Set a firm deadline for their return if they aren't used within a specific time limit.

Making Sales

It's a fact that too many sales are lost because photographers fail to send out their work. Of course, I'm not suggesting that you should package up any selection of photos and send them anywhere. If you expect to make consistent sales you have to study the markets, select quality photos, and submit them professionally. Then you'll become fully aware that the right way to sell your work to photo editors is simply a matter of common sense, courtesy and persistence.

Picque nec unit from tup control of toelees ware tubble est filt is general these ear

Creating a Profitable Stock Photography Business_____

BY NADINE ORABONA

If you're like many photographers who buy *Photographer's Market*, you'll skim through some listings, send out several query letters, get some responses, and then sell a few pictures. If occasional sales are all you're looking for, this is fine, but if you want to make MONEY in this business, you'll have to put a very serious effort into your marketing. You must find the buyers, send out submissions, and sell many photos on a regular basis. This requires organization, a large file of stock photos, and a professional appearance.

Getting Ready to Market

Before you do any serious marketing, compile a stock list of the subjects in your photo file. Your photo file may not yet be well organized, like those of many photographers just starting to sell. Organize now, because once your business gets underway, you'll have to be able to pull and file your photos quickly and routinely.

First, decide how to file your pictures. If you store transparencies in Kodak boxes or stacks of slide trays, it will take a long time to find or refile them. Although many photographers keep their slide sheets in three-ring binders, once your slide collection gets above 5,000, you'll need numerous binders. Repeatedly yanking open those rings becomes a nuisance. Plastic slide sheets will store your transparencies so you can find them easily. The sheets, arranged in a file, will allow you to review 20 slides at a time.

Store your slide sheets in file folders, with one folder per subject, and then group similar subjects together in a larger, hanging folder. This system also works well for black and white prints. The filing cabinet method of storing makes it easy for you to find a subject, view it, pull the necessary pictures to send out, and then refile them when they're returned. If you're running a successful stock photography business, you'll be pulling and filing hundreds of pictures a day. So these time-saving methods will make this part of your job much simpler.

There's no perfect system for organizing your photos—only the one which works for you and the subjects you photograph and sell. If you photograph a variety of subjects, a simple alphabetical system would probably be best. If you specialize, then you might want to organize your photos in a way which works for your specialty. For instance, I have several file drawers devoted to animal photos, which I file by their scientific classification: My koalas and kangaroos are filed under "marsupials" and my seals and walruses under "pinnapeds." If you're a travel photographer, group your photos by country and then city or area within the country and, finally, by landmark or point of interest.

Once your filing system is organized, compiling a stock list is easy. Either list your subjects alphabetically or by major category. In a major category such as "animals," list all your animal pictures regardless of where they are filed. List only those subjects which have enough representation in your files. I don't bother to list a subject unless I have at least twenty transparencies. People buying from a stock list

B. Nadine Orabona, a graduate of the School of Modern Photography is a freelance photographer who specializes in animal and nature photography. She is also a professional computer consultant with seventeen years' experience in the analysis, design, and implementation of data processing systems for business.

Her photographs have been published in such magazines as National Wildlife, International Wildlife, Animal Kingdom, and Flight. She is also the author of The

Photographer's Computer Handbook.

want to see a number of pictures on the subject they need.

The next step is to have professional-looking stationery and envelopes. You'll be taken more seriously if your correspondence is typed on businesslike letterhead. You'll need more items later when you start to send out photos, but for now this is enough.

Locating Potential Clients

The next step is to locate potential clients, and *Photographer's Market* is a good place to start. The potential buyers listed have already said they're interested in buying photos and have specified what photos they need, how to be contacted, and often what they're willing to pay. Go through this book cover to cover and mark those buyers who are interested in the types of photos you have. Don't concentrate only on the glamour markets, such as the calendar companies, but look under audiovisual and company publications, too.

You may also want to subscribe to newsletters such as the *Photographer's Market Newsletter* (9933 Alliance Rd., Cincinnati, OH 45242), the *Photoletter* (Osceola, WI 54020) and, if you're a nature photographer, *The Guilfoyole Report* (AG Editions, Inc., 142 Bank St., New York, NY 10014). Newsletters not specifically directed to photographers, but covering your market area, can also be a good source of potential photo buyers. *The Travelwriter's Marketletter* (Suite 1745, Plaza Hotel, New York, NY

10019) is a good source of clients interested in travel photos.

If you own a home computer and have a modem (a device allowing you to communicate with other computers by telephone), you can subscribe to PHOTONET (250 W. 57th St., New York, NY 10019). Photo buyers publish their current picture needs on PHOTONET, and you can advertise your picture specialties and travel

plans.

For additional source information for specialized photography needs, you can find in your library's reference section several directories listing hundreds of possibilities for your photos. Among these directories are the *Gift and Decorative Accessory Buyers Directory*, which lists more than 200 businesses that produce calendars, posters and greeting cards; the *EL-HI Textbooks in Print*, which lists hundreds of textbook publishers; *Writer's Market*; *Literary Market Place*, full of all types of book publishers; and the *Magazine Industry Market Place*, listing every imaginable magazine publisher. Don't overlook the Yellow Pages of major cities' phone books. Ask your librarian for other suggestions.

In using these other directories, however, remember that, unlike clients listed in Photographer's Market, these clients may NOT be interested in buying photos from freelance photographers. So your initial market effort will be to contact them and

discover whether they are interested in buying photos from you.

To do this, prepare a query letter. Your query need not be lengthy. It just introduces you and asks whether clients would be interested in buying photos from you. State your specialty, if you have one, tell them the number of photos in your file so they'll know you can provide a variety of pictures, and list your publication credits. Don't list each and every publication. Mention any prestigious ones; otherwise, just say your pictures have been published on calendars, greeting cards, in magazines, or whatever you have to your credit. Type a query for each name you've collected from your directory research and enclose a copy of your stock list. I also enclose a self-addressed, stamped post card on which th client can check whether he's interested in buying pictures from me. Post cards, easy to send back, increase the response rate and help me build a file of interested clients and eliminate those who aren't interested. Very few clients will immediately ask for pictures. Sometimes it isn't their buying season, or they buy only when they're starting a new project, or they may have just completed buying all the pictures they need. Keep their names on file, just the same.

Use a Computer

Does this seem like a lot of work? You're right. But a computer can simplify the whole process. If you have a minicomputer, you can buy a software package including word processing, file management, and merge capability. Word processors work much like a typewriter, except that your text is processed in the computer's memory and stored on a disk. You can easily change your text, and you can print it as many times as you wish on the computer's printer. You can also use a word processor to prepare your query letter and stock list. A file management system will store those names and addresses you've collected from the directories. The software merges these names and addresses with the query letter, and your printer then prints what appears to be individually-personalized letters to each potential client. When your post cards come back, delete from your file the names of clients who weren't interested. It's important to weed your files this way because you will be sending follow-up mailings to your hottest prospects, and you don't want to waste your time and postage.

Follow-up

After the initial mailing, you'll get some immediate picture requests, some responses from clients interested in buying pictures from you later, and some rejections. Some clients never answer. Although you'll be more pleased with the immediate requests, don't forget those clients who were only interested. Most of your potential clients will file your stock list and forget about it—even those who actually bought pictures. The best strategy is to send all of them updates of your stock list on a regular basis. I usually send a new stock list to my potential stock clients each quarter, and I've made several sales because my stock list crossed a client's desk at the right time. It was easier for them to contact me than to dig through all those old stock lists. This is where your computer is really invaluable. Write a new letter, update your stock list, and merge the letters with your weeded file again. Help your customers keep your name and your photos in mind.

Preparing Pictures for Clients

What do you do so you're ready when picture requests start arriving? First, caption your pictures. Each one should have subject identification, your copyright notice, your name and address, and a stock number. I put the identification and name and address information on the wide margins of my slides, and my stock number and copyright notice on the narrow margins. Why all this information? The subject identification increases your picture's value. Plants and animals must be identified by their common and scientific names. If you shoot travel, you must identify the subiect and its location. Pictures are often used in magazines and books, and this identification tells the editor what the subject is and how to write the caption. Don't expect the picture buyer to recognize subjects; you're the expert. The copyright notice establishes your ownership and should contain a © followed by your name and a date. I use Roman numerals because they're harder to read: My pictures won't appear obviously dated (1986 would be MCMLXXXVI). Have two rubber stamps made for the date and for your name and address. Your pictures could become separated from your package, and your name and address ensures their return. You'll also need a unique number to identify individual pictures. The client will refer to your pictures by their numbers, and you'll be able to know, for instance, which of your 200 sunsets is being used. If you sell black and white prints, put all this information on a label on the back of the print.

I put my slides in individual Kimac protectors (478 Long Hill Rd., Guilford, CT 06437) and then package them in plastic slide sheets. When the picture buyer pulls out a slide for review or decides to use a slide, it will still be protected. Although picture buyers are normally careful about the way they handle photos, do all you can to

assure that your pictures are well protected.

After assembling the pictures for submission, I list those I'm sending to a client and then write a letter indicating how many pictures are enclosed, what they cost, and what limitations I set on their use. I file one copy and send another with the submission. Rather than taping everything between cardboard protectors. I put the photos and paperwork in a Calumet cardboard mailer, SASE (Box 405, 16920 State St., South Holland, IL 60473). I then put the whole package in a large envelope. Some schools of thought recommend sending stamps or a check for the return postage, but this can be a real nuisance to the picture buyer. My method insures getting my package back in one piece, since my unsold pictures will probably stay in my self-addressed, stamped mailer. Once I'm established with clients, they generally pay the postage, but I provide the self-addressed mailer. Send the package first class certified mail with a return receipt. The return receipt will give you the peace of mind of knowing your package has been received. There's no point in insuring your package. The post office will only insure it up to \$400—hardly the value of several hundred of your best pictures.

Properly packaging your photos will insure their undamaged return. It will also make you look like a professional. Picture buyers are only human—when they see a sloppily-prepared package, they are very likely to assume that the pictures are not worth bothering with. You may feel that all this work is unnecessary and that your fantastic pictures will speak for themselves. But you're not the only photographer submitting pictures. If others' packages look better and more professional than yours, theirs are going to be opened first. A properly packaged shipment with a professional appearance can give you the selling edge.

Teaming Up with Other Photographers

When your picture requests start arriving, unexpected problems will develop. There will be requests for photos you don't have. As you fill requests, you may start running out of photos of certain subjects, partly because clients can hold onto pictures for a long time, leaving you with less on hand. You want to be able to send out a large selection. For example, one month I had numerous requests for photos of the Grand Canyon, waterfalls, and sunsets—and I never thought I'd run out of sunsets! One solution is to shoot a lot of photos of every subject. Another solution is to share marketing and picture files with other photographers.

You probably know freelance photographers who are running into the same problems. If you combine your picture file with theirs, you'll all have more subjects to offer clients and more pictures on any given subject. Doing this could even put you competitively in the same league with moderately-sized stock photo agencies. You could also share some of the marketing work, since you're probably duplicating

the other freelancers' efforts.

You can approach this teamwork in several ways. You can relay to other free-lancers picture requests you can't fill yourself. If the freelancer sells one of his pictures to a market you found, he could pay you a commission of something like 10%. You could make it a little more formal by sharing work and sending out a joint stock list. You could also form a mini-agency where one does all the marketing work for several freelancers and receives a 50% commission on all pictures sold. Each photographer would maintain his own picture file, so that it wouldn't be like burying all your prize photos among the thousands in the files of a stock photo agency.

To have a profitable stock marketing business remember to organize so that you can work efficiently, to make a serious marketing effort, and to look professional.

The rest is up to your pictures.

The Markets

Advertising, Public Relations & Audiovisual Firms

Photography for advertising, public relations, and audiovisual uses is probably the most lucrative of all freelance markets—as well as the most competitive.

The advertising photographer is almost a cliche character in the minds of many, but in truth, there are many different kinds of photographers who would fit that description. Most advertising photographers work in their own studios, where they have the equipment and resources to create virtually any illusion their clients need—from sandy beaches to extraterrestrial landscapes. Such photographers, who are responsible for most of the advertisements you see in magazines, on billboards, and, to some extent, on television, have thousands of dollars invested in large-format (4x5 and 8x10) cameras, sophisticated lighting systems, and other expensive gear; they must also employ the services of one or more assistants, modeling agencies, scenery and "prop" suppliers, and fashion and makeup stylists.

If all this sounds expensive—and it is—the potential rewards of success in this market make it all worthwhile. The American Society of Magazine Photographers (ASMP) suggests a price of at least \$3,000 for a two-page color advertising photograph used in a national magazine, and that's just for the one picture itself—advertising photographers routinely pass along most or all of their production costs to the ad agencies who hire them while the agencies, of course, pass their costs, plus a

profit, on to the companies who hire them.

Of course, no photographer, no matter how good, starts at the top of so competitive a market. It's quite possible to get started in advertising photography using your existing 35mm gear and without your own studio. All kinds of businesses, even the smallest, do at least some type of advertising from time to time—and such small, local companies may not want to go to the bother and expense of hiring an ad agency, preferring instead to deal directly with local freelance copywriters and photographers. You almost certainly know businesspersons in your area who could use the talents of a skilled photographer to help promote their products or services, and many more such potential clients are as close as the Yellow Pages. Also see the Businesses and Organizations section in this book.

But whether you're dealing with clients directly or through the advertising agencies listed in this section, you'll need to promote yourself and your photography in the most professional, businesslike manner possible. The promotional tool in this market is the *portfolio*: usually an oversize, leather-bound book (available in art supply stores) whose pages are plastic sheets containing your best—and only your best—photographs. Such book-style portfolios are especially effective for presenting large color and b&w prints, as well as tearsheets (actual copies) of advertising or

related work you've done. Some ad agencies will prefer to view transparencies (slides) of your best color work; a slide portfolio usually consists of a carousel of transparencies compatible with most carousel-type projectors. Whatever form you choose for your portfolio, the key to making it effective is to slant its contents toward the needs of the potential client you'll be showing it to. A photographic portfolio is not a fixed object. For example, while a manufacturer of machine tools might find your fashion layouts spectacular, chances are he'll hire a photographer whose in-

dustrial work more closely matches the kind of images he needs.

Photography for purposes of public relations (PR), also called publicity, is a mixed bag of styles and subjects which occupies a grey area between the overt sales-oriented approach of advertising, and the objective, documentary-style approach of editorial photography. Although most PR photography is intended for publication in newspapers, magazines, and other print media such as company organs and annual reports, it differs from straight photojournalism in that it must conform to the particular, deliberate viewpoint or purpose of whoever is paying for it—whether the buyer is a public relations firm working on behalf of a client, or the company, organization or individual himself. Such buyers use PR photography to present themselves in a positive light designed to incur public favor or goodwill. For the photographer who is not averse to letting the customer "call the shots," PR work can be a steady and rewarding source of income.

Many markets for publicity photography are detailed in this section: PR firms which specialize in such work, and ad agencies which also offer public relations services. Aspiring publicity photographers will also find a related market in the Company Publications section of this book; many editorial photographers supplement their incomes by taking on assignments for companies which publish their own magazines. And, of course, there are businesses and organizations in need of

favorable publicity just about everywhere.

The audiovisual (AV) media—filmstrips, slide/sound shows, multimedia kits, film, video and others—are used for many of the same purposes as advertising and public relations, as well as for documentation, education, entertainment and a host of other purposes. Photographing for these media demands that you produce technically perfect images; that you understand and can handle a wide assortment of audio, video and still-image equipment; and, most important, that you can conceptualize beyond the single, static picture and produce a series or sequence of images

which tell a story or convey a great deal of information.

Although not all audiovisual photography is in the form of moving pictures—film and video—it does all *move*: from image to image, from sound to sound, from idea to idea. And the technology of AV is also moving, as it learns and borrows from advances in computer, laser, fiber-optic, and disc technologies. At the moment, as any cable television subscriber knows, *video* reigns as the medium of choice in the entertainment industry, and its use is also on the rise in education, among corporations for employee recruitment and training, for the documentation of weddings and other special events, and in an assortment of other ways. Some photographers, including more than a few top advertising photographers, are turning to video as a new and potentially even more lucrative alternative to traditional still photography. And while the market for freelance video may not yet rival that for photography, the tremendous increase in the public appetite and applications for video certainly make it worth thinking about—if not investing in—for freelancers with an eye on the future.

Alabama

BARNEY & PATRICK ADVERTISING INC., 306 St. Francis St., Mobile AL 36601. (205)433-0401. Ad agency. Associate Creative Director: George Yurcisin. Senior Art Director: Barbara Spafford. Clients: industrial, financial, medical, food service, shipping.

Needs: Works with 5-10 freelance photographers/year. Uses photographers for billboards, consumer

magazines, trade magazines, direct mail, brochures, posters and newspapers. Also works with freelance filmmakers to produce "TV spots-videotape and 35mm."

Specs: Uses 8x10 and 11x14 glossy b&w prints, 35mm, 21/4x21/4, 4x5 and 8x10 transparencies; 35mm

film and videotape.

First Contact & Terms: Arrange a personal interview to show portfolio or query with samples. Does not return unsolicited material. Reports in 2 weeks. Payment "varies according to budget." Pays on acceptance. Buys all rights. Model release required.

Tips: Prefers to see "slides and prints of top quality work, on time and within budget."

J.H. LEWIS ADVERTISING, INC., 105 N. Jackson St., Drawer 3202, Mobile AL 36652. (205)438-2507. Senior Vice President/Creative Director: Larry Norris. Ad agency. Uses billboards, consumer and trade magazines, direct mail, foreign media, newspapers, P-O-P displays, radio and TV. Serves industrial, entertainment, financial, agricultural, medical and consumer clients. Commissions 25 photographers/year. Pays/job. Buys all rights. Model release preferred. Arrange a personal interview to show portfolio; submit portfolio for review; or send material, "preferably slides we can keep on file," by mail for consideration. SASE. Reports in 1 week.

B&W: Uses contact sheet and glossy 8x10 prints. Color: Uses 8x10 prints and 4x5 transparencies. Film: Produces 16mm documentaries. Pays royalties.

Arizona

FARNAM COMPANIES, INC., 301 W. Osborn, 2nd Floor, Phoenix AZ 85013-3928. (602)285-1660. Inhouse ad agency. Creative Director: Trish Spencer. Clients: animal health products, primarily for

horses and dogs; some cattle.

Needs: Works with 2 freelance photographers/month. Uses photographers for direct mail, catalogs, consumer magazines, P-O-P displays, posters, AV presentations, trade magazines and brochures. Subject matter includes horses, dogs, cats, farm scenes, ranch scenes, cowboys, cattle and horse shows. Occasionally works with freelance filmmakers to produce educational horse health films and demonstrations of product use.

Specs: Uses 81/2x10 glossy b&w and color prints; 35mm, 21/4x21/4 and 4x5 transparencies; 16mm and

35mm film and videotape.

First Contact & Terms: Arrange a personal interview to show portfolio; query with samples; send unsolicited photos by mail for consideration; provide resume, business card, brochure, flyer or tearsheets to be kept on file for possible future assignments. Works with freelance photographers on assignment basis only. SASE. Reports in 2 weeks or per photographer's request. Pays \$25-75/b&w photo; \$50-300/color photo. Pays on publication. Buys one-time rights. Model release required. Credit line given whenever possible.

Tips: "Send me a number of good, reasonably priced for one-time use photos of dogs, horses or farm scenes. Better yet, send me good quality dupes I can keep on file for rush use. When the dupes are in the file and I see them regularly, the ones I like stick in my mind and I find myself planning ways to use them. We are looking for original, dramatic work. We especially like to see horses, dogs, cats and cattle captured in artistic scenes or poses. All shots should show off quality animals with good conformation. We rarely use shots if people are shown and prefer animals in natural settings or in barns/stalls."

*GO-VIDEO, INC., Suite 201, 4160 N. Craftsman Ct., Scottsdale AZ 85251. (602)994-5547 or 256-0778. Contact: Richard Lang or R. Terren Dunlap. Clients: business, industry, consumer.

Needs: Works with 4-8 video producers/month. Subjects vary.

Specs: Open.

First Contact & Terms: Query with samples; provide resume, business card, self-promotion piece or tearsheets to be kept on file for possible future assignments. Works with freelancers by assignment only; interested in stock photos/footage. Does not return unsolicited material. Reports in 1 month. Pays/job. Pays on acceptance. Buys all rights. Model release required. Credit line sometimes given.

PAUL S. KARR PRODUCTIONS, Utah Division, 1024 N. 250 East, Orem UT 84057. (801)226-8209. Vice President: Michael Karr. Film & tape firm. Clients: industrial, business, education. Works

with freelance filmmakers by assignment only.

Needs: Uses filmmakers for motion pictures. "You must be an experienced filmmaker with your own location equipment, and understand editing and negative cutting to be considered for any assignment. We produce industrial films for training, marketing, public relations and government contracts. We do high-speed photo instrumentation. We also produce business promotional tapes, recruiting tapes and

instructional and entertainment tapes for VCR and cable."

Specs: Produces 16mm films and videotapes. Provides production services, including inhouse 16mm processing, printing and sound transfers, scoring and mixing and video production, post production, and film to tape services.

First Contact & Terms: Query with resume of credits and advise if sample reel is available. Pays/job; negotiates payment based on client's budget and photographer's ability to handle the work. Pays on production. Buys all rights. Model release required.

JOANNE RALSTON & ASSOCIATES, INC., 3003 N. Central, Phoenix AZ 85012. (602)264-2930. Vice President: Gail Dudley. PR firm. Clients: financial, real estate developers/homebuilders, industrial, electronics, political, architectural and sports.

Needs: Works with 3-4 freelance photographers/month on assignment only basis. Provide flyer, rate sheets & and business card to be kept on file for possible future assignments. Uses freelancers for

consumer and trade magazines, newspapers and TV.

First Contact & Terms: Call for personal appointment to show portfolio and send resume. SASE. Reports in 1 week. Prefers to see tearsheets, 8x10 or larger prints and most important b&w contact sheets of assignment samples in a portfolio. Freelancers selected according to needs, cost, quality and ability to meet deadlines. Pays \$35-80/hour; \$250-500/day. Negotiates payment based on client's budget, amount of creativity required from photographer, where the work will appear, complexity of assignment, and photographer's previous experience/reputation. "We try to work within ASMP rate structure where possible." Pays within 30 days of completed assignment.

Tips: "When interviewing a new photographer we like to see samples of work done on other

assignments-including contact sheets of representative b&w assignments.'

WETTSTEIN/BOLCHALK ADVERTISING & PR, (formerly Wettstein Advertising, Inc.), 620 N. Craycroft Rd., Tucson AZ 85711. (602)745-8221. Senior Art Director: Mary Alice Keller. Ad agency. Clients: retail and home building firms, savings institutions, travel.

Needs: Works with less than 10 freelance photographers/year on assignment only basis. Uses photographers for billboards, consumer and trade magazines, direct mail, P-O-P displays, brochures, catalogs, posters, signage, newspapers and AV presentations.

First Contact & Terms: Provide brochure to be kept on file for possible future assignments; arrange interview to show portfolio. Works primarily with local freelance photographers. SASE. Reports in 2 weeks. Negotiates payment by the project.

Tips: "We prefer to see original material and products related to advertising. Most formats are

acceptable.

Arkansas

BEDELL INC., 521 N. 6th St., Box 1028, Fort Smith AR. (501)782-8261. Ad agency. Creative Director: Bob Gisler. Production Schedules: Jean Woods. Clients: industrial, finance, retail, services. Needs: Works with 3 freelance photographers/month. Uses photographers for billboards, direct mail, catalogs, newspapers, consumer magazines, P-O-P displays, posters, AV presentations, trade magazines, brochures and signage. Also works with freelance filmmakers to produce training or inductory films.

Specs: Use "depends on each job and the needs for that job."

First Contact and Terms: Arrange a personal interview to show portfolio; provide resume, business card, brochure, flyer or tearsheets to be kept on file for possible future assignments. Works with freelance photographers on assignment basis only. Does not return unsolicited material. Reports in 2 weeks. Payment "depends on requirements of job." Pays on acceptance. Buys all rights. Model release required. Credit line given depending on job.

BLACKWOOD, MARTIN, AND ASSOCIATES, Box 1968, 31 East Center, Fayetteville AR 72702. (501)442-9803. Ad agency. Art Director: Cheryll Martin. Clients: food, financial, medical, insurance, some retail. Client list provided on request.

Needs: Works with 3 freelance photographers/month. Uses photographers for direct mail, catalogs, consumer magazines, P-O-P displays, trade magazines and brochures. Subject matter includes "food shots-fried foods."

Specs: Uses 8x10 high contrast b&w prints; 35mm, 4x5 and 8x10 transparencies.

First Contact & Terms: Arrange a personal interview to show portfolio; query with samples; provide resume, business card, brochure, flyer or tearsheets to be kept on file for possible future assignments. Works with freelance photographer on assignment basis only. Does not return unsolicited material. Reports in 1 month. Payment depends on budget-"whatever the market will bear." Pays on

acceptance. Buys all rights. Model release preferred.

Tips: Prefers to see "good, professional work, b&w and color" in a portfolio of samples. "Be willing to travel and willing to work within our budget. We are using less b&w photography because of newspaper reproduction in our area. We're using a lot of color for printing."

FRAZIER IRBY SNYDER, INC., 1901 Broadway, Box 6369, Little Rock AR 72216. (501)372-4350. Ad agency. Senior Vice President Creative: Pat Snyder. Clients: industrial, fashion, finance, entertainment.

Needs: Works with 3 freelance photographers/month. Uses photographers for consumer and trade magazines, direct mail, P-O-P displays, brochures, catalogs, posters and newspapers. Also works with freelance filmmakers to produce TV commercials and training films. "We have our own inhouse production company named Ricky Recordo Productions with complete 16mm equipment."

Specs: Uses 8x10 b&w prints; 21/4x21/4 and 4x5 transparencies; 16mm film and videotape.

First Contact & Terms: Query with list of stock photo subjects; provide resume, business card, brochure, flyer or tearsheets to be kept on file for possible future assignments. Works with freelance photographers on assignment basis only. Does not return unsolicited material. Reports in 3 weeks. Pays \$35-75/hour; \$200-500/day. Pays on acceptance. Buys all rights. Model release required. Credit line "sometimes given, if requested."

Tips: "Prefers to see samples of best work. Have good work and creative input."

California

AMVID COMMUNICATION SERVICES, INC., Box 577, Manhattan Beach CA 90266. (213)545-6691. President: James R. Spencer. AV firm. Clients: hospital, restaurant, corporation.

Needs: Buys about 500 photos and 20 filmstrips/year from freelance photographers. Uses photographers for slide sets, filmstrips and videotape. Subjects include employee training and orientation.

Specs: Requires 35mm for filmstrips. Produces videotape, 16mm (educational) and 35mm slides (industrial). Uses color transparencies.

First Contact & Terms: Arrange a personal interview to show portfolio; provide resume, calling card and brochure to be kept on file for future assignments. Pays \$300-600/day or by the job; pays 50% to start; 50% upon acceptance. Buys all rights. Model release required.

BAFETTI COMMUNICATIONS, #209, 2423 Camino Del Rio S., San Diego CA 92108. (619)297-5390. Ad agency and PR firm. President: Ron Bafetti. Clients: industrial, finance, technical, consumer, electronics, personalities.

Needs: Works with 1-3 photographers/month. Uses photographers for billboards, consumer and trade magazines, direct mail, P-O-P displays, brochures, catalogs, posters, newspapers, AV presentations. Subject matter "varies widely."

Specs: Uses 8x10 b&w glossy, "some matte" prints, 35mm, 21/4x21/4, 4x5 and 8x10 transparencies.

"Varies widely-we will direct photographer to what we need."

First Contact & Terms: Arrange a personal interview to show portfolio; query with samples; provide resume, business card, flyer or tearsheets to be kept on file for possible future assignments. Works with freelancers on assignment basis only. SASE. Reports in 2 weeks. Pays \$30-75/hour; \$200-300/day; \$100-500 or more/job; "will negotiate fair price on project basis. Payment made to photographer when we are paid by client." Buys all rights, but allows the photographer to retain the negatives. Model release preferred; captions optional. Credit line given "whenever possible."

Tips: Prefers to see "evidence that the person really is a photographer. The market is flooded with rank amateurs. Call me, I love photography/photographers and will look at a portfolio if time permits. We also refer business to worthy freelancers. You might note that 'prima donnas' are not going to make any points in this business. We use only working photographers—people who can deliver what we need. We look for the photographer's ability to do a good start to finish job. We really enjoy working with those who have the ability to take initiative for creative lighting and can make a hum-drum product look 'socko.' Photographers must be able to work within our budget. Many of our clients have restricted ability to buy photography."

BATTENBERG, FILLHARDT & WRIGHT, INC., 70 N. Second St., San Jose CA 95113. (408)287-8500. Vice President/Creative Director: Charles Fillhardt. Ad agency. Clients: highly technical electronics and some consumer firms.

Needs: Works with 3-4 freelance photographers/year on assignment only basis. Uses photographers for billboards, consumer and trade magazines, direct mail, P-O-P displays, brochures, posters, newspapers and AV presentations.

18 Photographer's Market '86

First Contact & Terms: Arrange interview to show portfolio. Payment is by the project; negotiates according to client's budget and sometimes on where work will appear.

RALPH BING ADVERTISING, 16109 Selva Dr., San Diego CA 92128. Production Manager: Ralph Bing. Ad agency. Serves industrial (specializing in ferrous and nonferrous metals, warehousing, stamping, and smelting); and consumer (automotive, political, building and real estate development, food and restaurant) clients. Commissions 1-2 freelance photographers/month on assignment only basis. Provide flyer to be kept on file for possible future assignments. Buys 50-60 photos/year. Pays \$10-250/ photo; \$10-50/hour; \$75-250/day; \$10-250/project. Pays within 30 days of receipt of invoice and delivery of prints. Buys all rights. Model release required. Arrange personal interview to show portfolio; does not view unsolicited material.

B&W: Uses 5x7 prints.

Color: Uses 5x7 prints and 35mm transparencies.

Film: Occasionally produces film for AV presentations and TV commercials. Does not pay royalties.

Tips: "Portfolio should be conveniently sized to be presented on desk or, possibly, lap."

BOOKE AND COMPANY, 2811 Wilshire Blvd., Santa Monica CA 90403. (213)829-4601. Vice President: George Palmer. PR firm. Clients: general and diversified.

Needs: Works with 1 freelance photographer/month. Uses photographers for annual reports, brochures and publicity shots.

First Contact & Terms: Call for appointment to show portfolio. Negotiates payment based on individual job requirements.

Tips: Interested more in ideas and individual style than with the product.

MICHAEL BOWER AND ASSOCIATES, (A Bower Communications Company), Suite 208, 7400 Center Ave., Huntington Beach CA 92647. (213)594-4478; (714)898-2054. President: Michael Bower. Production Manager: Marilyn Rowe. Ad agency & PR firm. Photos used in advertising, publicity, newsletters and brochures. Works with 3-5 freelance photographers/month on assignment only basis. Provide resume and product and architecturals, samples to be kept on file for possible future assignments. Pays \$25-60/hour; \$500-1,000/day; variable payment/job. Terms negotiated as per photographer's request, plus materials or hourly rate depending on experience of photographer. Submit portfolio. Reports in 2 weeks. SASE.

Tips: "We're interested in a fresh approach to typically mundane subject matter."

*CORTANI BROWN RIGOLI, 2073 Landing Dr., Mountain View CA 94043. Ad agency. Senior Art Director: Ruth Kleinjan. Clients: industrial.

Needs: Works with 1-4 photographers/month. Uses photographers for trade magazines, direct mail, posters, data sheets, annual reports, newsletters. Subjects include still life, special effects, people, locations.

Specs: Uses 35mm, 4x5 and 8x10 transparencies.

First Contact & Terms: Send unsolicited photos by mail for consideration; provide resume, business card, brochure, flyer or tearsheets to be kept on file for possible future assignments. Does not return unsolicited material. Pays/job. Pays on 30 days of invoice. Buys all rights. Model release preferred.

CANTOR ADVERTISING, 7894 Dagget St., San Diego CA 92111. (619)268-8422. Ad agency. Art Director: David R. Evans. Clients: retail, credit unions, realty, industrial, medical firms.

Needs: Works with 2 freelance photographers/month. Uses photographers for consumer and trade magazines, direct mail, brochures, newspapers. Needs product-type photos, also uses stock photography.

Specs: Uses 4x5, 8x10 and 11x14 b&w or color prints, 35mm, 21/4x21/4 and 4x5 transparencies. First Contact & Terms: Arrange a personal interview to show portfolio; submit portfolio for review; provide resume, business card, brochure, flyer or tearsheets to be kept on file for possible future assignments. Works with local freelance photographers on assignment basis only. Returns unsolicited material with SASE "only when requested." Reports in 1 week. Payment varies by job. Pays 30 days upon receipt of bill. Buys all rights. Model release required, and all jobs must meet applicable child labor law requirements. Credit line given "rarely."

R.B. CHENOWETH FILMS, 1860 E. North Hills Dr., La Habra CA 90631. (213)691-1652. Owner: Robert Chenoweth. AV firm. Serves clients in industrial business. Produces filmstrips, motion pictures, sound-slide sets and videotape. Buys 1 filmstrip and 6 films/year. Subject Needs: Sales promotion and employee training.

Film: Interested in stock footage. Photos: Uses prints and 35mm.

Payment & Terms: Pays/job. Pays on production. Buys one-time or all rights. Model release required. Making Contact: Submit portfolio. SASE.

CUNDALL/WHITEHEAD/ADVERTISING INC., 3000 Bridgeway, Sausalito CA 94965. (415)332-3625. Partner: Alan Cundall. Ad agency. Uses all media except foreign. Serves general consumer and trade clients. Rights vary. Works with 1 freelance photographer/month on assignment only basis. Provide resume, business card and brochure to be kept on file for future assignments. Pays on a per-photo basis; negotiates payment based on client's budget, amount of creativity required and where work will appear. Send samples. "Don't send anything unless it's a brochure of your work or company. We keep a file of talent—we then contact photographers as jobs come up."

DIMENSIONAL DESIGN, 11046 McCormick, North Hollywood CA 91601. (818)769-5694. Presi-

dent: Wayne Hallowell. Ad agency. Clients: corporations, manufacturers, entertainment.

Needs: Works with 80-95 freelance photographers/year. Uses photographers for brochures, catalogs, posters, AV presentations, newsletters, annual reports. Subject matter covers "all areas." Also works with freelance filmmakers to produce movie titles and training films; "all types dependent on requirement or effects desired by projects."

Specs: Uses 8x10 b&w and color prints; 35mm, 4x5 and 8x10 transparencies.

First Contact & Terms: Arrange a personal interview to show portfolio or submit portfolio for review; provide resume, business card and samples to be kept on file for possible future assignments. SASE. Reports in 2 weeks. Pays ASMP rates per hour or job; approximately \$250/photo color, \$75/photo b&w. AV presentations \$25-50/slide. Buys all rights or one-time rights. Model release and captions preferred. Credit line sometimes given.

Tips: "Know our needs, be professional and understand the message of our client."

DOCUMENTARY FILMS, Box 97, Aptos CA 95003. (408)688-4380. Producer: M.T. Hollingsworth. AV firm. Serves clients in schools, colleges, universities, foreign governments and service organizations. Produces motion pictures.

Subject Needs: Language arts, nature, marine science, physical education, anthropology, dance and special education. Uses freelance photos in series for consideration as possible film treatments. No individual photos designed for magazine illustrations. Film length requirements: 10, 15 and 20 minutes. Prefers 16mm color prints and camera originals.

Film: Produces 16mm ECO originals, color work print, color internegative and release prints. Interested in stock footage. Pays royalties by mutual agreement depending on production stage at which film is

submitted.

Photos: Uses 5x7 and 8x10 color prints and 21/4x21/4, 4x5 transparencies.

Payment/Terms: Pays by mutual agreement. "Royalties if a photographic series or essay is used as the basis for a film treatment. If the concepts are good, and the resulting film successful, the royalties will pay much more than single use rates." Buys all rights. Model release required. Captions required. Making Contact: Send material by mail for consideration. "On first submission, send prints, NOT ORIGINALS, unless requested." SASE. Reports in 2 weeks. Catalog available for \$1.

Tips: "For photos: Have a definite film treatment in mind. Use photos to illustrate content, sequence, continuity, locations and personalities. For films: have a specific market in mind. Send enough footage to show continuity, significant high points of action and content, personalities. Film should be clearly identified head and tails. Any accompanying sound samples should be in cassettes or 5 inch reel-to-reel at 33/4 ips clearly identified including proposed background music."

*EN-LIGHTNING PRODUCTIONS, INC., 4813 Convoy St., San Diego CA 92111. (619)565-4424. President: Stephen A. All. Clients: entertainment, education, religious-mostly for children. Uses photographers for films and videotapes.

Needs: Subjects include stock footage of "places and things."

Specs: Uses 16mm films, U-matic 3/4", 1" or 2" videotape.

First Contact & Terms: Interested in stock footage. Reports in 2 weeks or less. Pays each job on contract basis. Pays on acceptance. Buys all rights. Captions and model release required. Credit line given.

ESTEY-HOOVER, INC., Suite 225, 3300 Irvine Ave., Newport Beach CA 92660. (714)756-8501. Production Manager: Keri Lancaster. Ad agency. Clients: real estate, consumer, financial, industrial firms.

Needs: Works with freelance photographers on assignment only basis. Uses freelancers for brochures,

catalogs, posters, newspapers, AV presentations and annual reports.

First Contact & Terms: Local freelancers only. Query with samples; follow up with call for appointment. Payment is by the project; negotiates according to client's budget.

*EXPANDING IMAGES, A-143, 14252 Culver Dr., Irvine CA 92714. (714)720-0864. President: Robert Denison. Clients: commercial, industrial.

Needs: Works with 2 freelance photographers/month. Uses photographers for multimedia productions, films and videotapes. Subjects vary.

Specs: Uses 35mm transparencies; 35mm film; VHS and U-matic 3/4" videotape.

First Contact & Terms: Provide resume, business card, self-promotion piece or tearsheets to be kept on file for possible future assignments. Works with local freelancers on assignment basis only; interested in stock photos/footage. Does not return unsolicited material. Reports in 2 weeks. Pays \$350-1,200/day. Pays on acceptance. Buys all rights. Captions and model releases required. Credit line given.

*GRASS ROOTS PRODUCTIONS, Box 532, Malibu CA 90268. (213)463-5998. President: Lee Magid. Clients: record and video music companies.

Needs: Works with 5 photographers/year. Uses photographers for slide sets. Subjects vary.

Specs: Uses 5x7 b&w and color prints; 21/4x21/4 transparencies; VHS, Beta videotape. First Contact & Terms: Provide resume, business card, self-promotion piece or tearsheets to be kept on file for possible future assignments. Works with freelancers by assignment only. SASE. Reports in 3

weeks. Pay individually negotiated. Pays on acceptance or on publication. Buys all rights. Model release required. Credit line given.

Tips: "Don't send everything—only samples of your best. And, please, not your only or last copy."

BERNARD HODES ADVERTISING, 16027 Ventura Blvd., Encino CA 91436. (818)501-4613. Ad agency. Production Manager: Barbara Larson. Produces "recruitment advertising for all types of clients."

Needs: Works with 1 freelance photographer/month. Uses photographers for billboards, trade magazines, direct mail, P-O-P displays, brochures, catalogs, posters, newspapers, AV presentations, and internal promotion. Also works with freelance filmmakers to produce TV commercials, training films (mostly stills).

Specs: "Entirely depends on end product. As with all printing, the size, printing method and media determine camera and film. Have used primarily 35mm, 21/4, 4x5; both b&w and color.

First Contact & Terms: Query with samples "to be followed by personal interview if interested." Does not return unsolicited material. Reporting time "depends upon jobs in house. I try to arrange appointments within 3 weeks-1 month." Payment "depends upon established budget and subject." Pays on acceptance for assignments; on publication per photo. Buys all rights. Model release required. Tips: Prefers to see "samples from a wide variety of subjects. No fashion. People-oriented location shots. Nonproduct. Photos of people and/or objects telling a story—a message. Eye-catching." Photographers should have "flexible day and 1/2 day rates. Must work fast. Ability to get a full day's (or 1/2) work from a model or models. Excellent sense of lighting. Awareness of the photographic problems with newspaper reproduction."

*THE HOLLYWOOD ASSOCIATES, INC., 2800 West Olive, Burbank CA 91505. (818)841-4136. President: Michael Carr. AV firm. Serves clients in advertising agencies, production houses and clients directly. Produces motion pictures and videotapes. Works with freelance photographers on assignment only basis. Provide resume to be kept on file for possible future assignments. Buys 100 photos/year. Subject Needs: "Ranges from TV commercials to industrial to educational, and documentaries." Uses freelance photos in 16 and 35mm films and TV programs. Length requirements: 30 seconds to 2 hours. Uses color only unless historical and prior to the advent of TV.

Film: Interested in stock footage on all subjects.

Photos: Uses 8x10 or 11x14 prints and color transparencies.

Payment/Terms: Pays \$150-500/day; negotiates payment based on client's budget. Pays on production. Buys all rights. Model release required.

Making Contact: Query with resume. SASE. Reports in 2 weeks.

DEKE HOULGATE ENTERPRISES, Box 7000-371, Redondo Beach CA 90277. (213)540-5001. PR firm. Contact: Deke Houlgate. Clients: industrial, automotive, sports. Client list free with SASE. Needs: Works with 1-3 freelance photographers/month. Uses photographers for consumer and trade magazines, direct mail, brochures, posters, newspapers, and AV presentations. Works with freelance filmmakers to produce videotape/film newsclips for news and sports TV feature coverage. Occasionally works with producers of barter and free TV 30-60 minute features.

Specs: Uses 8x10 b&w ("mostly") glossy prints; 35mm and $2^{1/4}x2^{1/4}$ color transparencies, 16mm and 3/4" (news) and 1" or 2" (feature) videotape.

First Contact & Terms: Query with list of stock photo subjects. SASE. Reporting time "depends on situation—as soon as client concurs, but early enough not to inconvenience photographer." Pay

"variable but conforming to standard the photographer states. We don't ordinarily haggle, but we buy only what the client can afford." Payment by client, "immediately." Buys all rights. Model release and captions required. Credit line "usually not given, but not a hard and fast rule."

Tips: Prefers to see "photographer's grasp of story-telling with a photo; ability to take direction; ideas he/she can illustrate; understanding of the needs of editors. Take an outstanding photograph and submit, relating to one of our clients. If it's a good buy, we buy. If we buy, we strongly consider making assignments for otherwise unknown freelancers. Our company would rather service a photograph than a story, depending on quality. We'd rather pass on a photo than service a mediocre one. With cost-price squeeze, more PR firms will adopt this attitude.'

*IC COMMUNICATIONS, INC., 2050 S. Santa Cruz, Anaheim CA 92805. (714)634-9236. Vice President, Production: Don Ranson. Clients: industrial, commercial, design. Ues photographers for multimedia productions.

Needs: Subjects include people and product; "move fast and shoot quantity with quality."

Specs: Uses 35mm transparencies.

First Contact & Terms: Arrange a personal interview to show portfolio; provide resume, business card, self-promotion piece or tearsheets to be kept on file for possible future assignments. Works with freelancers by assignment only. Reports in 1 month. Pay individually negotiated. Pays by arrangement. Buys all rights.

IMAHARA & KEEP ADVERTISING & PUBLIC RELATIONS, 1263 Oakmead Parkway, Sunnyvale CA 94086. (408)735-7600. Ad agency. Creative Director: Peter Keep. Clients: industrial/high tech.

Needs: Works with 3 freelance photographers/month. Uses photographers for trade magazines, direct mail, brochures, catalogs, posters, and newspapers. Subject matter "industrial and high tech." Rarely works with freelance filmmakers.

Specs: Uses 11x14 or 16x20 b&w or color repro grade prints; 21/4x21/4 or 4x5 transparencies.

First Contact & Terms: Arrange a personal interview to show portfolio; query with samples. Works with local freelancers only. Reports in 2 weeks. Pays \$750-1,500/day. Pays on publication. Buys all rights. Model release required.

Tips: Prefers to see "table-top, lighting techniques, product photos and special effects" in a portfolio.

*KRUEGER DIRECT MARKETING, 171 Carlos Dr., San Rafael CA 94903. (415)499-0744. Ad agency. Creative Director: Mark Farmer. Clients: industrial, finance, travel, medical.

Needs: Works with 1 photographer/month. Uses photographers for trade magazines, direct mail, catalogs, posters and newspapers. Subjects include people or products.

Specs: Uses 8x10 glossy b&w prints and 35mm and 21/4x21/4 transparencies.

First Contact & Terms: Query with list of stock photo subjects; send unsolicited photos by mail for consideration.

LODESTAR PRODUCTIONS, 1330 Monument St., Pacific Palisades CA 90272. (213)454-0234. President: Dr. Edward D. Hurley. AV firm. Clients: business, nonprofit, educational.

Needs: Uses photographers for AV presentations.

First Contact & Terms: Provide resume, business card, brochure, flyer or tearsheets to be kept on file for possible future assignments. Works with local freelancers on assignment only. Does not return unsolicited material. Reports as soon as possible. Payment negotiable. Buys all rights or one-time rights. Model release required. Credit line sometimes given.

Tips: "Don't phone, but do send data."

LOTT ADVERTISING AGENCY, Box 710, Santa Monica CA 90400. (213)397-4217. Ad agency. President: Davis Lott. Clients: industrial.

Needs: Works with "perhaps 1 freelance photographer every 3 months." Uses photographers for trade magazines, direct mail, brochures, catalogs and newspapers. Subjects include: trade items and products.

Specs: Uses 4x5 glossy b&w prints.

First Contact & Terms: Provide resume, business card, brochure, flyer or tearsheets to be kept on file for possible future assignments. Works with local freelancers only. Does not return unsolicited material-"don't send any." Reports in 1 month. Pays/photo. Pays on publication. Model release and captions required. Credit line given.

M.F.I., 1905 Grace Ave., Hollywood CA 90028. (213)464-4537. Contact: Manuel S. Conde. AV firm. Serves schools and businesses. Produces multimedia kits, motion pictures, commercials in English and Spanish and videotape. Subject matter open. Produces a wide assortment of English and Spanish language films.

Photos: Uses 8x10 glossy b&w prints and 21/4x21/4 color transparencies.

Payment/Terms: Payment, on a per-job basis, is open. Pays on acceptance. Buys all rights. Model release required.

Making Contact: Query with resume of credits. SASE. Reports in 1 month.

*ED MARZOLA AND ASSOCIATES, 11846 Ventura Blvd., Studio City CA 91604. (818)506-5577. President: Ed Marzola. Clients: agencies and TV stations.

Needs: Works with 2-3 photographers/month. Uses photographers for films, videotapes. Subjects include live action.

Specs: Uses 4x5 and 8x10 b&w prints; 4x5 and 8x10 color prints; 35mm, 21/4x21/4 and 4x5 transparencies; U-matic 3/4", 1" and 2" videotapes.

First Contact & Terms: Provide resume, business card, self-promotion piece or tearsheets to be kept on file for possible future assignments. Works with freelancers by assignment only. SASE. Reports in 1 week. Pay individually negotiated. Pays on acceptance. Buys all rights. Credit line given.

Tips: "Be creative, cooperative, deliver as promised and stay with your quote."

*MEALER & EMERSON, 3186-C Airway Ave., Costa Mesa CA 92626. (714)957-1314 or (213)693-0968. Contact: Will Johnson. Clients: Variety. Client list free with SASE.

Needs: Works with 8-10 freelance photographers/month. Uses photographers for billboards, consumer and trade magazines, direct mail, P-O-P displays, catalogs, posters and newspapers.

Specs: Uses b&w and color prints, and 35mm, 21/4x21/4, 4x5 and 8x10 transparencies.

First Contact & Terms: Arrange a personal interview to show portfolio; submit portfolio for review; provide resume, business card, brochure, flyer or tearsheets to be kept on file for possible future assignments. Works with freelance photographers on an assignment basis only. Does not return unsolicited material. Pays \$800-2,000/day and by job. Pays on receipt on invoice. Buys all rights. Model release required.

BENNETT J. MINTZ/PUBLIC RELATIONS ADVERTISING, Suite 219, 16200 Ventura Blvd., Encino CA 91436. (818)783-5436. PR firm. Clients: nonprofit agencies, fly fishing products, retail. Needs: Works with freelance photographers on occasion. Provide brochure to be kept on file for future assignments. "Sometimes we get into doing a number of brochures/flyers or other materials for fundraising campaigns; other times we might go two months with little or nothing." Uses freelancers for consumer and trade magazines, newspapers and P-O-P displays.

First Contact & Terms: Call or write and request personal interview to show portfolio. Selection based on "type of work done, price, availability, proximity and budget." Negotiates payment based on client's budget, amount of creativity required from photographer, where work will appear and previous experience/reputation.

Tips: Wants to see "8-12 photos showing imagination."

*MOVING TARGETS, INC., #101, 1585 Crossroads of the World, Hollywood CA 90028. (213)871-1399. Production Coordinator: Laura Mahaffey. Clients: record companies, film/video distributors, production companies.

Needs: Works with 1-2 photographers/month. Uses photographers for films, videotapes. Subjects include production stills, still photography montages, publicity photos, assistant 35mm film cameramen for features/music videos, steadicam operators.

Specs: Uses b&w and color prints, size/finish varies; 35mm films; U-matic 3/4" videotape.

First Contact & Terms: Provide resume, business card, self-promotion piece or tearsheets to be kept on file for possible future assignments. Works with freelancers by assignment only; interested in stock photos/footage. Reports in 2 weeks. Pays by contractual agreement. Buys one-time rights and all rights. Model release preferred. Credit lines depending on contract.

Tips: "State approximate day rate on resume, specify what equipment you own and rate for use with your rate included."

*PACIFIC COAST PRODUCTIONS, 629 Terminal Way #7, Costa Mesa CA 92627. (714)645-1640. Production Manager: John Stevens. Clients: insurance, businesses with the need of slides/shows. Needs: Works with 1-2 photographers/month. Uses photographers for slide sets, multimedia productions. Subjects include sound track engineers. Specs: Uses 35mm transparencies.

First Contact & Terms: Provide resume, business card, self-promotion piece or tearsheets to be kept on file for possible future assignments. Works with freelancers by assignment only. SASE. Reports in 2 weeks. Pay open to budget. Pays on acceptance. Buys all rights.

*PENROSE PRODUCTIONS, Suite 204, 1690 Woodside Rd., Redwood City CA,94061. (415)361-8273. President: James R. Penrose. Clients: corporate, resort.

Needs: Works with 5-6 freelance photographers/month. Uses photographers for slide sets, multimedia productions, videotapes. Subjects include corporate training, sales promotion and entertainment.

Specs: Uses U-matic 3/4" videotape.

First Contact & Terms: Submit portfolio by mail; provide resume, business card, self-promotion piece or tearsheets to be kept on file for possible future assignments. Works with freelancers by assignment only; interested in stock photos/footage. Reports in 1 month. Pays \$20-90/hour; \$150-500/day. Pays on acceptance. Buys all rights. Model release required. Credit line sometimes given.

PHOTOCOM PRODUCTIONS, Box 3135, Pismo Beach CA 93449. (805)481-6550. President: Steven C. LaMarine. AV Firm. Clients: schools.

Needs: Works with 6 freelance photographers/year. "All subject matter is vocationally oriented, including career awareness and technical how-to's for trades." Subjects include vocational training in automotive, agriculture, machine trades, welding, etc.

Specs: Uses 35mm transparencies; VHS videotape OK for samples; U-matic 3/4" videotape needed for

production.

First Contact & Terms: Query with samples and resume. Works with freelancers by assignment only; interested in stock photo/footage. SASE. Reports in 2 weeks. Pays \$20-100/color photo. Pays on publication. Buys one-time rights and all A-V rights when series is purchased. Captions and model release preferred. Credit line given.

Tips: Sample photos must illustrate ability to portray people in work situations, as well as how to clearly illustrate a procedure that can be duplicated by students. "Highest priority is given to photographers who

can write their own scripts with our help and advice."

THE POMEROY COMPANY, Suite 179, 8033 Sunset Blvd., West Hollywood CA 90046. Executive Vice President/Creative Director: Chip Miller. Ad agency. Clients: entertainment, motion picture, TV, music.

Needs: Works with 3 freelance photographers/month. Provide business card, resume, references, samples or tearsheets to be kept on file for possible future assignments. Uses freelancers for trade magazines, displays, TV, brochures/flyers, posters and one sheets.

First Contact & Terms: Call for appointment to show portfolio. Negotiates payment based on client's

budget.

Tips: Wants to see minimum of 12 pieces expressing range of tabletop, studio, location, style and modeloriented work. Include samples of work published or planned.

PRAXIS CREATIVE PUBLIC RELATIONS, 1105 Rossmoor Tower, #1, Laguna Hills CA 92653. (714)855-6846. Contact: Pearce Davies. PR firm. Clients: realty (hold broker's license), travel agency, retail shopping, construction, etc. "Some are nonprofit. In general, any individual or firm with a public relations problem."

Needs: Works with freelance photographers on assignment only basis. Provide business card and brochures to be kept on file for possible future assignments. Uses freelancers for trade magazines, direct

mail, newspapers and TV.

First Contact & Terms: Send resume. "We find advertisements or business cards which detail specialties helpful. If assignment is out-of-town (many are), we try to engage nearby photographers (we have lists). For aerial, underwater or theatrical shots, we know specialists in these fields. In other words, we call on whom we consider the best people for the specific job." Negotiates payment based on client's budget and amount of creativity required from photographer.

PAUL PURDOM & CO., 1845 Magnolia Ave., Burlingame CA 94010. (415)692-8770. President: Paul Purdom. PR firm. Handles clients in finance, industry, architecture, high-tech. Photos used in brochures, newsletters, annual reports, PR releases, AV presentations, sales literature, consumer and trade magazines. Client list available. Provide business card, brochure and samples to be kept on file for possible future assignments. Buys 500 photos/year. Works with 100-200 freelance photographers/year. Negotiates payment based on client's budget, amount of creativity required from photographer, and photographer's previous experience/reputation. Pays \$50-50/hour; \$50 minimum/job; and \$100-1,200/day. Buys all rights. Model release preferred. Arrange a personal interview to show portfolio or send material by mail for consideration. SASE. Reports in 3 weeks. "Most interested in technical material."

B&W: Uses 8x10 glossy prints; contact sheet and negatives OK.

Color: Uses transparencies.

Film: 16mm television newsfilms; videotape.

Tips: Prefers to see "high technology shots—like computer rooms—done in a creative, clear manner showing a degree of intelligence that goes beyond holding and pointing a camera."

BILL RASE PRODUCTIONS, INC., 955 Venture Court, Sacramento CA 95825. (916)929-9181. Manager/Owner: Bill Rase. AV firm. Clients: industry, business, government, publishing and education. Produces filmstrips, slide sets, multimedia kits, motion pictures, sound-slide sets, videotape, mass cassette, reel duplication and video. Buys 100-300 filmstrips/year. Photo and film purchases vary. Payment depends on job. Pays 30 days after acceptance. Buys all rights. Model release required. Query with samples and resume of credits. Freelancers within 100 miles only. SASE. Reports "according to the type of project. Sometimes it takes a couple of months to get the proper bid info."

Subject Needs: "Script recording for educational clients is our largest need, followed by industrial training, state and government work, motivational, etc." Freelance photos used in filmstrips and slides; sometimes motion pictures. No nudes. Color only for filmstrips and slides. Vertical format for TV cutoff

only.

Film: 16mm sound for TV public service announcements, commercials, and industrial films. Some 35mm motion picture work for theater trailers. "We then reduce to Super 8 or video if needed." Uses stock footage of hard-to-find scenes, landmarks in other cities, shots from the 1920s to 1950s, etc. "We buy out the footage—so much for so much."

Color: Uses 8x10 prints and 35mm transparencies.

THE RUSS REID CO., 2 N. Lake Ave., 6th Floor, Pasadena CA 91101. (818)449-6100. Art Director: Robert Barrett. Ad agency. Clients: religious and cause-related organizations; client list provided upon request.

Needs: Works with "very few" freelance photographers on assignment only basis. Uses photographers for trade magazines, direct mail, brochures, posters and newspapers.

First Contact & Terms: Local photographers only. Arrange interview to show portfolio. Negotiates payment according to client's budget; "whether by the hour, project or day depends on job."

ROGERS & COWAN, INC., 10,000 Santa Monica Blvd., Los Angeles CA 90067. (213)201-8800. Contact: Account Executive. PR firm. Clients: entertainment.

Needs: Works with qualified freelance photographers on assignment only basis. Uses photographers for billboards, consumer and trade magazines, direct mail, posters, newspapers, AV presentations, news releases.

First Contact & Terms: Local freelancers only. Phone for appointment. Payment "depends on the job."

SARVER & WITZERMAN ADVERTISING, 3289 Industry, Long Beach CA 90806. (213)597-8040. Ad agency. President: Joe Witzerman. Clients: industrial and financial. Client list free with SASE. **Needs:** Works with 3 freelance photographers/month. Uses photographers for billboards, consumer and trade magazines, direct mail, P-O-P displays, brochures, catalogs, posters, and newspapers. Subject needs: "from food to trucks." Works with freelance filmmakers to produce TV commercials.

Specs: Uses 8x10 to 16x20 b&w glossy prints; 35mm and 4x5 transparencies; 16mm film and videotape. First Contact & Terms: Arrange a personal interview to show portfolio; send unsolicited material by mail for consideration. Works with freelance photographers on assignment basis only. SASE. Reports in 2 weeks. Pays \$500-1,000/day. Pays on completion. Buys all rights. Model release required. Credit line given "when requested."

*SAWYER CAMERA & INSTRUMENT CO., 1208 Isabel St., Burbank CA 91506. 843-1781. Clients: ad agencies, video producers, movie studios.

Needs: Works with 20-25 photographers/month. Uses photographers for multimedia productions, videotapes. Subjects include commercials, educational material and movies.

Specs: Uses VHS, Beta, U-matic 3/4" videotape.

First Contact & Terms: Provide resume, business card, self-promotion piece or tearsheets to be kept on file for possible future assignments. Works with freelancers by assignment only. SASE. Reports in 2 weeks. Pays/job. Pays on acceptance. Buys all rights. Captions preferred. Credit lines given.

J. STOKES & ASSOCIATES, (formerly Pettler, Degrassi & Hill), 5236 Claremont Ave., Oakland CA 94618. (415)933-1624. Contact: Creative Director. Ad agency. Clients: industrial, financial, agricultural and some consumer firms; client list provided upon request.

Needs: Works with 6 freelance photographers/year on assignment only basis. Uses photographers for trade magazines, direct mail, P-O-P displays, brochures, catalogs, posters, signage, newspapers and AV presentations.

First Contact & Terms: Local freelancers only. Arrange interview to show portfolio. Payment is by the project or by the hour; negotiates according to client's budget.

RON TANSKY ADVERTISING CO., 14852 Ventura Blvd., Sherman Oaks CA 91403. (818)990-9370. Ad agency and PR firm. Art Director: John Cecconi. Serves all types of clients.

25

Needs: Works with 2 freelance photographers/month. Uses photographers for billboards, consumer and trade magazines, direct mail, P-O-P displays, brochures, catalogs, signage, newspapers and AV presentations. Subjects include "mostly product—but some without product as well." Works with freelance filmmakers to produce TV commercials.

Specs: Uses b&w or color prints; 21/4x21/4 and 4x5 transparencies; 16mm and videotape film.

First Contact & Terms: Query with resume of credits; provide resume, business card, brochure, flyer or tearsheets to be kept on file for possible future assignments. SASE. Payment "depends on subject and client's budget." Pays in 30 days. Buys all rights. Model release required.

Tips: Prefers to see "product photos, originality of position and lighting" in a portfolio. Photographers

should provide "rate structure and ideas of how they would handle product shots."

ROGER TILTON FILMS, INC., 315 6th Ave., San Diego CA 92101. (619)233-6513. Production Manager: Robert T. Hitchcox. AV firm. Clients: business, military, industry, commerce and education. **Needs:** Works with freelance photographers on assignment only basis. Uses photographers for filmstrips, motion pictures and videotape.

Specs: Produces 16mm, 35mm and 65mm commercials, industrials, training, educational and docu-

mentaries. Uses stock footage, color prints and transparencies; size varies with client.

First Contact & Terms: Query with resume of credits. Prefers to see samples relevant to project. Provide resume to be kept on file for possible future assignments. Pay depends on job and contract. Payment made on production. Buys all rights. Model release required

*TRITRONICS INC. (TTI), 733 N. Victory Blvd., Burbank CA 91502. (818)843-2288. General Manager: Robert A. Sofia. Clients: corporate and broadcast video program producers.

Needs: Works with 3 photographers/month. Uses photographers for videotapes.

Specs: Uses U-matic 3/4" and Betacam.

First Contact & Terms: Query with resume. Works with freelancers by assignment only. Reports in l week. Pays \$150-300/job. Pays on acceptance. Buys all rights. Credit lines given with application.

*VIDEO IMAGERY, 204 Calle De Anza, San Clemente CA 92672. (714)492-5082. General Manager: Bob Fisher. Clients: industrial-manufacturing.

Needs: Works with 2 photographers/month. Uses photographers for videotapes. Subjects include training in the manufacturing concept, in light and heavy industrial.

Specs: Uses VHS, U-matic 3/4" videotape.

First Contact & Terms: Query with resume. Works with freelancers by assignment only. Reports in 3 weeks. Buys all rights. Captions and model release required. Credit line given if requested.

*VIDEO RESOURCES, Box 18642, Irvine CA 92713. (714)261-7266. Producer: Brad Hagen. Clients: industrial, electronics.

Needs: Works with 2 photographers/month. Uses photographers for slide sets, films and videotapes. Subjects include action, interior, exterior (including underwater, aerial).

Specs: Uses 16mm, 35mm film, U-matic 3/4", 1" Betacam videotape.

First Contact & Terms: Submit portfolio by mail; provide resume, business card, self-promotion piece or tearsheets to be kept on file for possible future assignments. Works with local freelancers only. Works with freelancers by assignment only. SASE. Reports in 1 month. Pays by day or job. Pays net 10-30 days. Buys one-time and all rights. Model releases preferred. Credit line sometimes given.

VOCATIONAL EDUCATION PRODUCTIONS, California Polytechnic State University, San Luis Obispo CA 93407. Contact: Jay Holm. AV firm. Serves clients in vocational-agricultural high schools, junior colleges and universities offering agricultural education. Produces 20-50 filmstrips and slide sets. Buys stock photos. Provide resume, business card, tearsheets, and sample dupe slides to be kept on file for reference. Pays on acceptance. Rates are negotiable. Assignments can be paid as progress is made, or in one sum at project completion. Buys one-time rights to stock shots; all rights to assignments. Brief captions on slide mounts preferred. Query with list of stock photos subjects. Reports in 4 weeks.

Subject Needs: "We cover all areas of agriculture. Our needs choose captible stock in the stock photos."

Subject Needs: "We cover all areas of agriculture. Our needs change constantly, so it's best to inquire about what is currently wanted. We almost never have any use for b&w materials. We would like sources

for stock video footage."

Color: Uses 35mm transparencies. Pays \$35 minimum/transparency; \$300-500/day; \$2,500-3,000/job;

\$200 maximum/cover. Assignments are negotiated.

Tips: "We don't mind paying for quality, so show us your best. If you can write filmstrip scripts and provide good photography you are in an excellent position to approach us. We like to see a wide variety of techniques. Send several slides dealing with one subject. We are very interested in seeing your ability to visually tell a story. We *rarely* get this type of sample. An agricultural background isn't necessary, but technical accuracy is a must."

WARNER EDUCATIONAL PRODUCTIONS, Box 8791, Fountain Valley CA 92708. (714)968-3776. Operations Manager: Philip Warner. AV firm. Serves clients in education. Produces filmstrips and multimedia kits. Buys 20 filmstrips/year. Provide business card, brochure and flyer to be kept on file for possible future assignments. Price negotiated for complete filmstrips; pays 5-15% royalty. Pays on acceptance. Buys all rights, but may reassign to photographer after use. Model release preferred. Arrange a personal interview to show portfolio. "We want to see only a written synopsis of the proposed unit of work. If we are interested in the topic we will arrange an interview to discuss the specifics. We are interested only in complete units suitable for production." SASE. Reports in 2 weeks. Free catalog. Subject Needs: "We produce only art/craft teaching units. Each filmstrip is a complete unit which teaches the viewer how to do the specific art or craft. We are only interested in collections of photos which could provide a complete teaching unit. We seldom need individual photos or small groups." Length: 60-140 frames/filmstrip. Color only.

Color: Uses 35mm transparencies.

*WEST COAST PROJECTIONS, INC., Suite 300, 533 F St., San Diego CA 92101. (619)544-0550. Director of Photography: Gordon Middleton. Clients: industrial, high-tech, real estate.

Needs: Uses photographers for slide shows, multimedia productions, films and videotapes. Subjects vary.

Specs: Uses 35mm, 21/4x21/4 transparencies, VHS, Beta, U-matic 3/4" videotape.

First Contact & Terms: Arrange a personal interview to show portfolio. Works with freelancers by assignment only; interested in stock photos/footage. SASE. Reports in 1 month.

ZHIVAGO ADVERTISING, 417 Tasso St., Palo Alto CA 94301. (415)328-7830. Ad agency and PR firm. Partner: Kristin Zhivago. Serves industrial and high-tech clients.

Needs: Uses photographers for consumer and trade magazines, direct mail, P-O-P displays, brochures, catalogs, posters, newspapers, AV presentations. Subjects include "electronic products; people using electronic products."

Specs: Uses 8x10 b&w or color glossy prints; 4x5 transparencies.

First Contact & Terms: Arrange a personal interview to show portfolio. Query with samples. Works with local freelance photographers on assignment basis only. Does not return unsolicited material. Pays \$50-250/hour; \$350-2,500/day. Pays in 30 days. Buys one-time rights. Model release preferred. Credit line rarely given.

Tips: Prefers to see "equipment shots; business-like people scenes" in a portfolio. "First show portfolio, then keep checking back by phone on a regular basis."

Los Angeles

BBDO/WEST, 10960 Wilshire Blvd., Los Angeles CA 90024. (213)479-3979. Contact: Creative Secretary. Ad agency. Uses billboards, consumer magazines, newspapers, P-O-P displays, radio, TV and trade magazines. Serves package goods, computer, automotive, newspaper, stereo components, restaurant, shipping, grocery, bank, real estate, food, beverage and religious clients. Deals with photographers in all areas. Provide brochure or flyer to be kept on file for possible future assignments. Payment & Terms: Negotiable.

Making Contact: Drop off portfolio for review.

Specs: Uses b&w photos, color transparencies and film.

BEAR ADVERTISING, 1424 N. Highland, Los Angeles CA 90028. (213)466-6464. Vice President: Bruce Bear. Ad agency. Uses consumer magazines, direct mail, foreign media, P-O-P displays and trade magazines. Serves sporting goods, fast foods and industrial clients. Works with 4 freelance photographers/month on assignment only basis. Provide business card and tearsheets to be kept on file for possible future assignments.

Payment & Terms: Pays \$150-250/b&w photo; \$200-350/color photo. Pays 30 days after billing to

client. Buys all rights.

Making Contact: Call to arrange interview to show portfolio. Prefers to see samples of sporting goods, fishing equipment, outdoor scenes, product shots with rustic atmosphere of guns, rifles, fishing reels, lures, camping equipment, etc. SASE. Reports in 1 week.

Specs: Uses b&w and color photos.

*BOSUSTOW VIDEO, 2207 Colby Ave., W. Los Angeles CA 90064-1504. (213)478-0821. Director: Tee Bosuston. Clients: broadcast, promotional, industrial, institional.

Needs: Uses photographers for videotapes. Subjects include documentary, news, interviews and informational.

Specs: Uses U-matic 3/4" videotape and Beta Cam.

First Contact & Terms: "Please, no phone calls. We'll contact you from resume and sample reel, when job comes up." Works with local freelancers usually-limited out-of-town and out-of-country. Reports when job comes up. Pays \$450-1,250/day. Payment based on payment schedule of client. Buys all rights. Credit line given.

Tips: "Use only videographers with documentary style experience; some production experience is nice; owning own gear is preferable. One-page resume only. List your best documentary and production experience, your rate, the gear you own and any awards. Short demo tapes are helpful, if you don't need

them back.

*CATZEL, THOMAS AND ASSOCIATES, INC., 2207 Colby Ave., Los Angeles CA 90064. (213)824-2700. Office Manager: Mary Sweeney. Clients: industrial, commercial, music video.

Needs: Works with 5 photographers/month. Uses photographers for slide sets, multimedia productions, films and videotapes. Subjects include people, places, equipment, etc.

Specs: Uses 35mm transparencies; 16mm and 35mm film; VHS and U-matic 3/4" videotape.

First Contact & Terms: Provide resume, business card, self-promotion piece or tearsheets to be kept on file for possible future assignments. Works with freelancers by assignment only; interested in stock photos/footage. SASE. Reports in 2 weeks. Pay individually negotiated. Payment made upon payment by client. Buys variable rights. Model release required. Credit line sometimes given.

Tips: "Send in resume and/or drop off book or sample of work."

CHIAT/DAY, 517 S. Olive St., Los Angeles CA 90013. (213)622-7454. President/Creative Art Director: Lee Clow. Advertising agency. Uses billboards, consumer magazines, direct mail, newspapers, P-O-P displays, radio, TV and trade magazines. Serves audio/video equipment, motorcycle, automotive, home loan, personal computer, hotel, photographic equipment, cable TV, and sportswear clients. Deals with 6 photographers/year.

Payment & Terms: Negotiable.

Making Contact: Send samples, then call to arrange interview to show portfolio.

Specs: Uses b&w and color photos.

*CRANIUM PRODUCTIONS, Suite 24, 1531 Fuller Ave., Los Angeles CA 90046. (213)874-6976. Director: Graham Dent. Clients: record companies.

Needs: Works with 1 photographer/month. Uses photographers for films, videotapes. Subjects include rock videos shot on film, mostly conceptual.

Specs: Uses 16mm and 35mm film.

First Contact & Terms: Query with resume. Works with freelancers by assignment only. SASE. Reports in 2 weeks. Pays \$100-400/day. Buys all rights. Credit line given whenever possible.

*USC DAVIDSON CONFERENCE CENTER, University Park, Los Angeles CA 90089-0871. (213)743-5219. Executive Director: Mr. Philip R. Rapa. Clients: outside companies such as IBM, ARCO, NBC, MONY, etc.

Needs: Uses photographers for slide sets, multimedia productions and videotapes. Subjects depend on

conference, clients.

Specs: Uses 8x10 high gloss b&w and color prints; 8x10 transparencies; 16mm film; VHS, Beta, U-

matic 3/4" videotape.

First Contact & Terms: Provide portfolio, query with samples and resume. Works with freelancers by assignment only. Reports in 3 weeks. Pay varies. Pays on publication. Buys all rights. Credit line depends on assignment.

EVANS/WEINBERG ADVERTISING, 5757 Wilshire Blvd., Los Angeles CA 90036. (213)653-2300. Art Director; Chuck Torosian. Ad agency. Client list provided upon request.

Needs: Uses photographers for billboards, consumer and trade magazines, direct mail, P-O-P displays, brochures, catalogs, posters, signage, newspapers and AV presentations.

First Contact & Terms: Local freelancers only. Arrange interview to show portfolio. Payment varies according to job.

GUMPERTZ, BENTLEY, FRIED, 5900 Wilshire Blvd., Los Angeles CA 90036. (213)931-6301. Art Directors: Susan Ichiyama and Steve Hollingsworth. Creative Director: Bob Porter. Ad agency. Uses billboards, consumer and trade magazines, newspapers, P-O-P displays, radio and TV. Serves stockbroker, bank, visitors bureau, tape recorder, automative and food clients. Deals with 6-10 photographers/

Payment & Terms: Negotiable.

Making Contact: Call to arrange interview to show portfolio.

Specs: Uses b&w and color photos. Will consider director reels (see Penny Webber, Producer).

HCM, (formerly Marsteller, Inc.), 3333 Wilshire Blvd., Los Angeles CA 90010. (213)386-8600. Vice President/Art Services Manager: Joseph Apablaza. Ad agency. Serves clients in air freight, computers, research, manufacturing and food.

Needs: Works with 3 freelance photographers/month. Uses photographers for collateral material and

consumer and trade magazines.

First Contact & Terms: Call for appointment to show portfolio. Selection based on portfolio review. Negotiates payment based on client's budget and where work will appear.

Portfolio Tips: Wants to see industrial shots to fit in with needs of clients. No fashion or cars.

MAXFILMS, INC., 2525 Hyperion Ave., Los Angeles CA 90027. (213)662-3285. Vice President: Y. Shin. AV firm. Serves clients in business and industry, associations, educational institutions, publishing, broadcasting, home video, theatrical distributing and foundations. Produces multimedia kits, motion pictures, sound-slide sets and videotape. Buys 150-200 photos and 3-4 films/year.

Subject Needs: "Any type of industrial, scientific or natural activity would be a logical candidate for color slides. For film, it is best to send resume or query with a statement of capability." Uses freelance photos in multimedia or slide/sound presentations, or as background for motion picture titles. "Personal statements, unless they have a wide appeal, are generally unacceptable, as are expressionistic or impressionistic art or effect photos." Length varies from a 10 second commercial to a 1 hour slide/sound or multimedia presentation, to a 2 hour television documentary. "We buy only color slides or transparencies from 35mm to 5x7. Black and white material may be submitted for demonstrating capability, but is almost never bought unsolicited. Motion picture footage of unusual locations or phenomena is sometimes bought for future use, but it must have been shot from a tripod, on 16mm or 35mm motion picture stock. Super 8mm is not acceptable.'

Film: Produces 16 or 35mm. Interested in stock footage. Photos: Uses 35mm, 21/4x21/4, 4x5 and 5x7 transparencies.

Payment & Terms: Pays by the job or \$15-100/photo. Pays on acceptance. Buys all rights. Model release required.

Making Contact: Query with resume or send color slides by mail for consideration. SASE. Reports in 3 weeks.

Tips: "Submit only work that is technically outstanding, or where the subject matter is so compelling that a slight degrading of quality becomes acceptable.

META-4 PRODUCTIONS, INC., 8300 Santa Monica Blvd., Suite 203, Los Angeles CA 90069. (213)655-6321. President and Producer/Director: Terry Carter. Producer: Stuart Parker Hall. AV firm. Serves clients in government and industry. Produces film, videotapes, filmstrips and motion-slide tapes. Buys 50 photos, 2 filmstrips and 3 films/year.

Subject Needs: Training, science, portraiture, nature, etc. "Don't exclude anything."

Film: Produces 16mm and 35mm color. Photos: Uses color transparencies and prints.

Payment/Terms: Payment is negotiated. Pays on acceptance. Buys all rights. Model release required.

Making Contact: Query with resume of credits. SASE. Reports in 2 weeks.

Tips: "Do not be reticent to make suggestions when you think you have a better idea than what is being presented by the producer or director.'

NW AYER, INC., 707 Wilshire Blvd., Los Angeles CA 90017. (213)621-1400 and 621-1497. Executive Art Director: Bob Bowen. Senior Art Director: Lionel Banks. Ad agency.

Needs: Works with freelance photographers on assignment only basis. Uses photographers for billboards, consumer magazines, direct mail, brochures, flyers, newspapers, P-O-P displays, TV, trade magazines and AV.

First Contact & Terms: Call for personal appointment to show portfolio. Pays 30 days after receipt of approved invoice in N.Y. office.

Tips: Wants to see "quality not quantity."

ROGERS, WEISS/COLE & WEBER, Suite 902, 2029 Century Park E., Los Angeles CA 90067. (213)879-7979. Contact: Marv Wartnik. Ad agency. Clients: consumer.

Needs: Uses 2-3 freelance photographers/month. Uses freelancers for billboards, P-O-P displays, consumer and trade magazines, stationery design, direct mail, TV, brochures/flyers and newspapers. First Contact & Terms: Call for personal appointment to show portfolio. Negotiates payment based on client's budget.

Tips: "We would like to see something good that shows the freelancer's style. B&w, color transparencies and 8x10 negatives OK."

STERN-WALTERS/EARLE LUDGIN, 9911 W. Pico Blvd., Los Angeles CA 90035. (213)277-7550. Art Director: Stewart Mills. Ad agency. Serves clients in a variety of industries.

First Contact & Terms: Call or write and request personal interview to show portfolio and/or resume.

"Pays whatever is the going rate for a particular job."

Tips: "No more than 25-30 examples—after that it's boring. Send along anything of quality that shows what you can do."

San Francisco

BAY CITY PUBLIC RELATIONS AND ADVERTISING, Room 300, 1 Sutter St., San Francisco CA 94104. (415)362-3633. PR firm. Contact: Creative Director. Handles community, corporate and health-related accounts. Photos used in brochures, newsletters, newspapers, AV presentations, posters, annual reports, catalogs, PR releases and magazines. Gives 5-10 assignments/year.

Subject Needs: Most interested in "photos of our clients and their business interests, their companies and their projects-indoor and outdoor installations, factories, equipment; merchandise; grand open-

Specs: Uses 8x10 glossy b&w and color prints, and 35mm color slides; contact sheet OK. For film, uses 16mm educational, industrial and public service 30- and 60-second spots and features.

Terms: Pays \$20 minimum/hour or \$100 minimum/day. Model release required.

Making Contact: Mail a resume of credits first; with samples or list of stock photo subjects. SASE. "Mark package 'Do Not Bend.' Do not send parcel post. Use regular mail service." Will keep samples

on file for possible future assignments.

Tips: "We do not maintain a staff photographer, avoid continuously using the same photographers, and try to use one or two new people each year. All our photographic needs are filled by freelancers. A recent example of outstanding photography was a black and white glossy, very sharp, tightly focused on two main characters and suitable for public relations (newspaper or magazine) use. It had multiple applications and could even be used in advertising as a focal point for a layout. The photographer was not moody. He was easy to direct, made creative suggestions, understood the assignment and the eventual media to use his photos. A high percentage of his photos were usable, so we had a choice for different publications. Because most of our photographers meet our clients, we insist that they be presentable and well groomed. This does not necessarily mean a coat and tie, but it does mean a neat appearance."

CHIAT/DAY, 77 Maiden Ln., San Francisco CA 94108. (415)445-3000. Contact: Art Director. Ad agency. Clients: packaged goods, consumer goods, computers, foods, corporate.

Needs: Works with freelance photographers on assignment only basis. Uses photographers for billboards, consumer and trade magazines, brochures, posters and newspapers.

First Contact & Terms: Phone one of the art directors to set up appointment for a showing with all art directors—"as many as are able will attend showing." Payment negotiated on client's budget and how soon the work is needed.

CUNNINGHAM & WALSH, 500 Sansome St., San Francisco CA 94111. (415)981-7850. Ad agency. Clients: commercial, industrial, fashion, insurance, consumer foods, airline, computer hardware. Needs: There are several art directors in this firm; each one works with 2-3 freelance photographers/year. Uses photographers for billboards, consumer and trade magazines, direct mail, brochures/flyers, newspapers and TV.

First Contact & Terms: Call for appointment to show portfolio. Selection based on portfolio review. All work done on assignment basis. Buys all rights but may reassign rights for editorial use. Negotiates payment based on client's budget, amount of creativity required from artist and where work will appear.

Tips: Wants to see individual style and adequate samples of work.

*HEAPING TEASPOON ANIMATION, 4002 19th St., San Francisco CA 94114. (415)626-1893. Art Director: Chuck Eyver. Clients: commercial, industrial.

Needs: Uses photographers for films and as reference for design work. Subjects, jobs and needs vary.

Specs: Uses b&w and color prints.

First Contact & Terms: Query with stock photo list; provide resume, business card, self-promotion piece or tearsheets to be kept on file for possible future assignments. Works with freelancers by assignment only. SASE. Reports in 2 weeks. Pays \$10-100/b&w or color photo. Pays on acceptance. Rights vary on project and use. Credit line sometimes given.

HOEFER-AMIDEI ASSOCIATES, PUBLIC RELATIONS, 426 Pacific Ave., San Francisco CA 94133. (415)788-1333. Graphic Services Manager: Marc Reed. PR firm. Photos used in publicity, brochures, etc. Works with 1-3 freelance photographers/month on assignment only basis. Provide business card, flyer and brochure of sample work to be kept on file for possible future assignments. Pays

\$70 minimum/job; negotiates payment based on client's budget, amount of creativity required from photographer and photographer's previous experience/reputation. Call to arrange an appointment. Does not return unsolicited material.

Tips: "Keep in touch by phone every month."

KETCHUM ADVERTISING, INC., 55 Union St., San Francisco CA 94111. (415)781-9480. Vice President, Associate Creative Director: Dave Sanchez. Ad agency. Serves clients in food, banking,

Needs: Occasionally works with freelance photographers for consumer and trade print ads. Also works on TV.

First Contact & Terms: Call for appointment to show portfolio. Negotiates payment based on client's budget, amount of creativity required and where work will appear.

Tips: Wants to see whatever illustrates freelancer's style. Include transparencies and prints. "Limited opportunity to review portfolios."

OUROBOROS COMMUNICATIONS,, (formerly Pointer Productions), Box 624, San Francisco CA 94101. Director Creative Affairs: H. Willard Phelan. AV firm. Serves cable TV, small businesses and various independent producers. Produces motion pictures and videotape. Buys 100 photos and 10-20 films/year.

Subject Needs: Material varies from industrial and promotional films to educational and dramatic applications. Photos used in motion pictures and video. Also looking for candid celebrity photos. Film: 16mm. Interested in stock footage.

Photos: Uses b&w and color 5x7 glossy prints and 35mm transparencies.

Payment & Terms: Pays by the job, on production; \$15 minimum/color photo, \$10 minimum/b&w photo, \$5 minimum/hour. Credit line given. Rights negotiated. Model release required ("except as allowed by law; news shots, for example").

Making Contact: Send material by mail for consideration. "Submitted work must be accompanied by S.A.S.E.—unsolicited work will otherwise be disposed of." Reports in 3 weeks.

Tips: "We encourage submissions of almost any type of photograph due to our diverse output. We don't want the photographer's style to smother his subject. Well-crafted, thoughtful work is what we like. A small percentage of 'walk-in' photography is used, so be patient."

PINNE GARVIN HERBERS & HOCK, INC., 200 Vallejo St., San Francisco CA 94111. (415)956-4210. Creative Director: Fred Murphy. Art Directors: Piere Jacot, Victor Elsey, John Johnson, Marcia Sessa, Floyd Yost, Nori Kumitomo. Ad agency. Uses all media including radio and TV. Serves clients in electronics, finance, banking, software and hardware and transportation. Buys all rights. Call to arrange an appointment or submit portfolio by mail if out of town. Reports in 5 days. SASE.

Color: Uses transparencies and prints; contact sheet OK. "Do not send originals unsolicited." Model release required.

Tips: "Out of town talent should not send original material unless requested." Photographers should "be realistic as to whether his/her style would be applicable to our client list. If so, call for an appointment. It's a waste of both our time for me to say, 'that's beautiful work, but we can't use that type.' "

UNDERCOVER GRAPHICS, Suite A, 1169 Howard St., San Francisco CA 94103. (415)626-0500. Creative Director: L.A. Paul. Ad agency. Uses billboards, consumer and trade magazines, P-O-P displays, radio and TV. Serves clients in entertainment (film, TV, radio and music), publishing and recreation. Buys 20-30 photos/year. Local freelancers preferred. Provide brochure, flyer and tearsheets to be kept on file for possible future assignments. Pays \$100-1,500/job or on a per-photo basis. Pays on acceptance. Rights purchased vary with job. Model release required. Query with resume of credits; will view unsolicited material. SASE. Reports in 1 month. Does not pay royalties.

B&W: Uses 8x10 prints; contact sheet OK. Pays \$25-500/photo.

Color: Uses 8x10 prints, 35mm and 4x5 transparencies; contact sheet OK. Pays \$25-500/photo. Film: Produces 16mm TV commercials and documentaries. Also produces 1/2" and 3/4" video and filmto-video and video-to-film transfers. Assignments include creative consultation and/or technical production.

Tips: The stylistic and technical trends that we are seeing are "bold colors; hazy pastels; sharp, slashing images and severe juxtapositions of subject matter."

*VIDEO VISION, #204, 130 Frederick, San Francisco CA 94117. (415)626-5354. Executive Producer: Scott Wiseman. Clients: ad agencies, industry, independent producers. Needs: Works with 2-5 photographers/month. Uses photographers for multimedia productions and

videotapes. Subjects vary with clients.

Specs: Uses 8x10 glossy b&w prints, 8x10 matt color prints, VHS, U-mtic 3/4", 1" videotape. First Contact & Terms: Submit resume. Works with freelancers by assignment only; interested in stock photos/footage. SASE. Reports in 3 weeks. Pay varies. Pays on acceptance and on publication. Buys one-time and all rights. Captions preferred; model releases required. Credit line given.

Colorado

BROYLES ALLEBAUGH & DAVIS, INC., 31 Denver Technological Center, 8231 E. Prentice Ave., Englewood CO 80111. (303)770-2000. Contact: Art Director. Ad agency. Clients: business to business, industrial, financial, health care, high-tech, travel and some consumer firms; client list provided upon request.

Needs: Works with approximately 25 freelance photographers/year on assignment only basis. Uses photographers for consumer and trade magazines, direct mail, P-O-P displays, brochures, catalogs,

posters, newspapers, AV presentations and TV.

First Contact & Terms: Arrange interview to show portfolio. Negotiates payment according to job.

BULLOCH & HAGGARD ADVERTISING INC., 226 E. Monument, Colorado Springs CO 80903. (303)635-7576. Ad agency. Contact: Linda Maurer. Clients: industrial, real estate, finance, high-tech. Needs: Works with 2 freelance photographers/month. Uses photographers for consumer and trade magazines, direct mail, brochures, catalogs, newspapers, and AV presentations. Subjects include studio setups, location, some stock material. Also works with freelance filmmakers to produce commercials. Specs: Uses b&w prints; 35mm, 21/4x21/4, 4x5 and 8x10 transparencies; 16mm and 35mm film and videotape.

First Contact & Terms: Arrange a personal interview to show portfolio; query with list of stock photo subjects. Provide resume, business card, brochure, flyer or tearsheets to be kept on file for possible future assignments. Works with freelance photographers on assignment basis only. Does not return unsolicited material. Reports in 2 weeks. Pays \$35-50/hour; \$350-500/day. Pays 30 days after billing. Buys all rights or one-time rights. Model release required; captions optional. Credit line "not usually

Tips: Prefers to see "professional (commercial only) work" in a portfolio. "We have little need for portraits and/or photojournalism. Photographers should be able to complete an assignment with minimal supervision. Our photographers solve problems for us. They need to understand deadlines and budgets, and should be able to take an assignment and add their creative input."

*CIMARRON PRODUCTIONS, Suite 215, 6875 E. Evans, Denver CO 80224. (303)753-0988. President: Don Cohen. Clients: corporate, ad agencies, government.

Needs: Works with 1 photographer/month. Uses photographers for slide sets, multimedia productions

and videotapes. Subjects include general assignment, specialty.

Specs: Uses 35mm, 21/4x21/4 and 4x5 transparencies; VHS, Beta and U-matic 3/4" videotapes. First Contact & Terms: Arrange a personal interview to show portfolio; query with stock photo list; provide resume, business card, self-promotion piece or tearsheets to be kept on file for possible future assignments. Works with local freelancers by assignment only; are interested in stock photos/footage. Does not return unsolicited material. Reports in 2 weeks. Pays \$50-200/color photo; \$20-40/hour; \$160-480/day. Pays within 30 days. Buys all rights. Model release required. Credit line given whenever possible.

CINE/DESIGN FILMS, 255 Washington St., Denver CO 80203. (303)777-4222. Producers: Jon Husband, Dan Boyd. AV firm. Serves a wide variety of clients. Works with 6-10 freelance photographers/month. Provide resume, letter of inquiry and published examples to be kept on file for future assignments.

Film: Uses 16mm and 35mm film. Works with freelancers by assignment only; interested in stock

photos/footage.

Payment & Terms: Pays by the job. Negotiates payment based on client's budget and photographer's previous experience/reputation. Pays on acceptance. Model release preferred. Buys one-time rights. Making Contact: Arrange personal interview or query with resume. SASE. Reports in 2 weeks.

EVANS & BARTHOLOMEW, INC., 2128 15th St., Denver CO 80202. (303)534-2343. Creative Director: Arnold Grossman. Ad agency. Annual billing: over \$10,000,000. Clients: consumer, food, health care, public service, institutions and financial.

Needs: Works with 6 freelance photographers/month. Uses photographers for consumer and trade

magazines, brochures/flyers, production companies and newspapers.

First Contact & Terms: Call for appointment to show portfolio. Negotiates payment based on client's budget and where work will appear.

FOX, SWEENEY & TRUE, 707 Sherman, Denver CO 80203. (303)837-0510. Creative Director: Fran Scannell. Art Director: Mary Ellen Hester. Ad agency. Serves clients in industry, finance and food. Needs: Works with 2-3 freelance photographers/month. Uses photographers for P-O-P displays, consumer and trade magazines, brochures/flyers and newspapers. Provide business card, brochure and flyer to be kept on file for possible future assignments.

First Contact & Terms: Call for appointment to show portfolio. Negotiates payment based on nature of

job. Pays in 30 days.

Tips: Prefers to see samples of best work; b&w, color transparencies and 8x10 negatives. "Be patient."

FRIEDENTAG PHOTOGRAPHICS, 356 Grape St., Denver CO 80220. (303)333-7096. Manager: Harvey Friedentag. AV firm. Serves clients in business, industry, government, trade, union organizations. Produces slide sets, motion pictures and videotape. Works with 5-10 freelance photographers/ month on assignment only basis. Provide flyer, business card and brochure and nonreturnable samples to show to clients. Buys 1,000 photos and 25 films/year.

Subject Needs: Business, training, public relations and industrial plants showing people and equipment or products in use. Uses freelance photos in color slide sets, motion pictures and printed material. No

posed looks. Length requirement: 3-30 minutes.

Film: Produces mostly 16mm Ektachrome and some 16mm b&w, videotape, 3/4 and Beta. Interested in stock footage on business, industry, education, recreation and unusual information.

Photos: Uses 8x10 glossy b&w prints; 8x10 glossy color prints and transparencies; and 35mm or 21/4x21/4 or 4x5 color transparencies.

Payment & Terms: Pays \$200/day for still; \$300/day for motion picture plus expenses, or \$25/b&w photo or \$50/color photo. Pays on acceptance. Buys rights as required by clients. Model release

Making Contact: Send material by mail for consideration, SASE. Reports in 3 weeks.

Tips: "More imagination needed, be different and above all, technical quality is a must. There are more opportunities now than ever, especially new people. We are looking to strengthen our file of talent across the nation."

MARSTELLER INC., 5500 S. Syracuse Circle, Englewood CO 80111. (303)773-3900. Contact: Associate Creative Director. Ad agency. Clients: financial, industrial and general consumer firms; client list provided upon request.

Needs: Works with 10 freelance photographers/year on assignment only basis. Uses photographers for billboards, consumer and trade magazines, direct mail, P-O-P displays, brochures, catalogs, posters, signage, newspapers and AV presentations.

First Contact & Terms: Local freelancers only. Phone creative director. Negotiates payment "job by job."

TRANSTAR PRODUCTIONS, INC., Suite 170, 750 West Hampden, Englewood CO 80110. (303)761-0595. Contact: Doug Hanes or Tony Wilson. Motion picture and video tape production. Serves clients in business and industry. Produces 16mm films, multiprojector slide shows, sound tracks, and video tapes. Also offering slide-to-film and slide-to-video transfers.

Subject Needs: Looking for freelance photographers, writers, and film production personnel experienced in a variety of film and video areas.

Payment & Terms: Pays by the job, or per day. Pays negotiable rates; 50% of expenses up front; balance upon delivery of approved product.

Making Contact: Send resume and/or material before phone contact. Previous sales experience very helpful. "Know the business of film production."

WEST WIND PRODUCTIONS, INC., Box 3532, Boulder CO 80307. (303)443-2800. President: Jeanne Kempers. AV firm. "We produce and distribute 16mm films to schools, libraries, government agencies, and private corporations." Provide resume and brochure to be kept on file for possible future assignments.

Subject Needs: Biology, outdoor sports, conservation, environment, nature.

Film: "We produce and distribute outdoor sports films and natural history films. Most of our films are photographed on ECN and released in 16mm color with sound." Interested in stock footage of natural history and outdoor sports; query first. "We require exclusive rights to distribution. 15-20% of all sales and rentals. Percentage depends on how much postproduction expense West Wind Productions has. The more completed a film is when turned over to us, the higher the royalty." Photos: "Usually we do not buy still photos from stock."

Payment & Terms: Pays a negotiated fee by the job. "Various production phases are contracted such as photography, writing, editing, sound, etc." Pays on acceptance. Buys all rights. Model release required. Making Contact: Query first—"but we must see samples of work." SASE. Reports in 1 month.

Connecticut

AETNA LIFE & CASUALTY, Corporate Communications, 151 Farmington Ave., Hartford CT 06156. Attention: Corporate Communications, DA 14, Robert Cooke. (203)273-1982. Contact: Administrator, photographic operations. Inhouse AV facility. Produces overhead transparencies and multiimage presentations. Subjects include safety and business, photojournalism, employees and businesses, business situations, architectural photos of company property. Extensive use of freelance photographers for inhouse magazine and newspaper photography. Provide portfolio or mailer to be kept on file for possible future assignments. Buys all rights, but may reassign to photographer. Negotiates payment based on project. Query first with resume of credits. Reports in 2 weeks. SASE.

Needs: Extensive use of still photography, b&w and color, for inhouse publications. **B&W**: Assignments require contact sheet with negatives. Model release required.

Color: Send transparencies or contact sheet. Model release required.

Tips: "Prefers freelancers from outside of Hartford area."

MERRILL ANDERSON CO., INC., 1166 Barnum Ave., Stratford CT 06497-5402. (203)377-4996. Art Director: Ellen Fairfield. Publishing. Uses trust publications and direct mail. Serves clients in finance. Buys 60 stock photos/year. Local freelancers only. Buys one-time rights. Model release required. Arrange a personal interview to show portfolio of human interest and still life shots, not product photos, or query with list of stock photo subjects. "We use mostly stock photos. Occasionally, we need a custom photo. We are interested in stock photos of affluent-looking and middle-aged couples, families and businessmen/women." SASE. Reports in 1 month. **B&W:** Pays \$50-150/b&w photo; \$75-275/color photo; \$50-100/hour or \$100-350 job.

Color: Uses transparencies, any size OK. Pays \$100/photo minimum.

BRAY STUDIOS INC., 19 Ketchum St., Westport CT 06880. (203)226-3777. Assistant President: Linda Hall. AV firm. Produces filmstrips, slide sets, multimedia kits, motion pictures, sound-slide sets, videotape. Buys 2-8 filmstrips and 10-25 films/year.

Subject Needs: Vary depending on client, e.g. detailed electronic display on traffic control to industrial psychology to a product demonstration.

Film: Produces 16mm, 35mm, video.

Payment & Terms: Pays/job or hour. Pays on production. Buys all rights or according to client needs. Model release required.

Making Contact: Query with resume of credits, or send resume and then telephone. SASE. Provide resume and business card to be kept on file for possible future assignments.

Tips: "Let us know what area you have worked in, with whom, and what equipment used."

CHARNAS, INC., 341 Broad St., Manchester CT 06040. Senior Art Director: Ralph Skogen. Ad agency. Clients: "all types-consumer products, industrial products, banks, utilities."

Needs: Works with 3 freelance photographers/month. Uses photographers for consumer magazines, trade magazines, direct mail, P-O-P displays, brochures, catalogs, posters, newspapers and AV presentations. Also works with filmmakers to produce TV commercials and training films.

Specs: Uses glossy b&w prints; 35mm, 21/4x21/4, 4x5 and 8x10 transparencies; 16mm and 35mm film and videotape.

First Contact & Terms: Arrange a personal interview to show portfolio or submit portfolio for review; provide resume, business card, brochure, flyer or tearsheets to be kept on file for possible future assignments. Works with freelance photographers on assignment basis only. Does not return unsolicited material. Reporting time varies. Pays \$30-150/hour and \$300-1,000/day. Payment is made following payment by clients. Buys all rights (work for hire). Model release required.

Tips: "Show good portfolio and reasonable rates."

*CURRENT AFFAIRS, 346 Ethan Allen Hwy., Ridgefield CT 06877. (203)431-0421. Vice President: Sharon Burke. Clients: educational, corporate.

Needs: Uses photographers for filmstrips, multimedia productions and videotapes.

Specs: Uses 35mm transparencies; VHS videotape.

First Contact & Terms: Provide resume, business card, self-promotion piece or tearsheets to be kept on file for possible future assignments. Works with local freelancers by assignment only; interested in stock photos/footage. Reports in 1 month. Pays individually negotiated. Buys one-time and all rights. Captions and model release required. Credit line sometimes given.

EDUCATIONAL DIMENSIONS GROUP, Box 126, Stamford CT 06904. (203)327-4612. Visual Editor: Marguerite Mead. Clients: educational market—schools and libraries nationwide. Uses photographers for filmstrips, slide sets, videotapes.

Needs: Subjects include travel, science, current affairs, language arts (staged dramatizations), careers,

etc.

Specs: Uses 35mm, 21/4x21/4 and 4x5 transparencies; VHS videotape.

First Contact & Terms: Arrange a personal interview to show portfolio; provide resume, business card, self-promotion piece or tearsheets to be kept on file for possible future assignments. Works with freelancers by assignment only; interested in stock photos/footage. Pay individually negotiated. Pays on acceptance. Buys one-time rights (for stock), and all rights. Model release required. Credit line given.

*GEOMATRIX ASSOCIATIONS, INC., 305 Bic Dr., Milford CT 06460. (203)878-6066. Producer: Cathie Reese. Clients: law firms, broadcast and industrial.

Needs: Works with 5-7 photographers/month. Uses photographers for videotapes. Subjects include

simple video recordings and documentaries.

First Contact & Terms: Query with resume; provide resume, business card, self-promotion piece or tearsheets to be kept on file for possible future assignments. Works with freelancers by assignment only; interested in stock photos/footage. Pays/job. Pays on receipt of invoice. Buys all rights. Credit line given.

GUYMARK STUDIOS, 3019 Dixwell Ave., Box 5037, Hamden CT 06518. (203)248-9323. President: A. Guarino. Offers complete production and technical service for film, video and sound communications. Clients include advertising agencies, financial and educational institutions, and industrial and commercial firms. Produces 16mm and 35mm films, filmstrips and multimedia kits. Pays \$125/day. Call to arrange an appointment.

Film: 16mm and 35mm documentary, industrial, TV location, studio camera work, commercial and educational films. Sample assignments include "anything from local factory shooting to extensive around the world travel/location shooting."

B&W: Uses negatives with 8x10 matte prints.

Color: Uses 35mm and 21/4x21/4 transparencies, or negatives with 8x10 glossy or matte prints.

INFORMATION COUNSELORS, INC., Box 88, Bethel CT 06801. (203)797-0307. President: Warren Owens. PR firm. Clients include consultants in various disciplines and service organizations. Photos used in brochures, PR releases, AV presentations and trade magazines. Free client list. Works with 1 freelance photographer/month on assignment only basis. Provide resume, business card and brochure to be kept on file for possible future assignments. Pays on a per-job basis; negotiates payment based on client's budget. Credit line given whenever possible. Buys one-time rights or all rights. Model release and captions preferred. Prefers to see samples of business executive in action shots and industrial photos in a portfolio. Local freelancers preferred. Usually does not consider unsolicited material. SASE. Reports in 2 weeks. Interested in action shots; sensitive posed shots, "aesthetic as well as informative."

B&W: Uses 5x7 glossy prints; contact sheet OK.

Color: Uses 5x7 glossy prints.

Tips: "Be enthusiastic and be able to answer technical photography questions. Know your stuff! (i.e. lighting, composition, etc.) Take initiative—ask questions."

JACOBY/STORM PRODUCTIONS, INC., 22 Crescent Rd., Westport CT 06880. (203)227-2220. President: Doris Storm. Vice President: Frank Jacoby. AV firm. Clients include industry and educational institutions. Produces filmstrips, motion pictures and videotapes. Needs occasional photos of people (all ages and ethnic mixtures), urban/suburban life, school/classroom situations, and scenery. Buys one-time rights. Pays \$150-300/day or on a per-job or per-photo basis. Call to arrange an appointment or query with resume of credits. SASE.

Film: 16mm documentary, industrial and educational films in color and b&w. Possible assignments include only freelance crew assignments: assistant cameraman, gaffer, sound, editing, etc.

Color: Uses 35mm transparencies. Pays according to number used.

Tips: "We suggest that you design your portfolio to suit potential client—in our case, emphasize photojournalism techniques in 35mm color slides."

THE McManus Company, Box 446, Greens Farms CT 06436. (203)255-3301. President: John F. McManus. National advertising, market and PR agency. Serves corporate, consumer, and industrial clients.

Needs: Works with freelance photographers on assignment only basis. Buys 24 filmstrips and 6 films/year. Uses photographers for print advertising, slide sets, motion pictures and TV commercials. Subjects include sales, marketing, training and documentaries.

Specs: Produces 16 and 35mm films. Uses b&w photos, color transparencies and prints.

First Contact & Terms: Query with resume of credits. Provide resume and calling card to be kept on file for possible future assignments. Pay \$50-200/hour; \$300-2,400/job. Pays on production. Buys all rights, but may reassign to photographer after use. Model release required; captions optional.

STANLEY H. MURRAY & ASSOCIATES, 45 E. Putnam Ave., Greenwich CT 06830. (203)869-8803. President: S.H. Murray. Ad agency. Uses all media. Serves a variety of clients. Buys 30-50 photos/year. Pays \$25-500/job. Local freelancers only. Call to arrange an appointment; query with resume of credits; or submit material by mail for consideration. SASE.

B&W: Uses 8x10 glossy prints. Color: Uses 8x10 glossy prints.

SAVE THE CHILDREN, Communications Center, 54 Wilton Rd., Westport CT 06880. (203)226-7272. Director: Joseph M. Loya. Nonprofit organization. Produces slide presentations, 16mm film, videotapes, publications, and displays. Subjects and photo needs relate to children in poverty areas both in the US and overseas, as well as "examples of self-help and development projects, sponsored by Save the Children." Works with 0-5 freelance photographers/month on assignment only basis. Provide letter of inquiry, flyer and tearsheets to be kept on file for possible future assignments. Buys 25-200 photos and 3,000-4,000 feet of film annually. Buys all rights, but may reassign to photographer. Pays \$75-250 minimum/day; negotiates payment based on client's budget and photographer's previous experience/ reputation. Pays on receipt of materials. Query first with resume of credits. Reports in 1 month. SASE. Film: 16mm color sound used as documentaries, fundraising films, public service films and TV commercials. Possible assignments include filming 1,500-2,500' of a Save the Children project on location, which will be submitted to Save the Children for processing and editing. "When catastrophe or natural disaster strike a country in which we have programs, footage is needed immediately," but only on assignment. Model release required.

B&W: Send contact sheet or negatives. Uses 8x10 glossy prints. Captions and model release required.

Color: Send 35mm transparencies. Captions and model release required.

Tips: "We need to communicate, as powerfully as possible, the desperate needs of the poor (have-not) people of the world—especially the children.

WESTON WOODS STUDIOS, 389 Newtown Turnpike, Weston CT 06883. (203)226-3355. Executive Producer: Judy Duris. AV firm and motion picture and distribution company. Clients: educational, TV.

Needs: Works with approximately 1 freelance photographer/month—"varies, depending on projects in production." Uses photographers for direct mail, catalogs, brochures and motion picture production. Subjects include product, candids, promotional for Weston Woods films, children's literature. Also works with freelance filmmakers to produce "films for children based on outstanding children's books." First Contact & Terms: Query with samples or sample reel; provide resume, business card, brochure, flyer or tearsheets to be kept on file for possible future assignments. Works with local freelancers on an assignment basis only. SASE. Pays \$35/roll for candids; "scale" per day. Pays on acceptance. Buys all rights. Model release required. Credit line given "when practical."

Tips: Prefers to see "sample motion picture reel for cinematography; portfolio for stills. Contact us with

sample reel or portfolio, then arrange interview.'

Delaware

KEN-DEL PRODUCTIONS, INC., 111 Valley Rd., Wilmington DE 19804-1397. (302)655-7488. President: H. Edwin Kennedy. AV firm. Produces slides, videos, filmstrips, motion pictures and overheads. Serves an industrial, educational and commercial market. Submit material by mail for consideration. Reports in 3 weeks. SASE.

Film: Produces documentary, industrial, educational and product sales films in 35mm, 16mm, Super 8mm and 3/4" U-matic, 1/2" VHS and Betamax. Model release required.

Color: Uses 21/4x21/4 or 4x5 and occasionally 35mm transparencies, motion picture footage or videotape. No originals.

LYONS, INC., 715 Orange St., Wilmington DE 19801. (302)654-6146. Vice President: Coleman du Pont. Director of Photography: Floyd Dean. AV firm. Clients: business, industrial.

Needs: Uses photographers for multimedia kits and videotape. Subjects include sales meetings/seminar openings/closings and educational/motivational presentations.

Specs: Produces color only; 35mm multiimage production: 3-30 projectors and video for business and

industry. Uses 35mm or 4x5 color transparencies; pays \$25-300/color photo.

First Contact & Terms: Arrange a personal interview to show portfolio or query with resume of credits; provide resume, calling card and samples to be kept on file for future assignments. Pays \$25-75/hour "to qualified professionals." Payment on acceptance. Buys all rights, but may reassign to photographer after use. Model release required.

Tips: Include "35mm multiimage sequences, published literature or videotape and provide samples with a short description of objective and audience."

MALCOLM L. MACKENZIE & ASSOCIATES, Box 25123, Wilmington DE 19899. (302)764-6755. Ad agency. Handles all types of accounts. Uses photos in advertising, sales literature and brochures. Works with 1 freelance photographer/month on assignment only basis. Provide resume and flyer to be kept on file for possible future assignments. Present model release on acceptance of photo. Negotiates payment based on client's budget; pays \$35 minimum/hour; \$250 minimum/day. Pays on production. Solicits photos by assignment only; submit samples by mail. Reports in 3 weeks. Does not return unsolicited material. Uses film and b&w and color photos; specifications given in person.

*TRICOLOR, INC., 118 Valley Rd., Wilmington DE 19804. (302)658-4163. Production Manager: John Reeves. Clients: commercial artists, designers, AV producers, professional photographers, advertising agencies, commercial, industrial firms.

Needs: Works with 30-40 photographers/month. Uses photographers for slide sets, reproduction-quality duplicates.

Specs: Uses 35mm, 21/4x21/4, 4x5, 8x10 color transparencies.

First Contact & Terms: Provide resume, business card, self-promotion piece or tearsheets to be kept on file for possible future assignments.

District of Columbia

ABRAMSON ASSOCIATES, 1275 K St. NW, Washington DC 20005. (202)289-6900. Ad agency, Art Director: Jim Spruell. Clients: industrial, finance, entertainment, real estate, hotels. Free client list. **Needs:** Works with 2-4 freelance photographers/month. Uses photographers for consumer magazines, trade magazines, brochures, posters, and newspapers. Subjects include: tabletop editorial products, location. Also works with freelance filmmakers to produce TV commercials.

Specs: Uses 8x10 and 11x14 b&w and color prints; any size transparencies; 35mm film and videotape. **First Contact & Terms:** Query with samples: provide resume, business card, brochure, flyer or tearsheets to be kept on file for possible future assignments. Works with freelance photographers on assignment basis only. Does not return unsolicited material. Reports in 2 weeks. Pays/job. Buys all rights (work for hire). Model release required.

Tips: "Be able to fill a need as a competent photographer with good skills."

DANIEL J. EDELMAN, INC., 1730 Pennsylvania Ave., NW, Washington DC 20006. (202)393-1300. Contact: Betty Lou Long. PR firm. Clients: trade associations, foreign governments, manufacturers.

Needs: Works with 2 freelance photographers/month. Uses photographers for press conferences and client functions, new business presentations.

First Contact & Terms: Call Betty Lou Long for appointment to show portfolio. Negotiates payment based on photographer's charges and client's budget.

KROLOFF, MARSHALL & ASSOCIATES, LTD., Suite 500, 1730 Rhode Island Ave. NW, Washington DC 20036. Vice President: Susanne Roschwalb. PR/management consulting firm. Clients: major corporate, public interest, international.

Needs: Needs photographers in the DC area with 24-hour development capabilities. Uses photographers for coverage of events, news photos and documentation.

First Contact & Terms: Query with resume of credits "and a Rolodex card with your name and phone number" to be kept on file. Payment is by the day; going rate. Credit line given.

Tips: "Find a specialty—if you cover an event on spec be sure to let organizers know what you have."

MacKENZIE McCHEYNE, INC., Suite 812, 2475 Virginia Ave. NW, Washington DC 20037. (202)338-9431. President: Ian MacKenzie. Ad agency and PR firm. Handles corporate accounts, foreign government accounts, principally from Latin America. Photos used in brochures, PR releases and sales literature. Works occasionally with freelance photographers on assignment only basis. Provide resume to be kept on file for possible future assignments. Gives 2-3 assignments/year. Pays \$100

minimum/job. Negotiates payment based on client's budget and photographer's previous experience/ reputation. Buys all rights. Model release preferred. Query with resume of credits or send material by mail for consideration. SASE. Most interested in "photographs that reflect different types of progress and economic growth (government programs, health, education, industry, agriculture); descriptive photographs taken from various perspectives." Photographers should be fluent in both English and Spanish. Experience with Latin America preferred.

B&W: Uses 8x10 glossy prints; contact sheet OK.

Color: Uses 35mm transparencies and glossy prints; contact sheet OK.

SCREENSCOPE, INC., Suite 204, 3600 M St., NW, Washington DC 20007. (202)965-6900. President: Marilyn Weiner. Motion picture and AV firm. Clients: education, government, business. Needs: Produces filmstrips, motion pictures and sound-slide sets. Works with 1-2 freelance photographers/month (predominately in motion pictures) on assignment only basis. Documentary; industrial; educational (science, geography, nature); public service and sales training. Photos used in filmstrips and slide presentations.

Specs: Produces 16mm color sound film. Interested in stock geographical footage for educational purposes, particularly foreign countries. Sometimes pays royalties, depending on film. Uses 8x10

glossy b&w prints and 35mm and 21/4x21/4 color transparencies.

First Contact & Terms: Query with resume of credits; provide resume, flyer, tearsheets and brochure to be kept on file for possible future assignments. SASE. Reports in 2 weeks. Pays by the job. Pays on production. Negotiates payment based on client's budget. Buys one-time rights. Model release required.

J. WALTER THOMPSON U.S.A., 1156 Fifteenth St. NW, Washington DC 20005. (202)861-8500. Art Director: Pedro Gonzalez. Ad agency. Serves clients in government agencies, finance, professional associations, US Marine Corps, and US Air.

Needs: Works with varying number of photographers. Uses photographers for all types of media. First Contact & Terms: Call for appointment to show portfolio or make contact through artists' rep. Tips: Prefers to see a broad spectrum of work that shows style but artist should also be able to show specialized work in one specific area.

UPITN, CORP., Suite 200, 1705 DeSales St. NW, Washington DC 20036. (202)835-0750. Bureau Manager, Washington: Paul C. Sisco. AV firm. "We basically supply TV news, both on film and tape, for TV networks and stations. At this time, most of our business is with foreign nets and stations." Produces motion pictures and videotape. Works with 6 freelance photographers/month on assignment only basis. Provide business card to be kept on file for possible future assignments. Buys dozens of films/year.

Subject Needs: Generally hard news material, sometimes of documentary nature.

Film: Generally hard news film clips using 16mm color silent and/or sound.

Payment & Terms: Pays \$100 minimum/job. Pays on receipt of material; nothing on speculation. Film cameraman \$100 and up, plus equipment; video rates about \$350/half day, \$650/full day or so. Negotiates payment based on amount of creativity required from photographer. Uses established union rates in many areas. Buys all rights. Dupe sheets for film required.

Making Contact: Send name, phone number, equipment available and rates with material by mail for consideration. Fast news material generally sent counter-to-air shipment; slower material by air freight.

SASE. Reports in 2 weeks.

Florida

ALLEGRO FILM PRODUCTIONS, INC., 10915 Boca Woods Lane, Boca Raton FL 33433. (305)484-5150. President: J.G. Forman. AV firm. Serves clients in *Fortune* 500 companies and schools. Produces filmstrips, motion pictures and videotape. Buys 5-10 films/year. Provide resume to be kept on file for possible future assignments.

Subject Needs: Needs science films for secondary schools pertaining to what man is doing to improve

the environment. Films should run 12-30 minutes.

Film: Produces film concerning the environment. Interested in stock footage.

Payment & Terms: Payment negotiable. Pays on acceptance. Buys all rights. Model release required. Making Contact: Query with resume of credits. SASE. Reports in 1 month.

AURELIO & FRIENDS, INC., 11110 SW 128th Ave., Miami FL 33186. (305)385-0723. President: Aurelio Sica. Vice President: Nancy Sica. Ad agency. Uses billboards, consumer and trade magazines, direct mail, newspapers, radio and TV. Serves clients in retail stores, shopping centers, developers,

manufacturers, resorts, entertainment and fashion. Commissions 10-12 photographers/year. Payment depends on assignment. Buys all rights. Model release required. Query with samples. SASE. Reports in 2 weeks.

Specs: Uses b&w prints and 35mm and 21/4x21/4 color transparencies.

C/F COMMUNICATIONS, Suite 223, 1040 Bayview Dr., Ft. Lauderdale FL 33304 (305)564-5198. Contact: Sherry Friedlander. Ad agency and PR firm. Handles manufacturing and industry, beauty, construction, entertainment, finance, government, florist, industrial, health care clients. Photos used in brochures, newsletters, annual reports, PR releases, AV presentations, sales literature, consumer and trade magazines. Works with 3 freelance photographers/month on assignment only basis. Provide business card and brochure to be kept on file for future assignments. Buys 300 photos/year. Pays \$40 minimum or \$250-500/day; pays also on a per-photo basis. Negotiates payment based on client's budget and amount of creativity required from photographer. Buys all rights. Model release required. Arrange a personal interview to show portfolio; query with resume of credits, samples, or list of stock photo subjects; send material by mail for consideration. SASE. Reports in 2 weeks. Most interested in hospital shots, art, fashion, construction and interiors—"anything as long as it is original in content and superb in technical excellence."

B&W: Uses 8x10 glossy prints; contact sheet OK. Pays \$25-100/photo. **Color:** Uses 4x5 transparencies and 8x10 glossy prints. Pays \$25-100/photo. **Film:** Uses Super 8 and 16mm for government, industry and sales purposes.

Tips: Needs photographers with "firm prices specifically broken out; creative black-and-white work; willingness to book quickly—we often don't have a lot of lead time on making assignments—and who take direction well from the account executive or art director. South Florida needs more black-and-white, competitively priced freelance photo people."

*COLEE & CO., 2000 Palm Beach Lakes, Blvd., West Palm Beach FL 33409. (305)689-4210. Ad agency. Art Director: Carol Klausman. Clients: industrial, finance, residential.

Needs: Works with 2-3 photographers/month. Uses photographers for trade magazines, newspapers, brochures. Subjects include residential, pertaining to client.

Specs: Uses b&w and color prints; 35mm, 21/4x21/4, and 4x5 transparencies.

First Contact & Terms: Arrange a personal interview to show portfolio; submit portfolio for review; provide resume, business card, brochure, flyer or tearsheets to be kept on file for possible future assignments. Works with local freelance photographers on an assignment basis only. Pays \$50-100/hour and \$250-1,000/day. Pays on receipt of invoice. Buys all rights. Model release required.

CREATIVE RESOURCES, INC., 2000 S. Dixie Highway, Miami FL 33133. (305)856-3474. General Manager: Mac Seligman. PR firm. Handles clients in travel (hotels, airlines). Photos used in PR releases. Works with 1-2 freelance photographers/month on assignment only basis. Provide resume to be kept on file for possible future assignments. Buys 10-20 photos/year. Pays \$50 minimum/hour or \$100 minimum/day. Negotiates payment based on client's budget. For assignments involving travel, pays \$60-200/day plus expenses. Pays on acceptance. Buys all rights. Model release preferred. Query with resume of credits. No unsolicited material. SASE. Reports in 2 weeks. Most interested in activity shots in locations near clients.

B&W: Uses 8x10 glossy prints; contact sheet OK.

Color: Uses 35mm or 21/4x21/4 transparencies and prints.

EDUCATIONAL DEALER GROUP, Box 1025, Orange City FL 32763. (904)755-4336. President: Ed Rancourt. Ad agency/publisher. Clients: educational distributors and teacher stores.

Needs: Works with 1 freelance photographer/month. Uses photographers for catalogs and brochures. Subjects include "children in various school settings; photos of educational products."

Specs: Uses any size color prints and 35mm transparencies.

First Contact & Terms: Query with list of stock photo subjects; provide resume, business card, brochure, flyer or tearsheets to be kept on file for possible future assignments. Works with freelance photographers on assignment basis only. Does not return unsolicited material. Reports in 2 weeks. Pays negotiable rate per job or per b&w photo. Pays on acceptance. Buys all rights. Model release optional. Credit line given "sometimes."

*FLORIDA PRODUCTION CENTER, 150 Riverside Ave., Jacksonville FL 32202. (904)354-7000. Vice President: Lou DiGiusto. AV firm. Clients: business, industrial, federal agencies, educational. Needs: Uses photographers for filmstrips, slide sets, multimedia kits, motion pictures and videotape. First Contact & Terms: Query with resume of credits; provide resume, calling card, brochure/flyer and tearsheet to be kept on file for future assignments. Pays by the job "depending on project." Buys all rights. Model release required.

GROUP TWO ADVERTISING, INC./FLORIDA, Suite 300, 2691 E. Oakland Park Blvd., Fort Lauderdale FL 33306. (305)563-3390. Art Directors: David Johnson and Renaldo Hernandez. Ad agency. Uses billboards, consumer and trade magazines, direct mail, foreign media, newspapers, P-O-P displays, radio, and TV — "anything that is appropriate to a specific client." Serves clients in finance, food service, real estate, automotives, retail and entertainment. Works with 1 freelance photographer/ month on assignment only basis. Provide business card, brochure, flyer and samples or portfolio to be kept on file for future assignments. Pays \$40 minimum/3 hours, \$300 minimum/day (7 hours); negotiates payment based on amount of creativity required from photographer and photographer's previous experience/reputation. Local freelancers preferred. Buys all rights. Model release required. Arrange personal interview to show portfolio or query with samples or list of stock photo subjects. Prefers to see samples of real estate, "lifestyle" i.e. Southern Florida-beaches, water, skylines, activities, sports and people. SASE.

B&W: Prefers contact sheet; uses glossy or semigloss prints, depending on assignment and subject.

Color: Uses prints and transparencies; size depends on assignment and subject.

*HILL & KNOWLTON, (formerly Gray & Associates PR), Suite 1511, 201 E. Kennedy Blvd., Tampa FL 33602. Vice President: Bill Gray. PR firm. Uses consumer and trade magazines, direct mail and newspapers. Serves general clients. Deals with 20 photographers/year.

Specs: Uses b&w photos and color transparencies. Works with filmmakers on industrial and business

films.

Payment & Terms: Pays by hour and day. Buys all rights. Model release required. Making Contact: Query with resume of credits. SASE. Reports in 2 weeks.

*INDIANER MULTI MEDIA, 16201 SW 95th Ave., Miami FL 33157. (305)235-6132; (800)327-7888. Production Supervisor: Paul Simon.

Needs: Works with 3 photographers/month. Uses photographers for filmstrips, slide sets, multimedia

productions, films and videotapes. All subjects.

Specs: Uses b&w and color prints; 35mm and 4x5 transparencies; 16mm and 35mm films; VHS, 3/4" Umatic and 1" or 2" videotapes.

First Contact & Terms: Submit portfolio by mail; provide resume, business card, self-promotion piece or tearsheets to be kept on file for possible future assignments. Interested in stock photos/footage. Reports in 2 weeks. Pays based on quality. Pays on acceptance. Buys one-time and all rights. Captions preferred: model release required. Credit line given.

SUSAN NEUMAN, INC., Suite 25K, 555 NE 15th St., Miami FL 33132. (305)372-9966. PR firm. President: Susan Neuman.

Needs: Uses photographers for brochures, newspapers, signage, AV presentations. Also works with freelance filmmakers to produce TV commercials.

Specs: Uses 8x10 glossy prints; 35mm, 2¹/₄x2¹/₄, and 4x5 transparencies.

First Contact & Terms: Arrange a personal interview to show portfolio. Works with freelance photographers on assignment only basis. Does not return unsolicited material. Payment varies. Pays on publication. Buys all rights. Model release required; captions preferred. Credit line "sometimes" given.

PRUITT, HUMPHRESS, POWERS & MUNROE ADVERTISING AGENCY, INC., 516 N. Adams St., Tallahassee FL 32301. (904)222-1212. Creative Director: G.B. Powers. Adagency. Clients: industrial, consumer.

Needs: Works with 3-4 freelance photographers/month. Uses freelancers for consumer and trade magazine, direct mail, newspapers, P-O-P displays. Provide brochure and tearsheets to be kept on file

for possible future assignments.

First Contact & Terms: Write and request personal interview to show portfolio or send portfolio for review and send resume. "Freelancers are given as much freedom as their skill warrants." Pays 30 days after production.

Tips: Would like to see "10 photos or less of past agency work in clean, businesslike fashion including written explanations of work."

ROBINSONS, INC., 2808 N. Orange Ave., Orlando FL 32854. (305)898-2808. Ad agency. Senior Vice President/Creative Director: Norman Sandhaus. Clients: hotels, resorts, boards of tourism.

Needs: Works with 3 freelance photographers/month. Uses photographers for consumer and trade magazines, direct mail, brochures, posters, AV presentations. Subjects include hotel/resort interiors and exteriors with models.

Specs: Uses 35mm, 21/4x21/4 and 4x5 transparencies.

First Contact & Terms: Query with samples; provide resume, business card, brochure, flyer or tearsheets to be kept on file for possible future assignments. Does not return unsolicited material. Reports in 2 weeks. Pays \$650 minimum/day. Pays on acceptance. Buys all rights. Model release required.

Tips: Prefers to see "use of interior lighting and use of models. Show examples of similar work."

BRUCE RUBIN ASSOCIATES, INC., Suite 203, 2655 Le Jeune Rd., Miami FL 33134. (305)448-7450. Contact: Bruce Rubin or Kim Foster. PR firm. Handles clients in finance, travel, education and electronics. Photos used in brochures, newsletters, newspapers, AV presentations, posters, annual reports, PR releases, magazines and advertisements. Gives 200-250 assignments/year. Fees negotiable depending on client's budget. Buys all rights. Model release required. Arrange a personal interview to show portfolio. Local freelancers preferred. No unsolicited material; does not return unsolicited material. Reports in 2 weeks.

B&W: Uses 8x10 glossy prints; contact sheet OK.

Color: Uses transparencies and glossy prints.

Film: Infrequently produces 7-10 minute shorts for clients; TV spots also. Assignment only.

Tips: Obtain agency photography assignment form.

STARR/ROSS CORPORATE COMMUNICATIONS, INC., 2727 Ponce de Leon Blvd., Coral Gables FL 33134. (305)446-3300. Contact: Photography Buyer. Clients: land developers, Fortune 500. Needs: Works with 3-4 freelance photographers/month. Uses freelance photographers for AV presentations, trade magazines and brochures. Subjects include "corporate photojournalism."

Specs: "Primarily accept 35mm Ektachrome for processing here from assignment."

First Contact & Terms: Provide resume, business card, brochure, flyer or tearsheets to be kept on file for possible future assignments. Works with freelance photographers on assignment basis only. Do not send unsolicited material. Pays \$200-400/day; \$50-10,000/job; "by negotiation including guarantees of minimum number of assignments." Pays within 30 days of job completion. Buys all rights. Model release and captions required.

Tips: "Generally we require a word-of-mouth recommendation from a business associate before we will

even talk to a freelancer."

*HACK SWAIN PRODUCTIONS, INC., 1185 Cattlemen Rd., Sarasota FL 33582. (813)371-2360. President: Tony Swain. Clients: corporate, educational.

Needs: "We have our own staff. Use freelance occasionally for special photo needs." Uses photographers for filmstrips, slide sets, multimedia productions, films and videotapes.

Specs: Uses 35mm and 21/4x21/4 transparencies; 16mm film; VHS, 1", U-matic 3/4 videotapes. First Contact & Terms: Query with stock photo list. Interested in stock photos/footage. SASE. Reporting time varies with complexity of project. Payment individually negotiated. Pays sometimes on acceptance; sometimes on completion of project. Buys one-time and all rights. Model release required.

Credit line given whenever practical. Tips: "We usually do our own photography, but seek freelance help for hard to find or hard to recreate

historical photo materials. We like to have on file sources for such materials."

TEL-AIR INTERESTS, INC., 1755 NE 149th St., Miami FL 33181. (305)944-3268. Contact: Sara Noll. AV firm. Serves clients in business, industry and government. Produces filmstrips, slide sets, multimedia kits, motion pictures, sound-slide sets and videotape. Buys 10 filmstrips and 50 films/year. Pays \$100 minimum/job. Pays on production. Buys all rights. Model release required, captions preferred. Arrange a personal interview to show portfolio or submit portfolio for review. SASE. Reports in 1 month.

Film: Documentary, industrial and educational film.

B&W: Uses prints.

Color: Uses 8x10 matte prints and 35mm transparencies.

TELFILM LTD, INC., Box 709, Homosassa Springs FL 32647. (904)628-2712. President: Mitch Needleman. PR firm. Serves businesses and various types of manufacturers. Produces motion pictures. Film: Produces 16mm film. Interested in stock footage.

Payment/Terms: Pays on a per-job basis, depending on experience and value to the particular production. Pays on completion. Buys all rights. Model release required.

Making Contact: Query with resume of credits; provide resume and business card to be kept on file for possible future assignments. SASE. Free photo guidelines.

YOUNG & RUBICAM/ZEMP INC., Suite 400, 6125 E. Princeton St., Orlando FL 32803. (305)896-1792. Ad agency and PR firm. Art Director: Ralph Newton. Clients: packaged goods, pesticides, insurance, financial. Client list free with SASE.

Needs: Works with 3-4 freelance photographers/month. Uses photographers for billboards, consumer

and trade magazines, direct mail, P-O-P displays, brochures, catalogs, posters, signage, newspaper, and AV presentations. Subject needs mostly product or people oriented. Also works with freelance filmmakers to produce TV commercials, demonstration films, P-O-P films and sales marketing films. Specs: Uses 8x10 to 16x20 "retouchable" b&w or color prints; 21/4x21/4, 4x5 and 8x10 transparencies; 35mm or videotape film.

First Contact & Terms: Arrange a personal interview to show portfolio. Works with freelance photographers on assignment basis only. SASE. Report in 2 weeks. Pays \$400-1,200/day. Pays in 30 to 60 days after invoice. Rights purchased vary according to job. Model release required; captions optional.

Credit line given depends on "nature of job or ad."

Tips: "We would like to see drama and excellent lighting on all photographs. Photographer must be professional and flexible."

Georgia

*ADAMSON PUBLIC RELATIONS & PROMOTIONS, 6280 Highway 42, Rex GA 30273. (404)968-1675. Owner: Sylvia Adamson. PR firm. Clients: profit and nonprofit organizations. Needs: Uses photographers for direct mail, newspapers, P-O-P displays, posters, audiovisual presentations, trade magazines, brochures. Subject matter and style "depends on client's needs."

Specs: Uses b&w or color 8x10 glossy prints; 35mm, 21/4x21/4 and 4x5 transparencies.

First Contact & Terms: Query with resume and list of stock photo subjects; provide resume, business card, brochure, flyer or tearsheets to be kept on file for possible future assignments. SASE. Reports in 3 weeks. Payment "depends on client and job assignment." Pays on acceptance. Model release and captions preferred. Credit line given.

Tips: "We work with a lot of small companies that don't have large budgets. Be reasonable with prices."

ADVANCE ADVERTISING & PUBLIC RELATIONS, 816 Cotton Ln., Augusta GA 30901. (404)724-7003. Ad agency. President: Connie Vance. Clients: automotive, industrial, manufacturing, residential.

Needs: Works with "possibly one freelance photographer every two or three months." Uses photographers for consumer and trade magazines, catalogs, posters, and AV presentations. Subject matter: 'product and location shots." Also works with freelance filmmakers to produce TV commercials on videotape

Specs: Uses glossy b&w and color prints; 35mm, 21/4x21/4 and 4x5 transparencies; videotape and film.

"Specifications vary according to the job."

First Contact & Terms: Provide resume, business card, brochure, flyer or tearsheets to be kept on file for possible future assignments. Works with freelance photographers on assignment basis only. Does not return unsolicited material. Reports in 1 month. Rates vary from job to job. Pays on publication. Buys all rights. Model release preferred.

Tips: Prefers to see "samples of finished work—the actual ad, for example, not the photography alone.

Send us materials to keep on file and quote favorably when rate is requested."

COMPRO PRODUCTIONS, Suite 114, 2080 Peachtree Industrial Court, Atlanta GA 30341. (404)455-1943. Director/Producer: Nels A. Anderson. Film/video producer. Industrial clients and ad agencies.

Needs: Works with variable number of freelance photographers each year. Uses photographers for AV presentations and brochures.

Specs: Uses b&w prints; 35mm transparencies; 16mm and 35mm film and videotape.

First Contact & Terms: Query with resume of credits; provide resume, business card, brochure, flyer or tearsheets to be kept on file for possible future assignments. Does not return unsolicited material. Reports in 2 weeks. Pays \$250-500/day. Pays on acceptance. Buys all rights or one-time rights. Model release required.

D'ARCY-MACMANUS & MASIUS, INC., Suite 1901, 400 Colony Sq., Atlanta GA 30361. (404)892-8722. Art Director: B.A. Albert. Ad agency. Clients: dairy products, real estate, sports equipment, clocks, banks, petroleum, theatre. Needs: Works with 20 freelance photographers/month. Uses all media.

First Contact & Terms: Arrange interview to show portfolio. Negotiates payment according to client's budget.

*FAHLGREN, SWINK AND NUCIFORA, Suite 1000, 2839 Paces Ferry Rd., Atlanta GA 30339. (404)892-9555. Ad agency. Clients: consumer goods, hi-tech, business-to-business. Client list free with SASE.

Needs: Works with 4 photographers/month. Uses photographers for billboards, consumer magazines, trade magazines, direct mail, catalogs, newspapers.

Specs: Uses 7x10 b&w and color prints; 35mm, 21/4x21/4, 4x5 and 8x10 transparencies.

First Contact & Terms: Arrange a personal interview to show portfolio; query with resume of credits; submit portfolio for review; provide resume, business card, brochure, flyer or tearsheets to be kept on file for possible future assignments. Does not return unsolicited material. Reports in 2 weeks. Pays/day or /job. Pays on receipt of invoice. Buys all rights. Model release required.

FLETCHER/MAYO/ASSOCIATES, INC., Suite 710, Five Piedmont Center, Atlanta GA 30305. (404)261-0831. Art Directors: Debra DeWitt, David Bridgeman, John Wieschhaus. Ad agency. Clients: primarily agricultural, industrial, consumer, fashion.

Needs: Works with "many" freelance photographers/month, usually on assignment only basis. Specializes in location photography. Most studio work done locally. Occasionally buys stock photos.

Uses all media.

First Contact & Terms: Arrange interview to show portfolio. Pays/day. Purchases all rights.

PAUL FRENCH & PARTNERS, INC., Rt. 5, Gabbettville Rd., LaGrange GA 30240. (404)882-5581. Contact: Gene Byrd. AV and video firm. Clients: industrial, corporate.

Needs: Works with freelance photographers on assignment only basis. Uses photographers for filmstrips, slide sets, multimedia. Subjects include: industrial marketing, employee training and orientation, public and community relations.

Specs: Uses 35mm and 4x5 color transparencies.

First Contact & Terms: Query with resume of credits; provide resume to be kept on file for possible future assignments. Pays \$75-150 minimum/hour; \$600-1,200/day; \$150 up/job, plus travel and expenses. Payment on acceptance. Buys all rights, but may reassign to photographer after use. Tips: "We buy photojournalism . . . journalistic treatments of our clients' subjects. Portfolio: industrial process, people at work, interior furnishings product, fashion. We seldom buy single photos.'

HAYNES ADVERTISING, 90 5th St., Macon GA 31201. (912)742-5266. Ad agency. Contact: Philip

Needs: Works with 1-2 freelance photographers/month. Uses photographers for direct mail, brochures and newspapers. Subjects include: products and people scenes.

Specs: Uses b&w and color prints; 35mm and 21/4x21/4 transparencies and videotape.

First Contact & Terms: Arrange a personal interview to show portfolio. Does not return unsolicited material. Pays \$25 minimum/job. Pays on publication. Buys all rights. Model release required.

*SMITH MCNEAL ADVERTISING, 368 Ponce de Leon Ave., Atlanta GA 30308. (404)892-3716. Sr. Art Director: Darryl Elliott. Ad agency. Clients: industrial, retail, food.

Needs: Works with one photographer/month. Uses photographers for billboards, consumer magazines, trade magazines, direct mail, P-O-P displays, annual reports, catalogs, posters, newspapers. Subject matter includes food and product.

Specs: Uses 81/2x11 glossy b&w prints and 21/4x21/4 and 4x5 transparencies.

First Contact & Terms: Send unsolicited photos by mail for consideration; query with samples; provide resume, business card, brochure, flyer or tearsheets to be kept on file for possible future assignments. Works with local freelancers only. SASE. Pays \$250-1,000/job, depending on complexity, props, number of models, etc. Pays within 90 days. Buys all rights. Model release required.

Tips: "Be persistent, it's often difficult, if not impossible to reach me. I like a casual, laid back photographer who is willing to go the extra mile in delivering excellent shots. Be on budget."

J. WALTER THOMPSON USA, 2828 Tower Place, 3340 Peachtree Rd. NE, Atlanta GA 30026. (404)266-2828. Art Directors: Anne Shaver, Bill Tomassi, Mark Ashley, Clem Bedwell, David Harner, Carey Morgan, John Boone. Ad agency. Clients: industrial and financial.

Needs: Works with 4-6 studios or photographers/month. Uses photographers for billboards, consumer and trade magazines, direct mail and newspapers. Uses experienced professional photographers only. First Contact & Terms: Send resume and samples. SASE. Reports in 2 weeks. Payment negotiable by photo, day or project.

TUCKER WAYNE & CO., Suite 2700, 230 Peachtree St. NW, Atlanta GA 30043. (404)522-2383. Contact: Business Manager/Creative. Ad agency. Serves a variety of clients including packaged products, food, utilities, transportation, agriculture and pesticide manufacturing.

Needs: Uses photographers for consumer and trade magazines, TV and newspapers.

First Contact & Terms: Call for appointment to show portfolio. Negotiates payment based on many factors such as where work will appear, travel requirements, budget, etc.

Hawaii

*PACIFIC PRODUCTIONS, Box 2881, Honolulu HI 96802. (808)531-1560. Manager: Robert Ebert. Clients: various, including educational.

Needs: Works with 6 photographers/month. Uses photographers for slide sets, multimedia productions, films and videotapes.

Specs: Uses 8x10 b&w and color prints; 35mm, 21/4x21/4, 4x5 transparencies; 16mm, 35mm film; VHS, Beta. U-matic 3/4", 1" videotape.

First Contact & Terms: Query with samples and stock photo list; provide resume, business card, self-promotion piece or tearsheets to be kept on file for possible future assignments. Works with freelancers by assignments only; interested in stock photos/footage. SASE. Reports in 2 weeks. Pay varies with job. Pays on acceptance. Buys one-time rights. Captions and model release required. **Tips:** Query first.

Idaho

DAVIES & ROURKE ADVERTISING, 1602 Franklin St., Box 767, Boise ID 83701. VP Creative Director: Bob Peterson. Ad agency. Uses billboards, direct mail, newspapers, P-O-P displays, radio, TV and trade magazines. Serves clients in utilities, industrial products, wood products, finance and fast food. Pays \$15 minimum/job. Buys all rights. Model release required. Query with resume of credits "listing basic day rate if possible" or query with samples (preferably printed samples, not returnable). Reports in 1 month.

B&W: Prefers contact sheet; print size and finish depends on job. **Color:** Uses prints and transparencies; size and finish depends on job.

Film: Produces 16mm TV commercials and presentation films. Does not pay royalties.

Illinois

ABS MULTI-IMAGE, 705 Hinman, Evanston IL 60202. (312)328-8697. President: Alan Soell. AV firm. Clients: commercial, industrial, educational, governmental.

Needs: Works with 1-2 freelance photographers/month. Uses photographers for AV presentations. Subjects include "people in working situations; abstract concepts; graphics, architecture." Also works with freelance filmmakers to produce commercials, training and development programming, marketing and P-O-P films.

Specs: Uses 35mm, 4x5 and 8x10 transparencies; 16mm film and videotape.

First Contact & Terms: Provide resume, business card, brochure, flyer or tearsheets to be kept on file for possible future assignments. Works with freelancers on assignment basis only. Reports in 1 month. Payment negotiated. Pays on completion. Buys all rights. Model release preferred. Credit line given "where appropriate."

Tips: Prefers to see "a variety of the jobs completed, the input given to contractor" in the form of slides in plastic pages or prints. List the field that you feel you have achieved the most success and quality, and

mention a desire to broaden your expertise."

AMERICAN ADVERTISING, 850 N. Grove, Elgin IL 60120. (312)741-2400. Manager: Karl Novak. Ad agency. Uses consumer and trade magazines, direct mail, newspapers and P-O-P displays. Serves clients in publishing and nonprofit foundations. Works with 2-3 freelance photographers/month on assignment only basis. Provide resume, flyer, business card and brochure to be kept on file for possible future assignments. Buys 100 photos/year. Local freelancers preferred. Interested in stock photos of families, groups of children, schools and teachers. Negotiates payment based on client's budget and amount of creativity required from photographer. Pays on production. Buys all rights. Model release required. Query with resume of credits. Does not return unsolicited material. Reports in 3 weeks.

B&W: Prefers contact sheet; print size depends on project. Pays \$100-150 minimum/photo. **Color:** Prefers 2¹/₄x2¹/₄ or 4x5 transparencies: 35mm semigloss prints OK. Pays \$100-400/photo.

BRAGAW PUBLIC RELATIONS SERVICES, Suite 322, 800 E. Northwest Highway, Palatine IL 60067. (312)934-5580. Contact: Richard S. Bragaw. PR firm. Clients: industrial, professional service firms, associations.

Needs: Works with 1 freelance photographer/month. Uses photographers for trade magazines, direct mail, brochures, newspapers, newsletters/news releases. Subject matter "products and people." **Specs:** Uses 3x5, 5x7 and 8x10 glossy prints.

First Contact & Terms: Provide resume, business card, brochure, flyer or tearsheets to be kept on file for possible future assignments. Works with freelance photographers on assignment basis only. SASE. Pays \$25-75/hour; \$200-500/day. Pays on receipt of invoice. Buys all rights. Model release preferred. Credit line "possible."

Tips: "Execute an assignment well, at reasonable cost, with speedy delivery. Would like to use more photography."

JOHN CROWE ADVERTISING AGENCY, 1104 S. 2nd St., Springfield IL 62704. (217)528-1076. President: John F. Crowe. Ad agency. Uses billboards, consumer and trade magazines, direct mail, newspapers, radio and TV. Serves clients in industry, commerce, aviation, banking, state and federal government, retail stores, publishing and institutes. Works with 1 freelance photographer/month on assignment only basis. Provide letter of inquiry, flyer, brochure and tearsheet to be kept on file for future assignments. Pays \$50 minimum/job or \$18 minimum/hour. Negotiates payment based on client's budget. Buys all rights. Model release required. Send material by mail for consideration. SASE. Reports in 2 weeks.

B&W: Uses glossy 8x10 prints.

Color: Uses glossy 8x10 prints and 21/4x21/4 transparencies.

GOLDSHOLL ASSOCIATES, 420 Frontage Rd., Northfield IL 60093. (312)446-8300. President of Design: Bob Lavin. Vice President of Design: Wendy Pressley Jacobs. AV firm. Serves clients in industry and advertising agencies. Produces filmstrips, slide sets, multimedia kits and motion pictures. Works with 2-3 freelance photographers/month on assignment only basis. Provide letter of inquiry and brochure to be kept on file for future assignments. Buys 100 photos, 5 filmstrips and 25 films/year. Subject Needs: Anything. No industrial equipment. Length requirement: 30 seconds to 30 minutes. Film: Uses 16 and 35mm industrial, educational, TV, documentaries and animation. Interested in stock footage.

Photos: Uses contact sheet or 35mm, 21/4x21/4, 4x5 or 8x10 color transparencies.

Payment/Terms: Pays by the job or by the hour; negotiates payment based on client's budget, amount of creativity required from photographer, photographer's previous experience/reputation. Pays in 30 days. Buys all rights. Model release required.

Making Contact: Query with resume. SASE. Reports in 1 week.

ELVING JOHNSON ADVERTISING, INC., 7800 West College Dr., Palos Heights IL 60463. (312)361-2850. President: Elving Johnson. Art Director: Mike McNicholas. Ad agency and PR firm. Uses billboards, consumer and trade magazines, direct mail, newspapers, P-O-P displays, brochures, collateral material. Serves clients in heavy machinery and construction materials. Buys 200 photos/year. Pays \$15-350/job or on a per-photo basis. Negotiates payment based on client's budget and amount of creativity required from photographer. Call to arrange an appointment and present portfolio in person; deals with local freelancers only. Reports in 1 week. SASE.

B&W: Uses 8x10 or 11x14 glossy prints. Pays \$15-150.

Color: Uses any size transparency or 8x10 and 11x14 glossy prints. Pays \$30-400.

WALTER P. LUEDKE AND ASSOCIATES, The Sweden House, 4615 E. State St., Rockford IL 61108. (815)398-4207. Contact: W. P. Luedke. Ad agency. Uses all media including technical manuals and bulletins. Serves clients in heavy machinery, RV vehicles, electronics, women's fashions and building supplies. Needs photos dealing with all kinds of recreation. Buys 10-20 annually. Buys all rights, but may reassign to photographer. Pays per hour, per photo, or \$50-500/job. Submit material by mail for consideration or submit portfolio. "We have occasions to find a photographer in a far away city for special location shots." Reports in 1 week. SASE.

B&W: Send 5x7 or 8x10 glossy prints. Model release required. Pays \$5-50.

Color: Send 35mm slides, 4x5 transparencies or contact proof sheet. Model release required. Pays \$10-75. "We have had the need for specified scenes and needed reliable on-location (or nearby) sources." Tips: "Although we don't have photo requirements that often we would be happy to hear from photographers. We like good, reliable sources for stock photos and good sources for unusual recreational, travel, pleasant scene shots." Advises beginners to "forget price—satisfy first."

*MACE ADVERTISING AGENCY, INC., Northwest Bank Bldg., Suite 212, 4516 N. Sterling Ave., Peoria IL 61614. (309)685-5505. Art Director: Kimberly Toothaker. Ad agency. Clients: industrial, finance. Works with 1 photographer/month. Uses photographers for billboards, trade magazines, direct mail, newspapers. Subjects include portrait, architectural, and medical.

Specs: Uses 8x10 b&w prints and 35mm transparencies.

First Contact & Terms: Arrange a personal interview to show portfolio; query with samples; provide resume, business card, brochure, flyer or tearsheets to be kept on file for possible future assignments.

Works with local freelancers only. Does not return unsolicited material. Reports in 3 weeks. Pays on receipt of invoice. Buys all rights. Model release preferred.

*MEDIA DEPARTMENT, Box 1006, St. Charles IL 60174. (312)377-0005. Manager: Bruce Mersner. Clients: business, industry.

Needs: Works with 1-2 photographers/month. Uses photographers for slide sets, multimedia productions, filmstrips. Subjects vary.

Specs: Uses b&w and color prints, 35mm, 21/4x21/4, 4x5 and 8x10 color transparencies.

First Contact & Terms: Query with stock photo list; provide resume, business card, self-promotion piece or tear sheets to be kept on file for possible future assignments. Works with freelancers by assignment only; interested in stock photos/footage. SASE. Reports in 2 weeks. Pays \$10-40/b&w photo and \$25-75/color photo. Pays on publication. Buys one-time and all rights. Model release required. Credit line sometimes given.

*ARTHUR MERIWETHER, INC., 1529 Brook Dr., Downers Grove IL 60515. Director of Photography: Steve Ouska. Clients: corporations, ad agencies, associations.

Needs: Works with 1 photographer/month. Uses photographers for films, videotapes, PR photos.

Subjects include documentation for PR releases, scientific photography.

Specs: Uses b&w negatives; 35mm, 21/4x21/4 and 4x5 transparencies; 16mm film; U-matic 3/4"

First Contact & Terms: Provide resume, business card, self-promotion piece or tearsheets to be kept on file for possible future assignments. Works with freelancers by assignment only; interested in stock photos/footage. Does not return unsolicited material. Payment individually negotiated. Pays within 30 days. Buys all rights. Model release required. Credit line sometimes given.

MOTIVATION MEDIA, INC., 1245 Milwaukee Ave., Glenview IL 60025. (312)297-4740. Vice President, Production Operations: Paul Snyder. Manager/Creative Graphics Division: Carol Defabio. AV firm. Clients: manufacturers of consumer and capital goods, business associations, service industries. Produces filmstrips, multimedia/multiscreen productions, sound slide shows, video productions, 16mm film. Subjects include new product announcements, sales promotion, and sales training programs and public relations programs—"all on a variety of products and services." Uses "a very wide variety" of photos obtained through assignment only. Provide resume to be kept on file for possible future assignments. Pays \$250-600/day, or per job "as negotiated." Query first with resume of credits. Reports in 1 week. SASE.

Film: Produces 16mm and videotape industrials. Possible assignments include serving as producer, responsible for all phases of production; serving as director, involved in studio and location photography and supervises editing; serving as film editor with "creative and conforming" duties; and serving as cinematographer.

Color: Uses 35mm, 21/4x21/4, 4x5 transparencies and 8x10.

Tips: "All freelancers must show evidence of professional experience. Still photographers should have examples of product photography in their portfolios. Contact Glen Peterson, Production Traffic and Administration Manager for appointment to show portfolio."

*BURT MUNK & COMPANY, Suite 503, 666 Dundee Rd., Northbrook IL 60062. (312)564-0855. President: Burton M. Munk. Clients: industrial.

Needs: Works with 3-4 photographers/year. Uses photographers for filmstrips, slide sets, films and videotapes. Subjects include industrial, educational, sales training, product information, profit sharing plans, EEO.

Specs: Uses 35mm transparencies; 16mm film; VHS, Beta and U-matic 3/4" videotapes.

First Contact & Terms: Query with resume; provide resume, business card, self-promotion piece or tearsheets to be kept on file for possible future assignments. Works with freelancers by assignment only; interested in stock photos/footage. SASE. Reports in 1 month. Payment varies. Pays on acceptance. Buys all rights. Model release required.

TRANSLIGHT MEDIA ASSOCIATES, INC., 931 W. Liberty Dr., Wheaton IL 60187. (312)690-7780. President: James B. Cudney. AV film. Clients: industrial, religious, advertising, communica-

Needs: Works with 2-5 freelance photographers/month. Uses photographers for AV presentations. Sometimes works with freelance filmmakers to produce "mostly documentary or educational films." Specs: Uses 35mm, 21/4x21/4 and 4x5 transparencies; 16mm film and U-matic 3/4" videotape.

First Contact & Terms: Arrange a personal interview to show portfolio. Works with freelancers on assignment basis only. SASE. Reports in 2 weeks. Pays \$25-75/hour; \$200-600/day. Pays 30 days from receipt of invoice. Buys one-time rights. Model release preferred. Credit line given "depending on use."

Tips: Prefers to see photographer's "area of specialty or expertise and more event and on-location photography rather than set shots. Know how photography should be shot for AV presentations. Be able to figure out what is required by the show and shoot it right."

UNIVERSAL TRAINING SYSTEMS CO., 255 Revere Dr. Northbrook IL 60062. (312)498-9700. Vice President/Executive Producer: Richard Thorne. AV producers. Serves financial institutions, electronics manufacturers, producers of farm equipment, food processors, sales organizations, data processing firms, etc. Produces filmstrips, sound slide sets, multimedia kits, 16mm and videotape. Subjects include training, product education, personnel motivation, etc. Needs documentary and location photos. Works with freelance photographers on assignment only basis. Provide resume, business card and brochure to be kept on file for possible future assignments. Produces 20-25 films and videotapes annually. Buys "the right to use pix in one film or publication (for as long as the film or publication is used by clients). Exclusivity is not required. The right to sell pix to others is always the seller's prerogative." Pays per job or on a per-photo basis. Negotiates payment based on client's budget. Ouery with resume of credits. Reports in 2 weeks. SASE.

Film: 16mm documentary, industrial and sales training films. "We handle all casting and direction. We hire crews, photographers, etc." Model release required.

B&W: Uses 8x10 prints. Model release required.

Color: Uses transparencies or prints. Model release required.

Tips: Prefers to see "work of which the photographer is especially proud plus work which the photographer feels represents capability under pressure." There is a "massive move to video training, especially in the area of interactive video."

Chicago

RONALD A. BERNSTEIN ASSOCIATES, INC., Chicago Place, 310 W. Chicago Ave., Chicago IL 60610. (312)440-3700. Art Director: Joe Gura. Ad agency. Uses consumer and trade magazines, direct mail, foreign media. Serves clients in sporting goods, home products, real estate, motivation and video products. Commissions 20 photographers/year. Local freelancers preferred. Pays \$200-600/job. Usually buys all rights. Model release required. Arrange personal interview to show portfolio.

B&W: Uses prints.

Color: Uses prints and transparencies.

BETZER PRODUCTIONS, INC., 450 E. Ohio St., Chicago IL 60611. (312)664-3257. President: Joseph G. Betzer. AV firm. Produces motion pictures, slide films, videotapes and multimedia kits. **Needs:** Subjects vary with client's desires.

First Contact & Terms: Pays per hour, per photo, or per job, "depending on the person involved and the assignment." Query first with resume of credits; "send nothing until asked."

Film: Uses 35mm, 16mm, and all sizes of videotape, "depending on client's desires." Does not pay royalties.

ROBERT E. BORDEN & ASSOCIATES, 6301 N. Sheridan Rd., Chicago IL 60660. Contact: Robert E. Borden. PR and some advertising. Clients: savings & loans, misc. manufacturing, hospitals, real estate and development firms, air conditioning-heating designers/installers, foreign trade commissioner. Needs: Works with varying number of freelance photographers on assignment only basis. Provide resume, brochure and business card to be kept on file for possible future assignments. Prefers to see news, architectural, industrial/commercial samples. "Listen to our needs and picture ideas and include some of your own." Selection is made according to specific projects. Negotiates payment based on client's budget, freelancer's hourly rate and commission arrangements.

E.H. BROWN ADVERTISING AGENCY, 20 N. Wacker Dr., Chicago IL 60606. (312)372-9494. Creative Director: Mr. Wasserman. Art Director: Stan Paluch. Ad agency. Clients: primarily industrial, financial and consumer products.

Needs: Works with 3 photographers/month. Uses photographers for consumer and trade magazines. **First Contact & Terms:** Call for appointment to show portfolio. Pays by day or bid basis.

Tips: Does not want to see table-top, food products or high fashion photography.

BURRELL ADVERTISING INC., 625 N. Michigan Ave., Chicago IL 60611. (312)266-4600. Art Directors: Raymond Scheller, Cortrell Harris, Tony Gregory, Michelle McKinney, Abbey Onikoyi, Mel Nickerson. Ad agency. Clients: soft drink, fast foods, beer and liquor, automotive, dental products and cosmetics manufacturers.

Needs: Uses freelance photographers for billboards, P-O-P displays, consumer magazines, still

photography for TV, brochures/flyers and newspapers.

First Contact & Terms: Call art director for appointment to show portfolio. Negotiates payment based on "national going rate," client's budget, amount of creativity required, where work will appear and artist's previous experience/reputation.

CINE-MARK, Division of Krebs Productions, Inc., Suite 2026, 303 E. Ohio St., Chicago IL 60611. (312)337-3303. President: Clyde L. Krebs. AV firm. Clients: industrial, travel, museums. Client list provided on request.

Needs: Works with 3-7 freelance photographers/month. Uses photographers for AV presentations. Subject matter "varies according to client need." Also works with freelance filmmakers to produce "corporate communications: marketing, training, travelogues and museum exhibits."

Specs: Uses 8x10 and 4x5 color prints; 35mm, 21/4x21/4, 4x5 and 8x10 transparencies; 16mm film and

videotape.

First Contact & Terms: Provide resume, business card, brochure, flyer or tearsheets to be kept on file for possible future assignments. Works with freelance photographers on assignment basis only. Does not return unsolicited material. Payment varies. Pays on completion of film. Buys all rights. Model release required; captions optional. Credit line given "seldom on photos, but in film credits."

*CLEARVUE, INC., 5711 N. Milwaukee Ave., Chicago IL 60646. (312)775-9433. President: W. O. McDermed.

Needs: Works with 4-5 photographers/year. Uses photographers for filmstrips.

Specs: Uses 35mm transparencies.

First Contact & Terms: Query with resume. Works with freelancers by assignment only. SASE. Reports in 3 weeks. Pays/job. Pays on acceptance. Buys all rights. Captions required.

FEELEY ENTERPRISES, 400 E. Randolph St., Chicago IL 60601. (312)467-1390. PR firm. Clients: celebrity and entertainment.

Needs: Works with varying number of freelance photographers/month as per clients' needs. Uses freelancers for billboards, consumer and trade magazines, direct mail, newspapers, P-O-P displays and TV. "Also, we're a syndicated news bureau."

First Contact & Terms: Send resume and/or portfolio for review. Selection of freelancers based on "known experience and referrals." Payment: "open; depending on assignment."

Tips: Wants to see "current, timely and newsworthy photographs of top celebrities and entertainers."

HBM/CREAMER, 410 N. Michigan Ave., Chicago IL 60611. (312)222-4900. Art Directors/Vice Presidents: Ralph Hahn, Arnie Paley, Amy Vander Stoup. Ad agency. Photos used in advertising, press releases, and sales literature; billboards, consumer and trade magazines, direct mail, foreign media. newspapers, radio and TV. Serves industrial, automotive, consumer, high tech and industry clients. Submit model release with photo. Payment is negotiable. Query with resume of credits and photos. Reports in 2 weeks. SASE.

B&W: Uses 5x7 glossy prints; send contact sheet.

Color: Uses 35mm transparencies or 5x7 glossy prints; contact sheet OK.

HILL AND KNOWLTON, INC., One Illinois Center, 111 E. Wacker Dr., Chicago IL 60601. (312)565-1200. Contact: Jacqueline Kohn, Lynne Strode. PR firm. Clients: manufacturing, consumer products, medical and pharmaceutical, public utilities.

Needs: Works with 6 freelance photographers/month. Uses photographers for executive portraits, slide

programs, multimedia presentations, etc.

First Contact & Terms: Call Jacqueline Kohn or Lynne Strode for appointment to show portfolio. Negotiates payment based on client's budget and photographer's previous experience/reputation.

BERNARD HODES ADVERTISING, Suite 1300, 205 W. Wacker Dr., Chicago IL 60606. (312)222-5800. Art Director: Susan Emerick. Ad agency.

First Contact & Terms: Call for personal appointment to show portfolio. Pays \$150-300/b&w photo;

\$200-500/color photo; \$300-500/hour; \$500-1,500/day; or \$800-1,500/job.

Tips: There seems to be a trend in advertising photography toward "more close-up shots than before, with natural-looking light, more collage and manipulated images." Will accept b&w and color photos. Uses stock photos mostly. Needs photos of people doing their jobs. "Send letter, business card and sample. We'll call you.'

*INTERAND CORPORATION, 3200 W. Peterson Ave., Chicago IL 60659. (312)478-1700. Director of Corporate Communications: Linda T. Phillips. Clients: Fortune 500 companies.

Needs: Works with 2-3 photographers/year. Uses photographers for product photos for brochures, industrial, in-house portrait. Subjects include building, manufacturing, product, portraits.

Specs: Uses 5x7 and 8x10 glossy or matt b&w prints; 5x7 and 8x10 glossy color prints; 35mm, 21/4x21/4

and 4x5 transparencies; U-matic 3/4" videotape.

First Contact & Terms: Provide resume, business card, self-promotion piece or tearsheets to be kept on file for possible future assignments. Works with local freelancers on assignment basis only. Reports in 2 weeks. Pays on acceptance. Buys all rights. Model release required.

MANDABACH & SIMMS, 20 N. Wacker, Chicago IL 60606. (312)236-5333. Vice President/ Creative: Burt Bentkover. Ad agency. Uses all media except foreign. Serves clients in food service, graphic arts, finance, real estate. Needs photos of food, equipment and people. Buys 15 photos/year. Pays \$75 minimum/job. Query; call to arrange an appointment. Reports in 1 month. SASE. Specs: Uses 35mm, 21/4x21/4 or 8x10 transparencies.

Tips: "Check our client list and submit relative samples when requested."

MARKETING SUPPORT, INC., 303 E. Wacker Dr., Chicago IL 60601. (312)565-0044. Ad agency. Executive Art Director: Robert Becker. Clients: manufactured products—industrial and consumer. Needs: Works with 3-4 freelance photographers/month. Uses photographers for consumer and trade magazines, direct mail, P-O-P displays, brochures, catalogs, posters, and AV presentations. Subject matter: "products, pets and people." Also works with freelance filmmakers to produce "some commercials and sales meeting slide shows."

First Contact & Terms: Arrange a personal interview to show portfolio; provide resume, business card, brochure, flyer or tearsheets to be kept on file for possible future assignments. Works with local freelance photographers on assignment basis only. Does not return unsolicited material. Pays \$100-300/b&w photo; \$125-3,500/color photo; or \$125-5,000/job. Pays 60 days after acceptance. Buys all rights. Model release required.

MARSTRAT, INC., Subsidiary of United States Gypsum, 101 S. Wacker Dr., Chicago IL 60606. (312)321-5826. Ad agency. Vice President/Executive Art Director: Edwin R. Wentz. Clients: industrial. Client list provided on request.

Needs: Works with 2-4 freelance photographers/month. Uses photographers for consumer and trade magazines, P-O-P displays, brochures, posters, and newspapers. Subjects include: "locations, industrial, studio, table-top—from fashion to nuts and bolts, done in a quality approach."

Specs: "Whatever it takes to do assignment to its best advantage."

First Contact & Terms: Arrange a personal interview to show portfolio; query with samples; provide resume, business card, brochure, flyer or tearsheets to be kept on file for possible future assignments. Works with freelance photographers on assignment basis only. Does not return unsolicited material. Pays \$650-1,200/b&w photo; \$650-3,500/color photo; and \$600-1,200/day; "also depends on caliber of talent and what the assignment is." Pays on acceptance. Buys all rights. Model release and captions required. Credit line "sometimes" given.

MULTIVISION INTERNATIONAL INC., 340 W. Huron, Chicago IL 60610. (312)337-2010. Creative Director: Michael Knab. PR and AV firm. Clients: "all types."

Needs: Works with 3 freelance photographers/month. Uses photographers for direct mail, posters, AV presentations, trade magazine, brochures, signage, internal communications. Subject matter "varies a great deal—especially looking for 'people' photographers. We will use freelance directors occasionally, and always freelance cinematographers for commercial and corporate image films."

Specs: Uses color prints; 35mm, 21/4x21/4, 4x5 and 8x10 transparencies; 16mm and 35mm film and

videotape.

First Contact & Terms: Query with samples, list of stock photo subjects or submit portfolio for review; provide resume, brochure, flyer or tearsheets to be kept on file for possible future assignments. Works with freelance photographers on assignment basis only. SASE. Reports in 2 weeks. Pays \$500-1,000/day; or per photo for stock color photos. Pays upon hiring. Buys one-time rights. Model release required. Credit line given "in some cases."

Tips: Prefers to see a "range of assignments in a photographer's portfolio or samples. Like to see outtakes if feasible on recent jobs."

O.M.A.R. INC., 5525 N. Broadway, Chicago IL 60640. (312)271-2720. Creative Director: Paul Sierra. Ad agency. Clients: consumer, food, TV, utilities.

Needs: Number of freelance photographers used varies. Works on assignment basis only. Uses photographers for consumer magazines, posters, newspapers and TV.

First Contact & Terms: Local freelancers only. Query with resume of credits and samples, then follow up by phone. Payment is by the project; negotiates according to client's budget, but generally \$150-500/

Close-up

Michael Knab, President, Multivision International, Inc.

Michael Knab recalls one of the most challenging projects his company, Multivision International, ever tackled. "One of Korea's largest conglomerates, Daewoo, held a competition among 15 to 20 multimedia production companies throughout the U.S., and we won that competition. Our clients were American educated, but couldn't speak English very well; however, one thing was clear. They were interested in creating a vision of the future without spending a great deal of money. The show, part of an industrial world's fair in Korea, was a tremendous success."

As Multivision president, Knab takes these tremendous challenges in stride, and expects the same of freelance photographers he hires.

"We serve large corporations—those found among the Fortune 500 and the relationships we have with them involve the use of a number of different media. The types of projects we handle are extremely varied because the clients are in a different evolutionary level in their media sophistication, and our photographers must be able to deal with that," Knab explains. "We tend to favor photographers whose portfolios show that they can capture people. We also look for good color saturation, and composition that is illustrative rather than unusual for the sake of the unusual

"Good advertising photographers generally have the sensitivity, but if we're doing multimedia rather than print, they frequently move too slowly or make too many demands. For a print project, we look for a photographer who will bring a great deal of art direction and new ideas to a project. In the case of an audiovisual photographer we look for an easy sense of style as well as a certain pacing in his work. By 'easy' I refer to photographers we've worked with who honestly never take a bad picture," he says.

Multivision favors photographers living near its Chicago location for local shoots, but Knab stresses that it's "good for photographers around the country to send us samples. The best way to get an assignment from us is to keep in touch. Local photographers should contact us twice a year; out-of-towners once a year," he recommends.

Knab relies heavily on his photographers. "Some photographers have Godgiven, rather than developed, talents for capturing this extremely photographic world. When that's the case, they make the job we do at Multivision—creating highly enjoyable, very communicative pieces of art—that much easier."

b&w photo; \$500-750/color photo; \$150-250/hour; or \$750-1,000/day.

Tips: "More women should go into photography."

PUBLIC COMMUNICATIONS, INC., 35 E. Wacker Dr., Chicago IL 60601. (312)558-1770. Chairman: Jim Strenski. PR firm. Clients: marketing, financial, corporate, nonprofit, institutional public relations.

Needs: Works with 10-12 freelance photographers/year. Uses photographers for annual reports, brochures, newsletters and exhibits. Also does extensive on-site case history photography for clients around the US and Canada. Provide resume and brochure to be kept on file for possible future

First Contact & Terms: Call for appointment to show portfolio. Negotiates payment based on client's budget. Pays within 30 days of invoice receipt. Does not return unsolicited material. Reports in 2 weeks.

*PULSE COMMUNICATIONS, 2445 North Sayre Ave., Chicago, IL 60635. (312)622-7066. Creative Director: Frank G. Konrath. Ad Agency.

Needs: Works with 5-15 freelance photographers/year. Uses photographers for brochures, audiovisual,

presentations, annual reports. Also uses freelance filmmakers.

First Contact & Terms: Provide resume, business card, brochure, flyer or tear sheets to be kept on file for possible future assignments. Does not return unsolicited material. Reports in one month. Pays \$100/job. Buys one-time or all rights, depending on job. Model release and captions required. Credit line negotiated.

Tips: "I'm looking for someone to do the kind of quality and style that they show me in their book, on

assignment.'

RUDER FINN & ROTMAN, INC., 444 N. Michigan Ave., Chicago IL 60611. (312)644-8600. Executive Vice President: Richard Rotman. PR firm. Handles accounts for corporations, trade and professional associations, institutions and other organizations. Photos used in publicity, AV presentations, annual stockholder reports, brochures, books, feature articles, and industrial ads. Uses industrial photos to illustrate case histories; commercial photos for ads; and consumer photos—food, fashion, personal care products. Works with 4-8 freelance photographers/month nationally on assignment only basis. Provide resume, flyer, business card, tearsheets and brochure to be kept on file for possible future assignments. Buys over 100 photos/year. Present model release on acceptance of photo. Pays \$25 minimum/hour, or \$200 minimum/day. Negotiates payment based on client's budget and photographer's previous experience/reputation. Query with resume of credits or call to arrange an appointment. Prefers to see publicity photos in a portfolio. Will not view unsolicited material.

SANDER ALLEN ADVERTISING, INC., Suite 1020, 230 N. Michigan Ave., Chicago IL 60601. (312)444-1771. Art Directors: Larry Malder and Sal Garcia. Ad agency. Clients: mostly industrial. **Needs:** Works with 2-3 freelance photographers/month. Uses photographers for P-O-P displays, consumer and trade magazines, direct mail, brochures/flyers and newspapers.

First Contact & Terms: Call for appointment to show portfolio. Negotiates payment based on client's

budget and where work will appear.

Tips: Likes to see a broad range. B&w, color transparencies and color prints.

SARKETT & ASSOCIATES, 333 N. Michigan Ave., Chicago IL 60601. (312)726-2222. Contact: John Sarkett. PR firm. Handles agricultural accounts. Photos used in brochures, newsletters, newspapers, AV presentations, annual reports and PR releases. Gives 10 assignments/year. Pay is negotiable. Credit line given sometimes. Model release required. Send material by mail for consideration. SASE. Reports in 1 week.

B&W: Uses prints.

Color: Uses transparencies.

*SOCIETY FOR VISUAL EDUCATION, INC., 1345 W. Diversey Pkwy, Chicago IL 60614. (312)525-1500. Graphic Arts Manager: Cathy Mijou. Clients: all work for SVE products and services, no outside clients.

Needs: Uses photographers for filmstrips, multimedia productions and slide sets. Subjects varies—for education market—preschool to Jr.-Sr. High, every subject area (Math, Geography, etc.).

Specs: Uses b&w and color prints and 35mm transparencies and film.

First Contact & Terms: Query with samples; provide resume, business card, self-promotion piece or tearsheets to be kept on file for possible future assignments. Samples should be non-returnable—will be kept on file. Works with freelancers by assignment only, interested in stock photos/footage. Returns material for review if requested with SASE, would prefer to keep as file samples. Reports if interested in using materials submitted. Pay varies according to scope and requirements of project. Pay specified at time of contract. Buys all rights.

Tips: "You should know about the company—products produced and markets sold to. We always look for technical expertise, composition, etc."

STONE & ADLER, INC., 1 South Wacker Dr., Chicago IL 60606. (312)346-6100. Creative Director: Tony Platt. Ad agency. Clients: consumer, retail, business to business, industry, travel, etc.

Needs: Works with 5 freelance photographers/month. Uses photographers for P-O-P displays, consumer and trade magazines, stationery design, direct mail, TV, brochures/flyers and newspapers.

First Contact & Terms: Call for appointment to show portfolio. Negotiates payment based on client's budget and the job.

Tips: B&w, color transparencies and 8x10 negatives OK; show style.

DON TENNANT COMPANY, 500 N. Michigan Ave., Chicago IL 60611. (312)644-4600. Senior Art Director: Dennis Osakada. Ad agency. Clients: all consumer firms; client list provided upon request. **First Contact & Terms:** Works primarily with local freelancers, but considers others. Query with resume of credits. Payment is by the project; negotiates according to client's budget. "Occasionally works with freelance photographers on assignment basis only."

G.W. VAN LEER & ASSOCIATES INTERNATIONAL, 1850 N. Fremont, Chicago IL 60614. (312)751-2926. President: G.W. Van Leer. AV firm. Serves schools, manufacturers, associations, stores, mail order catalog houses. Produces filmstrips, motion pictures, multimedia kits, overhead transparencies, slide and sound-slide sets, nature photobooks and videotapes. Makes 3 freelance assignments/year; purchases 300 illustrations/year. "We are looking for complete photo stories on wildflowers in full color." Query with resume and samples. Reports in 3 weeks. SASE.

THE JOHN VOLK COMPANY, 676 N. St. Clair, Chicago IL 60611. (312)787-7117. Ad agency.

Associate Creative Director: Tom Wright. Clients: agricultural. Free client list on request.

Needs: Works with 2-3 freelance photographers/month. Uses photographers for trade magazines, direct mail, P-O-P displays, brochures, posters, newspapers and AV presentations. Subjects include: "farm related products—tractors, chemicals."

Specs: Uses 35mm and 21/4x21/4 transparencies.

First Contact & Terms: Arrange a personal interview to show portfolio; provide resume, business card, brochure, flyer or tearsheets to be kept on file for possible future assignments. Works with freelance photographers on assignment basis only. Does not return unsolicited material. Pays \$500-1,500/job.

Rights purchased "depend on price and arrangement." Model release required.

Tips: "I would like to see examples of problem solving—something that would show that the photographer did more than just record what was there. I work with people who are always willing to shoot 'one more shot'. Farm ads are becoming more sophisticated and the quality of the photography is on a par with consumer ads. I'd like to see some new approaches to large equipment shooting (tractors, combines). I also like to shoot with people who add something to the photo, not just record what was there."

Indiana

CALDWELL-VAN RIPER, 1314 N. Meridian, Indianapolis IN 46202. (317)632-6501. Executive Creative Director: Joe Whitman. Associate Creative Director: John Nagy. Ad agency. Uses billboards, consumer and trade magazines, direct mail, foreign media, newspapers, P-O-P displays, radio and TV. Serves all types of clients. Works with 2-5 freelance photographers/month on assignment only basis. Provide brochure or samples to be kept on file for future assignments.

Specs: Uses b&w photos and color transparencies. Uses filmmakers for TV spots, corporate films and documentary films.

Payment & Terms: Pays \$200-2,000/ hour, day and job. Negotiates payment based on client's budget. Model release required. Buys all rights.

Making Contact: Arrange a personal interview to show portfolio or submit portfolio for review. SASE. Prefers local freelancers. Reports in 1 week.

GRIFFIN MEDIA DESIGN, INC., 802 Wabash Ave., Chesterton IN 46304. (219)926-8602. President: Michael J. Griffin. AV firm. Clients: business, industrial.

Needs: Works with freelance photographers on assignment only basis. Buys 25-50 photos, 10-15 filmstrips and 5-10 films/year. Uses photographers for filmstrips, overhead transparencies, slide sets, multimedia kits, motion pictures and videotape. Subjects include conventions, multi-image presenta-

tions, sales aids, motion pictures, training films, advertising, product photography and collateral

Specs: Photographers are assigned to shoot from prepared script. Some creative latitude is allowed, but most programs are professionally designed to achieve specific objectives. Produces 35mm, 16mm and Super 8 and videotape motion pictures, plus filmstrips, slide shows and multimedia. Uses color

transparencies (varies on use); payment quoted/job.

First Contact & Terms: Arrange a personal interview to show portfolio, provide resume and brochure to be kept on file for possible future assignments. Fees negotiated on per project basis; generally \$50-1,000/b&w photo; \$100-3,000/color photo; \$30-100/hour; \$250-1,500/day; or by the job. Payment made on production. Buys all rights, but may reassign to photographer after use. Model release required. Tips: "Our films and photographic productions are custom developed presentations designed for clients to achieve specific objectives. Our use of freelancers is somewhat limited as we have a staff of photography producers. However the need for specialized photography and/or work overloads often require that we draw upon freelance help. For this we keep a file of qualified freelancers. When a need arises, we call from this file. We deal with top paying customers who demand quality, creativity and fast turnaround. We look for people who can deliver these attributes."

GROVES & ASSOCIATES, INC., 105 Ridge Rd., Muncie IN 47304. (317)289-7334. Art Director: Ron Groves. Production Manager: Lori McGriff. Ad agency. Uses billboards, direct mail, newspapers, P-O-P displays, radio, TV, trade magazines. Serves clients in industry, finance, recreation, religion. Commissions 6 photographers/year; buys 100-200 photos/year. Buys all rights. Model release preferred. Arrange personal interview to show portfolio; will review unsolicited material. SASE. Reports in 1 week.

B&W: Uses prints. Pays \$15 minimum/photo.

Color: Uses 4x5 transparencies. Pays \$30 minimum/photo.

HANDLEY & MILLER, INC., 1712 N. Meridian, Indianapolis IN 46202. (317)927-5500. Art Director/Vice President: Irvin Showalter. Ad agency. Clients: health care, industrial and food products. **Needs:** Works with 2 freelance photographers/month. Uses photographers for P-O-P displays, consumer and trade magazines and newspapers.

First Contact & Terms: Call for appointment to show portfolio. Pays standard day rate.

Tips: Like to see variety unless photographer has one speciality. Especially needs specialists in food photography. "Currently using more people shots."

KELLER CRESCENT COMPANY, 1100 E. Louisiana, Evansville IN 47701. (812)426-7551 or (812)464-2461. Manager Still Photography: Cal Barrett. Ad agency, PR and AV firm. Uses billboards, consumer and trade magazines, direct mail, newspapers, P-O-P displays, radio and TV. Serves industrial, consumer, finance, food, auto parts, dairy products clients. Works with 2-3 freelance photographers/month on assignment only basis. Provide business card, tearsheets and brochure to be kept on file for possible future assignments.

Specs: Uses 8x10 b&w prints and 35mm, 4x5 and 8x10 color.

Payment & Terms: Pays \$200-2,500/job; negotiates payment based on client's budget, amount of creativity required from photographer and photographer's previous experience/reputation. Buys all rights. Model release required.

Making Contact: Query with resume of credits; list of stock photo subjects; send material by mail for consideration. Prefers to see printed samples, transparencies and prints. Does not return unsolicited

material.

OMNI COMMUNICATIONS, 12316 Brookshire Parkway, Carmel IN 46032-3104. (317)844-8482.

President: Winston Long. AV firm. Clients: industrial, corporate, educational.

Needs: Works with 6-12 freelance photographers/month. Uses photographers for AV presentations. Subject matter varies. Also works with freelance filmmakers to produce training films and commercials. **Specs:** Uses b&w and color prints; 35mm transparencies; 16mm and 35mm film and videotape.

First Contact & Terms: Provide resume, business card, brochure, flyer or tearsheets to be kept on file for possible future assignments. Works with freelance photographers on assignment basis only. Does not return unsolicited material. Payment varies. Pays on acceptance. Buys all rights. Model release required. Credit line given "sometimes, as specified in production agreement with client."

PRODUCERS INTERNATIONAL CORPORATION, 128 E. 36th St., Indianapolis IN 46205. (317)924-5163. Art Director: Gary Degler. Communications company. Serves businesses, TV, schools, special education. Produces slide sets, motion pictures and videotape. Works with freelance photographers on assignment only basis. Buys 50-300 photos/year.

Subject Needs: Employee motivation, training, travel promotion. Photos used in slide shows or films.

Length: 10-30 minutes.

Film: Produces 16mm, 35mm short subjects; business, corporate image, motivational. Interested in stock footage (travel, aerial).

Photos: Uses 35mm and 21/4x21/4 color transparencies.

Payment & Terms: Negotiates payment based on client's budget. Pays within 30 days of acceptance. Buys all rights. Model release required and captions required.

Making Contact: Query with resume of credits. "Do not send unsolicited material." Prefers to see 2x2 and 2¹/₄x2¹/₄ slides and 35mm in a portfolio. SASE. Reports as soon as possible. Free catalog available on request.

Tips: "Examples of film/slide/scripts of successful things you have done are most effective in demonstrating your qualifications."

A company of the state of the s

*BLACKHAWK FILMS, INC., 1 Old Eagle Brewery, Box 3990, Davenport IA 52808. (319)323-9736. Vice President: Tom Voss. Clients: ordinary consumers.

Needs: Works with variable photographers/month. Uses photographers for slide sets. Subjects include travel and special-interest slide sets, 40-60 slides per set.

Specs: Uses 35mm transparencies.

First Contact & Terms: Query with samples. Works with freelancers who submit their own works for distribution. SASE. Reports in 1 month. Pays per slide royalty paid for each set manufactured during a contract life. Usually 1¢ per slide. Pays quarterly. Buys exclusive license for contract period. Captions and model release required. Credit line given.

Tips: "Our strength is in the special interest category; such as natural phenomenon or things that do not change with age; i.e. vintage cars, etc. Slide set buyers now want an audio tape rather than just captions of the slides they are seeing."

EBEL ADVERTISING AGENCY, (formerly Griffith & Somers Advertising Agency), 770 Orpheum Bldg., Sioux City IA 51101. (712)277-3343. Ad agency. President: Elmer Ebel. Clients: financial, retail, industrial.

Needs: Works with 1 freelance photographer on an as needed basis. Uses photographers for brochures and AV presentations. Subjects include: products.

First Contact & Terms: Model release required.

LA GRAVE KLIPFEL CLARKSON ADVERTISING, INC., 1707 High St., Des Moines IA 50309. (515)283-2297. President: Ron Klipfel. Ad agency. Clients: financial, industrial and retail; client list provided upon request.

Needs: Works with 2 freelance photographers/month on assignment only basis. Uses photographers for all media.

First Contact & Terms: Local freelancers only. Phone first then follow with mailed information. Negotiates payment by the project and on freelancer's previous experience.

minore factors and the states and set with Kansas data year inquestion is new along the

MARKETAIDE, INC., Box 500, Salina KS 67402. (913)825-7161. Production Manager: Dennis Katzenmier. Ad agency. Uses all media. Serves industrial, retail, financial, agribusiness and manufacturing clients. Needs photos of banks, agricultural equipment, agricultural dealers, custom applicators and general agricultural subjects. Buys all rights. "We generally work on a day rate ranging from \$200-1,000/day." Pays within 30 days of invoice. Call to arrange an appointment. Provide resume and tearsheets to be kept on file for possible future assignments. Reports in 3 weeks. SASE.

Tips: Photographers should have "a good range of equipment and lighting, good light equipment portability, high quality darkroom work for b&w, a wide range of subjects in portfolio with examples of processing capabilities." Prefers to see "set-up shots, lighting, people, heavy equipment, interiors, industrial and manufacturing" in a portfolio. Prefers to see "8x10 minimum size on prints, or 35mm

transparencies, preferably unretouched" as samples.

MARSHFILM, INC., Box 8082, Shawnee Mission KS 66208. (816)523-1059. President: Joan K. Marsh. AV firm. Markets to education, libraries, health organizations, clinics. Produces filmstrips and computer Software. Works with freelance photographers on assignment only basis.

Subject Needs: Educational, health and guidance subjects for elementary and junior high school. No

porn. Length: 50 frames, 15 minutes/filmstrip. Uses 35mm original transparencies, color only, horizontal format.

Film: Stock footage of animals, nature, etc. used occasionally.

First Contact & Terms: Provide price list to be kept on file for possible future assignments. Buys 400 photos for 12-16 filmstrips/year; prefers local talent. Negotiates payment based on Marsh's budget. Pays on acceptance. Model release required for minors. Query with list of stock photo subjects. Does not return unsolicited material. Free catalog.

STEPHAN ADVERTISING AGENCY, INC., 247 N. Market, Wichita KS 67202. (316)265-0021. Art Director: Jack Billinger. Ad agency. Uses billboards, consumer and trade magazines, direct mail, newspapers, P-O-P displays, radio and TV. Serves clients in retail, industry, finance and fashion. Works with approximately 5 freelance photographers/month on assignment only basis. Provide business card, tearsheets, brochure and rates (hourly, day, etc.).

Specs: Uses b&w and color prints and color transparencies. Also does a lot of videotape and film

production. "Filmmakers should contact Gini Johnson."

Payment & Terms: Negotiates payment based on client's budget and where the work will appear. Buys

all rights. Model release required, captions preferred.

Making Contact: Arrange a personal interview to show portfolio or query with list of stock photo subjects. Prefers to see samples of product (food, industrial, people, fashion). SASE. Prefers local freelancers. Reports in 1 month.

Tips: "Have solid experience in working with agencies and art directors. Be very comfortable in working with models—both professional and nonprofessional types, i.e., employees of our clients, etc."

TRAVIS/WALZ & ASSOCIATES, 8500 W. 63rd St., Shawnee Mission KS 66202. (913)384-3550. Ad agency. Vice President/Creative Director: Gary R. Otteson. Clients: financial, utilities, insurance, consumer products, political, associations.

Needs: Works with 4-5 freelance photographers/month. Uses photographers for billboards, consumer and trade magazines, direct mail, P-O-P displays, brochures, catalogs, posters, newspapers, AV presentations. Subjects include location and product shots. Also uses freelance filmmakers to produce TV commercials.

First Contact & Terms: Arrange a personal interview to show portfolio. Works with local freelancers primarily. SASE. Payment by the job; "depends on the individual job budget." Pays on completion of job. Buys all rights. Model release required.

Tips: Prefers to see "entire range of photographic capabilities" in a portfolio. Photographers should "show us in person their work, including published work."

Kentucky

DULANEY ADVERTISING & PUBLIC RELATIONS, 600 Meidinger Tower, Louisville KY 40202. (502)587-1711. Creative Director: Jean Henderson. Ad agency. Uses consumer and trade magazines, direct mail, foreign media, newspapers, P-O-P displays, radio and TV. Serves local, regional & national clients in consumer goods & services, health care, fast food, industrial products and retail sales." Deals with 20 photographers/year. Deals in all media. Provide resume, business card, brochure and flyer to be kept on file for possible future assignments.

Specs: Uses b&w photos and color transparencies. Produces industrial films.

Payment & Terms: Pays \$500-1,000/day, negotiates pay/job. Pays on acceptance. Buys all rights. Model release preferred.

Making Contact: Query with samples. SASE. Reports in 2 weeks.

FESSEL, SIEGFRIEDT & MOELLER ADVERTISING, 1500 Heyburn Bldg., Box 1031, Louis-ville KY 40201. (502)585-5154. Executive Art Director: James A. Berry. Ad agency. Clients: industrial and consumer firms.

Needs: Works with 3 freelance photographers/year on assignment only basis. Uses photographers for all media.

First Contact & Terms: Works primarily with local freelancers. Arrange interview to show portfolio. Payment negotiated by the project. Buys one-time rights.

McCANN-ERICKSON, 1469 S. 4th St., Louisville KY 40208. (502)636-0441. Creative Director: Todd Hoon. Ad agency. Serves clients in banking, retailing, manufacturing, health care.

Needs: Uses mostly local freelance photographers. Works with out-of-town freelance photographers on

assignment only basis. Uses photographers for all printed media and TV.

First Contact & Terms: Call for appointment to show portfolio or make contact through artist's rep. Negotiates payment based on project. Rights individually negotiated.

Louisiana

BAUERLEIN, INC., 615 Baronne, New Orleans LA 70113. (504)522-5461. Senior Art Director: Phillip Collier. Ad agency. Serves clients in finance, food, transportation.

Needs: Works with 3-4 photographers/month. Uses freelancers for consumer and trade magazines,

brochures/flyers and newspapers.

First Contact & Terms: Call an art director and arrange for appointment to show portfolio (wants to see variety) or send resume and follow up with a call to an art director. Be able to provide samples to be kept on file for possible future assignments.

HERBERT S. BENJAMIN ASSOCIATES, 2736 Florida St., Box 2151, Baton Rouge LA 70821. (504)387-0611. Creative Director: Gus Wales. Ad agency. Clients: diversified including dairy, financial and industrial, heavy in food and beverage, some fashion and some jewelry.

Needs: Works with 10 freelance photographers/year. Uses photographers for industrial trade and business journals, TV, newspapers, magazines and brochures/flyers. Provide business card to be kept on

file for possible future assignments.

First Contact & Terms: Send samples, then call for appointment to show portfolio. Negotiates payment based on photographer's rate sheet, client's budget and amount of creativity required. Payment generally is \$500-1,200/day; or \$150-5,000/job.

Tips: Prefers to see color but also uses b&w prints; prefers to see product (beauty), architectural and industrial shots.

CARTER ADVERTISING, INC., 800 American Tower, Shreveport LA 71101. (318)227-1920. Ad agency. Creative Director: Fair Hyams. Serves a broad range of clients.

Needs: Works with 3-4 freelance photographers/month. Uses photographers for consumer and trade magazines, billboards, brochures, newspapers, and AV presentations. "No specific style or subject matter. It will vary as per the specifications of the job." Also works with freelance filmmakers to produce TV commercials.

Specs: Uses 35mm and large format still-photography and videotape.

First Contact & Terms: Provide resume, business card, brochure, flyer or tearsheets to be kept on file for possible future assignments. Works with freelance photographers on assignment basis only. SASE. Reports in 1 week. Payment "depends upon the job—we prefer paying by the job." Pays in 30 days. Model release preferred. Credit line "not given unless previously negotiated."

Tips: In a portfolio, prefers to see "creativity, originality, attention to detail. *Special* attention to lighting. Show high quality work done on other jobs—we are concerned with *quality*, not *quantity*."

DUKE UNLIMITED, Suite 205, Concourse Place, 1940 Interstate 10 Service Rd., Kenner LA 70065. (504)464-1891. Ad agency/PR firm. Art Director: Anne Esposite. Clients: hospital, industrial, restaurant, financial, jewelry, real estate development.

Needs: Works with 1-2 freelance photographers/month. Uses photographers for billboards, consumer and trade magazines, P-O-P displays, brochures, catalogs, signage, newspapers and AV presentations. Subjects include: jewelry, housing, food. Also works with freelance filmmakers to produce TV commercials.

Specs: Uses 8x10 glossy b&w and color prints; 35mm and $2^{1}/4x2^{1}/4$ and 4x5 transparencies; 16mm and 35mm film and videotape.

First Contact & Terms: Arrange a personal interview to show portfolio or send unsolicited photos by mail for consideration; provide resume, business card, brochure, flyer or tearsheets to be kept on file for possible future assignments. Works with freelance photographers on individual assignment, hourly or daily. SASE. Reports in 2 weeks. Pays/job. Pays on publication. Buys all rights. Model release required. Tips: Prefers to see "a neat, concise package including a list of credits and resume. If possible, a basic price sheet. It is important that it all be in one neat package."

*RICHARD SACKETT EXECUTIVE CONSULTANTS, Suite 404, 8600 Pontchartrain Blvd., New Orleans LA 70124. (504)282-2568. Ad agency. Art Director: Shawn Nevyen. Clients: industrial, optical, retail, real estate, hotel, shopping center management, marine. Client list free with SASE. Needs: Works with 3 photographers/month. Uses photographers for billboards, consumer and trade magazines, direct mail, P-O-P displays, posters, newspapers. Subject matter includes merchandise,

places, scenery of the city, scenery of the sites of construction, mood photos.

Specs: Uses 35mm, 4x5 and 8x10 transparencies.

First Contact & Terms: Arrange a personal interview to show portfolio; send unsolicited photos by mail for consideration. Works with freelance photographers on an assignment basis only. SASE. Reports in 1 week. Pays \$600-1,000/day and \$3,000-40,000/job. Pays on publication or on receipt of invoice. Buys all rights. Model release required. Credit line given when appropriate.

Maine

VIDEO WORKSHOP, 495 Forest Ave., Portland ME 04101. (207)774-7798. Director: Everett K. Foster. AV firm. Serves clients in business, industry and nonprofit organizations. Produces slide sets, multimedia kits, motion pictures, video films and sound-slide sets. Works with freelance photographers on assignment only basis. Provide resume and tearsheets to be kept on file for possible future assignments. Prefers to see industrial-related shots both in b&w and color. Buys 2 filmstrips and 8 video films/year.

Subject Needs: Employee training, public relations and scenic Maine. Uses freelance photos in slide

shows. Length requirements: 140 slides, running time of 12 minutes.

Film: Produces 16mm and video films. Interested in stock footage of period Maine. Photos: Uses 8x10 b&w and color prints and 35mm, 21/4x21/4 and 4x5 transparencies.

Payment & Terms: Pays \$100-300/job. Pays \$5-25 for b&w photo; \$5-25 for color photo. Negotiates payment based on client's budget. Pays on production. Buys all rights. Model release required.

Making Contact: Query with resume. SASE. Reports in 1 week.

Tips: "I hire talent by the job. A freelancer should be available and have resume in my file."

Maryland

*SAMUEL R. BLATE ASSOCIATES, 10331 Watkins Mill Dr., Gaithersburg MD 20879-2935. (301)840-2248. AV and stock photo firm. President: Samuel R. Blate. Clients: business/professional, US government, some private. SASE.

Needs: Works with 1-2 freelance photographers/month. Uses photographers for billboards, direct mail, catalogs, consumer and trade magazines, posters, audiovisual presentations, brochures and signage.

Subject "varies too much to say."

Specs: Uses 8x10 b&w glossy prints; 35mm, 21/4x21/4 and 4x5 transparencies.

First Contact & Terms: Query with list of stock photo subjects; provide resume, business card, brochure, flyer, tearsheets or sample 35mm slide duplicates to be kept on file for possible future assignments. "Also send a catagorical list of images available for stock use; we'll contact you as requirements dictate. We work with freelancers on an assignment basis only." SASE. Reports in 3 weeks. Pays \$50-1,500/b&w or color stock photos; \$45/hour and \$360/day. Pays on acceptance. "We try for one-time rights except when the client makes other demands, in which case we attempt a negotiated upward adjustment." Model release and captions required. Credit line given "whenever possible."

Tips: "Submit work that shows technical and aesthetic excellence. We are slowly expanding our use of

freelancers as conditions warrant.'

EISNER & ASSOCIATES, INC., 12 W. Madison St., Baltimore MD 21201. (301)685-3390. Senior Art Director: Steve Parks. Ad agency. Uses billboards, consumer and trade magazines, direct mail, newspapers, P-O-P displays, radio and TV. Serves clients in fashion, food, entertainment, real estate, health, recreation and finance. Works with 3-4 freelance photographers/month on assignment only basis. Provide brochure to be kept on file for possible future assignments.

Specs: Uses b&w photos and color transparencies. Also uses 35mm, 16mm film and videotape for 30

second commercials.

Payment & Terms: Negotiates payment based on client's budget and where the work will appear. Buys all rights or negotiates rights. Model release preferred.

Making Contact: Arrange for a personal interview to show portfolio. Prefers to see samples of experimental work (either still life or people-oriented photos) and tearsheets in a portfolio. SASE. Prefers local freelancers. Reports in 1 week.

*HOTTMAN EDWARDS ADVERTISING, 1003 N. Calvert St., Baltimore MD 21202. (301)385-1443. Senior Art Director: Mike Hohner. Ad agency. Clients: industrial, financial, food and real estate firms; client list provided upon request.

Needs: Works with 6-8 freelance photographers/year on assignment only basis. Uses photographers for

First Contact & Terms: Arrange interview to show portfolio; prefers phone call initially. Payment is by the project; negotiates according to client's budget.

*MEDIA MATERIALS, INC., 2936 Remington Ave., Baltimore MD 21211-2891. (301)235-1700. Marketing Production Manager: C.M. Szczech. Clients: elementary and secondary educators, adminis-

Needs: Works with 2 photographers/year. Uses photographers for catalogs and print brochures. Subjects include product photography (books, cassette tapes, computer accessories); subject photography (students, teachers, etc.).

Specs: Uses 5x7 glossy b&w prints and 4x5 transparencies.

First Contact & Terms: Provide resume, business card, self-promotion piece or tearsheets to be kept on file for possible future assignments. Works with local freelancers only; interested in stock photos/ footage. SASE. Reports in 2 weeks. All jobs are bid individually. Pays within 30 days of receiving completed prints, transparencies, etc. Buys all rights. Model release required.

SHECTER & LEVIN ADVERTISING/PUBLIC RELATIONS, 1800 N. Charles St., Baltimore MD 21201. (301)752-4088. Ad agency and PR firm. Production Manager: V. Lindler. Clients: "varied—no fashion." Client list provided on request.

Needs: Works with up to 4 freelance photographers/month. Uses photographers for consumer magazines, direct mail, posters, and newspapers. Subject needs varied. Also works with freelance filmmakers to produce TV commercials.

First Contact and Terms: Provide resume, business card, brochure, flyer or tearsheets to be kept on file for possible future assignments. Prefers to work with local freelance photographers. Does not return unsolicited material. Pay varies. Pays on publication. Buys one-time rights. Model release required. Credit line given "if demanded."

RAY THOMPSON AND ASSOCIATES, 11031 McCormick Rd., Hunt Valley MD 21031. (301)667-9100. Creative Director: Dana Brock. AV firm. Uses all media except foreign. Serves clients in finance, professional associations and business. Photo needs are determined by the creative director of each individual project. "This can cover a dramatic range of subjects, as wide as the combined visual imagination of an entire creative group." Works with freelance photographers on assignment only basis. Provide resume, business card and brochure to be kept on file for possible future assignments. Buys 5-100 photos/year. Negotiates payment based on client's budget, amount of creativity required from photographer and photographer's previous experience/reputation. Call to arrange an appointment, submit material by mail for consideration, or submit portfolio. Prefers to see varied samples with emphasis on commercial work. Reports in 2 weeks. SASE.

B&W: Send contact sheet or 8x10 glossy or matte prints.

Color: Send transparencies, contact sheet, or 8x10 glossy or matte prints.

Tips: "Since our requirements cover a wide range of subjects and styles, we like to see a varied portfolio. Obviously, we prefer the emphasis to be on commercial photography. Be eager to work in advertising. If you are interested in art for art's sake, don't apply. We are interested in art for advertising's sake."

THOMPSON RECRUITMENT ADVERTISING, 1111 N. Charles St., Baltimore MD 21201. Ad agency. Creative Director: Robert Cunningham. Clients: industrial, finance, computer-all recruitment. Needs: Works with 1-2 freelance photographers/month. Uses photographers for consumer and trade magazines, brochures, catalogs, posters, newspapers, and AV presentations. Subjects include people. Specs: Flexible.

First Contact & Terms: Provide resume, business card, brochure, flyer or tearsheets to be kept on file for possible future assignments. Works with freelance photographers on assignment basis only. SASE. Reports in 3 weeks to 1 month. Payment varies with budget. Pays as soon as possible. Buys all rights. Model release required.

Tips: Prefers to see "people shots" in portfolio. Photographer should demonstrate "flexibility and the ability to work within our budget."

VAN SANT, DUGDALE & COMPANY, INC., The World Trade Center, Baltimore MD 21202. (301)539-5400. Creative Director: J. Stanley Paulus. Ad agency. Clients: corporations, consumer products and services, associations and industrial firms; "very wide range" of accounts; client list provided upon request.

Needs: Works on assignment only basis. Negotiates with photographers on each assignment based on the individual job and requirements. Uses photographers for consumer and trade magazines, brochures, catalogs, newspapers and AV presentations.

First Contact & Terms: Local freelancers only. Query with resume and follow up with personal

appointment. Payment negotiated depending upon job.

Tips: "The freelancer should make a showing of his/her work to all our art directors and continue to keep us reminded of his/her work from time to time. Interviews and personal appointments not necessary."

Massachusetts

ALLIED ADVERTISING AGENCY, INC., 800 Statler Bldg., Boston MA 02116. (617)482-4100.

Ad agency. Production Manager: Dave Drabkin.

Needs: Works with 6 freelance photographers/month. Uses photographers for billboards, consumer and trade magazines, direct mail, P-O-P displays, brochures, catalogs, posters, signage, newspapers, AV presentations, packaging, and press releases. Subject needs "too varied to list one particular type. About 70% industrial, 25% consumer/retail, 5% PR." Also works with freelance filmmakers to produce TV commercials, industrial films, P-O-P film loops.

Specs: Uses 8x10 RC and glossy b&w prints; 4x5, 8x10 color transparencies for studio work; 16mm,

35mm and videotape film.

First Contact & Terms: Arrange a personal interview to show portfolio. Works with freelance photographers on assignment basis only. SASE. Reports in 2 weeks. Pays \$60-150/hour, \$600-3,000/day or \$100-2,500/photo. Pays on acceptance. Buys all rights. Model release required; captions optional. Credit line "usually not" given.

Tips: In a portfolio, prefers to see "cross section of types of photography that the photographer feels he/she handles most easily. Photographers are matched by their strong points to each assignment. Keep

agency updated as to new projects."

ARNOLD & COMPANY, Park Sq. Bldg., Boston MA 02116. (617)357-1900. Executive Creative Director: Wilson Siebert. Art Director: Len Karkavsok. Ad agency. Clients: fast food, financial and computer firms.

Needs: Works with 6-8 freelance photographers/month. Uses photographers for all media.

First Contact & Terms: Arrange interview to show portfolio; query with "good" samples. Negotiates payment according to client's budget and where work will appear.

Tips: "Don't show a lot of work in your portfolio—only your best."

*BLACK & MUSEN, INC., Box 465, East Longmeadow MA 01028-0465. (413)567-0361. Ad agency. Art Director: Victor Brisebois. Clients: industrial, fishing, hunting, greeting cards, stationery, sports, fashion (men's and women's).

Needs: Works with 3-4 photographers/month. Uses photographers for consumer and trade magazines, direct mail, catalogs, newspapers, and literature. Subject matter includes boys, girls, teenagers, sports,

industrial, product, fishing, hunting and fashion.

Specs: Uses b&w prints; 35mm, 21/4x21/4, 4x5 and 8x10 transparencies.

First Contact & Terms: Arrange a personal interview to show portfolio; provide resume, business card, brochure, flyer or tearsheets to be kept on file for possible future assignments. Works with freelance photographers on an assignment basis only. Does not return unsolicited material. Reports in 3 weeks. Pays \$35-90/hour; \$400-750/day; \$100-500/job; and \$50-300/photo. Buys all rights. Model release required. Credit line negotiable.

*CLARK GOWARD FITTS, 380 Stuart St., Boston MA 02116. Ad agency. Contact: Creative Director, Art. Clients: consumer products, high-tech, retail, industrial, fashion.

Needs: Works with 6-12 photographers/month. Uses photographers for consumer and trade magazines, direct mail, P-O-P displays, catalogs and posters. Subject matter includes still life or people.

Specs: Uses 35mm, 2¹/₄x2¹/₄, 4x5 and 8x10 transparencies. Provide resume, business card, brochure, flyer or tearsheets to be kept on file for possible future assignments. Does not return unsolicited material. Pays by estimate of job with photographer, art and director and client. Pays in 60-90 days. Rights purchased depend on the job. Model release required.

ANDREW CURCIO, INC., 8 Newbury St., Boston MA 02116. (617)262-6800. Ad agency. Art Director/Designer: Kenneth Thatcher. Clients: industrial, banks, hotels, real estate, schools. Client list provided on request.

Needs: Works with 3-4 freelance photographers/month. Uses photographers for consumer and trade magazines, direct mail, P-O-P displays, brochures, catalogs, newspapers, and AV presentations. Subjects include "some product shots, some location (landscape/on site) shots, and many 'people'

shots-both models and amateurs.

Specs: Uses 8x10 or 11x14 b&w and color prints; 35mm, 21/4x21/4 and 4x5 transparencies. First Contact & Terms: Arrange a personal interview to show portfolio. Provide resume, business card, brochure, flyer or tearsheets to be kept on file for possible future assignments. Does not return unsolicited material. Pays \$600-1,100/day. "At times we need bids on certain jobs-by day, job, or whatever." Buys all rights. Model release preferred; captions optional. Credit line "sometimes" Tips: "I don't ask for much-great quality and low price. To be truthful, a lot of the reason I hire a freelancer is because of personality. If he or she is a jerk . . . I don't care how great their book is. I gladly take any suggestions from the photographer as per format, content, etc.'

ELBERT ADVERTISING AGENCY, INC., 815 University Ave., Box 8150, Norwood MA 02062. (617)769-7666. Production Manager: Gary Taitz. Ad agency. Uses all media. Serves clients in fashion and industry. Needs photos of food, fashion and industry; and candid photos. Buys up to 600 photos/ year. Pays \$25 minimum/hour. Call to arrange an appointment or submit portfolio. Reports in 1 week. SASE.

B&W: Uses 8x10 semigloss prints; contact sheet OK.

Color: Uses prints and 35mm or 21/4x21/4, 4x5 and 11x14 transparencies.

FILM I, 990 Washington St., Dedham MA 02026. (617)329-3470. Account Executives: Robert Gilmore, Diane Scholl. AV firm. Serves clients in schools and business. Produces filmstrips, slide sets, multimedia kits, motion pictures, sound-slide sets and videotape. Produces programs for inhouse presentations and commercial spots for TV. Works with 3-10 freelance photographers/month on assignment only basis. Provide resume, flyer and tearsheets to be kept on file for possible future assignments.

Film: Produces 35mm slides, super slides and 4x5; 16mm and Super 8 movies.

Photos: Uses 8x10 prints and 35mm transparencies.

FRANKLIN ADVERTISING, 88 Needham St., Newton MA 02161. (617)244-8368. Art Director: Donna Knauer, Contact: Debbie Campbell. Ad agency. Clients: mostly industrial, some consumer firms (fashion catalog and furniture).

Needs: Works with 1-2 freelance photographers/month. Uses photographers for consumer and trade

magazines, direct mail, brochures, catalogs and newspapers.

First Contact & Terms: Arrange interview to show portfolio. Payment is by the hour or by the project.

HBM/CREAMER, 1 Beacon St., Boston MA 02108. (617)723-7770. Contact: Mary Pat Curran. Ad agency. Clients: consumer, financial and high tech. Client list provided upon request.

Needs: Works with freelance photographers on assignment basis.

First Contact & Terms: Send sample and follow up with phone call to art buyer. Payment is usually based on type of work involved.

BERNARD HODES ADVERTISING, INC., 264 Beacon St., Boston MA 02116, (617)262-3540. Creative Director: Paul Silva. Ad agency.

First Contact & Terms: Call or write for personal appointment to show portfolio. Pays \$45-1,000/hour,

\$400 minimum/day or \$45/b&w photo. Pays on completion of job.

Tips: Send 4-5 b&w photos. "We use a lot of b&w and some color. Our main concerns are with people in work situations and some portraiture. We like to see people in relaxed settings depicting the life styles of those particular employees.'

*RAYMOND KOWAL & WICKS, One Broadway, Cambridge MA 02142. (617)354-0900. PR firm. Executive Assistant: M. Hubler. Clients: industrial, business-to-business and consumer.

Needs: Uses 3-5 freelance photographers/month. Uses photographers for newspapers, trade magazines and brochures. Subject matter and style "varies widely depending on assignment from clients."

Specs: Uses primarily b&w prints; 35mm, 21/4x21/4 and 4x5 transparencies.

First Contact & Terms: "We work freelancers on an assignment basis only." Reports in 3 weeks. Payment varies "according to nature of job and needs of clients." Pays 45 days from invoice. "Net 30 days is our standard policy for rights. We like to have access to the negatives should future shots/prints be needed." Model release and captions required. Credit line "usually not" given.

Tips: "Drop us a note with some type of work sample. Do not telephone—anyone can telephone; good work is your best 'in.' We like to see product shots (in studio & on location—trade show, for instance), headshots (business), group shots, black & white and color shots, as well as tearsheets and high-tech product shots if available.'

*DETRICK LAWRENCE, Box 1722, Duxbury MA 02331. (617)934-6561. Executive Producer: Gordon Massingham. Clients: educational media distributors, corporate, broadcast.

60 Photographer's Market '86

Needs: Works with 2'3 photographers/month. Uses photographers for slide sets, multimedia productions, films, videotapes. Subjects include documentary, demonstration.

Specs: Uses 8x10 glossy b&w; 35mm transparencies; 16mm and 35mm films; U-matic 3/4" and 1"

videotapes.

First Contact & Terms: Query with resume or stock photo list; provide resume, business card, self-promotion piece or tearsheets to be kept on file for possible future assignments. Works with freelancers by assignment only; interested in stock photos/footage. SASE. Reports in 2 weeks. Pays \$150-400/day. Pays 30 days after receipt of invoice. Buys all rights. Model release preferred. Credit line given.

McKINNEY/NEW ENGLAND, 58 Commercial Wharf, Boston MA 02110. (617)227-5090. Senior Art Director: Robert A. Lamphier. Ad agency. Clients: 100% industrial.

Needs: Works with 2 freelance photographers/month. Uses photographers for print collateral—ads and brochures.

First Contact & Terms: Usually works by recommendation but does occasionally set up appointments by phone to review portfolio. Pays \$600-1,500/day. Negotiates payment based on client's budget, amount of creativity required from photographer, where work will appear and freelancer's expertise in area.

Tips: Wants to see original photographs. "Particular interest in black & white product photography applicable to industrial market. Imagination and creativity in set-ups of inherently dull objects are bonuses. Also interested in location work within manufacturing areas."

MILLER COMMUNICATIONS, INC., 607 Boylston, Copley Sq., Boston MA 02116. (617)536-0470. Production Manager: Maureen O'Rourke. PR firm. Handles high technology/computer accounts, computer communication. Photos used in brochures, newsletters, annual reports, PR releases, AV presentations, sales literature, consumer and trade magazines. Commissions 10 photographers/year. Pays \$75 minimum/half day. Buys all rights. Model release preferred; captions optional. Submit portfolio for review. SASE. Reports in 2 weeks. Most interested in human interest/news-type photographs, photo stories, sophisticated portraits in environment; creative product shots, and candids (annual report type).

B&W: Uses contact sheet.

Color: Uses 21/4x21/4 transparencies or contact sheet and negatives.

Tips: "Select a product the agency is representing and make up a portfolio showing this particular product from the simplest photography to the most sophisticated image-builder. Photographers we need must be thinkers, philosophers, not impulsive types who take 600 slides from which we can select 1 or 2 good pictures."

ARTHUR MONKS ASSOCIATES, INC., 350 Randolph Ave., Milton MA 02186. (617)698-0903. President: Arthur Monks. Ad agency and PR firm. Clients: primarily real estate, construction and land development.

Needs: Works with varying number of freelance photographers/month as per client's needs. Uses

freelancers for brochures, consumer and trade magazines, direct mail and newspapers.

First Contact & Terms: Call for personal appointment to show portfolio. Selection is made "on the basis of special needs. For architectural photos we select those we think have some experience and talent; for ordinary work we stick with a few we use very often." Negotiates payment based on client's budget, amount of creativity required from photographer, previous experience/reputation and "going rates in this area."

Tips: "Call, we will describe what kind of service we need and would expect to be shown relevant samples only."

PELLAND ADVERTISING ASSOCIATES, Box 878, Springfield MA 01101. (413)737-1474. Ad agency. Contact: Peter Pelland. Clients: travel and resort firms (e.g., ski resorts and family campgrounds, motels, country inns, and restaurants).

Needs: Works with 1-3 freelance photographers/month. Uses photographers for brochures, posters and AV presentations. Subject matter is "resorts at assigned locations throughout the United States although concentrated in the Northeast. Stock material used only occasionally."

Spec: Uses 35mm or larger transparencies. Prefers Kodachrome.

First Contact & Terms: Submit resume with appropriate samples and SASE, for potential personal interview—prerequisite to assignment. Works with freelance photographers on assignment basis only. SASE. Reports in 1 month. Pays \$150-250/day; or \$125-250/job. "The typical job requires 1 day of photography. Limited expenses are also paid for travel and lodging. Film and processing will be provided or expenses reimbursed." Pays within 30 days of receipt of completed work with invoice. Buys specific rights; additional rights may be negotiated. Model release required; captions preferred. Credit line given "occasionally, if appropriate to the product."

Tips: "Excel technically and compositionally, have a good working rapport with the public, and try to understand the specific marketing challenges of our clients-and transform all of that into quality photographs. We look for portfolios that include properly composed and exposed Kodachrome originals representing a cross-section of appropriate discipline: landscapes, sport, architecture, candids, interiors, food. No color prints, portraits, or wedding albums. Above all, you must be thoroughly professional in attitude and appearance if you are to, even briefly, represent yourself as a member of our team."

VIDEO/VISUALS, INC., 63 Chapel St., Newton MA 02158. (617)527-7800. President: Bob Lewis. Vice President/General Manager: Tom Nickel. AV firm. Serves clients in businesses and associations. Produces videotape.

Subject Needs: "We use videotapes for company/business presentations only occasionally—50% of our business is equipment rental."

Film: Videotape, VHS, BETA, 3/4", 1" C.

Payment & Terms: Pays \$5-20/hour or by the job. Pays on production. Buys all rights. Model release required.

Making Contact: Query with resume of credits. SASE. Reports in 1 week. Free brochure and price list.

WINARD ADVERTISING AGENCY, INC., 343 Pecks Rd., Pittsfield MA 01201. (413)445-5657. Ad agency. President: Bill Winslow. Uses billboards, consumer and trade magazines, direct mail, foreign media, newspapers, P-O-P displays and radio. Serves clients in industry, finance, manufacturing (wallpaper, coffee pots, sewing threads, trucks, paper), and housing developments. Works with 1 freelance photographer/month on assignment only basis. Provide resume and samples to be kept on file for possible future assignments. Pays \$50 minimum/hour; \$225 minimum/day; negotiates payment based on client's budget. Pays on acceptance. Buys all rights. Model release and captions preferred. Arrange personal interview to show portfolio. Prefers to see samples of studio merchandise shots and on location industrial shots (plants, machinery, etc.) in a portfolio. Will view unsolicited material. Local freelancers preferred. SASE. Reports in 2 weeks.

B&W: Uses 8x10 and 11x14 matte prints.

Color: Uses 8x10 matte prints and 35mm or 4x5 transparencies.

Michigan

BARSKY & ASSOCIATES ADVERTISING, 334 S. State St., Ann Arbor MI 48104. (313)996-0001. Ad agency. Creative Director: Allan Barsky. Clients: high technology, industrial, medical, retailfashion.

Needs: Works with 1-2 freelance photographers/month. Uses photographers for billboards, consumer and trade magazines, direct mail, P-O-P displays, brochures, catalogs, posters, signage, newspapers, AV presentations. Subjects include people.

First Contact & Terms: Provide flyer or tearsheets to be kept on file for possible future assignments. Does not return unsolicited material. Payment open; "every job is different." Buys all rights. Credit line "often" given.

CORPORATE COMMUNICATIONS, INC., 2950 E. Jefferson Ave., Detroit MI 48207. (313)259-3585. Ad and PR agency. Production Manager: Patrick Longe. Clients: health care, consumer products,

Needs: Works with 1-5 freelance photographers/month. Uses photographers for direct mail, catalogs, AV presentations, trade magazines and brochures. Subjects include clients' products. Also works with freelance filmmakers to produce videotapes for training and sales promotion.

Specs: Uses b&w and color prints; 35mm and 21/2x21/2 and 4x5 transparencies; 16mm and 35mm film and videotapes.

First Contact & Terms: Provide resume, business card, brochure, flyer or tearsheets to be kept on file for possible future assignments. Works with freelance photographers on assignment basis only. Does not return unsolicited material. Pays \$40-100/hour; \$250-600/day. Pays on acceptance. Buys all rights. Model release required; captions preferred.

Tips: Prefers to see an "all-around capability" in a photographer's samples. Photographer should also supply "clear, well-written materials."

CREATIVE HOUSE ADVERTISING, INC., Suite 200, 24472 Northwestern Hwy., Southfield MI 48075. (313)353-3344. Sr. Vice President/Executive Creative Director: Robert G. Washburn. Ad agency. Uses billboards, consumer and trade magazines, direct mail, newspapers, P-O-P displays, radio and TV. Serves clients in retailing, industry, finance, commercial products. Works with 2-3 freelance photographers/month on assignment only basis.

Needs: Uses b&w and color prints and transparencies. Also produces TV commercials (35mm and

16mm film) and demo film to industry. Does not pay royalties.

First Contact & Terms: Provide resume, business card, brochure, flyer and anything to indicate the type and quality of photos to be kept on file for future assignments. Pays \$40-60/hour or \$400-700/day; negotiates payment based on client's budget and photographer's previous experience/reputation. Pays in 1-4 months, depending on the job. Buys all rights. Model release required. Arrange personal interview to show portfolio; query with resume of credits, samples, or list of stock photo subjects; submit portfolio for review ("Include your specialty and show your range of versatility"); or send material by mail for consideration. Local freelancers preferred. SASE. Reports in 2 weeks.

W.B. DONER & CO., 26711 Northwestern Hwy., Southfield MI 48034. (313)354-9700. Vice President: Joe Minnella. Ad agency. Clients: retail (department stores, appliance, lumber), financial, food and beverage firms.

Needs: Works with several freelance photographers/month. Uses photographers for billboards, consumer and trade magazines, brochures, newspapers and TV.

First Contact & Terms: Arrange interview with one of the art directors to show portfolio. Negotiates payment according to client's budget.

Tips: Prefers to see product shots and interesting character shots of people.

DALLAS C. DORT AND CO., 815 Citizen's Bank Bldg., Flint MI 48502. (313)238-4677. President/ Creative Director: Dallas C. Dort. Ad agency. Uses all media except foreign. Serves food, health care, retail and travel clients. Works with freelance photographers on assignment basis only approximately 10 times/year.

B&W: Uses prints; specifications per assignment.

Color: Uses prints and film; specifications per assignment.

First Contact & Terms: Send resume and samples to be kept on file for possible future assignments. Buys all rights. "We outline the job to the photographer, he quotes on the job and it is billed accordingly." Submit portfolio. SASE. Reports in 2 weeks.

*T.S. JENKINS & ASSOCIATES, Suite 200, 400 N. Saginaw, Flint MI 48502. (313)235-5654. Ad agency. Art Director: Jack LeSage. Clients: industrial, retail, financial, cultural, education. Client list free with SASE. Works with 2 photographers/month. Uses photographers for billboards, consumer and trade magazines, direct mail, P-O-P displays, catalogs, posters, signage and newspapers. Subject matter varies.

Specs: Uses 8x10 contact sheets, and 35mm, 21/4x21/4 and 4x5 transparencies.

First Contact & Terms: Arrange a personal interview to show portfolio; provide resume, business card, brochure, flyer or tearsheets to be kept on file for possible future assignments. Works with local freelance photographers on an assignment basis only. Reports in 3 weeks. Payment based on photographer's fee. Buys all rights. Model release required. Credit line given.

PHOTO COMMUNICATION SERVICES, INC., 6410 Knapp, Ada MI 49301. (616)676-1499. Commercial/Illustrative and AV firm. President: Michael Jackson. Clients: commercial/industrial, fashion, food, general, human interest.

Needs: Works with variable number of freelance photographers/month. Uses photographers for catalogs, P-O-P displays, AV presentations, trade magazines and brochures. Photographers used for a "large variety of subjects." Sometimes works with freelance filmmakers.

Specs: Uses 8x10 gloss and semigloss b&w and color prints (or larger); 35mm, 21/4x21/4, 4x5 and 8x10

transparencies; 16mm film and videotapes.

First Contact & Terms; Query with resume of credits, samples or list of stock photo subjects. Works with freelance photographers on assignment basis only. SASE. Reports in 1 month. Pays \$5-60/hour; or by "private" agreement (project-oriented). Pays 30 days from acceptance. Buys all rights or one-time rights. Model release required. Credit line given "whenever possible."

Tips: Prefers to see "variety and advertising quality" in samples. "Do not want family or school projects, etc. If we are interested we will send guidelines. We also have a library of stock photography and can be reached on the (SOURCE BBH782) and (PhotoNet PHO1289) or MCI mail via your computer."

The asterisk before a listing indicates that the listing is new in this edition. New markets are often the most receptive to freelance contributions.

This photo, reproduced in thousands of billboards, posters and brochures helped make the 1985 United Way Campaign in Kent County, Michigan, the most successful ever held there. The photo was among a series Michael Jackson, president of Photo Communication Services, Inc. of Ada, Michigan, had taken for United Way. Part of the photo's success stems from Jackson's approach to the campaign's theme: The little girl is saying 'I love you' in sign language.

Minnesota

BATTEN, BARTON, DURSTINE & OSBORN, INC., 625 4th Ave. S., 900 Brotherhood Bldg., Minneapolis MN 55415. (612)338-8401. Art Buyer: Pam Schmidt. Ad Agency. Clients: corporate and financial, food products, high-tech systems/products.

Needs: Works with freelance photographers on assignment only basis. Uses photographers for consumer and trade magazines, direct mail, newspapers, P-O-P and collateral material.

First Contact & Terms: Call for personal appointment to show portfolio. Interested in people who "are professional and understand how to work with agencies." Negotiates payment based on "time involved and size of project. We also require estimates and review them with each clients' budget in mind." Sometimes where work will appear is a consideration.

Tips: Interested in previously published work such as slides and transparencies. Leave-behind material helpful.

BUTWIN & ASSOCIATES ADVERTISING, INC., Suite 202, 3601 Park Center Blvd., Minneapolis MN 55416. (612)929-8525. Ad agency. President: Ron Butwin. Clients: industrial, retail, corporate. Needs: Works with 1-2 freelance photographers/month. Uses photographers for billboards, direct mail, catalogs, newspapers, consumer magazines, P-O-P displays, posters, AV presentations, trade maga-

Market conditions are constantly changing! If this is 1987 or later, buy the newest edition of *Photographer's Market* at your favorite bookstore or order directly from Writer's Digest Books.

zines, brochures and signage. Uses "a wide variety" of subjects and styles. Also works with freelance filmmakers to produce TV commercials and training films.

Specs: Uses all sizes b&w or color prints; 35mm and 21/4x21/4, 4x5 and 8x10 transparencies; 16mm film and videotape.

First Contact & Terms: Provide resume, business card, brochure, flyer or tearsheets to be kept on file for possible future assignments. "We work with local freelancers only." Does not return unsolicited material. Buys all rights. Model release required. Credit line sometimes given.

CARMICHAEL-LYNCH, INC., 100 E. 22nd St., Minneapolis MN 55404. (612)871-8300. Ad agency. Executive Art Director: Dan Krumwiede. Clients: recreational vehicles, food, finance, wide variety. Client list provided on request.

Needs: Uses "maybe 8" freelance photographers/month. Uses photographers for billboards, consumer and trade magazines, direct mail, P-O-P displays, brochures, posters, newspapers, and other media as needs arise. Also works with freelance filmmakers to produce TV commercials.

Specs: Uses b&w and color prints; 35mm, 21/4x21/4, 4x5 and 8x10 transparencies; 16mm and 35mm film and videotape.

First Contact & Terms: Provide resume, business card, brochure, flyer or tearsheets to be kept on file for possible future assignments; submit portfolio for review; arrange a personal interview to show portfolio; works with freelance photographers on assignment basis only. Reports in 1 week. Pay depends on contract; \$400-2,500/day, \$200-2,500/job. Pays on acceptance. Buys all rights or one-time rights, "depending on agreement." Model release required; captions optional.

Tips: "Be close at hand (Minneapolis, Detroit, Chicago)." In a portfolio, we prefer to see "the photographer's most creative work—not necessarily ads. Show only your most technically, artistically satisfying work."

FABER SHERVEY ADVERTISING, 160 W. 79th, Minneapolis MN 55420. President: Paul Shervey. Ad agency. Clients: industrial, agricultural, consumer accounts. Photos used in advertising, sales literature and brochures. Buys 10-20 annually. Submit model release with photo. Submit material by mail on request for consideration. Prefers to see industrial, agricultural and on-location machinery. Reports in 1 month. SASE. Provide resume, brochure, and tearsheets to be kept on file for possible future assignments.

B&W: Uses 8x10 glossy prints; send contact sheet. Pays \$60-400. **Color:** Send 2¹/₄x2¹/₄ transparencies or contact sheet. Pays \$60-500.

STU GANG & ASSOCIATES INC., Mears Park Place, 120 On The Courtyard, St. Paul MN 55101. (612)224-4324. Vice President: Jeff Gould. Ad agency and PR firm. Photos used in brochures, newspapers, annual reports, catalogs, PR releases and magazines. Works with 2-3 freelance photographers/month on assignment only basis. Provide resume, tearsheet and samples to be kept on file for future assignments. Pays \$25-75/hour; negotiates payment based on client's budget and the amount of creativity required from photographer. Buys all rights. Model release preferred. Photos purchased on assignment only. SASE. Reports in I week. "All freelance photos are based on our specific assignments only. Jobs may involve anything from steel construction to a bank promotion."

B&W: Uses 8x10 glossy prints; contact sheet OK.

Color: Uses 8x10 glossy prints and 21/4x21/4 and 4x5 transparencies; contact sheet OK.

Film: 16mm for TV commercials and educational and corporate films. Filmmaker might be assigned anything from a 30-second television spot to a half-hour lip-sync sound film.

Tips: "Currently, we have five photographers we consistently work with, but we're not locked in."

GREY ADVERTISING, Midwest Plaza Bldg. E., Minneapolis MN 55402. (612)341-2701. Vice President/Creative Director: Peter Hale. Ad agency. Annual billing: \$23 million. Clients: retailers, manufacturers, TV, airline, financial institutions and health organizations.

Needs: Works with 3-10 freelance photographers/month. Uses freelancers for billboards, consumer and trade magazines, brochures/flyers, newspapers, P-O-P displays, catalogs, direct mail and TV.

First Contact & Terms: Call or write requesting appointment to show portfolio. Selection based on reputation and references. "We don't buy a lot of out-of-town freelance photos." Negotiates payment based on client's budget.

Tips: Wants to see best work; prefers color transparencies but will look at b&w, color prints and samples of published work. "Show us specific assignments that demonstrate problem solving ability and understanding of clients' needs or present photos done as self-promotion that demonstrate creativity, skill. Develop a style or area of specialization that will give you a unique niche; it helps people remember you in a business crowded with talent."

IMAGE MEDIA, INC., 1362 LaSalle Ave., Minneapolis MN 55403. (612)872-0578. President/ Creative Director: A. Michael Rifkin. AV firm. Clients: business and industry, agriculture, education, radio and TV. Produces filmstrips, motion pictures, sound-slide sets and videotape. Buys 50 photos, 5

filmstrips and 10 films/year.

Subject Needs: Product demonstration, employee training and general information. Uses freelance photos in slide sets, filmstrips and motion pictures. Length requirement: slide shows are usually 80 frames, films 3-15 minutes.

Film: Produces 16mm reversal or negative.

Photos: Uses 8x10 matte b&w prints, 5x7 matte color prints and 35mm color transparencies.

Payment & Terms: Pays \$250/job or \$25-50/hour. Pays on production. Buys rights depending on usage. Model release preferred.

Making Contact: Query with resume or send material by mail for consideration. SASE. Reports in 2 weeks.

*MARTIN-WILLIAMS ADVERTISING INC., 10 S. 5th St., Minneapolis MN 55402. (612)340-0800. Ad agency. Production Coordinator: Lyle Studt. Clients: industrial, retail, finance, agricultural, business-to-business, food. Client list free with SASE.

Needs: Works with 6-12 photographers/month. Uses photographers for billboards, consumer and trade

magazines, direct mail, catalogs, posters and newspapers. Subject matter varies.

Specs: Uses 8x10 and larger b&w and color prints, 35mm, 2¹/4x2¹/4, 4x5 and 8x10 transparencies. First Contact & Terms: Arrange a personal interview to show portfolio; provide resume, business card, flyer or tearsheets to be kept on file for possible future assignments. Works with freelance photographers on an assignment basis only. SASE. Reports in 2 weeks. Payment individually negotiated. Pays on receipt of invoice. Buys all rights and one-time rights. Model release required.

CHUCK RUHR ADVERTISING, INC., 1221 Nicollet Mall, Minneapolis MN 55403. (612)332-4565. Creative Director: Doug Lew. Ad agency. Clients: consumer and industrial firms; client list provided upon request.

Needs: Works with 6-8 freelance photographers/year on assignment only basis. Uses photographers for

all media.

First Contact & Terms: Send printed mail-in, small index form. Negotiates payment according to client's budget; then the amount of creativity, where work will appear and previous experience are taken into consideration.

RUSSELL—MANNING PRODUCTIONS, 905 Park Ave., Minneapolis MN 55404. (612)338-7761. Director of Photography: Bill Carlson. AV firm. Serves companies and advertising agencies. Produces filmstrips, slide sets, multimedia kits, motion pictures, sound-slide sets and videotape. Works with 1-2 freelance photographers/month on assignment only basis. Provide either resume, flyer, business card or tearsheets to be kept on file for possible future assignments.

Subject Needs: Photos used in slide shows, films, videotapes, posters, brochures. Length immensely

varied, usually 5-20 minutes. Special format: 35mm horizontal color.

Film: Produces 16mm and 35mm positive or negative. Interested in stock footage (historical, generic). Works out individual contracts based upon footage and program.

Photos: Uses 35mm color transparencies, 21/4 square, 4x5, 8x10 or panoramas.

Payment & Terms: Payment per photo or by day (\$400-850/day). Negotiates payment based on client's budget, where the work will appear, photographer's previous experience/reputation and difficulty entailed. Pays within 30 days unless otherwise specified. Buys one-time rights, all rights, or according to client needs. Model release required. Captions optional.

Making Contact: Arrange a personal interview, query with resume of credits, send material by mail for consideration, or submit portfolio. Prefers to see industrial shots, close-up work, lighting under varied conditions, filtration for varied available lighting conditions, studio photography and interpersonal relations. SASE. Reports as soon as possible.

TELEX COMMUNICATIONS, INC., 9600 Aldrich Ave. S, Minneapolis MN 55420. (612)884-5556. Inhouse ad agency of diversified manufacturing firm. Director, Marketing Services: Peter Schwarz.

Needs: Works with 3-4 freelance photographers/year. Uses photographs for trade magazine ads, direct mail, P-O-P displays, brochures, catalogs, AV presentations. Subjects include application photos ("products we make in actual use").

Specs: Uses up to 11x14 b&w or color prints; 35mm, 21/4x21/4 and 4x5 transparencies.

First Contact & Terms: Provide resume, business card, brochure, flyer or tearsheets to be kept on file for possible future assignments. Works with freelance photographers on assignment basis only. Does not return unsolicited material. Reports in 3 weeks. Pays \$100-750/job. Pays on acceptance. Buys all rights. Model release required; captions preferred.

Tips: "When seeing our products in user application, query us as to possible photo assignment. Polaroid

with query helpful. We're making higher use of freelancers who can produce usable materials as cost of travel escalates to prohibitive levels for own staff."

VANGUARD ASSOCIATES, INC., Suite 485, 15 S. 9th St., Minneapolis MN 55402. (612)338-5386. Contact: Creative Director. Ad agency. Clients: government, consumer, fashion, food. Needs: Uses photographers for billboards, consumer and trade magazines, direct mail, P-O-P displays, brochures, posters, newspapers, multimedia campaigns and AV presentations. Payment is by the project;

negotiates according to client's budget.

Mississippi

MARIS, WEST, & BAKER ADVERTISING, 5120 Galaxie Dr., Jackson MS 39211. (601)362-6306. Ad agency. Executive Art Director: Jimmy Johnson. Clients: financial, food, life insurance.

Needs: Uses photographers for billboards, consumer and trade magazines, direct mail, P-O-P displays, brochures, catalogs, posters, newspapers and AV presentations. Subjects include: food, table tops,

outside. Also uses freelance filmmakers for TV commercials and training films.

Specs: Uses 11x14 b&w prints; 4x5 and 8x10 transparencies; 16mm and 35mm film and videotape. First Contact & Terms: Submit portfolio for review. Works with freelance photographers on assignment basis only. SASE. Reports in 2 weeks. Pays per hour or per day-"depends on type of photography." Payment on 30 to 60 day billing. Buys all rights. Model release required. Credit line

given only if "entered in competition."

Tips: Prefers to see "good samples of food, table tops, outside, exhibiting good lighting techniques, composition and color. Be able to provide good service, excellent product at competitive price. Have positive attitude and be willing to experiment. We are always looking for excellent work and are conditioning most of our clients to want and pay for the same. Be available and punctual on getting back materials. Also be able to work under pressure a few times."

Missouri

BARICKMAN ADVERTISING, INC., 427 W. 12th St., Kansas City MO 64105. (816)421-1000. Contact: Art Directors. Ad agency. Uses all media except foreign. Serves industrial, retail and consumer organizations, and producers of hard goods, soft goods and food. Provide brochure to be kept on file for possible future assignments. Pays \$35-800/job. Pays on production. Call to arrange an appointment or submit portfolio showing unique and competent lighting and variety (agriculture, food, people); solicits photos by assignment only. SASE.

B&W: Uses 5x7, 8x10 or 11x14 prints.

Color: Uses transparencies or prints, will vary with need.

*AARON D. CUSHMAN AND ASSOCIATES, INC., Suite 900, 7777 Bonhomme, St. Louis MO 63105. (314)725-6400. Contact: Thomas L. Amberg. PR, marketing and sales promotion firm. Clients: real estate, manufacturing, travel and tourism, telecommunications, consumer products, corporate counseling.

Needs: Works with 3-5 freelance photographers/month. Uses photographers for news releases, special events photography, and various printed pieces. More news than art oriented.

First Contact & Terms: Call for appointment to show portfolio. Pays \$50-100 b&w/photo; \$50-250 color/photo; \$50-100/hour; \$350-750/day.

Tips: "We are using increasing amounts of architecturally oriented and health care-related stills."

EVERETT, BRANDT & BERNAUER, INC., 314 W. 24 Hwy., Independence MO 64050. (816)836-1000. Contact: James A. Everett. Ad agency. Clients: construction, finance, auto dealership, agribusiness, insurance accounts. Photos used in brochures, newsletters, annual reports, PR releases, AV presentations, sales literature, consumer magazines and trade magazines. Usually works with 2-3 freelance photographers/month on assignment only basis. Provide resume and business card to be kept on file for possible future assignments. Buys 100 photos/year. Pays \$35/b&w photo; \$50/color photo; \$50/hour; \$200-400/day. Negotiates payment based on client's budget and amount of creativity required from photographer. Buys all rights. Model release required. Arrange a personal interview to show portfolio. Local freelancers preferred. SASE. Reports in 1 week.

B&W: Uses 5x7 prints.

Color: Uses prints and transparencies.

Tips: "We anticipate increased use of freelance photographers, but, frankly, we have a good working

relationship with three local photographers and would rarely go outside of their expertise unless work load or other factors change the picture."

*GEORGE JOHNSON ADVERTISING, 763 New Ballas Rd. S., St. Louis MO 63141. (314)569-3440. President: George Johnson. Ad agency. Uses all media except foreign. Clients: real estate, financial and social agencies. Works with 2 freelance photographers/month on assignment only basis. First Contact and Terms:Provide resume and flyer to be kept on file for possible future assignments. Buys 25 photos/year. Pays \$10-50/hour; negotiates payment based on client's budget and amount of creativity required. Pays in 60 days. Prefers to see working prints of typical assignments and tearsheets (application). Submit material by mail for consideration.

MARITZ COMMUNICATIONS CO., 1315 North Highway Dr., Fenton MO 63026. (314)225-6000.

General Manager/Photo Services: Jack Lee. AV firm. Clients: business, industrial.

Needs: Uses photographers for filmstrips, slide sets, multimedia kits, motion pictures and videotape. Subjects include employee training, business meeting environment, automotive training, product photography, 35mm location shooting both in-plant and outdoors.

Specs: "Some travel involved, normally 2-3 day shoots. All color. Shoot a variety of filmstrips." Produces 35mm for industrial and educational filmstrips and multimedia shows. Uses 4x5 and 8x10

color transparencies.

First Contact & Terms: Arrange a personal interview to show portfolio (product photo, 35mm location and in-plant work photos in color). Works on assignment only. Provide resume and calling card to be kept on file for future assignments. Pays \$150-200/day. Payment made by agreement (30 days). Buys all rights. Model release required.

FLETCHER MAYO ASSOCIATES, John Glenn Rd., St. Joseph MO 64505. (816)233-8261. Ad agency. Vice President/Creative Director: Jim Gampper. Clients: industrial, agricultural, consumer and trade.

Needs: Works with 2-12 freelance photographers/month. Provide business card and brochure to be kept on file for possible future assignments. Uses freelancers for billboards, consumer and trade magazines,

direct mail, newspapers, P-O-P displays and TV.

First Contact & Terms: Write and request personal interview to show portfolio or send portfolio for review including actual photos that might be suited for our clients. Does not return unsolicited material. Reports in 2 weeks. Negotiates payment based on client's budget, photographer's previous experience/reputation and amount of creativity required.

*MILLIKEN PUBLISHING COMPANY, 1100 Research Blvd., St. Louis MO 63132. (314)991-4220. Managing Editor: Carol Washburne. Clients: teachers.

Needs: Works with very few photographers. Uses photographers for slide sets. Photos are needed now and then for covers. Needs vary widely from shots of children to landscapes, folkdance, other countries, monuments, etc.

Specs: Uses 8x10 glossy color prints, and 35mm and 4x5 transparencies.

First Contact & Terms: Arrange a personal interview to show portfolio; query with stock photo list; provide resume, business card, self-promotion piece or tearsheets to be kept on file for possible future assignments. Works with local freelancers. SASE. Reports in 1 month. Pays on acceptance. Buys all rights. Captions preferred; model release required. Credit line given.

PATON & ASSOCIATES, Box 8181, Kansas City MO 64112. (913)649-4800. Contact: N.E. (Pat) Paton, Jr. Ad agency. Clients: medical, financial, home furnishing, professional associations, vacation resorts.

Needs: Works with freelance photographers on assignment only basis. Uses freelancers for billboards, consumer and trade magazines, direct mail, newspapers, P-O-P displays and TV.

First Contact & Terms: Call for personal appointment to show portfolio. Negotiates payment based on amount of creativity required from photographer.

E.M. REILLY & ASSOCIATES, 11 Bonhomme, Clayton MO 63105. (314)725-4600. Ad agency. Art Director: Mike Slusher. Clients: industrial, financial, food.

Needs: Works with 1-2 freelance photographers/month. Uses photographers for trade magazines, direct mail, P-O-P displays, brochures and newspapers. Subjects include portraiture, people and still lifes. Specs: Uses 3x5 b&w or color glossy prints; 35mm or 4x5 transparencies.

First Contact & Terms: Query with resume of credits or submit portfolio for review. Provide resume, business card, brochure, flyer or tearsheets to be kept on file for possible future assignments. Works with freelance photographers on assignment basis only. Does not return unsolicited material. Pays \$35-100/

hour; \$750-1,000/day. Pays on publication. Buys all rights. Model release preferred. Credit line given "generally."

Tips: Prefers to see 8x10 prints and transparencies of food, industrial subjects and people in a portfolio.

*SMITH & YEHLE, INC., 3217 Broadway, Kansas City MO 64111. (816)842-4900. Creative Director: Mike Gettino. Art Directors: Bill Ost, Myra Colbert. Ad agency. Clients: consumer, industrial, financial, retail and utility clients.

Needs: Works with 6-10 photographers/year. Uses photographers for billboards, newspapers, P-O-P

displays, radio, TV.

Specs: Uses b&w photos and color transparencies. Also uses 16 and 35mm videotape for commercial TV and AV use.

Payment & Terms: Pays \$100-1,500/b&w photo; \$250-3,000/color photo; \$50-85/hour; \$750-1,500/day; \$150/job; and 50% advance, 50% when completed for films. Model release required.

Making Contact: Arrange a personal interview to show portfolio; query with samples or list of stock photo subjects; provide business card and brochure to be kept on file for possible future assignments.

SASE. Reports in 2 weeks.

Tips: "We look for clean, graphic shots—lots of b&w for ads, and need quick turnaround on short notice. We will pay well to get quality work. Typically, we use tape for lower budget jobs and/or training aids. We use film for 90% of our commercials. 75% of our clients are using video tape, 25% film, with all editing done on tape, rather than stills for promotional AV use. Know how to light and know composition. Let the action happen naturally in front of your lens. Don't force it. Direct the talent, they're paid to do what *you* want. Also, don't be simply a mechanic. Anyone can own a camera. Instead, be creative. Make suggestions. The people you're working for will love it. Then keep your promises, financially and creatively."

STOLZ ADVERTISING CO., 7701 Forsyth, St. Louis MO 63105. (314)863-0005. Executive Art Director: Helene Elein. Ad agency. Clients: consumer firms; client list provided upon request. **Needs:** Works with 2 freelance photographers/month on assignment only basis. Uses photographers for billboards, consumer and trade magazines, direct mail, P-O-P displays, brochures, posters, newspapers and AV presentations.

First Contact & Terms: Works with local artists and out-of-town artists. Arrange interview to show portfolio or query with samples. Negotiates payment according to particular job.

***VINYARD & LEE & PARTNERS, INC.**, 745 Old Frontenac Square, St. Louis MO 63131. (314)993-8080. Art Director: Paul Behnen. Art Director: Marty Chapo. Ad agency. Clients: food, finance, restaurants, retailing, consumer goods, produce, business, industry and manufacturing, health care, hospitals.

First Contact & Terms: Call for personal appointment to show portfolio. Negotiates payment based on client's budget, amount of creativity required from photographer, where work will appear and photographer's experience/reputation. "When there aren't set budgets, we set a price/hour."

Tips: "We like to see what you do best."

Montana

SAGE ADVERTISING, Box 1142, 2027 11th Ave., Helena MT 59624. (406)442-9500. Contact: Production Manager. Ad agency and PR firm. Clients: business, government agencies. Produces filmstrips, slide sets, multimedia kits, sound-slide sets and videotape. Buys 300 photos, 10 filmstrips and slides, and 15 films/year.

Subject Needs: Advertising and promotion in all client areas. Photos used in slide shows, brochures, newspaper ads, magazine ads, TV commercials, filmstrips. Not interested in stock filmstrips. Length:

up to 300 slides.

Film: Commercials covering all subjects from travel to sports. Interested in stock footage on wildlife, scenic Central Northwest.

Photos: Uses b&w prints and 21/4x21/4 color transparencies.

Payment & Terms: Pays by the job, \$25-1,000; or \$15-250/b&w photo, \$25-250/transparency. Buys all rights. Model release required.

Making Contact: Query with resume of credits; send material by mail for consideration. SASE. Reports in 3 weeks.

*VIDEO INTERNATIONAL PUBLISHERS, INC., 118 Sixth St. S., Great Falls MT 59405. (406)727-7133. Administrative Director: Penny L. Adkins (Ms.). Clients: industrial, educational, retail, broadcast.

Needs: Works with 3-15 photographers/month. Uses photographers for films, videotapes. Subjects include television commercials, educational/informational programs, AU video is shot "film-style" (lit for film, etc.).

Specs: Uses U-matic 3/4", prefers 1" C-format.

First Contact & Terms: Provide resume, business card, self-promotion piece or tearsheets to be kept on file for possible future assignments. Works with freelancers by assignment only; interested in stock photos/footage. SASE. Reports in 1 month. Pays upon completion of final edit. Buys all rights. Model release required. Credit line given.

Tips: "Send the best copy of your work on 3/4" cassette. Describe your involvement with each piece of

video shown."

Nebraska

*SIGHT & SOUND, INC., 6969 Grover, Omaha NE 68106. (402)393-0999. President/Owner: L.M. Bradley. Clients: medical, financial, business, government, agricultural.

Needs: Works with 2 photographers/month. Uses photographers for filmstrips, multimedia productions

and videotapes. Subjects include promotional, motivational, instructive.

Specs: Uses 21/2x21/4 transparencies, U-matic 3/4" videotape.

First Contact & Terms: Provide resume, business card, self-promotion piece or tearsheets to be kept on file for possible future assignments. Works with local freelancers only; interested in stock photos/ footage. Reports as need arises. Buys all rights.

J. GREG SMITH, Suite 102, 1004 Farnam, Burlington on the Mall, Omaha NE 68102. (402)444-1600. Art Director: Shelley Bartek. Ad agency. Clients: finance, banking institutions, national and state associations, agriculture, insurance, retail, travel.

Needs: Works with 10 freelance photographers/year on assignment only basis. Uses photographers for

consumer and trade magazines, brochures, catalogs and AV presentations.

First Contact & Terms: Arrange interview to show portfolio. Payment is by the project; negotiates according to client's budget.

SWANSON, ROLLHEISER, HOLLAND, 1222 P St., Lincoln NE 68508. (402)475-5191. Contact: Don Ellis, Chip Hackley or Dean Olson. Ad agency. Clients: primarily industrial, financial and agricultural; client list provided on request.

Needs: Works with 50 freelance photographers/year on assignment only basis. Uses photographers for consumer and trade magazines, direct mail, brochures, catalogs, newspapers and AV presentations. First Contact & Terms: Query first with small brochure or samples along with list of clients freelancer has done work for. Negotiates payment according to client's budget. Rights are negotiable.

Nevada

DAVIDSON ADVERTISING CO., 3940 Mohigan Way, Las Vegas NV 89119. (702)871-7172. President: George Davidson. Full-service advertising agency. Clients: beauty, construction, finance, entertainment, retailing, publishing, travel. Photos used in brochures, newsletters, annual reports, PR releases, AV presentations, sales literature, consumer magazines and trade magazines. Arrange a personal interview to show portfolio, query with samples, or submit portfolio for review; provide resume, brochure and tearsheets to be kept on file for possible future assignments. Gives 150-200 assignments/year. Pays \$15-50/b&w photo; \$25-100/color photo; \$15-50/hour; \$100-400/day; \$25-1,000 by the project. Pays on production. Buys all rights. Model release required. Local freelancers preferred. SASE. Reports in 3 weeks.

B&W: Uses 8x10 glossy prints; contact sheet and negatives OK.

Color: Uses 8x10 glossy prints and 4x5 and 21/4x21/4 transparencies; contact sheet OK.

Film: Uses 16mm; filmmakers might be assigned location shooting for television commercial or an industrial-type film.

Tips: "On certain assignments when the budget is low and there is time we will give a new photographer

a chance at the job."

New Hampshire

EDWARDS & COMPANY, 63 South River Rd., Bedford NH 03102. (603)624-1700. Ad agency. Creative Director: Paul Nelson. Clients: retail, food, service. Client list provided on request.

Needs: Works with 1-2 freelance photographers/month. Uses photographers for billboards, consumer and trade magazines, direct mail, P-O-P displays, brochures, newspapers. Subject needs "variable, dependent upon client needs." Also works with freelance filmmakers to produce TV spots.

Specs: "Depends entirely upon the individual project."

First Contact & Terms: Arrange a personal interview to show portfolio; query with samples; submit portfolio for review; provide resume, business card, brochure, flyer or tearsheets to be kept on file for possible future assignments. SASE. Reports in 2 weeks. Pays \$40-125/hour; \$400-1,000 + /day. Pays 30 days after billing. Buys all rights. Model release required. Credit line "not usually" given.

Tips: In a portfolio, prefers to see "loose prints, hopefully also with samples of pieces they appeared in. Contact me for interview with portfolio. I will keep resume, etc. on file and give the opportunity to bid on

a job when circumstances arise."

New Jersey

A.N.R. ADVERTISING AGENCY, 1140 Bloomfield Ave., West Caldwell NJ 07006. (201)575-6565. President: A. Scelba. Ad agency. Clients: industrial. Client list provided on request.

Needs: Works with 4 freelance photographers/month. Uses photographers for direct mail, catalogs, trade magazines and brochures. Subjects include high-tech.

Specs: Uses 4x5 or 8x10 b&w or color prints; 4x5 and 8x10 transparencies.

First Contact & Terms: Provide resume, business card, brochure, flyer or tearsheets to be kept on file for possible future assignments. Pays in 30 days. Buys all rights. Model release required.

SOL ABRAMS ASSOCIATES, INC., Box 221, New Milford NJ 07646. (201)262-4111. Contact: Sol Abrams. PR and AV firm. Clients: real estate, food, fashion, retailing, beauty pageant, theatrical entertainment, TV, agricultural, animal and pet, automotive, model agencies, schools, record companies, motion picture firms, governmental and political, publishing and travel.

Needs: Works with varying number of freelance photographers/month as per clients' needs. Uses freelancers for billboards, consumer magazines, trade magazines, direct mail, newspapers, P-O-P

displays and TV.

First Contact & Terms: Send resume, contact sheet or prints. Provide resume, letter of inquiry and sample to be kept on file for possible future assignments. Negotiates payment based on client's budget and where work will appear. SASE only. Selection based on "knowledge of freelancers' work. Most of our work is publicity and PR. I need things that are creative. Price is also important factor. I have a winning formula to get most mileage in publicity pictures for clients involving the 3 'B's'-beauties, babies and beasts-all human interest.'

Tips: "We also work with film and TV video producers and syndicators for theater or broadcast productions. We can represent select photographers, models and theatrical people in very competitive New York market. If using models, use great, super models. We are in New York City market and some of the models good photographers use destroy their work. Although it's a very small phase of our business, we have strong connections with two top men's magazines. In these cases we may be of help to both photographers and models."

ADLER, SCHWARTZ, INC., 140 Sylvan Ave., Englewood Cliffs NJ 07632. (201)461-8450. Executive Vice President: Peter Adler. Ad agency. Uses all media. Clients: automotive, electronic, industrial clients.

Needs: Works with freelance photographers on assignment only basis. Uses photographers for people, fashion, still life.

First Contact & Terms: Provide business card and tearsheets to be kept on file for possible future assignments. Buys all rights, but may reassign to photographer. Negotiates payment based on client's budget, amount of creativity required, where the work will appear and photographer's previous experience and reputation. Payment generally ranges from \$250-500/b&w photo; \$750-1,500/color photo; or \$750-1,500/hour. Call to arrange an appointment. "Show samples of your work and printed samples." Reports in 2 weeks.

B&W: Uses semigloss prints. Model release required. Color: Uses transparencies. Model release required.

Tips: "We are interested in still life (studio), location, editorial and illustration shots."

ARDREY INC., Suite 314, 100 Menlo Park, Edison NJ 08837. (201)549-1300. PR firm. Contact: Henry Seiz. Clients: industrial. Client list provided on request.

Needs: Works with 10-15 freelance photographers/month through US. Uses photographers for trade magazines, direct mail, brochures, catalogs, newspapers. Subjects include trade photojournalism.

Specs: Uses 4x5 and 8x10 b&w glossy prints; 35mm, 21/4x21/4 and 4x5 transparencies.

First Contact & Terms: Provide resume, business card, brochure, flyer or tearsheets to be kept on file for possible future assignments. Works with freelance photographers on assignment basis only. SASE. Pays \$150-600/day; "travel distance of location work—time and travel considered. Pays 30-45 days after acceptance. Buys all rights and negatives. Model release required.

Tips: Prefers to see "imaginative industrial photojournalism. Identify self, define territory he can cover from home base, define industries he's shot for industrial photojournalism; give relevant references and samples. Regard yourself as a business communication tool. That's how we regard ourselves, as well as

photographers and other creative suppliers."

*THE BECKERMAN GROUP, 35 Mill St., Bernardsville NJ 07924. (201)766-9238. Ad agency. Production Manager: Mary Ciccolella. Clients: industrial. Client list free with SASE.

Needs: Works with 3 photographers/month. Uses photographers for catalogs, posters, corporate internal organs and brochures. Subject matter includes tabletop.

Specs: Uses b&w prints and 21/4x21/4 transparencies.

First Contact & Terms: Arrange a personal interview to show portfolio; provide resume, business card, brochure, flyer or tearsheets to be kept on file for possible future assignments. Works with freelance photographers on an assignment basis only. Does not return unsolicited material. Payment individually negotiated. Pays on receipt of invoice. Buys all rights. Model release required.

CABSCOTT BROADCAST PRODUCTIONS, INC., 517 7th Ave., Lindenwold NJ 08021. (609)346-3400. AV firm. President: Larry Scott. Clients: broadcast, industrial, consumer. Client list provided on request.

Needs: Works with 2 freelance photographers/month. Uses photographers for broadcast, commercials and promotional materials. Subject matter varies. Also works with freelance filmmakers to produce TV

commercials, training and sales films. etc.

Specs: Uses up to 11x14 b&w glossy prints; 35mm transparencies; 16mm, 35mm and videotape/film. **First Contact & Terms:** Provide resume, business card, brochure, flyer or tearsheets to be kept on file for possible future assignments. Works with freelance photographers on assignment basis only. Does not return unsolicited material. Reports in 1 month. Pays \$50 minimum/job. Pays on acceptance. Buys all rights. Model release required; captions optional.

CREATIVE PRODUCTIONS, INC., 200 Main St., Orange NJ 07050. (201)676-4422. Contact: William E. Griffing. AV producer. Clients: industry, advertising, pharmaceuticals, business. Produces film, video, slide presentations, multimedia, multiscreen programs and training programs. Works with freelance photographers on assignment only basis. Provide resume and letter of inquiry to be kept on file for future assignments.

Subject Needs: Subjects include sales promotion, sales training, industrial and medical topics. No typical school portfolios that contain mostly artistic or journalistic subject matter. Must be 3:4 horizontal ratio for film, video and filmstrips: and 2:3 horizontal ratio for slides.

Specs: Uses b&w and color prints, transparencies. Produces 16mm industrial, training, medical and sales promotion films. Possible assignments include shooting "almost anything that comes along: industrial sites, hospitals, etc." Interested in stock footage.

Payment & Terms: Negotiates payment based on photographer's previous experience/reputation and client's budget. Pays on acceptance. Buys all rights. Model release required.

Making Contact: Query first with resume of credits and rates. SASE. Reports in 1 week.

Tips: "We would use freelancers out-of-state for part of a production when it isn't feasible for us to travel, or locally to supplement our people on overload basis."

*CUFFARI & CO, INC., 311 Claremont Ave., Montclair NJ 07042. (201)746-8084. Ad agency. Art Director: Nancy Martino. Clients: agriculture, animal health, chemical, industrial, transportation, furniture.

Needs: Works with 2-3 photographers/month. Uses photographers for trade magazines, direct mail, P-O-P displays, catalogs, posters, signage and newspapers. Subject matter includes products, food.

Specs: Uses b&w prints, and 35mm, 21/4x21/4, 4x5 and 8x10 transparencies.

First Contact & Terms: Query with list of stock photo subjects; send unsolicited photos by mail for consideration; query with samples; provide resume, business card, brochure, flyer or tearsheets to be kept on file for possible future assignments. Works with freelance photographers on an assignment basis only. Does not return unsolicited material. Payment individually negotiated. Pays in 30 days. Buys all rights. Model release required.

DIEGNAN & ASSOCIATES, RD #2, Lebanon NJ 08833. President: N. Diegnan. Ad agency/PR firm. Clients: industrial, consumer. Commissions 15 photographers/year; buys 20 photos/year from each. Local freelancers preferred. Uses billboards, trade magazines, and newspapers. Negotiates payment based on client's budget and amount of creativity required from photographer. Pays by the job. Buys all rights. Model release preferred. Arrange a personal interview to show portfolio. SASE. Reports in 1 week.

B&W: Uses contact sheet or glossy 8x10 prints.

Color: Uses 5x7 or 8x10 prints and 21/4x21/4 transparencies.

Film: Produces all types and sizes of films. Typical assignment would be an annual report. Pays royalties.

*GILBERT, WHITNEY & JOHNS, INC., 110 S. Jefferson Rd., Whippany NJ 07981. (201)386-1776. Ad agency and PR firm. Art Directors: Jim Wells, Pete Dillon, Eileen Tobin. Clients: wood finishing, products, banking and financial, chemicals. Client list free with SASE.

Needs: Works with 4 photographers/month. Uses photographers for consumer magazines, trade magazines, direct mail, P-O-P displays and newspapers. Subject matter includes horizons, scenics, chemical laboratories.

Specs: Uses 4x5 and 8x10 b&w prints and 4x5 transparencies.

First Contact & Terms: Arrange a personal interview to show portfolio; query with list of stock photo subjects. Works with freelance photographers on an assignment basis only. Does not return unsolicited material. Pays on acceptance or on receipt of invoice. Buys one-time rights. Model release required.

GRAPHIC WORKSHOP INC., 466 Old Hook Rd., Emerson NJ 07630. (201)967-8500. Sales promotion agency. President: Al Nudelman. Clients: industrial, fashion.

Needs: Works with 6 freelance photographers/year. Uses photographers for direct mail, catalogs, newspapers, consumer magazines, posters, AV presentations, trade magazines and brochures. Subjects include a "full range from men's fashion, women's fashion, tool and die, to AV and computers."

Specs: Uses 8x10 glossy air-dried b&w prints; 35mm and 4x5 transparencies.

First Contact & Terms: Query with list of stock photo subjects; send unsolicited photos by mail for consideration; provide resume, business card, brochure, flyer or tearsheets to be kept on file for possible future assignments. Works with local freelancers only. Does not return unsolicited material. Reports in 2 weeks. Pays by the job. Pays on acceptance. Buys all rights. Model release and captions required. Credit line given "sometimes, if negotiated."

Tips: Prefers to see "slides or finished samples" in a portfolio. "Submit samples—be willing to prove ability."

*HEALY, DIXCY AND FORBES ADVERTISING AGENCY, 1129 Bloomfield Ave., West Caldwell NJ 07006. (201)882-9440. Ad agency. Art Director: Lisa Gasperini. Clients: industrial. Needs: Works with 1 photographer/month. Uses photographers for trade magazines, direct mail, catalogs and newspapers. Subject matter includes industrial research and development, engineering, production, etc.

Specs: Uses various sizes and finishes b&w and color prints; and 4x5 and 8x10 transparencies. **First Contact & Terms:** Query with list of stock photo subjects; send unsolicited photos by mail for consideration; provide resume, business card, brochure, flyer or tearsheets to be kept on file for possible future assignments. Works with local freelancers only. Does not return unsolicited material. Reports in 1 month. Pay varies. Pays on receipt of invoice. Buys all rights. Model release required.

Tips: "We are looking for very creative photographers who can produce a job quickly, with quality and a reasonable price."

HFAV AUDIOVISUAL, INC., 375 Sylvan Ave., Englewood Cliffs NJ 07632. (201)567-8585. AV firm. President: Bob Hess. Clients: industrial.

Needs: Works with 1-2 freelance photographers/month. Uses photographers for trade magazines, P-O-P displays, brochures, catalogs, newspapers, AV presentations. Subjects include industrial and product photography.

Specs: Uses 8x10 b&w and color prints; 35mm, 21/4x21/4, 4x5 transparencies; videotape.

First Contact & Terms: Arrange a personal interview to show portfolio. Works with freelance photographers on assignment only basis. Reports in 2 weeks. Pays \$350-650/day. Pays 30 days after acceptance. Buys all rights. Model release required. Credit line sometimes given.

Tips: "Photographer must be creative and dress properly. Computer slides incorporated with photography to make a final slide" are increasingly used in advertising photography.

IMAGE INNOVATIONS, INC., 14 Buttonwood Dr., Somerset NJ 08873. (201)246-2622. President: Mark A. Else. AV firm. Clients: schools, publishers, business, industry, government.

Needs: Uses photographers for filmstrips, motion pictures, videotapes, multi-image and slide-sound.

Specs: Produces 16mm, 35mm slides and video.

First Contact & Terms: Query with resume of credits. Works on assignment only. Provide resume and tearsheets to be kept on file for future assignments. Pays \$20/hour; \$100-500/day; \$100 minimum/job. Payment 30 days after billing. Buys all rights. Model release required; captions not necessary. Work with talent only in New York metropolitan area.

INTERNATIONAL MEDIA SERVICES, INC., 718 Sherman Ave., Plainfield NJ 07060. (201)756-4060. AV firm/independant film and tape production company/media consulting firm. President/ General Manager: Stuart Allen. Clients: industrial, advertising, print, fashion, broadcast and CATV. Needs: Works with 0-25 freelance photographers/month; "depending on production inhouse at the time." Uses photographers for billboards, direct mail, catalogs, newspapers, consumer magazines, P-O-P displays, posters, AV presentations, trade magazines, brochures, film and tape. Subjects range "from scenics to studio shots and assignments"-varies with production requirements. Also works with freelance filmmakers to produce documentaries, commercials, training films.

Specs: Uses 8x10 glossy or matted b&w and color prints; 35mm, 21/4x21/4 and 8x10 transparencies;

16mm, 35mm film and 3/4-1" videotape.

First Contact & Terms: Provide resume, business card, brochure, flyer or tearsheets to be kept on file for possible future assignments; query with resume of credits; query with list of stock photo subjects; arrange a personal interview to show portfolio. SASE. Reporting time "depends on situation and requirements. We are not responsible for unsolicited material and do not recommend sending same. Negotiated rates based on type of work and job requirements." Usually about \$100-750/day, \$25-2,500/ job. Rights negotiable, generally purchase all rights. Model release required; captions preferred. Credit line given.

Tips: "Wants to see a brief book containing the best work of the photographer, representative of the type of assignment sought. Tearsheets are preferred but must have either the original or a copy of the original photo used, or applicable photo credit. Send resume and sample for active resource file. Maintain

periodic contact and update file.'

JANUARY PRODUCTIONS, 249 Goffle Rd., Hawthorne NJ 07507. (201)423-4666. President: Allan W. Peller. AV firm. Clients: school and public libraries; eventual audience will be primary, elementary and intermediate-grade school students. Produces filmstrips. Subjects are concerned with elementary education: science, social studies, math, conceptual development. Buys all rights. Call to arrange an appointment or query with resume of credits. SASE.

Color: Uses 35mm transparencies.

J.M. KESSLINGER & ASSOCIATES, 37 Saybrook Pl., Newark NJ 07102. (201)623-0007.

President: Joseph Dietz. Ad agency. Clients: variety of industries.

Needs: Works with 3 freelance photographers/month. Uses photographers for consumer and trade magazines, direct mail, brochures/flyers and occasionally newspapers.

First Contact & Terms: Call for appointment to show portfolio (include wide range); provide brochure and flyer to be kept on file for possible future assignments. Pays \$35-175/b&w photo; \$50-600/color photo; \$200-650/day. Pays on acceptance.

ROGER MALER, INC., Box 435, Mt. Arlington NJ 07856. (201)770-1500. Ad agency. President:

Roger Maler. Clients: industrial, pharmaceutical.

Needs: Works with 3 freelance photographers/month. Uses photographers for billboards, trade magazines, direct mail, P-O-P displays, brochures, catalogs, newspapers, AV presentations. Also works with freelance filmmakers.

First Contact & Terms: Send resume, business card, brochure, flyer or tearsheets to be kept on file for possible future assignments. Works with freelance photographers on assignment only basis. Does not return unsolicited material. Pay varies. Pays on publication. Model release required. Credit line sometimes given.

OPTASONICS PRODUCTIONS, 186 8th St., Cresskill NJ 07626. (201)871-0068. AV firm. President/producer: Jim Brown. Clients: all types. Client list free with SASE.

Needs: Uses photographers for direct mail, catalogs, AV presentations, brochures. Subject matter "varies with the project."

Specs: "Specifications are dependent on the job when it comes in."

First Contact & Terms: Query with resume of credits, samples or with list of stock photo subjects; provide resume business card, brochure, flyer or tearsheets to be kept on file for possible future assignments. Works with local freelance photographers on assignment basis only. Does not return unsolicited material. Reports "when need for services arises." Payment: "Give quote and if it fits our

budget, you'll get work." Pays "upon completion of assignment." Buys all rights but "will do otherwise if project warrants." Model release required. Credit line given "if our client doesn't object."

Tips: "Because we do multi-image, we cannot justify the high cost usually charged per shot if we are using hundreds of images."

ORGANIZATION MANAGEMENT, 47 Woodland Ave., East Orange NJ 07017. (201)675-5200. President: Bill Dunkinson. Ad agency and PR firm. Clients: construction, credit and collections, entertainment, finance, government, publishing and travel accounts. Photos used in brochures, newsletters, annual reports, PR releases, sales literature, consumer and trade magazines. Works with freelance photographers on assignment only basis. Buys 200 photos/year. Pays on a per-job basis. Negotiates payment based client's budget, amount of creativity required, where work will appear and photographer's previous experience/reputation. Credit line sometimes given. Arrange a personal interview to show portfolio. No unsolicited material. Local freelancers preferred. SASE. Reports in 2 weeks.

B&W: Uses 5x7 and 8x10 glossy, matte and semigloss prints.

Film: Freelance filmmakers may query for assignment.

*POP INTERNATIONAL CORP., (also known as American Mind Productions/Pop International Corp.), Box 527, Closter NJ 07624-0527. President: Arnold DePasquale. Board Chairman: Floyd Patterson. Producers Film and Videotape: Peter De Caro, Tom Smith. AV firm and feature entertainment corporation. Clients: airlines, advertising agencies, public relations firms, marketing groups. Pop International Productions also produces 'inhouse' public service media campaigns for regional sponsors. Produces motion pictures and videotape. Works with 1-3 freelance photographers/month on assignment only basis. Provide resume and business card to be kept on file for possible future assignments. Buys 30-50 photos and 1-2 films/year.

Subject Needs: "Pop International Productions is contracted directly by client or by agencies and also produces campaign, educational, promotional and sales projects (film/tape/multimedia) on speculation

with its own capital and resources for sale to regional sponsors.

Film: Produces "everything from 30 second TV spots using 5 stills to 9 minute shorts using 50 stills, stock and live-action film; or feature films/TV shows using title graphics." Interested in historical material only—sports and political. Pop International Corp also finances and produces feature films in the 35mm format for world distribution, and consequently contracts 'unit photographers' from union locals.

Photos: Uses 8x10 glossy b&w and 21/4x21/4 color transparencies.

Payment & Terms: "When using union photographers for feature projects we negotiate according to union regulations and scale. When using photographers on nonfeature productions such as promotional, educational or charitable multimedia or videotape projects we pay \$35-200/day; \$250-1,100/project; we negotiate payment based on client's budget and where work will appear. Refers to payment made by Pop International Corp. for shooting only if Pop International staff assumes all darkroom developing and printing"; or \$15-50/photo. When payment is made "depends on whether assigned by agency/client or directly solicited by Pop International Productions." Buys all rights. Model release required.

Making Contact: Query with resume of credits, often assigned by agencies and clients. Prefers to see action events which in one look explains all. Does not want to see artistic panoramas, portraits or scenics.

Does not return unsolicited material. Reports in 3 weeks.

Tips: "We consider two types of work. For publicity purposes we like work to reflect interesting action where as much Who What When Where & Why is illustrated. For nonentertainment productions we like work that reflects impeccable quality and supports the mood, atmosphere, emotion and theme of the project that will incorporate those photos. Forward material, preferably an illustrated brochure, with business card or like, and then follow up every 6 months or so by mail or phone, as projects arise quickly and are swiftly staffed by contract." Prefers to see photos that were published in the various formats or as they appear in films, filmstrips or videotapes. SASE.

RFM ASSOCIATES, INC., 35 Atkins Ave., Trenton NJ 08610. (609)586-5214. President: Rodney F. Mortillaro. Ad agency. Uses billboards, consumer and trade magazines, direct mail, foreign media, newspapers, P-O-P displays and radio. Clients: industrial, consumer, retail, fashion, entertainment clients. Commissions 45 photographers/year; buys 120 photos/year. Local freelancers preferred. Pays \$25 minimum. Buys all rights. Model release required. Query with resume of credits or samples. **B&W:** Uses 5x7 prints.

Color: Uses 5x7 prints and 4x5 transparencies.

SPOONER & COMPANY, Box 126, Verona NJ 07044. (201)857-0053. President: William B. Spooner III. Ad agency. Uses direct mail and trade magazines. Clients: industry. Works with 1-2 freelance photographers/month on assignment only basis. Provide resume, flyer and scope of operations

and territory. Pays/job or /day; negotiates payment based on client's budget, amount of creativity required from photographer and photographer's previous experience/reputation. Buys all rights. Model release preferred. Query with samples. SASE. Reports in 2 weeks.

B&W: Uses semigloss 8x10 prints.

Color: Uses semigloss 8x10 prints and 21/4x21/4 or 4x5 transparencies.

Film: Produces industrial films. Does not pay royalties.

*TROLL ASSOCIATES, 320 Rt. 17, Mahwah NJ 07430. Vice President of Production: Marian Schecter. AV firm. Clients: schools. Produces filmstrips and multimedia kits. Subjects include "all subjects that would interest young people and lots of human interest." Buys 100 photos/year. Buys all rights. Query first with resume of credits. Reports in 2 weeks. SASE.

Specs: Uses 5x7 or 8x10 glossy prints.

Payment & Terms: Send contact sheet. Model release required. Pays \$25 minimum.

Color: Uses 35mm transparencies or prints. Model release required. Pays \$25 minimum.

DOUGLAS TURNER, INC., 11 Commerce St., Newark NJ 07102. (201)623-4506. Vice President/ Creative Director: Gloria Spolan. Ad agency. Clients: banking institutions, window covering, office equipment, toys, optical, electronics (TV, radios, etc.), security, cosmetics.

Needs: Works on assignment only basis. Uses photographers for consumer and trade media, direct mail,

brochures, catalogs, posters and storyboards.

First Contact & Terms: Send in literature first—if interested will contact artist. Payment is by the project; negotiates according to client's budget.

VICTOR VAN DER LINDE CO. ADVERTISING, 381 Broadway, Westwood NJ 07675. (201)664-6830. Vice President: A.K. Kingsley. Contact: Peter Hutchins. Ad agency. Uses consumer and trade magazines, direct mail, newspapers, and P-O-P displays. Serves clients in pharmaceuticals and insurance. Call to arrange an appointment. SASE.

*WREN ASSOCIATES, INC., 208 Bunn Dr., Princeton NJ 08540. (609)924-8085. Production Manager: Debbie Schnur. Clients: corporate.

Needs: Works with 2 photographers/month. Uses photographers for slide sets, multimedia productions and videotapes. Subjects include mostly industrial settings and subjects.

Specs: Uses 35mm, 4x5 transparencies, U-matic 3/4" videotape.

First Contact & Terms: Arrange a personal interview to show portfolio. Works with freelancers by assignment only. SASE. Freelancer should call. Pays by day or job. Pays within 45 days. Buys one-time and all rights. Model release required.

Tips: "We are interested in the ability to deal with the special demands of industrials: high volume of

shots, filtering for available lighting, etc."

New Mexico

THE COMPETITIVE EDGE, Box 3500, Albuquerque NM 87190. (505)761-3000. Ad agency. Art Director: Daryl Bates. Clients: automotive.

Needs: Works with an occasional freelance photographer. Uses photographers for consumer and trade magazines, direct mail, P-O-P displays, brochures, newspapers, TV and AV presentations.

Specs: Uses 8x10 glossy b&w prints; 35mm transparencies; 35mm film and videotape.

First Contact & Terms: Query with list of stock photo subjects; provide resume, business card, brochure, flyer or tearsheets to be kept on file for possible future assignments. Does not return unsolicited material. Reports "as soon as possible." Pays \$50-1,000/job. Pays on acceptance. Buys all rights. Model release required; captions preferred. Credit line given "where applicable."

Tips: "Please inquire about current possibilities-no unsolicited material."

MEDIAWORKS, Suite 1, 6022 Constitution NE, Albuquerque NM 87110. (505)266-7795. President: Marcia Mazria. Ad agency. Clients: retail, industry, politics, government, law. Produces overhead transparencies, slide sets, motion pictures, sound-slide sets, videotape, print ads and brochures. Works with 1-2 freelance photographers/month on assignment only basis. Provide resume, flyer and brochure to be kept on file for possible future assignments. Buys 25-30 photos and 5-8 films/year.

Subject Needs: Health, business, environment and products. No animals or flowers. Length require-

ments: 80 slides or 15-20 minutes, or 60 frames, 20 minutes.

Film: Produces Super 8, 16mm silent and sync. sound and videotape. Interested in stock footage. **Photos:** Uses b&w or color prints and 35mm transparencies "and a lot of $2^{1/4}$ transparencies and some 4x5 transparencies."

Payment/Terms: Pays \$40-60/hour, \$350-400/day, \$40-800/job, \$40/b&w photo or \$40/color photo. Negotiates payment based on client's budget and photographer's previous experience/reputation. Pays on job completion. Buys all rights. Model release required.

Making Contact: Arrange personal interview or query with resume. Prefers to see a variety of subject

matter and styles in portfolio. Does not return unsolicited material. Reports in 2 weeks.

New York

GENE BARTCZAK ASSOCIATES, INC., Box E, N. Bellmore NY 11710 (516)781-6230. PR firm. Clients: high technology industrial. Provide resume and flyer to be kept on file for possible future assignments.

Needs: Works with 2-4 freelance photographers/month on assignment only basis. Uses freelancers for

motion pictures and video recordings.

First Contact & Terms: Write and request personal interview to show portfolio; send resume. SASE. Reports in 2 weeks. Selection based on "experience in industrial photography, with samples to prove. Also consider independent inquiries from studios and freelancers." Pays \$25/b&w photo; \$35/color photo; \$25/hour. Pays on acceptance.

*DON BOSCO MULTIMEDIA, Box T, 475 North Ave., New Rochelle NY 10802. (914)576-0122. Vice President: Rev. James L. Chiosso. Clients: schools, parishes, religious institutions.

Needs: Uses photographers for filmstrips, slide sets, films, videotapes. Subjects include realistic,

Specs: Uses 35mm and 4x5 transparencies, super 8 and 16mm film, VHS, Beta and U-matic 3/4"

videotapes.

First Contact & Terms: Submit portfolio by mail; query with stock photo list; provide resume, business card, self-promotion piece or tearsheets to be kept on file for possible future assignments. Works with freelancers by assignment only; interested in stock photos/footage. SASE. Reports in 3 weeks. Pay depends on assignment. Pays on publication. Buys one-time rights. Credit line given.

*WALTER F. CAMERON ADVERTISING, 50 Jericho Turnpike, Jericho, Long Island NY 11753. (516)333-2500. Ad agency. Art Directors: Richard Dvorak, Cathy Vernino. Clients: retail. Client list free with SASE.

Needs: Uses photographers for consumer magazines, trade magazines, catalogs and newspapers. Subject matter varies from time to time; furniture settings, cars, product shots, on-location shots.

Specs: Uses 4x5 or 8x10 b&w and color glossy prints.

First Contact & Terms: Arrange a personal interview to show portfolio; submit portfolio for review; provide resume, business card, brochure, flyer or tearsheets to be kept on file for possible future assignments. Works with freelance photographers on an assignment basis only. Pays per hour or \$300-400/day. Pays on receipt of invoice. Buys all rights. Model release required; captions preferred.

COMMUNIGRAPHICS INC., 100 Crossways Park West, Woodbury NY 11797. (516)364-2333. Ad agency. Art Director: Thomas R. Gabrielli. Clients: industrial-machine tool industry.

Needs: Occasionally works with freelance photographers. Uses photographers for trade magazines and brochures. Subjects include "machine tools and their applications/capabilities."

Specs: Uses color prints and 35mm, 21/4x21/4 and 4x5 transparencies.

First Contact & Terms: Provide resume, business card, brochure, flyer or tearsheets to be kept on file for possible future assignments. Works with freelance photographer on assignment basis only. Does not return unsolicited material. Pays by the job. Pays 30-60 days after billing. Buys all rights. Model release

Tips: "I am not interested in trends, but rather in quality and getting the shot done correctly."

*CONKLIN, LABS & BEBEE, 109 Twin Oaks Dr., Syracuse NY 13221. (315)437-2591. Ad agency, PR firm, marketing communciations. Senior Art Director: Jeanette Gryga. Art Director: Robert Wonders. Clients: industrial, fashion, finance.

Needs: Works with 4-6 freelance photographers/month. Uses photographers for billboards, consumer and trade magazines, P-O-P displays, catalogs and newspapers. Subject matter includes industrial, location and/or studio.

Specs: Uses 4x5 transparencies.

First Contact & Terms: Arrange a personal interview to show portfolio; query with resume of credits; provide resume, business card, brochure, flyer or tearsheets to be kept on file for possible future assignments. Works with freelance photographers on an assignment basis only. Does not return

unsolicited material. Reports in 3 weeks. Pay individually negotiated. Pays on receipt of invoice. Buys all rights. Model release required; captions preferred. Credit line sometimes given.

Tips: "We review your work and will call if we think a particular job is applicable to your talents. Our photos are not decorative. They must serve the purpose of conveying a message.'

*DE PALMA & HOGAN ADVERTISING, 3 Barker Ave., White Plains NY 10601, (914)997-2400. Ad agency. Art Director: Art Glazer. Clients: food, drug, publishing. Client list free with SASE. Needs: Works with 4 photographers/month. Uses photographers for consumer and trade magazines, direct mail, newspapers and TV.

Specs: Uses b&w and color prints, and 35mm, 21/4x21/4, 4x5 and 8x10 transparencies.

First Contact & Terms: Arrange a personal interview to show portfolio; query with resume of credits or a list of stock photo subjects; provide resume, business card, brochure, flyer or tearsheets to be kept on file for possible future assignments. Works with local freelancers only. Pays \$500-1,500/color photo. Pays on receipt of invoice. Buys all rights. Model release required; captions preferred.

DIDIK TV PRODUCTIONS, Box 133, Rego Park NY 11374, (718)843-6839, AV firm, Contact: A/V Logistics Coordinator. Clients: government, industrial companies, consumer-oriented firms.

Needs: Works with 1-3 freelance photographers/month. Uses photographers for direct mail, catalogs, consumer magazines, P-O-P displays, AV presentations, trade magazines, brochures and window displays. Subjects include catalog photography, industrial shots and certain types of inhouse sets. Also works with freelance filmmakers to produce television commercials shot on 35mm and 1" videotape; industrials and training on 3/4" and 16mm. "We use our own equipment."

Specs: Uses all formats and sizes.

First Contact & Terms: Ouery with resume of credits; "film and video people should send sample with list of credits and include return postage." Works with freelance photographers on assignment basis only. Reporting time "depends upon our workload. All fees are determined through negotiation." Payment time and rights purchased "depend upon our contract." Model release required; captions preferred. Credit line depends on contract.

Tips: "Send resume which should contain: 1) list of credits; 2) special skills of the applicant (i.e.,

animation).'

EDUCATIONAL IMAGES LTD., Box 3456, West Side Station, Elmira NY 14905. (607)732-1090. Executive Director: Dr. Charles R. Belinky. AV publisher. Clients: educational market, particularly grades 6-12 and college; also serves public libraries, parks and nature centers. Produces filmstrips, slide sets, and multimedia kits. Subjects include a heavy emphasis on natural history, ecology, anthropology, conservation, life sciences, but are interested in other subjects as well, especially chemistry, physics, astronomy, math. "We are happy to consider any good color photo series on any topic that tells a coherent story. We need pictures and text." Works with 12 freelance photographers/month. Buys 200-400 photos/ year; film is "open." Buys all rights, but may reassign to photographer. Pays \$150 minimum/job, or on a per-photo basis. Query with resume of credits; submit material by mail for consideration. Prefers to see 35mm or larger color transparencies and outline of associated written text in a portfolio. Reports in 1 month maximum. SASE.

Film: "At this time we are not producing films. We are looking for material and are interested in

converting *good* footage to filmstrips and/or slide sets." Query first. **Color:** Buys any size transparencies, but 35mm preferred. Will consider buying photo collections, any subjects, to expand files. Will also look at prints, "if transparencies are available." Captions required; prefers model release. Pays \$15 minimum if only a few pictures used.

Tips: "Write for our catalog. Write first with a small sample. We want complete or nearly complete AV programs—not isolated pictures usually. Be reliable. Follow up commitments on time and provide only sharp, well-exposed, well-composed pictures. Send by registered mail."

THE FURMAN ADVERTISING CO., INC., 155-161 Fisher Ave., Box 128, Eastchester NY 10709. (914)779-9188/9189. Ad agency. President: Roy L. Furman. Vice President: Murray Furman. Clients: automotive/industrial.

Needs: Works with 1-2 freelance photographers/month. Uses photographers for consumer and trade magazines, direct mail, brochures, catalogs. Subjects include "automotive aftermarket, hard parts, service facilities, wholesale and retail outlets."

Specs: Uses 11x14 b&w and color Type C and Cibachrome prints; 35mm and 4x5 transparencies. First Contact & Terms: Provide resume, business card, brochure, flyer or tearsheets to be kept on file for possible future assignments. Works with freelance photographers on assignment basis only. SASE. Pays "as budget from client dictates." Pays on acceptance. Buys all rights. Model release required. Tips: Prefers to see "any subject relating to automotive aftermarket" in a portfolio.

ABBOT GEER PUBLIC RELATIONS, 445 Bedford Rd., Box 57, Armonk NY 10504. (914)273-8736. PR firm. President: Abbot M. Geer. Clients: recreational and commercial marine industry, boat, engine and accessory/materials manufacturers. Client list free with SASE.

Needs: Works with 2-3 freelance photographers/month. Uses photographers for consumer and trade magazines, brochures, newspapers. Subject matter "power and sail boats in action; construction shots, engine close-ups, etc." Occasionally works with freelance filmmakers to produce industrial films, videotapes demonstrating boat performance or construction techniques.

Specs: Uses 8x10 glossy b&w prints; 35mm or 2¹/₄x2¹/₄ transparencies; 16mm and videotape film. First Contact & Terms: Provide resume, business card, brochure, flyer or tearsheets to be kept on file for possible future assignments. Works with freelance photographers on assignment basis only. SASE. Reports in 2 weeks. Pays on acceptance. Buys all rights.

S.R. LEON COMPANY, INC., 111 Great Neck Rd., Great Neck NY 10021. (516)487-0500. Creative Director: Max Firetog. Ad agency. Clients: food, retailing, construction materials, cosmetics, drugs. Provide business card and "any material that indicates the photographer's creative ability" to be kept on file for possible future assignments.

Needs: Works with 3-4 freelance photographers/month. Uses photographers for consumer and trade magazines, TV, brochures/flyers and newspapers.

First Contact & Terms: Call for appointment to show portfolio. Reports in 2 weeks. Pays \$50-1,000/b&w photo; \$100-3,000/color photo; \$650-2,500/day.

McANDREW ADVERTISING CO., 2125 St. Raymonds Ave., Bronx NY 10462. (212)892-8660. Ad agency. Contact: Robert McAndrew. Clients: industrial.

Needs: Works with 1 freelance photographer/month. Uses photographers for trade magazines, direct mail, brochures, catalogs, newspapers. Subjects include industrial products.

Specs: Uses 8x10 glossy b&w or color prints; 4x5 or 8x10 transparencies.

First Contact & Terms: Provide resume, business card, brochure, flyer or tearsheets to be kept on file for possible future assignments. Works with local freelancers only. Pays \$400-500/day plus expenses; \$35 minimum/job; \$45-100/b&w photo; \$85-200/color photo. Pays in 30 days. Buys all rights. Model release required.

Tips: Photographers should "let me know how close they are, and what their prices are. We look for photographers who have experience in industrial photography."

LLOYD MANSFIELD CO., 237 Main St., Buffalo NY 14203. (716)854-2762. Ad agency. Executive Art Director: Marti Cattoni. Clients: industrial and consumer.

Needs: Works with 2 freelance photographers/month. Uses photographers for direct mail, catalogs, newspapers, consumer magazines, P-O-P displays, posters, AV presentations, trade magazines and brochures. Needs product, situation and location photos. Also works with freelance filmmakers for TV commercials and training films.

Specs: Uses 11x14 b&w and color prints; 35mm, $2^{1}/4x2^{1}/4$, 4x5 and 8x10 transparencies; 16mm film and videotape.

First Contact & Terms: Arrange a personal interview to show portfolio or query with resume of credits. Works with freelance photographers on assignment basis only. Does not return unsolicited material. Reports in 2 weeks. Pays \$50-150/hour; \$450-1,100/day and \$35/b&w and \$500/color photo. Pays 1 month after acceptance. Buys all rights. Model release required.

Tips: In a portfolio, prefers to see 35mm slides in carousel, or books with 11x14 or 8x10 prints.

NATIONAL TEACHING AIDS, INC., 1845 Highland Ave., New Hyde Park NY 11040. (516)326-2555. President: A. Becker. AV firm. Clients: schools. Produces filmstrips. Uses science subjects; needs photomicrographs. Buys 20-100 photos/year. Call to arrange an appointment; prefers local freelancers. Does not return unsolicited material.

Color: Uses 35mm transparencies. Pays \$25 minimum.

PRO/CREATIVES, 25 W. Burda Pl., Spring Valley NY 10977. President: David Rapp. Ad agency. Uses all media except billboards and foreign. Clients: package goods, fashion, men's entertainment and leisure magazines, sports and entertainment. Negotiates payment based on client's budget. Submit material by mail for consideration. Reports in 2 weeks. SASE.

B&W: Send any size prints.

Color: Send 35mm transparencies or any size prints.

RICHARD—LEWIS CORP., 455 Central Park Ave., Scarsdale NY 10583. (914)723-3020. President: Dick Byer. Ad agency. Uses direct mail, trade magazines and P-O-P displays. Clients: industry.

Local freelancers preferred. Pays \$25/job minimum or on a per-photo basis. Buys all rights. Model release required. Arrange a personal interview to show portfolio or query with list of stock photo subjects. SASE.

B&W: Uses glossy 8x10 prints. Pays \$25/photo minimum.

RONAN, HOWARD, ASSOCIATES, INC., 11 Buena Vista Ave., Spring Valley NY 10977-3040. (914)356-6668. Contact: Muriel Brown. Ad agency and PR firm. Uses direct mail, foreign media, newspapers and trade magazines. Serves clients in slides, filmstrips, motion picture services, video support equipment, portable power units, motion picture cameras, electronic components, pet supplies. Works with 1-2 freelance photographers/month on assignment only basis. Buys 50-100 photos/year. Pays per photo, \$25-40/hour in photographer's studio or \$250-400/"shoot" on location plus travel expenses. Negotiates payment based on client's budget. Query first with resume of credits.

B&W: Uses glossy prints. Model release required.

Color: Uses transparencies and paper prints. Model release required. Pays \$100-500.

Tips: Extra sharp details on products are always the assignment. "Photographers must have new, or rebuilt to 'new' performance-ability cameras, high-powered (not the average strobe) strobes and other lights for location shooting, a full range of lenses including lenses suitable for macro, and must understand how to shoot color under fluorescents without going green. Be able to shoot client executives and have them show up with good 'head and shoulders' detail when reproduced in printed media."

STUDIO 8 PHOTO & FILM STUDIO, 246-17 Jamaica Ave., Bellerose NY 11426. Contact: Joel Sameth. Ad agency. Serves businesses, photographers and art galleries. Produces slide sets, motion pictures, sound-slide sets and videotape. Works with approximately 20 freelance photographers/year on assignment basis only. Buys 200 photos and 25 films/year.

Subject Needs: Sales, training and safety films, wedding & candid affairs.

Film: "Everything is video."

Photos: Uses b&w and color prints.

Payment & Terms: Pays by the job; negotiates payment based on client's budget and where the work will appear. Pays on acceptance. Buys all rights. Model release required.

Making Contact: Query with resume of credits. SASE. Reports in 3 weeks.

*TIFFEN MANUFACTURING, 90 Oser Ave., Hauppauge NY 11788. (516)273-2500. Advertising Manager: Stan Wallace.

Needs: Works with photographers as need arises. Uses photographers for slide sets and still photographs. Subjects include still photographs which utilize effects and color correction also, product shots.

Specs: Uses 4x5 and 8x10 color transparencies, and b&w and color prints.

First Contact & Terms: Arrange a personal interview to show portfolio; provide resume, business card, self-promotion piece or tearsheets to be kept on file for possible future assignments. SASE. Reports in 2 weeks. Pay depends on type of assignment. Payment would be discussed before giving assignments. Credit line sometimes given.

Tips: "Find out what the client is looking for and know how to shoot."

*TECHNICAL EDUCATIONAL CONSULTANTS, Suite 2010, 76 N. Broadway, Hicksville NY 11801. (516)681-1772. Vice President: Arnold Kleinstein. Clients: Fortune 500 Companies.

Needs: Uses photographers for videotapes. Require people also to design screens for Computer Based

First Contact & Terms: Provide resume, business card, self-promotion piece or tearsheets to be kept on file for possible future assignments. Works with local freelancers on assignment basis only. Reports in 2 weeks. Buys all rights.

VISUAL HORIZONS, 180 Metro Park, Rochester NY 14623. (716)424-5300. AV firm. President: Stanley Feingold. Clients; industrial.

Needs: Works with 2 freelance photographers/month. Uses photographers for AV presentations. Also works with freelance filmmakers to produce training films.

Specs: Uses 35mm transparencies; 16mm and videotape film.

First Contact & Terms: Provide resume, business card, brochure, flyer or tearsheets to be kept on file for possible future assignments. Works with freelance photographers on assignment basis only. Pays on publication. Buys all rights. Model release and captions required.

VOMACK ADVERTISING, CO., 1 Bennington Ave., Freeport, Long Island NY 11520. (516)378-6900. Ad agency. Art Director: Ray Wallace. Clients: fashion. Client list on request.

Needs: Works with 1-3 freelance photographers/month. Uses photographers for brochures and catalogs. Subject matter should include "models using products."

Specs: Uses 4x5 and 8x10 glossy b&w prints and 35mm, 21/4x21/4, 4x5 and 8x10 transparencies. First Contact & Terms: Arrange a personal interview to show portfolio. Works with freelance photographers on assignment basis only. SASE. Reports in 1 week. Pays by the hour or per photo. Pays on acceptance. Model release required.

WALLACK & WALLACK ADVERTISING INC., 33 Great Neck Rd., Great Neck NY 11021. (516)487-3974. Art Director: John Napolitano. Clients: fashion, industrial.

Needs: Works with 2-3 freelance photographers/month. Uses photographers for direct mail, catalogs, P-O-P displays, posters, trade magazines and brochures. Subject needs "really run the gamut—eyewear in

Specs: Uses 21/4x21/4 and 8x10 transparencies.

First Contact & Terms: Provide resume, business card, brochure, flyer or tearsheets to be kept on file for possible future assignments. We work with freelancers on an assignment basis only. SASE. Pays \$750-2,000/day; \$100-400/job or \$100-250/color photo. Pays on acceptance. Buys all rights. Written release required.

Tips: Prefers to see "whtat the photographer wants to shoot—his specialty, not a little of everything" in a

WINTERKORN AND LILLAS, Hiram Sibley Bldg., 311 Alexander at East Ave., Rochester NY 14604. (716)454-1010. Contact: Art Director. Ad agency. Clients: consumer packaged goods, industrial

Needs: Works with 25 freelance photographers/year on assignment only basis. Uses photographers for trade magazines, direct mail, P-O-P displays, brochures, posters, AV presentations and sales promotion

First Contact & Terms: Query with samples to be kept on file. Payment negotiable.

WOLFF ASSOCIATES, 250 East Ave., Rochester NY 14604. (716)546-8390. Ad agency. Vice President/Visuals: Terry Mutzel. Clients: industrial, fashion.

Needs: Works with 3-4 freelance photographers/month. Uses photographers for billboards, consumer magazines, direct mail, P-O-P displays, brochures, catalogs, posters, newspapers, AV presentations. Also works with freelance filmmakers to produce TV commercials.

First Contact & Terms: Provide resume, business card, brochure, flyer or tearsheets to be kept on file for possible future assignments. Does not return unsolicited material. Pays \$400-3,000/day.

*ZELMAN STUDIOS, LTD., 623 Cortelyou Rd., Brooklyn NY 11218. (718)941-5500. General Manager: Jerry Krone. AV firm. Clients: industrial, education, publishing, business.

Needs: Works with freelance photographers on assignment only basis. Buys 100 photos/year. Uses photographers for slide sets, filmstrips, motion pictures and videotape. Subjects include people to ma-

Specs: Produces Super 8, 16, 35mm documentary, educational and industrial films. Uses 8x10 color prints; 35mm transparencies; pays \$50-100/color photo.

First Contact & Terms: Query with samples; send material by mail for consideration; submit portfolio for review; provide resume, samples and calling card to be kept on file for possible future assignments. Pays \$250-800/job. Payment made on acceptance. Buys all rights. Model release required; captions pre-

Portfolio Tips: Likes to see informal poses of all ages of people; interiors—artificial and available light

New York City

A.V. MEDIA CRAFTSMAN, INC., Suite 600, 110 E. 23rd St., New York NY 10010. (212)228-6644. President: Carolyn Clark. AV firm. Clients: corporation, internal communications, public relations, publishing, ad agency.

Needs: Local artists only. Uses photographers for filmstrips, transparencies, slide shows, multimedia kits, location and studio setting. Subjects include training experience and education.

Specs: Requires extensive employee training shows which should be evident in portfolio. Others need not apply. Produces industrial 35mm filmstrip and slide shows; 35mm filmstrips for educational markets and 16mm animation. Uses 35mm color transparencies.

First Contact & Terms: Arrange a personal interview to show portfolio; provide resume, brochure/flyer and samples to be kept on file for future assignments. Pays \$350-500/day; \$250-750/day for educational filmstrips; payment made on agreed terms. Buys all rights. Model release required.

Tips: Prefers to see samples illustrating various lighting conditions (factory, office, supermarket), ability to conceptualize, people working in corporations and active school children. When you call, refer to Photographer's Market.

ADVERTISING TO WOMEN, INC., 777 3rd Ave., New York NY 10017. (212)688-4675. Contact: Art Buyer. Ad agency. Clients: women's products, fashion, beauty-client list provided upon request. Needs: Works on assignment basis only. Uses photographers for trade magazines, direct mail, P-O-P displays, posters, signage and newspapers.

First Contact & Terms: Call to arrange a personal interview to show portfolio. Negotiates payment by

the day according to client's budget.

AHREND ASSOCIATES, INC., Suite 1101, 80 5th Ave., New York NY 10011. (212)620-0015. Production Manager: Beth Lippman. Ad agency. Uses consumer and trade magazines, direct mail, foreign media, newspapers, radio and TV. Serves clients in direct mail, retailing, industry, book publishing and nonprofit organizations. Commissions 5 photographers/year. Provide brochure, flyer and tearsheets to be kept on file for possible future assignments. Pays \$25-500/job. Pays on production. Buys all rights. Model release required; captions preferred. Arrange personal interview to show portfolio, particularly direct mail, catalog samples, etc. Local freelancers preferred. SASE. Reports in 2 weeks.

B&W: Uses 5x7 and 8x10 prints.

Color: Uses 5x7 and 8x10 prints and 35mm transparencies.

*I.S. ALDEN PUBLIC RELATIONS, INC., 535 5th Ave., New York NY 10017. (212)867-6400. Public Relations Director: Jack H. Casper. PR firm. Photos used in newspapers, trade publications and general media. Clients: chemicals, health care, manufacturing. Pays \$24 minimum/hour. Model release required. "Write first; describe your area of specialization and general abilities; access to models; props; studio; area/event/people coverage; equipment used; time and fee information; agency/commercial experience; and location and availability." SASE. Reports in 1 month or less. Most interested in product publicity by assignment; event/area coverage by assignment; portraits for publicity use; occasional use of models/props.

B&W: Uses glossy prints.

Color: Uses glossy prints and transparencies; contact sheet and negatives OK. Film: Gives assignments to filmmakers for industrial and commercial films.

ALTSCHILLER, REITZFELD, SOLIN, 1700 Broadway, New York NY 10019. (212)586-1400. Contact Vice President of Operations: Florence Jesmajian. Call for names of Art Directors. Ad agency. Clients: fashion, cosmetic, publishing, paper products, food and drug products accounts.

Needs: Uses photographers for fashion magazines and TV, some P-O-P displays. Uses very few stills

(prints).

First Contact & Terms: Arrange interview to show portfolio, or drop off portfolio for review. Payment negotiable.

BACHNER PRODUCTIONS, INC., 360 First Ave., New York NY 10010. (212)673-2946. President: A. Bachner. Production company. Uses filmstrips, motion pictures and videotape. Works with 2 freelance photographers/month on assignment only basis. Provide resume, letter of inquiry and brochure to be kept on file for possible future assignments. Buys 10-20 photos/year. Pays on a per-job basis; negotiates payment based on client's budget and where the work will appear. Pays on acceptance of work. Buys one-time rights or all rights, but may reassign to photographer after use. Model release required. Query with resume of credits. Solicits photos/films by assignment only. Does not return unsolicited material. Reports in 1 month.

Subject Needs: Commercials, documentaries, and sales training films. Interested in stock photos of room interiors, exteriors without people or animals. Freelance photos used as backgrounds for titles or animation stand work. Do not send portfolio unless requested. Length: 30 seconds-30 minutes/film. Film: 16mm, 35mm, videotape. No 8mm. Filmmaker might be assigned to produce stills for animation

or titling. Needs for stock footage vary.

*CHRIS BALTON PRODUCTIONS, 310 East 46th St., New York NY 10017. (212)557-9834. Producer/Director: Chris Balton. Clients: corporate, ad agencies, record companies.

Needs: Works with 3-4 photographers/month. Uses photographers for videotapes and films. Subjects include multicamera video shoots, still photos for montage openings for programs, and production photos.

Specs: Uses 35mm film. Beta Cam and 1" C format and videotape.

First Contact & Terms: Provide resume, business card, self-promotion or tearsheets to be kept on file

for possible future assignments. Works with local freelancers only; interested in stock photos/footage. Does not return unsolicited material. Reports in 2 weeks. Pays \$250-750/day. Pays on acceptance. Buys all rights. Model release required.

BOARD OF JEWISH EDUCATION, INC., 426 W. 58th St., New York NY 10019. (212)245-8200. Director, Multimedia Services and Materials Development: Yaakov Reshef. AV firm. Clients: Jewish schools, community centers, youth groups and other Jewish organizations. Produces filmstrips, multimedia kits and some films; usually does not buy material from freelance filmmakers. Subjects and photo needs include "all areas of Jewish life and tradition, and Israel." Works with 1-2 freelance photographers/month. Negotiates payment based on client's budget. Buys 100-250 photos/year. Buys first rights. Submit material by mail for consideration or submit portfolio. SASE.

B&W: Send 8x10 glossy prints. Captions required. Pays \$35 minimum.

Color: Send transparencies. Captions required. Pays \$35 and up.

ANITA HELEN BROOKS ASSOCIATES, 155 E. 55th St., New York NY 10022. Contact: Anita Helen Brooks. PR firm. Clients: beauty, entertainment, fashion, food, publishing, travel, society, art, politics, exhibits, charity events. Photos used in PR releases, AV presentations, consumer magazines and trade magazines. Works with freelance photographers on assignment only basis. Provide resume and brochure to be kept on file for possible future assignments. Buys "several hundred" photos/year. Pays \$50 minimum/job; negotiates payment based on client's budget. Credit line given. Model release preferred. Query with resume of credits. No unsolicited material; does not return unsolicited material. Most interested in fashion shots, society, entertainment and literary celebrity/personality shots.

B&W: Uses 8x10 glossy prints; contact sheet OK. (B&w preferred.)

Color: Uses 8x10 glossy prints; contact sheet OK.

CINETUDES FILM PRODUCTIONS, LTD., 295 West 4th St.; New York, NY 10014. (212)966-4600. President: Christine Jurzykowski. AV firm. Serves corporations, businesses and TV. Produces motion pictures. Works with 1-2 freelance photographers/month on assignment only basis. Provide resume, business card and letter of inquiry to be kept on file for future assignments.

Subject Needs: Uses photos for promotion of films.

Film: Produces TV films.

Photos: Uses b&w and color. Prefers 11x14 b&w prints or contact sheets; color prints.

Payment & Terms: Negotiates payment based on amount of creativity required from photographer.

Pays on production. Buys all rights. Model release required.

Making Contact: Arrange personal interview, send material by mail for consideration or submit portfolio. SASE. Reports in 2 weeks.

CUNNINGHAM & WALSH INC., 260 Madison Ave., New York NY 10016. (212)683-4900. Art Buyer and Studio Manager: Harry Samalot. Ad agency.

First Contact & Terms: Call for appointment to show portfolio (print work and actual jobs done) or leave portfolios, Tuesday, Wednesday and Thursday only.

RAUL DA SILVA & OTHER FILMMAKERS, 311 E. 85th, New York NY 10028. (212)535-5760. Creative Director: Raul da Silva. AV firm. Clients: business and industrial, institutional, educational and entertainment.

Needs: Works on assignment only. Buys 1-3 filmstrips, 2-4 films/year, 2-4 videotapes; mixed AV photography for screen and print. Uses photographers for filmstrips, slide sets, multimedia kits, motion pictures and videotape. Subjects include sales promotion, public relations, internal and external corporate communications, educational and entertainment media.

Specs: Requires both location and studio light and set-up. Produces every phase of AV/film/tape—in every medium. No Super 8 work. Prefers 8x10 b&w glossies and all formats and sizes color transparencies.

First Contact & Terms: Query with resume of credits. Does not return unsolicited material. Reports in 3 weeks. Provide resume to be kept on file for possible future assignments. Pays \$300-1,000/job. Pays on acceptance. Buys all rights, but may reassign to photographer after use. Model release required; captions optional.

Tips: "We work with professionals only. People without commitment and dedication are a dime a dozen. List references with resume, include phone number and address."

DARINO FILMS, 222 Park Ave. S., New York NY 10003. (212)228-4024. Creative Director: Ed Darino. AV firm. Clients: industrial, communications and educational.

Needs: Works with freelance photographers on assignment only basis. Buys 5-10 films/year. Uses photographers for computerized animation, motion pictures and videotape. Subjects include 16mm

animated films for children, documentaries, features, graphic animation for TV and corporation identification.

First Contact & Terms: Query with list of stock photo subjects; do not send unsolicited materials. Provide calling card, brochure and flyer to be kept on file for possible future assignments. Pays minimum union rates/hour; basics/job. Payment on publication. Buys educational/TV rights. Model release required.

DISCOVERY PRODUCTIONS, 315 Central Park W 8E., New York NY 10025. (212)752-7575. Proprietor: David Epstein. PR/AV firm. Serves educational and social action agencies. Produces 16mm and 35mm films. Works with up to 2 freelance photographers/month on assignment only basis. Provide resume to be kept on file for possible future assignments. Buys 2 films annually. Pays on use and 30 days. Buys all rights, but may reassign to filmmaker. Query first with resume of credits.

Film: 16mm and 35mm documentary, educational and industrial films. Possible assignments include research, writing, camera work or editing. "We would collaborate on a production of an attractive and practical idea." Model release required. Pays 25-60% royalty.

JODY DONOHUE ASSOCIATES, INC., 32 E. 57th St., New York NY 10022. (212)688-8653. PR firm. Clients: fashion, beauty.

Needs: Uses freelancers for direct mail and P-O-P displays.

First Contact & Terms: Call for personal appointment to show portfolio. Selection based on "interview, review of portfolio, and strength in a particular area (i.e., still life, children, etc.)." Negotiates payment based on client's budget, amount of creativity required from photographer and where the work will appear. Pays freelancers on receipt of clients' payment.

Tips: Wants to see "recent work and that which has been used (printed piece, etc.)."

MARK DRUCK PRODUCTIONS, 300 E. 40th St., New York NY 10016. (212)682-5980. President/ Production Director: Mark Druck. AV firm. Clients: corporations, advertisers, etc. Produces 16mm and 35mm films, videotape and filmstrips. Pays on a per-job, per-day or per-week basis. Submit resume of credits. Reports in 1 week. SASE.

Film: 16mm and 35mm educational, industrial, sales and public relations films. Possible assignments include research and on-location filming.

RICHARD FALK ASSOCIATES, 1472 Broadway, New York NY 10036. (212)221-0043. President: Richard Falk. PR firm. Clients: industrial, entertainment. Provide business card and flyer to be kept on file for possible future assignments.

Needs: Works with about 4 freelance photographers/month. Uses photographers for newspapers and TV. First Contact & Terms: Send resume. Selection of freelancers based on "short letters or flyers, chance visits, promo pieces and contact at events." Also hires by contract. Does not return unsolicited material. Reports in 1 week. Pays \$10-50/b&w photo; \$50 minimum/hour; \$100 minimum/day.

*FANDANGO INTERCONTINENTAL NETWORK, Worldwide Representing and Production Services, Room 903, 15 W. 38th St., New York NY 10018. President: G. Edward Bibbo. Clients: ad agencies and companies in New York, Hartford, Chicago, Dallas, Los Angeles, Honolulu, Tokyo, Hong Kong and London.

Needs: Works with 40 photographers/month. Uses photographers for slide sets, multimedia productions, print, films, videotapes. Subjects include all types; "it just has to be the best."

Specs: Uses b&w and color according to client's request; 16mm, 35mm film; U-matic ³/₄" videotape. **First Contact & Terms:** Provide resume, business card, self-promotion piece or tearsheets to be kept on file for possible future assignments. Works with freelancers by assignment only. Reports in 1 month. Pays according to client. "We pay within 5 days of clearance of our payment." Rights bought according to clients' request and purchase. Captions and model release preferred. Credit line given whenever possible.

Tips: "Show only your best and strongest work. We stake our reputation on representing the best to our clients, and selling yourself to us will be the hardest sale you'll ever make."

FOOTE, CONE & BELDING COMMUNICATIONS, INC., 101 Park Ave., New York NY 10178. (212)907-1000. Art Buyers: Barbara Sabatino, Irene Jacobusky. Ad agency. Clients: food, fashion and beauty, tobacco, travel, industrial, communication, financial and consumer products.

Needs: Works with 5-10 freelance photographers/month. Uses freelancers for billboards, consumer and trade magazines, direct mail, newspapers, P-O-P displays and TV.

First Contact & Terms: Send portfolio for review. Selection of photographers based on "personal knowledge, files and mailers left after portfolios are screened." Negotiates payment based on client's budget and where the work will appear.

Tips: "Be flexible with prices; keep to the estimate; send receipts for expenses. Be innovative." Wants to see "10-15 chromes of experimental and/or job related work. Tearsheets if they're good."

GAYNOR FALCONE & ASSOCIATES, 133 E. 58th, New York NY 10022. (212)688-6900. Senior Art Director: John Cenatiempo. Ad agency. Clients: various. Client list provided upon request. **Needs:** Works on assignment basis only. Uses photographers for billboards, consumer and trade magazines, direct mail, P-O-P displays, brochures, catalogs, posters, signage, newspapers and AV presentations.

First Contact & Terms: Query with samples. Negotiates payment according to client's budget and where work will appear. Usually pays by the day or half-day.

PETE GLASHEEN ADVERTISING, INC., 300 E. 34th St., New York NY 10016. (212)889-3188. Vice President: Carol Glasheen. Ad agency. Uses consumer and trade magazines, direct mail, foreign media, newspapers, P-O-P displays, radio and TV. Serves cosmetic, health food, toy, art supply, office supply, executive toy, packaged goods and consumer and trade magazine clients. Works with 7 freelance photographers/month on assignment only basis. Provide business card to be kept on file for future assignments.

Specs: Uses b&w and color 5x7 and 8x10 prints. Also uses 1/2" VHS videotape.

Payment/Terms: Pays by job; negotiates payment based on client's budget, amount of creativity required from photographer and where the work will appear. Buys all rights. Model release required. Making Contact: Send photos and proposal or resume. SASE. Agency will contact.

THE GRAPHIC EXPERIENCE INC., 341 Madison Ave., New York NY 10017. (212)867-0806. Production Manager: John Marinello. Ad agency. Uses consumer and trade magazines, direct mail, newspapers and P-O-P displays. Clients: fashion, hard goods, soft goods and catalogs (fashion/gifts). Buys 600-1,200 photos/year. Pays \$100-1,500/day; negotiates payment based on client's budget. Buys all rights. Model release required. Arrange a personal interview to show portfolio or submit portfolio for review. Provide resume, flyer and tearsheets to be kept on file for future assignments. SASE. Reports in 2 weeks.

GRAPHIC MEDIA INC., 12 W. 27th St., New York NY 10001. (212)696-0880. AV firm. Contact: Marco Cardamone. Clients: all types. SASE.

Needs: Uses photographers for AV presentations. Subject matter "varied."

Specs: Uses 35mm transparencies.

First Contact & Terms: Arrange a personal interview to show portfolio; query with resume of credits. Does not return unsolicited material. Pays \$400-1,000/day. Buys all rights. Model release required.

HCM, (formerly Marsteller, Inc.), 866 3rd Ave., New York NY 10022. (212)752-6500. Associate Creative Director: Joe Mackenna. Ad agency. Clients: automotive, aerospace (military and commercial aircraft, sophisticated electronics) copiers, packaged goods, chemicals, telephone systems, business services (accounting, claim adjusting, insurance) commercial interiors, retail banking, pharmaceuticals, publishing firms.

Needs: "As general agency we are looking for all types of photography, consumer, business-to-business and corporate." Works with 10-100 freelance photographers/year. Photographers are retained for studio,

still life and location work, primarily illustrative with some specific situations.

First Contact & Terms: Arrange interview to show portfolio. Pays \$500-1,500/b&w photo; \$750-2,500/color photo; or \$600-6,500/job. "The agency's intent is to purchase as many rights as possible for the budget with the intent to own the work outright for the client with no limitations. Purchase orders should state clearly all intended uses and limits of the rights we wish to purchase in the event we are purchasing less than a buy-out. Rarely do we give photographers a credit line, but consideration will be made case by case."

Tips: Prefers to see only outstanding examples of work, critically edited by the photographer or his representative. "We like to see new 'points of view' of subjects."

JIM JOHNSTON ADVERTISING, INC., 551 5th Ave., New York NY 10017. (212)490-2121. Art Directors: Ann Lemon, Margaret Lee, Bob Pendleton. Creative Director: Jim Johnston. Ad agency. Uses consumer and trade magazines, direct mail, foreign media, newspapers, and radio. Serves clients in publishing and broadcasting, financial services and high technology. Buys 25-50 photos/year. Local freelancers preferred. Pays \$150-1,500/job. Buys all rights. Model release required. Query with resume of credits; query with samples or list of stock photo subjects; or submit portfolio for review. SASE. Reports in 2 weeks.

B&W: Uses 8x10 glossy prints; contact sheet OK.

Color: Uses 8x10 or larger glossy prints and 21/4x21/4 transparencies.

Film: Produces 16mm and 32mm documentary and sales film. Does not pay royalties.

JON-R ASSOCIATES, 630 9th Ave., New York NY 10036. (212)581-2121. PR firm. Manager, AV

Division: Tom Andron. Clients: corporate, travel.

Needs: Works with 2-3 freelance photographers/month. Uses photographers for consumer magazines, brochures, newspapers, AV presentations, TV, films (news and features). Subjects include "products in use—photojournalism." Also works with freelance filmmakers to produce training and sales films. **Specs:** Uses 4x5 to 11x14 b&w or color prints; 35mm, $2^{1}/4x2^{1}/4$, 4x5 or 8x10 transparencies; 16mm, 35mm film and videotapes.

First Contact & Terms: Arrange a personal interview to show portfolio; provide resume, business card, brochure, flyer or tearsheets to be kept on file for possible future assignments. Works with freelance photographers on assignment basis only. Does not return unsolicited material. Reports in 1 month. Pays \$150-350/day; \$350-500/job. Pays 60 days after invoicing. Buys all rights. Model release and captions required. Credit line given "whenever possible."

Tips: "Tell what makes your work unique and of value to us and our clients."

JORDAN/CASE & McGRATH, 445 Park Ave., New York NY 10022. (212)906-3600. Studio Manager: Jim Griffin. "There's a separate TV department which views TV reels." Ad agency. Uses all media. Clients include insurance companies, makers of cough medicine, frozen foods, liquor and wine, hosiery manufacturers, commercial banks, theatre, facial cleanser and food products. Needs still lifes and product photos. Buys 25-50 annually. Pays on a per-job or a per-photo basis. Call to arrange an appointment.

B&W: Uses contact sheets for selection, then double-weight glossy or matte prints. Will determine

specifications at time of assignment. Pays \$100 minimum.

Color: Uses transparencies. Will determine specifications at time of assignment. Pays \$100 minimum.

DON LANE PICTURES, INC., 35 W. 45th St., New York NY 10036. (212)840-6355. Producer/ Directors: John Armstrong and Don Lane. Industrial clients.

Needs: Buys 10-1,000 photos, 1-5 filmstrips and 5-15 films/year. Uses photographers for filmstrips, slide sets, 16mm documentary style industrial films and videotape. Subjects include agriculture, medicine and industrial chemicals.

First Contact & Terms: Arrange a personal interview to show portfolio. Provide calling card and tearsheets to be kept on file for possible future assignments. Pays \$150-500/day. Payment on acceptance. Buys all rights, but may reassign to photographer after use. Model release required; captions optional. **Tips:** Wants to see "location work; preferably available light; 'documentary' style. Include information on nature and purpose of assignment, technical problems solved, etc."

LAUNEY, HACHMANN & HARRIS, 292 Madison Ave., New York NY 10017. (212)679-1702. Contact: Hank Hachmann. Ad agency. Clients: textiles, clothing and manufacturing.

Needs: Works with 5-7 freelance photographers/month. Provide business card and printed samples to be kept on file for possible future assignments. Uses freelancers for billboards, consumer and trade

magazines, direct mail, newspapers, P-O-P displays and TV.

First Contact & Terms: Call for personal appointment to show portfolio. "When an assignment comes up I will either select a photographer I know whose style is suited for the job or I will review portfolios of other freelancers I am interested in using." Negotiates payment based on client's budget, amount of creativity required from photographer, where work will appear and previous experience/reputation. Set fee/job \$400-1,200.

Tips: Wants to see "15-20 samples" of work.

AL PAUL LEFTON COMPANY INC., 71 Vanderbilt Ave., New York NY 10017. (212)867-5100. Director of Graphics: Dick Page. Ad agency. Serves clients in manufacturing, publishing, automobiles, education and a variety of other fields.

First Contact & Terms: Call for personal appointment to show portfolio. Negotiates payment based on client's budget, amount of creativity required from photographer, where work will appear and previous experience/reputation. "We prefer to find out how much a freelancer will charge for a job and then determine whether or not we will hire him."

Tips: "Would like to see whatever they do best. We use just about all types of work."

WILLIAM V. LEVINE ASSOCIATES, INC., 31 E. 28th St., New York NY 10016. (212)683-7177. Contact: Art Director. AV firm. Clients: business, industry. Produces filmstrips, slide sets, multimedia presentations and motion pictures. Negotiates payment based on client's budget, amount of creativity required, where work will appear and previous experience/reputation. Pays on production. Model release and captions preferred. Query with list of stock photo subjects; provide resume and business card to be kept on file for possible future assignments. Local freelancers only. Does not return unsolicited material. Reports in 3 weeks.

Subject Needs: Freelance material used in multimedia presentations on selected business-related subjects. Frequent use of travel and scenic subjects keyed to specific locations.

Film: Produces 16mm industrial movies.

B&W: Uses 8x10 prints.

Color: Uses 21/4x21/4 transparencies or 8x10 prints.

Tips: "Our company produces multi-image slide presentations. Within a given module literally hundreds of slides may be utilized on the screen. Traditional costing is not applicable in this medium. We will also consider outright purchase of slide librarys on given subjects."

LEVINE, HUNTLEY, SCHMIDT & BEAVER, 250 Park Ave., New York NY 10017. (212)557-0900. Creative Director: Allan Beaver. Ad agency. Serves clients in food, publishing, liquor, fabrics and fragrances.

Needs: Works with 5-10 freelance photographers/month. Uses photographers for billboards, occasionally P-O-P displays, consumer and trade magazines, direct mail, TV, brochures/flyers and newspapers. First Contact & Terms: Call for appointment to show portfolio or mail preliminary samples of work (include use of design and lighting). Negotiates payment based on client's budget, amount of creativity required and where work will appear.

McCAFFREY AND McCALL, INC., 575 Lexington Ave., New York NY 10022. (212)421-7500. Art Buyer/Stylist Assistant: Barbara Bonschick. Art Adminstrator: Robin Devine-Ryan.. Ad agency. Serves clients in airlines, broadcasting, banking, oil, automobiles, liquor, retailing, jewelry and other

Needs: Works with 5-10 freelance photographers/month. Uses photographers for newspapers and magazines.

First Contact & Terms: Send for list of Art Directors and then contact individual director for appointment. Negotiates pay based on estimates from freelancer.

*MARSDEN, 30 E. 33 St., New York NY 10016. (212)725-9220. Vice President/Creative Director: Stephen Flores. Clients: corporate, nonprofit, Fortune 500.

Needs: Works with 2-3 photographers/month. Uses photographers for filmstrips, slide sets, multimedia productions, films and videotapes. Subjects include industrial technical, office, faces, etc.

Specs: Uses 35mm, 21/4x21/4, 4x5 and 8x10 transparencies; 16mm and 35mm film; U-matic 3/4", 1" and 'videotapes.

First Contact & Terms: Query with samples or a stock photo list; provide resume, business card, selfpromotion piece or tearsheets to be kept on file for possible future assignments. Works with local freelancers only; interested in stock photos/footage. "We call when we have a need-no response is made on unsolicited material." Pays \$250-500/day. Pays on acceptance. Buys one-time and all rights. Model release preferred. Credit line rarely given.

MEDICAL MULTIMEDIA CORP., 211 E. 43rd St., New York NY 10017. (212)986-0180. President: Stanley R. Waine. AV firm. Clients: doctors, technicians, nurses, educators, lay persons. Produces multimedia kits, videotape programs, slide-cassette sets and filmstrips. Subjects include educational programs dealing with medical hardware and software, as well as programs in the medical and health fields. Uses photos of machinery, people, x-rays, and medical scans. Buys 400-500 photos/ year. Buys all rights, but may reassign to photographer. Pays \$250-325/day. Call to arrange an appointment; deals by assignment only.

B&W: Uses prints up to 11x14. Model release required. Color: Uses 35mm transparencies. Model release required.

Tips: "We don't want any samples sent as we're not in the market for buying any."

*MEKLER/ANSELL ASSOCIATES, INC., 275 Madison Ave., New York NY 10016. (212)685-7850. President: Leonard Ansell. PR firm. Clients: marketing-oriented consumer, industrial public relations accounts. Photos used in news and feature publicity assignments. Buys "a selected few" annually. Present model release on acceptance of photo. Photographers seen by appointment only. Payment "by advance individual agreement."

B&W: Uses 5x7 glossy prints for people and 8x10 glossy prints for scenes, products, etc.; send contact sheet.

Color: Uses 35mm transparencies and prints; send contact sheet for prints.

MORRIS COMMUNICATIONS CORP., (MOR/COM), 124 E. 40th St., New York NY 10016. (212)883-8828. President: Ben Morris. Ad agency. Uses consumer and trade magazines, direct mail, newspapers, P-O-P displays and packaging. Clients: industry, mail order, book publishing, mass transit. Subject needs vary. Provide resume, business card, brochure and flyer to be kept on file for possible

future assignments. Buys second (reprint) rights, or all rights, but may reassign to photographer. Query first with resume of credits; works with local freelancers only. Reports in 1 month. SASE.

B&W: Uses 8x10 glossy prints. Model release required. Pays \$50-125.

Color: Uses 21/4x21/4 transparencies and 5x7 or 8x10 glossy prints. Model release required. Pays \$75-

Tips: "We are a very small shop—3 or 4 people. We buy only on an assignment need and then prefer working with the photographer. On rare occasion we seek outside work and would welcome hearing on the above basis.'

RUTH MORRISON ASSOCIATES, 509 Madison Ave., New York NY 10022. (212)838-9221. Contact: Melissa Itter. PR firm. Uses newspapers, P-O-P displays and trade magazines. Serves clients in home furnishings, food, travel and general areas. Commissions 4-5 photographers/year. Pays \$25 and up/hour. Model release required. Submit portfolio for review. SASE. Reports in 1 month.

B&W: Uses 8x10 prints. Color: Uses transparencies.

MOSS & COMPANY, INC., 49W 38th St., New York NY 10018. (212)575-0808. Executive Art & Creative Director: Georgia Macris. Ad agency. Serves clients in consumer products, manufacturing, utilities and entertainment. Annual billing: \$6,000,000.

Needs: Works with 3-4 freelance photographers/month. Uses photographers for billboards, consumer and trade magazines, direct mail, TV, brochures/flyers and newspapers.

First Contact & Terms: Call for appointment to show portfolio. Negotiates payment based on client's budget: \$300-1,500/job; \$400/b&w photo; \$1,500/color photo. Prefers to see samples of still life and

Tips: "Photographer must be technically perfect with regard to shooting still life and people. Then talent!"

MRC FILMS, 71 W. 23rd St., New York NY 10010. (212)989-1754. Executive Producer: Larry Mollot. AV firm. Serves clients in industry, government and television. Produces multimedia kits, motion pictures, sound-slide sets and videotape. Produces 6 sound-slide sets, 10 films and 40 video programs/year.

Subject Needs: Employee training; science: technical; motivational; orientation; and public relations. Film: Produces 16mm color sound motion pictures. "We are more interested in cinematographers than in still photographers, but we do use both.

Payment & Terms: Pays \$300-2,000/job. Pays on completion and acceptance. Buys all rights, since all work is done on assignment. Model release required.

Making Contact: Query with resume of credits, background information and description of equipment owned. Cannot return unsolicited material. Reports in 3 weeks.

MUIR, CORNELIUS MOORE, INC., 750 3rd Ave., 19th Floor, New York NY 10017. (212)687-4055, Chief Creative Director: Richard Moore, Ad agency/design firm, Clients: banking, manufacturing, systems, medical/scientific equipment, other industries. Commissions photographers for specific assignments. Ouery first with resume of credits.

Tips: "Send promotional material or drop off portfolio to Virginia Martin, Creative Resources Administrator. We need good corporate photographers."

*MULLER, JORDAN, WEISS, INC., 666 5th Ave., New York NY 10103. (212)399-2700. Creative Director: Jerry Coleman. Associate Creative Director: Ron Bacsa. Ad agency. Clients: fashion, agricultural, industrial/corporate, plastics, food firms, window and ceiling products.

Needs: Works with 15 freelance photographers/year on assignment only basis. Uses photographers for consumer and trade magazines, direct mail, P-O-P displays, brochures, posters, newspapers and AV presentations.

First Contact & Terms: Phone for appointment. Pays \$300/b&w photo; \$500/color photo; \$300-2,500/

OGILVY & MATHER, INC., 2 E. 48th St., New York NY 10017. (212)907-3400. Contact: Mary Mahon for list of creative directors. Ad agency. Clients: cosmetics, food, clothing, tourism and pharmaceuticals; telephone company.

First Contact & Terms: Contact Ellen Johnson, Art Buying Department, for creative directors and individual requirements and needs.

PARK PLACE GROUP, INC., 157 E. 57th St., New York NY 10022. (212)838-6024. Ad agency. President, Creative Director: Bette Klegon. Clients: fashion, publishing, architectural design, cosmetics

and fragrances, financial and retail stores.

Needs: Works with 1-5 freelance photographers/month. Uses photographers for consumer magazines, trade magazines, direct mail, brochures and posters. Subjects include: fashion and still life. Also works with freelance filmmakers to produce TV commercials and training films.

Specs: Uses 35mm, 21/4x21/4, 4x5 and 8x10 transparencies; Super 8mm and 16mm film.

First Contact & Terms: Submit portfolio for review; provide resume, business card, brochure, flyer or tearsheets to be kept on file for possible future assignments. Works with freelance photographers on assignment basis only. Does not return unsolicited material. Payment "depends on budget allocations and work involved." Pays on acceptance. Model release required.

Tips: Prefers men's and women's fashion in b&w and color; color still lifes.

*PRIMALUX VIDEO, 30 W. 26 St., New York, NY 10010. (212)206-1402. Production Coordinator: Barbara Stumacher. Clients: broadcasters, ad agencies, Fortune 500 companies.

Needs: Works with 2-3 photographers/month. Uses photographers for videotapes. Subjects include commercials.

Specs: Uses U-matic 3/4" and Betacam.

First Contact & Terms: Provide resume, business card, self-promotion piece or tearsheets to be kept on file for possible future assignments. Works with freelancers by assignment only. SASE. Reports in 1 month. Pay individually negotiated. Pays in 30 days.

*RANDOM HOUSE, 201 E. 50th St., New York NY 10022. Manager, Photo Research: Katherine T. Bendo.

Needs: Uses photographers for college textbooks. Subjects include all editorial, reportage, news, special effects, natural history, science, micrography-all college subjects.

Specs: Uses 8x10 repro quality b&w prints; color transparencies or repro-quality dupes.

First Contact & Terms: Provide resume, business card, self-promotion piece or tearsheets to be kept on file for possible future assignment. Do not send unsolicited photos. Interested in stock photos. Pay varies. Pays on acceptance after sizes are determined. Buys one-time rights. Captions and model releases preferred. Credit lines given.

RAPP & COLLINS, 475 Park Ave. S., New York NY 10016. (212)725-8100. Ad agency. A/V Producer/Art Buyer: Judi Radice. Serves all types of clients; specializes in direct response and direct

Needs: Works with 2-3 freelance photographers/month. Uses photographers for consumer and trade magazines, direct mail, brochures, catalogs, newspapers. AV presentations. Subject matter varies.

Specs: "Varies upon individual client requirements."

First Contact & Terms: Provide brochure, flyer or tearsheets at interview to be kept on file for possible future assignments. "Too many photographers call for personal interview-no time to see all." Pay "depends on particular jobs and budget." Rights purchased vary. Model release required; captions optional.

Tips: "In a portfolio, we would like to see how a photographer thinks. Be unique, reasonably priced and be patient. It is important that the photographer's work shows a good sense of color, proportion and lighting techniques. It is also important that they show creativity, something that will differentiate them from the rest. We are always interested in new and exciting talent. We tend to use freelancers upon recommendations. New uses for photography include converting photographs to mezotints and using high contrast color xeroxes of photographs to abstract colors. Liquor & camera photographs have been overdone."

RICHTER PRODUCTIONS, INC., 330 W. 42 St., New York NY 10036. (212)947-1395. President: Robert Richter. AV firm. Serves TV networks, local TV stations, government and private agencies. Produces 16mm and 35mm films. Subjects include the environment, science, international affairs, education, natural history, public health and politics. Works with 2 freelance photographers/month on assignment only basis. Provide resume to be kept on file for possible future assignments. Buys simultaneous rights. Pays \$250 minimum/day. Negotiates payment based on client's budget, amount of creativity required from photographer, where the work will appear and photographer's previous experience/reputation. Query first with resume of credits. SASE.

Film: 16mm documentaries; some 35mm. Sample assignments include working with sync-sound

filming. Model release required.

Tips: "We are primarily interested in talented cameramen and editors with top track records and credentials."

RICHARD H. ROFFMAN ASSOCIATES, Suite 6A, 697 West End Ave., New York NY 10025. (212)749-3647. Contact: Vice President. PR firm. Clients: all types of accounts, "everything from A to

Z." Free client list available with SASE. Photos used in public relations, publicity and promotion.

Works with about 3 freelance photographers/month usually on assignment only basis.

First Contact & Terms: Provide resume, flyer, business card and brochure to be kept on file for possible future assignments. Buys 50 photos annually. Negotiates payment based on client's budget, amount of creativity required, where work will appear and photographer's previous experience/reputation. Pays \$10-20/hour; \$50-100/day; \$50-100/job; \$35/b&w photo; \$85/color photo. Pays on delivery. Submit model release with photo.

Tips: "Nothing should be sent except a business card or general sales presentation or brochure. Nothing should be sent that requires sending back, as we unfortunately don't have the staff or time. We have assignments from time to time for freelancers but when we do then we seek out the photographers."

ROSS/GAFFNEY, INC., 21 W. 46th St., New York NY 10036. (212)719-2744. President: James Gaffney. AV firm. Provides completion services for motion pictures and does 20 video films and videotapes/year. Pays \$150-800/day. Pays on production. Buys all rights. Model release required. Solicits films by assignment only. Does not return unsolicited material. Provide resume to be kept on file for possible future assignments.

Film: 16mm, 35mm, 70mm. Uses stock footage occasionally.

PETER ROTHHOLZ ASSOCIATES, INC., 380 Lexington Ave., New York NY 10168. (212)687-6565. Contact: Peter Rothholz. PR firm. Clients: pharmaceuticals (health and beauty), government, travel. Photos used in brochures, newsletters, PR releases, AV presentations and sales literature. Works with 2 freelance photographers/year, each with approximately 8 assignments. Provide letter of inquiry to be kept on file for possible future assignments. Negotiates payment based on client's budget. Credit line given on request. Buys one-time rights. Model release preferred. Query with resume of credits or list of stock photo subjects. Local freelancers preferred. SASE. Reports in 2 weeks.

B&W: Uses 8x10 glossy prints; contact sheet OK.

Tips: "We use mostly standard publicity shots and have some 'regulars' we deal with. If one of those is unavailable we might begin with someone new—and he/she will then become a regular."

SAXTON COMMUNICATIONS GROUP, LTD., 605 3rd Ave., New York NY 10016. (212)953-1300. Art Director: Robert Levers. Director of Audiovisual Services: Michelle Starker. Serves a variety of clients in industry.

Needs: Uses photographers for multimedia slide shows, slide sets, multimedia kits, motion pictures and videotape. Subjects include employee training and sales meetings.

First Contact & Terms: Query with samples; provide business card, tearsheet and samples to be kept on file for future assignments. Buys all rights. Model release required; captions preferred.

Tips: "Include in letter specifics on type of work in portfolio and a ballpark figure on how much you require for a day's shooting, etc."

JACK SCHECTERSON ASSOCIATES, INC., 6 E. 39th St., New York NY 10016. (212)889-3950. Ad agency. President: Jack Schecterson. Clients: industrial, consumer.

Needs: Uses photographers for consumer and trade magazines, packaging, product, design, direct mail, P-O-P displays, brochures, catalogs, etc...

Specs: Uses b&w or color prints; 35mm, 21/4x21/4, 4x5 and 8x10 transparencies.

First Contact & Terms: Arrange a personal interview to show portfolio; provide resume, business card, brochure, flyer or tearsheets to be kept on file for possible future assignments. Works with freelancers on assignment only basis. Reporting time "subject to job time requirements." Buys all rights. Model release and captions required.

SPENCER PRODUCTIONS, INC., 234 5th Ave., New York NY 10001. General Manager: Bruce Spencer, PR firm, Clients: business, industry, Produces motion pictures and videotape. Works with 1-2 freelance photographers/month on assignment only basis. Provide resume and letter of inquiry to be kept on file for possible future assignments. Buys 2-6 films/year. Pays \$5-15/hour; \$500-5,000/job; negotiates payment based on client's budget. Pays a royalty of 5-10%. Pays on acceptance. Buys all rights, Model release required. Ouery with resume of credits. "Be brief and pertinent!" SASE. Reports

Subject Needs: Satirical approach to business and industry problems. Freelance photos used on special projects. Length: "Films vary-from a 1-minute commercial to a 90-minute feature."

Film: 16mm color commercials, documentaries and features.

Tips: "Almost all of our talent was unknown in the field when hired by us. For a sample of our satirical philosophy, see paperback edition of Don't Get Mad. . . Get Even by Alan Abel which we promoted, or How to Thrive on Rejection (December Books, Inc.)." **LEE EDWARD STERN ASSOCIATIES**, 1 Park Ave., New York NY 10016. (212)689-2376. PR firm; also provides editorial services. Clients: industrial, financial. Client list free with SASE.

Needs: Works with 1-2 freelance phtographers/year. Uses photographers for brochures, annual reports, news coverage. Subject needs vary—people, plants, equipment, destination shots. Also works with freelance filmmakers to produce TV news clips, industrial films.

First Contact & Terms: Provide resume, business card, brochure, flyer or tearsheets to be kept on file for possible future assignments. Works with freelancers on assignment only basis. Pays \$350 minimum/day. Pays after receiving client payment. Rights purchased vary. Model release required. Credit line sometimes given.

SUDLER & HENNESSEY INC., 1633 Broadway, New York NY 10019. (212)265-8000. Creative Director: Ernie Smith. Ad agency. Clients: medical and pharmaceutical.

Needs: Uses photographers for trade shows, booths, conventions, large displays, P-O-P displays, direct mail, brochures/flyers and medical photography.

First Contact & Terms: Call or submit portfolio to Art Coordinators. Negotiates payment based on going rate and client's budget.

Tips: "Although our clients are in the medical and pharmaceutical field we don't want to see test tubes or lab shots; we prefer more general photos. Largest and oldest agency in medical field."

TALCO PRODUCTIONS, 279 E. 44th St., New York NY 10017. (212)697-4015. President: Alan Lawrence. Vice President: Peter Yung. PR and AV firm. Clients: business and nonprofit organizations. Produces motion pictures and videotape. Works with freelance photographers on assignment only basis. Provide resume, flyer or brochure to be kept on file for possible future assignments. Prefers to see general work or "sample applicable to a specific project we are working on." Buys "a few" photos/year; does subcontract short sequences at distant locations. Pays/job; negotiates payment based on client's budget and where the work will appear. Pays on acceptance. Buys all rights. Model release required. Query with resume of credits only—don't send samples." We will ask for specifics when an assignment calls for particular experience or talents." Returns unsolicited material if SASE included. Reports in 3 weeks.

Film: 16mm-35mm film and cassette, 1", or 2³/₄" videotape; documentaries, industrials, public relations. Filmmaker might be assigned "second unit or pick-up shots,"

Tips: Filmmaker "must be experienced—union member is preferred. We do not frequently use freelancers except outside the New York City area when it is less expensive than sending a crew."

TELE-PRESS ASSOCIATES, INC., 342 E. 79th St., New York NY 10021. (212)744-2202. President: Alan Macnow. PR firm. Uses brochures, annual reports, PR releases, AV presentations, consumer and trade magazines. Serves beauty, fashion, finance and government clients. Works with 3 freelance photographers/month on assignment only basis. Provide resume, business card and brochure to be kept on file for possible future assignments.

Specs: Uses 8x10 glossy b&w prints, 35mm, $2^{1}/4x2^{1}/4$, 4x5 or 8x10 color transparencies. Works with freelance filmmakers in production of 16mm documentary, industrial and educational films.

Payment & Terms: Pays \$100 minimum/job; negotiates payment based on client's budget. Buys all rights. Model release and captions required.

Making Contact: Query with resume of credits or list of stock photo subjects. SASE. Reports in 2 weeks.

*TULCHIN STUDIOS, 240 East 45th St., New York NY 10017. (212)986-8270. Director of Operations: Susannah Eaton-Ryan. Clients: advertising agencies.

Needs: Subjects as required by production needs.

Specs: Uses 35mm, 21/4x21/4, 4x5 and 8x10 transparencies, VHS, 1" videotape.

First Contact & Terms: Provide resume, business card, self-promotion piece or tearsheets to be kept on file for possible future assignments. Works with freelancers only; interested in stock photos/footage. SASE. Reports in 3 weeks. Pays on publication. Buys all rights.

VAN BRUNT AND COMPANY, ADVERTISING MARKETING, INC., 300 E. 42nd St., New York NY 10017. (212)949-1300. Contact: Lisa Salay, Art Buyer. Ad agency. Clients: general consumer firms; client list provided upon request.

Needs: Works on assignment basis only. Uses photographers for consumer and trade magazines, direct mail, P-O-P displays, brochures, catalogs, posters, newspapers and AV presentations.

First Contact & Terms: Arrange interview to show portfolio. Payment is by the project; negotiates according to client's budget.

VENET ADVERTISING, 485 Chestnut St., Union NJ 07083. Vice President/Creative Director: Ray Aronne. Ad agency. Uses billboards, consumer and trade magazines, direct mail, newspapers, P-O-P

displays, radio and TV. Clients: finance, food, retailing, pharmaceuticals and industry. Works with 1-2 freelance photographers/month on assignment only basis. Provide flyer and business card to be kept on file for possible future assignments. Buys 5-10 freelance photos/year.

Specs: Uses 8x10 and 11x14 b&w prints, 5x7 and 8x10 color prints, and 4x5 color transparencies, all

35mm.

Payment & Terms: Pays \$150-1,500/b&w photo; \$75-2,100/color photo; \$2,500-3,500/day; or \$150-2,500/job. Payment negotiated according to client's budget. Buys all rights. Model release required. **Making Contact:** Arrange a personal interview to show portfolio ("work that is related to our type of accounts"). Prefers local freelancers. SASE. Reports ASAP.

WARING & LAROSA, INC., 555 Madison Ave., New York NY 10022. (212)755-0700. Contact: Art Directors. Ad agency. Serves clients in food, cosmetics and a variety of other industries.

Needs: Works with 25 freelance photographers/year. Uses photographers for billboards, P-O-P displays, consumer magazines, TV and newspapers.

First Contact & Terms: Call art directors for appointment to show portfolio. Negotiates payment based on client's budget.

WARNER BICKING & FENWICK, 866 U.N. Plaza, New York NY 10017. (212)759-7900. Ad agency. Art Director: Dick Grider. Clients: industrial and consumer. Client list provided on request. **Needs:** Works with 1-2 freelance photographers/month; "varies, however." Uses photographer for consumer and trade magazines, brochures.

Specs: Uses 4x5 transparencies; varies.

First Contact & Terms: Send unsolicited photos by mail for consideration. Does not return unsolicited material.

Tips: "Send samples of work by mail. There is not enough time to see people."

MORTON DENNIS WAX & ASSOCIATES, 200 W. 51st St., New York NY 10019. (212)247-2159. PR firm. Clients: entertainment, industry, health.

Needs: Works with varying number of freelance photographers on 2-3 jobs/month. Uses freelancers for consumer and trade magazines, newspapers and P-O-P displays.

First Contact & Terms: Write and request personal interview to show portfolio. "We select and use freelancers on a per project basis based on specific requirements of clients. Each project is unique.' Negotiates payment based on client's budget, amount of creativity required from photographer and previous experience/reputation.

ROSLYN WILLETT ASSOCIATES, INC., 2248 Broadway, New York NY 10024. (212)787-6060. President: R. Willett. PR firm. Clients: industrial, food accounts. Photos used in magazine articles and brochures. Works with 3-4 freelance photographers/month on assignment only basis.

First Contact & Terms: Provide resume, flyer, brochure and list of types of clients and resume of credits; do not send unsolicited material. Submit model release with photo. Pays \$300 minimum/day. Negotiates payment based on client's budget, photographer's previous experience/reputation and reasonable time rates (photos are mostly on location).

Tips: "We always need good photographers out of town. Prefers $2^{1/4}x2^{1/4}$ and larger sizes. 35mm only for color transparencies. Natural light."

*WINDSOR TOTAL VIDEO, 565 Fifth Ave., New York, NY 10017. (212)725-8080. Ad/Promotion Manager: Mark Magel. Works with 100 freelance photographers/month. Uses photographers for videotapes, inhouse promotion, videodisc. Clients' film and videotape industry, broadcast, agency, medical, educational, business, industry. Subjects vary—most often in training or generic high-tech. First Contact & Terms: Query with samples; provide resume, business card, self-promotion piece or tearsheets to be kept on file for possible future assignments. Works with freelancers by assignment only. Does not return unsolicited material. Reports in 1 month. Pays 30 days after receipt of invoice. Buys all rights. Model release preferred.

North Carolina

BOB BOEBERITZ DESIGN, (formerly Kelso Associates, Ltd.), 211 Charlotte St., Asheville NC 28801. (704)258-0316. Graphic Design Studio. Owner: Bob Boeberitz. Clients: ad agencies, malls, furniture manufacturers, resorts, industrial, restaurants.

Needs: Works with 1 freelance photographer/month. Uses photographers for consumer and trade magazines, direct mail, brochures, catalogs, posters. Subjects include studio product shots; some location.

Specs: Uses 8x10 b&w glossy prints; 4x5 transparencies, 35mm slides.

First Contact & Terms: Provide resume, business card, brochure, flyer or tearsheets to be kept on file for possible future assignments. Does not return unsolicited material. Reports "when there is a need." Pays \$50-70/hour; \$200-300/job. Payment made on a per-job basis. Rights purchased vary. Model release preferred.

Tips: Prefers to see "studio capabilities, both b&w and color, creativity" in a portfolio. "Have a unique capability (i.e., studio big enough to drive a bus into) and the ability to turn around a job fast and efficiently. I usually don't have the time to do something twice. Also, stay in budget. No surprises."

CLELAND, WARD, SMITH & ASSOCIATES, Suite 301, 201 N. Broad St., Winston-Salem NC 27101. (919)723-5551. Ad agency. Production Manager: James K. Ward. Clients: primarily industrial, business-to-business.

Needs: Uses photographers for trade magazines, direct mail, brochures and catalogs. Subjects include: "product shots or location shots of plants, offices, workers and production flow; also technical equipment detail shots."

Specs: Uses 8x10 b&w and color prints and transparencies.

First Contact & Terms: Arrange a personal interview to show portfolio. Works with freelance photographers on assignment basis only. Does not return unsolicited material. Pays/job. Pays on acceptance. Buys all rights. Model releases required.

Tips: Prefers to see "innovation-not just execution."

GARNER & ASSOCIATES, INC., Suite 350, 3721 Latrobe Dr., Charlotte NC 28211. (704)365-3455. Art Director: Aecon Stewart. Ad agency. Serves wide range of accounts; client list provided upon request.

Needs: Works with 1-2 freelance photographers/month on assignment only basis. Uses photographers for all media.

First Contact & Terms: Send printed samples or phone for appointment. Payment is by the project or day rate; negotiates according to client's budget. Negotiates photo rights.

LEWIS ADVERTISING, INC., 2309 Sunset Ave., Box Drawer L., Rocky Mount NC 27801. (919)443-5131. Art Director: Scott Brandt. Ad agency. Uses billboards, consumer and trade magazines, direct mail, newspapers, P-O-P displays, product packaging, radio and TV. Serves clients in restaurants, finance and other industries. Deals with a minimum of 6 photographers/year.

Specs: Uses 8x10 and 11x14 glossy b&w prints and 8x10 color transparencies.

Payment & Terms: Pays \$500/day, \$150/b&w photo, also by job and hour. Buys all and one-time rights. Model release required.

Making Contact: Arrange a personal interview to show portfolio or query with samples. SASE. Reports in 2 weeks.

SSF ADVERTISING, (formerly Short Shelper Fogleman Advertising), Drawer 1708, Hickory NC 28603. (704)328-5618. Ad agency. President: James Fry. Clients: industrial, finance, consumer.

Needs: Works with 2-3 freelance photographers/month. Uses photographers for billboards, consumer and trade magazines, direct mail, P-O-P displays, brochures, catalogs, posters, newspapers, AV presentations. Subject needs vary. Also works with freelance filmmakers to produce TV spots, films. **Specs:** Uses b&w or color prints; 35mm, $2^{1/4}x2^{1/4}$ and 4x5 transparencies; 8mm, Super 8mm, 16mm and videotape film.

First Contact & Terms: Query with samples. Works with freelance photographers on assignment basis only. Does not return unsolicited material. Reports back "as need dictates." Payment varies by day, job or per photo. Pays on acceptance. Buys all rights. Model release required; captions optional. **Tips:** Prefers to see "specialties and variety" in a portfolio.

Ohio

ALLIANCE PICTURES CORP., 7877 State Rd., Cincinnati OH 45230. (513)474-5818. Contact: John Gunselman or Don Regensburger. AV firm. Serves clients in advertising, media and entertainment. Produces motion pictures. Provide resume and business card to be kept on file for possible future assignments.

Subject Needs: Commercials to theatrical feature films. Length varies from 30 seconds for a TV spot to 100 minutes for theatrical feature picture. Format varies/production.

Film: Produces entertainment, promotional and special purpose films. 70mm, 35mm and 16mm ECN. Pays royalties "only if necessary."

Photos: Uses 8x10 b&w prints and 4x5 or 8x10 color transparencies.

Payment & Terms: Pays/job. Pays on signed agreement for a specific production. Usually buys world rights forever. Model release required.

Making Contact: Call or write. SASE. Reports in 2 weeks, "if we request its submission."

BARON ADVERTISING, INC., 840 Hanna Bldg., Cleveland OH 44115. (216)621-6800. Ad agency. President: Selma Baron. Clients are "diverse."

Needs: Uses 20-25 freelance photographers/month. Uses photographers for direct mail, catalogs, newspapers, consumer magazines, P-O-P displays, posters, AV presentations, trade magazines, brochures and signage. Subject matter "diverse." Also works with freelance filmmakers.

First Contact & Terms: Query with list of stock photo subjects; provide resume, business card, brochure, flyer or tearsheets to be kept on file for possible future assignments. Work with freelance photographers on assignment basis only. Does not return unsolicited material. Payment "depends on the

photographer." Payment made "when job is finished." Buys all rights. Model release required.

Tips: Prefers to see "food and equipment" photos in the photographer's samples. "Samples not be be returned other than regional photographers."

BRAND PUBLIC RELATIONS, 1600 Keith Bldg., Cleveland OH 44115. (216)696-4555. Division of ad firm. Director of Public Relations: Bruce Hackett. Clients: industrial, consumer, medical, consumer, agri-business, associations.

Needs: Works with 1 freelance photographer every 2 months. Uses photographers for trade magazines, feature story photos at varied sites. Subjects include "publicity photos of client's product in use for feature story." Occasionally works with freelance filmmaker or videographer to produce public service announcements or special projects.

Specs: Uses 5x7 and 8x10 b&w or color glossy prints; 35mm, 21/4x21/4 and 4x5 transparencies; 16mm,

35mm and videotape film.

First Contact & Terms: Provide resume, business card, brochure, rate schedule, flyer or tearsheets to be kept on file for possible future assignments. Works with freelance photographers on assignment basis only. Does not return unsolicited material. "No response if unsolicited." Pays \$50-700/job or negotiable with project quote. Pays on acceptance. Buys all rights including negatives. Model release required; captions preferred.

Tips: "Submit resume, rates and any description of publicity photo experience."

BRIGHT LIGHT PRODUCTIONS, 420 Plum St., Cincinnati OH 45202. (513)721-2574. President: Linda Spalazzi. Film and videotape firm. Clients: national, regional and local companies in the governmental, educational, industrial and commercial categories. Produces 16mm and 35mm films and videotape. Works with freelance photographers on assignment only basis. Provide resume, flyer and brochure to be kept on file for possible future assignments. Pays \$100 minimum/day for grip; negotiates payment based on photographer's previous experience/reputation and day rate (10 hrs). Pays on completion of job and within 30 days. Call to arrange an appointment or query with resume of credits. Wants to see sample reels or samples of still work.

Film: 16mm and 35mm documentary, industrial, educational and commercial films. Produces Super 8, reduced from 16mm or 35mm, but doesn't shoot Super 8 or 8mm. Sample assignments include camera

assistant, gaffer or grip.

CORBETT ADVERTISING, INC., 40 S. 3rd St., Columbus OH 43215. (614)221-2395. Art Director: Steve Beskid. Ad agency. Clients: hospitals, insurance, colleges, restaurants and industrial. **Needs:** Works on assignment basis only. Uses photographers for billboards, consumer and trade magazines, brochures, posters, newspapers and AV presentations.

First Contact & Terms: Arrange interview to show portfolio. Payment is by the hour, by the day, and by

the project; negotiates according to client's budget.

FAHLGREN & FERRISS, INC., 136 N. Summit, Toledo OH 43604. (419)241-5201. Art Director: Cathy Rennels. Ad agency. Clients: industrial and financial.

Needs: Works with 8 freelance photographers/month. Uses photographers for P-O-P displays, consumer and trade magazines, direct mail, brochures/flyers and newspapers.

First Contact & Terms: Call for appointment to show portfolio or make contact through photographer's representative. Negotiates payment based on client's budget, amount of creativity required and where work will appear.

GERDING PRODUCTIONS, INC., 2306 Park Ave., Cincinnati OH 45206. (513)861-2555. Vice President: Jeff Kraemer. AV producer. Clients: ad agencies, TV networks, business, industry, and state and US government. Produces multimedia kits, motion pictures and videotape. Works with 1 freelance

photographer/month on assignment only basis. Provide resume to be kept on file for future assignments. Buys 25 photos/year.

Subject Needs: Industrial and TV. Uses freelance photos within films and programs.

Film: Produces 16 and 35mm movies for TV, industry, education and commerce. Interested in stock footage.

Photos: Prefers 8x10 prints; transparencies or 4x5 or 8x10 transparencies.

Payment & Terms: Pays/job or /hour; negotiates payment based on client's budget. Buys all rights. Model release required.

Making Contact: Send material by mail for consideration. SASE. Reports in 2 weeks.

GRISWOLD INC., 55 Public Sq., Cleveland OH 44113. (216)696-3400. Executive Art Director: Tom Gilday. Ad agency. Clients: Consumer and industrial firms; client list provided upon request. Provide brochure to be kept on file for possible future assignments.

Needs: Works with freelance photographers on assignment only basis. Uses photographers for billboards, consumer and trade magazines, direct mail, P-O-P displays, brochures, catalogs, posters,

newspapers and AV presentations.

First Contact & Terms: Works primarily with local freelancers but occasionally uses others. Arrange interview to show portfolio. Payment is by the day or by the project; negotiates according to client's budget. Pays on production.

HAYES PUBLISHING CO., INC., 6304 Hamilton Ave., Cincinnati OH 45224. (513)681-7559. Office Manager: Marge Lammers. AV publisher. Clients: school, civic and right-to-life groups. Produces filmstrips and slide-cassette sets. Subjects include "miscellaneous baby, child and adult scenes." Needs photos of prenatal development of the human body and shots relating to abortion. Buys all rights. Contact by mail first. Reports in 2 weeks. SASE.

B&W: Contact by mail about specifications and needs first.

Color: Uses 35mm transparencies or 35mm negatives with 5x7 glossy prints. Captions and model release required. Pays \$50 minimum.

Tips: "We are always looking for excellent, thoroughly documented and authenticated photographs of early developing babies and of any and all types of abortions."

HESSELBART & MITTEN, INC., 2680 W. Market St., Fairlawn OH 44313. (216)867-7950. Director: John Ragsdale. Ad agency. Clients: one half consumer and one half industrial; client list provided on request. Provide business card and flyer to be kept on file for possible future assignments. Needs: Works with 5 freelance photographers/month on assignment only basis. Uses photographers for billboards, consumer and trade magazines, direct mail, P-O-P displays, brochures, catalogs, posters, signage and newspapers.

First Contact & Terms: Arrange interview to show portfolio. SASE. Reports in 1 month.

JACKSON/RIDEY & COMPANY, INC., 424 East 4th St., Cincinnati OH 45202. (513)621-8440. Production Director: Mark Schlachter. Advertising agency. Uses brochures, newsletters, annual reports, PR releases, AV presentations, sales literature, consumer and trade magazines. Serves fashion, food, finance, travel and industrial clients. Assigns 50-75 jobs/year.

Specs: Uses 8x10 b&w and color prints; 2¹/₄x2¹/₄ or 4x5 color transparencies. Works with freelance filmmakers on 16-35mm industrial and occasional production of stock for TV commercials.

Payment & Terms: Pays \$20-75/hour, \$20 minimum/job; \$600/day maximum. Buys all rights. Model release required.

Making Contact: Arrange a personal interview with Production Director Mark S. Schlachter to show portfolio or query with samples. SASE. Prefers local freelancers. Reports in 2 weeks.

Tips: "We want to see that a photographer can take direction and work to specifications. We are more concerned with getting what we want than what a photographer thinks we should have. We want to see good commercial and editorial work—b&w or color. The photographer should leave his artsy stuff at home. Seems to be a trend toward the use of large prints—30x40" and bigger."

LANG, FISHER & STASHOWER, 1010 Euclid Ave., Cleveland OH 44115. (216)771-0300. Senior Art Director: Larry Pillot. Ad agency. Clients: consumer firms.

Needs: Works with 5 freelance photographers/year on assignment only basis. Uses photographers for all media

First Contact & Terms: Local freelancers primarily. Query with resume of credits and samples. Payment is by the project; negotiates according to client's budget, amount of creativity required, where work will appear and freelancer's previous experience.

McKINNEY/GREAT LAKES, 1166 Hanna Bldg., Cleveland OH 44115. (216)621-0648. Art Directors: Doug Pasek, Harry Bush, Ed Gamary. An integrated full-service ad agency. Clients: consumer, business-to-business.

Needs: Uses freelancers for people, product and architectural photography.

First Contact & Terms: Call for appointment to show portfolio. Negotiates payment based on photographer's fees.

Tips: Mainly likes to see dramatic compositional and design elements. Primarily uses local photographers.

MANABACH & SIMMS/OHIO, INC., 228 Park Ave. West, Mansfield OH 44902. (419)522-7281. Art Director: Charles Bowen. Ad agency. Clients: industrial, trade, consumer-oriented products. Needs: Works with 2-3 freelance photographers/month. Uses photographers for trade magazines, direct mail, P-O-P displays, brochures, catalogs, posters, newspapers. "We occasionally purchase stock," Specs: Uses 4x5 to 16x20 medium matte prints; 35mm, 4x5 and 8x10 transparencies.

First Contact & Terms: Arrange a personal interview to show portfolio. Works with freelance photographers on assignment basis only. Does not return unsolicited material. Pays on acceptance. Buys

all rights. Model release required; captions optional.

Tips: "Proximity is relatively important."

MARK ADVERTISING AGENCY, INC., 411 E. Market St., Sandusky OH 44870. (419)626-9000. President: Joseph Wesnitzer. Ad agency. Media includes consumer and trade magazines, direct mail and newspapers. Serves clients in industry. Submit portfolio. Cannot return unsolicited material. B&W: Uses 8x10 glossy prints.

Color: Uses 35mm, 21/4x21/4 and 4x5 transparencies. Also uses 8x10 glossy prints.

NATIONWIDE ADVERTISING, INC., Euclid Ave. at E. 12th St., Cleveland OH 44115. (216)579-0300. Contact: Creative Director. Ad agency. "This is a recruitment agency which is utilized by a wide variety of clientele, really indiscriminate.

Needs: Works with "very few freelancers but this could change." Uses freelancers for billboards,

consumer and trade magazines, newspapers and TV.

First Contact & Terms: Send samples, but "does not want actual portfolio." Selects freelancers "by how easily accessible they are and the characteristics of their work." Negotiates payment based on client's budget. Does not return unsolicited material.

*NORTHLICH, STOLLEY, INC., 200 W. 4th St., Cincinnati OH 45202. Creative Director: Craig Jackson. Ad agency. Clients: financial, industrial, food service, package goods, durables; client list provided on request.

Needs: Works with 5-6 freelance photographers/month on assignment only basis. Uses photographers for consumer and trade magazines, direct mail, P-O-P displays, brochures, posters, signage, newspapers

and AV presentations.

First Contact & Terms: Query with list of stock photo subjects; provide brochure, flyer and tearsheets to be kept on file for possible future assignments.. Does not return unsolicited material. Reports in 1 week. Negotiates payment according to client's budget. Pays on production.

THE PARKER ADVERTISING COMPANY, 3077 S. Kettering Blvd., Dayton OH 45439. (513)293-3300. Art Director: Sazro Mahambrey. Ad agency. Clients: industrial.

Needs: Works with 3-4 freelance photographers/year. Uses photographers for trade magazines, direct mail, brochures, catalogs, posters and AV presentations.

First Contact & Terms: Send name, address and samples to be kept on file. Not returnable.

*THE SHOW BIZ, 3040 W. Market St., Akron OH 44313. (216)864-5433. President: Sam Brown. Clients: industrial (BFG, Babcock & Wilcox, Hilti, etc.), commercial (Revco, K-Mart, etc.), consumer (BMW, Porsche, GE Lamp).

Needs: Works with 4-5 photographers/month. Uses photographers for multimedia productions. Subjects include generic scenes: sports, geography, industry at work, topographical (mountains, oceans), mood (sunsets, etc.), shoppers.

Specs: Uses 35m and 4x5 transparencies.

First Contact & Terms: Submit portfolio; query with samples and stock photo list; provide resume, business card, self-promotion piece or tearsheets to be kept on file for possible future assignments. Works with freelancers by assignment only; interested in stock photos/footage. SASE. Reports in 2 weeks. Pays \$25-50/slide and \$300-500/day. Pays 30 days after receipt of invoice. Buys all rights. Model release preferred.

WYSE ADVERTISING, 24 Public Square, Cleveland OH 44113. (216)696-2424. Art Director: Tom Smith. Ad agency. Uses billboards, consumer and trade magazines, direct mail, newspapers, P-O-P displays, radio and TV. Serves clients in a variety of industries. Deals with 20 photographers/year. Specs: Uses b&w photos and color transparencies. Works with freelance filmmakers in production of TV commercials.

Payment/Terms: Pays by hour, day and job. Buys all rights. Model release required.

Making Contact: Arrange a personal interview to show portfolio.

Oklahoma

ADSOCIATES, INC., 3727 NW 63 St., Oklahoma City OK 73116. (405)840-1881. Creative Director: Bob Stafford. Ad agency. Clients: 50% industrial, 50% consumer firms; client list provided upon request.

Needs: Works with 6 freelance photographers/month on assignment only basis. Uses photographers for all media.

First Contact & Terms: Query with resume of credits and samples. Payment is by the project; negotiates according to client's budget.

DPR COMPANY, 6161 N. May, Oklahoma City OK 73112. (405)848-6407. Owner: B. Carl Gadd. Industrial PR firm. Photos used in brochures and press releases. Buys 35-100 photos/year. Pays \$50 minimum/hour, \$400 minimum/day. Pays on production. Photos solicited by assignment only; query with resume of credits or call to arrange an appointment; provide business card and flyer to be kept on file for possible future assignments. Reports in 1 week. Does not return unsolicited material.

Film: Produces all types of film. Buys all rights.

B&W: Uses 5x7 glossy prints.

SASE. Reports in 2 weeks.

Color: Uses any size transparencies and prints.

Tips: "All material should be dated and the location noted. Videotape is now 80% of my product needs."

JORDAN ASSOCIATES ADVERTISING & COMMUNICATIONS, 1000 W. Wilshire, Box 14005, Oklahoma City OK 73113. (405)840-3201. Director of Photography: John Williamson. Ad agency. Uses billboards, consumer and trade magazines, direct mail, foreign media, newspapers, P-O-P displays, radio and TV, annual report and public relations. Clients: banking, manufacturing, food, clothing. Generally works with 2-3 freelance photographers/month on assignment only basis.

Specs: Uses b&w prints and color transparencies. Works with freelance filmmakers in production of 16mm industrial and videotape, TV spots; short films in 35mm.

Payment & Terms: Pays \$25-55 minimum/hour for b&w, \$200-400 minimum/day for b&w or color (plus materials). Negotiates payment based on client's budget and where the work will appear. Buys all

rights. Model release required.

Making Contact: Arrange a personal interview to show portfolio (prefers to see a complete assortment of work in a portfolio); provide flyer and business card to be kept on file for possible future assignments.

LOWE RUNKLE CO., 6801 N. Broadway, Oklahoma City OK 73116. (405)848-6800. Art Director: Dean Clark. Ad agency. Uses billboards, consumer and trade magazines, direct mail, foreign media, newspapers, P-O-P displays, radio and TV. Serves industrial, fashion, financial, entertainment, fast food and consumer clients. Deals with 12 photographers/year.

Specs: Uses b&w photos and color transparencies.

Payment/Terms: Pays \$40-65/hour; \$300-500/day. Buys all and one-time rights. Model release required, wants to know where photos taken.

Making Contact: Arrange a personal interview to show portfolio. SASE. Prefers local freelancers. Reports in 2 weeks.

Tips: "Be fast and convenient and moderately priced for this market area and meet deadlines."

Oregon

*ASSOCIATED FILM PRODUCTION SERVICES, 1712-a Willamette St., Eugene OR 97401. (503)485-8537. Casting Executive: Katherine Wilson. AV firm. Serves national advertising agencies, filmmakers and print media. "We provide a full spectrum of services for film and video productions." Subject Needs: Photos of unusual places and people. ("We have national requests for these.") Special needs include photos of Oregon cities, interesting buildings and scenic wonders. Film: All types; videotape, all sizes.

Photos: Uses 8x10 b&w and 3x5 color. Prefers b&w contact sheets, color prints.

Payment & Terms: "Payment depends on the amount of money the project can afford, usually around \$20/hour for portfolio shots. Flat fees negotiated for stock photos."

Making Contact: Telephone. SASE. Reports in 1 week.

HUGH DWIGHT ADVERTISING, 4905 SW Griffith Dr., Beaverton OR 97005. (503)646-1384. Ad agency. Production Manager: Pamela K. Medley. Clients: industrial, outdoor sports equipment, lumber, funeral service.

Needs: Works with 3-4 freelance photographers/month. Uses photographers for trade magazines, P-O-P displays, brochures, catalogs, posters, AV presentations, news releases, product sheets, ads. Subjects include: "product shots (in-studio); feature photos (with accompanying manuscript) on wood products; photos of products made from Roseburg Lumber materials: people shots."

Specs: Uses 35mm, 21/4x21/4 and 4x5 transparencies.

First Contact & Terms: Arrange a personal interview to show portfolio; query with samples or send unsolicited photos by mail for consideration; provide resume, business card, brochure, flyer or tearsheets to be kept on file for possible future assignments. SASE. Reports in 3 weeks. Payment "depends on the work; we're flexible." Pays on acceptance with ad and public relation shots; on publication with feature photos and articles. Buys one-time rights with features. Model release and captions required. Credit line given on catalogs and magazines only.

Tips: Prefers to see tearsheets and prints. "Show a range of photos, from sharp studio photos (well lighted) to outdoor hunting shots, from traditional "mug" shots to shots of men working outdoors, from nuts and bolts to yachts at sea. Show capabilities of working with different lighting (indoor, outdoor,

available, etc.).'

RYAN/RYAN SOUTHWICK ADVERTISING & PUBLIC RELATIONS, Suite 400, 1201 SW 12th, Century Tower Bldg., Portland OR 97201. (503)227-5547. Art Directors: Leslie Herzfeld and Jerry Ketel. Ad agency and PR firm. Uses billboards, direct mail, foreign media, newspapers, promotions, P-O-P displays, radio, TV, trade and consumer magazines, brochures, annual reports and slide/tape presentations. Serves industrial, corporate, retail and financial clients. Deals with 5-10 photographers/year. Provide business card, brochure, and flyer to be kept on file for possible future assignments.

Specs: Uses 8x10 glossy b&w photos, RC prints for retouching and 35mm and 4x5 transparencies. Also uses freelance filmmakers in production on 16mm and tape industrial, training films and commercial

production.

Payment & Terms:Pays \$25 minimum/hour. "All projects quoted in advance." Buys all rights. Model release required.

Making Contact: Send material by mail for consideration. SASE. Prefers local freelancers. Reports in 2 weeks.

Tips: Prefers to see "industrial, financial, business, promotional, humorous, special effects and product shots" in a portfolio. Prefers to see "prints, tearsheets to support transparencies" as samples. "I like to know the format used and why—also what equipment, studios, etc. are available. Keep in touch, show us new projects. Send us sample postcards of mailings; we keep 'em on file and it really helps in selecting photographers!"

WILL VINTON PRODUCTIONS, 2580 NW Upshur St., Portland OR 97209. (503)225-1130. Contact: Office Manager. AV firm. Clients: theatrical and nontheatrical film market (foreign and domestic), TV. Produces motion pictures. Makes on the average 3 films/year.

Subject Needs: "Our films are made for the theatre and television, with few exceptions. They are clay-animated (in Claymation) and deal essentially with the human condition. Running time: 5 to 90 minutes."

Film: Produces 35mm films, mostly in Claymation.

Payment & Terms: Pays \$5-20/hour; negotiates payment based on amount of creativity required from photographer, where the work will appear and photographer's previous experience/reputation. Pays on production. Pays oll rights. Model along the production of the pays of th

production. Buys all rights. Model release and captions required.

Making Contact: Send letter with resume; send material by mail for consideration; or submit portfolio. "We don't want to see any still photos as examples of what the photographer can do in motion picture film. Sample reels will be viewed as time permits, and returned only if accompanied by SASE with proper postage. Mainly interested in seeing photographer's work in clay or object animation, and special effects." SASE. Reports in 2-3 weeks.

Tips: "Minimize your expectations. We only use outside work about twice a year, and almost always on impulse and for a week or so at a time. We'll put your name and number on file if you sound like a good prospect, but don't wait by the phone." Provide resume, brochure and tearsheets to be kept on file for possible future assignments.

Pennsylvania

ANIMATION ARTS ASSOCIATES, 1100 E. Hector St., Conshohocken PA 19428. (215)563-2520. President: Harry E. Ziegler, Jr. AV firm. Clients: industry, business, pharmaceutical firms, government, publishing, advertising. Produces filmstrips, slide sets, multimedia kits, motion pictures and soundslide sets. Works with 4 freelance photographers/month on assignment only basis. Provide resume to be kept on file for possible future assignments. Buys 100 photos, 25 filmstrips and 35 films/year. Pays \$150-350/day; negotiates payment based on client's budget. Pays 30 days after invoice. Buys all rights. Model release and captions required. Query with resume of credits in 16mm film production. Local freelancers only. Does not return unsolicited material. Reports "only when we have a requirement." Subject Needs: Location photography for training, sales promotion and documentary, mostly 16mm film. Photos used in slides also. Length: 80 frames/slides; 40-180 frames/filmstrips; 30 seconds-30 minutes/16mm film.

Specs: Uses 35mm, 21/4x21/4, 4x5 and 8x10 transparencies; 16mm and 35mm film; VHS, U-matic 3/4"

videotape.

TED BARKUS COMPANY, INC., 225 S. 15th St., Philadelphia PA 19102. (215)545-0616. Ad agency and PR firm. Vice President: Allen E. Barkus. Clients: industrial, finance, appliances, home furnishings, publishers.

Needs: Uses 1 freelance photographer/month. Uses photographer for direct mail, catalogs, newspapers, consumer magazines, P-O-P displays, posters, AV presentations, trade magazines and brochures. Subjects include "products, office scenes, etc." Uses freelance filmmakers to produce TV commercials and AV films.

Specs: Uses 4x5 and 8x10 b&w and color prints, 35mm transparencies, videotape.

First Contact & Terms: Arrange a personal interview to show portfolio. Works with local freelancers only. SASE. Reports in 3 weeks. Payment varies. Pays on acceptance. Buys all rights. Model release required; captions optional. Credit line sometimes given.

*DON BISHOP COMMUNICATIONS, 1142 E. Market St., York PA 17403. (717)846-3856. Producer: Don Bishop. Clients: business, industry, associations.

Needs: Works with 6 photographers/month. Uses photographers for slide sets, multimedia productions, films, videotapes.

Specs: Uses 35mm and 4x5 transparencies; 16mm film; U-matic 3/4" videotape.

First Contact & Terms: Query with resume. Works with freelancers by assignment only. Reports in 3 weeks. Pays \$250-900/day. Pays on acceptance. Buys one-time rights and all rights. Captions preferred; model release required. Credit line sometimes given.

BLUMENTHAL/HERMAN ADVERTISING, Gwynedd Plaza 2, Bethlehem Pike, Spring House, PA 19477. (215)628-3050. Ad agency. Art Director: Betsi Capraro. Clients: industrial, finance, health service, business forms, electronic engineering. Client list provided on request.

Needs: Uses 6 freelance photographers/year. Uses photographer for direct mail, newspapers, trade magazines and brochures. Subject matter includes products shots and locations. Uses freelance filmmakers to produce TV commercials.

Specs: Varies from job to job.

First Contact & Terms: Arrange a personal interview to show portfolio; query with samples; provide resume, business card, brochure, flyer or tearsheets to be kept on file for possible future assignments. Works with local freelance photographers only. SASE. Reports in 1 month. Pays \$300-1,200/day; \$75 minimum/job. Pays on publication. Rights are "always specified." Model release preferred. Credit line given if requested.

Tips: "Portfolio should be directed towards our client's needs. Show portfolio, tearsheets. If hired, be

dependable, quick, creative!"

*BRODY VIDEO, INC., 1400 Mill Creek Rd., Gladwyne PA 19053. (215)649-6200. Studio Manager: Duncan Love. Clients: commercial, industrial, record companies.

Needs: Works with 1-2 photographers/month. Uses photographers for films and videotapes.

Specs: Uses 16mm and 35mm film, U-matic 3/4" and 1" videotapes.

First Contact & Terms: Submit portfolio by mail. Works with local freelancers only. SASE. Reports if SASE is enclosed. Payment determined upon hire. Rights vary. Credit line given where applicable. Tips: "We use people who fit our needs. We are involved in several phases of video and film production. Music videos are in. Commercials shot on 35mm are great and industrial work pays the bills."

BULLFROG FILMS, Oley PA 19547. (215)779-8226. President: John Abrahall. AV firm. Clients: churches, schools, colleges, public libraries, adult groups. Produces and distributes 16mm films, filmstrips and video cassettes. Subjects and photo needs cover "nutrition, agriculture, energy, appropriate technology (helping people to 'live lightly' on the earth)." Works with freelance photographers on assignment only basis. Provide flyer to be kept on file for possible future assignments. Buys 10 filmstrips and 15 films annually. Pays royalties for all materials: "25% of the gross receipts on sales and rentals, payable quarterly." Submit material by mail for consideration. Reports in 1 month. SASE. Film: Completed 16mm films on nutrition, agriculture, energy and environmental issues, gardening and "appropriate technology" only.

Color: Send 35mm transparencies "or any transparency stock suitable for reproduction in quantity."

Completed filmstrips only.

Tips: "We are looking for films/filmstrips that have some specific education content in the subject areas mentioned. Practical instructions for the average person are preferred. 10-20 minutes is the best length.'

*BILL BYRON PRODUCTIONS, 1727 Elm St., Bethlehem PA 18017. (215)865-1083. Producer: Bill Byron. Clients: recording artists.

Needs: Works with 1-6 photographers/year. Uses photographers for album covers and promo. Subjects

vary according to projects.

Specs: Uses 8x10 matte b&w prints, 8x10 color prints; 4x5 transparencies; VHS, and U-matic 3/4

videotape.

First Contact & Terms: Provide resume, business card, self-promotion piece or tearsheets to be kept on file for possible future assignments. Works with local freelancers on assignment basis only. Reports in 1 month. Pay varies according to contract with artist. Pays on acceptance, royalties by sale. Buys one-time rights. Model release required. Credit line given.

DIX & EATON, INC., 1100 Baldwin Bldg., Erie PA 16501. (814)453-5767. Ad agency. Production Manager: Kris Baumann. Client: industrial.

Needs: Works with 4 freelance photographers/month. Uses photographers for trade magazines, brochures, AV presentations. Subjects: primarily machinery; industrial products. Also works with freelance filmmakers to produce AV presentations.

Specs: Uses 8x10 and 11x14 b&w or color glossy prints; 21/4x21/4 and 4x5 transparencies; videotape. First Contact & Terms: Provide resume, business card, brochure, flyer or tearsheets to be kept on file for possible future assignments. Does not return unsolicited material.

JERRYEND COMMUNCATIONS INC., Box 356H, RD #2, Birdsboro PA 19508. (215)689-9118. PR firm. Vice President: Jerry End. Clients: industrial, automotive aftermarket, financial, heavy equipment.

Needs: Works with 2 freelance photographers/month. Uses photographers for consumer and trade magazines, catalogs, newspapers, AV presentations. Subjects include case histories/product applications. Also works with freelance filmmakers to produce training films, etc.

Specs: Uses 8x10 b&w repro-quality prints and color negatives.

First Contact & Terms: Provide resume, business card, brochure, flyer or tearsheets to be kept on file for possible future assignments. Works with freelance photographers on assignment basis only. SASE. Reports in 1 week. Pays "by estimate for project." Pays on receipt of photos. Buys all rights. Model release required; captions preferred.

*KENNEDY/LEE, INC., RD 12, York PA 17406. (717)757-4666. AV firm. President: Don Kennedy. Clients: "primarily industrial. Some home furnishings, beer, bread, et. al." Client list free with SASE. Needs: Works with "almost no freelance photographers in Mid-Atlantic area. We do buy photography/ cinematography a few times per year from freelancers in other parts of the country." Uses photographers for AV presentations. Subjects include "industrial scenes, interior and exterior . . . and 'travelogue' shots representing a specific area of the country. We work with photographers, cinematographers, camerapersons for jobs including image films, product introduction, training, orientation, recruiting, TV spots, et al.'

Specs: Uses 35mm, 21/4x21/4, 4x5 or 8x10 (rarely) transparencies; 16mm, 35mm film; 1/2 3/4 and 1" videotape.

First Contact & Terms: Provide resume, business card, brochure, flyer or tearsheets to be kept on file for possible future assignments. Works with freelance photographers on assignment basis only. Does not return unsolicited material. "Please do not submit anything on spec." Pays \$50 first hour; \$150 for halfday; \$250 for one-person day; \$350 for a two-person day. Pays on acceptance. Buys all rights (work for hire). Model release required.

Tips: "Studio tabletops not needed. Prefers industrial interiors and exteriors; travelogue shots of freelancers, geographic area; also information on camera and lighting equipment available for stills, motion picture, and videotape. We'd like information and samples we can keep on file. Do not go to great

expense. After initial contact, 16mm or videotape samples will be returned."

*HOWARD MILLER ASSOCIATION, INC., 103 S. Duke St., Lancaster PA 17602. (717)291-1130.

Associate Creative Director: Barry Tager. Clients: industrial, 90%; other, 10%.

Needs: Works with 1-2 photographers/month. Uses photographers for trade magazines, direct mail, posters, corporate and product brochures. Subject matter is quite variable, from studio product and "beauty" shots to industrial location shots.

Specs: Uses 8x10 glossy b&w prints; others depending on job.

First Contact & Terms: Query with resume of credits, query with samples; provide resume, business card, flyer or tearsheets to be kept on file for possible future assignments. Works with freelance photographers on an assignment basis only. Does not return unsolicited material. Reports in 3 weeks. Pays \$300-1,000/day. Pays on receipt of invoice, net 30 days. Buys all rights. Model release required. Tips: "We want to see portfolio *after* submission of a few samples/tearsheets—any subject OK/industrial preferred. Most important is evidence of creativity."

RICHARSON MYERS & DONOFRIO, 10 Penn Center, Philadelphia PA 19037. (215)569-0500. Ad

agency. Contact Art Director. Client list provided on request.

Needs: Uses photographers for billboards, consumer and trade magazines, direct mail, brchures, catalogs, posters, newspapers. Subjects include fashion, agriculture, chemicals. Also works with

freelance filmmakers to produce TV commercials.

First Contact & Terms: Query with resume of credits or samples; arrange a personal interview to show portfolio; query with list of stock photo subjects. Provide resume, business card, brochure, flyer or tearsheets to be kept on file for possible future assignments. Works with freelance photographers on assignment basis only. Pays by the job. Busy rights "agreed upon per job." Model release required. Credit line sometimes given.

Tips: "Show portfolio-contact and update from time to time."

LIZ SCOTT ENTERPRISES, Box 7138 Pittsburgh PA 15213. (412)661-5429. Contact: Liz Scott. Ad agency and PR firm. Clients: community organizations, publishing and private enterprise. Photos used in brochures, newsletters and PR releases. Works with 1 freelance photographer/month on assignment only basis. Provide resume and letter of inquiry to be kept on file for possible future assignments. Buys 5-10 photos/year. "We often receive our photos from our clients and rarely use freelancers. Photos are usually purchased by the client separately." Credit line given. Negotiates payment based on client's budget and where the work will appear. Buys all rights. Query with resume of credits. Local freelancers preferred. SASE. "Photographer must follow up queries unless SASE is included." Interested in photos of persons involved in industrial, community or client projects. No art photos.

B&W: Uses 5x7 prints; contact sheet OK. Pays \$10 minimum/photo.

Color: "There is little demand at this time for color."

PERCEPTIVE MARKETERS AGENCY, LTD., Suite 903, 1920 Chestnut St., Philadelphia PA 19103. (215)665-8736. Ad agency. Art Director: Marci Mansfield Fickes. Clients: retail furniture, contract furniture, commuter airline, lighting distribution companies; nonprofit organizations for the arts, publishing houses. Client list free with SASE.

Needs: Buys 100 freelance photographs and makes 10-15 assignments/year. Uses photographers for consumer and trade magazines, direct mail, catalogs, posters, newspapers. Subjects include product,

people, industrial (on location). No fashion.

Specs: Uses 8x10 b&w prints and 35mm, 21/4x21/4, 4x5 and 8x10 transparencies.

First Contact & Terms: Query with resume of credits and list of stock photo subjects; send unsolicited photos by mail for consideration; provide resume, business card, brochure, flyer or tearsheets to be kept on file for possible future assignments. Works with local freelance photographers on an assignment basis only. Reports after contract. Pay individually negotiated. Pays on receipt of invoice. Buys all rights. Model release required. Credit line negotiable, depending on photo's use.

SPIRO & ASSOCIATES, 100 S. Broad St., Philadelphia PA 19110. (215)923-5400. Ad agency. Vice President/Creative Director: H. Robert Lesnick. Executive Art Director: Jack Bythrow. Offers a

"complete range of services" to all types of clients. Client list available on request.

Needs: Works with 10-20 freelance photographers/month. Uses photographers for billboards, consumer and trade magazines, direct mail, P-O-P displays, brochures, posters, newspapers, AV presentations. Subjects include travel shots utilizing people. Also works with freelance filmmakers to produce TV. **Specs:** Uses varied b&w and color prints; 35mm, $2^{1}/4x2^{1}/4$, 4x5 and 8x10 transparencies.

First Contact & Terms: Arrange a personal interview to show portfolio; submit portfolio for review; provide resume, business card, brochure, flyer or tearsheets to be kept on file for possible future assignments. Works with local freelancers on assignment basis only. "Prefer not to" return unsolicited material. Pays by the day, job, or photo; payment varies. Pays on acceptance. Buys all rights. Model release required.

The use of photography to convey a message is exemplified in this series of trade advertising photos taken by Philadelphia freelance photographer Wayne Cozzolino for Perceptive Marketers Agency. Inc., an ad agency in Philadelphia. The client, Lighting Consultants. Cleveland, Ohio, used the ad for a national home center show featuring its products.

Tips: Prefers to see photos "utilizing people doing things, enjoying life. Show us samples first, we will wait for appropriate time."

THOMPSON/MATELAN & HAWBAKER, INC., Gateway Towers, Suite 318, Gateway Center, Pittsburgh PA 15222. (412)261-6519. Head Art Director: Ron Larson. Ad agency. Uses direct mail, newspapers, trade magazines, radio and TV. Serves primarily industrial clients. Commissions 10 photographers/year. Buys all rights. Model release required. Query with resume of credits. SASE. Reports in 2 weeks.

B&W: Uses 8x10 glossy prints; contact sheet and negatives OK. Color: Uses 8x10 glossy prints, 35mm and 4x5 transparencies.

South Carolina

BRADHAM-HAMILTON ADVERTISING, Box 729, Charleston SC 29402. (803)884-6445. Ad agency. Contact: Art Director. Clients: industrial, fashion, finance, insurance, real estate, tourism, hotel, beverage, etc.

Needs: Works with 2 freelance photographers/month. Uses photographers for billboards, direct mail, newspapers, consumer magazines, P-O-P displays, posters, AV presentations, trade magazines and brochures. Subjects: all types.

Specs: Uses 8x10 b&w and color glossy prints; 35mm or 21/4x21/4 transparencies.

First Contact & Terms: Query with samples or submit portfolio for review; provide resume, business card, brochure, flyer or tearsheets to be kept on file for possible future assignments. Works with freelance photographers on assignment basis only. Pays according to budget and relative value of job and by quotation, generally \$25-150/b&w photo; \$50-400/color photo; \$100/hour; or \$750/day. SASE. Reports in 1 week. Pays on acceptance. Buys all rights or one-time rights. Model release required. **Tips:** "Show us your best and keep us up-dated on any of your particular interesting new work."

*LOWE & HALL ADVERTISING, INC., 215 W Stone Ave., Box 3357, Greenville SC 29602. (803)242-5350. Vice President/Art Director: Tom Hall. Ad agency. Uses billboards, consumer and trade magazines, direct mail, newspapers, P-O-P displays, radio and TV. Clients: finance and industry. Commissions 6 photographers/year; buys 50 photos/year. Buys all rights. Model release required. Arrange personal interview to show portfolio or query with list of stock photo subjects; will view unsolicited material. SASE. Reports in 2 weeks.

B&W: Uses 8x10 semigloss prints.

Color: Uses 8x10 semigloss prints and 21/4x21/4 transparencies.

Film: Produces 16mm industrial films and filmstrips. Does not pay royalties.

*SHOREY AND WALTER, INC., 1617 E. North St., Greenville SC 29607. (803)242-5407. Art Directors: Bo Coyle/Frank VanAuken. Ad agency. Uses all media. Clients: textiles, industrials, hosiery, packaging, sporting goods, treated wood products, finance, pharmaceuticals. Needs fashion, nature, architectural and special effects photos; table-top product shots; etc. Negotiates payment based on client's budget, amount of creativity required from photographer and photographer's previous experience/reputation. Call to arrange an appointment. No original art or photos; will not return material. Provide flyer, business card and brochure to be kept on file for possible future assignments.

Tennessee

BRUMFIELD-GALLAGHER, 3401 W. End Ave., Nashville TN 37203. (615)385-1380. Creative Art Director: Chuck Creasy. Senior Art Director: Kathy Benson. Clients: industrial, finance, real estate, package goods and service.

Needs: Works with 6 freelance photographers/month. Uses photographers for direct mail, catalogs, newspapers, consumer and trade magazines, P-O-P displays, posters, AV presentations and brochures. Subjects include people for banks, products, books. Also works with freelance filmmakers for corporate films and finance spots.

Specs: Uses 8x10 b&w or color prints; 35mm, 21/4x21/4, 4x5 transparencies and 16mm film or videotape.

First Contact & Terms: Arrange a personal interview to show portfolio. Works with freelance photographers on assignment basis only. Does not return unsolicited material. Reports in 2 weeks. Pays \$50-150/hour; \$35-1,500/day and \$200 minimum/job. Pays on acceptance. Buys all rights. Model release required.

*BUNTIN ADVERTISING, INC., 1001 Hawkins St., Nashville TN 37203. (605)244-5720. Ad agency. Vice President Operations: Jack Pentzer. Clients: food, financial, retail.

Needs: Works with 5 photographers/month. Uses photographers for billboards, consumer and trade magazines, direct mail, P-O-P displays, catalogs, posters and newspapers. Subject matter varied.

Specs: Uses 8x10 b&w prints and 35mm, 4x5, and 8x10 transparencies.

First Contact & Terms: Arrange a personal interview to show portfolio, or submit portfolio for review; provide resume, business card, brochure, flyer or tearsheets to be kept onfile for possible future assignments. Works with freelance photographers on an assignment basis only. Does not return unsolicited material. Reports in 2 weeks. Payment per hour negotiable. Pays 60 days after receipt of invoice, unless negotiated. Buys all rights. Model release required. Credit line rarely given.

CARDEN & CHERRY ADVERTISING AGENCY, 1220 McGauock St., Nashville TN 37203. (615)255-6694. Ad agency. Associate Creative Director: Glenn Petack. Clients: TV stations, dairies, savings and loans, car dealers (40%), industrial (40%), all others (20%).

Needs: Works with 2 freelance photographers/month. Uses photographers for direct mail, trade magazines and brochures. Subjects needs vary.

Specs: Uses 8x10 b&w prints; 35mm and 4x5 transparencies and 16mm film.

First Contact & Terms: Provide resume, business card, brochure, flyer or tearsheets to be kept on file for possible future assignments. Works with local freelancers. Does not return unsolicited material. Reports in 3 weeks. Pays \$40-120/hour; \$300-1,000/day. Pays on acceptance. Buys all rights. Model release preferred.

*MADDEN & GOODWIN, 4301 Hillsboro Rd., Nashville TN 37215. (615)292-4431. Creative Director/Art Division: John Madden or John Fussee. Ad agency. Clients: retail, fashion, finance, etc.

Needs: Works with 2-4 photographers/month. Uses photographers for billboards, consumer magazines, trade magazines, direct mail, P-O-P displays, catalogs, posters, signage and newspapers. Subject matter varies.

First Contact & Terms: Arrange a personal interview to show portfolio; query with samples or submit portfolio for review. Works with freelance photographers on an assignment basis only. Does not return unsolicited material. Reports in 2 weeks. Payment negotiable individually. Pays on receipt of invoice. Buys variable rights. Model release required.

DALLAS NELSON ASSOCIATES, Suite 223, 3387 Poplar, Memphis TN 38111. (901)324-9148. Ad agency. Contact: Dallas Nelson. Clients: industrial, farm.

Needs: Works with 1 freelance photographer/month. Uses photographers for trade magazines, direct mail, brochures, catalogs, newspapers and AV presentations. Also works with freelance filmmakers to produce 16mm sound and color demonstration films.

Specs: Uses 8x10 glossy b&w and color prints; 35mm and 21/4x21/4 transparencies; 16mm film and

videotape.

First Contact & Terms: Provide resume, business card, brochure, flyer or tearsheets to be kept on file for possible future assignments. Works with freelance photographers on assignment basis only. Does not return unsolicited material. Pays/job. Pays at the end of month. Buys all rights. Model release required; captions preferred.

Tips: Prefers to see samples "similar to assignment."

JOHN M. ROSE AND CO., 6517 Deane Hill Dr., Knoxville TN 37919. (615)588-5768. Ad agency. Creative Director: Ken Canup. Clients: industrial (50%), retail (50%). SASE.

Needs: Works with 4-5 freelance photographers/month. Uses photographers for direct mail, catalogs, newspapers, consumer and trade magazines, AV presentations and brochures. Subjects include "studio"

photography of products; location photography.

Specs: Uses 8x10 and 16x20 color glossy prints; 35mm, 2¹/₄x2¹/₄ and 4x5 transparencies and videotape. **First Contact & Terms:** Provide resume, business card, brochure, flyer or tearsheets to be kept on file for possible future assignments. Works with local freelancers only. SASE. Reports in 2 weeks. Payment depends on budget. Pays on publication. Rights purchased depend on situation demands. Model release and captions preferred.

Tips: Prefers to see "studio set-ups and product photography" in a portfolio. "Just show continued

interest on a continued basis. There seems to be a lot of freelancers out there."

Texas

*ADAMS & ADAMS FILMS, Box 5755, Austin TX 78763. (512)477-8846. Contact: Marjorie V. Adams. Clients: schools, libraries, industry, museums and nature centers, government agencies, public and commercial television and others.

Needs: "Contact producer to find good products on continuous basis. Distributes nationally and to some foreign markets. We need movies on almost any subject; our main requirement is *quality*."

Specs: Uses 16mm film and videotape up to 1/2 hour long.

First Contact & Terms: Query with resume and description of film or video subject. Returns materials only when insurance forms included. Reports in 1 month. Royalty percentage paid on each sale. Pays made questerly or according to individual contract. Pays all rights if possible

made quarterly or according to individual contract. Buys all rights if possible.

Tips: "We like to work with film and video producers *before* final edit if possible to assure producer best marketability of his production. Also, will offer ideas for productions to qualified producers." Looks for original ideas or approaches; style and pace, professional *quality*, and integrity and accuracy—above all, emotional impact.

ALAMO AD CENTER, INC., 217 Arden Grove, San Antonio TX 78215. (512)225-6294. Ad agency, PR and AV firm. Art Director: Elias San Miguel. Clients: industrial, fashion, finance.

Needs: Uses 3 freelance photographers/month. Uses photographers for billboards, direct mail, catalogs, newspapers, consumer magazines, P-O-P displays, trade magazines and brochures. Subject matter varies. Uses freelance filmmakers to produce TV commercials.

First Contact & Terms: Provide resume, business card, brochure, flyer or tearsheets to be kept on file for possible future assignments. Works with freelance photographers on assignment basis only. Does not return unsolicited material. Reporting time varies. Pays \$25-75/hour; \$50-200/day; payment by job varies. Pays on acceptance. Buys all rights. Model release required.

*ARGUS COMMUNICATIONS, (Division of DLM, Inc.), One DLM Park, Allen TX 75002. Photo Editor: Linda Bailey. Clients: education, religion, publishing.

Needs: Uses photographers for videotapes. Subjects include: documentaries, talk shows, entertainment. **Specs:** Uses color prints; and 35mm, $2^{1/4}x2^{1/4}$, 4x5 and 8x10 transparencies; 16mm film; and VHS and U-matic 3/4" videotape.

First Contact & Terms: Submit portfolio by mail; query with samples; query with resume; query with stock photo list; provide resume, business card, self-promotion piece or tearsheets to be kept on file for possible future assignments. Works with freelancers by assignment only; interested in stock photos/footage. SASE. Reports in 1 month. Pays on acceptance. Rights purchased depend on job. Captions preferred; model release required. Credit line given.

ARNOLD HARWELL MCCLAIN & ASSOCIATES, INC., Suite 510, 4131 N Central Expy, Dallas TX 75204. (214)521-6400. Ad agency and PR firm. Senior Vice President: Patrick Carrithers. Assistant Creative Director: John McEown. Serves clients in food retailing, media, finance and utilities.

Needs: Works with approximately 10 freelance photographers/month. Uses freelancers for billboards, consumer and trade magazines, direct mail, newspapers, P-O-P displays and TV.

First Contact & Terms: Call for personal appointment to show portfolio. "Select primarily from sample books. Freelancers used regularly on project basis."

Tips: "Want to see best work whether varied or not, i.e., if you're good in color and adequate in b&w, then we would not be interested in your b&w work."

BOZELL & JACOBS ADVERTISING & PUBLIC RELATIONS, Suite 3300, Republic Bank Center, 700 Louisiana St., Houston TX 77002. (713)228-9551. Creative Director: Ron Spataro. Ad agency. Clients: industrial, packaged goods, service, bank and financial.

Needs: Works with 15-20 freelance photographers/month. Uses freelancers for consumer and trade magazines, brochures/flyers, newspapers and TV.

First Contact & Terms: Call for appointment to show portfolio. Negotiates payment based on "going rate."

Tips: Wants to see food, electronic equipment, industrial & people photos of all kinds (except fashion).

JOE BUSER & ASSOCIATES, #400, 2800 Texas Ave., Bryan TX 77802. (409)775-0400. Ad agency. Account Executive: Lee Leschper. Clients: manufacturing, industrial, financial. Client list provided on request.

Needs: Uses 3-4 freelance photographers/month. Uses photographers for newspapers, AV presentations, trade magazines and brochures.

Specs: Uses b&w and color prints; 35mm and 21/4x21/4 transparencies.

First Contact & Terms: Query with list of stock photo subjects; provide resume, business card, brochure, flyer or tearsheets to be kept on file for possible future assignments. Works with freelance photographers on assignment basis only. Returns unsolicited material with SASE. Reports in 2 weeks. Pays maximum \$50/hour and by the job. Pays on acceptance. Buys all rights or one-time rights. Model release required; captions preferred. Credit line given "only in lieu of payment."

DORSEY ADVERTISING AGENCY/GENERAL BUSINESS MAGAZINE, Box 64951, Dallas TX 75206. (214)361-9300. Ad agency and PR firm. President: Lon Dorsey. Clients: all types.

Needs: Works with varied amount of freelance photographers/month. Uses photographers for bill-boards, direct mail, catalogs, newspapers, consumer and trade magazines, P-O-P displays, posters, AV presentations and brochures. Subjects include business.

Specs: Uses 4x5 color glossy prints and 4x5 transparencies.

First Contact & Terms: Query with SASE; reports "as we are able to get to them." Works with local freelancers only. SASE. Pays per agreement. Pays on acceptance or publication. Buys all rights "with exceptions." Model release and captions required. Credit line given "in some cases." Send \$2 for guidelines and open market information regarding present photographic needs.

DYKEMAN ASSOCIATES, INC., 4205 Herschel, Dallas TX 75219. (214)528-2991. Contact: Alice Dykeman or Carolyn Whetzek. PR firm. Clients: health, finance, real estate, sports and energy accounts. Photos used in brochures, AV presentations, catalogs, news releases and magazines. Gives 100 assignments/year. Model release required. Arrange a personal interview to show portfolio. Photos purchased on assignment only. Provide business card and tearsheets to be kept on file for possible future assignments. Some interest in stock photos: industrial, construction, nature, recreation, architectural. Negotiates payment based on client's budget and photographer's previous experience/reputation. Does not return unsolicited material. "Whatever is needed to help tell the story in brochures, news releases or documentation of an event."

B&W: Uses glossy prints; contact sheet OK.

Color: Uses prints and transparencies.

Film: 35mm transparencies for AV presentations; 16mm and videotape for educational, training or fundraising films.

Tips: "In Dallas, we build a good group of photographers that we like working with, but for out-of-town assignments it's a little more difficult to find someone we know will perform right, follow through on time and can be easy to work with." Finds most out-of-town photographers by references of PR firms in other cities.

FIRST MARKETING GROUP, INC., (formerly Ketchum Advertising/Houston), Suite 1300, 1900 W. Loop S., Houston TX 77027. (713)626-2500. Vice President/Associate Creative Director: Dick Baker. Ad agency and PR firm. Clients: financial, automotive, oil, jewelry, real estate.

Needs: Works with 7-8 freelance photographers/month on assignment only basis. Provide flyer, business card and tearsheets to be kept on file for possible future assignments. Uses freelancers for billboards, consumer and trade magazines, direct mail, brochures/flyers, newspapers and P-O-P displays.

First Contact & Terms: Call for appointment to show portfolio (local and out of town). Send samples or portfolio for review (out of town). "Pays on 30-day basis." Negotiates payment based on client's budget.

Portfolio Tips: Interested in "anything showing ability. B&w, color transparencies or prints are all' OK."

GOODMAN & ASSOCIATES, 601 Penn Ave., Fort Worth TX 76102. (817)332-2261. Production Manager: Eloise Pemberton. Ad agency. Clients: financial, fashion, industrial, manufacturing and straight PR accounts.

Needs: Works with freelance photographers on assignment only basis. Uses photographers for bill-boards, consumer and trade magazines, direct mail, P-O-P displays, brochures, catalogs, posters, signage and AV presentations.

First Contact & Terms: Local freelancers only. Arrange interview to show portfolio. Payment is by the project, by the hour or by the day; negotiates according to client's budget.

HEPWORTH ADVERTISING CO., 3403 McKinney Ave., Dallas TX 75204. (214)526-7785. Manager: S.W. Hepworth. Ad agency. Uses all media except P-O-P displays. Clients: industrial, consumer and financial. Pays \$350 minimum/job; negotiates payment based on client's budget and photographer's previous experience/reputation. Submit portfolio by mail; solicits photos by assignment only. SASE.

Color: Uses transparencies or prints.

Tips: "For best relations with the supplier, we prefer to seek out a photographer in the area of the job location."

HILL AND KNOWLTON, INC., 1500 One Dallas Centre, Dallas TX 75201. (214)979-0090. Contact: Production Coordinator. PR firm. Clients: corporations.

Needs: Works with 2 freelance photographers/month.

First Contact & Terms: Call for appointment to show portfolio. Negotiates payment based on client's budget. Works on buy-out basis only.

McCANN-ERICKSON WORLDWIDE, INC., Briar Hollow Bldg., 520 S. Post Oak Rd., Houston TX 77027. (713)965-0303. Contact: The Art Directors. Ad agency. Clients: all types including industrial, fashion, financial, entertainment.

Needs: Works with 15 freelance photographers/month. Uses photographers in all media.

First Contact & Terms: Call for appointment to show portfolio. Selection based on portfolio review. Negotiates payment based on client's budget and where work will appear.

Tips: Should be based on photographer's preferences. Especially interested in transparencies.

*MULTI-IMAGE RESOURCES, 14832 Venture Dr., Dallas TX 75234. (214)247-8585. Executive Producer: Andy Denes. Clients: ad agencies, real estate developers.

Needs: Works with photographers once every several months. Uses photographers for multimedia productions. Subjects include studio product shots, some on location—depending on the job.

Specs: Uses 35mm, 21/4x21/4 and 4x5 transparencies; Beta, U-matic 3/4" videotape.

First Contact & Terms: Arrange a personal interview to show portfolio; provide resume, business card, self-promotion piece or tearsheets to be kept on file for possible future assignments. Works with freelancers by assignment only; interested in stock photos/footage. SASE. Reports in 2 weeks. Pays \$35-50 hour and \$300-500/day. Pays when billed. Buys one-time and all rights depending on material. Model release required.

Tips: "Be honest about capabilities or specialty. Arrange for interview with portfolio and credits."

*SANDERS, WINGO, GALVIN & MORTON ADVERTISING, Arthur Centre, Suite 100, 4171 N. Mesa, El Paso TX 79902. (915)533-9583. Creative Director: Roy Morton. Ad agency. Uses photo-

106 Photographer's Market '86

graphs for consumer and trade magazines, direct mail, foreign media, newspapers, P-O-P displays, radio and TV. Clients: retailing and finance. Free client list. Deals with 5 photographers/year.

Specs: Uses b&w photos and color transparencies. Works with freelance filmmakers in production of slide presentations and TV commercials.

Payment & Terms: Pays \$25-200/hour, \$250-3,000/day, negotiates pay on photos. Buys all rights. Model release required.

Making Contact: Query with samples, list of stock photo subjects; send material by mail for consideration; or submit portfolio for review. SASE. Reports in 1 week.

SHABLE SAWYER & PITLUK, 2950 N. Loop West, #840, Houston TX 77092. (713)869-9200. Ad agency. Creative Director: R.J. Sawyer. Clients: consumer, industrial (primarily energy-related), financial, retail.

Needs: Works with 8 freelance photographers/month. Uses photographers for direct mail, catalogs, newspapers, consumer and trade magazines, P-O-P displays, posters, AV presentations and brochures. Subjects include "product, product in-use, industry or business at work (environment)." Also works with freelance filmmakers to produce TV commercials, industrial films.

Specs: Uses b&w prints; 35mm and 21/4x21/4 transparencies and 35mm film and videotape.

First Contact & Terms: Arrange a personal interview to show portfolio or query with samples. Works with freelancers on an assignment basis only. SASE. Reports in 3-4 weeks. Pays \$1,000-1,500/day; photographer submits quotes on job rates; payment rates cover film, processing and other expenses. Pays on acceptance. Buys one-time rights unless otherwise stated prior to job. Model release required. Credit line "rarely" given.

Tips: In a portfolio, prefers to see "ability to handle actual photographic problems. The coincidence of the photographer witnessing a beautiful scene is nice but ineffective if it isn't in the context of presenting a product or service with graphic impact. Demonstrate through samples of prior work an ability to turn in striking, interesting shots with a variety of lighting problems."

STAR ADVERTISING AGENCY, Box 66625, Houston TX 77266. (713)977-5366. Ad agency. President: Jim Saye. Clients: industrial.

Needs: Works with 3 freelance photographers/month. Uses photographers for trade magazines, direct mail, P-O-P displays, brochures, catalogs, posters, newspapers and AV presentations. Subjects include: oil field shots, automotive parts. Also works with freelance filmmakers to produce training films. **Specs:** Uses 8x10 glossy b&w and color prints; 2¹/₄x2¹/₄ transparencies and 16mm film.

First Contact & Terms: Query with resume of credits; provide resume, business card, brochure, flyer or tearsheets to be kept on file for possible future assignments. Works with local freelancers primarily on assignment basis. SASE. Reports in I week. Pays \$80 maximum/hour and \$700 maximum/day. Pays 30 days from receipt of invoice. Buys all rights. Model release required. Credit line given "sometimes—not on ads or brochures."

Tips: Prefers to see "product shots—*not* 'sunsets' and 'blue skies'. Have a professional, reliable attitude, good credits and reasonable prices."

*TEXAS PACIFIC FILM VIDEO, INC., 501 N. 135, Austin TX 78702. (512)478-8585. Production Manager: Vicki Margolin. Clients: ad agencies, music companies.

Needs: Works with 2-3 photographers/month. Uses photographers for slide sets, multimedia productions, films, videotapes and production stills. Subjects include commercials, music videos, feature films.

Specs: Uses various b&w and color prints; 35mm transparencies; 16mm and 35mm film; U-matic ³/₄", 1" videotape.

First Contact & Terms: Query with samples. Works with freelancers by assignment only. SASE. Reports if interested. Pays by day or job. Pays on payment from client. Buys one-time rights. Model release preferred. Credit line given depending on project.

*WOMACK/CLAYPOOLE/ADVERTISING, 8585 N. Stemmons Fny. Ste. 501N, Dallas TX 75247-3805. Art Director: Bob Hult. Ad agency. Clients: Petroleum, aviation, financial, insurance, retail firms.

Needs: Works with 12 freelance photographers/month. Uses photographers for billboards, brochures, AV presentations and printed collateral pieces.

First Contact & Terms: Arrange interview to show portfolio or send samples. Payment is by the project; negotiates according to client's budget or where work will appear.

*ZACHRY ASSOCIATES, INC., 709 North 2nd, Box 1739, Abilene TX 79604. (915)677-1342. Art Director: T. Rigsby. Clients: industrial, institutional, religious service.

Needs: Works with 2 photographers/month. Uses photographers for slide sets, videotapes and print.

Subjects include industrial location, product, model groups.

Specs: Uses 5x7, 8x10 b&w prints, 8x10 color prints, 35mm, 2½x2½ transparencies, VHS videotape. First Contact & Terms: Query with samples and stock photo list; provide resume, business card, self-promotion piece or tearsheets to be kept on file for possible future assignments. Works with freelancers by assignment only; interested in stock photos/footage. SASE. Reports as requested. Pay negotiable. Pays on acceptance. Buys one-time and all rights. Model release required. Credit line usually given.

Utah

CHARLES ELMS PRODUCTIONS, INC., 1260 South 350 West, Bountiful UT 84010. (801)298-2727. Production Manager: Charles D. Elms. AV firm. Clients: industry, government, associations, education. Produces filmstrips, overhead transparencies, slide sets, multimedia kits, motion pictures, and sound-slide sets. Buys 40 filmstrips and 8 films/year.

Film: Interested in stock footage.

Photos: Uses b&w contact sheet or 35mm color transparencies.

Payment & Terms: Pays by the job. Pays on production. Buys all rights. Model release required. Captions required.

Making Contact: Query with resume. SASE. Guidelines available.

*EVANS/SALT LAKE, 110 Social Hall Ave., Salt Lake City UT 84111. (801)364-7452. Ad agency. Art Director: Michael Cullis. Clients: industrial, finance.

Needs: Works with 2-3 photographers/month. Uses photographers for billboards, consumer and trade magazines, direct mail, P-O-P displays, posters and newspapers. Subject matter includes scenic and people.

Specs: Uses color prints and 35mm, 21/4x21/4 and 4x5 transparencies.

First Contact & Terms: Query with list of stock photo subjects; submit portfolio for review; provide resume, business card, brochure, flyer or tearsheets to be kept on file for possible future assignments. Works with freelance photographers on an assignment basis only. SASE. Reports in 1-2 weeks. Payment negotiated individually. Pays on receipt of invoice. Buys one-time rights. Model release required; captions preferred. Credit live given when possible.

*FOTHERINGHAM & ASSOCIATES, 139 East S. Temple, Salt Lake UT 84111. (801)521-2903. Ad agency. Art Director: Glade Christensen. Clients: industral, financial, development, resort, retail, commercial, automotive, high tech.

Needs: Works with 6 photographers/month. Uses photographers for trade magazines, direct mail, P-O-P displays, catalogs and newspapers. Purchases all subjects.

Specs: Uses 8x10 b&w and color prints, 35mm, 21/4x21/4 and 4x5 transparencies.

First Contact & Terms: Arrange a personal interview to show portfolio; query with samples; provide resume, business card, brochure, flyer or tearsheets to be kept on file for possible future assignments. Works with freelance photographers on an assignment basis only. Does not return unsolicited material. Reports in 2 weeks. Payment negotiated individually. Pays on receipt of invoice. Buys all rights or one-time rights. Model release required. Credit line sometimes given.

Tips: "We're growing, therefore our photography needs are growing."

PAUL S. KARR PRODUCTIONS, UTAH DIVISION, 1024 No. 250 East, Orem UT 84057. (801)226-8209. Vice President & Manager: Michael Karr. Clients: education, business, industry, TV-spot and theatrical spot advertising. Provides inhouse production services of sound recording, looping, printing & processing, high-speed photo instrumentation as well as production capabilities in 35mm and 16mm.

Subject Needs: Same as Arizona office but additionally interested in motivational human interest material—film stories that would lead people to a better way of life, build better character, improve situations of the families.

tions, strengthen families.

First & Terms: Query with resume of credits and advise if sample reel is available. Pays by the job, negotiates payment based on client's budget and ability to handle the work. Pays on production. Buys all rights. Model release required.

Virginia

ADVANCED COMMUNICATIONS GROUP, A Division of Stackig, Sanderson & White, Inc., 7680 Old Springhouse Rd., McLean VA 22102. (703)893-1828. Design agency. President/Creative: Andrew Radigan. Clients: industrial, high tech.

108 Photographer's Market '86

Needs: Works with 5-6 freelance photographers/month. Uses photographers for direct mail, annual reports, trade magazines and high muality collateral. Subjects include "imaginative shots of computer components, tech projects, product usage, people, animated setups and environmental setups." Works with freelance filmmakers "infrequently.

First Contact & Terms: Query with samples; provide resume, business card, brochure, flyer or tearsheets to be kept on file for possible future assignments. Does not return unsolicited material. Reports in 1 month. Pays \$45-150/hour; \$300-1,500/day; per job rates subject to bid; \$100/b&w photo and \$350/color photo. Pays "when billed." Buys all rights. Model release required; captions preferred. Tips: In a portfolio or samples, prefers to see "slide tray, coordinated presentation, no fashion or retail. Prints and printed pieces OK, if well organized." Photographer should demonstrate "willingness to work within budgets, meet demanding delivery needs and follow heavy art direction at times.'

HOUCK & HARRISON ADVERTISING, Box 12487, Roanoke VA 24026. Senior Vice President: Jerry Conrad. Ad agency. Uses billboards, consumer and trade magazines, direct mail, foreign media, newspapers, P-O-P displays, radio, and TV. Clients: home furnishings, travel industry, men's and women's fashions, computer software programs, fast foods, health insurance, banking, industry, consumer products. Works with 5-6 freelance photographers/month on assignment only basis. Provide flyer, tearsheets and brochure to be kept on file for possible future assignments. Buys 200-300 photos/year. Pays \$60-250/hour or \$50-2,000/job. Negotiates payment based on client's budget and amount of creativity required from photographer. Pays on acceptance. Buys all rights. Model release required. Arrange personal interview to show portfolio. Prefers to see wide range of samples in portfolio. "Phone or write beforehand—don't make a cold call!" Will view unsolicited material. SASE. Reports in 2 weeks.

B&W: Uses 8x10 or larger prints.

Color: Uses 35mm to 8x10 transparencies.

Film: Produces 16mm, 35mm and videotape TV commercials and industrial films.

THE MEDIA EXCHANGE, INC., 217 S. Payne St., Alexandria VA 22314. (703)548-7039. President: Tom D'Onofrio. AV firm. Produces filmstrips, slide sets, multimedia kits, motion pictures, sound-slide sets, videotape and print. Works with freelance photographers on assignment only basis. Provide resume.

Photos: 35mm transparencies and special effects work.

Payment & Terms: Negotiates payment based on client's budget. Model release required depending on the job.

Making Contact: Query with resume. SASE. Reports in 1 month.

Washington

*AMERICAN VIDEO LABORATORY, 7023 15th Ave. N.W., Seattle WA 98117. (206)789-8273. Contact: Ken Kortge. Clients: mostly industrial and educational producers, corporate producers. AVLs STUDIO ONE works mostly with commercials producers.

Needs: Works with variable number of freelance photographers/month. Uses photographers for videotapes. Subject matter includes commercial productions for :30 and :60 minute commercials, usually shot on 1" video or 35mm motion picture film, and industrial shoots which are usually shot in 3/4" video.

Specs: Uses 16mm and 35mm film, U-matic 3/4", Betacam, and 1" videotapes.

First Contact & Terms: Provide resume, business card, self-promotion piece or tearsheets to be kept on file for possible future assignments. Works with local freelancers on assignment basis only. Does not return unsolicited material. "Reports only if we are interested and there is a need at that time." Payment negotiated individually. Rights negotiated. Credit line negotiated.

Tips: "Get involved in the community film and video organizations, in the Northwest it would be ITVA (International Television Association) and WFVA (Washington Film and Video Association); they will

then become familiar with procedures."

BROOKS BAUM PRODUCTIONS, 2265 12th Ave., W., Seattle WA 98119. (206)283-6456. Owner: William B. Baum. AV firm. Clients: advertising agencies, film producers and direct accounts. Produces motion pictures, videotape and TV commercials. Works with 1-2 freelance photographers/year on assignment only basis. Provide resume and business card to be kept on file for possible future assignments. Subject Needs: All types of TV commercial and sales promo films. Freelance photos used for produc-

Film: Produces 16 and 35mm films.

Photos: Uses 8x10 glossy b&w prints and 21/4x21/4 or 4x5 color transparencies.

Payment & Terms: Negotiates payment based on client's budget and amount of creativity required

from photographer. Pays on acceptance. Buys all rights. Model release required. Making Contact: Submit portfolio. SASE. Reporting time "depends on value."

COMMUNICATION NORTHWEST INC., 111 W. Harrison St., Seattle WA 98119. (206)285-7070. Contact: Office Manager Personnel. PR firm. Photos, primarily industrial, used in publicity, slide shows and brochures. Works with 2-4 freelance photographers/month on assignment only basis. Provide business card, brochure and list of rates to be kept on file for future assignments. Payment "depends on client situation. Each job is different." Deals with local freelancers only. Call to arrange an appointment.

*EHRIG & ASSOCIATES, 4th and Vine Bldg., Seattle WA 98121. (206)623-6666. Associate Creative Directors: Vicki Brems, Jack Higgins, Gregory J. Ericson. Art Directors: Renae Lovre, Tom Schere, David Dijuzio, Betty Kamifugi. Ad agency. Uses billboards, consumer and trade magazines, direct mail, newspapers, P-O-P displays, radio and TV. Clients: industry, fashion, finance, tourism, travel, real estate, package goods. Commissions 50 photographers/year; buys 300 photos/year. Rights purchased vary. Model release required. Arrange personal interview to show portfolio. "Show us something better than anybody else is doing." SASE.

B&W: Uses prints; contact sheet OK.

Color: Uses prints and transparencies; contact sheet OK.

Film: Produces 16mm and 35mm 30- or 60-second commercials.

Wisconsin

ADS, INC., 4100 W. River Lane, Milwaukee WI 53209. (414)354-7400. Ad agency. Art Director: Paul

Young. Clients: industrial, fashion, finance and retail.

Needs: Works with 5 freelance photographers/month. Uses photographers for direct mail, catalogs, newspapers, consumer magazines P-O-P displays, posters and brochures. Subjects include "product/ table-tops; fashion; location." Also works with freelance filmmakers to produce TV commercials and industrial films.

Specs: Uses 8x10 b&w or color prints; 35mm, 21/4x21/4, 4x5 and 8x10 transparencies; 16mm, 35mm

film and videotape.

First Contact & Term: Query with samples. Send unsolicited photos by mail for consideration. Provide resume, business card, brochure, flyer or tearsheets to be kept on file for possible future assignments. We work with freelancers on an assignment basis only. Returns unsolicited material with SASE. Reports in 1 week. Pays \$600-1,200/day. Pament on publication. Buys all rights or one-time rights. Model release required; captions optional. Credit line sometimes given.

Tips: Prefers to see "original ideas" in a photographer's samples. "Samples are essential since I keep an

active photographer's file. If someone's not on file, they won't get called.'

*HASTINGS, DOYLE & CO., INC., 735 W. Wisconsin Ave., Milwaukee WI 53233. (414)271-1442. Ad agency. President: Arthur Hastings. Art Director: Jerry Zdanowicz. Clients: fashion, retail, finance, automotive. Client list free with SASE.

Needs: Works with 1-2 freelance photographers/month. Uses photographers for direct mail, catalogs, newspapers, consumer and trade magazines, P-O-P displays, posters, AV presentations and brochures.

Also works with freelance filmmakers to produce commercials and training films.

Specs: Uses 4x5, 8x10 b&w and color prints; 35mm or 4x5 transparencies; 16mm film and videotape. First Contact & Terms: Arrange a personal interview to show portfolio. Works with freelance photographers on assignment basis only. SASE. Pays per hour, per day or per job. Model release required.

HOFFMAN YORK AND COMPTON, INC., 2300 N. Mayfair Rd., Milwaukee WI 53226. (414)289-9700. Agency Executive Art Director: Pete Zoellick. Clients: machinery, food service, appliances, consumer.

Needs: Works with many freelance photographers/year. Uses photographers for most print media. Provide brochure, flyer and samples to be kept on file for possible future assignments.

First Contact & Terms: Call for appointment to show portfolio. "We pay standard rates."

NELSON PRODUCTIONS, INC., 3929 N. Humboldt Blvd., Milwaukee WI 53212. (414)962-4445. President: David Nelson. Clients: industry, advertising. Produces motion pictures, videotapes, and slide shows.

Subject Needs: Industrial, people, graphic art and titles.

Photos: Uses transparencies.

110 Photographer's Market '86

Payment & Terms: Pays by the project. Buys one-time rights. Model release required. **Making Contact:** Query with resume of credits or send material by mail for consideration. "We're looking for high quality photos with an interesting viewpoint."

Canada Ca

DYNACOM COMMUNICATIONS INTERNATIONAL, Box 702, Snowdon Station, Montreal, Quebec, Canada H3X 3X8. Director: David P. Leonard. AV firm. Clients: business, industry, government, educational and health institutions for training, exhibits, presentations and related communications projects. Produces slide sets, multimedia kits, motion pictures, sound-slide sets, videotape, and multiscreen, split-screen and mixed-media presentations. Fees are negotiated on a perproject basis. Buys all rights, but may reassign to photographer after use. Model release required; captions preferred. Send material by mail for consideration. Solicits photos/films by assignment only. Provide resume, flyer, business card, tearsheets, letter of inquiry and brochure to be kept on file for possible future assignments. Does not return unsolicited material. Reports only when interested. Subject Needs: Employee training and development, motivation, and management communications presentations. Photos used in slide sets, films, videotapes, and multiscreen mixed-media presentations.

Thin and vidence to The Charles of Annal Sher with respiler freed proofs rediffratively infilted one recursive Provide Fourther Younges, and smoother three unableded to be kept on the English Charles on a new mount. Yet

provided the communication of the analytic of the control of the c

No cliche imagery. 35mm only for slides.

Film: Super 8 and 16mm documentary, training and industrial film.

B&W: Uses 5x7 or 8x10 prints.

Color: Uses 5x7 or 8x10 prints or 35mm transparencies.

Book Publishers

Book publishers are voracious users of freelance photography, as you'll see when you read the listings—including many major publishing houses listed for the first time—in this section. One photo editor with a book publisher contacted for listing information told us that she purchased "thousands" of freelance photos annually—and she spoke for only one division of that publisher!

Most photography purchased in this market is used for *text illustration*—that is, to illustrate the subjects of nonfiction books such as "how-to" titles and textbooks. Encyclopedias are also obvious heavy photo users, with hundreds or thousands of subject entries requiring photographic illustration. Publishers also use the services of freelance photographers to produce eye-catching book covers and dust jackets.

as well as for the promotional materials used to sell their products.

Editorial photography, which includes photography for books as well as magazines and newspapers, differs from advertising photography in that most photos are purchased from *stock*, rather than on assignment. That means editorial picture buyers select the images they need from the *existing* photo files of photographers and stock photo agencies, rather than hiring photographers to create new images. Freelancers interested in selling to this market should work to build up their own stock files in those subjects of greatest interest to potential buyers (check the subject needs in each listing). Once you have a file large and varied enough to be marketable, you'll need to prepare a *stock list*—a typewritten or typeset sheet which lists those subject areas in which you have a large available inventory. Your stock list, and possibly some samples of your best work, should then be circulated to those potential buyers you think likeliest to have a need for your types of pictures, based on the information in these listings.

If you're a photographer who also writes, you might become a published *author*. As an expert photographer you might be in a position to write a book about photography, but chances are that photography isn't the only subject you could write about knowledgeably. For example, you might also be a first-class sailor, and could combine your sailing expertise with your photography to produce an illustrated text on the subject. Of course, you'll have to do some *market research* to determine whether there's any need for such a book; you can do this very simply by examining the titles available at bookstores in your area. Ask the salespeople which titles and subjects are selling well. If you have an idea for a book you believe would sell, check the appropriate subject category in *Books in Print* at your local library to see if any other

books on that topic have already been published.

Of course, you'll still have to convince a publisher that your book idea is a good one. To do this, you'll need a convincing *query* or *book proposal* that outlines your idea in such a way that it piques an editor's interest. As a photographer you have one major advantage: along with your proposal, include a few of the stunning photographs you've taken to illustrate the book so the editor can visualize what the

finished product might look like.

An even higher ambition for many photographers is publication of their own picture book or *monograph*: a lavish, bound edition consisting solely of one photographer's vision, with page after page of fabulous photographs strong enough to stand alone with little or no text. Because such picture books are very expensive to produce—and hence very high in price—publishers must be convinced that the quality of the images—or the name-recognition factor of the photographer—is high enough to justify their investment in the work. Most monographs you find in bookstores are the work of only the most famous photographers, so if you're not one of those, you'll have a harder time convincing any publisher to risk his dollars.

But if you're convinced that your work deserves a book of its own, there are two alternatives to the large commercial publishing houses. Some of the publishers listed in this section, along with hundreds more listed in the *International Directory of Little Magazines*, and Small Presses (Dustbooks), fall into the category of small

presses. These publishers value literary or artistic quality for its own sake and are less concerned with turning a profit than with exposing what they deem to be worthwhile work, and many are receptive to queries from photographers.

The second alternative is self-publishing, which means exactly what its name implies: you become the publisher of your own book. Although the risks of self-publishing are enormous-you'll have to assume responsibility for financing, designing, typesetting, printing, binding and distributing in addition to providing the photography-many photographers and writers who self-publish find the psychic benefits of getting their work into print at any cost worthwhile, and a few do so well as to turn a profit—and even become small presses themselves.

A.D.BOOK CO., 10 E. 39th St., New York NY 10036, (212)889-6500, Art Director: Amy Sussman. Publishes books on advertising, design, photography and illustration. Photos used for promotional materials and dust jackets. Buys 10-25 photos annually; gives 5 freelance assignments annually. Subject Needs: Most interested in advertising and design photos. Model release and captions required.

Specs: Uses 8x10 b&w and color prints and transparencies.

Payment & Terms: Pays \$100/b&w photo and \$200/color photo. Buys book rights. Simultaneous submissions OK.

Making Contact: Arrange a personal interview to show portfolio. Prefers to see advertising and design samples. Provide letter of inquiry to be kept on file for possible future assignments. SASE. Reports in 3 weeks.

ADDISON-WESLEY PUBLISHING COMPANY, 6 Jacob Way, Reading MA 01867. (617)944-3700. Art Director: Geri Davis. Design Coordinator: Suzanne Stone. Publishes college textbooks. Photos used for text illustration, promotional materials, book covers and dust jackets.

Subject Needs: Science, math, computer, business photos.

Spees: B&w prints and color transparencies.

Payment & Terms: Credit line given on copyright or photo credit page. Buys one-time rights. Simultaneous submissions OK "as long as they are not in same market."

Making Contact: Query with list of stock photo subjects; provide resume, business card, brochure, flyer or tearsheets to be kept on file for possible future assignments. Interested in stock photos. SASE.

Reports in 1 week.

AERO PUBLISHERS, INC., 329 W. Aviation Rd., Fallbrook CA 92028, (619)728-8456, President: Ernest J. Gentle. Publishes technical and semi-technical books on aviation and space. Photos used for text illustration, promotional materials and dust jackets.

Subject Needs: "Although most of our photos are supplied by authors, we are open to submissions of rare, historical, military, or technical photos under a single theme, such as the evolution of a particular plane or aircraft series. Expertise in some area of aviation therefore helps; so does the ability to write captions for readers who know their aviation." Model release and captions required.

Specs: Uses b&w prints.

Payment & Terms: Pays \$10-25/b&w photo; \$50-150/color photo. Credit line given. Buys book rights.

Simultaneous submissions and previously published work OK.

Making Contact: Query with resume of credits or with list of stock photo subjects. SASE. Reports in 3 weeks. Provide resume and tearsheets to be kept on file for possible future assignments.

AGLOW PUBLICATIONS, (formerly Women's Aglow Fellowship, International), Box 1, Lynnwood WA 98046-1557. (206)775-7282. Art Director: Kathy Boice. Publishes Christian publications. Bible studies, books, booklets, magazine. Photos used for book covers and magazines. Buys 30 freelance photos annually, and gives 30 freelance assignments annually.

Subject Needs: Nature scenes, portraits, special effects, "portraits and special effects are specifically assigned." Model release and captions preferred.

Specs: Uses 35mm, 21/4x21/4 and 4x5 transparencies.

Payment & Terms: Pays \$80-250/color photo; and \$80/job. Credit line given. Buys one-time rights. Simultaneous submissions and previously published work OK.

Making Contact: Query with samples or with list of stock photo subjects; interested in stock photos.

SASE. Reports in 1 month.

Tips: "We look for nature scenes that have a central focal point. Prefer horizontals, but will crop if photo suits purpose. Call and inquire about our needs."

ALASKA NATURE PRESS, Box 632, Eagle River AK 99577. Editor/Publisher: Ben Guild. Publishes nature and field guides, outdoor wilderness experiences (no hunting/fishing), natural histories, limited edition art prints and portfolios, juvenile picture books, and line poetry in hardcover or paperback. Recent titles include The Alaska Psychoactive Mushroom Handbook, Homegrown Mushrooms in Alaska (or anywhere else), And How to Cook Them, The Alaska Wildfoods Guide. Photos used for text illustration, book covers, dust jackets and picture portfolios. Buys 100-200 photos/year. Provide resume, business card, letter of inquiry, brochure and examples of photographic prowess to be kept on file for possible future assignments. "I purchase duplicate slides for my files as references. If and when I decide to use them, I send for originals and pay the going rate." Credit line given. Buys one-time rights or all rights. Model release and captions preferred. Query with list of stock photo subjects on Alaska nature or send material by mail for consideration. Prefers to see 35mm transparencies or 8x10 b&w contact sheets in a portfolio. SASE. Previously published work OK. Reports in 6-8 weeks, "usually less.'

Subject Needs: "Alaska nature material only." Special needs include 8x10 b&w photos of Alaska wildlife species, and short monographs of any natural history subject of interest. Special needs include a 24-volume set "Alaska Nature Series" (wildlife natural histories); unlimited handbook series—Alaska

Nature Notebooks, any special natural subject.

B&W: Uses 8x10 glossy prints; contact sheet OK. Pays \$5-50/photo.

Color: Uses 35mm and 21/4x21/4 transparencies. "Duplicate slides OK for reference files, but we prefer originals for publication." Pays \$10-75/photo.

Jacket/Cover: Uses 8x10 or 11x14 glossy b&w prints or 35mm, 21/4x21/4 or 4x5 color transparencies.

Pays \$150/photo.

ALASKA NORTHWEST PUBLISHING COMPANY, Box 4-EEE, Anchorage AK 99509. (907)274-0521. Editor: Tom Gresham. Publishes adult nonfiction on northern subjects-people, resource use, history, geography, and first person accounts. Photos used for text illustration, promotional materials, book covers and dust jackets. Buys 1,200 photos/year. Credit line given. Buys one-time rights; occasionally buys all rights. Captions required. Query with samples. SASE. Reports in 4-6 weeks. Free photo guidelines.

Subject Needs: Alaska and northwestern Canada only-nature shots, scenics and people doing things.

B&W: Uses glossy prints; contact sheet OK. Pays \$20-50/photo.

Color: Uses 35mm or larger transparencies. Kodachrome originals recommended. Pays \$20-200/photo. Jacket/Cover: Uses 35mm or larger color transparencies.

ALCHEMY BOOKS, Suite 531, 685 Market St., San Francisco CA 94105. (415)777-2197. Art Director: Candy Martin. Publishes fiction, nonfiction, outdoors, politics and language books. Photos used for text illustration, promotional materials, book covers and dust jackets. Buys 10-25 photos annually; gives 0-10 freelance assignments annually.

Subject Needs: Model release preferred.

Specs: Uses 3x5, 5x8 or 8x10 glossy b&w prints.

Payment & Terms: Pays \$5 minimum/b&w photo; \$10 minimum/color photo; \$10 minimum/job; "dependent on project, subject, style or complexity, etc." Credit line given "in most cases." Buys book rights. "We do not wish to receive unsolicited material that must be returned. We will keep all samples on file for future reference."

Making Contact: Provide resume, business card, brochure, flyer or tearsheets to be kept on file for possible future assignments; interested in stock photos. Does not return unsolicited material. "We do not

Tips: "We prefer samples that we may keep on file (photocopies are fine); lists of stock photos and/or subjects available are also appreciated."

ALPINE PUBLICATIONS, INC., 214 SE 19th St., Loveland CO 80537. (303)667-2017. President: Betty McKinney. Publishes how-to books and breed books on dogs and horses. Photos used for text illustration, books covers, dust jackets.

Subject Needs: Dogs, horses—all must be purebred. Model release and captions required. Specs: Uses 8x10 glossy b&w and color prints; 35mm and 21/4x21/4 transparencies.

Payment & Terms: Pays\$10-20/b&w photo; \$20-35 color photo. Credit line given. Buys book rights. Making Contact: Query with samples; send photos by mail for consideration; provide resume, business card, brochure, flyer or tearsheets to be kept on file for possible future assignments. Interested in stock photos. SASE. Reports in 2 weeks.

AMPHOTO, AMERICAN PHOTOGRAPHIC BOOK PUBLISHING CO., 1515 Broadway, New York NY 10036. (212)764-7300. Senior Editor: Marisa Bulzone. Publishes instructional and how-to books on photography. Photos usually provided by the author of the book. Query with resume of credits

and book idea, or submit material by mail for consideration. Pays on royalty basis. Rights purchased vary. Submit model release with photos. Reports in 1 month. SASE. Simultaneous submissions and previously published work OK.

Tips: "Submit focused, tight book ideas in form of a detailed outline, a sample chapter, and sample

photos. Be able to tell a story in photos and be aware of the market.

*AND BOOKS, 702 S. Michigan, South Bend IN 46618. (219)232-3134. Senior Editor/Visuals: Emil Krause. Publishes nonfiction, adult and general. Photos used for text illustration and book covers. Buys 5-10 photos annually; gives 2-5 freelance assignments annually.

Subject Needs: Vary. Model release required; captions preferred.

Specs: Open.

Payment & Terms: Varies. Credit line given. Buys all rights. Simultaneous submissions and previously

published work OK.

Making Contact: Provide resume, business card, brochure, flyer or tearsheets to be kept on file for possible future assignments. Interested in stock photos. SASE. Reports in 1 month.

ARCsoft PUBLISHERS, Box 132, Woodsboro MD 21798. (301)845-8856. President: Anthony R. Curtis. Publishes "books in personal computing and electronics trade paperbacks." Photos used for book covers. Buys 10 photos annually; gives 10 freelance assignments annually.

Subject Needs: Personal-computer/human interaction action shots and electronics close-up. Captions

required.

Specs: Uses 35mm, 21/4x21/4 and 4x5 slides.

Payment & Terms: Payment per color photo or by the job varies. Credit line given. Buys one-time rights

and book rights. Simultaneous submissions and previously published work OK.

Making Contact: Query with resume of credits, samples or with list of stock photo subjects; provide resume, business card, brochure, flyer, tearsheets to be kept on file for possible future assignments. SASE. Reports in 1 month.

Tips: "Send query and limit lists or samples to subjects in which we have an interest."

ARGUS COMMUNICATIONS, One DLM Park, Box 9000, Allen TX 75002. Photo Editor: Linda J. Bailey. Publishes children's books, educational materials, religious books and adult trade books. Photos used for text illustration, promotional materials, filmstrips, book covers and dust jackets. Buys "hundreds" of photos annually for use in posters, greeting cards, post cards and various paper products. We also produce educational videos. Gives "some" freelance assignments; "we usually work from existing stock material."

Subject Needs: "Animals-humorous, not obvious zoo animals; nature scenics; man in relation to nature; sports; inspirational; hot air balloons; florals; children in family relationships." Model release,

captions and locations required.

Specs: Uses b&w prints and 35mm, 21/4x21/4, 4x5, 5x7 and 8x10 color transparencies.

Payment & Terms: Pays ASMP rates. Credit line given. Buys one-time rights, but fees and rights "vary with project." Simultaneous submissions and previously published work OK "as long as other rights are

not conflicting.'

Making Contact: Query with resume of credits or list of stock photo subjects; provide resume, business Card, brochure, flyer or tearsheets to be kept on file for possible future assignments; interested in stock photos. "We are interested in top quality photos and will work with individuals. We prefer a query first."

Reports in 1 month. Photo guidelines free with SASE.

Tips: "Unless the project is for a b&w book, send transparencies only—well edited, sharp and crisp material. Must be well labeled with photo information and photographer's name. A list must be enclosed itemizing submission. Large format preferred for scenics; 35mm OK for filmstrips and animals. Photographers should note that "the biggest trend involves increasing concern regarding released material—even for editorial use. Editors tend to be less likely to use a photo of an individual without releases in hand. Be persistent and call frequently to make yourself known. Don't depend on callouts to make submissions. Take constructive criticism and progress from there." See also listing under Paper Products.

ART DIRECTORS BOOK CO., 10 E. 39th St., New York NY 10016. (212)889-6500. Art Director: Amy Sussman Heit. Publishes advertising art, design, photography. Photos used for dust jackets. Buys 10 photos annually.

The asterisk before a listing indicates that the listing is new in this edition. New markets are often the most receptive to freelance contributions.

Subject Needs: Advertising. Model release and captions required.

Payment & Terms: Pays \$200 minimum/b&w photo; \$500 minimum/color photo. Buys one-time rights. Simultaneous submissions OK.

Making Contact: Submit portfolio for review. Solicits photos by assignment only. SASE. Reports in 1 month.

ASSOCIATED BOOK PUBLISHERS, Box 5657, Scottsdale AZ 85261. (602)998-5223. Editor: Ivan Kapetanovic. Publishes adult trade, juvenile, travel and cookbooks. Photos used for promotional materials, book covers and dust jackets. Buys 24/year.

Specs: Uses 8x10 glossy b&w and color prints and 4x5 and 8x10 color transparencies.

Payment & Terms: Pays \$10-100/b&w photo and \$50-1,000/color photo. Credit line and rights negotiable.

Making Contact: Send material by mail for consideration. SASE. Solicits photos by assignment only. Reports in 2 weeks.

AUGSBURG PUBLISHING HOUSE, Publication Development Office, Box 1209, Minneapolis MN 55440. (612)330-3300. Librarian, Publication Development Office: Gene Janssen. Publishes Protestant/Lutheran books (mostly adult trade), religious education materials, audiovisual resources and periodicals. Photos used for text illustration, book covers, periodical covers and church bulletins. Buys 120 color/1000 b&w annually; gives very few freelance assignments annually.

Subject Needs: People of all ages, variety of races, activities, moods and unposed; color: nature,

seasonal, church year and mood.

Specs: Uses 8x10 glossy or semiglossy b&w, 35mm color transparencies and 21/4x21/4 color transparencies.

Payment & Terms: Pays \$20-75/b&w photo; \$40-125/color photo and occasional assignments (fee negotiated). Credit line nearly always given. Buys one-time rights. Simultaneous submissions and previously published work OK.

Making Contact: Send material by mail for consideration. "We are interested in stock photos." Provide tearsheets to be kept on file for possible future assignments. SASE. Reports in 6-8 weeks. Guidelines free with SASE.

"This was a carefully thought-out photo set up to project a outdoorsy farm feeling," says Fresno, Ohio, freelance photographer Ron Meyer. "This photo has sold four times for a total of \$100. Augsburg Publishing House, Mennonite Publishing House and Standard Publishing used it for denominational materials. Mennonite Mutual Aid Association purchased onetime rights for use on the cover of an annual report. I regularly send photos on approval to about 50 publishers. Often a publisher will photocopy an appealing photo for his files. When a need comes up. he'll contact me and I'll send a print. Many of my photos have sold this wav."

AVON BOOKS, 1790 Broadway, New York NY 10019. (212)399-1372. Art Director: Matt Tepper. Publishes books on adult and juvenile, fiction and non-fiction in mass market and soft cover trade. Photos used for book covers. Gives several assignments monthly.

Subject Needs: Most interested in photos of single women, couples (man & woman) in color. Model

release required.

Specs: Uses 35mm, 4x5 and 8x10 color transparencies.

Payment & Terms: Pays \$300-800/job. No simultaneous submissions.

Making Contact: Query with samples and list of stock photo subjects; or make an appointment to show portfolio on Thursdays; provide business card, flyer, brochure and tearsheets to be kept on file for possible future assignments. SASE. Reports in 1 month.

*AZTEX CORPORATION, Box 50046, Tucson AZ 85703. (602)882-4656. Publishes adult trade, nonfiction. Photos used for text illustration, book covers and dust jackets.

Subject Needs: Transportation, how-to, historical, futuristic detail. "Most photos are provided by authors—we acquire very few." Model release and captions required.

Specs: Open.

Payment & Terms: Payment negotiated individually. Buys all rights.

Making Contact: Query with list of stock photo subjects. Does not return unsolicited material. "We keep queries on file; and contact the photographer only if and when we receive photos with potential for immediate use."

Tips: "We expect the author who submits the ms to acquire all photos, arrange payment and acquire all releases. Occasionally we commission or purchase cover photo."

*BAKER BOOK HOUSE, 6030 E. Fulton Rd., Ada MI 49301. (616)676-9185. Art Director: Dwight Baker. Publishes religious textbooks, devotionals, self-help books and adult trade. Photos are used for book covers and dust jackets. Buys 15-20 freelance photos annually (including stock photos), and gives 10-15 freelance assignments annually.

Subject Needs: Nature scenes (sunsets, flowers, landscapes, mountains, beaches) and studio set-ups (still-lifes of books, flowers). Model release and captions optional.

Specs: Uses 35mm and 21/4x21/14 transparencies.

Payment & Terms: Pays \$200-300/color photo; \$50-250/stock photo. Credit line given "if requested." Buys complete reprint rights with original title used.

Making Contact: Arrange a personal interview to show portfolio; query with samples or with list of

stock photo subjects; interested in stock photos. SASE. Reports in 3 weeks.

Tips: "Before submitting photos, be aware of our budget. We look for technical ability that reveals experience; originality of ideas; ability to make interesting photos of ordinary subjects; and a style that is appropriate to our book covers. We are *always* looking for interesting shots from the Holy Land (ruins, natives, landscapes)."

BALLANTINE/DELREY/FAWCETT BOOKS, 201 E. 50th St., New York NY 10022. (212)572-2251. Art Director: Don Munnson. Publishes fiction, science fiction and general nonfiction. Photos used for book covers on assignment only. Buys all rights. "Freelancers must have 5 years "mass-market experience."

BANTAM BOOKS, 666 5th Ave., New York NY 10103. (212)765-6500. Photo Researcher: Ms. Toby Greenberg. Publishes a wide range of books. Photos used for book covers. Buys 30 photos annually. **Subject Needs:** Many scenics, children, romantic couples. Model release required.

Specs: Uses 35mm, 4x5 and 8x10 transparencies.

Payment & Terms: Pays per job or \$400-700/color photo. Credit line given. Buys book rights. Simultaneous submissions and previously published work OK.

Making Contact: Submit portfolio or samples for review; interested in stock photos. SASE. Reporting time depends on monthly schedule.

Tips: Prefers to see "a selection of photographer's best work in all the categories in which photographer works." Portfolio should be "professional—concise and easy to handle. Work around client's schedule—be flexible! We publish a great number of romance novels, some of which incorporate photography; also nonfiction, how-to, and cookbooks."

BHAKTIVEDANTA BOOK TRUST, 9715 Venice Blvd., Los Angeles CA 90034. (213)559-8540. Manager, Photo Dept.: Jennifer Gaasbeck. Publishes translations from the Vedic Literatures and a monthly journal of the Hare Krishna movement, *Back to Godhead*. Photos used for text illustration and promotional materials. Buys 12/year. Credit line given. Query with samples or list of stock photo subjects. Prefers to see 35mm slides in a portfolio. SASE. Simultaneous submissions and previously published work OK. Reports in 1 month.

Subject Needs: Photos of Swami A.C. Bhaktivedanta, the founder of the Hare Krishna movement, especially before 1970; and photos of the devotees of the Hare Krishna movement.

B&W: Uses 8x10 glossy prints; contact sheet OK. Pays \$15-150/photo.

Color: Uses transparencies. Pays \$25-250/photo.

BOOK PUBLISHERS OF TEXAS, Box 8262, Tyler TX 75711. (214)595-4222. President: James R. Parrish. Publishes adult and juvenile trade historical fiction and non-fiction about Texas by Texas writers. Photos used for text illustration, promotional materials, book covers, dust jackets. Number of freelance photos used not yet established.

Subject Needs: Needs photos to illustrate historical fiction and all types of non-fiction. Model release

and captions required.

Specs: Uses 5x10 b&w and color prints; 35mm, 21/4x21/4, 4x5 and 8x10 transparencies.

Payment & Terms: "Based solely on individual contract per job." Credit given somewhere in book.

Buys book rights. Simultaneous submissions OK.

Making Contact: Query with resume of credits; provide resume, business card, brochure, flyer or tearsheets to be kept on file for possible future assignments. Solicits photos by assignment only; "would, however, like to see query with outline of Texas non-fiction photo book." SASE. Reports in 1 month. Tips: "Send queries, resume, business card, brochure, flyer or tearsheets only. A freelance photographr should make his talents and availability known to publishers. More photos are being used in non-fiction books to illustrate."

BOSTON PUBLISHING COMPANY, INC., 314 Dartmouth St., Boston MA 02116. Senior Picture Editor: Julene Fischer. "Our major project at this time is a 20-volume book series on the history of US involvement in Vietnam. Fourteen volumes have been published. Each volume is illustrated with about 150 pictures. We use stock agencies and independent photographers as sources. Still interested in Vietnam pictures for an exclusively photographic book, 1945-75 inclusive." Captions required. Specs: Uses 8x10 b&w prints and 35mm, 21/4x21/4 or 4x5 slides. Simultaneous submissions and

previously published work OK.

Making Contact: Query with list of stock photo subjects. SASE. Reports in 1 month.

*BRIDGE PUBLICATIONS, INC., 1414 N. Catalina St., Los Angeles CA 90027. (213)661-0478. Art Director: Eugenia May-Monit. Publishes adult trade: self help and fiction (including science fiction). Photos used for promotional materials, book covers, dust jackets, trade shows, P-O-P displays. Buys 10-30 freelance photos annually, and gives 10 or more freelance assignments annually.

Subject Needs: Outdoor sports, family, special effects (galaxies and outerspace), some nature scenes,

executives with computers, etc. Model release required; captions optional.

Specs: Uses 8x10 matte b&w prints and 35mm and 4x5 transparencies.

Payment & Terms: Payment negotiated individually. Buys all rights, "depending upon agreement." Making Contact: Arrange a personal interview to show portfolio; query with samples; send unsolicited photos by mail for consideration; or submit portfolio for review; provide resume, business card, brochure, flyer or tearsheets to be kept on file for possible future assignments "be sure to include prices and fees." Deals with local freelancers only. SASE. Reports in 3 weeks.

Tips: "Do not send any more than 10 photos or transparencies. Be professional regarding deadlines,

quality and prices. Do not be extravagant."

WILLIAM C. BROWN CO. PUBLISHERS, 2460 Kerper Blvd., Dubuque IA 52001. (319)588-1451. Vice President and Director, Production Development and Design: David A. Corona. Manager of Design: Marilyn Phelps. Manager, Photo Research: Mary Heller. Publishes college textbooks for most disciplines (music, business, computer and data processing, education, natural sciences, psychology, sociology, physical education, health, biology, zoology, art). Photos used for book jackets and text illustration. Buys 6,000 b&w and color photos annually. Provide business card, brochure or stock list to be kept on file for possible future use. Submit material by mail for consideration. Pays up to \$80/b&w photo; up to \$125/color photo. Buys English language rights. Reports in 1-2 months. SASE. Previously published work OK. Direct material to Photo Research. Pays on acceptance.

B&W: Send 8x10 glossy or matte prints.

Color: Send transparencies.

Jacket: Send glossy or matte b&w prints or color transparencies. Payment negotiable.

*BUSINESS PUBLICATIONS INC., Suite 390, 1700 Alma Rd., Plano TX 75075. (214)422-4389. Art Director: Patti Holland. Publishes business, marketing, accounting, business law, finance, and business communication textbooks. Photos used for text illustration and book covers. Subject Needs: Portraits and candid type shots of people at work. Also product type shots from data

communication and computer areas.

Specs: Uses 5x7 and larger b&w prints and 21/4x21/4 transparencies.

Payment & Terms: Payment negotiated individually. Credit line given. Buys one-time rights.

Simultaneous submissions and previously published work OK.

Making Contact: Query with samples, or list of stock photo subjects; provide resume, business card, brochure, flyer or tearsheets to be kept on file for possible future assignments; interested in stock photos. SASE. Reports in 1 month.

Tips: "We are using an increasing number of photos inside with text, and fewer used photos as covers."

M.M. COLE PUBLISHING COMPANY, 919 N. Michigan Ave., Chicago IL 60611. (312)787-0804. Contact: Mike L. Stern. Handles educational records and books. Photographers used for album covers, books, advertising and brochures. Gives 50 assignments/year. Negotiates payment. Credit line given. Buys all rights. Query with resume of credits. Does not return unsolicited material. Specs: Uses 60% b&w prints; 40% color prints.

CONCORDIA PUBLISHING HOUSE, 3558 S. Jefferson, St. Louis MO 63118. (314)664-7000, ext. 358. Super/Administrative Support: Vanessa Young. "All our publications are strictly religious (Lutheran) in nature." Photos used for text illustration, promotional materials, book covers and dust

Subject Needs: Nature and people interacting. Model release required; captions preferred.

Specs: Uses 8x10 b&w and color prints; 4x5 transparencies.

Payment & Terms: "Determined by publication budget. Credit line given. Buys one-time rights; "bulletins constitute 3 year license for stock and 1 year license for every Sunday." Simultaneous submissions OK.

Making Contact: Send unsolicited photos by mail for consideration. Interesested in stock photos. SASE. Reports in 3-6 months.

DAVID C. COOK PUBLISHING CO., 850 N. Grove, Elgin IL 60120. Director of Design Services: Gregory Clark. Photo Acquisition Coordinator: Cindy Carter. Publishes books and Sunday school material for pre-school through adult readers. Photos used primarily in Sunday school material for text illustration and covers, particularly in Sunday Digest (for adults), Christian Living (for senior highs) and Sprint (for junior highs). Younger age groups used, but not as much. Buys 200 photos minimum/year; gives 20 assignments/year. Pays \$50-250/job or on a per-photo basis. Credit line given. Buys first rights, second (reprint) rights, or all rights, but may reassign rights to photographer after publication. Model release preferred. Prefers to see people, action, sports, Sunday school, social activities, family shots. SASE. Previously published work OK.

Subject Needs: Mostly photos of junior and senior high age youth of all races and ethnic backgrounds,

also adults and children under junior high age, and some preschool.

B&W: Uses glossy b&w and semigloss prints. Pays \$20-50/photo. 8x10 prints are copied and kept on file for ordering at a later date.

Color: Uses 35mm and larger transparencies; contact sheet OK. Pays \$50-200/photo.

Jacket/Cover: Uses glossy b&w prints and 35mm and larger color transparencies. Pays \$50-250/photo. Tips: "Make sure your material is identified as yours. Send material to the attention of Cindy Carter, Photo Acquisitions Coordinator."

*CRAFTSMAN BOOK COMPANY, 6058 Corte Del Cedro, Carlsbad CA 92008. (619)438-7828. Art Director: Bill Grote. Publishes construction books. Photos used for text illustration, promotional materials, and book covers. Buys 60 freelance photos annually, and gives 10 freelance assignments annually.

Subject Needs: Photos of construction contractors at work, and carpenters at work. Model release required.

Specs: Uses 5x7 b&w prints and 35mm transparencies.

Payment & Terms: Pays \$25/b&w photo; and \$100/color photo. Buys all rights. Simultaneous

submissions and previously published work OK.

Making Contact: Query with samples; provide resume, business card, brochure, flyer or tearsheets to be kept on file for possible future assignments; interested in stock photos. SASE. Reports in 2 weeks. Tips: "We especially need shots of construction workers on rooftops with lots of sky visible."

THE CROSSING PRESS, Box 640, Trumansburg NY 14885. (607)387-6217. Publishers: Elaine and John Gill. Publishes fiction, feminist fiction, calendars and postcards. Photos used for book covers, calendars and postcards. Buys 10-20 photos/year; gives 2-5 freelance assignments/year. Subject Needs: "Portraits of famous men and women for our postcard series." Model release required.

Specs: Uses 5x8 b&w glossy prints.

Payment & Terms: Pays \$50-100/b&w photo. Credit line given. Simultaneous submissions and previously published work OK.

Making Contact: Query with samples or list of stock photo subjects. Solicits photos by assignment

only. SASE. Reports in 3 weeks.

DELMAR PUBLISHERS, INC., 2 Computer Drive W, Box 15-015, Albany NY 12212. Contact: Art Department. Publishes vocational/technical and college textbooks. Photos used for text illustration and on book covers. Needs photos in a "very wide variety" of topics ranging "from nursing to computers." Works with freelance photographers on assignment only basis. Provide flyer to be kept on file for possible future assignments. Notifies photographer if future assignments can be expected. When writing please mention areas of expertise. Buys all rights. Present model release on acceptance of photo. Previously published photos OK, "depending, of course, upon where the material was published." To see themes used write for free catalog.

B&W: Send 8x10 glossy prints.

Cover: Send 8x10 glossy b&w prints or color slides.

Tips: "We assign a list of photo needs for each text to select freelancers. We are always in need of new photographers." Quality and deadlines are "the most important things."

DELTA DESIGN GROUP, INC., 518 Central Ave., Box 112, Greenville MS 38702. (601)335-6148. President: Noel Workman. Publishes cookbooks and magazines dealing with architecture, dentistry, gardening, libraries, inland water transportation, shipbuilding (offshore and towboats), travel and southern agriculture. Photos used for text illustration, promotional materials and slide presentations. Buys 25 photos/year; gives 10 assignments/year. Pays \$25 minimum/job. Credit line given, except for photos used in ads. Rights negotiable. Model release required; captions preferred. Query with samples or list of stock photo subjects or send material by mail for consideration. SASE. Simultaneous submissions and previously published work OK. Reports in 1 week.

Subject Needs: Southern architecture and agriculture; all aspects of life and labor on the lower Mississippi River; Southern historical (old photos or new photos of old subjects); recreation (boating,

water skiing, fishing, canoeing, camping).

Tips: "Wide selections of a given subject often deliver a shot that we will buy, rather than just one landscape, one portrait, one product shot, etc.'

THE DONNING CO./PUBLISHERS, INC., 5659 Virginia Beach Blvd., Norfolk VA 23502. (804)461-8090. Editorial Director: Robert S. Friedman. Publishes "pictorial histories of American cities, counties and states, coffee table volumes, carefully researched with fully descriptive photo captions and complementary narrative text, 300-350 photos/book." Query first with resume of credits and outline/synopsis for proposed book. Buys first rights or second (reprint) rights. Pays standard royalty contract. Permission from sources of nonoriginal work required. Reports in 2 months. SASE. Simultaneous submissions and previously published work OK. Free author guidelines.

Tips: Suggests that "photographers work with an author to research the history of an area and provide a suitable photographic collection with accompanying ms. In some cases the photographer is also the

author.'

DORCHESTER PUBLISHING CO., INC., Suite 900, 6 E. 39th St., New York NY 10016. (212)725-8811. Editorial Director: Jane Thornton. Publishes mass market paperbacks-chiefly fiction. Photos used for book covers. Buys 36 photos/year. "All our cover art is freelance, though most of it involves painting. We do 120 titles per year."

Subject Needs: "Attractive, sexy ladies; soft-focus, romantic shots of women, male action-adventure; still life relating to subject of the book." Model release required.

Specs: Uses 35mm transparencies.

Payment & Terms: Pays \$75-500/color photo; negotiates pay by the hour and job. No credit line "as a

rule." Buys all rights. Simultaneous and previously published submissions OK.

Making Contact: Query with resume of credits, samples, or list of stock photo subjects. "If we are interested in photographer's work, we will set up a personal appointment to see portfolio." Interested in stock photos. SASE. Reports in 1 month.

DOUBLEDAY AND COMPANY, INC., 245 Park Ave., New York NY 10167. Photo Research Editor: Jane Gilbert. Publishes all types of books. Photos used for text illustration, promotional materials, book covers and dust jackets. Buys approximately 200 photos annually; 15-20% supplied by freelancers. Subject Needs: "Depends on the subject of the book, the deadline and the art director—usually geared around sound lighting, color, well-omposed frames." Model release required.

Specs: Uses 8x10 glossy b&w and color prints; 35mm and 4x5 transparencies.

Payment & Terms: Pays \$400-550 for each color hard cover; \$750-1,000 for covers used for both hard

and soft copies. Inside photo prices depend upon rights purchased. Credit line given. Usually purchases one-time rights, but may vary according to use of photo. Simultaneous submissions and previously published work OK.

Making Contact: Arrange a personal interview to show portfolio; query with resume of credits, samples or with list of stock photos subjects; submit portfolio for review; provide resume, business card, brochure, flyer or tearsheets to be kept on file for possible future assignments. Solicits photos from local freelancers on assignment only; interested in stock photos. Pays "as soon as possible."

Tips: "Charge less than any stock photo house in New York to beat the competition. Make your work worth our search by showing us unique photos of obscure topics."

EASTVIEW EDITIONS, INC., Box 783, Westfield NJ 07091. (201)964-9485. Contact: Manager. "Will consider collection of photos depending on subject matter. Eastview publishes or distributes arts internationally-fine arts, architecture, design, music, dance, antiques, hobbies, nature and history." Photos wanted for publication as books.

Payment & Terms: Pays royalties on books sold. At present requires some financial commitment or support.

Making Contact: Query with samples. SASE. Reports in 6 weeks. Free photo guidelines and book catalog on request.

Tips: "No samples that must be returned. Send only 'second generation' materials."

EMC PUBLISHING, 300 York Ave., St. Paul MN 55101. (612)771-1555. Editor: Rosemary J. Barry. Publishes educational textbooks. Photos used for text illustration and book covers. Buys 10-15 photos annually; gives 1 freelance assignment annually.

Subject Needs: Vary. Model release required.

Specs: Uses 5x7 glossy b&w prints; 4x5 transparencies.

Payment & Terms: Payment varies. Credit line given. Rights purchased varies.

Making Contact: Query with resume of credits; provide resume, business card, brochure, flyer or tearsheets to be kept on file for possible future assignments. Solicits photos by assignment only; interested in stock photos. Does not return unsolicited material. Reports in 2 weeks.

*FALCON PRESS PUBLISHING CO., INC., Box 279, Billings MT 59103. (406)245-0550. Photo Editor: Michael S. Sample. Publishes adult trade (mostly recreational guides) and calendars (scenes and nature). Photos used for text illustration, promotional materials, and book covers. Buys 450 freelance photos annually.

Subject Needs: Scenery, wildlife, general nature and people having fun outdoors (hiking, fishing, etc.). Model release and captions preferred.

Specs: Uses b&w prints and 35mm, 21/4x21/4, 4x5 or 8x10 transparencies.

Payment & Terms: Pays \$10-35/b&w photo; and \$25-200/color photo. Credit line given. Buys onetime rights. Previously published work OK.

Making Contact: Provide a list of stock photos subjects to be kept on file for future requests; interested in stock photos. Does not return unsolicited material. Reports in 2 weeks.

FLORA AND FAUNA PUBLICATIONS, Suite 100, 4300 NW. 23rd Ave, Gainesville FL 32606. Editor-in-Chief: Ross H. Arnett, Jr. Publishes books emphasizing "natural history, plants and insects." Readers are "advanced high school and college students, educated laypersons." Photo guidelines free

Photo Needs: Needs "close-ups of insects showing features needed for identification; all parts must be in frame and insect must occupy at least 50% of frame; approximately same requirements for flower pictures and other groups. We publish only books with author-provided photos. We maintain a file of suppliers for our authors.

Making Contact & Terms: Query with list of stock photo subjects; provide resume to be kept on file for possible future assignments. Returns unsolicited material with SASE; "however, we have received hundreds this way and have never made a purchase." Reports in 1 month. Pays \$75/color cover photo; \$10/b&w inside photo; \$50/color inside photo. May purchase 50-300 photos for books at \$20 each plus. Pays on acceptance. Credit line given "depending on circumstances." Buys one-time rights. Simultaneous submissions and previously published work OK.

FOCAL PRESS, 80 Montvale Ave., Stoneham MA 02180. (617)438-8464. General Manager and Editor: Arlyn Powell. Publishes 20 photo titles average/year. Subject Needs: "Generally speaking, we are interested in informational rather than aesthetic or artistic

books on photography.

Payment & Terms: Authors of text paid by royalty; photographers paid by outright purchase.

Making Contact: Submit outline/synopsis and sample chapters. Provide resume and tearsheet to be kept on file for possible future assignments. SASE. Simultaneous and photocopied submissions OK. Reports in 4-6 weeks. Free catalog. We publish at all levels, from amateur to advanced professional. As a rule we do not publish books of photographs but how-to books with photos that demonstrate technique." Free catalog.

Recent Titles: Nikon/Nikkormat Way by Keppler; The Life of a Photograph by Lawrence Keefe and

Dennis Inch; Starting Your Own Photography Business by Ted Schwarz.

*GARDEN WAY PUBLISHING, Schoolhouse Rd., Pownal VT 05261. (802)425-2171. Contact: Martha Storey, Production Dept. Publishes adult trade books on gardening, country living, alternate energy, raising livestock, cooking, and nutrition. Has added line of business books. Nearly all "how-to" books showing specific skills and processes. Photos used for text illustration, promotional materials and book covers. Buys 50-75 photos/year, or makes 6-8 assignments/year. Provide resume, business card and tearsheets to be kept on file for possible future assignments. Notifies photographer if future assignments can be expected.

Subject Needs: Country living, gardening; "how-to" photos. "Generally we seek specific photos for specific book projects, which we solicit; or we assign a local freelancer. Do not want art photos or urban

scenes." Model release and captions preferred.

Specs: Uses 5x7 and 8x10 glossy and semigloss b&w and color prints, 4x5 and 35mm color transparencies. For jacket/cover uses glossy or semigloss b&w prints (contact sheet OK), and 35mm or 4x5 color transparencies.

Payment & Terms: Pays by the job or \$10-50/photo depending on assignment. For jacket/cover photos pays \$10-100/photo. Credit line usually given. Buys book rights. Previously published work OK.

Making Contact: Query with samples or arrange a personal interview to show portfolio. Prefers to see in a portfolio a dozen or more photos, published work; general samples, especially book photos; and 'how-to' photos. SASE. Reports in 3 weeks.

Tips: "The best thing would be a broad familiarity with Garden Way books, which are largely 'how-to' books. Versatility and an interest in country living plus quality work would count most.

GLENCOE PUBLISHING CO., 17337 Ventura Blvd., Encino CA 91316. Photo Editor: Leslie Andalman. Publishes elementary and high school, religious education, home economics and vocationaltechnical textbooks. Photos used for text illustration and book covers. Buys 500 photos annually; gives occasional freelance assignments.

Subject Needs: People—children at play, school, Catholic church; interrelationships with parents, friends, teachers; and Catholic church rituals; housing; homemaking; food preparation; child develo-

pent; consumersim. Also, people working, US only. Model release preferred.

Specs: Uses 8x10 glossy b&w prints and 35mm slides.

Payment & Terms: Pays \$35-50/b&w photo, \$50-100/color photo and \$50-300/cover color photo. Credit line given. Buys one-time rights. Simultaneous submissions and previously published work OK. Making Contact: Query with list of stock photo subjects and SASE; interested in stock photos. Reports as soon as possible—"sometimes there are delays. We will keep your subject list of material available in stock to be kept on file for possible future assignments."

Tips: "Send us a good subject list, be negotiable as to price (book budgets are sometimes low). Show us your best work and be patient. We look for very contemporary, upbeat, spontaneous unposed shots, and a

good ethnic mix represented by the models."

DAVID R. GODINE, PUBLISHER, 306 Dartmouth St., Boston MA 02116. (617)536-0761. President: David R. Godine. Publishes 2-3 photo titles/year. Authors paid by royalty. Query first; submit outline/synopsis and sample chapters; or submit sample photos. In portfolio, prefers to see "as representative of book project proposed as possible. We publish scholarly books and monographs almost exclusively; we never use freelance photographers." SASE. Simultaneous submissions OK. Free

Recent Titles: Urban Romantic by George Tice; Second Sight by Sally Mann; Photographs by Joyce

Tenneson.

GOLDEN WEST BOOKS, Box 80250, San Marino CA 91108. (213)283-3446. Photography Director: Harlan Hiney. Publishes books on transportation, history, and sports. Photos used in books. Buys "very few" annually. Query first with a resume of credits. Buys first rights. Reports in 1 week. SASE. Previously published work OK.

B&W: Uses 8x10 glossy prints. Pays \$8-10.

GRAPHIC ARTS CENTER PUBLISHING COMPANY, Box 10306, Portland OR 97210. (503)226-2402. Editorial Director: Douglas A. Pfeiffer. Publishes adult trade photographic essay books. Photos

"Jean-Claude LeJeune is a Chicago-based photographer who is particularly good with people shots," says Photo Editor Leslie Andalman of Glencoe Publishing Co. "We use his b&w photos in many of our books. He can be depended upon to furnish good quality pictures, and he has a nice eye for the out-of-the-ordinary as illustrated by this photograph. We were talking about faith, the mystery of existence, children learning about God in the universe. It was especially nice that the hands were brown and a little grubby; it avoided the slick, too-good-to-be-true that results from the carefully planned studio shot."

used for photo essays. Gives 5 freelance assignments annually.

Subject Needs: Landscape, nature, people, historic architecture, other topics pertinent to the essay. Captions preferred.

Specs: Uses 35mm, 21/4x21/4 and 4x5 (35mm as Kodachrome 64 or 25) slides.

Payment & Terms: Pays by royalty—amount varies based on project; minimum, but advances against royalty are given. Credit line given. Buys book rights. Simultaneous submissions OK.

Making Contact: Query with resume of credits; provide resume, business card, brochure, flyer or tearsheets to be kept on file for possible future assignments. SASE. Reports in 1 month. Photo guidelines

Tips: "Prepare an original idea as a book proposal. Full color essays are expensive to publish, so select topics with strong market potential. We see color essays as being popular compared to b&w in most

H. P. BOOKS, Box 5367, Tucson AZ 85703. Publisher: Rick Bailey. Publishes 5 photo titles average/ year. Publishes books on photography; how-to and camera manuals related to 35mm SLR photography; and lab work.

Specs: Uses 81/2x11 format, 160 pages, liberal use of color; requires 200-400 illustrations. Pays royalty on entire book.

Making Contact: Query first. SASE. Contracts entire book, not photos only. No simultaneous or photocopied submissions. Reports in 2 weeks. Free catalog.

Recent Titles: Pro Techniques of People Photography, and Pro Techniques of Glamour Photography, both by Gary Bernstein; Basic Guide to Close-Up Photography; and How to Use Electronic Flash. Tips: "Learn to write."

*HAYDEN BOOK COMPANY, 10 Mulholland Dr., Hasbrouck Heights NJ 07604. Art Director: Jim Bernard. Publishes textbooks, how-to's, and tutorials—all dealing with computers. Photos used for text illustration, promotional materials, book covers, dust jackets and software. Buys 25-50 or more freelance photos annually, and gives 3-5 or more freelance assignments annually.

Subject Needs: Computers in business, schools, home, computers in general, robotics, and computer generated art. Captions preferred.

Specs: Uses any size b&w and color prints and 35mm, 21/4x21/4 and 4x5 transparencies.

Payment & Terms: Payment negotiated individually. Credit line given. Buys book rights. Simultaneous submissions OK.

Making Contact: Provide resume, business card, brochure, tlyer or tearsheets to be kept on file for possible future assignments; interested in stock photos. SASE. Reports in 3-4 weeks "unless rush requested."

HEALTH SCIENCE, Box 7, Santa Barbara CA 93117. (805)968-1028. Contact: Art Department. Publishes health books and literature. Photos used for text illustration and promotional materials. Buys varied amount of photos from year to year.

Subject Needs: Foods and body (health-related). Model release preferred; captions required.

Specs: Uses b&w prints.

Payment & Terms: "Variable" payment. Credit line "can be" given.

Making Contact: Provide resume, business card, brochure, flyer or tearsheets to be kept on file for possible future assignments. Solicits photos by assignment only. SASE. Reports in 1 month.

D.C. HEATH AND CO., (Div. Raytheon), 125 Spring St., Lexington MA 02173. (617)862-6650. Art Director, School Division: David A. Libby. Publishes language arts, reading, math, science, social studies, and foreign language textbooks for elementary and high school; separate division publishes college texts. Buys hundreds photos/year, mostly from stock, but some on assignment. "Furnish us with a list of available subject matter in stock." May also call to arrange an appointment or submit material by mail for consideration. Usually buys one-time North American rights. Pays on a per-job or a per-photo basis. "Varies by project from minimum up to ASMP rates—generally similar to other textbook publishers." Reports in 1 month. SASE. Previously published photos OK, "but we want to know if it was used in a directly competitive book.'

B&W: Uses any size glossy, matte, or semigloss prints; contact sheet OK.

Color: Uses any size transparency.

Covers: Mostly done on assignment. Prefers 21/4x21/4 or 4x5 color transparencies.

Tips: "For initial contact the list of a photographer's available subject matter is actually more important than seeing pictures; when we need that subject we'll request a selection of photos. Textbook illustration requirements are usually quite specific. We know you can't describe every picture, but stock lists of general categories such as 'children' don't give us much clue as to what you have."

*HEMISPHERE PUBLISHING CORPORATION, Suite 1110, 79 Madison Ave., New York NY 10016. (212)725-1999. Promotion Production Manager: Susan T. Mohamed-zahzam. Publishes technical and medical trade and textbooks, i.e., engineering (all aspects), psychology, toxicology, etc. Photos used for promotional materials. Buys 100 freelance photos/year, and gives approximately 25 freelance assignments annually.

Subject Needs: Book photography (groups and/or singles).

Specs: Uses 5x7 to 8x10 silhouetted b&w prints.

Payment & Terms: Pays \$25/5x7 print (single photo rate), \$75/8x10 print (group rate), or as arranged.

Buys all rights.

Making Contact: Arrange a personal interview to show portfolio; provide resume, business card, brochure, flyer or tearsheets of work applicable to publishing needs to be kept on file for possible future assignments. Solicits photos by assignment only.

Tips: "We look for book shots; standard positions and/or creativity of layout, special effects-all in b&w. Many of the shots we use have become standardized (i.e., position) for clarification of need, such as catalog work."

HOLT, RINEHART AND WINSTON, 383-385 Madison Ave., New York NY 10017. (212)872-1931. "Our department is the school department and publishes all textbooks for kindergarten to grade 12." Photos used for text illustration, promotional materials and book covers. Buys 5,000 photos annually. Subject Needs: Photos to illustrate mathematics; the sciences—life, earth and physical; chemistry; and the humanities, as well as stories for reading and language arts. Model release and captions required. Specs: Uses any size glossy b&w and color transparencies.

Payment & Terms: Rates of payment are "within reason-negotiable." Credit line given. Buys one-

time and other rights. Simultaneous submissions OK.

Making Contact: "We reserve Thursdays at 11 a.m. for photographers to come in and show pictures." Otherwise, query with resume of credits, stock photo list or samples. Interested in stock photos. Does not

return unsolicited material. Reports "as soon as project allows."

Tips: "We use all types of photos, from portraits to setups to scenics. We like to see slides displayed in sheets or by carousel projector. Send a letter and printed flyer with a sample of work and a list of subjects in stock and then call to set up an appointment to show pictures to our staff."

HORIZON PRESS PUBLISHERS LTD., 156 Fifth Ave., New York NY 10010. Managing Editor: John Brace Latham. Publishes books on photography, architecture, literary criticism, music (adult trade) and fiction. Photos used for text illustration and book covers.

Subject Needs: "Depends on books we are publishing." Payment & Terms: Negotiates payment. Credit line given.

Making Contact: Query with resume of credits or with list of stock photo subjects. Does not return unsolicited material. Reports in 3 months.

THE HOUSE OF COLLECTIBLES, INC., 1900 Premier Row, Orlando FL 32809. (305)857-9095. Editor: Donna Laughlin. Publishes "price guide series to all categories of antiques and collectibles for all ages." Photos used for text illustration, promotional materials and book covers. Annual amount of photos purchased "to be determined."

Subject Needs: "Various types of antiques and collectibles—shot individually and in groups." Captions required.

Specs: Uses 4x5 glossy b&w prints; 4x5, 21/4x21/4 and 35mm color transparencies.

Payment & Terms: Pays \$5 maximum/b&w photo and \$50 maximum/color transparency. Credit line given if requested. Buys all rights. Simultaneous submissions and previously published work OK. Making Contact: Query with list of stock photo subjects; send unsolicited photos by mail for consideration; interested in stock photos. SASE. Reports in 3 weeks. Photo guidelines free with SASE. Tips: "We need good contrast b&w photos of single items. All photos should have plain backgrounds with the subject totally contained within the frame. The 4x5 or 35mm color transparencies are usually group shots of rare or desirable items related to the title. Specific specs available upon request."

CARL HUNGNESS PUBLISHING, Box 24308, Speedway IN 46224. (317)244-4792. Publishes books and magazines on USA open cockpit auto racing. Photos used for text illustration, promotional materials, book covers and dust jackets. Buys 500+ photos annually and gives 5-10 freelance assignments annually.

Subject Needs: Interested in "auto racing cars and people photos; we do not buy single car pan photos of cars going by." Model release optional; captions required (photos are not considered without captions).

Specs: Uses 5x7 or 8x10 b&w; and 5x7 or 8x10 color prints.

Payment & Terms: Pays \$3-25/b&w photo; \$6-75/color photo. Gives credit line at least 95% of the time. Buys all rights, but may reassign rights to photographer after publication. Simultaneous submissions and previously published work OK.

Making Contact: Query with samples. Works with freelance photographers on assignment only. Provide business card and letter of inquiry to be kept on file for possible future assignments. SASE.

Reports in 2 weeks.

Tips: "Our biggest gripe is photos submitted without ID's on back or photographer's name. Send your best; look at our publications to get better ideas."

ILLUMINATI, Suite 204, 8812 W. Pico Blvd., Los Angeles CA 90035. President: P. Schneidre. Publishes books of art and literature. Photos are used for text illustrations, book covers, dust jackets or subject matter.

Subject Needs: Art photos. Specs: Uses b&w prints only.

Payment & Terms: Payment negotiated. Credit line given. Buys one-time rights.

Making Contact: Query with nonreturnable samples. Reports in 2 weeks if SASE is provided. Provide samples to be kept on file for possible future use.

Tips: "We don't assign; we only use already existing but unpublished work."

INTERNATIONAL READING ASSOCIATION, Publications Division, 800 Barksdale Rd., Box 8139, Newark DE 19714. Graphics Design Coordinator: Larry F. Husfelt. Publishes books and journals for professional educators, especially reading teachers. Special needs include photos depicting people using print in their environment, and any type of print in an unusual medium. Send photos for consideration. Buys all rights, but may reassign to photographer after use. Reports in 1 month. SASE. B&W: Send 5x7 or 8x10 glossy prints. Pays \$5-10 (inside editorial use); \$35 (front cover).

Jacket: See requirements for b&w. Uses photos illustrating education; especially reading activities.

*THE KRANTZ COMPANY PUBLISHERS, 2210 N. Burling, Chicago IL 60614. (312)472-4900. Publishes adult trade, how-to, and art. Photos used for text illustration, promotional materials, book covers, and dust jackets. Buys 3-5 photos annually; gives 1-2 freelance assignments annually.

Subject Needs: Needs all types of subjects. Model release required; captions preferred.

Specs: Uses b&w prints and 35mm, 21/4x21/4, 4x5 and 8x10 transparencies.

Payment & Terms: Credit line given. Buys one-time or book rights. Simultaneous submissions OK. Making Contact: Provide resume, business card, brochure, flyer or tearsheets to be kept on file for possible future assignments. Deals with local freelancers on assignment only. "We are interested in stock photos." SASE. Reports in 1 month.

LAKEWOOD BOOKS, INC., 1062 Cephas Rd., Clearwater FL 33575. (813)461-1585. President: Thomas D. Stephens. Publishes books on diet, exercise, cooking, puzzles and romantic fiction. Photos used for dust jackets. Buy 12-24 photos annually; gives 6 assignments annually.

Subject Needs: Model release required.

Specs: Use 4x5 or 35mm prints and transparencies.

Payment & Terms: Pays \$50-150/job. Credit lines given. Buys book rights. Simultaneous submissions

and previously published work OK.

Making Contact: Query with list of stock photo subjects and send material by mail for consideration. Provide brochure to be kept on file for possible future assignments. SASE. Reports in 3 weeks. "Please contact us for samples of our publications."

LAY LEADERSHIP INSTITUTE, INC., 1267 Hicks Blvd., Fairfield OH 45014. (513)829-1999. Director of Development: James D. Craig. Publishes religious education materials. Photos used for text illustration, promotional materials and book covers. Buys 20 photos/year; gives 2 freelance assignments/year.

Subject Needs: Church, small groups of adults, children in small groups playing, reading, etc.; people worshipping, singing, etc. Model release required; captions optional.

Specs: Uses 81/2x11 b&w glossy prints; 35mm, 21/4x21/4, 4x5 or 8x10 transparencies.

Payment & Terms: Pays \$15-75/b&w photo; \$20-100/color photo; \$25-100/by the job. Buys one-time

rights. Simultaneous and previously published submissions OK.

Making Contact: Query with samples or list of stock photo subjects; send photos by mail for consideration; provide resume, business card, brochure, flyer or tearsheets to be kept on file for possible future assignments. Interested in stock photos. SASE. Reports in 1 month.

Tips: Prefers to see "a wide variety of photographs of children of mixed races, ages 4-12, and in a wide variety of activities, enjoying themselves. Also interested in small groups of adults having discussions in a home setting as well as in a church setting. Ensure high technical quality, strive for active composition with lots of life, i.e., people enjoying themselves."

LEBHAR-FRIEDMAN, 425 Park Ave., New York NY 10022. (212)371-9400. Senior Art Director: Milton Berwin. Publishes trade books, magazines and advertising supplements for the entire retailing industry. Photos used for text illustration, book covers, and ad supplements. Pays \$250/day and on a perphoto basis. Buys all rights. Model release required. Send material by mail for consideration. SASE. Reports in 2 weeks.

Subject Needs: In-store location and related subject matter.

B&W: Uses 8x10 prints. Pays \$50-100/photo or less, according to size and use.

Color: Uses transparencies. Pays \$150-300/photo.

Covers: Uses b&w prints and 21/4x21/4 color transparencies. Pays \$50-300/photo.

LIGHT IMPRESSIONS CORPORATION, Box 940, Rochester NY 14603. (716)271-8960. President: William D. Edwards. Publishes 5 photo titles average/year. "Light Impressions Publishing specializes in technical photography titles, archival science, and photographic history."

Subject Needs: "The Extended Photo Media Series is an ongoing series of titles dealing with photographic processes, both contemporary and traditional/historical. For this series we are particularly interested in tests dealing with processes that have received little or no coverage in other books."

Payment & Terms: Submit outline/synopsis and sample chapters or submit complete ms. SASE. Photocopied submissions OK. Payment negotiable.

Tips: "We do not publish monographs of photographer's work." Recently published: Arnold Gassan, The Color Print Book.

LIGHTBOOKS, Box 1268, Twain Harte CA 95383. (209)533-4222. Senior Editor: Paul Castle. Publishes books for professional photographers, principally books that tell them how to be more successful in the business of photography, how to make more money, and how to run a better studio. Buys 150-200 photos annually *only* as part of ms/photo package.

Subject Needs: Must relate to subject matter of the book. "We do not publish books of pretty pictures for the coffee table." Model release required; captions preferred.

Specs: Uses 8x10 glossy b&w and any size color transparencies.

Payment & Terms: Pays 10% minimum royalties. Gives credit line. No rights purchased. "All rights remain in the photographer's name and we copyright it." Previously published work OK.

Making Contact: Write and submit a one-page summary of ideas. Also should submit samples of the illustrations used. SASE. Reports instantly on the initial submission; about 4 weeks on detailed outlines of mss. "We do not look at portfolios/samples, only at suggested books with photos."

Tips: "Have a fresh book idea that will help other photographers do a better job or make more money in studio photography. We are now limiting our publishing efforts to small editions for studio photographs. The Master Book of Portraiture and Studio Management is a current, typical example."

LITTLE, BROWN & CO., 34 Beacon St., Boston MA 02106. (617)227-0730. Photo Researcher: Mary F. Rhinelander. Publishes adult trade. Photos used for book covers and dust jackets. Buys 20 photos annually; gives 5 freelance assignments annually.

Subject Needs: Model release required.

Payment and Terms: Credit line given. Buys one-time rights.

Making Contact: Query or arrange a personal portfolio viewing; provide resume, business card, brochure, flyer or tearsheets to be kept on file for possible future assignments; interested in stock photos. SASE. Reporting time varies.

*THE LITTLE HOUSE PRESS, INC., 2544 N. Monticello Ave., Chicago IL 60647. (312)342-3338. Senior Editor: Gene Lovitz. Estab. 1984. Publishes adult trade nonfiction, selected fiction, Americana, politics, business, guide books, institutional and regional histories. Photos used for pictorial books. Subject Needs: "We are only interested in collections of photographs that are in manuscript form, (i.e., pictorial biographies of notables; nudes; Americana pictorial histories; architecture; sports, animals, etc. Not interested in porno nudes; only nudes in art form (Adam & Eve; in nature; and even sexy cheesecake; good taste)."

Specs: Uses 8x10 b&w and color glossy prints and $2^{1/2}x2^{1/4}$ and 4x5 transparencies (prefer 4x5 transparencies but will work with decent 35mm or $2^{1/4}$).

Payment & Terms: "We pay standard royalties of around 10%." Credit line given. Buys book rights; "depends upon the agreement with the author."

Making Contact: "Query with samples or completed manuscript only if sent SASE—must include

postage and mailer." Reports in approximately 2 weeks.

Tips: Submissions should consist of "only photographs to be used in a pictorial book (showing subject handling and text samples). We want to know if a book will be 50% photography, 60%, 90%, etc. Use a copyright stamp in light blue ink of the photographer's name and address on the backside of each photo print, or labeled on transparency sleeves; use rubber cement on caption labels; orient text with photographs as closely as possible. Photography will more and more be used for dust jackets and paperback covers in preferences to art work; to illustrate books; more pictorial books. Some mysteries, and even novels, will use photographs of models for fictional characters to illustrate the book inside. Hardcover books are published under the Little House Press imprint; paperbacks under the Elephant Walk imprint.

LIVRES COMMONER'S BOOKS, 432 Rideau St., Ottawa, Ontario, Canada K1N 5Z1. (613)233-4997. Manager: Glenn Cheriton. Publishes adult trade, poetry and fiction. Recent titles include: Stepfamilies: Making Yours a Success and Ottawa in Postcards. Photos used for text illustration and book covers. Buys 8-12 photos/year. Provide business card to be kept on file for possible future assignments. Credit line given. Buys one-time rights. Model release preferred. Send material by mail for consideration. SASE. Simultaneous submissions and previously published work OK. Reports in 1 month. Free photo guidelines and catalog with SASE.

B&W: Uses 8x10 glossy prints. Pays \$10-100/photo. **Color:** Uses 35mm transparencies. Pays \$20-200/photo.

Jacket/Cover: Uses glossy b&w prints and color transparencies. Pays \$10-200/photo.

*LLEWELLYN PUBLICATIONS, Box 64383, St. Paul MN 55164. (612)291-1970. Editor: Terry Buske. Publishes consumer books (mostly trade paperback) with astrology and new age subjects, geared toward a young, high tech minded audience, and book catalogs. Buys 2-3 freelance photos annually. Subject Needs: Science/fantasy, space photos, special effects. Model release and captions optional. Accepts photos with or without accompanying ms.

Payment & Terms: Pays \$300-500/color cover photo. Pays on publication. Credit line given. Buys one-

time rights.

Making Contact: Query with samples; provide resume, business card, brochure, flyer or tearsheets to be kept on file for possible future assignments. SASE. Reports in 3 weeks.

*MACMILLAN PUB. INC., School Division, 866 Third Ave., New York NY 10022. (212)876-6680. Contact: Selma Pundyk. Publishes textbooks. Photos used for text illustration and book covers. Buys freelance photos annually, and gives freelance assignments annually.

Subject Needs: Varying according to projects in production. Captions and complete labelling are essen-

tial.

Specs: Open.

Payment & Terms: Pays \$75-150/b&w photo, \$150-300/color photo, and negotiates rates/job. Buys

one-time rights; other terms may be possible.

Making Contact: Arrange a personal interview to show portfolio; query with samples; send unsolicited photos by mail for consideration; or submit portfolio for review; provide resume, business card, brochure, flyer or tearsheets to be kept on file for possible future assignments. Reporting time varies.

MCDOUGALL, LITTELL, Box 1667, Evanston IL 60204. (312)967-0900. Picture Researcher: Katherine Nolan. Textbooks. Photos used for text illustration and book covers.

Subject Needs: Needs photos of "children, elementary-high; news events, fine art photos." Model release preferred.

Specs: Uses 4x5 transparencies.

Payment & Terms: Pays ASMP rates. Credit line given. Buys one-time rights. Simultaneous

submissions OK

Making Contact: Query with samples and list of stock photo subjects. "We deal with local freelancers only." Interested in stock photos. SASE. Reports in 1 month.

*MAVERICK PUBLICATIONS, Drawer 5007, Bend OR 97708. (503)382-6978. Contact: Ken Asher. Publishes all types of books. Photos used for book covers for cookbooks. Buys 10-25 freelance photos annually, and gives 10 freelance assignments annually.

Subject Needs: Kitchen scenes, food scenes, closeups of food for book covers for community

cookbooks. Captions optional.

Specs: Uses 8x10 smooth color prints and 35mm, 21/4x21/4, and 4x5 transparencies.

Payment & Terms: Pays \$50-150/color photo. Credit line given. Buys all rights or subsequent rights. Simultaneous submissions and previously published work OK.

Making Contact: Send unsolicited photos by mail for consideration; interested in stock photos. SASE.

Reports in 1 week. Photo guidelines free with SASE.

Tips: "We look for vertical shots suitable for 51/2x81/2 full bleed book covers with some area (about 1/4 of the photo) usually at the top where the title will not detract from the importance of the photo. Probably any photos we can use for cookbook covers will have to be staged set-ups with good lighting. Keep it light, bright and appetizing. Our company has plans to get into community cookbooks in a big way. Since many of these books find their way into a national market, we think it is important that each book has its own distinctive cover—therefore, our use of color photos will be increasing."

MEADOWBROOK INC., 18318 Minnetonka Blvd., Deephaven MN 55391. (612)473-5400. Art Director: Nancy MacLean. Publishes books on "infant and child care, pre-natal, post-natal care, infant health care—tips and how-to's; juvenile mysteries series—ages 6-13; travel tips; emergency first aid—how-to's; board books on baby animals and their mothers. Photos used for text illustration, promotional materials, book covers and 'illustration reference.' All photography purchased out-of-house."

Subject Needs: "Nature scenes—recreational camping; points of interest—international and national scenes; baby/infant—developmental; parenting scenes; baby animals and their mothers." Model release

required.

Specs: Uses 8x10 glossy b&w and color prints; 35mm, 21/4x21/4, 4x5 and 8x10 transparencies.

Payment & Terms: Pays \$45-100/hour. Credit line given on credit/copyright page. Buys one-time rights, book rights, all rights; "depends upon use of photograph." Simultaneous submissions and

previously published work OK.

Making Contact: Query with samples or with list of stock photo subjects; send unsolicited photos by mail for consideration; submit portfolio for review; provide resume, business card, brochure, flyer or tearsheets to be kept on file for possible future assignments. Solicits photos by assignment only; interested in stock photos. SASE. Reports in 3 weeks.

Tips: Prefers to see "excellent composition and highest quality reproduction" in a photographer's portfolio or samples. "Send materials that can be kept in our files. Many projects arise from an urgent

request that does not allow time for a specific talent search."

CHARLES E. MERRILL PUBLISHING COMPANY, 936 Eastwind Dr., Westerville OH 43081. (614)890-1111. Photo Manager: Cynthia Donaldson. Publishes "college level textbooks in a variety of disciplines, biology, physics, geology, geography, computer science, business, marketing, management, psychology, education and special education." Photos used for text illustration, promotional ma-

terials, book covers and dust jackets. Buys 1,000 photos annually; gives 10 freelance assignments annually.

Subject Needs: "Education/classroom interaction between teacher-student(s); business scenes; biology/nature: plants, animals; computers; photo micrographs." Model release required.

Specs: Uses 8x10 glossy b&w prints; 35mm transparencies.

Payment & Terms: Pays \$100 maximum/b&w photo; \$20 minimum, \$200 maximum inside and \$500 maximum cover/color photos; \$10-50/hour and \$200-2,000/job. Credit line given. Buys one-time

rights. Simultaneous submissions and previously published work OK.

Making Contact: Arrange a personal interview to show portfolio; query with samples or with list of stock photo subjects; send unsolicited photos by mail for consideration; provide resume, business card, brochure, flyer or tearsheets to be kept on file for possible future assignments. Solicits photos from local freelance photographers on assignment only; interested in stock photos. SASE. Reports in 1 month.

Tips: Prefers to see "b&w and color—variety of topics and published samples" in a photographer's portfolio or samples. "Make an investment in the future; order duplicate slides or extra prints and contact sheets for the publisher to hold until needed. We are using more photography than ever before."

*MILADY PUBLISHING CORPORATION, 3839 White Plains Rd., Bronx NY 10467. (212)881-3000. Creative Director-Cosmetology: Mary Healy. Publishes textbooks for vocational education in areas of cosmetology, business education, personal development, fashion. Photos used for text illustration and trade magazine illustration.

Subject Needs: Hair styling, business education, manicuring, esthetics, and modeling. Model release

and captions preferred.

Specs: B&w glossy prints.

Payment & Terms: Payment negotiated individually. Credit line given. Rights purchased varies per usage. Simultaneous submissions and previously published work OK.

Making Contact: Provide resume, business card, brochure, flyer or tearsheets to be kept on file for possible future assignments. Solicits photos by assignment only. SASE. Reports in 2 weeks.

*MOODY PRESS, 2101 W. Howard, Chicago IL 60645. (312)973-7800. Production Manager: Dallas Richards. Publishes religious, academic and trade books. Photos used for text illustration, book covers and dust jackets. Buys 12 freelance photos annually, and gives no freelance assignments.

Subject Needs: Nature scenics and special material set-ups.

Specs: Uses 81/2x11 glossy b&w prints and 35mm, 21/4x21/4, and 4x5 transparencies.

Payment & Terms: Pays \$25/b&w photo; \$75/color photo. Credit line not available, but photographer

receives mention elsewhere in book. Buys book rights.

Making Contact: Query with list of stock photo subjects; provide resume, business card, brochure, flyer or tearsheets to be kept on file for possible future assignments. Solicits photos by assignment only. SASE. Reports in 1 month.

MODERN CURRICULUM PRESS, 13900 Prospect Rd., Cleveland OH 44136. Production Assistant: Vicki Lewis. Publishes educational workbooks and textbooks for K-6th grade. Photos used for text illustration and book covers. Buys approximately 300 photos annually.

Subject Needs: All subject matters of interest to children. Model release required.

Specs: Uses 3x5 transparencies, 8x10 b&w photos and slides.

Payment & Terms: Payment depends on usuage. Credit line given. Buys one-time rights. Simultaneous

submissions and previously published work OK.

Making Contact: Provide resume, business card, brochure, flyer or tearsheets to be kept on file for possible future assignments. Solicits photos by assignment only; interested in stock photos. SASE. Reports as soon as possible.

Tips: "It is best to send a resume listing desired fees for various types of photographs, b&w and color, for slides and transparencies along with a general listing of types of photos available from stock."

MORGAN & MORGAN, INC., 145 Palisade St., Dobbs Ferry NY 10522. (914)693-0023. President: Douglas O. Morgan. Publishes 10 photo titles average/year. Authors paid by royalty or by outright purchase. Submit outline/synopsis and sample chapters or submit sample photos. SASE. Reports in 2 months. Free catalog. Recently published William Crawford, The Keepers of Light and The Morgan & Morgan Darkroom Book, both technical books; Martha Graham: Sixteen Dances in Photographs by Barbara Morgan and Rising Goddess by Cynthia MacAdams, both fine art photography books. Standard reference books include: Photo-Lab-Index which is kept current with supplements four times per year; Compact Photo-Lab-Index.

MOTT MEDIA, 1000 E. Huron, Milford MI 48042. (313)685-8773. Contact: Joyce Bohn or Leonard G. Goss. Publishes Christian books—adult and young adult trade, biographies and textbooks. Photos

Close-up

Bruce Johnson, Photo Manager,

Charles E. Merrill Publishing Company

The Charles E. Merrill Publishing Company uses almost 2,000 photos a year in its college division, and with needs that great its photo manager Bruce Johnson says he's more than interested in working with freelance photographers.

"We buy photos for preschool to secondary education college textbooks (with emphasis on reading, science, general education and physical education), and for educational administration, special education and school

counseling.

"We try to fill our needs from our existing stock of photos, but if we can't find what we need, we'll contact our freelance photographers," Johnson ex-

plains.

Because Merrill buys only one-time rights and pays extremely competitive rates, the company is a good market for freelancers, especially for those who have an extensive stock list. "We do not use major stock photo agencies because we can't justify their rates," John-

son explains.

"We like to place prints in an open file and hold them until they become dated. We keep a file of 100 to 200 pictures from a freelancer and some photos are used two or three times, with payment on a per-use basis unless we acquire all rights, which is rare. We pay based on the value of the work to us. Payment, too, often depends in part on the print run of a particular text," Johnson says.

On assignments, Johnson works with both local and regional photographers. "If we're doing local set-ups, we pay local day-rates and then buy the pictures outright." A typical rate for 80 original four-color photos is \$6,000 for all rights. "Where we have need for only a few shots in a particular subject area, we send out a needs list monthly to photographers who can meet our needs," Johnson says.

He advises photographers to send a

request to Mary Hagler for the company's policies and procedures. If photographers feel they can meet Merrill's needs, additional arrangements will be made to view samples. No unsolicited samples will be accepted.

Johnson discourages "shotgun" submissions and is selective about whom he works with. "We only have one photo editor, so we don't like to send a blanket list of our needs out to everyone. If we get pictures that are unacceptable technically or subject-wise, then we'll notify the photographer that we don't need his work."

Photographers should also have photocopies of model releases available. "We get a lot of pictures that we're reluctant to use because we don't have model releases for them," he says.

Johnson's final word of advice is something freelancers might apply to all markets: "Be sure that your work fits our specs."

-Michael Banks

used for text illustration and book covers. To see style/themes used write for free catalog. Buys book rights; buys all rights for covers. Model release required; captions preferred. Query with resume of credits or list of stock photo subjects. SASE. Previously published work OK. "We prefer to keep a list in resource file of photographers/resumes and their lists of stock photos. When a book design and graphics are planned, we either assign project and pay per photo, or ask to see photos from a list for possible purchase."

B&W: Uses 5x7 or larger glossy prints. Pays \$50 minimum, "depending on rights purchased and if

agreement is for a whole book, or just one shot."

Color: Uses transparencies. Pays \$35-50, "depending on rights purchased and if agreement is for a whole book, or just one shot."

Jacket/Cover: Uses glossy b&w prints and color transparencies. Pays \$75 minimum/b&w; \$150 minimum/color (all rights); and \$500-700 for total cover design, including photos.

*MULTNOMAH PRESS, 10209 SE Division, Portland OR 97266. (503)257-0526. Design Director: Al Mendenhall. Publishes Christian publications, adult trade and juvenile books. Photos used for text illustration, promotional materials, book covers, dust jackets and trade shows/materials. Buys 50-100 freelance photos annually.

Subject Needs: Nature, special effects, and symbolic themes. Model release required; captions

optional.

Specs: Uses 8x10 prints and 35mm and 21/4x21/4 transparencies.

Payment & Terms: Contact Multnomah Press for specific rates. Buys one-time rights, book rights, or

all rights. Simultaneous submissions and previously published work OK.

Making Contact: Query with list of stock photo subjects; provide brochure, or tearsheets to be kept on file for possible future assignments; interested in stock photos. Does not return unsolicited material. Tips: "Most often, photos are selected from stock or photography assigned after concept has been developed."

MUSIC SALES CORP., 24 E. 22 St., New York NY 10010. (212)254-2100. Contact: Daniel Earley. Publishes instructional music books, song collections, and books on music. Recent titles include: *The Complete Guitar Players Guide*. Photos used for text illustration and book jackets. Buys 200 photos annually. Query first with resume of credits; provide business card, brochure, flyer or tearsheet to be kept on file for possible future assignments. Buys one-time rights. Present model release on acceptance of photo. Reports in 2 months. SASE. Simultaneous submissions and previously published work OK. B&W: Uses 8x10 glossy prints. Captions required. Pays \$25-50.

Color: Uses 35mm, 2x2 or 5x7 transparencies. Captions required. Pays \$25-75.

Jacket: Uses 8x10 glossy b&w prints or 35mm, 2x2, 5x7 color transparencies. Captions required. Pays \$50-150.

Tips: "We keep photos on permanent file for possible future use. We need rock, jazz, classical—on stage and impromptu shots. Please send us an inventory list of available stock photos of musicians. We rarely send photographers on assignment and buy mostly from material on hand."

THE NAIAD PRESS, INC., Box 10543, Tallahassee FL 32302. (904)539-9322. Editor: Barbara Grier. "We are the oldest and largest of the lesbian and lesbian/feminist publishing houses. We publish trade and mass-market size paperback books, fiction, poetry, autobiography, biography, mysteries, adventure, self-help, sexuality, history, etc." Photos used for text illustration and book covers. Buys 6-20 photos annually.

Subject Needs: Inquire. Model release required; captions optional.

Specs: Uses 5x7 glossy b&w prints.

Payment & Terms: Credit line given. Buys all rights. Previously published work OK.

Making Contact: "Drop a note outlining work area." SASE. Reports in 3 weeks.

Tips: "We are interested in submissions from lesbian photographers particularly, and lesbian feminist photographers even more so. Very interested in having a location file of photographers for assigning author pictures (i.e. where the photographer is asked to photograph a local author for publicity purposes)."

NATIONAL GEOGRAPHIC SOCIETY, 17th and M Streets NW, Washington DC 20036. Book Service, Illustrations Editor: Linda B. Meyerriecks. Publishes 2 large format adult books/year. Special Publications, Assistant Director: William L. Allen. Publishes 4 adult and 8 children's book/year, World magazine and filmstrips. Photos used for text illustration, promotional materials, book covers and dust jackets. Photos purchased and freelance assignments given annually vary.

Subject Needs: "High quality—all subjects except advertising." Captions required.

Specs: Uses 35mm, 21/4x21/4, 4x5 and 8x10 transparencies.

Payment & Terms: Pays \$75-200/b&w page; \$100-200/color page and payment per job varies.

Filmstrips pay \$75/frame. Credit line given. Buys one-time rights.

Making Contact: Arrange a personal interview to show portfolio; query with samples or with list of stock photo subjects; provide resume, business card, brochure, flyer or tearsheets to be kept on file for

possible future assignments. Interested in stock photos. SASE. Reports in 3 weeks.

Tips: "Prefers to see a portfolio for review—40-60 transparencies; half showing ability to handle different situations, the rest giving in-depth approach to one subject. Keep working at story ideas and stock file."

NATURE TRAILS PRESS, 933 Calle Loro, Palm Springs CA 92262. (619)323-9420. Vice President: Jim Cornett. Publishes nature and outdoor books. Photos used for text illustration and book covers. **Subject Needs:** Wildlife, nature scenes, outdoor recreation.

Specs: Uses 5x7 and 8x10 b&w glossy prints; 35mm and 21/4x21/4 transparencies.

Payment & Terms: Pays \$7.50-50/b&w photo; \$10-75/color photo. Credit line given. Buys one-time rights. Simultaneous submissions and previously published work OK.

Making Contact: Query with list of stock photo subjects. SASE. Reports in 1 month.

NELSON-HALL PUBLISHERS, 111 N. Canal St., Chicago IL 60606. Editor: Steven Ferrara. Publishes educational books for libraries and colleges. Heavy emphasis in social sciences. Photos used for text illustration, promotional materials, book covers and dust jackets. Model release required; captions preferred.

Payment & Terms: Pays \$25 minimum/b&w photo; \$50 minimum/color photo. Gives credit lines.

Buys all rights. Previously published work OK.

Making Contact: Query with resume of credits and list of stock photo subjects. Provide resume, flyer and business card to be kept on file for possible future assignments. Does not return unsolicited material.

NEWBURY HOUSE PUBLISHERS INC., 54 Warehouse Lane, Rowley MA 01969. (617)948-2704. Associate Editor: Olivia Gould. Publishes reference and textbooks in language learning, language teaching, language science and English as a second or foreign language. Photos used for text illustration. Commissions 3 photographers/year. Provide resume, flyer, tearsheet and brochure to be kept on file for possible future assignments. Credit line given. Buys all rights. Model release preferred. Query with list of stock photo subjects. Does not return unsolicited material.

Subject Needs: Cultural and classroom photos of the US and foreign countries plus special photos for

particular texts.

B&W: Uses 5x7 and 8x10 glossy and semigloss prints. Pays \$5-20/photo. **Color:** Uses 5x7 and 8x10 glossy and semigloss prints. Pays \$10-35/photo.

Tips: "Send us one sheet giving name, address, phone, availability, and generalizations about or range of pricing photos."

NITECH RESEARCH GROUP, Box 638, Warrington PA 18976. Director: Dr. William White, Jr. Publishes adult books on the Bible and ancient world. Photos used for text illustration, book covers and

dust jackets. Buys 500-1,200 photos annually.

Subject Needs: "Expert 35mm transparencies of ancient sites in Greece, Turkey, Lebanon, Israel, Egypt, Jordan, Syria, particularly ancient inscriptions, texts, papyri, scrolls, etc. Photomicrography and photomacrography. We want precise focus, detailed formats, true colors, more scientifically acceptable qualities, less soft focus, and no false colors." Captions required.

Specs: Uses 35mm, 21/4x21/4 and 4x5 slides.

Payment & Terms: Pays \$35-100/b&w photo; \$35-250/color photo. Credit line given. Buys one-time and all rights, book rights or all rights, but may reassign to the photographer after publication. Simultaneous submissions and previously published work OK.

Making Contact: Query with list of stock photo subjects or send unsolicited photos by mail for

consideration. SASE. Reports in 1 month.

Tips: "Compositions appear to be getting worse, mere color or snap-shots of people will not work for commercial usage. The composition even in 35mm transparencies must be professional quality. Take fewer shots and better ones. Do your *own* processing. Learn what goes on in the color darkroom. Good color balance and professional composition. Good, solid architectural or natural science technique, no zoom lenses, must have resolution for high-magnification enlargements and strong color contrast. Good accurate captions and technical details. See our publication: Kodak Workshop Series 22, **Close-Up Photography** (1984) for what we want."

*NORTHWOODS PRESS, Box 88, Thomaston ME 04861. (207)354-6550. Owner: Robert Olmstad. Publishes "all types of books except porn and evangelical." Photos used for promotional materials, book covers, and dust jackets. Buys 8-10 photos annually. Subject Needs: Model release required if identifiable.

Specs: Uses 3x5 to 8x10 glossy b&w prints.

Payment & Terms: Pays \$5-25/b&w photo; by the job negotiable. Credit line given. Buys one-time or book rights. Previously published work OK.

Making Contact: Query with list of stock photo subjects. Send unsolicited photos by mail for consideration. SASE. Reports in 1 week.

*101 PRODUCTIONS, 834 Mission St., San Francisco CA 94103. (415)621-4960. Art Director: Lynne O'Neil. Publishes cookbooks, food related guides (shopping, restaurant), travel guides. Photos used for text illustration and book covers. Gives 3 freelance assignments annually.

Subject Needs: Food related shots only—either set ups of actual recipes or sensitive shots of ingredients.

Specs: Uses color prints and 35mm and 21/4x21/4 transparencies.

Payment & Terms: Pays negotiable/day rate. Credit line given. Buys book rights.

Making Contact: Query with samples; provide resume, business card, brochure, flyer or tearsheets to be kept on file for possible future assignments. Deals with local freelancers only. Solicit photos by

assignment only. SASE. Reports in 1 month.

Tips: "We are interested in maintaining a 'fine art' approach to illustrating our books. This has been our attitude with paintings, drawings and prints in the past, will be with photography in the future. We have just started using photography to illustrate our books in the past year as a response to public demand. People seem to want to see photographs of the recipes."

*ORTHO BOOKS, 575 Market St., San Francisco CA 94105. (415)894-3215. Photographic Director: Alan Copeland. Publishes how-to, cooking, and horticulture/gardening books.

Subject Needs: "Well lit subjects displaying great depth of field on Kodachrome transparencies that are technically perfect." Model release and exact captions required. Genus, species, variety captions required for horticultural subjects.

Specs: Uses 35mm, 21/4x21/4, 4x5 and 8x10 transparencies—Kodachrome only.

Payment & Terms: Rates negotiable by ASE. Credit line given at the front of the book rather than on each photo. Buys book rights or all rights. Previously published work OK.

Making Contact: Arrange a personal interview to show portfolio; provide resume, business card, brochure, flyer or tearsheets to be kept on file for possible future assignments; interested in stock photos. SASE. Reports in 6 months—send only dupes.

Tips: "We look for technical excellence, strong use of light and composition and organization."

OUTDOOR EMPIRE PUBLISHING, INC., Box C-19000, Seattle WA 98109. Publishes how-to, outdoor recreation and large-sized paperbacks. Photos used for text illustration, promotional materials, book covers and newspapers. Buys 6 photos annually; gives 2 freelance assignments annually. **Subject Needs:** Wildlife, hunting, fishing, boating, outdoor recreation. Model release and captions preferred.

Specs: Uses 8x10 glossy b&w and color prints and 35mm, 21/4x21/4 and 4x5 transparencies.

Payment & Terms: Pays \$10 minimum/b&w photo; \$25 minimum/color photo and \$100 minimum/job. Credit line given. Buys all rights; "depends on situation/publication." Simultaneous submissions and previously published work OK.

Making Contact: Query with samples or send unsolicited photos by mail for consideration; provide resume, business card, brochures, flyer or tearsheets to be kept on file for possible future assignments. Solicits photos by assignment only. SASE. Reports in 3 weeks.

Tips: Prefers to see slides or contact sheets as samples. "Be persistent; submit good quality work. Since we publish how-to books, clear, informative photos that tell a story are very important."

PADRE PRODUCTIONS, Box 1275, San Luis Obispo CA 93406. Editor: Lachlan P. MacDonald. Publishes general nonfiction books, children's books, art books and texts dealing with Western history; travel and antiques and collectibles. Photos used for illustrating art and travel books. We're interested in California travel books dealing with a single county." Buys 30-100 photos and 1-2 photo books annually. Query with resume of credits. Provide flyer, tearsheets, letter of inquiry and brochure to be kept on file for possible future assignments. Does not notify photographer when future assignments can be expected. Buys all rights, but may reassign to photographer after publication. Present model release on acceptance of photo. Reports in 4 weeks. SASE. Previously published work OK.

B&W: Send contact sheet. Captions required. Pays \$5-100. **Color:** Send transparencies. Captions required. Pays \$10-150.

Jacket: Send glossy prints for b&w, negatives with glossy prints or transparencies for color. "We're interested in Western photographers available to do travel books and covers. Author jacket photos are supplied by authors when used." Pays \$10-150.

Tips: "Return postage must accompany everything. Book ideas that include the text as well as

photographs are most welcome. We would like to work with a photographer who knows the subject or area well, can take photos to fit a predetermined layout, and can prepare for camera-ready book manufacture. Photographers who can do that can expect author credit and a standard royalty contract rather than a flat fee."

PALADIN PRESS, Box 1307, Boulder CO 80306. Art Director: Fran Porter. Publishes nonfiction books: self-sufficiency and survivalism, military, police science, and martial arts. Photos are used primarily for promotional materials; also text illustration, promotional materials, book covers and dust jackets. Buys 100+ annually; gives 6 freelance assignments annually.

Subject Needs: Police & military science, self-sufficiency and survivalism: technique and how-to

shots. Also equipment samples. Model releases required; captions preferred.

Specs: Uses 5x7 & 8x10 b&w prints.

Payment & Terms: Pays \$5-100/b&w photo; \$10-150/color photo and \$10-30/hour. Credit line given. Buys all rights, but may reassign to the photographer after publication. Simultaneous submissions OK; previously published work OK for military and police science photos only.

Making Contact: Query with samples or with list of stock photo subjects; interested in stock photos. SASE. Reports in 3 weeks. Provide flyer and tearsheets to be kept on file for possible future

assignments.

Tips: "We are particularly interested in obtaining unusual military and police photographs for use in catalogs and other promotional items. Producing 6 catalogs annually, in addition to other promo items mean we always have an immediate need for any photos pertaining to the above-mentioned subjects (self-sufficiency, survivalism, martial arts, military and police science and equipment, self-defense). We keep photos on file and are always on the lookout for fresh photos. Photographers with appropriate material should query with sample of available work (good quality photocopies of half-tone stats), or indicate range of subjects in stock."

PANTHEON BOOKS, 201 E. 50th St., New York NY 10022. Managing Editor: Betsy Amster. Publishes books both on and of photography; 3 photo titles average/year.

Subject Needs: "Text often as important—or more important—than photographs. Subject matter

should be socially relevant."

Payment & Terms: Authors paid by royalty of 15% maximum on retail price. Offers advances; average advance is \$1,500-5,000.

Making Contact: Query first. SASE. Simultaneous and photocopied submissions OK. Reports in 1-6 months. Free catalog with SASE; 7x10 envelope, 50¢ postage. Publishes books both on and of photography.

Recent Titles: Annie Leibovitz Photographs, All Under Heaven, London in the Thirties and Cindy

Sherman.

PEANUT BUTTER PUBLISHING, 911 Western Ave., Suite 401, Seattle WA 98104. (206)628-6200. Publisher: Elliott Wolf. Publishes cookbooks (primarily gourmet); restaurant guides; assorted adult trade books. Photos used for promotional materials and book covers. Buys 24-36 photos/year; gives 0-5 freelance assignments/year.

Subject Needs: "We are primarily interested in shots displaying a variety of foods in an appealing table or buffet setting. Good depth of field and harmonious color are important. We are also interested in

cityscapes that capture one or another of a city's more pleasant aspects. No models."

Specs: Uses 21/4x21/4 or 4x5 slides.

Payment & Terms: Pays \$50-150/color photo. Credit line given. Buys one-time rights. Simultaneous

submissions and previously published work OK.

Making Contact: Arrange a personal interview to show portfolio; query with samples or send unsolicited photos by mail for consideration. Interested in stock photos. SASE. Reports in 2 weeks. Tips: "We need to see photos—samples or stocks—that meet our needs."

PELICAN PUBLISHING CO., INC., 1101 Monroe St., Gretna LA 70053. (504)368-1175. Production Director: Sam Bububin. Publishes general trade books. Photos used for book jackets. Buys 10-15 photos/year. Query first with resume of credits. Buys all rights. Present model release on acceptance of photo. Pays \$30-125/job. Reports in 6 weeks. Previously published photos OK. Photos purchased with accompanying ms.

Jacket: Uses glossy b&w prints or color "as specified." Captions required.

POCKET BOOKS, 1230 Avenue of the Americas, New York NY 10020. (212)246-2121. Art Director: Milton Charles. Publishes mass market and trade paperbacks. Photos used for book covers. Payment & Terms: Pays \$500-1,500/b&w photo; \$1,000-2,500/color photo. Buys one-time rights.

Model release required.

Making Contact: Submit portfolio for review; provide tearsheets to be kept on file for possible future assignments; also interested in stock photos. SASE. Previously published work OK. Reports in 3 weeks.

PROMETHEUS BOOKS, 700 E. Amherst St., Buffalo NY 14215. (716)837-2455. Art/Production Director: Gregory Vigrass. Publishes philosophy, religion, paranormal, and psychology books; some trade novels. Photos used for promotional materials, book covers and dust jackets. Buys 100 photos/year; gives 100 freelance assignments/year.

Subject Needs: Academic and psychology/religion-related photos.

Specs: Uses 8x10 matte b&w prints.

Payment & Terms: B&w photo payment negotiable. Credit line given. Buys one-time rights or book

rights. Simultaneous submissions and previously published work OK.

Making Contact: If convenient, arrange a personal interview to show portfolio; query with resume of credits or samples; submit portfolio for review; provide resume, business card, brochure, flyer or tearsheets to be kept on file for possible future assignments. Solicits photos by assignment only; interested in stock photos. SASE. Reports in 1 week.

Tips: "Craftsmanship, design and format are often determined by art staff, but personal initiative and design sense will be considered. Send letters to the art director—samples if possible—be persistent and

emphasize the ability to meet deadlines."

REGAL'S BOOKS, INC., 104 Charles St., Boston MA 02114. Editor: Don K. Davis. Publishes adult books. Photos used for text illustrations and dust jackets. Buys 300-500 photos/year; gives assignments.

Subject Needs: Naked nature, nudes, erotic scenes, adult lovemaking, etc.

Specs: Uses b&w and color prints and 4x5 slides.

Payment & Terms: Pays up to \$55/b&w photo; \$85-135/color photo. Credit line given. Buys one-time rights. Simultaneous submissions and previously published work OK.

Making Contact: Send unsolicited photos by mail for consideration. SASE. Reports in 3 weeks. **Tips:** "Interested particularly in explicit lovemaking scenes of all kinds, and solo nudes."

REGENTS PUBLISHING COMPANY, INC., 2 Park Ave., New York NY 10016. (212)889-2780. Photo Editor: Robert Sietsema. Publishes language texts, primarily English as a second language. Photos used for text illustration and book covers. Buys over 200 photos annually; gives 20 freelance assignments annually.

Subject Needs: Model release usually not required; captions optional.

Payment & Terms: Pays \$40-80/b&w photo; \$75-250/color photo. Credit line given. Buys one-time

rights. Simultaneous submissions and previously published work OK."

Making Contact: Arrange personal interview to show portfolio, Wednesday afternoons only; interested in stock photos, anything related to communications with people (different races); other photographs more general, or specific to the photographer's work. Photos taken in Spanish-speaking countries often needed. Does not return unsolicited material. Reports in "one month if specific project is in production." Submissions of photocopies of photos encouraged.

RESOURCE PUBLICATIONS, INC., Suite 290, 160 E. Virginia St., San Jose CA 95112. Publisher: William Burns. Publishes religious books. Photos used for text illustration and promotional materials. Buys 6 photos/year. Pays \$15-35/hour. Credit line given. Buys all rights, but may reassign rights to photographer after publication. Model release required. Send material by mail for consideration. SASE. Reports in 6 weeks.

Subject Needs: Photos of music groups at worship; unique church architecture or interior design; and dramatic readings, processions, or any part of a ritual ceremony. Also photos of families celebrating the seasons or celebrating religious feasts together. No nature photos, still life, nudes. "All photos must be of interest to families or professional leaders of worship." To see style/themes used write for sample issue: \$3.

B&W: Uses 8x10 prints. Pays \$5-25/photo. **Color:** Uses 8x10 prints. Pays \$5-25/photo.

Jacket/Cover: Uses b&w prints and color transparencies. Pays \$5-25/photo.

RODALE PRESS INC., 33 E. Minor St., Emmaus PA 18049. (215)967-5171. Director of Photography: Thomas L. Gettings. Publishes gardening, bicycling, build-it, shelter, health, cookbooks and farming books and magazines. Photos used for text illustration, promotional materials, book covers, dust jackets and advertising. Gives 50 freelance assignments annually.

Subject Needs: Needs gardening, bicycling, build-it, shelter, health, cookbook and farming photos. Model release required; captions preferred.

riodel release required, captions pre

Specs: Uses b&w negatives.

Payment & Terms: Payment "varies from \$25 in smallest publication to \$600 for a color book cover." Buys all rights and multi-use rights. Simultaneous submissions OK.

Making Contact: Arrange a personal interview to show portfolio; submit portfolio for review. Solicits photos by assignment. Interested in stock photos. SASE. Reports in 1 month.

Tips: "Know what Rodale publishes. Read and study any material published by a potential client before arriving for an interview. I am seeing 'more color' in photography for books."

WILLIAM H. SADLIER, INC., 11 Park Place, New York NY 10007. (212)227-2120. Director of Photo Research, Sadlier/Oxford Editorial: Mary Ellen Donnelly. Publishes religious education materials for all ages; academic textbooks, kindergarten-adult. Photos used for text illustration, promotional materials, book covers, filmstrips and posters. Buys 500 photos annually; gives freelance assignments annually.

Subject Needs: Jr & Sr. high school students interacting with families, friends, members of the opposite sex (all ethnic groups); nature; worship; and technical. Model release required.

Specs: Uses glossy 8x10 b&w prints; 35mm and 21/4x21/4 transparencies.

Payment & Terms: Pays \$25-100/b&w photo; \$50-350/color photo. "Assignments are negotiated individually." Credit line given. Buys one-time rights, book rights or all rights. Simultaneous submissions OK.

Making Contact: Query with list of stock photo subjects; provide resume, business card, brochure, flyer or tearsheets to be kept on file for possible future assignments; interested in stock photos. SASE. Reports in 1 month.

Tips: Looks for "only superior quality photos with good interaction. No product labels or logos visible. Interior and exterior shots from various economic levels and representation of all parts of the US."

THE SCHOLADY PUBLISHING GROUP, INC., (formerly Intercontinental Book Publishing Company), Box 855, Mars PA 16046. (412)586-9404. Publisher/Chief Operating Officer: Michael D. Cheteyan II. Publishes textbooks on management, psychology, human relations, theology, etc. Photos used for text illustration and book covers. Buys 16 photos/year; gives 5 assignments/year. Pays \$15-75/job. Credit line given. Buys book rights. Model release and captions required. Query with resume of credits or list of stock photo subjects. SASE. Simultaneous submissions and previously published work OK. Reports in 1 month.

Subject Needs: Nature shots, human portraits. B&W: Uses 8x10 glossy prints; contact sheet OK.

Color: Uses 8x10 glossy prints and 35mm transparencies; contact sheet OK. Jacket/Cover: Uses glossy b&w and color prints and 35mm color transparencies.

SIMON & SCHUSTER, 1230 6th Ave., New York NY 10020. (212)245-6400. Art Director: Lisa Hollander. Publishes adult how-to and juvenile non-fiction. Photos used for book covers and dust jackets. Buys 30 photos/year; gives varied number of freelance assignments/year.

Subject Needs: Uses all subjects. Model release required.

Specs: Varies with job.

Payment & Terms: Pays \$250 maximum/b&w photo; \$350 maximum/color photo. Credit line given on back covers. Buys one-time rights. Simultaneous submissions and previously published work OK. Making Contact: Query with samples or with list of stock photo subjects; provide resume, business card, brochure, flyer or tearsheets to be kept on file for possible future assignments. Solicits photos by assignment only; interested in stock photos. Does not return unsolicited material. Reporting time varies.

GIBBS M. SMITH, INC./PEREGRINE SMITH BOOKS, (formerly Peregrine Smith Books), 1877 E. Gentile St., Box 667, Layton UT 84041. (801)554-9800. Editor: Buckley C. Jeppson. Publishes 4 photo titles average/year.

Subject Needs: Prefers architecture, pop culture and nature shots. Needs architectural photography to complement written studies and serious thematic photo essays or studies of 30-100 b&w photos.

Payment & Terms: Authors paid by royalty of 10-15%. Pays negotiable rates.

Making Contact: Query first; submit outline/synopsis and sample chapters; or submit sample photos and resume. SASE. Simultaneous and photocopied submissions OK. Reports in 3 months maximum. Catalog 53¢.

Recent Titles: Cole Weston: Eighteen Photographs; Photographers Photographed: Poetry of the Eye by Bill Jay; Edward Weston on Photography edited by Peter C. Bunnell; Edward Western Omnibus, edited by Beaumont Newboll. In Plain Sinker to Photography

by Beaumont Newhall; In Plain Sight; the Photographs of Beamont Newhall.

Tips: "Gibbs M. Smith, Inc./Peregrine Smith Books is now actively seeking books of photographs as well as books about photography. Collections of photographers and evocative photo essays are also very welcome. We are seeking someone who can send a vision—something new, striking, innovative, radical. We want "grass roots" rather than fussy "high fashion."

*SOUTH-WESTERN PUBLISHING COMPANY, 5101 Madison Rd., Cincinnati OH 45227. Assistant Director of Photographic Services: Paula Hickey. Clients: South-Western publishes texts for the high school and college market, as well as some vocational materials.

Needs: Works with 15-20 stock photographers/month. Uses photographers for textbook publishing. Subjects include occupational shots, human relations, work environment, high-tech, particularly in the field of computer technology.

Specs: Uses 8x10 b&w prints and 35mm, 21/4x21/4, 4x5 and 8x10 color transparencies.

First Contact & Terms: Provide business card, self-promotion piece or tearsheets to be kept on file for possible future assignments. Interested in stock photos. No response unless or until images are needed. Pay negotiated by use. Buys one-time rights usually. Model release preferred for technical subjects only. Credit line given.

STANDARD EDUCATIONAL CORP., 200 W. Monroe St., Chicago IL 60606. (312)346-7440. Picture Editor: Irene L. Ferguson. Publishes the New Standard Encyclopedia. Photos used for text illustration. Buys about 200 photos/year. Credit line given. Buys one-time rights. Model release preferred; captions required. Query with list of stock photo subjects. SASE. Simultaneous submissions and previously published work OK. Reports in 1 month. To see style/themes used look at encyclopedias in library.

Subject Needs: Major cities and countries, points of interest, agricultural and industrial scenes, plants and animals. Photos are used to illustrate specific articles in encyclopedia—the subject range is from A-7.

B&W: Uses 8x10 glossy prints; contact sheet OK. Pays \$50-75/photo.

Color: Uses transparencies. Pays \$100-200/photo.

STECK-VAUGHN COMPANY, Box 2028, Austin TX 78768. (512)476-6721. Photo Editor: Jeanne Payne. Publishes elementary, secondary, special education, and adult education textbooks and work-

"It really pays to be ready for unexpected events," says freelance photographer John Gerlach of Lapeer, Michigan. "This bird, an American avocet, was nesting near my blind and assumed this pose when an earthquake rolled through the area. I sold this photo to Standard Educational Corporation for \$125 for use in their encyclopedia line."

books in all academic subject areas. Photos used for text illustration. Buys 1000 + photos/year; gives 6-

10 freelance assignments/year.

Subject Needs: Children and adults in every facet of living; geographic, social, and political coverage of specific states. Also a need for photos showing handicapped individuals leading productive lives—show in various occupations. Model release required and captions preferred.

Specs: Uses 8x10 b&w and color glossies and 35mm, 21/4x21/4 and 4x5 transparencies.

Payment & Terms: Pays \$25-50/b&w photo; \$45-150/color photo and payment by job negotiable. Credit line given. Buys one-time rights. Simultaneous submission and previously published work OK.

Making Contact: Query with list of stock photo subjects. SASE. Reports in 1 month.

Tips: Do not send photos unless requested.

STEIN & DAY/PUBLISHERS, Scarborough House, Briarcliff Manor NY 10510. (914)762-2151. Art Director: Janice Rossi. Publishes adult trade fiction and nonfiction-war-related, self-help, hard and trade paperback and mass market paperbacks. Photos used for book covers and dust jackets. Buys 10-12 freelance photos annually and gives 1 freelance assignment annually.

Subject Needs: Photos for types of books listed above. Model release required.

Specs: Uses 8x10 b&w glossies; 4x5 and 3x3 color transparencies.

Payment & Terms: Pays \$250/b&w photo; \$400-500/color photo. Credit line given. Buys one-time

rights. Simultaneous submissions and previously published work OK.

Making Contact: Query with samples and list of stock photo subjects. Prefers to see samples of published and experimental work and some contact sheets. Provide resume, flyer, brochure and tearsheets to be kept on file for possible future assignments. SASE. Reports in 2 weeks.

STONE WALL PRESS, 1241 30th St. NW, Washington DC 20007. President: H. Wheelwright. Publishes national outdoor books and nonfiction. Photos used for text illustration, book covers and dust jackets. Buys all rights. Model release required. Query with samples. Interested in stock photos. SASE. Simultaneous submissions OK. Reports in 2 weeks.

Subject Needs: Outdoor shots dealing with specific subjects.

SYMMES SYSTEMS, Box 8101, Atlanta GA 30306. Photography Director: Ed Symmes. Publishes books about bonsai, the art of growing miniature plants. Needs pictures relating to bonsai. Special needs include images of 19th century photographers. Photos used for text illustration and for book jackets. Buys 75 annually. Query first with resume of credits; provide tearsheets, brochure and dupe slides to be kept on file for possible future assignments. Notifies photographer if future assignments can be expected. Buys first rights or all rights. Present model release on acceptance of photo. Reports in 2 weeks. SASE. Simultaneous submissions and previously published work OK.

B&W: Send negatives with 8x10 glossy prints. Captions required; include location and species of

subject. Pays \$10 minimum.

Color: Send transparencies. Captions required; include location and species of subject. Pays \$25

minimum.

Jacket: Send negatives with glossy prints for b&w, transparencies for color. Captions required; include location and species of subject. Pays \$25 minimum.

Tips: "We're looking for super sharp images with uncluttered backgrounds."

TAB BOOKS, INC., Box 40, Blue Ridge Summit PA 17214. (717)794-2191. Vice President, Editorial: Raymond A. Collins. Publishes books on computers, energy, solar, robots, electronics, video, lasers, fiberoptics, aviation, house how-to, woodworking, metalworking, toymaking, furniture construction, appliance repair, antique restoration, audio recording, electronic music, consumer medicine, model railroading, reference books, how-to-make-money-at books, science tricks and experiments, and musical instrument building and repair. Photos used for book covers and dust jackets. Buys up to 100 freelance photos annually.

Subject Needs: Most interested in color slides or transparencies for covers. Model release and captions

Specs: Uses 35mm and larger color transparencies.

Payment & Terms: Pays \$50-300/color photo. Credit lines given. Buys all rights, but may reassign rights to photographer after publication. Simultaneous submissions and previously published work OK. Making Contact: Query with samples. Provide resume, flyer, letter of inquiry, brochure and tearsheets to be kept on file for possible future assignments. SASE. Reports in 4-6 weeks. Photo guidelines free on

Tips: "Submit a resume including all photography experiences, samples of black and white photos,

color slides and reasonable rates.

THORNDIKE PRESS, Box 157, Thorndike ME 04986. (207)948-2962. Senior Editor: Tim Loeb. Publishes adult trade, outdoors/nature, how-to, humor, and material of New England regional interest.

138 Photographer's Market '86

Photos used for text illustration, book covers and dust jackets. Buys 200 photos annually; gives no freelance assignments annually.

Subject Needs: "Types of photos depend on the particular project." Model release required; captions preferred.

Specs: Uses 5x7 or larger b&w matte prints and 35mm, 21/4x21/4 and 4x5 transparencies.

Payment & Terms: Pays \$25-35/b&w photo and \$75-150/color photo. Credit line given. Buys one-time rights. Simultaneous and previously published submissions OK.

Making Contact: Query with list of stock photo subjects; interested in stock photos. SASE. Reports in 1 month.

TIME-LIFE BOOKS INC., 777 Duke St., Alexandria VA 22314. (703)838-7000. Director of Photography: John C. Weiser.

Subject Needs: Photography needs in the near future are limited. Special interest in interior photos for decorating series, studio still life for Civil War series.

Payment & Terms: Pays \$300/day. Submit sample photos; transparencies preferred. SASE. Reports in 3 weeks.

TROLL ASSOCIATES, 320 Rt. 17, Mahwah NJ 07430. Photography Director: Marian Schecter. Publishes textbooks for elementary through high school age audiences. Query first with a resume of credits. Usually buys all rights. Present model release on acceptance of photo; captions "usually" required. Reports in 3 weeks. Sometimes considers previously published photos.

B&W: Uses 5x7 or 8x10 glossy prints; send contact sheet. Pays \$25 minimum.

Color: Uses 35mm transparencies, or prints. Pays \$25 minimum.

TYNDALE HOUSE PUBLISHERS, 336 Gundersen Dr., Wheaton IL 60187. (312)668-8300. Art Director: Tim Botts. Publishes books "on a wide variety of subjects from a Christian perspective." Photos used for book jackets and text illustration and for a magazine, *The Christian Reader*. Buys 250 annually. Submit photos by mail for consideration. Prefers to see originals or dupes "from which we can select and hold for further consideration. Resumes and lists of subjects are not very helpful. We do not have time to send out guidelines, but we will reply to any photos sent with SASE." Buys one-time rights. Previously published work OK in non-competitive books. Direct material to Tim Botts, Production Department.

B&W: Send 8x10 glossy prints. Average page: \$35-50.

Jacket: Send 8x10 glossy prints for b&w, transparencies for color. Average pay: \$150-200. Uses nature, people, especially the family and groups of mixed ages and backgrounds. Special effects are sometimes useful.

Tips: "We have found it difficult to find candid pictures of people in various relationships such as working, helping, eating, and playing together. The best photos for our use usually tell a story. Send only your very best work. We are looking only for unique, fresh images."

UNIVELT, INC., Box 28130, San Diego CA 92128. (714)746-4005. Manager: H. Jacobs. Publishes technical books on astronautics. Photos used for text illustration and dust jackets.

Subject Needs: Uses astronautics; most interested in artists' concept of space. Model release preferred; captions required.

Specs: Uses 6x9 or 6x41/2 b&w photos.

Payment & Terms: Pays \$25 minimum/b&w photo. Credit line given, if desired. Buys one-time rights. Simultaneous submissions and previously published work OK.

Making Contact: Query with resume of credits; interested in stock photos; provide business card and letter of inquiry to be kept on file for possible future assignments. SASE. Reports in 1 month.

***VEND-O-BOOKS/VEND-O-PRESS**, Box 3736, Ventura CA 93006. (805)642-3488. Managing Editor: Dr. Bill Busche. Publishes how-o and humor books. Photos used for promotional materials, book covers and dust jackets. Buys 150-200 freelance photos annually, and gives 10 freelance assignments annually.

Subject Needs: People, special effects, landscapes, seascapes, and sports events. Model release required; captions preferred.

Specs: Uses b&w and color prints and 21/4x21/4 and 4x5 transparencies.

Payment & Terms: Pays AMP and AAAP rates. Credit line usually given. Buys one-time rights or all rights. Simultaneous submissions and previously published work OK.

Making Contact: Query with samples or with list of stock photo subjects; interested in stock photos. SASE. Reports in 3 weeks. Photo guidelines free with SASE.

"This photo illustrates the value of patience, a quality freelance photographers need," says Detroit, Michigan, freelance photographer Jim West. "I had sent a stack of photos to Tyndale House Publishers several years ago. They soon came back with one of those polite form letters we see all too frequently, 'Thank you for sharing your photos with us, unfortunately' I thought that was the end of it. But they had made photocopies, and called twice recently asking for two photos I had sent them years before. This one sold for \$45 for their book Trivia."

VICTIMOLOGY, INC., 2333 N. Vernon St., Arlington VA 22207. (703)528-8872. Photography Director: Sherry Icenhower. Publishes books about victimology focusing on the victims not only of crime but also of occupational and environmental hazards. Recent titles include: Spouse Abuse, Child Abuse, Fear of Crime and Self-defense. Photos used for text illustration. Buys 20-30 photos/year. Query with a resume of credits or submit material by mail for consideration. Buys all rights, but may reassign to photographer after publication. Submit model release with photo. Reports in 6 weeks. SASE. Simultaneous submissions and previously published work OK.

B&W: Send contact sheet or 8x10 glossy prints. Captions required. Payment depending on subject matter and use.

Color: Send 35mm transparencies, contact sheet or 5x7 or 8x10 glossy prints. "We will look at color photos only if part of an essay with text." Captions required. Pays \$30 minimum.

Jacket: Send contact sheet or glossy prints for b&w; contact sheet, glossy prints or 35mm transparencies for color. Captions required. Pays \$100-150 minimum.

WADSWORTH PUBLISHING COMPANY, 10 Davis Drive, Belmont CA 94002. (415)595-2350. Contact: Art Director. Publishes college textbooks—all subjects. Photos used for text illustration and book covers. Buys 500+ freelance photos annually; gives 3-5 freelance assignments annually. Model release preferred; captions optional.

Specs: Uses 8x10 glossy b&w prints; 35mm (for interiors), 4x5 and 8x10 (for covers) transparencies. Payment & Terms: Pays \$80-150/b&w photos; \$80-250/color photos (ASMP rates). Credit line "not usually" given. Buys one-time, book or all rights. Simultaneous and previously published submissions OK

Making Contact: Query with samples or list of stock photo subjects; provide resume, business card, brochure, flyer or tearsheets to be kept on file for possible future assignments; interested in stock photos. SASE. Reports in 3 weeks.

Tips: "Most of our photos are obtained through photo researchers or stock houses. We assign photography for cover only, usually."

WALKER & COMPANY, 720 5th Avenue, New York NY 10019. (212)265-3632. Art Director: Laurie McBarnette. Publishes mysteries, young adult romances, westerns, educational, paperback massmarket British mysteries-mostly library sales. Photos used for text illustration and dust jackets. Buys 50 freelance photos annually; gives 150 freelance assignments annually.

Subject Needs: "B&w suitable for cover photo of 3-color dust cover of hard-cover mystery (cloak and

dagger genre); murder mysteries." Model release preferred; captions required. Specs: Uses b&w and color matte or glossy prints; 35mm transparencies.

Payment & Terms: Pays \$250-300/color cover photo; \$100-350/b&w photo; \$100-500/color photo; or \$7-15/hour. Negotiates rates by the job. Credit line given, "usually on back flap. Walker and Company reserves first publication rights, including book club. Payment in 30-60 days."

Making Contact: Provide resume, business card, brochure, flyer or tearsheets to be kept on file for possible future assignments. Solicits photos by assignment only. SASE. Reports "when job applies." Tips: "Along with mystery cover photos, there is a rare instance where a photo for an education book is needed and has not been provided by the authors-usually depicting young children in an activity situation with adult supervision. Photographers should provide clear, crisp reproductions for the mystery jackets. And keep in mind that type placement will be a factor when a layout cannot be provided.

WHITAKER HOUSE, Pittsburgh & Colfax Sts., Springdale PA 15144. (412)274-4440. Editor: Diana Matisko. Publishes adult trade inspirational literature (Christian paperbacks). Photos used for book covers. Buys 20-30/year. Provide resume, brochure and flyer to be kept on file for possible future assignments.

Subject Needs: "We are most interested in beautiful nature shots which are colorful and which do not usually include people or man-made objects." Model release required. No photos of groups of people, buildings, cities, or barren deserts. "Pay special attention to our specification sheets."

Specs: Uses color transparencies for cover photos only.

Payment & Terms: Pays \$150-250/color photo. Credit line given if requested. Buys one-time rights. Simultaneous submissions and previously published work OK.

Making Contact: Query with samples or list of stock photo subjects. "Just contact us with sources for nature and scenic photos. We are open to all solicitations." SASE. Reports in 3 weeks.

JOHN WILEY & SONS, INC., 605 3rd Ave., New York NY 10158. (212)850-6731. Photo Research Manager: Stella Kupferberg. Publishes college texts in all fields. Photos used for text illustration. Buys 4,000/year.

Subject Needs: Uses primarily b&w photos for use in textbooks in psychology, sociology, business, computer science, anthropology, biology, geography, geology, government and foreign languages. No posed advertising-type shots. Captions required.

Specs: Uses 8x10 glossy and semigloss b&w prints and 35mm color transparencies. "We would prefer no dupes when reviewing color transparencies."

Payment & Terms: Pays \$50-90/b&w print and \$75-125/color transparency. Credit line given. Buys one-time rights. Simultaneous submissions and previously published work OK. Making Contact: Query with list of stock photo subjects. SASE. Reports in 1 month. "We return all

photos securely wrapped between double cardboard by registered mail."

Tips: "Initial contact should spell out the material photographer specializes in, rather than a general inquiry about our photo needs.'

WILSHIRE BOOK CO., 12015 Sherman Rd., North Hollywood CA 91605. (213)875-1711. President: Melvin Powers. Publishes books on self-development, horse instruction, inspiration and nonfiction. Photos used for covers. Buys 50 annually. Call to arrange an appointment. Buys second (reprint) rights. Present model release on acceptance of photo. Reports in 1 week. SASE. Simultaneous submissions and previously published work OK.

Jacket: Uses color prints, 35mm and 21/4x21/4 color transparencies. Pays \$100 minimum.

Tips: Particularly needs photos of couples and horse photos of all kinds. Always needs photos of women and men suitable for book covers. "Just call with your material. Our door is always open."

WISCONSIN TRAILS BOOKS, Box 5650, Madison WI 53705. (608)231-2444. Production Manager: Nancy Mead. Publishes adult nonfiction, guide books and photo essays. Photos used for text illustration and book covers. Buys "many" photos and gives "many" freelance assignments annually. Subject Needs: Wisconsin nature and historic scenes and activities. Location information for captions

Specs: Uses 5x7 or 8x10 b&w prints and any size transparencies.

Payment & Terms: Pays \$10-20/b&w photo; \$50-150/color photo; payment by the job varies. Credit line given. Buys one-time rights. Simultaneous submissions and previously published work OK. **Making Contact:** Query with samples or list of stock photo subjects, or send unsolicited photos by mail for consideration. SASE. Reports in 1 month. Provide resume to be kept on file for possible future assignments. Photo guidelines free on request with SASE.

Tips: "See our products and know the types of photos we use." Also see listing under Consumer

Magazines.

WRITER'S DIGEST BOOKS, 9933 Alliance Rd., Cincinnati OH 45242. (513)984-0717. Contact: Art Director. Publishes books about writing, art, and photography. Also publishes Writer's Digest magazine. Photos used for book jackets and inside illustrations. Query first with samples. Prefers to see 20-25 b&w photos and/or tearsheets. Provide resume, flyer, business card and brochure to be kept on file for future assignments. Buys first North American rights. Pays \$25 minimum/job or on a per-photo basis. Reports in 2 weeks. SASE. Simultaneous submissions and previously published work OK. Tips: "Study our books before submitting anything. We rely heavily on local photographers."

ZONDERVAN PUBLISHING HOUSE, 1415 Lake Dr., Grand Rapids MI 49506. (616)698-6900. Art Director: Art Jacobs. Publishes religious and conservative books. Photos used for book jackets and text illustration. Submit material by mail for consideration. Prefers $2^{1/4}x^{2^{1/4}}$ or $4x^5$ transparencies in a portfolio. Provide flyer, brochure or samples that can be kept on file for possible future assignments. Present model release on acceptance of photo. SASE. Simultaneous submissions OK. Payment is worked out on a per project basis.

Color: Send transparencies, negatives, prints or negatives with prints.

Jacket: Send color transparencies.

Businesses and Organizations.

If "Businesses and Organizations" sounds like an extremely varied assortment of potential markets for freelance photography, that's because it is—but the marketing opportunities represented and suggested by these listings should not be overlanded by any extremising photographer.

looked by any enterprising photographer.

In addition to corporations and other commercial ventures, this section includes a broad range of nonprofit and institutional organizations such as civic and governmental bureaus and offices; schools, hospitals and other service organizations; professional, trade and labor associations, and more. The common thread running through all of these is a regular demand for the services of the freelance

photographer.

The companies and groups listed here—as well as thousands more across the country, including at least several in your community—use photography for dozens of purposes, and the freelancer who services this market must be prepared to handle a wide variety of assignments under all sorts of working conditions—from making portraits of executives in oak-paneled boardrooms to shooting nuts and bolts (literally) on the assembly line. Your finished product may be used in press releases for publication in local newspapers; to illustrate stories in the organization's inhouse magazine or newsletter; for advertising in catalogs or brochures; or in the company's annual report to its stockholders.

But whatever the ultimate purpose of the pictures taken, the key to working successfully in this market is *professionalism*. To deal with businessmen, it pays to be businesslike; this means presenting yourself as a professional, keeping appointments, following instructions, meeting deadlines—even dressing neatly. Corporate and institutional executives expect to deal with photographers as they would with any other supplier or service contractor. If you've never dealt with the client before, this means calling for an appointment to present your resume and samples of similar work you've done in the past. It also helps to have a *business card*, and perhaps additional materials such as a brochure or flyer describing your services and illustrating your work. Clients can keep these materials on file to refer to when future photo jobs come up.

If you're currently working another job to support your photography habit, the best bet for your first business client is probably right down the hall—in the office of the company's president or public relations department. Let these people know that they have a qualified photographer right there on the premises, one who's available for any photo assignments that might arise. Even if you're asked to work on a voluntary or expenses-only basis to start, such jobs can give you invaluable experience in meeting the demands of business buyers, and may well lead to bigger and more profitable assignments down the road, both inside and outside the company.

THE ADVERTISING COUNCIL, INC., 25th floor, 825 3rd Ave., New York NY 10022. (212)758-0400. Director of Public Affairs: Benjamin S. Greenberg. A nonprofit association chartered by the advertising profession to produce public service advertising campaigns in the public interest. Photos used in brochures, slide presentations, annual reports, news releases and regular publications. Buys a limited number of freelance photos/year; gives 2-4 freelance assignments/year. Pays \$40-60/hour or \$150-250/day. Send resume of capabilities and resources. Provide resume, brochure and cover letter to be kept on file for possible future assignments. No unsolicited samples. Reports in 2 weeks. SASE.

B&W: Uses 8x10 or 4x5 glossy prints.

Color: Uses 35mm transparencies or prints.

Tips: "If the photographer looks for any local stories about the Advertising Council and its public service campaigns in his community, we would be interested in pix. Also pix of billboards with Advertising Council public service ads."

ALFA-LAVAL, INC., Box 1316, 2115 Linwood Ave., Fort Lee NJ 07024. (201)592-7800. Manager, Marketing Communications: David E. Closs. Manufactures industrial centrifuges, heat exchangers and process systems. Gives 6-10 assignments/year. Photos used in brochures, audiovisual presentations, PR releases and for file reference.

Subject Needs: Installation photos of equipment.

Specs: Uses 8x10 b&w and color prints; 35mm and 21/4x21/4 slides; b&w contact sheet; b&w or color negatives OK.

Payment & Terms: Pays \$40-75/hour and \$50 minimum/job. Buys all rights. Model release required; captions preferred.

Making Contact: Arrange a personal interview to show portfolio. Provide business card and flyer to be kept on file for possible future assignments. Makes assignments in response to correspondence. SASE. Reports in 2 weeks. In a portfolio prefers to see "photos of large equipment in industrial environment. Alfa-Laval has installations throughout the US. Our equipment and locations are not glamorous. They are difficult to light. Our assignments generally do not require more than a ½-day shoot."

ALLRIGHT AUTO PARKS, INC., Suite 1200, Concorde Tower, 1919 Smith St., Houston TX 77002. (713)222-2505. National Director of Public Relations: H. M. Sinclair. Company operates in 75 cities in the US and Canada. Uses photos of parking facilities, openings, before and after shots, unusual parking situations, and Allright facilities. Photos used in brochures, newsletters, newspapers, audiovisual presentations and catalogs. Pays \$25 minimum/hour or on a per-photo basis. Buys all rights. Model release preferred. Arrange a personal interview to show portfolio; provide resume, brochure, flyer and tearsheets to be kept on file for future assignments. Does not notify photographer if future assignments can be expected. SASE. Reports in 2 weeks.

B&W: Uses 8x10 glossy prints.

Color: Uses 35mm transparencies or 8x10 glossy prints.

Tips: "We hire local photographers in our individual operating cities through the local manager, or directly by phone with photographers listed at national headquarters, or by prints, etc. sent in with prices from local cities to national headquarters or through local city headquarters."

AMERICAN ANIMAL HOSPITAL ASSOCIATION, Box 768, Mishawaka IN 46544. Director of Public Relations: David Dufour. Provides "veterinary continuing education, pet health information to consumers and sets standards for animal hospitals." Buys 10 freelance photos/year. Photos used in newsletters, annual reports, AV-presentations, and PR releases.

Subject Needs: "Publicity shots (our meetings); people and pet photos (dogs & cats primarily—some birds); veterinarians with pets in clinical settings (no surgeries, please)." Uses 5x7 or 8x10 b&w and

color glossy prints; and 35mm, 21/4x21/4 transparencies.

Payment & Terms: Pays \$400-800/day; "all other rates should be negotiated." Credit line given if requested, but not on publicity shots. Prefers to purchase all rights, but will negotiate depending on usage." Model release preferred.

Making Contact: Provide resume, business card, brochure, flyer or tearsheets to be kept on file for possible future assignments. SASE. Reports in 1 month.

AMERICAN FUND FOR ALTERNATIVES TO ANIMAL RESEARCH, 175 W. 12th St., Suite 16-G, New York NY 10011. (212)989-8073. Contact: Dr. E. Thurston. Finances research to develop research methods which will not need live animals. Also informs the public this and about current methods of experimentation. Needs b&w or color photos of laboratory animal experimentation and animal use connected with fashions (trapping) and cosmetics (tests on animals). Uses photography for reports, advertising and publications. Buys 10+ freelance photos/year; gives 5+ freelance assignments/year. Pays \$5 minimum/b&w photo, \$5 or more/color photo; \$30/minimum by the job. Credit lines are given. Rights purchased are arranged with photographer. Model release preferred. Arrange a personal interview to show portfolio, query with samples and list of stock photo subjects. Provide brochure and flyer to be kept on file for possible future assignments. Notifies photographer if future assignments can be expected. SASE. Reports in 2 weeks.

B&W: Uses 5x7 b&w prints.

Film: Interested in 16mm educational films.

AMERICAN MUSEUM OF NATURAL HISTORY LIBRARY, PHOTOGRAPHIC COLLECTION, Library Services Department, Central Park West, 79th St., New York NY 10024. (212)873-1300, ext. 346 and 347. Assistant Librarian for Reference Services: Mary Genett. Provides services for advertisers, authors, film & TV producers, general public, government agencies, picture researchers, publishers, scholars, students and teachers. Photos used for brochures, newsletters, posters, newspapers, audiovisual presentations, annual reports, catalogs, magazines, PR releases, books and exhibits. Payment & Terms: No payment. Credit line given. Model releases and captions required.

Making Contact: Arrange personal interview to show portfolio and query with resume of credits and samples. Reports in 1-2 weeks. "We accept only donations with full rights (non-exclusive) to use; we offer visibility through credits. Please document well."

AMERICAN NATIONAL RED CROSS, Photographic Section, 18th & E Sts. NW, Washington DC 20006. (202)639-3560. Photographic Coordinator: Stephen Anderson. Photos used to illustrate annual reports, articles, slide shows, ads, brochures and news releases. Submit model release with photo. Submit material by mail for consideration. Pays \$15-100/b&w photo; \$15-100/color photos; payment negotiable, depending on job requirments. SASE. Reports within 2 weeks. "In case of disaster photos, call collect."

B&W: Send contact sheet or 8x10 glossy prints. Pays \$15-100.

Color: Send 35mm transparencies. Pays \$15-100.

Tips: "Although we have photographers on staff, we do need freelancers occasionally. We would be interested in developing a pool of Washington, DC area photographers from which to draw talent for our overflow assignments. Contact us for an appointment for a portfolio review. We are always interested in looking at work depicting Red Cross activities, particularly during disasters. If a photographer thinks he or she has something we can use from a disaster, we need to see it immediately. Generic disaster photos, unless of extraordinary quality, are of little use to us."

AMERICAN SOCIETY FOR THE PREVENTION OF CRUELTY TO ANIMALS (ASPCA), 441 E. 92nd St., New York NY 10128. (212)876-7700. Head of Publications: Joyce Moskowitz. Publishes quarterly newsletter, pamphlets, booklets and posters. Photos used in brochures, newsletters, posters, newspapers and annual report. Needs photos of animals. Buys 25 freelance photos and gives 5 freelance assignments/year. Pay \$100 maximum/job. Credit lines given. Model release and captions preferred. Arrange a personal interview to show portfolio. Prefers samples of animal-related photos in a portfolio. Provide brochure and resume to be kept on file for possible future assignments. SASE. Reports in 3 weeks. Notifies photographer if future assignments can be expected.

*ARIZONA THEATRE COMPANY, Box 1631, Tucson AZ 85702. (602)884-8210. Communications Director: Gary Bacal. "We produce professional theater, performing full seasons in Tucson and Phoenix, and touring the state." Photos used in brochures, newsletters, posters, newspapers, audiovisual presentations, magazines, and PR releases.

Subject Needs: "We purchase all our photo needs from freelance photographers—either for one-time

assignments or on an annual contract.

Specs: Uses 8x10 b&w prints, 35mm transparencies, contact sheets, and possibly negatives. Uses freelance videographers to produce tapes of production rehearsals for promotional purposes.

Payment & Terms: Payment negotiated individually. Credit line given. Rights purchased are negotiable. Model release and captions (names, dates, ID's) required.

Making Contact: Query with samples; provide resume, business card, brochure, flyer or tearsheets to be kept on file for possible future assignments. SASE.

Tips: "Be relaxed and flexible! We are seeing an increased need for color."

ASSOCIATION FOR RETARDED CITIZENS OF THE UNITED STATES, National Headquarters, 2501 Avenue J, Arlington TX 76011. (817)640-0204. Director of Communications Department: Liz Moore. "Largest non-profit organization of 160,000 members working for better services and opportunities for this nation's 6.5 million citizens with mental retardation." Gives 3 assignments/year. Photos used in brochures, newsletters, newspapers, annual reports, PR releases and magazines. Specs: Uses 5x7 glossy prints; contact sheet and negatives OK.

Payment & Terms: Pays \$3.50-25/b&w photo; \$30 maximum/hour including return of contact sheets, excluding film. Pays \$300 maximum/job or day. Credit line given. Buys all rights. Model release and

captions required. Does not pay royalties.

Making Contact: Query with samples or stock photo series; provide resume, business card, brochure, flyer or tear sheets to be kept on file for possible future assignments. SASE. Reports in 3 weeks. Tips: "We are desperately in need of new photos for our morgue file. Because we're a nonprofit association, we cannot afford to pay 'going rates'. However, photographers can enjoy tax breaks if they're astute about those matters. Educational settings ideal. We particularly need more photographs of people who are mentally retarded who are living, working and playing in community settings (as opposed to institutional). Knowledge of mental retardation and ability to erase stereotypes are most valuable. The photographer needs to be motivated to help our cause."

*BAKER STREET PRODUCTIONS LTD., Box 3610, 502 Range St., Mankato MN 56001. (507)625-2482. Contact: Karyne Jacobsen. A book and catalog production service. Buys 500 photos/year; gives 2 freelance assignments/year. Photos used in brochures, catalogs, and juvenile books. Subject Needs: Wildlife.

Specs: Uses b&w and color prints and 35mm transparencies.

Payment & Terms: Pays \$65/b&w photo, \$85/color photo. Credit line given. Buys reproduction rights

for life-time of book. Model release required; captions preferred.

Making Contact: Query with list of stock photo subjects; provide resume, business card, brochure, flyer or tearsheets to be kept on file for possible future assignments; interested in stock photos. SASE. Reports in 1 month.

*LAWRENCE BENDER & ASSOCIATES, 512 Hamilton Ave., Palo Alto CA 94301. (415)327-3821. Contact: L. Bender. Graphic design firm. Buys numerous photos/year; gives numerous assignments/year. Photos used in brochures and annual reports.

Subject Needs: A variety of photo needs and subjects.

Specs: Uses b&w prints and 35mm, 21/4x21/4 and 4x5 transparencies.

Payment & Terms: Payment negotiated individually. Buys one-time rights. Model release required. Making Contact: Arrange a personal interview to show portfolio, query with resume of credits, with samples, or with list of stock photo subjects; provide resume, business card, brochure, flyer or tear sheets to be kept on file for possible future assignments. Interested in stock photos. SASE. Tips: "Call for appointment after sending promotional material."

*THE BERKSHIRE PUBLIC THEATRE, Box 860, 30 Union St., Pittsfield MA 01202. (413)445-4631. Managing Director: Iris Bessell. "We provide year round productions of plays, musicals, cabarets and children's theater in our 284-seat theatre." Buys contact sheets/30 freelance photos/year; gives 3 assignments/year. Photos used in brochures, newsletters, posters, PR releases, and lobby displays. Subject Needs: "We are looking for dramatic production shots that capture the essence of the particular piece of work we are exploring."

Specs: Uses 5x7 glossy or studio b&w prints, b&w contact sheets and negatives. "We are interested in video but to date have only recorded our productions on videotape, and have not solicited freelance vi-

deography."

Payment & Terms: Credit line given. Buys all rights—"we often reprint photos for promos and list credits."

Making Contact: Query with resume of credits; provide resume, business card, brochure, flyer or tearsheets to be kept on file for possible future assignments. Solicits photos by assignment only. SASE. Reports in 1 month or sooner.

Tips: "We are a small but growing regional repertory theater in the Berkshires. Our capital is often limited and *strictly* budgeted. Patience and understanding goes a long way. We look for compelling photos that 'jump out' at us—photos that evoke a visceral response are theatrically 'trendy'—and work."

*BEROL USA, Eagle Rd., Danbury CT 06810. Sales Promotion Manager: Marvin Zimmerman. Manufacturers writing instruments. Buys 250 photos/year; gives 200 assignments/year. Photos used in brochures, posters, newspapers, audiovisual presentations, catalogs, magazines, and releases.

Subject Needs: Office shots.

Specs: Uses 8x10 glossy b&w and color print and 4x5 transparencies. Uses freelance filmmakers to

produce educational pieces.

Payment & Terms: Pays \$50/b&w photo, \$60/color photo. Buys all rights. Mødel release preferred. Making Contact: Arrange a personal interview to show portfolio or query with list of stock photo subjects; interested in stock photos. Does not return unsolicited material. Reports in 3 weeks. Tips: "We need product or in use photos."

*BIKECENTENNIAL, Box 8308, Missoula MT 59807. (406)721-1776. Editor: Daniel D'Ambrosio. A service organization for touring bicyclists; publishes maps of bicycle routes nationwide, runs a trips program, produces a magazine. Buys very few photos/year; gives very few assignments/year. Uses photos is brochures, posters, catalogs, magazines and PR releases.

Subject Needs: Bicycle touring.

Specs: Uses 5x7 and 8x10 glossy b&w prints.

Payment & Terms: Pays \$5-15/b&w photo. Credit line given. Buys one-time rights. Model release and captions preferred.

Making Contact: Query with samples. SASE. Reports in 2 weeks.

Tips: "We need good bicycle photos, with a twist—something that sets them apart from the typical bike along the road or bike leaning against signpost shots. We normally only buy photos that accompany a manuscript."

W.H. BRINE CO., 47 Sumner St., Milford MA 01757. (617)478-3250. President: Peter Brine. Manufacturers soccer and lacrosse equipment. Buys 10-15 photos/year; gives 8 assignments/year. Photos used in brochures, posters, catalogs and magazines.

Close-up

Dennis Mansell, Freelance Photographer. England

British freelance photographer Dennis Mansell remembers when as a young press photographer he and a feature writer toured a Ford plant. "I was sure I had loaded my camera the previous evening, and it was only after the tour that I realized there was no film in it. Having enjoyed the PR man's lunch, it was embarrassing having to ask for handout photos to illustrate the writer's feature." Mansell says.

With more than 25 years' photographic experience to Mansell's credit, similar "horror stories" are now rare for him, and today he is one of England's most successful international freelance photographers. For the last seven years, his photos have been published in such well-known American periodicals as Christian Science Monitor and Christianity Today. He also shoots stock photos for FPG International in New York City.

In his sixteen years as a freelancer, Mansell has developed his own ways of handling assignments and longdistance stock work. "For assignment work I try to make life easy for myself by getting together as much information as possible before I leave. I read guidebooks and press releases so that I'm not in a completely strange environment when I arrive. Also, if I need access to areas restricted to the public, I'll get passes and letters of introduction." Mansell savs.

His approach to selling stock photos is equally methodical. "If I'm trying to sell to magazines, I'll study copies to see what their editors need. This is often impossible with small U.S. publications, so I rely on listings in Photographer's Market and Photographer's Market Newsletter. When I'm trying for an assignment, I'll usually send tearsheets of similar material I've photographed. Tearsheets show editors that you have produced the 'goods' in the past, and that they aren't taking a chance on an

unknown," he explains.

If you're a beginner to freelancing, serve your apprenticeship with smallpaying publications, Mansell says. 'Many beginners aim too high at the start and lose interest when the almost inevitable rejections come in. A photographer needs his ego boosted by seeing his work reproduced, and the confidence this brings, even if the rewards are small, leads to acquiring the ability to tackle the top end of the market.' Mansell says.

"This leads to another point. One of the biggest mistakes freelancers can make is to take pictures to please themselves, rather than to satisfy an editor's needs. They don't study a market, and instead send a batch of photos, sit back and wait for the checks to roll in. If you're selling stock, you've got to realize it's a long-term project, and to be successful, photographers need a large quantity of material circulating to a large number of markets. So as soon as a batch has gone out, forget about it and concentrate on getting the next lot out," he emphasizes.

A common mistake many beginning freelance photographers make is to take photos THEY want to take, rather than those their clients need. Others fail to study their markets. Instead they send out photos inappropriate to a particular market and then expect the money to roll in. Rejections are bound to follow. Study your markets, supply photos clients can use and send out as many submissions as you can. That's the only way to make it in freelancing, says British freelance photographer Dennis Mansell. These photos, which he took, have all been successfully marketed and have paid him well.

Subject Needs: Soccer action photos using Brine balls.

Specs: Uses 35mm and 4x5 transparencies.

Payment & Terms: Pays \$5-200 depending on quality. Credit line given. Buys all rights. Model release preferred.

Making Contact: Call to discuss needs. SASE. Reports in 2 weeks.

BUCKNELL UNIVERSITY, Lewisburg PA 17837. (717)523-3200. Contact: Sharon Poff. Buys 25-50 photos/year; gives 20 assignments/year. Photos used for brochures, newsletters, newspapers and audiovisual presentations.

Subject Needs: Campus events, student activities, campus scenes, alumni photos.

Specs: Uses 8x10 b&w prints; 35mm slides and contact sheets.

Payment & Terms: Pays \$10-25/b&w photo, \$20-50/color photo; \$10-50/hour. Credit line given depending on specific usage. Buys one-time or all rights—either, depending on usage. Model release preferred.

Making Contact: Query with samples or submit portfolio for review. Deals with local freelancers only in the Pennsylvania/NY/NJ area. Provide brochure, flyer or tearsheets to be kept on file for possible future assignments. SASE. Reports in 1 month.

Tips: Prefers to see "primarily 'people' shots, unusual perspectives on scenic views. We use virtually no posed or studio shots. Look for new ways to see old, tired subjects—college buildings, students. Concentrate on details of the whole."

CALIFORNIA REDWOOD ASSOCIATION, 591 Redwood Hgwy., Suite 3100, Mill Valley CA 94941. (415)381-1304. Contact: Patricia Young. "We publish a variety of literature, a small black and white magazine, run color advertisements and constantly use photos in magazine and newspaper publicity. We can use new, well-designed redwood applications—residential, commercial, exteriors, interiors and especially good remodels and outdoor decks, fences, shelters. Color of wood must look fresh and natural." Gives 40 assignments/year. "We can look at scout shots and commission a job or pick up existing photos on a per piece basis. Payment based on previous use and other factors." Credit line given whenever possible. Usually buys all but national advertising rights. Model release required. Send query material by mail for consideration for assignment or send finished speculation shots for possible purchase. Prefers photographers with architectural specialization. Reports in 1 month. Simultaneous submissions and previously published work OK if other uses are made very clear.

B&W: Uses 8x10 prints; contact sheet OK.

Color: Uses 4x5 and 21/4x21/4 transparencies, contact sheet OK.

Tips: "We like to see any new redwood projects showing outstanding design and use of the wood. We don't have a staff photographer and work only with freelancers. We do, however, tend to use people who are specialized in architectural photography. New photo uses might include color shots chosen with an eye for TV usage (commercial or editorial). We generally look for justified lines, true color quality, ability to judge style and design and tasteful props."

CAMPBELL SOUP COMPANY, Campbell Place, Camden NJ 08101. (609)342-4800. Director of Public Relations: Scott Rombach. Uses photos in brochures, audiovisual presentations, catalogs and annual reports. No photography purchased from freelancers except on specific assignment.

Making Contact: Provide resume, brochure and tearsheets to be kept on file for future assignments. Notifies photographer if future assignments can be expected. "Most requirements are handled by staff photographers. We will take initiative in contacting photographer in limited instances in which a freelance assignment is under consideration. Wants photographers with verifiable credentials." SASE. Reports in 1-2 weeks.

CAROLINA BIOLOGICAL SUPPLY COMPANY, 2700 York Rd., Burlington NC 27215. (919)584-0381. Audiovisual Development: Roger Phillips. Stock Photo Manager: Cathy Dollins. Produces educational materials in the biological, earth science, chemistry, physics and computer fields. Gives 10 or less assignments/year. Buys 50 or less freelance photos annually. Photos used in text illustration, promotional materials and filmstrips.

Subject Needs: Nature scenes, natural history, geological, etc. for use on specific projects, or to add to their extensive stock photo library.

Specs: Uses 3x5 and 8x10 glossy color prints and 35mm and 21/4x21/4 transparencies.

Payment & Terms: Pays \$30-125/color photo. Will also work on royalty basis. Pays within 30 days of acceptance. Credit line given. Buys one-time rights. Model release required; captions preferred. Making Contact: Query with resume of credits; samples or with list of stock photo subjects; or send un-

solicited photos by mail for consideration. SASE. Reports in 1 month.

Tips: "As the oldest and largest supplier of biological materials in the USA, we are contacted by authors in the sciences who need photographs. We encourage photographers to send us material for review,

whether they have 1 photo or 1,000. The chances of a science author requesting a photo from us are ex-

CHILD AND FAMILY SERVICES OF NEW HAMPSHIRE, 99 Hanover St., Box 448, Manchester NH 03105. (603)668-1920. Contact: Director of Public Relations. Statewide social service agency providing counseling to children and families. Uses photos of children, teenagers and families; "pictures depicting our services, such as an unwed mother, teenager on drugs or emotionally upset, couples and/or families—possibly indicating stress or conflict." Photos used in brochures, newspapers, posters, annual reports, PR releases, and displays and exhibits. Buys 3-4 photos/year; gives 1-2 assignments/year. Pays \$10 minimum/hour and on a per-photo basis. Credit line given on request. Buys all rights. Model release required. Send material by mail for consideration. Stock photos OK. Provide business card and tearsheets to be kept on file for future assignments. Notifies photographer if future assignments can be expected. SASE. Reports in 1 month. **B&W:** Uses 5x7 glossy prints. Pays \$10-50/photo. **Color:** Uses 5x7 glossy prints. Pays \$10-50/photo.

Tips: "Submit a few copies of applicable photos in which we might be interested rather than just a letter or form telling us what you have done or can do."

*CHRIST HOSPITAL, 176 Palisade Ave., Jersey City NJ 07306. (201)795-8200. Contact: Public Information Coordinator. Needs hospital-related candid photos and portraits. Photos used in brochures, newsletters, newspapers, quarterly magazine, annual reports and exhibits. Buys all rights. Query, then call to arrange a personal interview to show portfolio. Prefers to see b&w PR shots and creative mood shots in a portfolio. Include tight, crisp newspaper-style shots and any innovative work (color xerox, special lens/filter shots) etc., presented in an organized fashion. Gives assignments to any freelancer who can provide on-location shots. Negotiates payment. Provide flyer and price list to be kept on file for possible future assignments. Usually notifies photographer if future assignments can be expected. SASE. Reports in 1 month.

Specs: Uses 8x10 glossy or matte prints. Size varies for exhibits. Contact sheet OK.

*CLYMER'S OF BUCKS COUNTY, 141 Canal St., Nashua NH 03061. (603)882-2180. Catalog Director: Joan Litle. Produces direct mail gift and apparel catalog. Buys 900-1,000 freelance photos/year; places 4 assignments/year. Photos used in catalog.

Subject Needs: Hard and soft goods, and fashion.

Specs: Uses 4x5 and 8x10 transparencies.

Payment & Terms: Payment negotiated individually. Buys all rights. Model release required. Making Contact: Provide resume, business card, brochure, flyer or tearsheets to be kept on file for possible future assignments, deals with local freelancers only. SASE. Reports in 1 month.

COLMAN COMMUNICATIONS CORP., 3651 Woodhead Dr., Northbrook IL 60062. (312)498-6161. President: Warren Colman. Produces educational filmstrips and promotional media. Number of freelance photos purchased annually varies widely—from 1,000 to 4,000; number of freelance assignments given also varies.

Subject Needs: "All areas, but generally those dealing with subjects which relate directly to school curricula.

Specs: Uses 35mm transparencies. Uses freelance filmmakers to produce educational, institutional, and promotional films in 16-35mm.

Payment & Terms: Payment "varies according to budget." Photographers given production credit. Making Contact: Query with resume of credits, samples or list of stock photo subjects. Solicits photos by assignment only. Interested in stock photos. SASE. Reports in 2 weeks.

Tips: Prefers to see "technical excellence; an ability to capture mood and facial expressions."

COLORADO SPRINGS CONVENTION & VISTORS BUREAU, 801 S. Tejon, Colorado Springs CO 80903. (303)635-7506. Staff Writer: Adrienne Frucci. "We promote visitors to the Pikes Peak Region and offer visitor services to groups and individuals." Photos used in brochures, newsletters, posters, newspapers, audiovisual presentations, annual reports, catalogs, magazines and PR releases. Subject Needs: "Scenic shots of the area; some coverage of newsworthy events."

Specs: Uses prints, transparencies, contact sheets and negatives. Does not yet work with freelance filmmakers, but interested in local scenic promotional films.

Payment & Terms: Payment varies. Credit line given. Rights vary with photographer. Model release required and captions preferred.

Making Contact: Arrange a personal interview to show portfolio. Interested in stock photos. Reporting time varies with project.

COMMUNITY AND GOVERNMENT AFFAIRS, San Diego Unified Port District, Box 488, San Diego CA 92112. (619)291-3900. Director of Community and Government Affairs: William Dick. Government agency. Photos used in brochures, annual reports, PR releases, audiovisual presentations, sales literature and trade magazines. Infrequently uses freelance photography. Pays \$25-50/hour; \$200-300/day; and also on a per-photo basis. Credit line given. Buys one-time rights or other depending on photo and usage. Model release and captions required. Arrange a personal interview to show portfolio, query with resume of credits, or query with list of stock photo subjects. No unsolicited material. Local freelancers preferred. SASE. Reports in 1 week. Most interested in unusual photos of maritime or commercial aviation scenes in and around San Diego Bay; also scenic and aerial of San Diego Bay and shots of recreational activities with people ("model releases in this case are absolutely required.") No "pictures without captions or 'junk' pictures sent in the hope they'll be bought."

B&W: Uses 8x10 prints; contact sheet OK. Pays \$5-25/photo.

Color: Uses 35mm transparencies.

Film: Interested in stock footage of appropriate subject matter.

*CUSTOM STUDIOS, 1337 W. Devon, Chicago IL 60660. (312)761-1150. President: Gary Wing. Manufacturers custom imprinted products such as T-shirts, jackets, caps, custom printed cups, key tags, ashtrays. Buys 10 freelance photos/year; gives 10 freelance assignments/year. Photos used in brochures, posters, newspapers, catalogs, and magazines.

Subject Needs: Product shots and models wearing custom imprinted products.

Specs: Uses 4x5 to 8x10 matte or glossy b&w and color prints and b&w and color contact sheets. **Payment & Terms:** Pays \$20/b&w photo, \$25/color photo; \$20-30/hour. Credit line given. Buys all rights. Model release required.

Making Contact: Send unsolicited photos by mail for consideration; provide resume, business card, brochure, flyer or tearsheets to be kept on file for possible future assignments. "We are open to solicitations from anywhere, but prefer to deal with local freelancers." Does not return unsolicited material. Reports in 3 weeks.

*THE DANCE GALLERY, 242 E. 14 St., New York NY 10003. Administrative Director: J. Siciliano. Buys 20-30 freelance photos/year; gives 6-8 freelance assignments/year. Photos used in brochures, posters, newspapers, audiovisual presentations, catalogs, magazines, PR releases, and for foreign publicity.

Subject Needs: Dance and theater photos.

Specs: Uses 8x10 glossy color prints. Uses freelance filmmakers to produce 35mm films. Payment & Terms: Payment negotiated individually. Credit line given. Buys all rights.

Making Contact: Provide resume, business card, brochure, flyer or tearsheets to be kept on file for possible future assignments. SASE. Reports in 2 weeks.

DAYCO CORPORATION, 333 W. 1st St., Dayton OH 45402. (513)226-5927. Public Relations Director: Bill Piecuch. Manufacturer and distributor of highly engineered original equipment and component and replacement parts for a variety of machinery. Uses photos of inplant operations, personnel on the job and products in application. Photos used in newsletters, newspapers, PR releases, annual and quarterly reports and magazines. Buys 100 freelance photos/year. Pays \$250 maximum/day for b&w; \$300 maximum/day for color. Buys all rights. Model release required. Query with resume of credits or samples. Prefers to see "industrial photos directly related to our products that exhibit the photographer's ability in that area." Buys photos by assignment only. Provide "past work done for us to be kept on file for possible future assignments." Does not notify photographer if future assignments can be expected. SASE. Reports in 2 weeks-2 months.

B&W: Uses 8x10 glossy prints; contact sheet and negatives OK.

Color: Uses transparencies and 8x10 matte prints.

Tips: "There is a good chance of Dayco using freelancers. An outstanding photo purchased in the past year showed an individual looking through a piece of plastic tubing. The contrast, centering, content and facial expression impressed me. We want to see shots that would show an unusual product application. I'm seeing good photography used in editorial (product publicity) replacing some advertising budget money. The reason is simple: Well-placed, creative product publicity costs less for the dollars invested. It will never replace advertising—and any product publicity person worth his salt will agree—but it does give marketing another excellent shot at potential buyers. Know our company. Ask for our annual report or product listings before you contact us. We don't have time to educate or converse on an individual basis."

*DAYTON BALLET, 140 N. Main St., Dayton OH 45402. (513)222-3661. Public Relations/Marketing Director: Phyllis Lesser. Schedules 5 ballet programs yearly. Gives 5 freelance assignments/year. Photos used in brochures and posters.

Subject Needs: "Shots of our dance works."

Specs: Uses b&w and color contact sheets; or transparencies.

Payment & Terms: Pays \$6 maximum/b&w photo; \$3 maximum/slide. Credit line given. Buys all

ights.

Making Contact: Query with resume of credits; provide resume, business card, brochure, flyer or tearsheets to be kept on file for possible future assignments. SASE. "Call us for reports on queries." Tips: "Make an appointment to come and shoot a dress rehearsal (no fee) and submit your contact sheets. We'll order from contact. If you're good, we'll invite you to shoot in the future and negotiate a fee. We're still looking for a photographer in our region who can capture fast movement in a low-light theater situation."

*GEORGE DELL INC., 133 W. 25th St., New York NY 10001. Office Manager: Jack Carter. Manufeatures display items, Christmas trees and mannequins. Buys 30-35 freelance photos/year, gives several freelance assignments/year. Photos used in brochures, catalogs, and magazines.

Subject Needs: Vary according to assignment and projects.

Specs: Uses 4x5 transparencies.

Payment & Terms: Pays \$1,000 maximum/day; \$150 maximum/job. Credit line may be available.

Making Contact: Solicits photos by assignment only. SASE. Reports in 2 weeks.

Tips: "We have increased our use of photos by 200% in the last 2 years."

DENMAR ENGINEERING & CONTROL SYSTEMS, INC., 2309 State St., West Office, Saginaw MI 48602. (517)799-8208. Advertising: Chester A. Retlewski. Produces newspaper vending machines. Photos used in brochures, audiovisual presentations, magazines and PR releases. Needs photos on new product lines. Buys 20-30 freelance photos annually; gives 150 freelance assignments annually. Pays \$20-50/b&w photo, \$50/color, \$18-25/hour and \$175-500/job. Credit line given. Buys all rights. Model release preferred. Submit portfolio for review; provide resume to be kept on file for possible future assignments. Notifies photographer if future assignments can be expected. SASE. Reports in 1 month. **Film:** Interested in 16mm industrial films. Pays 10% minimum royalty.

GARY PLASTIC PACKAGING CORP., 530 Old Post Rd., No. 3, Greenwich CT 06830. (203)629-1480. Director, Marketing: Marilyn Hellinger. Manufacturers of custom injection molding; thermoforming; and stock rigid plastic packaging. Buys 10 freelance photos/year; gives 10 assignments/year. Photos used in brochures, catalogs and flyers.

Subject Needs: Product photography.

Specs: Uses 8x10 b&w and color prints; 21/4x21/4 slides; and b&w or color negatives.

Payment & Terms: Pays by the job and the number of photographs required. Buys all rights. Model re-

lease required

Making Contact: Query with resume of credits or with samples. Follow-up with a call to set up an appointment to show portfolio. Prefers to see b&w and color product photography. Deals with local free-lancers only. Solicits photos by assignment only. Provide resume to be kept on file for possible future assignments. Notifies photographer if future assignments can be expected. Does not return unsolicited material. Reports in 2 weeks.

Tips: The photographer "has to be willing to work with our designers."

GEORGIA-PACIFIC CORP., 133 Peachtree NE, Atlanta GA 30303. Chief Photographer: Steve Dinberg. Produces timber, chemicals, plywood, lumber, gypsum, pulp and paper. Photos/films used for print media publicity, TV documentaries, news film clips, catalogs and sales promotion literature. Solicits photos by assignment only. Provide resume, business card, brochure, flyer, tearsheets and nationwide itineraries to be kept on file for possible future assignments. Does not notify photographer if future assignments can be expected. Submit portfolio on request only. Payment determined from contract or purchase order.

Film: Video and stills. Does not pay royalties.

Tips: "Send samples (not portfolio) to be circulated."

*THE GRACE BRETHREN HOME MISSIONS COUNCIL, INC., Box 587, Winona Lake IN 46590. (219)267-5161. Promotional Secretary: Liz Cutler. "We are the church-planting arm of the Fellowship of Grace Brethren Churches. We also have a Navajo Boarding School and Mission in northwestern New Mexico." Buys 6 freelance photos/year and gives 1-2 assignments/year. Photos used for brochures, newsletters, posters, audiovisual presentations, annual reports, magazines and PR releases. Subject Needs: Photos related to our ministries.

Specs: Uses 5x7 glossy b&w prints and 35mm transparencies.

Payment & Terms: Credit line given. Buys all rights. Model release preferred.

Making Contact: Arrange a personal interviewe to show portfolio, query with list of stock photo sub-

jects; provide resume, business card, brochure, flyer or tear sheets to be kept on file for possible future assignments. Solicits photos by assignment only. Interested in stock photos. Does not return unsolicited material. Reports in 1 month.

Tips: "I'm looking for photos which feature specific Home Mission ministries. I would suggest contact-

ing me before taking any photos."

*HARPER & ASSOCIATES, INC., 2285 116th Ave. NE, Bellevue WA 98004. (206)462-0405. Office Manager: Kelley Wood. Design studio/ad agency. Buys 100-200 freelance photos/year; gives 50-100 freelance assignments/year. Photos used in brochures, newsletters, posters, audiovisual presentations, annual reports, and catalogs.

Subject Needs: People and/or products.

Specs: Open. Uses freelance filmmakers when clients' needs dictate.

Payment & Terms: Payment depends on use based on ASMP rates. Credit line "sometimes" given.

Rights purchased depends on use of photo. Model release required.

Making Contact: Query with samples; interested in stock photos. SASE. Reports generally in 2 weeks, depending on work load.

Tips: "We like to see creative solutions to mundane situations. We're using more dramatic shots these days. Show us your best work and don't bug us too much."

HIMARK ENTERPRISES, INC., 155 Commerce Dr., Hauppauge NY 11787. Contact: Manager, Marketing. Manufactures giftware and housewares. Buys "hundreds" of freelance photos/year. **Subject Needs:** Products.

Specs: Uses 5x7 and 8x10 b&w and color prints; b&w and color contact sheets and b&w and color nega-

tives

Payment: Payment is based on competitive finding. Buys all rights.

Making Contact: Query with samples. Deals with local freelancers only. Provide business card to be kept on file for possible future assignments. Notifies photographer if future assignments can be expected. SASE. Reports in 1 week.

HUDSON COUNTY DIVISION OF CULTURAL AND HERITAGE AFFAIRS, County Administration Building, 114 Clifton Place, Jersey City NJ 07304. (201)659-5062. Director: Jean Byrne. Needs photos of its project (usually public events). Photos used in brochures and reports. Gives 6-12 assignments/year. Provide resume to be kept on file for possible future assignments. "We prefer to employ residents of New Jersey, particularly residents of Hudson County. Each photographer is employed for a minimum of 1 day. Fees are negotiated directly with the photographer and the Director of this division." Query with samples. Prefers to see non-returnable b&w 8x10 or 5x7 shots of indoor/outdoor events and some portraits. SASE. Reports "within the week."

B&W: Uses 8x10 prints.

IDAHO DEPARTMENT OF PARKS & RECREATION, Statehouse Mail, 2177 Warm Springs, Boise ID 83720. (208)334-2284. Information Specialist: Rick Just. Uses photos of Idaho park and recreation activities and events. Photos used in brochures, newsletters, audiovisual presentations, research studies and reports. "We are producing more and more slide programs and others in the tourism industry seem to be doing the same." No payment. Credit line given whenever possible. Query with list of stock photo subjects, send material by mail for consideration, or telephone. SASE. Reports in 2 weeks. **B&W:** Uses 8x10 glossy prints; negatives OK.

Color: Uses transparencies.

Tips: "We simply do not have a budget for buying or assigning photographs. We do offer a credit line for a picture used. We need Kodachrome transparencies (35mm) or b&w glossies of activities in state parks, and scenics in and near the state parks. We need stock photos of outdoor recreation activities, urban, rural, wilderness, etc., from throughout Idaho. We're looking for photos that convey life or movement—people having fun. Transparencies are used in slide presentations (credit not always possible) and for display prints and article illustrations. We need horizontal shots (even of vertical objects and scenes) particularly. Duplicates are preferred over originals."

INDUSTRIAL FABRICS ASSOCIATION INTERNATIONAL, Suite 450, 345 Cedar Building, St. Paul MN 55101. (612)222-2508. Director of Publications. Publishes WES Magazine, a design and merchandising publication for window treatment retailers; Industrial Fabric Products Review, a trade publication for manufacturers of fabric products (tents, awnings, hot air balloons, etc.); and Geotechnical Fabrics Report, a trade quarterly for engineers and specifiers of ground fabrics. Buys 30 photos/year; gives 15-20 assignments/year. Photos used in brochures and magazines.

Subject Needs: Photos of "commercial and residential interiors; photos of presidents, employees in their workplaces; fabric products/applications (from sails to camping tents, sport dome covers to soft

luggage).'

Specs: Uses 5x7 glossy b&w prints; 35mm, 21/4x21/4, 4x5 and 8x10 transparencies; b&w contact sheets. Payment & Terms: Pays \$25/b&w photo; \$35/color photo; \$30-75/hour; \$200-300/day; \$100-300/job.

Credit line given. Buys one-time rights.

Making Contact: Query with list of stock photo subjects; send photos by mail for consideration; or submit portfolio for review. Solicits photos by assignment only. Interested in stock photos. SASE. Reports in 2 weeks.

Tips: "Request review copies of our publications."

*INNOVATIVE DESIGN & GRAPHICS, Suite 252, 708 Church St., Evanston IL 60201. Art Director: Maret Thorpe. Photos used in brochures, newsletters, posters, catalogs and magazines.

Subject Needs: Product shots, people shots, and topical shots for magazines.

Specs: Uses 8x10 glossy b&w prints, 35mm, 21/4x21/4, and 4x5 transparencies, b&w contact sheets, and b&w negatives.

Payment & Terms: Payment per job negotiated individually. Credit line given. Buys one-time rights or

all rights. Model release required; captions preferred.

Making Contact: Provide resume, business card, brochure, flyer or tearsheets to be kept on file for possible future assignments. Solicits photos by assignment only. Interested in stock photos. SASE. "Reports when applicable assignment is available."

Tips: "We look for crisp photos to illustrate ideas, clear photos of products and products in use, and relaxed photos of business people at work. We prefer that freelancers submit work produced on larger-format equipment. Never call.'

*INTERNATIONAL RESEARCH & EDUCATION (IRE), 21098 IRE Control Center, Eagan MN 55121. IP Director: George Franklin, Jr. IRE conducts in-depth research probes, surveys, and studies to improve the decision support process. Company conducts market research, taste testing, brand image/ usage studies, premium testing, and design and development of product/service marketing campaigns. Buys 75-110 photos/year; gives 50-60 assignments/year. Photos used in brochures, newsletters, posters, audiovisual presentations, annual reports, catalogs, PR releases, and as support material for specific project/survey/reports.

Subject Needs: "Subjects and topics cover a vast spectrum of possibilities and needs."

Specs: Uses prints (15% b&w, 85% color), transparencies and negatives. Uses freelance filmmakers to produce promotional pieces for 16mm or videotape.

Payment & Terms: Pays on a bid, per job basis. Credit line given. Buys all rights. Model release required.

Making Contact: Provide resume, business card, brochure, flyer or tearsheets to be kept on file for possible future assignments; "materials sent are put on optic disk for options to pursue by project managers responsible for a program or job." Solicits photos by assignment only. Does not return unsolicited material. Reports when a job is available.

Tips: "We look for creativity, innovation, and ability to relate to the given job and carry-out the mission

accordingly."

*AL KAHN GROUP, 221 W. 82 St., #PH-N, New York NY 10024. President: Al Kahn. Produces corporate I.D., brochures, annual reports and advertising. Buys 100 photos/year; gives 20 assignments/ year. Photos used in brochures, posters, annual reports, and magazines.

Subject Needs: Conceptual designs.

Specs: Uses prints, transparencies, contact sheets and negatives.

Payment & Terms: Pays \$500-3,000/b&w photo; \$500-3,000/job. Credit line given. Buys one-time rights. Model release required.

How to Contact: Query with samples, send unsolicited photos by mail for consideration, or submit portfolio for review. SASE. Reports when project is assigned.

LA CROSSE AREA CONVENTION & VISITOR BUREAU, Box 1895, Riverside Park, La Crosse WI 54602-1895. (608)782-2366. Administrative Assistant: Mary Waldsmith. Provides "promotional brochures, trade show and convention planning, full service for meetings and conventions." Buys 8 + photos/year; gives "several" assignments/year "through conventions. Conventions also buy photos." Photos used in brochures, newspapers, audiovisual presentations and magazines.

Subject Needs: "Scenic photos of area; points of interest to tourists, etc."

Specs: Uses 5x7 glossy b&w prints and color slides.

Payment & Terms: Payment depends on size/scope of project. Credit line given "where possible."

Buys all rights. Model release required; captions preferred.

Making Contact: Provide resume, business card, brochure, flyer or tearsheets to be kept on file for possible future assignments. Deals with local freelancers only. Solicits photos by assignment only. Does not return unsolicited material. Reports in 3 weeks.

LIFETIME CUTLERY COPORATION, 820 3rd Ave., Brooklyn NY 11232. (212)499-9500. Advertising Manager: Paul Burton. Manufactures cutlery, flatware and kitchen tools. Photos used in brochures, catalogs and packaging.

Subject Needs: "Our products in action with food."

Payment & Terms: Pays by photo or job. Buys all rights. Model release required.

Making Contact: Arrange a personal interview to show portfolio. Deals with local freelar cers only. Provide brochure, flyer and tearsheets bo be kept on file for possible future assignments. SASE.

LONG BEACH SYMPHONY ASSOCIATION, 121 Linden Ave., Long Beach CA 90802. (213)436-3203. Uses photos of musicians, concerts, audiences and special events. Photos used in brochures, newsletters, newspapers, posters, PR releases and magazines. Gives 1-20 assignments/year. Payment negotiated. Credit line given. Buys all rights. Query with samples. Buys photos by assignment only. SASE. Reports in 1 month.

B&W: Uses 5x7 or 8x10 glossy prints.

Color: Uses prints or slides.

Film: "We have not yet begun to explore this area, but we would be interested in queries from filmmakers."

Tips: "We are very interested in working with freelancers who have experience in performance photography and special event/social occasions."

*THE LOST COLONY, Box 40, Manteo NC 27954. Director of Public Relations: Maggie Klekas. An outdoor drama on the Outer Banks of North Carolina that is performed 6 nights a week from mid-June through the end of August. Buys 100 photos/year; gives 10 assignments/year. Photos used in brochures, posters, newspapers, audiovisual presentations, magazines and PR releases.

Subject Needs: Scenes from the Lost Colony and photos of individual cast members.

Specs: Uses 5x7 glossy b&w and color slides, 21/4x21/4 transparencies, and b&w contact sheets. Uses freelance filmmakers to produce super 8 and 16mm promotional films.

Payment & Terms: Payment negotiated individually. Credit line given. Buys all rights. Captions preferred.

Making Contact: Query with resume of credits or send unsolicited photos by mail for consideration. SASE. Reports in 2 weeks.

Tips: "Be good at taking both action and posed shots."

*ROB MACINTOSH COMMUNICATIONS, INC., 288 Newberry St., Boston MA 02115. Creative Services Director: Jamie Scott. Buys 50 photos/year; gives 24 assignments/year. Photos used in brochures, posters, audiovisual presentations, annual reports, catalogs, magazines, and PR releases. Subject Needs: "We need photos of people."

Specs: Uses 8x10 glossy b&w prints, 35mm, 21/4x211/4, 4x5 and 8x10 transparencies, b&w contact

sheet and negatives.

Payment & Terms: Pays \$200-1,800/day; per job rate varies. Use of credit line depends on job and client. Buys one-time rights. Model release required.

Making Contact: Provide resume, business card, brochure, flyer or tearsheets to be kept on file for possible future assignments; interested in stock photos. SASE.

Tips: "There is an increasing demand on the photographer to reach beyond the expected and come up with technical solutions that challenge the viewer."

MENLO COLLEGE, 1000 El Camino Real, Atherton CA 94025. (415)323-6141. Publications Manager: Penny Hill. Small, independent college with curriculum in liberal arts, sciences, mass communication, computer information systems and business. Uses photos of general campus life. Photos used in brochures, posters, direct-mail pieces and catalogs; "for student recruitment and fundraising materials, mainly." Buys 150-200 photos/year; gives 6-10 assignments/year. Local freelancers only. Provide resume and business card to be kept on file for possible future assignments. Notifies photographer if future assignments can be expected. Pays \$20-30/hour; \$200-300/day; or on a per-photo basis. Pays \$5-10/b&w photo. Buys all rights. Arrange personal interview to show portfolio. Prefers to see photos of people doing things in work or school environment as samples. Will not return unsolicited material. Reports in 30 days.

B&W: Uses 8x10 glossy prints; contact sheet required. Pays \$5/print.

Color: Uses 35mm and larger transparencies; negotiates rights.

Tips: "Our opportunities are limited to the local freelancer with a facility for photojournalistic style. Our freelancers must excel as 'people' photographers."

MINNESOTA DANCE THEATRE AND SCHOOL, INC., Hennepin Center for the Arts, 528 Hennepin Ave., Minneapolis MN 55403. General Manager: John M. Coughlin. Photos used in advertising, brochures and fundraising exhibits.

Subject Needs: Needs photos of dance performances and rehearsals. "All photographs need to be of the Minnesota Dance Theatre specifically." Also produces 16mm documentary or educational films. Buys about 100 photos/year.

Payment & Terms: Pays at least expenses.

Making Contact: Solicits photos by assignment only; call to arrange an appointment.

Tips: "Dance photography experience is essential."

*THE MINNESOTA OPERA, Suite 20, 400 Sibley St., St. Paul MN 55101. (612)221-0122. Public Relations: Katie Cerny. Produces four opera productions each year. Buys 10 photos/year; gives 4 assignments/year. Photos used in brochures, posters, and PR releases/publicity.

Subject Needs: Operatic productions. Specs: Uses 5x7 glossy b&w prints.

Payment & Terms: Pays \$15-25/hour. Credit line given. Model release preferred; captions required. Making Contact: Send unsolicited photos by mail for consideration; provide resume, business card, brochure, flyer or tearsheets to be kept on file for possible future assignments. Deals with local freelancers only. Does not return unsolicited material. Reporting time depends on needs.

Tips: "We look for photography which dynamically conveys theatrical/dramatic quality of opera with clear, crisp active pictures. Photographers should have experience photographing theater, and have a

good sense of dramatic timing."

MSD AGVET, Division of Merck and Co. Inc., Box 2000, Rahway NJ 07060. (201)574-4000, Manager, Marketing Communications: Gerald J. Granozio. Manufacturers agricultural and veterinary products. Buys 20-75 freelance photos/year; gives 2-3 assignments/year. Photos used in brochures, posters, audiovisual presentations and advertisements.

Subject Needs: Agricultural—crops, livestock and farm scenes. Specs: Uses 35mm, 21/4x21/4, 5x5 and 8x10 slides.

Payment/Terms: Pays \$150-200/b&w; \$200-400/color photo. Buys one-time rights. Model release re-

quired; captions preferred.

Making Contact: Query with samples or with a list of stock photo subjects; interested in stock photos; provide brochure and flyer to be kept on file for possible future assignments. Notifies photographer if future assignments can be expected. SASE. Reports in 2 weeks.

THE NATIONAL ASSOCIATION FOR CREATIVE CHILDREN & ADULTS, 8080 Springvalley Dr., Cincinnati OH 45236. Editor: Dr. Wallace Draper, Ball State University, Muncie IN 47306. Photos used for brochures, newsletters, magazines and books. Needs photos on people (portraits and persons engaged in creative activities). Credit lines given. Model release required and captions preferred. Query with samples. SASE. Pays only in copies of The Creative Child and Adult quarterly and other publications.

*NATIONAL ASSOCIATION OF EVANGELICALS, Box 28, Wheaton IL 60189. (312)665-0500. Executive Editor: Don Brown. Produces a magazine centered on news events of a religious nature. Buys 25 photos/year. Photos used in brochures, posters, and magazines.

Subject Needs: Leaders in the evangelical community addressing or involved in some current issue or newsworthy event; people involved in marches, prayer vigils, and protests that have a religious/political slant.

Specs: Uses 5x7 glossy b&w prints.

Payment & Terms: Pays \$40/b&w photo. Credit line given. Buys one-time rights. Model release re-

quired; captions preferred.

Making Contact: Query with samples or list of stock photo subjects; provide resume, business card, brochure, flyer or tearsheets to be kept on file for possible future assignments; interested in stock photos. SASE. Reports in 3 weeks.

Tips: "We prefer photos that have a news or photojournalistic feel. We are looking for the best in b&w."

NATIONAL ASSOCIATION OF LEGAL SECRETARIES, Suite 211, 3005 E. Skelly, Tulsa OK 74105. (918)749-6423. Publications Director: Tammy Hailey. Publishes "an association magazinefor providing continuing legal education along with association news." Buys 6 photos/year; gives 6 assignments/year. Photos used in magazine.

Subject Needs: Needs legal, secretarial photos.

Specs: Uses b&w prints and 35mm transparencies. Uses freelance filmmakers to produce educational and promotional slideshows.

Payment & Terms: Pays \$20-100/job. Credit line given. Rights purchased vary with photos. Making Contact: Query with list of stock photo subjects. Deals with local freelancers only. Interested in stock photos. Does not return unsolicited material. Reports in 1 week.

NATIONAL FUND FOR MEDICAL EDUCATION, 999 Asylum Ave., Hartford CT 06105. (203)278-5070. Research and Development Director: Nancy Lundebjerg. Buys 6-10 freelance photos annually. Photos used in newsletters, annual reports and special reports.

Subject Needs: Medical students in educational settings.

Specs: B&w contact sheet.

Payments & Terms: Payment negotiable. Works on assignment only basis. Credit line given. Model release necessary; captions optional.

Making Contact: Query with list of stock photo subjects or send unsolicited photos by mail for consideration. SASE. Reports in 1 month.

NATIONAL HOT DOG & SAUSAGE COUNCIL, Suite 1100, 1211 W. 22nd St., Oak Brook IL 60521. (312)986-6224. Executive Secretary: Fran Altman. Photos used in newsletters and PR releases. Subject Needs: "We purchase specialized topics: prefer photos of current head of state, US President, etc. eating a hot dog. Would consider other famous persons of current interest, movie stars, etc. eating a

Specs: B&w prints.

Payment & Terms: Pays \$100/b&w photo. Credit line given. Buys all rights. Captions preferred. Making Contact: Query before sending photo.

OAKLAND CONVENTION & VISITORS BUREAU, Suite 200, 1000 Broadway, Oakland CA 94607. (415)839-9000. Director of Public Relations: Patricia Estelita. Promotes Oakland as a convention and tourist center. Uses scenes of Oakland area; facilities, attractions and people; some aerials. Photos used in brochures, newsletters, newspapers, audiovisual presentations, PR releases and magazines. Buys 50-100 photos/year. Credit line given in some circumstances. Buys one-time rights or all rights. Model release required. Arrange a personal interview to show portfolio unless we know photographer or photographer has been referred by another client. Prefers to see people-oriented shots (b&w) with location or attractions in the background. Local freelancers only. Provide resume, business card, brochure and flyer to be kept on file for possible future assignments. Notifies photographer if future assignments can be expected. Stock photos OK. SASE. Reports immediately.

B&W: Uses 8x10 glossy prints; contact sheet OK. Pays \$5-10/photo.

Color: Uses transparencies. Prefers large format, but 35mm OK. Pays \$15-50.

Tips: "I'm more interested in composition and 'uniqueness'—if a photo strikes me as something I must have, I'll pay more for it. Our needs change frequently and rapidly. We've been forced to put together displays with a week's notice, so I like to know who is available to do various photographic assignments."

OHIO BALLET, 354 E. Market St., Akron OH 44325. (216)375-7900. Contact: Public Relations Director. Uses photos of performances and rehearsals and shots of backstage and studio as well as posed business shots. Photos used in brochures, newsletters, newspapers, audiovisual presentations, posters, catalogs, PR releases, magazines, and also for public display and in advertising. Buys 80 photos/year. Credit line given. Buys all rights. Model release required. Query with samples; prefers samples of dance performances. Usually deals with local freelancers. No material returned. Reports in 3 weeks.

B&W: Uses 8x10 glossy prints; contact sheet OK. Pays \$2 minimum/photo.

Color: Uses 35mm transparencies. Pays \$2 minimum/photo.

PALM SPRINGS CONVENTION AND VISITORS BUREAU, Airport Park Plaza, Suite 315, 255 N. El Cielo Rd., Palm Springs CA 92262. (619)327-8411. Director of Publicity and Promotions: Richard Koepke. "We are the tourism promotion entity of the city." Buys 50 freelance photos/year; gives 20 assignments/year. Photos used in brochures, posters, newspapers, audiovisual presentations, magazines and PR releases.

Subject Needs: "Those of tourism interest . . . specifically in the City of Palm Springs."

Specs: Uses 8x10 b&w prints; 35mm slides; b&w contact sheet and negatives OK. "We buy only transparencies in color and prefer 35mm."

Payment & Terms: Pays \$25/b&w photo; \$40-75/hour. Buys all rights—"all exposures from the job. On assignment, we provide film and processing. We own all exposures." Model release and captions required.

Making Contact: Query with resume of credits or list of stock photo subjects. Provide resume, business card, brochure, flyer, and tearsheets to be kept on file for possible future assignments. Notifies photographer if future assignments can be expected. SASE. Reports in 2 weeks.

Tips: "We will discuss only photographs of Palm Springs, California. No generic materials will be considered.'

PGA OF AMERICA, 100 Ave. of Champions, Palm Beach Gardens FL 33410. (305)626-3600. Editor/Advertising Sales Director: W.A. Burbaum. Services 13,000 golf club professionals and apprentices

nationwide. Photos used for brochures, posters, annual reports and monthly feature magazine. Subject Needs: Special needs include golf scenery, good color action of amateurs as well as tour stars. Buys 50 freelance photos and gives 15 freelance assignments annually.

Payment & Terms: Pays \$25 minimum/b&w photo; \$50-200 color photo; and \$300-375/day. Credit

line negotiable. Buys one-time and all rights. Model release preferred; captions optional.

Making Contact: Arrange personal interview to show portfolio and query with list of stock photo subjects. Prefers to see 35mm slides in the portfolio. Provide tearsheets to be kept on file for possible future assignments. Notifies photographer if future assignments can be expected. SASE. Reports in 2 weeks. Tips: Prefers to see cover/gee whiz, good (inside) golf action, photo essay approach.

P.M. CRAFTSMAN, Box K, 3525 Craftsman Blvd., Eaton Park FL 33840. (813)665-0815. Creative Director: Linda Schofield. Manufactures metal decorative accessories. Gives less than 10 assignments/ year. Photos used in newsletters, newspapers, catalogs and magazines.

Subject Needs: Product shots.

Specs: Uses 8x10 b&w prints; 5x7 color prints.

Payment & Terms: Pays per photo. Buys all rights. Model release required; captions optional. Making Contact: Query with samples. Solicits photos by assignment only. Provide photos of sculptural work to be kept on file for possible future assignments. Notifies photographer if future assignments can be expected. SASE. Reports in 1 month.

Tips: "Prefer to see photos of brass decorative accessories or quality photographic representations of 3-

dimensional art pieces.'

*POSEY SCHOOL OF DANCE, INC., Box 254, Northport NY 11768. (516)757-2700. President: Elsa Posey. Sponsors a school of dance, and a regional dance company. Buys 6-10 photos/year; gives 3 assignments/year. Photos used in brochures and newspapers.

Subject Needs: Dancers dancing and at rest.

Specs: Uses 8x10 glossy b&w prints.

Payment & Terms: Payment negotiated individually. Credit line given if requested. Buys one-time

rights. Model release required.

Making Contact: "Call us." Solicits photos by assignment only. Interested in stock photos. SASE. Reports in 1 week.

*PULPDENT CORPORATION, 75 Boylston St., Brookline MN 02146. Advertising Manager: Jane Hart Berk. Manufacturers dental supplies. Buys 10-25 photos/year; gives 10 assignments/year. Photos used in brochures, catalogs, magazines, and PR releases.

Subject Needs: Product photos.

Specs: Uses 5x7 glossy b&w prints, b&w contact sheets, and b&w negatives.

Payment & Terms: Payment negotiated individually. Credit line given "if appropriate." Buys all

rights. Model release required.

Making Contact: Query with samples; provide resume, business card, brochure, flyer or tearsheets to be kept on file for possible future assignments. Deals with local freelancers only. SASE. Reports in 3 weeks.

*THE QUARASAN GROUP, INC., Suites 7 & 14, 1845 Oak St., Northfield IL 60093. (312)446-4777. Design Supervisor: Marcia Vecchione. "A complete book publishing service including design of interiors and covers to complete production stages, art and photo procurement." Buys 250-300 photos/ year; gives 10-15 assignments/year. Photos used in brochures and books.

Subject Needs: "Most products we produce are educational in nature. The subject matter can vary. For textbook work, male-female/ethnic/handicapped/minorities balances must be maintained in the photos

we select to insure an accurate representation.'

Specs: Prefers 8x10 b&w prints, 35mm, 21/4x21/4, 4x5, or 8x10 transparencies, or b&w contact sheets. Payment & Terms: Fee paid is based on final use size. Pays \$60-135/b&w photo; \$100-200/color photo. Credit line given, but may not always appear on page. Buys exclusive use rights or other rights determined by publisher. Model release required.

Making Contact: Query with list of stock photo subjects or nonreturnable samples (photocopies OK); provide resume, business card, brochure, flyer or tearsheets to be kept on file for possible future assignments; interested in stock photos. Does not return unsolicited material. "We contact once work/project

requires photos.'

Tips: "Learn the industry. Analyze the books on the market to understand why those photos were chosen. Be organized and professional and meet the agreed upon schedules and deadlines. We are always looking for experienced photo researchers local to the Chicago area.'

*QUARSON ASSOCIATES, 160 S. Arrowhead Ave., San Bernardino CA 92408. (714)885-4442. Art Director: Joel Pilcher. Produces advertisements, newspaper, magazines, brochures, catalogs, annu-

"This cover shot was photographed by Tom Rizzo of Riverside, California." says Joel Pilcher of Quarson Associates, a business in San Bernadino, California. "We chose Tom because he knew how to shoot the LED readout so the numbers would pop. He knew how to use lighting to highlight product features. Our client has been very happy with the shot and has ordered extra wall prints for offices. The product is selling well, in part because of Tom's excellent ability as a studio photographer."

al reports, posters, flip charts, newsletters, trade shows, and data sheets. Buys nearly 100 photos/year; gives about 12 assignments/year. Photos used in brochures, newsletters, posters, newspapers, annual reports, catalogs, and magazines.

Subject Needs: College photos, high tech products (computers, etc.).

Specs: Uses 5x7 and 8x10 glossy b&w prints and 35mm, 21/4x21/4, and 4x5 transparencies.

Payment & Terms: Payment arranged on a per photo, hourly, daily or per job rate. Credit line sometimes given. Rights purchased depend on the contract. Model release required.

Making Contact: Arrange a personal interview to show portfolio; provide resume, business card, brochure, flyer or tearsheets to be kept on file for possible future assignments; interested in stock photos. SASE. "If SASE is enclosed, reports in 1 week."

Tips: "We look for strong graphic photos and printed pieces using your photos. Present new ideas that we can use which stress your strongest photos. Be flexible with your rates. Keep in touch with us."

QUEENS COLLEGE, Flushing, New York NY 11367. (212)670-4170. Director of College Relations: Ron Cannava. Buys 15-20 photos/year; gives 75-85 assignments/year. Photos used in brochures, newsletters, posters, newspapers, audiovisual presentations, annual reports, catalogs, magazines, PR releases, displays/exhibits.

Subject Needs: Close human interaction in academic, business, scientific, political settings, etc. **Specs:** Uses 8x10 b&w prints and 35mm, $2^{1/4}$ x2^{1/4} slides. Uses freelance filmmakers to produce film clips—cable and independent stations. Interested in 16mm educational film.

Payment & Terms: Pays \$60 minimum/hour; \$75 minimum/day. Credit line given if possible. Buys all

rights. Model release and captions preferred.

Making Contact: Arrange a personal interview to show portfolio or query with samples. Deals with local freelancers mostly; interested in stock photos. Provide business card and brochure to be kept on file for possible future assignments. Reports in 2 weeks—"unless we get a great many."

Tips: Prefers to see "a few high quality prints—best work samples" in a portfolio or samples. "We're a relatively low paying, demanding customer. Worthwhile if you are interested in higher education, science and technology."

RECO INTERNATIONAL CORP., 138-150 Haven Ave., Port Washington NY 11050. (516)767-2400. President: Heio W. Reich. Manufactures gourmet kitchen accessories, collectors plates and lithographs. Buys 20-60 photos/year; gives 30-50 assignments/year. Photos used in brochures, newsletters, posters, newspapers, catalogs, magazines and PR releases.

Subject Needs: Product shots.

Specs: Uses 5x7 b&w and color prints and color negatives.

Payment & Terms: Payment determined by agreement. Buys all rights. Model release required; captions optional. Query with resume of credits; provide resume, business card and flyer to be kept on file for possible future assignments. Does not return unsolicited material. Reports when needed.

RECREATIONAL EQUIPMENT, INC., Box C-88126, Seattle WA 98188. (206)575-4480. Contact: Sue Brockmann. Retailer of muscle-powered sporting goods. Buys varied amount of photos/year. Photos used for catalogs. Sample copy free with SASE.

Subject Needs: "We need mountain sports, scenics and outdoor shots for use as catalog covers."

Specs: Uses transparencies.

Payment & Terms: Buys one-time rights. Model release required.

Making Contact: Query with samples; provide resume, business card, brochure, flyer or tearsheets to be kept on file for possible future assignments. SASE. Reports in 4 weeks.

Tips: "Scenics with people doing muscle-powered sports are our main need."

*RECREATION WORLD SERVICES, INC., Drawer 17148, Pensacola FL 32522. (904)478-4372. Executive Vice President: Ken Stephens. Serves publishers and membership service organizations. Buys 5-10 photos/year; gives 2-5 assignments/year. Photos used in brochures, newsletters, newspapers, magazines, PR releases.

Subject Needs: Recreation type.

Specs: Uses 3x4 prints. Buys all rights. Model release required; captions preferred.

Making Contact: Send unsolicited photos by mail for consideration; provide resume, business card, brochure, flyer or tearsheets to be kept on file for possible future assignments. SASE. Reports in 2 weeks.

REPERTORY DANCE THEATRE, Box 8088, Salt Lake City UT 84108. (801)581-6702. General Manager: Douglas C. Sonntag. Uses photos of dance company for promotion. Photos used in brochures, newspapers, posters, PR releases and magazines. Buys all rights. Local freelancers only. Arrange a personal interview to show portfolio. Prefers to see dance or movement photos. Queries by mail OK; SASE. Reports in 2 weeks.

B&W: Uses 8x10 glossy prints; contact sheet OK. Payment is negotiable.

*RSVP MARKETING, Suite 5, 450 Plain St., Marshfield MA 02050. President: Edward C. Hicks. Direct marketing consultant/agency. Buys 5-100 photos/year; gives 5-10 assignments/year. Photos used in brochures, catalogs, and magazines.

Subject Needs: Industrial equipment, travel/tourism topics, and fund raising events.

Specs: Uses 2x2 and 4x6 b&w and color prints, and transparencies.

Payment & Terms: Payment per photo and per job negotiated individually. Buys all rights. Model re-

lease preferred.

Making Contact: Query with list of stock photo subjects; provide resume, business card, brochure, flyer or tearsheets to be kept on file for possible future assignments. Solicits photos by assignment only. Interested in stock photos. SASE. Reports with needs and relevant jobs dictate.

Tips: "We look for photos of industrial and office products, and high tech formats."

*SAN FRANCISCO OPERA CENTER, War Memorial Opera House, San Francisco CA 94102. (415)861-4008. Business Manager: Russ Walton. Produces live performances of opera productions of both local San Francisco area performances and national touring companies. Buys 2-3 photos/year; gives 1 assignment/year. Photos used in brochures, newspapers, annual reports, PR releases and production file reference/singer resume photos.

Subject Needs: Production and performance shots, and artist/performer shots.

Specs: Uses 8x10 standard finish b&w prints, and b&w negatives.

Payment & Terms: Pays \$10-20/hour. Credit line given. Buys all rights.

Making Contact: Query with resume of credits; provide resume, business card, brochure, flyer or tearsheets to be kept on file for possible future assignments. SASE. Reports in 2 weeks.

Tips: "We need live performance shots and action shots of individuals; scenery also. Photographers should have previous experience in shooting live performances and be familiar with the opera product. Once good photographers are located, we contract them regularly for various production/social/public events."

SAINT VINCENT COLLEGE, Rt. 30, Latrobe PA 15650. (412)539-9761. Director of Publications: Don Orlando. Uses photos of students/faculty in campus setting. Photos used in brochures, newsletters, posters, annual reports and catalogs. Buys 50 photos/year. Credit line given. Buys all rights. Send material by mail for consideration. SASE. Reports in 1 month.

B&W: Uses 5x7 prints; contact sheet OK. Pays \$10-50/photo.

Color: Uses 5x7 prints and 35mm transparencies; contact sheet OK. Pays \$5 minimum/photo. Tips: Impressed with technical excellence first, then the photographer's interpretative ability.

SAN JOSE STATE UNIVERSITY, Athletic Department, San Jose CA 95192. (408)277-3296. Sports Information Director: Lawrence Fan. Uses sports action photos. Photos used in brochures, newspapers and posters. Buys 50 photos/year; gives 5-10 assignments/year. Credit line given. Buys all rights. Arrange a personal interview to show portfolio. SASE. Reports in 2 weeks.

B&W: Uses 8x10 glossy prints; contact sheet OK. Pays \$2 minimum/photo.

Color: Uses 35mm transparencies. Pays \$3 minimum/photo.

THE SCHOLARLY PUBLISHING GROUP, INC., (formerly Intercontinental Book Publishing), Box 855, Mars PA 16046. (412)586-9404. Publisher/Chief Operating Officer: Michael D. Cheteyan II. Publishes textbooks on management, psychology, human relations, theology, etc. Photos used for text illustration and book covers. Buys 16 photos/year; gives 5 assignments/year. Pays \$15-75/job. Credit line given. Buys book rights. Model release and captions required. Query with resume of credits or list of stock photo subjects. SASE. Simultaneous submissions and previously published work OK. Reports in 1 month.

Subject Needs: Nature shots, human portraits. B&W: Uses 8x10 glossy prints; contact sheet OK.

Color: Uses 8x10 glossy prints and 35mm transparencies; contact sheet OK. Jacket/Cover: Uses glossy b&w and color prints and 35mm color transparencies.

THE SOCIETY OF AMERICAN FLORISTS, (formerly SAF-The Center for Commercial Floriculture), 1601 Duke St., Alexandria VA 22314. (703)836-8700. Communications Director: Drew Gruenburg. National trade association representing growers, wholesalers and retailers of flowers and plants. Gives 1-2 assignments/year. Photos used in magazines.

Subject Needs: Needs photos of personalities, greenhouses, inside wholesalers, flower shops and conventions.

Specs: Uses b&w and color contact sheets.

Payment & Terms: Rates negotiable. Credit line given. Model release required; captions preferred. Making Contact: Query with samples; provide resume, business card, brochure, flyer or tearsheets to be kept on file for possible future assignments; interested in stock photos. SASE. Reports in 1 week.

*SOHO REPERTORY THEATRE, 80 Varick St., New York NY 10013. (212)925-2588. Artistic Director: Jerry Engelbach. An off off Broadway theatre. Buys 50 photos/year; gives 6 assignments/year. Photos used in brochures, newspapers, and press releases.

Subject Needs: "Photos of our theatrical productions; particularly close-ups and action shots."

Specs: Uses 8x10 b&w prints and b&w contact sheets.

Payment & Terms: Pays \$100-250/job. Credit line given. Buys all rights.

Making Contact: Query with resume of credits or samples; provide resume, business card, brochure, flyer or tearsheets to be kept on file for possible future assignments. SASE. Reports in 1 month. Tips: "Practice shooting candids in theatres—catch the rising moments at their peak."

SOUTHSIDE HOSPITAL, E. Main St., Bay Shore NY 11706. (516)435-3202. Director of Community Relations: J.W. Robinson. Uses publicity photos of people, medical equipment, etc. Photos used in brochures, newsletters, newspapers, audiovisual presentations, posters, annual reports and PR releases. Gives 50 assignments/year. Buys all rights. Model release required; captions preferred. Arrange a personal interview to show portfolio or send material by mail for consideration. Assignment only. Provide resume and price sheet to be kept on file for possible future assignments. Notifies photographer if future assignments can be expected. SASE. Reports in 2 weeks.

B&W: Uses 5x7 glossy prints; contact sheet OK.

STATE HISTORICAL SOCIETY OF WISCONSIN, 816 State St., Madison WI 53706. (608)262-9606. Needs photos of the society's six outdoor museums. Buys all rights, but may reassign to photographer after use. Model release and captions preferred. Query with resume of credits. Send no unsolicited material.

B&W: Uses 8x10 b&w glossies.

Color: Uses 8x10 color glossies and 35mm or larger color transparencies.

*SYMPHONY ON THE SOUND, INC., 18 Zygmont Ln., Greenwich CT 06830. Music Director: Joseph Leniado-Chira. Produces music concerts for children, adults and the general public. Photos used in brochures, posters, newspapers, audiovisual presentations, catalogs, magazines, and PR releases.

Subject Needs: Portraits and action shots of concerts and audiences.

Specs: Uses 8x10 glossy b&w and color prints. Uses freelance filmmakers to produce features, including documentaries.

Payment & Terms: Payment negotiated individually. Credit line given. Buys all rights.

Making Contact: Arrange a personal interview to show portfolio, query with samples, send unsolicited photos by mail for consideration or submit portfolio for review; provide resume, business card, brochure, flyer or tearsheets to be kept on file for possible future assignments. Reports in 2 weeks.

*TALENT CLEARINGHOUSE, 348-354 Congress St., 4th Floor, Boston MA 02210. (617)876-8710. Editor: Diane Cotman. Photo Editor: Kathy Thompson. Associated with all types of publications. "We are a clearinghouse. Magazine publications, corporate art directors and advertising agencies review the portfolios which we maintain on file. We maintain files of complete portfolios in 8 ½x11 format. When organizations come to us they are looking for a new talent, or talent in a specific geographic area."

Photo Needs: Reviews photos with or without accompanying ms. Model release preferred.

Making Contact & Terms: Submit portfolio for file; provide resume, business card, brochure, flyer or tearsheets to be kept on file for possible future assignments. Uses 8½ or smaller b&w and color prints. Does not return unsolicited material. Reports in 2 weeks. Credit line given. Simultaneous submissions and previously published work OK.

Tips: "We prefer that photographers submit a portfolio for our permanent file at the clearinghouse. The portfolio is presented in 8½x11" file-size format. Photographers may choose any photos best exhibiting

the quality and range of their work. Files may be as elaborate as desired."

TREASURE CRAFT/POTTERY CRAFT, 2320 N. Alameda, Compton CA 90222. President: Bruce Levin. Manufactures earthenware and stoneware housewares and gift items. Buys 30 freelance photos/year; gives 30 assignments/year. Photos used in catalogs and magazines.

Specs: Uses 5x7 and 8x10 b&w and color prints.

Payment & Terms: Pays \$85-100/color photo. Buys all rights. Query with samples. Solicits photos by assignment only. Provide business card and flyer to be kept on file for possible future assignments. SASE. Reports in 3 weeks.

*T-SHIRT GALLERY LTD., 154 E. 64, New York NY 00000. (212)838-1212. President: Finn. Manufactures clothing and printed fashions. Buys 30 photos/year; gives 20 assignments/year. Photos used in brochures, newspapers, magazines and PR releases.

Subject Needs: Models in T-shirts.

Specs: Uses b&w and color prints and 8x10 transparencies.

Payment & Terms: Payment negotiable on a per photo basis. Buys all rights. Model release preferred. Making Contact: Query with samples or send unsolicited photos by mail for consideration. SASE. Reports in 3 weeks.

UNITED AUTO WORKERS (UAW), 8000 E. Jefferson, Detroit MI 48214. (313)926-5291. Editor: David Elsila. Trade union representing 1.2 million workers in auto, aerospace, and agricultural-implement industries. Publishes *Solidarity* magazine. Photos used for brochures, newsletters, posters, magazines and calendars. Needs photos of workers at their place of work and social issues for magazine story illustrations. Buys 85 freelance photos and gives 12-18 freelance assignments/year. Pays \$25/b&w photo; \$40/hour minimum; \$125/job minimum; or \$235/day. Credit lines given. Buys one-time rights. Model releases and captions preferred. Arrange a personal interview to show portfolio, query with samples and send material by mail for consideration. Uses stock photos. Provide resume and tearsheets to be kept on file for possible future assignments. Notifies photographer if future assignments can be expected. SASE. Reports in 2 weeks.

B&W: Uses 8x10 prints; contact sheets OK.

Film: Uses 16mm educational films.

Tips: In portfolio, prefers to see b&w workplace shots; prefers to see published photos as samples.

UNITED CEREBRAL PALSY ASSOCIATIONS, INC., 66 E. 34th St., New York NY 10016. (212)481-6345. Publications Director: Mark Fadiman. Uses photos of children and adults with disabilities in normal situations. Photos, which must be taken at UCP affiliate-sponsored events, used in brochures, newsletters, newspapers, posters, annual reports, PR releases and magazines. Gives 6 assignments/year. Pays \$25 minimum/hour or \$25 minimum/job. Credit line given if stipulated in advance.

Model release and captions required. Query with samples or send material by mail for consideration. "Don't phone." SASE. Reports in 3 weeks.

B&W: Uses 5x7 or 8x10 prints.

Tips: "Work by photographers who themselves have physical disabilities is particularly invited. Contact a local UCP affiliate and make your presence known-work at reasonable prices."

UNITED STATES STUDENT ASSOCIATION, 1 Dupont Circle, Suite 300, Washington DC 20036. (202)775-8943. President: Gregory P. Moore. Legislative Director: Kathy Ozer. Publishes student affairs information. Uses photos in promotional materials, newsletters, newspapers, for text illustration and book covers. Buys 5 photos/year. Pays \$5-40/job. Credit line given if requested. Buys all rights, but may reassign to photographer. Captions preferred. Query with samples, send material by mail for consideration or call. SASE. Simultaneous submissions and previously published work OK. Reports in 1 month

Subject Needs: People (students) on university and college campuses; student activists; classroom shots. "Experimental photography is fine. Conference photography also needed—speakers, forums, groups." No nature shots, shots of buildings or posed shots.

B&W: Uses 5x7 prints; contact sheet OK.

Tips: "Contact us in late February and July for conference photography needed. We need photos of student activities such as Women's Centers at work; Minority Students' activities; college registration scramble; admissions officers; administration types; any clever arrangement or experiment disclosing campus life or activities."

UNIVERSITY OF NEW HAVEN, 300 Orange Ave., West Haven CT 06516. (203)932-7243. News Bureau Director: Noel Tomas. Uses University of New Haven campus photos. Photos used in brochures, newsletters, newspapers, annual reports, catalogs, and PR releases. Payment negotiable on a per-photo basis. Credit line often negotiable. Query with resume "and one sample for our files. We'll contact to arrange a personal interview to show portfolio." Local freelancers preferred. SASE. "Can't be responsible for lost materials." Reports in 1 week.

B&W: Uses 5x7 glossy prints; contact sheet OK.

Color: Mostly 35mm transparencies.

*WALTER VAN ENCK DESIGN LIMITED, 3830 N. Marshfield, Chicago IL 60613. President: Walter Van Enck. Produces corporate communications materials (primarily print). Buys 25 photos/year; gives 10 assignments/year. Photos used in brochures, newsletters, posters, audiovisual presentations, annual reports and catalogs.

Subject Needs: Corporate service related activities and product and architectural shots.

Specs: Uses 8x10 glossy and matte b&w prints, 21/4x21/4 and 4x5 transparencies, and b&w contact sheets.

Payment & Terms: Pays \$600-1,500/day. Credit line seldom given. Model release required.

Making Contact: Arrange a personal interview to show portfolio or query with samples; provide resume, business card, brochure, flyer or tearsheets to be kept on file for possible future assignments. Deals with local freelancers only. Interested in stock photos. SASE. "Queries not often reported ononly filed.'

Tips: "We look for straight corporate (conservative) shots with a little twist of color or light, and ultra high quality b&w printing. Try to keep your name and personality on the tip of our minds."

WEST JERSEY HEALTH SYSTEM, Mt. Ephraim and Atlantic Ave., Camden NJ 08104. (609)342-4676. Assistant Vice President: James Durkan. Uses b&w of hospital event coverage, feature shots of employees and photo essays on hospital services. Assigns 35mm color slides for audiovisual shows and photo layouts. Photos are used in brochures, audiovisual presentations, posters, annual reports and PR releases. Gives 50 assignments/year; buys 500 photos/year. Pays \$25 minimum/hour and \$100 minimum/day; maximum negotiable. Pays also on a \$5/photo basis for b&w. Buys one-time rights or all rights. Model release required from patients; captions required. Query with list of stock photo subjects or submit portfolio for review. "No walk-ins, please. Call or write first." Assignment only. Provide business card and price list to be kept on file for possible future assignments. SASE. Reports in 2 weeks. B&W: Uses 8x10 glossy or semigloss prints; contact sheet OK. Pays \$5 minimum/photo, \$1.75/reprint of the same exposure.

Color: Uses 35mm transparencies.

WESTERN WOOD PRODUCTS ASSOCIATION, 1500 Yeon Bldg., Portland OR 97204. (503)224-3930. Manager of Product Publicity: Raymond W. Moholt. Uses photos of new homes or remodeling using softwood lumber products; commercial buildings, outdoor living structures or amenities. Photos used in brochures, newspapers and magazines. Buys 20 photos/year; gives 5 assignments/

year. Pays a daily rate or on a per-photo basis. Fee is sometimes split with architect, builder, or editor. Credit line given. Buys all rights. Model release required. Query with samples or send material by mail for consideration. Wants experienced professionals only. Provide brochure to be kept on file for possible future assignments. Notifies photographer if future assignments can be expected. SASE. Reports in 2 weeks.

B&W: Uses 8x10 glossy prints. Pays \$35 minimum/photo.

Color: Uses 4x5 transparencies. 21/4x21/4 transparencies OK. Pays \$50 minimum/photo.

Tips: Needs photos that will "quickly capture an editor's attention, not only as to subject matter but also photographically.

WILDERNESS, 1901 Pennsylvania Ave. NW, Washington DC 20006. (202)828-6600. Editor: Tom Watkins. Provides services on conservation and education. Especially concerned with public lands and wilderness designations. Photos used for magazines. Needs photos on threatened areas and wilderness wildlife. Buys 40-60 photos/year. Buys one-time rights. Model release and captions required. Query with resume of credits and list of stock photo subjects. Provide resume, brochure, flyer on tearsheets to be kept on file for possible future assignments. Does not notify photographer of future assignments. SASE. Reports in 2-6 weeks.

B&W: "We occasionally use 8x10 prints. Full caption information including location of subject is re-

quired." Pays \$50-75/b&w print.

Color: The magazine uses original 35mm or larger transparencies. Full caption information including location of subject is required. Photographs on covers and inside generally relate to article content. Pays \$200/cover photo; \$100/inside photo.

‡WORLD WILDLIFE FUND-US, 1255 23rd St. NW, Washington DC 20037. (202)387-0800. Photo Librarian: Sally Russell. "WWF-US, a private international conservation organization, is dedicated to saving endangered wildlife and habitats around the world and to protecting the biological diversity upon which human well-being depends." Buys 25-30 photos/year. Photos used in brochures, newsletters, posters, audiovisual presentations, annual reports, PR releases, and WWF Calendar.

Subject Needs: Coverage of over 100 WWF worldwide projects, and endangered plants, animals, and

habitat types (around the world).

Specs: Uses 5x7 or 8x10 glossy b&w prints; 35mm transparencies; and b&w contact sheets. Rarely works with freelance filmmakers. "We are interested in photos of key WWF projects. We rarely purchase material. If the location being visited is of interest or coverage of unusual species is anticipated, we would discuss providing stock and processing."

Payment & Terms: Pays \$25/b&w photos used in publications and \$25/color photos used in slide shows. Small budget for calendar photos. Credit line given. Buys non-exclusive rights. Prefers donation

for on-going use in WWF publications and audiovisuals as needed." Captions preferred.

Making Contact: Query for list of WWF projects. Follow up with list of photos subjects and/or locations that appear to be of interest to WWF. Send credentials on request. SASE. Reports in 1 month. Tips: "We look for close-ups of wildlife and plants worldwide, candids of conservationists working in the field, and scenics worldwide. We need photographers who are already traveling to WWF project areas; we prefer experience in nature photography. Write us to request a current list of WWF projects. Contact us again if you are planning a trip; we will advise on valuable locations. Call us for advice on valuable locations.

XEROX EDUCATION PUBLICATIONS, 245 Long Hill Rd., Middletown CT 06457. (203)638-2557. Senior Photo Librarian: MaryEllen Renn. Publishes periodicals for children ages 4-13. Gives 25-30 freelance assignments annually "varies according to needs." Photos used in newspapers and catalogs.

Subject Needs: News and feature materials appropriate for children/youth audience.

Specs: Uses 8x10 b&w and color glossies; 35mm, 21/4x21/4, 4x5 and 8x10 transparencies and b&w contact sheets.

Payment & Terms: Payment varies. Credit line given. Buys one-time rights. Model release preferred;

captions required.

Making Contact: Query with samples or list of stock photo subjects; send unsolicited photos by mail for consideration; provide resume, business card, brochure, flyer or tearsheets to be kept on file for possible future assignments. Reports in 1 month.

Tips: In portfolio prefers to see "black and white photos and color transparencies related to news fea-

tures appropriate for children/youth audience."

Galleries.

To many photographers, exhibiting their work on the walls of a gallery or other exhibition space is among the most cherished of dreams. This section lists places where that dream can come true.

This isn't to say that convincing a gallery director your work deserves public display is easy—but it is possible. Obviously, the first requirement is that your photographs are in fact good enough to stand up under public scrutiny—and more, that they are good enough to attract the dollars of art lovers and investors. Most of the galleries listed here are commercial properties in business to make a profit, and while anyone who gets into the gallery business is probably an art lover himself, he

isn't likely to waste precious wall space on work that won't sell.

Commercial galleries make their money by taking a *commission*: a percentage of the sales price of every work sold. Gallery commissions typically range between 15 and 40 percent, with most falling around 30 to 35 percent, or one-third, of the price. Many photographers and other artists who exhibit in and sell through galleries follow the rule of thumb of setting the prices that *they* want for each piece, and then letting the gallery tack its profit onto that. Exhibitors are thus assured of receiving the prices they want while allowing the gallery to handle the promotion necessary to sell the work with the markup *it* wants.

But before you can start sticking price tags on your photographs, you have to find a gallery willing to show them. If you're a well-known photographer with extensive prior publication or exhibition credits to your name, this probably won't be a problem, but the unknown photographic artist must depend on the strength of his art to sell itself. Only you know if your work has reached the point where it is worthy of gallery exhibition; even if you believe it is, you still face the task of finding that gallery which is both willing and appropriate to exhibit and sell your photographs.

Study the listings in this section carefully to determine which are likeliest to be interested in your work. In most cases, the gallery director has indicated what types, subjects and formats of photographic art his gallery handles. The general price range listed for works sold will give you an idea of whether a particular gallery's prices are close to what you think your photographs are worth. Since it can be advantageous for you to be present at your exhibition's opening and periodically during the length of the show (and some galleries prefer or require this), you may also want to find a gallery close to home, although it is possible to have your work shown just about anywhere.

Gallery directors, like other decision-makers in the business of selling photography, tend to be overwhelmed with exhibition proposals and queries, so most have developed fairly rigid procedures for reviewing potential exhibitors' work. Since a simple resume or query letter tells a director very little about a photographer's work, most prefer in-person appointments where possible—another good reason to begin with a local gallery. You'll be asked to bring a large, representational sampling of the images you wish to place with the gallery, and from there it's up to the director's own aesthetic and marketing judgment as to whether your work is good enough and salable enough to show.

Out-of-town galleries may want to receive a query letter and biographical data first, but most will also have to examine the work in question before committing themselves to scheduling a show. The work and risk involved in shipping your invaluable prints across the country just on the *chance* of getting a show demand that you take the greatest possible care in submitting your work for review, and this should not be undertaken without a definite display of interest on the gallery's part.

If you cannot find a commercial gallery interested in your photographs, or if you feel your work isn't *quite* up to competing with the big-name fine-art photographers, it's still quite possible to arrange for public viewing of your work. Some of the listings here are nonprofit exhibition spaces, and these are far more receptive to showing the work of (previously) unknown artists since they are free from the con-

straints of trying to make money. Some of these sell work at whatever price the photographer wants, taking no commission at all or only a nominal commission to cover costs; others do not offer work for sale and are strictly opportunities to share your work with the viewing public. This latter type of exhibit can still go a long way in promoting your photography and your career; you're free to arrange sales privately to interested customers, and prior exhibition experience of any kind is an asset to your resume.

Many photographers have found that no gallery or other traditional exhibition space of any kind is necessary to show and sell their pictures. Some public buildings such as schools and libraries make wall space available to local artists, and even some commercial establishments such as restaurants and banks will make *quid pro quo* arrangements with photographers: free exhibit space in exchange for what amounts to free wall decor, and again, you're free to set your own prices. Check with the administrators or managers of such institutions in your area to see if you can work out similar arrangements.

ACCESS TO THE ARTS, INC., Access to the Arts Gallery, 600 Central Ave., Dunkirk NY 14048. Galley Manager: Daniel Riscili. Interested in b&w and color photography of all types. All works must be insured and ready to be put on exhibit upon date of exhibit. Presents 1-2 shows/year. Shows last 1 month. "Arrangements set up with artist." Photographer's presence at opening preferred. Receives 25% sponsor commission. General price range: \$250-800. Will review transparencies. Interested in framed, mounted and matted work only. Send material by mail for consideration. SASE. Reports in 1 month.

THE AFTERIMAGE PHOTOGRAPH GALLERY, The Quadrangle 151, 2800 Routh St., Dallas TX 75201. (214)748-2521. Owner: Ben Breard. Interested in any subject matter. Photographer should "have many years of experience and a history of publication and museum and gallery display; although if one's work is strong enough, these requirements may be negated." Open to exhibiting work of newer photographer; "but that work is usually difficult to sell." Prefers Cibachrome "or other fade-resistant process" for color and "archival quality" for b&w. Sponsors openings; "an opening usually lasts 2 hours, and we only do 2 or 3 a year." Receives 50% sales commission (photographer sets price), or buys photos outright. Price range: \$20-10,000. Query first with resume of credits and biographical data or call to arrange an appointment. SASE. Reports in 2 days-2 months. Unframed work only.

Tips: "Work enough years to build up a sufficient inventory of, say, 20-30 prints, and make a quality presentation. Landscapes are currently selling best. The economy in Dallas just keeps getting better and

AMERICAN SOCIETY OF ARTISTS, INC., Box 1326, Palatine IL 60078. (312)991-4748 or (312)751-2500. Membership Chairman: Helen Del Valle. Gallery located in Alton IL. (St. Louis area). Gallery open to public; only members may exhibit. "Our members range from internationally known artists to unknown artists—quality of work is the important factor. We have shows throughout the year which accept photographic art." Price range: "varies." Send SASE for membership information and application. Reports in 2 weeks. Framed mounted or matted work only. Lecture and demonstration service provided for members. Member Publication: ASA Artisan.

better-aiding sales.'

- *ANDERSON GALLERY, Virginia Commonwealth University, 9071/2 W. Franklin St., Richmond VA 23284. (804)257-1522. Contact: Director. Interested in historical and contemporary photography. Sponsors openings. Presents 3-4 shows/year. Shows last 1 month. Photographer's presence at opening and during show preferred. Receives 20% sales commission. Will review transparencies. SASE. Reports in 1 month. Mounted and matted work only.
- *ANDOVER GALLERY, 68 Park St., Andover MA 01810. (617)475-7468. Director: Howard Yezerski. Interested in any photography of high quality. Presents 8-10 shows/year. Shows last 4-5 weeks. Sponsors openings; announcements, refreshments. Photographers's presence at opening is preferred. Photography sold in gallery. Receives 50% commission. General price range: \$200-1,500. Will review transparencies. Interested in framed or unframed, mounted or unmounted, matted or unmatted work. Requires exclusive representation within metropolitan area. Arrange a personal interview to show

portfolio; query with resume of credits or with samples; send material by mail for consideration. SASE. Reports in 1 week.

*THE ANSEL ADAMS GALLERY, (Best's Studio, Inc.), Box 455, Yosemite National Park CA 95389. (209)372-4413. President: Jeanne Adams. Subject matter includes landscape, detail; black and white and color. "It is difficult to accept new photographic work, primarily because of limited space, for exhibition, display, and storage. Maturity of recognizable style and vision, and fine printing count.' Presents 10 shows/year. Shows last 4-6 weeks. Receives either 50% or 60/40% commission. Price range: \$60-12,000. Framed or unframed matted or unmatted and mounted work only. Arrange a personal interview to show portfolio. "We do not want unsolicited material."

Tips: "We are supportive of photography, but our primary business in Yosemite National Park is retail merchandising of fine handcrafts, books, Indian artifacts, cards, film, etc. More photographers submit

work than we could ever accommodate. One must be patient. Contact is essential.

*ARMORY ART GALLERY, Virginia Polytechnic Institute and State University, Blacksburg VA 24061. (703)961-5547. Gallery Director: Robert Graham. Interested in all types of photography. Sponsors openings. Very receptive to exhibiting the work of newer photographers. Presents 1 show/year. Show lasts 3 weeks. Photography sold only during exhibition. Receives 15% commission, which is donated to the department's Educational Fund. Query with resume of credits. Will review transparencies. SASE. Reports in 1 month. Size: "Limits established by size of gallery."

Tips: "At the present time, the gallery budget is very limited, and we are unable to pay high rental fees

for exhibitions.'

ASCHERMAN GALLERY/CLEVELAND PHOTOGRAPHIC WORKSHOP, Suite 4, 1846 Coventry Village, Cleveland Heights OH 44118. (216)321-0054. Director: Herbert Ascherman, Jr. Sponsored by Cleveland Photographic Workshop. Subject matter: all forms of photographic art and production. "Membership is not necessary. A prospective photographer must show a portfolio of 40-60 slides or prints for consideration. We prefer to see distinctive work —a signature in the print, work that could only be done by one person, not repetitive or replicative of others." Very receptive to exhibiting work of newer photographers, "they are our primary interest." Presents 10 shows/year. Shows last about 5 weeks. "Openings are held for most shows. Photographers are expected to contribute toward expenses of publicity if poster desired." Photographer's presence at show "always good to publicize, but not necessary." Receives 25-40% commission, depending on the artist. Sometimes buys photography outright. Price range: \$50-1,500. "Photos in the \$100-500 range sell best." Will review transparencies. Matted work only for show.

Tips: "Be as professional in your presentation as possible: identify slides with name, title, etc.; matte, mount, box prints. We are a midwest firm and people here respond to competent, conservative images better than experimental or trendy work. Traditional landscapes, mood or emotional images (few people

pictures) and more studies currently sell best at our gallery.'

THE BALTIMORE MUSEUM OF ART, Art Museum Dr., Baltimore MD 21218. (301)396-6330. Contact: Department of Prints, Drawings and Photographs. Interested in work of quality and originality; no student work. Arrange a personal interview to show portfolio or query with resume of credits. SASE. Reports in 2 weeks-1 month. Unframed and matted work only.

BC SPACE, 235 Forest Ave., Laguna Beach CA 92651. (714)497-1880. Contact: Jerry Burchfield or Mark Chamberlain. Interested only in contemporary photography. Presents 8 solo or group shows per year; 6 weeks normal duration. General price range: \$150-3,000; gallery commission 40%. Collaborates with artists on special events, openings, etc. For initial contact submit slides and resume. Follow up by arranging personal portfolio review. SASE. Responds "as soon as possible—hopefully within a month, but show scheduling occurs several times a year. Please be patient.'

Tips: "Keep in touch—show new work periodically. If we can't give a show right away, don't despair, it may fit another format later. The shows have a rhythm of their own which takes time. Salability of the work is important, but not the prime consideration. We are more interested in fresh, innovative work."

BERKEY K & L GALLERY OF PHOTOGRAPHIC ART, 222 E. 44th St., New York NY 10017. (212)661-5600. Director: Jim Vazoulas. Interested in fine art color photography. Commission received varies. Price range: \$100-3,000. Call first, then submit portfolio. Will review transparencies. SASE.

Tips: "Submit pleasing photos about pleasant objects. Corporate executives are not interested in spending company funds on depressing topics. Cheerful, lovely scenics and activities are admired. The Gallery direction has changed from exhibit art to commercial art. Experimental, abstracted, overly-impressionistic concepts are not for our clients. We seek the photographer who can shoot reality yet lift it above the mundane so it has appeal. There is a greater demand for wall-size murals and cityscapes and land-scapes."

*THE BERKSHIRE MUSEUM, 39 South St., Pittsfield MA 01201. (413)443-7171. Contact: Bartlett Hendricks. Interested in all types of photography "but shows on a specific subject seem to have greatest audience appeal." Presents 12 shows/year. Shows last 1 month. Receives no commission. Price range: \$20-100. Arrange a personal interview to show portfolio or query with samples. Will review transparencies. SASE. Reports in 1 week. Prefers unframed, matted work. Prefers exclusive representation in county.

Tips: "Avoid metal frames. We have 16x20 natural wood frames and also panels covered with natural color monk's cloth. High quality landscapes seem to be most in demand. Also our art department likes to

have an occasional exhibit of very arty, modern type photos."

*MONA BERMAN GALLERY, 168 York St., New Haven CT 06510. (203)562-4720. Director: Mona Berman. Subject matter varies. The work must be archival. Number of shows varies each year. Shows last 4 weeks. Sponsors openings. Photographer's presence at opening is preferred. Receives 50% commission. General price range: \$200-1,000. Will review transparencies. "Interested in seeing slides for initial review; then if still interested will look at any format." Requires exclusive representation within metropolitan area. Send slides, resume, credits and price list. Reports in 2 weeks.

JESSE BESSER MUSEUM, 491 Johnson St., Alpena MI 49707. (517)356-2202. Contact: Director. Chief of Resources: Robert Haltiner. Interested in a variety of photos suitable for showing in general museum. Presents 1 show/year. Shows last 6-8 weeks. Receives 20% sales commission. Price range: \$10-1,000. "However, being a museum, emphasis is not placed on sales, per se." Submit samples to museum exhibits committee. Framed work only. Will review transparencies. SASE. Reports in 2 weeks. "All work for exhibit must be framed and ready for hanging."

*BLACK HILLS CREATIVE ARTS CENTER, 721 Canyon St., Spearfish SD 57783. (605)642-2712. Executive Director: Jonathan Betz. Estab. 1984. "We are interested in all types of photography. The general theme of the center is the intermixture of photography with the other mediums of the arts. We have no requirements as we were incorporated to help expose new talent as well as the professional." Presents 12 solo or group shows/year. Shows last 3-4 weeks. Sponsors openings; "the arrangements depend on the type of show we are having for that month." Photography sold in gallery. Receives negotiable commission. General price range: \$25-750. Will review transparencies. Interested in mounted or unmounted work. Photos up to 16x20 sells better. Query with samples; send material by mail for consideration. SASE. Reports in 3 weeks.

Tips: "We like to have our exhibits set for the different seasons with about a 3-4 month lead time. The

photographer should demonstrate common sense in submitting their material."

BREA CIVIC CULTURAL CENTER GALLERY, Number One Civic Center Circle, Brea CA 92621. (714)990-7713. Cultural Arts Supervisor: Emily Keller. Gallery Cordinator: Marie Sofi. Sponsored by City of Brea. Presents 2 juried all media shows/year and a photography show on the average of once every 2 years. Shows last 6 weeks. Sponsors openings. Photographer's presence at opening and show preferred. Receives 30% sales commission. Will review slides. Framed work only, ready to hang.

*CANON PHOTO GALLERY, 3321 Wilshire Blvd., Los Angeles CA 90010. (213)387-5010. Gallery Coordinator: Jess Bailey. "We have no restrictions on style or types. We prefer the use of Canon photo equipment." Presents 12 shows/year. Shows last 1 month. General price range: \$25 + . Will review transparencies. Interested in framed or unframed work; mounted and matted work only. Shows are limited to a maximum of 20 prints. Arrange a personal interview to show portfolio. SASE. Reports in 1

Tips: "Show only your best work."

*THE CANTON ART INSTITUTE, 1001 Market Ave., Canton OH 44702. (216)453-7666. Associate Director: M.J. Albacete. "We are interested in exhibiting all types of quality photography, preferably using photography as an art medium, but we will also examine portfolios of other types of photography work as well: architecture, etc. The photographer must send preliminary letter of desire to exhibit; send samples of work (upon our request); have enough work to form an exhibition; complete Artist's Form detailing professional and academic background, and provide photographs for press usage." Presents 2-5 shows/year. Shows last 6 weeks. Sponsors openings; minor exhibits (shown in photo salon), only news announcement. Major exhibits (in galleries), postcard or other type mailer, public reception. Photography sold in gallery. Receives 20% commission. Occasionally buys photography outright.

General price range: \$300 or more. Interested in exhibition-ready work. No size limits. Query with sam-

ples. SASE. Reports in 2 weeks. **Tips:** "Submit letter of inquiry first, with samples of photos; we look for photo exhibitions which are unique, not necessarily by "top" names. Anyone inquiring should have some exhibition experience, and have sufficient materials; also, price lists, insurance lists, description of work, artist's background, etc. Most photographers and artists do little to aid galleries and museums in promoting their works—no good publicity photos, confusing explanations about their work, etc. We attempt to give photographers-new and old-a good gallery exhibit when we feel their work merits such. While sales are not our main concern, the exhibition experience and the publicity can help promote new talents."

CATSKILL CENTER FOR PHOTOGRAPHY, 59A Tinker St., Woodstock NY 12498. (914)679-9957. Exhibitions Director: Kathleen Kenyon. Interested in all fine arts photography. No commercial or hobby. Presents 10 shows/year. Shows last 3-4 weeks. Sponsors openings. Receives 33 1/3% sales commission. Price range: \$75-1,000. Photographs should not be 30"x40" unless by invitation. Send material by mail for consideration. SASE. Reports in 1 month.

Tips: "Visit us first—set up an appointment, or write us a brief letter, enclose resume, statement on the work, 20 slides, SASE. We are closed Wednesdays and Thursdays. We sell more contemporary photot-

graphy than historical."

*C.E.P.A. (CENTER FOR EXPLORATORY & PERCEPTUAL ART), 700 Main St., 4th Floor, Buffalo NY 14202. (716)856-2717. Curator/Exhibitions Coordinator: Robert Collignon. "C.E.P.A. is a not-for-profit organization whose raison d'etre is the advancement of photography which engages contemporary issues within the visual arts. C.E.P.A.'s varied programs explore aesthetic and intellectual issues within the camera arts of still photography, photo-installation, video, film and multimedia performance. An artist must meet the aesthetic standards of the curator and also must produce work that conforms to the aesthetic mission stated above. C.E.P.A. provides a venue of innovative work as well as original visions by known and unknown artists that break new ground in the photo-related arts." Presents 8 major exhibitions of four artists per show a year with six satellite and 12 public transit exhibits. Shows last 4-6 weeks. Sponsors openings; provides postcard announcement and curator's statement in the C.E.P.A. Newsletter. Cash Bar at reception. Photography sold in gallery. Receives 10% commission. General price range: \$250-5,000. Will review transparencies. Requires submission of a representative slide portfolio, a resume and a statement of intent or explanation of the work proposed for exhibition. Interested in seeing slides only. Considers any size, shape, form, or permutation of any camera art. Send material by mail for consideration. SASE. Reports in 1 month.

CITY OF LOS ANGELES PHOTOGRAPHY CENTERS, 412 S. Parkview St., Los Angeles CA 90057. (213)383-7342. Director: Glenna Boltuch. Interested in all types of photography. Presents 12 shows/year. Exhibits last 4 weeks. Offers rental darkrooms, studio space, outings, lectures, classes, monthly newsletter, juried competitions, a photo library, and free use of models for shooting sessions. Arrange a personal interview to show portfolio or query with samples. SASE. Reports in 1 month. Mounted work only. Gallery retains 20% of sold photographs.

Tips: "We are interested in seeing professional photography which explores a multitude of techniques and styles, while expanding the notion of the art of photography. We have been extremely receptive to exhibiting the work of newer, lesser-known photographers. We are interested in seeing series of works that are unique, and work together as a body of work, that have a message or explore a technical area that

is unique, that expand the art of photography in some way."

PERRY COLDWELL GALLERY, 4727 Camp Bowie Blvd., Fort Worth TX 76107. (817)731-1801. Contact: Perry Coldwell. Interested in any subject matter, archivally processed and mounted, color or b&w. Photography must be technically excellent. Must be silver or platinum prints, carbro, dye transfer, cibachrome glossy and mounted archivally. Presents 10-12 shows/year. Shows last 1 month. "Partially" sponsors openings; provides beverages and waiter. Photographer's presence at opening preferred. Receives 30% commission. Will review transparencies. Arrange a personal interview to show portfolio or query with samples. SASE. Reports in 1 week.

Tips: "We look for technical expertise coupled with strong imagination and originality. Especially inter-

ested in artists trying new directions."

COLORFAX LABORATORIES, Design & Exhibits Office, 4238 Wisconsin Ave., N.W., Washington DC 20016. (202)966-7290 or (301)622-1500. Director: Sarah Rathsack. Interested in photography on any subject for galleries in Washington, DC, Maryland and Virginia. The sale of prints is optional and handled directly by the photographer. Colorfax takes no commission. Price range: \$25-500. Call to arrange an appointment.

CONTEMPORARY ART WORKSHOP, 542 W. Grant Place, Chicago IL 60614. (312)525-9624. Administrative Director: Lynn Kearney. "We encourage artists with professional background or art school." Fine art photography only. Presents 1-2 shows/year. Shows last 3½ weeks. Photographer's presence at opening required. Receives 33% sales commission. Price range: \$100-300. Query with resume of credits and samples. SASE. Reports in 1 month. Framed, mounted and matted work only. Tips: "We're not a big selling place; we're more for exposure. We are a nonprofit gallery primarily showing painting, graphics and sculpture but have been showing 1 to 2 photo shows a year. We prefer beginning careerists from the Midwest. We also have one studio with darkroom for rental at moderate cost. Send slides and SASE for studio consideration."

CREATIVE PHOTOGRAPHY GALLERY, University of Dayton, Dayton OH 45469. (513)229-2230. Director: Sean Wilkinson. Interested in "all areas of creative photography." Photographers with exhibition experience are preferred. Submit 20 slides of work (including dimensions) with resume of credits and SASE in February. Decision is in March, material returned by end of month.

Tips: "Ours is the only gallery in this area that continually and exclusively features photography. A large number of people see the work because of its location adjacent to an active university photography facility. We want to see work that is unified by a particular individual quality of vision. This could be traditional or not, it simply must be good. Don't apply for shows unless you feel you have a mature, well thought out statement to make through your work."

*DUNEDIN FINE ARTS & CULTURAL CENTER, 1143 Michigan Blvd., Dunedin FL 33528. (813)733-4446. Executive Director: Carla Crook. "All work would be considered. This is a family-oriented art center and as such, consideration is given to the subject matter." Present resume and a set of slides or small portfolio along with proposal for show if it is a group of individuals. Presents variable number shows/year. Shows last 1 month. Sponsors opening. Photographer's presence at opening is preferred. "I like to have a talk by the artist either following the reception or on a Sunday afternoon. Scheduling is flexible and this is not required. All work in the gallery is for sale unless the artist chooses not to sell." Receives 30% commission. General price range: varies. "I like to see work as the artist presents it for gallery showing." No restrictions unless they get to be billboard size. Send material by mail for consideration; personal interview granted to everyone. SASE. Reports in 1 week.

Tips: "I am interested in the serious artists who present themselves and their work in a professional man-

ner."

EATON/SHOEN GALLERY, 315 Sutter St., San Francisco CA 94108. (415)788-3476. Director: Timothy A. Eaton. Interested in modern and contemporary. Photographers "must meet a standard of excellence which can only be determined by gallery staff." Presents 3-4 shows/year. Shows last 4 weeks. General price range: \$200-800. Will review transparencies only with SASE. Reports in 1 month.

Tips: "Present thorough, complete and detailed resume in correct form. We are seeing a trend toward the use of travel photography, which currently sells best at our gallery."

*EQUIVALENTS GALLERY, 115 S. Jackson St., Seattle WA 98104. (206)467-8864. Director: Charles Rynd. "Primarily interested in 20th century photography with an emphasis on the contemporary. We represent a wide range of styles and subject matter." Presents 12 shows/year. Shows last 1 month. Sponsors openings, arrangements vary according to agreement with artist. Photographer's presence at opening preferred. Receives 40-50% commission. Buys photographs. General price range: \$150-2,000. Will review transparencies. Interested in unframed work and matted work only. Generally requires exclusive representation within metropolitan area. Submit portfolio for review. SASE. Reports in 1 month.

Tips: "Try to visit gallery at least once to get an idea of the type of work we carry—then determine whether your work might be appropriate."

ETHERTON GALLERY, 424 E. 6th St., Tucson AZ 85705. (602)624-7370. Director: Terry Etherton. Interested in contemporary photography with emphasis on artists in Western and Southwestern US. Photographer must "have a high-quality, consistent body of work—be a working artist/photographer—no 'hobbyists' or weekend photographers." Presents 8-9 shows/year. Shows last 5 weeks. Sponsors openings; provides wine and refreshments, publicity, etc. Photographer's presence at opening and during show preferred. Receives 50% commission. Occasionally buys photography outright. General price range: \$100-1,000 + . Will review transparencies. Interested in matted or unmatted unframed work. Arrange a personal interview to show portfolio or send material by mail for consideration. SASE. Reports in 3 weeks.

Tips: "You must be fully committed to photography as a way of life. I'm not interested in 'hobbyists' or weekend amateurs. You should be familiar with photo art world and with my gallery and the work I show. Do not show more than 20 prints for consideration—show only the best of your work—no fillers.

Have work sent or delivered so that it is presentable and professional.'

EVANSTON ART CENTER, 2603 Sheridan Rd., Evanston IL 60201. Executive Director: MaryBeth Murphy. Interested in fine art photography. Photographer is subject to exhibition committee approval. Presents 10 shows/year. Shows last 5 weeks. Sponsors openings; provides opening reception. Photographer's presence at opening is preferred. Receives 35% commission. Will review transparencies. Interested in matted work only. Requires exclusive area representation during exhibition. Send material by mail for consideration. SASE. Reports in up to 3 months.

FOCAL POINT GALLERY, 321 City Island Ave., New York NY 10464. (212)885-1403. Photographer/Director: Ron Terner. Subject matter open. Presents 9 shows/year. Shows last 4 weeks. Photographer's presence at opening preferred. Receives 30% sales commission. Price range: \$75-250. Arrange a personal interview to show portfolio. Cannot return unsolicited material. "Since it is a personal interview, one will be given an answer right away.'

Tips: "The gallery is geared towards exposure—letting the public know what contemporary artists are doing—and is not concerned with whether it will sell. If the photographer is only interested in selling, this is not the gallery for him/her, but if the artist is concerned with people seeing the work and gaining

feedback, this is the place."

FOCUS GALLERY, 2146 Union St., San Francisco CA 94123. (415)921-1565. Contact: Helen Johnston. Interested in "all approaches to photography, but mostly contemporary." Photographer must be well established. Presents 11 shows/year. Shows last 4 weeks. Sponsors openings. Photographer's presence at opening required. Receives 40% commission. Will review transparencies. Interested in unframed, mounted work only.

THE FOTO-TEK DARKROOM, (formerly The Darkroom), 428 E. 1st Ave., Denver CO 80203. (303)777-9382. Gallery Director: Jim Johnson. "Very open to exhibiting work of newer photographers if the work meets our standards." Interested in "everything." Gallery capacity is 40-55 prints; exhibits changed every month. Receives 33 1/3% sales commission; sometimes buys outright; the artist sets the retail price. Price range: \$50-800. Call to arrange an appointment, or send unmounted samples and include SASE. Mounted and unframed work only. Size: 16x20 maximum.

Tips: "We are primarily concerned with the visual & technical level of the photographs, rather than sub-

ject matter.'

THE FRIENDS OF PHOTOGRAPHY, Box 500, Sunset Center, San Carlos at 9th, Carmel CA 93921. (408)624-6330. Executive Director: James Alinder. Executive Associate: David Featherstone. Interested in all types of photography, especially significant and challenging contemporary and historical imagery. No restrictions . Sponsors openings; "a preview and reception for the artist is held for each exhibition." Presents 9-10 shows/year. Shows last 4-6 weeks. Receives no commission, "but members receive 10% discount." Price range: \$75-1,000. Arrange a personal interview to show portfolio or submit portfolio for review. Call ahead for appointment. Will review transparencies, "but preferably not." Matting or mounting not necessary for review. For exhibition, work is hung as presented. SASE. "Portfolios are reviewed all year."

Tips: "Photographers should recognize that only a few exhibitions each year are selected from unsolicited portfolios. The Friends of Photography publishes a newsletter which serves as the announcement for each exhibition. We also sponsor two grants; The Fergson Grant and the Ruttenberg Award. Interested persons should send SASE in February of each year for Grant Guidelines and due dates."

*JEFFREY FULLER FINE ART, 2108 Spruce St., Philadelphia PA 19103. (215)545-8154. Owner/ Director: Jeffrey Fuller. "Submit one sheet of slides of current work with a curriculum vitae and a selfaddressed stamped envelope for their return." Presents 6 shows/year. Shows last 5 weeks. Sponsors openings; handles all arrangements. Photographer's presence at opening is preferred. Photography sold in gallery. Receives variable commission. Buys vintage photography outright. General price range: \$250 and up. Will review transparencies. Interested in seeing slides first. Requires exclusive representation within metropolitan area. No size limitations. SASE. Reports in 1 month.

GALERIJA, 226 W. Superior St., Chicago IL 60610. (312)280-1149. Director: Al Kezys. Interested in contemporary photography. Presents 2-3 shows/year. Shows last 3 weeks. Sponsors openings; provides wine and hors d'oeuvres. Photographer's presence at opening preferred. Occasionally buys photography outright "if possible." Receives 40% commission. General price range: \$75-350; limited edition portfolios up to \$3,000. Will review transparencies. Arrange a personal interview to show portfolio. SASE. Reports in 3 weeks.

Tips: "Our gallery is semi-cooperative; if no sales are made, exhibitor must cover expenses. We are seeing a return to the documentary as the most enduring type of photographic art. Local scenes (pictures of

the city of Chicago) currently sell the best."

*GALLERY IMAGO, 619 Post St., San Francisco CA 94109. (415)775-0707. Director: Will Stone. The photographer must submit 6-10 slides of available works, resume, SASE and review fee of \$35. Presents 2 shows/year. Shows last 3 weeks. Receives 50% commission. General price range: \$200-500. Will review transparencies. Framed work only. Requires exclusive representation in area. Pieces limited to 40x60 size. Send material by mail for consideration; submit portfolio for review. SASE. Reports in 3 weeks.

GALLERY 614, 0350 County Rd. #20, Corunna IN 46730. (219)281-2752. Contact: President. Interested only in carbro and carbon prints (nonsilver processes). "The only limitations are the limits of the imagination." Sponsors openings. Receives 30% sales commission or buys outright. Price range: \$200-1,000. Call to arrange an appointment. No unsolicited material. SASE. Mounted, matted work.

LENORE GRAY GALLERY, INC., 15 Meeting St., Providence RI 02903. President/Director: Lenore Gray. Interests include contemporary, innovative photography. Requires professionalism. Presents various numbers/year. Shows last 4 weeks. Photographer's presence at opening is preferred. Receives 40-50% commission. General price range: \$200 and up. Will review transparencies. Interested in unframed work only (mounted or unmounted, matted or unmatted). Requires exclusive representation within metropolitan area. Arrange a personal interview to show portfolio or send material by mail for consideration.

THE HALSTED GALLERY, 560 N. Woodward, Birmingham MI 48011. (313)644-8284. Contact: Thomas Halsted. Interested in 19th and 20th century photographs and out-of-print photography books. Sponsors openings. Presents 10-11 shows/year. Shows last 6-8 weeks. Receives 40% sales commission or buys outright. General price range: \$300-10,000. Call to arrange a personal interview to show portfolio only. Prefers to see 10-15 prints overmatted. Send no slides or samples. Unframed work only. Requires exclusive representation.

*IMAGES, IMAGES, IMAGES, 328 West Fourth St., Cincinnati OH 45202. (513)241-8124. Director: Nancy Koehler. Interested in fine quality photographs in all media. No commercial work or travel photography. Documentary photographs which speak to social issues will be considered. Must have a portfolio of work which contains a strong thematic series dealing with a subject or art concern. Presents 7 shows/year. Shows last 6 weeks. Sponsors openings, evening open hours; invitation (no food or beverage). Photogapher's presence at opening is preferred. Receives 40% commission. Rarely buys photographs. General price range: \$90-1,500. Will review transparencies. Interested in mounted and matted work only. Arrange a personal interview to show portfolio or send material for consideration. SASE. Reports in 1 month.

Tips: "This gallery will show more work by a variety of photographers, that is exciting and reasonably

priced, and less one-man shows by famous photographers."

*IMPRIMATUR, LTD., 415 1st Ave. N., Minneapolis MN 55401. (612)333-9174. Director: Christopher A. Frommer. Subjects include all types and styles, with a strong emphasis on alternative and nonsilver process. Presents 8-10 shows/year. Shows last 5-6 weeks. Sponsors openings. Photographer's presence at opening is preferred; photographers' presence during show is preferred. Photography sold in gallery. Receives 50% commission. General price range: \$400-4,000. Will review transparencies. Requires exclusive representation within metropolitan area. Submit portfolio for review. SASE. Reports in 1 month.

INTERNATIONAL CENTER OF PHOTOGRAPHY, 1130 5th Ave., New York NY 10128. (212)860-1777. Contact: Department of Exhibitions. "Before you submit a portfolio of photographs, please first write ICP and briefly describe the work and your background in photography. Appointments may be arranged by phone."

*IRIS PHOTOGRAPHICS, 15 W. Walnut St., Asheville NC 28810. (704)254-6103. Owners: Ralph and Brigid Burns. "Emphasis has been on non-traditional but the gallery exhibits a broad range of types and styles. We are looking for a body of work which is cohesive or thematic and expresses a personal style or viewpoint." The photographer must present approximately 10 exhibition quality prints (these do not need to be matted or mounted). Presents 4 shows/year. Shows last 5 weeks. Sponsor openings, cost usually the photographer's expense but gallery does contribute. Receives 35-50% commission. General price range: \$125-300. Will review transparencies. For exhibitions work must be matte to professional standards; framing optional. Requires exclusive 1 year contract pertaining to exhibited work only. "We provide standard size glass only. Other sizes can be exhibited but photographer must provide glass." Query with samples or submit portfolio for review. SASE. Reports in 2 weeks by mail; if portfolio is submitted in person, we ask to keep it overnight.

Tips: "Interested in working with photographers who have a cohesive idea or statement to make with their show. Good idea to submit written proposal for show as well."

JANAPA PHOTOGRAPHY GALLERY LTD., 303 W. 13th St., New York NY 10014. (212)741-3214. Director: Stanley Simon. Interested in contemporary, fine-art, avant-garde, photojournalism and art photography. Photographers must be professional. Presents 12 shows/year, both group and one-person. Shows last 3-4 weeks. Sponsors openings; provides press and public mailing list, local listing, and advertising at photographer's expense. "We charge a fee of \$225/person, one person show or proportionate amount for group shows." Photographer's presence at opening and show preferred. Receives 50% commission. Will buy some photography outright in future. General price range: \$150 + . Will review transparencies. Interested in unframed, matted work only. Requires exclusive area representation "if possible." Arrange a personal interview to show portfolio or query with resume of credits. SASE. Reports in 2 weeks.

Tips: "We only accept exceptional work in both composition and originality, including technical concepts. We lean toward innovative and technical work." There is a strong trend toward "technical styles-multi-imaging, abstracts, hand coloring on prints, infra-red toning in colors, and panoramics."

JEB GALLERY, INC., 305 S. Main St., Providence RI 02903. (401)272-3312. Contact: Ronald Caplain or Claire Caplain. All contemporary photographers are represented. Color is accepted. Photographer receives 40% commission, with prices ranging from \$300-5,000. No slides. Requires exclusive representation in New England. "Portfolios of photographers are reviewed by appointment."

PETER J. KONDOS ART GALLERIES, 700 N. Water St., Milwaukee WI 53202. (414)271-9600. Owner: Peter J. Kondos. Interested in photos of women, seascapes and landscapes. Sponsors openings; "arrangements for each opening are individualized." Receives a negotiable sales commission or buys photos outright. Price range: \$8 and up. Submit material by mail for consideration. SASE. Size: standard framing sizes. Requires exclusive representation in area.

Tips: Subject matter should be well-defined and of general human interest. "Emphasis is on precise detail."

LAURENTIAN UNIVERSITY MUSEUM & ARTS CENTRE, Department of Cultural Affairs, Laurentian University, Sudbury, Ontario, Canada P3E 2C6. (705)675-1151, ext. 400. Director: Pamela Krueger. Interested in all types of photography. Presents 2-3 shows/year. Shows last 4 weeks. Receives 20% sales commission. Price range: \$50-1,000. Send material by mail for consideration; send photos or transparencies with biography. SASE. Reports in 1 month.

JANET LEHR PHOTOGRAPHS, INC., Box 617, New York NY 10028. (212)288-1802. Contact: Janet Lehr. We offer "fine photographs both 19th and 20th century. For the contemporary photographer needing public exhibition I offer minimal resources. Work is shown by appointment only." Presents 8 shows/year. Shows last 6 weeks. Receives 40% commission or buys outright. General price range: \$350-15,000. Send a letter of introduction with resume; do not arrive without an appointment. Will review transparencies, but prints preferred. SASE. Reports in 2 weeks.

LIGHT, 724 Fifth Ave., New York NY 10019. (212)582-6552. Director: Robert Mann. Interested in "photographs which extend our dialogue with contemporary history." Sponsors openings. Presents 15-20 shows/year. Shows last 6 weeks. Photographer's presence at opening and during show preferred. Receives 40-50% sales commission. Price range: \$250-25,000. Contact for appointment to arrange to leave portfolio for at least 3 days. Will review transparencies. SASE. Unframed work only. Prefers exclusive representation.

Tips: "Send transparencies and if we feel it is work in which we may have interest we will request a portfolio be dropped off. No comments are offered unless we would like to exhibit. Include as much bio-

graphical data as possible with the transparencies."

*LONGAN GALLERY, 104 N. Broadway, Billings MT 59101. (406)259-3440. Owner: Fred Longan. Subjects include classic 19th & 20th century images, 19th century images of the Northern Plains. "We do not have regular exhibits." Buys photography outright. General price-range: mat works are \$75-2,500. Most works in \$500-2,500 range. Does not return unsolicited material. "If I am interested, I'll contact the artist. I am a poor bet for unsolicited work."

Tips: "Do well; grow old; then contact me. I don't mean to be facetious, but I buy no work of unestablished artists. If I were to change that policy I would represent artists living in this region; the North-

ern Plains States, Alberta, Saskatchewan, possibly British Columbia."

MARI GALLERIES OF WESTCHESTER, LTD., 133 E. Prospect Ave., Mamaroneck NY 10543. (914)698-0008. Owners/Directors: Carla Reuben and Claire Kaufman. Interested in all types of photography. Photographer should have a comprehensive selection of framed photographs ready to hang. Presents 4-6 shows/year. Shows last 5-6 weeks. Sponsors openings. "Five to six artists are featured per show. Each artist sends flyers to their own people, plus gallery sends mailing list of its own. Press is invited. Refreshments are provided by gallery on opening day." Photographer's presence at opening is preferred. Receives 40% sponsor commission. General price range: open. Will review transparencies. Interested in framed or unframed; mounted or unmounted; matted or unmatted work. Requires exclusive area representation. Arrange a personal interview to show portfolio; send material by mail for consideration or submit portfolio for review. SASE. Reports in 2 weeks.

Tips: "The aim of MARI Galleries is to act as a showcase for talented artists. Presenting good to excellent art to be viewed by the public is of prime importance for the survival of art in this country. Unfortunately, government support falls far short of the requirements for this maintenance. We therefore try, in our small way, to nurture artists through exhibitions supported by informative publicity. MARI presents a spectrum of contemporary work in varied media. Our old barn acts as a perfect backdrop."

*MARLBOROUGH GALLERY, INC., 40 West 57th St., New York NY 10019. (212)541-4900. Director, Graphics & Photos: Bruce Cratsley. Presents 2-4 shows/year. Shows last 4 weeks. Photography sold in gallery. Receives 40-50% commission. General price range: \$700-7,000. Will review transparencies with SASE. Usually requires exclusive representation. Submit portfolio overnight, by appointment. SASE. Reports in 2 weeks.

Tips: "We work only with "blue chip" photographers—i.e., Brassai, Berenice Abbott, Irving Penn, Bill Brandt and occasionally with outstanding younger contemporary photographers, usually in group

exhibitions."

*MATTINGLY BAKER, 3004 McKinney, Dallas TX 75204. (214)526-0031. Assistant Director: Debbie Nance. Interested in abstract/figurative photography. Send slides to be reviewed; we then prefer to contact the artist personally. Presents 10 shows/year. Shows last 1 month-6 weeks. Sponsors openings; arrangements negotiable. Photographer's presence at opening preferred. Sometimes buys photos outright and will take on consignment, general price range: retail price is between \$500-2,000. Will review transparencies. Interested in framed and unframed, mounted or unmounted, matte or unmatted work. Prefers exclusive representation with metropolitan area. Send material by mail for consideration. SASE. Reports in 3-4 weeks.

Tips: "We represent several artists who work with silver prints, and hand color."

MIDTOWN Y PHOTOGRAPHY GALLERY, 344 E. 14th St., New York NY 10003. (212)674-7200. Director: Michael Spano. Interested in all types of photography. Sponsors openings. Presents 9 or 10 shows/year. Shows last 4 weeks. "During the year we have 2- or 3-person shows." Photographer's presence at opening preferred. Receives no commission. Price range: \$100-250 (average). Arrange a personal interview to show portfolio; "call for an appointment. Carefully edit work before coming and have a concept for a show." Will review transparencies; prints preferred. SASE. Reports in 1 month. Unframed work only. Size: 8x10 to 30x40 prints.

Tips: "We do not show work that has already been seen in this area. We prefer to exhibit photographers living in the metropolitan area but we have shown others. We try to have an exhibition or two each year

dealing with New York City."

THE MILL GALLERY, Ballard Mill Center for the Arts, S. William St., Malone NY 12953. (518)483-5190. Curator: Caryl Levine. Interested in photojournalism, color, fine b&w images and new techniques. Presents 2 shows/year. Shows last 6 weeks. Sponsors openings. "We print invitations, mail them, send press releases, and offer wine and cheese, and sometimes music." Photographer's presence at opening preferred. Receives 30% sponsor commission. General price range: \$100 (depends on matting). Will review transparencies. Interested in framed work only. Query with resume of credits or samples. SASE. Reports in 2 weeks.

Tips: "We are a unique complex of craft, studio and small business spaces—the hub of cultural activity in northern New York. Any artistic input and interest is welcomed. Photography in the past decade has

become an acceptable art form. Our area is very responsive to this.'

MINOT ART GALLERY, North Dakota State Fairgrounds, Minot ND 58701. (701)838-4445. Director: Connie Rosecrans. Sponsors openings; "the first Sunday of each month is usually when we have each exhibit's grand opening." Open to work of newer photographers. Presents 11 shows/year. Closed January. Shows last about 1 month. 1985—8th Annual North Dakota National Juried Exhibit, sponsored by gallery (juried show). Send resume and slides for consideration. Gallery receives 30% sales commission. Price range: \$10-2,500. Submit portfolio or at least six examples of work for review. Will review transparencies. SASE. Reports in 1 month. Size: 3x5 to 72x72.

Tips: "Wildlife, landscapes and floral pieces seem to be the trend in North Dakota."

MUSEUM OF NEW MEXICO, Box 2087, Santa Fe NM 87503. (505)827-4455. Associate Director of Museum of Fine Arts: David Turner. Curator of Photographs: Steven A. Yates. Emphasis on photography in New Mexico and the Southwest. Sponsors openings. Presents 1-2 shows/year. Shows last 2-3 months. Contact Curator of Photographs.

MUSKEGON MUSEUM OF ART, 296 W. Webster, Muskegon MI 49440. (616)722-2600. Curator of Photography: Douglas A. Fairfield. Interested in creative photography of the highest quality. Prefers established photographers with past exhibition experience. Presents 1-2 shows/year. Shows-last 1-2 months. Sales agreement arranged on an individual basis. Query with resume and samples. Will review transparencies. SASE.

NEIKRUG PHOTOGRAPHICA LTD., 224 E. 68th St., New York NY 10021. (212)288-7741. Owner/Director: Marjorie Neikrug. Interested in "photography which has a unique way of seeing the contemporary world. Special needs include photographic art for our annual Rated X exhibit." Sponsors openings "in cooperation with the photographer." Photographer's presence preferred. Receives 40% sales commission. Price range: \$100-\$5,000. Call to arrange an appointment or submit portfolio in person. SASE. Size: 11x14, 16x20 or 20x30. Requires exclusive representation in area.

Tips: "We are looking for meaningful and beautiful images—images with substance and feeling! Edit work carefully; have neat presentation. We view portfolios once a month. They should be left on the assigned Wednesday between 1-5 pm and picked up the next day between 1-5 pm."

NEW ORLEANS MUSEUM OF ART, Box 19123, City Park, New Orleans LA 70179. (504)488-2631. Curator of Photography: Nancy Barrett. Interested in all types of photography. Presents shows continuously. Shows last 1-3 months. Buys outright. No longer have NEA grant for purchase of contemporary American work. Query with resume of credits only. SASE. Reports in 1-3 months.

NEXUS, 608 Ralph McGill Blvd., Atlanta GA 30312. (404)688-1970. Executive Director: Louise Shaw. Contact: Alan Sondheim, Gallery Curator. "Open to any approach to the medium as long as it is original and executed with care and concern. Nexus exhibits a mix of regional and local work. Mostly contemporary. We also show work other than photography, and are particularly interested in installation and performance work." Exhibiting artists meet all or most expenses. Provides assistance with PR, invitations, installation, etc. Presents 8 shows/year. Shows last 3-5 weeks, with 4 weeks as the average. Open to work of newer photographers. Contact gallery curator to arrange an interview or send material by mail for consideration. Gallery retains 20% commission on all work sold—"Our emphasis is on being an 'alternative space' rather than a commercial gallery." Price range: \$100-2,250. SASE. Reports in 3-4 weeks. Unframed work only. Prefers not to deal with work larger than 16x20 through the mail. Tips: "If applying for one-man exhibit, please try to see the exhibition space if possible. Send only the actual work you wish to have considered for exhibition. A statement about the work and resume are required. We like to exhibit photographic work with content rather than work simply concerned with aesthetic issues (example: El Salvador Show; George Mitchell's "Faces of the South"). We are a nonprofit artist's space gallery with 10 years of expertise in the national photography community. As a regional organization, Nexus is particularly adept at providing emerging photographers with and in making national connections with other galleries and other supporting organizations. We also have an offset printing operation called the Nexus Press which considers proposals for artist's books. Contact Michael Goodman or Clifton Meaders."

NIKON HOUSE, 620 5th Ave., New York NY 10020. (212)586-3907. Interested in "creative photography, especally 35mm, that expresses an idea or attitude. We're interested in many subjects, just as long as they are visually stimulating and done tastefully. Our gallery shows all types of work. We prefer photographers with gallery experience. We'll see 'emerging' newcomers and established pros." Photographer must pay for printing, mounting and frames; "Nikon pays for press releases, invitations, posters, etc." Presents 12 shows/year in the gallery. Shows last one calendar month. Photographer's presence at opening required and during show preferred. Photography is not sold in gallery, but will give out the photographer's phone number and/or address. Arrange a personal interview to show portfolio or query with resume of credits. Will review transparencies but prints preferred. For submission of works call: K.C.S.&A. Inc., 99 Park Ave., New York NY 10016. (212)682-6300.

NORMANDALE GALLERY, 9700 France Ave. S., Bloomington MN 55431. (612)830-9300, ext. 338. Director of College Center: Gael Cywinski. Interested in all types of photography, both traditional and experimental. Sponsors openings. Presents 6 shows of photography/year. Shows last 8 weeks. Photographer's presence at opening preferred. Buys outright. Price range: \$25 and up. Submit portfolio or slides for review. Will review transparencies. SASE. Reports in 2 weeks. Photographer should frame, mount and matte his/her work for exhibition if accepted.

OPEN SPACE GALLERY, 510 Fort St., Victoria, British Columbia, Canada. (604)383-8833. Curator: Michael Harding. Interested in photographs as fine art in an experimental context, as well as interdisciplinary works involving the photograph. No traditional documentary, scenics, sunsets or the like. Sponsors openings. Presents 5 shows/year. Shows last 3-4 weeks. Pays the C.A.R.F.A.C fees. Price range: \$100-250. Query with transparencies of work. SASE. Reports in 6 weeks.

OPTICA-A CENTRE FOR CONTEMPORARY ART, 3981 Blvd. St.-Laucent, #501, Montreal, Quebec, Canada H2W 1Y5. (514)287-1574. Contact: Administrator. "There is no limit in subject matter and exhibitions; only a portion of our program is photography." Sponsors openings. Presents 15 shows/year. Shows last 1 month. Artist's presence at opening preferred. Does not buy. "We have jury by slides every three months. Photographers are asked to submit 15 slides, a CV, and a short letter describing their work. We are funded by the Provincial Federal and Municipal Governments." Prefers to review transparencies. SASE. "We will consider unframed and unmatted works as well."

ORLANDO GALLERY, 14553 Ventura Blvd., Sherman Oaks CA 91403. (213)789-6012. Director: Philip Orlando. Interested in photography demonstrating "inventiveness" on any subject. Sponsors openings. Open to work of newer photographers. Shows last 3 weeks. Receives 50% sales commission. Price range: \$200-1,000. Submit portfolio. SASE. Framed work only. Requires exclusive representation in area.

*THE PHOTO GALLERY AT PORTLAND SCHOOL OF ART, 619 Congress ST., Portland ME 04101. (207)775-3052. Head, Photo Department: John Eide. Requires work that has been matted and ready to hang. Presents 7 + shows/year. Shows last 4 weeks. Photography could be sold in gallery. General price range: \$100-500. Will review transparencies. Interested in unmounted work only. Submit portfolio for review. SASE. Reporting time varies.

PHOTOGRAPHIC INVESTMENTS GALLERY, 468 Armour Dr., Atlanta GA 30324. (404)876-7260. Contact: Ed Symmes. Interested in "19th century vintage images and 20th century images of technical and visual excellence. All work must be framed, delivered and picked up at gallery." Presents 10-12 shows/year. Shows last 1 month. Photographer's presence at opening preferred. Receives 50% commission. Sometimes buys 19th century photography outright; rarely 20th century. General price range: \$75-2,000. Will review transparencies. "Will look at anything, hang only framed work." Arrange a personal interview to show portfolio; query with samples or submit portfolio for review. SASE. Reports in 1 month "or sooner."

Tips: "Prefers working with artists in person who can appear at openings. Would like to encourage re-

gional artists, but not exclusively."

PHOTOGRAPHICS UNLIMITED GALLERY, 43 W. 22nd St., New York NY 10010. (212)255-9678. Contact: Pat O'Brien. Interested in "competent, progressive women photographers." Presents 9 shows/year. Shows last 1 month. Photographer's presence during show required. Receives 20% commission. General price range: \$250-500. Will review dupe transparencies only with SASE. Interested in unframed, mounted and matted work. 20x24 size limit. Query with resume of credits. SASE. "We are booked through 1986."

PHOTOGRAPHY AT OREGON GALLERY, University of Oregon Museum of Art, Eugene OR 97403. (503)344-5010. Contact: Paul Neevel. "We are interested in all approaches to the photographic medium in which both technical virtuosity and serious intent on the part of the artist are displayed." Presents 10 shows/year. Shows last 1 month. "Review to be held in May for individual shows in the following year." Receives 30% sales commission. Submit portfolio for review in early May. Will review transparencies or copy slides with 1 print example. Send resume and letter of interest. No portfolios returned without prepaid postage.

Tips: "There seems to be a stylistic return to straight imagery. Our clients are interested in seeing first-rate photography. They rarely buy, except at our annual auction of donated photographs."

*THE PHOTOGRAPHY GALLERY, 7468 Girard Ave., La Jolla CA 92037. (619)459-1800. Director: Holly Howell. Shows contemporary fine art photography. "Prints must be of archival quality and the artist must have a track record of pursuing a career as a fine art photographer." Presents 6 shows/year. Shows last 6-7 weeks. Receives 50% commission. General price range: \$400-2,000. Will review transparencies. Interested in unframed work only. Requires exclusive representation within metropolitan area. Query with resume of credits or submit portfolio for review. SASE. Reports in 1 month.

PHOTOWORKS, INC., 204 N. Mulberry St., Richmond VA 23220. (804)359-5855. President: David L. Everette. Interested in "fine arts, mainly, but open to journalism, etc." Sponsors openings on-

176 Photographer's Market '86

ly for local and Virginia artists in all areas of photography. General price range: \$100-400. Will review transparencies. Interested in framed or unframed work. Requires exclusive area representation. Send material by mail for consideration. SASE. Reports in 2 weeks.

POPULAR PHOTOGRAPHY GALLERY, *Popular Photography Magazine*, 1 Park Ave., New York NY 10016. (212)503-3500. Director: Monica R. Cipnic. Interested in all types of photography. Presents 8 shows/year. Shows last 6 weeks. Photographer's presence at opening required. Receives no commission. Price range: ASMP standard. Arrange a personal interview to show portfolio or submit portfolio for review; query with samples; or send material by mail for consideration. Will review transparencies. SASE. Reports in 4 weeks.

*POSITIVE PHOTOGRAPHICS GALLERY, 180 Massachusetts Ave., Arlington MA 02174. (617)646-6080. Partner: James Rohan. Subjects include all types; good commercial, fashion and architectural photography is as welcome as art photography. Presents 8-10 shows/year. Shows last 4-6 weeks. Will review transparencies. Interested in framed or unframed work, mounted work only and matted or unmatted work. Arrange a personal interview to show portfolio.

Tips: "Work must be competent technically as well as artistically. Gallery complements our main business which is custom photographic printing, so your work should meet our technical standards."

THE PRINT CLUB, 1614 Latimer St., Philadelphia PA 19103. (215)735-6090. Director: Ofelia Garcia. Interested in the work of student nonprofessionals, professionals, all persons. Does some non-selling photography shows. Sponsors openings. Receives 40-50% sales commission. Price range: \$100-1,000. Write to arrange an appointment. Prefers unframed work.

Tips: "We prefer high quality experimental work, though we do show some vintage photographs."

PROJECT ART CENTER, 141 Huron Ave., Cambridge MA 02138. (617)491-0187. Photo Gallery Director: Karl Baden. Interested in all types of photography. Artists' major expenses, including openings, paid for by gallery. Presents 13 shows/year. Shows last 25 days. Receives 40% commission. Price range: \$100-1,000. Arrange a personal interview to show portfolio or submit slides for review. SASE. Reports in 6-8 weeks. Unframed work only.

REFLECTIONS, 199 River St., Leland MI 49654. (616)256-7120. Contact: Richard Braund. Interested in all type and subjects from nature to nude. Presents 3 shows/year. Shows last 2 months. Receives 45% sponsor commission. General price range: \$5-100. Will review transparencies. Interested in framed or unframed; mounted or unmounted; matted or unmatted work. Requires exclusive area representation. No works larger than 20x30. Query with samples; send material by mail for consideration or submit portfolio for review. SASE. Reports in 3 weeks.

RIDER COLLEGE STUDENT CENTER GALLERY, Box 6400, Lawrenceville NJ 08648. (609)896-5326. Director of Cultural Programs: Sarah-Ann Harnick. Group or one-person shows; photographers "need to fill 150 running feet of wall space." Sponsors 2-hour opening at beginning of show; photographers must be present at opening. Price range: \$50-150. Receives 33% sales commission. Submit material by mail for consideration. SASE. Framed work only.

RINHART GALLERIES, INC., Upper Grey, Colebrook CT 06021. (203)379-9773. President: George R. Rinhart. Interested in 19th and 20th century photographs. Presents 4-6 shows/year. Shows last approximately 1 month. Sponsors openings; provides drinks, hor d'oeuvres, music, etc. Photographer's presence at opening is preferred. Receives 40% commission. Buys photography outright. General price range: \$50-25,000. Will review transparencies. Interested in unframed work. Requires exclusive area representation. Query with resume of credits. Does not return unsolicited material. Reports in 1 month. Sees photographers by appointment only.

SANDER GALLERY INC., 51 Greene St., New York NY 10013. (212)219-2200. President: Gerd Sander. Vice-President: Christine Sander. Interested in Vintage European photography (as well as contemporary European and American). No photojournalism or commercial advertising type of photography. Work shown by appointment only.

DONNA SCHNEIER FINE ARTS, 251 E. 71st St., New York NY 10021. (212)988-6714. President: Donna Schneier. Interested in vintage photographs. Receives sales commission or buys outright. Price range: \$100-10,000.

MARTIN SCHWEIG STUDIO/GALLERY, 4658 Maryland Aye., St. Louis MO 63108. (314)361-3000. Gallery Director: Lauretta Schumacher. Interested in all types of photography. Shows last 6

weeks. Receives 40% sales commission. Price range: \$100-1,000. Submit portfolio for review. Will review transparencies. SASE. Reports in 3-4 weeks. Finished work must be professionally mounted and ready to display. Mounting and framing must be decided with gallery.

*SCHWEINFURTH MEMORIAL ART CENTER, Box 916, 205 Genesee St., Auburn NY 13021. (315)255-1553. Director: Heather Tunis. Interested in black and white, color, other toned or manipulated images, primarily realism; artistic, personal vision, travelogue, photodocumentation. Relevance to the region, outstanding quality, confirmed reputation are all significant, however not necessarily interrelated, criteria. "We require quality, professionalism, appropriately mounted and framed images, labels and biographical information." Presents an average of 4 shows/year. Shows last 6-8 weeks. Sponsors openings; provides wine and cheese or seasonally appropriate refreshments. Dependent upon other exhibitions, music and/or thematic environment is provided. Photographer's presence at opening is preferred. Photography is sold "discretely; we are not a sales gallery per se. We are primarily an exhibition site." Receives 25% commission. General price range: \$50-250. Will review transparencies. Interested in seeing slides or unframed, unmounted protected prints; interested in exhibiting matted, framed images only. Requires exclusive representation within 50-mile radius. "We do not seek large format photography per se." Send resume and slides or sample prints for review. SASE. Reports in 1 month to 6

Tips: "Work should be professional, beyond amateur, not too experimental but rather expressive of the photographer's vision and control of media. By virtue of location, size and typical audience, work should be of relevance to exhibition in small, northeastern city."

SEA CLIFF PHOTOGRAPH CO., 310 Sea Cliff Ave., Sea Cliff NY 11579, (516)671-6070. Coordinators: Don Mistretta, Diann Mistretta, Interested in serious vintage and contemporary works. Are expanding to include other media. "The images must stand on their own either separately or in a cohesive grouping." Presents 25 shows/year. Shows last 4-8 weeks. Sponsors openings; provides press coverage: opening reception and framing facilities. Photographer's presence at opening preferred. Receives 40% commission. Occasionally buys photography outright. General price range: \$100-500. Will review transparencies. Interested in unframed work only. Arrange a personal interview to show portfolio or query with resume of credits. Does not return unsolicited material. Reports in 2 weeks.

Tips: "Come to us with specific ideas and be willing to explore alternative avenues of thought. All forms of photographic imagery are acceptable. The buying public is looking for good contemporary and

fine vintage photography.

THE SILVER IMAGE GALLERY, 92 S. Washington St., Seattle WA 98104. (206)623-8116. Director: Dan Fear. Interested in contemporary fine art photography. Photographer "must have plans to further his or her career in fine art photography." 6-sponsors openings. Receives 30-50% sales commission; buys work by the "masters" and early photographs outright. Price range: \$100-2,000. Query with resume of credits, call to arrange an appointment, submit material by mail for consideration, or submit portfolio. SASE. Reports in 2 months.

Tips: "The main goal of the gallery is to sell fine photographic prints. The Silver Image Gallery is one of the oldest in the country. Communication is very important. Photographers should also be interested in working closely with the gallery. They need to know the gallery before a good working relationship can be formed. We are interested in fine art photography posters that might be included in our mail order photography poster catalog. For catalog send \$2. If you have a poster for consideration, send sample. In-

terested primarily in nudes, landscapes and hand-colored photographs."

SIOUX CITY ART CENTER, 513 Nebraska St., Sioux City IA 51101. (712)279-6272. Assistant Director: Tom Butler. Contemporary expressive photography (color/b&w); altered/alternative; conceptual; generative. No student work (except advanced graduate). Send slides, resume first. SASE. Tips: "The graphics gallery contains 107 running feet of display space. Send 25-40 good quality slides, resume, SASE for return of materials, and letter of introduction."

SOL DEL RIO, 1020 Townsend, San Antonio TX 78209. (512)828-5555. Director: Dorothy Katz. Interested in photography on any subject. Open to work of newer photographers. Sponsors openings. Shows last 3 weeks. Receives 40% sales commission. Price range: \$85-200. Query first with resume of credits and examples of work. SASE. Requires exclusive representation in area.

Tips: "Landscapes, and object shots currently sell best at our gallery."

SOUTHERN LIGHT, Box 447, Amarillo TX 79178. (806)376-5111. Director: Robert Hirsch. Sponsored by Amarillo College. "Very open to work of newer photographers. We don't believe that the only good artist is a dead artist." Presents 12-18 shows/year. Shows last 3-4 weeks. Receives 10% sales commission. Price range: \$100 and up. "We are now showing video art (prefer 3/4"). Looking for features

and shorts for gallery and to air on twice a week film program on college cable station. Include detailed statement for TV consideration. Include resume, statement and postage in all cases." For still works, will review transparencies. Prefers to see portfolio of 20-40 pieces. Wants to see unmounted work for preview; matted work for shows.

Tips: "We are open to anything since we don't rely on sales to stay open. We want to show work that is on the cutting edge. People photographs currently sell best at our gallery."

SUSAN SPIRITUS GALLERY, INC., 522 Old Newport Blvd., Newport Beach CA 92663. (714) 31-6405. Owner: Susan Spiritus. Interested in contemporary art photography archivally processed. Also sells fine art and photography, line art photo books, and posters. Very open to work of newer photographers. Sponsors several person exhibitions/month with gallery reception. Has group shows; sponsored symposium on photography. Receives 50% sales commission. Price range: \$150-10,000. Prefers to see slides and resume, then set up appointment. SASE. Unframed work mounted on 100% rag board only. No size limits, but must conform to stock size frames for exhibitions.

Tips: "Landscapes (color or black and white), currently sell best. The economy most definitely has affected the amount of photographs sold. We still exhibit on a regular basis, but the amount our collectors purchase is dependent on the economic times. We are also showing selected other fine art mediums."

Economy, malaise and chic decadence are words that have been used to describe the work of fine art photographer Marsha Burns of Seattle, Washington. This photograph, from a collection of her works entitled 'The Dreamer's Portfolio,' is on display at the Susan Spiritus Gallery in Newport Beach, California. "Her work is very well known, appearing in galleries and art museums throughout the United States and Europe. She's extremely innovative in that she photographs only in black and white, and only in her studio. In many instances, the women look like men and vice versa. The photos are quite strange, but quite wonderful," says Susan Spiritus Art Director Sharon Thomas.

Market conditions are constantly changing! If this is 1987 or later, buy the newest edition of *Photographer's Market* at your favorite bookstore or order directly from Writer's Digest Books.

SUNPRINT CAFE & GALLERY, 638 State St., Madison WI 53703. (608)255-1555. Directors: Rena Gelman, Linda Derrickson, Interested in all types of photography, Sponsors openings, Receives 40% sales commission. Price range: \$50 and up. Submit a 10-piece mounted portfolio; include name, address, and price of each print. Mounted or matted work only. "We need 1 month to view each portfolio and expect a follow-up phone call from the photographer. We prefer the mount boards to be a standard 11x14 or 16x20, for we put all photos behind glass; also framed photos of any size.'

Tips: "We have a small cafe inside the gallery which allows people to sit and view the work in a relaxed

atmosphere. We have 2 showrooms for the exhibits which hang approximately 6 weeks."

TERRAIN GALLERY, 141 Greene St., New York NY 10012. (212)777-4426. Contact: Carrie Wilson, Advisory Directors: Dorothy and Chaim Koppelman. Basis for selection and exhibition of work the Aesthetic Realism of Eli Siegel which states: "In reality opposites are one; art shows this." Receives 40% sales commission. Price range: \$35-250. "We request photographers to call in advance for an appointment."

Tips: "We recommend that every artist exhibiting at the Terrain Gallery study Eli Siegels's Fifteen

Questions about Beauty: 'Is Beauty the Making One of Opposites?' and ask if it is true about his or her

work.'

*THOMAS COLLEGE ART GALLERY, W. River Rd., Waterville ME 04901. (207)873-0771. Financial Consultant: Ford A. Grant. Presents 5 shows/year. Shows last 1 month. Interested in seeing framed or unframed; mounted work only; matted or unmatted. Query with resume of credits. SASE. Reports in 2 weeks.

TIDEPOOL GALLERY, 22762 Pacific Coast Hwy., Malibu CA 90265. (213)456-2551. Partner: Jan Greenberg. Interested in "any photography related to the ocean—sea life, shore birds, etc." Sponsors openings; "we have 2 shows every year, with a reception for the artists. The shows last 1 month to 6 weeks." Photographer must be present for opening. Receives 33 1/3% sales commission. Price range: \$25-1,500. Call to arrange an appointment or submit material by mail for consideration. SASE. Dry mounted work only. "The work must be able to be hung, and protected by being framed or in acetate sleeves." Size: "nothing smaller than 1' square or larger than 3' long or wide." Requires exclusive representation in area "for a certain period of time when we are sponsoring a show." Tips: "Keep the price as low as possible."

*T.M. GALLERY, Thomas More College, Crestview Hills KY 41017. (606)344-3419. Gallery Director: Barbara Rauf. Presents 1-2 shows/year. Shows last 3-4 weeks. Sponsors openings; refreshments, publicity provided. Photographer's presence at opening is preferred. Infrequently buys outright. Will review transparencies. Interested in framed work only. Submit portfolio for review. Reports in 1 month.

*TONGASS HISTORICAL MUSEUM, 629 Dock St., Ketchikan AK 99901. (907)225-5600. Secretary: Karla Sunderland. Accepts photographs relevant to southeastern Alaska and depicting Alaskan lifestyles and scenery only. "It is imperative that we review materials prior to purchase or exhibit." Presents at least 2 shows/year. Shows last 4 weeks. Provides publicity only. Receives 40-50% commission. Buys photography outright. General price range: \$3-20. Will review transparencies. Unmounted or matted work only. Requires exclusive representation within metropolitan area. "We require that photographs be reasonably priced for sale to a heavy influx of tourists during the summer tourist season." Send material by mail for consideration; submit portfolio for review. SASE. Reports in 1 week.

TOUCHSTONE GALLERY, 2130 P St. NW, Washington DC 20037. (202)223-6683. Director: Luba Dreyer. Interested in fine arts photography. Photographer "must be juried in and pay the membership fee. We are an artists' cooperative." Presents one feature show per artist; plus group shows each year. Shows last 3 weeks. Photographer's presence at opening preferred. Receives 33 1/3% sponsor commission. General price range: \$90-400. Submit portfolio consisting of current work plus transparencies for review at time of jurying, once a month; must be picked up next day. Reports "one day after jurying." Tips: "We offer more exposure than sales."

*BERTHA URDANG, 23 E. 74th St., New York NY 10021. (212)288-7004. The only requirement is that a photographer submit very good, innovative work. Presents 8 shows/year. Shows last 1 month. "The artist pays for a simple invitation which the gallery mails; the gallery pays for the opening reception." Receives 50% commission. Seldom buys photography outright. General price range: \$250-\$1,500. Will review transparencies. Matted work only. Arrange a personal interview by photo to show portfolio. "I do not want to see material without a prior interview."

Tips: "The photographer should come here again and again, anonymously, and get the feel of what this

gallery is about. If he/she feels an affinity, we'll talk."

VISION GALLERY INC., (formerly Douglas Elliot Gallery), 1151 Mission St., San Francisco CA 94103. (415)621-2107. President: Joseph G. Folberg. Interested in contemporary and vintage 19th century. Presents 8 shows/year. Shows last 4-6 weeks. Sponsors openings. Photographer's presence at opening is preferred. Receives 50% sales commission. Buys photography outright. Price range: \$200-15,000. Interested in mounted work only. Does not return unsolicited material. Arrange a personal interview to show portfolio. Reports immediately.

VISUAL STUDIES WORKSHOP GALLERY, 31 Prince St., Rochester NY 14607. (716)442-8676. Exhibitions Coordinator: Glenn Knudsen. Interested in "contemporary mid-career and emerging artists working in photography, video, and artists' books; new approaches to the interpretation of historical photographs. Theme exhibitions such as 'Text/Picture: Notes,' 'Visual Mapping and Cataloguing,' and exhibitions which draw parallels between picture-making media.' "No requirements except high quality. Presents 15-20 shows/year. Shows last 4-8 weeks. Sponsors openings; provides lectures, refreshments. Photographer's presence at opening preferred. Receives 40% commission. Rarely buys photography outright. General price range: \$150-500. Prefers to review transparencies. Send material by mail for consideration. SASE. Submissions are reviewed twice yearly—spring and fall. "We prefer slides which we can keep and refer to as needed."

Tips: "It is important that the photographer be familiar with the overall programs of the Visual Studies Workshop. We represent mostly younger, emerging photographers whose work we see as being significant in our time. Therefore, I feel that most of our clients buy the work they do because they are responding to the qualities of the image itself."

VOLCANO ART CENTER, Box 189, Volcano HI 96785. (808)967-7511 or 967-7676. Executive Director: Marsha A. Morrison. Gallery Manager: Margot Griffith. Interested in "b&w, and good Cibachrome prints. Preferably, work should reflect an artist's relationship with Hawaii, its landscapes, peoples, cultures, etc. All work is juried by director and gallery manager." Presents up to 12 shows/year. Shows last 3 weeks. Sponsors openings. "Sunday afternoon openings are usual. Invitations go to a mailing list of 1,600, Hawaii and West Coast press coverage is provided and refreshments served." Photographer's presence at opening preferred. Receives 40% sponsor commission. Will review transparencies or unmounted prints. Work must be presented ready for hanging. Send material for consideration or submit portfolio for review. SASE. Reports in 3 weeks.

WARD-NASSE GALLERY, 178 Prince St., New York NY 10012. (212)925-6951. Director: Rina Goodman. Interested in photography on any subject. Open to work of newer photographers. Photographer must be voted in by other members. Price range varies. "Artist determines prices with guidance from Director if desired. No commission. We are a non-profit organization." Query about memberships, call to arrange an appointment, and submit name and address and ask to be notified about voting schedules. SASE. Photographs should be signed and in a numbered edition. Prints must be in plastic pages.

Tips: "Individual artist maintains binders containing biographical information, press clippings, slides, etc. These are easily accessible to the visitor who wants to focus on a particular mode or artist's work."

WEDGE PUBLIC CULTURAL CENTER FOR THE ARTS, 110 S. LaSalle, Box 1331, Aurora IL 60507. (312)897-2757. Director: Danford Tutor. Interested in all types of photography. Presents one show/year. Show lasts 1 month. Sponsors openings; provides publicity and space. Photographer's presence at opening required. No commission. General price range: \$25-250. Will review transparencies. Framed work only. Query with resume of credits or samples; send material by mail for consideration. SASE. Reports in 2 weeks.

*RICK WESTER PHOTOGRAPHIC, Room 102A 568 Broadway, New York NY 10012. (212)219-1680. President: Rick Wester. Interested in contemporary experimental, work that risks a lot. The photographer must be able to think, work and answer questions. Presentations of shows and number of weeks varies. Photography sold in gallery. Receives 50% commission. Buys photography outright. General price range: \$300-30,000. Will review transparencies. Interested in original work in whatever manner the artist prescribes. Size limits include anything not larger than any one wall. SASE. Reports in 1 month.

Tips: "Don't expect anything at first, and then don't give up. Generally it looks like galleries are showing what they think is the best work available. People will buy anything that pleases them, and even then they may not do that either."

THE WITKIN GALLERY, INC., 415 W. Broadway, New York NY 10012. (212)355-1461. Interested in photography on any subject. "We will also be showing some work in the other media: drawing, litho, painting—while still specializing in photography." Will not accept unsolicited portfolios. Query

first with resume of credits. "Portfolios are viewed only after written application and recommendation from a gallery, museum, or other photographer known to us." Buys photography outright. Price range: \$10-14,000.

DANIEL WOLF, INC., 30 W. 57th St., New York NY 10019. (212)586-8432. Contact: Tiana Wimmer or Bonni Benrubi. Interested in 19th century to contemporary photography. Sponsors openings. Presents 10 shows/year. Photographer's presence at opening required. Receives 50% of selling price. Price range: \$200-10,000. "We look at work once every 3 months; photographer must drop off work and pick up the following day. Call for viewing date."

*WOMEN'S ART REGISTRY OF MN (WARM), 414 1st Ave. N., Minneapolis MN 55410. (612)5672. Exhibition Coordinator: Jody Williams. Interested in photography by women—limited to women living in MN, midwest and New York city—reviews all styles and contents. Must be an associate member of WARM. \$20 annual fee. Out of state artists must apply to invitational program. Presents 2-3 shows/year. Shows last 1 month. Sponsors openings; refreshments, and provides publicity. Photographer's presence at opening is preferred. Receives 15% commission. General price range: \$50-300. Will review transparencies. Interested in slides submitted during competition. Request invitational space application form. Reports in 1-2 months after application deadline.

*THE WOODSTOCK GALLERY AND DESIGN CENTER, Woodstock East, Woodstock VT 05091. (802)457-1900. Gallery Director: Jon Gilbert Fox. Interested in landscape, abstract, seasonal, experimental—black-and-white, color, hand-made. Photographer must submit portfolio and resume to the Gallery Director for consideration. All work selected should be archivally mounted and matted, preferably framed. Presents 2 photography exhibits only/year, 6-10 with other media/year. Shows last 1 month. Sponsors openings; shares expenses. Photographer's presence at opening is preferred. Receives 40% commission. Occasionally buys outright. General price range: \$100-1,500. Will review transparencies. Interested in framed or unframed work. Generally requires exclusive representation in metropolitan area. Unless they are to be labeled and priced accordingly, color photographs should be Cibachrome or Dye Transfer prints. Arrange a personal interview to show portfolio; query with samples; send material by mail for consideration or submit portfolio for review. Reporting time varies "according to how busy we are at time."

Tips: "The best sellers are regional and collectible (good investments) and medium to low price ranges. We tend not to give one-man shows to first time exhibitors at the gallery, but try out the waters with a sampling of a photographer's work first. Photographer's work carried and displayed in gallery at all times."

CHARLES A. WUSTUM MUSEUM OF FINE ARTS, 2519 Northwestern Ave., Racine WI 53404. (414)636-9177. Director: Bruce W. Pepich. "Interested in all fine art photography. It's regularly displayed in our Art Sales and Rental Gallery and the Main Exhibition Galleries. We sponsor a biennial exhibit of Wisconsin Photographers. The biennial show is limited to residents of Wisconsin; the sales and rental gallery is limited to residents of the Midwest. There is no limit to applicants for solo, or group exhibitions, but they must apply in January of each year. Presents an average of 3 shows/year. Shows last 4-6 weeks. Sponsors openings. "We provide refreshments and 50 copies of the reception invitation to the exhibitor." Photographer's presence at opening preferred. Receives 30% commission from exhibitions, 40% from sales and rental gallery. General price range: \$125-350. Will review transparencies. Interested in framed or unframed work. "Must be framed unless it's a 3-D piece. Sale prices for sales and rental gallery have a \$1,000 ceiling." Query with resume of credits or send material by mail for consideration. SASE.

Tips: "Photography seems to fare very well in our area. Both the exhibitors and the buying public are trying more experimental works. The public is very interested in presentation and becoming increasingly aware of the advantage of archival mounting. They are beginning to look for this additional service. Our clients are more interested in work of newer (and more affordable) photographers. Landscapes currently sell best at our gallery."

Paper Products_

"Paper products" is a generic term which covers a variety of merchandise for which freelance photography is utilized. Calendars, greeting and post cards, and posters are the most familiar of these products. The market also includes playing cards, placemats, buttons, puzzles, and other goods—not always made of paper, but all of which feature photographic imagery.

You've probably seen and admired—and perhaps envied—the beautiful color photographic calendars featuring cats, horses, "buns" and other photogenic subjects; you may have wondered how the poster companies select the photographers to shoot those barely-swimsuit-clad pin-ups. There's no mystery involved—photographers break into the paper product market by proving they can provide the

requisite images to the art directors who make the decisions.

First things first: in addition to knowing what subjects and styles are currently popular for paper-product use—which you discover by reading these listings and conducting informal market research in stationery and gift stores—you must also be able to produce technically perfect photographs. Calendar photos are printed large, posters even larger, and any flaw in a picture will be magnified many times. Some markets have a strong preference for medium- and large-format photos for this reason, so proficiency in these formats is a definite edge here. Note also that most paper products use photography in color transparency form. Although a few

greeting card lines use b&w, color sells better and is much preferred.

First contact with paper-product art directors is usually in the form of a query with exemplary samples; some companies make so many photographic products that they'll also want to review your stock list. Although prices in this market climb quite high—and although seeing your work in one of these showy forms is highly gratifying—note that the payment policies standard in the industry may require that you wait quite awhile before getting your share of the profits. Many companies pay photographers on a royalty basis; that is, a percentage of the gross or net profits made on that photographer's product. In these cases, it's clear that the more popular the product carrying your photo is, the more payment you'll receive—but these royalties accrue slowly and may be paid no more often than quarterly. Keep in mind, too, that many paper product companies require that you sell all rights to the photos you submit. While this means you give up ownership of your photos, it also means the company must be willing to pay you significantly more for them. Those companies which pay a flat fee to use your photographs may not pay until the product is actually on the market, and in an industry where the lead time (the time span between a product's development and its actual production) can be as long as two years, it may again be a long time before you realize your profit. The paper product industry is experiencing tremendous growth now, and its photographic needs are likewise expanding. But remember that payment can be slow although the rewards of seeing your work published can be great. You'll have to strike a balance between the two and always have other buying markets available to take up the time lapse.

Some photographers prefer to create and sell their own paper products. Post cards are fairly easy to make in the darkroom; distribution and marketing can be more of a problem. Check with gift and card stores in your area to see if they would be interested in selling your work on a *consignment* basis—that is, when the product sells, you get paid. Some photographers go so far as to produce their own calendars and other, more ambitious paper products, selling them through the mail as well as in stores. If you're interested in going into this business for yourself, you'll find companies which make post cards from your photos in the classifieds of the major photography magazines, as well as some which will turn your pictures into posters or buttons.

A.F.B. MANUFACTURING & SALES CORP., 117 Evergreen Dr., Box 12665, Lake Park FL 33403. (305)848-8721. President: Al Brooks. Specializes in brochures/bulletins. Buys 3 photos/year. Subject Needs: Needs subjects of animals, flowers or themes. Special needs include birds (1 inch negatives). No scenics.

Specs: Uses negatives.

Payment & Terms: Pays by the job. Pays on acceptance. Buys all rights, but may reassign to photogra-

pher after use. Model release and captions required.

Making Contact: Arrange a personal interview to show portfolio or send unsolicited photos by mail for consideration. Interested in stock photos, SASE. Reports in 1 month. Simultaneous submissions and previously published work OK.

Tips: "Negatives must be able to produce a transfer or decal."

THE AMERICAN POSTCARD COMPANY, INC., 285 Lafayette St., New York NY 10012. (212)966-3673. Art Director: George Williams. Specializes in novelty post cards. Buys 1,500 photos/ year; 50% purchased from freelance photographers. Photo guidelines free with SASE.

Subject Needs: Humorous type, Christmas, birthday, Halloween, Easter, Valentines Day, unusual animal situations, erotic. No traditional post card material, i.e., no scenic, landscapes or florals.

Specs: Uses any size b&w or color prints; 35mm, 21/4x21/4, or 4x5 color transparencies; b&w and color contact sheet.

Payment & Terms: Payments made on royalty basis paid quarterly; some outright purchases made at

\$100/photo. Credit line given. Buys one-time rights. Model release required.

Making Contact: Query with samples or with list of stock photo subjects; send unsolicited photos; submit portfolio for review. Interested in stock photos. SASE. Reports in 6 weeks. Simultaneous submissions and previously published work OK. "We take no responsibility for loss or damage of submissions." Photo guidelines free on request with SASE.

Tips: "We look for unique, outrageous, and off-beat humor in our selections."

*ARGONAUT PRESS, RR1, #142, Fairfield IA 52556. (515)472-4668. Editor: John Koppa. Specializes in post cards. Buys 40# freelance photos/year.

Subject Needs: "Scenes and events showing the various cultural situations and behavior of ODD people. Humorous animal shots. Contemporary art shots. "Behind the scenes" in America shots. Specs: Uses 8x10 or smaller glossy b&w and color prints; and 35mm and 21/4x21/4 transparencies.

Payment & Terms: Pays \$60/b&w color photo, plus royalty of \$60 per each 6,000 cards printed. Pays on acceptance for photo; royalty paid at time of printing. Credit line given. Buys exclusive rights (for post card use only). Model release required.

Making Contact: Query with samples or send unsolicited photos by mail for consideration. Interested in stock photos. SASE. Simultaneous submissions and previously published work OK. SASE. Guideline sheets available.

ARGUS COMMUNICATIONS, 1 DLM Park, Box 9000, Allen TX 75002. (214)248-6300, ext. 283. Photo Editor: Linda J. Bailey. Specializes in greeting cards, calendars, post cards, posters, stationery, filmstrips, books, educational materials. Buys "thousands" of freelance photos/year.

Subject Needs: "Varied-humorous, animals, inspirational, people relationships (must have releases), spectacular scenics (also illustration)." No animals in captivity (zoo) or family snapshots. "This year we're looking for front shots of animals with good eye contact, and soft focus couples.'

Specs: Uses 35mm, 21/4x21/4, 4x5, 5x7 and 8x10 transparencies.

Payment & Terms: Depends on purchase; pays ASMP rates. Pays on publication. Credit line given.

Normally buys one-time rights. Model release required; captions preferred.

Making Contact: Query with resume of credits; provide resume, business card, brochure, flyer or tearsheets to be kept on file for possible future assignments. Interested in stock photos. Submit seasonal material 8 months-1 year in advance. SASE. Reports in 1 month. Previously published work OK. Photo guidelines free on request.

Tips: "In a portfolio we look for vibrant color, crisp focus, depth of field, good lighting, highlights and back lighting."

*ARPEL GRAPHICS, Box 21522, Santa Barbara CA 93121. (805)965-1551. President: Patrick O'Dowd. Specializes in greeting cards, calendars, post cards, posters, framing prints, stationery, books, puzzles. Buys 150 freelance photos/year.

Subject Needs: "Product lines are developed by artist not by subject, so coverage is very broad with most all genre of photography included." Uses 35mm, 21/4x21/4, 4x5 and 8x10 transparencies. Royalty and other payments negotiated by artist. Credit line given. Buys exclusive product rights. Model release and captions required.

Making Contact: Arrange a personal interview to show portfolio; query with resume of credits; provide

Close-up

Charles Mauzy, Vice President. **Arpel Graphics**

Having work published by Arpel Graphics is a goal many top photographers hope to attain. Unlike most paper product companies. Arpel develops its product lines artist by artist, rather than image by image, and its photographers are among the finest in the world.

Its ranks include Lucien Clergue, David Muench, Francis Giacobetti, David Hamilton, Roland Michaud, Art Wolfe, Francisco Hidalgo and Charles

Mauzy-Arpel's vice president.

Mauzy was a founder and chief executive of Sempervirens Press (another paper product company) when he met Patrick O'Dowd, the president of Arpel Graphics. Mauzy initially worked with Arpel as a photographer, but he left Sempervirens and began working with Arpel's American office in management.

Arpel has its roots in France and developed its initial product line with Editions AGEP-one of Europe's most prestigous printers. In its two years, the Santa Barbara-based French offshoot has developed its own extensive product line-books, gallery posters, calendars, puzzles, notebooks, flat cards and note cards-and currently represents more than 75 photographers worldwide. Its photographs depict nature, wildlife, studio, fashion, glamour, and figure studies. Arpel is also the exclusive North American representative for publications of Editions AGEP and SilverWest Designs, a new paper products company.

Having worked on both sides of the fence—as a freelance photographer and as a photo editor-Mauzy strives to treat Arpel's artists well. "I like to think we have a personal relationship with our photographers. For new artists, I try to review a photographer's portfolio as quickly as possible, to be constructive [in my criticism] and to direct photographers to other markets if their work doesn't meet our needs.'

Arpel reviews 20 to 60 queries a

week. From this and his own freelancing experience, Mauzy recommends freelancers target a market suitable to their strongest work, study its products and edit their work very carefully. "Think like an editor when selecting shots for submission but, perhaps more important, look for new ways of seeing the familiar when photographing. Don't just reshoot a prominent photographer's picture to make a sale. Landscape publishers, for example, do not need another David Muench clone-be original. Also, don't try to be a jack-of-all-trades. Shoot something you love and then your photos will become works of art-the images will come alive," Mauzy says.

Photographers wishing to submit to Arpel should study its existing lines very carefully. "We generally look for artist who already have established themselves in their fields and have solid archives of work to draw upon. In order to more fully do justice to each artist, we usually work with a limited number in

each genre of photography."

Arpel Graphics of Santa Barbara, California, publishes work of many of the finest photographers in the world, including (clockwise from top left) Charles Mauzy, David Hamilton, Francis Giacobetti and Lucien Clergue. The last photograph was also taken by David Hamilton.

resume, business card, brochure, flyer or tearsheets to be kept on file for possible future assignments. "SASE required for reply." Solicits photos by assignment. Reports in 1 month. Previously published work OK.

Tips: "Photographers interested in submitting work for review by Arpel should study the existing line carefully. We generally look for artists who have already established themselves in their field and have solid archives of work to draw upon. In order to more fully do each artist justice, we usually work with a limited number of artists in each genre of photography."

*ART IN SAN DIEGO, Box 40083, San Diego CA 92104. (619)692-9439. Editor: Jose Rosa. Estab. 1984. Specializes in magazines. Buys 10 freelance photos/year.

Subject Needs: Art and art related subjects.

Specs: Uses 8x10 glossy finish b&w and color prints and 4x5 transparencies.

Payment & Terms: Payment negotiated individually. Pays on publication. Credit line given. Buys all

rights pertaining to magazine. Model release and captions required.

Making Contact: Provide resume, business card, brochure, flyer or tearsheets to be kept on file for possible future assignments. Deals with local freelancers only. Submit seasonal material 6 months in advance. SASE. Reports in 6 weeks. Simultaneous submissions and previously published work OK.

*ART SOURCE, 3 Glenview Dr., Aurora, Ontario L3R 4C2 Canada. (416)475-8181. President: Lou Fenninger. Specializes in greeting cards, posters, stationery, wall decor. Buys 100-150 photos/year. Subject Needs: Artistic nature.

Specs: Uses b&w and color prints, 35mm, $2^{1/4}x2^{1/4}$, 4x5 and 8x10 transparencies; b&w and color contact sheets.

Payment & Terms: Pay individually negotiated. Pays on publication and on royalty as per sales. Credit line given. "We buy exclusive product rights for our products only." Model release required.

Making Contact: Query with samples; send unsolicited photos by mail for consideration; submit portfolio for review; provide resume, business card, brochure, flyer or tearsheets to be kept on file for possible future assignments. Interested in stock photos. Submit seasonal material any time. SASE. Reports in 1 month. Simultaneous submissions and previously published work OK.

CAROLYN BEAN PUBLISHING, LTD., 120 Second St., San Francisco CA 94105. (415)957-9574. Art Director: Tom Drew. Specializes in greeting cards and stationery. Buys 10-25 photos/year for the Sierra Club Notecard and Christmas card series only.

Subject Needs: "Our line is diverse."

Specs: Uses 35mm, 21/4x21/4, 4x5, etc., transparencies.

Payment & Terms: Negotiated by Sierra Club direct; up to \$200/color photo. Credit line given. Buys exclusive greeting card product rights; anticipates marketing broader product lines for Sierra Club and

may want to option other limited rights. Model release required.

Making Contact: Submit by mail. Interested in stock photos. Prefers to see dramatic wilderness and wildlife photographs "of customary Sierra Club quality." Provide business card and tearsheets to be kept on file for possible future assignments. Submit seasonal material 1 year in advance; all-year-round review. Publishes Christmas series February; everyday series January and July. SASE. Reports in 1 month. Simultaneous submissions and previously published work OK.

Tips: "Send only your best-don't use fillers."

*BEAUTYWAY, Box 340, Flagstaff AZ 86002. (602)779-3651. President: Kenneth Schneider. Specializes in greeting cards, calendars, post cards, and posters. Buys 300-400 freelance photos/year (fee pay and joint venture).

Subject Needs: Nationwide landscapes, animals, flowers, sports, marine life. All photos must have a dramatic value, strong color and contrast. Animals shots should focus on eyes, young animals and interaction. Rarely people's faces or people's bodies, except in sports, scale, or powerful mood shots.

Specs: Uses 35mm, 21/4x21/4, 4x5 and 8x10 transparencies.

Payment & Terms: Pays \$100 first printing for cards, \$5 per 1,000 on reprinting. Royalties: 40% on joint venture (gross wholesale). Posters and calendars paid by arrangement. Pays on publication; joint venture every 6 months. Credit line given. Buys exclusive product rights and property (where relevant).

Model release required; captions preferred, and titles required.

Making Contact: Query with samples or list of stock photo subjects. Interested in stock photos according to our assortment priorities. Submit in January for summer subjects, July for winter subjects, others anytime. SASE. First report averages 2 weeks, second report variable. Previously published work OK. "Good publication record for photo is a plus, except where directly competitive." Photo guidelines free with SASE.

Tips: When reviewing samples, prefers to see landscapes, shots of animals and flowers, water and air sports, skiing and water sports, marine life and shells.

Entitled "Early Morning on the Merced River," this photograph taken by Diane Dietrich-Leis of Phoenix, Arizona, was purchased by Beautyway for its post card line. Beautyway, a paper products company in Flagstaff, Arizona, paid Dietrich-Leis \$150 for the image, and continues to pay her a royalty for it on a quarterly basis. Paper product companies can be excellent markets if your photos suit their needs and prove readily salable.

*BERNARD PICTURE CO., Box 4744 Largo Park, Stamford CT 06907. (203)357-7600. Art Director: Janine Mayhew. Specializes in posters and prints. Buys 50 freelance photos/year.

Subject Needs: "Scenics, still lifes, fine art, abstractions, music-related shots, cars, florals, sports, miscellaneous.

Specs: Uses 35mm, 21/4x21/4, 4x5 and 8x10 transparencies.

Payment & Terms: Pays 10% royalty. Pays on acceptance; advance on acceptance, royalties on sale. Credit line given. Usually buys exclusive product rights. Model release required.

Making Contact: Query with samples or send unsolicited photos by mail for consideration. Interested in stock photos. SASE. Reports in 2 weeks. Simultaneous submissions and previously published work OK.

*DAVIS-BLUE ARTWORK INC., 3820 Hoke St., Culver City CA 90230. (213)202-1550. Art Director: Robert Blue. Specializes in greeting cards, calendars, post cards, posters, limited edition silkscreening.

Subject Needs: Floral; nature; and animals. Pays according to contract agreement. Model release and captions required.

Making Contact: Arrange a personal interview to show portfolio; query with samples; query with list of stock photo subjects; send unsolicited photos by mail for consideration. Deals with local freelancers only; interested in stock photos. SASE. Reports in 3 weeks.

*DICKENS COMPANY, 61-12 Parsons Blvd., Flushing NY 11365. (718)762-6262. Art Director: David Podwal. Specializes in musical greeting cards. Buys 50 freelance photos/year.

Subject Needs: "Valentines' Day, nature, humorous."

Specs: Whatever is suitable for photographer or artist.

Payment & Terms: Pays/job. Pays on acceptance. Credit line given. Model release and captions preferred.

Making Contact: "Phone us." Deals with local freelancers only. Submit seasonal material 6 months in advance. SASE. Reports in 3 weeks. Simultaneous submissions and previously published work OK. *FIXOPHOTOS, D-24, M.I.D.C., Satpur, NASIK-422 007, Nasik India 30181. Partner: H.L. Sanghavi. Specializes in greeting cards, calendars. Buys 80-100 freelance photos/year.

Subject Needs: Nature, wildlife, landscapes, flowers. No religious.

Specs: Uses b&w and color prints.

Payment & Terms: Pays \$30/color photo. Pays on acceptance. Credit line given. Buys one-time rights.

Captions preferred.

Making Contact: Query with samples. Interested in stock photos. Submit seasonal material any time, but preferably before April. SASE. Reports in 1 month. Previously published work OK.

FLASHCARDS, INC., 781 W. Oakland Park Blvd., Fort Lauderdale FL 33311. (305)563-9666. Photo Researcher: Micklos Huggins. Specializes in post cards and notecards. Buys 500 photos/year. **Subject Needs:** Humorous, human interest, animals in humorous situations, nostalgic looks, Christmas material, valentines, children in interesting, humorous situations. No traditional post card material; no florals, nudes, scenic or art. "If the photo needs explaining, it's probably not for us."

Specs: Uses any size b&w prints, transparencies and b&w contact sheets.

Payment & Terms: Pays \$150 for each 100,000 postcards printed. Pays on publication. Credit line giv-

en. Buys exclusive product rights. Model release required.

Making Contact: Query with samples; send photos by mail for consideration; or provide resume, business card, brochure, flyer or tearsheets to be kept on file for possible future assignments. SASE. Interested in stock photos. Submit seasonal material 8 months in advance. Reports in 3 weeks. Simultaneous and previously published submissions OK. Photo guidelines free with SASE.

FREEDOM GREETINGS, 1619 Hanford St., Levittown PA 19057. (215)945-3300. Vice President: Jay Levitt. Specializes in greeting cards. Buys 200 freelance photos/year.

Subject Needs: General greeting card type photography of scenics, etc., and black ethnic people.

Specs: Uses larger than 5x7 color prints; 35mm and 21/4x21/4 transparencies.

Payment & Terms: Payment negotiable. Pays on acceptance. Credit line given. Model release required.

Making Contact: Query with samples. Submit seasonal material 1½ years in advance. SASE. Reports in 1 month. Simultaneous submissions OK. Photo guidelines free on request.

Tips: "Keep pictures bright—no 'soft touch' approaches."

C.R.GIBSON, Knight St., Norwalk CT 06856. (203)847-4543. Photo Coordinator: Marilyn Schoenleber. Specializes in stationery, gift wrap, and gift books and albums. Buys 30 photos/year. Pays on acceptance. Credit line given if space allows. Buys all rights. Model release required. "Query and ask about our present needs." Send check to cover mailing, postage and insurance. Simultaneous submissions and previously published work OK, "but not if published by or sold to another company within this industry." Reports in 6 weeks.

Subject Needs: Still life, nature, florals. No abstracts, nudes, "art" photography or b&w.

Color: Uses transparencies. Pays \$100/photo.

GOLDEN TURTLE PRESS, 1619 Shattuck Ave., Berkeley CA 94709. (415)548-2314. Publisher: Jordan Thorn. Production Manager/Art Director: Robert Young. Specializes in calendars and greeting cards. Buys up to 200 or more photos a year.

Subject Needs: Scenic rainbows, Himalayan mountains.

Specs: Uses ORIGINAL 35mm, 21/4x21/4, 4x5 and larger transparencies.

Payment & Terms: Pays \$400/photo for calendar submissions; \$500 for cover; \$250 for cards; \$225 for introduction—possibility of special sales bonus. Payment due on publication. Credit line given. Buys one-time rights for calendars. Model release required.

Making Contact: Write for guidelines, issued once a year in the spring. SASE. Reports in thirty days

during submission period. No liability assumed for unsolicited material.

Tips: "Please submit your best work. We look for images that are unique in their quality of light, color or contrast, or present unusual and/or striking composition. Sharpness a must in all submissions. We consider ourselves as calendar and card specialists who produce some of the highest quality pieces on the market."

GRAND RAPIDS CALENDAR CO., 906 S. Division Ave., Grand Rapids MI 49507. Photo Buyer: Rob Van Sledright. Specializes in retail druggist calendars. Buys 10-12 photos/year. Pays on acceptance. Model release required. Submit material January through June. SASE. Simultaneous submissions and previously published work OK. Free photo guidelines; SASE.

Subject Needs: Used for drug store calendars. Baby shots, family health, medical-dental (doctor-patient situations), pharmacist-customer situations, vacationing shots, family holiday scenes, winter play activities, senior citizen, beauty aids and cosmetics. No brand name of any drug or product may show.

B&W: Uses 5x7 and 8x10 glossy prints. Pays \$10-20/photo.

THE GRAPHIC ARTISAN LTD., 3 Crass St., Suffern NY 10901. (914)368-1700. President: Peter A. Aron. Specializes in greeting cards, calendars, posters, framing prints, stationery and brochures/bulletins. Buys 10-20 photos/year. Pays on acceptance. Credit line given depending on use. Buys all rights. Model release required. Send material by mail for consideration. "Please do not send originals." Provide samples (photocopies or inexpensive prints) to be kept on file. Stock photos OK. Submit seasonal material 9 months in advance. Simultaneous submissions OK. Reports in 4 weeks.

Subject Needs: "All subjects are desired; however, our greatest interest occurs in Jewish religious and

wedding/birth/engagement subjects.'

B&W: Uses prints; contact sheet OK. Pays \$10-150/photo.

Color: Uses prints or transparencies; contact sheet OK. Pays \$10-150/photo.

Tips: "Most of our work is known for 'pastoral' or 'modern romantic' scenes, but not the 'gushy' Clairol-type ads." Computers and scanners have drastically changed photography and graphic arts. "Computer copies can tell if a picture is interesting and rebuilds the picture except for content and interest level."

GRAPHIC IMAGE PUBLICATIONS, Box 1740, La Jolla CA 92038. (619)755-6558. Photo Editor: Rodger Delp. Specializes in greeting cards, calendars, posters; also publishes how-to and travel. Buys

150-250 photos/year.

Subject Needs: Nature scenes for calendar shots; tasteful location or studio female shots (nude, seminude) for calendar and poster shots. Greeting cards have similar needs (scenics). For posters, tasteful seminudes, studio or location, with a "glamour" look (product illustration). "We are always looking for a new model to promote in the poster market."

Specs: Uses b&w and color prints; 35mm and 21/4x21/4 transparencies, and b&w and color contact

Payment & Terms: Pays \$15-35/b&w photo, \$35 and up/color photo; commissions \$10-75/hour; but job rates "depend on subject and experience-query." Credit line given. Buys all rights, or pays royalty, but may reassign to photographer after use. Model release and identification required. "Finders fee paid for a salable model when used."

Making Contact: Query with resume of credits or send unsolicited photos by mail for consideration; provide resume, business card, brochure, flyer or tearsheets to be kept on file for possible future assignments. SASE. Reports in 5 weeks. Simultaneous submissions and previously published work OK. Pho-

to guidelines \$1 on request. No phone calls, please.

Tips: Prefer to see "clean, well-composed transparency samples. Can be artsy but must be mood-impacting and original. Be creative, have a flair for your own style, submit some examples and we'll evaluate from there.

H.W.H. CREATIVE PRODUCTIONS, INC., 87-53 167 St., Jamaica NY 11432. (212)297-2208. Contact: President. Specializes in greeting cards, calendars, post cards, brochures/bulletins and magazines. Buys 20 photos/year.

Subject Needs: Science, energy, environmental, humorous, human interest, art, seasonal, city, high

tech, serialized photo studies.

Specs: Uses 8x10 semi-matte color and b&w prints; 35mm, 21/4x21/4 and 4x5 transparencies.

Payment & Terms: Pays \$15/b&w, \$30/color photo; \$35-100/job. Pays on publication or completion of job. Credit line "sometimes" given. Buys all rights, but may reassign to photographer after use. Model release required; captions preferred.

Making Contact: Arrange a personal interview to show portfolio or query with list of stock photo subjects; send unsolicited photos by mail for consideration. Interested in stock photos. Provide resume and brochure to be kept on file for possible future assignments. Submit seasonal material 6 months in advance. SASE. Reports in 3 weeks. Simultaneous submissions and previously published work OK.

INTERCONTINENTAL GREETINGS, LTD., 176 Madison Ave., New York NY 10016. (212)683-5830. Contact: Robin Lipner, Creative Marketing. Specializes in greeting cards, calendars, post cards, posters, stationery and gift wrap. Subject Needs: "Seasonal holidays, concepts. Not interested in ordinary florals, landscapes, nature; no

35mm unless extraordinary!" Specs: Uses 4x5 transparencies.

Payment: Pays \$100/b&w photo; 20% royalties. Payment on sale to publisher. Credit line "generally

not given." Buys exclusive product rights. Model release preferred.

Making Contact: Query with sample and list of stock photo subjects; send unsolicited photos by mail for consideration; provide resume, business card, brochure, flyer or tearsheets to be kept on file for possible future assignments. "We deal with local freelancers only." SASE. Reports in 1-3 weeks. Previously published work OK.

Tips: Prefers to see "new commercial concepts" in a photographer's samples—"can be almost any sub-

ject matter suitable for the above mentioned products. We look for good design, technical quality and a different viewpoint on familiar subjects. Come in and see us sometime."

JOLI GREETING CARD CO., 2520 W. Irving Park Rd. Chicago IL 60618. (312)588-3770. President: Joel Weil. Specializes in greeting cards and stationery. Buys variable number of photos/year. **Subject Needs:** Humorous, seasonal.

Payment & Terms: Pays 30 days from acceptance of merchandise. Payment varies. Credit line optional. Buys all rights or exclusive product rights. Model release required; captions preferred.

Making Contact: Query with samples. Interested in stock photos. Submit seasonal material as soon as possible. SASE. Reports in 1 month. Simultaneous submissions OK.

Tips: "Subject must be humorous."

*ARTHUR A. KAPLAN CO., INC., 460 West 34th St., New York NY 10001. (212)947-8989. President: Arthur Kaplan. Specializes in posters, wall decor, and fine prints and posters for framing. Buys the rights to 50-100 freelance photos/year.

Subject Needs: Flowers, scenes, animals, ballet, autos, still life, oriental mofit, and musical instru-

ments.

Specs: Uses any size color prints; 35mm, 21/4x21/4, 4x5 and 8x10 transparencies.

Payment & Terms: Royalty 5-10% on sales. Pays on publication. Credit line given if requested. Buys all rights, exclusive product rights. Model release required; captions preferred.

Making Contact: Send unsolicited photos or transparencies by mail for consideration. Interested in stock photos. Reports in 1-2 weeks. Simultaneous submissions and previously published work OK.

*LEON KLAYMAN PUBLISHING, Box 281 Prince Station, New York NY 10012. Publisher: Leon Klayman. Specializes in post cards. Buys 20 freelance photos/year.

Subject Needs: "We select new high quality photographs that express human concerns and excite the human spirit. We specialize in photos of people with themes of integrity and humor."

Specs: Uses 21/4x21/4 transparencies; b&w contact sheets.

Payment & Terms: Royalties to be negotiated. Pays on publication. Credit line given. Buys one-time rights. Model release required; captions preferred.

Making Contact: Send unsolicited photos by mail for consideration. SASE. Reports in 1 month. Previously published work OK.

LANDMARK GENERAL CORP. Suite 227, 475 Gate Five Rd., Box 1100, Sausalito CA 94966. (415)331-6400. Contact: Photo Department. Specializes in greeting cards, calendars, framing prints, stationery and posters. Buys 5,000 photos/year.

Subject Needs: Animals, scenic, cities, fish, food, men, women, sports, collectibles, nature, art and teddy bears.

Specs: Any format.

Payment & Terms: Pays 5% royalty for full calendars; \$100-300/individual photo according to sales. Payment time varies. Credit line given. Buys one-time rights and exclusive product rights. Model release and captions required.

Making Contact: Request guidelines. Interested in stock photos. Submit seasonal material 1 year in advance for calendars, 6 months in advance for cards. SASE. Reports in 2-6 weeks. Previously published work OK. Photo guidelines free with SASE.

MAINE LINE COMPANY, Box 418, Rockport Me 04856. (207)236-8536. Art Director: Elizabeth Stanley. Specializes in greeting cards. "Our readers are 90% women who are sophisticated, have college degrees, and good senses of humor." Buys 100 photos/year.

Subject Needs: "Humorous, nontraditional, nonconservative photos of any kind; photos for occasions—birthday, etc.; unusual cat photography. We do not publish greeting cards for children; no scenics or sentimental pictures."

Specs: Prefers prints, and 35mm slides, $2^{1/4}x2^{1/4}$, 4x5 transparencies. "We will look at any size b&w or color print; may wish to have negatives for production."

Payment & Terms: "Payment varies and is individually discussed with each photographer." Pays on publication; "sometimes partially on acceptance." Credit line given. Buys exclusive product rights. Model release required; captions optional. "Photographer must warrant that he/she has rights to sell to us for reproduction."

Making Contact: Query with samples; send photos by mail for consideration; submit portfolio for review; or provide resume, business card, brochure, flyer or tearsheets to be kept on file for possible future assignments. Interested in stock photos. Christmas material should be submitted 12 months in advance; Valentines Day, 9 months. SASE. Reports in 1 month. Previously published submissions OK "but not if it is previously published as a greeting card. Ad or editorial OK." Photo guidelines free with SASE.

Tips: In a portfolio or samples, prefers to see the "best of what's on hand—images that would be available to us for reproduction. Submit photos that can bear humorous messages that communicate woman's concerns, attitudes and feelings, and that have good technical quality. Check us out first to see if your submissions are appropriate."

ALFRED MAINZER, INC., 27-08 40th Ave., Long Island City NY 11101. (718)392-4200. Art Buyer: Arwed H. Baenisch. Specializes in greeting cards, calendars and post cards. Submit seasonal material 1 year in advance. SASE.

Color: Uses transparencies. Payment is negotiated on an individual basis.

MARK I, INC., 1733-1755 Irving Park Rd., Chicago IL 60613. (312)281-1111. Attention: Art Department. Specializes in greeting cards. Buys 500 photos/year; almost all supplied by freelance photographers. Pays on acceptance. Buys exclusive world-wide rights on stationery products. Model release required. Send material by mail for consideration. Submit seasonal material 3-6 months in advance. SASE. Previously published work OK. Reports in 6 weeks. Free photo guidelines with SASE only. Subject Needs: Pictures of children or animals in humorous situations.

B&W: Uses 8x10 glossy prints. Pays \$100-200/photo (humorous baby photos only).

Color: Will accept any size transparency as long as subject is vertical format. Pays \$100-150/photo.

MIDWEST ART PUBLISHERS, 1123 Washington Ave., St. Louis MO 63101. (314)241-1404. Sales Manager: Karen Strobach. Specializes in calendars, pad and pen sets, photo albums and pocket calendars.

Subject Needs: Mixed: scenic, animals and floral.

Specs: Uses color prints or transparencies.

Payment & Terms: Pays per photo or by the job. Buys all rights. Model release required.

Making Contact: Query with samples; provide resume and brochure to be kept on file for possible future assignments. SASE. Does not return unsolicited material. Simultaneous submissions and previously published work OK.

NATURESCAPES, INC., 24 Mill St., Box 90, Newport RI 02840. (401)847-7464. General Manager: Jim Dodez. Specializes in photographic wall murals (7'x9' to 14'x9').

Subject Needs: Nature photographs (landscapes); city skylines; famous neighborhoods; underwater. **Specs:** Uses 4x5, 5x7 and 8x10 transparencies. No 35mm or b&w without prior approval. "Technical perfection, zero to infinity focus, foreground detail to reinforce viewers presence (but not overwhelming when enlarged) are a must."

Payment & Terms: Usually on a royalty basis; negotiable.

Making Contact: Send unsolicited transparencies or prints with cover letter and contents list; send certified return receipt mail SASE with some Penerts in 3.4 weeks

tified, return receipt mail. SASE with same. Reports in 3-4 weeks.

Tips: "We deal with a group of the finest naturalist/photographers in the country on a regular basis. To break into our limited market you must present a top quality professional presentation. Send only your absolute best efforts as we use only 'first choices.' In evaluating your own submissions, imagine the image blown up to wall size and hanging in a home or office; is it interesting enough that the viewer would not become bored with it after seeing it every day for a year? We look at thousands of submissions a year so limit yours to a small number of bests rather than a large number of possibles. Quality is much more important than quantity!"

PAPERCRAFT CORP., Papercraft Park, Pittsburgh PA 15238. (412)362-8000. Art Director/Production Manager: Dan O'Donnell. Needs photographs from professional artists. Specializes in Christmas wraps, packaging and promotion. Prices will vary; goes by day rates. Submissions accepted year-round. Buys all rights. Reports in 4 weeks. SASE. Free catalog and photo guidelines. **Tips:** Include prices with all submissions.

PARAMOUNT CARDS, INC., Box 1225, Pawtucket RI 02862. (401)726-0800. Photo Editor: T.R. Anelunde. Specializes in greeting cards. Buys approximately 700 photos annually. Pays on acceptance, usually \$100-225/color photo. Buys exclusive world greeting card—all time rights. Model release required. Send material by mail for consideration. Prefers to see scenes, florals, still lifes, some animals. Submit Christmas and fall seasonal material January 1-May 1; Valentine material June 1-August 1; Easter material June 1-October 1; and Mother's Day, Father's Day and Graduation October 1-December 15. SASE. Simultaneous submissions OK. Reports in 2-4 weeks. Free photo guidelines.

Subject Needs: People ("black or white, single or couples, in age groups of 20s, 40s or 60s, in love, friendship or general situations"); animals (cats, dogs, horses); humorous (wild and domestic animals); scenic (landscapes and seascapes in all four seasons); sport (fishing, golf, etc.); and still life (suitable for all occasions in greeting cards). No farm animals (pigs, cows, chickens, etc.), desert or tropical scenes

192 Photographer's Market '86

or family get-togethers (e.g., birthday parties). Sharp or soft focus.

Color: Uses transparencies; prefers colorful, vertical transparencies with light title area at the top. Pays \$100-225/photo.

Tips: "Send small submissions (20-40 transparencies) of only the best that are suitable for greeting

cards."

PEMBERTON & OAKES, Department PM, 133 E. Carrillo St., Santa Barbara CA 93101. (805)963-1371. Photo Researcher: Patricia Kendall. Specializes in limited edition collector's porcelain plates. Buys 10-15 photos/year.

Subject Needs: "Interested only in photos of kids, kids and pets, kittens and puppies and nutcracker

ballet.'

Specs: Uses any size or finish color prints and any size transparencies. Will consider small b&w prints. **Payments & Terms:** Pays \$1,000 minimum/color or b&w photo. Payment on acceptance. Buys "limited exclusive rights to be determined at time of purchase."

Making Contact: Send unsolicited photos by mail for consideration. Interested in stock photos. SASE. Reports in 3 weeks. Simultaneous submissions and previously published work OK. Photo guidelines

free on request.

Tips: "We are adding new artists and will acquire more photos. Submit a good selection and keep us in mind when shooting new material."

PHOTO/CHRONICLES, LTD., 500 West End Ave., New York NY 10024. (212)595-8498. President: David W. Deitch. Specializes in post cards. Buys 50-60 photos/year.

Specs: Uses 8x10 b&w prints.

Payment & Terms: Pays royalty on wholesale price times size of press run. Pays on publication. Credit line given. Buys exclusive product rights. Model release and captions required.

Making Contact: Arrange a personal interview; send photocopies. Not interested in stock photos. SASE. Reports in 2 weeks.

*PRODUCT CENTRE-S.W. INC., THE TEXAS POST CARD CO., Box 708, Plano TX 75074. (214)423-0411. Art Director: Susan Hudson. Specializes in greeting cards, calendars, post cards, posters, melamine trays and coasters. Buys approximately 150 freelance photos/year.

Subject Needs: Texas towns, Texas scenics, Oklahoma towns/scenics, regional (Southwest) scenics, humorous, inspirational, nature (including animals), staged studio shots—model and/or products. No

hardcore nudity.

Specs: Uses "C" print 8x10 or smaller color glossy prints; 35mm, 21/4x21/4, 4x5 and 8x10 transparencies.

Payment & Terms: Pays up to \$100/photo. Pays on acceptance of printing proof. Buys all rights. Model release required.

Making Contact: Arrange a personal interview to show portfolio, or may send insured samples with return postage/insurance. Submit seasonal material 1 year in advance. SASE. Reports usually 1-2 weeks, depending on season. Photo guidelines free with SASE.

PVA-EPVA, Stoneybook Dr., Wilton NH 03086. (603)654-6141. Creative Director: Hank Yaworski. Specializes in greeting cards, calendars, post cards and stationery. Buys 25 photos/year.

Subject Needs: Religious, nature, florals, Christmas set-ups, scenics.

Specs: Uses 4x5 transparencies.

Payment & Terms: Pays \$200-250/color photo. Pays on acceptance. Credit line sometimes given.

Buys exclusive 1 year greeting card rights. Model release required.

Making Contact: Query with samples; send photos by mail for consideration. Interested in stock photos. Submit seasonal material 3 months in advance. SASE. Reports in 3 weeks. Simultaneous and previously published submissions OK.

QUADRIGA ART, INC., 11 E. 26th St., New York NY 10010. (212)685-0751. President: Thomas B. Schulhof. Specializes in greeting cards, calendars, post cards, posters and stationery. Buys 400-500 photos/year; all supplied by freelance photographers.

Subject Needs: Religious, all-occasion, Christmas, Easter, seasonal, florals, sunsets. No buildings or

sports.

Specs: Uses color prints; 4x5 or 8x10 transparencies. Prefers Ektachrome, and transparencies submitted in sets of 4 to 6.

Payment & Terms: Pays \$100-150/color photo. Pays on acceptance. Model release and captions optional.

Making Contact: Arrange a personal interview to show portfolio; query with samples; send photos by mail for consideration, or submit portfolio for review. Interested in stock photos. Submit seasonal ma-

terial 1 year in advance. SASE. Reports in 1 week. Simultaneous submissions OK.

Tips: "We prefer shots that focus on a singular subject, rather than a subject hidden in a busy backdrop."

ROCKSHOTS, INC., 632 Broadway, New York NY 10012. (212)420-1400. Art Director: Tolin Greene. Assistant Art Director: Francesca Agnelli. Specializes in greeting cards, calendars, post cards and posters. Buys 70 photos/year.

Subject Needs: Sexy, outrageous, satirical, ironical, humorous photos. "We are not interested in pretty pictures or fashion photography." Looking for funny animal pictures.

Specs: Uses b&w and color prints; 35mm, 21/4x21/4 and 4x5 slides.

Payment & Terms: Pays \$150/b&w, \$200/color photo; \$300-500/job. Pays on acceptance. Credit line

given. Buys all rights. Model release required.

Making Contact: Arrange a personal interview to show portfolio or submit portfolio for review. Interested in stock photos. Provide flyer and tearsheets to be kept on file for possible future assignments. Submit seasonal material 6 months in advance. SASE. Reports in 1 week. Simultaneous submissions and previously published work OK.

Tips: Prefers to see "greeting card themes, especially birthday, Christmas, Valentine's Day."

*SACKBUT PRESS, 2513 E. Webster, Milwaukee WI 53211. Editor-in-Chief: Angela Peckenpaugh. Poem notecards.

Photo Needs: Uses 1 photo/card; all supplied by freelance photographers. Needs art photos, specific illustrations.

Making Contact & Terms: Query with samples. SASE. Reports in 1 month. Pays \$10/photo. Credit line given. Buys all rights. Simultaneous submissions OK.

Tips: "Ask for exact subjects needed; we never use stock photos."

*SCAFA-TORNABENE PBG. CO., 100 Snake Hill Rd., West Nyack NY 10994. (914)358-7600. Vice President: Claire Scafa. Specializes in inspirationals, religious, contemporary florals, dramatic wildlife, nostalgia, children of yesteryear.

Specs: Uses camera ready prints, 35mm, 21/4x21/4, 4x5 and 8x10 transparencies.

Payment & Terms: Royalty negotiated individually. Pays on acceptance. Credit line sometimes given. Buys all rights. Model release required.

Making Contact: Query with samples. Deals with local freelancers only. SASE. Reports in 2 weeks. Simultaneous submissions and previously published work OK.

SORMANI CALENDARS, 613 Waverly Ave., Mamaroneck NY 10543. Vice President: Donald H. Heithaus. Specializes in calendars. Buys 50 freelance photos/year.

Subject Needs: Scenics of the USA.

Specs: Uses 4x5 and 8x10 transparencies.

Payment & Terms: Pays \$100 minimum/color photo. Pays on publication. Buys one-time rights. Mod-

el release preferred.

Making Contact: Query with samples or send unsolicited photos by mail for consideration. SASE. Reports in 2 weeks. Simultaneous submissions and previously published work OK. Tips: Prefers to see "scenic pictures of the USA . . . lots of color and distance."

T.N.T. DESIGNS, INC., 35 W. 24th St., New York NY 10010. (212)929-8904. President: John Devere. Specializes in greeting cards. Buys 90 photos/year. Subject Needs: Humorous, nudes and very stylized images. No nature, religious or faces.

Specs: Uses 5x7 b&w photos of any finish; 35mm and 21/4x21/4 slides.

Payment & Terms: Pays \$75-100/b&w photos; \$75-125/color photo; royalties on occasion. Pays on acceptance. Credit line given "if desired." Buys greeting card rights only. Model release required with

Making Contact: Arrange a personal interview to show portfolio; send unsolicited photos by mail for consideration; or submit portfolio for review. Interested in stock photos. Provide resume, business card and brochure to be kept on file for possible future assignments. Christmas material should be submitted no later than March 15. SASE. Reports in 2 weeks. Simultaneous submissions and previously published work OK.

Tips: "Interested in up-to-date material: current fads, trendy ideas. Must be professional."

THE UNSPEAKABLE VISIONS OF THE INDIVIDUAL, Box 439, California PA 15419. Copublishers: Arthur and Kit Knight. Specializes in books and post cards. Buys 50 + photos/year. Buys first serial rights. Send material by mail for consideration. "Work not accompanied by SASE is destroyed." Simultaneous submissions and previously published work OK. Reports in 2 months. Sample copy available for \$3 and SASE.

Subject Needs: "We are only interested in work pertaining to Beat writers so know who they are, and, generally, as much about them as possible. Representative writers we're interested in seeing photos of include Allen Ginsberg, William S. Burroughs, Gary Snyder, Gregory Corso, Lawrence Ferlinghetti, Philip Whalen, Peter Orlovsky, etc. Representative photographers we've published work by include Fred W. McDarrah, Richard Avedon, Jill Krementz and Larry Keenan, Jr."

B&W: Uses 8x10 glossy prints. Pays \$10 maximum.

WARNER PRESS, INC., 1200 E. 5th St. Anderson IN 46012. Contact: Janet Galaher. Specializes in weekly church bulletins. Buys 100 photos/year. Submit material by mail for consideration; submit only November 1-15. Buys all rights. Present model release on acceptance of photo. Reports when selections are finalized.

Subject Needs: Needs photos for 2 bulletin series; one is of "conventional type"; the other is "meditative, reflective, life- or people-centered. May be 'soft touch.' More 'oblique' than the conventional, lending itself to meditation or worship thoughts contributive to the Sunday church service."

Color: Uses transparencies (any size 35mm-8x10). Pays \$100-150.

Tips: "Send only a few (10-20) transparencies at one time. Identify *each* transparency with a number and your name and address. Avoid sending 'trite' travel or tourist snapshots. Don't send ordinary scenes and flowers. Concentrate on *verticals*—many horizontals eliminate themselves. Do not resubmit rejections. If we couldn't use it the first time, we probably can't use it later!"

*WILDERNESS STUDIO, INC., 874 Broadway, New York NY 10003. (212)228-0866. Picture Editor: Patricia Fried. Specializes in greeting cards, posters. Buys 1-5 freelance photos/year.

Subject Needs: Fine photography, major cities, cats.

Payment & Terms: Payment negotiated individually. Credit line given. Buys exclusive product rights. Making Contact: Query with resume and tearsheet or other printed material. "Absolutely no original unsolicited material returned."

Tips: "We are a small venture, essentially an expanded self-publication enterprise. We use almost no outside work."

WISCONSIN TRAILS, Box 5650, Madison WI 53705. (608)231-2444. Production Manager: Nancy Mead. Specializes in calendars portraying seasonal scenics and activities from Wisconsin. Needs photos of nature, landscapes, wildlife and Wisconsin activities. Buys 12/year. Submit material by mail for consideration or submit portfolio. Makes selections in January; "we should have photos by December." Buys one-time rights. Reports in 4 weeks. Simultaneous submissions OK "if we are informed, and if there's not a competitive market among them." Previously published work OK.

Color: Send 4x5, 35mm, and 21/4x21/4 transparencies. Captions required. Pays \$150.

Tips: "Be sure to inform us how you want materials returned and include proper postage. Scenes must be horizontal to fit 8½x11 format. Submit only Wisconsin scenes."

Periodicals.

Virtually all photographers yearn to see their names and images in print. In the five subgroups which comprise this section—Association Publications, Company Publications, Consumer Magazines, Newspapers and Newsletters, and Trade Journals—you'll find more than *one thousand* opportunities to do precisely that.

With that many periodical markets actively seeking freelance photographic talent, your chances of placing your work in one or more of these publications are virtually assured—if you follow some straightforward guidelines of photo marketing.

Market research is the first and most important principle in selling editorial photography. You can't begin to hope to sell your work, no matter how wonderful, if you don't know anything about the magazine you're submitting it to. Most publications listed here offer free or low-cost sample copies to prospective contributors, and many also offer specific printed guidelines for freelance writers and photographers. Request both before you even query the editor, let alone submit photos, and study them carefully. Even if photo guidelines are not available, close study of back issues will tell you not only what styles and subjects of photographic coverage are preferred, but also how many photos are used in an average issue, the ratio of color to b&w photos used, how big most photos are printed, how photographers are credited, and many more important details.

Once you have a feel for how a given publication uses freelance photography, query the editor by letter, explaining your background and qualifications, what types of photography you have available, your availability for assignments, and—most important—any well-thought-out ideas you have for subjects or stories your market research tells you the magazine might need, and which you'd be happy to provide. Publication editors are responsible for coming up with hundreds of story ideas over the course of a year and will welcome contributors who can help ease the load. This especially benefits the *photographer-writer* who can provide harried edi-

tors with both pictures and words.

As with any other large, competitive market, you can't expect to start at the top of the magazine industry, but the sheer number and variety of publications make it possible to find paying markets for your work no matter what your specialty or area of interest. Practically every subject of interest to even a small group of people has its own magazine. For example, there are magazines about square dancing, video games, billiards, dolls, gambling, gymnastics, kiteflying—any subject, activity, hobby, philosophy, business or other interest shared by sufficient numbers of people to make publishing a magazine on that topic financially worthwhile. This means that you can combine your photography expertise with your experience in or knowledge of virtually any other field to connect with those publications which share your concerns. If you're an avid bowler, for instance, a logical first publication market for your work might be Bowlers Journal.

Magazine editors buy freelance photography both from stock and on assignment, so you should provide them with your stock list and advise them of your availability for assignments in your area. Although some photographers deal exclusively in stock, and some do only assignment work, most do some of each. Assignments are better-paying but take a lot of time to find and shoot, while stock photos pay less

individually but sell more steadily.

It's important in this market to work closely with editors, striving to establish a rapport which enables you to anticipate and interpret their needs and wishes. Editors like to work with freelancers they know to be attuned to their requirements and on whom they can depend to supply their photo needs accurately and punctually. Achieving this kind of professional working relationship takes time and demands sensitivity and cooperation on your part, but it will pay off many times over the long run as you develop long-lasting partnerships with editors who will turn to you time and again for bigger and better assignments.

Association Publications

The periodicals listed here are published by groups and organizations—trade unions, professional associations, charitable groups, social and political advocacy organizations, fraternal brotherhoods, and others-usually to provide their mem-

bers with news and information about the group's activities.

Although some of these publications may be available to the general public by subscription, most are for members only and will never be found at the local newsstand. For this reason, it's especially important to request and study sample issues to gain an understanding of the purpose and activities of the organization and its members. These readers are likely to share certain highly definable interests, and association publication editors are far more likely to work with freelancers who understand and sympathize with these interests.

While some association-sponsored periodicals use a broad variety of generalinterest material, most have specific, regular areas of coverage. If you're interested in pursuing this market, it makes sense to begin with an organization that either you already belong to, or one you identify or sympathize with. If you do belong to a professional, labor or other group which publishes its own magazine, start with

that-you already know what kind of photography it uses.

In some cases, association publications need photo/text packages, so the photographer who has writing skills and knowledge of the topic could have greater

accessibility to these markets.

Many national organizations have local branches throughout the country and have a steady need for photographers in various locales to shoot regional events; let both the national and local offices know of your availability and services. If you know of such organizations in your vicinity but don't find them listed here, don't hesitate to contact them as well. Association publications may be hard to find, but the freelancer who makes the effort to find and contact them may develop steady, profitable sources of income in a relatively noncompetitive, wide-open market.

AAA MICHIGAN LIVING, 17000 Executive Plaza Dr., Dearborn MI 48126. (313)336-1211. Editor: Len Barnes. Managing Editor: Jo-Anne Harman. Monthly magazine. Circ. 820,000. Emphasizes auto use, as well as travel in Michigan, U.S. and Canada. "We rarely buy photos without accompanying ms. We maintain a file on stock photos and subjects photographers have available." Buys 100-200 photos/ year. Credit line given. Pays on publication for photos, on acceptance for mss. Buys one-time rights. Query with list of stock photo subjects. SASE. Simultaneous submissions and previously published work OK. Reports in 6 weeks. Free sample copy and photo guidelines.

Subject Needs: Scenic and travel. Captions required.

B&W: Uses 8x10 glossy prints. Pay is included in total purchase price with ms.

Color: Uses 35mm, 21/4x21/4 or 4x5 transparencies. Pays \$35-100/photo.

Cover: Uses 35mm, 4x5 or 8x10 color transparencies. Vertical format preferred. Pays up to \$350. Accompanying Mss: Seeks mss about travel in Michigan, U.S. and Canada, Pays \$150-300/ms.

*AEROBICS & FITNESS, The Journal of the Aerobics and Fitness Association of America, Suite 802, 15250 Ventura Blvd., Sherman Oaks CA 91403. (818)905-0040. Editor: Peg Angsten. Art Director: Larry Brown. Publication of the Aerobics and Fitness Association of America. Bimonthly trade. Emphasizes exercise, fitness, health, sports nutrition, aerobic sports. Readers are fitness enthusiasts and professionals 75% college educated, 66% female, majority between 20-45. Circ. 30,000. Sample copy \$1.05.

Photo Needs: Uses about 20-40 photos/issue; most supplied by freelance photographers. Needs action photography of runners, aerobic classes, high drama for cover: swimmers, bicyclists, aerobic dancers,

The asterisk before a listing indicates that the listing is new in this edition. New markets are often the most receptive to freelance contributions.

runners, etc. Special needs include food choices, male and female exercises, dos and don'ts. Model release required.

Making Contact & Terms: Query with samples or with list of stock photo subjects, send b&w prints, 35mm, 21/4x21/4 transparencies, b&w contact sheets by mail for consideration. SASE. Reports in 2 weeks. Pays \$200/color cover, \$35/inside b&w photo, \$50-100 for text/photo package. Pays on publication. Credit line given. Buys first North American serial rights. Simultaneous submissions and previously published work OK.

*AIR FORCE MAGAZINE, 1501 Lee Highway, Arlington VA 22209-1198. (703)247-5800. Editor: John Correll. Photo Editor: Guy Aceto. Publication of the Air Force Association. Monthly. Emphasizes aerospace technology, high technology, weapons systems, Air Force. Readers are manufacturers and retired, active duty and foreign members of the Air Force. Circ. 218,000. Free sample copy for SASE. Photo Needs: Uses about 30-45 photos/issue; 3-5 supplied by freelance photographers. Needs photos of specific aircraft, special effects, space. Photos purchased with accompanying ms only. Special needs include composite special effects, high-tech. Captions preferred.

Making Contact & Terms: Query with samples; provide resume, business card, brochure, flyer or tearsheets to be kept on file for possible future assignments. SASE. Reports in 2 weeks. Pays \$100-500 cover/color or by job. Pays on publication. Credit line given. Buys all rights. Simultaneous submissions

OK.

*AIR LINE PILOT, 1625 Massachusetts Ave. NW, Washington DC 20036, (202)797-4183, Editor: C.V. Glines. Photo Editor: Henry Gasque. Monthly magazine. Circ. 45,000. Emphasizes the past, present and future world of commercial aviation from the viewpoint of the airline pilot. For members of Air Line Pilots Association (ALPA). Photos purchased with or without accompanying ms. Buys 4 photos/issue. Credit line given. Pays on acceptance. Buys all rights, but may reassign to photographer after publication. Send material by mail for consideration; query first for guidelines and listing of member airlines. Mark name clearly on each slide and use plastic slide pages. SASE. Previously published work OK if photographer has rights. Reports in 1 month. Photo guidelines free with SASE. Sample copy \$1. Subject Needs: Human interest (members of Air Line Pilots Association in sports or unusual off-duty activities; how someone overcame obstacles to become pilot; what airline pilot training is like; former ALPA pilots now actors, congressmen, etc.); photo essay/photo feature ("Day in the Life" of ALPA pilot; ALPA member who also excels in other fields; aviation event; or any activity clearly related to the airline pilot's world); product shot (photos of U.S. air carriers on the ground and in flight with strong compositions or taken under unusual circumstances); travel (ALPA member airlines in unusual and/or foreign settings); documentary (our crowded skies and airports; fuel crunch; noise pollution; underequipped airports or very modern airports); spot news (important or out of ordinary aviation event). Also needs unusual historical aviation shots. No photos unrelated to commercial aviation; no photos of carriers whose pilots are not members of ALPA. Wants on a regular basis vertically composed color transparencies that dramatically evoke some specific aspect of the airline pilot's world. These photos should have people in them. Model release and captions preferred. Departments with special photo needs include Tech Talk (technical aspects of commercial aviation, e.g. instrumentation, flight data); Government and Industry sections (news events in commercial aviation-must be timely); and Guess What? (photos of aircrafts that played a part in the history of commercial aviation, but are not generally known).

B&W: Uses 8x10 glossy prints. Pays \$10-20/photo.

Color: Uses 35mm or 21/4x21/4 transparencies and glossy prints. Pays \$20-35/photo.

Cover: Uses 35mm or 21/4x21/4 color transparencies. 35mm Kodachrome preferred. Vertical format required. Pays \$250/photo.

Accompanying Mss: Seeks articles dealing with technical, air safety or historical subjects of interest to airline pilots. Pays \$100/published page. Free writer's guidelines.

Tips: "Covers are our most important purchases. We need good color and strong compositions. We particularly need photos of our smaller member airlines and dramatic color photos that show pilots in their working environment."

AMERICAN ATHEIST, Box 2117, Austin TX 78768. (512)458-1244. Editor: Robin Murray-O'Hair. Published by American Atheist Press. Monthly magazine. Circ. 60,000. "The *American Atheist* con-

Market conditions are constantly changing! If this is 1987 or later, buy the newest edition of *Photographer's Market* at your favorite bookstore or order directly from Writer's Digest Books.

centrates on atheist thought and history but also deals with First Amendment issues. Many articles appear concerning the lifestyle of atheists as well as their civil rights and special concerns. Our audience consists exclusively of atheists, agnostics, rationalists, materialists, etc." Sample copy and photo guidelines free with SASE.

Photo Needs: "We only use photos for special events and for seasonal covers. The covers only are supplied by freelancers. We usually need only four such covers a year. We need nature shots seasonally for our cover to celebrate the equinoxes and solstices; photos dealing with pagan celebrations of the solstices and equinoxes, such as Stonehenge."

Making Contact & Terms: Query with samples. Pays \$100/color cover. Pays on publication. Credit line given. Buys one-time rights. Simultaneous and previously published submissions OK.

Tips: "Be competent and persistent."

AMERICAN BIRDS, 950 3rd Ave., New York NY 10022. (212)546-9193. Assistant Editor: Anne Wagner. Publication of National Audubon Society. Bimonthly. Circ. 15,000. "Our major areas of interest are the changing distribution, population, migration, and rare occurrence of the avifauna of North and South America, including Middle America and the West Indies. Readers are 'bird people only'. Of our 29,000 readers, 11% are professional ornithologists, or zoologists, 79% serious amateurs, the rest novices." Sample copy \$3; photo guidelines free with SASE.

Photo Needs: Uses one cover-quality shot, vertical format, color/issue. This most often supplied by freelance photographer. A. a very interested in excellent b/w photos for inside use. Birds can be flying or perched, singly or in flocks, in any wild American habitat; picture essays on bird behavior. Avoid zoo or back-vard shots. "Since we never know our needs too far in advance, best to send representative sam-

pling.'

Making Contact & Terms: Quary with samples; send any size glossy prints, transparencies, contact sheet or negatives by mail for consideration; provide resume, business card, brochure, flyer or tearsheets to be kept on file for possible future assignments. SASE. Reports in 1 month. Pays \$100/color cover photo; \$25-35 for inside b&w photo; \$50-100/inside color photo. Pays on publication. Credit line given.

Tips: "We will probably be able to publish more photos this year than we have in the past. With rare exception, we look for very clear, easily identifiable birds. Diagnostic marks should be clearly visible,

eyes open."

AMERICAN CRAFT, 401 Park Ave. S., New York NY 10016. (212)696-0710. Editor: Lois Moran. Senior Editor: Pat Dandignac. Bimonthly magazine of the American Craft Council. Circ. 40,000. Emphasizes contemporary creative work in clay, fiber, metal, glass, wood, etc. and discusses the technology, materials and ideas of the artists who do the work. Pays on publication. Buys one-time rights. Arrange personal interview to show portfolio. SASE. Previously published work OK. Reports in 1 month. Free sample copy.

Subject Needs: Visual art. Shots of crafts: clay, metal, fiber, etc. Captions required. **B&W**: Uses 8x10 glossy prints. Pays according to size of reproduction; \$35 minimum.

Color: Uses 4x5 transparencies and 35mm film. Pays according to size of reproduction; \$35 minimum.

Cover: Uses 4x5 color transparencies. Vertical format preferred. Pays \$150-300.

AMERICAN FORESTS MAGAZINE, 1319 18th St., NW, Washington DC 20036. Editor: Bill Rooney. Association publication for the American Forestry Association. Emphasizes use and enjoyment of forests and natural resources. Readers are "laymen (rather than professional foresters) who are landowners (10 acres or more), mostly suburban to rural rather than urban." Monthly. Circ. 50,000. Free sample copy; free photo guidelines with magazine-size envelope and 85¢ postage.

Photo Needs: Uses about 40 photos/issue, 35 of which are supplied by freelance photographers (most supplied by article authors). Needs woods scenics, wildlife and forestry shots. Model release and cap-

tions preferred.

Making Contact & Terms: Query with resume of credits. SASE. Reports in 4-6 weeks. Pays on acceptance \$150-200/color cover photo; \$25/b&w inside; \$40-75/color inside; \$250-400 for text/photo package. Credit line given. Buys one-time rights.

AMERICAN HEALTH CARE ASSOCIATION JOURNAL, 1200 15th St., NW, Washington DC 20005. (202)833-2050. Director of Communications: Sheran Hartwell. Bimonthly. Circ. 18,000. Emphasizes long term health care. Readers are nursing home administrators, professional staff, organizations, associations, individuals concerned with long term care. Sample copy available.

Photo Needs: Uses about 10-15 photos/issue; 1-3 supplied by freelance photographers. Needs "long term care-related photos (residents, staff training, patient care, quality of life, facility extensions, etc.)." Model release preferred. Payment varies.

Making Contact & Terms: Arrange a personal interview to show portfolio. Does not return unsolicited

material. Reports in 2 weeks. Pays on publication. Credit line given. Buys all rights. Simultaneous submissions and previously published work OK.

Tips: Prefers to see "shots which show the 'human element.'"

AMERICAN HOCKEY MAGAZINE, (formerly American Hockey & Arena), 2997 Broadmoor Valley Road, Colorado Springs CO 80906. (303)576-4990. Managing Editor: Mike Schroeder. Publication of the Amateur Hockey Association of the U.S. Published 7 times/year. Circ. 35,000. Emphasizes ice hockey, including rinks and arenas, coaching tips, referee's information, Americans playing professional ice hockey, youth hockey, college hockey plus other features. Readers are hockey players, coaches, referees, parents and fans. Sample copy \$2.

Photo Needs: Uses about 25-30 photos/issue; 100% supplied by freelance photographers. Needs photos

of hockey action, plus special-request photos. Captions preferred.

Specs: B&w or color transparencies only.

Making Contact & Terms: Query with samples; "telephone calls also acceptable." Does not return unsolicited material. Reports in 2 weeks. Pays \$50-200 for text/photo package, and approximately \$25 for each photo (contact the editor for specifics). Pays on publication. Credit line given. Buys all rights; "agreements can be arranged." Simultaneous submissions OK.

Tips: "We look for good action photos (color and/or b&w)."

AMERICAN HUNTER, 1600 Rhode Island Ave. NW, Washington DC 20036. (202)828-6230. Editor: Tom Fulgham. Monthly magazine. Circ. 1,400,000.

Subject Needs: Uses wildlife shots and hunting action scenes. Captions preferred.

Specs: Uses 8xl0 glossy b&w prints and 35mm color transparencies. (Uses 35mm color transparencies for cover.) Vertical format required for cover.

Accompanying Mss: Photos purchased with or without accompanying mss. Seeks general hunting stories on North American game. Free writer's guidelines.

Payment & Terms: Pays \$25/b&w print; \$40-275/color transparency; \$275/color cover photo; \$200-450 for text/photo package. Credit line given. Pays on publication for photos. Buys one-time rights. **Making Contact:** Send material by mail for consideration. SASE. Reports in 2 weeks. Free sample copy and photo guidelines.

*AMERICAN LIBRARIES, 50 E. Huron St., Chicago IL 60611. (312)944-6780. Assistant Managing Editor: Edith McCormick. Publication of the American Library Association. Magazine published 11 times/year. Emphasizes libraries and librarians. Readers are "chiefly the members of the American Library Association but also subscribing institutions who are not members." Circ. 40,000-45,000. Samula Samula

ple copy free with SASE. Photo guidelines free with SASE.

Photo Needs: Uses about 5-20 photos/issue; 1-3 supplied by freelance photographers. "Prefer vertical shots. Need sparkling, well-lit color transparencies of beautiful library exteriors—35mm and larger. Dramatic views; can be charming old-fashioned structure with character and grace or striking modern building. Library should be *inviting*. Added color enrichment helpful: colorful foliage, flowers, people engaged in some activity natural to the photo are examples." Special needs include "*color* photos of upbeat library happenings and events—must be unusual or of interest to sophisticated group of librarian-readers."

Making Contact & Terms: "Supply possible cover photos of library exterior—as many views as possible of same subject." Send transparencies and contact sheet by mail for consideration. SASE. Reports in 2-6 weeks. Pays \$100-150/cover photo; \$200-300/color cover photo; \$50-75/b&w inside photo; \$75-100/color inside photo; and \$100-450/text/photo package. Credit line always given. Buys first North

American serial rights.

Tips: "Read or scan at least two issues thoroughly. We look for excellent, focused, well-lit shots, especially in color, of interesting events strongly related to library context—off-beat and upbeat occurrences in libraries of interest to sophisticated librarian audience. Also looking for rich color photos of beautiful library exteriors, both old-fashioned and charming and modern strutures . . . people should be included in photos (e.g., one or two entering library building)."

AMERICAN MOTORCYCLIST, Box 141, Westerville OH 43081. (614)891-2425. Executive Editor: Greg Harrison. Associate Editors: Bill Wood, John Van Barriger. Monthly magazine. Circ. 130,000. For "enthusiastic motorcyclists, investing considerable time in road riding or competition sides of the sport." Publication of the American Motorcyclist Association. "We are interested in people involved in, and events dealing with, all aspects of motorcycling." Buys 10-20 photos/issue. Buys all rights. Mail query required. Provide letter of inquiry and samples to be kept on file for possible future assignments. Credit line given. Pays on publication. Reports in 3 weeks. SASE. Sample copy and photo guidelines for \$1.50.

Subject Needs: Travel, technical, sport, humorous, photo essay/photo feature, celebrity/personality,

head shot.

B&W: Send 5x7 or 8x10 semigloss prints. Captions preferred. Pays \$15-40.

Color: Send transparencies. Captions preferred. Pays \$20-60.

Text/Photo Package: Photo rates as described above; pays \$2/column inch minimum for story. **Cover:** Send color transparencies. "The cover shot is tied in with the main story or theme of that issue and generally needs to be with accompanying ms." Pays \$75 minimum.

Tips: "Work to be returned *must* include SASE. Show us experience in motorcycling photography and suggest your ability to meet our editorial needs and complement our philosophy."

AMERICAN TRAVELER, 60 E. 42nd St., New York NY 10165. (212)682-3710. Art Director: Phyllis Busell. Emphasizes travel for members of September Days Club which includes people 55 and older whose common interest is travel. Quarterly. Circ. 450,000. Sample copy \$2.

Photo Needs: Buys 15-20 photos/issue; all provided by freelance photographers. Works with professional photographers on an ongoing basis. Choose from those who have carried out assignment well in past. Use photos to accompany ms. primarily. Interested in dramatic generic cover shots. "I'd like to review brochures and tearsheets so that freelancers could be contacted when needs arise. We feature four cities of areas of U.S. per issue. Need area photos at those times." Wants on a regular basis travel photos. "Always looking for good covers (vertical)." Model and informational captions required.

Specs: Kodachrome preferred.

Making Contact & Terms: Do not send unsolicited photos or slides. Upon request, send by mail the actual color prints or 35mm, 21/4x21/4, 4x5 or 8x10 color transparencies. Query with resume of photo credits and clippings. Provide brochure, tearsheet and samples to be kept on file for possible future assignments. SASE. Reports in 3 weeks. Pays \$200 for each inside page, and \$500 minimum/color cover photo. Pays on publication. Credit line given. Buys one-time rights. Previously published work OK. Tips: "We like to review brochures and tearsheets so freelancers can be contacted when needs arise. We're talking with freelancers new to the company all the time."

AN GAEL, c/o Irish Arts Center, 553 W. 51st St., New York NY 10019. (212)757-3318. Director: Abby Karp. Publication of the Irish Arts Center. Quarterly. Circ. 3,000. Emphasizes traditional Irish culture: poetry, fiction, book reviews, biography, interviews, etc., as well as the Irish in America and in Ireland. Readers are middle class and college educated. Sample copy \$1 to cover mailing costs.

Photo Needs: Uses about 10-12 photos/issue; all supplied by freelance photographers. Needs photos of people, scenery, well-known musicians and artists, anonymous and famous people—*all* Irish or relating to Irish subject matter in general. Special needs include cover or other photos; may relate to the Irish in Ireland, in America or in other places. Captions required.

Making Contact & Terms: Query with samples; send 5x7 or 8x10 b&w prints for consideration; a written or phoned description is acceptable. SASE. Reports in 1 month. Pays \$20/b&w cover photo; \$10/b&w inside photo. Pays on publication. Credit line given. Buys one-time rights. Simultaneous submissions and previously published work sometimes accepted; "each case is given individual consideration."

Tips: "An Gael is devoted to the Irish experience in Ireland and in America. Strong photos of immigrants—lumberjacks, railroad workers in USA—as well as all other related material is very much wanted."

*ANCHOR NEWS, 809 S. 8th St., Manitowoc WI 54301. (414)684-0218. Editor: Isacco A. Valli. Publication of the Manitowoc Maritime Museum. Bimonthly magazine. Emphasizes Great Lakes maritime history. Readers include learned and lay readers interested in Great Lakes History. Circ. 1,700. Sample copy \$1. Guidelines free with SASE.

Photo Needs: Uses 8-10 photos/issue; infrequently supplied by freelance photographers. Needs historic/nostalgic, personal experience, and general interest articles on Great Lakes maritime topics. How-to and technical pieces and model ships and shipbuilding are OK. Special needs include historic photography or photos that show current historic trends of the Great Lakes. Photos of waterfront development, bulk carriers, sailors, recreational boating etc. Model release and captions required.

Making Contact & Terms: Query with samples, send 4x5 or 8x10 glossy b&w prints by mail for consideration. SASE. Reports in 1 month. Pays in copies only on publication. Credit line given. Buys first North American serial rights. Simultaneous submissions and previously published work OK.

ANGUS JOURNAL, 3201 Frederick Blvd., St. Joseph MO 64501. (816)233-0508. Editor: Nancy Sayer. Publication of the American Angus Association. Monthly. Circ. 26,000. Emphasizes purebred Angus cattle. Readers are Angus cattle breeders. Sample copy and photo guidelines free with SASE. Photo Needs: "Cover shots only" are supplied by freelancers. Needs scenic color shots of angus cattle. Special needs include "cover shots, especially those depicting the four seasons. Autumn scenes especially needed—vertical shots only." Captions preferred.

Making Contact & Terms: Send 8x10 color prints; 35mm, 21/4x21/4, 4x5, or 8x10 transparencies; color

contact sheet; color negatives (all vertical shots). Provide resume, business card, brochure, flyer or tearsheets to be kept on file for possible future assignments. SASE. Pays \$150-250/color cover photo. Pays on acceptance. Credit line given. Buys all rights; rights purchased are negotiable. Simultaneous and previously published submissions OK.

APA MONITOR-AMERICAN PSYCHOLOGICAL ASSOCIATION, 1200 17th St. NW, Washington DC 20036. (202)955-7690. Editor: Jeffrey Mervis. Associate Editor: Kathleen Fisher. Monthly newspaper. Circ. 70,000. Emphasizes "news and features of interest to psychologists and other behavioral scientists and professionals, including legislation and agency action affecting science and health, and major issues facing psychology both as a science and a mental health profession." Photos purchased on assignment. Buys 60-90 photos/year. Pays by the job; \$30-50/hour; or \$25-40 per b&w photo; or \$300-400/day. Credit line given. Pays on publication. Buys first serial rights. Arrange a personal interview to show portfolio or query with samples. SASE. Simultaneous submissions and previously published work OK. Free sample copy.

Subject Needs: Head shot; feature illustrations; and spot news. **B&W**: Uses 5x7 and 8x10 glossy prints; contact sheet OK.

Tips: "Become good at developing ideas for illustrating abstract concepts and innovative approaches to cliches like meetings and speeches. We look for quality in technical reproduction, and innovative approaches to subjects."

*APERTURE, 20 E. 23rd St., New York NY 10010. (212)505-5555. Editor: Mark Holborn. Editor: Larry Frascella. Publication of Aperture. Quarterly. Emphasizes fine art and contemporary photography. Readers include photographers, artists, collectors. Circ. 8,000.

Photo Needs: Uses about 60 photos/issue; all supplied by freelance photographers. Model release and

captions required.

Making Contact & Terms: Submit portfolio for review. SASE. Reports in one month. Pay varies. Pays on publication. Credit line given.

APPALACHIA, Appalachian Mountain Club, 5 Joy St., Boston MA 02108. (617)523-0636. Managing Editor: Diane Welebit. Monthly. Circ. 32,000. Emphasizes "outdoor activities, conservation, environment, especially in the Northeastern U.S.A. We run extensive listings of club outings, workshops, etc." Readers are "interested in outdoor activities and conservation." Sample copy available for \$1, SASE and 50¢ postage. Photo guidelines free with SASE.

Photo Needs: Uses about 10 photos/issue; all supplied by freelance photographers. Needs "scenic, wildlife, outdoor activities in the Northeast U.S.A. especially mountains; color slides for covers (prefer vertical); b&w for inside." Model release preferred for inside photos; required for cover photos. Subject

description required.

Making Contact & Terms: Arrange a personal interview to show portfolio; query with samples or send unsolicited photos by mail for consideration. Send 8x10 b&w glossy prints, 35mm transparencies by mail for consideration. SASE. Reports in 1 month. No payment. Credit line given. Simultaneous submissions and previously published work (with permission) OK.

Tips: "Think vertical (for covers)."

APPALACHIAN TRAILWAY NEWS, Box 807, Harpers Ferry WV 25425. (304)535-6331. Editor-in-Chief: Judith Jenner. Publication of the Appalachian Trail Conference. Published 5 times/year. Circ. 21,000. Emphasizes the Appalachian Trail. Readers are "Appalachian Trail supporters, volunteers, hikers." Guidelines free with SASE; sample copies \$2.

Photo Needs: Uses about 25 photos/issue; 4-5 supplied by freelance photographers. Needs b&w photos

relating to Appalachian Trail. Captions preferred.

Making Contact & Terms: Query with list of stock photo subjects. Send 5x7 or larger b&w prints or b&w contact sheet by mail for consideration. Provide resume, business card, brochure, flyer and tearsheets to be kept on file for possible future assignments. SASE. Reports in 1 month. Pays on publication; \$15-100/b&w photo. Credit line given. Buys one-time rights. Simultaneous submissions and previously published work OK.

Tips: "We're inundated with Macro shots of flora and fauna but we need pictures of trail users—hikers and maintainers. Since we primarily use b/w we often choose the prints which will reproduce well-good,

crisp tones-solid blacks and whites."

ARCHITECTURAL METALS, 221 N. LaSalle, Chicago IL 60601. (312)346-1600. Editor: Don Doherty. Publication of the National Association of Architectural Metal Manufacturers. Published 4 times/year. Circ. 21,000. Emphasizes "architectural metal manufacturing and fabrication for four divisions: architectural metal products, hollow metal doors and frames, metal bar grating, metal flagpoles. Sample copy free with SASE.

Photo Needs: Uses 3-6 photos/issue on assignment only. Needs "architectural metal manufacturing or fabricating by NAAMM member companies." Photos purchased with accompanying ms only. Making Contact & Terms: "Send business card and promotional literature which editor can file for fu-

ture reference. When needed will assign photographer." SASE. Reports in 1 month. Pays \$100/b&w cover photo; \$25-50/b&w inside photo. Pays on publication. Credit line given. Buys one-time rights. Simultaneous submissions and previously published work OK.

Tips: "We use freelancers on assignment only. We suggest they send us something we can file for future reference."

ASH AT WORK, National Ash Association, Suite 510, 1819 H St., NW, Washington DC 20006. (304)367-3255. Editor-in-Chief: Allan W. Babcock. Bimonthly. Circ. 2,700. Emphasizes coal ash production and utilization. Readers are in the electric utility, government, marketing, consulting, construction and civil engineering industries. Free sample copy.

Photo Needs: Uses about 6-7 photos/issue. Needs photos concerning applications of power plant ash.

Model release and captions preferred.

Making Contact & Terms: Send 5x7 or 8x10 glossy b&w prints; 21/4x21/4 transparencies or b&w and color negatives by mail for consideration. SASE. Reports in 2 weeks. Negotiates payment. Pays on publication. Credit line given. Buys all rights. Simultaneous submissions OK.

ATA MAGAZINE, 4180 Elvis Presley Blvd., Memphis TN 38116. (901)761-2821. Editor-in-Chief: Milo Dailey. Publication of the American Taekwondo Association. Quarterly. Circ. 13,000. Photo guidelines free with SASE.

Photo Needs: Uses 40+ photos/issue; 5 supplied by freelance photographers. Model release and captions required. Query with samples. SASE. Reports in 2 weeks. Pays \$25/published page, "to include both word and photo copy." Pays on publication. Credit line given. Buys all rights; "unless otherwise agreed." Simultaneous submissions OK.

Tips: Virtually all photos are from people with an "ATA connection" due to subject matter. Photographers need not be members, but do need familiarity with ATA.

AUTO TRIM NEWS, 1623 Grand Ave., Baldwin NY 11510. (516)223-4334. Editor: Nat Danas. Publication of National Association of AutoTrim Shops. Monthly. Circ. 8,000. Emphasizes automobile restoration and restyling. Readers are upholsterers for auto marine trim shops; body shops who are handling cosmetic soft goods for vehicles. Sample copy \$1 with SASE; photo guidelines free with SASE.

Photo Needs: Uses about 15 photos/issue; 6-10 supplied by freelance photographers. Needs "how-to photos; photos of new store openings; Restyling Showcase photos of unusual completed work." Special needs include "restyling ideas for new cars in the after market area; soft goods and chrome add-ons to update Detroit." Captions preferred.

Making Contact & Terms: Provide resume, business card, brochure, flyer or tearsheets to be kept on file for possible future assignments; submit ideas for photo assignments in local area. Photographer should be in touch with a cooperative shop locally. SASE. Reports in 1 week. Pays \$35/b&w cover photo; \$75-95/job. Pays on acceptance. Credit line given if desired. Buys all rights. Simultaneous submissions and previously published work OK.

Tips: "First learn the needs of a market or segment of an industry. Then translate it into photographic ac-

tion so that readers can improve their business."

BACK TO GODHEAD, Bhaktivedanta Book Trust, Box 18928, Philadelphia PA 19119. Picture Editor: Yamaraja Dasa. Monthly magazine. Circ. 120,000. Publication of the Hare Krishna religious movement, its activities and philosophical ideas. Buys 12 photos/year. Credit line given. Pays on publication. Buys one-time or other rights. Query by mail or in person with samples or list of stock photo subjects. SASE. Simultaneous submissions and previously published work OK. Reports in 1 month.

Subject Needs: "Most specifically, photos of Swami A.C. Bhaktivedanta, the founder of the Hare Krishna movement. Generally, photographs of the devotees of the Hare Krishna movement."

B&W: Uses 8x10 glossy prints; contact sheet OK. Pays \$15-150/photo.

Color: Uses transparencies. Pays \$25-250/photo.

Tips: "We also seek participation from professional photographers who would like to use their abilities for an exalted spiritual purpose through contributions of photos and/or photographic assistance. It would help if the photographer became familiar with our philosophy and/or developed sympathy for our movement's goals. This would help him become unattached to the results of his work and more inclined to donate his talents."

BIKEREPORT, Box 8308, Missoula MT 59807. (406)721-1776. Managing Editor: Daniel D'Ambrosio. Publication of Bikecentennial, Inc. Bimonthly journal. Circ. 18,000. Emphasizes "bicycle touring. Readers are mostly under 40, active." Sample copy and photo guidelines free with SASE.

Photo Needs: Uses about 8 photos/issue; mostly assigned. Needs bicycling-related photos. Model release required.

Making Contact & Terms: Query with resume of credits. SASE. Reports in 3 weeks. Pays \$50/b&w cover photo; \$5-10/b&w inside photo. Pays on publication. Credit line given. Buys one-time rights

BOWLING MAGAZINE, 5301 S. 76th St., Greendale WI 53129. (414)421-6400. Editor: Rory Gillespie. Published by the American Bowling Congress. Emphasizes bowling for readers who are bowlers, bowling fans or media. Published 11 times annually. Circ. 140,000. Free sample copy; photo guidelines for SASE.

Photo Needs: Uses about 20 photos/issue, 1 of which, on the average, is supplied by a freelance photographer. Provide calling card and letter of inquiry to be kept on file for possible future assignments. "In some cases we like to keep photos. Our staff takes almost all photos as they deal mainly with editorial copy published. Rarely do we have a photo page or need freelance photos. No posed action." Model release required; captions required.

Making Contact & Terms: Send by mail for consideration actual 5x7 or 8x10 b&w or color photos. SASE. Reports in 2 weeks. Pays on publication \$10-15/b&w photo; \$15-20/color photo. Credit line given. Buys one-time rights but photos are kept on file after use. No simultaneous submissions or previous-

ly published work.

BROTHERHOOD OF MAINTENANCE OF WAY EMPLOYES JOURNAL, 12050 Woodward Ave., Detroit MI 48203. Associate Editor: R.J. Williamson. Monthly magazine. Circ. 120,000. Emphasizes trade unionism and railroad track work. For members of the international railroad maintenance workers' union, "who build, repair and maintain the tracks, buildings and bridges of all railroads in the U.S. and Canada." Needs "strong scenics or seasonals" and photos of maintenance work being performed on railroad tracks, buildings and bridges; large format color transparencies only. Uses average of 10 photos/issue; 1 supplied by freelance photographer. Credit line sometimes given. Not copyrighted. Query first. Pays on acceptance. Reports in 2 weeks. SASE. Simultaneous submissions and previously published work OK. Free sample copy.

Cover: Send 4x5 or larger color transparencies. Photos must be "dynamic and sharp." Uses vertical

format. Pays \$100-200.

B&W: Pays \$10-15/photo for inside use. Captions preferred. Buys one-time rights.

BULLETIN OF THE ATOMIC SCIENTISTS, 5801 S. Kenwood Ave., Chicago IL 60637. (312)363-5225. Production Editor: Lisa Grayson. Monthly (except bimonthly in summer, 10 issues/year). Circ. 25,000. Emphasizes science and world affairs. "Our specialty is nuclear politics; we regularly present disarmament proposals and analysis of international defense policies. However, the magazine prints more articles on politics and the effects of technology than it does on bombs. The *Bulletin* is not a technical physics journal." Readers are "educated, interested in foreign policy, moderate-to-left politically; high income levels; employed in government, academe or research facilities; about 50% are scientists." Sample copy \$2.50.

Photo Needs: Uses about 7-10 photos/issue; "few if any" supplied by freelance photographers. "Our publication is so specialized that we usually must get photos from the insiders in government agencies." Needs photos of "people using alternative technologies in Third World countries, defense workers, or protesters of weapons or environmental policies." Future needs include shots of "Eastern Europe (unusual scenes of people), Soviet Union, Japan, Middle East—for special reports on the regions."

Making Contact & Terms: Provide resume, business card, brochure, flyer or tearsheets to be kept on file for possible future assignments. "Don't send a manuscript or photos without a preliminary query." SASE. Reports in 2-4 weeks. Photographers are paid by the job; amount of payment is negotiable. Pays on publication. Credit line given. Buys one-time rights. Previously published work OK "on occasion." Tips: "Make sure you examine several issues of any magazine you consider soliciting. This will save you time and money. Editors weary of reviewing photos and art from contributors with no knowledge of the publication. You'll make a better impression if you know what the magazine's about."

BULLETIN OF THE PHILADELPHIA HERPETOLOGICAL SOCIETY, 4607 Spruce, Philadelphia PA 19139. (215)898-6477 or 474-5005. Editor-in-Chief: Mike Balsai. Photo Editor: Don Clements. Publication of the Philadelphia Herpetological Society. Annually. Circ. 300. Emphasizes amphibians and reptiles. Readers are "grade school through postdoctorate; the only common denominator is an interest in herpetology." Sample copy "\$6 for current copies, \$3-4 for earlier ones."

Photo Needs: Uses about 3 photos/issue. Needs "anything related to amphibians or reptiles." Model re-

lease and captions required.

Making Contact & Terms: Send 5x8 and up b&w glossy prints by mail for consideration. Can also print (in b&w) from 35mm transparencies, either b&w or color. SASE. Reports as soon as possible. Payment is in copies of printed photo. Pays on publication. Credit line given. Buys one-time rights.

THE CALIFORNIA STATE EMPLOYEE, 1108 O St., Sacramento CA 95814. (916)444-8134. Communications Director: Keith Hearn. Publication of the California State Employees Association. Local 1000 of the Service Employees International Union, AFL-CIO. Semiannual magazine. Circ. 128,000. Emphasizes "labor union news." Readers are California State civil service and State University employees. Sample copy free for SASE and 54¢ postage.

Photo Needs: Uses about 15 photos/issue, 1 supplied by freelance photographer. Needs "strictly concept' photos to accompany staff-written articles on labor issues-salaries, negotiations, women's is-

sues, health and safety, stress, etc."

Making Contact & Terms: Send 8x10 glossy or matte prints by mail for consideration. Provide resume, business card, brochure, flyer or tearsheets to be kept on file for possible future assignments. SASE. Reports in 3 weeks. Pays \$25-40/b&w inside photo. Pays on acceptance. Buys first North American serial rights. Simultaneous submissions and previously published work OK.

CATHOLIC FORESTER, 425 W. Shuman Blvd., Naperville IL 60566. (312)983-4920. Editor: Barbara Cunningham. Publication of the Catholic Order of Foresters. Bimonthly. Circ. 155,000. Publication is "Catholic-religious in tone, but not necessarily held to religious subjects." Readers are mostly middle-class people, all Catholic. Sample copy available for SASE and 56¢ postage.

Photo Needs: "We would be interested in any unusual, dynamic shots, not particularly scenic, but animal, wildlife, children or child, unusual occupation, etc., and of course, religious (Catholic). Model re-

lease and captions preferred. Picture stories especially welcome.'

Making Contact & Terms: Send color prints, 4x5 or 8x10 transparencies by mail for consideration; submit portfolio for review. Reports in 1 month or ASAP. Pay is negotiable. Pays on acceptance. Credit line given. Simultaneous and previously published submissions OK.

CEA ADVISOR, Connecticut Education Association, 21 Oak St., Hartford CT 06106. (203)525-5641. Managing Editor: Michael Lydick. Monthly tabloid. Circ. 30,000. Emphasizes education. Readers are public school teachers. Sample copy free for 75¢ postage.

Photo Needs: Uses about 20 photos/issue; 1 or 2 supplied by freelance photographers. Needs "class-room scenes, students, school buildings." Model release and captions preferred.

Making Contact & Terms: Send b&w contact sheet by mail for consideration. Provide resume, business card, brochure, flyer or tearsheets to be kept on file for possible future assignments. Does not return unsolicited material. Reports in 1 month. Pays \$50/b&w cover photo; \$25/b&w inside photo. Pays on publication. Credit line given. Buys all rights. Simultaneous submissions and previously published work OK.

*CESSNA OWNER MAGAZINE, Box 75068, Birmingham AL 35253. (205)879-7414. Editor: John W. Cargile. Publication of the Skyhawk, Skylane, Centurion. Monthly. Emphasizes Cessna Skyhawks, Cessna Skylanes, Cessna Centurions. Readers include members who are owners/operators of these aircraft, and maintenance personnel. Circ. 5,500. Free sample copy and photo guidelines with SASE. Photo Needs: Uses 5 photos/issue. "We need aerial shots of our airplanes for cover; new product pix; profiles of people in our industry; how-to's illustrations, maintenance, etc. At present, we need sharp color photos of our planes for use on the cover." Model release and captions required.

Making Contact & Terms: Send 5x7 and 8x10 b&w or color prints by mail for consideration. SASE.

Reports in 2 weeks. Pays \$25/b&w; \$75/color cover photo. Pays on publication. Credit line given. Buys

first North American serial rights. Simultaneous submissions OK.

CHESS LIFE, 186 Route 9W, New Windsor NY 12550. (914)562-8350. Editor-in-Chief: Larry Parn. Publication of the U.S. Chess Federation. Monthly. Circ. 55,000. Chess Life covers news of all major national and international tournaments; historical articles, personality profiles, columns of instruction, fiction, humor . . . for the devoted fan of chess. Sample copy and photo guidelines free with SASE. Photo Needs: Uses about 20 photos/issue; 10-15 supplied by freelance photographers. Needs "news photos from events around the country; shots for personality profiles." Special needs include "Chess Review" section. Model release and captions preferred.

Making Contact & Terms: Query with samples. Provide business card and tearsheets to be kept on file for possible future assignments. SASE. Reports in "2-4 weeks, depending on when the deadline crunch occurs." Pays \$50-100/b&w or color cover photo; \$10-25/b&w inside photo. Pays on acceptance. Credit line given. Buys one-time rights; "we occasionally purchase all rights for stock mug shots." Simultaneous submissions and previously published work OK.

Tips: Using "more color, and more illustrative photography. The photographer's name and date should appear on the back of all photos. 35mm color transparencies are preferred for cover shots."

CHILDHOOD EDUCATION, Suite 200, 11141 Georgia Ave., Wheaton MD 20902. (301)942-2443. Editor: Lucy Prete Martin. Association publication for the Association for Childhood Education International. Bimonthly. Emphasizes the education of children from infancy through early adolescence. Readers include teachers, administrators, day care workers, parents, psychologists, student teachers, etc. Circ. 10,000. Sample copy free with 7x10 SASE and \$1 postage; photo guidelines free with SASE. Photo Needs: Uses 8-10 photos/issue; 2-3 supplied by freelance photographers. Subject matter includes children from 0-14 years in groups or alone, in or out of the classroom, at play, in study groups; boys and girls, of all races, and in all cities and countries. Reviews photos with or without accompanying ms. Special needs include photos of miniority children; photos of children from different ethnic groups to-

Making Contact & Terms: Send unsolicited photos by mail for consideration. Uses 8x10 glossy b&w prints. SASE. Reports in 1-4 months. Pay individually negotiated. Pays on publication. Credit line giv-

en. Buys one-time rights. No simultaneous submissions or previously published work.

gether in one shot; boys and girls together. Model release required.

Tips: "Send pictures of unposed children, please."

*CHINA PAINTER, 2641 NW 10, Oklahoma City OK 73107. (405)943-3841. Editor: Pauline Salver. Publication of The World Organization of China Painters. Bimonthly, Emphasizes those interested in hand painted porcelain china. Circ. 8,500.

Photo Needs: Needs designs of anything that can be painted on china—flowers, animals, birds, land-

scapes, fruit, etc.

Making Contact & Terms: Send 8½x11 b&w/color prints by mail for consideration. Does not return unsolicited material. Reports in one month. Credit line given.

THE CHOSEN PEOPLE, Box 2000, Orangeburg NY 10962. (914)359-8535. Managing Editor: Jonathan Singer. Publication of the American Board of Missions to the Jews. Monthly. Emphasizes Jewish subjects, Israel. Readers are Christians interested in Israel and the Jewish people. Circ. 75,000. Sample copy free with SASE.

Photo Needs: Uses about 3-4 photos/issue; 3 supplied by freelance photographers. Needs "scenics of Israel, preferably b&w; photos of Jewish customs and traditions." Model release preferred.

Making Contact & Terms: Ouery with samples or with list of stock photo subjects; send 81/2x10 glossy b&w photos by mail for consideration; provide resume, business card, brochure, flyer or tearsheets to be kept on file for possible future assignments. SASE. Reports in 3 weeks. Pays \$160/b&w cover photo and \$75/b&w inside photo. Pays on acceptance. Credit line given. Buys one-time rights. Simultaneous submissions OK.

*THE CHRISTIAN ARTIST, 16428 Harvest Ave., Norwalk CA 90650. (213)865-6736. Editor: Ren Dueck. Publication of the Christian Artist Fellowship. Quarterly newsletter. Emphasizes Christian Art—chalk drawings for international readers. Circ. 300. Free sample copy; set of back issues available for \$10.

Photo Needs: Uses 6 photos/issue; all supplied by freelance photographers. Needs how-to-actual

drawing scenes. Photos purchased with accompanying ms only.

Making Contact & Terms: Send any size glossy b&w prints by mail for consideration. Does not return unsolicited material. Reports ASAP. Credit line given. Simultaneous submissions OK.

CHURCH & STATE, 8120 Fenton St., Silver Spring MD 20910. (301)589-3707. Managing Editor: Joseph L. Conn. Publication of the Americans United for Separation of Church and State. Monthly, except August. Circ. 52,000. Emphasizes "religious liberty, church and state separation." Readers are "interfaith, nondenominational." Sample copy free with SASE.

Photo Needs: Uses about 8-10 photos/issue; 1 supplied by freelance photographer. Needs photos cover-

ing "churches and church-related events."

Making Contact & Terms: Query with resume of credits or list of stock photo subjects. Reports in 1 month. Pays \$75-150/b&w cover photo; pay negotiable for inside photo; up to \$150. Pays on acceptance. Credit line given. Buys one-time rights. Simultaneous submissions and previously published work OK.

CINCINNATI BAR ASSOCIATION REPORT, 26 E. 6th St., Suite 400, Cincinnati OH 45202. (513)381-8213. Director of Public Relations: Nancy L. Valyo. Publication of the Cincinnati Bar Association. Monthly journal. Circ. 3,500. Emphasizes the legal profession. Readers are "attorneys-members of the local bar association." Sample copy free for SASE and 22¢ postage.

Photo Needs: Uses about 5 photos/issue. Needs people and how-to photos. Model release and captions

required. Payment varies.

Making Contact & Terms: Provide resume, business card, brochure, flyer or tearsheets to be kept on file for possible future assignments. Pays on publication. Credit line given. Buys all rights.

CIVIL ENGINEERING—ASCE, 345 East 47th St., New York NY 10017-2398. (212)705-7507. Editor: Virginia Fairweather. Publication of the American Society of Civil Engineers. Monthly magazine. Civil Engineering—ASCE deals with "design and construction engineering; all topics related to civil engineering." Readers are "practicing engineers, academics, government engineers, consulting engineers." Circ. 95,000.

Photo Needs: Uses 30 photos/issue; a maximum of 2 supplied by freelance photographers. Needs photos of "construction in progress, buildings, bridges, roads, environmental-related, rehabilitation of public works." Special needs include "occasional concept cover or major inside art." Only reviews photos if accompanied by ms. Written release and captions required.

Making Contact & Terms: Arrange a personal interview to show portfolio. Pays varies. Payment is made on publication. Buys one-time rights or all rights, "depending on the negotiation and deal con-

cluded."

Tips: "Consider major construction projects in your area; contact the magazine and query about interest; contact the owners, builders or designers of the project."

CLEARWATERS, Engineering Bldg. Room 112, Manhattan College, Riverdale NY 10471. (212)920-0307. Managing Editor: John Pensieri. Editor: Walter P. Saukin. Quarterly magazine. Circ. 3,500. Publication of the New York Water Pollution Control Association, Inc. "Clearwaters deals with design, legislative and operational aspects of water pollution control." Buys 12 photos/year. Pays \$12 minimum/hour, or on a per-photo basis. Credit line given. Pays on acceptance. Buys all rights, but may reassign to photographer after publication. Arrange personal interview to show portfolio or query with samples. SASE. Simultaneous submissions OK. Reports in 1 month. Free sample copy and photoguidelines.

Subject Needs: Photo essay/photo feature (on most aspects of water pollution control); and nature ("any good water shots"). "We particularly want shots from New York state, and are looking for a familiarity with the water pollution control industry." Model release preferred; captions required.

B&W: Uses 8x10 glossy prints. Pays \$10 minimum/photo.

Cover: Uses b&w prints. Vertical format preferred. Pays \$50 minimum/photo.

COACHING REVIEW, 333 River Rd., Ottawa, Ontario, Canada K1L 8B9. (613)741-0036. Editor: Vic Mackenzie. Publication of the Coaching Association of Canada. Bimonthly. Circ. 12,000. Emphasizes "coaching of all sports." Readers are "60% men, 40% women. Most are actively engaged in the coaching of athletes." Free sample copy.

Photo Needs: Uses about 35-50 photos/issue; 20% supplied by freelance photographers. Needs photos of "coaches in action, working with athletes. Prefer well-known coaches; photo profiles on different

coaches." Model release and captions preferred.

Making Contact & Terms: Query with samples. Send 21/4x21/4 transparencies, b&w or color contact sheets by mail for consideration. SASE. Reports in 2 weeks. Pays \$25-750 per job. Negotiates rights purchased. Simultaneous submissions OK.

*COMMUNICATION WORLD, Suite 940, 870 Market St., San Francisco CA 94102. (415)433-3400. Editor: Cliff McGoon. Photo Editor: Gloria Gordon. Publication for the International Association of Business Communicators. Monthly. Emphasizes public relations, international and external communication. Readers include public relations professionals, editors, writers, communication consultants for businesses—small and large corporations, and nonprofit organizations. Circ. 15,000. Free sample copy.

Photo Needs: Uses 6-10 photos/issue; 50% supplied by freelance photographers. Needs editorial "illustration" shots of corporate interest, i.e., annual reports, company publications' interest. Special needs include portfolio section featuring excellence in photography, 4-color and b&w—3 pp, center section. "We look for innovative and creative handling of often boring subjects." Model release preferred; cap-

tions required.

Making Contact & Terms: Arrange a personal interview to show portfolio; query with samples; send 5x7 b&w/color glossy prints, 35mm, 21/4x21/4, 4x5 or 8x10 transparencies by mail for consideration; submit portfolio; provide resume, business card, brochure, flyer or tearsheets to be kept on file for possible future assignments. SASE. Reports in 1 month. Pays by the job. Pays on publication. Credit line given. Buys one-time rights. Simultaneous submissions and previously published work OK.

CURRENTS, Voice of the National Organization for River Sports, 314 N. 20th St., Colorado Springs CO 80904. (303)473-2466. Editor: Eric Leaper. Bimonthly magazine. Circ. 10,000. Membership publication of National Organization for River Sports, for canoeists, kayakers and rafters. Emphasizes river conservation and river access, also techniques of river running. Provide tearsheets or photocopies of work to be kept on file for possible future assignments.

Subject Needs: Photo essay/photo feature (on rivers of interest to river runners). Need features on rivers that are in the news because of public works projects, use regulations, Wild and Scenic consideration or access prohibitions. Sport newsphotos of canoeing, kayaking, rafting and other forms of river and flatwater paddling, especially photos of national canoe and kayak races; nature/river subjects, conserva-

tion-oriented; travel (river runs of interest to a nationwide membership). Wants on a regular basis closeup action shots of river running and shots of dams in progress, signs prohibiting access. Especially needs for next year shots of rivers that are threatened by dams showing specific stretch to be flooded and dambuilders at work. No "panoramas of river runners taken from up on the bank or the edge of a highway. We must be able to see their faces, front-on shots. We always need photos of the twenty (most) popular whitewater river runs around the U.S." Buys 10 photos/issue. Captions required.

Specs: Uses 5x7 and 8x10 glossy b&w prints. Occasional color prints. Query before submitting color

Accompanying Mss: Photos purchased with or without accompanying ms. "We are looking for articles on rivers that are in the news regionally and nationally-for example, rivers endangered by damming; rivers whose access is limited by government decree; rivers being considered for Wild and Scenic status; rivers hosting canoe, kayak or raft races; rivers offering a setting for unusual expeditions and runs; and rivers having an interest beyond the mere fact that they can be paddled. Also articles interviewing experts in the field about river techniques, equipment, and history." Pays \$25 minimum. Free writer's and photographer's guidelines with SASE.

Payment & Terms: Pays \$15-35/b&w print or color prints or transparencies; \$35-100 for text/photo package. Credit line given. Pays on acceptance. Buys one-time rights. Simultaneous submissions and

previously published work OK if labeled clearly as such.

Making Contact: Send material or photocopies of work by mail for consideration. "We need to know of photographers in various parts of the country." SASE. Reports in 1 month. Sample copy 75¢; free photo

guidelines with SASE. **Tips:** "We look for three key elements: (1) Faces of the subjects are visible; (2) Flesh is visible; (3) Lighting is dramatic; catching reflections off the water nicely. Send a few river-related photos, especially 8x10 b&w glossies. We'll reply as to their usefulness to us. Look at the publication first! Send action photos.'

DEFENDERS, 1244 19th St. NW, Washington DC 20036. (202)659-9510. Editor: James G. Deane. Publication of the Defenders of Wildlife. Bimonthly. Circ. 60,000. Emphasizes wildlife and wildlife habitat. Readers are "those interested in the protection of wildlife and its habitat." Sample copy and photo guidelines free with SASE.

Photo Needs: Uses approximately 50 photos/issue; "almost all" from freelance photographers. Needs

photos of wildlife and wildlife habitat. Captions information required.

Making Contact & Terms: Query with list of stock photo subjects. SASE. Reports ASAP. Pays \$40/ b&w photo; \$60-350/color photo. Pays on publication. Credit line given. Buys one-time rights.

Tips: "More and more Defenders is focusing on endangered species and destruction of their habitats, primarily North American endangered species. We are featuring 4 to 6 international stories per year. Above all, the images must be sharp. Just because a plant or animal happens to be rare doesn't mean it will sell if the image is soft. Covers must be vertical, able to take the logo up top, and be arresting, simple images. Think twice before submitting anything but low speed (preferably Kodachrome) transparencies.'

THE DEKALB LITERARY ARTS JOURNAL, 555 N. Indian Creek Dr., Clarkston GA 30021. Editor-in-Chief: Frances Ellis. Quarterly. Circ. 1,000. Publication of Dekalb Community College. Emphasizes literature for students and writers. Sample copy \$4.

Photo Needs: Uses about 8-10 photos/issue; all supplied by freelance photographers. Needs "anything

of quality." Photos purchased with or without accompanying ms.

Making Contact & Terms: Submit portfolio for review or send by mail for consideration b&w prints or b&w contact sheet. SASE. Reports in 6 months. Pays in contributors copies. Pays on publication. Credit line given. Buys one-time rights. Simultaneous submissions OK.

*DENTAL HYGIENE, Suite 3400, 444 N. Michigan, Chicago IL 60611. (312)440-8900. Editor: Janet Seefeldt. Art Director: Mary Kushmir. Publication of the American Dental Hygienists' Association. Monthly. Emphasizes dental hygiene and the special concerns of the dental hygienist. Circ. 35,000.

The asterisk before a listing indicates that the listing is new in this edition. New markets are often the most receptive to freelance contributions.

Photo Needs: Uses photos for cover only. Needs photos of dental office; classroom setting; young, at-

tractive, mostly female models. Model release required.

Making Contact & Terms: Arrange a personal interview to show portfolio; query with samples; provide resume, business card, brochure, flyer or tearsheets to be kept on file for possible future assignments. Reports in 1 week. Pays \$350/color cover photo. Pays on publication. Credit line given. Buys one-time rights. Simultaneous submissions and previously published work OK.

Tips: "Photos depicting positive image for young working women—particularly the dental hygienist.

Good portraits.'

DePAUW ALUMNUS, Charter House, DePauw University, Greencastle IN 46135. (317)658-4626, ext. 241. Editor: J. Patrick Aikman. Quarterly magazine. Circ. 28,500. Alumni magazine emphasizing alumni-related events and personalities, interest in university, its programs, future and past. Subject Needs: Uses celebrity/personality, photo essay/photo feature, head shot, spot news, all relating

to alumni or campus events. Captions and model release preferred.

Specs: Uses glossy b&w contact sheets and negatives. Cover—b&w contact sheets and negatives; color transparencies, vertical or horizontal wraparound format.

Accompanying Mss: Photos purchased with or without accompanying ms. Seeks alumni related fea-

tures-but not on speculation. Query first.

Payment & Terms: Pays \$25/b&w photo; \$100/cover photo; and \$20/ms with photo. Credit line sometimes given. Pays on publication. Buys one-time rights. Simultaneous submissions and/or previously published work OK.

Making Contact: First contact with resume of credits and basic information only. Works with photographers on assignment basis only. Advise of availability for assignments. Reports in 2 weeks. Free sam-

Tips: "Like to see how they handle people (personality) photos. We use these with feature stories on our interesting alumni, but often we can't get the photos ourselves so we assign them to freelancer in vicini-

DIABETES FORECAST, American Diabetes Association, 2 Park Ave., New York NY 10016. (212)683-7444. Art Director: Meg Richichi. Publication of American Diabetes Association. Bimonthly. Circ. 170,000. Emphasizes "diabetes-includes food, fitness, profiles, medical pieces." Readers are "diabetics, men-women, aged 20-80. Also has sections for children." Sample copy \$3. Photo Needs: Uses about 3-10 photos/issue; most supplied by freelance photographers. Needs "color

slides or b&w glossies, anything diabetes-related. Model release and captions required.'

Making Contact & Terms: Arrange a personal interview to show portfolio; query with resume of credits or list of stock photo subjects. Provide resume, business card, brochure, flyer or tearsheets to be kept on file for possible future assignments. Reports in 1 month. Payment varies. Pays on publication. Credit line given. Prefers to buy all rights "but will negotiate." Tips: "Call first and speak to art director."

THE DOLPHIN LOG, Suite 110, 8430 Santa Monica Blvd., Los Angeles CA 90069. (213)656-4422. Editor: Pamela Stacey. Publication of The Cousteau Society, Inc., a nonprofit organization. Quarterly magazine. Emphasizes "ocean and water-related subject matter for children ages 7 to 15." Circ. 40,000. Sample copy \$2. Photo guidelines free with SASE.

Photo Needs: Uses about 22 photos/issue; 8 supplied by freelance photographers. Needs "selections of images with a story in mind, such as architects and builders of the sea, how sea animals eat, the smallest and largest things in the sea, the different forms of tails in sea animals, children of the sea, resemblances of sea creatures to other things, different vessels of the sea. Also excellent potential cover shots or images which elicit curiosity, humor or interest." Please request photographer's guidelines. Model release

required; captions preferred.

Making Contact & Terms: Query with samples, list of stock photos or send duplicate 35mm transparencies or b&w contact sheets by mail for consideration. Send duplicates only. SASE. Reports in 1 month. Pays \$100/color cover photo; \$25/inside b&w photo, \$50/color full or half page photo, \$25/color less than half page photo. Pays on publication. Credit line given. Buys one-time rights and worldwide translation rights. Simultaneous and previously published submissions OK.

Tips: Prefers to see "rich color, sharp focus and interesting action of water-related subjects" in samples.

DUCKS UNLIMITED, 1 Waterfowl Way at Gilmer Road, Long Grove IL 60647. (312)438-4300. Assistant Editor: Niki Barrie. Publication of Ducks Unlimited, Inc. Bimonthly magazine. Emphasizes waterfowl, waterfowl hunting and conservation for "highly affluent, well-educated professionals and executives, primarily under 55 with genuine interest in outdoor activity. Median age: 38; median income: Circ. 620,000. Sample copy \$1.50. Photo guidelines free with SASE.

Photo Needs: Uses up to 28 photos/issue; 24 donated by freelance photographers. Needs waterfowl and

hunting photos. Captions preferred.

Making Contact & Terms: Send photos by mail for consideration with the understanding that the magazine does not pay for the use of freelance material. "We prefer transparencies but will accept any format." SASE. Reports in 3 weeks. Credit line given. Requires one-time rights. Simultaneous and previously published submissions OK.

DYNAMIC YEARS, 215 Long Beach Blvd., Long Beach CA 90802. (213)432-5781. Editor: Lorena Farrell. Photo Editor: M.J. Wadolny. Bimonthly magazine. Circ. 200,000. Affiliated with the American Association of Retired Persons emphasizing stories about or relating to people 40-60 years old. Photos purchased with or without accompanying ms, or on assignment. Buys 25 photos/issue. Pays \$150-300/day; \$300-1,500 for text/photo package; \$400/color cover photo; \$75-175/b&w inside and \$125-300/color inside photo. Credit line given. Pays on acceptance. Buys one-time rights. Send material by mail for consideration or query with samples. SASE. Reports in 3 weeks. Free sample copy and photo guidelines.

Subject Needs: Celebrity/personality; documentary; fine art; head shot; human interest; photo essay/photo feature; scenic; special effects and experimental; sport; travel; and wildlife. Model release and

captions required.

B&W: Contact sheet and negatives OK. Pays \$75-125/photo.

Color: Uses 35mm, 21/4x21/4 or 4x5 transparencies. Pays \$125-300/photo.

Cover: Uses 35mm, 21/4x21/4 or 4x5 color transparencies. Vertical format preferred. Pays \$150 minimum/photo.

Accompanying Mss: Free writer's guidelines.

Tips: "Always looking for possible cover shots."

EL PASO MAGAZINE, 10 Civic Center Plaza, El Paso TX 79901. (915)544-7880. Editor: Russell S. Autry. Publication of the Chamber of Commerce. Monthly. "City magazine." Circ. 5,000. Readers are "owners and/or managers of El Paso businesses." Sample copy free with SASE.

Photo Needs: Uses about 10 photos/issue; all supplied by freelance photographers. Needs "photos of El

Paso people and scenes." Model release and captions required.

Making Contact & Terms: Arrange a personal interview to show portfolio. Does not return unsolicited material. Reports in 6 weeks. Pays \$300/color cover; \$10/b&w inside photo, \$50/color inside photo. Pays on publication. Credit line given. Buys first North American serial rights. Simultaneous submissions OK.

Tips: "We are actively seeking freelance photographers. Call editor for appointment."

THE ENSIGN, Box 31664, Raleigh NC 27622. (919)821-0892. Editor: Carol Romano. Publication of the United State Power Squadrons. Published 11 times/year, (July-August issue combined). Average circ. 52,189. "We serve USPS, an organization of over 50,000 male and female boat operators nationwide whose primary interests lie in boating and boating education. All articles in our publication relate to boating." Sample copy for 8x12 SAE and 85¢ postage.

Photo Needs: Uses 40 photos/issue; "none at this time" supplied by freelance photographers. "We look for action boating shot, power and sail boating photos. Most inside photos tend to be b&w's relating to cruises in different areas of the world or shipboard activities; cover shots are color and often more scenic." Special needs include "shots stressing power boating activities." Model release required; captions

preferred.

Making Contact & Terms: Send 5x7 or 8x10 b&w glossies or 35mm or 21/4x21/4 color photos by mail for consideration. SASE. Reports in 2 weeks. Pays in copies and certificate of recognition from organization. Acquires all rights.

ENVIRONMENT NEWS DIGEST, 1025 Connecticut Ave. NW, Washington DC 20036. (202)347-0020. Vice President: Charles W. Felix. Publication of Single Service Institute, Inc. Bimonthly. Circ. 10,000. Emphasizes "public health and food service sanitation." Readers are "public health officials in the U.S." Sample copy free with SASE.

Photo Needs: Uses about 4-5 photos/issue; none supplied by freelance photographers. Needs photos of "the use of disposable paper and plastic cups, plates and containers in food service demonstrating their

sanitary quality, convenience, and all-around utility." Model release required.

Making Contact & Terms: Send 4x5 or 8x10 b&w glossy prints by mail for consideration. SASE. Reports in 3 weeks. Pays \$75/b&w cover photo; \$35/b&w inside photo. Pays on acceptance. Buys all rights. Simultaneous submissions and previously published work OK.

*FACETS, 535 N. Dearborn, Chicago IL 60614. (312)645-4470. Editor: Kathleen T. Jordan. Publication of the AMA Auxiliary. Publishes magazine 5 times/year. Emphasizes health/health care. Readers are physicians' spouses. Circ. 80,000. Free sample copy free with SASE. Photo guidelines free with SASE.

Photo Needs: Uses about 5-10 photos/issue; 5-10 supplied by freelance photographers. Needs photos of community health projects—health fairs, screenings, etc. "Assigns jobs in areas of country as needed."

Model release required.

Making Contact & Terms: Query with samples; provide resume, business card, brochure, flyer or tearsheets to be kept on file for possible future assignments. SASE. Reports in 8 weeks. Pays \$300-500 plus expenses/job. Pays on acceptance. Credit line given. Buys first North American serial rights. Tips: "Color photos to indicate quality or variety of work; particularly interested in treatment of people."

*FLORIDA WILDLIFE, 620 S. Meridian St., Tallahassee FL 32301. (904)488-5563. Editor: John M. Waters Jr. Publication of the Florida Game & Fresh Water Fish Commission. Bimonthly magazine. Emphasizes wildlife, hunting, fishing, conservation. Readers are wildlife lovers, hunters, and fishermen. Circ. 28,000. Sample copy \$1.25. Photo guidelines free with SASE.

Photo Needs: Uses about 20-40 photos/issue; 75% supplied by freelance photographers. Needs 35mm color transparencies and b&w glossies of southern fishing and hunting, all wildlife (flora and fauna) of southeastern U.S.A.; how-to; covers and inside illustration. Do not feature products in photographs, where they can be subdued. No alcohol or tobacco. Special needs include hunting and fishing activities in southern scenes; showing ethical and enjoyable use of outdoor resources. Model release required. Making Contact & Terms: Query with samples, or send "mostly 35mm transparencies, but we use some b&w enlarged prints" by mail for consideration. "Do not send negatives." SASE. Reports in 1 month or longer. Pays \$35/back color cover; \$75/front color cover; \$10-35/b&w inside photo. Pays on publication. Credit line given. Buys one-time rights; "other rights are sometimes negotiated." Simultaneous submissions OK "but we prefer originals over duplicates." Previously published work OK but must be mentioned when submitted.

Tips: "Use flat slide mounting pages or individual sleeves. Show us your best."

FLYFISHER, 1387 Cambridge Dr., Idaho Falls ID 83401. (208)523-7300. Editor: Dennis G. Bitton. Quarterly magazine. Circ. 10,000. Emphasizes fly fishing for members of the Federation of Fly Fishers. Uses 100 photos/year, most bought with ms. Pays \$50-200 for text/photo package, or on a per-photo basis. Credit line given. Pays on publication. Buys first North American serial rights. Query with resume of credits or samples. "Send us 20-40 slides on spec with due date for returning." SASE. Reports in 1 month. Sample copy \$3, available from Federation of Fly Fishers, Box 1088, West Yellowstone MT 59758. Photo guidelines free with SASE.

Subject Needs: How-to (on tying flies, fishing techniques, etc.); photo essay/photo feature; and scenic. No photos of angling unrelated to fly fishing. Captions required.

B&W: Uses 8x10 glossy prints. Pays \$15-50/photo.

Color: Uses 35mm, 21/4x21/4 or 4x5 transparencies. Pays \$25-100.

Cover: Uses 35mm, 21/4x21/4 or 4x5 color transparencies. Needs scenics. Vertical or square formats required. Pays \$100-150.

Accompanying Mss: "Any mss related to fly fishing, its lore and history, fishing techniques, conservation, personalities, fly tying, equipment, etc." Writer's guidelines free with SASE.

*FOREIGN SERVICE JOURNAL, 2101 E. St. NW, Washington DC 20037. (202)338-4045. Editor: Stephen R. Dujack. Publication of the American Foreign Service Association. Monthly magazine except August. Emphasizes foreign service issues. Readers are US diplomats. Circ. 9,000. Sample copy \$2.

Photo Needs: Uses 7 photos/issue; 0-1 supplied by freelance photographers. Needs news items, political pictures. Model release and captions preferred.

Making Contact & Terms: Provide resume, business card, brochure, flyer or tearsheets to be kept on file for possible future assignments. Does not return unsolicited material. Pays by the job. Pays on publication. Credit line usually given. Buys one-time rights.

FORT WORTH MAGAZINE, 700 Throckmorton St., Fort Worth TX 76102-5073. (817)336-2491. Art Director: Susan Abbenante. Publication of the Chamber of Commerce of Fort Worth. Monthly. Circ. 10,000. Emphasizes community events and people. Readers are chamber members and the community at large. Sample copy \$1.58 and 75¢ postage.

Photo Needs: Uses 25 photos/issue; all supplied by freelance photographers. Uses photos "to accompany articles upon specification." Special needs include "up-to-date skyline, aerial and quality-of-life

shots." Model release and captions required.

Making Contact & Terms: Provide resume, business card, brochure, flyer or tearsheets to be kept on file for possible future assignments. Does not return unsolicited material. Pays \$75/color cover photo; \$15/b&w inside photo. Pays on acceptance. Credit line given. Rights purchased are negotiated at time of purchase.

4-H LEADER—THE NATIONAL MAGAZINE FOR 4-H,, (formerly National 4-H News), 7100 Connecticut Ave., Chevy Chase MD 20815. Editor: Suzanne C. Harting. Monthly magazine. Circ. 70,000. For "volunteers of all ages who lead 4H clubs." Emphasizes practical help for the leader and personal development for leader and for club members. Photos "must be genuinely candid, of excellent technical quality and preferably shot 'available light' or in that style; must show young people or adults and young people having fun learning something. How-to photos or drawings must supplement instructional texts. Photos do not necessarily have to include people." Buys 10-12/year. Buys first serial rights or one-time rights. Submit photos by mail for consideration. Works with freelance photographers on assignment only basis. Provide resume samples and tearsheets to be kept on file for possible future assignments. Credit line given for cover; not usually for inside magazine. Pays on acceptance. Reports in 1 month. SASE. Free sample copy and editorial guidelines.

Subject Needs: Kids working with animals; nature; human interest; kids and adults working together; still life; special effects/experimental; kids enjoying leisure living activities; teens involved together in

appropriate activities.

B&W: Send 5x7 or 8x10 glossy prints or contact sheet. Captions required. Pays \$25-100.

Cover: Uses 21/4x21/4 color transparencies. Covers are done on assignment; query first. Captions re-

quired. Pays \$100-250.

Tips: "Photos are usually purchased with accompanying ms, with no additional payment."

FUSION MAGAZINE, Box 1438, Radio City Station, New York NY 10101. (212)247-8439. Art Director: Alan Yue. Photo Editor: Carlos DeHoyos. Published 6 times/year. Circ. 150,000. Publication of Fusion Energy Foundation. Emphasizes fusion, fission, high technology and frontiers of science for lay/ technical readers. Sample copy \$3.

Photo Needs: Uses about 50 photos/issue; 2-3 supplied by freelance photographers. Needs same catego-

ries as listed above. Model release required.

Making Contact & Terms: Query with resume of credits or samples (not originals). Reports in 3 months. Provide samples or tearsheets to be kept on file for possible future assignments. Negotiates payment. Pays on publication. Credit line given. Buys one-time rights and all rights. Simultaneous submissions and/or previously published work OK.

*FUTURE MAGAZINE, Box 7, Tulsa OK 74121-0007. (918)584-2481. Editor: Terry Misfeldt. Photo Editor: Heather Dietrich. Publication of the U.S. Jaycees. Bimonthly magazine. Emphasizes volunteerism. Readers are men and women 18 to 36. Circ. 270,000. Sample copy \$2.

Photo Needs: Uses 6-10 photos/issue; 1 supplied by freelance photographers. Needs of photos varies,

primarily people, also meetings. Model release required; captions preferred.

Making Contact & Terms: Query with list of stock photo subjects. SASE. Reports in 3 weeks. Pay varies by assignment. Pays on acceptance. Credit line given. Buys one-time rights. Previously published work OK.

GARDENS FOR ALL NEWS, 180 Flynn Ave., Burlington VT 05401. (802)863-1308. Managing Editor: Katharine Anderson. Publication of the National Association for Gardening. Monthly. Circ. 250,000. Emphasizes food gardening. Readers are home and community gardeners. Sample copy for \$1

postage. Photo guidelines free with SASE.

Photo Needs: Uses about 50 photos/issue; half supplied by freelance photographers. Needs photos of "food plants and gardens; people gardening; special techniques; how to; specific varieties; unusual gardens and food gardens in different parts of the country. We often need someone to photograph a garden or gardener in various parts of the country for a specific story." Model release required; captions preferred.

Making Contact & Terms: Query with samples or list of stock photo subjects. SASE. Reports in 2 weeks. Pays \$50-150/color cover photo; \$15-25/b&w and \$20-40/color inside photo. Pays on accept-

ance. Credit line given. Buys one-time rights.

*GOLD PROSPECTOR MAGAZINE, Box 507, Bonsall CA 92003. (619)728-6620. Editor: Steve Teter. Association publication of the Gold Prospectors Association. Bimonthly. Emphasizes prospecting, gold mines, rocks and minerals. Readers include men age 35-54, middle class, sportsmen, etc. Circ. 100,000. Sample copy \$1; photo guidelines free with SASE.

Photos Needs: Uses 12-15 photos/issue; 100% supplied by freelance photographers. Needs prospecting-pictures of gold-historical mines, gold rush, etc. Reviews photos with accompanying ms only.

Model release and captions required.

Making Contact & Terms: Send unsolicited photos by mail for consideration; provide resume, business card, brochure, flyer or tearsheets to be kept on file for possible future assignments. Uses any size finish b&w and color prints. SASE. Reports in 3 weeks. Pays \$100/color cover, \$15-25/b&w inside, \$25-50/color, \$100-500/text/photo package. Pays on publication. Credit line given. Buys first North American serial rights. Previously published work OK.

GOLF COURSE MANAGEMENT, 1617 St. Andrews Dr., Lawrence KS 66046. (913)841-2240. Director of Communications: Clay Loyd. Publication of the Golf Course Superintendents Association of America. Monthly. Circ. 15,000. Emphasizes "golf course maintenance/management." Readers are golf course superintendents and managers." Sample copy and photo guidelines free with SASE.

Photo Needs: Uses about 12-18 photos/issue; 1-2 supplied by freelance photographers. Needs "scenic shots of famous golf courses, good composition, unusual holes dramatically portrayed." Model release

required; captions preferred.

Making Contact & Terms: Query with samples. Provide business card, brochure, flyer or tearsheets to be kept on file for possible future assignments. SASE. Reports in 3 weeks. Pays \$125-250/color cover photo. Pays on acceptance. Credit line given. Buys one-time rights.

Tips: Prefers to see "good color, unusual angles/composition for vertical format cover."

THE GREYHOUND REVIEW, Box 543, Abilene KS 67410. (913)263-4660. Contact: Gary Guccione or Tim Horan. Publication of the National Greyhound Association. Monthly. Circ. 5,000. Emphasizes greyhound racing and breeding. Readers are greyhound owners and breeders. Sample copy with SASE and \$2.50 postage.

Photo Needs: Uses about 15 photos/issue; 10 supplied by freelance photographers. Needs "anything pertinent to the greyhound that would be of interest to greyhound owners." Captions required.

Making Contact & Terms: Query with samples; send b&w or color prints and contact sheets by mail for consideration; submit portfolio for review; provide resume, business card, brochure, flyer or tearsheets to be kept on file for possible future assignments. Can return unsolicited material if requested. Report within 1 month. Pays \$50/b&w and \$100/color cover photo; \$10-50/b&w and \$25-100/color inside photo. Pays on acceptance. Credit line given. Buys one-time North American rights. Simultaneous and previously published submissions OK.

Tips: "We look for human-interest or action photos involving greyhounds. No muzzles, please, unless the greyhound is actually racing. When submitting photos for our cover, make sure there's plenty of cropping space on all margins around your photo's subject; full bleeds on our cover are preferred."

HISTORIC PRESERVATION, 1785 Massachusetts Ave., NW, Washington DC 20036. (202)673-4084. Editor: Thomas J. Colin. Bimonthly magazine. Circ. 160,000. For a "diversified national readership comprised of members of the National Trust for Historic Preservation and newsstand buyers, interested in preservation of America's heritage, including historic buildings, sites and objects." No obviously posed shots or photos of architecture distorted by use of a wide-angle lens. Mainly works with top-quality freelance photographers on assignment only basis. Provide resume, brochure, flyer, samples, tearsheets or list of credits to be kept on file for possible future assignments. Buys 300 photos annually. Copyrighted. Send sample photos for consideration or query. Credit line given. Pays on acceptance. Reports in 2-4 weeks. SASE. No previously published work. Free photo guidelines.

Subject Needs: Historical; architectural; people involved in restoration; unusual history, urban and rural features sought. Photos essays/features. No shots of buildings unless unusually interesting or esthet-

B&W: Send 8x10 glossy prints or contact sheets. Pays \$10-50/b&w used.

Color: Send transparencies. Pays \$50-200.

Cover: See requirements for color.

Tips: "It is helpful to have photographer's itinerary for travel; we need article ideas from Middle America and the West. Freelance photographs are used for their relevance to the subject matter. HP wants a wide range of articles dealing with American culture, from urban restoration to rural preservation. The keys are readability and relevance."

HOBIE HOTLINE, Box 1008, Oceanside CA 92054. (619)758-9100. Editor: Brian Alexander. Publication of the World Hobie Class Association. Bimonthly. Circ. 26,000. Emphasizes "Hobie Cat sailing in the U.S. and foreign countries." Readers are "young adults and sailing families, average age 26 to 35. Enthusiastic active group of people who love sailing." Sample magazine \$1 and photo guidelines free with SASE.

Photo Needs: Uses about 30-35 photos/issue; 90% supplied by freelance photographers. Needs "action photos of Hobie Cats; scenics that correspond to location of shoot." Special needs include "mid-Ameri-

ca photo essays; lake sailing on a Hobie Cat; wave surfing on a Hobie Cat."

Making Contact & Terms: Send 8x10 b&w glossy prints; 35mm or 21/4x21/4 transparencies or b&w contact sheet by mail for consideration. Prefers Kodachrome. SASE. Reports in 1 month. Pays \$200/ color cover photo; \$10-60/b&w and \$25-100/color inside photo; \$35/b&w and \$65/color page; and \$150-300 for text/photo package. Pays on publication. Credit line given. Buys one-time rights. Simultaneous submissions and previously published work OK.

Tips: "We are looking for sharp, clear, exciting Hobie Cat action shots as well as mood shots."

HOME & AWAY MAGAZINE, Box 3535, Omaha NE 68103. (402)390-1000. Editor-in-Chief: Barc Wade. Bimonthly. Circ. 1,500,000. Emphasizes travel (foreign and domestic), automotive, auto safety, consumerism from the viewpoint of auto ownership. Readers are between 45-50 years of age, above average income, broadly traveled and very interested in outdoor recreation and sports. Free sample copy with SASE.

Photo Needs: Uses 20-30 photos/issue; 75% supplied by freelance photographers/travel writers. Needs photos on travel subjects. "Not generally interested in scenic alone; want people in the photos-not posed, but active." Photos purchased with accompanying ms only; "exception usually for cover pho-

to." Model release optional; captions preferred.

Making Contact & Terms: Query with list of stock photo subjects. SASE. Reports in 2 weeks. Provide resume, brochure, flyer and tearsheets to be kept on file for possible future assignments. Pays an average of \$150-250/color photo (cover); \$35-50/color photo (inside); \$250-600 for text/photo package. Pays on acceptance. Credit line given. Buys one-time rights. Simultaneous submissions and/or previously published work OK, as long as not in territory of magazine circulation.

Tips: "Pay attention to our photo guidelines; provide us with catalog of subjects; pray a lot that we will

call you someday."

HOOF BEATS, 750 Michigan Ave., Columbus OH 43215. (614)224-2291. Executive Editor: Dean Hoffman. Managing Editor: Ed Keys. Publication of the U.S. Trotting Association. Monthly. Circ. 26,000. Emphasizes harness racing. Readers are participants in the sport of harness racing. Sample copy free

Photo Needs: Uses about 30 photos/issue; about 50% supplied by freelance photographers. Needs "artistic or striking photos that feature harness horses for covers; other photos on specific horses and drivers by assignment only."

Making Contact & Terms: Query with samples. SASE. Reports in 3 weeks. Pays \$150 + /color cover photo; freelance assignments negotiable. Pays on publication. Credit line given if requested. Buys one-

time rights. Simultaneous submissions OK.

Tips: "We look for photos with unique perspective and that display unusual techniques or use of light. Be sure to shoot pictures of harness horses only, not Thoroughbred or riding horses."

IMPRINT, 555 W. 57th St., New York NY 10019. Managing Editor: B.J. Nerone. Publication of the National Student Nurses' Association, Magazine published 5 times/year, Emphasizes education, health issues and health care for undergraduate students of nursing. Circ. 33,000. Sample copy \$4.

Photo Needs: Uses about 10-15 photos/issue; none currently supplied by freelance photographers Needs photos showing health care, current issues and education. Model release and captions required. Making Contact & Terms: Query with samples or list of stock photo subjects. SASE. Reports in 3 weeks. Pays \$50/b&w inside photo; other rates negotiable. Pays on publication. Credit line given. Simultaneous and previously published submissions OK.

INTERRACIAL BOOKS FOR CHILDREN BULLETIN, 1841 Broadway, New York NY 10023. (212)757-5339. Photo Editor: Ruth Charnes. Published 8 times/year. Circ. 5,000. Publication of Council on Interracial Books for Children. Emphasizes antiracism and antisexism in children's books for librarians, teachers, writers, editors and parents.

Photo Needs: Uses 0-10 photos/issue. Needs photos of "multiracial groups of children, nonsexist portrayals of children, multiracial children with adults, etc." Photos purchased with or without accompany-

ing ms. Model release preferred.

Making Contact & Terms: Query with samples. SASE. Reports in 4 weeks. Provide resume, business card and tearsheets to be kept on file for possible future assignments. Pays \$50 b&w cover, \$25 b&w inside. Pays on publication. Credit line given. Simultaneous submissions and/or previously published work OK.

*INTERNATIONAL CHRISTIAN NEWS, Box 489, Rush Springs OK 73082. (405)476-2383. Editor: Joan Hash Cox. Photo Editor: Tammy Cox. Religious, nondenominational association publication. Monthly newspaper. Emphasizes religious and inspirational articles. Readers are all ages of Christian people. Circ. 2,000. Estab. 1984. Sample copy \$1.50; photo guidelines free with SASE.

Photo Needs: All photos are supplied by freelance photographers. Needs photos which "tell a story; churches or cathedrals; anything with a religious point of view; holiday scenes; crosses." Model release

required.

Making Contact & Terms: Send unsolicited photos by mail for consideration; provide resume, business card, brochure, flyer or tearsheets to be kept on file for possible future assignments. Send 3x5 glossy or semi-glossy b&w prints. SASE. Reports in 2-6 weeks. Pays \$50/b&w cover photo, \$10-25/inside b&w photo, \$25-100/text/photo package. Pays on publication. Credit line given. Buys first North American serial rights. Simultaneous submissions and previously published work OK.

Tips: "We need to reach the photographers to get submissions that we need. We will print more photos if we had them, but now we are not getting the photo submissions to print. We feel our market is wide open for freelance submissions."

THE JOURNAL OF FRESHWATER, 2500 Shadywood Rd., Box 90, Navarre MN 55392. (612)471-7467, (612)471-8407. Editor: Linda Schroeder. Annual magazine. "The Journal explores the world of freshwater: how we affect it and how it affects us. The Journal's goal is to translate and interpret freshwater issues and their implications for the public, and to instill greater appreciation for the freshwater environment." Text/photo package is best, but will buy photos without accompanying ms. Buys 20-30 photos/issue. Credit line given. Pays on publication (November). Buys one-time rights or all rights, but may reassign to photographer after publication. Send material by mail for consideration. SASE. Previously published work "rarely" OK. Reports in 4-6 weeks. Sample copy \$6; free photo guidelines for SASE.

Subject Needs: All subjects should be very closely water-related. Animal, documentary, fine art, how-to, human interest, still life, nature, photo essay/photo feature, scenic, travel, sport and wildlife. "No marine or saltwater photos, special effects (must be seen as is in nature) or pollution pictures." Captions preferred. Columns needing photos include Freshwater Folio, a section of fine art photos.

B&W: Uses 5x7 or 8x10 glossy or matte prints. Pays \$50/photo. **Color:** Uses 35mm, 2¹/₄x2¹/₄ or 4x5 transparencies. Pays \$50/photo.

Cover: Uses glossy color prints or 35mm, 21/4x21/4, 4x5 or 8x10 color transparencies. Pays \$100-125/photo.

Accompanying Mss: "Factual, well-researched articles dealing with the freshwater biological world or with freshwater issues and their implications for the public." Pays \$100 per 1,000 words used. Free writer's guidelines for SASE.

Tips: "Our photography needs usually crystallize in the summer. From May to June is the time to send in speculative material."

JOURNAL OF PHYSICAL EDUCATION, RECREATION & DANCE, American Alliance for Health, Physical Education, Recreation & Dance, Reston VA 22091. (703)476-3400. Managing Editor: Barbara Beach. Monthly magazine. Emphasizes "teaching and learning in public school phsycial education, youth sports, youth fitness, dance on elementary, secondary, or college levels (not performances; classes only), recreation for youth, children, families, girls and women's athletics and physical education and fitness." Circ. 35,000. Sample copy free with SASE. Photo guidelines free with SASE. Photo Needs: Freelancers supply cover quotes only. Written release and captions preferred. B&w by contract.

Making Contact & Terms: Query with list of stock photo subjects. Buys 5x7 or 8x10 color prints and 35mm transparencies. Returns unsolicited photos with SASE. Reports in 2 weeks. Credit line given. Buys one-time rights. Previously published work OK.

*JOURNAL OF SCHOOL HEALTH, Box 708, Kent OH 44240. (216)678-1601. Editor: R. Morgan Pigg, Jr., HSD, MPH. Photo Editor: T.M. Reed. Association publication of the American School Health Association. Monthly journal except June/July. Emphasizes school health. Readers include health educators at all academic levels; school nurses, school physicians, counselors, psychologists and nutritionists. Circ. 8,000. Sample copy available.

Photo Needs: Uses cover shots; children; schools. Model release required.

Making Contact & Terms: Query with samples or send unsoclited photos by mail for consideration. Uses color prints. SASE. Reports in 2 weeks. Pays with a contributor's copy only. Credit line given. Previously published work OK.

JOURNAL OF THE SENSES, 814 Robinson Rd., Topanga CA 90290. (213)455-1000. Editor: Ed Lange. Publication of the Elysium Institute. Quarterly. Circ. 20,000. Emphasizes "human potential, body self-appreciation and self-image." Readers are students and educators. Sample copy for SAE and \$1 postage. Photo guidelines for SASE.

Photo Needs: Uses about 25 photos/issue; half supplied by freelance photographers. Needs photos of "people: intimate, emotional, joyous." Model release and captions required.

Making Contact & Terms: Query with samples; send b&w contact sheets by mail for consideration. SASE. Reports in 2 weeks. Pays \$30/b&w or color cover photo; \$20/b&w or color inside photo. Pays on publication. Credit line given. Buys all rights. Previously published work OK.

*JOURNAL OF SOIL AND WATER CONSERVATION, 7515 N.E. Ankeny Rd., Ankeny IA 50021. (515)289-2331. Editor: Max Schnepf. Association publication for the Soil Conservation Society of America. Bimonthly journal. Emphasizes land and water conservation. Readers include a multidisciplinary group of professionals and laymen interested in the wise use of land and water resources. Circ. 13,800. Free sample copy.

Photo Needs: Uses 25-40 photos/issue; 0-2 supplied by freelance photographers. Needs photos illustrating land and water conservation problems and practices used to solve those problems; including items related to agriculture, wildlife, recreation, reclamation, and scenic views. Reviews photos with or

without accompanying ms. Model release and captions preferred.

Making Contact & Terms: Send unsolicited photos by mail for consideration. Uses 5x7, 8x10 b&w prints, and 35mm, 21/4x21/4, 4x5 and 8x10 color transparencies; b&w contact sheet. SASE. Reports in 2 weeks. Pays \$50/color covers, \$10/up inside b&w. Pays on acceptance. Credit line given. Buys one-time rights.

KIWANIS MAGAZINE, 3636 Woodview Trace, Indianapolis IN 46268. (317)875-8755. Executive Editor: Chuck Jonak. Art Director: Jim Patterson. Published 10 times/year. Circ. 300,000. Emphasizes organizational news, plus major features of interest to business and professional men involved in community service. Send resume of stock photos. Provide brochure, calling card and flyer to be kept on file for future assignments. 'We work regularly with local freelancers who make an appointment with photo editor to show portfolio." Buys one-time rights.

B&W: Uses 8x10 glossy prints. Pays \$25-200/b&w photo.

Color: Uses 35mm but would rather use $2^{1/4}x2^{1/4}$ and 4x5 transparencies. Pays \$50-400/color photo. **Accompanying Mss:** Pays \$250-750/ms with photos. Free sample copy and writer's guidelines. **Tips:** "We are a nonprofit organization and subsequently do not have a large budget. But we can offer the photographer a lot of freedom to work *and* worldwide exposure. And perhaps an award or two if the work is good. We are now using more black and white and more conceptual photos, rather than studio set up shots. When we assign work, we want to know if a photographer can follow a concept into finished photo without on sight direction."

LACMA PHYSICIAN, Box 3465, Los Angeles CA 90054. (213)483-1581. Managing Editor: Howard Bender. Published 20 times/year—twice a month except January, July, August and December. Circ. 10,500. Emphasizes Los Angeles County Medical Association news and medical issues. Readers are physicians and members of LACMA.

Photo Needs: Uses about 1-20 photos/issue; 1-20 are supplied by freelance photographers. Needs photos of meetings of the association, physician members, association events—mostly internal coverage.

Photos purchased with or without accompanying ms. Model release required.

Making Contact & Terms: Arrange a personal interview to show portfolio. Does not return unsolicited material. Pays by hour, day or half day; negotiable. Pays on publication with submission of invoice. Credit line given. Buys one-time rights or first North American serial rights "depending on what is agreed upon."

Tips: Prefers to see "a wide variation, b&w and color of people, meetings, special subjects, etc. A good

overall look at what the photographer can do."

LANDSCAPE ARCHITECTURE, 1733 Conn Ave. NW, Washington DC 20009. (202)466-7730. Art Director: Pam Morrison. Publication of the American Society of Landscape Architects. Bimonthly magazine. Emphasizes "landscape architecture, urban design, parks and recreation, architecture, earth art" for professional planners and designers. Circ. 20,000. Sample copy \$4; photo guidelines free with SASE.

Photo Needs: Uses about 20-25 photos/issue; 1-5 supplied by freelance photographers. Needs photos of landscape- and architecture-related subjects as described above. Special needs include aerial photogra-

phy. Model release required, captions preferred.

Making Contact & Terms: Query with samples or list of stock photo subjects; provide resume, business card, brochure, flyer or tearsheets to be kept on file for possible future assignments. SASE. Reporting time varies. Pays \$100/color cover photo; \$35/b&w inside; \$50/color inside photo. Pays on publication. Credit line given. Buys one-time rights. Previously published submissions OK.

*LEFTHANDER MAGAZINE, Box 8249, Topeka KS 66608. (913)234-2177. Managing Editor: Susan Menendez. Publication of Lefthanders International. Emphasizes lefthandedness. Our readers are "lefthanders, mostly women between 25-40 who are college-educated. Mid-high income." Circ. 8,000. Sample copies free with SASE and \$2 postage. Guidelines free with SASE.

Photo Needs: Uses about 10 photos/issue; 20% supplied by freelance photographers. Needs "how-to, people, and still life photos—must relate to lefthanded athletes, celebrities." Prefers photos with manu-

scripts. Model release and photos required.

Making Contact & Terms: Query with samples. SASE. Reports in 3 weeks. Payment varies. Pays on publication. Credit line given. Simultaneous submissions and previously published work OK.

THE LION, 300 22nd St., Oak Brook IL 60570. (312)986-1700. Editor: Robert Kleinfelder. Monthly magazine. Circ. 650,000. For members of the Lions Club and their families. Emphasizes Lions Club

service projects. Works with freelance photographers on assignment only basis. Provide resume to be kept on file for possible future assignments. Buys 10 photos/issue. Buys all rights. Submit model release with photo. Query first with resume of credits or story idea. "Generally photos are purchased with ms (300-1,500 words) and used as a photo story. We seldom purchase photos separately." Pays \$50-100/page; \$50-400/text/photo package. Pays on acceptance. Reports in 2 weeks. SASE. Free sample copy and photo guidelines.

Subject Needs: Photos of Lions Club service or fundraising projects. "All photos must be as candid as possible, showing an activity in progress. Please, no award presentations, meetings, speeches, etc." B&W: Uses 5x7 or 8x10 glossy prints. Also accepts color prints and 35mm transparencies. Captions re-

quired. Pays \$10-25.

*THE LUTHERAN STANDARD, Box 1209, Minneapolis MN 55440. Editor: Lowell G. Almen. Publication of American Lutheran Church. Published 20 times/year. Emphasizes religion: Christian, Lutheran. Readers are members of congregations of the American Lutheran Church. Circ. 579,000. Sample copy and photo guidelines free with SASE.

Photo Needs: Uses 20 photos/issue; 7 supplied by freelance photographers. Especially need photos of

children, youth, minorities, family life. Reviews with or without accompanying ms.

Making Contact & Terms: Query with samples; send unsolicited photos by mail for consideration with SASE "Attention Photo Editor." Uses 8x10 b&w prints. Reports in 4-8 weeks. Pays \$40/b&w cover, \$15/b&w inside. Pays on publication. Credit line given in credits block at front of magazine. Buys one-time rights. Simultaneous submissions and previously published work OK.

*THE MAGAZINE FOR CHRISTIAN YOUTH!, Box 801, Nashville TN 37202. (615)749-6463. Editor: Sidney D. Fowler. Publication of The United Methodist Church. Monthly. Emphasizes what it means to be a Christian teenager in the 80's—developing a Christian identity and being faithful. Readers are junior and senior high teenagers (Christian). Circ. estimated 50,000. Estab. 1985. Free sample copy with SASE.

Photo Needs: Uses about 16 photos/issue; 11 supplied by freelance photographers. Needs photos of teenagers. Special needs include "up-to-date pictures of teens in different situations—at school, at home, with parents, friends, doing activities, etc. Need photos of both white and ethnics." Model release required. Query with samples and list of stock photo subjects; send unsolicited photos by mail for consideration. Send 8x10 b&w prints, 35mm, 2½x2¼ and 4x5 transparencies, and b&w contact sheet by mail for consideration. SASE. Reports in 1 month. Pays on acceptance. Credit line given. Buys one-time rights. Simultaneous submissions OK.

Tips: Prefers to see "quality photographs of teenagers in various situations, settings. Should appear realistic, not posed, and should be up-to-date in terms of clothing, trends (break-dancing, use of alcohol, hanging out in malls, etc). Photos of single teens plus some of teens with others. Give us photographs that don't look posed or set-up. Don't give us photos that are blurry and/or have bad compositions. Give

up pictures of today's teens.'

MAINSTREAM—ANIMAL PROTECTION INSTITUTE OF AMERICA, Box 22505, 5894 South Land Park Dr., Sacramento CA 95822. (916)422-1921. Publications Coordinator: Marta Lopez-Renasco. Publication of the Animal Protection Institute of America. Quarterly. Circ. 90,000. Emphasizes "humane education towards and about animal issues and events concerning animal welfare."

Readers are "all ages; people most concerned with animals." Sample copy available.

Photo Needs: Uses approximately 30 photos/issue; 15 supplied by freelance photographers. Needs "photos of animals in the most natural settings as possible. No limit as to which species. Photos of particular species of animals may be needed to highlight feature stories for future issues. We need to build our companion animal files. We also need photos of people and animals working together, photos of whales, dolphins, porpoises, endangered species, primates, animal experimentation and in factory farming. API also uses fine animal photos in various publications besides its magazine. Vertical format required for *Mainstream* covers." Model release and captions required.

B&W: Send 5x7 or 8x10 glossy prints.

Color: Send 35mm or 21/4x21/4 transparencies.

Making Contact & Terms: Query with resume and credits, samples or list of stock photo subjects. After query, send photos by mail for consideration. Provide business cards, brochure, flyer or tearsheets to keep on file for possible future assignments. We welcome all contacts. SASE. Reports in approximately 2 weeks. Pays \$150-200/color cover photo; \$20/b&w inside photo, \$50-150/color inside photo. Depends on each photograph and usage. Pays on publication. Credit line given. Buys one-time or all rights; if photographer will allow us to reprint with notification. Simultaneous submissions and previously published work OK.

Tips: "We prefer to see animals in natural settings. We need excellent quality photos."

*MAP INTERNATIONAL, Box 50, Brunswick GA 31520. (912)265-6010 or 800-225-8550 (interstate toll free). Association publication of MAP International. Bimonthly. Emphasizes the organization's efforts to distribute \$5 million in donated medicines and supplies to relief agencies in 75 countries in the developing world. Sample copy and photo guidelines free with SASE.

Photo Needs: "Specifically, we need photos depicting the health needs of people in the developing countries of Africa, Asia and Latin America, and the work being done to meet those needs." Captions

required.

Making Contact & Terms: Query with resume of credits; query with samples; query with list of stock photo subjects. Uses b&w 5x7 glossy prints; 35mm transparencies. SASE. Reports in 1 month. Pays \$75/b&w cover photo; \$35/b&w inside photo; payment for color photos individually negotiated. Pays on acceptance. Credit line given. Buys one-time rights. Simultaneous submissions and previously published work OK, "depending on where else they had been submitted or used."

Tips: "Photos should center on people: children, patients receiving medical treatment, doctors, community health workers with the people they are helping, hospitals, health development projects and informal health education settings. The kind of photography coming out of Ethiopia during its crisis is fairly typical of what we use although our interest is much broader than crisis situations and emergency aid

alone, and we frequently try to show the hopeful side of what is being done."

*MATURE YEARS, 201 Eighth Ave. S., Nashville TN 37203. (615)749-6438. Editor: Daisy Warren. Publication of the United Methodist Church Association. Monthly magazine. "Mature Years is a leisure-time resource for older adults in The United Methodist Church. It contains fiction, articles dealing with health, matters related to aging, poetry, and lesson material." Readers are "adults over fifty-five in The United Methodist Church. The magazine may be used in classroom, home, or nursing home." Circ.

100,000. Sample copies free with SASE.

Photo Needs: Uses about 15 photos/issue; all supplied by freelance photographers. Needs "mainly photos showing older adults in various forms of activities. We have problems finding older adults pictured as healthy and happy. We desperately need pictures of older adults that are in the ethnic minority. Making Contact & Terms: Query with list of stock photo subjects. Send 8x10 b&w glossy prints and any transparencies by mail for consideration. SASE. Reports in 1-2 weeks. Pays \$65-175/cover photo; \$10-45/inside photo. Pays on acceptance. Credit line given on copyright page. Buys one-time rights. Simultaneous submissions and previously published work OK.

Tips: Prefers to see "ethnic minority older adults, older adults who are healthy and happy-pictures portraying the beauty and wonder of God's creation. Remember that all older adults are not sick, desti-

tute, or senile."

THE MAYO ALUMNUS, Harwick 8, Mayo Clinic, Rochester MN 55905. (507)284-4084. Editor: Mary Ellen Landwehr. Quarterly magazine. Circ. 11,000. Alumni journal for Mayo Clinic-trained physicians, scientists and medical educators. Photos purchased with or without accompanying ms or on assignment. Pays \$20-50/hour, \$25-200/job, \$100-400 for text/photo package, or on a per-photo basis. Credit line given. Pays on acceptance. Buys all rights. Query with samples. SASE. Previously published work OK. Free sample copy.

Subject Needs: Human interest or photo essay/photo feature on Mayo-trained physicians, scientists and medical educators, "who are interesting people or who are involved in pertinent medical issues." Can-

not use photos of subjects unrelated to Mayo-trained physicians. Captions preferred.

B&W: Uses 8x10 glossy prints and transparencies; contact sheet or contact sheet with negatives OK. Also uses color. Pays \$3-10/photo.

Cover: Uses 35mm color transparencies. Horizontal and vertical wraparound or square format pre-

ferred. Pays \$25-100/photo.

Accompanying Mss: Needs human interest features on Mayo-trained physicians. Pays \$100-275/ms.

MISSISSIPPI STATE UNIVERSITY ALUMNUS, Box 5328, Mississippi State MS 39762. (601)325-3442. Editor: Linsey H. Wright. Quarterly magazine. Circ. 15,000. Emphasizes articles about Mississippi State graduates and former students. For alumni of Mississippi State University; readers are well educated and affluent. Photos purchased with accompanying ms. "Send us a well-written article that features Mississippi State University or its graduates or former students. We'll help with the editing, but the piece should be interesting to our alumni readers. We welcome articles about MSU grads in interesting occupations. We welcome profiles on prominent Mississipi State alumni in business, politics, medicine, the arts, the sciences, agriculture, public service and sports." Buys 3-4 annually, but welcomes more submissions. Buys one-time rights. Query or send complete ms. Pays on publication. SASE. Reports in 1 month. Simultaneous submissions and previously published work OK. Free sample copy.

B&W: Uses 8x10 prints. Captions required. Pays \$50-150, including ms.

Color: Uses 35mm transparencies.

Photographer's Market '86

Tips: "Write a story about an interesting MSU alumnus and illustrate it, or get a freelance writer to write the story and split the payment with him for the photos."

MODERN MATURITY, 215 Long Beach Blvd., Long Beach CA 90801. Editor: Ian Ledgerwood. Picture Editor: M.J. Wadolny. Bimonthly magazine. Circ. 11,000,000. For people over age 50. Needs "spectacular scenics" and photos dealing with "stories of interest to retired and working people in the following categories: human interest (celebrities in education, science, art, etc., as well as unknowns); practical information on health, finances, fashion, housing, food, etc.; inspiration; Americana; nostalgia; and crafts." Buys 100 photos/year. Buys first North American serial rights . Submit model release with photo. Send photos for consideration. Credit line given. Pays space rates. Reports in 1 month, SASE. Sample copy and free photo guidelines; enclose SASE.

B&W: Send 8x10 glossy prints. Captions required. Pays \$75 minimum. Color: Send transparencies. Captions required. Pays \$150 minimum.

Cover: Send color transparencies. "We occasionally use cover shots with people in them." Captions required. Pays \$600/inside cover, \$750/front cover.

MOMENTUM, National Catholic Educational Association, Suite 100, 1077 30th St. NW, Washington DC 20007. (202)293-5954. Editor: Patricia Feistrizer. Quarterly magazine. Circ. 16,000. For Catholic school administrators and teachers. Needs photos relevant to Catholic elementary and secondary education. Buys one-time rights. Credit line given. Reports in 3 weeks. Free sample copy.

B&W: Uses 8x10 glossy prints. Pays \$7.

THE MORGAN HORSE, Box 1, Westmoreland NY 13490. (315)736-8306. Photo Editor: Carol Misiaszek. Publication of the American Morgan Horse Association. Monthly. Circ. 9,000. Emphasizes Morgan horses. "The audience of The Morgan Horse is composed of primarily Morgan owners, breeders and horse enthusiasts in general. Over half of the readers are members of the American Morgan

Horse Association." Sample copy \$3; photo guidelines free with SASE.

Photo Needs: "The Morgan, being the model of versatility that it is, offers photographers a wide range of possibilities. Whether used for driving, dressage, jumping, trail riding, farming, ranch work, parading, or as a family pleasure horse, the Morgan's real asset is his versatility. Photos submitted should not only reflect the true natural beauty and action of the Morgan, but should also reflect his versatility. We're looking for not only beautiful pictures of Morgans, but also of people enjoying their Morgans. (Sorry, no show ring shots will be accepted.) We also publish a calendar each year in which we like to show the beauty and action of the Morgan horse." Model release required; captions preferred; "The following basic information should accompany each photo: 1) the horse's name and registration number, 2) the owner's name and address, 3) the location where the photo was taken, and 4) a model release. Your name and address should appear on the back of each photo as well. Photos and manuscript packages will also be considered."

Making Contact & Terms: Query with list of stock photo subjects or send 8x10 glossy color prints, 35mm, 21/4x21/4 or 4x5 color transparencies by mail for consideration. SASE. Reports in 1 month "but this may vary." Provide resume and tearsheets to be kept on file for possible future assignments. Pays \$50 minimum/color cover and \$5/b&w inside photo. Color for calendar and promotion use varies. Pays on publication. Credit line given. Buys one-time rights unless otherwise arranged. Simultaneous and previously published work OK. **Tips:** "When you do submit photos, be patient. Sometimes it takes weeks before a decision is made to

use or not to use a photo. We are always interested in creative photography. Hope to be hearing from you

soon."

MUSIC EDUCATORS JOURNAL, 1902 Association Dr., Reston VA 22091. (703)860-4000. Production Manager: Pamela Halonen. Publication of the Music Educators National Conference. Magazine published 9 times/year. Emphasizes music education. Readers are "private and public school music teachers, elementary through college level." Circ. 56,000. Sample copy for \$4.

Photo Needs: Uses approximately 20 photos/issue; "few" supplied by freelance photographers. Needs

"action shots of music teachers and students (black and white prints)." Payment varies. Written release

and captions required.

Making Contact & Terms: Arrange a personal interview to show portfolio. Payment varies. Pays on publication. Credit line given. Buys one-time rights. Simultaneous submissions and previously published work OK.

Tips: In a portfolio, prefers to see "quality and mood; human shots of music education situations."

MUZZLE BLASTS, Box 67, Friendship IN 47021. (812)667-5131. Editor: Maxine Moss. Publication of The National Muzzle Loading Rifle Association. Monthly. "Our publication relates to the muzzleloading firearms (rifles, pistol, shotguns), primitive aspects of these firearms and to our heritage as signified within early Americana history." Readers are "a membership audience of shooters of muzzleloading firearms, hunters, and historians desiring general information of the muzzle-loading era." Circ.

27,000 + . Sample copy free. Photo guidelines free upon request. Uses color only.

Photo Needs: Most photos are purchased from writers as part of text/photo packages, but "we will have a need for cover photos depicting the muzzle-loading era. We also use photos of paintings or will be glad to accept cover work in order to promote cover work of photographer. This only upon review of the material presented." Model release preferred; captions required.

Making Contact & Terms: Call to discuss needs. Reports in 2 weeks. "No rate schedule set up at

present." Credit line given. Previously published work OK.

Tips: "Past experience in rejecting photos has been due to poor lighting on subject matter. To bring out the richness of wood, embellished with silver inlay work, a photographer's knowledge of highlighting comes into play. When photographing a group of people, do not pose to face camera other than if it is only suitable with photo captions to identify those in the picture.'

THE NATIONAL FUTURE FARMER, 5632 Mount Vernon Highway, Box 15160, Alexandria VA 22309. (703)360-3600. Managing Editor: Michael Wilson. Publication of the Future Farmers of America. Bimonthly. Circ. 475,000. Emphasizes "youth in agriculture, production agriculture and agribusiness topics, former FFA members, general youth interest items for FFA members." Readers are "between ages 14-21, primarily male rural youth." Sample copy free. **Photo Needs:** Uses about 30-35 photos/issue; 5-10 supplied by freelance photographers. "Our largest

need is creative photos to use as illustration, photos that show FFA members as an illustration; usually the idea is so specific it must be assigned first, but general agriculture shots are used also." Model re-

lease and captions preferred.

Making Contact & Terms: Query with samples or list of stock photo subjects. SASE. Reports in 1 month, "sometimes longer." Pays \$75-100/color cover photo; \$15/b&w inside photo, \$25-35/color inside photo. Pays on acceptance. Credit line given. Buys all rights.

Tips: "Know the organization/magazine inside and out. If you really want to be accepted, submit a sto-

ry idea with illustration. We look for quality."

THE NATIONAL NOTARY, 23012 Ventura Blvd., Box 4625, Woodland Hills CA 91365. (818)347-2035. Editor-in-Chief: Milton G. Valera. Photo Editor: Deborah M. Thaw. Bimonthly. Circ. 40,000. Emphasizes "Notaries Public and notarization-goal is to impart knowledge, understanding and unity among Notaries nationwide and internationally. Readers are employed primarily in the following areas: law, government, finance and real estate. Sample copy \$4.

Photo Needs: Uses about 20-25 photos/issue; 10 are supplied by freelance photographers. "Photo subject depends on accompanying story/theme; some product shots used." Unsolicited photos purchased with accompanying ms only. Special needs include "Profile," biography of a specific notary, living anywhere in the United States. "Since photos are used to accompany stories or house ads, they cannot be too abstract or artsy. Notaries, as a group, are conservative, so photos should not tend towards an ultra-

modern look." Model release required.

Making Contact & Terms: Query with samples. Prefers to see prints as samples. Does not return unsolicited material. Reports in 4-6 weeks. Provide business card, tearsheets, resume or samples to be kept on file for possible future assignments. Pays \$25-300 depending on job. Pays on publication. Credit line given "with editor's approval of quality." Buys all rights. Previously published work OK.

Tips: "Since photography is often the art of a story, the photographer must understand the story to be able to produce the most complementary photographs. Trends are leading away from standard mugs or

poses and into a slightly more experimental range."

THE NATIONAL RURAL LETTER CARRIER, 1448 Duke St., Alexandria VA 22314. Managing Editor: RuthAnn Saenger. Weekly magazine. Circ. 65,000. Emphasizes Federal legislation and issues affecting rural letter carriers and the activities of the membership for rural carriers and their spouses and postal management. Photos purchased with accompanying ms. Buys 52 photos/year. Credit line given. Pays on publication. Buys first serial rights. Send material by mail for consideration or query with list of stock photo subjects. SASE. Previously published work OK. Reports in 4 weeks. Sample copy 34¢; photo guidelines free with SASE.

Subject Needs: Animal; geese and other hunting birds; wildlife; sport; celebrity/personality; documentary; fine art; human interest; humorous; nature; scenics; photo essay/photo feature; special effects & experimental; still life; spot news; and travel. Needs scenes that combine subjects of the Postal Service and rural America; "submit photos of rural carriers on the route." Especially needs for next year features of the state of Kentucky, particularly the city of Louisville. Model release and captions required.

B&W: Uses 8x10 glossy prints. Pays \$50/photo. Color: Uses 8x10 glossy prints. Pays \$50/photo.

Cover: Uses b&w or color glossy prints. Vertical format preferred. Pays \$50/photo.

Tips: "Please submit sharp and clear photos with interesting and pertinent subject matter. Study the publication to get a feel for the types of rural and postal subject matter that would be of interest to the membership. We receive more photos than we can publish, but we accept beginners' work if it is good."

NATIONAL UTILITY CONTRACTOR, Suite 606, 1235 Jefferson Davis, Arlington VA 22202. (703)486-5555. Director of Communications: Janis L. Hampton. Publication of the National Utility Contractors Association. Monthly. Circ. 11,000. Emphasizes underground, construction (sewer, water, electric line, gas line, etc.), by private construction companies. Readers are presidents and CEOs of private construction companies as well as suppliers, distributors and manufacturers of construction equipment and supplies. Sample copy available.

Photo Needs: Publishes photos "seldom;" "seldom" uses photos supplied by freelancers. Needs "primarily cover shots—4-color 35mm Kodachrome or larger format—of underground construction activi-

ty." Model release preferred; captions required.

Making Contact & Terms: Send 35mm, 21/4x21/4, 4x5 or 8x10 transparencies by mail for consideration. SASE. Reports in 1 month. Pays \$325/color cover photo; \$50/b&w inside photo. Pays on publication. Credit line given. Buys all rights; will negotiate "at photographer's preference." Simultaneous and previously published submissions OK.

Tips: "All photography requirements are keyed to articles by leading industry experts."

THE NATURE CONSERVANCY NEWS, Suite 800, 1800 N. Kent, Arlington VA 22209. (703)841-5377. Photo Editor: Susan Bournique. Publication of The Nature Conservancy. Bimonthly. Emphasizes "nature, rare and endangered flora and fauna, ecosystems in North and South America." Readers are the membership of The Nature Conservancy. Circ. 240,000.

Special Needs: Migrating waterfowl central flyway—Texas, Gulf Coast, Platt and Dakota potholes and Atlantic flyway. The Nature Conservancy welcomes permission to make duplicates of slides submitted

to the News for use in slide shows only.

Photo Needs: Uses about 17 photos/issue. Captions preferred (location and names of flora and fauna). Making Contact & Terms: Send stock photo list to be kept on file. Many photographers contribute the use of their slides. Uses color transparencies. Pays \$150/color cover photo; \$50-100/color inside photo. Pays on publication. Credit line given. Buys one-time rights. Previously published work OK.

Tips: "Membership in the Nature Conservancy is only \$10/year and the *News* will keep photographers up to date on what the Conservancy is doing in your state. Many of the preserves are open to the public. Occasionally submit updated stock photo lists as to where and what (species) you have added to your collection. We look for rare and endangered species, wetlands and flyways."

ND REC MAGAZINE, Box 727, Mandan ND 58554. Managing Editor: Dennis Hill. Publication of the ND Rural Electric Cooperatives. Monthly. Circ. 75,000. Emphasizes rural electrification and the rural lifestyle. Readers are rural or farm dwellers. Sample copy available.

Photo Needs: Uses about 12 photos/issue; 2-3 supplied by freelance photographers. "We're always

looking for attractive scenes of rural North Dakota for our 4-color cover."

Making Contact & Terms: Query with samples; send 35mm transparencies by mail for consideration. SASE. Pays \$25/color cover photo; \$5/b&w inside photo. Pays on acceptance. Credit line given on cover photos only. Buys one-time rights. Simultaneous and previously published submissions OK. Tips: "We cover North Dakota only, especially rural lifestyle."

NETWORK, The Paper for Parents, 410 Wilde Lake Village Green, Columbia MD 21044. (301)997-9300. Editor: Chrissie Bamber. Publication of the National Committee for Citizens in Education. Tabloid published 8 times/year. Circ. 6,000. Emphasizes "parent/citizen participation in public school." Readers are "parents, citizens, educators." Sample copy available.

Photo Needs: Uses various numbers photos/issue. Needs photos of "children (elementary and high school) in school settings or with adults (parents, teachers) shown in helping role." Model release re-

quired; captions preferred.

Making Contact & Terms: Query with samples. Send glossy prints, contact sheets or good quality duplicator facsimiles by mail for consideration. SASE. Reports in 2 weeks. Pays \$50/b&w cover photo; \$25/b&w inside photo. Pays on acceptance. Credit line given. Negotiates rights purchased. Simultaneous submissions and previously published work OK.

Tips: "Photos of school buildings and equipment are more appealing when they include children. Pic-

tures of children should be ethnically diverse."

NEW GUARD, Box 1002, Woodland Rd., Sterling VA 22170. (703)450-5162. Editor: R. Cort Kirkwood. Publication of Young Americans for Freedom. Emphasizes "politics, national and international events." Readers are "age 14-30. Virtually all are politically conservative with interests in politics, economics, philosophy, current affairs. Most are students or college graduates." Monthly. Circ. 20,000. Free sample copy.

Photo Needs: Uses about 60 photos/issue, 15 of which are supplied by freelance photographers. Needs photos of "political and politically related people, of political events (i.e., demonstrations, speeches, military battles, rallies, anything relating to political issues). Most freelance photos used are submitted by members of Young Americans for Freedom. Will select and use freelance photographers on basis of the relevance of their photos to the articles to be run in the magazine (must be current-affair or politically oriented)." Model release and captions not required.

Making Contact & Terms: Send by mail for consideration actual 5x7 or 8x10 b&w photos; query with resume of photo credits or list of stock photo subjects. SASE. Reports in 2 weeks. Credit line given.

Buys one-time rights. Simultaneous and previously published submissions OK.

NJEA REVIEW, 180 W. State St., Box 1211, Trenton NJ 08607. (609)599-4561, ext. 322. Editor: Martha O. DeBlieu. Monthly magazine (September-May). Circ. 120,000. Emphasizes educational issues for teachers and school personnel. Photos purchased with or without accompanying ms and on assignment. Provide resume, brochure, letter of inquiry, prices and samples to be kept on file for possible future assignments. Buys 25 photos/year. Credit line given. Pays on acceptance. Buys all rights, but may reassign to photographer after publication. Contact by mail only. SASE. Previously published work OK. Free sample copy.

Subject Needs: Celebrity (in New Jersey state government or on federal level in education); how-to (classroom shots); human interest (of children and school staff; classroom shots; shots of supportive staff, i.e., secretaries, custodians, bus drivers, cafeteria personnel, aids, etc.); wildlife (environmental education); photo essay/photo feature (of an educational nature); and shots of educational facilities.

Model release preferred.

B&W: Uses 5x7 glossy prints. Pays \$10-25/photo. **Cover:** Uses b&w glossy prints. Pays \$25-100/photo.

Accompanying Mss: Seeks mss on education. Pays \$50-250/ms. Writer's guidelines free on request. Tips: "Do not make fun of school staff or children in scene. We prefer a multiethnic approach."

NLADA CORNERSTONE, 1625 K St., N.W., Washington DC 20006. Editor-in-Chief: Maureen A. Murray. Bimonthly. Circ. 10,000. Emphasizes legal and public defender services to poor people. Readers are NLADA members—legal aid attorneys and professionals, clients, private attorneys, some news media and general public.

Photo Needs: Uses about 1 photo/issue; "none currently" are supplied by freelance photographers. Needs photos "of poor people, photos of legal aid going to poor people, poor neighborhoods, perhaps other photos depending on the article." Photos purchased with or without accompanying ms. Special needs include photos for general use, such as an annual report—are needed more than those for the pub-

lication. Model release and captions preferred.

Making Contact & Terms: Query with samples or with list of stock photo subjects. Prefers to see b&w samples of magazine work. Does not return unsolicited material. Reports in 1 month. Provide business card, flyer or tearsheets to be kept on file for possible future assignments. Payment negotiable. Pays on acceptance or publication. Credit line given "either on photo or in contents section." Buys all rights. Simultaneous submissions and previously published work OK.

NORTH AMERICAN HUNTER, Box 35557, Minneapolis MN 55435. Editor/Associate Publisher: Mark LaBarbera. Associate Editor: Bill Miller. Publication of North American Hunting Club Inc. Bimonthly. Circ. 100,000. Emphasizes hunting. Readers are all types of hunters with an eye for detail and an appreciation of wildlife. Sample copy \$3.

Photo Needs: Uses about 20 photos/issue; 1-2 supplied by freelance photographers; remainder bought as part of ms package. Needs "action wildlife centered in vertical format. North American game and ga-

mebirds only." Model release and captions required.

Making Contact & Terms: Send 35mm, $2^{1}/4$, 4x5 or 8x10 transparencies by mail for consideration or submit list of photos in your file. SASE. Reports in 1 month. Pays \$250/color cover photo; \$75-100/b&w photo; \$75-250/color photo. "We recently began paying \$100 for both b&w and color photos used $^{1}/_{2}$ page or larger inside, since they require equal effort from the photographer"; and \$225-325 for text/photo package. "Pays promptly on acceptance." Credit line given. Buys all rights.

Tips: "Practically all photos are purchased in conjunction with a manuscript/photo package. We want top quality photos of North American big game that depict a particular behavior pattern that members of the North American Hunting Club might find useful in pursuing that animal. Action shots are especially

sought. Get a copy of the magazine and check out the type of photos we are using."

OCAW REPORTER, (formerly Ocaw Union News), Box 2812, Denver CO 80201. (303)987-2229. Editor: Gerald Archuleta. Publication of the Oil, Chemical & Atomic Workers International Union. Bimonthly. Circ. 125,000. Emphasizes labor union, consumer, political and social topics, as well as job health and safety. Readers are principally blue-collar workers. Free sample copy.

Photo Needs: Uses about 75 photos/issue; 1-2 supplied by freelance photographers. Needs spot news-

related photos. Model release and captions required.

Making Contact & Terms: Send 8x10 b&w glossy prints by mail for consideration. SASE. Reports in 1 week. Pays \$25/b&w cover photo; \$20/b&w inside photo; \$35 minimum/hour; \$35 minimum/job. Pays on acceptance. Credit line given. Buys one-time rights or all rights; "depends on photo subject and whether photographer was hired for specific assignment." Simultaneous and previously published submissions OK.

OKLAHOMA TODAY, Box 53384, Oklahoma City OK 73152. (405)521-2496. Managing Editor: Kate Jones. Bimonthly magazine. "We are the official publication of the state of Oklahoma, published by the Department of Tourism and Recreation. We cover all aspects of Oklahoma, from history to people profiles, but we emphasize travel and tourism." Readers are "Oklahomans, whether they live in state or are exiles; studies show them to be above average in education and income." Circ. 26,000. Sample copy \$2; photo guidelines free with SASE.

Photo Needs: Uses about 50 photos/issue; 90-95% supplied by freelance photographers. Needs photos of "Oklahoma subjects only; the greatest number are used to illustrate a specific story on a person, place or thing in the state. We are also interested in stock scenics of the state." Model release preferred; cap-

tions required.

Making Contact & Terms: Query with samples or send 8x10 b&w glossy prints, 35mm, 21/4x21/4, 4x5, 8x10 transparencies or b&w contact sheets by mail for consideration. SASE. Reports in 4-6 weeks. Pays \$100-200/color cover photo; \$100/color page; \$25-75/b&w photo; \$50-200/color photo; \$50-600/by the job; \$250-750 for text/photo package. Payment for text material on acceptance; payment for photos as soon as layout is final and rate can be figured. Buys one-time rights, plus right to reproduce photo in promotions for magazine, without additional payment with credit line. Simultaneous and previously published submissions OK (on occasion).

Tips: "We love to see large-format color transparencies of people and places in Oklahoma; also high-

quality b&w prints and original approaches. No color prints. We're small-try us!"

OPERA NEWS, 1865 Broadway, New York NY 10023. (212)582-3285. Associate Editor: Gerald Fitzgerald. Published by the Metropolitan Opera Guild. Biweekly (December-April) and monthly (May-November) magazine. Emphasizes opera performances and personalities for operagoers, members of opera and music professions. Circ. 120,000. Sample copy \$2.50.

Photo Needs: Uses about 45 photos/issue; 15 supplied by freelance photographers. Needs photos of "opera performances, both historical and current; opera singers, conductors and stage directors." Cap-

tions preferred.

Making Contact & Terms: Query with samples; provide resume, business card, brochure, flyer or tearsheets to be kept on file for possible future assignments. SASE. Reporting time varies. Payment negotiable. Pays on publication. Credit line given. Buys one-time rights. Simultaneous submissions OK.

PACIFIC DISCOVERY, California Academy of Sciences, Golden Gate Park, San Francisco CA 94118. Editor: Sheridan Warrick. Quarterly magazine. Circ. 24,000. Journal of nature and culture worldwide, emphasizing natural history for scientists, teachers and nature lovers. Photos purchased with accompanying captions or text only. Buys 150 photos/year; 30-40 photos/issue. Credit line given. Pays on publication. Buys one-time rights. Send material by mail for consideration. SASE. Reports in 2-3 months. Sample copy and photo guidelines free with large SASE.

Subject Needs: Wildlife and nature. Captions required. Color and b&w. Uses color transparencies and

8x10 glossy prints. "We also make b&w conversions." Pays \$70-200/photo.

Accompanying Mss: Behavior and natural history of animals and plants; ecology; anthropology; geology; paleontology; biogeography; taxonomy; and natural science-related topics. Pays \$250-1,000/ms. Free writer's guidelines. "We favor series of photos that tell a story. Photographers will have the best chance if they think in editorial terms when they're shooting. Our favorite photographers seek out topics and people (authorities) and then behave as if they were writers: taking notes, interviewing scientists and taking pictures. Their submissions come in with obvious relationships to the subject-photos are very carefully edited into sections highlighting, for example, aspects of the natural history of an animal. Tips: Read the magazine and spec sheet; "then send photo story and text. On photo stories, queries are useless-what counts is the photos themselves. For us, the chances of freelancing are fine. Although we pay relatively little per shot, we usually buy 5-15 photos at once to go with a story. In captions or text accompanying photos of individual plants or animals include scientific names and be sure they're accurate."

*PASSAGES NORTH, Wm. Bonifas Fine Arts Center, Escanaba MI 49829. (906)786-3833. Editor: Elinor Benedict. Association publication for the William Bonifas Fine Arts Center (non profit). Semiannual tabloid. Emphasizes high-quality fiction and poetry. Readers include those interested in contemporary literature. Circ. 2,000. Sample copy \$1.50. General guidelines for all submissions free with SASE.

Photo Needs: Uses 15 photos/most issues; all supplied by freelance photographers. Needs b&w portfolios of work by single photographer as group of related work by more than one (guild, group, school,

etc.). Inquire with resume and 1 sample at first. Model release and captions preferred.

Making Contact & Terms: Query with resume of credits; provide resume, business card, brochure, flyer or tearsheets to be kept on file for possible future assignments. SASE. Reports in 1 month. Pays only in case of grants available; pre-arranged commissions. Credit line given. Pays on publication. Buys first North American serial rights.

Tips: "Send for sample issue first for \$1.50. We use few photos but still are interested."

PENNSYLVANIA ANGLER, Box 1673, Harrisburg PA 17105-1673. (717)657-4520. Editor: Art Michaels. Monthly. Circ. 68,000. "*Pennsylvania Angler* is the Keystone State's official fishing magazine, published by the Pennsylvania Fish Commission." Readers are "anglers who fish in Pennsylvania waterways." Sample copy free with 9x12 SASE and 73¢ postage. Photo guidelines free with SASE.

Photo Needs: Uses about 25 photos/issue; 75% supplied by freelance photographers. Needs "action

fishing and boating shots." Model release preferred; captions required.

Making Contact & Terms: Query with resume of credits, samples or list of stock photo subjects. Send 8x10 glossy b&w prints; 35mm or larger transparencies by mail for consideration. SASE. Reports in 2 weeks. Pays up to \$150/color cover photo; \$5-25/b&w inside photo, \$25 and up/color inside photo; \$50-250 for text/photo package. Pays on acceptance. Credit line given. Buys all rights. "After publication, rights can be returned to contributor."

Tips: "Consider a fishing subject that's been worked to death and provide materials with a fresh approach. For instance, take fishing tackle and produce extreme close-ups, or take a photograph from an unusual angle. Crisp, well-focused action shots get prompt attention. I can't seem to get enough of

these."

*PENNSYLVANIA HERITAGE, Box 1026, Harrisburg PA 17108-1026. (717)787-1396. Photo Editor: Linda Ries. Published by the Pennsylvania Historical & Museum Commission, The Official State History Agency for the Commonwealth of Pennsylvania. Quarterly magazine. Emphasizes Pennsylvania history and culture. Readers are "varied—generally well-educated with an interest in history, museums, travel, etc." Circ. 10,000. Sample copies free with SASE and 65¢ postage. Photo guidelines free with SASE.

Photo Needs: Uses approximately 75 photos/issue; "at this time, very few" supplied by freelance photographers. Needs photos of "historic sites, artifacts, travel, scenic views, objects of material culture, etc." Photos purchased with accompanying ms only. "We are generally seeking illustrations for specific

manuscripts." Captions required.

Making Contact & Terms: Query with samples and list of stock photo subjects. Provide resume, business card, brochure, flyer or tearsheets to be kept on file for possible future assignments. SASE. Reports in 1 month. Pays \$100/color cover photo; \$5/b&w inside photo; \$25/color inside photo. Pays on acceptance. Credit line given. Buys all rights. Simultaneous submissions OK.

THE PENNSYLVANIA LAWYER, 100 South St., Harrisburg PA 17108. (717)238-6715. Editor: Donald C. Sarvey. Publication of the Pennsylvania Bar Association. Published 7 times/year. Circ. 26,000. Emphasizes "news and features about law and lawyering in Pennsylvania." Readers are "the 23,000 members of the Pennsylvania Bar Association plus allied professionals and members of the Pennsylvania press corps." Sample copy free with SASE.

Photo Needs: Uses about 12 photos/issue; "very few" supplied by freelance photographers. "Mostly we use photos of individuals about whom we are writing or photos from association functions; some-

times photos to illustrate special story subject." Model release and captions preferred.

Making Contact & Terms: Query with resume of credits. Provide resume, business card, brochure, flyer or tearsheets to be kept on file for possible future assignments. SASE. Reports in 2 weeks. Pays up to \$200/b&w cover photo; up to \$50/b&w inside photo. Pays on acceptance. Credits listed on contents page. Buys one-time rights. Simultaneous submissions and previously published work OK.

PENTECOSTAL EVANGEL, 1445 Boonville, Springfield MO 65802. (417)862-2781. Editor: Richard G. Champion. Managing Editor: Harris Jansen. Weekly magazine. Circ. 290,000. Official organ of the Assemblies of God, a conservative Pentecostal denomination. Emphasizes denomination's activities and inspirational articles for membership. Credit line given. Pays on acceptance. Buys one-time rights; all rights, but may reassign to photographer after publication; simultaneous rights; or second serial (reprint) rights. Send material by mail for consideration. SASE. Simultaneous submissions and previously published work OK. Reports in 1 month. Free sample copy and photo guidelines.

Photo Needs: Uses 25 photos/issue; 5 supplied by freelance photographers. Human interest (very few

children and animals). Also needs seasonal and religious shots. "We are interested in photos that can be used to illustrate articles or concepts developed in articles. We are not interested in merely pretty pictures (flowers and sunsets) or in technically unusual effects or photos." Model release and captions preferred. **B&W:** Uses 8x10 glossy prints any size providing enlargements can be made. Pays \$10-20/photo.

Color: Uses 8x10 prints or 35mm or larger transparencies. Pays \$15-50/photo.

Cover: Uses color 21/4x21/4 to 4x5 transparencies. Vertical format preferred. Pays \$25-60/color.

Accompanying Mss: Pays 21/2-4¢/word. Free writer's guidelines.

Tips: "Writers and photographers must be familiar with the doctrinal views of the Assemblies of God and standards for membership in churches of the denomination. Send seasonal material 6 months to a year in advance—especially color."

THE PENTECOSTAL MESSENGER, Box 850, Joplin MO 64802. (417)624-7050. Editor: Don Allen. Monthly magazine. Circ. 10,000. Official publication of the Pentecostal Church of God. Buys 20-30 photos/year. Credit line given. Pays on publication. Buys second serial rights. Send samples of work for consideration. SASE. Simultaneous submissions and previously published work OK. Reports in 4 weeks. Free sample copy with 9x12 SASE; free photo guidelines with SASE.

Subject Needs: Scenic; nature; still life; human interest; Christmas; Thanksgiving; Bible and other religious groupings (Protestant). No photos of women or girls in shorts, pantsuits or sleeveless dresses. No

men with cigarettes, liquor or shorts.

Cover: Uses 8x10 color prints. Pays \$25/photo; 3½x5 color prints. Vertical format required. Tips: "We must see the actual print or slides (120 or larger). Do not write on back of picture; tape on name and address. Enclose proper size envelope and adequate postage. We need open or solid space at top (preferably left) of photo for name of magazine. We also print in the foreground often. Several seasonal photos are purchased each year. In selecting photos, we look for good composition, good color and detail. We anticipate the use of *more* photography (and less art) on covers. Most of our cover material comes from stock material purchased from freelance photographers."

PHI DELTA KAPPAN, Box 789, Bloomington IN 47402. (812)339-1156. Editor-in-Chief: Dr. Robert Cole, Jr. Photo Editor: Kristin Herzog. Publication of Phi Delta Kappa, Inc. Monthly (September-June). Circ. 140,000. Education magazine. Readers are "higher education administrators, curriculum and counseling specialists, professional staffs, consultants and state and federal education specialists." Sample copy \$2.50; photo guidelines free with SASE.

Photo Needs: Uses 2-3 b&w photos/issue; "very few supplied by freelancer—we would use more if appropriate photos were submitted." Needs 1) portrait shots of newsmakers in education; 2) news photos of education and related events; 3) thematic shots that symbolically portray current issues: i.e., desegregation, computer learning, 4) teacher/child interaction, classroom scenes." Model release required. Making Contact & Terms: Query with samples or with list of stock photo subjects. Send 5x7 or 8x10 b&w prints or photo copies by mail for consideration. We do not use color photos." Provide business card, to be kept on file for possible future assignments. SASE. Reports in 3 weeks. Pays \$15-35/b&w inside photo. Pays on acceptance. Credit line given. Buys one-time rights. Simultaneous submissions and previously published work OK.

Tips: Prefers to see "good technical quality, good composition; content related to our editorial subject matter and style. *Read* the publication before submitting—most libraries have copies. Do what we ask and do it on time. Get model releases. If I don't have a release I can't run the photo no matter how great it

is."

*PHOTO MARKETING MAGAZINE, 3000 Picture Place, Jackson MI 49201. (517)788-8100. Editor: Therese Wood. Publication of Photo Marketing Association International. Monthly. Emphasizes photography. Readers are photo retailers, photo processors and manufacturers who are in the business of marketing photo products. Circ. 15,000. Sample copy free with SASE.

Photo Needs: Uses about 3 photos/issue; 0-1 supplied by freelance photographers. Needs how-to—business for camera store, i.e., how to sell telescopes would use an action shot of salesperson demon-

strating features. Model release and captions required.

Making Contact & Terms: Provide resume, business card, brochure, flyer or tearsheets to be kept on file for possible future assignments. Does not return unsolicited material. Reports in 3 weeks. Pays \$75-150/b&w inside photo; \$75-150/color inside photo; \$250-650/text/photo package. Pays on acceptance. Credit line given. Buys first North American serial rights. Simultaneous submissions OK. "Know my market/needs before submitting."

PLANNING, American Planning Association, 1313 E. 60th St., Chicago IL 60637. (312)955-9100. Monthly magazine. Circ. 25,000. Editor: Sylvia Lewis. Photo Editor: Richard Sessions. "We focus on urban and regional planning, reaching most of the nation's professional planners and others interested in the topic." Photos purchased with accompanying ms and on assignment. Buys 50 photos/year. Credit

line given. Pays on publication. Buys all rights. Query with samples. SASE. Previously published work

OK. Reports in 1 month. Free sample copy and photo guidelines.

Subject Needs: Photo essay/photo feature (architecture, neighborhoods, historic preservation, agriculture); scenic (mountains, wilderness, rivers, oceans, lakes); housing; and transportation (cars, railroads, trolleys, highways). "No cheesecake; no sentimental shots of dogs, children, etc.; no trick shots with special filters or lenses. High artistic quality is very important." Captions required.

B&W: Uses 8x10 glossy and semigloss prints; contact sheet OK. Pays \$35-100/photo.

Cover: Uses 4-color; 35mm or 4x5 transparencies. Pays up to \$250/photo.

Accompanying Mss: "We publish high-quality nonfiction stories on city planning and land use. Ours is an association magazine but not a house organ, and we use the standard journalistic techniques: interviews, anecdotes, quotes. Topics include energy, the environment, housing, transportation, land use, agriculture, neighborhoods, urban affairs." Pays \$200 maximum/ms. Writer's guidelines included on photo guidelines sheet.

Tips: "Just let us know you exist. Eventually, we may be able to use your services. Send tear sheets or photocopies of your work, or a little self-promo piece. Subject lists are only minimally useful. How the

work looks is of paramount importance."

POLICE TIMES, Voice of Professional Law Enforcement, 1100 NE 125th St., North Miami FL 33161. (305)891-1700. Managing Editor: Gerald Arenberg. Published 8 times/year. Circ. 100,000. Emphasizes "law enforcement and other police-related activities." Readers are "members of the law enforcement community."

Photo Needs: Needs "action photos, b&w preferred. Photos dealing with law enforcement trends and

events."

Making Contact & Terms: SASE. Pays \$5-10 for each photo used. Pays on acceptance.

*THE PRACTICAL REAL ESTATE LAWYER, A11, 4025 Chestnut St., Philadelphia PA 19104. (215)243-1655. Editor: Mark Carroll. Photo Editor: Robert O'Leary. Bimonthly. Emphasizes real etate law. Readers include lawyers. Estab. 1985. Sample copy available.

Photo Needs: Photos of skylines, commercial real estate. Needs pictures of buildings, specifically sky-

scrapers.

Making Contact & Terms: Query with samples and list of stock photo subjects. Send b&w 8½x10 glossy, matte prints. Reports in 1 week. Payment individually negotiated. Pays within 6 weeks. Credit line given. Buys one-time rights. Simultaneous submissions and previously published work OK.

Tips: "Please query me first, our needs are very limited."

THE PRESBYTERIAN RECORD, 50 Wynford Dr., Don Mills, Ontario, Canada M3C 1J7. (416)441-1111. Production Editor: Mary Visser. Monthly magazine. Circ. 77,320. Emphasizes subjects related to The Presbyterian Church in Canada, ecumenical themes and theological perspectives for church-oriented family audience. Uses 2 photos/issue by freelance photographers.

Subject Needs: Religious themes related to features published. No formal poses, food, nude studies, al-

coholic beverages, church buildings, empty churches or sports. Captions are required.

Specs: Uses prints only for reproduction; 8x10, 4x5 glossy b&w prints and 35mm and 2½x2½ color transparencies. Usually uses 35mm color transparency for cover or ideally, 8x10 transparency. Vertical format used on cover.

Accompanying Mss: Photos purchased with or without accompanying mss.

Making Contact: Send photos. SASE. Reports in 1 month. Free sample copy and photo guidelines. Payment & Terms: Pays \$5-25/b&w print, \$35-50/cover photo and \$20-50 for text photo package. Credit line given. Pays on publication. Simultaneous submissions and previously published work OK. Tips: "Unusual photographs related to subject needs are welcome."

PRINCETON ALUMNI WEEKLY, 41 William St., Princeton NJ 08540. (609)452-4885. Editor-in-Chief: Charles L. Creesy. Photo Editor: Margaret Keenan. Publication of the Princeton Alumni Association. Biweekly. Circ. 50,000. Emphasizes Princeton University and higher education. Readers are alumni, faculty, students, staff and friends of Princeton University. Sample copy \$1.

Photo Needs: Uses about 15 photos/issue; 10 supplied by freelance photographers. Needs photos of "people, campus scenes; subjects vary greatly with content of each issue. Show us photos of Prince-

ton." Captions required.

Making Contact & Terms: Arrange a personal interview to show portfolio. Provide brochure to be kept on file for possible future assignments. SASE. Reports in 1 month. Pays \$50/b&w and \$100/color cover photos; \$20/b&w inside photo; \$40/color inside photo; \$35/hour. Pays on publication. Buys one-time rights. Simultaneous submissions and previously published work OK.

*PRINCIPAL MAGAZINE, 1615 Duke St., Alexandria VA 22314-3406. (703)684-3345. Editor: Lee Greene. Association publication of the National Association of Elementary School Principals. Bi-

monthly. Emphasizes public education—kindergarten to 8th grade. Readers are mostly principals of el-

ementary and middle schools. Circ. 23,000. Sample copy free with SASE.

Photo Needs: Uses 5-10 photos/issue; all supplied by freelance photographers. Needs photos of school scenes (classrooms, playgrounds, etc.); teaching situations; school principals at work. No posed groups. Closeups preferred. Reviews photos with or without accompanying ms. Special needs include seasonal scenes (especially fall and winter); children playing in school setting (indoors or outdoors). Model release preferred; captions required.

Making Contact & Terms: Arrange a personal interview to show portfolio; query with samples and list of stock photo subjects; send unsolicited photos by mail for consideration. Send b&w prints; 35mm and 21/4x21/4 transparencies; b&w and color contact sheet by mail for consideration. SASE. Reports in 1 month. Pays \$200/color cover photo; \$50/b&w inside photo; \$150/day. Pays on publication. Credit line given. Buys one-time rights and all rights. Simultaneous submissions and previously published work

OK.

PROBE, 1548 Poplar Ave., Memphis TN 38104. (901)272-2461. Editor: Timothy C. Seanor. Monthly magazine. Circ. 50,000. For boys age 12-17 who are members of a mission organization in Southern Baptist churches. Photos purchased with or without accompanying ms. Buys 30 photos/year. Credit line given. Pays on acceptance. Buys one-time rights. Send material by mail for consideration. SASE. Simultaneous submissions and previously published work OK. Reports in 1 month. Free sample copy and photo guidelines with 9x12 SASE and \$1.18 postage.

Subject Needs: Celebrity/personality (with Christian testimony) and photo essay/photo feature (teen interest, school, nature/backpacking, sports, religious). No "posed, preachy shots that stretch the point.

We like teens in action." Captions required.

B&W: Uses 8x10 glossy prints. Pays \$20/photo.

Accompanying Mss: Seeks mss on subjects of interest to teens, sports and the religious activities of

teens. Pays 31/2¢/word. Free writer's guidelines.

Tips: "We look for action shots, clear focus, good contrast and dramatic lighting. We target 14-15 yearold males. Coed shots welcome.'

THE PSYCHIC OBSERVER, Box 8606, Washington DC 20011. (202)723-4578. Publisher: Rev. Henry J. Nagorka. Published by the National Spiritual Science Center. Bimonthly. Emphasizes parapsychology, metaphysics, frontiers of science. Readers are 12 years old and up. Circ. 10,000. Sample copy \$1.50.

Photo Needs: Uses about 6-10 photos/issue; all supplied by freelance photographers. "All paranormal, major events, famous individuals in the psychic field." Special needs include "documentation of psychic events." Model release required; captions preferred.

Making Contact & Terms: Query with samples. SASE. Reports in 1 month. Pays on publication; \$25/ b&w photo. Credit line given. Buys all rights.

Tips: "We look for documentation and portraiture of events and persons in psychic phenomena, frontiers, or science. Become acquainted with parapsychology."

*THE QUILL, 840 N. Lake Shore Dr., Chicago IL 60611. (312)649-0129. Editor: Ron Dorfman. Art Director: Kate Friedman. Publication of the Society of Professional Journalists. Monthly. Circ. 30,000. Emphasizes journalism. Readers are "professional journalists in all media; students and teachers of journalism." Sample copy \$1.

Photo Needs: "Very few. Assignments made in connection with articles."

Making Contact & Terms: Provide resume, business card, brochure, flyer or tearsheets to be kept on file for possible future assignments. Reports in 2 weeks. Pays \$300/color cover photo; \$150/b&w page. Pays on acceptance. Credit line given. Buys one-time rights.

REAL ESTATE TODAY, 430 N. Michigan Ave., Chicago IL 60611-4087. (312)329-8277. Editor: Karin L. Nelson. Publication of the National Association of Realtors. Published 9 times/year. Circ. 680,000. Emphasizes "real estate for active practitioners. We cover residential sales, brokerage-management and commercial-investment sales." Readers are "real estate brokers and salespeople, most of whom are members of the Association; approximately 80% are salespeople." Sample copy available on request.

Photo Needs: Uses about 14 photos/issue (plus photos with mss) supplied by freelance photographers. B&w and 4-color. "Subject matter depends entirely upon the articles to be published. Usually, we assign a project to a photographer based upon our immediate needs." Reviews photos with accompanying ms or appropriate press release only. Special needs include photos relating to "energy conservation in housing and commercial buildings, or to rehabbed and adaptive reuse of commercial buildings." Model release and caption information required.

Making Contact & Terms: Query with resume of credits or samples; provide resume, business card,

brochure, flyer or tearsheets to be kept on file for possible future assignments. SASE. Reports in 1 month. Pay is negotiable and based on the particular assignment. Pays on "acceptance and submission of invoice." Credit line given "if desired. We prefer to buy all rights, but will negotiate."

Tips: "Contact us with query letter, samples, etc. We maintain a file and will call if our needs and photographer's portfolio match up. Best tip: ask for a copy of our magazine to see if what we do is what you

do.'

THE RETIRED OFFICER MAGAZINE, 201 N. Washington St., Alexandria VA 22314. (703)549-2311. Associate Editor: Marjorie J. Seng. Monthly. Circ. 345,000. Publication represents the interests of retired military officers from the seven uniformed services: history (particulary Vietnam, Korea, and WWII), travel, hobbies, humor, second-career job opportunities and current affairs. Readers are officers or warrant officers from the Army, Navy, Air Force, Marine Corps, Coast Guard, Public Health Service and NOAA. Free sample copy and photo guidelines.

Photo Needs: Uses about 24 photos/issue; 1 (the cover) usually supplied by freelance photographers. "We use many scenics showing areas across the country. We hope to run more people shots of Americans or of those native to a particular foreign country featured in a particular issue. We're always looking for holiday-related (Christmas, Veteran's Day, Fourth of July) shots with a military theme." Model re-

lease not needed; prefers captions and credit line on a separate sheet.

Making Contact & Terms: Send original 35mm, 2x2 or 4x5 transparencies by mail for consideration. SASE. Reports in 3 weeks. Pays \$125/color cover photo; \$20/color or b&w inside photo. Pays on acceptance. Credit line and complimentary copies given. Buys first serial rights. Previously published submissions OK.

Tips: "Be persistent. If we return all your samples the first time, query us again three to four months later. Some photographers regularly send samples. Keep in mind we're a patriotic organization-color shots of flags or patriotic events (or people at patriotic events) are what works best for us."

RODEO NEWS, INC., Box 587, Pauls Valley OK 73075. (405)238-3310. Associate Editor: G. Del Hollingsworth. Publication of the International Professional Rodeo Association. Monthly (December-January combined-11 issues). Circ. 15,000 + . Emphasizes rodeo. Readers are "rodeo contestants, producers, stock contractors, committees and fans." Sample copy and photo guidelines free.

Photo Needs: Uses about 30-40 photos/issue; 100% supplied by freelance photographers. Needs "rodeo action, arena shots and rodeo-related still shots. Must have identifying cutlines." Captions required. Making Contact & Terms: Send 5x7 or 8x10 b&w or color glossy prints by mail for consideration. SASE. Reports in 2 weeks. Pays negotiable rate. Pays on publication. Credit line given. Buys all rights.

THE ROTARIAN, 1600 Ridge Ave., Evanston IL 60201. (312)328-0100. Editor: Willmon L. White. Photo Editor: Judy Lee. Monthly magazine. Circ. 488,000. For Rotarian business and professional men and their families in 159 countries and geographical regions. "Our greatest need is for the identifying face or landscape, one that says unmistakably, 'This is Japan, or Minnesota, or Brazil, or France, or Sierra Leone,' or any of the other countries and geographical regions this magazine reaches." Buys 10/issue. Buys first-time international rights. Query with resume of credits or send photos for consideration. Pays on acceptance. Reports in 1-2 weeks. SASE. Free sample copy and photo guidelines.

B&W: Uses 8x10 glossy prints; contact sheet OK. Pays \$35. Color: Uses 8x10 glossy prints or transparencies. Pays \$75-100.

Cover: Uses color transparencies. Photos are "generally related to the contents of that month's issue."

Tips: "We prefer vertical shots in most cases. The key words for the freelance photographer to keep in mind are internationality and variety. Study the magazine. Read the kinds of articles we publish. Think how your photographs could illustrate such articles in a dramatic, story-telling way. Key submissions to general interest, art-of-living material." Plans special pre-convention promotion coverage of 1986 Rotary International convention in Las Vegas, Nevada.

*ROWING USA, #4 Boathouse Row, Philadelphia PA 19130. (215)769-2068. Editor: Kathryn Reith. Publication of the U.S. Rowing Association. Bimonthly magazine. Emphasizes competitive and recreational rowing. Readers are competitive and recreational rowers, male and female, ages from 12 to 90. Circ. 11,500. Sample copies \$3.

Photo Needs: Uses about 20 photos/issue; 15 supplied by freelance photographers. Needs "rowing pho-

tos, particularly news photos of large regattas." Captions preferred.

Making Contact & Terms: Query with samples. SASE. Reports in 3 weeks. Pays \$100/b&w cover photo and \$25/b&w inside photo. Pays on publication. Credit line given. Buys one-time rights. Simultaneous submissions OK.

Tips: Prefers to see "just good rowing photos—no cliches."

ST. LAWRENCE, Publication Office, St. Lawrence University, Canton NY 13617. (315)379-5586. Editor: Neal S. Burdick. Publication of St. Lawrence University. Quarterly. Circ. 21,000. Coverage is

"limited exclusively to St. Lawrence University, a small, private, highly selective liberal arts college." Readers are "college graduates, many with advanced degrees; and parents of college students." Sample copy \$2.

Photo Needs: Uses about 40 photos/issue; 20 supplied by freelance photographers. Needs "all kinds of

photos." Model release preferred; captions required.

Making Contact & Terms: Arrange a personal interview to show portfolio; query with list of stock photo subjects. SASE. Reports in 1 week. Pays \$125/color cover photo; \$10/b&w inside photo; \$15-40/hour. Pays on acceptance. Buys all rights. Simultaneous and previously published submissions OK.

*SAM ADVANCED MANAGEMENT JOURNAL, 2331 Victory Pkwy., Cincinnati OH 45206. (513)751-4566. Editor: Dr. M.H. Abdelsamad. Association publication for the Society for Advancement of Management. Quarterly journal. Emphasizes business management. Readers are upper- and middle-level management executives. Circ. 13,000. Sample copy \$6.

Photo Needs: Uses 8 photos/issue. Needs photos of business subjects. Reviews photos with accom-

panying ms only. Model release required.

Making Contact & Terms: SASE. Reports in 1 month. Pays on publication. Credit line given. Simultaneous submissions and previously pulbished work OK.

SAVINGS INSTITUTIONS, 111 E. Wacker Dr., Chicago IL 60601. (312)644-3100. Editor: Lee Crumbaugh. Publication of the U.S. League of Savings Insitutions. Monthly. Circ. 30,000. Emphasizes savings-institution management. Free sample copy.

Photo Needs: Uses about 25 photos/issue; 5 supplied by freelance photographers, 3-5 photos on assign-

ment, 2-3 firm stock. Model release preferred.

Making Contact & Terms: Query with samples; provide resume, business card, brochure, flyer or tearsheets to be kept on file for possible future assignments. SASE. Reports in 1 month. Payment varies. Pays on acceptance. Credit line given "if requested." Rights purchased vary. Previously published submissions OK.

Tips: "We're looking for photos that fit our style. Request a sample of the publication to see this. Good luck. Keep plugging."

*SCIENCE AND CHILDREN, 1742 Connecticut Ave. NW, Washington DC 20009. (202)328-5800. Editor: Phyllis R. Marcuccio. Association publication for the National Science Teachers. Published 8 times/year, September-May. Emphasizes science education. Readers include teachers of science in grades K-8. Circ. 16,500. Free sample copy and photo guidelines with SASE.

Photo Needs: Uses 20 photos/issue; 5 supplied by freelance photographers. Needs "children and young adolescents participating in science activities outdoors or indoors; teachers leading such activities." Reviews photos with or without accompanying ms. Photographers must hold model release; captions re-

quired.

Making Contact & Terms: Query with samples and list of stock photo subjects; or send unsolicited photos by mail for consideration. Uses b&w prints, 35mm transparencies, b&w contact sheets. SASE. Pays \$50/color cover photo, \$35 b&w inside photo. Pays on acceptance. Credit line given. Buys first North American serial rights.

SCOUTING MAGAZINE, Boy Scouts of America, 1325 Walnut Hill Lane, Irving Tx 75062. Photo Editor: Gene Daniels. Bimonthly magazine. Circ. 1,000,000. For adults within the Scouting movement. Needs photos dealing with success and/or personal interest of leaders in Scouting. Wants no "single photos or ideas from individuals unfamiliar with our magazine." Pays \$200 per day against space. "No assignments will be considered without a portfolio review by mail or in person." Call to arrange a personal appointment, or query with ideas. Buys first rights only. Pays on acceptance. Reports in 10 working days. SASE. Free photo guidelines.

SEA FRONTIERS, 3979 Rickenbacker Causeway, Virginia Key, Miami FL 33149. (305)361-5786. Editor-in-Chief: Dr. F.G. Walton Smith. Photo Editor: Jean Bradfisch. Bimonthly magazine. Circ. 40,000. For anyone with an interest in any aspect of the sea, the life it contains and its conservation. Buys 80 photos annually. Buys one-time rights. Send photos for consideration. Credit line given. Pays on publication. Reports in 10 weeks. SASE. Sample copy \$2.50; photo guidelines for business-sized SAE with 22¢ postage.

Subject Needs: Animal (marine); nature (marine); photo feature (marine); scenic (marine); wildlife (marine); vessels, structures and geological features; ocean-related subjects only.

B&W: Send 8x10 glossy prints. Captions required. Pays \$10 minimum.

Color: Send 35mm or 21/4x21/4 transparencies. Captions required. Pays \$15 minimum.

Cover: Send 35mm or 21/4x21/4 color transparencies. Captions required. Uses vertical format. Allow space for insertion of logo. Pays \$50 for front cover and \$35 for back cover.

*THE SECRETARY, 301 East Armour Blvd., Kansas City MO 64111-1299. (816)531-7010. Editor: Shirley S. Englund. Association publication of the Professional Secretaries International. Published 9 times/year. Emphasizes secretarial profession-proficiency, continuing education, new products/methods, and equipment related to office administration/communications. Readers include career secretaries, 98% women, in myriad offices, with wide ranging responsibilities. Circ. 50,000. Free sample copy

Photo Needs: Uses 6 photos/issue. Needs secretaries (predominately women, but occasionally men could be used) in appropriate and contemporary office settings using varied office equipment or performing varied office tasks. Must be in good taste and portray professionalism of secretaries. Reviews

photos with or without accompanying ms. Model release preferred.

Making Contact & Terms: Query with samples or send unsolicited photos by mail for consideration. Uses 3½x4½, 8x10 glossy prints, 35mm, 2½x2¼, 4x5 and 8x10 transparencies. SASE. Reports in 1 month, Pays on publication. Credit line given. Buys first North American serial rights, Simultaneous submissions and previously published work OK.

SECURITY MANAGEMENT, 1655 N. Fort Myer Dr., Arlington VA 22209. (703)522-5800, Managing Editor: Pamela James Blumgart. Monthly magazine. Circ. 23,000. Emphasizes security and loss prevention programs, techniques and news. Photos purchased with or without accompanying ms, and on assignment. Generally works with freelance photographers on assignment only basis. Provide resume, brochure, flyer, letter of inquiry and tearsheet to be kept on file for possible future assignments. Buys 5-10 photos/year. Pays \$10-200/job or text/photo assignment, or on a per-photo basis. Credit line given. Pays on acceptance if photo fits particular need; pays on publication if photo is for use for particular piece. Buys one-time rights. Query with list of stock photo subjects; submit portfolio for review; or query with samples. SASE. Simultaneous submissions to noncompetitive publications OK; previously published work OK. Reports in 1 month. Sample copy \$3.

Subject Needs: Documentary; fine art (i.e., security/vandalism in museums); photo essay/photo feature; spot news; how-to; human interest; humorous; crime prevention measures; transportation security; terrorism; and computers and retail store security. Model release required; captions preferred. Needs photos of private security industry "not emphasizing 'rent-a-cop' image, rather looking for professionalism in security." Needs photos for convention locations: Dallas (1985), New Orleans (1986), Las Ve-

gas (1987), Boston (1988).

B&W: Uses 5x7 and 8x10 glossy prints. Pays \$25-150/photo.

Color: Uses 5x7 and 8x10 glossy prints; prefers 35mm, 2¹/₄x2¹/₄ and 4x5 transparencies. Pays \$75-200/

photo, depending upon size published.

Cover: Uses b&w and color glossy prints; prefers 35mm, 21/4x21/4, 4x5 and 8x10 transparencies. Format varies within an 81/4x11 trim. Pays \$100-250/photo.

Accompanying Mss: Management and security how-tos; crime prevention; security profiles; news articles featuring a security aspect. Pays \$50-200/ms, only for assigned mss; inquire first. Free photographer's guidelines.

Tips: "Our subject is difficult to illustrate except with studio shots. Imaginative ideas about how to tackle photos illustrating concepts are helpful. Don't just show us a portfolio of standard people studio

shots.'

SERGEANTS, Box 31050, Temple Hills MD 20748. (301)899-3500. Executive Editor: Mark L. Ward, Sr. Publication of the Air Force Sergeants Association. Monthly. Circ. 125,000. Emphasizes aviation and military life. Readers are Air Force enlisted.

Photo Needs: Uses photos to illustrate features on personality profiles, aviation topics, and travel."

Model release and captions preferred.

Making Contact & Terms: Query with samples. Pays on publication. Buys one-time rights. Previously

published work OK.

Tips: "Articles with pictures would sway us more than pictures alone—and articles need only be 1,000-1,500 words with enough facts and quotes for us to do a rewrite. Most photography is purchased along with articles from author. Our emphasis has been shifting from military hardware to human interest.'

THE SEWANEE NEWS, University of the South, Sewanee TN 37375. (615)598-5931. Editor: Latham Davis. Publication of the University of the South. Quarterly. Circ. 22,000. Emphasizes events at the university and feature stories about alumni. Readers are alumni and friends of the university throughout the country. Free sample copy.

Photo Needs: Uses about 40-50 photos/issue; 10 supplied by freelance photographers. Needs photos of "campus events not covered by our publication, and of alumni in action." Special needs include "good feature articles about alumni doing things accompanied by 2-3 photos." Written release preferred. Making Contact & Terms: Query with samples; send 5x7 b&w glossy prints; b&w contact sheet by

mail for consideration. SASE. Pays "\$8 and up"/b&w inside photo. Pays on acceptance. Credit line

given. Buys "right to use in any university publication." Simultaneous and previously published submissions OK.

SIERRA, 530 Bush St., San Francisco CA 94108. Editor: James Keough. Magazine published 6 times annually. Circ. 290,000. For members of the Sierra Club, an environmental organization. Emphasizes outdoor activities, enjoyment of the land and the problems of preserving the environment. Pays \$250-600 for text/photo package. Credit line given. Buys one-time rights. Contact Art and Production Manager, Linda K. Smith, by mail with 20-40 slides/transparencies representative of stock file. Reports in 2-4 weeks. SASE. Editorial and photography guidelines available.

Subject Needs: Animal (wildlife, endangered species, general-no pet shots); nature/scenic (general scenics of wide variety of places, foreign and domestic, wilderness areas, National Parks, forests, monuments, etc., BLM or Forest Service lands, out-of-the-way places; seasonal shots); outdoor recreation (camping, rafting, skiing, climbing, backpacking); documentary (areas of environmental crises, pollution/industrial damage etc.). "No dupes, superimposed photos, urban/commercial style photos, zoos or

nightlife. No submissions strictly of butterflies, flowers, etc."

B&W: Send 8x10 prints. Captions required. Pays \$100 minimum. B&w submissions not encouraged. Color: Send transparencies. Captions required. Pays \$100 minimum; \$125/half page, \$150/full page, \$175/spread.

Cover: Send color transparencies. Verticals. Captions required. Pays \$200.

Tips: "We keep a list of photographers who have sent us samples of their work and contact them when we require subjects they have on hand. You are welcome to send us a selection of not more than 40 of your best 35mm (or larger) color transparencies and/or 8x10 b&w prints, with captions as to location and species, so that we have an idea of the kind of work you do.'

SIGNPOST MAGAZINE, 16812 36th Ave. W., Lynnwood WA 98037, (206)743-3947, Editor: Ann Marshall. Publication of the Northwest Trails Association. Monthly. Emphasizes "backpacking, hik-

Freelance photography is a career talented individuals at any age can pursue. Anton Nieberl of Seattle, Washington, took this shot near Mt. Rainier for Signpost Magazine. Signpost Editor Ann Marshall says, "Mr. Nieberl is in his 80s and is still an active freelance photographer and hiker. This photo was used as a simple but dramatic filler for a page of winter backcountry travel information."

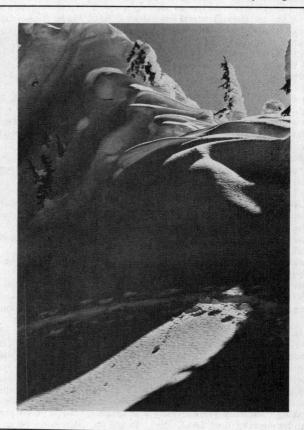

ing, cross-county skiing, all nonmotorized trail use, outdoor equipment, and survival techniques." Readers are "people active in outdoor activities, primarily backpacking; residents of the Pacific Northwest, mostly Washington. Age group: 18-80, family-oriented, interested in wilderness preservation, trail maintenance." Circ. 3,800. Free sample copy. Photo guidelines free with SASE.

Photo Needs: Uses about 10-15 photos/issue; 30% supplied by freelance photographers. Needs "wilderness/scenic; people involved in hiking, backpacking, canoeing, skiing; wildlife; outdoor equipment

photos, all with Pacific Northwest emphasis." Captions required.

Making Contact & Terms: Send 5x7 or 8x10 glossy b&w prints by mail for consideration. SASE. Reports in 1 month. No payment for inside photos. Pays \$20/b&w cover photo. Pays on publication. Credit line given. Buys one-time rights. Simultaneous submissions and previously published work OK.

Tips: "We are always looking for photos that meet our cover specifications. We look for prints that are in focus and contrast enough to reproduce well. We look for the ability of the photographer to think like the editor: to compose and crop the shot for the magazine page. And subjectively, we like to feel part of the scene we are viewing. The photographer should be familiar with Signpost. He needn't be a subscriber, but he should at least request a sample copy, or should look up back issues in his library. Contributing to Signpost won't help pay your bills, but it can help you 'break into print,' and besides, sharing your photos with other backpackers and skiers has its own rewards."

"Stock photography has become an increasingly important part of my freelance business and my sales have more than tripled since 1982," says freelance photographer Dave Swan of Bend, Oregon. His wife, Sam, mar-kets his work. "It is very gratifying to realize that we have survived the trepidation of not knowing quite how to send out the dozen or so prints which we thought had potential. Now the large publishing houses are calling us. Photographer's Market has been critical to our business," he says. The Single Parent featured this Swan photo on one of its covers, and paid him \$75.

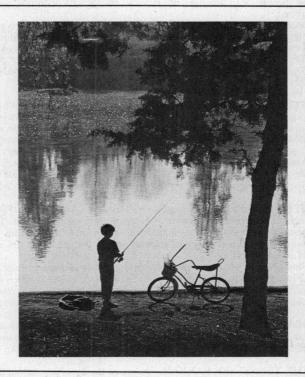

THE SINGLE PARENT, 7910 Woodmont Ave., Suite 1000, Bethesda MD 20814. (301)654-8850. Acting Editor: Ginnie Nuta. Assistant Editor: Elizabeth Bostick. Publication of Parents Without Partners, Inc. Published 10 times/year. Circ. 210,000. Emphasizes "issues of concern to single parents, whether widowed, divorced, separated or never-married, and their children, from legal, financial, emotional, how-to, legislative or first-person experience." Readers are "parents mainly between 30-55, U.S. and Canada." Sample copy free with SASE.

Photo Needs: Uses about 3 photos/issue; all supplied by freelance photographers. "We usually make assignments for a particular story. We also buy shots of children or parents and children." Model release

and captions required.

Making Contact & Terms: Query with samples. Send 8x10 b&w prints, b&w contact sheets by mail for consideration. Provide resume, business card, brochure, flyer or tearsheets to be kept on file for possible future assignments. SASE. Reports in 1 month. Pays \$75/b&w cover photo; \$50/b&w inside photo. Pays on publication. Credit line given. Negotiates rights purchased. Simultaneous submissions OK.

*SNAPDRAGON, Library - Humanities University of Idaho, Moscow ID 83843. (208)885-6584. Editors: Gail Eckwright, Ron McFarland, Tina Foriyes. Photo Editor: Karen Buxton. Association publication for the University of Idaho. Semiannual. Emphasizes poetry, short fiction, art and photography of Idaho and the Pacific Northwest. Circ. 200. Sample copy \$2; free photo guidelines with SASE.

Photo Needs: Uses about 6 photos/issue; all supplied by freeance photographers. Needs "artistic photography, of any subject matter. Photographs are run galley style and should have a theme. Six or more photographs should be submitted at once. We are interested in photographs depicting the people and places in Idaho and the Northwest.'

Making Contact & Terms: Send unsolicited photos by mail for consideration. Uses 8x10, 5½x7 b&w prints. SASE. Reports in 3 weeks. Buys one-time rights. Simultaneous submissions OK.

*SPRAY DUST MAGAZINE, (Indelible Images Inc.), Box 1705, Rahway NJ 07065. (201)382-1447. Editor: Richard C. Fink. Photo Editor: Leanne Metz. Association publication for the Central Jersey Auto Body Association. Monthly. Emphasizes auto body industry, local politics affecting auto body industry. Readers include auto bodyshops, auto dealerships, new and used parts shops. Circ. 2,500. Free sample copy with SASE.

Photo Needs: Uses 12-20 photos/issue or supplied by freelance photographers. Needs auto body-related, people, objects/equipment. Reviews photos with or without accompanying ms. Model release re-

quired.

Making Contact & Terms: Arrange a personal interview to show portfolio; provide resume, business card, brochure, flyer or tearsheets to be kept on file for possible future assignments. SASE. Reports in 1 month. Pays \$20-35/b&w cover, \$5-10/b&w inside photo. Pays on publication. Buys one-time rights. Simultaneous submissions and previously published work OK.

Tips: "Photos that would inform, interest, or instruct the auto body industry (can be humorous, high

tech)."

STUDENT LAWYER, 750 N. Lake Shore Drive, Chicago IL 60611. Editor: Lizanne Poppens. Associate Editor: Sarah Hoban. Publication of the American Bar Association. Magazine published 9 times/ school year. Emphasizes social and legal issues for law students. Circ. 45,000. Sample copy \$2. Photo Needs: Uses about 5-8 photos/issue; all supplied by freelance photographers. "All photos are as-

signed, determined by story's subject matter." Model release and captions preferred.

Making Contact & Terms: Arrange a personal interview to show portfolio. SASE. Reports in 3 weeks. Pays \$300/color cover photo; \$75-200/b&w, \$100-250/color inside photo. Pays on publication. Credit line given. Buys one-time rights. Previously published submissions OK.

TEEN TIMES, 1910 Association Dr., Reston VA 22091. (703)476-4900. Editor: Deb Olcott. Publication of the Future Homemakers of America. Bimonthly magazine. Emphasizes youth leadership development for home economics students through grade 12. Readers are "350,000 FHA/HERO membersjunior and senior high school students and 12,000 adult advisers and supporters." Sample copy for \$1.00 and SASE.

Photo Needs: Uses approximately 10-15 photos/issue; approximately 80% by freelance photographers (20% sent in by members). Needs photos of "FHA/HERO members and chapters in action; FHA/HERO advisers in action. We occasionally need photographers to cover chapter events (almost everywhere in country), and will need editorial photographer for national meeting in Orlando FL, July 1986." Written release preferred.

Making Contact & Terms: Provide resume, business card, brochure, flyer or tearsheets to be kept on file for possible future assignments. Payment "depends on assignment/location/use, etc." Credit line given. Buys all rights.

THE TENNESSEE BANKER, Tennessee Bankers Association, 21st Floor, Life & Casualty Tower, Nashville TN 37219. (615)244-4871. Managing Editor: Dianne W. Martin. Monthly magazine. Circ. 2,200. Emphasizes Tennessee bankers and banking news. Buys 12 photos/year; 1 photo/issue. Credit line given. Pays on publication. Buys one-time rights. Query by phone or mail query with samples. SASE. Simultaneous submissions and previously published work OK. Reports immediately. Subject Needs: Tennessee scenics, historical sites, etc. (cannot use "people" scenes) for the cover. Will

not use anything that is outside the state of Tennessee.

Cover: Uses 35mm and 4x5 transparencies. Vertical format preferred. Pays \$35/photo.

Market conditions are constantly changing! If this is 1987 or later, buy the newest edition of Photographer's Market at your favorite bookstore or order directly from Writer's Digest Books.

TEXTILE RENTAL MAGAZINE, Box 1283, Hallandale FL 33009. (305)457-7555. Managing Editor: Nancy Jenkins-Briceno. Publication of the Textile Rental Services Association of America. Monthly magazine. Emphasizes the "linen supply, industrial and commercial laundering industry." Readers are "heads of companies, general managers of facilities, predominantly male audience; national and international readers." Circ. 6,000.

Photo Needs: Photos "needed on assignment basis only." Model release preferred; captions preferred

or required "depending on subject."

Making Contact & Terms: "We contact photographers on an as-needed basis selected from a directory of photographers." Does not return unsolicited material. Pays \$250/color cover plus processing; "depends on the job." Pays on acceptance. Credit line given if requested. Buys all rights. Previously published work OK.

Tips: "Meet deadlines; don't charge more than \$100-200 for a series of b&w photos that take less than

half a day to shoot."

THE TOASTMASTER, Box 10400, 2200 N. Grand Ave., Santa Ana CA 92711. (714)542-6793. Editor: Tamara Nunn. Monthly magazine. Circ. 100,000. Emphasizes self-improvement, especially in the areas of communication and leadership. Photos purchased on assignment. Buys 1 photo/issue. Pays \$25-150 for text/photo package or on a per-photo basis. Credit line given on request. Pays on acceptance. Buys all rights, but may reassign to photographer after publication. Query with list of stock photo subjects. SASE. Simultaneous submissions and previously published work OK. Reports in 3 weeks. Free sample copy.

Subject Needs: Celebrity/personality (to illustrate text); head shot (speaking, listening management and interviewing); how-to ("definitely—on speaking, listening, interviewing and management"); hu-

man interest; and humorous (for special issue relating to speaking situations).

B&W: Uses 8x10 glossy prints. Pays \$10-50/photo.

Color: Uses 35mm or 21/4x21/4 transparencies. Pays \$10-50/photo.

Cover: Uses b&w and color glossy prints or 35mm and 21/4x21/4 color transparencies. Vertical format re-

quired. Pays \$35-75/photo.

Accompanying Mss: Seeks educational mss; how-to with plenty of illustrative examples; on the subjects of speaking, listening techniques, time management, leadership, audiovisuals, etc. Length: 1,500-3,000 words. Pays \$25-150/ms. Free writer's guidelines.

Tips: "We would rather buy photos with manuscripts."

TODAY'S INSURANCE WOMAN, Box 4410, Tulsa OK 74159. (918)744-5195. Director of Communications: Vieki J. Rex. Publication of the National Association of Insurance Women. Quarterly. Circ. 20,000. Emphasizes women in business and insurance/financial planning. "TIW is edited for the woman who is already somewhat established in her insurance career and planning to move up. Our average reader is involved in some sort of continuing education program to assist her in her career advancement." Sample copy \$2.50.

Photo Needs: Limited use of photography from outside sources. Special needs include photos of "women featured in business settings in capacities other than secretarial." Model release preferred. Query with list of stock photo subjects. SASE. Reports in 1 week. Pays \$50/color cover photo; \$10-20/b&w and \$20-35/color inside photo. Pays on publication. Credit line given. Buys one-time rights. Si-

multaneous and previously published work OK.

*TORSO/JOCK MAGAZINES, #210, 7715 Sunset Blvd., Los Angelès CA 90046. (213)850-5400. Editor: Timothy Neuman. Creative Art Director: Alfonso Sabelli. Association publication for the GPA (Gay Press Association). Monthly. Emphasizes gay male erotica. The readers include average gay male

from all walks of life. Sample copy \$5; photo guidelines free with SASE.

Photo Needs: Uses 20-30 photos/issue; 30% supplied by freelance photographers. Needs male nudes. Reviews photos with or without accompanying ms. Model release and captions required. Arrange a personal interview to show portfolio, query with samples or send unsolicited photos by mail for consideration, submit portfolio for review. Uses 5x7 glossy b&w or color prints, 35mm transparencies, contact sheets, negatives. SASE. Reports in 1 month. Pays \$200-300/job. Pays on publication. Credit line given. Buys first North American serial rights.

Tips: Needs "good lighting, interesting subject matter, etc. Keep the continuity in color throughout

your work. Don't get too artsy. Just simple, good photography.'

TOUCH, Box 7244, Grand Rapids MI 49510. (616)241-5616. Managing Editor: Carol Smith. Publication of the Calvinettes. Monthly. Circ. 14,000. Emphasizes "girls 7-14 in action. The magazine is a Christian girls' publication geared to the needs and activities of girls in the above age group." Readers are "Christian girls ages 7-14; multiracial." Sample copy and photo guidelines free with 8x10 SASE. "Also available is a theme update listing all the themes of the magazine for six months."

Photo Needs: Uses about 8-10 photos/issue; "most" supplied by freelance photographers. Needs "photos of cross-cultural girls aged 7-14 involved in sports, Christian service and other activities young girls would be participating in." Model release preferred.

Making Contact & Terms: Send 5x7 b&w glossy prints by mail for consideration. SASE. Reports in 1 month. Pays \$20-25/b&w photo. Pays on publication. Credit line given. Buys one-time rights. Simulta-

neous submissions OK.

Tips: "Make the photos simple. We prefer to get a spec sheet rather than photos and we'd really like to be able to hold photos sent to us on speculation until publication. We select those we might use and send others back. Freelancers should write for our biannual theme update and try to get photos to fit the theme of each issue."

TURKEY CALL, Box 530, Edgefield SC 29824. (803)637-3106. Publisher: National Wild Turkey Federation, Inc. (nonprofit). Editor: Gene Smith. Bimonthly magazine. Circ. 28,000. For members of the National Wild Turkey Federation—people interested in conserving the American wild turkey. Needs photos of "wild turkeys, wild turkey hunting, wild turkey management techniques (planting food, trapping for relocation), wild turkey habitat." Buys 20-30 annually. Copyrighted. Send photos to editor for consideration. Credit line given. Pays on acceptance. Reports in 4 weeks. SASE. Sample copy \$2. Free contributor guidelines for SASE.

B&W: Send 8x10 glossy prints. Captions required. Pays \$10-20.

Cover: Send color transparencies. Uses any format. Requires space for insertion of logo. Pays \$50-100. **Tips:** Wants no "poorly posed or restaged shots, mounted turkeys representing live birds, domestic turkeys representing wild birds, or typical hunter-with-dead-bird shots."

UNITED EVANGELICAL ACTION, Box 28, 450 E. Gundersen, Wheaton IL 60189. (312)665-0500. Editor: Christopher M. Lutes. Bimonthly. Circ. 7,500. Emphasizes religious concerns as those concerns relate to current news events. Readers are evangelicals concerned about putting their faith into practice. Free sample copy and photo guidelines with SASE.

Photo Needs: Uses about 5-10 photos/issue; all are supplied by freelance photographers. No travel or scenic photos. "Think 'news.' On the lookout for photos depicting current news events that involve or are of concern to evangelicals. Interested in photos demonstrating current moral/social problems or needs; Christians reaching out to alleviate human suffering; Christians involved in political rallies, marches or prayer vigils; and leading evangelicals addressing current moral/social issues." Photos purchased with or without accompanying ms. Model release required.

Making Contact & Terms: Query with sample; list of stock photo subjects and send by mail 8x10 b&w glossy or matte prints for consideration. Provide brochure, flyer and periodic mailings of shots available to be kept on file for possible future assignments. SASE. Reports in 1 month. Pays \$35-125/b&w photo.

Pays on publication. Credit line given. Buys one-time rights.

Tips: "Would like to see 'people' shots with a strong news or current events, or religious orientation. Please no family or children shots. Send a wide variety of samples. This will allow us to see if your work fits our editorial needs."

UTU NEWS, 14600 Detroit Ave., Cleveland OH 44107. (216)228-9400. Editor: Art Hanford. Published as a twice monthly newsletter (4 pages) and also as a tabloid (8 pages) 6 times each year. Circ. 165,000 (newsletter), 220,000 (tabloid). For railroad and bus employees who are members of the United Transportation Union (UTU). Needs news photos of rail and bus accidents, especially if an employee has been killed. "Avoid gory scenes, but try to get people somewhere in the picture." Wants no photos of simple derailments—"there are hundreds of these every week. Nor do we want grade crossing accident shots unless the train is derailed or a crewman injured." Also needs "unusual shots of rail or bus employees at work." Buys 10-30 photos/year. Not copyrighted. Send photos for consideration. Pays on publication. Reports in 1 month. SASE. Simultaneous submissions OK.

B&W: Send 8x10 glossy prints. Caption material required. Pays \$10-25. Photographer must supply So-

cial Security number to be paid.

Tips: "Speed is a must with accident photos. The quicker we get the prints, the better chance they have of being used. Please enclose newspaper clippings with accident shots, if possible." Wants no photos of clean-up operations. Rescue shots "OK."

VIRGINIA WILDLIFE, 4010 W. Broad St., Box 11104, Richmond VA 23230. (804)257-1000. Editor: Harry L. Gillam. Monthly magazine. Circ. 55,000. Emphasizes Virginia wildlife, as well as outdoor features in general, fishing, hunting, and conservation for sportsmen and conservationists. Photos purchased with accompanying ms. Buys 2,000 photos/year. Credit line given. Pays on acceptance. Buys one-time rights. Send material by mail for consideration. SASE. Reports (letter of acknowledgement) within 10 days; acceptance or rejection within 45 days of acknowledgement. Free sample copy and photo guidelines.

Subject Needs: Good action shots relating to animals (wildlife indigenous to Virginia); action hunting and fishing shots; photo essay/photo feature; scenic; human interest outdoors; nature; travel; outdoor recreation (especially boating); and wildlife. Photos must relate to Virginia. No "dead game and fish!"

B&W: Uses 8x10 glossy prints. Pays \$10/photo.

Color: Uses 35mm and 21/4x21/4 transparencies. Pays \$10-20/photo.

Cover: Uses 35mm and 21/4x21/4 transparencies. Vertical format required. Pays \$100/photo.

Accompanying Mss: Features on wildlife; Virginia travel; first-person outdoors stories. Pays 10¢/

printed word. Free writer's guidelines; included on photo guidelines sheet.

Tips: "We don't have time to talk with every photographer who submits work to us. We discourage phone calls and visits to our office, since we do have a system for processing submissions by mail. Our art director will not see anyone without an appointment. Show only your best work. Name and address must be on each slide. Plant and wildlife species should also be identified on slide mount. We look for outdoor shots (must relate to Virginia); close ups of wildlife."

VITAL CHRISTIANITY, 1200 E. 5th St., Anderson IN 46011. (317)644-7721. Editor-in-Chief: Arlo F. Newell. Managing Editor: Richard L. Willowby. Publication of the Church of God. Published 20 times/year. Circ. 25,000. Emphasizes Christian living. "Our audience tends to affiliate with the Church of God." Sample copy and photo guidelines \$1 with SASE.

Photo Needs: Uses about 5 photos/issue; 2 supplied by freelance photographers. Needs photos of "people doing things, family life, some scenic." Special needs include "minorities, people 40-93." Model

release preferred.

Making Contact & Terms: Query with samples. Send b&w glossy prints; 4x5 or 8x10 transparencies by mail for consideration. SASE. Reports in 1 month. Pays \$125-150/color cover photo; \$25-40/b&w inside photo. Pays on acceptance. Credit given on contents page. Buys one-time rights. Simultaneous submissions and previously published work OK.

Tips: "Send carefully selected material quarterly (not every month), and make sure people photos are

up-to-date in dress and hairstyle."

THE WAR CRY, The Salvation Army, 799 Bloomfield Ave., Verona NJ 07044. (201)239-0606. Editor-in-Chief: Lt. Colonel Henry Gariepy. Publication of The Salvation Army. Biweekly. Circ. 280,000. Emphasizes the inspirational. Readers are general public and membership. Sample copy free with SASE.

Photo Needs: Uses about 6 photos/issue. Needs "inspirational, scenic, general illustrative photos." **Making Contact & Terms:** Send b&w glossy prints or contact sheets by mail for consideration. SASE. Reports in 2 weeks. Pays \$35/b&w cover photo; \$10-25/b&w inside photo; payment varies for text/photo package. Pays on acceptance. Credit line given "if requested." Buys one-time rights. Simultaneous submissions and previously published work OK.

WASHINGTON WILDLIFE MAGAZINE, Washington Deptartment of Game, 600 N. Capitol Way, Olymmpia WA 98504. (206)754-2645. Editor: Janet O'Mara. Quarterly magazine. Emphasizes wildlife and wildlife recreation in Washington state. Readers include hunters, fishermen, nongamers, bird watchers, hikers and photographers. Circ. 15,000. Photo guidelines free with SASE.

Photo Needs: Uses about 7-9 color and 10-15 b&w photos/issue; ½ to ½ supplied by freelance photographers. Needs "shots of wildlife that live *in Washington*; occasionally Washington scenics on habitat, wraparound covers, some how-tos." Special needs include "photos to enlarge for wrap-around cov-

ers." Model release and captions preferred.

Making Contact & Terms: Arrange a personal interview to show portfolio; query with samples; send no smaller than 5x7 matte or glossy prints, 35mm, $2\frac{1}{4}x2\frac{1}{4}$ or 4x5 transparencies by mail for consideration; provide resume, business card, brochure, flyer or tearsheets to be kept on file for possible future assignments. SASE. Pays in copies of magazine. Credit line given. "We do not purchase rights. We may ask to use photos in our other publications or displays with approval."

Tips: Prefers to see "clarity, sharpness, unusual angles and interesting animal expressions" in photos. "Strive for highlights in wildlife's eyes, good close-up animal portraits, interesting lighting, subjects

that appeal to families."

WASTE AGE MAGAZINE, 10th Floor, 1730 Rhode Island Ave. NW, Washington DC 20036. (202)659-4613. Editor: Joseph A. Salimando. Publication of the National Solid Wastes Management Association. Monthly magazine. Emphasizes management of solid wastes. Readers are sanitation departments, refuse haulers, etc. Circ. 30,000.

Photo Needs: Uses about 12-20 photos/issue; 3-5 supplied by freelance photographers. Needs "cover shots in color illustrating main story in magazine; inside shots to go with that story. We need names of artists who can take cover photos of quality in various areas of the country."

Making Contact & Terms: Provide resume, business card, brochure, flyer or tearsheets to be kept on

file for possible future assignments. SASE. Reports in 3 weeks. Pays \$200/color cover. Pays on acceptance. "Sometimes" gives credit line. Buys all rights.

Tips: "Print up a cheap brochure, resume or similar item describing experience, covers taken, etc., (maybe include a photocopy, offering sample on request) and price range."

*THE WATER SKIER, Box 191, Winter Haven FL 33882. (813)324-4341. Editor: Duke Cullimore. Publication of the American Water Ski Association. Bimonthly magazine. Emphasizes water skiing. Readers are members of American Water Ski Association, active competitive and recreational water skiers. Circ. 18,500. Photo guidelines free with SASE.

Photo Needs: Uses 40-50 photos/issue; "few" supplied by freelance photographers. Needs photos of water skiers. Photos purchased with accompanying manuscript only. Model release and captions re-

quired.

Making Contact & Terms: Query with photo story ideas. SASE. Reports in 3 weeks. Pays lump sum for text/photo package. Pays on acceptance. Credit line given. Buys one-time rights.

WILDERNESS, 1400 Eye St. NW, Washington DC 20005. (202)842-3400. Editor: T.H. Watkins. Quarterly magazine. Circ. 130,000. Membership publication of The Wilderness Society; emphasizes wilderness preservation and wildlife protection in the U.S. Buys 80-100 photos/year. Pays on publication. Buys first serial rights. "Query first with 'want' list. There may be a considerable wait for return of unsolicited material. It is best for the photographer to send a stock list so we can solicit directly." SASE (8½x11). Sample copy \$2; free photo guidelines.

Subject Needs: "We are concerned especially with unprotected federal lands, so snapshots of a favorite pond in one's backyard or a favorite woods or seashore are of no interest. Photos of people are not used."

Captions required.

B&W: Uses 8x10 glossy prints. Pays \$50 minimum/photo.

Color: Uses 35mm but prefers 4x5 or larger transparencies. No duplicates. Pays \$100/full inside page or smaller.

Cover: Uses color transparencies. No duplicates. Pays \$150/back cover, \$200/front cover.

WIRE JOURNAL, 1570 Boston Post Rd., Guilford CT 06437. (203)453-2777. Editor: Arthur Slepian. Monthly. Circ. 13,000. Emphasizes wire industry (worldwide). Readers are members of the Wire Association International and others including industry suppliers, manufacturers, research and development, production engineers, purchasing managers, etc. Free sample copy with SASE.

Photo Needs: Uses about 30 photos/issue; "very few" are supplied by freelance photographers. Needs photos of "wire manufacturing of all descriptions that highlights a production activity or products (finished and in fabrication). Also fiber optics, and plant engineering in wire plants." Photos purchased with or without accompanying ms. Special needs include cover photos (4 special issues) in color. Model

release and captions preferred.

Making Contact & Terms: Send by mail for consideration 8x10 b&w glossy prints, 2¹/₄x2¹/₄ or 4x5 slides or b&w contact sheet; query with samples or submit portfolio for review. SASE. Reports in 2 weeks. Provide resume, business card and tearsheets to be kept on file for possible future assignments. Pays \$350/color cover photo; \$25/b&w inside photo and \$250-350 for text/photo package. Pays on publication. Credit line given for cover photos only. Buys all rights:

Tips: Prefers to see "industrial subjects showing range of creativity."

WOODMEN OF THE WORLD, 1700 Farnam St., Omaha NE 68102. (402)342-1890, ext. 302. Editor: Leland A. Larson. Monthly magazine. Circ. 470,000. Official publication for Woodmen of the World Life Insurance Society. Emphasizes American family life. Photos purchased with or without accompanying ms. Buys 25-30 photos/year. Credit line given on request. Pays on acceptance. Buys one-time rights. Send material by mail for consideration. SASE. Previously published work OK. Reports in 1 month. Free sample copy and photo guidelines.

Subject Needs: Historic; animal; celebrity/personality; fine art; photo essay/photo feature; scenic; special effects & experimental; how-to; human interest; humorous; nature; still life; travel; and wildlife.

Model release required; captions preferred.

B&W: Uses 8x10 glossy prints. Pays \$10-25/photo.

Color: Uses 35mm, 21/4x21/4 and 4x5 transparencies. Pays \$25 minimum/photo.

Cover: Uses b&w glossy prints and 4x5 transparencies. Vertical format preferred. Pays \$25-150/photo. Accompanying Mss: "Material of interest to the average American family." Pays 5¢/printed word. Free writer's guidelines.

Tips: "Submit good, sharp pictures that will reproduce well. Our organization has local lodges throughout America. If members of our lodges are in photos, we'll give them more consideration."

WORDS, 1015 N. York Rd., Willow Grove PA 19090. (215)657-3220. Editor: Mark Hertzog. Art Director: Judy L. Clark. Bimonthly. Circ. 18,000. Emphasizes information/word processing. Readers are

word processing managers, office automation consultants, educators and manufacturers-male and fe-

male, ages 20-50. Free sample copy with SASE.

Photo Needs: Uses about 2-4 photos/issue; 1-2 are supplied by freelance photographers. Needs photos of management shots; equipment shots; people and word processing equipment and creative, editorial photos of the industry. Photos purchased with or without accompanying ms. Model release required. **Making Contact & Terms:** Arrange a personal interview to show portfolio or query with samples. Reports in 2 weeks. Provide resume, business card or tearsheets to be kept on file for possible future assignments. Pays \$50-200/b&w photo; \$50-400/color photo; \$5-15/hour; or \$30-75/day. Pays on publication. Credit line given. Buys all rights.

Tips: "Know the information/word processing field. Prefers to see printed samples and photographer's favorites, as well as clean, neat prints. We are a professional organization that has to work within strict deadlines, and demands quality images. We look for variety (fun pieces, serious, special effects, etc.)."

WYOMING RURAL ELECTRIC NEWS, 340 W. B St., Suite 101, Casper WY 82601. (307)234-6152. Editor: Gale A. Eisenhauer. Publication of Rural Electric. Monthly. Circ. 38,500. "Electricity is the primary topic. We have a broad audience whose only common bond is an electrical line furnished by their rural electric system. Most are rural, some are ranch." Sample copy free with SASE and 54¢ postage.

Photo Needs: Uses about 4 photos/issue; 1 supplied by freelance photographer. Needs "generally scenic or rural photos—wildlife is good, something to do with electricity—ranch and farm life." Model re-

lease and captions preferred.

Making Contact & Terms: Query with samples or list of stock photo subjects. SASE. Reports in 1 month. Pays up to \$50/color cover photo; \$5/b&w inside photo. Pays on publication. Credit line given. Buys one-time rights. Simultaneous submissions and previously published work OK.

YABA WORLD, 5301 S. 76th St., Greendale WI 53129. (414)421-4700. Editor: Paul Bertling. Monthly magazine November-April. Official publication of Young American Bowling Alliance. Circ. 81,000. Emphasizes news of junior bowlers, bowling tips. Photos purchased with or without accompanying ms and on assignment. Provide brochure, calling card and flyer to be kept on file for possible future assignments. Buys 5 photos/year. Credit line given. Pays on acceptance. Buys all rights. Query with samples. SASE. Previously published work OK. Reports in 2-3 weeks. Free sample copy. Photo guidelines free with SASE.

Subject Needs: Sport (young bowlers) or unusual bowling shots. No lineups of a team or pro bowlers (unless involved in an interesting activity with a youngster). Model releases and captions preferred.

B&W: Uses 5x7 glossy prints. Pays \$5-25/photo.

Color: Uses 35mm and 4x5 transparencies. Pays \$10-50/photo.

Cover: Uses b&w glossy prints or 35mm, 4x5 or 8x10 color transparencies. Square or vertical format required. Pays \$50-100/photo.

YOGA JOURNAL, 2054 University Ave., Berkeley CA 94704. (415)841-9200. Editor-in-Chief: Stephan Bodian. Photo Editor: Diane McCarney. Publication of California Yoga Teachers' Association. Bimonthly. Circ. 25,000. Emphasizes yoga.

Photo Needs: Buys about 20 photos/issue; all supplied by freelance photographers. Needs "mostly yo-

ga related photos; some food, scenic." Model release required; captions preferred.

Making Contact & Terms: Arrange a personal interview to show portfolio or query with samples. SASE. Reports in 1 month. Pays \$150-250/color cover photo and \$15-30/b&w inside photo. Pays on publication. Credit line given. Buys one-time rights. Simultaneous submissions OK.

YOUNG CHILDREN, 1834 Connecticut Ave., NW, Washington DC 20009. (202)232-8777. Editor: Jan Brown. Bimonthly journal. Circ. 44,000. Emphasizes education, care and development of young children and promotes education of those who work with children. Read by teachers, administrators, social workers, physicians, college students, professors and parents. Photos purchased with or without accompanying ms. Buys 5-10 photos/issue. Credit line given. Pays on publication. Also publishes 5 books/year. Query with samples. SASE. Simultaneous submissions and previously published work OK. SASE. Reports in 2 weeks. Free sample copy and photo guidelines.

Subject Needs: Children (from birth to age 8) unposed, with/without adults. Wants on a regular basis "children engaged in educational activities: art, listening to stories, playing with blocks—typical nursery school activities. Especially needs ethnic photos." No posed, "cute" or stereotyped photos; no "adult interference, sexism, unhealthy food, unsafe situations, old photos, children with workbooks.

depressing photos, parties, religious observances." Model release required.

B&W: Uses 5x7 or 8x10 glossy prints. Pays \$15/photo. **Cover:** Uses color transparencies. Pays \$50/photo.

Accompanying Mss: Professional discussion of early childhood education and child development topics. No pay. Free writer's guidelines.

Company Publications

Most company publications, like those published by associations, are intended for and read by a specific, identifiable group of people—in this case, the employees of a given corporation. The audience for some company magazines ranges beyond those who work there to include shareholders, professionals in the same or related industries, and members of the general public. A few corporate-sponsored magazines, especially those published by the airlines and other travel-oriented companies, are virtually indistinguishable from any large, general-interest consumer publication.

For the most part, the same principles used in freelancing for association publications apply here. You must know something about the company and its products or services, and you must familiarize yourself with the way its inhouse publication makes use of photography. Once again, a good place to start is with the magazine published by the company you work for, if there is one, or with the magazines published by companies headquartered or with offices in your area. Also bear in mind that since you'll be working with—and for—corporate executives, it will pay to present yourself in the most businesslike and professional manner possible.

Note also that company publications are often edited by public relations personnel, not journalists, so the work you'll be asked to do may smack more of publicity than news; rare is the company that publishes exposés on itself. You may find, too, that photography some companies require is pretty straight-forward, which might not be ideal for the photographer seeking a true challenge to his creative talents. On the other hand, it isn't uncommon for the larger companies to pay their freelance photographers American Society of Magazine Photographers' rates, which can be lucrative indeed. With careful study of the company publications market, an enterprising photographer may be able to find the best of two worlds.

ABOARD, 135 Madeira Ave., Coral Gables FL 33134. (305)442-0752. Editor: Olga Connor. Art Director: Aymee Martinez. Inflight magazine of Dominicana/Ecuatoriana/Air Panama/Air Panaguay/ Lloyd Aereo Boliviano/LanChile/TACA/VIASA. Quarterly. Circ. 100,000. Emphasizes travel destinations for passengers on the eight airlines listed above. Sample copy free with SASE and \$1.90 postage; photo guidelines free with SASE.

Photo Needs: Uses about 50-60 photos/issue; 20 supplied by freelance photographers. "Photos *must* be related to the article and submitted along with copy of article for editor's approval. Mostly destinations of the airlines, but also sports, business, health and travel-related photo essays." Model release and captions required.

Making Contact & Terms: Send 5x7 or 8x10 b&w glossy prints; 35mm, 21/4x21/4, 4x5, 8x10 transparencies; or b&w contact sheet by mail for consideration. SASE. Reports in 1 month. Pays \$50-150 for text/photo package. Credit line given. Buys simultaneous and reprint rights. Simultaneous submissions and previously published work OK.

Tips: Prefers to see "colorful, crisp, informative shots related to interesting stories."

ALICO NEWS, Box 2226, Wilmington DE 19899. (302)428-3975. Manager, Publications: Sandra Todd. Publication of American Life Association Company. Quarterly. Circ. 5,000. Emphasizes insurance for agents and employees. Sample copy free with SASE.

Photo Needs: Uses about 25-70 photos/issue; 0-70 supplied by freelance photographers. Needs photos of "people of different ethnic backgrounds at home, with kids; scenes of Africa, South America, New Zealand, Japan, etc." Uses b&w photos, occasionally color. Payment varies. Model release and captions preferred.

Making Contact & Terms: Provide resume, business card, brochure, flyer or tearsheets to be kept on file for possible future assignments. Reports in 3 weeks. Pays on publication. Credit line given. Buys all rights. Previously published work OK.

*AMERICAN NURSERYMAN, 111 N. Canal St., Chicago IL 60606. (312)782-5505. Editor: Brian Smucker. A semimonthly publication of the American Nurseryman company. Emphasizes horticulture—the woody ornamental nursery business. Readers include owners and managers of nurseries, garden centers and landscaping companies. Circ. 154000. Sample copy \$3.

Photo Needs: Uses about 50-75 photos/issue; some supplied by freelance photographers. Needs individual plant habits and detail shots, store displays, people shots, created landscapes (residential and commercial property landscaping). Reviews photos with or without accompanying ms. Special needs

include photos for business management articles. Captions required.

Making Contact & Terms: Query with list of stock photo subjects; send unsolicited photos by mail for consideration. Uses 5x7 or 8x10 glossy b&w/any size transparencies. SASE. Reports in 3 weeks. Pays \$10/color or b&w cover; \$10/inside color or b&w photo. Pays on publication. Credit line given if requested. Buys one-time rights. Simultaneous submissions and previously published work OK if not submitted to or published by other national nursery trade magazines.

Tips: "We pay very little, but we believe we're the best, most respected trade magazine in the nursery

business.'

*APPLIED CARDIOLOGY, 825 South Barrington, Los Angeles CA 90049. (213)826-8388. Editor: Esther Gross. Photo Editor: Tom Medsger. Company publication of the Medical journal. Bimonthly. Emphasizes cardiology in all its aspects. Not open heart surgery. Readers are cardiologists.

Photo Needs: Uses 2-3 photos/issue; all supplied by freelance photographers. Needs everything relating to the heart and cardiology. Abstracts, stylized treatments for covers. Reviews photos with or without

accompanying ms. Model release required; captions preferred.

Making Contact & Terms: Query with resume of credits, samples and list of stock photo subjects. Uses any size color prints, 35mm, 21/4x21/4 transparencies. SASE. Reports in 2 weeks. Pays \$400/color cover photo, \$100 inside cover photo. Pays on acceptance. Credit line given for cover photo. Buys all rights. Photo is returned to photographer. Brentwood Publishing reserves the right to use photo again in any of its publications.

AUTOMOTIVE GROUP NEWS, 5200 Auto Club Dr., Dearborn MI 48126. Editor-in-Chief: Patricia La Noue Stearns. Bimonthly. Circ. 20,000. Publication of United Technologies. Emphasizes high-technology electronics and automotive components. Readers are employees, press and executives. Free sample copy with SASE (when available).

Photo Needs: Uses about 16-20 photos/issue; all are supplied by freelance photographers. Photos pur-

chased with or without accompanying ms. Model release and captions preferred.

Making Contact & Terms: Send query with samples. Does not return unsolicited material. Reports in 4-6 weeks. Provide business card and tearsheets to be kept on file for possible future assignments. Payment negotiable. Pays on acceptance. Buys all rights. Simultaneous submissions OK.

Tips: Assigns photos of high-technology products and applications in the auto industry.

*THE BODY POLITIC, Station A, Box 7289, Toronto, Ontario Canada M5W-1X9. (416)364-6320. Photo Editor: Sonja Mills. Company publication of the Pink Triangle Press. Monthly. Emphasizes gay/lesbian issues. Readers are lesbians/gay men. Circ. 10,000. Sample copy \$1.

Photo Needs: Uses about 40 photos/issue; 50% supplied by freelance photographers. "We generally use set-up shots with people and things pertinent to a particular article. However, we do run photo portfolios occasionally." Reviews photos with or without accompanying ms. Special needs include photos of gay/

lesbian interest. Model release preferred.

Making Contact & Terms: Query with samples, send unsolicited photos by mail for consideration. Send 5x7 or 8x10 glossy or matte, high contrast b&w prints and b&w contact sheet. SASE. Reports ASAP. Offers no payment. Credit line given. Rights purchased are the photographer's choice. Simultaneous submissions and previously published work OK. Prefers to see "photographs dealing with gay/ lesbian issues, the 'gay scene,' sexy pictures of men or women. Don't be shy. Sexy sells."

BUCKET/HERBS & SPICES, (formerly Bucket; Herbs & Spices Magazines), Box 32070, Louisville KY 40232. (502)456-8366. Editor: Jean Litterst. Publication of Kentucky Fried Chicken. Quarterly.

The asterisk before a listing indicates that the listing is new in this edition. New markets are often the most receptive to freelance contributions. Circ. 14,000. Emphasizes quick-service restaurant employees, franchises and operators. Readers are store employees, and corporate office franchises employees.

Photo Needs: Uses about 28-38 photos/issue; almost all are supplied by freelance photographers. Needs "celebration" shots (but no line-'em-up or grip 'n' grins); personality profile photos; event shots. Payment varies.

Making Contact & Terms: Provide resume, business card, brochure, flyer or tearsheets to be kept on file for possible future assignments. Pays on acceptance. Buys all rights; also negatives.

CAROLINA COOPERATOR, Box 2419, Raleigh NC 27602. Managing Editor: Ken Ramey, Magazine published 10 times/year. Circ. 60,000. Emphasizes farming and coop members for Carolina farmers and agricultural workers who are members of FCX co-op. Buys 6-12 freelance photos/year-most material is staff prepared. Not copyrighted. Send photos for consideration. Pays on acceptance. Reports 'quickly-usually the same day." SASE. Previously published work OK. Free sample copy and photo guidelines.

Subject Needs: Farm or farm-related photos. Animal, how-to, human interest, humorous, nature, photo essay/photo feature, scenic and wildlife. No urban photos or mug shots. "Shy away from the cute and quaint." Photos must be Southern if the locale is obvious.

B&W: Send 8x10 glossy prints. Pays \$10 minimum.

Cover: Send color transparencies. "Exceptional b&w might make it." Cover shots must relate to farming, seasonal subjects or Carolina general interest. Pays \$10 minimum.

Tips: "We're looking for technical excellence."

CATERPILLAR WORLD, 100 NE Adams ABID, Peoria IL 61629. Editor: Tom Biederbeck. Quarterly magazine. Circ. 75,000. Emphasizes Caterpillar people, products, plants and human interest features with Caterpillar tie-in, for Cat employees, dealers and customers. Photos purchased with accompanying ms or on assignment. Pays on acceptance. Submit portfolio for review or query with samples. "SASE necessary." Reports in 2 weeks.

Subject Needs: Personality and documentary (of anything relating to Caterpillar); photo essay/photo feature (on construction projects, etc.); product shot; and human interest. "We don't want to see Cat products without accompanying texts. Feature the people, then show the product. Please don't send anything that doesn't have a Caterpillar tie." Model release preferred; captions required.

Color: Uses all format transparencies; contact sheet and negatives OK.

Cover: Color contact sheet OK; or color transparencies.

Accompanying Mss: "Anything highlighting Caterpillar people, products, plants or dealers." Free writer's guidelines and sample copy.

Tips: "Please send photos well protected and insured. We have had some lost in transit."

CENTERSCOPE, 1325 N. Highland Ave., Aurora IL 60506. (312)859-2222. Public Relations Director: Sharon Muhlethaler. Publication of Mercy Center for Health Care Services. Quarterly. Circ. 6,500. Emphasizes medical care, technology, wellness.

Photo Needs: Uses about 40 photos/issue; 2 supplied by freelance photographers. Needs photos of peo-

ple and faces; medical/hospital scenes. Model release required; captions preferred.

Making Contact & Terms: Query with samples. Provide resume, business card, brochure, flyer or tearsheets to be kept on file for possible future assignments. SASE. Reports in 2 weeks. Pays \$125-500 per job. Pays on acceptance. Credit line given. Buys all rights.

CHESSIE NEWS, Box 6419, Cleveland OH 44101. (216)623-2367. Editor: Kathy Swan. Monthly newspaper. Circ. 50,000. Emphasizes items of interest to employees of Chessie System Railroads, a unit of CSX Corp. Photos purchased on assignment. Buys 2 photos/issue. Pays \$75/b&w cover; \$50/ b&w inside; \$20-45/hour; \$50 minimum/job; \$100/minimum for text/photo package. Credit line given if requested. Pays on acceptance. Buys all rights, but may reassign to photographer after publication. Works with freelance photographers on assignment only basis. Query with resume of credits and work sample. Provide resume, business card and phone number to be kept on file for possible future assignments. Simultaneous submissions and previously published work OK.

Subject Needs: Human interest, documentary, head shot and special effects/experimental. "We can only use those photos assigned by us." Captions required.

B&W: Contact sheet or negatives OK.

Tips: "We are interested in compiling and maintaining a list of possible freelance photographers, to call on assignment. Photographers are needed within a 13-state area including New York, Pennsylvania, Maryland, Virginia, West Virginia, Kentucky, Indiana, Illinois, Ohio and Michigan." Prefers to see "unique approaches to human interest photos. We are more interested in the human aspect of the railroad. Chessie News is the employee publication of the railroad, and many photographers assume that we only publish photos of trains."

CONTACT MAGAZINE, 700 IDS Tower, Minneapolis MN 55402. (612)372-3543. Editor: Marie Davis. Publication of IDS Financial Services, Inc. Bimonthly. Circ. 8,000. Emphasizes financial services. Readers are home office employees, registered representatives throughout the country, retirees and others. Sample copy free with SASE.

Photo Needs: Uses about 25 photos/issue; all are supplied by freelance photographers. Needs "photo-

iournalist impressions of people or work. Generally, we do not purchase file photos."

Making Contact & Terms: Query with samples. SASE. Reports in 1 month. Pays \$10-50 maximum/

hour; \$50-500/day. Pays on acceptance. Credit line given. Buys all rights.

Tips: Prefers to see "b&w photojournalism" in samples. "Offer good work and pleasant client/photographer working arrangements. Be involved in the whole project, from the concept stage. Know the story you're trying to tell.'

CREDITHRIFTALK, Box 59, 601 NW 2nd St., Evansville IN 47701. (812)464-6638. Editor: Gregory E. Thomas. Monthly magazine. Circ. 3,800. "The publication emphasizes company-related news and feature stories. Employees read CTT for in-depth information regarding company events and policy and to gain a better understanding of fellow employees." Photos purchased with or without accompanying ms. Works with freelance photographers on assignment only basis. Provide business card to be kept on file for possible future assignments. Credit line given if requested. Pays on acceptance. Not copyrighted. Ouery with b&w contact sheet showing business portraits and/or candid people photos. SASE. Simultaneous submissions and previously published work OK. Reports in 2 weeks. Free sample copy

and photo guidelines for SASE.

Photo Needs: Uses 30 photos/issue; 20 supplied by freelance photographers. Head shot ("the majority of photos purchased are of this type—subjects include newly promoted managers, and photos are also used for advertising, files, etc."); and photo essay/photo feature (depicting company offices or employees). "I don't want to see photos that don't relate to either our company or the finance industry. Credithriftalk is published by Credithrift Financial, which has over 850 consumer finance branches in 27 states coast-to-coast. Also known as General Finance. In California we are known as Morris Plan. Feature subjects have ranged from an employee working as a volunteer probation officer to one coaching a softball team. Any subject will be considered and in some cases I may be able to supply a subject for a photographer who lives near an office. We always need good portrait photographers. Please include your daytime phone number in your query." Pays \$10-20/b&w for portraits and office exterior shots: \$50-250/job for photo essay assignments.

Accompanying Mss: Feature stories describing employees involved in any activity or interest, and arti-

cles of general interest to the finance or credit industry.

CSC NEWS, Computer Sciences Corporation, 2100 E. Grand Ave., El Segundo CA 90245, (213)615-0311. Manager, Employee Publications: Sue Thorne. Bimonthly. Circ. 15,000. Emphasizes computer services. Readers are "professional and high technically oriented individuals." Sample copy free with SASE.

Photo Needs: Uses about 20 photos/issue; 1 supplied by freelance photographers. Needs photos of people at work—special projects (military and space oriented). Photos purchased with accompanying ms

only. Captions preferred.

Making Contact & Terms: Query with list of stock photo subjects; send b&w prints, contact sheet, b&w negatives by mail for consideration. Provide resume, business card, brochure, flyer or tearsheets to be kept on file for possible future assignments. SASE. Reports in 1 week, Pays \$5-50/job, Pays on acceptance. Credit line given. Buys one-time rights. Simultaneous submissions and previously published work OK.

DEPARTURES, Suite 909, 75 The Donway West, Don Mills, Ontario, Canada M3C 2E9, (416)441-2080. Editor: Dianne Dukowski. Quarterly. Circ. 80,000. Emphasizes travel. Readers are active travellers. Sample copy free with SASE.

Photo Needs: Interested in highest quality photography only. Prefers articles submitted with accom-

panying photography.

Making Contact & Terms: Query articles with a sample of photography, preferably previously published work that does not need to be returned. Provide list of destinations and subject matter. SASE. Pays \$50-200/color inside photo and \$350 minimum for text/photo package. Pays on acceptance. Credit line given. Buys one-time rights. Previously published work OK.

Tips: "Deals primarily with Canadian writers/photographers."

*DESERT MAGAZINE, Box 1318, Palm Deser CA 92261. (619)366-3344. Photo Editor: Michael Bandini. Bimonthly magazine. Circ. 26,000. Emphasizes "the desert-mining, ghost towns, flowers and animals, railroads, desert living, Indians, history." Sample copy \$3.

Photo Needs: Uses 42 photos/issue; 60% supplied by freelance photographers. Needs "desert scenes,

flowers in bloom, ghost towns, ruins, desert travel, hummingbirds, etc." Model release preferred; cap-

tions optional.

Making Contact & Terms: Query with samples; send any size b&w or color prints or 21/4x21/4 transparencies by mail for consideration. SASE. Reports in 4-6 weeks. Payment varies. Pays on publication. Credit line given. Buys all rights. Previously published submissions OK.

Tips: "We prefer to accept photos that relate to an article or subject included in an issue or that captures the special feeling of the desert. Know your subject—i.e., history, birds, etc.—not just how to photo-

graph.'

DISCOVERY, Allstate Motor Club, 3701 Blake, Glenview IL 60025. (312)480-5642. Editor: Mary Kaye Stray. Publication of Allstate Motor Club. Quarterly. Circ. 1,300,000. Emphasizes travel. Readers are members of the Allstate Motor Club. Free sample copy and photo guidelines with large SASE and

Photo Needs: Uses about 40 photos/issue; all supplied by freelance photographers. Needs travel photos—"but not straight travel scenic shots. Should have a specific subject." Model release and captions

Making Contact & Terms: Query with resume of credits or with samples. SASE. Reports in 2 weeks. Pays ASMP rates. Pays on acceptance. Credit line given. Buys one-time rights. Previously published work OK.

Tips: Portfolio "should be good solid photojournalism—we're not just looking for pretty nature shots or scenics. Be familiar with the magazine you're working with. Be persistent.'

THE EDISON, % Communications Service Dept., Box 767, Chicago IL 60690. (312)294-3001. Editor: Rebecca Grill. Publication of Commonwealth Edison. Quarterly. Circ. 26,000. Emphasizes electric utility's service territory of the northern fifth of Illinois. Audience is company employees and retirees, and designated opinion leaders. Sample copy available upon request.

Photo Needs: Uses about 20 photos/issue; half supplied by freelance photographers. Photo needs "depend on story"; mostly location 35mm work, b&w, Tri-X to Pan-X. Model release and captions re-

quired.

Making Contact & Terms: Arrange a personal interview to show portfolio. Payment is "competitive." Tips: Prefers to see "talent, patience, creativity with a limited budget. Study our publication."

ENTERPRISE, Southwestern Bell Corporation, Room 1204, 1010 Pine, St. Louis MO 63101. (314)247-2407. Editor: Peter J. Faur. Quarterly magazine. Circ. 95,000. Emphasizes "activities and policies of the telephone company and other subsidiaries. The magazine shows employees at work, construction projects and service restoration in the face of adversity (after storms, floods, etc.). It's designed to interpret the programs of Southwestern Bell and recognize employees' contributions both to the company and to their communities." All work purchased on assignment only. Buys 200 photos/year. Pays on a per-assignment basis. Credit line given for excellent work. Pays on completion of assignment. Not copyrighted. Submit portfolio for review.

Color: Uses 35mm transparencies.

Cover: Uses 35mm or 21/4x21/4 color transparencies. Vertical format required.

ESPRIT, #1 Horace Mann Plaza, Mail #E002, Springfield IL 62715. (217)789-2500, ext. 5944. Marketing Communications Manager: Marilyn Titone Schaefer. Publication of The Horace Mann Companies. Quarterly. Circ. 1,400. Emphasizes the "concerns of our agents' personal lives; what they do when they're not working." Readers are sales agents and their families. Sample copy free with SASE.

Photo Needs: Uses about 4 photos/issue; all supplied by freelance photographers. Needs photos of "agents and their families—for example, the wife of an agent in her daycare school; an agent and his

wife who raise Salukis. We write the mss." Captions preferred.

Making Contact & Terms: Provide resume, business card, brochure, flyer or tearsheets to be kept on file for possible future assignments. SASE. Reports "when we need a photographer in his/her area of the country." Pays \$25-30/hour; \$125 maximum/job. Pays on acceptance. Credit line given. Buys all rights. Simultaneous submissions and previously published work OK.

Tips: "Let us know you're interested in working for us and we'll call you when we need a photographer

from your area. We're now using freelance photographers more often than in the past.'

THE EXPLORER, Cleveland Museum of Natural History, Wade Oval, University Circle, Cleveland OH 44106. (216)231-4600. Editor-in-Chief: Wm. C. Baughman. Emphasizes natural history and science for members of 41 natural history and science museums located all over the country. Quarterly. Circ. 29,000. Free photo guidelines.

Photo Needs: Uses about 40 photos/issue, 30% of which are supplied by freelance photographers. "Most of our color and b&w photos are submitted by mail. Museums which are members of our 41 insti-

tution consortium have their own photographic staffs which contribute pictures. Our policy is to use only technically excellent, professional quality, sharp photographs with superior storytelling content. This does not rule out amateurs' work—but your pictures have to equal professional quality. Our printing quality is top-notch and done on heavy glossy paper. We want both the editor and the photographer to be proud of the photo(s) printed in *The Explorer*, the only picture magazine publication published solely for a large group of fine natural history and science museums. The magazine runs on a shoestring budget but we take a backseat to no publication in scientific approach to relating words and pictures. The Explorer has coast to coast circulation distributed through museum memberships. It now has national magazine status in the eyes of public and educational institution libraries where you may find a copy to study. We wish to see b&w photos of animals (not domesticated), nature subjects, oddities of nature, people engaged in exploring nature and science—everything from butterfly catching, looking through binoculars at birds, collecting insects, underwater photography, weather, big close-ups of unusual species of fauna and flora to subjects you specialize in shooting in nature. We are always in the market for vertical color covers and full-page color shots of U.S. animals."

Column Needs: "Explorations"—a roundup of briefly stated facts about nature and science, using a lead-off photo to illustrate the feature. "We sometimes build the lead item around a fine, storytelling

photo." Captions required.

Making Contact & Terms: Send by mail for consideration actual 5x7 or 8x10 b&w and color prints: 35mm, 21/4x21/4, 4x5 or 8x10 color transparencies; or b&w or color contact sheet; query with resume of photo credits or with list of stock photo subjects. SASE. Reports in 3-6 weeks, sooner if possible. Pays on publication with 5 free copies/byline and sometimes a biography or profile of photographer. Credit line given. Buys one-time rights. Simultaneous and previously published work OK.

*FAMILY PET, Box 22964, Tampa FL 33622. Editor: M. Linda Sabella. Quarterly magazine. Circ. 3,000. Emphasizes pet ownership and enjoyment for pet owners. Needs photos of "anything pet-related." Buys 10-12 annually. Buys one-time publication rights. Model release "preferred if possible if individuals are recognizable." Send photos for consideration. Pays \$20 for text/photo package. Pays on publication. Reports in 6-8 weeks. SASE. Free sample copy and photo guidelines with 9x12 SASE. **B&W**: Send 5x7 glossy prints. Captions required. Pays \$3-5 for use inside.

Cover: Send 5x7 glossy b&w prints. Captions required. Pays \$10 for cover use.

Tips: "No restrictions, only must be in good taste. No 'cute,' artificially posed photos of animals in unnatural situations. Study back issues and submit quality (sharp prints), general appeal. More market for pictures that might be used to illustrate an existing article or for cover use. Almost all photos are purchased from stock. We very rarely make specific assignments."

*FOCUS ON THE FAMILY, 40 E. Foothill Blvd., Arcadia CA 91006. (818)445-1579. Editor: Scott Sawyer. Photo Editor: Melinda Delahooke. Company publication focus on the family (non-profit). Monthly. Emphasizes family, couples, children, elderly. Readers include housewives ages 25-45. Circ. 700,000. Free sample copy. Free photo guidelines.

Photo Needs: Uses 7-10 photos/issue; 3-5 supplied by freelance photographers. Needs families-active nonstaged. Couples, children, elderly, etc. Anything dealing with the home or family. Also special edi-

torial needs for each issue.

Making Contact & Terms: Query with samples and list of stock photo subjects; send unsolicited photos by mail for consideration. Uses any size, finish b&w prints, 35mm, 21/4x21/4, 4x5 transparencies. SASE. Reports in 3 weeks. Credit line given. Buys one-time rights. Simultaneous submissions and previously published work OK.

FORD TIMES, Rm. 751, Box 1899, The American Road, Dearborn MI 48121. Editor: Arnold S. Hirsch, Graphics Manager: Jerry L. Anderson, Monthly, Circ. 1,200,000. General interest; current topics with a magazine featuring slant. Free sample copy and photo guidelines with SASE.

Photo Needs: Uses about 25 photos/issue; most from freelance photographers. Photos purchased with

accompanying ms or by assignment. Model release and captions required.

Making Contact & Terms: Query with samples. Prefers to see published works in a printed form and original photography as samples. SASE. Reports in 1 month. Pays \$350/b&w or color inside photo, full page or more; \$150/b&w or color inside photo, less than page size; \$500/cover photo. Pays on publication. Credit line given. Buys one-time rights.

Tips: Prefers to see "a good choice of well-composed, high-impact photos, utilizing both natural and artificial lighting. Go beyond the obvious requirements of an assignment, and come up with the unexpect-

ed."

FRANKLIN MINT ALMANAC, Franklin Center PA 19091. (215)459-7016. Editor-in-Chief: Samuel H. Young. Photo Editor: Peter Richardson. Bimonthly. Circ. 1,200,000. Emphasizes "collecting" for buyers. Free sample copy on request.

Photo Needs: Uses about 40 photos/issue; 35 are supplied by freelance photographers and stock agencies. Photos purchased with or without accompanying ms. Model release and captions required.

Making Contact & Terms: Query with resume of credits. SASE. Reports in 2 weeks. Provide resume and tearsheets to be kept on file for possible future assignments. Pays standard ASMP page rates; pays ASMP day rate plus expenses for assigned stories but is negotiable on length, difficulty and cost of assignment. Pays on publication. Credit line given. Buys world rights. Previously published work OK. Tips: "We're hard to reach—geographically. Sending tearsheets or 35mm slides is most practical. We want to see that the photographer can handle both people and the items they collect. Have a good eye, be technically proficient and understand what we're looking for. It helps to be in a location not populated with our 'regulars.'"

FRIENDS MAGAZINE, 30400 Van Dyke Ave., Warren MI 48093. (313)575-9400. Editor: Tom Morrisey. Publication of Chevrolet. Monthly. Circ. 1,000,000. Emphasizes Chevrolet products and general interest material. Readers are Chevrolet owners. Sample copy free with SASE.

Photo Needs: Uses about 20 photos/issue; 75% supplied by freelance photographers. Needs "action, adventure, people-oriented photos limited to United States." Model release and captions required. All

stories and photo essays must "tie-in" Chevrolet or Chevy product.

Making Contact & Terms: Query with resume of credits and query in writing with story outline. SASE. Reports in 2 weeks. Pays \$200/color page and \$400 minimum for photo package. Pays on acceptance. Credit line given. Rights purchased "to be negotiated."

Tips: "Submit tearsheets of samples along with specific queries in brief outline. Photos are used primarily to support a text, therefore a photographer should team with a top-notch writer, or be able to supply a well-written text."

FRUITION, Box 872-PM, Santa Cruz CA 95061. (408)425-1708. Editor: C.L. Olson. Publication of The Fruition Project. Biannually. Circ. 300. Emphasizes "public access food trees via community and other food tree nurseries; healthful living through natural hygiene. Readers are naturalists, health minded, environmentalists, humanists. Sample copy \$2.

Photo Needs: Uses about 4-5 photos/issue; all supplied by freelance photographers. "B&w is what we print; color prints acceptable: food trees and bushes and vines (fruit and nut) in single and multiple settings; good contrast photos of various fruits and nuts and various states of ripening, and the foliage flowers and parts of the plants." Special needs include "photos of the state of Massachusetts' project planting public access food trees; photos of chestnut trees on Corsica (island); photos of Portland, Oregon's Edible City Project; photos of trees in parks and public lands to include government offices." Model release and captions preferred.

Making Contact & Terms: Send unsolicited photos by mail for consideration. SASE. Reports in 2 weeks. "All rates negotiable; prefer trade for subscriptions; low rates paid." Pays on either acceptance or publication. Credit line given on request. Negotiates rights purchased. Simultaneous submissions and

previously published work OK.

Tips: "Prints with excellent contrast best. Expect low pay and/or tax deductions or subscriptions as payment. Some work paid for in cash."

*GENERATION, Box G, Harriman Suny, Buffalo NY 14214. (716)831-2748. Editor: EF Coppolino. Photo Editor: Doreen Fertel. Company publication of the Sun-Board One, Inc. Emphasizes student issues. Readers include university community of 29,000. Circ. 10,000. Estab. 1984. Free sample copy with SASE. Free photo guidelines with SASE.

Photo Needs: Uses 10 photos/issue; 1-2 supplied by freelance photographers. Needs political figures, corporate figures. Reviews photos with or without accompanying ms. Special needs include camp shots

in mid-west, west and southern US.

Making Contact & Terms: Query with samples. Uses 8x10 b&w or color prints, 35mm, 21/4x21/4 b&w negatives. SASE. Reports in 3 weeks. Pays \$10/color photo. Pays on publication. Credit line given. Buys first North American serial rights. Simultaneous submissions OK.

Tips: "Needs specialty of photographer, i.e., portraits."

*HEALTHPLEX MAGAZINE, 8303 Dodge St., Omaha NE 68114. (402)390-4528. Editor: Gini Goldsmith. Company publication of the Methodist/Childrens' Hospital. Quarterly. Emphasizes health care. Readers include health care consumers. Circ. 35,000. Estab. 1985. Sample copy \$1.

Photo Needs: Uses 12-15 photos/issue; most supplied by freelance photographers. Needs health care photos. Reviews photos with or without accompanying ms. Model release required.

Making Contact & Terms: Query with samples. Reports in 3 weeks. Pays \$50-300/job. Pays on acceptance. Buys all rights. Previously published work OK.

Tips: "We prefer photos which relate to consumer health-care articles on topics, such as heart attacks, breast cancer, Reyes Syndrome, Alzheimer's Disease, etc. Send samples of printed work in subject area."

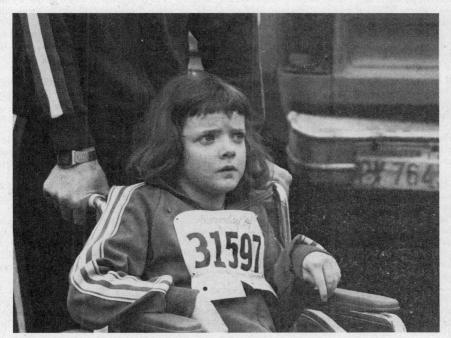

Being able to capture intensity and emotions are critical to the success of any freelance photography venture. This photo was taken by Judy Rotter, an intern working at the time for The Illuminator, a company periodical in Spokane, Washington. It dramatically shows the feelings of a young girl about to participate in the 1984 Bloomsday Run, in which more than 30,000 people competed. "I feel the photo is a good example of how a 'semipro' photographer can produce good work, partly through serendipity, but primarily because the 'art' in any creative endeavor is in the mind, not in the equipment or credentials," says Steve Blewett, publications coordinator for The Illuminator.

THE ILLUMINATOR, Box 3727, Spokane WA 99220. (509)489-0500, ex. 2577. Publications Coordinator: Steve Blewett. Publication of Washington Water Power. Monthly. Circ. 3,000. Emphasizes company interests. Readers are employees. Sample copy free with SASE.

Photo Needs: Uses about 6-10 photos/issue. Needs mostly photos of "employees involved in a variety of work and hobby areas. Little chance for any but local photographer to supply photos."

Making Contact & Terms: Arrange a personal interview to show portfolio. SASE. Reports in 3 weeks. Payment negotiated. Pays on publication. Credit line given. Rights purchased "as dictated by subject matter."

Tips: Prefers to see "range of work, including posterization, etc. I need anyone with ideas and imagination on how to get the best job completed in the least time. Be professional!"

INLAND, Inland Steel Co., 30 W. Monroe St., Chicago IL 60603. (312)346-0300. Managing Editor: Sheldon A. Mix. Emphasizes "steel specifically, Middle West generally." Readers are purchasing agents and company executives. Quarterly. Circ. 12,000. Free sample copy.

Photo Needs: Uses about 20-30 photos/issue; about half are supplied by freelance photographers; 80% on assignment to freelancers. "We assign Chicago-area freelance photographers to produce photo essays, also to provide photos to illustrate various articles, most of which are related to the steel half of our pages. We also welcome photo essays and stories submitted on an unsolicited basis for our review. Show us how assignments were carried out without on location direction. Our subject area is the Middle West: the seasons, topography, natural features." Captions required.

Making Contact & Terms: Send by mail for consideration actual 8x10 b&w photos or query with re-

sume of photo credits. SASE. Reports in 2-4 weeks, "usually." Pay is negotiable, based on quality and space given: \$250 and up/day. Pays on acceptance. Credit line given. Buys one-time rights. No simultaneous or previously published submissions.

Tips: "Look at the publication, come up with some sound creative ideas, perhaps collaborate with a solid writer who can produce good text and captions. Learn about the magazine's interests and needs (es-

says that are timeless, except for those related to particular seasons).'

*LEADERSHIP, 465 Gundersen Dr., Carol Stream IL 60188. (312)260-6200. Editor: Terry Muck. Company publication for Christanity Today, Inc. Quarterly. Emphasizes the clergy. Circ. 90,000. Sample copy \$5.

Photo Needs: Uses about 12 photos/issue; 100% supplied by freelance photographers, most designed.

Reviews photos with accompanying ms only.

Making Contact & Terms: Review photos only with ms. Send b&w contact sheet. SASE. Reports in 2 weeks. Payment individually negotiated. Pays on acceptance. Credit line given. Buys first North American serial rights. Simultaneous submissions and previously published work OK; depends on material.

THE LOOKOUT, 50 Broadway, New York NY 10004. (212)269-2710. Editor: Carlyle Windley. Publication of Seamen's Church Institute of New York/New Jersey. Triannually. Circ. 6,000. Emphasizes the maritime/shipping industry. Sample copy available.

Photo Needs: Uses about 14-20 photos/issue; 2-3 supplied by freelance photographers. Needs "ocean

shots; aboard ships at sea—seafarers at work." Captions required.

Making Contact & Terms: Query with resume of credits or with list of stock photo subjects. Reports in 2 weeks. Pays \$50/b&w cover photo; \$20-50/hour; \$50-150 for text/photo package. Pays on publication. Credit line given. Buys one-time rights unless on assignment, then all rights plus negatives. Previously published work OK.

*MOTORLAND MAGAZINE, 150 Van Ness Ave., San Francisco CA 94102. (415)565-2464. Editor: John Holmgren. Photo Editor: Al Davidson. Company publication for the California State Auto Association. Bimonthly. Emphasizes travel. Readers include RVH travelers 40-45 median age. Circ. 1,500,000. Free sample copy and photo guidelines with SASE.

Photo Needs: Uses 35 photos/issue; 30 supplied by freelance photographers. Needs include travel, scenic. Reviews photos with or without accompanying ms. Model release and captions required.

Making Contact & Terms: Arrange a personal interview to show portfolio. SASE. Reports in 3 weeks. Pays \$300/color cover photo, \$175/inside color photo, \$400-600/text/photo package. Pays on acceptance. Credit line given. Buys one-time rights. Previously published work OK.

*MUSCULAR DEVELOPMENT MAGAZINE, Box 1707, York PA 17405. (717)767-6481. Editor: John C. Grimek. Photo Editor: Jan Dellinger. Company publication for the York Barbell Company. Monthly. Emphasizes competitive bodybuilding, powerlifting and general heavy exercise. Readers in-

clude the serious weight training public. Circ. 80,000.

Photo Needs: Uses 100 + photos/issue; most supplied by freelance photographers. Needs b&w and color shots from various bodybuilding contests, some of top name bodybuilders training or posing individually, casual shots of some individuals. Reviews photos with or without accompanying ms. Model release preferred; captions required. Query with list of stock photo subjects; send unsolicited photos by mail for consideration. Uses 5x7 glossy b&w prints, 21/4x21/4 transparencies, b&w or color contact sheet. SASE. Reports in 2 weeks. Pays \$250-300/color cover photo, \$10-15/inside b&w photo and \$30-40 color photo. Pays on publication. Credit line given. Buys all rights. Previously published work OK.

*NEW BODY MAGAZINE, 888 Seventh Ave., New York NY 10601. (212)315-3000. Art Director: Cynthia Magalian. Company publication for the G.C.R. New Body. Bimonthly. Emphasizes health and fitness. Readers include men and women 25-45 years old. Circ. 275,000.

Photo Needs: Needs beauty, beach, bodies, workout and exercise photos. Reviews photos with or with-

out accompanying ms. Model release and captions required.

Making Contact & Terms: Arrange a personal interview to show portfolio; submit portfolio for review; provide resume, business card, brochure, flyer or tearsheets to be kept on file for possible future assignments. Does not return unsolicited material. Reports in 2 weeks. Pays by the job. Pays on publication. Credit line given. Buys one-time rights. Previously published work OK.

NEW WORLD OUTLOOK, Rm. 1351, 475 Riverside Dr., New York NY 10115. (212)870-3758/ 3765. Editor: Arthur J. Moore. Executive Editor: George M. Daniels. Monthly magazine. Circ. 38,000. Features Christian mission and involvement in social concerns and problems around the world. For United Methodist lay persons; not clergy generally. Credit line given. Pays on publication. Buys onetime rights. Send material by mail for consideration; submit portfolio for review or query with samples. SASE. Previously published work OK. Reports in 3 weeks. Sample copy available.

Subject Needs: Query for needs. Captions preferred.

B&W: Uses 5x7 or larger glossy prints. Pays \$15 minimum/photo. **Color:** Uses 35mm or larger transparencies. Pays \$50-100/photo.

Cover: Uses color transparencies. Vertical format required. Pays \$100-150/photo.

OZARK MAGAZINE, 5900 Wilshire Blvd., Los Angeles CA 90036. (213)937-5810. Art Director: Carla Schrad. Publication of Ozark Airlines. Monthly magazine. "We chronicle the good life in the Midwest, with emphasis on sports, personalities, lifestyle, food, fashion, etc." Readers are passengers of Ozark Airlines (mostly executives). Circ. 120,000. Sample copy for \$2.

Photo Needs: Uses approximately 27 photos/issue; 12 supplied by freelance photographers. Subject needs "depend on the story—wide range." Special needs include "photo essays in association with the

Midwest." Captions required.

Making Contact & Terms: Query with samples. Provide resume, business card, brochure, flyer or tearsheets to be kept on file for possible future assignments. Returns unsolicited material with SASE. Pays \$350/color cover photo; \$125/b&w; \$250/color; \$150-500/job; \$250/text/photo package. Pays on acceptance. Credit line given. Buys one-time rights.

Tips: Prefers to see "graphic, powerful images that show the creative ability of the photographer."

PAGES, 300 N. State St., Chicago IL 60610. (317)674-6441. Editor-in-Chief: Shirley A. Lambert. Monthly. Circ. 3,000. Publication of the Berry Publishing Co. "Call for photo guidelines."

Photo Needs: Uses 1 cover photo/issue; supplied by freelance photographer. Needs "snow scenes suitable for duotone; full color spring flowers; full color autumn leaves and miscellaneous summer photos." Photos purchased with or without accompanying ms. Captions optional.

Making Contact & Terms: Query with list of stock photo subjects. SASE. Reports in 3 weeks. Provide business card or flyer to be kept on file for possible future assignments. Pays \$35/b&w or color photo or will consider photographer's asking price. Pays on acceptance. Credit line not generally given, "but might if requested." Buys one-time rights. Simultaneous submissions and previously published work

OK.

PERSPECTIVE, Box 1766, Rochester NY 14603. (716)475-9000. Contact: Editor. Publication of Pennwalt Prescription Division. Quarterly. Circ. 500. Emphasizes pharmaceuticals. Readers are company sales force, managers, executives. Sample copy 50-75¢ with SASE.

Photo Needs: Uses about 20-30 photos/issue; none currently are supplied by freelance photographers. Needs photos of "subjects that deal with pharmaceuticals, research, medicine." Model release required;

captions preferred.

Making Contact & Terms: Send 5x7 b&w glossy prints by mail for consideration. SASE. Reports in 3 weeks. Pays \$75-150/b&w cover photo. Pays on publication. Credit line given. Buys all rights. Simultaneous submissions OK.

THE PILOT'S LOG, 501 Boylston St., Boston MA 02117. (617)578-2662. Editor: Wayne Worcester. Bimonthly. Circ. 5,000. Publication of New England Mutual Life Insurance Co. Emphasizes selling insurance and related products and services. "The Pilot's Log is New England Life's feature magazine for its national sales force of 5,000." Free sample copy with SASE.

Photo Needs: Uses about 6-10 photos/issue; 2-3 are supplied by freelance photographers. Needs photos of "mostly New England Life agents in business settings. Occasionally, we assign a photographer to take photos for illustrative purposes." Photos purchased with or without accompanying ms. Model re-

lease required.

Making Contact & Terms: Arrange a personal interview; query with samples or submit portfolio for review. "Absolutely no unsolicited photos." Does not return unsolicited material. Reports in 1 month. Provide brochure, flyer, tearsheets and samples to be kept on file for possible future assignments. Pays \$50-100/b&w, \$150-250 color/cover photo; \$100-200 for text/photo package. Pays on acceptance. Buys all rights.

Tips: "We need quality freelancers in almost every major metropolitan area in the country for sporadic photo assignments." Prefers to see b&w candid shots and cover shots for business periodicals.

QUEST, #1 Horace Mann Plaza, Mail #E002, Springfield IL 62715. (217)789-2500, ext. 5944. Marketing Communications Manager: Marilyn Titone Schaefer. Publication of The Horace Mann Companies. Quarterly. Circ. 1,400. Emphasizes multiline insurance for sales agents and managers. Sample copy free with SASE.

Photo Needs: Uses about 30 photos/issue; at the present, none are supplied by freelance photographers. Needs photos of "agents at work in our field offices; agents in the schools (our primary market is teachers); other needs as they arise. We supply all the mss." Captions (at least names of subjects) preferred.

Making Contact & Terms: Provide resume, business card, brochure, flyer or tearsheets to be kept on file for possible future assignments. SASE. Reports "as soon as we would need a photographer from his/her area of the country." Pays \$25-30/hour; \$125 maximum/job. Pays on acceptance. Credit line given. Buys all rights. Simultaneous submissions and previously published work OK.

ROCHESTER TELEPHONE TIELINE, 700 Sibley Tower, Rochester NY 14604. (716)423-7059. Editor: B J Weiss. Bimonthly. Circ. 3,000. Publication of Rochester Telephone Corporation. Emphasizes telephone/telecommunications services. Readers are 2,800 employees in all levels at Rochester Telephone and its subsidiaries, along with several hundred interested outside parties. Free sample copy (limited number/month—send manila envelope with 40¢ postage).

Photo Needs: Uses about 25 photos/issue; "most of them" are supplied by freelance photographers, "but we use primarily local freelancers on a long-term basis." Needs photos on "new applications of telephone technology, interesting gimmick shots (telephone theme), location work being done by our subsidiaries (Rotelcom divisions and RCI) in area other than Western New York." Photos purchased with or without accompanying ms. Pays \$50-100/photo. Model release preferred "except when they are RTC employees, then not necessary"; captions required.

Making Contact & Terms: Send by mail for consideration slides or b&w contact sheet; or query with resume of credits or with list of stock photo subjects. "We do not use color." SASE. "Queries answered only in affirmative (no response—no work available)." Materials submitted returned in 1 month. Payment negotiated. Pays on acceptance. Credit line given "only in exceptional cases." Rights purchased depends on determination of use. Simultaneous submissions and previously published work OK if not previously used by another telephone company.

ROOMMATE, Suite 310, 9600 SW Oak, Portland OR 97223. (503)244-2299. Editor: Robert E. Patterson. Publication of Thunderbird/Red Lion Inns. Quarterly. Circ. 50,000. Emphasizes business and travel. Readers are affluent, well-educated businessmen. Sample copy \$3 with SASE; photo guidelines free with SASE.

Photo Needs: Uses about 25 photos/issue; about 30% supplied by freelance photographers. Needs photos "to accompany articles—travel, business, sports, etc." Photos purchased with accompanying ms only. Model release preferred; captions required.

Making Contact & Terms: Send transparencies or b&w contact sheet by mail for consideration only with ms. SASE. Reports in 1 month. Pays \$100-300 for text/photo package. Pays on publication. Credit line given. Buys first North American serial rights.

ROSEBURG WOODSMAN, c/o Hugh Dwight Advertising, Suite 101, 4905 SW Griffith Dr., Beaverton OR 97005. Editor: Shirley P. Rogers. Monthly magazine. Circ. 8,000. Publication of Roseburg Lumber Company. Emphasizes wood and wood products for customers and others engaged in forest products/building materials industry. Wants on a regular basis interesting uses of wood in construction, industrial applications, homes and by hobbyists and craftsmen. "Look for uses of wood. Show us your interests and outlook." Especially needs for next year Christmas-oriented features related to wood. "Will not buy photos that are grainy, lacking in contrast, or badly composed, no matter how well the subject fits our format." Buys 100 or more annually. Buys all rights, but may reassign to photographer after publication. Submit model release with photo. Query. Provide resume and calling card to be kept on file for possible future assignments. Pays on publication; fee negotiable on assignment. Reports in 1 month. Free sample copy and photo guidelines.

Color: Transparencies preferred; 35mm acceptable. Captions required. Pays \$25-50, up to \$125 each for unsolicited submissions.

Cover: Color transparencies or 35mm slides. Captions required. Pays \$75-125.

Tips: Prefers to buy package of pix and ms. Background information must accompany photos, but polished copy "not mandatory. We are looking for sharp, clean shots that need little if any cropping. I like to see versatility, imagination, awareness of all elements and sensitive framing."

THE SENTINEL, Industrial Risk Insurers, 85 Woodland St., Hartford CT 06102. (203)525-2601. Editor: A. Waller. Quarterly magazine. Circ. 54,000. Emphasizes industrial loss prevention for "insureds and all individuals interested in fire protection." Pays on acceptance. Send material by mail for consideration. Previously published work OK. Reports in 2 weeks. Free sample copy and photo guidelines. **Photo Needs:** Uses 4-8 photos/issue; 2-3 supplied by freelance photographers. Needs photos of fires, explosions, windstorm damage and other losses at industrial plants. Prefers to see good industrial fires and industrial process shots. No photos that do not pertain to industrial loss prevention (no house fires). Model release preferred. Credit line given. Buys one-time rights.

B&W: Uses glossy prints. Pays \$15-35/photo. **Color:** Uses glossy prints. Pays \$25-100/photo.

Cover: Uses b&w or color glossy prints. Vertical format required. Pays \$35-100/photo.

SKYLITE, 12955 Biscayne Blvd., North Miami FL 33181. (305)893-1520. Editor: Julio C. Zangroniz. Publication of Butler Aviation International. Monthly. Circ. 25,000. Emphasizes business and business personalities. Readers are corporate executives and their families. Sample copy \$3: photo

guidelines free with SASE.

Photo Needs: Uses about 30-40 photos/issue; 90% supplied by freelance photographers. "The magazine covers a wide spectrum, in addition to business/industry: sports, science, domestic and foreign travel, lifestyle, etc." Photos usually purchased with accompanying ms. Model release and captions

Making Contact & Terms: Provide resume, business card, brochure, flyer or tearsheets to be kept on file for possible future assignments. SASE. "Sometimes it may take 2-3 months" to report. Pays \$150/ color cover photo; \$50/color inside photo; \$50/color page and \$300-500 for text/photo package. Pays on publication. Credit line given. Buys one-time rights. Simultaneous submissions OK.

Tips: "Be persistent-it's a very competitive field, but quality will find a market."

SPERRY NEW HOLLAND NEWS, Sperry New Holland, New Holland PA 17557. (717)354-1121. Editor: Gary Martin. Published 8 times/year. Circ. 450,000. Emphasizes agriculture. Readers are farmers. Sample copy and photo guidelines free with SASE.

Photo Needs: Buys 30 photos/year of scenic agriculture relating to the seasons, harvesting, farm animals, farm management and farm people. Also, photos with one-paragraph story/captions. Model re-

lease and captions required. "Large collections viewed and returned quickly."

Making Contact & Terms: "Show us your work." SASE. Reports in 2 weeks. Payment negotiable. Pays on acceptance. Buys first North American serial rights. Previously published work OK.

Tips: Photographers "must see beauty in agriculture and provide meaningful photojournalistic caption material to be successful here. It also helps to team-up with a good agricultural writer and query us on a photojournalistic idea."

SYBRON QUARTERLY MAGAZINE, 1100 Midtown Tower, Rochester NY 14604. (716)546-4040. Manager, Public Relations: Scott Perkins. Quarterly. Circ. 10,000. Emphasizes internal company events and developments. Readers are employees and interested outside parties (e.g., shareholders). Sample copy free.

Photo Needs: Uses about 25-35 photos/issue; 75% supplied by freelance photographers. Needs product, people and factory-environment photos. "Photos are assigned by editor; never bought on specula-

tion." Mostly b&w. Model release required.

Making Contact & Terms: Arrange a personal interview to show portfolio. Pays \$200-2,000/job and \$500-2,500 for text/photo package. Pays on acceptance. Credit line given in masthead only. Buys all

Tips: Prefers to see "industrial-type publicity photography (photojournalist and studio stilllife)" in a

portfolio.

TOPICS, 270 Park Ave., 34th Floor, New York NY 10017. (212)286-6000. Editor: Nancy Daigler. Publication of Manufacturers Hanover Corporation. Monthly. Emphasizes people, new products and services in banking and finance industry. Readers are 35,000 employees mostly in New York metropolitan area, some overseas distribution.

Photo Needs: Uses about 15-20 photos/issue; 3-5 supplied by freelance photographers. Needs b&w photos of employees in office or on location. "We occasionally need shots of employees in other cities

across the U.S. or overseas." Captions preferred.

Making Contact & Terms: Query with samples. Provide resume, business card, brochure, flyer or tearsheets to be kept on file for possible future assignments. Does not return unsolicited material. Reports in 1 month. Pays \$100-200/b&w cover photo; \$100-150/b&w inside photo; \$150-200/half-day. Pays on acceptance. Credit line given. Buys all rights; sometimes negotiable depending upon photo use. Previously published work OK.

Tips: Prefers to see "b&w photos of business executives and staff in office and on location. Journalistic

flair preferred (i.e., an eye for photo story); sharp, dramatic b&w photos."

TRADEWINDS, 2520 W. Freeway, Ft. Worth TX 76102. (817)335-7031, ext. 408. Editor: Steve McLinden. Publication of Pier 1 Imports. Bimonthly. Emphasizes "fun of the business" in importing. Readers are 3,000 Pier 1 employees nationwide, mostly young (16-30 age group). Sample copy free

Photo Needs: Uses about 30-35 photos/issue; "just a few, if any" are supplied by freelance photogra-

phers. Needs "photos of employees in freelancer's area (mostly metro areas)."

Making Contact & Terms: Send 4x5 glossy b&w prints or b&w contact sheet by mail for consideration. SASE. Reports in 1 week. "Will consider most price scales." Pays on acceptance. Buys all rights. Simultaneous submissions and previously published work OK.

*TRAILBLAZER MAGAZINE, 15325 SE 30th Place, Bellevue WA 98007. (800)426-5045. Associate Editor: Rudy Yuly. Thousand Trails, Inc. Monthly magazine. Emphasizes the outdoors, destinations, leisure time, hobbies and self-improvement. Readers are 50 +, \$30,000 a year, who enjoy traveling and camping; active, fairly well educated. Circ. 70,000. Sample copies \$1.50 with SASE. Photo guidelines free with SASE.

Photo Needs: Uses 25-30 photos/issue; 10 supplied by freelance photographers. Needs "photos to accompany articles—activities, destinations, studio shots." Photos purchased with accompanying ms.

Model release preferred; captions required.

Making Contact & Terms: Provide resume, business card, brochure, flyer or tearsheets to be kept on file for possible future assignments. SASE. Reports in 1 month. Pays \$35/b&w cover photo; \$200/color cover photo; \$15-35/b&w inside photo and \$25-100/color inside photo. Pays on publication. Credit line given. Buys first North American serial rights.

VOLKSWAGEN'S WORLD, (formerly Small World), Volkswagen of America, Box 3951, 888 W. Big Beaver Rd., Troy MI 48099. (313)362-6000. Editor: Ed Rabinowitz. Quarterly magazine. Circ. 250,000. For owners of Volkswagen (VW) automobiles. Buys 50 annually. Buys all rights. Submit model release with photo or present model release on acceptance of photo. Query first with story or photo essay idea. Photos purchased with accompanying ms; "features are usually purchased on a combination words-and-pictures basis." Credit line given. Pays on acceptance, \$150-450 for full photo feature; \$150-450 for text/photo package; and \$150 page rate. Reports in 6 weeks. SASE. Previously published work OK. Free sample copy and contributor's guidelines.

Subject Needs: Celebrity/personality, how-to, human interest, humorous, photo essay/photo feature.

sport, and travel.

Color: Send transparencies; prefers 35mm but accepts any size. Captions required. Pay is included in total purchase price with ms.

Cover: Submit color transparencies. Uses vertical format. Captions required. Pays \$50-300.

Tips: Needs photos for "Talk About Volkswagen" department which features "offbeat VWs—no commercial 'kit' cars, please." Prefers photos featuring new generation VWs—Golf, Scirocco, Jetta, Vanagon, Camper and Quantum models. Pays \$15 minimum.

Consumer Magazines

With the possible exception of the advertising industry, consumer magazine publishers represent the largest and most prestigious of all photography markets. What photographer has not dreamed of seeing his work published in the pages of Audubon, Sports Illustrated, National Geographic, Life or any of the other large, na-

tional magazines listed here?

While almost all freelancers aspire to such lofty heights, it takes most photographers years of hard work to reach them. Fortunately, the path to the top of the consumer magazine market is open to all, and the steps along the way may also be found here in the form of the many hundreds of smaller, lesser-known magazines which form the majority of this market. By establishing yourself as a contributor of highquality photography to a series of progressively larger, more demanding magazines, you can demonstrate to the editors of even the very biggest publications that you can provide the top-notch material they seek.

Just what is a consumer magazine, and how does it differ from the other types of periodicals? Consumer magazines are those publications offered by subscription and often on the newsstand-to the general reading public. Their readers need not belong to any particular group or profession-although they almost certainly share certain identifiable interests. Consumer magazines, with very few exceptions, are operated as businesses for the purpose of making a profit, deriving income from both sales of the magazine itself, and from sales of advertising space within the

magazine's pages.

Virtually all the magazines found at any newsstand are consumer magazines. There are hundreds or thousands more sold only by subscription; these usually have a small circulation of readers who share some narrow interest or hobby-kiteflying, for example, or crocheting. In fact, there's a consumer magazine for virtually every conceivable interest or activity shared by more than a few hundred peopleand this is a convenient starting point for your own marketing efforts in this market. Start by identifying your own biggest interests and pursuits, and then check the listings to locate those magazines devoted to the subjects you follow. If you already subscribe to one or more specialized magazines, concentrate your initial marketing efforts there—you're already familiar with the types of material the editors use.

Editors of all consumer magazines like freelancers who can provide more than just pictures. Wherever you choose to begin marketing your work, it's important to study the magazine thoroughly. Identify the specific editorial slant of its stories. Determine for yourself what types of coverage the magazine's editors seem to prefer. Then, when you contact an editor, don't just say "I have pictures of such-and-such." Based on your research, provide the editor with ideas for stories, areas of coverage or complete photo essays you believe are well suited to the magazine. If you can write as well as photograph—and this is a skill well worth learning—so much the better, because magazine editors would much rather get their two biggest needs. words and pictures, from the same source whenever possible.

Such an approach does not guarantee sales—there's always an element of luck involved, since the editor may have run a similar story a year ago, or have just assigned one like it to another freelancer-but it does demonstrate to the editor that you've taken the time to think about his magazine's needs, and it improves the chances that he will think of you first when a related assignment comes up.

Of course, it's quite possible to sell photos to consumer magazines without this type of large-scale, assignment-oriented thinking; many freelancers specialize in selling only stock images to magazines and other markets. Nature, travel, and other types of publications use a great deal of stock photography to illustrate their articles, and the well-organized stock photographer will find many ready markets here.

Whether you choose the assignment or stock photography route, bear in mind that success in the consumer magazine market depends on your ability to provide what the editor wants, when he wants it.

*THE ABSOLUTE SOUND, 2 Glen Ave., Sea Cliff NY 11579. (516)676-2830. Editorial Director: Brian Gallant. Quarterly magazine. Emphasizes the "high end of audio-component reviews and record reviews. Readers are audiophiles and doctors. Circ. 15,000-20,000. Sample copies free with SASE and \$1.94 postage.

Photo Needs: Uses about 10-20 photos/issue; all supplied by freelance photographers. Needs photos of people at trade shows in recording industry, artists, audio components." Model release optional; cap-

tions preferred.

Making Contact & Terms: Query with samples. Send unsolicited 4x5 b&w prints; b&w contact sheet; and b&w negatives by mail for consideration. Provide resume, business card, brochure, flyer or tearsheets to be kept on file for possible future assignments. SASE. Reports in 1 month. Pays on publication. Credit line given. Buys one-time rights.

ACCENT, Box 10010, Ogden UT 84409. Editor: Peggie Bingham. Monthly magazine. Circ. 89,000. Emphasizes travel-interesting places, foreign and domestic advice to travelers, new ways to travel, money-saving tips, new resorts, innovations and some humor. Stories and photos are usually purchased as a package. "We work 1 year in advance, so keep the seasonal angle in mind." Buys 15-20 photos/issue. Sample copy \$1 with 9x12 envelope.

Subject Needs: Scenic (color transparencies) for cover usually goes along with lead story). Captions re-

quired. "We can't use moody shots."

Specs: Uses color transparencies; 4x5 preferred but will use 35mm. Vertical or square format used on cover.

Accompanying Mss: Seeks mss between 1,000 and 1,200 words.

Payment/Terms: Pays \$35/color transparency and \$50 minimum/cover; 15¢/printed word. Credit line

given. Pays on acceptance. Buys first North American rights.

Making Contact: Query with list of stock photo subjects. If submitting cover possibilities, "please send us your best pix with a cover letter and SASE." Provide brochure, samples and tearsheet to be kept on file for possible future assignments.

ACCENT ON LIVING, Box 700, Bloomington IL 61702. (309)378-2961. Editor: Betty Garee. Quarterly magazine. Circ. 18,000. Emphasizes successful disabled people who are getting the most out of life in every way and how they are accomplishing this. For physically disabled individuals of all ages and socioeconomic levels and professionals. Buys 20-50 photos annually. Buys first-time rights. Query first with ideas, get an OK, and send contact sheet for consideration. Provide letter of inquiry and samples to be kept on file for possible future assignments. Pays on publication. SASE. Reports in 2 weeks. Simultaneous submissions and previously published work OK "if we're notified and we OK it." Sample copy \$2. Free photo guidelines; enclose SASE.

Subject Needs: Photos dealing with coping with the problems and situations peculiar to handicapped persons: how-to, new aids and assistive devices, news, documentary, human interest, photo essay/photo feature, humorous and travel. "All must be tied in with physical disability. We want essentially action shots of disabled individuals doing something interesting/unique or with a new device they have developed. Not photos of disabled people shown with a good citizen 'helping' them."

B&W: Send contact sheet. Uses glossy prints. Manuscript required. Pays \$5 minimum.

Cover: Send b&w contact sheet or prints. Captions required. Cover is usually tied in with main feature

inside. Pays \$15-50.

Tips: Needs photos for Accent on People department, "a human interest photo column on disabled individuals who are gainfully employed or doing unusual things." Also uses occasional photo features on disabled persons in specific occupations: art, health, etc. Pays \$25-200 for text/photo package. Send for guidelines. "Concentrate on improving photographic skills. Join a local camera club, go to photo seminars, etc. We find that most articles are helped a great deal with good photographs—in fact, good photographs will often mean buying a story and passing up another one with very poor or no photographs at all.

ADIRONDACK LIFE, Box 97, Rt. 86, Jay NY 12941. (518)946-2191. Editor: Jeffrey G. Kelly. Bimonthly. Circ. 40,000. Emphasizes the Adirondacks and the north country of New York State. Sample copy \$4; photo guidelines free with SASE.

Photo Needs: "We use about 40 photos/issue, most supplied by freelance photographers. All photos must be taken in the Adirondacks and all shots must be identified as to location and photographer." Making Contact & Terms: Send one sleeve (20 slides) of samples. Send b&w prints (preferably 8x10) or 35mm color transparencies. SASE. Reports in 1 month. Pays \$300/cover photo; \$75/full-age color photo; \$50/half-page color photo; \$25/b&w photo. Pays on publication. Credit line given. Buys first North American serial rights. Simultaneous submissions OK.

Tips: "Send quality work pertaining specifically to the Adirondacks." In addition to technical proficiency, we look for originality and imagination. We avoid using typical shots of sunsets, lakes, reflec-

tions, mountains, etc.

AFRICA REPORT, 833 UN Plaza, New York NY 10017. (212)949-5731. Editor: Margaret A. Novicki. Bimonthly magazine. Circ. 12,000. Emphasizes African political, economic and social affairs, especially those significant for US. Readers are Americans with professional or personal interest in Africa. Photos purchased with or without accompanying ms. Buys 20 photos/issue. Provide samples and list of countries/subjects to be kept on file for future assignments. Pays \$80-250 for text/photo package or also on a per-photo basis. Credit line given. Pays on publication. Buys one-time rights. SASE. Simultaneous submissions and previously published work OK. Reports in 1 month. Free sample copy.

Subject Needs: Personality, documentary, photo feature, scenic, spot news, human interest, travel, socioeconomic and political. Photos must relate to African affairs. "We will not reply to 'How I Saw My First Lion' or 'Look How Quaint the Natives Are' proposals." Wants on a regular basis photos of economics, sociology, African international affairs, development, conflict and daily life. Captions re-

quired.

B&W: Uses 8x10 glossy prints. Pays \$15-35/photo.

Cover: Uses b&w glossy prints. Vertical format preferred. Pays \$25-50/photo.

Accompanying Mss: "Read the magazine, then query." Pays \$50-150/ms. Free writer's guidelines. Tips: "Read the magazine; live and travel in Africa; and make political, economic and social events humanly interesting.'

*AFTA-THE ALTERNATIVE MAGAZINE, 153 George St., Suite 2, New Brunswick NJ 08901. (201)828-5467. Editor-in-Chief: Bill-Dale Marcinko. Quarterly. Circ. 25,000. Emphasizes films, rock music, TV, books and political issues. Readers are young (18-30), male, regular consumers of books, records, films and magazines, socially and politically active, 40% gay male, 60% college educated or at-

tending college. Sample copy \$3.50.

Photo Needs: Uses 50 photos/issue; 25 supplied by freelance photographers. Needs photos of rock concert performers, film and TV personalities, political demonstrations and events, erotic photography (no pornography); b&w only. No nature or landscape photography. Photos purchased with or without accompanying ms. Column needs: Rock Concerts (section needing photos taken at rock concerts); Issues (section needing photos taken at political demonstrations). "We are expanding our coverage of political demonstrations and international news coverage—any photographs of same would be appreciated. We are also using New-Wave-art photos and surreal, dada and experimental photos.

Making Contact & Terms: Query with samples. Prefers to see b&w prints or published clippings as samples. "Photos should be stark, provocative and surreal." SASE. Reports in 2 weeks. Pays in contributor's copies only. Pays on publication. Credit line "and also biographies/profiles" given. Buys

one-time rights. Simultaneous submissions and previously published work OK.

AIM MAGAZINE, 7308 S. Eberhart Ave., Chicago IL 60619. (312)874-6184. Art Director: Bill Jackson. Quarterly journal. Emphasizes "material of social significance." Readers are "high school, college students and the general public." Circ. 10,000. Sample copy \$2.50.

Photo Needs: Uses about 15 photos/issue; 4 supplied by freelance photographers. Needs "photos depicting society's deprivation-ghetto shots and ethnic group activities (Indian, Mexican, Hispanic)." Photos purchased with accompanying ms only. Special needs include photos "depicting inequities in our society, economically, educationally." Model release and captions preferred.

Making Contact & Terms: Query with samples. Send 81/2x11 b&w prints by mail for consideration. SASE. Reports in 1 month. Pays \$10/b&w cover photo; \$5/b&w inside photo. Pays on acceptance.

Credit line given. Buys one-time rights. Simultaneous submissions OK.

Tips: "Look for incidents of police brutality-activities of organizations such as the KKK, etc."

ALASKA OUTDOORS MAGAZINE, Box 82222, Fairbanks AK 99708. (907)455-6691. Editor: Chris Batin. Bimonthly. Circ. 70,000. Emphasizes "hunting and fishing in Alaska; sometimes covers other outdoor-oriented activity." Readers are "outdoor oriented, male, interested in Alaska, whether for trip planning or just armchair reading." Sample copy \$1; photo guidelines free with SASE.

Photo Needs: Uses about 40 photos/issue; 90% supplied by freelance photographers. Needs outdoor, hunting and fishing action, scenic, wildlife, adventure-type photo essays. Captions required.

Making Contact & Terms: Send 5x7, 8x10 b&w glossy prints; 35mm, 21/4x21/4 transparencies; or b&w contact sheet by mail for consideration. SASE. Reports in 3 weeks. Pays \$200/color cover photo; \$10-25/b&w inside photo, \$25-100/color inside photo; \$50-275 for text/photo package. Pays on publication. Credit line given. Buys one-time rights. Previously published work OK.

Tips: :"Tell the whole story through photos—from grain of sand subjects to mountain scenics. Capture

the 'flavor' of Alaska in each photo."

ALCOHOLISM/The National Magazine, 2100 N. 105th, Seattle WA 98133. (206)362-8162. Art Director: Linda Vander Zyl. Bimonthly. Circ. 35,000. Emphasizes recovery from alcohol or drugs. Readers are recovering alcoholics and drug addicts. Sample copy for \$1 with SASE.

Photo Needs: Uses 40-50 photos/issue; 25% supplied by freelance photographers. Needs "photos showing horror/pain of alcoholism—people; photos showing how good life can be—people." Special

needs include "photo illustrations of alcohol-related subjects." Model release required.

Making Contact & Terms: Arrange a personal interview to show portfolio; send 8x10 b&w or color prints; 35mm, 21/4x21/4, 4x5 or 8x10 transparencies; b&w or color contact sheet; or b&w or color negatives by mail for consideration; provide resume, business card, brochure, flyer or tearsheets to be kept on file for possible future assignments. SASE. Pays \$200-500/color cover photo; \$50-75/color inside photo; \$30-50/hour and \$100-200/job. Pays 30 days after publication. Buys one-time rights. Simultaneous submissions and previously published work OK.

Tips: Prefers to see concept photos and photo illustrations in a portfolio. "Emphasis must be on the posi-

tive if we're to use the photo at all."

ALIVE! for Young Teens, Box 179, St. Louis MO 63166. (314)371-6900. Assistant Editor: Vandora Elfrink. Monthly. Circ. 12,000. "*Alive!* is a church-sponsored magazine for young adolescents (12-16) in several Protestant denominations. We use a wide variety of material that appeals to this audience." Sample copy \$1; writer's guidelines with some photo information available free with SASE.

Photo Needs: Uses about 10-15 photos/issue; most supplied by freelance photographers. Needs photos of "younger adolescents in a variety of activities. In overall usage we need multi-ethnic variety and

male/female balance. A few scenics and animal shots."

Making Contact & Terms: Query with list of stock photo subjects; send b&w glossy prints by mail for consideration. SASE. "We also consider copies of photos we can keep and file for reference." Reports in 1 month. Pays \$35/b&w cover photo; \$15-25/b&w inside photo; payment for text/photo package varies. Pays on acceptance. Credit line given. Buys one-time rights. Simultaneous submissions and previously published work OK.

Tips: "Don't send photocopies of your work. We can't judge quality from a photocopy."

alive now! MAGAZINE, 1908 Grand Ave., Box 189, Nashville TN 37202. (615)327-2700, ext. 466. Assistant Editor: Pamela J. Watkins. Bimonthly magazine published by The Upper Room. "alive now! uses poetry, short prose, photography and contemporary design to present material for personal devotion and reflection. It reflects on a chosen Christian concern in each issue. The readership is composed of primarily college-educated adults." Circ. 80,000. Sample copy free with SASE; photo guidelines available.

Photo Needs: Uses about 25-30 b&w prints/issue; 90% supplied by freelancers. Needs b&w photos of "family, friends, people in positive and negative situations; scenery; celebrations; disappointments; ethnic minority subjects in everyday situations—Native Americans, Hispanics, Asians and blacks."

Model release preferred.

Making Contact & Terms: Query with samples; send 8x10 glossy b&w prints by mail for consideration; submit portfolio for review. SASE. Reports in 1 month; "longer to consider photos for more than one issue." Pays \$20-30/b&w inside photo; No color photos. Pays on publication. Credit line given. Buys one-time rights. Simultaneous and previously published submissions OK.

Tips: Prefers to see "a variety of photos of people in life situations, presenting positive and negative slants, happy/sad, celebrations/disappointments, etc. Use of racially inclusive photos is preferred."

ALOHA, THE MAGAZINE OF HAWAII, 828 Fort St. Mall, Honolulu HI 96813. (808)523-9871. Editor: Rita Ariyoshi. Emphasizes Hawaii. Readers are "affluent, college-educated people from all over the world who have an interest in Hawaii." Bimonthly. Circ. 85,000. Sample copy \$2; photo guidelines for SASE.

Photos: Uses about 50 photos/issue; 40 of which are supplied by freelance photographers. Needs "scenics, travel, people, florals, strictly about Hawaii. We buy primarily from stock. Assignments are rarely given and when they are it is to one of our regular local contributors. Subject matter must be Hawaiian in some way. A regular feature is the photo essay, 'Beautiful Hawaii,' which is a 6-page collection of images illustrating that theme." Model release required if the shot is to be used for a cover; captions required.

Making Contact & Terms: Send by mail for consideration actual 35mm, 21/4x21/4 or 8x10 color transparencies; or arrange personal interview to show portfolio. SASE. Reports in 6-8 weeks. Pays \$25/b&w photo; \$50/color transparency; \$150 for cover shots. Pays on publication. Credit line given. Buys one-time rights. No simultaneous submissions; previously published work OK if other publications are specified.

Tips: Prefers to see "a unique way of looking at things, and of course, sharp, well-lit images."

ALTERNATIVE SOURCES OF ENERGY MAGAZINE, 107 S. Central Ave., Milaca MN 56353. (612)983-6892. Editor: Donald Marier. Bimonthly magazine. Circ. 8,000. Emphasizes alternative en-

ergy sources and the exploration and innovative use of renewable energy sources. For people "conscious of environmental situations, energy limitations, etc." Needs photos of "any alternative energy utilization situation or appropriate technology application." Buys 20/issue. Buys all rights, but may reassign to photographer after publication. Submit model release with photo. Send contact sheet or photos for consideration. Pays on acceptance. Reports in 2 weeks. SASE. Simultaneous submissions and previously published work OK "if we are so notified." Sample copy \$2.

B&W: Send contact sheet or 8x10 glossy prints. Captions required. Pays \$7.50.

Cover: See requirements for b&w.

Tips: "We prefer to purchase pix with mss rather than alone. Advice: study the magazine; understand the issues."

*AMERICAN CAGE-BIRD MAGAZINE, One Glamore Court, Smithtown NY 11787. (516)979-7962. Editor: Arthur Freud. Photo Editor: Anne Frizzell. Monthly. Emphasizes care, breeding and maintenance of pet cage birds. Readers include bird fanciers scattered throughout the United States,

Canada and other countries. Circ. 13,000. Sample copy \$2.

Photo Needs: Uses about 10 photos/issue; 6 supplied by freelance photographers. Needs sharp, clear black and white photos of budgies, cockatiels, canaries, parrots, toucans and people with such birds. Clever seasonal shots also good (Xmas, etc.). We choose photos which inform and/or entertain. Identification of the bird type or species is crucial." Special needs include Christmas theme, Fourth of July theme, etc. Model release preferred; captions required.

Making Contact & Terms: Send 5x7 glossy b&w prints by mail for consideration. SASE. Reports in 1 week. Pays \$15-25/photo. Pays on publication. Credit line given. Buys one-time rights. Previously

published work OK.

AMERICAN SURVIVAL GUIDE, (formerly Survival Guide), 2145 West La Palma Ave., Anaheim CA 92801. (714)635-9040. Editorial Director: Dave Epperson. Associate Editor: Jim Benson. Monthly. Circ. 92,000. Emphasizes "self-reliance and survival. People whose chief concern is protection of life and property. Preparedness and how to meet the threats posed in day-to-day living: urban violence, natural disaster, ecological and environmental considerations, economic breakdown, nuclear conflict. The technology, hardware, weapons and practice of survival. The magazine is a textbook and a reference," Average reader is "age 34, male, \$28,000/year income, spouse provides second income. Is interested in food preservation and storage, weaponry, tactics, techniques, shelter, products, related to preparedness, self-reliance and survival." Photo guidelines free with SASE.

Photo Needs: Uses about 7 photos/article; half supplied by freelance photographers. "Photos must, in all cases, illustrate accompanying text material. How-to and preparedness situational photos." Photos purchased with accompanying ms only. Special photo needs include "disaster, earthquake, chemical

spill, wildfire, urban riot and crime scene." Model release and captions required.

Making Contact & Terms: Query with samples or with list of stock photo subjects. SASE. Reports in 1 month. Pays \$100-250/color cover photo, \$70 maximum/b&w cover photo; \$70 maximum/b&w or color inside photo; \$70 maximum/b&w or color page. Pays on publication. Credit line given. Buys first North American serial rights.

Tips: "Learn the survivalist marketplace, philosophy, hardware, attitudes and people."

*ANIMAL KINGDOM, New York Zoological Park, Bronx NY 10460. (212)220-5121. Editor: Eugene J. Walter, Jr. Bimonthly. Emphasizes wildlife conservation, natural history. Readers include mature people (over 12), interested in wildlife and nature. Circ. 138,000. Sample copy available for \$2; photo guidelines free with SASE.

Photo Needs: Uses 25 photos/issue; supplied by freelance photographers varies. Needs wildlife photos.

Captions required.

Making Contact & Terms: Query with list of stock photos subjects. Does not return unsolicited material. Reports in 1 month. Pays \$125-175/b&w cover photo, \$150-200/color cover photo, \$150/b&w page, \$150/color page. Other page sizes and approximate rates available; request rate sheet. Pays on publication. Credit line given. Buys one-time rights. Simultaneous submissions OK.

*ANN ARBOR OBSERVER, 206 South Main, Ann Arbor MI 48103. (313)769-3175. Editor: Mary Hunt. Monthly magazine. Emphasizes "what's going on in Ann Arbor." Readers are 70,000 Ann Arbor adults. Sample copies \$1.

Photo Needs: Uses about 20 photos/issue. Needs "mostly photos of buildings and people in Ann Ar-

bor." Model release preferred; captions required.

Making Contact & Terms: Query with resume of credits. SASE. Reports in 2 weeks. Pays \$30/b&w inside photo. Pays on publication. Credit line given. Buys all rights.

*ANTIQUING HOUSTON, Box 40734, Houston TX 77240. (713)465-9842. Editor: William Taber. Photo Editor: Susan Taber. Bimonthly tabloid. Emphasizes antiques and collectibles. Readers include

middle class antique collectors and buyers. Circ. 10,000. Estab. 1984. Free sample copy and photo guidelines for SASE.

Photo Needs: Uses about 29 photos/issue; 5-6 supplied by freelance photographers. Needs unusual and interesting antique and collectible items. Special needs include antiques and collectibles associated with holidays-Easter, Christmas, Valentines, Mother's Day, etc. Model release and captions preferred. Making Contact & Terms: Send glossy b&w prints by mail for consideration. SASE. Reports in 1 month. Pays \$3-10/b&w cover photo, \$3-10/b&w inside photo, \$5-15/text/photo package. Pays on acceptance. Credit line sometimes given. Buys reprint rights. Previously published work OK.

*APPALOOSA RACING RECORD, Box 1709, Norman OK 73070. (405)364-9444. Editor: G.D. Hollingsworth. Monthly magazine. Emphasizes "Appaloosa horses-racing, training, and breeding." Readers are owners, breeders, trainers of Appaloosa race horses. Circ. 2,000. Sample copies \$3. Photo Needs: Uses 20 photos/issue; 90% supplied by freelance photographers. Subject needs are "varied. Most photos are done on assignment, by freelancers." Captions required.

Making Contact & Terms: Provide resume, business card, brochure, flyer or tearsheets to be kept on

file for possible future assignments. Reports in 2 weeks. Pays \$125/color cover photo; \$15/b&w inside photo; and \$50/color inside photo. Pays on publication. Credit line given. Buys all rights. Previously

published work OK.

*ARCHERY WORLD, 225 E. Michigan, Milwaukee WI 53202. Contact: Editor. Bimonthly magazine. Circ. 125,000. Emphasizes the "entire scope of archery—hunting, bowfishing, indoor target, outdoor target, field." Photos purchased with or without accompanying ms. Buys 5-10 photos/issue. Pays \$75-225 for text/photo package, or on a per-photo basis. Credit line given. Pays on publication. Negotiates rights. Query with samples. SASE. Simultaneous submissions OK. Reports in 3 weeks. Sample copy \$1; free photo guidelines.

Subject Needs: Animal (North American game species), product, wildlife and general archery shots (of

contests, people, etc.). Model release required; captions preferred.

B&W: Uses contact sheet or 8x10 glossy prints. Pays \$25-50/photo. Color: Uses 35mm and 21/4x21/4 color transparencies. Pays \$25-150/photo.

Cover: Uses 35mm color transparencies. Vertical format preferred. Pays \$150/photo.

Accompanying Mss: Knowledgeable texts on archery. Free writer's guidelines. Tips: "We look for crisp, clear photos in good lighting of North American game species. Eyes must be

bright and in focus, and we like to see big racks on game species. Verticals are preferred with room for logo and blurbs. Virtually all our photos are purchased from stock agencies. *ARCHERY WORLD, Suite 100, 11812 Wayzata Blvd., Minnetonka MN 55343. (612)545-2662.

Editor: Richard Sapp. Bimonthly magazine. "Archery World is the oldest and most respected magazine in print for the hunting archer. It focuses editorially on all aspects of hunting with a bow and arrow in North America. Our 100,000 + circulation is primarily male: college-educated, avid bowhunters who participate in their sport year-round and who make an above average income." Circ. 105,000. Free sample copy and photo guidelines with SASE.

Photo Needs: Uses 10-25 photos/issue; "many are from freelancers. We want to see wildlife photos—especially or almost exclusively—those wildlife subjects commonly hunted as big game species in North America." Special needs include "big game species for cover selections." Captions optional. Making Contact & Terms: Send 35mm/21/4x21/4 transparencies by mail for consideration. SASE. Reports in 2-4 weeks. Pays \$150/color cover photo; \$25/b&w inside photo; \$25-75 color/inside photo; and \$50-250/text/photo package. Pays on publications. Credit line given. Buys one-time rights. Simultaneous submissions and previously published work OK.

ARCHITECTURAL DIGEST, 5900 Wilshire Blvd., Los Angeles CA 90036. Graphics Director: Charles Ross. For people interested in fine interior design. "We are interested in seeing only the work of photographers with background and portfolio of architecture, interiors and/or gardens. We cannot accept tearsheets or prints; only 4x5 or 21/4x21/4 transparencies. We have no staff photographers." Works with freelance photographers on assignment only basis. Provide transparencies. Reports once a month.

*ART & CINEMA, Box 1208, Imperial Beach CA 92032. (619)429-5533. Quarterly. Emphasizes art, theater, dance, video, film. Readers are instructors in universities and colleges; and university libraries. Circ. 5.000.

Photo Needs: Needs photographs of art works, of theater, dance and video performances, and of film subjects. Special needs include experimental theatre and contemporary paintings. Model release and captions required.

Making Contact & Terms: Query with resume of credits. Reports in 3 weeks. Pays by job; text/photo package negotiated. Pays on publication. Previously published work OK.

*ASSETS, Box 448, Jericho NY 11753. (516)681-8305. Bimonthly magazine. Emphasizes "investments in any tangible or collectible item-if it's an 'asset,' we're interested." Readers are collectors and investors. Circ. 50,000. Sample copy free with SASE and \$1.22 postage. **Photo Needs:** Uses 25 photos/issue; five by freelance photographers. Needs "investment-oriented pho-

tos: tax shelters (horses, land, houses, oil fields, etc.); collectibles, gold, silver, etc." Photos purchased

with accompany ms. Model release and captions preferred.

Making Contact & Terms: Query with list of stock photo subjects; provide resume, business card, brochure, flyer or tearsheets to be kept on file for possible future assignments. Reports in 2 weeks. Pays "whatever is reasonable." Pays on publication. Credit line given. Buys all rights. Simultaneous submissions and previously published work OK.

Tips: Provide photographers name and phone number for contact when photos are needed. "Have as many photos as possible available in your portfolio, regarding what magazine you're interested in sell-

ing to.'

ATLANTIC CITY MAGAZINE, 1637 Atlantic Ave., Atlantic City NJ 08401. (609)348-6886. Editor-in-Chief: Jill Schoenstein. Art Director: Drew Hires. Monthly. Circ. 50,000. Sample copy \$2 plus

\$1 postage.

Photo Needs: Uses 50 photos/issue; all are supplied by freelance photographers. Model releases and captions required. Prefers to see b&w and color fashion, product and portraits, sports, theatrical. Making Contact & Terms: Query with portfolio/samples. Does not return unsolicited material. Reports in 3 weeks. Provide resume and tearsheets to be kept on file for possible future assignments. Payment negotiable; usually \$35-50/b&w photo; \$50-100/color; \$250-450/day; \$175-300 for text/photo package. Pays on publication. Credit line given. Buys one-time rights.

Tips: "We promise only exposure, not great fees. We're looking for imagination, composition, sense of

design, creative freedom and trust."

THE ATLANTIC MONTHLY, 8 Arlington St., Boston MA 02116. (617)536-9500. Editor: William Whitworth. Art Director: Judy Garlan. Monthly magazine. Circ. 425,000. Emphasizes literature (poetry and fiction) and public affairs (political, sociological, cultural, scientific and environmental) for a professional, academic audience. "The Atlantic Monthly is a general interest magazine; a magazine of literature and public affairs which assumes, on the part of readers, a certain sophistication in literature and political matters and a willingness to be challenged by controversial and sometimes conflicting points." Works with freelance photographers on assignment only basis. Provide calling card, tearsheet, list of stock photos or samples to be kept on file for possible future assignments. Buys 60 photos/year. Credit lines given. Pays on publication. Buys one-time rights. Submit portfolio for review; or query with samples. SASE. Reports in 2 weeks.

Subject Needs: "Subject matter varies greatly for feature articles. However, photographs of major national and international events and people in the news are always needed. Our use of freelance photography is not extensive. We prefer to see a photographer's portfolio, acquiring an idea of his/her style and subject matters, and then to get in contact with him/her should an occasion arise suitable to their work.

We never publish randomly submitted photographs." Model release required. B&W: Uses 5x7 prints. Pays \$25 minimum/photo, or negotiable rate/job.

Color: Uses 5x7 prints, or transparencies. Pays \$25 minimum/photo.

Cover: Uses b&w and color prints and transparencies. Vertical, horizontal and square formats used.

*ATTAGE, ONLINE DATA ACCESS, DATABASE MONTHLY, 11754 Jowyville Rd., Austin TX 78759. (512)250-1255. Photo Editor: Fred Graber. Tabloid. Emphasizes computer industry. Readers in-

clude users. Circ. 30,000. Free sample copy.

Photo Needs: Uses 8-10 photo/issue; all supplied by freelance photographers. Needs product/cover shots. Special needs digitized, special effects, computer graphics, bloc pix, etc. Model release required. Making Contat & Terms: Arrange a personal interview to show portfolio; provide resume, business card, brochure, flyer or tearsheets to be kept on file for possible future assignments. Does not return unsolicited material. Reports in 2 weeks. Pays up to \$325/color cover photo; inside photo rates vary. Pays on publication. Credit line given. Buys first North American serial rights. Simultaneous submissions OK.

AUDUBON MAGAZINE, 950 3rd Ave., New York NY 10022. Picture Editor: Martha Hill. Bimonthly magazine. Circ. 400,000. Emphasizes wildlife. Photos purchased with or without accompanying mss. Freelancers supply 100% of the photos. Credit line given. Pays on publication. Buys one-time rights. Send photos by mail for consideration. No simultaneous submissions. SASE. Reports in 1 month. Sample copy \$3.

Subject Needs: Photo essays of nature subjects, especially wildlife, showing animal behavior, unusual portraits with good lighting and artistic composition. Nature photos should be artistic and dramatic, not

Close-up

Martha Hill, Picture Editor, Audubon

In the course of a year Audubon Picture Editor Martha Hill and her small staff may review 100,000 transparencies sent by freelance photographers who hope to see their work published in this very prestigious nature magazine. But only one-half of one percent, equal to some 500 images for six issues, ever see publication. A photographer's work must truly be extraordinary to make the pages of Audubon.

"Audubon prides itself on the quality of its writing as well as its photography, but it is the photography which is responsible for its reputation as a 'coffee table' publication. It's a photographic showcase without being a photo-

graphic magazine," Hill says.

So many of the photographs we receive are ordinary-what I call 'backyard boring'-but what we are looking for in nature photography is something fresh and exciting. A few years ago a very creative young man in Canada (Tim Fitzharris) built a floating blind to photograph waterbirds from water level. Now he has a lot of imitators, but when his work first came to me it was, 'Wow! This is terrific!' A Minnesotan (R. Hamilton Smith) took the old dewy cobweb cliche and really made something of it. Using macro lenses he turned the dewdrops into jewels, like strings of reflective pearls. We published it as a portfolio, and it exemplifies what I mean by 'a photographic showcase'," Hill explains.

Hill's selection process is straightforward. "Selection is primarily personal taste with an eye on editorial needs. Technical requirements must be met first, with good color saturation and sharp focus being absolute necessities. Beyond that I look for subject matter, composition and lighting," she says.

Photographers interested in submitting their photographs to Hill should send a list of published credits or

tearsheets and query her about subject matter. Audubon buys one-time rights

and pays on publication.

"Amateurs aspiring to be nature photographers should spend a lot of time in the field learning the habits and cycles of those animals or things they want to shoot. You need to be a naturalist to get the edge on competition, of which there is a lot, and there are few markets for nature subjects. Good equipment is a must for achieving the standards needed for publication, but beyond that you need what I call 'an informed eye'," Hill explains.

"Generally speaking, the best advice I can offer to aspiring photographers is to do their homework well. That means studying the publications they plan to solicit and making sure they send material that is appropriate. Approach a story in subject form. Think about which images would best introduce the idea to the reader, which details are important points, what would be a good summary image. It is surprising how few photographers know how to treat an idea as visual storytelling,"

Hill stresses.

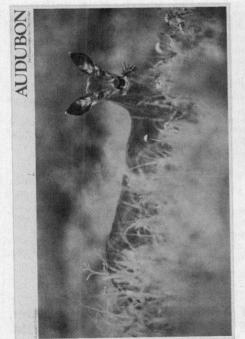

Audubon has featured photos by photographers such as (clockwise from the top) Tim Fitzharris, Art Wolfe, R. Hamilton Smith and Robert P. Carr.

the calendar or postcard scenic. Query first before sending material; include tearsheets or list previous published credits. Portfolios should be geared to the magazine's subject matter. Must see original transparencies as samples. Also uses some journalistic and human interest photos. No trick shots or set-ups; no soft-focus, filtered or optical effects like those used in some commercial photography. Captions are required.

B&W: Uses 8x10 glossy prints. Pays \$100-250, inside.

Color: Uses 35mm, 21/4x21/4 and 4x5 transparencies. Pays \$100-250, inside; \$600, cover. Plastic sheets only. No prints. No dupes.

Cover: Uses color covers only. Horizontal wraparound format requires subject off-center. Pays \$600. **Accompanying Mss:** Seeks articles on environmental topics, natural areas or wildlife, predominantly North America.

Tips: "Content and subject matter can be determined by careful study of the magazine itself. We do not want to see submissions on subjects that have recently appeared. We have very high reproduction standards and can therefore only use the best quality photographs. Try photographing less popular subjects—certain areas such as the national parks and the Southwest are overphotographed. Study the magazine and edit carefully if you are interested in working with us. Learn to be very selective about images submitted and don't be afraid to send only one or two pictures."

*AUSTIN HOMES & GARDENS, Box 5950, Austin TX 78763. (512)479-8936. Editor: Marsia Hart Reese. Monthly magazine. Emphasizes "homes, gardens, and people of Austin and its environs." Circ. 25,000. Sample copy \$1.95 plus \$1.05 postage.

Photo Needs: Uses 86 photos/issue; 42 supplied by freelance photographers. Needs photos of "home interiors, architecture, food, restaurants, some travel. Always interested in experienced photographers specializing in interiors, architecture, and food." Model release and captions preferred.

Making Contact & Terms: Arrange a personal interview to show portfolio; query with resume of credits; provide resume, business card, brochure, flyer or tearsheets to be kept on file for possible future assignments. "Do not call during the week prior to the 10th of the month." Reporting time "depends on schedule." Pays \$75-300 + processing/job. Pays on acceptance. Credit line given. Buys one-time rights or "depending on use." Simultaneous submissions OK.

Tips: "We seldom use photographs already taken, due to the specific nature of our magazine. Usually, we make assignments of subjects that we wish illustrated." In a portfolio prefers to see "color transparencies of interiors, architecture, gardens and landscaping, food; b&w prints of architecture, people."

AUTOBUFF MAGAZINE, Suite 100, 4480 N. Shallowford Rd., Atlanta GA 30338. (404)394-0010. Publisher: D.B. Naef. Monthly. "High-performance (late model), domestic automobiles (Camaros, Firebirds, Chevelles, Mustangs, etc.) that have been modified into street racers. No foreign makes. Topless models are featured (no lower nudity, please) as well as swimwear models. Young, 18- to 26-year-old, well-developed models get our attention." Readers are "young men (18-24) with an above-average interest in high-performance cars and beautiful women." Circ. 200,000. Free sample copy. Photo guidelines free with SASE.

Photo Needs: Uses about 250 photos/issue; 100 supplied by freelance photographers. Needs "high-performance cars (domestic) as car features and/or car features shot with female models." Model release required.

Making Contact & Terms: Query with samples; send b&w prints, 21/4x21/4 transparencies by mail for consideration. SASE. Reports in 3 weeks. Pays \$100-500/job, depending on needs, quality, etc. Pays on acceptance. Credit line given. Buys all rights. Simultaneous submissions OK.

Tips: "Read the magazine. Learn the type vehicles and the type models we require."

BABY TALK, 185 Madison Ave., New York NY 10016. (212)679-4400. Art Director: Doris Manuel. Monthly. Circ. 925,000. Emphasizes infants and toddlers. Readers are "pregnant and new parents." Sample copy with SASE and 88¢ postage.

Photo Needs: Uses about 8-10 photos/issue; most are supplied by freelance photographers. Needs photos of "babies, expectant parents, babies with mothers."

Making Contact & Terms: Send transparencies by mail for consideration. SASE. Reports in 3 weeks. Pays \$150-200/color cover photo 4 color transparencies; \$25/b&w inside photo, \$50/color inside photo. Pays on acceptance. Credit line given. Buys one-time rights.

Market conditions are constantly changing! If this is 1987 or later, buy the newest edition of *Photographer's Market* at your favorite bookstore or order directly from Writer's Digest Books.

BASSIN' MAGAZINE, (formerly Pro Bass Magazine), 15115 S. 76th East Ave., Bixby OK 74008. (918)366-4441. Managing Editor: André Hinds. Published 8 times/year. Emphasizes freshwater fishing, especially bass fishing. Readers are predominantly male, adult; nationwide circulation with heavier concentrations in South and Midwest. Circ. 170,000 + subscribers, 30,000 + newsstand sales. Free sample copy. Photo guidelines free with SASE.

Photo Needs: Uses about 50-75 photos/issue; "almost all of them" are supplied by freelance photographers. "We need both b&w and color action shots of freshwater fishing; close-ups of fish with lures,

tackle, etc., and scenics featuring lakes, streams and fishing activity." Captions preferred.

Making Contact & Terms: Query with samples. SASE. Reports in 6 weeks. Pays \$250-300/color cover photo; \$25/b&w inside photo; \$35-50 color inside photo; \$175-300 for text/photo package. Pays on acceptance. Credit line given "sometimes-if photos are exceptional." Buys first North American seri-

al rights. Previously published work OK.

Tips: "We will be using many more color photos in the magazine, as well as freelance b&w. Cover photos should show action—fishermen hauling in a big bass. The same goes for the inside, although we occasionally use more moody photos there (these are kept to a minimum). Send lots of photos and give me a deadline in which to send them back. Don't send lists-I can't pick a photo from a grocery list. In the past, we used only photos sent in with stories from freelance writers. However, we would like higher quality stuff. I urge freelance photographers to participate."

BC OUTDOORS, 202-1132 Hamilton St., Vancouver, B.C., Canada V6B 2S2. (604)687-1581. Editor: Henry L. Frew. Emphasizes any outdoor activity that is not an organized sport. "We're interested in family recreation." Readers are "persons interested in any way in the outdoors." Published 10 times/ year (January/February, February, March, April, May, June, July, August, September, November/De-

cember). Circ. 37,000. Free sample copy and writer's guidelines.

Photo Needs: Uses about 30-35 photos/issue; 99% of which are supplied by freelance photographers. "Fishing (in our territory) is a big need—people in the act of catching, not standing there holding a dead fish. Hunting, canoeing, hiking, camping, snowmobiling, cross-country skiing-any outdoor recreation that's not a competitive sport. Family oriented. By far most photos accompany mss. We are always on lookout for good covers-wildlife, recreational activities, people in the outdoors-vertical format, primarily of B.C., and Yukon. Photos with mss must, of course, illustrate the story. There should, as far as possible, be something happening. Photos generally dominate lead spread of each story. They are used in everything from double-page bleeds to thumbnails. Column needs basically supplied inhouse." Model release preferred; captions or at least full identification required.

Making Contact & Terms: Send by mail for consideration actual 5x7 or 8x10 b&w prints; 35mm, 21/4x21/4, 4x5 or 8x10 color transparencies; color contact sheet; if color negative send jumbo prints and negatives only on request; or query with list of stock photo subjects. SASE, Canadian stamps. Reports in 4-6 weeks normally. Pays \$10/b&w photo; \$15 and up/color photo; and \$125/cover photo. "Payment for photos when layout finalized so we know what we're using. We try to give 'photos-only' contributors an approximate publication date at time of acceptance. We reach an arrangement with the contributor in such cases (usually involving dupes)." Credit line given. Buys one-time rights inside; with covers "we retain the right for subsequent promotional use." Simultaneous submissions not acceptable if com-

petitor; previously published work OK.

*BEAUTIFUL BRITISH COLUMBIA MAGAZINE, 929 Ellery St., Victoria B.C. V9A 7B4 Canada. (604)384-5456. Editor: Bryan McGill. Photo Editor: Tony Owen. Quarterly. Emphasizes beauty of the province of B.C. Circ. 350,000. Photo guidelines free with SASE.

Photo Needs: Uses about 70 photos/issue; 100% supplied by freelance photographers. Needs animal or wildlife shots, how-to, travel, scenic, etc. Reviews photos with or without accompanying ms. Captions

required.

Making Contact & Terms: Send unsolicited photos by mail for consideration. Send fine-grained (25 ASA) 35mm, 21/4x21/4, 4x5 and 8x10 transparencies by mail for consideration. SASE. Reports in 4 weeks. Pays \$100/photo; 25 cents/word. Pays on publication. Credit line given. Buys one-time rights. Simultaneous submissions and previously published work OK.

Tips: "Before you submit any proposals to us it would be wise to carefully study several recent issues of Beautiful British Columbia. Use them as a rough guide, but don't limit yourself only to those types of stories which you see in past issues. Be imaginative! If an idea doesn't excite you, how can you expect us

The asterisk before a listing indicates that the listing is new in this edition. New markets are often the most receptive to freelance contributions.

to get excited about it? Which subject do you find fascinating? What is the story you have always wanted to shoot? What is the most beautiful place you know? We want your ideas and we will value your suggestions.'

BEAUTY DIGEST MAGAZINE, Suite 802, 126 Fifth Ave., New York NY 10011. (212)255-0440. Art Director: Maria Perezz. Published 6 times/year. Circ. 750,000. Emphasizes beauty, health, fitness, diet, emotion. Readers are "women age 18-35, who are into fitness and beauty." Sample copy and photo guidelines free with SASE.

Photo Needs: Uses about 35 photos/issue; 75% supplied by freelance photographers. Needs photos of "beauty, fashion, women engaged in a variety of activities, still life shots of food, clothes. Color and black and white." Model release required.

Making Contact & Terms: Arrange a personal interview to show portfolio or submit portfolio for review. SASE. Reports in 2 weeks. Pays \$45/b&w inside photo, \$85/color inside photo. Pays on publication. Credit line given. Buys one-time rights. Simultaneous submissions OK.

Tips: "In general we look for beauty, lighting, good skin tones, minimal shadows."

BEND OF THE RIVER MAGAZINE, Box 239, Perrysburg OH 43551. (419)874-7534. Co-editors: Christine Alexander and R. Lee Raizk. Monthly magazine. Circ. 2,500. Emphasizes northwestern Ohio history, and Ohio places and personalities. Photos purchased with cutline or accompanying ms. Buys 50 photos/year. Credit line given. Pays on publication. Buys one-time rights. SASE. Previously published work OK. Reports in 1 month. Sample copy 75¢.

Subject Needs: Historic buildings, memorials, inns, and items about historic renovation and preserva-

tion. Captions required.

B&W: Uses 5x7 glossy prints; will accept other print sizes and finishes. Pays \$1-3/photo.

Color: Uses 5x7 glossy prints. Pays \$1-3/photo.

Cover: Uses b&w or color glossy prints. Vertical format only. Pays \$1-3/photo.

Accompanying Mss: Pays \$5-10/ms.

Tips: "We are always interested in Toledo area places and people. Ohio pictures are also in demand. Send us something!"

BEST WISHES, Family Communications Inc., 37 Hanna Ave., Box 8, Station C, Toronto, Ontario, Canada M6J 3M8. Publisher: Donald G. Swinburne. Quarterly magazine. Circ: 270,000. For new mothers who have just given birth (not for pregnant women). Buys first Canadian serial rights. Query first with resume of credits. Pays on publication. Reports in 1 month. SAE and International Reply Coupons. Simultaneous submissions and previously published work OK. Free sample copy and editorial guidelines.

Subject Needs: Infants and toddlers, with and without parents.

Color: Uses transparencies. Negotiates pay.

Tips: Submit seasonal material 4 months in advance.

*BICYCLE GUIDE, 128 North 11th St., Allentown PA 18102. (215)435-7570. Editor: John Schubert. Photo Editor: Imre Barsy. Published 9 times a year. Emphasizes bicycles and the sport of cycling. Readers include bicycle enthusiasts. Circ. 150,000. Estab. 1984. Free sample copy and photo guidelines.

Photo Needs: Uses about 100 photos/issue; 25-35% supplied by freelance photographers. Model release and captions required.

Making Contact & Terms: Query with resume of credits and list of stock photo subjects; provide resume, business card, brochure, flyer or tearsheets to be kept on file for possible future assignments. SASE. Reports in 1 month. Payment negotiated individually. Pays on publication. Credit line given. Buys first North American serial rights.

BICYCLING, 33 E. Minor St., Emmaus PA 18049. (215)967-5171. Editor and Publisher: James C. McCullagh. Photo Editor: Sally Shenk Ullman. 6 monthly issues, 3 bimonthly issues. Circ. 250,000. Emphasizes touring, commuting, health, fitness and nutritional information, recreational riding and technical gearing for the beginning to advanced bicyclist. Buys 5-10 photo/issue. Photos purchased with accompanying ms. Credit line given. Pays on publication. Buys all rights. Send material by mail for consideration or query with resume of credits. SASE a must. Reports in 3 months. Sample copy \$2; photo guidelines free with SASE.

Subject Needs: Celebrity/personality, documentary, how-to, human interest, photo essay/photo feature, product shot, scenic, special effects and experimental, sport, spot news and travel. "No cheesecakes nor beefcakes." Model release and captions required.

B&W: Uses negatives. Pays \$35-75/photo.

Color: Uses 35mm, 21/4x21/4, 4x5 transparencies. Pays \$75-150/photo.

Cover: Uses 35mm, 21/4x21/4, 4x5 color transparencies. Vertical format required. Pays \$400/photo. Accompanying Mss: Seeks mss on any aspects of bicycling (nonmotorized); commuting, health, fitness and nutritional information, touring or recreational riding. Pays \$25-500/ms. Writer's guidelines

on photo guidelines sheet.

Tips: "We prefer photos with ms. Major bicycling events (those that attract 500 or more) are good possibilities for feature coverage in the magazine. Use some racing photos. The freelance photographer should contact us and show examples of his/her work; then, talk directly to the editor for guidance on a particular shoot. For covers: Shoot vertical. The logo and blurbs run on every cover. These are constant; be aware of their location and what that means while shooting. A large single image that creates a simple cover often works best.

Riding: While shooting people riding, be aware of the background. Watch out for wires, shadows, or other major distractions. Make sure people are riding in proper positions and on the correct side of the

road.'

BILLIARDS DIGEST, Suite 1801, 875 N. Michigan Ave., Chicago IL 60611. (312)266-7179. Editor: Michael Panozzo. Bimonthly magazine. Circ. 10,000. Emphasizes billiards and pool for tournament players, room owners, tournament operators, dealers, enthusiasts and beginning players, distributors, etc. Buys 5-10 photos/issue. Pays on publication. Not copyrighted. Send material by mail for consideration. Works with freelance photographers on assignment only basis. Provide resume, tearsheet and samples (photostats of 6 are adequate) to be kept on file for possible future assignments. Credit line given. Reports in 2 weeks. SASE.

Subject Needs: "Unusual, unique photos of billiards players, particularly at major tournaments. Should also stress human emotions, their homelife and outside interests." No stock hunched-over-thetable shot. "We want photos that convey emotion, either actively or passively. Show pool people as hu-

man beings." Captions required.

B&W: Uses prints; contact sheet OK. Pays \$5-50/photo.

Color: Uses transparencies. Pays \$10-50/photo. **Cover:** Uses transparencies. Pays \$10-50/photo.

*BIOLOGY DIGEST, 143 Old Marlton Pike, Medford NJ 08055. (609)654-6500. Editor: Mary Suzanne Hogan. Photo Editor: Dorothy Whitaker. Monthly. Comprehensive abstracts journal covering all the life sciences from anatomy to zoology. Readers include high school and undergraduate college students. Circ. 1,700. Sample copy \$12.

Photo Needs: Uses about 20 photos/issue. Photos purchased with descriptive captions only.

Making Contact & Terms: Send 8x10 or 5x7 b&w prints by mail for consideration. SASE. Reports in 1 month. Pays \$10-15/b&w cover photo; b&w inside photo. Pays on acceptance. Credit line given. "If photographer desires one-time rights, we will honor that but prefer to have all rights (non-exclusive) so that we may use again."

*BIRD TALK, Box 6050, Mission Viejo, CA 92690. (714)240-6001. Editor: Linda W. Lewis. Monthly magazine. Emphasizes "better care of pet birds through informative and entertaining articles. Birds of interest are: canaries, finches, parrots, parakeets, toucans, macaws, conures, lovebirds, cockatiels, cockatoos, mynahs." Readers are "owners of one pet bird or breeders of many." Estab. 1984. Sample copy \$3. Photo guidelines free with SASE.

Photo Needs: Uses 15-20 photos/issue; all by freelance photographers. Needs photos of "any and all pet birds either in portraits or in action—doing anything a bird is able to do." Model release and captions

preferred.

Making Contact & Terms: Send 5x7, 8x10 b&w prints; 35mm, 2¹/₄x2¹/₄, 4x5, 8x10 transparencies, or b&w contact sheets by mail for consideration. SASE. Reports in 2 weeks. Pays \$10/b&w (partial page) inside photo; \$50/color (partial page) inside photo; full pages: \$25/b&w, \$50-100 color. Color prints acceptable but will probably be used b&w. Pays on publication. Credit line given. Buys one-time rights. Tips: Prefers to see "sharp feather focus. Cage bars acceptable, cages and perches must be clean. More b&w photos are used per issue than color. Send us clear shots of a variety of pet birds with cover letter specifying each *species* of bird. We also need a variety of shots of people interacting with their birds."

BIRD WATCHER'S DIGEST, Box 110, Marietta OH 45750. (614)373-5285. Editor-in-Chief: Mary B. Bowers. Bimonthly. Circ. 40,000. Emphasizes birds and bird-watchers. Readers are bird watchers/birders (backyard and field, veterans and novices). Digest size. Sample copy \$2.

Photo Needs: Uses 10-15 photos/issue; all supplied by freelance photographers. Needs photos of "birds; appropriate photos for travel pieces." For the most part, photos are purchased with accompanying ms. Model release preferred.

Making Contact & Terms: Query with list of stock photo subjects. SASE. Reports in 1 month. Pays

\$10/b&w and \$25/color inside. Pays on publication. Credit line given. Buys one-time rights. Previously published work OK.

BITTERSWEET, Box 266, Cornish ME 04020. (207)625-3975. Editor: Nancy Marcotte. Magazine published 12 times/year. Emphasizes "northern New England (Maine, New Hampshire and Vermont) topics—particularly people, also the arts, history, life in general for well-educated professionals over 30 who have chosen rural living for its pleasures and benefits." Circ. 6,500. Sample copy for SASE and \$1.24 postage.

Photo Needs: Uses about 20-30 photos/issue; 80% supplied by freelance photographers. Needs all subjects, "but put people in them." Special needs include "historical photos or copies in particular; color

essays on a theme." Model release required; captions preferred.

Making Contact & Terms: Query with samples; send any size b&w glossy prints, transparencies and contact sheets by mail for consideration. SASE. Reports in 6 weeks. Pays \$50/color cover; \$5-10/b&w inside color; \$15-40/color inside photo; \$25-100 for text/photo package. Pays on publication. Credit

line given. Buys one-time rights. Simultaneous submissions OK; "let us know."

Tips: Prefers to see "transparencies in display sheets or b&w prints or contact sheets showing brilliant color and sharp contrast. Edit yourself before submitting. A lot of the same stuff or a lot of anything is boring. Remember we're regional and arts/literature/living oriented. No 'issues.' Keep trying. We're into a major growth exercise. We'll be adding more pages and more color over the next few months, and that means more opportunity for freelancers."

BLACK AMERICA MAGAZINE, 24 W. Chelten Ave., Philadelphia PA 19144. (215)844-8872. Feature Editor: Michael Rice. Editor: Martine Charles. Quarterly magazine. Circ. 500,000. For blacks between ages of 18-45 who are "fairly well educated, affluent or aspiring to be, interested in fashion, race, 'poetic photography' featuring blacks, especially women. Interested in exciting black personalities, glamour, music and social problems. We need an archive of shots of blacks of all ages and both sexes in a variety of poses. We also need shots depicting a variety of occupations in which blacks participate—anything interesting." Wants no "homey, ordinary shots of ordinary-looking people." Buys 4 annually. Buys first serial rights or second serial (reprint) rights. Submit model release with photo. Send photos or contact sheet for consideration. Provide resume, calling card and samples to be kept on file for possible future assignments. Pays on publication. Reports in 2 months. SASE. Simultaneous submissions and previously published work OK. Free sample copy.

B&W: Send contact sheet or 8x10 glossy prints. Pays \$5-15.

Cover: Send glossy color prints or color transparencies. "Glamour, fashion, elegance, romance or sex appeal, and mood-setting are all important. Both black women and men necessary." Pays \$10-25. Tips: "B&w only, except for fashion shots, which will be considered only as a part of a set of 8-10 transparencies or prints." Needs photos for following departments: Mankind in Black—needs photos of "interesting, handsome black male, successful whether or not he is well known; needs accompanying ms." Same needs as Mankind in Black, but concerns women; needs accompanying ms. Social Problems-uses shots depicting social or racial problems such as poverty, ghetto misfortunes, etc. Black History—uses photo essays with brief accompanying mss dealing with black history. News Events-current news events with ms, Travel with or without ms.

THE BLADE MAGAZINE, Box 22007, Chattanooga TN 37422. Editor-in-Chief: J. Bruce Voyles. Bimonthly. Circ. 30,000. Emphasizes knives and edged weapons. Readers are "blade enthusiasts, col-

lectors and users." Sample copy \$3.

Photo Needs: Uses about 80-100 photos/issue, "usually the photos we buy accompany articles." 85% supplied by freelance photographers. "Usually needs photos for manuscripts on a specific maker or manufacturer. Photographer's geographic proximity to the article subject would be the primary consideration for the assignment—the photos to accompany an already submitted article or profile." Most photos purchased with accompanying ms only. Model release preferred; captions required.

Making Contact & Terms: Query with samples or with list of stock photo subjects. Send 35mm slides, b&w contact sheet or color prints by mail for consideration. Prefers to see "photos of knives well done in an unusual or interesting way." SASE. Reports in 1 month. Pays \$50 and up/color cover photo; \$5 and up/color inside photo; \$5/photo and 5¢/word up to \$8/photo and 7¢/word for text/photo package. Pays on publication. Credit line given. Buys all rights. Previously published work OK.

Tips: "Most of our needs are filled by writers who are also photographers—and some of them are quite good photographers, too. We've broadened our coverage to take in sporting use of knives. We are an

easy to sell market if the photos fit our needs."

BLAIR & KETCHUM'S COUNTRY JOURNAL, Box 870, Manchester Center VT 05255. (802)362-1022. Picture Editor: Stephen R. Swinburne. Monthly. Emphasizes country living in rural northern America (snowbelt). Readers are upper middle class, well-educated professionals who chose

"Ever since July 1974, when we published our first photograph by Richard W. Brown, he has been a major contributor to Blair & Ketchum's Country Journal," says its editor, Stephen Swinburne. "We have asked him to photograph his neighbors and the countryside near his home in northern New England. and in our behalf he has traveled as far away as Hawaii and New Zealand to document rural life. His photographs have appeared on 31 of our covers and in every case the pictures that appeared were our selections. For our tenth anniversary edition. we decided it would be interesting to have Richard do the choosing. This is one of his selections."

to live in rural areas or small towns. Circ. 300,000. Sample copy \$2. Photo guidelines free with SASE. Photo Needs: Uses about 25-30 photos/issue; most supplied by freelance photographers. Needs photos of "wild animals and birds of the northern states; farm life, people doing things in a rural setting; country humor; sports; chores around the house. Continuing need for color shots of people engaged in all kinds of activities in the country. Activity must be believable for a country setting. Special need for shots of humorous nature for 'This Country Life' page, color only." Model release preferred; captions required. Making Contact & Terms: Arrange a personal interview to show portfolio; send 8x10 lustre b&w prints; 35mm, 21/4x21/4, 4x5 or 8x10 transparencies by mail for consideration; submit portfolio for review. SASE. Reports in 3 weeks to a month. Pays \$275-500/color cover photo; \$140-225/b&w page; \$140-225/color page. Pays on acceptance. Credit line given. Buys one-time or first North American serial rights.

Tips: "Send only photos that show country life, either as a selection of related shots that tell a story, or individual shots that demonstrate photographer's ability. Please study back issues, and send me only

what you think are the best in the bunch.'

THE BLOOMSBURY REVIEW, Box 8928, Denver CO 80201. (303)455-0593. Art Director: Steve Lester, Editor: Tom Auer, Monthly, Circ. 18,000. Emphasizes book reviews, articles and stories of interest to book readers. Sample copy \$2.

Photo Needs: Uses 2-3 photos/issue; all supplied by freelance photographers. Needs photos of people who are featured in articles. Photos purchased with or without accompanying ms. Model release and

captions preferred.

Making Contact & Terms: Provide brochure, tearsheets and sample print to be kept on file for possible future assignments, SASE. Reports in 1 month. Payment by the job varies. Pays on publication. Credit line and one-line bio given. Buys one-time rights.

Tips: "Send good photocopies of work to Art Director."

BLUEGRASS UNLIMITED, Box 111, Broad Run VA 22014. (703)361-8992. Editor: Peter V. Kuykendall. Monthly magazine. Circ. 17,500. Emphasizes old-time traditional country music for musicians and devotees of bluegrass, ages from teens through the elderly. Buys 50-75 annually. Buys all rights, but may reassign to photographer after publication. Send photos for consideration or call. Pays on publication. Credit line given. Reports in 2 months. SASE. Previously published work OK. Free sample copy and photo guidelines.

Subject Needs: Celebrity/personality, documentary, head shot, how-to, human interest, humorous,

photo essay/photo feature, product shot, spot news and travel.

B&W: Send 5x7 glossy prints. Pays \$20-40/printed page of photos.

Color: Send 5x7 glossy prints or transparencies. Pays \$30-80/printed page of photos.

Cover: Send 5x7 glossy b&w prints, 5x7 glossy color prints or color transparencies. Pays \$100-150.

THE B'NAI B'RITH INTERNATIONAL JEWISH MONTHLY, 1640 Rhode Island Ave. NW, Washington DC 20036. (202)857-6645. Editor: Marc Silver. Monthly magazine. Circ. 200,000. For Jewish family members. Emphasizes religious, cultural and political happenings worldwide. Buys 30 photos annually, usually on assignment only. Occasional photo essays. Buys first serial rights. Send sample photos for consideration. Pays on publication. Reports in 6 weeks. SASE.

B&W: Pays \$20-150/photo.

Color: Pays \$50-250/photo; \$250 by the day.

An excellent and comprehensive command of studio techniques can lead to good payment. This cover photograph earned Arlington, Virginia. freelance photographer Lloyd Wolf almost \$400 Wolf has been freelancing for four years, working for neighboring Washington DC clients and newspapers. Many of his photos have been published by the Associated Press

*BOAT PENNSYLVANIA, Box 1673, Harrisburg PA 17105-1673. (717)657-4520. Editor: Art Michaels. Bimonthly magazine. Emphasizes "non-angling boating in Pennsylvania: powerboating, canoeing, kayaking, sailing, rafting, and water skiing." Sample copy free with 9x12 SASE and 73¢ postage. Photo guidelines free with SASE.

Photo Needs: Uses about 30 photos/issue; 75% supplied by freelance photographers. Model release and

captions required.

Making Contact & Terms: Query with resume of credits. Send 35mm, 21/4x21/4 transparencies by mail

for consideration. SASE. Reports in 1 week on queries; 1 month on submissions. Pays on acceptance.

Credit line given. Buys all rights. Occasionally considers previously published work.

Tips: "We are hungry for top-quality materials, but no matter how good a picture is, we insist on a few items. For one thing, all boaters must be wearing PFDs. We feature subjects appropriate to Pennsylvania, so we can't use pictures with foreign backgrounds, palm trees, saltwater settings, and snow-capped mountain ranges. We prefer to show boats registered only in Pennsylvania. If this is a problem, try to hide the boat registration completely. Finally, *Boat Pennsylvania* stresses safety, so pictures must show boaters accordingly. For instance, we would not publish a picture of a powerboat under way with people lying on the gunwale or leaning over the side."

BOATING, 1 Park Ave., New York NY 10016. (212)725-3979. Editor: Roy Attaway. Monthly magazine. Circ. 200,000. For powerboat enthusiasts, informed boatmen.

Subject Needs: Uses powerboat adventure stories; practical information on boats, marine products,

seamanship, and maintenance.

Specs: B&w prints and color transparencies (No Ektachrome, please!).

Accompanying Mss: Photos purchased with accompanying ms or singly.

Payment/Terms: Pays \$75-150/b&w print; payment for color transparencies dependent on size and us-

age; \$500/cover shot. Pays on acceptance.

Making Contact: Most work assigned, but do use some freelancers. Query or send material for consideration. SASE. Reports in 3 weeks.

Tips: "We want tack-sharp Kodachrome slides—modern production fiberglass powerboats. No sail-boats."

*BOB'S VIDEOMANIA MAGAZINE, 115 Stanton St., Ripon WI 54971. (414)748-2245. Monthly tabloid. Emphasizes home video, plus the world of entertainment (Hollywood, movies, TV, etc.). Readers are predominantly male, average age: 30-40 "very into home video and entertainment." Circ.: a few thousand. Sample copy \$1.50.

Photo Needs: Uses 12-15 photos/issue; 50 supplied by freelance photographers. Needs basically, anything of interest to home video buffs/entertainment fans—video products, celebrities, convention photographers.

tos, etc. Model release required.

Making Contact & Terms: Send b&w prints by mail for consideration. SASE. Reports in 1 week. Pays \$2.50/b&w cover photo; \$1.50/b&w inside photo. Pays on acceptance. Credit line given. Buys all rights, may reassign after publication.

Tips: "Aim for candid shots concerning celebrities; and sharp, clear photos with good contrast. Instead

of trying to take the entire scene in, look for an interesting focal point."

BOP, 7060 Hollywood Blvd. #720, Hollywood CA 90028. (213)469-3551. Editor: Julie Laufer. Monthly. Emphasizes teenage entertainment; includes music stars, TV and film personalities of interest to the teenage/youth market. Readers are primarily teenage girls, average age 13 years. Circ. 350,000. Sample copy \$1.75. Photo guidelines free with SASE.

Photo Needs: Uses about 215 photos/issue; 60 supplied by freelance photographers. Needs photos of entertainment personalities. "We're always looking for new and unusual photos of celebrities popular

among young people." Model release required; captions preferred.

Making Contact & Terms: Query with samples; send 5x7 or 8x10 b&w, matte or glossy, prints; 35mm or 21/4x21/4 transparencies; b&w contact sheet by mail for consideration. Pays \$75 +/color cover photo; \$15/b&w and \$35-50 +/color inside photo; \$50 minimum for text/photo package. Pays on publication. Buys all rights. Simultaneous submissions and previously published work OK.

Tips: "Send b&w prints or contact sheets or color transparencies of TV, film and music celebrities popular with young people. Please provide clear, focused photos, preferably never before published in the

U.S."

BOW & ARROW, Box HH, Capistrano Beach CA 92624. Editor: Jack Lewis. Bimonthly magazine. Circ. 96,000. For archers and bowhunters. "We emphasize all facets of archery—bowhunting—with technical pieces, how-tos, techniques, bowhunting tips, personality profiles and equipment tests." Photos purchased with accompanying ms; rarely without. "We buy approximately 4 text/photo packages per issue. Most cover shots are freelance." Pays \$50-250 for text/photo package or on a per-photo basis for photos without accompanying ms. Credit line given. Pays on acceptance. Buys all rights. Query with samples OK, but prefers to see completed material by mail on speculation. SASE. Reports in 2-3 weeks. Subject Needs: Animal (for bowhunting stories); celebrity/personality (if the celebrity is involved in archery); head shot ("occasionally used with personality profiles, but we prefer a full-length shot with the person shooting the bow, etc."); how-to (must be step-by-step); human interest; humorous; nature, travel and wildlife (related to bowhunting); photo essay/photo feature; product shot (with equipment tests); scenic (only if related to a story); sport (of tournaments); and spot news. "No snapshots (particu-

268 Photographer's Market '86

larly color snapshots), and no photos of animals that were not hunted by the rules of fair chase. We occasionally use photos for Bow Pourri, which is a roundup of archery-related events, humor, laws and happenings." Captions required.

B&W: Uses 5x7 or 8x10 glossy prints.

Color: Uses 35mm or 21/4x21/4 transparencies.

Cover: Uses 35mm or 21/4x21/4 color transparencies. Vertical format preferred.

Accompanying Mss: Technical pieces, personality profiles, humor, tournament coverage, how-to stories, bowhunting stories (with tips), equipment tests and target technique articles. Writer's guidelines included with photo guidelines.

Tips: "We rarely buy photos without an accompanying manuscript, so send us a good, clean manuscript

with good-quality b&w glossies (our use of color is limited).'

BOWHUNTER, 3150 Mallard Cove Lane, Fort Wayne IN 46804. (219)432-5772 or 456-3580. Editor/ Publisher: M.R. James. Bimonthly magazine. Circ. 160,000. Emphasizes bow and arrow hunting. Photos purchased with or without accompanying ms. Buys 50-75 photos/year. Credit line given. Pays on acceptance. Buys one-time publication rights. Send material by mail for consideration or query with samples. SASE. Reports on queries in 1-2 weeks; on material in 4-6 weeks. Sample copy \$2. Photo guidelines free with SASE.

Subject Needs: Scenic (showing bowhunting) and wildlife (big and small game of North America). No

cute animal shots or poses.

B&W: Uses 5x7 or 8x10 glossy prints. Pays \$15-50/photo.

Color: Uses 5x7 and 8x10 glossy prints or 35mm and 21/4x21/4 transparencies. Pays \$50-100/photo. Cover: Uses 35mm and 21/4x21/4 color transparencies. Vertical format preferred. Pays \$50-100/photo, "more if photo warrants it."

Accompanying Mss: "We want informative, entertaining bowhunting adventure, how-to and where-

to-go articles." Pays \$25-250/ms. Writer's guidelines free with SASE.

Tips: "Know bowhunting and/or wildlife and study 1 or more copies of our magazines before submitting. We're looking for better quality and we're using more color on inside pages. Get to know our magazine before submitting any material."

BOWLERS JOURNAL, 875 N. Michigan Ave., Chicago IL 60611. (312)266-7171. Editor: Mort Luby. Managing Editor: Jim Dressel. Monthly magazine. Circ. 18,000. Emphasizes bowling. For people interested in bowling: tournament players, professionals, dealers, etc. Needs "unusual, unique photos" of bowlers." Buys 20-30 annually. Not copyrighted. Send contact sheet or photos for consideration. Pays on publication. Reports in 3 weeks. SASE. Simultaneous submissions OK.

B&W: Send contact sheet or 8x10 glossy prints. Captions required. Pays \$5-50.

Color: Send transparencies. Captions required. Pays \$10-75.

Cover: See requirements for color.

Tips: "Bowling is one of the most challenging areas for photography, so try it at your own risk . poor lighting, action, etc."

BOY'S LIFE, Boy Scouts of America, 1325 Walnut Hill Lane, Irving TX 75062. Editor: Robert Hood. Photo Editor: Gene Daniels. Monthly magazine. Circ. 1,500,000. Emphasizes topics of interest to boys, such as Boy Scouting, sports, stamp and coin collecting, fiction and careers. For boys age 8-17. Wants no single photos or photos with no "story theme." Submit portfolio or query with "strong story outline." Pays on acceptance. Reports in 1 week. SASE. Free photo guidelines.

Color: Send 35mm transparencies. Captions required. Pays \$200/day.

Cover: Send 35mm color transparencies. Cover photos must pertain directly to an inside story. Captions required. Pays \$500 minimum.

Tips: "All photography is assigned to first-class talent. A properly prepared portfolio is a must." Query before submitting photos.

BREAD, 6401 The Paseo, Kansas City MO 64131. (816)333-7000. Editor: Gary Sivewright. Monthly magazine. Circ. 25,000. Christian leisure reading magazine for junior and senior high school students, published by the department of youth ministries. Church of the Nazarene. Buys 150 photos annually. Free sample copy and photo guidelines with SASE.

Subject Needs: Family scenes involving teens, teens in action, seasonal photos involving teens and all types of photos illustrating relationships among teens. "No obviously posed shots or emphasis on teens involved in negative situations (smoking, drinking, etc.). Prefers photos of teens fully clothed, e.g., no teens in swimwear."

Specs: Uses 8x10 glossy b&w prints inside and color transparencies for cover.

Payment & Terms: Pays \$15-25/b&w and \$50-125/cover. Buys first rights. Pays on acceptance. Simultaneous submissions and previously published work OK.

Making Contact: Send photos by mail for consideration. Reports in 6-8 weeks. SASE. Tips: "Make sure photos are *current*—watch clothing styles, etc."

*BREED & SHOW, The Magazine for Champions, 1115 Vida Dr., Anniston AL 36206. (205)820-9309. Editor: Janet A. Brunson. Monthly. Emphasizes all-breed dog magazine. Readers include professional dog breeders, exhibitors, professional handlers, hobbyists. Circ. 4,000. Estab. 1984. Free sample copy.

Photo Needs: Uses 4 photos/issue; 25-50% supplied by freelance photographers. Needs photos to accompany articles which are on all aspects of dog ownership and the sport of dog showing. Photographers should contact editor for schedule of upcoming articles and photographic requirements. Model release

and captions preferred.

Making Contact & Terms: Send 3x5 and larger b&w or color prints; or b&w negatives. SASE. Reports in 1 month. Pays \$50/b&w cover photo; \$10/b&w inside photo. Pays on publication. Credit line given. Buys one-time rights. Simultaneous submissions OK.

BRIGADE LEADER, Box 150, Wheaton IL 60189. (312)665-0630. Editor: David R. Leigh. Art Director: Lawrence Libby. Quarterly magazine. Circ. 12,000. For Christian men, age 20 and up. Seeks "to make men aware of their leadership responsibilities toward boys in their families, churches, and communities." Buys 2-7/issue. Buys first serial rights. Arrange a personal interview to show portfolio or send photos for consideration. Pays on publication. Reports in 6 weeks. SASE. Simultaneous submissions and previously published work OK. Sample cop \$1.50. Photo guidelines available. Include a

Subject Needs: Photos of men in varied situations (alone, with their sons, with groups of boys or with one boy, with their families or at work), head shot, photo essay/photo feature and scenic.

B&W: Send 8x10 glossy prints. Pays \$25. **Cover:** Send glossy b&w prints. Pays \$50-75.

BRITISH HERITAGE, Historical Times, Inc., 2245 Kohn Rd., Box 8200, Harrisburg PA 17105. (717)657-9555. Executive Editor: Mrs. Gail Huganir. Bimonthly magazine. Emphasizes British history, Commonwealth history and travel. Readers are professional, middle-aged. Circ. 65,000. Sample copy \$4, author guidelines available with SASE.

Photo Needs: Uses about 80 photos/issue; 60% supplied by freelance photographers. Needs travel, sce-

nic and historical photos. Captions required.

Making Contact & Terms: Provide resume, business card, brochure, flyer or tearsheets to be kept on file for possible future assignments. SASE. Reports in 3 weeks. Negotiates pay for cover photos. Pays \$10/b&w inside photo; \$20/color inside photo. Pays on publication. Credit line given. Buys one-time rights.

CALIFORNIA MAGAZINE, Suite 1800, 11601 Wilshire Blvd., Los Angeles CA 90025. Photo Assistant: Hope Wittman-Adams. Monthly. Circ. 300,000. Emphasizes California—people, places and events. Readers are national (U.S.—most subscribers in California). Sample copy \$2 for current; \$3.50 for back issues.

Photo Needs: Uses about 30-50 photos/issue (depends on features); 20% supplied by freelance photographers. Needs photos of people (minor celebrities) and specific events. Model release required: cap-

tions preferred.

Making Contact & Terms: Query with list of stock photo subjects; submit portfolio for review; provide resume, business card, brochure, flyer or tearsheets to be kept on file for possible future assignments. SASE. Reports in 2 weeks. Pays approximately \$500/b&w cover photo, approximately \$800/color cover photo; \$100-200/b&w page, \$150-250/color page; \$600-1,500 for text/photo package (depends on work involved). Pays on publication. Credit line given. Buys one-time rights. Simultaneous submissions OK.

Tips: Prefers to see "tearsheets or photographs with an editorial emphasis" in a portfolio. "First step would be to drop off his/her portfolio with a card enclosed so we can notify them. If you are interested in working with our publication we suggest you look at our magazine before submitting photos."

CALLALOO: A Tri-Annual Black South Journal of Arts and Letters, English Department, University of Kentucky, Lexington KY 40506. Editor-in-Chief: Charles H. Rowell. Photo Editor: Martha Wells. Triannual. Circ. 500. Emphasizes "the creative work of black south writers, artists and photographers as well as scholarly works about these artists." Readers are interested in black south art and culture. Sample copy \$7; photo guidelines free with SASE.

Photo Needs: Uses about 6 photos/issue; all supplied by freelance photographers. Needs "photos about black life in the South; photos by and about blacks. We always have a photo essay or photo section."

Model release and captions preferred.

Making Contact & Terms: Query with list of stock photo subjects. Send 5x7 b&w prints by mail for consideration. SASE. Reports in 1 month. Pays in copies. Credit line given. Buys one-time rights. Simultaneous submissions OK.

CAMPUS LIFE, 465 Gundersen Dr., Carol Stream IL 60188. (312)260-6200. Senior Editors: Gregg Lewis, Jim Long. Photo Editor: Verne Becker. Monthly magazine except May/June and July/August. Circ. 155,000. "Campus Life is a magazine for high school and college-age youth. We emphasize balanced living—emotionally, spiritually, physically and mentally." Photos purchased with or without accompanying ms. Buys 20 photos/issue. Credit line given. Pays on publication. Buys one-time rights. SASE. Simultaneous submissions and previously published work OK. Reports in 4-6 weeks. Sample copy \$2; photo guidelines for SASE.

Subject Needs: Head shots (of teenagers in a variety of moods); humorous, sport and candid shots of teenagers/college students in a variety of settings. "We want to see multiracial teenagers in different situations, and in every imaginable mood and expression, at work, play, home and school. No travel, howto, still life, travel scenics, news or product shots. We stay away from anything that looks posed. Shoot

for a target audience of 18-year-olds.'

B&W: Uses 8x10 glossy prints. Pays \$50-75/photo.

Color: Uses 35mm or larger format transparencies. Pays \$90-125 minimum/photo.

Cover: Uses 35mm or larger format color transparencies. Pays \$250/photo.

Accompanying Mss: Query. Pays \$150 minimum/ms. Writer's guidelines for SASE.

Tips: "Concentrate on candid shots of teenagers being themselves. Go where they go; catch them in their natural habitat. Photographers should submit all color transparencies in protective sleeves, carefully packaged to prevent post office damage. Don't submit until you've seen a recent issue of the magazine."

CAMPUS VOICE, 505 Market St., Knoxville TN 37902. (615)521-0600. Editor: Keith Bellows. Photo Researcher: Kathy Getsey. Bimonthly magazine distributed during the school year on college campuses. Emphasizes college life, careers, job hunting and consumer articles. Circ. 1.2 Million. Sample copy for \$2 and SASE (9x12 envelope).

Photo Needs: Uses about 25 photos/issue both b&w and color to illustrate features in both the Youth and Adult Divisions (e.g. the college experience, the world of business, the world of travel, etc.); 10-15 supplied by freelance photographers. Wants to hear from photographers who can supply photos of students and their activities. Interested in classroom situations, fads, fashions, leisure activities and travel appro-

priate to college students. Model release and captions required.

Making Contact & Terms: Query with resume of photo credits and tearsheets; or samples along with SASE. Also indicate availability and location for assignments. B&w photography should be submitted as 5x7 glossy prints; color as 35mm, 21/4x21/4 or 4x5 transparencies. All slides sent on speculation will be returned promptly. Payment is commensurate with photographer's experience and extent of assignment. Buys one-time rights.

CANADIAN FICTION MAGAZINE, Box 946, Station F, Toronto, Ontario, Canada M4Y 2N9. Editor: Geoffrey Hancock. Quarterly literary magazine. Circ. 1,800. Emphasizes Canadian fiction, short stories and novel excerpts. "Each issue is an anthology devoted exclusively to the work of writers and artists resident in Canada and Canadians living abroad." Buys 8-16 photos/issue, plus cover. Buys first North American serial rights. Model release required. Submit portfolio. Credit line given. Pays on publication. Reports in 6 weeks. SAE and International Reply Coupons. Sample copy \$5.50, in Canadian funds.

Cover: Uses 5x7 glossy b&w prints of "exhibition quality." Pays \$25.

Tips: "Please examine back issues for the type of work required. Previous contributors include Sam Tata, Walter Curtin, Kryn Taconis, John Reeves, Kéro, Paul Orenstein, Arnaud Maggs, Peter Milroy, Helena Wilson. Especially receptive to portraits of contemporary Canadian writers, musicians, actors, playwrights and artists."

CANOE, Box 597, Camden ME 04843. (207)236-4393. Senior Editors: Virginia Hostetter and George Thomas. Managing Editor: David Getchell, Jr. Bimonthly magazine. Circ. 55,000. Emphasizes a variety of river sports as well as how-to material and articles about equipment. For canoe and kayak enthusiasts at all levels of ability. Also publishes calendar and special projects/posters. Photos purchased with

Market conditions are constantly changing! If this is 1987 or later, buy the newest edition of *Photographer's Market* at your favorite bookstore or order directly from Writer's Digest Books.

or without accompanying mss. Buys 150 annually. Pays \$100-600 for text/photo package or \$25-200 on a per-photo basis. Credit line given. Pays on acceptance and on publication. Buys one-time rights, first serial rights and exclusive rights; will accept second serial (reprint) rights. Model release required "when potential for litigation." Query with resume of credits, submit portfolio for review or send material. "Let me know those areas in which you have particularly strong expertise and/or photofile material. Send best samples only and make sure they relate to the magazine's emphasis and/or focus. (If you don't know what that is, pick up a recent issue first, before sending me unusable material.) Also, if you have something in the works or extraordinary photo subject matter of interest to our audience, let me know! It would be most helpful to me if those with substantial reserves would supply indexes by subject matter. I urgently need very strong b&w photography." SASE. Simultaneous submissions and previously published work OK, in noncompeting publications. Reports in 1 month. Free sample copy with 9x12 envelope and postage only.

Subject Needs: Canoeing, kayaking, ocean touring, canoe sailing, fishing when compatible to the main activity, canoe camping and, occasionally, rafting. No photos showing subjects without proper equipment in evidence, such as modem, Type III lifejackets in other than still water; no photos showing disregard for the environment, be it river or land; no photos showing gasoline-powered, multi hp engines; no photos showing unskilled persons taking extraordinary risks to life, etc. Captions are required, unless

impractical.

B&W: Uses 5x7 and 8x10 glossy prints. Pays \$25-50 minimum.

Color: Uses 35mm, 21/4x21/4 and 4x5 transparencies. Pays \$35-200 minimum. Cover: Uses color transparencies; vertical format preferred. Pays \$100-250.

Accompanying Mss: "Editorial coverage strives for balanced representation of all interests in today's paddling activity. Those interests include paddling adventures, both close to home and far away; camping; fishing; flatwater; whitewater; ocean kayacking; racing; poling; sailing; outdoor photography; howto projects; instruction and historical perspective. Regular columns feature paddling techniques, competition, conservation topics, safety, interviews, equipment reviews, book/movie reviews, new products and reader letters."

Tips: "We have a highly specialized subject and readers don't want just 'any' photo of the activity; they want something they can identify with, can wallow in over the memories it recalls of trips, feats, cruises gone by. We're particularly interested in photos showing paddlers *faces*; the faces of people having a good time. We're after anything that highlights the paddling activity as a lifestyle and the urge to be 'in' the out-of-doors." All photos should be "as natural as possible with authentic subjects."

THE CAPE ROCK, Southeast Missouri State University, Cape Girardeau MO 63701. (314)651-2156. Editor-in-Chief: Harvey Hecht. Emphasizes poetry and poets for libraries and interested persons. Semi-

annual. Circ. 1,000. Free sample copy and photo guidelines.

Photo Needs: Uses about 16 photos/issue; all supplied by freelance photographers. "We like to feature a single photographer each issue. Submit 30 thematically organized 8x10 glossies, or send 5 pictures with plan for complete issue. We favor most a series that conveys a sense of place. Seasons are a consideration too: we have winter and summer issues. Photos must have a sense of place: e.g., an issue featuring Chicago might show buildings or other landmarks, people of the city (no nudes), travel or scenic. No how-to or products. Sample issues and guidelines provide all information a photographer needs to decide whether to submit to us." Model release not required "but photographer is liable"; captions not required "but photographer should indicate where series was shot."

Making Contact & Terms: Send by mail for consideration actual 8x10 b&w photos, query with list of stock photo subjects, or submit portfolio by mail for review. SASE. Reporting time varies. Pays \$100 and 10 copies on publication. Credit line given. Buys "all rights, but may release rights to photographer

on request." No simultaneous submissions or previously published work.

CAR COLLECTOR, Box 28571, Atlanta GA 30328. (404)998-4603. Editor: Donald R. Peterson. Monthly. Emphasizes collector automobiles. Readers are "people who collect or are otherwise interested in cars more than 10 years old." Sample copy \$2. Photo and writers guidelines free with SASE. Photo Needs: Uses about 50-75 photos/issue; "nearly all" supplied by freelance photographers. Needs photos of "automobiles." Photos purchased with accompanying ms only. Captions required.

Making Contact & Terms: Query with samples; send b&w prints; 35mm, 2\(^1/4x\)2\(^1/4\), 4x5 and/or 8x10 transparencies by mail for consideration. Pays minimum of \$50/color cover photo; \$5/b&w and \$10/col-

or inside photo. Pays on publication. Credit line always given. Buys all rights.

Tips: "Do not submit photos to us without accompanying story and captions. No "fish-eye" or other "trick lens" photos purchased."

CAR CRAFT, 8490 Sunset Blvd., Los Angeles CA 90069. (213)657-5100. Editor: Jeff Smith. Monthly magazine. Circ. 400,000. Emphasizes how-to's, car features, technical features, racing coverage, etc. "We cater to the high-performance automotive and drag racing fan. People read it to keep abreast of

cruising news and to learn how to 'hop up' their cars, what the latest trends in high-performance are, and what the newest cars are like." Buys 6-7 photos/issue. Pays \$150-350 for text/photo package, and on a per-photo basis. Credit line given. Pays on publication. Buys all rights. Send material by mail for con-

sideration. SASE. Reports in 3 weeks. Free sample copy and photo guidelines.

Subject Needs: How-to (e.g., how to build portable air compressors; how to swap engines; how to paint and polish your car) and sport (drag racing events). Wants features on street machine enthusiasts. No snapshots, no auto racing other than drag racing (unless there's a tie-in), no back-lit black cars, no color technical how-to shots, no car models older than '49. Hi Riser column uses b&w shots of recognized automotive individuals. Etc. section uses unusual, humorous and spectacular b&w photos, usually of drag racers, car gatherings, etc. Racing Action is a color showcase of spectacular drag racing cars.

B&W: Uses 8x10 glossy prints. Pays \$30-150/photo.

Color: Uses 35mm or 21/4x21/4 transparencies. Pays \$50-300/photo.

Cover: Uses 35mm or 21/4x21/4 color transparencies. Vertical format preferred. Pays \$150-300/photo.

Cover shots seldom purchased from freelancers.

Accompanying Mss: Seeks mss detailing technical information, as in swapping engines, installing clutches, adding custom items; featuring drag racing drivers, owners, mechanics; featuring citizens with street machines, etc. Pays \$100-300/ms. and \$100-700 for a text/photo package.

Tips: "Become involved with the editorial subject matter so you have a specific knowledge of the maga-

zine's market and requirement.'

CAR REVIEW MAGAZINE, (formerly *Car Exchange Magazine*), Dobbs Publication, Inc., Box Drawer 7157, Lakeland FL 33803. (813)646-5743. Editor: Donald Farr. Car collector magazine with emphasis on late 50's-'60's and early 70's factory original muscle cars. Monthly. Circ. 105,000. Free sample copy and photo guidelines.

Photo Needs: Uses about 50 photos/issue supplied by freelance photographers. Needs include celebrities/muscle car owners, photo essay/features, special effects/experimental, human interest, humorous; all with collectible muscle car. Especially needs color photos. No "autos hidden by people or pictures

missing part of auto." Model release and captions required.

Making Contact & Terms: Send by mail for consideration actual 5x7 b&w photos, 35mm, 21/4x21/4 or 4x5 color transparencies; query with list of stock photo subjects, resume of credits, or samples; or submit portfolio for review. Provide resume, brochure, calling card, flyer, tearsheet and samples to be kept on file for possible future assignments. SASE. Reports in 1 month. Pays on acceptance \$10 minimum/ b&w inside photo; \$50/color transparencies for cover and inside. Credit line given. No simultaneous submissions or previously published work.

CAROLINA QUARTERLY, Greenlaw Hall, 066-A, University of North Carolina, Chapel Hill NC 27514. (919)962-0244. Editor: Mary Titus. Circ. 1,000 and up. Emphasizes "current poetry, short fiction and reviews." Readers are "literary, artistic—primarily, though not exclusively, writers and serious readers." Sample copy \$3.

Photo Needs: Uses 1-8 photos/issue; all supplied by freelance photographers. "No set subject matter.

Artistic outdoor as well as interior scenes. Attention to form. No photojournalsim, please."

Making Contact & Terms: Send b&w prints by mail for consideration. SASE. Reports in 1-3 months, depending on deadline. Pays \$10/b&w cover photo and \$5/b&w inside photo. Pays on publication. Credit line given. Buys one-time rights.

Tips: Prefers to see "high quality artistic photography. Attention to form, design. Look at a few high

quality small literary magazines which use photos. Subject matter is up for grabs.'

CAT FANCY, Fancy Publications, Inc., Box 4030, San Clemente CA 92672. (714)498-1600. Editor-in-Chief: Linda Lewis. Readers are "men and women of all ages interested in all phases of cat ownership." Monthly. Circ. 130,000. Sample copy \$3; photo guidelines for SASE.

Photo Needs: Uses 20-30 photos/issue; 100% freelance supplied. Each issue focuses on a specific purebred. Prefers photos "that show the various physical and mental attributes of the breed. Include both environmental and portrait-type photographs, but in both cases we would prefer that the animals be shown without leashes or collars. We also need good-quality, interesting b&w photos of any breed cat for use with feature articles." Model release required.

Making Contact & Terms: Send by mail for consideration actual 8x10 b&w photos, 35mm or 2 \(^1/4x2 \)^1/4 color transparencies. SASE. Reports in 6 weeks. Pays \(^1/20)/b&w photo; \(^5/20)/100/color photo; \) and \(^5/20)/250 for text/photo package. Credit line given. Buys first North American serial rights.

Tips: "Nothing, but sharp, high contrast shots, please. Send SASE for list of specific photo needs."

*CATALOG SHOPPER MAGAZINE, 1300 Galaxy Way #8, Concord CA 94520. (415)671-9852. Marketing Director: Wayne Lin. Quarterly mail order catalog for mail order buyers. Circ. 50,000. Sample copy \$1. Photo guidelines free with SASE.

Photo Needs: Uses 1 photo/issue; all by freelance photographers. Needs "seasonal, outdoor, natural and scenic" photos. Model release required; captions preferred.

Making Contact & Terms: Query with samples. Send 35mm, 21/4x21/4 and 4x5 transparencies by mail for consideration. SASE. Reports in 2 months. Pays \$50/b&w cover photo. Pays on publication. Credit line given. Buys first North American serial rights. Simultaneous submissions OK.

CATHOLIC NEAR EAST MAGAZINE, 1011 1st Ave., New York NY 10022. Editor: Michael Healy. Quarterly magazine. Circ. 130,000. Emphasizes "charitable work conducted among poor and refugees in Near East; religious history and culture of Near East; Eastern Rites of the Church (both Catholic and Orthodox)." General readership, mainly Catholic; wide educational range. Buys 40 photos/year. Buys first North American serial rights. Query first. Credit line given. "Credits appear on page 3 with masthead and table of contents." Pays on publication. Reports in 3 weeks; acknowledges receipt of material immediately. SASE. Simultaneous submissions and previously published work OK, "but neither one is preferred. If previously published please tell us when and where." Sample copy and photo guidelines free with SASE.

Subject Needs: "We are interested in shots taken in the Middle East, and we consider a variety of subjects within that general category. Mainly, though, we are oriented toward people pictures, as well as those which show the Christian influence in the Holy Land. We are also interested in good shots of artistic and cultural objects/painting, crafts and of the Eastern Rite Churches/priests/sacraments/etc." No posed shots, pictures showing combat, violence, etc. or "purely political pictures of the area." Payment varies; \$25 and up, depending on size, quality, etc.

B&W: Uses 8x10 glossy prints. Captions required.

Color: Uses 35mm or larger transparencies. Captions required.

Cover: Send color negatives or color transparencies. "Generally, we use shots which show our readers what the people and places of the Middle East really look like. In other words, the shot should have a dis-

tinctly Eastern look." Captions required.

Tips: "We always need *people* pictures. Additionally, we use shots of the Eastern Rites of the Catholic Church. Finally, we do a story on cities and countries of the Middle East in almost every issue. If the pictures were good enough, we would consider doing a photo story in any of the above categories." Also, "try to put the photos you send into some kind of context for us—briefly, though. We would welcome a ms accompanying photos, if the freelancer has a good deal of knowledge about the area."

CATS MAGAZINE, Box 37, Port Orange FL 32029. Monthly magazine. Circ. 109,000. For cat owners and breeders; most are adult women. Buys 30 photos/year. Buys first serial rights. Send contact sheet or photos for consideration. Pays on publication. Reports in 8-12 weeks. SASE. Free sample copy and photo guidelines. Provide tearsheets to be kept on file for possible future assignments.

Subject Needs: Felines of all types; celebrity/personality (with their cats); fine art (featuring cats); head shot (of cats); how-to (cat-oriented activities); human interest (on cats); humanous (cats); photo essay/photo feature (cats); sport (cat shows); travel (with cats); and wildlife (wild cats). No shots of clothed cats or cats doing tricks.

B&W: Send contact sheet or 5x7 or 8x10 glossy prints. Wants no silk finish. Pays \$5-25.

Cover: Send 2¹/₄x2¹/₄ color transparencies. Prefers "shots showing cats in interesting situations." Pays \$150. Send to Linda J. Walton, above address.

Tips: "We are always receptive to seasonal themes." If purebred cats are used as subjects, they must be representative specimens of their breed. "Our most frequent causes for rejection: cat image too small; backgrounds cluttered; uninteresting; poor quality purebred cats; dirty pet-type cats; shot wrong shape for cover; colors untrue; exposure incorrect."

CAVALIER, Suite 204, 2355 Salzedo St., Coral Gables FL 33134. (305)443-2378. Editor: Douglas Allen. Photo Editor: Nye Willden. Sexually oriented men's magazine. Readers are 18-35, single males, educated, aware, heterosexual, "affluent, intelligent, interested in current events, ecology, sports, adventure, travel, clothing, good fiction." Monthly. Circ. 250,000. Sample copy \$3; photo guidelines for SASE.

Photo Needs: Uses about 100 photos/issue; all of which are supplied by freelance photographers consisting of 5 girl sets, 1 feature set and 5-10 singles, all color. "First priority—we buy picture sets of girls. We also publish photo features of special interest and they are selected for uniqueness and excellence of photography but they must appeal to our male readership . . . everything from travel to sports but not current events (we have a 4 month lead time) and no subjects which have been done over and over in the media." Runs 4-5 picture sets of nudes/issue. Model release required.

Making Contact & Terms: Query first with list of stock photo subjects or with resume of photo credits. "Photographers should contact by mail only, describe your material, and we'll respond with a yes or no for consideration." Provide calling card, tearsheets and samples to be kept on file for possible future assignments. SASE. Reports in 2-3 weeks. Pays on publication \$250/color cover photo, \$150/b&w, \$250/

color inside photo; \$100-350/job and \$500-750/nude set. Credit line given. Buys first North American one-time rights. No simultaneous submissions.

Tips: "Study the market. See what is selling. When sending samples, show a rounded sampling, the wider and more varied the better. Include photo studies of nudes if applicable."

CENTRAL MASS MEDIA INC./WORCESTER MAGAZINE, (formerly *Worcester Magazine*), Box 1000, Worcester MA 01614. (617)799-0511. Photo Editor: Patrick O'Connor. Weekly newsmagazine. Circ. 48,000. Emphasizes alternative hard journalism plus heavy lifestyle and leisure coverage of central Massachusetts. Photos purchased with or without accompanying mss. Pays \$15-100/job or \$5-25/photo. Credit line given. Pays on publication. Buys all rights. Model release required "where appropriate." Query with resume of credits. SASE. Simultaneous submissions and previously published work OK. Reports in 3 weeks. Sample copy \$1.

Subject Needs: Anything with a local angle. Celebrity/personality ("either celebrities or local individuals who will be interesting enough to our readers to warrant coverage"); documentary; fine art (possible use as a gallery piece on a local photographer); sport ("not spot action, but interpretive"); human interest; photo essay/photo feature ("our bread and butter but the pieces submitted must have a good local slant, must be relevant to our readers and possess that elusive magical ingredient: quality!"); and fashion/beauty (used seasonally or applied to some editorial illustration). "We also use some concept photography; the illustration of ideas or events through especially creative photographs." Captions are required. "In addition, we produce special supplements on various topics throughout the year. These supplements require varying amounts of photographic illustration, e.g., restaurant interiors, homes educational institutions, etc."

B&W: Uses 8x10 glossy and semigloss prints.

Cover: Uses b&w and some 4-color covers; vertical or square format used on cover.

Accompanying Mss: Seeks expose, how-to, interview, personal experience and personal opinion articles.

*CHANGING MEN: ISSUES IN GENDER, SEX & POLITICS, 306 N. Brooks St., Madison WI 53715. Editor: Mike Bierubaum. Photo Editor: Jon Bailiff. Quarterly. Emphasizes men's issues, feminist, male politics, gay issues. Readers are male and female feminists, gay, political activists. Circ. 25,000. Sample copy \$4.50.

Photo Needs: Uses 4-5 photos/issue; 100% supplied by freelance photographers. Needs art photography, male nude, images of men at work, play, etc.; journalism on gay and male feminist gatherings. Special needs include features on mens' issues, AIDS epidomic, gay issues antiporn, etc. Model release preferred.

Making Contact & Terms: Query with list of stock photo subjects. Send b&w prints and b&w contact sheets, limit 5. SASE. Reports in 1 month. Pays \$15-50/text/photo package. Pays on publication. Credit line given. Buys one-time rights.

Tips: "Display sensitivity to subject matter; provide political photos showing conscience, strong journalism on gay issues."

CHANGING TIMES MAGAZINE, 1729 H St. NW, Washington DC 20006. (202)887-6400. Assistant Editor: Susan J. Sherry. Monthly. Emphasizes personal finance and consumer subjects. Readers are "males and females from age 20-50 with middle-class to high incomes." Circ. 1,500,000.

Photo Needs: Uses about 15-20 photos/issue; all are supplied by freelance photographers and assigned by the magazine. Needs "depend on subject matter of articles." Model release required.

Making Contact & Terms: Arrange a personal interview to show portfolio. Pays \$1,000/color cover photo, \$500/color page, 330-500/color photo, and \$350-500 by the day; payment for inside color photos "depends on size." Pay rates set by ASMP space rates. Pays on acceptance. Credit lines given. Buys 1st time rights.

Tips: "Examine back issues of the magazine to see what we are using. We use freelancers on assignment only. Generally, they are established photographers who have shown us work that has been published elsewhere."

CHARLOTTE MAGAZINE, Box 36639, Charlotte NC 28236-6639. (704)375-8034. Editor: Terry Byrum. Emphasizes probing, researched articles on local people and local places. Readers are "upper income group, 30s or early 40s, college degree, married with children, homeowners, travelers, men and women with executive-type jobs." Monthly. Circ. 20,000. Sample copy \$2; photo guidelines for SASE. Provide tearsheets to be kept on file for possible future assignments.

Photo Needs: Uses about 4 photos/issue, all of which are supplied by freelance photographers. "Freelance photographers are usually sent out on assignments according to editorial content for a specific issue." Sometimes photo essays, which are all regional in nature, are assigned by the editor. Column needs: Travel (worldwide), Town Talk (various short articles of information and trivia), The Arts, Res-

taurants, Music, Galleries, Theatre, Antiques, etc. Model release and captions required. **Making Contact & Terms:** Arrange personal interview to show portfolio, or if sending by mail for consideration, call first (do not call collect). SASE. Reports in 3 weeks. Pays 30 days after publication \$10-100/job. Credit line given. Buys one-time rights. Simultaneous and previously published submissions OK

CHERI PUBLICATIONS, 215 Lexington Ave., New York NY 10016. (212)686-9866. Publisher: Mike Evans. Monthly. Emphasizes topics for the male sophisticate. Readers are 18- to 45-year-old, blue-collar men. Circ. 500,000 + . Sample copy \$3.75. Photo guidelines free with SASE.

Photo Needs: Uses about 325/photos per issue; 50% supplied by freelance photographers. Needs nude

glamour layouts. Model release required.

Making Contact & Terms: Arrange a personal interview to show portfolio; query with samples; send 35mm, 21/4x21/4 transparencies by mail for consideration. SASE. Reports in 1 month. Pays \$450/color cover photo; \$750-1,500/job. Pays on publication. Buys first North American serial rights. Simultaneous submissions OK.

Tips: Photographer should "be familiar with our publication. Have an adequate number of models available."

THE CHESAPEAKE BAY MAGAZINE, 1819 Bay Ridge Ave., Annapolis MD 21403. (301)263-2662. (DC)261-1323. Art Director: Ginny Leonard. Monthly. Circ. 20,000. Emphasizes boating—Chesapeake Bay only. Readers are "people who use Bay for recreation." Sample copy available. Photo Needs: Uses "approximately" 5-20 photos/issue. Needs photos that are "Chesapeake Bay related (must); vertical power boat shots are badly needed (color)." Special needs include "vertical 4-color slides showing boats and people on Bay." Model release and captions optional.

Making Contact & Terms: Query with samples or list of stock photo subjects; send 35mm, 21/4x21/4, 4x5 or 8x10 transparencies by mail for consideration. SASE. Reports in 3 weeks. Pays \$100/color cover photo. Pays on publication. Credit line given. Buys one-time rights. Simultaneous submissions OK. Tips: "We prefer Kodachrome over Ektachrome. Vertical shots of the Chesapeake bay with *power* boats

badly needed, but we use all subject matter related to Bay."

CHICAGO, 303 E. Wacker, Chicago IL 60601. (312)565-5000. Editoral Director: Don Gold. Art Director: Bob Post. Monthly magazine. Circ. 220,000. "Chicago is a basic guide to what's happening around the city." Readers are "95% from Chicago area; 90% college trained; upper income; overriding interest in the arts, dining, good life in the city and suburbs. Most are 25-50 age bracket and well read and articulate." Photos purchased with accompanying ms or on assignment. Buys 150 photos/year. Pays ASMP prices: \$50 minimum/job, \$250-1,000 for text/photo package, or on a per-photo basis. Credit line given. Pays on publication. Buys one-time rights. Send material by mail for consideration or arrange personal interview to show portfolio. Interviews every Wednesday afternoon. SASE. Simultaneous submissions OK. Reports in 2 weeks. Sample copy: send \$3 to Circulation Department.

Subject Needs: Photo essay/photo feature. Model release preferred; captions required.

B&W: Uses 8x10 prints. Pays \$35-200/photo.

Color: Uses transparencies. Negotiable ASMP prices.

Cover: Uses color transparencies. Vertical format preferred. Negotiable ASMP prices.

Accompanying Mss: Pertaining to Chicago and the immediate environment. Negotiable ASMP prices. Free writer's guidelines.

CHICKADEE MAGAZINE, 59 Front St. E, Toronto, Ontario, Canada M5E 1B3. (416)364-3333. Editor: Janis Nostbakken. Published 10 times/year. Circ. 75,000-80,000. "This is a natural science magazine for children 4-8 years. Each issue has a careful mix of stories and activities for different age levels. We present animals in their natural habitat." Sample copy with SAE and 64¢ Canadian postage (no American postage).

Photo Needs: Uses about 3-6 photos/issue; 2-4 supplied by freelance photographers. Needs "crisp,

bright, close-up shots of animals in their natural habitat." Model release required.

Making Contact & Terms: Query with list of stock photo subjects. SAE (Canadian postage). Reports in 6-8 weeks. Pays \$125 Canadian/color cover; \$125 Canadian (centerfold); pay negotiable for text/photo package. Pays on publication. Credit line given. Buys "one-time rights, nonexclusive, to reproduce in *Owl* and *Chickadee* in Canada and affiliated children's publications in remaining world countries."

CHILD LIFE, Box 567, Indianapolis IN 46206. (317)636-8881. Editor: Steven Charles. Magazine published 8 times/year. For children 7-9. Photos purchased only with accompanying ms. Credit line given. Pays on publication. Buys all rights to editorial material, but usually one-time rights on photographs. Send material by mail for consideration. Query not necessary. SASE. Reports within 10 weeks. Sample copy 75¢; free writer's guidelines with SASE.

Subject Needs: Health, medical and safety articles are always needed. Captions required. Model release required.

B&W: Prefer 8x10 or 5x7 glossy to accompany mss. Will consider color transparencies 35mm or larger. but magazine prints all b&w and duotone. Pays \$7/photo.

Color: Transparencies 35mm or larger. Pays \$7/photo. Uses only a few pages for 4-color photos. Prefers

Accompanying Mss: All photos must be accompanied by mss. Do not send individual photos without accompanying ms. Pays approximately 6¢/word for mss.

Tips: "Address all packages to Editor and mark 'Photo Enclosed.' "

*CHRISTIAN BUSINESS MAGAZINE, Box 64951, Dallas TX 75206-0951. (214)288-8900, Contact: Editor. Monthly. Emphasizes Christians in business, Christian and moral living. Business to Business, Business to Consumer. Readers include Christian communities nationally, Christian retail consumer market, Christian business market, Secular business to Christian consumer. Circ. 10,000. Estab. 1984. Sample copy \$3.50 with SASE. Photo guidelines \$2 or free when ordering sample copy.

Photo Needs: Uses 15-20 photos; 80% supplied by freelance photographers. Needs photo-stories on Christian businesspersons (business related), fishing, sports, seminars, conventions, etc. which are Christian business related or perhaps travel, advertisers, inventors, Christian novelists, photographers, and general subjects. Photos purchased with accompanying ms only. Organizational guidelines should be ordered prior to any submissions. "Christian Business will need work from photographers who have a developed understanding of our guidelines and can assist with photography from their local areas or who can travel to on-locale spots to shoot assignments. Must be professional." Model release and captions required.

Making Contact & Terms: Order copy of publication first and include resume of credits, sample of work. Does not return unsolicited photos. Reports in 2-3 weeks. Pays on acceptance and publication. Credit line sometimes given. Buys one-time rights, first North American serial rights. Simultaneous submissions, previously published work OK. "Photographers and photojournalists should be aware of our format. Before trying to get started, send for guideline packet or order copy of publication so that you'll know what CBM is looking for. Then go for it. Persons needed in every state! Remember, clean, wholesome principles will net a job which may have lasting job relationships. CBM does not utilize sex, cigs, perversion. Christian Business is looking for the hot shot who can shoot straight and knows how to work well within the Christian community. Professionalism a must! Follow the rules."

THE CHRISTIAN CENTURY, 407 S. Dearborn St., Chicago IL 60605. (312)427-5380. Editor: James M. Wall. Photo Editor: Dean Peerman. Magazine published 40 times/year. Circ. 35,000. Emphasizes "concerns that arise at the juncture between church and society, or church and culture." Deals with social problems, ethical dilemmas, political issues, international affairs, the arts, and theological and ecclesiastical matters. For college-educated, ecumenically minded, progressive church clergy and laymen. Photos purchased with or without accompanying ms. Buys 50 photos/year. Credit line given. Pays on publication. Buys all rights. Send material by mail for consideration. SASE. Simultaneous submissions OK. Reports in 4 weeks. Free sample copy and photo guidelines for SASE.

Subject Needs: Celebrity/personality (primarily political and religious figures in the news); documentary (conflict and controversy, also constructive projects and cooperative endeavors); scenic (occasional use of seasonal scenes and scenes from foreign countries); spot news; and human interest (children, human rights issues, people "in trouble," and people interacting). Model release and captions preferred. **B&W:** Uses 5x7 glossy prints. Pays \$15-50/photo.

Cover: Uses glossy b&w prints. Alternates among vertical, square and horizontal formats. Pays \$20 minimum/photo.

Accompanying Mss: Seeks articles dealing with ecclesiastical concerns, social problems, political issues and international affairs. Pays \$35-100. Free writer's guidelines for SASE.

Tips: Needs sharp, clear photos. "We use photos sparingly, and most of those we use we obtain through an agency with which we have a subscription. Since we use photos primarily to illustrate articles, it is difficult to determine very far in advance or with much specificity just what our needs will be."

*CHRISTIAN COMPUTING MAGAZINE, 72 Valley Hill Rd., Stockbridge GA 30281. (404)474-0007. Editor: Dr. Nancy White Kelly. Bimonthly magazine. Emphasizes computing. Readers are "Christians who have an interest in computing in a Christian environment." Circ. 12,000. Estab. 1984. Sample copy \$3.

Photo Needs: Uses about 6 photos/issue; five by freelance photographers. Needs "pictures that relate to computer use, especially in a Christian environment. We would like a photo of a computer set against a

church stained glass window (back drop)." Model release preferred.

Making Contact & Terms: Query with samples. Send any prints or contact sheet by mail for consideration. SASE. Reports in 3 weeks. Pays \$50 and up/b&w cover photo. Pays on publication. Credit line given "if requested." Buys all rights. Simultaneous submissions and previously published work OK.

*CHRISTIAN HERALD, 40 Overlook Dr., Chappaqua NY 10562. (914)769-9000. Art Director: Peter A. Gross. Monthly magazine. Emphasizes "evangelical Christian life as revealed in the Bible." Readers are "evangelical Christian families." Circ. 200,000. Sample copy \$2. Photo guidelines free with SASE.

Photo Needs: Uses 10-15 photos/issue; all supplied by freelance photographers. Needs "photos of Christian performers, authors, and speakers; general scenes of worship and Christian life." Model re-

lease and captions preferred.

Making Contact & Terms: Send 8x10 b&w prints, 35mm, 2½x2½ transparencies by mail for consideration. SASE. Reports in 1 month. Pays \$300/color cover photo; \$50-175/b&w inside photo, \$75-200/color inside photo and \$200-350/text/photo package. Pays on publication. Credit line given. Buys one-time rights. Previously published work OK.

CHRISTIAN HOME, 1908 Grand Ave., Box 189, Nashville TN 37202. (615)327-2700. Editor: David I. Bradley. Quarterly. Emphasizes parenting, family life and marriage. Readers are families, parents and couples. Circ. 70,000. Free sample copy.

Photo Needs: Uses about 30-50 photos/issue; 98% supplied by freelance photographers. Needs photos of family relationships, marriage, dating and children and teens in various secular and religious activi-

ties.

Making Contact & Terms: Send 8x10 b&w prints, 35mm or 21/4x21/4 transparencies, b&w contact sheet by mail for consideration. SASE. Reports in 3 weeks. Pays \$35-75/b&w and \$60-125/color cover photo; \$20-35/b&w and \$35-60/color inside photo. Pays on acceptance. Credit line given. Buys one-time rights. Simultaneous submissions and previously published work OK.

Tips: "Send only your best work. Don't get discouraged."

*CHRISTIAN SINGLE, 127 Ninth Ave. N, Nashville TN 37234. (615)251-2469. Art Director/Designer: Dawn Rodgers. Monthly magazine. Emphasizes "Christian material which caters to ages 20-45 generally, and emphasizes values and subjects related to the Christian life. Readers are mostly college grads, most are church-members and are single. Enjoy scenics, shots of groups, moods of people, and sports." Circ. 100,000. Sample copy free with SASE.

Photo Needs: Uses 20 photos/issue; 15 supplied by freelance photographers. Needs "scenics and shots

of people in all situations, within the age group described."

Making Contact & Terms: Send 8x10 b&w prints or 35mm, 21/4x21/4 transparencies by mail for consideration. Provide resume, business card, brochure, flyer or tearsheets to be kept on file for possible future assignments. SASE. Reports in 2 weeks. Pays \$150/color cover photo and \$30/b&w inside photo. Pays on publication. Credit line given. Buys one-time rights. Simultaneous submissions and previously published work OK.

*CHRISTIAN TALENT SOURCE DIRECTORY/CHRISTIAN BUS SERVICES SOURCE BOOK, Box 64951, Dallas TX 75206-0951. Contact: Editor. Association publication for the Christian Models U.S.A. Company publication of the CMUSA News Today Newsletter. Semi-annual. Directories emphasize Christian principles, photography requirements for models, actors and other talent photography needs nationwide. Talent procurement necessitates photographers who work within our guidelines. Readers include the National Christian communities, both consumer and business. Circ. 2,500-10,000. Sample copy \$14.95 for Directory, \$3 SASE for newsletter.

Photo Needs: Photo guidelines \$3 with SASE or free with newsletter or directory order \$14.95 postpaid. Uses 75-100 photos/issue; 98% supplied by freelance photographers. "CMUSA requires stationary photographers within their local areas to work with our organization who can see the necessity of Christian principles within our photography; to assist our talent on a nationwide basis. Photos purchased with accompanying ms only. "CMUSA needs photographers of above persuasion to contact us immediately. Guidelines, Directory of newsletter must be ordered if person is serious about receiving work from CMUSA in order to know what our format is." Model release required.

Making Contact & Terms: Send query with resume. SASE. Prefer contact prior to receipt of photographer's material. Persons should order guidelines before submissions. Reports in 2-3 weeks. Pay rates in-

cluded in photo guidelines. Pays on acceptance or publication.

THE CHURCH HERALD, 1324 Lake Dr. SE, Grand Rapids MI 49506. (616)458-5156. Editor: John Stapert. Photo Editor: Chris Van Eyl. Biweekly magazine. Circ. 58,800. Emphasizes current events, family living, evangelism and spiritual growth, from a Christian viewpoint. For members and clergy of the Reformed Church. Needs photos of life situations—families, vacations, school; religious, moral and philosophical symbolism; seasonal and holiday themes; nature scenes—all seasons. Buys 2-4 photos/issue. Buys first serial rights, second serial (reprint) rights, first North American serial rights or simultaneous rights. Send photos for consideration. Pays on acceptance. Reports in 2 weeks. SASE. Simultane-

ous submissions and previously published work OK. Free sample copy.

B&W: Send 8x10 glossy prints. Pays \$25-50.

Cover: B&w or color. Pays \$50-100.

CINCINNATI MAGAZINE, Suite 300, 35 E. 7th St., Cincinnati OH 45202. (513)421-4300. Editor: Laura Pulfer. Art Director: Kay Walker Ritchie. Monthly magazine. Circ. 28,000. Emphasizes Cincinnati city life for an upscale audience—average household income \$59,000, college educated. Ouerv with resume of credits or arrange a personal interview to show portfolio. Works with freelance photographers on assignment only basis. Provide resume, letter of inquiry and samples to be kept on file for possible future assignments. Pays \$20-600/job; \$50-150 for text/photo package. Pays on publication. Buys first serial rights. Reports in 2 weeks. SASE. Simultaneous submissions and previously published work

B&W: Uses 5x7 or 8x10 glossy prints; contact sheet OK. Pays \$20/photo. Color: Uses 35mm, 21/4x21/4, 4x5 or 8x10 transparencies. Pays \$50/photo.

Cover: Uses 21/4x21/4 or 4x5 color transparencies. Special instructions given with specific assignments.

Pays \$200-400.

Tips: Most photography is oriented toward copy. Study the magazine. Address submissions in care of art director. "A good portfolio should have no more than 15-20 samples—a good cross section of techniques and different kinds of lighting situations that the photographer has mastered."

CIRCLE K MAGAZINE, 3636 Woodview Trace, Indianapolis IN 46268, (317)875-8755. Executive Editor: Karen J. Pyle. Published 5 times/year. Circ. 12,000. For community service-oriented college leaders "interested in the concept of voluntary service, societal problems, and college life. They are politically and socially aware and have a wide range of interests." Assigns 5-10 photos/issue. Works with freelance photographers on assignment only basis. Provide calling card, letter of inquiry, resume and samples to be kept on file for possible future assignments.

Subject Needs: General interest, though we rarely use a nonorganization shot without text. Also, the annual convention (Boston, 1986) requires a large number of photos from that area. Captions required,

"or include enough information for us to write a caption."

Specs: Uses 8x10 glossy b&w prints or color transparencies. Uses b&w covers only; vertical format required for cover.

Accompanying Mss: Prefers ms with photos. Seeks general interest features aimed at the better than average college student. "Not specific places, people topics."

Payment/Terms: Pays up to \$200-250 for text/photo package, or on a per-photo basis—\$15 minimum/ b&w print and \$50 minimum/cover. Credit line given. Pays on acceptance. Previously published work OK if necessary to text.

Making Contact: Send query with resume of credits. SASE. Reports in 3 weeks. Free sample copy.

COAST MAGAZINE, Drawer 2448, Myrtle Beach SC 29577. (803)449-7121. Editor: Catherine Black. Emphasizes sports, recreation and entertainment. Readers are "tourists to the Grand State of

South Carolina." Weekly. Circ. 850,000. Free sample copy and photo guidelines.

Photo Needs: Uses about 10 photos/issue; 2-3 of which are supplied by freelance photographers. "All submitted material is reviewed for possible publication." Makes "occasional use of color for color section. These photos must be easily associated with the Grand Strand of South Carolina such as beach or pool scenes, sports shots, sunsets, etc. B&w photos primarily used in conjunction with feature articles, except for use weekly in 'Beauty and the Beach' page which features swimsuit or playsuit clad females (no nudes)." Model release required; captions not required.

Making Contact & Terms: Send by mail for consideration actual b&w photos, or 35mm or 21/4x21/4 color transparencies. SASE. Reports in 2 weeks; "color may be held longer on occasion." Pays on acceptance \$15/b&w photo; \$25-50/color transparency. Credit line given for color only. Buys one-time rights. Simultaneous submissions OK "if not in the same market area." Previously published work OK.

COINS MAGAZINE, 700 E. State St., Iola WI 54990. (715)445-2214. Editor: Arlyn G. Sieber. Monthly, Circ. 120,000. Emphasizes coin collecting. Readers are coin, paper money and medal collectors and dealers at all levels. Free sample copy with SASE.

Photo Needs: Uses 100 photos/issue; 5-10 supplied by freelance photographers. Needs photos of coins, paper money, medals, all numismatic collectibles. Photos purchased with or without accompanying ms.

Model release required; captions preferred.

Making Contact & Terms: Query with samples. SASE. Reports in 2 weeks. Provide brochure and tearsheets to be kept on file for possible future assignments. Pays \$25-200/color cover, \$5/b&w inside. \$25/color inside. Pays on acceptance. Credit line "not usually" given. Buys all rights. Previously published work OK.

COLONIAL HOMES MAGAZINE, 1700 Broadway, New York NY 10019. (212)247-8720. Art Director: Richard Lewis. Bimonthly. Circ. 600,000. Emphasizes traditional architecture and interior design. Sample copy available.

sign. Sample copy available.

Photo Needs: All photos supplied by freelance photographers. Needs photos of "American architecture of 18th century or 18th century style—4-color chromes—no people in any shots; some food shots." Special needs include "American food and drink; private homes in Colonial style, historic towns in America." Captions required.

Making Contact & Terms: Submit portfolio for review. Send 4x5 or 8x10 transparencies by mail for consideration. Provide resume, business card, brochure, flyer or tearsheets to be kept on file for possible future assignments. SASE. Reports in 1 month. Pays \$500/day. Pays on acceptance. Credit line given. Buys all rights. Previously published work OK.

COLUMBIA MAGAZINE, Drawer 1670, New Haven CT 06507. (203)772-2130, ext. 263. Editor: Elmer Von Feldt. Photo Editor: John Cummings. Monthly magazine. Circ. 1,370,812. For Catholic families; caters particularly to members of the Knights of Columbus. Features dramatizations of a positive response to current social problems. Buys 18 photos/issue.

Subject Needs: Documentary, photo essay/photo feature, human interest and humorous. Captions re-

quired. Model release preferred.

Specs: Uses 8x10 glossy color prints. Uses 4x5 color transparencies for cover. Vertical format required.

Accompanying Mss: Photos purchased with accompanying ms only.

Payment/Terms: Pays up to \$750 lump sum for text/photo package. Credit line given. Pays on acceptance. Buys all rights.

Making Contact: Query with samples. SASE. Reports in 1 month. Free sample copy and photo guidelines.

*COLUMBUS HOMES & LIFESTYLES, Box 21208, 2144 Riverside Dr., Columbus OH 43221. (614)486-2483. Editor: Eugenia Snyder Morgan. Bimonthly. Emphasizes homes and lifestyles. Readers are 35 age group, middle and higher income brackets, mostly from Columbus and Central Ohio area. Circ. 15,000. Sample copy \$3.90.

Photo Needs: Uses about 65-75 photos/issue; 75% supplied by freelance photographers. Needs include collectibles; historical shots of Central Ohio; complete interiors of Central Ohio homes and offices; generics of rooms and interior-related subjects, e.g., kitchens, baths, fireplaces, porches. Reviews photos with or without accompanying ms. Special needs include "humorous—but tasteful—photos for our "Finale" page (closing shot on last page of magazine)." Model release and caption information required.

Making Contact & Terms: Query with resume of credits, samples and list of stock photo subjects. If local, call and arrange for personal interview. SASE. Reports in 3 weeks. Pays \$25-35/inside photo, \$45-65/hour, \$50-400/job, \$50-400/text/photo package. Pays on publication. Credit line given. Buys one-time and first North American serial rights. Previously published work OK.

Tips: Prefers to see "originality and good use of color. Continue to keep us updated on projects and assignments completed for others."

COLUMBUS MONTHLY, 171 E. Livingston Ave., Columbus OH 43215. (614)464-4567. Editor: Max S. Brown. Associate Editor: Julia Osborne. Monthly magazine. Circ. 44,000. Emphasizes local and regional events, including feature articles; personality profiles; investigative reporting; calendar of events; and departments on politics, sports, education, restaurants, movies, books, media, food and drink, shelter and architecture and art. "The magazine is very visual. People read it to be informed and entertained." Photos purchased with accompanying ms or on assignment. Buys 150 photos/year. Pays \$35-200/job, \$50-500 for text/photo package, or on a per-photo basis. Credit line given. Pays on publication. Buys one-time rights. Arrange personal interview with design director Sandford Meisel, to show portfolio or query with resume of credits. Works with freelance photographers on assignment only basis. Provide calling card, samples and tearsheet to be kept on file for possible future assignments. SASE. Previously published work OK. Reports in 3-4 weeks. Sample copy \$2.50.

Subject Needs: Celebrity/personality (of local or regional residents, or big name former residents now living elsewhere); fashion/beauty (local only); fine art (of photography, fine arts or crafts with a regional or local angle); head shot (by assignment); photo essay/photo feature on local topics only; product shot ("for ads, primarily—we rarely use out-of-town freelancers"); scenic (local or regional Ohio setting usually necessary, although once or twice a year a travel story, on spots far from Ohio, is featured); and sport (should accompany an article unless it has a special angle). No special effects or "form art photog-

raphy." Model release required; captions preferred.

B&W: Uses 8x10 glossy prints; contact sheet OK. Pays \$20-50/photo.

Color: Uses 8x10 glossy prints or 35mm, 21/4x21/4 or 4x5 transparencies; contact sheet OK. Pays \$35-100/photo.

Cover: Uses color prints or 21/4x21/4 or 4x5 color transparencies. Vertical format preferred, Pays \$150-500/photo.

Accompanying Mss: "Any manuscripts dealing with the emphasis of the magazine. Query suggested." Pays \$25-600/ms.

Tips: "Live in the Columbus area. Prior publication experience is not necessary. Call for an appointment."

*COMMONWEALTH, THE MAGAZINE OF VIRGINIA, 121 College Place, Norfolk VA 23510. (804)625-4800. Art Director: Lucy Alfriend. Monthly magazine. Emphasizes "feature articles and consumer/lifestyle stories specific to Virginia. Readers are upscale; 35-50. Circ. 30,000. Sample copy free with SASE and \$1.35 postage.

Photo Needs: Uses about 40 photos/issue; 10 by freelance photographers. "Prefer to assign photos spe-

cific to stories." Model release and captions required.

Making Contact & Terms: Arrange a personal interview to show portfolio. Reports within 3 months. Pays \$35-60/b&w inside photo and \$50-100/color inside photo. Pays on publication. Credit line given. Buys all rights.

Tips: Prefers to see "exceptional portraits and photo illustrations" in a portfolio.

CONNECTICUT MAGAZINE, 636 Kings Highway, Fairfield CT 06430. (203)576-1207. Art Director: Lori Bruzinski Wendin. Monthly. Circ. 68,000. Emphasizes issues and entertainment in Connecticut. Readers are Connecticut residents, 40-50 years old, married, average income of \$55,000. Sample copy \$1.75 and postage; photo guidelines free with SASE.

Photo Needs: Uses about 100 photos/issue; all supplied by freelance photographers. Needs photos of Connecticut business, arts, education, interiors, people profiles, restaurants. Model release required. Making Contact & Terms: Arrange a personal interview to show portfolio; query with samples or list of stock photo subjects; provide resume, business card, brochure, flyer or tearsheets to be kept on file for possible future assignments. SASE. Does not return unsolicitied material. Reports in 3 months. Pays \$200-500/color cover photo; \$25-100/b&w inside photo, \$50-200/color inside photo. Pays on publication. Credit line given. Buys one-time rights. Previously published work OK.

CONSERVATIVE DIGEST, 7777 Leesburg Pike, Falls Church VA 22043. (703)893-1411. Editor: Lee Edwards. Photo Editor: Marla Mernin. Monthly magazine. Circ. 30,000. Emphasizes activities and political issues for "New Right" conservatives. Photos purchased with or without accompanying ms, or on assignment. Buys 4 photos/issue. Credit line given. Pays on publication. Buys one-time rights or second serial (reprint) rights. Send material by mail for consideration, query with list of stock photo subjects, or query with samples. SASE. Simultaneous submissions and previously published work OK. Reports in 3 weeks. Sample copy \$3.

Subject Needs: Political celebrity/personality, head shot, human interest, humorous and spot news.

Model release preferred; captions required.

B&W: Uses 5x7 or 8x10 glossy prints. Pays \$15-50/photo.

Cover: Uses 35mm color transparencies. Vertical format preferred. Pays \$100-175/photo.

Accompanying Mss: Pays \$50-100.

*CONTACT MAGAZINE, Box 9248, Berkeley CA 94709. (415)644-0696. Editor: Elliott Leighton. Monthly magazine. Emphasizes singles lifestyle. Readers are "single (including divorced, widowed) and all have concerns about aloneness, dating, and travel." Circ. 150,000. Sample copy \$3. Photo guidelines free with SASE.

Photo Needs: Uses 4-6 photos/issue; "most all" by freelance photographers. Needs photos "relating to singles lifestyle, people, places, etc., and others according to subject matter of articles. Have special

need for travel, adventure stories with photos." Model release and captions optional.

Making Contact & Terms: Query with sample and list of stock photo subjects. Send 8x10 or less prints by mail for consideration. SASE. Reports in 3 weeks. Pays \$75/b&w cover photo and \$10-60/inside photo. Pays on publication. Credit line given. Buys one-time rights. Simultaneous submissions and previously published work OK.

Tips: "We are interested in pictures showing the experience of the subject."

CORNERSTONE, 4707 N. Malden, Chicago IL 60640. (312)561-2450. Editor: Dawn Herrin. Bimonthly magazine. Emphasizes "contemporary issues in the light of evangelical Christianity." Readers are "active, dedicated Christians interested in today's issues." Circ. 90,000. Sample copy on request. **Photo Needs:** Uses about 1-3 photos/issue; "usually none" supplied by freelance photographer. Subject needs "depend on what we're writing on."

Making Contact & Terms: Send prints, transparencies and b&w negatives by mail for consideration. SASE. Payment negotiable. Credit line given, if requested. Buys one-time rights. Simultaneous and

previously published submissions OK.

CORVETTE FEVER MAGAZINE, Box 55532, Ft. Washington MD 20744. (301)839-2221. Editor-in-Chief: Patricia Stivers-Bauer. Bimonthly. Circ: 35,000. Emphasizes Corvettes—"their history, restoration, maintenance and the culture that has grown around the Corvette—swap meets, racing, collecting, concourse, restoring, etc." Readers are young (25-45), primarily male but with growing number of women, Corvette owners and enthusiasts looking for anything new and different about their favorite sports car and Corvette events. Sample copy \$2; contributor's guidelines free with SASE.

Photo Needs: Uses 30-40 photos/issue; 30-40% supplied by freelance photographers. Needs "photos of Corvettes, especially unusual Corvettes (rare originals or unique customs); must have details of car for accompanying story." Photos purchased with accompanying ms only. Special needs: centerfold Vette-

mate photo features. Model release and lengthy captions required for Vettemate.

Making Contact & Terms: Query with samples or send by mail 5x7 glossy b&w or color prints; 35mm, $2^{1/4}x^{2^{1/4}}$ or 4x5 transparencies. SASE. Reports in 1 month. Provide resume or brochure and tearsheets to bé kept on file for possible future assignments. Pays \$150 + /color cover; \$5-15/b&w inside, \$10-20/color inside plus 10¢/word for text/photo package; \$175/Vettemate center spread. Pays on publication. Buys first rights and reprint rights.

*COUNTRY MAGAZINE, Box 246, Alexandria VA 22313. (703)548-6177. Managing Editor: Philip Hayward. Monthly magazine. Emphasizes the "Mid-Atlantic region: travel, history, sports, nature, food, gardening, architecture, etc." Readers are 43 median age, 50-50 male/female, affluent, educated, well-read, who travel extensively. Circ. 100,000. Sample copy \$2.50. Photo guidelines free with SASE.

Photo Needs: Uses about 30-35 photos/issue; all supplied by freelance photographers. Captions preferred.

Making Contact & Terms: Query with resume of credits. Send 5x7 b&w glossy prints; 35mm, 2\frac{1}{4}x2\frac{1}{4}, 4x5 or 8x10 transparencies; b&w or color contact sheet; no negatives. Provide resume, business card, brochure, flyer or tearsheets to be kept on file for possible future assignments. SASE. Reports in 5-8 weeks. Pays \$25/b&w cover photo, \$25/color cover photo, \$25/full page b&w inside photo, and \$25/full page color inside photo. Pays on publication. Credit line given. Buys one-time rights. Will consider simultaneous submissions and previously published work.

THE COVENANT COMPANION, 5101 N. Francisco Ave., Chicago IL 60625. Editor: James R. Hawkinson. Managing Editor: Jame K. Swanson-Nystrom. Art Director: David Westerfield. Monthly denominational magazine of The Evangelical Covenant Church of America. Circ. 27,000. Emphasizes "gathering, enlightening and stimulating the people of our church and keeping them in touch with their mission and that of the wider Christian church in the world." Credit line given. Pays within one month following publication. Buys one-time rights. Send photos. SASE. Simultaneous submissions OK. "We need to keep a rotating file of photos for consideration." Sample copy \$1.50.

Subject Needs: Mood shots of nature, commerce and industry, home life and people. Also uses fine art,

a few sports shots, scenes, city life, etc.

B&W: Uses 5x7 and 8x10 glossy prints. Pays \$10.

Color: Uses prints only. Pays \$10.

Cover: Uses b&w prints.

Tips: "Give us photos that illustrate life situations and moods. We use b&w photos which reflect a mood or an aspect of society—wealthy/poor, strong/weak, happiness/sadness, conflict/peace. These photos or illustrations can be of nature, people, buildings, designs, and so on. Give us a file from which we can draw—rotating all the time—and we will pay per use in month after publication."

*CREATIVE COMPUTING, 39 E. Hanover Ave., Morris Plains NJ 07950. (201)540-0445. Editor: Betsy Staples. Art Director: Peter Kelley. Monthly. Emphasizes personal computers. Readers are mostly males who enjoy all aspects of computers. Circ. 250,000.

Photo Needs: Uses 25 photos/issue; 0 currently supplied by freelance photographers. Needs photos of computers and technology-related subjects, computer graphics, computer applications, computer products. Reviews photos with or without accompanying ms. Always willing to review innovative computer

graphics/photographs. Model release and captions preferred.

Making Contact & Terms: Query with samples and list of stock photo subjects; send unsolicited photos by mail for consideration. Send 5x7 or 8x10 glossy b&w prints and 35mm, 2\(^1/4x2\)\(^1/4x\) and 8x10 transparencies. SASE. Reports in 3 weeks. Pays \$250-1,000/color cover photo, \$150-250/inside b&w photo, \$150-500/inside color photo and \$200-800/text/photo package. Pays on acceptance. Credit line given. Buys one-time rights.

CREATIVE CRAFTS & MINIATURES, Box 700, Newton NJ 07860. (201)383-3355. Editor: Walter C. Lankenau. Bimonthly magazine. Circ. 50,000. Emphasizes how-to material on all aspects of crafts and miniatures. For the serious adult hobbyist. Photos purchased with accompanying ms. Buys 5-

6 photos/ms. Pays \$50 maximum/printed ms page for text/photo package. Pays \$2/diagonal inch/b&w photo; \$3/diagonal inch/color photo. Credit line given. Pays on publication. Buys all rights, but may reassign to photographer after publication. Query. SASE. Sample copy \$2.

B&W: Uses 5x7 glossy prints.

Color: Uses 35mm transparencies.

Cover: Uses 35mm color transparencies. Vertical format preferred. Pays \$50 per cover.

Accompanying Mss: How-to craft and miniature (one-twelfth scale) articles. Free writer's guidelines. **Tips:** "We prefer that our authors/photographers be craftsmen themselves and execute the projects described."

CREEM, Suite 209, 210 S. Woodward, Birmingham MI 48011. (313)642-8833. Photo Editor: Charles Auringer. Monthly magazine. Circ. 150,000. Emphasizes rock stars, musical instruments and electronic audio and video equipment. For people, ages 16-35, interested in rock and roll music. Needs photos of rock stars and other celebrities in the music and entertainment business. Buys 1,200 photos/year. Buys one time use with permission to reuse at a later time. Send photos for consideration. SASE. Simultaneous submissions OK.

B&W: Send 8x10 glossy prints. Pays \$35 minimum.

Color: Send transparencies. Pays \$50-250.

Cover: Send color transparencies. Allow space at top and left of photo for insertion of logo and blurbs.

Tips: "Send in material frequently."

*THE CRIB SHEET, 6400 Hwy., 99 Unit F, Vancouver VA 98665. (206)696-4666. Editor: Karen La-Clergue. Emphasizes family life, especially for expectant or new parents. Readers include female, 18-36, many new parents. Circ. 5,000. Free sample copy.

Photo Needs: Uses 5-10 photos/issue; all supplied by freelance photographers. Needs cover photos of young child 0-4 years. Some with holiday setting. Many of young children or child and parent(s). Young mothers—many different settings, etc. Some 6-9 year olds with activity settings (biking). Would like parents release for cover picture—as well as name/age of child, and parents name and general location. Making Contact & Terms: Send any size, non-matte b&w or color prints by mail for consideration. Will be printed as b&w. SASE. Reports in 1 month. Pays \$5/b&w cover; \$2.50/b&w inside photo; \$7.50/text/photo package. Pays on publication. Credit line given. Buys one-time rights. Simultaneous submissions and previously published work OK.

CROSSCURRENTS, 2200 Glastonbury Rd., Westlake Village CA 91361. Editor-in-Chief: Linda Brown Michelson. Photo Editor: Michael Hughes. "This is a literary quarterly that uses a number of photos as accompaniment to our fiction and poetry. We are aimed at an educated audience interested in reviewing a selection of fiction, poetry and graphic arts." Circ. 3,000. Sample copy \$5. Free photo guidelines with SASE.

Photo Needs: Uses about 8-11 photos/issue; half supplied by freelance photographers. Needs "work that is technically good: sharp focus, high b&w contrast. We are also eager to see arty, experimental b&w shots." Photos purchased with or without accompanying ms.

Making Contact & Terms: Include SASE with all submissions. Reports in 1 month. Pays \$15/b&w cover photo or b&w inside photo; \$25/color cover photo. Pays on acceptance. Credit line given. Buys first one-time use.

Tips: "We want the following: b&w submissions—5x7 vertical print, publication quality, glossy, no mat; color submissions—slide plus 5x7 vertical print. Study our publication. We are in greatest need of b&w material."

CRUISING WORLD MAGAZINE, Box 452, Newport RI 02840. (401)847-1588. Photo Editor: Susan Thorpe. Circ. 120,000. Emphasizes sailboat maintenance, sailing instruction and personal experience. For people interested in cruising under sail. Needs "shots of cruising sailboats and their crews anywhere in the world. Shots of ideal cruising scenes. No identifiable racing shots, please." Buys 15 photos/year. Buys all rights, but may reassign to photographer after publication; or first North American serial rights. Credit line given. Pays on publication. Reports in 2 months. Sample copy free for 8½x11 SASE.

B&W: "We rarely accept miscellaneous b&w shots and would rather they not be submitted unless accompanied by a manuscript. Pays \$15-75.

Color: Send 35mm transparencies. Pays \$50-200.

Cover: Send 35mm Kodachrome transparencies. Photos "must be of a cruising sailboat with strong human interest, and can be located anywhere in the world." Prefers vertical format. Allow space at top of photo for insertion of logo. Pays \$500. "Submit original Kodachrome slides sharp focus works best. *No* duplicates, No Ektachrome. Most of our editorial is supplied by author, rarely use freelance submis-

sions. We look for good color balance, very sharp focus, the ability to capture sailing, good composition, and action. Always looking for *cover shots*."

Cruising World Photo Editor Susan Thorpe chose this photograph taken by freelancer Wayne Dennis for the January 1984 cover mainly because of its unique composition. "Aerials always seem to make good covers. Also, the people pictured are attractive and seem to be enjoying themselves. The color also worked well with the logo," she says. Wayne Dennis owns the Dennis/ Mokma Advertising Agency in Holland, Michigan.

CRUSADER, 1548 Poplar Ave., Memphis TN 38104. (901)272-2461. Monthly magazine. Circ. 110,000. Southern Baptist missions education magazine for boys in grades 1-6 in Royal Ambassador program. Needs close-ups or action shots of boys from all ethnic backgrounds and in foreign countries. Boys can be involved in nature/camping, sports, crafts, games, hobbies, etc. Also buys boy/man shots and animal pictures. Buys 6 photos/year. Buys first serial rights, first North American serial rights, second serial (reprint) rights or simultaneous rights. Send photos for consideration. Pays on acceptance. Reports in 1 month. SASE. Simultaneous submissions OK "assuming there is no conflict in market." Previously published work OK. Free sample copy and photo guidelines.

Cover: Send 8x10 glossy b&w prints or color transparencies. "Seasonal tie-ins help." Pays \$25-35 for b&w; color \$35-50.

CURRENT CONSUMER LIFESTUDIES, 3500 Western Ave., Highland Park IL 60035. (312)432-2700. Photo Editor: Barbara A. Bennett. Monthly magazine published from September to May. Emphasizes consumer education and interpersonal relationships for students in junior and senior high. Photo Needs: Pays on publication. Buys one-time rights. Credit line given. Model release "preferred." Reports in 2-4 weeks. Simultaneous submissions and previously published work OK. Free sample copy and subject outline with 8x11 SASE.

B&W: Uses 8x10. Payment negotiable.

Tips: "Research our publication; we don't use photos of cute puppies or sunsets. Be patient. Be persistent. Don't let one rejection stop you from sending in another submission. We like to work with *new* photographers."

CURRENT HEALTH 1, 3500 Western Ave., Highland Park IL 60035. (312)432-2700. Photo Editor: Barbara A. Bennett. Monthly health magazine for 4-6 grade students. List of upcoming article topics and sample copy free with 8x11 SASE. Simultaneous submissions and previously published work OK.

Reports in 2-4 weeks. Pays on publication. Credit line given. Buys one-time rights.

Subject Needs: B&w: Junior high aged children geared to our health themes for inside use. Color: 35mm or larger transparencies geared to our monthly focus article for cover use. Send 8x10 b&w prints or transparencies. Payment negotiable.

CURRENT HEALTH 2, 3500 Western Ave., Highland Park IL 60035. (312)432-2700. Photo Editor: Barbara A. Bennett. Monthly health magazine for 7-12 grade students. List of upcoming article topics and sample copy free with 8x11 SASE. Simultaneous submissions and previously published work OK. Reports in 2-4 weeks. Pays on publication. Credit line given. Buys one-time rights.

Subject Needs: B&w: teens with emphasis on health themes for inside use. Color: 35mm or larger transparencies geared to our monthly focus article for cover use. Send 8x10 b&w prints or transparencies.

Payment negotiable.

Tips: "Study our publication and future article topics. We need sharp, clear photos of teens interacting with friends and family. Don't let one rejection stop you from sending in another submission."

*DAILY WORD, Unity School of Christianity, Unity Village MO 64065. (816)524-3550. Editor: Jeanne Allen. Monthly. Emphasizes daily devotional—non-denominational. General audience. Circ. 2,500,000. Free sample copy.

Photo Needs: Uses 3-4/photos/issue; all submitted by freelance photographers. Needs scenic and sea-

sonal photos.

How to Contact: Send 35mm, $2^{1/4}$ x $2^{1/4}$ or 4x5 transparencies by mail for consideration. SASE. Reports in 1 month. Pays \$100/color cover photo; \$100/inside color photo. Pays on acceptance. Credit line given. Buys one-time rights. Previously published work OK.

DANCE MAGAZINE, 33 W. 60th St., New York NY 10023. (212)245-9050. Photo Editor: Deirdre Towers. Monthly magazine. Emphasizes "all facets of the dance world." Readers are 85% female, age 18-24. Circ. 75,000.

Photo Needs: Uses about 60 photos/issue; almost all supplied by freelance photographers. Needs photos of all types of dancers—from ballroom to ballet. Written release required; captions preferred.

Making Contact & Terms: Send 8x10 b&w or color prints; 35mm transparencies by mail for consideration. SASE. Reports in 1 month. Pays up to \$285/color cover photo; \$15-75/b&w inside photo; \$40-\$100 color inside photo. Pays on publication. Credit line given. Buys one-time rights. Previously published work OK.

published work OK. **Tips:** "We look for a photojournalistic approach to the medium—photos that catch the height of a partic-

ular performance or reveal the nature of a particular dancer."

DARKROOM PHOTOGRAPHY MAGAZINE, Suite 600, One Hallidie Plaza, San Francisco CA 94102. Editor: Richard Senti. Publishes 10/year. Circ. 80,000. Emphasizes darkroom-related photography.

Subject Needs: Any subject if darkroom related. Model release preferred, captions required.

Specs: Uses 8x10 or 11x14 glossy b&w prints and 35mm, 2¹/₄x2¹/₄, 4x5 or 8x10 color transparencies or 8x10 glossy prints. Uses color covers; vertical format required.

Payment/Terms: Pays \$50-500/text and photo package, \$30-75/b&w, \$50 minimum/color and \$400/cover; \$200/portfolio. Credit line given. Pays on publication. Buys one-time rights.

Making Contact: Query with samples. SASE. Reports in 2 weeks-1 month. Free editorial guide.

DARKROOM AND CREATIVE CAMERA TECHNIQUES, Preston Publications, Inc., 7800 Marrimec Ave., Box 48321, Niles IL 60648. (312)965-0566. Publisher: Seaton Preston. Editor: David Alan Jay. Bimonthly magazine focusing mainly on darkroom techniques, creative camera use, photochemistry and photographic experimentation and innovation—particularly in the areas of photographic processing, printing and reproduction—plus general user-oriented photography articles aimed at advanced workers and hobbyists. Circ. 45,000. Pays on publication. Credit line given. Buys one-time rights.

Photo Needs: "The best way to publish photographs in *Darkroom Techniques* is to write an article on photo or darkroom techniques and illustrate the article. Except for article-related pictures, we publish few single photographs. The two exceptions are cover photographs—we are looking for strong poster-like images that will make good newsstand selling covers—and Professional Portfolio, which publishes exceptionally fine professional, planned photographs of an artistic or human nature. Model releases are

required where appropriate."

Making Contact & Terms: "To submit for cover or Professional Portfolio, please send a selected number of superior photographs of any subject; however, we do not want to receive more than ten or twenty in any submission. Prefer color transparencies over color prints. B&w submissions should be 8x10. Color only for covers. Payment up to \$250 for covers. Articles pay up to \$100/page for text/photo pack-

age." SASE for free photography and writers guidelines. Sample copy \$3.

Tips: "We are looking for exceptional photographs with strong or graphically startling images. No runof-the-mill postcard shots please."

DASH, Box 150, Wheaton IL 60189. (312)665-0630. Managing Editor: David R. Leigh. Art Director: Lawrence Libby. Magazine published 7 times a year. Circ. 25,000. Sample copy \$1.50. For Christian boys ages 8-11. Most readers are in a Christian Service Brigade church program. Needs on a regular basis boys 8-11 in family situations, camping, scenery, sports, hobbies and outdoor subjects. Buys 1-2 photos/issue. Buys first serial rights. Arrange a personal interview to show portfolio or send photos for consideration. Pays on publication. Reports in 2-6 weeks. SASE. Simultaneous submissions and previously published work OK. Photo guidelines available for a SASE.

B&W: Send 8x10 glossy prints. Pays \$25. **Cover:** Send glossy b&w prints. Pays \$50-75.

DEER AND DEER HUNTING, Box 1117, Appleton WI 54912. (414)734-0009. Art Director: Jack Brauer. Bimonthly. Distribution 100,000. Emphasizes whitetail deer and deer hunting. Readers are "a cross-section of American deer hunters—bow, gun, camera." Sample copy and photo guidelines free with SASE (9x11 envelope) with \$2 postage.

Photo Needs: Uses about 25 photos/issue; 20 supplied by freelance photographers. Needs photos of

deer in natural settings. Model release preferred.

Making Contact & Terms: Query with resume of credits and samples. "If we judge your photos as being usable, we like to hold them in our file. It is best to send us duplicates because we may hold the photo for a lengthy period." SASE. Reports in 2 weeks. Pays \$350/color cover; \$30/b&w inside; \$100/color inside. Pays within 10 days of publication. Credit line given. Buys one-time rights. Simultaneous submissions and previously published work OK.

Tips: Prefers to see "adequate selection of b&w 8x10 glossy prints and 35mm color transparencies. Submit a limited number of quality photos rather than a multitude of marginal photos. Have your name

on all entries. Cover shots must have room for masthead."

DELAWARE TODAY, Box 4440, Wilmington, DE 19804. Design Director: Janice Engelke. Monthly magazine. Circ. 17,000. Emphasizes people, places and events in Delaware. Buys 250 photos/year. Credit line given. Pays on the 15th of the month after publication. Buys first North American serial rights. Arrange a personal interview to show portfolio. Works with freelance photographers on assignment only basis. Provide calling card, samples and tearsheet to be kept on file for possible future assignments. SASE. Reports in 2-4 weeks. Free sample copy.

Subject Needs: Fashion/beauty, how-to, human interest, photo essay/photo feature, special effects and

experimental, still-life, travel and some news. Model release required. **B&W:** Uses 8x10 glossy prints. Pays \$100-200/photo story, \$25/photo.

Cover: Uses 35mm or larger color transparencies. Vertical format preferred. Pays \$100/transparency. Tips: Prefers to see "a variety of shots illustrating news stories as well as people and human interest stories" in a portfolio. Photographer "should have a good eye for the usual and work within given deadlines."

DELTA SCENE, Box B-3, D.S.U., Cleveland MS 38733. (601)846-1976. Editor: Curt Lamar. Business Manager: Sherry Van Liew. Quarterly magazine. Circ. 2,000. For "persons wanting more information on the Mississippi Delta region, i.e., folklore, history, Delta personalities." Readers are art oriented. Needs photos of "Delta scenes, unusual signs in the Delta, historical buildings, photo essays accompanied with ms, Delta artists, Delta writers, hunting, fishing, skiing, etc." Buys 1-3 annually. Buys first serial rights. Query with resume of credits for photos for specific articles or send photos for consideration. Pays on publication. Reports in 6 weeks. SASE. Simultaneous submissions OK. Sample copy \$1.50; free photo guidelines "when available."

B&W: Send negatives or 5x7 glossy prints. Captions required. Pays \$5-10. **Color:** Send 5x7 glossy prints or transparencies. Captions required. Pays \$5-10.

Cover: See requirements for color.

Tips: "Because *Delta Scene* is a regional magazine, it is suggested that only local photographers should apply for assignments."

*DERBY, Box 5418, Norman OK 73070. (405)364-9444. Editor: G.D. Hollingsworth. Monthly magazine. Emphasizes owners, breeders, and trainers of Thoroughbred race horses in the central and southwestern states. Circ. 5,000. Sample copy \$3.

Photo Needs: Uses about 20 photos/issue; 15 supplied by freelance photographers. Needs photos of horses and people. "Most photos are done on assignment by freelancers." Captions required.

Making Contact & Terms: Provide resume, business card, brochure, flyer or tearsheets to be kept on

file for possible future assignments. Reports in 2 weeks. Pays \$25/b&w inside photo; \$75/color inside photo. Pays on publication. Buys all rights. Previously published work OK.

THE DISCIPLE, Box 179, St. Louis MO 63166. Editor: James L. Merrell. Monthly magazine. Circ. 58,000. Emphasizes religious news of local churches of the Christian Church (Disciples of Christ), of the national and international agencies of the denomination and of the total church in the world. For a general church audience, largely adult. Buys 25-30 annually. Buys simultaneous rights. Works with freelance photographers on assignment only basis. Provide samples and tearsheet to be kept on file for possible future assignments. Pays on acceptance. Reports in 2 weeks. SASE. Simultaneous submissions and previously published work OK. Sample copy \$1.25; free photo guidelines; enclose SASE.

Subject Needs: Persons of all ages in close-ups; and photographs of people in worship environment—praying, participating in church functions.

B&W: Send 8x10 glossy prints. Captions required. Pays \$15-25. **Cover:** Send glossy b&w prints. Captions required. Pays \$25-50.

DISCOVERIES, 6401 The Paseo, Kansas City MO 64131. (816)333-7000. Editor: Libby Huffman. Weekly Sunday school publication. Circ. 50,000-75,000. Emphasizes Christian principles for children 8-12. Freelancers supply 95% of the photos. Buys 1-2 photos/issue. Pays on acceptance. Model release required. Send photos. SASE. Simultaneous submissions and previously published work OK. Reports in 1-2 weeks. Free sample copy and photo guidelines.

Subject Needs: Children with pets, nature, travel, human interest pictures of interest to 3rd-6th grade children. No nude, fashion, sport or celebrity photos.

B&W: Uses 8x10 glossy prints. Pays \$15-30.

Cover: Uses b&w prints; vertical format preferred. Pays \$20-30.

Tips: "Subjects must be suitable for a conservative Christian denomination and geared toward 10 to 12 year olds. Children prefer pictures with which they can identify. For children, realistic, uncluttered photos have been the standard for many years and will continue to be so. Photographing children in their natural environment will yield photos that we will buy."

THE DIVER, Box 249, Cobalt CT 06414. (203)342-4730. Publisher/Editor: Bob Taylor. Bimonthly. Emphasizes springboard and platform diving. Readers are divers, coaches, officials and fans. Circ. 5,000. Sample copy free with SASE and 54¢ postage.

Photo Needs: Uses about 25 photos/issue; 1/3 supplied by freelance photographers. Needs action shots, portraits of divers, team shots and anything associated with sports. Special needs include photo spreads

on outstanding divers and tournament coverage. Captions required.

Making Contact & Terms: Send 4x5 or 8x10 b&w glossy prints by mail for consideration; "simply query about prospective projects." SASE. Reports in 3 weeks. Pays \$15-25/b&w cover photo; \$7-15/b&w inside photo; \$35-100 for text/photo package. Pays on publication. Credit line given. Buys one-time rights. Simultaneous submissions and previously published work OK.

Tips: "Study the field, stay busy."

DIVER MAGAZINE, Suite 210, 1807 Maritime Mews, Granville Island, Vancouver, British Columbia, Canada V6H 3W7. (604)681-3166. Publisher: Peter Vassilopoulos. Editor: Neil McDaniel. Magazine published 9 times/year. Emphasizes sport scuba diving, ocean science, technology and all activities related to the marine environment. Photos purchased with or without accompanying ms, and on assignment. Buys 20 photos/issue. Credit line given. Pays within 4 weeks of publication. Buys first North American serial rights or second serial rights. Send material by mail for consideration. SAE and International Reply Coupons must be enclosed. Previously published work OK. Reports in 4 weeks. Guidelines available for SAE and International Reply Coupon.

Subject Needs: Animal (underwater plant/animal life); celebrity/personality (for interview stories); documentary (sport, commercial, military, scientific or adventure diving); photo essay/photo feature; product shot (either static or "in use" type, should be accompanied by product report; scenic; special effects & experimental; sport (all aspects of scuba diving above and below surface); how-to (i.e., building diving related equipment, performing new techniques); humorous; nature; travel (diving worldwide); and wildlife (marine). No sensational photos that portray scuba diving/marine life as unusually dangerous or menacing. Special needs include "a travel issue, a special issue requiring transparencies—please send duplicates only for review—not originals." Model release preferred; captions required.

B&W: Uses 5x7 and 8x10 glossy prints. Pays \$7 minimum/photo. **Color:** Uses 35mm transparencies. Pays \$15 minimum/photo.

Cover: Uses 35mm transparencies. Vertical format required. Pays \$60 minimum/photo.

Accompanying Mss: Articles on dive sites around the world; diving travel features; marine life—habits, habitats, etc.; personal experiences; ocean science/technology; commercial, military, and scientific diving, written in layman's terms. Writer's guidelines for SAE and International Reply Coupon.

Tips: Prefers to see "a variety of work: close-ups, wide angle—some imagination!"

DOG FANCY, Box 4030, San Clemente CA 92672. (714)498-1600. Editor-in-Chief: Linda Lewis. Readers are "men and women of all ages interested in all phases of dog ownership." Monthly, Circ.

85,000. Sample copy \$3; photo guidelines available.

Photo Needs: Uses 20-30 photos/issue all supplied by freelance photographers. Specific breed featured in each issue. Prefers "photographs that show the various physical and mental attributes of the breed. Include both environmental and portrait-type photographs, but in both cases we would prefer that the animals be shown without leashes or collars. We also need good-quality, interesting b&w photographs of any breed dog or mutts in any and all canine situations (dogs with veterinarians; dogs eating, drinking, playing, swimming, etc.) for use with feature articles." Model release required; captions not required. **Making Contact & Terms:** Send by mail for consideration actual 8x10 b&w photos, 35mm or 2½x2½ color transparencies. Reports in 6 weeks. Pays \$10-20/b&w photo; \$50-100/color photo and \$50-150 per text/photo package. Credit line given. Buys first North American serial rights.

Tips: "Nothing but sharp, high contrast shots. Send SASE for list of photography needs."

"I had left my camera at home," says freelance photographer Enrique Ramon. "But having a keen nose for the unusual I was determined not to let this remarkable situation go unrecorded. The dogs had stood an all-night vigil guarding their companion who was killed by a car the day before. I borrowed a Nikon and shot this photo. It was released by Associated Press and, as a result, I began to get calls from all over the country requesting a copy. I've sold it so far to the Globe, Dog Fancy and World News, for a total of \$50, and the calls keep coming in."

DOLLS—The Collector's Magazine, 170 5th Ave., New York NY 10010. (212)989-8700. Editor: Krystyna Poray Goddu. Quarterly. Circ. 55,000. Estab. 1982. Emphasizes dolls—antique and contemporary. Readers are doll collectors nationwide. Sample copy \$2.

Photo Needs: Uses about 75-80 photos/issue; 12 supplied by freelance photographers. Needs photos of dolls to illustrate articles. Photos purchased with accompanying ms only. "We're looking for writers/photographers around the country to be available for assignments and/or submit queries on doll collec-

tions, artists, etc."

Making Contact & Terms: Query with samples; provide resume, business card, brochure, flyer or tearsheets to be kept on file for possible future assignments. SASE. Reports in 6-8 weeks. Pays \$100-300/job; \$150-350 for text/photo package. Pays on publication. Credit line given. Buys one-time or first North American serial rights ("usually"). Previously published work "sometimes" OK. Tips: Prefers to see "relevant (i.e., dolls) color transparencies or black and white prints; clear, precise—

not 'artsy'-but well-lit, show off doll."

DOWN EAST MAGAZINE, Camden ME 04843. (207)594-9544. Art Director: F. Stephen Ward. Monthly magazine. Circ. 80,000. Empahsizes Maine contemporary events, outdoor activities, vacations, travel, history and nostalgia. For residents and lovers of the Pine Tree State. Buys 25-40 photos/issue. Buys first North American serial rights. Virtually all photographs used are shot on assignment. Very few individual stock photos purchased. Query with portfolio and/or story ideas. Reports in 4 weeks SASE.

Subject Needs: Varies widely according to individual story needs, but heavy emphasis is on landscape and "photo-illustration". Photos must relate to Maine people, places and events.

B&W: Send 8x10 or larger prints; brief captions required. Pays \$25 minimum.

Color: Send 35mm or larger transparencies. Brief captions required. Transparencies must be in sleeves and stamped with photographer's name. Do *not* submit color prints. Pays \$25 minimum.

Tips: Prefers to see landscapes, people. In portfolios, on-location lighting. Submit seasonal material 6 months in advance.

DRAMATIKA, 429 Hope St., Tarpon Springs FL 33589. Editor: John Pyros. Photo Editor: Andrea Pyros. Semiannual magazine. Circ. 1,000. For people interested in the performing arts. Buys 6 photos/issue. Buys all rights, but may reassign to photographer after publication. Pays on publication. Reportsin 1 month. Previously published work OK if editors are informed. Sample copy \$2. **Subject Needs:** Celebrity/personality, documentary and special effects/experimental. Must relate to

performance arts. **B&W:** 8x10 prints; smaller prints used for filler material. Captions required. Pays \$10-25.

*DRAW MAGAZINE, Box 98, Brookville OH 45309. (513)833-5677. Editor: A. Lincoln. Photo Editor: A. Lincoln. Quarterly. Emphasizes drawing, lettering and some calligraphy. Readers include artists (fine & commercial), designers, sign writers, tech illustrators, cartoonists. Sample copy \$2. Estab. 1984.

Photo Needs: Uses 20 photos/issue; over half supplied by freelance photographers. Needs photos of drawing by artists featured in articles. Some photos of interesting people (faces) with model releases to be published and used by artists to draw. Special needs include interesting buildings or scenes to publish for artists to use as guide to drawing. Model release and captions required.

Making Contact & Terms: Send 4x5 or 8x10 smooth b&w prints by mail for consideration; provide resume, business card, brochure, flyer or tearsheets to be kept on file for possible future assignments. SASE. Reports in 3 weeks. Pays \$10-25/b&w photo. Pays on publication. Credit line given. Buys all rights.

Tips: Needs photos of "artists drawing. But most important would be photos of faces, buildings, scenes to be published in draw for the purpose of subscribers copying/drawing. Cyrstal clear photos so all details can be seen by artists."

EAGLE, 1115 Broadway, New York NY 10010. (212)807-7100. Contact: Jim Morris. Bimonthly. Circ. 200,000. Emphasizes adventure, military and paramilitary topics for men. Free sample copy; photo guidelines free with SASE.

Photo Needs: Uses about 50 photos/issue; all supplied by freelance photographers. Needs "photos to accompany articles on combat, espionage, personal defense and survival. Cover pictures are very military-oriented. Photo essays with establishing text are used." Photos purchased with or without accompanying ms. Model release required when recognizable people are included; captions required.

Making Contact & Terms: Query with list of stock photo subjects or send by mail for consideration 8x10 b&w glossy prints, any size transparencies or b&w contact sheet. SASE. Reports in 3 weeks. Pays \$300/color cover; \$25-100/b&w or color inside and \$100-300 with accompanying ms. Pays on acceptance. Credit line given. Buys one-time rights. Simultaneous submissions and/or previously published work OK if indicated where and when published.

*EARTHTONE, Publication Development, Inc., Box 23383, Portland OR 97223. (503)620-3917. Editor: Pat Jossy. Bimonthly magazine. Emphasizes "general interest (country living, food, folk art); historical/nostalgic; how-to (crafts, home projects, small scale low cost building); humor; interview/profile (on people living this sort of lifestyle); new product (if unusual or revolutionary); animal husbandry; health; energy; organic gardening; recreation; aspects of homesteading, self-sufficient lifestyle,

country living." Readers are "people with a back-to-the-land lifestyle as well as urban dwellers interested in becoming more independent and self-sufficient in their current residence; western US readership

primarily." Circ. 50,000. Sample copy \$2. Photo guidelines free with SASE.

Photo Needs: Uses about 20-30 photos/issue; approximately 30% supplied by freelance photographers. Needs "how-to; interview portrait; new products (if unusual); animal husbandry; energy-related ideas; small-scale, low-cost building ideas; general interest to accompany articles." Photos purchased with accompanying ms only. Model release preferred; captions required.

Making Contact & Terms: Submit 4x5 or 5x7 b&w glossy prints by mail for consideration. SASE. Reports in 1 month. Pays \$50-300/text/photo package. Pays on publication. Credit line given. Buys first

North American serial rights.

Tips: Submit seasonal/holiday material 6 months in advance; photocopied submissions OK. Prefers to see "clear, top-quality (no fuzzy, out-of-focus) b&w photos to accompany manuscript; 35mm or larger transparencies with manuscript. We're looking for the article or story that stands out (offbeat, unusual, revolutionary, etc.). Include good quality photos with your manuscripts. We're a good market for unpublished writers and photographers as we are less concerned with an impressive resume as with the technical merits of the photo/essay package. We welcome new writers."

EARTHWISE POETRY JOURNAL, Box 680536, Miami FL 33168. (305)688-8558. Editor-in-Chief: Barbara Albury. Photo Editors: Katie Hedges and Susan Holley. Quarterly journal. Circ. over 3,000. Emphasizes poetry. Readers are "literate, cultured, academic, eclectic, writers, artists, etc."

Sample copy \$4; photo guidelines free with SASE.

Photo Needs: Uses 2-4 photos/issue; all supplied by freelance photographers. Needs photos of poets in their locale. Photos purchased with or without accompanying ms. Special needs: interviews, articles on ecology and wildlife preservation and human interest. Special issues include one on American Indian,

one on The Dance & Music. Model release and captions preferred.

Making Contact & Terms: Query with resume of credits or samples; send by mail for consideration 5x7 b&w matte prints, contact sheet or Velox; provide resume and 1-25x7 stats to be kept on file for possible future assignments. "We cannot use color pictures unless halftone repros have been made." SASE. Reports as soon as possible. Pays \$5-50/b&w photo. Pays on publication. All rights revert to owner. Original photos returned.

EBONY, 820 S. Michigan, Chicago IL 60605. (312)322-9200. Publisher: John H. Johnson. Photo Editor: Basil Phillips. Monthly magazine. Circ. 1,800,000. Emphasizes the arts, personalities, politics, education, sports and cultural trends. For the black American. Needs photo stories of interest to black readers. Buys all rights. Submit model release with photo. Query first with resume of credits to Charles L. Sanders, managing editor. Photo stories are purchased with or without an accompanying ms. Pays on publication. Reports in 3-4 weeks. SASE.

B&W: Prefers negatives and contact prints. Pays \$50/photo, \$150 minimum with accompanying ms.

Pays \$150-250/day.

Color: Uses 35mm, 21/4x21/4 or larger transparencies. Pays \$75 minimum, \$200 with accompanying ms.

Cover: Cover shots are rarely done by freelancers.

EBONY JR!, 820 S. Michigan Ave., Chicago IL 60605. (312)322-9200. Managing Editor: Marcia V. Roebuck-Hoard. Circ. 200,000. Emphasizes reading and language arts skills for children, especially black children, ages 6-12, who want to discover more about the world of learning (past, present and future). Uses 5 photos/issue. Photos purchased with or without accompanying mss. Works with photographers on assignment basis only. Pays by assignment, \$200 for text/photo package, or on a per-photo basis. Credit line given. Pays on acceptance. Buys all rights, first North American serial rights and second serial (reprint) rights. Simultaneous submissions and previously published work OK. Model release required. Query. Prefers b&w prints and slides as samples. Provide resume, brochure, samples and tearsheets to be kept on file for possible future assignments. SASE. Reports in 6 weeks to 3 months. Sample copy \$1.

Subject Needs: Animal/wildlife (especially in Africa, U.S. and the West Indies); celebrity/personality (blacks, especially black children); scenic (especially seasonal, must be submitted four months in advance); special effects & experimental (especially those related to nature); sport (blacks, especially star athletes and children); human interest (especially unposed shots of black children in everyday situations—school, home, play, etc.); humorous (unposed shots of black children that don't reinforce racial stereotypes); and nature and travel (especially in U.S., Africa and the West Indies). Wants on a regular basis b&w and/or color photos of seasonal events (such as Christmas, Halloween, etc.). Special needs: seasonal photos and photos of children in action. Captions required. No unclear shots, Instamatic prints, photos with no captions or photos sent without model releases (if posed).

B&W: Uses 5x7 and 8x10 glossy prints. Pays \$10-15.

Color: Uses 35mm, 21/4x21/4 and 4x5 transparencies. Pays \$25, inside; \$50, cover.

Cover: Uses color covers only. Vertical format required. Negotiates pay.

Accompanying Mss: Seeks nonfiction (400-1,500 words). "We use short factual articles dealing with blacks (adults or children) of unusual achievement, past or present, in all types of careers." Also uses fiction (400-1,500 words). "Write realistic fiction dealing with emotional growth in children, in every-day living situations. Stories should show black children enjoying themselves and solving problems. Fiction may be past, present or future." Fantasy is acceptable, as is verse (400-1,500 words). Also acceptable—crafts, recipes and games.

THE ELECTRIC COMPANY MAGAZINE, 1 Lincoln Plaza, New York NY 10023. (212)595-3456. Editor: Susan Dias. Art Director: Paul Richer. Monthly. Circ. 370,000. Emphasizes "infomative, entertaining articles, stories, games and activities that encourage reading for 6-9 year olds."

Photo Needs: Uses about 12 photos/issue; all supplied by freelance photographers. Assigned. Needs

vary.

Making Contact & Terms: Submit portfolio for review on Wednesdays and Thursdays. Reports when an assignment is available. Provide flyer to be kept on file for possible future assignments. Pays \$200-500 for color cover photo. Pays between acceptance and publication. Credit line given. Rights purchased negotiated by contract with each assignment.

*THE ELECTRON, 4781 East 55th St., Willoughby OH 44094. (216)946-9065. Editor: R.C. Westfall. Bimonthly tabloid. School publication. Emphasizes electronics. Readers are 75% CIE grads or CIE students. Circ. 65,000. Free sample copy.

Photo Needs: Uses about 35-40 photos/issue; 15-20 supplied by freelance photographers. Needs photos of how-to technical, people at work, and product usage. Reviews photos with or without accompanying

ms. Model release preferred.

Making Contact & Terms: Send 5x7 glossy unsolicited photos by mail for consideration; provide resume, business card, brochure, flyer or tearsheets to be kept on file for possible future assignments. SASE. Reports in 1 month. Pays \$20/b&w inside photo; \$50 minimum/hour. Pays on publication. Credit line given if desired. Buys all rights. Previously published work OK.

ELYSIUM GROWTH PRESS, 5436 Fernwood Ave., Los Angeles CA 90027. (213)465-7121. Publisher: Ed Lange. Quarterly. Emphasizes naturism/nudism/alternative lifestyles. Readers are New Aged Human Potential participants. Circ. 20,000. Sample copy varies from \$4.95 to \$19.95 and 50¢ postage. Photo guidelines free with SASE.

Photo Needs: Uses about 30 photos/issue; 70% supplied by freelance photographers. Needs photos of "outdoor recreational activities—option to do so without clothes." Model release and captions re-

quired.

Making Contact & Terms: Query with samples. SASE. Reports in 2 weeks. Pays \$100/b&w or color cover photo; \$25/b&w or color inside photo; \$25/color page and \$150-300 with accompanying ms. Pays on acceptance or publication. Credit line given. Buys all rights. Previously published work OK.

*ENVIRONMENT, 4000 Albemarle St., Washington DC 20016. (202)362-6589. Editor: Jane Scully. Photo Editor: Ann Rickerich. Magazine published 10 times/year. Emphasizes natural and human systems. "We cover a wide range of environmental topics —acid rain, tropical deforestation, nuclear winter, hazardous waste disposal, worker safety, genetic engineering and environmental legislation." Readers include libraries, colleges and universities and professionals in the field of environmental sciences. Circ. 12,500. Sample copy \$4.

Photo Needs: Uses 15 photos/issue; varying number supplied by freelance photographers. "Our needs vary greatly from issue to issue—but we are always looking for good photos showing man's impact on the environment—powerlines, plants, industrial sites, cities, alternative energy sources." Special needs include photos depicting nuclear winter, acid rain, population. Model release preferred; captions re-

quired.

Making Contact & Terms: Query with list of stock photo subjects; send unsolicited photos by mail for consideration; provide resume, business card, brochure, flyer or tearsheets to be kept on file for possible future assignments. Send any size b&w print by mail for consideration. SASE. Reports in 1 month. Pays \$35-50/b&w inside photo. Pays on publication. Credit line given. Buys one-time rights. Simultaneous submissions and previously published work OK.

EQUINOX MAGAZINE, 7 Queen Victoria Dr., Camden East, Ontario, Canada K0K 1J0. (613)378-6661. Executive Editor: Frank B. Edwards. Bimonthly. Circ. 150,000. Emphasizes "Canadian subjects of a general 'geographic' and scientific nature." Sample copy \$5; photo guidelines free with SAE and International Reply Coupon.

Photo Needs: Uses 80-100 photos/issue; all supplied by freelance photographers. Needs "photo essays of interest to a Canadian readership as well as occasional stock photos required to supplement assign-

ments; wildlife, landscapes, profiles of people and places." Captions required.

Making Contact & Terms: Query with samples; submit portfolio for review. SASE. Reports in 6 "Most stories are shot on assignment basis—average \$1,000 price—we also buy packages at negotiable prices and stock photography at about \$200 a page if only one or two shots used." Pays on publication. Credit line given. Buys first North American serial rights.

Tips: Prefers to see "excellence and in-depth coverage of a subject. Stick to Kodachrome/Ektachrome

transparencies."

ERIE & CHAUTAUQUA MAGAZINE, Charles H. Strong Bldg., 1250 Tower Lane, Erie PA 16505. (814)452-6070. Editor: Mary J. Brownlie. Quarterly magazine covering the City of Erie, Erie County, Crawford County, Warren County, Pennsylvania and Chautauqua County, New York, for upscale readers with above average education and income. Circ. 20,000, three issues; 30,000 Spring Guide Issue. Sample copy \$2. Photo guidelines free with SASE.

Photo Needs: Uses about 125 photos/issue; 60-70 supplied by freelance photographers. "Because so much of our content is region-oriented, most of our photography work has to be done on an assignment basis, by photographers who live in the region. May need photos for specific sports: sailing, boating, skiing, ice skating, horseback riding, golf, tennis, etc." Model release and captions required.

Making Contact & Terms: Query with samples or list of stock photo subjects; provide resume, business card, brochure, flyer or tearsheets to be kept on file for possible future assignments. "Photographers living in our coverage area are encouraged to arrange for personal interview to show portfolio.' SASE. "All photographic fees are negotiated with photographer, according to type of assignment." Pays \$15-25/b&w photo; \$15-25 + film/color photo; "occasionally negotiates on a per-job basis. Will not consider an hourly or daily basis." Pays 30 days after publication. Credit line given. Buys all rights on assignments; "will buy one-time or first North American serial rights only on stock photos." Previously published submissions OK.

Tips: "We want to know that the photographer's work has the quality and clarity we are looking forours is a quality book with excellent reproduction on coated stock. Most new photographers show us b&w work that does not have the clarity and contrasts that will reproduce well; color shots are often fuzzy or faded. We welcome seeing portfolios of any photographers living in our coverage area. Those outside our coverage area would have their best opportunity via stock photos and should let us know

what kinds of subjects they've covered."

*EUROPE FOR TRAVELERS!, 408 Main St., Nashua NH 03060. (603)888-0633. Publisher: Carol Grasso. Quarterly. Emphasizes travel in Europe. Readers include upscale professionals, librarians, travel agents. Circ. 5,000. First issue March 1985; 1984 (incorporated). Writers guidelines free with SASE.

Photo Needs: Uses 20 photos/issue; most supplied by freelance photographers. Usually purchased as part of article package. Needs occasional scenic travel photos for use as illustrations. Model release re-

quired.

Making Contact & Terms: Send any size glossy b&w or color prints, or 35mm, 21/4x21/4, or 4x5 transparencies by mail for consideration, or query with resume of credits or list of stock photo subjects. SASE. Reports in 1 month. Pays \$80/color cover photo; \$10 maximum/inside b&w photo, \$20 maximum/color photo and \$35-100/text/photo package. Pays on publication. Credit line given. Buys onetime rights or first North American serial rights. Previously published work OK.

Tips: "We generally look over the samples, take notes, and return all the photos; when need arises, we recontact the photographer. The more detailed the stock list, the better—our needs are usually quite specific. Looking for beauty or interest that catches the eye and/or the "right photo" to illustrate a particular

article.'

THE EVANGELICAL BEACON, 1515 E. 66th St., Minneapolis MN 55423. (612)866-3343. Editor: George M. Keck. Circ. 40,000. Magazine of the Evangelical Free Church of America. Emphasizes Christian living, evangelism, denominational news; inspiration and information. Uses 2 or 3 photos/issue. Photos purchased with or without accompanying mss. Credit line usually given. Pays on acceptance for photos; on publication for articles. Buys all or one-time rights. Model release preferred. Send material. SASE. Simultaneous submissions and previously published work OK. Reports in 4-8 weeks. Subject Needs: Human interest: children and adults in various moods and activities; and scenic shots:

churches and city scenes. Captions not required, but helpful (especially locations of scenes). No cheese-

B&W: Uses 8x10 glossy prints. Pays \$10-15.

Cover: Uses glossy color prints; vertical format required. Pays \$20-25, b&w.

Accompanying Mss: Seeks personal testimonies, Christian living, Christian and life issues and concerns, and church outreach ideas.

EVANGELIZING TODAY'S CHILD, Child Evangelism Fellowship Inc., Warrentown MO 63383. (314)456-4321. Editor: Mrs. Elsie Lippy. Bimonthly magazine. Circ. 30,000. Written for people who work with children, ages 5-12, in Sunday schools, Bible clubs and camps. Buys 1-2 photos/issue. Pays on a per-photo basis. Credit line given. Buys one-time rights. Prefers to retain good quality photocopies of selected glossy prints and duplicate slides in morgue for future use. Send material by mail with SASE for consideration. Publication is under no obligation to return materials sent without SASE. Simultaneous submissions and previously published work OK. Free photo guidelines with SASE.

Subject Needs: Children, ages 5-12. Candid shots of various moods and activities. "We use quite a few shots with more than one child and some with an adult. The content emphasis is upon believability and appeal. Religious themes may be especially valuable." No nudes, fashion/beauty, glamour or still lifes. **B&W:** Uses 8x10 glossy prints. Pays \$20-25/photo; color: uses 35mm or larger transparencies, inside

\$30-35/photo; cover shots \$100-150.

Tips: Each issue built around a theme (i.e., children's ministries, evangelism & follow-up, Christian education).

EVENT, Kwantlen College, Box 9030, Surrey, B.C., Canada V3T 5H8. (604)588-4411. Editor: Leona Gom. Visuals Editor: Ken Hughes. Magazine published every 6 months. Circ. 1,000. Emphasizes literature and fine art graphics (essays, short stories, plays, reviews, poetry, verse, photographs and drawings). Photos purchased with or without accompanying ms. Buys 20 photos/issue. Pays \$5-10/page. ("Normally, one photo appears per page.") Credit line given. Pays on publication. Query, send material by mail for consideration or submit portfolio for review. SAE and International Reply Coupons or Canadian stamps. Simultaneous submissions OK. Reports in 2-4 weeks. Sample copy \$3; free photo guidelines.

Subject Needs: Animal, celebrity/personality, documentary, fine art, human interest, humorous, nature, nude, photo essay/photo feature, scenic, special effects/experimental, still life, travel and wildlife. Wants any "nonapplied" photography, or photography not intended for conventional commercial purposes. Needs excellent quality. Must be a series. Model release and captions required. "No unoriginal, commonplace or hackneyed work."

B&W: Uses 8x10 prints. Any smooth finish OK.

Color: "No color work unless the photographer agrees to reproduction in b&w and unless work is of a sufficient standard when in b&w."

Cover: Uses b&w prints. Any smooth finish OK. Vertical format preferred.

Tips: "We prefer work that appears as a sequence: thematically, chronologically, stylistically. Individual items will only be selected for publication if such a sequence can be developed. Photos should preferably be composed for vertical, small format (6x9) and in b&w."

*THE EXCEPTIONAL PARENT, 605 Commonwealth Ave., Boston MA 02215. (617)536-8961. Editor: Ellen Herman. Publishes 8 issues/year. Emphasizes disabled children and parents of disabled children. Readers include parents of disabled children and professionals working with disabled children, also some disabled teens. Circ. 30,000. Free sample copy.

Photo Needs: Uses 30 photos/issue; very few supplied by freelance photographers. Needs pictures of disabled kids and their families, playing, at school, eating, sleeping, etc. Also pictures of mobility de-

vices and other aids for disabled individuals. Model release required.

Making Contact & Terms: Send any size glossy b&w prints by mail for consideration. SASE. Reports in 2 months. Payment negotiated individually; "unfortunately, we cannot afford to pay much of anything." Pays on publication. Buys one-time rights. Simultaneous submissions and previously published work OK.

EXPECTING MAGAZINE, 685 3rd Ave., New York NY 10017. (212)878-8642. Art Director: Ruth M. Kelly. Quarterly. Circ. 1,200,000. Emphasizes pregnancy and birth. Readers are pregnant women 18-40. Sample copy available.

Photo Needs: Uses about 12 photos/issue. Works with freelance photographers on assignment only basis. Provide card to be kept on file for future assignment. Occasionally uses stock color transparencies of

women during labor and birth, hospital or doctor visits. Model release required.

Making Contact & Terms: Arrange for drop off to show portfolio; send 35mm, 21/4x21/4, 4x5 or 8x10 transparencies by mail for consideration. SASE. No b&w photos used. "Usually reports immediately." Pays \$250/color page. Pays on publication. Credit line given. Buys one-time rights. Simultaneous submissions and previously published work OK.

*FACES: The Magazine About People, 20 Grove St., Peterborough NH 03458. (603)924-7209. Editor-in-Chief: Carolyn P. Yoder. Monthly (except July and August) magazine. Emphasizes cultural anthropolgy for young people ages 8 to 14. Estab. 1984. Sample copy \$2.95.

Photo Needs: Uses about 15-20 photos/issue; "none so far" supplied by freelance photographers.

"Photos (b&w) for text must relate to themes; cover photos (color) should also relate to themes. Model release and captions preferred.

Making Contact & Terms: Query with samples. SASE. Reports in 1 month. No set fees for photos.

Pays on publication. Credit line given. Buys all rights.

FACT MAGAZINE, 305 E 46th St. New York NY 10017. (212)319-6868, ext. 24. Art Director: Christopher Goldsmith. Monthly magazine. Emphasizes "consumer money management and investment." Readers are "consumers interested in money management, with income of \$50,000 and up."

Circ. 107,000. Sample copy free.

Photo Needs: Uses about 8 photos/issue; 2 or 3 supplied by freelance photographers. Needs "good photos directly associated with subject matter, often real estate, stocks, funds, bonds, collectibles: gems, coins, etc." Written release and captions preferred "only to identify specific info, i.e., 1957 Cadillac." Making Contact & Terms: Query with samples. Provide resume, business card, brochure, flyer or tearsheets to be kept on file for possible future assignments. "Any format OK. Prefers color transparent material." Returns unsolicited material if indicated. Reports 2-3 weeks. Pays \$200-300/color cover photo; \$100-200/color inside photo. Pays on acceptance. Credit line given. Buys one-time rights. Simultaneous submissions and previously published work OK.

Tips: Prefers to see "refreshing, well-designed shots that are well executed and outstanding."

FAMILY AFFAIRS, Box 1314, Teaneck NJ 07666. (201)836-9177. Publisher: Jackie Lewis. Bimonthly magazine. Emphasizes "explicit sexual encounters involving relatives" for male audience, 18 years old and up. Sample copy \$3. Photo guidelines free with SASE.

Photo Needs: Uses 1 photo/issue; supplied by freelance photographer. Needs "erotic photographs of

women." Model release required.

Making Contact & Terms: Query with samples or send 8x10 color prints or 35mm transparencies by mail for consideration. SASE. Reports in 2 weeks. Pays \$150/color photo. Pays on publication. Buys

one-time rights. Simultaneous and previously published submissions OK.

Tips: "When querying us, a photographer should send a list of credits and an 8x10 b&w contact sheet of material representative of his best work. The best advice we can give is to work hard, work instinctively and persevere. If he's serious, his work will improve with each roll of film and we'll notice it. We buy a lot, and nearly every photographer turns out something appropriate for us sometime."

FAMILY COMPUTING, 730 Broadway, New York NY 10003. (212)505-3578. Design Director: Vincent Ceci. Monthly. Emphasizes home computers. Readers are "parents of the computer generation." Circ. 375,000. Free sample copy."

Photo Needs: Uses 30 photos/issue; 6 supplied by freelance photographers. Photos purchased with ac-

companying ms only. Model release required.

Making Contact & Terms: Query with samples; submit portfolio for review. Reports in 1 month. Pays on acceptance. Credit line given. Buys first world rights.

FAMILY FESTIVALS, Suite 290, 160 E. Virginia St., San Jose CA 95112. (408)286-8505. Art Director: Carol Trasatto. Bimonthly. Circ. 14,000. Emphasizes "family celebrations of the feasts and seasons of the year in a religious context—at home, parents and children, covers ethnic, popular and traditional feasts." Readers are "parents who want to get the most out of family life." Sample copy \$2.75. **Photo Needs:** Uses about 6 photos/year; 2 supplied by freelance photographers. Needs "photos depict-

reflective the second of photosyear; 2 supplied by freelance photographers. Needs "photos depicting family celebrations; photos showing reverence for a natural or man-made object; photos showing the seasons." Special needs include "photo stories of local families." Model release and captions preferred.

Making Contact & Terms: Query with samples; send 4x5 or 8x10 b&w glossy prints by mail for consideration. SASE. Reports in 1 month. Pays \$40/b&w cover photo; \$20/b&w inside photo. Pays on publication. Credit line given. Buys one time and first North American serial rights, promotional use rights. Previously published work OK.

*FAMILY MAGAZINE, Box 4993, Walnut Creek CA 94596. (415)284-9093. Editor: Mary Jane Ryan. Monthly except January/July. Emphasizes military families. Readers include women between ages of 18-45 whose husbands are in the military. Circ. 525,000. Sample copy \$1.25.

Photo Needs: Uses 10-25 photos/issue; all supplied by freelance photographers. Needs photos related to

travel, families-men, women, children, food. Captions preferred.

Making Contact & Terms: Send any size b&w or color prints or transparencies by mail for consideration. SASE. Reports in 1 month. Pays \$135-150/color cover photo; \$25/b&w inside photo and \$50/color inside photo, or on a per job basis. Pays on publication. Credit line given. Buys first North American serial rights. Simultaneous submissions OK.

FAMILY PET, Box 22964, Tampa FL 33622. Editor: M. Linda Sabella. Quarterly magazine. Circ. 3,000. Emphasizes pet ownership and enjoyment for pet owners. Needs photos of "anything pet-related." Buys 10-12 annually. Buys one-time publication rights. Model release "preferred if possible if individuals are recognizable." Send photos for consideration. Pays \$20 for text/photo package. Pays on publication. Reports in 6-8 weeks. SASE. Free sample copy and photo guidelines with 9x12 SASE. **B&W:** Send 5x7 glossy prints. Captions required. Pays \$3-5 for use inside.

Cover: Send 5x7 glossy b&w prints. Captions required. Pays \$10 for cover use.

Tips: "No restrictions, only must be in good taste. No 'cute,' artificially posed photos of animals in unnatural situations. Study back issues and submit quality (sharp prints), general appeal. More market for pictures that might be used to illustrate an existing article or for cover use. Almost all purchased from stock. We very rarely make spcific assignments.

FARM & RANCH LIVING, 5400 S. 60th St., Greendale WI 53129. (414)423-0100. Associate Editor: Tom LaFleur. Bimonthly. Circ. 270,000. "Concentrates on people and places in agriculture, but not the 'how to increase yields' type. We show farming and ranching as a way of life, rather than a way to make a living." Readers are "farmers and ranchers in all states in a wide range of income." Sample copy for \$2; photo guidelines free with SASE.

Photo Needs: Uses about 100-125 photos/issue; all supplied by freelance photographers. Needs "agricultural photos: farms and ranches, farmers and ranchers at work and play. Work one full season ahead—send summer photos in spring, for instance." Special needs include "good-looking seasonal

photos of a rural nature." Model release and captions optional.

Making Contact & Terms: Query with samples or list of stock photo subjects; send 35mm, 2¹/₄x2¹/₄ or 4x5 transparencies by mail for consideration. SASE. Reporting time varies; "immediately to a month." Pays \$150/color cover photo; \$35-50 b&w inside photo, \$75-150 color inside photo; \$200-400 for text/photo package. Pays on acceptance. Buys one-time rights. Previously published work OK.

Tips: "Looking for brilliant colors in photos of agricultural and rural nature. Also looking for shots of photogenic farms and ranches to feature in series 'Prettiest Place in the Country.' A little imagination goes a long way with us. We like to see an unusual angle or approach now and then, but don't see nearly enough like that."

FARM WOMAN NEWS, Box 643, Milwaukee WI 53201. (414)423-0100. Managing Editor: Ruth Benedict. Circ. 350,000. Emphasizes rural life and a special quality of living to which rural (farm and ranch) women can relate; at work or play, in sharing problems, etc. Photos purchased with or without accompanying ms. Uses 20-40 photos/issue, color and b&w. Pays \$350-600/assignment or on a per-photo basis; \$10-80/hour; \$100-400/day; \$100-400 for text/photo package. Pays on acceptance. Buys one-time rights. Send material by mail for consideration. Provide brochure, calling card, letter of inquiry, price list, resume and samples to be kept on file for possible future assignments. SASE. Previously published work OK. Reports in 6 weeks. Sample copy \$2.25 and free photo guidelines.

Subject Needs: "We're always interested in seeing good shots of farm wives (in particular) and farm families (in general) at work and at play." Uses photos of farm animals, children with farm animals, farm and country scenes (both with and without people), photo essay/photo feature (with country or farm theme of interest to farm women) and nature. Wants on a regular basis scenic (rural), seasonal, photos of farm women and their families at work on the farm. "We like large and small concept essays—a mini look at one aspect of the county fair, or a full-blown approach. We're always happy to consider coverideas. Covers are seasonal in nature. Additional information on cover needs available. Always need good harvest, planting, livestock photos too. We try to show the best of agriculture—healthy cattle, bright green fields of soybeans, etc." Captions are required. Work 3-6 months in advance. "No poor quality b&w or color prints, posed photos, etc. In general, if subject guidelines described above are met and quality is good, there should be no problem with sales."

B&W: Uses 8x10 glossy prints. Pays \$25-75/photo. **Color:** Uses transparencies. Pays \$50-225/photo.

Tips: Prefers to see "rural scenics, in various seasons; emphasis on farm women, ranch women and their families. Slides appropriately simple for use with poems or as accents to inspirational, reflective essays, etc."

FARMSTEAD MAGAZINE, Box 111, Freedom ME 04941. (207)382-6200. Publisher: George Frangoulis. Managing Editor: Heidi Bruggar. Magazine, published 6 times a year. Circ. 170,000. Emphasizes home gardening, livestock care, alternative energy, shelter, and country living. Manuscript preferred with photo submissions. Freelancers supply 90% of material. Credit line given. Pays on publication. Submit portfolio for review. SASE. Reports in 3 months. Free sample copy. Provide resume, business card or brochure to be kept on file for possible future assignments.

Subject Needs: Photos of home gardening related subjects such as people in their gardens and close-ups

of vegetables, flowers and some domestic farm animals. Captions required.

B&W: Uses 5x7 or 8x10 glossy prints. Pays \$10 minimum/5x7 b&w print.

Color: Uses transparencies. Pays \$25/transparency. **Cover:** Uses transparencies. Pays \$50-100/photo.

Accompanying Mss: Seeks mss on gardening, homesteading, care of livestock, construction, insects

(beneficial and injurious), etc.

Tips: Prefers to see "country life scenes, vegetables, flowers, wildlife, gardens and people in them, small farm and garden equipment in use and some domestic farm animals as samples. Photographers should be willing to start small and cheap and *work* to build a relationship through time and patience."

FIGHTING WOMAN NEWS, Box 1459, Grand Central Station, New York NY 10163. (212)228-0900. Editor: Valerie Eads. Photo Editor: Muskat Buckby. Quarterly. Circ. 6,300. Emphasizes women's martial arts. Readers are "adult females actively practicing the martial arts or combative sports."

Sample copy \$3.50; photo guidelines free with SASE.

Photo Needs: Uses 18 photos/issue; 14 supplied by freelance photographers. Needs "action photos from tournaments and classes/demonstrations; studio sequences illustrating specific techniques, artistic constructions illustrating spiritual values. Please do not send piles of snapshots from local tournaments unless there is something important about them, such as illustration of fine technique, etc. Obviously, photos illustrating text have a better chance of being used. We have little space for fillers. We are always short of photos suitable to our magazine. Model release preferred; captions and identification required.

Making Contact & Terms: Query with resume of credits or with samples or send 8x10 glossy b&w prints or b&w contact sheet by mail for consideration; provide resume, business card, brochure, flyer or tearsheets to be kept on file for possible future assignments. SASE. Reports "as soon as possible." Pays \$10 plus film cost cover/photo; payment for text/photo package to be negotiated. Pays on publication. Credit line given. Buys one-time rights. Simultaneous submissions and previously published work OK; "however, we insist that we are told concerning these matters; we don't want to publish a photo that is in the current issue of another martial arts magazine."

Tips: Prefers to see "technically competent bow photos of female martial artists in action. No glamour, no models; no cute little kids unless they are also skilled. Don't just go to a tournament and shoot blind. Get someone knowledgeable to caption your photos or at least tell you what you have—or don't have. We are a poor alternative publication chronically short of material, yet we reject 90% of what is sent because the sender obviously never saw the magazine and has no idea what it's about. The cost of buying

sample copies is a lot less than postage these days."

FINE DINING MAGAZINE, 1897 NE 164th St., Miami FL 33162. (305)947-9352. Editor: Joanne Taylor. Bimonthly. Emphasizes restaurants, food and travel. Circ. 66,000. "Will send free sample copy

on request to qualified photographer."

Photo Needs: Uses about 40 photos/issue; all supplied by freelance photographers. Needs "restaurant photos and close-ups of gourmet preparations from restaurants; also travel or foods from a particular geographic area; and hotels and resorts. We prefer photos of food and/or beverages, without people." Special needs include "photos done on assignment in Atlanta, Boston, New York City, Philadelphia, Washington, D.C., Florida, Chicago, Los Angeles, Dallas and Houston." Model release required and captions preferred.

Making Contact & Terms: Query with resume of credits; query with samples. SASE. Reports in 1 month. Pays on acceptance. Credit line given. Buys all rights. Simultaneous submissions and previous-

ly published work OK "in some cases. Most work is done on assignment."

FINESCALE MODELER, 1027 N. 7th St., Milwaukee WI 53233. (414)272-2060. Editor: Bob Hayden. Photo Editor: Burr Angle. Bimonthly. Circ. 39,500. Emphasizes "how-to-do-it information for hobbyists who build nonoperating scale models." Readers are "adult and juvenile hobbyists who build nonoperating model aircraft, ships, tanks and military vehicles, cars and figures." Sample copy \$2.50; photo guidelines free with SASE.

Photo Needs: Uses more than 50 photos/issue; "anticipates using" 10 supplied by freelance photographers. Needs "in-process how-to photos illustrating a specific modeling technique; photos of full-size

aircraft, cars, trucks, tanks and ships." Model release and captions required.

Making Contact & Terms: Provide resume, business card, brochure, flyer or tearsheets to be kept on file for possible future assignments. "Phone calls are OK." Reports in 8 weeks. Pays \$25 minimum/color cover photo; \$5 minimum/b&w inside photo, \$7.50 minimum/color inside photo; \$30/b&w page, \$45/color page; \$50-500 for text/photo package. Pays for photos on publication, for text/photo package on acceptance. Credit line given. Buys one-time rights. "Will sometimes accept previously published work if copyright is clear."

Tips: Looking for "clear b&w glossy 5x7 or 8x10 prints of aircraft, ships, cars, trucks, tanks and sharp color positive transparencies of the same. In addition to photographic talent, must have comprehensive knowledge of objects photographed and provide copious caption material. Freelance photographers

should provide a catalog stating subject, date, place, format, conditions of sale and desired credit line before attempting to sell us photos. We're most likely to purchase color photos of outstanding models of all types for our regular feature, FSM Showcase."

FIRST HAND MAGAZINE, MANSCAPE, 310 Cedar Lane, Teaneck NJ 07666. (201)836-9177. Editor: Brandon Judell. Monthly magazine. "First Hand deals with all aspects of homosexuality: Manscape will lean towards the kinky." Readers are "men, glorious men." Circ. 60,000. Sample copy \$3. Photo guidelines free with SASE.

Photo Needs: Uses about 2 photos/issue; 2 supplied by freelance photographers. Needs photos of "sexy men. No uncovered groin shots. Cover photo should show face. Back cover can show behind." Written

release required.

Making Contact & Terms: Arrange a personal interview to show portfolio; query with samples. Send 35mm, 21/4x21/4, 4x5 transparencies, color contact sheet by mail for consideration. SASE, Reports in 3 weeks. \$150/front cover photo; \$100/back cover photo. Credit line given. Buys one-time rights. Simultaneous submissions OK.

Tips: "Don't send in photos of people with acne. Don't overload the company with your work. It's better to send 20 slides than 100.

THE FISHERMAN, (Long Island, Metro Edition), (formerly Long Island Fisherman), Box 1994, Sag Harbor NY 11963. (516)725-4200. Editor: Fred P. Golofaro. Weekly magazine. Circ. 45,000. Emphasizes salt water recreational angling. Photos are purchased with or without accompanying ms. Credit line given. Pays on publication. Buys all rights, but may reassign to photographer after publication. Query with list of stock photo subjects and samples. SASE. Reports in 6-10 weeks. Free photo guide-

Subject Needs: Salt water fish from NE coastal region, how-to (salt water fishing), human interest (children with fish) and sport (action fishing). No dead fish photos. Captions required.

B&W: Uses 8x10 or 5x7 glossy prints. Pays \$10/photo.

Cover: Uses 8x10 glossy prints. Square or vertical format required. Pays \$25/photo.

Accompanying Mss: Marine angling in New York metropolitan area. Pays \$100/full feature, \$50/short feature. Free writer's guidelines.

FISHING WORLD, 51 Atlantic Ave., Floral Park NY 11001. Editor: Keith Gardner. Bimonthly magazine. Circ. 285,000. Emphasizes techniques, locations and products of both freshwater and saltwater fishing. For men interested in sport fishing. Needs photos of "worldwide angling action." Buys 18-30/ annually. Buys first North American serial rights. Send photos for consideration. Photos purchased with accompanying ms; cover photos purchased separately. Pays on acceptance. Reports in 3 weeks. SASE. Free sample copy and photo guidelines.

B&W: Send glossy prints. Captions required. Pays \$25-100 for text/photo package under 1,000 words. Color: Send transparencies. Requires originals. Captions essential. Pays \$300 for complete text/photo

package.

Cover: Send color transparencies. "Drama is desired rather than tranquility. Fish portraits and tight

close-ups of tackle are often used." Requires originals. Captions essential. Pays \$250.

Tips: "In general, queries are preferred, though we're very receptive to unsolicited submissions accompanied by smashing photography." Inside photos are primarily color, but b&w is used to supplement these.

FLORIDA SINGLES, Box 83, Palm Beach FL 33480. (305)833-8507. Editor-in-Chief: Harold Alan. Emphasizes problems with life, dating, children, etc., for single, divorced, widowed or separated individuals who comprise more than 60% of the adult population over 18. Monthly. Circ. 12,000. Sample copy \$2.

Photo Needs: Uses I b&w photo/issue (cover); supplied by freelance photographers. Interested in photos of couples in happy situations and singles and single parents in everyday situations. Model release re-

quired; captions not required. 2-4 months before notification.

Making Contact & Terms: Send by mail for consideration actual 8x10 b&w photos; or query with resume of photo credits and tearsheets. SASE. Reports up to 4 months or when an assignment becomes available. Pays within 30 days of publication \$15-40 for b&w photo for one-time use. Associated with East Coast, and Atlanta and Kentucky Singles magazines and same photo could be used with each at 1/2 the first-time price.

FLY FISHERMAN, Historical Times, Inc., Editorial Offices, 2245 Kohn Rd., Box 8200, Harrisburg PA 17105. (717)657-9555. Founding Publisher: Donald D. Zahner. Editor: John Randolph. Emphasizes all types of fly fishing for readers who are "99% male, 79% college educated, 79% married. Average household income is \$62,590 and 55% are managers or professionals. 85% keep their copies for future reference and spend 35 days a year fishing." Bimonthly. Circ. 130,000. Sample copy \$2.95; photo/

writer guidelines for SASE.

Photo Needs: Uses about 45 photos/issue, 70% of which are supplied by freelance photographers. Needs shots of "fly fishing and all related areas—scenics, fish, insects, how-to." Column needs are: Fly Tier's Bench (fly tying sequences); Tackle Bag; and Casting About (specific streams and rivers).

Model release not required; captions required.

Making Contact & Terms: Send by mail for consideration 5x7 or 8x10 b&w prints or 35mm, 2 \(^1/4x2 \)^4, 4x5 or 8x10 color transparencies. SASE. Reports in 4-6 weeks. Pays on publication \(^30-75/b\)&w photo; \(^40-200/color transparency; \(^400/color covers; \(^250 maximum day rate; \(^335-400 for text/photo package. Credit line given. Buys one-time rights. No simultaneous submissions; previously published work OK.

FOCUS: NEW YORK, 375 Park Ave., New York NY 10022. Editor-in-Chief: Kristine B. Schein. Annually. Circ. 250,000. A guide to shops, restaurants and galleries. Readers are New York visitors. Sam-

ple copy \$1.50.

Photo Needs: Uses 125 photos/issue; 10 supplied by freelance photographers. Needs photos "done specifically for each shop; e.g. boutiques (fashion), gift shops, etc.—mostly b&w, occasionally color." Special needs: stock color photos of food, interior design, women's and men's fashion, antiques and gifts for editorial use in return for photo credit in publication.

Making Contact & Terms: Query with resume of credits and samples. Does not return unsolicited material. Reports in 3 weeks. Provide resume, business card and/or tearsheets to be kept on file for possible

future assignments. Pays \$75 and up/b&w inside. Pays on publication.

FOOD & WINE, 1120 Avenue of the Americas, New York NY 10036. (212)382-5600. Art Director: Elizabeth Woodson. Monthly. Circ. 500,000. Emphasizes food and wine. Readers are an "upscale audience who cook, entertain, dine out and travel stylishly."

Photo Needs: Uses about 25-30 photos/issue; mostly studio photography on assignment basis. "We look for editorial reportage specialists who do restaurants, food on location and travel photography."

Model release and captions required.

Making Contact & Terms: Drop-off policy to show portfolio, third week of month. Provide tearsheets to be kept on file for possible future assignments. Pays \$300-400/color page. Pays on acceptance. Credit line given. Buys one-time world rights.

FOR MEN ONLY, Box 2121, Station B, Scarborough, Ontario, Canada M1N 2E5. Photo Editor: Tom Philips. Bimonthly magazine. Circ. 180,000. Emphasizes erotica and sexually explicit photos. Photos purchased without accompanying ms. Freelancers supply 85% of material. Credit line given. Pays on publication. Buys one-time rights. Send material by mail for consideration. Simultaneous submissions and previously published work OK. Reports in 4-5 months. *Prints* preferred: material either returned or kept on file for future consideration."

Subject Needs: Nude; female solo or with partners. **B&W**: Uses glossy prints. Pays \$800 maximum/photo.

Color: Uses prints and transparencies. Pays \$1,200 maximum/photo.

Cover: Uses color covers; vertical format preferred. Pays \$1,200 maximum/cover.

Tips: "Our biggest need is erotica sexually explicit material. Some of our best pictorials have been supplied by photographers (not always professionals) working with models who were their sisters or girlfriends. Of course, we also use fully posed pix as well. Multiple-model scenarios (any combination) are also needed and in short supply. We strongly advise identifying each item submitted with the photographer's name, to avoid confusion."

FOR PARENTS, 7052 West Lane, Eden NY 14057. (716)992-3316. Editor-in-Chief: Carolyn Shadle. Published 5 times/year. Circ. 3,000. Emphasizes parenting. Readers are "middle class church-related parents." Sample copy free with SASE.

Photo Needs: Uses one photo/issue; all supplied by freelance photographers. Needs photos of "parent-child interaction. Families with school age children. Together time (families doing things together—at

the dinner table, in the car)."

Making Contact & Terms: Query with list of stock photo subjects. Provide brochure, flyer and tearsheets to be kept on file for possible future assignments. Reports in 1 month. Pays \$15-20/b&w inside photo. Pays on publication. Credit line given "if desired." Buys one-time rights. Simultaneous submissions and previously published work OK.

FORTUNE, Time-Life Bldg., New York NY 10020. (212)841-2583. Managing Editor: William Rukeyser. Picture Editor: Alice Rose George. Emphasizes analysis of news in the business world for management personnel. Photos purchased on assignment only. Portfolios seen by appointment.

Photographer's Market '86

FORUM, Penthouse International Ltd., 1965 Broadway, 2nd Floor, New York NY 10023. Editor-in-Chief: Phillip Nobile. Art Director: John Aracho. Circ. 700,000. Monthly magazine featuring health and sexual advice for an audience split almost evenly between males and females.

Making Contact & Terms: Drop off portfolio on Wednesday morning. No appointment necessary. Payment on invoice.

Accompanying Mss: Seeks 2,000-3,000 word articles and shorter fillers. Pays \$200-800/ms.

*FRANCE TODAY MAGAZINE, 1051 Divisadero St., San Francisco CA 94115. (415)921-5100. Editor: Anne Prah-Perochon. Bi-annual. Emphasizes modern-day France. Readers are Americans who travel often to Europe; teachers and students of the French language. Circ. 40,000. Estab. 1984. Sample copy free with SASE.

Photo Needs: Uses 30 photos/issue; 20 supplied by freelance photographers. Needs photos depicting travel, food and wine, products, personalities and holiday activities. Reviews photos with or without ac-

companying ms. Captions preferred.

Making Contact & Terms: Query with samples; send unsolicited photos by mail for consideration. Send b&w 8x10 prints; 35mm transparencies. SASE. Reports in 1 month. Pays \$50/b&w inside photo; \$200/color cover photo; and \$100/color inside photo. Pays on publication. Credit line given. Buys onetime rights. Simultaneous submissions OK.

FREEWAY, Scripture Press, Box 623, Glen Ellyn IL 60138. Editor: Cindy Atoji. Four-page magazine. Circ. 70,000. For older Christian teens. Photos purchased with or without accompanying ms. Freelancers supply 90% of the photos. Pays on acceptance. Buys one-time rights and simultaneous rights. "Mail portfolio with SASE; we will photocopy prints we're interested in for future ordering." Simultaneous submissions and previously published work OK. Reports in 1 month. Free sample copy and photo guidelines available on request.

Subject Needs: "Photos should include teenage subjects when possible. We need action photos, human

relationships, objects, trends and sports." Also uses some religious and mood photos. No fine art; no photos with too-young subjects or outdated styles; no overly posed or obviously gimmicky shots. No

B&W: Uses 8x10 b&w prints. Pays \$20-35. **Accompanying Mss:** "Freeway emphasizes personal experience articles which demonstrate God working in the lives of older teens and young adults. Most of our readers have an interest in Christian

Tips: "We would like to use a greater percentage of photos in our layouts. Thus, we'd like to see more action photos of teenagers which we can use to illustrate stories and articles (teen personal crisis, selfhelp, how-to). We'd like to see some creativity and real-life situations. We're overstocked with close-up reflective shots, and teens at school and other typical actions and settings."

FRETS MAGAZINE, 20085 Stevens Creek, Cupertino CA 95014. (408)446-1105. Editor: Phil Hood. Photo Editor: Cachlan Throndson. Emphasizes personality profiles, how-to material and feature stories. Readers are serious musicians devoted to string acoustic music. Monthly. Circ. 69,350. Free sample copy and photo guidelines.

Photo Needs: Uses about 15 photos/issue; most supplied by freelance photographers. Selects photographers "on merits of each piece." Needs include photos of musicians with instruments (playing) and not eating mikes. Group or solo artist shots. Model release not required; include dates, location, and names of people involved; captions required.

Specs: Uses any size, 5x7 or larger, b&w print, glossy; or contact sheet. Needs 35mm color slides for

Making Contact & Terms: Send by mail for consideration actual prints, slides, and/or contact sheet. Query with lists of stock photo subjects. SASE. Reports "after publication of material." Pays on publication \$25 minimum for b&w photo full shots, depending on size used; \$75, and up/color transparency. Credit line given, "except for mugshots, 'coming next month' ad, and table of contents photos." Buys one-time rights and one-time reprint rights. No simultaneous submissions.

FRONT PAGE DETECTIVE, Official Detective Group, 460 W. 34th St., 20th Floor, New York NY 10001. Editor: Rose Mandelsberg. Emphasizes factual articles and fact-based stories about crime. Readers are "police buffs, detective story buffs, law and order advocates." Monthly. Circ. 500,000. Sample copy \$1.50; photo guidelines for SASE.

Photo Needs: "Only color covers are bought from freelance photographers. Situations must be crime, police, detective oriented; man and woman; action must portray impending disaster of a crime about to happen; No bodies. Modest amount of sensuality, but no blatant sex." Model release required; captions not required.

Making Contact & Terms: Send by mail for consideration actual color photos, or 35mm/21/4x21/4/4x5

color transparencies. SASE. Reports in 1 month, after monthly cover meetings. Pays on acceptance. \$200/color photo. No credit line given. Buys all rights. No simultaneous or previously published submissions.

*FUN IN THE SUN, 5436 Fernwood Ave., Los Angeles CA 90027. (213)465-7121. Publisher: Ed Lange. Quarterly. Emphasizes nudism/naturism/alternative lifestyles. Circ. 5,000. Photo guidelines free with SASE.

Photo Needs: Uses about 50 photos/issue; 20 supplied by freelance photographers. Needs photos of "mudity fun in sun (nonsexist)" Model release and existing the photographers.

"nudity; fun in sun (nonsexist)." Model release and captions required.

Making Contact & Terms: Query with samples. SASE. Reports in 3 weeks. Pays \$50/b&w cover photo; \$100/color cover photo; \$25/b&w inside photo; \$25/color inside photo. Pays on acceptance. Credit line given. Buys one-time or all rights. Previously published work OK.

*FUN/WEST, Box 2026, North Hollywood CA 91602. Editor: S. Richard Adlai. Quarterly magazine. Emphasizes living on the West Coast for young, single people; resorts in the U.S. and jet set activities. Subject Needs: Travel, fashion/beauty, glamour, few nude ("good taste only"), product shot, wine and gourmet food. Captions preferred; model release required.

Specs: Uses 8x10 b&w and color prints. Uses b&w and color covers.

Payment/Terms: Payment negotiable. Credit line given. Pays on publication. Buys all rights. Simultaneous submissions and proviously published used OK.

neous submissions and previously published work OK.

Making Contact: Query only with list of stock photo subjects. Unsolicited materials will be discarded. SASE. Reports in 1 month or more.

Tips: "Exercise good taste at all times. Concentrate on showing the same subjects under different light or style."

FUR-FISH-GAME, 2878 E. Main St., Columbus OH 43209. Editor: Ken Dunwoody. Monthly magazine. Cir. 190,000. Emphasizes hunting, fishing, trapping, camping, conservation and guns in the U.S. For outdoor enthusiasts of all ages. Buys 200 text/photo packages annually, paying \$50-200. Also buys photos depicting game animals, birds or fish in their natural environment, or photos which depict the mood of fishing, hunting, camping or trapping. Pays \$10-20 for most photos, rights negotiable. Pays on acceptance. Reports in 1 month. SASE. Sample copy \$1; photo guidelines free.

Specs: Uses mostly b&w prints. Send 5x7 or 8x10 glossy prints (3x5 sometimes accepted). Caption in-

formation required.

Tips: "We need photos that capture the general spirit of fishing, hunting, trapping or camping and can be used to fit a variety of story ideas. We also have a shortage of photos that depict small game and waterfowl."

FUTURIFIC MAGAZINE, Suite 1210, 280 Madison Ave., New York NY 10016. Editor-in-Chief: Mr. Balint Szent-Miklosy. Monthly. Circ. 10,000. Emphasizes future related subjects. Readers range from corporate to religious leaders, government officials all the way to blue collar workers. Free sample copy with SASE (85¢).

Photo Needs: Uses 10 photos/issue; all supplied by freelance photographers. Needs photos of subjects relating to the future. Photos purchased with or without accompanying ms. Captions preferred. Making Contact & Terms: Send by mail for consideration b&w prints or contact sheets. Provide name, address and telephone number to be kept on file for possible future assignments. SASE. Reports in 1 month. Payment negotiable. Pays on publication. Buys one-time rights. Simultaneous submissions and/

or previously published work OK.

Tips: "Photographs should illustrate what directions society and the world are heading. Optimistic on-

lv."

*G&S PUBLICATIONS, 1472 Broadway, New York NY 10036. (212)840-7224. Editor: Will Martin. Publishes two magazines—Gem and Buf, bimonthly men's sophisticate publications. "Gem features photo sets of models with extra-large size breasts. Although we look for models as pretty as we can get, big breasts take precedence. Buf Pictorial features large women, plumpers and super plumpers. Models should be shown eating in some shots. Models' measurements and food preferences should be included with submissions." Readers are men." Circ. 100,000. Sample copy \$3.95; photo guidelines free with SASE. Bimonthly; 12 issues/year—6 of each.

Photo Needs: "We look for a variety of poses, the object being to present attractive, titillating photo spreads for our readers. Poses should be erotic but *not* pornographic. Sets should include full-figure nudes seen from front, side and back. A set requires both color (35mm) and black and white. The B/Ws should be submitted on contact sheets, accompanied by several 8x11 blow-ups to give an idea as to the quality of the photography." Model release required.

Making Contact & Terms: Query with samples; send unsolicited photos by mail for consideration.

SASE. Reports in 1 month. "Payment depends on several factors, whether it is a first rights set or not, how often the model has been used in other publications (or ours) even if it is a first rights set, the quality of the model and the quality of the photography. Generally speaking, for a first rights set with a new model, we pay \$400; \$450 if the set includes a cover shot. These fees include the ordering of about 15 prints." Pays two weeks after receipt of b&w photos and model release. Credit line given "if requested." Buys first rights. No simultaneous submissions.

GALLERY MAGAZINE, 800 2nd Ave., New York NY 10017. (212)986-9600. Photo Editor: Judy Linden. Monthly. Circ. 550,000. Emphasizes men's interests. Readers are male, collegiate, middle class. Free photo guidelines with SASE.

Photo Needs: Uses 80 photos/issue; 30 supplied by freelance photographers. Needs photos of nude women and celebrities. Photos purchased with or without accompanying ms. Model release and cap-

tions required.

Making Contact & Terms: Send by mail for consideration at least 80 35mm transparencies. SASE. Reports in 4 weeks. Provide flyer and tearsheets to be kept on file for possible future assignments. Pays \$50/b&w photo; \$75/color photo. Pays \$500/color cover, and up. Pays on publication. Credit line given. Buys one-time rights. Simultaneous submissions OK.

Tips: "If it is unique, send the photo. If it includes people, we must have releases."

GAMBLING TIMES MAGAZINE, 1018 N. Cole Ave., Hollywood CA 90038. (213)466-5261. Editor: Len Miller. Monthly magazine. Circ. 100,000. Emphasizes gambling. Buys 6-12 photos/issue. Credit line given. Pays on acceptance. Buys all rights. Send material by mail for consideration. SASE. Reports in 2 weeks. Free photo guidelines.

Subject Needs: Celebrity/personality (in a gambling scene, e.g., at the track); sport (of football, basketball, jai alai and all types of racing); and gambling scenes. Model release not required if photo is of a gen-

eral scene; captions preferred.

B&W: Uses 5x7 or 8x10 prints; contact sheet OK. Pays \$5-25/photo.

Cover: Uses color transparencies or prints. Vertical format preferred. Pays \$75.

GAME & FISH PUBLICATIONS, Box 741, Marietta GA 30061. (404)953-9222. Editor: David Morris. Publishes 9 monthly magazines: Alabama Game & Fish, Arkansas Sportsman, Carolina Game & Fish, Georgia Sportsman, Louisiana Game & Fish, Mississippi Game & Fish, Oklahoma Game & Fish, Tennessee Sportsman, Texas Sportsman. Circ. 225,000 (total). All emphasize "hunting-white tailed deer and other species; fishing—bass and other species." Readers are hunters/fishermen. Sample copy \$2.50; photo guidelines free with SASE.

Photo Needs: Uses approximately 40 photos for all magazines per month; 50% supplied by freelance photographers. Needs photos of live or dead deer; action fishing shots. Model release preferred; cap-

tions required.

Making Contact & Terms: Query with samples. Send 8x10 b&w glossy prints; 35mm transparencies by mail for consideration. SASE. Reports in 1 month. Pays \$250/color cover photo; \$75/color inside photo; \$150 minimum for text/photo package. Pays on acceptance. Credit line given. Buys one-time rights. Simultaneous submissions not accepted.

Tips: "Study our publications."

GAMUT, Cleveland State University, Cleveland OH 44118. (216)687-4679. Editor: Louis T. Milic. Triannual journal. General interest. Circ. 1,000. Sample copy \$2.50.

Photo Needs: Uses about 25-50 photos/issue; 1-2 at present supplied by freelance photographers. Subject needs "depend on the sort of articles we print. But we also print groups of interesting photographs (portfolios) on any subject." Model release preferred; captions required.

Making Contact & Terms: Query with b&w samples. SASE. Reports in 1 month. Pays in cash and contributor's copies. Range is \$25 for a single full-page photo to \$125 for a group (portfolio). Pays on publication. Credit line given. Buys first North American serial rights.

GARDEN, New York Botanical Garden, Bronx NY 10458. Photo Editor: Anne Schwartz. Bimonthly magazine. Circ. 30,000. Emphasizes botany, agriculture, horticulture and the environment for members of botanical gardens and arboreta. Readers are largely college graduates and professionals, united by a common interest in plants and the environment. Provide letter of inquiry and samples with SASE, especially related to plants, gardening and the environment, "however, we are adding very few new photographers. We call for photos on subjects wanted." Photos purchased with or without accompanying ms. Buys 12 photos/issue. Credit line given. Pays on publication. Buys one-time rights. SASE. Reports in 1 month. Sample copy \$2.50.

Subject Needs: Nature and wildlife (of botanical and environmental interest) and scenic (relating to plants, especially to article subjects). Captions not required, "but plants must be accurately identified."

B&W: Uses 5x7 glossy prints. Pays \$35-50/photo.

Color: Uses 35mm or 4x5 transparencies. Pays \$40-70/photo.

Cover: Uses 35mm or 4x5 color transparencies. Vertical format preferred. Pays \$100-150/photo. Accompanying Mss: Articles relating to emphasis of the magazine. No photo essays. Length: 1,500-2,500 words. Pays \$100-300/ms. Request writer's guidelines separately.

GARDEN DESIGN, 1733 Connecticut Ave. NW, Washington DC, 20009. 202-466-7730. Editor: Ken Druse. Art Director: Pamela Morrison. Quarterly. Emphasizes residential landscape architecture and garden design. Readers are gardeners, home owners, architects, landscape architects, garden designers and garden connoisseurs. Sample copy \$5; photos guidelines free with SASE.

Photo Needs: Uses about 80 photos/issue; three-quarters supplied by freelance photographers. Needs photos of "indoor-outdoor garden rooms; public and private gardens which exemplify professional quality design; specific horticultural shots, and exhibits the total design intent." Model release and cap-

tions preferred.

Making Contact & Terms: Query with resume of credits, with samples or with list of stock photo subjects or submit proposal with samples; provide resume, business card, brochure, flyer or tearsheets to be kept on file for possible future assignments. Reports in 2 months or sooner if requested. Pays \$250/color cover photo; \$100 inside photo over ½ p; \$150 double page special; \$50 ½ page or smaller (color or b&w.) "Assignment photography is negotiated according to our system." Pays on publication "with expenses paid on acceptance." Credit line given. Buys 2-time reproduction rights. Previously published work OK.

Tips: "Read the magazine as well as observe the photographs to gain insight to philosophy of *Garden Design*. Photographs and text carry equal editorial weight. Our format is very flexible; talk to us about ideas. In color, show both detailed and comprehensive views that reveal the design intent and content of a garden. In black and white, subjective, interpretative views of the garden. A letter and resume are not enough—must see evidence of the quality of your work, in samples or tearsheets."

*GARDEN GOURMET, Suite 1405, 6 N. Michigan, Chicago IL 60602. (312)346-4790. Publisher: Tom Aikins. Monthly magazine. Emphasizes gardening and cooking. Circ. 150,000. Sample copy \$2.50.

Photo Needs: Uses about 20 photos/issue; number of freelance photographers used varies. Needs photos of "vegetables in the garden and the kitchen; prepared dishes." Model release required.

Making Contact & Terms: Query with list of stock photo subjects. SASE. Reports in 2 weeks. Pays on publication. Credit line given. Buys first North American serial rights. Simultaneous submissions and previously published work OK.

*GENERATION, 79 Harrman Hall, S.U.N.Y. at Buffalo, Buffalo NY 14214. (716)831-2249. Photo Editor/Chief Photographer: Scott R. Stevenson. Weekly magazine. Emphasizes "stunning feature stories or gripping investigative journalism, both with social-humanistic approach. Stories must have impact." Readers are "mainly college students with a broad interest. We are expanding our community distribution to a general readership also. Circ. 10,000. Estab. 1984. Sample copy free with SASE and \$1 postage. Photo guidelines free with SASE.

Photo Needs: Uses about 4-10 photos/issue; "none so far" by freelance photographers. "We are looking for photos that have great impact. Human interest, social issues, success-over-all-odd type of stories. We also need single photos that can be used alone as humor. We will be doing stories on the poor, the migrant farm worker's lifestyles, the old and aging, the homeless, the drug department, minority group

discrimination, etc." Model release preferred; captions required.

Making Contact & Terms: Send 4x5, 8x10 "F" or "N" b&w prints and b&w contact sheets. "Never send negatives unless requested." SASE. Reports in 1 month. Credit line "always" given; byline given for story if mss is with photographs. Buys one-time rights. "All other reprints after us must have credit line: Reprint from GENERATION by (your name)." Simultaneous submissions and previously published work OK.

Tips: Prefers to see "strong impact images—no pot luck shots that might say something! Throw away the motordrives and learn to judge the moment; don't just push the button and hope for a good one."

GENESIS, 770 Lexington Ave., New York NY 10021. (212)486-8430. Editor: J.J. Kelleher. Art Director: Ray Mondesire. Monthly magazine. Circ. 450,000. Emphasizes celebrities, current events, issues and personal relationships. For the young male.

Subject Needs: Celebrity/personality, nude, product shot, sport and humorous. Model release required.

"We have a constant need for girl sets."

Specs: Uses 35mm color transparencies. Uses color covers; vertical format required.

Payment/Terms: Pays \$500-750/job; girl sets \$1,200 and up; and \$250-500 extra/cover. Credit line given. Pays within 30 days of acceptance. Buys one-time rights.

Making Contact: Send material by mail for consideration. "Send 'return receipt requested.' " SASE. Reports in 2 weeks. Free sample copy and 6-page photo guidelines for 9x12 SASE.

Tips: "We are looking for photos of exceptionally beautiful and new models only. Quality of work must show experience and expertise in this specialized field."

GENT, 2355 Salzedo St., Suite 204, Coral Gables FL 33134. (305)443-2378. Editor: John Fox. Monthly magazine. Circ. 150,000. Showcases full-figure nude models. Credit line given. Pays on publication. Buys one-time rights or second serial (reprint) rights. Send material by mail for consideration. SASE. Previously published work OK. Reports in 2 weeks. Sample copy \$4.50. Photo guidelines free with SASE.

Subject Needs: "Nude models must be extremely large breasted (minimum 38" bust line). Sequence of photos should start with woman clothed, then stripped to brassiere and then on to completely nude. Bikini sequences also recommended. Cover shots only of torso with nipples covered. Chubby models also considered if they are reasonably attractive and measure up to our 'D-Cup' image." Model release required. Buys in sets, not by individual photos.

B&W: Uses 8x10 glossy prints; contact sheet OK. Pays \$150 minimum/set.

Color: Uses transparencies. Pays \$250-400/set.

Cover: Uses color transparencies. Vertical format required. Pays \$150/photo.

Accompanying Mss: Seeks mss on travel, adventure, cars, racing, sports and products. Pays \$125-175/

GEOMUNDO, 6355 NW 36th St., Virginia Gardens FL 33166. (305)871-6400. Editor-in-Chief: Pedro J. Romanach. Monthly magazine. Emphasizes geography, history, the natural sciences and art. Readers are well-educated, Spanish-speaking persons in Latin America and the U.S. Circ. 175,000. Free sample copy and photo guidelines with SASE.

Photo Needs: Uses about 140 photos/issue; 80% supplied by freelance photographers. Needs 35mm (or larger) color slides, very accurately identified, pertaining to geography, history, the natural sciences or

art for Hespanic markets only. Model release and captions required.

Making Contact & Terms: Arrange a personal interview to show portfolio; query with resume of credits; query with samples; query with list of stock photo subjects; provide resume, business card, brochure, flyer or tearsheets to be kept on file for possible future assignments. Does not return unsolicited material. Reports in 1 month. Pays on acceptance; "texts are paid for separately about two months before publication." Buys one-time rights or all rights; "depends on subject and quality." Simultaneous submissions and previously published work OK.

GOLDEN YEARS MAGAZINE, Box 537, Melbourne FL 32901. (305)725-4888. Editor-in-Chief: Carol B. Hittner. Monthly magazine. Emphasizes lifestyles. Readers are the over-50 generation-active

seniors. Circ. 504,000. Free sample copy with SASE and \$1 postage.

Photo Needs: Uses about 12-20 photos/issue; all supplied by freelance photographers. Needs vary, but uses "basically good-looking seniors in active life situations." Model release and captions required. Making Contact & Terms: Query with samples; query with list of stock photo subjects; send prints, transparencies or contact sheet by mail for consideration; submit portfolio for review. SASE. Reports in 2 weeks. Pays \$2.50/b&w \$5/color photo. Pays on publication. Credit line given. Buys one-time rights. Previously published work OK.

GOLF DIGEST, 5520 Park Ave. Box 0395, Trumbell CT 06611. (203)847-5811. Editorial Art Director: Nick Didio. Monthly magazine. Circ. 1,000,000. Emphasizes golf instruction and features on golf personalities and events. Buys 10-15 photos/issue from freelance photographers. Pays \$50 minimum/ job and also on a per-photo or per-assignment basis. Credit line given. Pays on publication. Send material by mail for consideration. "The name and address of the photographer must appear on every slide and print submitted." SASE. Simultaneous submissions OK. Reports in 1 month. Free sample copy. Free photo guidelines with SASE.

Subject Needs: Celebrity/personality (nationally known golfers, both men and women, pros and amateurs); fashion/beauty (on assignment); head shot (golfing personalities); photo essay/photo feature (on assignment); product shot (on assignment); scenics (shots of golf resorts and interesting and/or unusual shots of golf courses or holes); and sport (golfing). Model release preferred; captions required. "The captions will not necessarily be used in print, but are required for identification."

B&W: Uses 8x10 glossy prints. No contact sheet. Pays \$25-150/photo. Color: Uses 35mm transparencies. No duplicates. Pays \$50-350/photo.

Cover: Uses 35mm color transparencies. Vertical format required. Pays \$350 minimum/photo.

Tips: "We are a very favorable market for a freelance photographer who is familiar with the subject. Most of the photos we use are done on specific assignment, but we do encourage photographers to cover golf tournaments on their own with an eye for unusual shots, and to let the magazine select shots to keep

on file for future use. We are always interested in seeing good quality color and b&w work." Prefers Kodachrome-64 film: no Ektachrome.

GOLF JOURNAL, Golf House, Far Hills NJ 07931. (201)234-2300. Editor: Robert Sommers. Managing Editor: George Eberl. Art Director: Janet Seagle. Emphasizes golf for golfers of all ages and both sexes. Readers are "literate, professional, knowledgeable on the subject of golf." Monthly. Circ.

145,000. Free sample copy.

Photo Needs: Uses 20-25 photos/issue, 5-20 supplied by freelance photographers. "We use color photos extensively, but usually on an assignment basis. Our photo coverage includes amateur and professional golfers involved in national or international golf events, and shots of outstanding golf courses and picturesque golf holes. We also use some b&w, often mugshots, to accompany a specific story about an outstanding golfing individual. Much of our freelance photo use revolves around USGA events, many of which we cover. As photo needs arise, we assign photographers to supply specific photo needs. Selection of photographers is based on our experience with them, knowledge of their work and abilities, and, to an extent, their geographical location. An exceptional golf photo would be considered for use if accompanied by supportive information." Column needs are: Great Golf Holes, a regular feature of the magazine, calls for high quality color scenics of outstanding golf holes from courses around the country and abroad. Model release not required; captions required.

Making Contact & Terms: Query Managing Editor George Eberl with resume of photo credits; or call (do not call collect). Works with freelance photographers on assignment only basis. Provide calling card, resume and samples to be kept on file for possible future assignments. SASE. Reports in 2 weeks. Pays on acceptance. Negotiates payment based on quality, reputation of past work with the magazine, color or b&w and numbers of photos. Pays \$25 minimum. Credit line given. Rights purchased on a

work-for-hire basis. No simultaneous or previously published work.

GOOD HOUSEKEEPING, 959 8th Ave., New York NY 10019. (212)262-3614. Editor: John Mack Carter. Art Director: Herb Bleiweiss. Monthly magazine. Circ. 5,500,000. Emphasizes food, fashion, beauty, home decorating, current events, personal relationships and celebrities for homemakers. Photos purchased on assignment. Buys 200 photos/issue. Pays \$50-400/printed page, or on a per-photo basis. Credit line given. Pays on acceptance. Buys all rights. Drop off portfolio for review or send with SASE. Reports in 2 weeks.

Subject Needs: Submit photo essay/photo feature (complete features on children, animals and subjects interesting to women that tell a story with only a short text block) to the Articles Department. All other

photos done on assignments only basis. Model release required; captions preferred.

B&W: Uses 8x10 prints. Pays \$50-300/photo.

Color: Uses 35mm transparencies. Pays \$150-400/photo.

Cover: Query. Vertical format required. Pays \$1,200 maximum/photo.

GRAND RAPIDS MAGAZINE, 1040 Trust Bldg., 40 Pearl St., NW, Grand Rapids MI 49503. (616)459-4545. Publisher: John H. Zwarensteyn. Editor: John Brosky. Monthly magazine. Emphasizes community-related material; local action and local people. Works with staff photographer almost exclusively, but some freelancers as well. Provide business card to be kept on file for possible future assignments; "only people on file are those we have met and personally reviewed." Pays \$15-100/job and on a per-photo basis. Buys one-time rights. Arrange a personal interview to show portfolio, query with resume of credits, send material by mail for consideration, or submit portfolio for review. SASE. Reports in 3 weeks. Model release and captions required.

Subject Needs: Animal, nature, scenic, travel, sport, fashion/beauty, photo essay/photo feature, fine art, documentary, human interest, celebrity/personality, humorous, wildlife, vibrant people shots and special effects/experimental. Wants on a regular basis western Michigan photo essays and travel-photo essays of any area in Michigan. Especially needs for next year color work, but on assignment only.

B&W: Uses 8x10 or 5x7 glossy prints; contact sheet OK. Pays \$15-25/photo.

Color: Uses 35mm, 120mm or 4x5 transparencies or 8x10 glossy prints. Pays \$15-25/photo. **Cover:** Uses 2¹/₄x2¹/₄ and 4x5 color transparencies. Pays \$100/photo. Vertical format required. **Tips:** "Most photography is by our staff photographer, so freelancers should sell us on the unique nature of what they have to offer."

GRAY'S SPORTING JOURNAL, 205 Willow St., Hamilton MA 01982. (617)468-4486. Editor: Ed Gray. Quarterly magazine. Circ. 50,000. Covers strictly hunting, fishing and conservation. For "readers who tend to be experienced outdoorsmen." Needs photos relating to hunting, fishing and wildlife. "We have 4 issues/year. We want no 'hunter or fisherman posed with an idiot grin holding his game.' No snapshots." Buys 150 photos/year. Buys first North American serial rights. Send photos for consideration. Pays on publication. Reports in 6-8 weeks. SASE. Sample copy \$5; photo guidelines free with SASE.

Color: Send transparencies; Kodachrome 64 preferred. Captions required. Pays \$50 minimum. **Tips:** "We like soft, moody, atmospheric shots of hunting and fishing scenes, as well as action. We like to blow our pix up *big* i.e., clarity is a must. Look at the photos we have published. They are absolutely the best guide in terms of subject matter, tone, clarity, etc."

GREAT LAKES FISHERMAN, 1570 Fishinger Rd., Columbus OH 43221. (614)451-9307. Editor: Ottie M. Snyder. Monthly. Circ. 41,000. Emphasizes fishing for anglers in the 8 states bordering the Great Lakes. Sample copy and photo guidelines free with SASE.

Photo Needs: 12 covers/year supplied by freelance photographers. Needs transparencies for covers; 99% used are verticals. No full frame subjects; need free space top and left side for masthead and titles. Fish and fishermen (species common to Great Lakes Region) action preferred. Photos purchased with or

without accompanying ms. Model release required for covers; captions preferred.

Making Contact & Terms: Query with tearsheets or send unsolicited photos by mail for consideration. Prefers 35mm transparencies. SASE. Reports in I month. Provide tearsheets to be kept on file for possible future assignments. Pays minimum \$100/color cover. Pays on acceptance. Credit line given. Buys one-time rights.

*GREATER PORTLAND, 142 Fee St., Portland ME 04101. (207)772-2811. Editor: Colin Sargent. Quarterly magazine. "We're like a baby *New York* magazine, with fashion, art, theater, nightlife, music, features and interviews. Contemporary graphics. We use many b&w and selected color photos in each issue. Our layouts are "highly visual, with a lot of gutter-jumping." Our readers are "upscale city maga-

zine readers." Circ. 10,000. Sample copy \$1 with \$1.35 postage.

Photo Needs: Uses about 50 photos/issue; all supplied by freelance photographers. Needs "Portland cityscapes, local fashion photos—everything must have local appeal. Also: Casco Bay Island photos. We're always looking for cover transparencies. We have both beautiful process color and b&w signatures, and full-bleed color covers on an 8½x11 vertical format—a lavish production that makes for good clips." Arrange a personal interview to show portfolio. Query with resume of credits. Send 8x10 b&w or color glossy prints and 4x5 transparencies by mail for consideration. Submit portfolio for review. Provide resume, business card, brochure, flyer or tearsheets to be kept on file for possible future assignments. "Very open to new talent." SASE. Reports in 2 weeks. Pays \$150 color cover photo; all others negotiable. Pays on publication. Credit line given. Buys first North American serial rights. Simultaneous submissions and previously published work (if identified as such) OK.

*THE GRENADIER MAGAZINE, 3833 Lake Shore Ave., Oakland CA 94610. (415)763-0928. Senior Editor: S.A. Jefferis-Tibbetts. Bimonthly magazine. Emphasizes "military theory, history, and simulation." Our readers are "military professionals, agents, war gamers, computer programmers." Circ. 5,600. Sample copy free with SASE and \$1.25 postage/large envelope. Photo guidelines free with SASE.

Photo Needs: Uses about 12 photos/issue; 1-2 supplied by freelance photographers. Needs photos of "current military hardware, military personnel, and present military development (i.e., The Falklands, Kharg Island, etc.)" Special needs include, "Biannual Reforger Exercises." Captions preferred. **Making Contact & Terms:** Send any size b&w prints by mail for consideration. SASE. Reports in 2 weeks. Pays \$125/b&w cover photo, \$250/color cover photo and \$25/b&w inside photo. Pays on publi-

cation. Credit line given. Buys all rights. Previously published work OK.

Tips: Prefers to see "crisp detail and technical nuance (e.g., is this a Mark IVHc or Mark IVHf type tank)."

*GULF COAST GOLFER, Suite 212, 9182 Old Katy Rd., Houston TX 77055. (713)464-0308. General Manager: Bob Gray. Monthly tabloid. Emphasizes golf in the gulf coast area of Texas. Readers are average 50, \$50,000 + income, upscale lifestyle and play golf 2-3 times weekly. Circ. 30,000. Estab. 1984. Sample copy free with SASE and 75¢ postage.

Photo Needs: Uses about 20 photos/issue; none supplied by freelance photographers. "Photos are bought only in conjunction with purchase of articles." Photos purchased with accompanying ms only.

Model release and captions preferred.

Making Contact & Terms: "Use the telephone." SASE. Reports in 2 weeks. Pays on publication. Credit line given. Buys one-time rights or all rights, if specified.

GULFSHORE LIFE, 3620 Tamiami Trail N., Naples FL 33940. (813)262-6425. Editor: Molly J. Burns. Monthly magazine. Circ. 18,000. Emphasizes lifestyle along the Southwest Florida Gulfcoast. Readers are affluent, leisure class with outdoor activities such as golf, tennis, boating. Photos purchased with or without accompanying ms. Uses 40-50 photos/issue; 10% supplied by freelance photographers. Pays on a per-photo basis. Credit line given. Pays on publication. Buys one-time rights. Query with resume and samples or send photos by mail for consideration. SASE. Simultaneous submissions or previ-

ously published work OK. Reports in 5 weeks. Sample copy \$2; photo guidelines free with SASE. **Subject Needs:** Wildlife and nature that pertain to the Southwest Florida Gulfshore. "We are strictly regional, and other than travel, feature only things pertaining to this coast." No photos that aren't sharp and dramatic. Model release and captions preferred; photo subjects must be identified.

B&W: Uses 5x7 glossy prints. Pays \$10/photo.

Color: Uses 35mm and 21/4x21/4 transparencies. Pays \$25/photo.

Cover: Uses color transparencies. Vertical format required. Pays \$35 minimum/photo.

Accompanying Mss.: Seeks mss on personalities, community activities, hobbies, boating, travel and

nature. Pays 5¢/word. Writer's guidelines free with SASE.

Tips: Prefers to see nature, boating, leisure activities, travel. "Photos *must* be sharp and regionalized to Southwest Florida: Marco Island/Naples/Fort Myers/Sanibel-Captiva. A sample copy is helpful. No color prints are used. Photos with mss stand a better chance unless assigned." SASE required.

*GUN WORLD, 34249 Camino Capistruno, Capistrano Beach CA 92624. (714)493-2101. Editor: Jack Lewis. Photo Editor: Dan Grennell. Monthly. Emphasizes firearms, all phases. Readers are middle to upper class, aged 25-60. Circ. 136,000. Sample copy \$2; photo guidelines free with SASE.

Photo Needs: Uses 70-80 photos/issue; about 50% (with mss) supplied by freelance photographers. Needs hunting and shooting scenes. Reviews photos with accompanying ms only. Model release pre-

ferred; captions required.

Making Contact & Terms: Query with samples; send unsolicited photos by mail for consideration. Send 5x7 minimum glossy b&w prints and 35mm, 21/4x21/4 and 4x5 transparencies. SASE. Reports in 1 month. Pays \$100/color cover photo; \$5-100/inside b&w photo; \$40/color inside cover; \$100-350/text/photo package. Pays on acceptance. Credit line given if requested. Buys one-time rights. Simultaneous submissions OK.

HADASSAH MAGAZINE, 50 W. 58th St., New York NY 10019. Photo Editor: Pearl Weisinger. Monthly magazine (combined issues June/July and August/September). Circ. 370,000. Emphasizes Jewish life, culture, arts and politics. Needs "unique color transparencies and b&w prints of Jewish subjects showing the vitality of Israel and Jewish life." Pays \$30-50/b&w photo; \$50-200/color photo; \$200/day; \$50/first photo, \$30/each additional photo for text/photo package. Buys first North American serial rights. Send photos for consideration or call. Pays on publication. Reports in 1 month. SASE. Cover: Send color transparencies. "Bull's-eye pix are best. Jewish holiday themes are desirable." Captions required.

THE HAPPY WANDERER, 7842 N. Lincoln Ave., Skokie IL 60077. (312)676-1900. Photo Editor: Mark Greenfield. Bimonthly magazine. Circ. 210,000. Emphasizes the planning of vacations and leisure-time activities featuring resorts, cruises, adventures, trips, and accommodations all over the world for travelers and travel agents. Buys 80-120 photos/year. Credit line given. Pays on publication. Buys one-time rights. Send material by mail for consideration. Prefers to see color prints or slides. SASE. Previously published work OK. "Rejects are returned immediately."

Subject Needs: Travel, outdoor activities and scenic. Wants on a regular basis photos of people at tourist attractions. "No shots of overdone subjects (e.g., the Eiffel Tower or the Lincoln Memorial), or subjects that could be in any locale (beaches, harbors, aerial city views) with no distinguishing visual features pegging the area. No art photos." Model release preferred; captions required. Pays \$40/photo.

Cover: Please inquire before submitting color transparencies. Pays \$75 minimum/photo.

Tips: "The more photos a freelancer sends in to me, the more chance he/she has of selling a photo."

HARROWSMITH, Camden East, Ontario, Canada K0K 1J0. (613)378-6661. Editor/Publisher: James Lawrence. Magazine published 6 times/year. Circ. 154,000. Emphasizes alternative lifestyles, self-reliance, energy conservation, gardening, solar energy and homesteading. Photos purchased with or without accompanying ms and on assignment. Provide calling card, samples and tearsheet to be kept on file for possible future assignments. Buys 400 photos/year, 50 photos/issue. Pays \$50-500/job or \$200-1,000 for text/photo package. Credit line given. Pays on acceptance. Buys First North American rights. Query with samples and list of subjects. SASE. Previously published work OK. Reports in 4 weeks. Sample copy \$5; free photo guidelines.

Subject Needs: Animal (domestic goats, sheep, horses, etc., on the farm); how-to; nature (plants, trees, mushrooms, etc.); photo essay/photo feature (rural life); scenic (North American rural); and wildlife (Canadian, nothing exotic). "Nothing cute. We get too many unspecific, pretty sunsets, farm scenes and

landscapes." Captions preferred.

B&W: Uses 8x10 glossy prints. Contact sheet and negatives OK. Pays \$50-250/photo. **Color:** Uses 35mm and 2¹/₄x2¹/₄ transparencies and 8x10 glossy prints. Pays \$75-300/photo.

Cover: Uses b&w glossy or matte prints occasionally or color 35mm, 21/4x21/4, 4x5 or 8x10 transparencies or glossy prints. Vertical format preferred. Pays \$200-500/photo.

Accompanying Mss: Pays \$125-1,000/ms. Free writer's guidelines.

Tips: Prefers to see portfolio with credits and tearsheets of published material. Samples should be "preferably subject oriented. There is a much greater chance of success if a submission is made in a photo essay type package."

HARVEY FOR LOVING PEOPLE, 450 7th Ave., New York NY 10001. (212)564-0112. Creative Director: Jeff Gherman. Monthly. For men ages 25-34. "We're a men's magazine but we love and esteem women." Circ. 150,000.

Photo Needs: Uses 85 photos/issue, 5 nude sets supplied by freelancers. Model release required; cap-

tions not required.

Making Contact & Terms: Send 35mm slides by mail for consideration; query with resume of photo credits, tearsheets and 35mm slides; or arrange personal interview to show portfolio. Does not return unsolicited material. Reports in 1 week. Pays \$300-500/photo set. Pays on publication. Buys one-time rights. Simultaneous submissions OK if indicated with submission; previously published work OK "if indicated where and when."

*HEALTH MAGAZINE, 3 Park Ave., 32st Floor, New York NY 10016. (212)340-9200. Assistant Art Director: Michael Dowdy. Monthly magazine. Emphasizes health, sports and general well-being for women. Readers are women, median age 35, college graduates, both working and homemakers. Circ. 950,000.

Photo Needs: Uses approximately 35 photos/issue. Needs photos of "women in health situations—jogging, sports; some beauty; some generic scenes—family, office situations—all geared towards wom-

en." Model release preferred; captions required.

Making Contact & Terms: Submit portfolio for review. Provide resume, business card, brochure, flyer or tearsheets to be kept on file for possible future assignments. Reports in 1 week. Rates given "upon photo submissions." Pays on publication. Credit line given. Buys one-time rights. Simultaneous submissions and previously published work OK.

Tips: In a portfolio, prefers to see "women—health, sports, some fashion, outdoors, food, beauty

slots."

THE HERB QUARTERLY, Box 275, Newfane VT 05345. (802)365-4392. Editor: Sallie Ballantine. Readers are "herb enthusiasts interested in herbal aspects of gardening or cooking." Quarterly. Circ. 22,000. Sample copy \$5.

Photo Needs: Needs photo essays related to some aspect of herbs. Captions required.

Making Contact & Terms: Query with resume of credits. SASE. Reports in 1 month. Pays on publication \$25/essay. Credit line given. Buys first North American serial rights or reprint rights.

HIDEAWAYS GUIDE, Box 1459, Concord MA 01742. (617)369-0252. Managing Editor: Betsy Thiel. Published 3 times/year. Circ. 5,000. Emphasizes "travel, leisure, real estate, vacation homes, yacht/house boat charters, inns, small resorts." Readers are "professional/executive, affluent retirees." Sample copy \$5.

Photo Needs: Uses 12-15 photos/issue; half supplied by freelance photographers. Needs "travel, scenic photos, especially horizontal format for covers." Special needs include "spectacular and quaint scenes for covers, snow on mountains, lakes and tropics, etc." Model release and captions preferred.

Making Contact & Terms: Arrange for personal interview to show portfolio; query with samples; send 8x10 b&w glossy prints by mail for consideration. SASE. Reports in 3 weeks. Payment is "negotiable but not more than \$100." Pays on publication. Credit line given. Buys one-time rights. Simultaneous submissions and previously published work OK.

*HIGH SCHOOL SPORTS, Suite 5450, 30 Rockefeller Plaza, New York NY 10012. (212)765-3300. Editor: Gale Benn. Bimonthly during school year. Emphasizes the efforts and achievements of high school athletes. Readers include teenagers who participate in high school athletics across the United States. Circ. 500,000. Estab. 1985. Sample copy \$2; free photo guidelines with SASE.

Photo Needs: Uses 30-35 photos/issue; 100% supplied by freelance photographers. Needs photos of boys and girls participating in high school sports. Photos that accompany feature stories will be assigned. Reviews photos with or without accompanying ms. Color transparencies of outstanding performances, for 6-page news roundup. Also, humorous sports photo for full-page "Photo Finish." Captions required.

Making Contact & Terms: Query with samples; send unsolicited photos by mail for consideration; provide resume, business card, brochure, flyer or tearsheets to be kept on file for possible future assignments. Uses 35mm transparencies. SASE. Reports in 1 month. Pays \$350/day. Pays on acceptance. Credit line given. Buys one-time rights. Previously published work "in some situations."

Tips: "Prefers samples of color sports action as well as set ups. When possible, we would like to see published feature assignments. We are people-oriented and are not interested in still life or scenics."

HIGH TIMES, 17 W. 60th St., New York NY 10023. (212)974-1990. Editor: John Howell. Art Director: Dan Zedek. Monthly magazine. Circ. 300,000. For persons under 35 interested in lifestyle changes. cultural trends, personal freedom, sex and drugs. "Our readers are independent, adventurous freethinkers who want to control their own consciousness." Needs youth-oriented photos relating to drugs (natural and synthetic), entertainment, travel, politics and music. Buys first rights or second serial (reprint) rights. Query first. Do not send original material. Reports in 2 months. SASE. Sample copy

B&W: Uses any size prints. Pays \$25-150.

Color: Uses any size prints or transparencies. Pays \$50-250.

Cover: Pays \$500.

HIS MAGAZINE, Box 1450, Downers Grove IL 60515. (312)964-5700. Art Director: Kathy Lay Burrows. Monthly October-May magazine. Directed toward Christian students on the secular campus. Readers are Christian students (university). Circ. 30,000. Free sample copy. Photo guidelines free with SASE.

Photo Needs: Uses about 12 photos/issue; 4 supplied by freelance photographers. Needs photos of "stu-

dents-groups or singles (racially mixed).'

Making Contact & Terms: Arrange a personal interview to show portfolio. Query with samples. SASE. Reports in 1 month. Pays \$300/b&w cover photo; \$100/color cover photo; \$60/color inside photo. Pays on acceptance. Credit line given. Buys one-time rights. Simultaneous submissions and previously published work OK.

HOME, 140 E. 45th St., New York NY 10017. (212)682-4040. Editor: Olivia Buehl. Monthly. Circ. 700,000. Emphasizes "home remodeling, home building, home improving and interior design with special emphasis on outstanding architecture, good design and attractive decor." Readers are "home owners and others interested in home enhancement." Sample copy free with SASE.

Photo Needs: Uses 50-70 photos/issue; 100% provided by freelancers; "however, 95% are assigned rather than over the transom." Needs "4-color transparencies of residential interiors and exteriors—any subject dealing with the physical home. No lifestyle subjects covered." Model release and captions re-

quired.

Making Contact & Terms: Portfolio drop-off 5 days/week; same day pick-up; query with resume and samples; send transparencies ("4x5 and 2 1/4 are preferred") by mail for consideration; provide resume, business card, brochure, flyer or tearsheets to be kept on file for possible future assignments. Payments are in line with ASMP guidelines. "Material submitted on spec paid on publication. Assigned material paid on acceptance." Credit line given. Buys all rights.

Tips: Prefers to see "recent residential work showing a variety of lighting situations and detail shots as well as overall views. We accept only quality material and only use photographers who have the equip-

ment to handle any situation with expertise."

THE HOME SHOP MACHINIST, Box 1810, Traverse City MI 49685. (616)946-3712. Editor: Joe D. Rice. Bimonthly. Circ. 17,000. Emphasizes "machining and metal working." Readers are "amateur machinists, small commercial machine shop operators and school machine shops." Sample copy and photo guidelines free with SASE.

Photo Needs: Uses about 30-40 photos/issue; "most are accompanied by text." Needs photos of "machining operations, how-to-build metal projects." Special needs include "good quality machining oper-

ations in b&w."

Making Contact & Terms: Send 4x5 or larger b&w glossy prints by mail for consideration, SASE, Reports in 3 weeks. Pays \$40/b&w cover photo; \$9/b&w inside photo; \$30 minimum for text/photo package ("depends on length"). Pays on publication. Credit line given. Buys one-time rights. Simultaneous submissions OK.

Tips: "Photographer should know about machining techniques or work with a machinist. Subject should be strongly lit for maximum detail clarity."

*THE HOMEMAKER, 7375 E. Peakview Ave., Englewood CO 80111. (303)779-0077. Contact: Editor. Bimonthly magazine. Emphasizes homemaking. Readers are 98% + women, median age 46. Circ. 180,000. Sample copy \$2.

Photo Needs: Uses about 20 photos/issue; half supplied by freelance photographers. Subject needs are "usually very specific to illustrate articles. Photos purchased with accompanying ms. Model release

and captions required.

Making Contact & Terms: Query with samples or provide resume, business card, brochure, flyer or tearsheets to be kept on file for possible future assignments. SASE. Reports in 1 week. Pays \$100/color cover photo, \$15/b&w inside photo and \$25/color inside photo. Assignment rates negotiated. Pays on publication. Credit line given. Rights purchased are negotiated, usually one-time. Previously published work OK.

HORSE AND RIDER, 104 Ash Road, Sutton, Surrey, England SM3 9LD. Editor: Kate O'Sullivan. Monthly. Circ. 35,000. For adult horse enthusiasts.

Photo Needs: Needs general interest photos related to equestrian sports, personalities, trades and howto. Also photo stories, possibly with an instructional bias. Wants no photos of "riders incorrectly dressed" on thin/sick ponies with ill-fitting tack!"

Making Contact & Terms: Send by mail for consideration 5x7 or 8x10 b&w prints or 35mm color transparencies with SAE. Captions required. Payment insures first serial rights. Pays \$8.50 English cur-

rency/b&w photos; 40 pounds/color cover.

Tips: "Study the publication before submitting work. Photographer should have knowledge of and experience with horses to photograph them well.

HORSE & RIDER MAGAZINE, 41919 Moreno Rd., Temecula CA 92390. (714)676-5712. Photo Editor: Laurie Guidero. Monthly consumer mgazne. Emphasizes training and care of horses. Circ.

400,000. Sample copy \$2.60; free photo guidelines with SASE.

Photo Needs: Uses 45 photos/issue; 40 supplied by freelance photographers. Needs photos of horses, perfer action, verticals, slides or 8x10 prints. Riders should be wearing Western hats and boots. The horse should be the emphasis of the photo; the horse expression is also important. Reviews photos with

or without accompanying ms. Captions preferred.

Making Contact & Terms: Send 8x10, matte b&w or color prints; 35mm, 21/4x21/4 transparencies; b&w contact sheets with ms, b&w negatives with ms by mail for consideration. SASE. Reports in 1 month unless used in magazines. Pays \$100/color cover photo, \$5-30/inside b&w photo, \$5-50/color photo, \$50/page, and \$25-450/text/photo package. Pays prior to publication. Credit line given. Simultaneous submissions OK. Prefers "western riders" with the Marlboro man appearance. Be patient if your material is not published right away.'

*THE HORSE DIGEST, Patterson House, 4 Loudoun St. SE, Leesburg VA 22075. (703)777-6508. Managing Editor: Cathy Laws. Monthly. Emphasizes horses-all aspects of horse industry, both English and Western. Readers include young adult—average age 30—who own 1 or 2 horses. The audience used to be mostly children, but has changed with the focus on industry news. Free sample copy with SASE.

Photo Needs: Uses 20-40 photos/issue; 75% supplied by freelance photographers. "Needs photos of horses, horse equipment, people in horse industry. Reviews photos with or without accompanying ms. "Sometimes we do special reports and supplements—for example, a supplement on the unique environment (barns, pastures, etc.) is scheduled for late 1985." Model release and captions preferred.

Making Contact & Terms: Query with samples and list of stock photo subjects; provide resume, business card, brochure, flyer or tearsheets to be kept on file for possible future assignments. SASE. Reports in 3 weeks. Pays \$150/color cover, \$20-50/inside b&w. Pays on publication. Credit line given. Buys one-time rights. Simultaneous submissions and previously published work OK.

Tips: Prefers "b&w prints for inside consideration. Color slides for cover consideration. Be prepared to

show samples related to what we would be interested in-horse subjects."

HORSE ILLUSTRATED, Box 6050, Mission Viejo CA 92690. (714)498-1600. Editor: Jill-Marie Jones. Readers are "primarily young horsewomen who ride and show mostly for pleasure and who are very concerned about the well being of their horses." Circ. 40,000. Sample copy \$3; photo guidelines free with SASE.

Photo Needs: Uses 20-30 photos/issue, all supplied by freelance photographers. Specific breed featured every issue. Prefers "photos that show various physical and mental aspects of horses. Include environmental, action and portrait-type photos. Prefer people to be shown only in action shots (riding, grooming, treating, etc.). We also need good-quality, interesting b&w photos of any breed for use in feature articles." Model release required.

Making Contact & Terms: Send by mail for consideration actual 8x10 b&w photos or 35mm and 21/4x21/4 color transparencies. Reports in 6 weeks. Pays \$10-20 /b&w photo; \$50-100/color photo and \$50-250 per text/photo package. Credit line given. Buys first North American serial rights.

Tips: "Nothing but sharp, high contrast shots. Send SASE for a list of photography needs."

HORSEMAN, THE MAGAZINE OF WESTERN RIDING, 5314 Bingle Rd., Houston TX 77092. (713)688-8811. Editor: Linda Blake. Monthly magazine. Circ. 146,001. For youth and adult owners of stock-type horses who show, rodeo, breed and ride horses for pleasure or as a business. Needs how-to photos showing training, exhibiting and keeping horses. Buys 15-30 photos/issue. Buys first serial rights, all rights or first North American serial rights. Query first. Credit line given. Pays on publication. Reports in 1 month. SASE. Free sample copy and photo guidelines. B&W: Uses 5x7 or 8x10 glossy prints. Captions required. Pays \$15.

Color: Uses 35mm and 21/4x21/4 transparencies. Captions required. Pays \$30/photo.

Tips: "Photographing horses properly takes considerable technical skill. We use only a few photographers throughout the country and work with them on a personal basis. We want to see photos as part of a complete story effort. We want photo essays, with minimum text, both color and b&w, on Western horsemanship subjects." Wants no photos dealing with results of horse shows.

HORSEPLAY, 11 Park Ave., Box 545, Gaithersburg MD 20877. (301)840-1866. Publisher: John M. Raaf. Editor: Cordelia Doucet. Photo Editor: Cathy Heard. Monthly magazine. Circ. 50,000. Emphasizes horse shows and events and fox hunting. Photos purchased on assignment. Buys 150 photos/year, or 13 photos/issue. Pays \$50/job plus \$20/photo used. Credit line given. Pays on publication. Buys all rights, but may reassign to photographer after publication. Send material by mail for consideration. SASE. Reports in 1 month. Sample copy \$2.75.

Subject Needs: Animals, humorous, photo essay/photo feature and sport. No western riding shots.

Captions preferred.

B&W: Uses 8x10 semigloss prints. Pays \$20/photo.

Cover: Uses 35mm color transparencies. Vertical format required. Pays \$175 minimum/photo.

Accompanying Mss: Writer's guidelines free with SASE.

Tips: Needs "clear, uncluttered pix—send only best work. Know the subject matter well. The photographer must have a good understanding of horses and the sports in which they compete. Just because a photo has got a horse in it doesn't make it a good photo of a horse."

HORTICULTURE, 755 Boylston St., Boston MA 02116. Photo Editor: Tina Schwinder. Monthly magazine. Circ. 150,000. Emphasizes gardening, nursery procedures, plant disease, soils and equipment for people interested in horticulture. Buys 120-200 annually. Buys first North American serial rights. "We prefer written queries with specific suggestions first. If the query appeals to us, we may then contact the photographer to show us his portfolio. However, if promoting stock images, send samples and/or tearsheets of your best material." Pays on publication. Reports in 6 weeks. SASE. Free photo guidelines.

Subject Needs: Needs photos dealing with plants and their relationship with people. Needs good shots of both the usual and unusual in the area of horticulture. Complete picture stories are welcome.

B&W: Uses 8x10 glossy prints; send contact sheets. Negatives may be required. Captions required. Pays \$200/printed page.

Color: Uses transparencies of all sizes. Captions required. Pays \$200/printed page.

Cover: Uses color transparencies. Pays \$325.

Tips: "To ensure safe processing of the material, an accurate packing list and captions must accompany work submitted. Photos or transparencies should be numbered and a description of the subject must be included either on the photo or the packing list. Without an accurate description it is very difficult for us to make the best use of the material submitted. The owner's name must be on each item."

HOT BIKE/STREET CHOPPER, 2145 W. La Palma, Anaheim CA 92801. (714)635-9040. Editor: Paul Garson. Monthly. Emphasizes custom and high-performance motorcycles. Readers are motorcycling enthusiasts. Circ. 50,000. Sample copy \$2.25. Photo guidelines free with SASE.

Photo Needs: Uses about 200 photos/issue; 75 supplied by freelance photographers. Needs photos of motorcycle events, technical articles and motorcycle features. Special needs include photos of motorcycle events, feature bikes. Model release required; captions preferred.

Making Contact & Terms: Query with samples; send 5x7 b&w glossy prints; 35mm or 2¹/₄x2¹/₄ transparencies by mail for consideration. SASE. Reports in 2 weeks. Payment for text/photo package varies. Credit line given. Buys all rights.

Tips: "The work we need is basic. No artsy concepts; just clean, sharp, well-detailed photography."

HOT ROD MAGAZINE, 8490 Sunset Blvd., Los Angeles CA 90069. (213)657-5100. Editor: Leonard Emanuelson. Monthly magazine. Circ. 850,000. For enthusiasts of high performance and personalized automobiles. Typical subject areas include drag racing, street rods, customs, modified pickups, off-road racing, circle track racing. Will consider b&w and color photo features on individual vehicles; of race of event coverage with information; or b&w photos of technical or how-to subjects accompanied by text. However, best market is for "Roddin at Random" section, which uses single photo and/or short copy on any "newsy" related subject, and "Finish Line," which runs short pieces on a wide variety of vehicular racing or other competition. These sections pay \$50-150 per photo or item used. Model release necessary. Buys all rights. Credit line given. Pay on acceptance. Reports in 2 weeks. B&W: Send 8x10 glossy prints or contact sheets with negs. Pays \$50-250.

Color: Send transparencies. Pays \$100-500.

Tips: "Look at the magazine before submitting material. Use imagination, bracket shots, allow for cropping, keep backgrounds clean. We generally need very sharp, crisp photos with good detail and plenty of depth of field. Majority of material is staff generated; best sell is out-of-area (non-Southern

California) coverage, or items for new/human interest/vertical interest/curiosity columns (i.e., "Roddin' at Random" and "Finish Line"). Again, study the magazine to see what we want."

HOUSE BEAUTIFUL, 1700 Broadway, New York NY 10019. (212)903-5206. Editor: JoAnn Barwick. Art Director: Jeanne Dzienciol. Monthly magazine. Circ. 900,000. Emphasizes design, architecture, building and home improvement. Primarily for home-oriented women. Buys first serial rights or all rights. Present model release on acceptance of photo. Query with resume of credits or send photos for consideration. Pays on publication. Reports in 2 weeks. SASE. Free photo guidelines.

B&W: Send contact sheet. Captions required. Pays \$25-150 (based on space rates). Color: Send transparencies. Captions required. Pays \$25-250 (based on space rates). Tips: "Wants no travel photos. Study the magazine."

*HUDSON VALLEY MAGAZINE, Box 425, Woodstock NY 12498. (914)679-5100. Editor-in-Chief: Joanne Michaels. Monthly magazine. Emphasizes regional events, history, etc. Readers are upscale in both education and income; age 35-55, homeowners, most married. Circ. 26,750. Sample copy free with SASE and \$1.25 postage.

Photo Needs: Uses about 35 photos/issue; all supplied by freelance photographers. Needs photos of "local shops, hotels/inns, caterers/food (we have 2 dining guides each year)." Model release preferred;

captions required.

Making Contact & Terms: Query with resume of credits. SASE. Reports in 2 weeks. Pays \$5/b&w inside photo and \$10/color inside photo. Pays on publication. Credit line given. Buys one-time rights. Simultaneous submissions and previously published work OK.

HUSTLER MAGAZINE/CHIC MAGAZINE, 2029 Century Park E., Suite 3800, Los Angeles CA 90067. (213)556-9200. Contact: Photo Editor. Monthly magazine. Circ. 2,000,000. For the middleclass man, age 18-35.

Photo Needs: "High caliber, imaginative girl-sets in 35mm and 120 mm formats. Explicit and erotic pictorial and sequential. Sets must have a range from soft to hard. A model release is a must. We are opening up to both editorial and illustrative photography.'

Making Contact & Terms: Submit transparencies in plastic protector sheets: "We will return with a rejection/acceptance reply within 60-90 days." Pays \$300/page. "We assume all rights to photos."

*IDEALS MAGAZINE, 11315 Watertown Plank Rd., Milwaukee WI 53226. (414)771-2700. Editor: Dorothy Gibbs. Magazine published 8 times/year. Emphasizes "seasonal themes—bright flowers and scenics for Thanksgiving, Christmas, Easter and Mother's Day—all thematically related material. Other 4 issues are variable from year to year, but still overall seasonal in appearance." Readers are "mostly college-educated women who live in rural areas, aged 35-70." Circ. 200,000. Sample copy \$3.50. Photo guidelines free with SASE.

Photo Needs: Uses about 21 or 22 photos/issue; half supplied by freelance photographers. Needs photos of "bright, colorful flowers, scenics, primarily; subject-related shots depending on issue. We regularly send out a letter listing the photo needs for our upcoming issue." Model release required.

Making Contact & Terms: Query with samples. Send 35mm, 21/4x21/4 or 4x5 transparencies by mail for consideration. SASE. Reports in 1 month. Pays \$200-450/color cover photo, \$50-100/b&w inside photo, \$75-150/single color inside photo and \$150-300/double page spread. Pays on publication. Credit line given. Buys one-time rights. Simultaneous submissions OK.

Tips: "Would suggest the photographer purchase several recent issues of Ideals magazine and study photos for our requirements. Ideals' reputation is based on quality of its color reproduction of photos."

ILLINOIS MAGAZINE, Box 40, Litchfield IL 62056. (217)324-3425. Editor: Peggy Kuethe. Bimonthly. Emphasizes travel, history, current events, points of interest, people—all in Illinois. Readers are people primarily interested in Illinois history, (e.g. genealogists, teachers, students, historians), mostly rural. Circ. 12,000. Sample copy \$2.25. Photo guidelines free with SASE.

Photo Needs: Uses about 35-40 photos/issue; 90% supplied by freelance photographers. Needs "cover photos: 35mm vertical photos of Illinois scenes, natural attractions, points of interest, botanical sub-

jects." Model release preferred and captions required.

Making Contact & Terms: Query with list of stock photo subjects; send 35mm transparencies by mail for consideration. SASE. Reports in 1 month. Pays \$50/color cover photo; \$8/b&w inside photo. Pays on publication. Credit line given. Buys one-time rights. Previously published work OK. Tips: "Obtain a sample copy to see what we've published in the past—and stick to the standards already

set-we do not deviate.'

IMAGE MAGAZINE, Box 28048, St. Louis MO 63119. (314)752-3703. Managing Editor: Anthony J. Summers. Triannually. Circ. 700. Emphasizes literary arts. Readers are poets, writers, artists, photographers, students, thinkers. Sample copy \$3.

Photo Needs: Uses 4-15 photos/issue; "most" supplied by freelance photographers. Needs "unusual. creative shots, weird scenes." Model release and captions optional.

Making Contact & Terms: Query with samples. SASE. Reports in 2-6 weeks. Pays \$10-50 for text/

photo package. Pays on publication. Buys one-time rights.

IN TOUCH, Box 2000, Marion IN 46952. (317)674-3301. Editor: Jim Watkins. Weekly. Circ. 30.000. Emphasizes "Christian living." Readers are teens. Photo guidelines free with SASE.

Photo Needs: Uses about 5 photos/issue; all supplied by freelance photographers. Needs photos of "sharp-looking teens in school, home, church setting. Excessive makeup and jewelry offends some of our readers." Special needs include "Seventeen or Campus Life type 8x10 b&w cover shots." Model release and captions optional.

Making Contact & Terms: Query with samples; send 8x10 b&w glossy prints by mail for consideration. SASE. Reports in 2 weeks. Pays \$25/b&w cover photo; \$15-35/b&w inside photo. Pays on publication. Credit line given. Buys one-time rights. Simultaneous submissions and previously published

work OK.

INDIAN LIFE MAGAZINE, Box 3765, Station B, Winnipeg, Manitoba, Canada R2W 3R6. (204)949-9452. Editor: George McPeek. Bimonthly. Circ. 10,000. Emphasizes North American Indian people. Readers are members of Christian Indian churches spanning more than 30 denominations and missions. Sample copy \$1 (Canadian); photo guidelines free with SAE and International Reply Coupon. Photo Needs: Uses about 5 photos/issue; currently none are supplied by freelance photographers. Needs anything depicting Indian people in a positive light-monuments; historic sites; day-to-day life; crafts—most anything that covers some aspect of Canadian-U.S. Indian scene." Model release and captions required.

Making Contact & Terms: Query with samples or list of stock photo subjects; send 5x7 or larger b&w or color glossy prints; 35mm, 21/4x21/4, 4x5, 8x10 transparencies or b&w or color contact sheet by mail for consideration. Provide resume, business card, brochure, flyer or tearsheet to be kept on file for possible future assignments. SASE—must have Canadian postage or International Reply Coupon. Reports in 1 month. Pays \$10/b&w and \$25/color cover photo; \$5/b&w and \$10/color inside photo; \$25-50 for text/photo package. Pays on publication. Credit line given. Buys one-time rights. Simultaneous submissions and previously published work OK.

INDIANAPOLIS 500 YEARBOOK, Box 24308, Speedway IN 46224. (317)244-4792. Editor-in-Chief: Carl Hungness. Annually. Circ. 50,000. Emphasizes auto racing. Readers are auto racing fans. Sample copy \$14.95.

Photo Needs: Uses 750 photos/issue; 50% supplied by freelance photographers. Model release and cap-

tions required.

Making Contact & Terms: Query with 5x7 b&w/color glossy prints. SASE. Provide brochure, flyer and tearsheets to be kept on file for possible future assignments. Pays \$5/b&w inside, \$7/color inside. Pays on publication. Credit line given. Buys one-time rights. Simultaneous submissions and previously published work OK.

Tips: Need to submit race photos by June 10 for consideration.

INDIANAPOLIS MAGAZINE, 32 E. Washington St., Indianapolis IN 46204. (317)639-6600. Editor: Nancy Comiskey. City magazine. Emphasizes Indianapolis-related problems/features or regional related topics. Readers are "upper income and highly educated with broad interests." Monthly, Circ. 20,000. Sample copy \$1.75.

Photo Needs: Uses 40 photos/issue, 100% of which are supplied by freelance photographers. Photos must have "city focus; normally used to illustrate specific stories." Model release and captions re-

quired.

Making Contact & Terms: Send by mail for consideration b&w photos, 35mm, 21/4x21/4 or 4x5 color transparencies, b&w contact sheet or b&w negatives. Arrange personal interview to show portfolio or submit portfolio by mail for review. Prefers to see active pictures or candid pictures in a portfolio. Prefers to see "a good variety—people, design, arty, pictures that treat a potentially trite subject re-freshingly"—as samples. Provide calling card and tearsheets to be kept on file for possible future assignments. SASE. Reports in 2 weeks; "may be longer depending on production schedule and flow of material." Pays on publication \$30/b&w photo or \$50/color photo. Credit line given. Buys one-time rights. Simultaneous submissions and previously published work OK.

Tips: "We're looking for tighter pictures, more focus on a narrow object, e.g., a horse's face or a runner's leg instead of, or in addition to, the whole horse or whole body. Load your portfolio with unusual, good quality shots with unusual angles or lighting or design. We don't want to give a detailed outline of a picture when we make an assignment; we want the photographer to use his/her head and artistic talents.

We want to see those talents in the portfolio."

INSIDE DETECTIVE, Official Detective Group, 460 W. 34th St., 20th Floor, New York NY 10001. (212)947-6500. Editor: Rose Mandelsberg. Readers are "police buffs, detective story buffs, law and order advocates." Monthly. Circ. 400,000. Sample copy \$1.50; photo guidelines for SASE.

Photo Needs: "Only color covers are bought from freelance photographers. Subjects must be crime, police, detective oriented, man and woman. Action must portray impending disaster of a crime about to happen. No bodies. Modest amount of sensuality but no blatant sex." Model release required; captions not required.

Making Contact & Terms: Send by mail for consideration color photos or 35mm, 21/4x21/4 or 4x5 color transparencies. SASE. Reports in 1 month after monthly cover meetings. Pays on acceptance \$200/color photo. No credit line given. Buys all rights. No simultaneous or previously published submissions.

INSIGHT, Box 7244, Grand Rapids MI 49510. (616)241-5616. Art Editor: John Knight. Managing Editor: Martha Kalk. Magazine published monthly except June and August. Circ. 22,000. For "young people, age 15-21. They have Christian backgrounds and are well exposed to the Christian faith." Needs photos of young people in a variety of activities. No landscapes, sunsets, churches or still lifes. Prefers action shots of youth, young adults, faces, expressions, sports, hobbies, interaction, couples, multiracial subjects in a portfolio. Buys first North American serial rights, simultaneous rights, or second serial (reprint) rights. Send photos for consideration. Submit seasonal material 6 months in advance. Pays on publication. Reports in 1 month. SASE. Simultaneous submissions and previously published work OK. Free sample copy and editorial guidelines. Request should include a 9x12 SASE. B&W: Send 8x10 glossy prints. Pays \$15-30.

Color: Send transparencies. Pays \$150/cover; \$50 inside. Pays \$80-150 for text/photo package. Tips: "We like breezy, fresh stills that say 'youth' and portray an exuberant lifestyle. We're sensitive to

ethnic minorities.'

INSTRUCTOR MAGAZINE, 545 Fifth Ave., New York NY 10017. (212)503-2888. For elementary school teachers. Magazine published 9 times a year. Circ. 260,000. Photos are purchased with accompanying ms. Payment per job varies. Credit line given. Pays on acceptance. Purchases one-time rights. Query with list of stock photo subjects. SASE. Reports in 1 month. Free photo guidelines.

Subject Needs: Elementary school children, human interest, photo essay/photo feature (relating to elementary education), scenic ("if includes kids and relates to elementary education") and wildlife (educa-

tional). Model release required.

B&W: Uses 5x7 and 8x10 glossy prints. Pays \$20 minimum/photo.

Color: Uses 5x7 glossy prints and 35mm and 21/4x21/4 transparencies. Pays \$25 minimum/photo. Accompanying Mss: Seeks "manuscripts relating to elementary education, teachers, students, and all associated activities." Free writer's guidelines.

Tips:"No unsolicited photos, please!"

INTERNATIONAL GYMNAST, 410 Broadway, Santa Monica CA 90401. (213)451-8768. Publisher: Glenn M. Sundby. Editor: Dwight Normile. Monthly magazine. Circ. 26,000. Primarily for youngsters and teens interested in gymnastics; also for coaches, teachers, athletes, international gymnasts and their associations, schools and libraries. Rights purchased vary. Needs action shots. Send photos for consideration. Credit line given. Buys 10-15 photos/issue. Pays on publication. Reports in 1 month. SASE. Previously published work OK if published outside U.S. Sample copy \$1; free editorial guide-

B&W: Send 5x7 or 8x10 glossy prints with "loose cropping." Captions required. Pays \$3-8. Color: Send 35mm or 21/4x21/4 transparencies. Captions required. Pays \$10-35; pays up to \$50 for full color spread or for photos used as posters.

Cover: Captions required. Pays \$35.

Tips: "The magazine was born on, and grows on, voluntary writers and photographers. It is not on newsstands, so has a limited readership and therefore limited payments. We do encourage writers/photographers and will pay for quality material if need be. Must be gymnastic-oriented and all sources identified."

INTERNATIONAL WILDLIFE, 1412 16th St. NW, Washington DC 20036. (703)790-4000. Editor: John Strohm. Photo Editor: John Nuhn. Bimonthly magazine. Circ. 400,000. For outdoor enthusiasts, armchair travelers, hunters and fishermen; "our readers are concerned about the world environment, and they appreciate the drama and beauty of all the world's wildlife, both plant and animal." Buys 40-50 photos/issue. Buys one-time publication rights. Query with story ideas or send photos for consideration. Invite letters of inquiry and stock lists to be kept on file. Pays on acceptance. Reports in 4 weeks. SASE. Free photo guidelines.

Subject Needs: On an international level: mammals, birds, fish, reptiles, insects (action shots, closeups, sequence, complete picture stories, unusual, dramatic and humorous single shots); people and how

they live (environment issues, people profiles and adventure stories); flowers; plant life; scenics. Especially needs distinctive, cover-quality photos; b&w stories that use the medium to its fullest and would not be more effective in color; subjects in Canada, South America, Asia, West Africa, Eastern Eurone and islands. No pets or "wild" animals that have been domesticated; no garden flowers unless there is a very unusual story line.

B&W: Uses 8x10 glossy prints. Captions required. Pays \$125 minimum/single photo.

Color: Uses 35mm (prefer Kodachrome), 21/4x21/4 or 4x5 transparencies, Captions required, Pays \$125

minimum/single photo.

Tips: "International Wildlife magazine depends heavily on contributions from photographers, both professionals and outstanding amateurs, from around the world. We urge the photographer to think editorially. Although single photos are always needed for covers and inside use, we want the photographer's ideas on 'packaging' photos into a feature that will give the reader a different way of seeing a familiar or not so familiar place, or some aspect of wildlife. Study our last few issues to see how these packages are done. Also, we prefer to receive photos in protective sheets rather than slide boxes or rubber bands. We cannot accept cash, checks or money orders for payment of postage, so please ensure that the proper amount of stamps are glued to the return envelope." Also publishes National Wildlife which has the same needs within the U.S. Direct queries and submissions to the photo editor.

INTERSTATE, Box 7068, University Station, Austin TX 78713. (512)928-2911. Editor-in-Chief: Loris Essary, Photo Editor; Mark Loeffler, Annually, Circ. 500-600. Emphasizes art and literature. Readers are international, with interest in avant-garde. Sample copy \$5.

Photo Needs: Uses variable number photos/issue. "We are interested only in photography as art not as

illustrations."

Making Contact & Terms: Send by mail for consideration 8x10 b&w glossy prints. SASE. Reports "as soon as possible." Pays in contributor's copies. Pays on publication. Credit line given. Previously published work OK.

*THE IOWAN MAGAZINE, 214 Ninth St., Des Moines IA 50309. (515)282-8220. Editor: Charles W. Roberts, Ouarterly magazine. Emphasizes "Iowa—its people, places, events, and history." Readers are over 40, college-educated, middle to upper income. Circ. 23,000. Sample copy \$3.75. Photo guidelines free with SASE.

Photo Needs: Uses about 60-70 photos/issue; 50% by freelance photographers. Needs "Iowa scenics—

all seasons." Captions required.

Making Contact & Terms: Send b&w prints; 35mm, 21/4x21/4 or 4x5 transparencies; or b&w contact sheet by mail for consideration, SASE, Reports in 1 month. Pays \$50/color cover photo, \$45/color inside photo and \$150-400/text/photo package. Pays on publication. Credit line given. Buys one-time rights.

ISLANDS, 3886 State St., Santa Barbara Ca 93105. (805)682-7177. Photo Coordinator: Suzette Curtis. Bimonthly magazine. Circ. 110,000. Covers "all aspects of islands: people, scenics, architecture. sports, travel, underwater, flora and fauna, etc." Readers are "upscale, well-educated travelers and arm-chair traveler—Islomaniacs." Sample copy \$4.65; photo guidelines free with SASE.

Photo Needs: Uses about 100 photos/issue; all supplied by freelance photographers. Uses "a wide vari-

ety" of subjects as described above. Model release preferred; captions required.

Making Contact & Terms: Accepting queries from published professional travel photographers only. Ouery with resume and stock list of islands. Send at least 200 35mm, 21/4x21/4 and 4x5 transparencies by mail for consideration. SASE required. Reports in 1 month. Pays \$300/color cover photo; \$75/1/4 page, \$100/1/2 page, \$150/full page, \$200 crossover page. Assignments negotiated. Pays within 30 days after publication. Credit line given. Buys first worldwide serial rights. Simultaneous submissions OK. Tips: Prefers to see "superb composition, image quality and editorial applicability. Please label slide

mounts with photographer's name and include caption information."

IT WILL STAND, 1505 Elizabeth Ave., Charlotte NC 28204. (704)377-0700. Editor: Chris Beachley. Monthly. Circ. 2,500. Emphasizes music for middle to upper middle class, 18-55 years old. Sample copy free with 9x12 SASE.

Photo Needs: Uses about 50 photos/issue; none at the present are supplied by freelance photographers.

Needs photos of R&B musicians (list available) and/or shots of beaches (East Coast).

Making Contact & Terms: Query with list of stock photo subjects; send prints by mail for consideration. SASE. Reports in 1 month. Payment negotiable. Pays on publication. Credit line given. Buys all rights. Previously published work OK.

*THE ITINARY MAGAZINE, Box 1084, Bayonne NJ 07002-1084. (201)858-3400. Editor: Robert S. Zywicki. Bimonthly. Emphasizes travel for persons with disabilities. Circ. 5,000 + . Free sample copy and photo guidelines with SASE.

Photo Needs: Uses 10-15 photos/issue; 5 supplied by freelance photographers. Needs travel type photos—scenic—famous cities, etc. Especially showing people with disabilities in the photos, Reviews

photos with or without accompanying ms. Model release and captions required.

Making Contact & Terms: Query with samples and list of stock photo subjects; send 5x7 and 8x10 glossy b&w prints, b&w contact sheets by mail for consideration; submit portfolio for review; provide resume, business card, brochure, flyer or tearsheets to be kept on file for possible future assignments. SASE. Reports in 1 month. Pays \$25-100/job and \$100-300/text/photo package. Pays on publication. Credit line given. Buys one-time rights. Simultaneous submissions and previously published work OK. Tips: Prefers "travel photos with people, especially disabled. Disabled make up 20% of our population. Represent them in your photos showing other people."

*JAZZIZ MAGAZINE, Box 8309, Gainesville FL 32605-8309. (904)375-3705. Publisher: Michael Fagien. Bimonthly magazine. Emphasizes "the spectrum of jazz music." Circ. 45,000. Sample copy \$2. Photo guidelines free with SASE.

Photo Needs: Uses about 35 photos/issue; 20 supplied by freelance photographers. Needs photos of

"jazz musicians, color and b&w, playing or posed."

Making Contact & Terms: Query with samples and list of stock photo subjects. Send color or b&w prints by mail for consideration. Submit portfolio for review. SASE. Reports in 1 month. Payment by the job negotiable by contact. Pays on publication. Credit line given. Rights purchased negotiable. Simultaneous submissions OK.

Tips: Prefers to see "high quality photos with expression—photos which give the essence of inner feeling of the person phtographed."

*JOCK MAGAZINE, #210, 7715 Sunset Blvd., Los Angeles CA 90046. (213)850-5400. Editor: Timothy Neuman. Photo Editor: Alfonso Sabelli. Publication of the GPA. Monthly. Emphasizes gay male. Readers are young to old gay males, aged 18-60. Estab. 1985. Sample copy \$5; photo guidelines free with SASE.

Photo Needs: Uses 25 photos/issue; 75% supplied by freelance photographers. Needs nude shots of males. Photographic portfolios of artistically erotic subjects, etc. Reviews photos with or without ac-

companying ms. Model release and captions required...

Making Contact & Terms: Arrange a personal interview to show portfolio; query with samples and list of stock photo subjects; send 8x10 b&w and color glossy prints, 35mm, 21/4x21/4, 4x5 and 8x10 transparencies, b&w and color contact sheet, and negatives by mail for consideration. SASE. Reports in 1 month. Pays \$200-400/job. Pays on publication. Credit line given. Buys first North American serial rights. Simultaneous submissions OK.

Tips: "Work should be technically superior and subjects should be attractive. Shoot basic backgrounds

with good color usage, etc. Lighting continuity is important."

*JUNIOR RIDERS, Box 50384, St. Louis MO 63105. (314)4330. Editor: Beth Weston. Photo Editor: G.A. Smith. Company publication of the Flegel Publishing Co. Bimonthly. Emphasizes horses and horsemanship for young riders aged 12-14. Readers include young people who love horses. Circ. 1,970. Estab. 1984. Free sample copy and photo guidelines with SASE.

Photo Needs: Needs cover shots, illustrations for articles, wild photos and horses and young riders. Uses 20 photos/issue; 100% supplied by freelance photographers. Reviews photos with or without accom-

panying ms. Model release required; captions preferred.

Making Contact & Terms: Query with samples; send 5x7 glossy b&w print, b&w contact sheets by mail for consideration. SASE. Reports ASAP. Pays \$45-60/b&w cover photo and \$15-20/inside b&w photo. Pays on publication. Credit line given. Buys one-time rights. Simultaneous submissions OK. Tips: "I am looking for illustrative photos and a certain feel in cover photos—please contact me."

KANSAS, 6th Floor, 503 Kansas Ave., Topeka KS 66603. (913)296-3810. Editor: Andrea Glenn. Quarterly magazine. Circ. 40,000. Emphasizes Kansas scenery, arts, crafts and industry. Photos are purchased with or without accompanying ms or on assignment. Buys 60-80 photos/year. Credit line given. Pays on acceptance. Not copyrighted. Send material by mail for consideration. SASE. Previously published work OK. Reports in 1 month. Free sample copy and photo guidelines.

Subject Needs: Animal, documentary, fine art, human interest, nature, photo essay/photo feature, scenic, sport, travel and wildlife, all from Kansas. No nudes, still life or fashion photos. Transparencies

must be identified by location and photographer's name.

Color: Uses 35mm, 21/4x21/4 or 4x5 transparencies. Pays \$25 minimum/photo.

Cover: Uses 35mm color transparencies. Vertical and horizontal format required. No black and whites. Pays \$35 minimum/photo.

Accompanying Mss: Seeks mss on Kansas subjects. Pays \$75 minimum/ms. Free writer's guidelines. Tips: Kansas-oriented material only. Prefers Kansas photographers.

KEEPIN' TRACK OF VETTES, Box 48, Spring Valley NY 10977. Editor: Shelli Finkel. Monthly magazine. Circ. 30,000 monthly, plus additional 50,000 on newsstands February, June and October. For people interested in Corvette automobiles. Buys all rights. Send contact sheet or photos for consideration. Credit line given. Photos purchased with accompanying ms. Pays on publication. Reports in 6 weeks. Free sample copy and editorial guidelines.

Subject Needs: Needs interesting and different photos of Corvettes and picture essays. Human interest,

documentary, celebrity/personality, product shot and humorous.

B&W: Send contact sheet or 5x7 or 8x10 glossy prints. Pays \$10-100 for text/photo package.

Color: Send transparencies. Pays \$25-150 for text/photo package.

KEYBOARD, 20085 Stevens Creek Blvd., Cupertino CA 95014. (408)446-1105. Editor: Tom Darter. Photo Editor: Bob Doerschuk. Monthly magazine. Circ. 63,000. Emphasizes "biographies and feature articles on keyboard players (pianists, organists, synthesizer players, etc.) and keyboard-related material. It is read primarily by musicians to get background information on their favorite artists, new developments in the world of keyboard instruments, etc." Photos purchased with or without accompanying ms and infrequently on assignment. Buys 10-15 photos/issue. Pays on a per-photo or per-job basis. Pays expenses on assignment only. Credit line given. Pays on publication. Buys rights to one-time use with option to reprint. Query with list of stock photo subjects. SASE. Send first class to Bob Doerschuk. Simultaneous submissions OK. Reports in 2-4 weeks. Free sample copy and photo guidelines.

Subject Needs: Celebrity/personality (photos of pianists, organists and other keyboard players at their instruments). No "photos showing only the face, unless specifically requested by us; no shots where either the hands on the keyboard or the face are obscured." Captions required for historical shots only.

B&W: Uses 8x10 glossy prints. Pays \$35-75/photo.

Color: Uses 35mm color transparencies for cover shots. Vertical format preferred. Leave space on left-hand side of transparencies for cover shots. Pays \$250/photo; for cover, \$50-100 for shots used inside.

Accompanying Mss: Free photographer's and writer's guidelines.

Tips: "Send along a list of artist shots on file. Photos submitted for our files would also be helpful—we'd prefer keeping them on hand, but will return prints if requested. Prefer live shots at concerts or in clubs. Keep us up to date on artists that will be photographed in the near future. Freelancers are vital to *KM*."

KITE LINES, 7106 Campfield Rd., Baltimore MD 21207-4699. (301)484-6287. Publisher-Editor: Valerie Govig. Quarterly. Circ. 8,000. Emphasizes kites and kiteflying exclusively. Readers are international adult kiters. Sample copy \$3.00; photo guidelines free with SASE.

Photo Needs: Uses about 40 photos/issue; "50-80% are unassigned and over-the-transom—but nearly all are from *kiter*-photographers." Needs photos of "unusual kites in action (no dimestore plastic kites), preferably with people in the scene (not easy with kites). Needs to relate closely to *information* (article or long caption)." Special needs include major kite festivals; important kites and kiters. Captions required.

"Identify kites as well as people."

Making Contact & Terms: Query with samples or send 2-3 b&w 8x10 uncropped prints or 35mm or larger transparencies by mail for consideration. Provide relevant background information, i.e., knowledge of kites or kite happenings. SASE. Reports in "2 weeks to 2 months (varies with workload, but any obviously unsuitable stuff is returned quickly—in 2 weeks." Pays \$0-30 per inside photo; \$0-50 for color cover photo; special jobs on assignment negotiable; generally on basis of expenses paid only. "Important to emphasize that we are not a paying market and usually do not pay for photos. Sometimes we pay lab expenses. Also we provide extra copies to contributors. Our limitations arise from our small size and we hope to do better as we grow. Meantime, Kite Lines is a quality showcase for good work and helps build reputations. Also we act as a referral service between paying customers and kite photographers. This helps us feel less stingy! Admit we can do this because we cater to kite buffs, many of whom have cameras, rather than photographers who occasionally shoot kites." Pays on acceptance. Buys one-time rights. Usually buys first world serial rights. Previously published work OK. "There are no real competitors to Kite Lines, but we avoid duplicating items in the kite newsletters."

Tips: "Just take a great kite picture, and be patient with our tiny staff."

LAKELAND BOATING, 106 W. Perry St., Port Clinton OH 43452. (419)734-5774. Editor: David G. Brown. Photo Editor: Carol B. Brown. Monthly magazine. Circ. 47,000. Covers freshwater pleasure boating focusing on the Great Lakes and major rivers of the Midwest. Photos purchased with or without accompanying ms and on assignment.

Payment & Terms: Pays \$35-250 for text/photo package or on a per-photo basis. Credit line given. Pays in the month of publication. Buys one-time rights. Send photo/text packages by mail for consider-

ation or query. SASE. Reports in 4-6 weeks. Sample copy \$2.

Subject Needs: "Cruising" (real life experiences motoring or sailing on fresh water); Great Lakes boat-

316 Photographer's Market '86

ing action; river boating, houseboating; and people on boats. Cannot use salt water settings.

B&W: Uses 4x5 to 8x10 prints or negatives. **Color:** Uses 35mm or 2¹/₄x2¹/₄ transparencies.

Cover: Uses transparencies.

Tips: "Must shoot from a boat—shore shots almost never make it. 'Mood' shots (sunsets, seagulls, rusty buoys, etc.) not needed. We want colorful, lively shots of people enjoying boating. Look carefully at current issues, then query."

THE LAUGHING MAN MAGAZINE, 750 Adrian Way, Suite III, San Rafael CA 94903. (707)994-8281. Art Director: James Lampkin, Matt Barna. Director: Ron Straus. Quarterly. Emphasizes "the alternative to scientific materialism and religious provincialism—as experienced in all aspects of life." Readers are "upper middle class, educated to college or graduate degree status, who are interested in literally a new understanding of life." Circ. 10,000 +.

Photo Needs: Uses about 30-50 photos/issue; 10-20 supplied by freelance photographers. Needs are "almost impossible to say—shots are usually designed or suggested by art director to accompany editorial—people, places, objects . . .!" Photos purchased with accompanying ms only. Special needs include "science, technology, wealth, health, dancers and artisans, ethnic groups, humorous images

(clever)." Model release required.

Making Contact & Terms: Query with samples; send b&w prints or 35mm transparencies by mail for consideration; submit portfolio for review. SASE. Reports in 3 weeks. Pays \$500/color cover photo; \$100/b&w inside page. Pays on "time agreed." Credit line given. Buys one-time rights. Previously published work OK.

Tips: "Regard us as good exposure to target audience worldwide rather than a major source of income."

LET'S LIVE, 444 N. Larchmont Blvd., Los Angeles CA 90004. (213)469-3901. Art Director: John DeDominic. Monthly. Circ. 125,000. Emphasizes nutrition, health and recreation. Readers are "health-oriented typical family-type Americans seeking advice on food, nutritional supplements, dietary and exercise guidelines, preventive medicine, drugless treatment and latest research findings.

Ages: 20-35 and 49-70." Sample copy \$1.50; photo guidelines for SASE.

Photo Needs: Uses 9-15 photos/issue, 6 supplied by freelance photographers. Needs "candid life scenes; before-and-after of people; celebrities at work or leisure; glamour close-ups; organic uncooked foods; 'nature' views; sports; human organs (internal only); cross-sections of parts and systems (from color art or models); celebrities who are into nutrition and exercise; travel is OK if connected with food, medical research, triumph over disease, etc.; 'theme' and holiday motifs that tie in with health, health foods, clean living, preferably staged around known celebrity. Emphasis on upbeat, wholesome, healthy subject or environment with strong color values for bold full-page or double-truck layouts." Model release required; captions not required, but preferred when explanatory.

Making Contact & Terms: Send by mail for consideration 5x7 or 4x5 b&w or color prints, 35mm color transparencies, or tearsheets with publication name identified; write or call (do *not* call collect); or query with list of stock photo subjects. Provide calling card, club/association membership credits, flyer, samples and tearsheets to be kept on file for possible future assignments. SASE. Reports in 3-5 weeks. Pays on publication \$17.50/b&w photo; \$20/color transparency; \$50-200 for text/photo package. Credit line given. Buys first North American serial rights. Simultaneous submissions and previously published

work OK.

LET'S GO, 1st Floor, 9 Kingsway, London WC2B 6XF, England. (01)379-7995. Editors: Ray Watson, Stephen Roe. Bimonthly in-flight magazine of British Caldonian Airway. Readers include travellers—mostly on business, mostly British, European or American. Circ. 80,000. Sample copy free with SASE.

Photo Needs: Uses 50 photos/issue; 90% supplied by freelance photographers. Needs include showbiz personalities; general-interest photo features. Reviews photos with or without accompanying ms, syn-

opsis preferred. Model release and captions preferred.

Making Contact & Terms: Query with list of stock photo subjects; provide resume, business card, brochure, flyer or tearsheets to be kept on file for possible future assignments. SASE. Reports in 2 weeks. Pays \$200/color cover photo, \$30-50/inside b&w photo, \$40/inside color, \$70-100/page; price for text/photo package varies. Pays on publication. Credit line given. Buys one-time rights. Simultaneous submissions OK.

LETTERS, 310 Cedar Lane, Teaneck NJ 07666. Editor-in-Chief: Jackie Lewis. Monthly. Emphasizes "sexual relations between people, male/female; male/male; female/female." Readers are "primarily male, older; some younger women." Sample copy \$2.50.

Photo Needs: Uses about 1 photo/issue; all supplied by freelance photographers. Needs photos of scantily attired females; special emphasis on shots of semi- or completely nude buttocks. Model release re-

quired.

Making Contact & Terms: Query with samples. Send 8x10½ b&w and color glossy prints or 35mm 2½x2¼ slides or b&w contact sheet by mail for consideration. Provide brochure, flyer and tearsheets to be kept on file for possible future assignments. SASE. Reports in 2-3 weeks. Pays \$150/color cover photo. Pays on publication. Buys first North American serial rights.

Tips: Would like to see "material germane to our publication's needs. See a few issues of the publication

before you send in photos."

LIBERTY MAGAZINE, 6840 Eastern Ave., NW, Washington DC 20012. (202)722-6691. Editor: Roland R. Hegstad. Bimonthly magazine. Circ. 400,000. Emphasizes subjects related to religious freedom and church-state separation issues, federal involvement in church activities and Sunday laws. For federal, state and local government officials, attorneys, educators, ministers, doctors and laymen interested in the field of religious liberty. "Photographs are purchased to accompany mss, usually, but on occasion we can use photos on religious liberty themes independent of or to accompany other articles." Buys first serial rights. Send a small sample selection of work with query letter. Credit line given. Pays on acceptance. Reports in 4 weeks. SASE. Simultaneous submissions OK. Sample copy \$1. Guidelines for SASE.

B&W: Send glossy 5x7 or larger prints, or negatives. Pays \$35.

Color: Send prints or transparencies (negatives preferred) suitable for inside or outside cover. Pays \$200 minimum for cover photo; \$45-50 for inside single photo; \$150 for inside package/series.

Tips: "We print only church-state material." Photos must relate to this theme.

LIFE, Time-Life Bldg., Rockefeller Center, New York NY 10020. (212)841-4523. Photo Editor: John Loengard. Deputy Picture Editor: Melvin L. Scott. Assistant Photo Editor: Bobbi Baker Burrows. Monthly magazine. Circ. 1,400,000. Emphasizes current events, cultural trends, human behavior, nature and the arts, mainly through photojournalism. Readers are of all ages, backgrounds and interests. Photo Needs: Uses about 100 photos/issue. Prefers to see topical and unusual photos. Must be up-to-the minute and newsworthy. Send photos that could not be duplicated by anyone or anywhere else. Especially needs humorous photos for last page article "Just One More."

Making Contact & Terms: Send material by mail for consideration. SASE. Uses 35mm, 21/4x21/4, 4x5

and 8x10 slides. Pays \$400-500/page; \$750/cover. Credit line given. Buys one-time rights.

Tips: "Familiarize yourself with the topical nature and format of the magazine before submitting photos and/or proposals."

LIGHT AND LIFE, 901 College Ave., Winona Lake IN 46590. (219)267-7656. Managing Editor: Lyn Cryderman. Monthly magazine. Circ. 48,000. Emphasizes Evangelical Christianity with Wesleyan slant for a cross-section readership. Photos purchased on freelance basis. Buys 5-10 photos/issue. Credit line given. Pays on publication. Buys one-time rights. Send material by mail for consideration. Provide letter of inquiry and samples to be kept on file for possible future assignments. SASE, postage or check. Simultaneous submissions and previously published work OK. Reports in 1 month. Sample copy, photo guidelines, and cover directions \$1.50.

Subject Needs: Head shot, human interest, children, parent/child, family, couples, scenic, some special effects (symbolic and religious ideas) and unposed pictures of people in different moods at work and play. No nudes, no people with immodest dress, no sexually suggestive shots. Model release required.

B&W: Uses 8x10 glossy or semigloss prints. Pays \$10 minimum/photo.

Cover: Uses color slides. Vertical preferred. Prefers to tie covers in editorially. Pays \$25/photo. Tips: "Send seasonal slides for covers four months in advance. Study the magazine, then show us your work. Send us 10-15 prints, then be patient."

LIGHTS AND SHADOWS, Box 27310, Market Square, Philadelphia PA 19150. (215)224-1400. Editor: R.W. Lambert. Magazine consisting entirely of freelance photography. Buys first rights. Submit material by mail for consideration. Reports in 1 month. SASE. Previously published work OK.

B&W: Send 8x10 glossy prints. Typical payment is \$50.

Color: Send 35mm or 21/4x21/4 transparencies. Typical payment is \$100.

LILITH, Suite 1328, 250 W. 57 St., New York NY 10019. (212)757-0818. Editor: Susan Weidman Schneider. Quarterly magazine. Circ. 10,000. Emphasizes women's issues in a Jewish context for Jewish men and women and interested non-Jews. Needs photos of "Jewish women of all ages, particularly when involved in new roles or women's conferences or rituals—praying together, playing together, building a succah, etc." Buys 50 photos/year. Buys all rights. Submit model release with photo. Arrange a personal interview to show portfolio or send contact sheets or photos for consideration. Provide samples and tearsheets to be kept on file for possible future assignments. Pays on publication. Reports in 4-6 weeks. SASE. Simultaneous submissions OK. Sample copy \$4.

B&W: Send contact sheet or 5x7 glossy prints. "We can transfer color photos to b&w." Captions re-

quired. Pays \$10 minimum.

LIVE!, 801 Second Ave., New York NY 10017. (212)661-7878. Managing Editor: Christopher Wagner, Monthly. Circ. 425,000. Emphasizes the "erotic, glamourous and on-location shootings." Readers are males 18-40.

Photo Needs: Uses about 200 photos/issue; all supplied by freelance photographers. Needs "erotic coverage of adult entertainment events all over United States and Canada." Model release required. Making Contact & Terms: Query with samples; send 35mm or 21/4x21/4 transparencies by mail for consideration. SASE. Reports in 2 weeks. Payment is "negotiable if we are interested in material." Pays on publication. Credit line given. Buys first North American serial rights. Tips: "Study a recent issue."

LIVE STEAM MAGAZINE, Box 629, Traverse City MI 49685. (616)941-7160. Editor-in-Chief: Joe D. Rice. Monthly. Circ. 13,000. Emphasizes "steam-powered models and full-size equipment (i.e., locomotives, cars, boats, stationary engines, etc.)." Readers are "hobbyists-many are building scale models." Sample copy and photo guidelines free with SASE.

Photo Needs: Uses about 80 photos/issue; "most are supplied by the authors of published articles." Needs "how-to-build (steam models), historical locomotives, steamboats, reportage of hobby model steam meets. Unless it's a cover shot (color), we only use photos with ms." Special needs include

"strong transparencies of steam locomotives, steamboats, or stationary steam engines."

Making Contact & Terms: Query with samples. Send 3x5 b&w glossy prints by mail for consideration. SASE. Reports in 3 weeks. Pays \$40/color cover photo; \$8/b&w inside photo; \$30/page plus \$8/ photo; \$25 minimum for text/photo package (maximum payment "depends on article length"). Pays on publication—"we pay bimonthly." Credit line given. Buys one-time rights. Simultaneous submissions OK.

Tips: "Be sure that mechanical detail can be seen clearly. Try for maximum depth of field."

THE LOOKOUT, Standard Publishing, 8121 Hamilton Ave., Cincinnati OH 45231. (513)931-4050. Editor: Mark A. Taylor. Weekly magazine. Circ. 150,000. For adults in conservative Christian Sunday schools interested in family, church, Christian values, answers to current issues and interpersonal relationships. Buys 2-5 photos/issue. Buys first serial rights, second serial (reprint) rights or simultaneous rights. Send photos for consideration to Ralph M. Small, publisher. "His office will circulate your work among about two dozen other editors at our company for their consideration." Credit line given if requested. Pays on acceptance. Reports in 2-6 weeks. SASE. Simultaneous submissions and previously published work OK. Sample copy 50¢; free photo guidelines for SASE.

Subject Needs: Head shots (adults in various moods/emotions); human interest (families, scenes in church and Sunday school, groups engrossed in discussion).

B&W: Send contact sheet or 8x10 glossy prints. Pays \$10-25. Color: Send 35mm or 21/4x21/4 transparencies. Pays \$25-150.

Cover: Send 35mm or 21/4x21/4 color transparencies. Needs photos of people. Pays \$50-150. Vertical shots preferred; but "some horizontals can be cropped for our use."

LOS ANGELES MAGAZINE, 1888 Century Park E., Los Angeles CA 90067. (213)552-1021. Editor: Geoff Miller. Associate Art Director: James Griglak. Editorial Coordinator and Photo Editor: Judith Grout. Monthly magazine. Circ. 160,000. Emphasizes sophisticated southern California personalities and lifestyle, particularly Los Angeles area. Most photos are purchased on assignment, occasionally with accompanying ms. Provide brochure, calling card, flyer, resume and tearsheets to be kept on file for possible future assignments. Buys 45-50 photos/issue. Pays \$50 minimum/job. Credit line given. Pays on publication. Buys first serial rights. Submit portfolio for review. SASE. Simultaneous submissions and previously published work OK. Reports in 2 weeks.

Subject Needs: Celebrity/personality, fashion/beauty, human interest, head shot, photo illustration/ photo journalism, photo essay/photo feature (occasional), sport (occasional), food/restaurant and trav-

el. Most photos are assigned.

B&W: Send contact sheet or contact sheet and negatives. Pays \$50-100/photo.

Color: Uses 4x5, 21/4x21/4 or 35mm transparencies. Pays \$50-200/photo.

Cover: All are assigned. Uses 21/4x21/4 color transparencies. Vertical format required. Pays \$400/photo. Accompanying Mss: Pays 10¢/word minimum. Free writer's guidelines.

Tips: To break in, "Bring portfolio showing type of material we assign. Leave it for review during a business day (a.m. or p.m.) to be picked up later. Photographers should mainly be active in L.A. area and be sensitive to different magazine styles and formats.

*LOS ANGELES READER, 8471 Melrose Ave., 2nd Floor, Los Angeles CA 90069. (213)655-8810. Editor: Dan Barton. Art Director: Miriam King. Weekly newspaper. Emphasizes entertainment. Readers are "hip, affluent, well-educated young adults in Los Angeles." Circ. 82,000. Sample copy free with SASE and \$1.00. Photo guidelines free with SASE.

Photo Needs: Uses about 10 photos/issue; all by freelance photographers. Needs "Los Angeles or Southern California subject matter only." Model release and captions required.

Making Contact & Terms: Submit portfolio for review. SASE. Reports in 1 month. Pays \$60/b&w cover photo, \$200/color cover photo, \$30/b&w inside photo. Pays on publication. Credit line given. Buys one-time rights.

Tips: Prefers to see "(1) technical competence in photography; (2) good eye; (3) ability to work under pressure."

*LOTTERY & GAMING REVIEW, 2306 Church Rd., Cherry Hill NJ 08002. (609)667-0501. Editor: John A. Murphy. Photo Editor: Brent Ottaway. Monthly. Emphasizes lotteries, bingo games, casinos. Readers include 21 to 80 lottery and game players, casino-goers. Circ. 65,000. Estab. 1984. Sample copy free with SASE.

Photo Needs: Uses 5 photos/issue; none currently supplied by freelancers. Needs b&w of lottery winners, slot winners, etc. with captions. Reviews photos with or without accompanying ms. Model release

preferred; 25-50 word caption required.

Making Contact & Terms: Send 5x8 or 9x12 unsolicited photos by mail for consideration. SASE. Reports in 3 weeks. Pays \$35-50/b&w inside photo with caption. Pays on publication. Credit line given. Buys one-time rights. Simultaneous submissions and previously published work OK.

Tips: "Call (609)667-0501 for a briefing."

LOUISVILLE MAGAZINE, One Riverfront Plaza, Suite 604., Louisville KY 40202. (502)566-5050. Editor: Betty Lou Amster. Managing Editor: Jim Oppel. Monthly magazine. Circ. 20,000. Emphasizes community and business developments for residents of Louisville and vicinity who are involved in community affairs. Buys 12 photos/issue. Buys all rights, but may reassign to photographer after publication. Model release required "if photo presents an apparent legal problem." Submit portfolio. Photos purchased with accompanying ms; "photos are used solely to illustrate accompanying text on stories that we have already assigned." Works with freelance photographers on assignment only basis. Provide calling card, portfolio, resume, samples and tearsheets to be kept on file for possible future assignments. Pays on publication. Reports in 1 week. SASE. Sample copy \$1.

Subject Needs: Scenes of Louisville, nature in the park system, University of Louisville athletics, fashion/beauty and photo essay/photo feature on city life. Needs photos of people, places and events in and

around the Louisville area.

B&W: Send 8x10 semigloss prints. Captions required. Pays \$10-25.

Color: Send transparencies. Captions required. Pays \$10-25.

Cover: Send color transparencies. Uses vertical format. Allow space at top and on either side of photo

for insertion of logo and cover lines. Captions required. Payment negotiable.

Tips: "All ideas must focus on the Louisville market. A photographer's portfolio, of course, may be broader in scope." Wants no prints larger than 11x14 or smaller than 5x7; 8x10 preferred. Annual Kentucky Derby issue needs material dealing with all aspects of Thoroughbred racing. Deadline for submissions: January 1.

THE LUTHERAN, 2900 Queen Lane, Philadelphia PA 19129. (215)438-6580. Editor: Edgar R. Trexler. Photo Editor: Bernhard Sperl. Biweekly magazine. Circ. 570,000. For members of congregations of the Lutheran church in America. Needs photos of church activities, family life and photos related to social issues, prayer life, etc. Wants no "posed, stilted photos or photos that are not contemporary in hair styles, clothing, etc. No Polaroids; no Instamatic." Buys "several" annually. Buys first serial rights. Send photos for consideration. Pays on acceptance. Reports in 1 month. SASE. Simultaneous submissions and previously published work OK. Free photo guidelines.

B&W: Send 8x10 glossy prints. Pays \$20-30.

Cover: Send 35mm color transparencies. Pays \$75-100.

LUTHERAN FORUM, 308 W. 46th St., New York NY 10036. (212)757-1292. Editor: Glenn C. Stone. Emphasizes "Lutheran concerns, both within the church and in relation to the wider society, for the leadership of Lutheran churches in North America." Quarterly. Circ. 4,500. Sample copy \$1.50. **Photo Needs:** Uses 6 photos/issue, 3 supplied by freelance photographers. "While subject matter varies, we are generally looking for photos that include people, and that have a symbolic dimension. We use few purely 'scenic' photos. Photos of religious activities, such as worship, are often useful, but should not be 'cliches'—types of photos that are seen again and again." Model release not required; captions not required but "may be helpful."

Making Contact & Terms: Query with list of stock photo subjects. SASE. Reports in 1-2 months. Pays on publication \$12.50-20/b&w photo. Credit line given. Buys one-time rights. Simultaneous or previ-

ously published submissions OK.

THE LUTHERAN JOURNAL, 7317 Cahill Rd., Edina MN 55435. (612)941-6830. Editor: Rev. Armin U. Deye. Photo Editor: John Leykom. Quarterly magazine. Circ. 136,000. Family magazine for Lutheran Church members, middle aged and older.

Photo Needs: Uses about 6 photos/issue; 1 or 2 of which are supplied by freelance photographers. Needs "scenic—inspirational." Captions not required but invited; location of scenic photos wanted.

Making Contact & Terms: Send by mail for consideration actual b&w or color photos or 35mm, 2¹/₄x2¹/₄ and 4x5 color transparencies. SASE. Pays on acceptance \$5/b&w photo; \$5-10/color transparency. Credit line given. No simultaneous submissions.

THE LUTHERAN STANDARD, 426 S. 5th St., Box 1209, Minneapolis MN 55440.(612)330-3300. Editor: Lowell Almen. Biweekly magazine. Circ. 574,000. Emphasizes news in the world of religion, dealing primarily with the Lutheran church. For families who are members of congregations of the American Lutheran Church.

Photo Needs: Needs photos of persons who are members of miniority groups. Also needs photos of families, individual children, groups of children playing, adults (individual and group). Buys 100 annually. Buys first serial rights or simultaneous rights. Send photos for consideration. Pays on acceptance or publication. Reports in 4-6 weeks. SASE. Simultaneous submissions and previously published work OK. Free sample copy and photo guidelines.

Making Contact & Terms: Send inquiries to James Lipscomb, Augsburg Publishing House, 426 S. 5th St., Box 1209, Minneapolis MN 55440. Send contact sheet or 8x10 glossy or semiglossy b&w prints. Pays \$15-35.

Tips: No obviously posed shots. Wants photos of "real people doing real things. Find shots that evoke emotion and express feeling."

McCALLS MAGAZINE, 230 Park Ave., New York NY 10169. (212)551-9430. Editor: Robert Stein. Art Director: Modesto Torre. Monthly magazine. Circ. 6,200,000. Emphasizes personal relationships, health, finance and current events for the contemporary woman. Query first. Drop off portfolio for review. All photos done on assignment only basis. Payment negotiable.

*THE MAGAZINE OF UTAH, C.S.B. Tower, Suite 600, 50 S. Main, Salt Lake City UT 84144. (801)521-9467. Bimonthly. Emphasizes scenic—nature, human interest, high tech, travel, adventure. Note: Diverse subjects but all driven by high quality photography. Readers are 25-44 years old, most are college educated and earn an average of \$40,000. Seventy one percent traveled in 1984, either on business or for vacation; 81% traveled by air. Circ. 15,000. Estab. 1985. Free sample copy and photo guidelines with SASE.

Photo Needs: Uses 70-85 photos/issue; 90% supplied by freelance photographers. Needs travel, scenic, Utah high-tech, human interest (local), adventure. Reviews photos with or without accompanying ms. Model release preferred.

Making Contact & Terms: Query with resume of credits, send unsolicited photos by mail for consideration, provide resume, business card, brochure, flyer or tearsheets to be kept on file for possible future assignments. Uses b&w 35mm, 21/4x21/4 or 4x5 transparencies. SASE. Reports in 1 month. Pay individually negotiated. Pays on publication. Credit line given. Buys one-time rights. Simultaneous submissions OK.

MANDATE, 11th Floor, 155 Avenue of the Americas, New York NY 10013. (212)691-7700. Editor-in-Chief: Sam Staggs. Monthly. Emphasizes male nudes, presented tastefully. Readers are gay men whose ages range from under 20 to 60 and beyond, (median ages 25-40); some women readers who prefer *Mandate* to *Playgirl*. Circ. 100,000. Sample copy \$5. Photo guidelines free with SASE.

Photo Needs: Uses about 50 photos/issue; all supplied by freelance photographers. Needs photos of attractive men who look like fashion models, photographed nude in imaginative settings; erections permitted; also, head shots for cover consideration. Model release required.

Making Contact & Terms: Send b&w glossy prints; 35mm transparencies; b&w contact sheet; b&w negatives by mail for consideration. SASE. Reports in 1 month. Pays \$200/color cover photo; \$75/full-page color inside photo; and \$50/full-page b&w photo. Pays on publication. Credit line given. Buys first North American serial rights.

MARIAN HELPERS BULLETIN, Eden Hill, Stockbridge MA 01262. (413)298-3691. Editor: Father Donald Van Aistyne, MIC. Quarterly magazine. Circ. 1,000,000. Readers are Catholics of varying ages with moderate religious views and general education. Pays \$35-55 for text/photo package and on a per-photo basis. Credit line given. Pays on acceptance. Not copyrighted. Send material by mail for consideration. SASE. Simultaneous submissions and previously published work OK. Reports in 4-8 weeks. Free sample copy.

B&W: Uses 8x10 glossy prints. Pays \$10 minimum/photo.

Color: Uses 5x7 prints. Pays \$15 minimum/photo.

Cover: Uses b&w or color prints. Vertical format preferred. Pays \$15 minimum/photo.

Accompanying Mss: Seeks mss 400-1,100 words in length on devotional, spiritual, moral and social topics "with a positive and practical emphasis." SASE. Pays \$35 minimum/ms.

MARRIAGE AND FAMILY LIVING MAGAZINE, Abbey Press, St. Meinrad IN 47577. (812)357-8011. Photo Editor: Jo R. Brahm. Monthly magazine. Circ. 50,000. Emphasizes Christian marriage and family enrichment for parents, couples, counselors and priests. Buys 100-120 photos/year. Credit line given. Pays on publication. Buys one-time rights. Query with samples. SASE. Reports in 1-3 months. Free guidelines; sample copy 50¢.

Subject Needs: Photos of couples, families, teens, or children; candids; and a few scenics. Photos

should suggest mood or feeling. No posed, studio-style shots.

B&W: Uses 8x10 glossy prints. Pays \$15-35/photo.

Cover: Uses color transparencies or 35mm slides. Pays \$150/color cover. Prefers uncluttered field as background.

Tips: "Marriage magazine likes to keep its files up-to-date by rotating them every six months to a year. When photos are returned to you, we request a new set of current photos to keep on file for possible use." Also, "be sure to include sufficient return postage, SASE, and label each photo with your name, address and phone number."

MENDOCINO REVIEW, Box 1580, Mendocino CA 95460. (707)964-3831. Editor-in-Chief: Camille Ranker. Direct inquiries to Bob Avery, Art Director. Annually. Circ. 5,000. Emphasizes litera-

ture, music and the arts. Circulated throughout the U.S.

Photo Needs: Uses about 40-50 photos/issue; all supplied by freelance photographers. Needs "general and scenic photos as we do publish poetry and photos are used with each poem to help carry through on the feeling of the poem. Very open!" Model release preferred when indicated; captions preferred. Making Contact & Terms: Query with samples or with list of stock photo subjects. Send 5x7 b&w matte or glossy prints by mail for consideration. SASE. Reports in 6-8 weeks. Pays with copies; ad exchanges considered. Pays on publication. Credit line given. Buys one-time rights only. Simultaneous

submissions OK. Tips: "We use photos to illustrate stories and poetry. Photo essays will be considered as well as sequence photography."

MICHIGAN NATURAL RESOURCES MAGAZINE, Box 30034, Lansing MI 48909. (517)373-9267. Editor: Norris McDowell. Photo Editor: Gijsbert VanFrankenhuyzen. Bimonthly. Circ. 140,000. Emphasizes natural resources in the Great Lakes region. Readers are "appreciators of the out-of-doors; 15% readership is out of state." Sample copy \$2; photo guidelines free with SASE.

Photo Needs: Uses about 40 photos/issue; 25% supplied by freelance photographers. Needs photos of "animals, wildlife, all manner of flora, how-to, travel in Michigan, energy usage (including wind, water, sun, wood). Model release and captions preferred. Query with samples or list of stock photo subjects; send 35mm color transparencies "only" by mail for consideration. SASE. Reports in 1 month. Pays \$50-200/color page; \$200/job; \$400 maximum for text/photo package. Pays on acceptance. Credit line given. Buys one-time rights. Simultaneous submissions and previously published work OK.

Tips: Prefers "Kodachrome 64 or 25, 35mm, razor sharp in focus! Send about 40 slides with a list of stock photo topics. Be sure slides are sharp, labeled clearly with subject and photographer's name and address. Send them in plastic slide filing sheets."

MICHIGAN OUT-OF-DOORS, Box 30235, Lansing MI 48909. (517)371-1041. Editor: Kenneth S. Lowe. Monthly magazine. Circ. 110,000. For people interested in "outdoor recreation, especially hunting and fishing; conservation; environmental affairs." Buys first North American serial rights. Credit line given. Send photos for consideration. Reports in 1 month. SASE. Previously published work OK "if so indicated." Sample copy \$1; free editorial guidelines.

Subject Needs: Animal; nature; scenic; sport (hunting, fishing and other forms of noncompetitive recreation); and wildlife. Materials must have a Michigan slant.

B&W: Send any size glossy prints. Pays \$15 minimum.

Cover: Send 35mm transparencies or 2¹/₄x2¹/₄. Pays \$60 for cover photos, \$25 for inside color photos. **Tips:** Submit seasonal material 6 months in advance.

*MICHIGAN SPORTSMAN, Box 2266, Oshkosh WI 54903. Editor: Steve Smith. Emphasizes fishing, hunting and related outdoor activities. Sample copy \$2 with a SASE; photo guidelines free with SASE.

Photo Neds: Uses 15-20 photos/issue; all supplied by freelance photographers. Reviews photos with or without accompanying ms. Captions preferred.

Making Contact & Terms; Query with list of stock photo subjects; send 5x7 or larger glossy prints, 35mm and 21/4x21/4 transparencies and b&w contact sheet by mail for consideration; submit portfolio for

review. SASE. Reports in 3-5 weeks. Pays \$300-400/color cover photo, \$25-250 b&w inside photo, \$50-400/color inside photo. Pays on acceptance. Credit line given. Buys one-time rights. No simultaneous submissions. Previously published work OK.

THE MIDWEST MOTORIST, Auto Club of Missouri, 12901 North Forty Dr., St. Louis MO 63141. Editor: Michael Right. Emphasizes travel and driving safety. Readers are "members of the Auto Club of Missouri, ranging in age from 25-65 and older." Bimonthly. Circ. 325,000. Free sample copy; photo

guidelines for SASE; use large E-20 envelope.

Photo Needs: Uses 8-10 photos/issue, most supplied by freelancers. "We use b&w and four-color photos inside to accompany specific articles. Our magazine covers topics of general interest, historical (of Midwest regional interest), humor (motoring slant), interview, profile, travel, car care and driving tips. Our covers are full color photos mainly corresponding to an article inside. Except for cover shots, we use freelance photos only to accompany specific articles. These are normally submitted by the author along with the article, although occasionally we have to purchase accompanying photos separately through another freelance photographer." Model release not required; captions required.

Making Contact & Terms: Send by mail for consideration 5x7 or 8x10 b&w photos, 35mm, 21/4x21/4 or 4x5 color transparencies; query with resume of photo credits; or query with list of stock photo subjects. SASE. Reports in 3-6 weeks. Pays \$100-250/cover; \$10-25/photo with accompanying ms; \$10-50/b&w photo; \$50-200/color photo. \$75-200 for text/photo package. Pays on publication. Credit line

given. Rights negotiable. Simultaneous or previously published submissions OK. Tips: "Send for sample copies and study the type of covers and inside work we use."

THE MILEPOST (All-the-North Travel Guide), Box 4-EEE, Anchorage AK 99509. (907)563-5100. Managing Editor: Kris Valencia. Annual paperback. Circ. 75,000. For travelers to and in Alaska.

Needs photos of "Alaska and Northwestern Canada travel destinations, attractions and people doing things unique to the North. No sunsets, please." Buys first serial rights. Send photos for consideration. Photo selection begins July, ends in September. Pays on publication. Reports in 4-8 weeks. SASE. Sam-

ple copy \$12.95; free photo guidelines.

Color: Send 35mm, 21/4x21/4 or 4x5 transparencies (Kodachrome or Ektachrome preferred). No duplicate slides. Captions required. Pays \$20-45.

Cover: Send 35mm, 21/4x21/4 or 4x5 color transparencies. Captions required. Pays \$200 maximum. Tips: "Don't send color prints. Sharp, properly exposed color transparencies only." Send photos by certified mail with return postage for certified return and "we'll return the same way."

MINNESOTA SPORTSMAN, Box 2266, Oshkosh WI 54903. (414)233-7470. Managing Editor: Chuck Petrie. Bimonthly magazine. Circ. 45,000. Emphasizes informational material on fishing, hunting and other outdoor activities in Minnesota. Photos purchased with or without accompanying ms. Buys 15-20 photos/year. Pays \$300-400/color cover photo, \$25-50 b&w inside photo, \$50-400/color inside photo. Credit line given. Pays on acceptance. Send material by mail for consideration 5x7 or larger glossy prints 35mm and 21/4x21/4 transparencies and b&w contact sheets, submit portfolio for review, or query with a list of stock photo subjects. SASE. Previously published work OK. Reports in 3 weeks. Buys one-time rights. No simultaneous submissions. Previously published work OK.

Subject Needs: Animal (Upper Midwest wildlife); photo essay/photo feature (mood, seasons, Upper Midwest regions); scenic (Upper Midwest with text); sport (fishing, hunting and vigorous nonteam outdoor activities); how-to; nature; still life (hunting/fishing oriented); and travel. "Exciting fishing/hunting action scenes receive special consideration." No Disneyland-type characters; nothing that does not

pertain to hunting and fishing in Minnesota. Captions preferred.

Accompanying Mss: How-tos oriented toward fishing, hunting and outdoor activities in the Upper Midwest; where-tos for these activities in Minnesota.

MISSOURI LIFE, 1205 University Ave., Suite 500, Columbia MO 65201. (314)449-2528. Editor: Bill Nunn. Photo Editor: Gina Setser. Bimonthly. Circ. 30,000. Emphasizes "Missouri people, places and history and things to do and see around the state." Readers are older, upper middle incomes. Sample copy \$3.50; photo guidelines free with SASE.

Photos Needs: Uses about 18-25 photos/issue; 15-20 supplied by freelance photographers. Needs trav-

el, scenic, historic and personality photos. Captions preferred.

Making Contact & Terms: Query with samples. SASE. Reports in 1 month. Pays \$50-200/color cover photo; \$10-25/b&w or color inside photo or \$50-150 for text/photo package. Pays on publication. Credit line given. Buys one-time rights. Simultaneous submissions and previously published work OK. Tips: "Submit photos that show a unique image of Missouri. Keep the photos uncomplicated, and look for subject matter that immediately brings Missouri to mind-subjects uniquely Missourian."

MODERN DRUMMER MAGAZINE, 870 Pompton Ave., Cedar Grove NJ 07009. (201)239-4140. Editor: Ronald Spagnardi. Managing Editor: Rick VanHorn. Magazine published 12 times/year. Buys 50-75 photos annually. For drummers at all levels of ability: students, semiprofessionals and professionals.

Subject Needs: Celebrity/personality, product shots, humorous, action photos of professional drummers and photos dealing with "all aspects of the art and the instrument."

Specs: Uses b&w contact sheet, b&w negatives, or 5x7 or 8x10 glossy b&w prints; color transparencies. Uses color covers.

Payment/Terms: Pays \$10-75; \$100/cover. Credit line given. Pays on publication. Buys one-time rights. Previously published work OK.

Making Contact: Send photos for consideration. Reports in 3 weeks. SASE. Sample copy \$2.50.

MODERN LITURGY, 160 E. Virginia St., Box 290, San Jose CA 95112. Editor: Kenneth Guentert. Magazine published 9 times annually. Circ. 15,000. For "religious artists, musicians, pastors, educators and planners of religious celebrations." who are interested in "aspects of producing successful worship services." Buys one-time rights. Present model release on acceptance of photo. Query first with resume of credits "or send representative photos that you think are appropriate." Pays on publication. Reports in 6 weeks. SASE. Sample copy \$4.

B&W: Uses 8x10 glossy prints. Pays \$5-25.

Color: Note: color photos will be reproduced in b&w. Uses 35mm transparencies. Pays \$5-25.

Cover: Send 8x10 glossy b&w prints. Pays \$5-25.

*MODERN PERCUSSIONIST, 870 Pompton Ave., Cedar Grove NJ 07009. (201)239-4140. Editor: Rick Mattingly. Photo Editor: David Creamer. Quarterly. Emphasizes percussion. Readers include percussionists at all levels, from student to professional. Circ. 15,000. Estab. 1984. Sample copy \$2. Photo guidelines with SASE.

guidelines with SASE. **Photo Needs:** Uses 20-25 photos/issue; 75% supplied by freelance photographers. Needs portraits of percussionists featured in interviews, along with performance shots featuring instruments. Reviews

with or without accompanying ms.

Making Contact & Terms: Query with samples or send 8x10, 5x7 matte b&w prints, 35mm, 2½x2½ transparencies, b&w contact sheets by mail for consideration. SASE. Reports in 2 weeks. Pays \$100-125/color cover photo, \$25-45/inside b&w photo and \$50-75/color photo. Pays on publication. Credit line given. Buys one-time rights. Previously published work OK.

MODERN PHOTOGRAPHY, ABC Leisure Magazines, Inc., 825 7th Ave., New York NY 10019. (212)265-8360. Publisher/Editorial Director: Herbert Keppler. Editor: Julia Scully. Picture Editor: Andy Grundberg. Monthly magazine. Circ. 690,000. For the advanced amateur photographer. Buys 10 photos/issue. Pays \$100-250/printed page, or on a per-photo basis. Pays on acceptance. Buys one-time rights. Send material for consideration or submit portfolio for review. SASE. Reports in 1 month. Free photo guidelines for SASE.

Subject Needs: "All sorts, since we cover photography from gadgetry to fine art."

B&W: Uses 8x10 prints. Pays \$50 minimum/photo.

Color: Uses prints or 35mm, 2¹/₄x2¹/₄, 4x5 or 8x10 transparencies. Pays \$100 minimum/photo. **Cover:** Uses 35mm, 2¹/₄x2¹/₄, 4x5 or 8x10 color transparencies. Pays \$400 minimum/photo.

MOMENT MAGAZINE, 462 Boylston St., Suite 301, Boston MA 02116. Managing Editor: Nechama Katz. Monthly magazine. Circ. 25,000. Emphasizes Jewish affairs and concerns; "includes fiction, poetry, politics, psychology, human interest, community concerns and pleasures." Send brochure, tearsheets, business card or list of stock photos for possible future assignment. Credit line given. Pays on publication. Rights purchased vary. Sample copy \$2.50 plus postage and handling.

Subject Needs: Celebrity/personality, documentary, fine art, human interest, humorous, photo essay/photo feature, scenic, still life and travel. All subjects should deal with Jewish life.

B&W: Uses 8x10 glossy prints. Pays \$15 minimum/photo.

THE MOTHER EARTH NEWS, Box 70, Hendersonville NC 28791. (704)693-0211. Editor: Bruce Woods. Submissions Editor: Roselyn Edwards. Bimonthly magazine. Circ. 900,000. Buys 150-200 illustrated articles annually.

Accompanying Mss: Photos purchased with accompanying ms only.

Specs: Uses b&w with accompanying negatives or color transparencies. Captions required.

Payment/Terms: Pays \$40-500 for ms and photo package.

Making Contact: Send all photos with the article they illustrate. Reports in 3 months. SASE. Free editorial guidelines.

Tips: "Include information on the type of film used, speed and lighting."

MOTOR BOATING & SAILING MAGAZINE, 224 W. 57th St., New York NY 10019. (212)262-8768. Editor: Peter A. Janssen. Emphasizes powerboats and large sailboats for those who own boats and participate in boating activities. Monthly magazine. Circ. 145,000. Information on and enjoyment of boating. Photos are purchased on assignment. Buys 30-50 photos/issue. Pays \$250/day. Credit line given. Pays on acceptance. Buys one-time rights. Send material by registered mail for consideration.

SASE. Reports in 1-3 months. Provide flyer and tearsheets to be kept on file for possible future assignments.

Subject Needs: Power boats; scenic (with power and sail, high performance, recreational boats of all kinds and boat cruising). "Sharp photos a must!" Model release and captions required.

Color: Kodachrome 25 preferred; Kodachrome 64 OK; no Ektachrome. Pays \$75-150/page.

Cover: Uses 35mm color transparencies. Vertical format preferred. Pays \$500.

MOTORCYCLIST, Petersen Publishing Co., 8490 Sunset Blvd., Los Angeles CA 90069. (213)657-5100. Editor: Art Friedman. Monthly magazine. Circ. 250,000. For "totally involved motorcycle enthusiasts." Buys 6-20 photos/issue. "Most are purchased with mss, but if we like a photographer's work, we may give him an assignment or buy photos alone." Provide calling card, letter of inquiry, resume and samples to be kept on file for possible future assignments.

Subject Needs: Scenic, travel, sport, product shot; special effects/experimental and humorous. "We need race coverage of major national events; shots of famous riders; spectacular, funny, etc. photos." Wants no "photos of custom bikes, local races, unhelmeted riders or the guy down the block who just

happens to ride a motorcycle." Captions preferred.

Specs: Uses 8x10 glossy b&w prints and color transparencies.

Payment/Terms: Pays \$25-75/photo. Credit line given. Pays on publication. Buys all rights, but may reassign to photographer after publication. Present model release on acceptance of photo.

Making Contact: Written query preferred; or query with resume of credits or send photos for consideration. Reports in 1 month. SASE. Sample copy \$1.25; free photo guidelines.

MOTORHOME, 29901 Agoura Rd., Agoura CA 91301. (213)991-4980. Editor: Bob Livingston. Assistant Managing Editor: Gail Harrington. Monthly. Circ. 130,000. Emphasizes motorhomes and travel. Readers are "motorhome owners with above-average incomes and a strong desire for adventurous travel." Sample copy \$1; photo guidelines for SASE.

Photo Needs: Uses 25 photos/issue; 12 from freelancers. Needs "travel-related stories pertaining to motorhome owners with accompanying photos and how-to articles with descriptive photos. We usually buy a strong set of motorhome-related photos with a story. Also we are in the market for cover photos. Scenes should have maximum visual impact, with a motorhome included but not necessarily a dominant element. Following a freelancer's query and subsequent first submission, the quality of his work is then evaluated by our editorial board. If it is accepted and the freelancer indicates a willingness to accept future assignments, we generally contact him when the need arises." Captions required.

Making Contact & Terms: Send by mail for consideration 8x10 (5x7 OK) b&w prints or 35mm or 2½x2½ (4x5 or 8x10 OK) slides. Also send standard query letter. SASE. Reports as soon as possible, "but that sometimes means up to one month." Pays on acceptance \$200-400 for text/photo package; up to \$300 for cover photos. Credit line given if requested. Buys first rights. No simultaneous submissions

or previously published work.

MUSCLE MAG INTERNATIONAL, Unit 7, 2 Melanie Dr., Brampton, Ontario, Canada L6T 4K8. (416)457-3030. Editor: Robert Kennedy. Monthly magazine. Circ. 130,000. Emphasizes male and female physical development and fitness. Photos purchased with accompanying ms. Buys 500 photos/year. Credit line given. Pays on acceptance. Buys all rights. Send material by mail for consideration; send \$3 for return postage. Reports in 2-4 weeks. Sample copy \$3.

Subject Needs: Celebrity/personality, fashion/beauty, glamour, how-to, human interest, humorous, special effects/experimental and spot news. "We require action exercise photos of bodybuilders and fitness enthusiasts training with sweat and strain." Wants on a regular basis "different" pics of top names, bodybuilders or film stars famous for their physique (i.e. Schwarzenegger, The Hulk, etc.). No photos of mediocre bodybuilders. "They have to be among the top 20 in the world or top film stars exercising." Captions preferred.

B&W: Uses 8x10 glossy prints. Query with contact sheet. Pays \$10/photo. **Color:** Uses 2¹/₄x2¹/₄, 4x5, or 8x10 transparencies. Pays \$10-500/photo.

Cover: Uses color 2¹/₄x2¹/₄ or 4x5 transparencies. Vertical format preferred. Pays \$100-500/photo. Accompanying Mss: Pays \$85-200/ms. Writer's guidelines \$3.

MUSIC CITY NEWS, Box 22975, Nashville TN 37203. (615)244-5187. General Manager: John Sturdivant. Editor: Neil Pond. Readers of this tabloid are "country music consumers and industry personnel." Monthly. Circ. 120,000. Sample copy free with large SASE.

Photo Needs: Uses 30-50 photos/issue, 2-5 supplied by freelancers. "We use very few freelance photos, relying mostly on staff photos. We buy selected country music feature photos, but not concert shots." No Polaroid or Instamatic photos. Model release not required if news; captions and full identification required.

Making Contact & Terms: Send by mail for consideration 8x10 b&w glossy photos or b&w contact sheets. "Prefer to look at contact sheets for b&w." SASE. Mostly works with freelance photographers

on assignment only basis. Reports in 1 month. Pays on publication \$10/b&w photo; \$25/color transparency. Credit line given. Buys one-time rights. Simultaneous submissions OK.

N. Y. HABITAT, 928 Broadway, New York NY 10010. (212)505-2030. Managing Editor: Tom Soter. Bimonthly. Emphasizes co-op, condominium and loft living in New York City. Readers are owners and potential owners of lofts, co-ops and condos in New York City. Circ. 10,000. Sample copy \$2.50 Photo Needs: Uses about 2-5 photos/issue; 50% supplied by freelance photographers. Needs "co-op. condo and loft related photos; photos tied into articles." Model release and captions required. Making Contact & Terms: Ouery with resume of credits, SASE, Reports in 3 weeks, Pays in cover photos and cover credit for cover photo; \$50/b&w inside photo; \$75/color inside photo; all payments negotiable. Pays on publication. Credit line given. Buys one-time rights.

NATIONAL GEOGRAPHIC, 17th and M Sts. NW, Washington DC 20036. Director of Photography: Bob Gilka. Monthly magazine. Circ. 11,000,000. For members of the National Geographic Society, a nonprofit scientific and educational organization. Publishes photo series about interesting places, done in a journalistic way. Posed photographs frowned on. Usually buys first serial rights and option to reprint in National Geographic Society publications. Send photos for consideration only after careful study of magazine. Works with freelance photographers on assignment only basis. Pays on acceptance. Reports in 1 month. SASE. If the color photographs submitted, or others on the same subject taken at the same time, have been published or sold elsewhere before being submitted to National Geographic this must be clearly stated. Sample copy \$1.25.

Color: Send transparencies; 35mm preferred. Complete, accurate captions required. Pays \$300/page of

photos, or \$100 minimum/photo; \$300/day.

NATIONAL GEOGRAPHIC TRAVELER, 17th & M St., NW, Washington DC 20036. Illustrations Director: David R. Bridge. Quarterly. Emphasizes "travel, primarily in the U.S. and Canada. One or two foreign articles per issue on high interest, low-risk, readily accessible areas. Occasional photographic essay with no text. Approximately 150 pages, 8½"x11", 9-10 articles per issue." Readers are members of the National Geographic Society, Circ. 1,000,000 + . Estab. 1984. Photo guidelines free with SASE. Sample copy available for \$4.70 from Robert Dove, National Geographic Society, Gaithersburg MD 20760.

Photo Needs: Uses approximately 150 photos per issue, all color; 95% assigned to freelance photographers. Occasional needs for "travel, scenic, (wildlife photos, when related to some travel destination)."

Captions required.

Making Contact & Terms: Provide resume, business card, brochure, flyer or tearsheets to be kept on file for possible future assignments. SASE. Reports in 2 weeks. Pays \$100 minimum/color inside photo; \$300/color page. Pays on publication. Credit line given. Buys one-time world rights. Does not piggyback on other assignments or accept articles previously published or commissioned by other magazines.

NATIONAL GEOGRAPHIC WORLD, 17th and M Sts. NW, Washington DC 20036. Editor: Pat Robbins. Associate Editor: Margaret McKelway. Art Director: Ursula Vosseler. Illustrations Editor: Dave Johnson. Monthly magazine. Circ. 1,300,000. Emphasizes natural history and child-oriented human interest stories. "Children age 8 and older read it to learn about other kids their age and to learn about the world around them. We include activities, supersize pullout pages and other special inserts." Buys more than 500 photos/year, at least 50 photos/issue. Credit line given on contents page and on supersize pages. Pays on publication. Buys one-time rights. Send material by mail for consideration or query with story proposals listing photo possibilities. SASE. Simultaneous submissions and previously published work (if not in a recent children's publication) OK. Reports in 4 weeks. Provide business card, and stock list to be kept on file. Index available for \$4.50 from National Geographic Society, Department 4787, Washington, DC 20036.

Subject Needs: Animal; (children); how-to (for children); science, technology and earth science; human interest (children); humorous; nature; photo essay/photo feature; special effects/experimental; sport (children); and wildlife. No dangerous activities where proper safety equipment is not being used. No travelog without specific focus. Model release preferred; captions with complete ID required. Departments with special photo needs include Kids Did It!, a photo of an outstanding or newsworthy child aged 8-16; What in the World . . . ?, a photo that tricks the eye or is unusual in some way, or a set of 9 close-ups with a theme to be guessed; and Far-Out Facts, a photo illustrating a "gee whiz" statement or

out of the ordinary fact that children would not know.

Color: Uses 35mm or 21/4x21/4 or larger transparencies. No color prints, duplicates or motion picture frames. Prefers Kodachrome, Ektachrome or Fujichrome. Pays \$75-400/photo.

Cover: Uses 35mm or 21/4x21/4 or larger color transparencies. Vertical format preferred. Pays \$400/photo. Must relate to story inside.

NATIONAL PARKS MAGAZINE,, 1701 18th St. NW, Washington DC 20009. Editor: Michele Strutin. Bimonthly magazine. Circ. 45,000. Emphasizes the preservation of national parks and wildlife. Pays on publication. Buys one-time rights. SASE. Simultaneous submissions and previously published work OK. Reports in 1 month. Sample copy \$3; free photo guidelines only with SASE.

Subject Needs: Photos of wildlife and people in national parks, scenics, national monuments, national recreation areas, national seashores, threats to park resources and wildlife. "Send sample (40-60 slides)

of one or two national park service units to photo editor." B&W: Uses 8x10 glossy prints. Pays \$25-70/photo.

Cover: Pays \$200/wraparound color covers. Pays \$35-100/4x5 or 35mm color transparencies. Accompanying Mss: Seeks mss on national parks, wildlife. Pays \$200/text and photo package. Tips: "Photographers should be more specific about areas they have covered that our magazine would be interested in. We are a specalized publication and are not interested in extensive lists on topics we do not cover. Send stock list with example of work if possible."

NATIONAL SCENE MAGAZINE, 22 E. 41st St, New York NY 10017. (212)689-1989. Editor: Claude Reed, Jr. Monthly magazine. Emphasizes general-interest magazine geared toward a black readership that is upscale, professional, business-oriented, 63% female. Circ. 1,600,000. Sample copy

Photo Needs: Uses approximately 20 photos/issue; 7 supplied by freelance photographers. Needs how-

to and personality photos. Model release and captions preferred.

Making Contact & Terms: Provide resume, business card, brochure, flyer or tearsheets to be kept on file for possible future assignments. SASE. Reports in 2 weeks. Pays \$75-100/b&w cover photo, \$150-200/color cover photo; \$10/b&w inside photo; \$20/color inside photo; negotiates pay by the hour and by the job. Pays on publication. Credit line given. Buys all rights.

NATIONAL WILDLIFE, 1412 16th Street NW, Washington DC 20036. (703)790-4000. Editor: John Strohm. Photo Editor: John Nuhn. Bimonthly magazine. Circ. 800,000. For outdoor enthusiasts, armchair travelers, hunters and fishermen; "our readers are concerned about our environment, and they appreciate the drama and beauty of all wildlife, both plant and animal." Buys 40-50 photos/issue. Buys one-time publication rights. Query with story ideas or send photos for consideration. Invite letters of inquiry and stock lists to be kept on file. Pays on acceptance. Reports in 4 weeks. SASE. Free photo guide-

Subject Needs: Mammals, birds, fish, reptiles, insects (action shots, close-ups, sequences, complete picture stories, unusual, dramatic and humorous single shots); people and how they live (environmental issues, people profiles and adventure stories); flowers; plant life; scenics. Especially needs distinctive. cover-quality photos and b&w stories that use the medium to its fullest and would not be more effective in color. No pets or "wild" animals that have been domesticated, such as friendly squirrels or songbirds; no garden flowers unless there is a very unusual story line.

B&W: Send 8x10 glossy prints. Captions required. Pays \$125 minimum/single photo.

Color: Send 35mm (prefer Kodachrome), 21/4x21/4 or 4x5 transparencies. Captions required. Pays \$125

minimum/single photo.

Tips: "We urge the photographer to think editorially. Although single photos are always needed for covers and inside use, we want the photographer's ideas on 'packaging' photos into a feature that will give the reader a different way of seeing a familiar or not so familiar place, or some aspect of wildlife. Study our last few issues to see how these packages are done. We are always looking for that distinctive single photo . . . the sprightly, dramatic, colorful, human interest photo that lends itself to a cover or an accompanying short story. Send quality originals rather than dupes where possible; originals will be given proper care and they may increase chances of acceptance. Captions must be on mounts, backs of prints. or keyed to separate sheet. Do not tape photos to paper or cardboard. Don't send protective photo sheets in binders, attached to cardboard individually, or use any other method which prevents a quick review. Never send glass-mounted slides because of possible breakage in transit. Also we prefer to receive photos in protective sheets rather than slide boxes or rubber bands. We cannot accept cash, checks or money orders for payment of postage, so please ensure that the proper amount of stamps are glued to the return envelope." Also publishes International Wildlife, which has basically the same needs. Direct queries and submissions to the photo editor.

The asterisk before a listing indicates that the listing is new in this edition. New markets are often the most receptive to freelance contributions.

NATURAL HISTORY MAGAZINE, Central Park W. at 79th St., New York NY 10024, (212)873-1498. Editor: Alan Ternes. Picture Editor: Kay Zakariasen. Monthly magazine. Circ. 460,000. Buys

400-450 annually. For primarily well-educated people with interests in the sciences.

Subject Needs: Animal behavior, photo essay, documentary, plant and landscape. Photos used must relate to the social or natural sciences with an ecological framework. Accurate, detailed captions required. Specs: Uses 8x10 glossy, matte and semigloss b&w prints; and 35mm, 21/4x21/4, 4x5, 6x7 and 8x10 color transparencies. Covers are always related to an article in the issue.

Payment/Terms: Pays \$75-250/b&w print, \$75-375/color transparency and \$375 minimum/cover. Credit line given. Pays on publication. Buys one-time rights. Previously published work OK but must be

indicated on delivery memo.

Making Contact: Query with resume of credits. SASE. Reports in 2 weeks. Free photo guidelines. Tips: "Study the magazine—we are more interested in ideas than individual photos. We do not have the time to review portfolios without a specific theme in the social or natural sciences."

*NATURE FRIEND MAGAZINE, 22777 State Rd. 119, Goshen IN 46526. (219)534-2245. Editor/ Publisher: Stanley K. Brubaker. Monthly. Emphasizes the operation of God's Creation. Readers include children ages 4 and older of Christian families who hold a literal view of Creation, Circ. 2,100. Sample

copy with SASE and 56¢ postage. Photo guidelines \$1.

Photo Needs: Uses 6-10 photos; most supplied by freelance photographers. Special needs include sharp Kodachrome, or glossy b&w 8x10's of wildlife up close; birds and animals, including some pets. Photo stories and sequences considered. Hardly any adult scenery such as stilllife, sunsets, etc.—must appeal to children. Review photos with accompanying ms only. Special needs include "sharp colorful popular bird and mammal photos, as well as reptiles, insects, amphibians, ocean life if high quality." Model release preferred.

Making Contact & Terms: Send 8x10 glossy b&w prints, 35mm, 21/4x21/4 transparencies, b&w or color contact sheets by mail for consideration. SASE. Reports in 1 month. Pays \$60/color cover photo, \$15-20/b&w inside photo, \$15-40/color photo, and \$40-150/text/photo package. Pays on publication unless delayed more than 2 months. Buys one-time rights. Previously published work OK if "we are

made aware of other submissions or past use.'

*NAUTICA MAGAZINE, Pickering Wharf, Salem MA 01970. (617)745-6905. Art Director: Donna Chuldzinski. Bimonthly magazine. "Nautica covers the sea, lake, rivers, and subjects connected with our water world. History, science, nature, sports, education are the main focuses of articles. Nautica is written and edited for the juvenile, 8-16 years of age." Circ. 10,000. Sample copy with SASE and \$1.20 postage. Photo guidelines free with SASE.

Photo Needs: Uses about 25-30 photos/issue; 85% supplied by freelance photographers. "Photo needs usually fall into two categories: to illustrate articles; cover and center spread shots. Most article needs are covered when article is assigned; cover shots are always welcome. Most important; we need photos

showing young people interacting with our water world." Captions preferred.

Making Contact & Terms: "Query with samples if possible, since our needs are rather special." SASE. Reports up to six weeks. Pays \$150/color cover photo, \$25/b&w inside photo, and \$50/color inside photo. Pays on publication. Credit line given. Buys one-time rights "except on assignment." Previously published work OK.

Tips: Prefers to see photos of "high interest for young people. As few 'pretty' or 'experimental' shots as possible. Direct, photo essay style: people, especially young, interacting with the world around them."

NEVADA MAGAZINE, Capitol Complex, Carson City NV 89710-0005, (702)885-5416, Publisher and Editor: Caroline J. Hadley. Bimonthly magazine. Circ. 62,000. Devoted to promoting tourism in Nevada, particularly for people interested in travel, people, history, events and recreation; age 30-70. Buys 20-30 photos/issue. Credit line given. Buys first North American serial rights. Pays on publication. Reports in 1 month. Send samples of Nevada photos. SASE. Sample copy \$1.

Subject Needs: Towns and cities, scenics, outdoor recreation, people, events, state parks, tourist attractions, travel, wildlife, ranching, mining, and general Nevada life. Must be Nevada subjects.

B&W: Send 8x10 glossy prints. Must be labeled with name and address. Captions required. Pays \$10-75

Color: Send transparencies. Must be labeled with name and address. Captions required. Pays \$10-75. Cover: Send color transparencies. Prefers vertical format. Captions required. Pays \$50-75.

Tips: "Send the best of your work; edit out marginals. Label each slide or print properly with name and address and also put caption right on slide or print, not on a separate sheet. Don't send photos of California or Rhode Island.

*NEW AGE JOURNAL, 342 Western Ave., Boston MA 02135. (617)787-2005. Editor: Lee Fowler. Photo Editor: Greg Paul. Monthly. Emphasizes achievement, commitment, creative living, new ideas in

health, nutrition, business, lifestyle, Readers are young, educated, motivated, inner-directed. Circ.

Photo Needs: Uses 40 photos/issue: 25 supplied by freelance photographers. Needs portraits, photojournalism, food, product shots, photo-illustration, and photo essays. Reviews photos with or without accompanying ms. 'We need to find good international photo stringers from Britain, France. Italy. Australia Central America, etc." Model release and captions required.

Making Contact & Terms: Ouery with samples and list of stock photo subjects. SASE. Reports in 1 month, Pays \$350/day maximum. Pays on publication. Credit line given. Buys one-time rights. Simul-

taneous submissions OK.

NEW ALASKAN, Rt. 1. Box 677, Ketchikan AK 99901, (907)247-2490, Editor-in-Chief: Bob Pickrell. Monthly. Circ. 6,000. Emphasizes the Southeastern Alaska life-style, history, politics and general

features. Send \$1 for sample copy with SASE.

Photo Needs: Uses about 25 photos/issue; 5 supplied by freelance photographers. "All photos must have Southeast Alaska tie-in. Again, we prefer finished mss with accompanying photos concerning lifestyle, history, politics, or first-person adventure stories dealing with Southeast Alaska only." Photos purchased with accompanying ms. Model release and captions preferred.

Making Contact & Terms: Query with samples. SASE. Reports in 3 months. Provide business card and tearsheets to be kept on file for possible future assignments. Pays \$25/b&w cover photo; \$2.50/b&w inside photo; and text/photo package dependent on number of pictures used and story length. Pays on publication. Credit line given. Buys one-time rights. Simultaneous submissions and/or previously published work OK.

NEW BREED, 30 Amarillo Dr., Nanuet NY 10954. (914)623-8426. Editor-in-Chief: Major Harry Belil Bimonthly, Circ. 178,000, Emphasizes "military, combat weapons, survival, martial arts, heroism, etc." Readers are "military, persons interested in para-military, law officers." Sample copy \$2.50;

photo guidelines free with SASE.

Photo Needs: Uses about 120 photos/issue; 75% supplied by freelance photographers. Needs "photo stories, such as conventions, gun clubs, shooting matches." Model release and captions required. Making Contact & Terms: Ouery with samples or with list of stock photo subjects. Send 8x10 b&w prints, 35mm, 21/4x21/4 or 4x5 slides or b&w contact sheet by mail for consideration. Provide resume and sample photos to be kept on file for possible future assignments. SASE. Reports in 3 weeks. Pays \$35/b&w and \$50/color inside photo; \$200-500 for text/photo package. Pays on publication. Credit line given. Buys first rights.

NEW CATHOLIC WORLD, 997 MaCarthur Blvd., Mahmuah NJ 07430. (201)825-7300. Editor: Lori Felkman, Bimonthly magazine, Circ. 13,000, Buys 25 photos/issue, Credit line given, Pays on publication. Buys one-time rights. Send material by mail for consideration. SASE. Simultaneous submissions and previously published work OK. Reports in 1 month.

Subject Needs: Human interest, nature, fine art and still life.

B&W: Uses 8x10 glossy prints. Pays \$20/photo.

*NEW CLEVELAND WOMAN JOURNAL, 106 E. Bridge St., Berea OH 44107. (216)243-3740. Editor; Jan Snow, Monthly magazine. Emphasizes "news and features pertaining to working women in the Cleveland/Akron area." Readers are working women, 50% married, average age 35. Circ. 30,000. **Photo Needs:** Uses about 10 photos/issue; 2 supplied by freelance photographers. Needs "photo illustrations of subject-careers, travel, finance, etc." Model release preferred; captions required. Making Contact & Terms: Query with samples. Provide business card and brochure to be kept on file for possible future assignments. SASE. Reports in 1 month. Pays \$25/b&w inside photo. Pays on publication. Credit line given. Buys first North American serial rights. Simultaneous submissions OK. Tips: "Indicate availability on short notice for assignments in Cleveland area."

NEW DRIVER, 3500 Western Ave., Highland Park IL 60035. (312)432-2700. Photo Editor: Barbara A. Bennett. Quarterly magazine for high school students in driver ed classes. Sample copy and photo

guidelines free with 8x11 SASE.

Photo Needs: Color: 35mm or larger transparencies of student drivers involved in safety, maintenance. etc; b&w: 8x10 prints "geared to our article topics." Credit line given. Buys one-time rights. Payment on publication. Negotiates rates. Simultaneous and previously published submissions OK.

Tips: "Article topics are available in February. Submit photos for consideration in March and April. We like to work with new and student photographers."

NEW ENGLAND MONTHLY, Box 446, Haydenville MA 01039, (413)268-7262. Art Director: Hans Teensma, Associate Art Director: Kandy Littrell, Monthly magazine, Circ. 75,000. Estab. 1984.

"He's one of my tops. I can count on him for any assignment," says New England Monthly Art Director Hans Teensma of freelance photographer Kip Brundage. "We had one day to photograph former Portland, Maine, City Councilor Pamela Plumb. We photographed her before dawn. Everything had to be anticipated—sunrise, the light anglessurprisingly, the resulting photograph wasn't one of Kip's favorites, but the cover it appeared on turned out to be our number one best seller. We paid him \$500 for shooting

Emphasizes contemporary New England life for regional, general interest audience. Editorial content includes investigative journalism, reviews, profiles, portfolios, lifestyle and "photo-heavy" articles. **Photo Needs:** Uses approximately 30 b&w and color photos/issue; all supplied by freelance photographers. Needs "general interest photos of the New England area—travel, scenic, photojournalistic art, etc." Model release and captions preferred.

Making Contact & Terms: Provide resume, business card, brochure, flyer or tearsheets to be kept on file for possible future assignment. SASE. Reports in 1 month. Pays \$50-300/b&w photo; \$50-300/color photo; \$200/page; \$150-300/day. Pays on publication. Credit line given. Simultaneous and previous-

ly published submissions OK.

Tips: "Send copies to be kept on file—no originals. Stay in touch by mail. Send clippings, printouts and mailers often."

*NEW ENGLAND SKIERS' GUIDE, c/o Historical Times, Inc., Box 8200, 2245 Kohn Rd., Harrisburg PA 17105. (717)657-9555. Managing Editor: Kathie Kull. Consulting Editor: Mimi E. B. Steadman. Photo Editor: Kathie Kull. Annual. Emphasizes skiing—Alpine and cross-country; New England only. Readers include skiers in New England and beyond who ski or are considering so. Circ. 100,000. Sample copy \$4; photo guidelines free with SASE.

Photo Needs: Needs include skiing in New England and related activities on snow and apres ski. Reviews photos with or without accompanying ms. Model release preferred; IDs for photos required. **Making Contact & Terms:** Query with samples and list of stock photo subjects; send 5x7 and 8x10 b&w prints, 35mm, $2^{1}/4x2^{1}/4$, 4x5, 8x10 transparencies by mail for consideration. SASE. Reports in 1 month or "depends on how close to production we are—but we will at least acknowledge receipt and serial back to those we aren't considering." Pays \$200-300/b&w or color cover photo, \$100-150/b&w or color inside photo. Pays on publication. Credit line given. Buys one-time rights. Previously published work OK.

*NEW FRONTIER MAGAZINE, 129 N. 13th St., Philadelphia PA 19107. (215)567-1685. Editor: Swami Virato. Monthly. Emphasizes holistic health, transportation, new age. Readers include sensi-

tive, seeking, spiritual, natural awareness. Circ. 25,000. Sample copy \$2.

Photo Needs: Uses 4-5 photos/issue; all supplied by freelance photographers. Needs nature, cosmic (stars, etc.). Reviews photos with or without accompanying ms. Model release and captions preferred. Making Contact & Terms: Send 5x7 and 8x10 glossy b&w prints by mail for consideration; provide resume, business card, brochure, flyer or tearsheets to be kept on file for possible future assignments. SASE. Reports in 1 month. Pays \$50/color cover photo and \$10/b&w inside photo. Pays on publication. Credit line given. Buys one-time rights. Previously published work OK.

NEW HAMPSHIRE PROFILES, 109 N. Main, Concord NH 03301. (603)224-5193. Editor: Stephen Bennett. Monthly. Circ. 25,000. Editorial content, both written and photographic, addresses the social, political, economic and cultural climate of New Hampshire; how various issues, problems and ideas affect the people living in the state, the quality of life they want to enjoy. Photos purchased with or without accompanying ms and on assignment. Buys 10-20 photos/issue (b&w or color). Credit line given. Pays on publication after receiving written invoice including Social Security number for payment from writer and/or photographer. Buys first North American serial rights. Write for editorial and photography guidelines, then submit query with story idea or list of stock photo subjects. Samples are returned. SASE. Reports in 2 months. Sample copy \$2. Photo guidelines free with SASE.

Subject Needs: "We publish a periodic list of suggested photographic stock needs as well as photo essay ideas we are interested in publishing. We will publish photos of a subject idea captured on film by several different photographers as well as a series of photos by one photographer. We accept freelance submis-

sions and make specific photo assignments.

B&W: Uses 5x7 and 8x10 glossy prints. Pays \$15-30/photo.

Color: Uses 21/4x21/4 or 4x5 transparencies, and 35mm slides. Pays \$50-100/photo. Vertical and hori-

Cover: Same requirements as for color photos, generally of a personality featured in magazine. Also uses artist's drawings and graphics. Pays \$200-300.

Tips: "We are seeking photographers who are excited by what we are trying to do at Profiles and show an eagerness to submit photo essay ideas. We want clear, concise non-cluttered photos stating/showing one specific subject matter."

NEW MEXICO MAGAZINE, Bataan Memorial Building, Santa Fe NM 87503. (505)827-6186. Editor: V.B. Price. Monthly magazine. Circ. 100,000. For people interested in the Southwest or who have lived in or visited New Mexico.

Photo Needs: Needs New Mexico photos only landscapes, people, events, architecture, etc. "Most work is done on assignment in relation to a story, but we welcome photo essay suggestions from photographers." Buys 40 photos/issue. Buys one-time rights.

Making contact & Terms: Submit portfolio to Bonnie Bishop Tremper. Credit line given. Pays on publication. SASE. Sample copy \$1.95; free photo guidelines with SASE.

Color: Send transparencies. Captions required. Pays \$50-100.

Cover: Cover photos usually relate to the main feature in the magazine. Pays \$100.

Tips: Prefers transparencies submitted in plastic pocketed sheets.

NEW ORLEANS REVIEW, Box 195, Loyola University, New Orleans LA 70118. (504)865-2152. Editor: John Mosier. Magazine published 4 times a year. Circ. 3,000. Literary journal for anyone interested in literature, film and art. Buys 20-30 annually. Buys all rights. Submit portfolio for consideration. Pays on publication. Reports in 2 months. SASE. Sample copy \$7.

Subject Needs: Everything including special effects/experimental.

B&W: Send 5x7 or 8x10 prints; prefers glossy, but semigloss OK. Each issue includes Portfolio Department, which features 6 or more photos by a single artist.

Cover: Send glossy prints for b&w; glossy prints or transparencies for color. Uses vertical format-81/2x11.

NEW REALITIES, 680 Beach St., Suite 408, San Francisco CA 94109. (415)776-2600. Editor: James Bolen. Managing Editor: Shirley Christine. Bimonthly magazine. Circ. 20,000. For people interested in a holistic approach to life including holistic health, spirituality, parapsychology, consciousness research, personal growth and the frontiers of human potential and the mind. Buys 4-6 annually. Buys all rights. Query with resume of credits or send contact sheet or photos for consideration. Photos purchased with accompanying ms. Pays on publication or in 30 days. Credit line given. Reports in 6 weeks. SASE. Sample copy \$2.50.

Subject Needs: "Study the magazine for photo format and style." Documentary, how-to, human interest, nature and photo essay/photo feature.

B&W: Uses 5x7 glossy prints; send contact sheet. Pays \$10.

Color: Send 35mm transparencies. Pays \$50-100.

Cover: Send 35mm or 21/4x21/4 color transparencies. Pays \$75-150.

*NEW TIMES, 111 W. Monroe #918, Phoenix AZ 85003. (602)271-0040. Editor: Michael Lacey. Photo Editor: Rand Carlson. Weekly. Emphasizes news and arts. Readers are young, professional, affluent and stylish. Circ. 120,000.

Photo Needs: Uses 15 photos/issue; none currently supplied by freelance photographers. Needs odd

shots, environmental, cultural, etc. Model release and captions required.

Making Contact & Terms: Query with resume of credits and with list of stock photo subjects; provide resume, business card, brochure, flyer or tearsheets to be kept on file for possible future assignments. Does not return unsolicited material. Reports in 1 month. Pays \$150/b&w cover photo, \$50-75/b&w inside photo. Pays on publication. Credit line given. Buys one-time rights.

NEWS CIRCLE/MIDEAST BUSINESS EXCHANGE, 6730 San Fernando Rd., Glendale CA 91201. (818)240-1917. Editor: Joseph Haiek. Photo Editor: Mark Arnold. Monthly magazine. Circ. 5,000. For American businessmen doing business in the Middle East and North Africa and the Arab American community. Needs photos of business, construction, refinery and other topics related to Americans in the Middle East and Arabic Americans. No posed shots. Buys 20 photos/annually. Buys all rights. Submit model release with photo. Submit portfolio. Photos usually purchased with an accompanying story or study. Pays on publication. Reports in 1 month. SASE. Simultaneous submissions and previously published work OK. Free sample copy and photo guidelines.

B&W: Send 8x10 glossy prints. Captions required. Pays \$10-25.

*NEW YORK ALIVE, 152 Washington Ave., Albany NY 12210. (518)465-7511. Editor/Photo Editor: Mary Grates Stoll. Bimonthly. Emphasizes the people, places and events of New York State. Readers include young adults to senior citizens, well-educated, fairly affluent, who enjoy reading about life (past and present) in New York State. Circ. 30,000. Sample copy \$2.45; photo guidelines free with SASE.

Photo Needs: Uses 40-50 photos/issue; 75% supplied by freelance photographers. Needs scenic (appropriate to season of cover date) and illustrations for specific features. Reviews photos with or without ac-

companying ms. Model release preferred.

Making Contact & Terms: Query with samples. SASE. Pays \$200/color cover photo; \$10-25/b&w inside photo; \$25-100/color inside photo; \$25 maximum/hour; \$300 maximum/job; and \$500 maximum/text/photo package. Pays on publication. Credit line given. Buys one-time rights. Previously published work OK.

*NY TALK, Suite 423, 1133 Broadway, New York City NY 10010. (212)206-1661. Editor: Walter Thomas. Photo Editor: Mark Michaelson. Monthly tabloid. Emphasizes fashion, art, film. Readers include young urban professionals. Circ. 55,000. Estab. 1984. Sample copy free with SASE.

Photo Needs: Uses 20 photos/issue; all supplied by freelance photographers. Needs fashion, portraits. Reviews photos with or without accompanying ms. Model release and captions preferred.

Reviews photos with or without accompanying ms. Model release and captions preferred.

Making Contact & Terms: Query with samples; submit portfolio for review, provide resume, business card, brochure, flyer or tearsheets to be kept on file for possible future assignments. SASE. Reports in 2 weeks. Pays \$150/b&w cover photo, \$50-100/b&w inside photo. Pays on publication. Credit line given. Buys one-time rights.

*NIGHTBEAT MAGAZINE, Box 55573, Houston TX 77255. (713)668-3880. Editor: Menda Stewart. Photo Editor: Hank Smith. Monthly slick tabsize. Emphasizes entertainment. Readers are fun loving, relaxed, entertainment seeking people. Circ. 100,000. Free sample copy and photo guidelines with SASE.

Photo Needs: Uses 100 photos/issue; 50% supplied by freelance photographers. Needs entertainers on stage, back stage or relaxed at home or work. Reviews photos with accomanying ms only. Model release

and captions required.

Making Contact & Terms; Query with samples, send any b&w prints, 35mm transparencies, b&w or color contact sheet by mail for consideration; provide resume, business card, brochure, flyer or tearsheets to be kept on file for possible future assignments. SASE. Reports in 1 month. Pays \$100/color cover photo, \$25/b&w inside photo, \$50/color inside photo, \$18-50/hour. Pays on publication. Credit line given. Buys all rights. We give a release after use. Simultaneous submissions and previously published work OK.

*NIGHT LIFE MAGAZINE, Box 6372, Moore OK 73153. (405)685-3675. Editor: Vernon L. Gowdy III. Monthly tabloid. Emphasizes music and entertainment. "Readers include people aged 14-30 who love music and entertainment." Circ. 10,000. Estab. 1984. Free sample copy and photo guidelines with SASE.

Photo Needs: Uses 10-12 photos/issue; 4-5 supplied by freelance photographers. Needs concert, entertainment photos. Reviews photos with or without accompanying ms. Model release preferred.

Making Contact & Terms: Send 5x7, 8x10 glossy and semi-glossy b&w prints by mail for consideration. Reports in 3 weeks. Pays \$25/b&w cover photo and \$10/b&w inside photo. Pays on publication. Credit line given. Buys one-time rights. Previously published work OK.

NIT & WIT, CHICAGO'S ARTS MAGAZINE, Box 14685, Chicago IL 60614. (312)248-1183. Editor: Leonard J. Dominguez. Publisher: Kathleen J. Cummings. Photo Editor: Maude Huffman. Bimonthly. Circ. 7,500. Emphasizes visual and performing arts and literature. Readers are 25-40 year old professionals, "interestingly eclectic, very well educated, well traveled and above all, gifted with a global view of life, the arts and the rich cultures which surround us." Sample copy \$2.

Photo Needs: Uses 10-15 photos/issue; all supplied by freelance photographers. Needs photos of all types. Photos purchased with or without accompanying ms. Model release required, when necessary. Making Contact & Terms: Arrange interview to show portfolio or send by mail for consideration b&w prints or contact sheet. SASE. Reports in 6-8 weeks. Pays in contributor's copy on publication. Credit

line given. Buys one-time rights.

Tips: "Send us samples of what you consider your best." Also sponsors annual photography contest: Deadline October 15th. Send SASE for rules, judges and prizes. "We are *committed* to freelancers and discovering talent. Have a positive attitude, be patient and get to know the mailperson better."

NORTHEAST OUTDOORS, Box 2180, Waterbury CT 06722-2180. (203)755-0158. Editor: Howard Fielding. Monthly tabloid. Circ. 14,000. Emphasizes family camping in the Northeast. Photos purchased with accompanying ms. Buys 15 photos/issue with accompanying ms.

Subject Needs: Camping, nature and scenic. Needs shots of camping and recreational vehicles. No noncamping outdoor themes or poor quality prints. Model release and captions preferred.

Accompanying Mss: Photos purchased with accompanying ms only. Seeks mss about camping—how-to or where—in the Northeast (i.e., campground or tourist destinations). Free editorial guidelines. Specs: Uses 3x5 glossy b&w prints. Uses b&w covers; 8x10 vertical format preferred for covers. Payment/Terms: Pays \$40-80/job or on a per-photo basis—\$5-10/b&w print and \$50/cover. Credit line

given. Pays on publication. Buys one-time rights.

Making Contact: Send material by mail for consideration. SASE. Reports in 2-3 weeks. Free sample

copy and editorial guidelines (includes photography).

Tips: "Read and study the magazine. Try to use RVs, travel trailers, tents, camping scenes, especially for cover shots. Go camping in our area (northeastern United States), take b&w verticals of campgrounds and campsites, and let us see a few."

NUCLEAR TIMES, 298 5th Ave., Rm. 512, New York NY 10001. (212)563-5940. Art Director: Lolyd Dangle. Publishes 10 times/year. "We are the newsmagazine for the antinuclear-weapons movement in the U.S. and abroad." Readers are anti-nuclear-weapons-movement people and interested people. Circ. 30,000. Sample copy \$1.

Photo Needs: Uses about 10-20 photos/issue; all supplied by freelance photographers. Needs "news photos of antinuclear events, people, places, activities, etc.; weapons photos; anything relating to the

antinuclear issue."

Making Contact & Terms: Arrange a personal interview to show portfolio; query with samples; query with list of stock photo subjects; provide resume, business card, brochure, flyer or tearsheets to be kept on file for possible future assignments; call. SASE. Reports in 2 weeks. Pays \$25-50/b&w cover photo; \$25/b&w inside photo; and by arrangement for text/photo package. Pays on publication. Credit line given. Buys one-time rights. Simultaneous submissions and previously published work OK.

Tips: "We look for material relevant to our magazine—or a photographer showing an interest and talent in news/political photography and portraits. Show your work around. We need photographers who are both telepted and interested in the actional leaves the second in the actional leaves to the property of the action of the

both talented and interested in the antinuclear movement, since we don't pay large sums.'

NUGGET, Suite 204, 2355 Salzedo St., Coral Gables FL 33134. (305)443-2378. Editor: John Fox. Bimonthly magazine. Circ. 150,000. Emphasizes sex and fetishism for men and women of all ages. Uses 100 photos/issue. Credit line given. Pays on publication. Buys one-time rights or second serial (reprint) rights. Submit material (in sets only) for consideration. SASE. Previously published work OK. Reports in 2 weeks. Sample copy \$4.50; photo guidelines free with SASE.

Subject Needs: Interested only in soft-core nude sets, single woman, female/female or male/female. All photo sequences should have a fetish theme (sadomasochism, leather, bondage, transvestism, transsexuals, lingerie, boots, wrestling—female/female or male/female—women fighting women or women fighting men, etc.). Model release required. Buys in sets not by individual photos. No Polaroids or ama-

teur photography.

B&W: Uses 8x10 glossy prints; contact sheet OK. Pays \$150 minimum/set.

Color: Uses transparencies. Pays \$200-300/set.

Cover: Uses color transparencies. Vertical format required. Pays \$150 minimum/photo.

Accompanying Mss: Seeks mss on sex, fetishism and sex-oriented products. Pays \$100-150/ms.

NUTSHELL NEWS, Clifton House, Clifton VA 22024. (703)830-1000. Editor: Bonnie Schroeder. Monthly magazine. Circ. 40,000. For miniature collectors, crafters and hobbyists. Emphasizes human interest features on new craftspeople, collections, shows, exhibits, shop and product information; also,

how-to articles with step-by-step photos.

Subject Needs: Product shots, how-to, human interest, shots of featured miniaturists at work to accompany articles and shots of miniature room settings, furniture groupings, dollhouse interiors and exteriors and shadow box. "We're striving for Architectural Digest quality in shots of miniature interiors and exteriors. No poorly lit, out-of-focus shots in which the dollhouse miniatures look like toys. Avoid flash unless you can get realistic, even lighting and true color." Captions required.

Specs: Uses 5x7 b&w glossy prints, 35mm transparencies or large format. Uses color covers only; verti-

cal format preferred.

Accompanying Mss: Photos purchased with accompanying ms on assignment.

Payment/Terms: Works with photographers on assignment basis only. Provide resume, business card, brochure to be kept on file for possible future assignments. "Both portfolio and samples should include photos/slides taken using close-up lenses, since most of our work is macro." Pays \$7.50/b&w print; \$10/color transparency printed as color; and \$25-75/color cover. Pay for photos and transparencies is included in total purchase price with ms. Credit line given. Pays on publication. Buys all rights in the field but will reassign on request to editor. Previously published work OK, "if not published previously within the miniatures field.'

Making Contact: Query with resume and samples of close-up photography.

Tips: "To work for this magazine, photographers should be very conscious of precise detail and sharp focus/depth of field, and should have a sense of realism when shooting 1" to 1' dollhouse miniatures."

OCEAN REALM, 2333 Brickell Ave., Miami Fl 33129. (305)285-0252. Editor-in-Chief: Richard H. Stewart. Quarterly. Circ. 50,000. Emphasizes the ocean and underwater. Readers are sport divers. Sample copy \$3; photo guidelines free with SASE.

Photo Needs: Uses about 35 photos/issue. Needs "any ocean scenes, topside and underwater." Special needs include "travel, people, photography, portfolio, technology, ecology." Model release preferred;

captions required.

Making Contact & Terms: Query with samples; send color prints, 35mm or 21/4x21/4 slides (no originals); provide resume, business card or tearsheets to be kept on file for possible future assignments. SASE. Reports in 1 month. Pays \$150/color cover photo; \$10-50/b&w photo; \$25-100/color photo; \$100/full page color inside photo; \$100-300/job. Pays on publication. Credit line given. Buys one-time rights. Simultaneous submissions and previously published work OK.

OCEANS, Fort Mason Center, Bldg. E., San Francisco CA 94123. (415)441-1104. Editor: Jake Widman. Bimonthly magazine. Circ. 60,000. Emphasizes exploration, conservation and life of the sea. For well-educated persons who enjoy science and marine art and are concerned with the environment. Buys 100/photos annually. Buys first serial rights. Send photos for consideration. Credit line given. Pays on publication. Reports in 1 month. SASE. \$2 sample copy; free photo guidelines.

Subject Needs: Animal, nature, scenic, sport, wildlife and marine art. All photos must be marine-relat-

ed. "Photos should have a definite theme. No miscellanies."

B&W: Send contact sheet or 8x10 semigloss prints. Captions required. Pays \$25-50.

Color: Send 35mm or 21/4x21/4 transparencies or duplicates. Captions required. Pays \$30-100.

Cover: Send 35mm or 21/4x21/4 color transparencies. Captions required. Pays \$150.

Tips: Prefers ms with photos (pays \$100/printed page). Wants transparencies in sleeves.

ODYSSEY, Box 6227, San Jose CA 95150. (408)296-6060, ext. 38. Photo Editor: Virginia R. Parker. Quarterly. Emphasizes travel. Readers are mostly over 45, from the South and the East coast. Circ. 200,000. Free sample copy. Photo guidelines free with SASE. Photo Needs: Uses about 30 photos/issue; all supplied by freelance photographers. "We require origi-

nal transparencies for separation." Model release and captions required.

Making Contact & Terms: Query with list of stock photo subjects. SASE. Reports in 1 month. Pays \$350/front color cover photo; \$250/back color cover photo; \$100-175/color inside photo. Pays on publication. Credit line given. Buys one-time rights. Simultaneous submissions and previously published work OK.

Tips: "We prefer a stock list and brief cover letter from the photographer instead of an impersonal questionnaire.'

OFF DUTY AMERICA, 3303 Harbor Blvd., Suite C-2, Costa Mesa CA 92626. Editor: Bruce Thorstad. Off Duty Pacific, Box 9869, Hong Kong. Editor: Jim Shaw. Off Duty Europe, Eschersheimer Landstr. 69, 6 Frankfurt/M, West Germany. European Editor: J.C. Hixenbaugh. "Off Duty Magazines publish 3 editions. American, Pacific and European, for U.S. military personnel and their families stationed around the world." Combined circ. 683,000. Emphasis is on off duty travel, leisure, military shopping, wining and dining, sports, hobbies, music and getting the most out of military life. Overseas editions lean toward foreign travel and living in foreign cultures. Free sample copy and contributor guidelines.

Photo Needs: "Travel photos to illustrate our articles, especially shots including people who could be our readers depicted in travel locations. Need to hear from professional photographers having access to military personnel or uniforms and who can do set-up shots to illustrate our articles. Amateur models usually OK." Uses 5x7 or similar glossy b&w prints and color transparencies. "Must have at least vertical-format 35mm for cover."

Making Contact & Terms: "Material with special U.S., Pacific or European slant should be sent to separate addresses above; material common to all editions may be sent to U.S. address and will be forwarded as necessary. Photographers living or traveling in European or Pacific locations should contact Frankfurt or Hong Kong offices above for possible assignments." Pays \$25/b&w; \$50/color; \$100/full-page color; \$200/cover. "Usually pays more for assignments." Pays on acceptance. Buys first serial or second serial rights. Tips: "We need establishing shots with a strong sense of people and place for our travel stories. We are interested in building a file of color and b&w shots showing the U.S. military and their dependents (our only readers) at work and at play. Learn to write, or work closely with a writer who can offer us several article proposals . . . start with the written word and take photos that illustrate the story, or—better yet—that tell an essential part of the story that the words alone cannot tell. We often avoid sending a staffer long distances and go instead to a freelancer on the scene. Become a particularly good source for some subject or group of subjects. Then send us a stock list describing what you have. Photographers looking for assignments probably prefer to characterize themselves as all-around shooters. But since we're most often looking for pre-existing pictures, we deal a lot with photographers who have established something of a specialty and a reputation for delivering quality."

Army Captain and freelance photographer Richard Jansen took this cover photo for Off Duty America, which used it for an issue spotlighting life in the Ozarks. The photo also appeared on the cover of a sister publication Off Duty Pacific, a joint use which garnered Jansen a payment of \$500. Jansen says Off Duty America rarely uses freelancers for their covers. but they bought his photo because it fit in perfectly with the theme of the Ozarks article.

OFFSHORE, New England's Boating Magazine, Box 148, Waban MA 02168. (617)244-7520. Editor: Herb Gliick. Monthly tabloid. Emphasizes boating in New England for boat owners. Circ. 18,000. **Photo Needs:** Uses about 24 photos/issue; 12 supplied by freelance photographers. Needs photos of "boats and New England harbors and waterfronts." Model release optional; captions preferred.

Making Contact & Terms: Query with samples—contact sheets are sufficient. SASE. Reports in 1 week. Pays \$125/color cover; \$10/b&w inside photo; \$50/page rate; \$50-150 for text/photo package. Pays on acceptance. Credit line given. Buys one-time rights "plus the right to use in promotional materials."

Tips: "We prefer interesting rather than pretty subjects."

OHIO FISHERMAN, 1570 Fishinger Rd., Columbus OH 43221. (614)451-5769. Editor: Ottie M. Snyder. Monthly. Circ. 41,000. Emphasizes fishing. Readers are the Buckeye State anglers. Sample copy and photo guidelines free with SASE.

Photo Needs: 12 covers/year supplied by freelance photographers. Needs transparencies for cover; 99% used are verticals with as much free space on top and left side of frame as possible. Fish and fishermen (species should be common to coverage area) action preferred. Photos purchased with or without ac-

companying ms. Model release preferred; required for covers. Captions preferred.

Making Contact & Terms: Query with tearsheets or send unsolicited photos by mail for consideration. Prefers 35mm transparencies. SASE. Reports in 1 month. Provide tearsheets to be kept on file for possible future assignments. Pays minimum \$100/color cover. Pays on publication. Credit line given. Buys one-time rights.

OHIO MAGAZINE, 40 S. 3rd St., Columbus OH 43215. (614)461-5083. Art Director: Thomas E. Hawley. Monthly magazine. Emphasizes features throughout Ohio for an educated, urban and urbane readership. Pays \$150/day plus expenses for photojournalism or on a per-photo basis. Credit line given. Pays on acceptance. Buys first world rights and permission to reprint in later issues or promotions. Send material by mail for consideration; query with samples; or arrange a personal interview to show portfolio. Work from Ohio only. SASE. Reports in 3 weeks.

Subject Needs: Travel, sport, photo essay/photo feature, celebrity/personality, product show and spot

news. Photojournalism and concept-oriented studio photography.

B&W: Uses 8x10 glossy prints; contact sheet mandatory. Pays \$25/in-stock shot.

Color: Pays \$25-75/35mm, 21/4x21/4 or 4x5 transparencies.

Cover: Uses 35mm, 21/4x21/4 or 4x5 transparencies. Vertical square format preferred. Pays \$400 maximum/photo.

Tips: "Send sheets of slides and/or prints with return postage and they will be reviewed. We are leaning more towards well-done documentary photography and less toward studio photography."

*OHIO RENAISSANCE REVIEW, Box 804, Ironton OH 45638. (614)532-0846. Editor: James R. Pack. Quarterly. Emphasizes general literature. Readers include lovers of contemporary poetry; science fiction, fantasy, mystery prose, and visionary graphics. Estab. 1984. Sample copy \$4.

Photo Needs: Uses 3 photos/issue; all supplied by freelance photographers. Needs scenic shots that emphasizes ideas, new perspectives, a sense of mystery and the imagination. Reviews photos with or with-

out accompanying ms.

Making Contact & Terms: Send 5x7 matte and glossy prints by mail for consideration. SASE. Reports in 4-6 weeks. Pays on publication. Credit line given. Buys first North American serial rights. No simultaneous submissions or previously published work.

OKLAHOMA LIVING MAGAZINE, Box 75579, Oklahoma City OK 73147. (405)943-4289. Managing Editor: Linda Adlof. Bimonthly. Emphasizes housing industry—homes, apartments, condominiums, plus a city living section with general interest. Readers are a mixed audience—people moving to Oklahoma City, those looking for shelter, general population. Circ. 68,000. Sample copy free with SASE and \$2 postage.

Photo Needs: Uses about 100 photos/issue; half supplied by freelance photographers. Needs photos relating to the housing industry—how-to, architectural photo journals, Oklahoma-related photos, interior decorating. "We have a City Living feature every issue, and our needs vary. We need to be familiarized with work so we can determine how individual photographer's work can fill our needs. Model release

and captions preferred.

Making Contact & Terms: Query with samples; query with list of stock photo subjects; send 5x7 b&w or color glossy prints; 21/4x21/4, 4x5 or 8x10 transparencies; b&w or color contact sheet; b&w or color negatives (with contact sheet) by mail for consideration; provide resume, business card, brochure, flyer or tearsheets to be kept on file for possible future assignments. SASE. Reports in 1 month. Payment per assignment. Pays on publication. Credit line given. Buys all rights.

OLD WEST, Box 2107, Stillwater OK 74076. Editor: John Joerschke. Quarterly. Circ. 100,000. Emphasizes history of the Old West (1830 to 1910). Readers are people who like to read the history of the West. Sample copy available.

Photo Needs: Uses 100 or more photos/issue; "almost all" supplied by freelance photographers. Needs

"mostly Old West historical subjects, some travel, some scenic (ghost towns, old mining camps, historical sites). Prefers to have accompanying ms. Special needs include western wear, cowboys, rodeos, western events.

Making Contact & Terms: Query with samples, b&w only for inside, color covers. SASE. Reports in 1 month. Pays \$150 ("sometimes more")/color cover photos; \$10/b&w inside photos. Pays on acceptance. Credit line given. Buys all rights; "covers are one-time rights."

Tips: "Looking for transparencies of existing artwork as well as scenics for covers, pictures that tell stories associated with Old West for the inside. Most of our photos are used to illustrate stories and come with manuscripts; however, we will consider other work (scenics, historical sites, old houses)."

*ON CABLE, 25 Van Zant St., Norwalk CT 06855. (203)866-6256. Monthly national. Emphasizes cable television: programs, subject, personalities, etc. Readers are cable television subscribers-/magazine available through cable operators. Limited newsstand sales in New York City. Circ. 1.6 million. Photo Needs: Uses about 47 color photos/issue; number supplied by freelancers varies. Needs photos of celebrity personalities; subjects relating to cable television, news, entertainment, music, movies, etc.; sports; movie/television production. Interested in color photos only; no manuscripts. Captions or identifications required.

Making Contact & Terms: Arrange a personal interview to show portfolio; query with resume of credits, samples and list of stock photo subjects; provide resume, business card, brochure, flyer or tearsheets to be kept on file for possible future assignments. "We are interested in speaking with photographers if they are in the Southeast Connecticut/New York area; seeing nonreturnable examples of photos from photographers." Does not return unsolicited material. "We will not respond except where interested in purchasing rights to reproduce stock photography or to make photo assignments." Pays \$300-400/color cover; \$100-125/color inside photo one quarter page, \$150/color half page; \$175/color three-quarter page; \$200/color full page; \$150/half-day; \$300/full day. Pays within 30 days of receipt of bill for assignment work. Credit line given. "We generally buy first North American serial rights; for assignment work purchase rights for period of 6 months then return to photographer. For stock: one-time rights. We prefer work that has not been published and is not currently being considered by another similar-subject magazine. We are interested in photographers who can produce excellent quality work and are flexible in terms of price/use structure."

ON THE LINE, 616 Walnut Ave., Scottdale PA 15683. (412)887-8500. Contact: Editor. Weekly magazine. Circ. 15,000. For junior high students, ages 9-14. Needs photos of children, age 9-14. Buys one-time rights. Send photos for consideration. Pays on acceptance. Reports in 1 month. SASE. Simultaneous submissions and previously published work OK. Free sample copy and editorial guidelines. **B&W:** Send 8x10 prints. Pays \$10-30.

Tips: "We need quality black & white photos for use on cover. Prefer vertical shots, use some horizontal. We need photos of children, age 9-14 representing a balance of male/female, white/minority/international, urban/country, clothing and hair styles must be contemporary, but not faddish."

*1001 HOME IDEAS, 3 Park Ave., New York NY 10016. 340-9258. Art Director: R. Thornton. Monthly magazine. Emphasizes interiors, gardening and food. Sample copy free with SASE. **Photo Needs:** Uses about 30-40 photos/issue; all supplied by freelance photographers. Needs photos of

Making Contact & Terms: Arrange a personal interview to show portfolio. Send 2 ¹/₄x2 ¹/₄, 4x5 or 8x10 transparencies by mail for consideration. Reports in 3 weeks. Payment varies. Pays on publication. Credit line given. Buys all rights.

ONTARIO OUT OF DOORS, 3 Church St., Toronto, Ontario, Canada M5E 1M2. (416)368-3011. Editor: Burton J. Myers. Monthly magazine. Circ. 55,000. Emphasizes hunting, fishing, camping and conservation. For outdoors enthusiasts. Needs photos of fishing, hunting, camping, boating ("as it relates to fishing and hunting"), wildlife and dogs. Dogs department uses b&w action photos of hunting dogs in the field. Wants no "lifeless shots of large numbers of dead fish or game." Buys 50-75 annually. Buys first North American serial rights. Model release "not required except when featuring children under 18"; when required, present on acceptance of photo. Send photos for consideration. Pays \$100-350 for text/photo package. Pays on acceptance. Reports in 6 weeks. SAE and International Reply Coupons. Previously published work OK. Free sample copy and photo guidelines.

B&W: Send 8x10 glossy prints. Captions required. Pays \$25-75. **Color:** Uses transparencies to accompany feature articles. Pays \$35-150.

Cover: Send color transparencies. "Photos should portray action or life." Uses vertical format. Captions required. Pays \$350-450.

Tips: "Examine the magazine closely over a period of six months. Concentrate on taking vertical format pictures. We see a rise in the use of freelance photography to cover submissions by freelance writers. We look for clear, crisp dramatic photos rich with colour of action or life."

OPEN WHEEL MAGAZINE, Box 715, Ipswich MA 01938. (617)356-7030. Editor: Dick Berggren. Bimonthly. Circ. 175,000. Emphasizes sprint car supermodified and midget racing with some Indy coverage. Readers are fans, owners and drivers of race cars and those with business in racing. Photo guidelines free for SASE.

Photo Needs: Uses 100-125 photos/issue supplied by freelance photographers. Needs documentary, portraits, dramatic racing pictures, product photography, special effects, crash. Photos purchased with or without accompanying ms. Model release required for photos not shot in pit, garage or on track; captions required.

Making Contact & Terms: Send by mail for consideration 8x10 b&w or color glossy prints and any size slides. SASE. Reports in 1 week. Pays \$20/b&w inside; \$35-250/color inside. Pays on publication.

Tips: "Send the photos. We get dozens of inquiries but not enough pictures. We file everything that comes in and pull 80% of the pictures used each issue from those files. If it's on file, the photographer has a good shot."

*ORANGE COAST MAGAZINE, 18200 W. McDurmott St., Irvine CA 92714. (714)660-8622. Editor: Janet Eastman. Photo Editor: Suzanne Reid. Monthly. Emphasizes general interest—all subjects. Sample copy \$3.

Photo Needs: Uses 35 photos/issue; all supplied by freelance photographers. Needs graphic studio shots, travel shots, food shots; mostly 4x5 format. Reviews photos with accompanying ms only. Special needs include travel shots of the world. Model release preferred; captions required.

Making Contact & Terms: Query with samples. SASE. Reports in 1 week. Pays on acceptance. Credit

line given. Buys one-time rights. Simultaneous submissions and previously published work OK.

Tips: "Studio work, still life and travel shots."

ORGANIC GARDENING, 33 E. Minor St., Emmaus PA 18049. (215)967-5171. Art Director: Robert Ayers. Monthly magazine. Circ. 1,400,000. Emphasizes vegetable and flower gardening. Readers are "a diverse group whose main hobby is growing their own healthy food." Sample copy and photo guidelines free with SASE.

Photo Needs: Uses 35-40 photos/issue; 10-15 supplied by freelance photographers. Needs "vegetable close-ups, garden overviews, pictures of gardeners with innovative techniques. We stress gardening without harmful chemicals." Special needs include "more photos of gardeners with lots of flowers;

landscaping with flowers." Model release optional; captions required.

Making Contact & Terms: Query with sample or list of stock photo subjects; send 5x7 and 8x10 glossy prints or any size transparencies by mail for consideration. SASE. Reports in 2 weeks. Pays \$300-400/ color cover photo; \$35-55/b&w inside photo; \$55-75/color inside photo. Pays on acceptance. Credit line given. Buys negotiable rights. Previously published submissions OK.

Tips: "Send us shots of unusual vegetable varieties with all the information you can gather on them."

THE ORIGINAL NEW ENGLAND GUIDE, 2245 Kohn Rd., Box 8200, Harrisburg PA 17105. (717)657-9555. Managing Editor: Kathie Kull. Consulting Editor: Mimi E. B. Steadman. Annual magazine. Circ. 160,000, nationwide and international. For vacationers, visitors, conventioneers, travelers to New England. Forty-two percent are New Englanders. Buys 25-30 photos/issue. Buys one-time rights. Credit line given. Pays on publication (early spring). Reports in 2 weeks after publication. SASE. Previously published work OK. Sample copy \$4.50; free photo guidelines. Deadline is December 31 each year. Publication in early spring.

Subject Needs: "We seek photographs that reflect the beauty and appeal of this region's countryside, seacoast, and cities, and entice readers to travel and vacation here. In addition to seeking specific photo subjects to illustrate scheduled articles, we welcome unsolicited submissions, provided they are of professional quality and are accompanied by SASE. We use scenics taken in spring, summer, and sometimes autumn; photos of landmarks and attractions, especially those with historical significance; and photos of groups and individuals participating in action sports (such as hiking, mountain climbing, sailing, canoeing) and special events (auctions, craft shows, fairs, festivals and the like). We will also consider artistic impressions (dramatic weather, sunsets, landscapes, etc.). All photos must convey a distinctly New England atmosphere." Wants no "posed shots, faked shots, shots of commercial property." **B&W:** Send contact sheet or 5x7 or 8x10 glossy prints. Captions required. "Make photo locations spe-

cific." Pays up to \$150.

Color: Send 35mm, 21/4x21/4 or 4x5 transparencies (prefers 4x5) or 5x7 glossy prints, color transparencies are far preferable to prints, and should be sent in plastic pocket sheets. "Please label every slide and print with photographer's name and address." Captions required. Pays up to \$150.

Cover: Send 35mm, 21/4x21/4 or 4x5 color transparencies. Captions required. Pays \$200.

Tips: "Study the magazine—we only use 7 real scenics—one for cover and one to open each of 6-state sections. All the rest of the photos illustrate specific articles, so it's wise to send a list of subjects availa-

ble so we can pick those that fit with articles being planned and then request only those. Clarity of photo in transparency or color print, composition, good contrast in b&w, and strong colors in color work" are important. "Please mark each photo clearly with your name and address and indicate the location in which it was taken." No Polaroids. "We are happy to consider work by amateurs, but please don't just send us all the slides of your New England vacation. Edit first, and send only those of very best quality. You'll save yourself some postage, and save both of us a lot of time. Know what states are and what states aren't in New England—we're not going to use a shot of New York or Maryland or New Jersey, or wherever, no matter how spectacular it is. And please don't try to slip a non-New England slide by us by mislabeling it—it's been tried and it won't work! It just makes us mistrust the photographer in the future "

THE OTHER SIDE, Box 12236, Philadelphia PA 19144. (215)849-2178. Art Director: Cathleen Boint. Monthly magazine. Circ. 14,000. Emphasizes social justice issues from a Christian perspective. Buys 6 photos/issue. Credit line given. Pays within 4 weeks of acceptance. Buys one-time rights. Send samples or summary of photo stock on file. SASE. Simultaneous submissions and previously published work OK. Reports in 1 month. Sample copy \$1.

Subject Needs: Documentary and photo essay/photo feature. "We're interested in photos that relate to

current social, economic or political issues, both here and in the Third World."

B&W: Uses 8x10 glossy prints. Pays \$15-30/photo.

Cover: Uses color transparencies. Vertical format required. Pays \$125-175/photo.

OTTAWA MAGAZINE, Suite 2, 340 MacLaren St., Ottawa, Ontario, Canada K2P 0M6. (613)234-7751. Editor-in-Chief: Louis Valenzuela. Art Director: Peter di Gannes. Emphasizes life-style for sophisticated, middle and upper-income, above-average-educated professionals. Most readers are women. Monthly. Circ. 43,500. Sample copy \$1.

Photo Needs: Uses about 30-40 photos/issue; 20-40 are supplied by freelance photographers. Needs photos on travel and life-styles pegged to local interests. Model release and captions required.

Making Contact & Terms: Send material by mail for consideration, arrange personal interview to show portfolio and query with list of stock photo subjects. Prefers creative commercial, product and studio shots; also portraiture (for magazine) in portfolio. Uses 8x10 b&w and color prints; 35mm and 21/4x21/4 slides. SASE. Reports in 30 days. Pays \$30-50/b&w photo; \$30-150/color photo; \$150-250/ day; \$125 minimum/page; \$125-250/job and \$200-500 for text/photo package. Credit line given. Payment made on acceptance. Buys first time or second rights or by special arrangement with photographer. Simultaneous and previously published work OK.

Tips: "Contact art director, send work samples or photocopies. No originals. Have a well-rounded portfolio. I look for photos that tell me the photographer went through some sort of thinking. I look for wit or at least a sign that he/she had the good judgement to recognize a good photo and seized the opportunity to

take it."

OUR FAMILY, Box 249, Battleford, Saskatchewan, Canada SOM 0E0. Editor: Albert Lalonde, O.M.I. Photo Editor: Reb Materi, O.M.I. Monthly magazine. Circ. 17,638. Emphasizes Christian faith as a part of daily living for Roman Catholic families. Photos are purchased with or without accompanying ms. Buys 5-10 photos/issue. Credit line given. Pays on acceptance. Buys one-time rights and simultaneous rights. Send material by mail for consideration or query with samples after consulting photo spec sheet. Provide letter of inquiry, samples and tearsheets to be kept on file for possible future assignments. SAE and International Reply Coupons. (Personal check or money order OK instead of International Reply Coupon.) Simultaneous submissions or previously published work OK. Reports in 2-4 weeks. Sample copy \$1.50. Free photo guidelines with SAE and payment for postage (37¢). Subject Needs: Head shot (to convey mood); human interest ("people engaged in the various experiences of living"); humorous ("anything that strikes a responsive chord in the viewer"); photo essay/

photo feature (human/religious themes); and special effects/experimental (dramatic-to help convey a specific mood). "We are always in need of the following: family (aspects of family life); couples (husband and wife interacting and interrelating or involved in various activities); teenagers (in all aspects of their lives and especially in a school situation); babies and children; any age person involved in service to others; individuals in various moods (depicting the whole gamut of human emotions); religious symbolism; and humor. We especially want people photos, but we do not want the posed photos that make people appear 'plastic,' snobbish or elite. In all photos the simple, common touch is preferred. We are especially in search of humorous photos (human and animal subjects), particularly pictures that involve young children. Stick to the naturally comic, whether it's subtle or obvious." Model release required if editorial topic might embarrass subject; captions required when photos accompany ms.

B&W: Uses 8x10 glossy prints. Pays \$25/photo.

Color: Transparencies or 8x10 glossy prints are used on inside pages, but are converted to b&w. Pays \$75-100/photo.

Cover: Uses color transparencies for cover. Vertical format preferred. Pays \$75-100/photo. Accompanying Mss: Pays 7-10¢/word for original mss; 4-6¢/word for nonoriginal mss. Free writer's guidelines with SAE and payment for postage (37¢).

Tips: "Send us a sample (20-50 photos) of your work after reviewing our Photo Spec Sheet."

OUTDOOR CANADA, 953A Eglinton Ave., E., Toronto, Ontario, Canada M4G 4B5. (416)429-5550. Editor: Sheila Kaighin. Magazine published 8 times annually. Circ. 133,000. Needs Canadian photos of canoeing, fishing, backpacking, hiking, wildlife, cross-country skiing, etc. Wants "good ac-

"After I got the phone call from Saskatchewan requesting this photo of my daughter, I had to laugh. Who would ever think that a Canadian magazine would have to go as far south as Atlanta to get a snow picture for its cover?" says freelance photographer Roger Neal. Our Family paid the Atlanta, Georgia, photographer \$50 for the photo, which has since been sold six times to other denominational publications. His sales show that denominational publications can be excellent freelance markets.

tion shots, not posed photos." Buys 70-80 annually. Buys first serial rights. Send photos for consideration. Pays on publication. Reports in 3 weeks; "acknowledgement of receipt is sent the same day material is received." SAE and International Reply Coupons for American contributors; SASE for Canadians must be sent for return of materials. Free writers' and photographers' guidelines "with SASE or SAE and International Reply Coupons only." No phone calls, please.

B&W: Send 8x10 glossy prints. Pays \$10-45.

Color: Send transparencies. Pays \$20-150 depending on size used.

Cover: Send color transparencies. Allow undetailed space along left side of photo for insertion of blurb. Pays \$250 maximum.

Tips: "Study the magazine and see the type of articles we use and the types of illustration used" and send a number of pictures to facilitate selection.

OUTDOOR LIFE MAGAZINE, 380 Madison Ave., New York NY 10017. (212)687-3000. Art Director: Jim Eckes. Monthly. Circ. 1,500,000. Emphasizes hunting, fishing, shooting, camping and boating. Readers are "outdoorsmen of all ages." Sample copy "not for individual requests." Photo guidelines free with SASE.

Photo Needs: Uses about 50-60 photos/issue; ³/₄ of total supplied by freelance photographers. Needs photos of "all species of wildlife and fish, especially in action and in natural habitat; how-to and where-to. No color prints—preferably Kodachrome 35mm slides." Captions preferred. No duplicates. **Making Contact & Terms:** Send 5x7 or 8x10 b&w glossy prints; 35mm or 2½x2½ transparencies; b&w contact sheet by mail for consideration. Pays \$35-275/b&w photo, \$50-700/color photo depending

b&w contact sheet by mail for consideration. Pays \$35-275/b&w photo, \$50-700/color photo depending on size of photos; \$800-1,000/cover photo. SASE. Reports in 1 month. Rates are negotiable. Pays on publication. Credit line given. Buys one-time rights. "Multi subjects encouraged."

Tips: "Have name and address clearly printed on each photo to insure return, send in 8x10 plastic sleeves."

OUTSIDE, 1165 N. Clark St., Chicago IL 60610. (312)951-0990. Editor: John Rasmus. Photography Director: Larry Evans. Published 12 times/year. Circ. 220,000. For a young (29 years old), primarily male audience specifically interested in nonmotorized outdoor sports. Buys 50-60 photos/issue. Buys first serial rights. Send photos for consideration. Pays on publication. Reports in 4-6 weeks. SASE. Free photo guidelines.

Subject Needs: Photo essay/photo feature; scenic; wildlife; and photos of people involved in sports such as: backpacking, mountain climbing, skiing, kayaking, canoeing, sailing, river rafting and scuba div-

ing.

Color: Send transparencies. Captions required. Pays \$25-200.

Cover: Send color transparencies. Prefers action photos "close enough to show facial expression." Captions required. Pays \$450.

OVERSEAS!, Bismarckstr. 17, 6900 Heidelberg, West Germany. Editorial Director; Charles Kaufman. Monthly magazine. Circ. 83,000. Emphasizes entertainment and information of interest to the G.I. in Europe. Read by American and Canadian military personnel stationed in Europe, mostly males ages 18-30. Buys 12 cover photos/year. Pays on acceptance. Buys rights for "American and Canadian military communities in Europe." Query or send photos. SAE with International Reply Coupons. Simultaneous submissions OK. Previously published work OK. Reports in 2 weeks. Sample copy for 4 International Reply Coupons.

Subject Needs: "Women! All we want is cover shots of women. Pretty women, active women, clothed women. No nudes. No head shots (prefer full to ³/₄ body shots). Nothing perverted. No women's fashion-type photos. We prefer the unposed, healthy look. The woman should not look into the camera. Subjects of women we are always in need of: winter-women skiing, sledding, playing in the snow, etc.; summer-women on the beach, in bikinis, on a sail boat, fishing, motorcycling (or standing next to a motorcycle), on a jet ski, wind surf board, anything with a summer-type activity. Also need photos of women in or next to cars, women at a disco, woman with luggage or traveling." Pays \$200. Will negotiate.

Color: Uses 35mm or larger transparencies. No prints. Pays DM 80/photo if used as b&w; DM 100/photo if published in color.

OWL, 59 Front St. E., Toronto, Ontario, Canada M5E 1B3. (416)364-3333. Editor: Sylvia S. Funston. Magazine published 10 times/year. Circ. 100,000. Children's natural science magazine for ages 8-12 emphasizing relationships of all natural phenomena. Photos purchased with or without accompanying ms and on assignment. Buys approximately 200 photos/year. Pays \$100-600 for text/photo package or on a per-photo or per-job basis. Credit line given. Pays on publication. Buys one time rights, nonexclusive to reproduce in OWL and Chickadee in Canada and affiliated children's magazines. Send material by mail for consideration. Provide business card and stock photo list. SASE. (Canadian postage, no American postage.) Previously published work OK. Reports in 6-8 weeks. Sample copy available. Subject Needs: Animal (not domesticated), documentary, photo feature, how-to (children's activities), nature (from micro to macro) photo puzzles and wildlife. Wants on a regular basis cover shots and centerfold close-ups of animals. No zoo photographs—all animals must be in their natural habitat. No staged photos or mood shots. Model release required; captions preferred.

B&W: Uses 8x10 glossy prints. Pays \$10-25/photo.

Color: Uses original transparencies. Pays \$40-125/photo.

Cover: Uses color transparencies. Vertical and horizontal formats required. Pays \$40 minimum/photo, depending on size.

Accompanying Mss: Fully researched, well-organized presentation of facts on any natural history or science topic of interest to 8- to 12-year-old children. Pays \$100 minimum/ms. Free writer's guidelines. Tips: "Know your craft, know your subject and remember that children love surprises. We need cover store of children, the appropriate age for our readership; close-ups of animals in their natural habitat that are unusual or humorous. Seasonal material i.e., Halloween, winter, summer, etc. These need to be a vertical format with room at top for logo."

PACIFIC BOATING ALMANAC, Box Q, Ventura CA 93002. (805)644-6043. Editor: Bill Berssen. Circ. 25,000. Emphasizes orientation photos of ports, harbors, marines; particularly aerial photos. For boat owners from Southeastern Alaska to Acapulco, Mexico. "We only buy specially commissioned art and photos." Query. Provide resume to be kept on file for possible future assignments. "No submissions, please."

PAINT HORSE JOURNAL, Box 18519, Fort Worth TX 76118. (817)439-3400. Editor: Bill Shepard. Emphasizes horse subjects—horse owners, trainers and show people. Readers are "people who own, show or simply enjoy knowing about registered paint horses." Monthly. Circ. 11,000. Sample copy \$1; photo guidelines for SASE. Provide resume, business card, brochure, flyer and tearsheets to be kept on

file for possible future assignments.

Photo Needs: Uses about 50 photos/issue; 3 of which are supplied by freelance photographers. "Most photos will show paint (spotted) horses. Other photos used include prominent paint horse showmen, owners and breeders; notable paint horse shows or other events; overall views of well-known paint horse farms. Most freelance photos used are submitted with freelance articles to illustrate a particular subject. The magazine occasionally buys a cover photo, although most covers are paintings. Freelance photographers would probably need to query before sending photos, because we rarely use photos just for their artistic appeal—they must relate to some article or news item." Model release not required; captions required. Wants on a regular basis paint horses as related to news events, shows and persons. No "posed, handshake and award-winner photos."

Making Contact & Terms: Query with resume of photo credits or state specific idea for using photos. SASE. Reports in 3-6 weeks. Pays on acceptance \$7.50 minimum/b&w photo; \$10 minimum/color transparency; \$50 minimum/color cover photo; \$50-250 for text/photo package. Credit line given. Buys

first North American serial rights or per individual negotiaton.

PALM BEACH LIFE, Box 1176, Palm Beach FL 33480. (305)837-4762. Design Director: Anne Wholf. Monthly magazine. Circ. 23,000. Emphasizes entertainment, gourmet cooking, affluent lifestyle, travel, decorating and the arts. For a general audience. Photos purchased with or without accompanying mss. Freelance photographers supply 20% of the photos. Pays \$100-300/job, \$200-350 for text/photo package or on a per-photo basis. Credit line given. Pays on publication. Query or make appointment. SASE. Simultaneous submissions OK. "Palm Beach Life cannot be responsible for unsolicited material." Reports in 4-6 weeks. Sample copy \$3.50.

Subject Needs: Fine art, scenic, human interest and nature. Captions are required.

B&W: Uses any size glossy prints. Pays \$10-25.

Color: Uses 35mm, 21/4x21/4 and 4x5 transparencies. Pays \$25-50.

Cover: Uses color transparencies; vertical or square format. Payment negotiable.

Tips: "Don't send slides—make an appointment to show work. We have staff photographers, are really only interested in something really exceptional or material from a location that we would find difficult to cover. We are looking for dramatic, graphic covers of subjects relating to Florida or life-style of the affluent."

PARENTS MAGAZINE, 685 3rd Ave., New York NY 10017. (212)878-8700. Editor-in-Chief: Elizabeth Crow. Photo Editor: Dianna J. Caulfield. Emphasizes family relations and the care and raising of children. Readers are families with young children. Monthly. Circ. 1,670,000. Free sample copy and photo guidelines.

Photo Needs: Uses about 60 photos/issue; all supplied by freelance photographers. Needs family and/or children's photos. No landscape or architecture photos. Column needs are: fashion, beauty and food. Model release required; captions not required. Pays ASMP rates for b&w; color: standard rates-/change

yearly.

Making Contact & Terms: Works with freelance photographers on assignment only basis. Provide brochure and calling card to be kept on file for possible future assignments. Arrange for drop off to show portfolio. "Clifford Gardener, Art Director, and Dianna Caulfield, Photo Editor, see photographers by appointment. By looking at portfolios of photographers in whom we are interested we will assign a job." Report time depends on shooting schedule, usually 2-6 weeks. Payment depends on layout size. SASE. Credit line given. Buys one-time rights. No simultaneous submissions; previously published work OK.

PASSENGER TRAIN JOURNAL, Box 860, Homewood IL 60430. (312)957-7245. Publisher: Kevin McKinney. Emphasizes modern rail passenger service. Readers are train enthusiasts who read about and ride trains, as well as some industry people. Monthly. Circ. 13,000. Free photo guidelines. Sample copy: \$2.

Photo Needs: Uses about 40 photos/issue; 20 of which are supplied by freelance photographers. Freelancers used are usually known specialists in railroad field or with credit lines seen in related publications. Needs include anything railroad related, 80-90% exterior shots. "Contemporary passenger train

shots as well as 1940-present." Monthly photo feature: "On the Property." Also publishes *Passenger Train Annual* (softcover book). Model release not required; informational captions required. "We don't

need much in subway or streetcar area—although a few are OK."

Making Contact & Terms: Send by mail for consideration actual b&w photos (prefers 8x10, accepts 5x7 also); or 35mm color transparencies. SASE. Reports in 2-6 weeks. Pays within 60 days \$5-10/b&w photo; \$20-35/color transparency. Credit line given. Buys one-time rights. No simultaneous submissions; previously published work OK.

*PASSPORT MAGAZINE, Box 2241, Paterson NJ 07509. (201)684-6147. Editor: Lynn K. Thompson. Monthly. Emphasizes upscale black market; covers people, places, pleasures and professions in the state of New Jersey. Readers include college graduates, young urban professionals and mature urban professionals between the ages of 25 and 50, with 75% below the ages of 38. Circ. 20,000. Estab. 1984. Sample copy for SASE and 75¢ postage. Photo guidelines free with SASE.

Photo Needs: Needs wide variety, usually compliments editorial content. Reviews photos with or with-

out accompanying ms. Model release preferred; captions required.

Making Contact & Terms: Query with list of stock photo subjects, send unsolicited photos by mail for consideration; provide resume, business card, brochure, flyer or tearsheets to be kept on file for possible future assignments. Uses 5x7 prints. SASE. Reports in 1 month. Pays \$10-20/inside b&w photo. Pays on publication. Credit line given. Buys one-time rights. Simultaneous submissions and previously published work OK.

PC WORLD, 555 De Haro, San Francisco CA 94107. (415)861-3861. Editor: Andrew Fluegelman. Monthly. Circ. 145,000. Emphasizes IBM personal computers and IBM-compatible computers. Readers are affluent, professional.

Photo Needs: Uses 15-25 photos/issue; 50% supplied by freelance photographers. Needs photos of equipment (computers) and photos of people using computers; trade shows. Special needs include

"good indoor photos using flash equipment." Model release and captions preferred.

Making Contact & Terms: Provide resume, business card, brochure, flyer or tearsheets to be kept on file for possible future assignment. SASE. Reports in 2 weeks. Pays \$100 minimum/b&w and \$150 minimum/color inside photo; cover rates vary. Pays on publication. Credit line given. Buys all rights. Simultaneous submissions OK.

*PENNSYLVANIA, Box 576, Camp Hill PA 17011. (717)761-6620. Editor: Albert E. Holliday. Quarterly. Emphasizes history, travel and contemporary issues and topics. Readers are 40-60 years old professional and retired; income average is \$46,000. Circ. 21,000. Sample copy \$2.50; photo guidelines free with SASE.

Photo Needs: Uses about 40 photos/issue; most supplied by freelance photographers. Needs include

travel and scenic. Reviews photos with or without accompanying ms. Captions required.

Making Contact & Terms: Query with samples and list of stock photo subjects; send 5x7 and up b&w prints and 35mm and 21/4x21/4 transparencies by mail for consideration. SASE. Reports in 2 weeks. Pays \$75-100/color cover photo, \$10-25/inside b&w photo, \$50-400/text/photo package. Credit line given. Buys one-time rights. Simultaneous submissions and previously published work OK.

PENNSYLVANIA GAME NEWS, Box 1567, Harrisburg PA 17105-1567. (717)787-3745. Editor: Bob Bell. Monthly magazine. Circ. 210,000. Published by the Pennsylvania Game Commission. For people interested in hunting in Pennsylvania. Buys all rights, but may reassign to photographer after publication. Model release preferred. Send photos for consideration. Photos purchased with accompanying ms. Pays on acceptance. Reports in 1 month. SASE. Free sample copy and editorial guidelines. **Subject Needs:** Considers photos of "any outdoor subject (Pennsylvania locale), except fishing and boating."

B&W: Send 8x10 glossy prints. Pays \$5-20.

Tips: Buys photos without accompanying ms "rarely." Submit seasonal material 6 months in advance.

*PENNSYLVANIA OUTDOORS, Box 2266, Oshkosh WI 54903. Editor: Steve Smith. Emphasizes fishing, hunting and related outdoor activities. Photo guidelines free with a SASE; sample copy \$2 with a SASE.

Photo Needs: Uses 15-20 photos/issue; all supplied by freelance photographers. Reviews photos with or

without accompanying ms. Captions required.

Making Contact & Terms: Query with list of stock photo subjects; send 5x7 or larger glossy prints, 35mm and 21/4x21/4 transparencies and b&w contact sheet by mail for consideration; submit portfolio for review. SASE. Reports in 3-5 weeks. Pays \$300-400/color cover photo, \$25-250 b&w inside photo, \$50-400/color inside photo. Pays on acceptance. Credit line given. Buys one-time rights. No simultaneous submissions. Previously published work OK.

*THE PENNYSLVANIA REVIEW, English Department University of Pittsburgh, Pittsburgh PA 15260. (412)624-0026. Editor: Ellen Darion. Biannually. Emphasizes fiction, poetry, nonfiction, art reproduction, interviews, parts of novels. Circ. 1,000. Estab. 1984. Sample copy \$5.

Photo Needs: "Needs striking, well-composed photos which go well with our print content."

Making Contact & Terms: Query with samples; send 5x7 b&w prints by mail for consideration. SASE. Reports in 1 month. Pay varies. Pays on publication. Credit line given. Buys first North American serial rights. Simultaneous submissions OK. "We prefer to see the best he/she has to offer."

THE PENNSYLVANIA SPORTSMAN, Box 5196, Harrisburg PA 17110. Contact: Editor. Eight times a year. Circ. 50,000. Emphasizes field sports—hunting, fishing and trapping. "No ball sports." Photo guidelines free for SASE.

Photo Needs: Uses about 20-25 photos/issue; half supplied by freelance photographers. Needs "wild-life shots, action outdoor photography, how-to photos to illustrate outdoor items." Photos purchased

with or without accompanying ms. Model release and captions preferred.

Making Contact & Terms: Send by mail for consideration 5x7 or 8x10 b&w glossy prints or 35mm or 2½x2¼ slides or query with list of stock photo subjects. SASE. Reports in 3 weeks. Pays \$75/slide for cover; \$10/b&w or \$20/color inside photo. Pays on publication. Credit line given. Buys one-time rights. Previously published work OK.

PENTHOUSE, 1965 Broadway, 2nd Floor, New York NY 10023-5965. Editor: Bob Guccione. Monthly magazine. Circ. 3,500,000. Emphasizes beautiful women, social commentary and humor. For men, age 18-34. Photos purchased with or without accompanying ms and on assignment. Pays on a per-job or per-photo basis. Credit line given. Pays on acceptance. Buys all rights. Send material by mail for consideration. SASE. Reports in 1 month. Photo guidelines free with SASE.

Subject Needs: Nudes and photo essay/photo feature. Model release required. Needs nude pictorials.

Color: Uses 35mm and 21/4x21/4 transparencies.

PERSONAL COMPUTING, 10 Mulholland Dr., Hasbrouck Heights NJ 07604. (201)393-6000. Editor: Charles Martin. Monthly. Circ. 600,000. Emphasizes personal computers. Readers are "40-year-old business people, heads of household, earning \$40,000 and up." Sample copy free with SASE. **Photo Needs:** Uses about 6-15 photos/issue; 6-10 supplied by freelance photographers. Needs "illustrative photos of creative people with product shots. All have a personal computer worked into the shot. Most four-color, some b&w. Photos reviewed only if assigned; may be assigned with articles. Model release required; captions preferred.

Making Contact & Terms: Submit portfolio for review. Provide business card and tearsheets to be kept on file for possible future assignments. Reports in 1 month. Payment varies. Pays on acceptance. Credit

line given. Buys all rights.

PETERSEN'S HUNTING MAGAZINE, Petersen Publishing Co., 8490 Sunset Blvd., Los Angeles CA 90069. (213)657-5100. Editor: Craig Boddington. Monthly magazine. Circ. 275,000. For sport hunters who "hunt everything from big game to birds to varmints." Buys 4-8 color and 10-30 b&w photos/issue. Buys one-time rights. Present model release on acceptance of photo. Send photos for consideration. Pays on publication. Reports in 3-4 weeks. SASE. Free photo guidelines.

Subject Needs: "Good sharp wildlife shots and hunting scenes. No scenic views or unhuntable spe-

cies."

B&W: Send 8x10 glossy prints. Pays \$25. **Color:** Send transparencies. Pays \$100-200. **Cover:** Send color transparencies. Pays \$300-500.

Tips: Prefers to see "photos that demonstrate a knowledge of the outdoors, heavy emphasis on game animal shots, hunters and action. Try to strive for realistic photos that reflect nature, the sportsman and the flavor of the hunting environment. Not just simply 'hero' shots where the hunter is perched over the game. Action . . . such as running animals, flying birds, also unusual, dramatic photos of same animals in natural setting." Identify subject of each photo.

PETERSEN'S PHOTOGRAPHIC MAGAZINE, 8490 Sunset Blvd., Los Angeles CA 90069. Publisher: Paul R. Farber. Editor: Karen Geller-Shinn. Feature Editor: Bill Hurter. Monthly magazine. For the beginner and advanced amateur in all phases of still and motion picture photography. Buys 1,500 annually. Buys all rights, but may reassign to photographer after publication. Send photos for consideration. Pays on publication. "Mss submitted to *Photographic Magazine* are considered 'accepted' upon publication. All material held on a 'tentatively scheduled' basis is subject to change or rejection right up to the time of printing." Reports in 3 weeks. SASE. Free photo guidelines.

Subject Needs: Photos to illustrate how-to articles: animal, documentary, fashion/beauty, fine art, glamour, head shot, human interest, nature, photo essay/photo feature, scenic, special effects and ex-

perimental, sport, still life, travel and wildlife. Also prints general artistic photos.

B&W: Send 8x10 glossy or matte prints. Captions required. Pays \$25-35/photo, or \$60/printed page. **Color:** Send 8x10 glossy or matte prints or transparencies. "Color transparencies will not be accepted on the basis of content alone. All color presentations serve an absolute editorial concept. That is, they illustrate a technique, process or how-to article." Captions required. Pays \$25/photo or \$60/printed page. **Cover:** Send 8x10 glossy or matte color prints or color transparencies. Captions required. "As covers are considered part of an editorial presentation, special payment arrangements will be made with the author/photographer."

Tips: Prints should have wide margins; "the margin is used to mark instructions to the printer." Photos accompanying how-to articles should demonstrate every step, including a shot of materials required and at least one shot of the completed product. "We can edit our pictures if we don't have the space to accommodate them. However, we cannot add pictures if we don't have them on hand." Publishes b&w portfolio of "a photographer of high professional accomplishment" each month—minimum of 15 prints with comprehensive captions must accompany submissions.

PHOEBE, The George Mason Review, 4400 University Dr., Fairfax VA 22030. (703)323-2168. Editor-in-Chief: David Canter. Quarterly. Circ. 5,000. Emphasizes literature and the arts. Sample copy \$3. **Photo Needs:** "We could publish up to 15 photos provided they fit our needs. We are looking for abstract, still life, geometric, and high-contrast photos. Any kind of subject matter so long as it reflects the serious creative photographer." Only b&w photos. Photos accepted with or without accompanying ms. Model release and captions optional.

Making Contact & Terms: Send by mail for consideration up to 8½x11 b&w prints. SASE. Reports in 4-6 weeks. Pays in contributor's copies. Pays on publication. Credit line given. Buys first North Ameri-

can serial rights.

PHOENIX HOME/GARDEN, 3136 N. 3rd Ave., Phoenix AZ 85013. (602)234-0840. Editor-in-Chief: Manya Winsted. Monthly. Circ. 32,000. Emphasizes homes, entertainment and gardens, life-style, fashion, travel, fitness and health. Readers are Phoenix-area residents interested in better living. Sample copy \$2.

Photo Needs: Uses about 50 photos/issue; all supplied by freelance photographers. Needs photos of still lifes of flowers, food, wine and kitchen equipment. "Location shots of homes and gardens on assignment only." Photos purchased with or without accompanying ms. Model release and very specific iden-

tification required.

Making Contact & Terms: Arrange a personal interview to show portfolio, query with samples, list of stock photo subjects and tearsheets. Prefers b&w prints, any size transparencies and b&w contact sheets. SASE. Reports in 1 month. Provide resume and tearsheets to be kept on file for possible future assignments. Pays \$15-20/b&w inside and \$25-40/color inside for stock photos, by the job or by photographer's day rate. Pays on publication. Credit line given. Buys one-time rights for stock photos; all rights on assignments.

Tips: "The number of editorial pages has diminished as advertising pages increased, so we now use

fewer photos."

PHOENIX MAGAZINE, 4707 N. 12th St., Phoenix AZ 85014. (602)248-8900. Editor: Carrie Sears Bell. Monthly magazine. Circ. 40,000. Emphasizes "subjects that are unique to Phoenix: its culture, urban and social achievements and problems, its people and the Arizona way of life. We reach a professional and general audience of well-educated, affluent visitors and long-term residents." Buys 10-35 photos/issue.

Subject Needs: Wide range. All dealing with life in metro Phoenix. Generally related to editorial subject matter. Wants on a regular basis photos to illustrate features, as well as for regular columns on arts, restaurants, etc. No "random shots of Arizona scenery, etc. that can't be linked to specific stories in the magazine." Special issues: Restaurant Guide, Valley "Superguide" (January); Desert Gardening Guide, Lifestyles (March); Summer "Superguide" (June); Phoenix Magazine's Book of Lists (July); Valley Progress Report (August). Photos purchased with or without an accompanying ms.

Payment & Terms: B&w: \$25-100; color: \$25-200; cover: \$250-300. Pays within two weeks of publication. Payment for manuscripts includes photos in most cases. Payment negotiable for covers and other

photos purchased separately.

Making Contact: Query. Works with freelance photographers on assignment only basis. Provide resume, samples, business card, brochure, flyer and tearsheets to be kept on file for possible future assignments. SASE. Reports in 3-4 weeks.

Tips: "Study the magazine, then show us an impressive portfolio."

PHOTO COMMUNIQUE, Box 129, Station M, Toronto, Ontario, Canada M6S 4T2. (416)363-6004. Editor/Publisher: Gail Fisher-Taylor. Quarterly. Circ. 10,000. Emphasizes fine art photography for

"photographers, critics, curators, art galleries and museums." Sample copy \$3.

Photo Needs: Uses about 35 photos/issue; "almost all" supplied by freelance photographers. Model re-

lease preferred; captions required.

Making Contact & Terms: Send 8x10 b&w/color prints or 35mm or large format transparencies by mail for consideration. SASE. Reporting time "depends on our schedule." Credit line given. Acquires one-time rights. Simultaneous submissions not accepted.

Tips: Prefers to see "strong, committed work. We are interested in seeing work of dedicated artists whose lives are committed to photography. Do not send us stock lists or brochures since we never are

able to use them.'

PHOTO LIFE, 100 Steelcase Rd. E, Markham, Ontario, Canada L3R 1E8. Editor: Norm Rosen. Monthly magazine. Circ. 85,000. "Canada's leading magazine for the amateur photographer, providing information, entertainment and technical tips which help readers develop their interest in photography. Reader participation emphasized through gallery sections, contests and portfolio features. All articles and photography assigned specifically, but most assignments are given to readers who contact Photo Life with ideas or sample photography. Canadian photos and articles given priority, although features of interest to Canadian photographers but not written or photographed by Canadians will also be considered. Sample copy available for \$2 and SASE. Photo guidelines free with SASE.

Photo Needs: Interested in all subjects of interest to amateur photographers. Uses 8x10 glossy b&w prints. Pays \$25 (Canadian) minimum/photo. Uses 35mm or larger color transparencies or 8x10 color prints, glossy preferred. Unless assigned, covers are derived from content of each issue. Uses vertical format 35mm slides or larger format slides only. Pays \$200/cover. Canadian content only. Credit line given. Payment on publication. Buys first North American rights. Virtually all content is assigned 6 months prior to publication. Article ideas are welcome but no unsolicited mss please. Payment for arti-

cles ranges from \$100 Canadian minimum. Writer's guidelines free with SASE.

Tips: "Contact us prior to sending unsolicited material. We operate by assignment exclusively."

*PHOTO METRO, 6 Rodger 207C, San Francisco CA 94103. (415)861-6453, Editor: Henry Brimmer. Photo Editor: Paul Raedeke. Monthly. Circ. 20,000. "No specialty—photography in general, fine art to commercial; emphasis on San Francisco metropolitan area." Readers are serious professional and amateur photographers and the photo-interested public. Sample copy and photo guidelines free with SASE.

Photo Needs: "We publish a portfolio each month plus reviews and press photos." Model release and

captions required.

Making Contact & Terms: Query with resume of credits or samples; send any size b&w prints, 35mm or 21/4x21/4 transparencies by mail for consideration; submit portfolio for review; provide resume, business card, brochure, flyer or tearsheets to be kept on file for possible future assignments. SASE. Reports in 1 month. No payment. Credit line given. Uses one-time rights. Simultaneous submissions OK. Tips: Prefers to see "maximum of 15 unmounted prints or page of transparencies with resume and

SASE.

PHOTOGRAPHER'S MARKET, 9933 Alliance Rd., Cincinnati OH 45242. Editor: Robin Weinstein. Annual hardbound directory for freelance photographers. Credit line given. Pays on publication. Buys one time rights. Send material by mail for consideration. SASE. Simultaneous submissions and

previously published work OK.

Subject Needs: "We hold all potential photos and make our choice in early May. We are looking for photos you have sold (but still own the rights to) to buyers listed in Photographer's Market. The photos will be used to illustrate to future buyers of the book what can be sold. Captions should explain how the photo was used by the buyer, how you got the assignment or sold the photo, what was paid for the photo, your own self-marketing advice, etc. Reports after May deadline. For the best indication of the types of photos used, look at the photos in the book." Buys 20-50 photos/year.

B&W: Uses 8x10 glossy prints. Pays \$25 minimum for photos previously sold.

PICKUPS & MINI-TRUCKS MAGAZINE, 8490 Sunset Blvd., Los Angeles CA 90069. (213)657-5100. Editor: John J. Jelinek. Managing Editor: Chriss Bonhall. Monthly magazine. Circ. 185,000. Emphasizes test data, how-to articles and features concerning the light truck market as it applies to the street truck. "We rarely use photos unaccompanied by a ms." Credit line given. Buys all rights. Model release required. Query first with resume of credits. Pays on publication. Reports in 2 months. SASE. Free editorial guidelines with SASE.

B&W: Uses 8x10 glossy prints. Captions required. Pays \$10-75.

Color: Uses 35mm transparencies, prefers 21/4x21/4 transparencies. Captions required. Pays \$25-75.

Cover: "Covers are mostly staff produced."

Tips: Submit seasonal material 3-4 months in advance.

PITTSBURGH MAGAZINE, 4802 5th Ave., Pittsburgh PA 15213. (412)622-1358. Art Director: Michael Maskarinec. Emphasizes culture, feature stories and public broadcasting television schedules. Readers are "city mag style, upwardly mobile." Monthly. Circ. 60,000. Sample copy \$2.

Photo Needs: Uses 3 photos/issue, all supplied by freelance photographers. Needs b&w photos to illustrate stories; some color used. Column needs are: dining, sports. Model release and captions required. Making Contact & Terms: Arrange personal interview to show portfolio. Reports in 2 weeks. Pays \$50-100 for a b&w photo used inside; \$600 maximum/cover and inside color; \$250-400 by the day. Pays on publication. Credit line given. Buys one-time rights. Simultaneous submissions and previously published work OK.

PLANE & PILOT, HOMEBUILT AIRCRAFT, 16200 Ventura Blvd., Encino CA 91436. (818)986-8400. Art Director: J.R. Martinez. Monthly magazine. Emphasizes personal, business and home-built aircraft. Readers are private, business and hobbyist pilots. Circ. 70,000-100,000.

Photo Needs: Uses about 50 photos/issue; 90% supplied by freelance photographers. Needs photos of "production aircraft and homebuilt experimentals." Special needs include "air-to-air, technical, gener-

al aviation and special interest" photos. Written release and captions preferred.

Making Contact & Terms: Query with samples. Send 9x7 or 8x10 b&w glossy prints; 35mm transparencies; b&w contact sheets. SASE. Reports in 1 month. Pays \$150-200 color cover photo; \$25-50/inside photo; \$100-150/color inside photo; \$500/job; \$250-500/text/photo package. Pays on acceptance. Credit line given. Buys one-time rights. Simultaneous submissions and previously published work OK. Tips: Prefers to see "a variety of well-shot and composed color transparencies and b&w prints dealing with mechanical subjects (aircraft, auto, etc.)" in samples. "Use good technique, a variety of subjects and learn to write well."

PLEASURE BOATING, 1995 NE 150th St., North Miami FL 33181. (305)945-7403. Editor: Joe Green. Monthly. Circ. 30,000. Emphasizes recreational fishing and boating. Readers are "recreational boaters throughout the South." Free sample copy.

Photo Needs: Uses about 35-40 photos/issue. Needs photos of "people in, on, around boats and water."

Model release and captions preferred.

Making Contact & Terms: Query with samples. Provide brochure to be kept on file for possible future assignments. SASE. Reports in 4 weeks. Pays \$100-300/color photo/feature illustrations. Pays on publication. Credit line given. Buys all rights. Simultaneous submissions OK.

*PODIATRY MANAGEMENT, 401 N. Broad ST., Philadelphia PA 14108. (215)925-9744. Editor: Dr. Barry Block. Photo Editor: Bob Gantz. Published 8 times/year. Emphasizes podiatry. Readers include podiatrists. Circ. 11,000. Free sample copy with 9x12 SASE.

Photo Needs: Uses 4 photos/issue; 3 supplied by freelance photographers. Needs cover—office or surgical shots. Reviews photos with accompanying ms only. Model release and captions required. **Making Contact & Terms:** Query with resume of credits. SASE. Payment individually negotiated;

\$100-250. Pays on publication. Buys all rights.

*POETRY MAGAZINE, Box 4348, Chicago IL 60680. (312)996-7803. Editor: Joseph Parisi. Monthly. Emphasizes contemporary poetry, in English and translation. Readers include highly educated, professionals. Circ. 7,000. Sample copy \$3.25.

Photo Needs: Uses 1 photo/issue; all supplied by freelance photographers. Needs depend on subject matter of particular issues; inquiry should be made. Lead time is 3- months. Reviews photos with or without accompanying ms. "We will need three photos for covers; other covers are graphics." Model release required.

Making Contact & Terms: Arrange a personal interview to show portfolio, query with samples. Send 8x10 glossy b&w prints by mail for consideration. SASE. Reports in 1 month. Pay varies. Pays on publication. Credit line given on masthead page. Buys one-time rights.

Tips: Prefers to see "strong work that repro's well in b&w. Read past two years' issues, note cover illustrations."

POPULAR CARS MAGAZINE, 2145 W. LaPalma, Anaheim CA 92801. Monthly magazine. Emphasizes "restored and/or modified vehicles of 1955-1985 vintage specifically those that are of the 1960s 'muscle-car' or 1955-present street machine-type automobiles." Audience is predominantly male, 18-35 years of age. Circ. 100,000. Sample copy \$1.25; photo guidelines with SASE.

Photo Needs: Uses about 140 photos/issue; 25-35% supplied by freelance photographers. Needs automotive-oriented photos. Model release required; captions professed

motive-oriented photos. Model release required; captions preferred.

Making Contact & Terms: Query with samples; send 35mm or $2^{1/4}x2^{1/4}$ transparencies or b&w contact sheet by mail for consideration. SASE. Reports in 2 weeks. Pays \$100/color cover photo; \$50/b&w page, \$75/color page; \$100-300 for text/photo package. Pays on publication. Buys all rights.

POPULAR COMPUTING, (A McGraw-Hill Publication), Box 397, Hancock NH 03449. (603)924-9281. Art Director: Erik Murphy. Monthly. Circ. 300,000. Emphasizes personal computing for nontechnical people.

Photo Needs: Uses 15-25 photos/issue; most supplied by freelance photographers. Needs very few "shots showing people operating micro computers. Publishes more creative photos of home, education

and small business applications." Model release and captions required.

Making Contact & Terms: Query by telephone. Samples not returned. Payment according to ASMP guidelines. Pays in 90 days. Buys first North American rights.

Tips: "Keep in touch regularly."

POPULAR PHOTOGRAPHY, 1 Park Ave., New York NY 10016. Editorial Director: Arthur Goldsmith. Features Editor: Steve Pollack. Picture Editor: Monica R. Cipnic. Consulting Picture Editor: Charles Reynolds. Monthly magazine. Circ. 925,000. Emphasizes good photography, photographic instructions and product reports for advanced amateur and professional photographers. Buys 50 + photos/issue. "We look for portfolios and single photographs in color and b&w showing highly creative, interesting use of photography. Also, authoritative, well-written and well-illustrated how-to articles on all aspects of amateur photography." Especially needs for next year art photography, photojournalism, portraits, documentary and landscapes. Photos submitted also considered for photography annual. Wants "no street shots or portraits without releases. No frontal nudity." Buys first serial rights and promotion rights for the issue in which the photo appears; or all rights if the photos are done on assignment, but may reassign to photographer after publication. Present model release on acceptance of photo. Submit portfolio or arrange a personal interview to show portfolio. Pays on publication. Reports in 4 weeks. SASE. Previously published work generally OK "if it has not appeared in another photo magazine or annual." Free photo guidelines.

B&W: Send 8x10 semigloss prints. Captions are appreciated: where and when taken, title and photographer's name; technical data sheets describing the photo must be filled out if the photo is accepted for publication. Pays \$150/printed page; but "prices for pictures will vary according to our use of them." **Color:** Send 8x10 prints or any size transparencies. Captions required; technical data sheets describing the photo must be filled out. Pays \$200/printed page; but "prices for pictures will vary according to our

use of them."

Cover: Send color prints or color transparencies. Caption required; technical data sheets describing the

photo must be filled out. Pays \$500.

Tips: "We see hundreds of thousands of photographs every year; we are interested only in the highest quality work by professionals or amateurs." No trite, cornball or imitative photos. Submissions should be insured.

POPULAR SCIENCE, 380 Madison Ave., New York NY 10017. Editor-in-Chief: C.P. Gilmore. Monthly magazine. Circ. 1,850,000. Emphasizes new developments in science, technology and consumer products. Freelancers provide 25% of photos. Pays on an assignment basis. Credit line given. Pays on acceptance. Buys one-time rights and first North American serial rights. Model release required. Send photos by mail for consideration or arrange a personal interview. SASE. Reports in 1 month.

Subject Needs: Documentary photos related to science, technology and new inventions; product pho-

tography. Captions required.

B&W: Uses 8x10 glossy prints; pays \$35 minimum.

Color: Uses transparencies. Pay variable.

Cover: Uses color covers; vertical format required.

Tips: "Our major need is for first-class photos of new products and examples of unusual new technologies. A secondary need is for photographers who understand how to take pictures to illustrate an article."

*PRAYING, Box 281, Kansas City MO 64141. (800)821-7926. Editor: Art Winter. Photo Editor: Rich Heffern. Quarterly. Emphasizes spirituality for everyday living. Readers include mostly Catholic laypeople. Circ. 44,000. Sample copy and photo guidelines free with SASE.

Photo Needs: Uses 12 photos/issue; 80% supplied by freelance photographers. Needs quality photographs which stand on their own as celebrations of people, relationships, ordinary events, work, nature,

etc. Reviews photos with or without accompanying ms.

Making Contact & Terms: Query with samples; send 8x10 b&w prints by mail for consideration. SASE. Reports in 2 weeks. Pays \$50/b&w cover, \$30/b&w inside photo. Pays on publication. Credit line given. Buys one-time rights. Simultaneous submissions and previously published work OK.

PRESBYTERIAN SURVEY, 341 Ponce de Leon Ave. NE, Atlanta GA 30365. (404)873-1531. Art Director: Linda Colgrove. Monthly. Circ. 195,000. Emphasizes religion and moral values. Readers are

members of the Presbyterian Church. Sample copy free with SASE.

Photo Needs: Uses about 35 photos/issue; 10 supplied by freelance photographers. Needs "photos to illustrate the articles, sometimes how-to, scenic, people, countries, churches." Model release and cap-

tions preferred.

Making Contact & Terms: Query with samples or list of stock photo subjects; send prints or contact sheet by mail for consideration. SASE. Reports in 1 month. Pays \$100 maximum/b&w cover photo, \$200 maximum/color cover photo, \$30 maximum/b&w inside photo; \$75 maximum/color cover inside photo. Pays on acceptance. Credit line given. Buys one-time rights. Simultaneous submissions and previously published work OK.

PRESENT TENSE, 165 E. 56th St., New York NY 10022. (212)751-4000. Editor: Murray Polner. Photo Editor: Ira Teichberg. Quarterly magazine. Circ. 45,000. Emphasizes Jewish life and events in U.S. and throughout the world for well-educated readers. Photos purchased with or without accompanying ms. Buys 100 photos/year, 25/issue. Credit line given. Pays on publication. Buys one-time rights. Arrange personal interview to show portfolio; query with list of stock photo subjects; or query with photo essay ideas. Provide business card, letter of inquiry and samples to be kept on file for possible future assignments. SASE. Reports in 1 month.

Subject Needs: "Subjects of Jewish interest only." Prefers photojournalism essays and documentary

and human interest photos. Model release and captions required. **B&W:** Uses 8x10 glossy prints; contact sheet OK. Negotiates pay.

Cover: Query with b&w contact sheet.

PRIMAVERA, University of Chicago, 1212 E. 59th St., Chicago IL 60637. Contact: Editor. Annually. Circ. 500. Emphasizes art and literature by women. Readers are those interested in contemporary literature and art. Sample copy for \$4; free photographer's guidelines.

Photo Needs: Uses 5-10 photos/issue; all supplied by freelance photographers. "We use more photos with each new issue. We are open to a wide variety of styles and themes. We want work expressing womens' experiences." Prefers to see b&w prints, preferably designed to fit 8½x11 page, in a portfolio and as samples. Photos purchased with or without accompanying ms. Model release required.

Making Contact & Terms: Arrange interview to show portfolio (local photographers should call for appointment); send by mail for consideration 8½x11 b&w prints. SASE. Reports in 1 month. Pays in contributor's copies. Pays on publication. Credit line given. Buys first North American serial rights. Tips: "Our magazine specializes in the experiences of women. We would like more work with women figures."

PRIME TIME SPORTS & FITNESS, Box 6091, Evanston IL 60204. (312)864-8113 or 276-2143. Executive Editor: Nicholas Schmitz. Bimonthly magazine. Emphasizes "recreational sports, fashion, tennis, bodybuilding, racquetball, swimming, handball, squash, running." Readers are "high-income health club users." Circ. 29,000. Sample copy free with SASE. Photo guidelines free with SASE.

Photo Needs: Uses about 100 photos/issue; 80 supplied by freelance photographers. Needs photos of "sports fashion with description; specific and general fitness photo features such as aerobics, exercises and training tips; any other sport mentioned." Special needs include "photo sequences explaining various training techniques in recreational sports and exercises." Model release required; captions preferred.

Making Contact & Terms: Query with samples and with list of stock photo subjects. Send b&w or color glossy prints by mail for consideration. Submit portfolio for review. "Query by phone as to what you might have first if possible." SASE. Reports in 1-6 weeks. Pays \$25-150/text/photo package. Pays on publication. Credit line given. Buys all rights. "We will return rights to photographer after use of photo with permission for us to use elsewhere." Simultaneous submissions and previously published work OK.

Tips: "We are in constant need for aerobic, exercise, sports training pieces, and sports fashion with detailed fashion explanations. Be aware of subject matter. Women in sports can be the best way of breaking into our publication."

PROBLEMS OF COMMUNISM, U.S. Information Agency, Room 402, 301 4th St. SW, Washington DC 20547. (202)485-2230. Editor: Paul A. Smith, Jr. Photo Editor: Wayne Hall. Bimonthly magazine. Circ. 34,000. Emphasizes scholarly, documented articles on politics, economics and sociology of Communist societies and related movements. For scholars, government officials, journalists, business people, opinion-makers—all with higher education. Needs "current photography of Communist societies, leaders and economic activities and of related leftist movements and leaders. We do not want nature shots or travelogues, but good incisive photos on economic and social life and political events. Although the magazine is not copyrighted, it does bear the following statement on the index page: 'Graphics and pictures which carry a credit line are not necessarily owned by *Problems of Communism*, and users bear

responsibility for obtaining appropriate permissions.' "Query first with resume of credits, summary of areas visited, dates and types of pix taken. Pays on acceptance. Reports in 1 month. SASE. Simultaneous submissions and previously published work OK. Free sample copy and photo guidelines.

B&W: Uses 8x10 glossy prints. "Captions with accurate information are essential." Pays \$45-75. Color: "We occasionally convert transparencies to b&w when no appropriate b&w is available." Uses

35mm transparencies. Captions required. Pays \$45-75.

Cover: Uses 8x10 glossy b&w prints. Also uses 35mm color transparencies, but will be converted to b&w. "The stress is on sharp recent personalities in Communist leaderships, although historical and mood shots are occasionally used." Pays \$50-150.

Tips: "Photos are used basically to illustrate scholarly articles on current Communist affairs. Hence, the best way to sell is to let us know what Communist countries you have visited and what Communist or leftist movements or events you have covered."

THE PROGRESSIVE, 409 E. Main St., Madison WI 53703. (608)257-4626. Art Director: Patrick JB Flynn. Monthly. Circ. 50,000. Emphasizes "political and social affairs-international and domestic." Sample copy \$1.07 postage.

Photo Needs: Uses about 10 photos/issue; all supplied by freelance photographers and photo agencies. Needs photos of "political people and places (Central America, Middle East, Africa, etc.)." Special photo needs include "Third World governments, antinuke and war resistance." Captions and credit in-

formation required.

Making Contact & Terms: Query with samples or with list of stock photo subjects; provide tearsheets to be kept on file for possible future assignments. SASE. Reports in 1 month. Pays \$200/b&w cover photo; \$25-75 b&w inside photo; \$100/b&w full page. Pays on publication. Credit line given. Buys onetime rights. Simultaneous submissions and previously work OK.

Tips: "We are open to photo-essay work by creative photographers with original ideas. Shoot people in

situations that reflect their personality or lifestyle. Look for interesting background."

*PSYCHIC GUIDE, Box 701, Providence RI 02901. (401)351-4320. Editor: Paul Zuromski. Quarterly. Emphasizes new age, natural living, metaphysical topics. Readers are split male/female interested in personal transformation and growth. Circ. 100,000. Sample copy \$3.95.

Photo Needs: Uses 10-15 photos/issue; 5-10 supplied by freelance photographers. Needs inspirationals, natural scenes, paranormal photography: photos that are uplifting, spiritual (not religious) and illus-

trative of the New Age. Model release and captions required.

Making Contact & Terms: Query with samples, provide resume, business card, brochure, flyer or tearsheets to be kept on file for possible future assignments. SASE. Reports in 1-3 months. Pays \$10-200/job. Pays on publication. Credit line given. Buys first North American serial rights. Previously published work OK.

THE QUARTER HORSE JOURNAL, Box 32470, Amarillo TX 79120. (806)376-4811. Editor: Audie Rackley. Monthly magazine. Circ. 82,000. Emphasizes breeding and training of quarter horses. Buys first North American serial rights and occasionally buys all rights. Photos purchased with accompanying ms only. Pays on acceptance. Reports in 2-3 weeks. SASE. Free sample copy and editorial guidelines.

B&W: Uses 5x7 or 8x10 glossy prints. Captions required. Pays \$50-250 for text/photo package. Color: Uses 21/4x21/4, 35mm or 4x5 transparencies and 8x10 glossy prints; "we don't accept color prints on matte paper." Captions required. Pays \$50-250 for text/photo package.

Cover: Pays \$150 for first publication rights.

Tips: "Materials should be current and appeal or be helpful to both children and adults." No photos of other breeds.

RACING PIGEON PICTORIAL, 19 Doughty St., London, WCIN 2PT England. (01)242-0566. Editorial Assistant: R.W. Osman. Monthly magazine. Circ. 15,000. Emphasizes how-to and scientific pieces concerning racing pigeons. Freelancers supply 20% of photos. Manuscript preferred with photo submissions. Credit line given. Pays on publication. Prefers to buy all rights but will negotiate. Send material by mail for consideration. SASE and International Reply Coupons. Previously published work OK. Reports in 3 weeks. Sample copy \$2.

B&W: Uses 8x10 and 11x14 glossy and semigloss prints. Pays \$10 and up/photo.

Color: Uses transparencies. Pays \$20 and up/photo.

Cover: Uses color covers; square format preferred. Pays \$30 and up.

Accompanying Mss: Prefers a ms with photo submissions. Anything connected with racing pigeons considered. Pays \$30-120 for text/photo package.

RACQUETBALL ILLUSTRATED, 4350 Dipalo Center, Dearlove Rd., Glenview IL 60025. (312)699-1703. Executive Editor: Jason Holloman. Editor-in-Chief: Chuck Leve. Photo Editor: Jean Sauser. For beginning and advanced racquetball players; most are members of clubs. Monthly. Circ.

105,000. Sample copy \$2.

Photo Needs: Freelancers supply 25% of photo needs. "Will consider specific photos with or without ms. Will look at portfolio of action sports photos and make assignment." Needs photos "pertaining to racquetball: action photos, instructional and personalities of national significance." Column needs are: Celebrity Players. "Would be interested in seeing collage work; I may run one a month if I receive good composition." Model release required; informational captions required.

Making Contact & Terms: Send by mail for consideration any size b&w prints or color slides or contact sheet; submit portfolio by mail for review (sports and action photos only). Mostly works with freelance photographers on assignment only basis. Provide resume, letter of inquiry and samples to be kept on file for possible future assignments. SASE. Reports in 1 month. Pays \$15 mininum/color cover; \$15/b&w inside. No color inside. Credit line given. Buys one-time rights. No simultaneous submissions or previously published work.

Tips: "Looking all the time for celebrity photos, unusual action or humorous photos for 'Off the Wall' sec-

tion and general good action photos.'

RADIO-ELECTRONICS, 200 Park Ave. S., New York NY 10003. (212)777-6400. Editor: Art Kleiman. Monthly magazine. Circ. 221,000. Consumer publication. Emphasizing practical electronics applications for serious electronics activists and pros. Photos purchased with accompanying ms. Buys 3-4 photos/issue. Pays \$25-50/job; \$100-350 for text/photo package; or on a per-photo basis. Credit line given on request. Buys all rights, but may reassign other rights after publication. Query with samples. SASE. Reports in 2 weeks. Free sample copy.

Subject Needs: Photo essay/photo feature, spot news and how-to "relating to electronics." Model re-

lease required; captions preferred.

B&W: Uses 5x7 glossy prints. Pays \$25 minimum/photo, included in total purchase price with ms. Color: Uses 35mm, 21/4x21/4 or 4x5 transparencies. Pays \$25 minimum/photo, included in total purchase price with ms. Color rarely used.

Cover: Uses 35mm, 21/4x21/4, 4x5 or 8x10 color transparencies. Pays \$100-350/photo.

Accompanying Mss: Articles relating to electronics, especially features and how-to's. Pays \$100-350. Free writer's guidelines.

RAIN, 2270 NW Irving, Portland OR 97210. (503)227-5110. Editor: Tanya Kucak. Bimonthly. Emphasizes "access on appropriate technology, community self-reliance, environment/conservation. Readers are "aged 25-45, current and former community and environmental activists who read lots of periodicals." Circ. 3,000. Sample copy free (\$1 donation requested).

Photo Needs: Uses about 6 photos/issue; all supplied by freelance photographers. Needs "scenics or

photos relating to specific articles." Model release and captions preferred.

Making Contact & Terms: Query with samples. Does not return unsolicited material without SASE. Reports in 3 weeks. No payment. Credit line given. Simultaneous submissions OK.

THE RANGEFINDER, Box 1703, 1312 Lincoln Blvd., Santa Monica CA 90406. (213)451-8506. Editor: Arthur Stern. Monthly. Circ. 50,000. Emphasizes topics, developments and products of interest to the professional photographer. "We follow trends which can help the professional photographer expand his business." Sample copy \$2.50. Free photo and editorial guidelines.

Photo Needs: Photos are contributed. The only purchased photos are with accompanying ms. Subjects include animal, celebrity/personality, documentary, fashion/beauty, glamour, head shot, photo essay/ photo feature, scenics, special effects and experimental, sports, how-to, human interest, nature, still life, travel and wildlife. "We prefer photos accompanying 'how-to' or special interest stories from the

photographer." Model release required; captions preferred.

Making Contact & Terms: Submit query with outline of proposed pictorial or story. Uses 8x10 b&w prints of any finish; 8x10 color prints and 35mm or 21/4x21/4 color transparencies. SASE. Reports in 6 weeks. Credit line given. Payment on publication. Buys first North American serial rights. Pays \$60 per published page.

RANGER RICK, 1412 16th St. NW, Washington DC 20036. Photo Editor: Robert L. Dunne. Monthly magazine. Circ. 700,000. For children interested in the natural world, wildlife, conservation and ecology; age 6-12. Buys 400 photos annually; 90% from freelancers. Credit line given. Buys first serial rights and right to reuse for promotional purposes at half the original price. Submit portfolio of 20-40 photos and a list of available material. Photos purchased with or without accompanying ms, but query first on articles. Pays 3 months before publication. Reports in 2 weeks. SASE. Previously published work OK. Sample copy \$1; free photo guidelines.

Subject Needs: Wild animals (birds, mammals, insects, reptiles, etc.), humorous (wild animals), pet animals children would keep (no wild creatures), nature (involving children), wildlife (US and foreign), photo essay/photo feature (with captions), celebrity/personality (involved with wildlife—adult or child) and children (age 6-12) doing things involving wild animals, outdoor activities (caving, snowshoeing, backpacking), crafts, recycling and helping the environment. No plants, weather or scenics. No soft focus, grainy, or weak color shots.

B&W: Uses 8x10 prints; prefers matte-dried glossy paper. Pays \$60-180.

Color: Uses original transparencies. Pays \$180 (half page or less); \$480 (2-page spread).

Cover: Uses original color transparencies. Uses vertical format. Allow space in upper left corner or

across top for insertion of masthead. Prefers "rich, bright color." Pays \$300.

Tips: "Come in close on subjects." Wants no "obvious flash." Mail transparencies inside 20-pocket plastic viewing sheets, backed by cardboard, in a manila envelope. "Don't waste time and postage on fuzzy, poor color shots. Do your own editing (we don't want to see 20 shots of almost the same pose). We pay by reproduction size."

THE RAZOR'S EDGE-HAIR NEWS, Box 685, Palisades NY 10964. (212)832-1365. Editor: C. Stanley. Photo Editor: Bob Fitzgerald. Monthly magazine. Circ. 3,000. Specializing in "unusual, radical, bizarre hairstyles and fashions, such as a shaved head for women, waist-length hair or extreme hair transformations, from very long to very short." Photos purchased with or without accompanying ms and on assignment. Buys 15-30 photos/issue. Pays \$50 minimum/job or on a per-photo basis. Credit line given. Pays on acceptance. Buys one-time rights or all rights, but may reassign after publication. Send material by mail for consideration. SASE. Provide samples of work and description of experience. Simultaneous submissions or previously published work OK. Reports in 3 weeks. Sample copy \$2; photo guidelines free with SASE.

Subject Needs: Celebrity/personality, documentary, fashion/beauty, glamour, head shot, nude, photo essay/photo feature, spot news, travel, fine art, special effects/experimental, how-to and human interest "directly related to hairstyles and innovative fashions. We are also looking for old photos showing hairstyles of earlier decades—the older the better. If it's not related to hairstyles in the broadest sense, we're

not interested." Model release and captions preferred.

B&W: Uses 5x7 or 8x10 prints; contact sheet and negatives OK. Pays \$10-100/photo.

Color: Uses 5x7 prints and 35mm transparencies; contact sheet and negatives OK. Pays \$10-100/photo. Cover: Uses b&w and color prints and color transparencies; contact sheet OK. Vertical format preferred. Pays \$25/photo.

Accompanying Mss: "Interviews, profiles of individuals with radical or unusual haircuts." Pays \$50

minimum ms.

Tips: "The difficulty in our publication is in finding the subject matter, which is unusual and fairly rare. Anyone who can overcome that hurdle has an excellent chance of selling to us."

*REEVES JOURNAL, Box 30700, Laguna Hills CA 92654. (714)830-0881. Editor: Larry Dill. Monthly. Emphasizes plumbing, heating, and cooling industry in 14 Western states. Readers include primarily plumbing contractors, also wholesalers, manufacturers and government officials. Majority of features and major news stories involve Western industry members. Circ. 22,000. Free sample copy with SASE.

Photo Needs: Uses 20-30 photos/issue; very few supplied by freelance photographers. Needs unusual installations, special projects. Reviews photos with or without accompanying ms. Special needs include

news photos concerning the plumbing, heating, cooling industry. Captions required.

Making Contact & Terms: Send 5x7 and 8x10 glossy b&w prints by mail for consideration; telephone queries accepted. SASE. Pays \$50-100/color cover photo, \$10 b&w inside photo, \$15-25/color photo; other payment negotiable. Pays on publication. Credit line given. Buys one-time rights.

Tips: "We are looking for feature material on leading contractors in the West. Find a contractor who is working on an unusual or unique project and let us know about it. We are also always open for 'spot news' photos concerning the industry."

*REVIEW OF OPTOMETRY, Chilton Way, Radnor PA 19380. (215)964-4372. Editor: Richard L. Guerrein. Photo Editor: Stan Herrin. Monthly. Emphasizes optometry. Readers include 22,000 practicing optometrists nationwide; academicians, students. Circ. 28,000.

Photo Needs: Uses 40 photos/issue; 8-10 supplied by freelance photographers. "Most photos illustrate news stories or features. Ninety-nine percent are solicited. We rarely need unsolicited photos. We will need top-notch freelance news photographers in all parts of the country for specific assignments." Mod-

el release preferred; captions required.

Making Contact & Terms: Provide resume, business card, brochure, flyer or tearsheets to be kept on file for possible future assignments, tearsheets and business cards or resumes preferred. Pay varies. Credit line given. Rights purchased vary with each assignment. Simultaneous submissions and previously published work OK.

RELIX MAGAZINE, Box 94, Brooklyn NY 11229. (212)645-0818. Editor: Toni A. Brown. Bimonthly. Circ. 20,000. Emphasizes rock and roll music. Readers are music fans, ages 13-40. Sample copy \$2.

Photo Needs: Uses about 50 photos/issue; "almost all" supplied by freelance photographers. Needs photos of "music artists-in concert and candid, backstage, etc." Special needs: "Photos of rock groups, especially the Stones, Grateful Dead, Bruce Springsteen, San Francisco-oriented groups, etc." Captions optional.

Making Contact & Terms: Send 5x7 or larger b&w and color prints by mail for consideration. SASE. Reports in 1 month. "We try to report immediately; occasionally we cannot be sure of use." Pays \$100-150/b&w or color cover; \$45/b&w inside full page. Pays on publication. Credit line given. Buys all rights. Simultaneous submissions and previously published material OK.

Tips: "B&w photos should be printed on grade 4 or higher for best contrast."

*RIVER RUNNER MAGAZINE, Box 2047, Vista CA 92025. (619)744-7170. Editor: Mark C. Larson. Bimonthly. Emphasizes whitewater river running. Readers are predominately male, college grads, aged 18-40. Circ. 15,000. Sample copy \$2 and photo guidelines free.

Photo Needs: Uses 30 photos/issue; 25 supplied by freelance photographers. Needs shots of conveying. kayaking, rafting or anything that might be of interest to outdoor enthusiasts. Reviews with or without accompanying ms. Special needs include the "best crashes" of 1986 for the whitewater photo contest.

Captions preferred.

Making Contact & Terms: Query with samples, with list of stock photo subjects; send b&w prints, 35mm transparencies by mail for consideration. SASE. Reports in 1 month. Pays \$100/color cover, \$10-25/inside b&w, \$18-30/inside color photo, \$75 minimum/text/photo package. Pays on publication. Credit line given. Buys first North American serial rights. Simultaneous submissions in nonrelated publications OK.

THE ROANOKER, Box 12567, Roanoke VA 24026. (703)989-6138. Editor: Kurt Rheinheimer. Monthly. Circ. 10,000. Emphasizes Roanoke and Western Virginia. Readers are upper income, educated people interested in their community. Sample copy \$2.

Photo Needs: Uses about 60 photos/issue; less than 10 are supplied by freelance photographers. Need "travel and scenic photos in Western Virginia; color photo essays on life in Western Virginia." Model

release preferred; captions required.

Making Contact & Terms: Send any size b&w or color glossy prints and transparencies by mail for consideration. SASE. Reports in 1 month. Payment negotiable. Pays on publication. Credit line given. Rights purchased vary. Simultaneous submissions and previously published work OK.

*ROCHESTER WOMEN MAGAZINE, 771 Ridge Rd., Webster NY 14580. (716)671-1490. Editor: Carolyn Zaroff. Art Director: Chris Anderson. Monthly. Emphasizes women in professions, business, sports, high tech, consumer reports. Readers are upper demographic women aged 22-64. Circ. 20,000. Photo Needs: Uses 8-12 photos/issue; all supplied by freelance photographers. Needs head shots-profiles; consumer for high tech and homestyles columns. Special needs include fall-spring fashions, women and computers, Christmas gift ideas. Model release and captions required.

Making Contact & Terms: Query with samples. Send 5x7 glossy b&w prints by mail for consideration. Does not return unsolicited material. Pays \$40/color cover photo and \$5/inside b&w photo. Pays on publication. Credit line given. Buys one-time rights. Simultaneous submissions and previously

published work outside of local region OK.

RODALE'S NEW SHELTER, 33 E. Minor St., Emmaus PA 18049. Photo Editor: Mitch Mandel. Published 9 times/year. Circ. 700,000. Emphasizes contemporary home design and home management. Readers are 30-50 year old male, college educated homeowners. Free sample copy and photo guidelines with photo samples and SASE.

Photo Needs: Uses 50-75 photos/issue; 1/3 supplied by freelance photographers. "We need attractive, contemporary, practical single-family homes, and other residential projects, i.e., kitchens, baths, remodelings, additions, etc. All projects must be unique and well designed. We have ongoing needs for stock photos of greenhouses, solar heating and cooling devices, and other energy-related home improvements." Photos purchased with or without accompanying ms. Model release required; captions required "or at least background information for us to caption.

Making Contact & Terms: Query with list of stock photo subjects or send by mail for consideration 8x10 b&w prints; 35mm, 21/4x21/4 transparencies or b&w contact sheets. SASE. Reports in 1 month. Provide resume, business card, brochure and flyer to be kept on file for possible future assignments. Pays \$300/color cover, \$25-50/b&w inside, \$50-100/color inside. Pays "just prior to publication."

Credit line given. Buys all rights. Previously published work OK.

Tips: "We do a lot of contract assignment work, and are constantly looking for top quality photographers across the country. We invite inquries, which will be handled as they arrive, on a case-by-case basis."

*RODEO NEWS, Box 5418, Norman OK 73070. (405)364-9444. Editor: G.D. Hollingsworth. Monthly magazine. Emphasizes rodeo. Readers are rodeo performers and fans. Circ. 15,000. Sample copy \$3.

Photo Needs: Uses about 30 photos/issue; all supplied by freelance photographers. Subject needs var-

ied. "Most photos are done on assignment by freelancers." Captions required.

Making Contact & Terms: Provide resume, business card, brochure, flyer or tearsheets to be kept on file for possible future assignments. Reports in 2 weeks. Pays \$200/color cover photo, \$25/b&w inside photo, and \$75/color inside photo. Pays on publication. Credit line given. Buys all rights. Previously published work OK.

THE RUNNER, 1 Park Ave., New York NY 10016. (212)725-4248. Editor-in-Chief: Marc Bloom. Art Director: Helene Winkler-Elek. Monthly. Circ. 265,000. Emphasizes running as a means of health and fitness. Readers are young, mostly male, well educated, high income, "upscale." Free sample copy with SASE.

Photo Needs: Uses at least 25 photos/issue; all supplied by freelance photographers. Needs photos of running personalities, events, odd happenings. Photos purchased with or without accompanying ms.

Model release and captions preferred.

Making Contact & Terms: Query with resume of credits and samples. SASE. Reports in 2 weeks. Provide business card and tearsheets to be kept on file for possible future assignments. Pays \$350 and up/cover; \$75-425 for each b&w or color inside photo; \$150 and up/day; payment for inside photos varies. Pays on acceptance. Credit line given. Buys one-time rights.

RUNNER'S WORLD, Box 366, Mountain View CA 94042. (415)965-8777. Editor: Bob Anderson. Managing Editor: Mark Levine. Monthly magazine. Circ. 412,000. Emphasizes long-distance running, health and fitness for runners and fitness enthusiasts. Photos purchased with or without accompanying ms. Buys 30-40 photos/issue. Credit line given depending on where photos are used. Pays on publication. Buys one-time rights, unless shot on assignment; then we own all rights. Query by letter, phone, personal appearance or portfolio (not necessary, but helps). Provide resume, samples and tearsheets to be kept on file for possible future assignments. SASE. "Mark every picture with your name and address on back. It's incredible the number of people who do not do this and then complain when we can't locate their photos." Previously published work OK, "if so noted." Reports in 4-6 weeks. Sample copy \$1; free photo guidelines.

Subject Needs: Wants on a regular basis photos of top runners in action and striking running photos for all types of editorial illustrations. "We will look at anything that covers the subject of running." No out

of focus or improperly exposed photos. Captions required.

B&W: Uses 8x10 prints. Pays \$20/photo.

Color: Uses transparencies only; prefers Kodachrome 64. Pays \$75-250/photo. **Cover:** Uses color transparencies. Vertical format preferred. Pays \$350/photo.

Accompanying Mss: Writer's guidelines on request.

Tips: "View running from a fresh angle. No photographer we know has consistently captured the sport, so there is a lot of virgin territory to be explored. Edit submissions to include only technically perfect material. Study recent issues carefully."

RUNNING TIMES, Suite 20, 14416 Jefferson Davis Highway, Woodbridge VA 22191. (703)643-1646. Editor: Edward Ayres. For runners, racers and others interested in fitness. Monthly. Circ. 41,000. **Photo Needs:** Uses 15-20 photos/issue; 75% supplied by freelance photographers. Selection is based on news appeal, technical and artistic qualities. Needs poster style and personality photos, people racing, running (with scenic backgrounds). "Overall aesthetics of picture might be as valuable to us as the running aspect." Department needs: Running Shorts, photos to accompany humor and anecdotes. Model release required only in cases where runner is not in race or public event; captions preferred (but not essential).

Making Contact & Terms: Send by mail for consideration actual b&w 5x7 or 8x10 glossies or 35mm color transparencies. SASE. Reports in 4-8 weeks. Pays on publication \$25-60/b&w photo; \$30-100/color inside; \$200-250/cover. Buys one-time rights. Indicate if simultaneous submission; previously published work OK if so indicated. Sample copy \$2; photo guidelines for SASE; mention *Photogra-*

pher's Market.

Tips: "We look for unusual angles or perspectives (the head-on finish line shot is a cliché), and for the significant moments in a competition. Photos of races should be submitted ASAP after the event; we often receive excellent photos a month or two after a race, when it's too late for publication."

SACRAMENTO MAGAZINE, 620 Bercut Dr., Sacramento CA 95814. (916)446-7548. Editor: Cheryl Romo. Managing Editor: Ann McCully. Art Director: Chuck Donald. Emphasizes business, government, culture, food, outdoor recreation, and personalities for middle- to upper middle class, urban-oriented Sacramento residents. Monthly magazine. Circ. 32,000. Free sample copy and photo

guidelines.

Photo Needs: Uses about 40-50 photos/issue; mostly supplied by freelance photographers. "Photographers are selected on the basis of experience and portfolio strength. No work assigned on speculation or before a portfolio showing. Photographers are used on an assignment only basis. Stock photos used only occasionally. Most assignments are to area photographers and handled by phone. Photographers with studios, mobile lighting and other equipment have an advantage in gaining assignments. Darkroom equipment desirable but not necessary." Needs news photos, essay, avante-garde, still life, landscape, architecture, human interest and sports. All photography must pertain to Sacramento and environs. Captions required.

Making Contact & Terms: Send slides, contact sheets (no negatives) by mail or arrange a personal interview to show portfolio. Also query with resume of photo credits or mail portfolio. SASE. Reports up to 4 weeks. Pays \$5-45/hour; pays on acceptance. Average payment is \$15-20/hour; all assignments are negotiated to fall within that range. Credit line given on publication. Buys rights on a work-for-hire basis. Will consider simultaneous submissions and previously published work, providing they are not in

the Northern California area.

SAIL, 34 Commercial Wharf, Boston MA 02110. (617)227-0888. Editor: Keith Taylor. Monthly magazine. Circ. 185,000. For audience that is "strictly sailors, average age 35, better-than-average education." Needs cover photos of racing or cruising. Buys first North American serial rights. Model release necessary "if model requires it." Send slides for consideration. Pays on publication. Reports in 1 month. SASE. Free sample copy and photo guidelines.

B&W: Send contact sheet or 8x10 prints. Captions required. Pays \$50-200/photo.

Color: Send transparencies. Kodachrome preferred. Captions required. Pays \$50-250/photo.

Cover: Send color transparencies. Uses vertical and horizontal format. Subject should fill the frame and shots should be "conceptually clear (readers should be able to discern the mood and context immediately; good Sail covers are usually but not always action shots)." Covers should portray people and boats acting in close interrelationship. Captions required. Pays \$600/photo.

Tips: For photos used inside, "mss and photos usually bought as a package." Inside work not accompanying an article is mostly on commission and is discussed at the time of assignment. "We will return negatives and transparencies via certified mail whenever possible. Return envelope and postage request-

ed."

SAILING, 125 E. Main St., Port Washington WI 53074. (414)284-3494. Editor: Wm. F. Schanen III. Monthly magazine. Circ. 47,000. Buys 100 photos annually. Emphasizes sailing for sailors, ages 25-44; about 75% own their own sailboats.

Subject Needs: Travel (sailing cruise), sport (sailing, cruising and racing in small or large yachts), photo essay/photo feature (pictorial sailing spreads) and celebrity/personality (sailing).

Specs: Uses 8x10 glossy b&w prints and 35mm or larger color transparencies. Uses color covers only and some inside color.

Payment & Terms: Pays \$18 minimum/b&w print; \$75 minimum/color cover photo; \$25-100/color inside; \$10-20/b&w inside. Credit line given. Pays on publication. Simultaneous submissions and previously published work OK.

Making Contact: "Photographers can query with suggested features, but the best method is to send a selection of sailing (action and detail) shots to the magazine on speculation." SASE. Reports in 3 weeks. Free sample copy and photo guidelines.

SAILORS' GAZETTE, Suite 110, 337 22nd Ave. N., St. Petersburg FL 33704. (813)823-9172. Editor: Alice N. Eachus. Monthly. Emphasizes sailing in the southeastern USA. Readers include sailors-both racing and cruising. Circ. 15,000. Sample copy \$2.

Photo Needs: Uses 15 photos/issue; 10 supplied by freelance photographers. Needs sailing—action or mood. Prefers b&w 5x7 glossy lake and ocean gulf sailing shots. Reviews with or without accompany-

ing ms. Model release and captions preferred.

Making Contact & Terms: Query with samples and list of stock photo subjects; send 5x7 glossy b&w prints by mail for consideration. SASE. Reports in 2 weeks. Pays \$25/b&w cover photo; \$10-15/inside b&w photo. Pays on publication. Credit line given. Buys one-time rights. No simultaneous submissions or previously published work. "Must be sailing or we cannot use."

ST. LOUIS MAGAZINE, 7110 Oakland Ave., St. Louis MO 63117. (314)781-8787. Art Director: Michael Ogle. Circ. 50,000. Emphasizes life in St. Louis for "those interested in the St. Louis area, recreation issues, lifestyles, etc."

This photo, taken by St. Louis, Missouri, freelancer Ed Italo, was used in a fashion layout in the April 1985 issue of St. Louis Magazine. "It is the opening shot of the section, run as a spread," says St. Louis Magazine Art Director Michael Ogle. "The issue's theme is 'The Midwest—It's an Attitude.' This type of available-light photography is what we've been favoring lately." The shot suggests that photographers' work needn't be of the slick, studio variety to win assignments.

Subject Needs: Celebrity/personality, documentary, fine art, scenic, local color, sport, human interest, travel, fashion/beauty and political. Photos purchased with or without accompanying mss. Freelancers supply 90% of the photos. Pays by assignment or on a per-photo basis.

Making Contact & Terms: Provide calling card, resume and samples to be kept on file for possible future assignments. Credit line given. Pays on publication. Arrange a personal interview or submit portfolio for review. SASE. Reports in 1 month. Sample copy \$1.95 and free photo guidelines.

B&W: Uses 8x10 glossy prints. Pays \$50-250/photo.

Color: Uses 35mm, 21/4x21/4 and 4x5 transparencies. Pays \$100-300/photo.

Cover: Uses color covers only. Vertical format required. Pays \$200-1,000/text photo package. Tips: Prefers to see "b&w prints, color photos or transparencies of St. Louis people, events and places, fashion and history. Any printed samples, especially from magazines. Don't be a jack-of-all trades. Any photographer who has an 'I can do it all' portfolio is not as likely to get a general assignment as a specialty photographer."

ST. LOUIS WEEKLY, 222 S. Meramec, Clayton MO 63105. (314)725-3101. Editor: Rodger Hahn. Weekly. Circ. 48,000. Free sample copy.

Photo Needs: Needs include local celebrity/personality and head shot, photo essay/photo feature, and travel photos. Rarely takes photos only; needs photos with accompanying ms. B&w: \$25-500. Color cover: \$100/up.

Making Contact & Terms: Send by mail for consideration actual 8x10 b&w glossies. SASE. Pays on publication. Buys one-time rights.

SALOME: A LITERARY DANCE MAGAZINE, 5548 N. Sawyer, Chicago IL 60625. (312)539-5745. Editor: E. Mihopoulos. Quarterly. Circ. 1,000. Emphasizes dance. Readers are the general public, dance oriented, students, librarians, etc. Sample copy \$4 for double issues; photo guidelines free with SASE.

Photo Needs: Uses about 200-250 photos/issue; 80% supplied by freelance photographers. Needs "dance photos—any photo/photo collages relating to dance." Model release preferred; captions required.

Making Contact & Terms: Query with samples or submit portfolio for review or send b&w prints (no larger than 8½x11) by mail for consideration. SASE. Reports in 2 weeks. Pays with one copy of magazine the photo appears in. Pays on publication. Credit line given. Buys first North American serial rights. Previously published work OK, "but please specify date and source of previous publication." Tips: Looks for "quality of photo's design, subject matter, relation to other photos already accepted in magazine. I am looking for clear, concise, attention-grabbing photos, images that are interesting to look at and are compelling."

SALT WATER SPORTSMAN, 186 Lincoln St., Boston MA 02111. (617)426-4074. Editor: Barry Gibson. Monthly magazine. Circ. 115,000. Emphasizes all phases of salt water sport fishing for the avid beginner-to-professional salt water angler. "Only strictly marine sportfishing magazine in the world." Buys 1-3 photos/issue (including covers) without ms; 20-30 photos/issue with ms. Pays \$175-350 for text/photo package. Accepting slides and holding them for 1 year and will pay as used. Pays on acceptance. Buys one-time rights. Send material by mail for consideration or query with samples. SASE. Provide resume and tearsheets to be kept on file for possible future assignments. Reports in 1 month. Free sample copy and photo guidelines.

Subject Needs: Salt water fishing photos. "Think scenery with human interest, mood, fishing action, storytelling close-ups of anglers in action. Make it come alive—and don't bother us with the obviously posed 'dead fish and stupid fisherman' back at the dock. Wants, on a regular basis, cover shots, vertical Kodachrome (or equivalent) original slides depicting salt water fishing action or 'mood.'"

B&W: Uses 8x10 glossy prints. Pay included in total purchase price with ms, or pays \$20-100/photo. **Color:** Uses 8x10 glossy prints and 35mm or 2½x2½ transparencies. Pay included in total purchase price with ms, or pays \$20-100/photo.

Cover: Uses 35mm and 21/4x21/4 transparencies. Vertical format required. Pays \$300 minimum/photo. Accompanying Mss: Fact/feature articles dealing with marine sportfishing in the U.S., Canada, Caribbean, Central and South America. Emphasis on how-to. Free writer's guidelines.

Tips: "Prefers to see a selection of fishing action or mood—no scenics, lighthouses, birds, etc.—must be sport fishing oriented. Be familiar with the magazine and send us the type of things we're looking for. Example: no horizontal cover slides with suggestions it can "be cropped" etc. Don't send Ektachrome slides."

*SATELLITE DEALER, Box 29, Boise ID 83707. (208)322-2800. Editor: Howard Shippey. Monthly. Emphasizes home satellite television. Readers include retailers of satellite television equipment. Circ. 18,700. Sample copy and photo guidelines free with SASE.

Photo Needs: Uses 20-30 photos/issue; 5-10 supplied by freelance photographers. Needs "scenics that make use of satellite dishes; electronics shots; assignment photos." Reviews photos with or without accompanying manuscript. Model release preferred; captions required.

Making Contact & Terms: Query with samples. SASE. Reports in 1 month. Pays \$150-300/color cover photo, \$25-75/inside b&w photo, \$50-100/inside color photo. Pays on publication. Credit line given. Buys all rights; "if we don't pay for film and developing, we will negotiate first rights." Previously published work OK.

Tips: Prefers to see "a shot that would be beautiful, with or without a dish in it" in a photographer's samples. "Keep shooting, keep writing queries and keep trying."

THE SATURDAY EVENING POST SOCIETY, Benjamin Franklin Literary & Medical Society, 1100 Waterway Blvd., Indianapolis IN 46202. (317)634-1100. Editor: Cory SerVaas, M.D. Photo Editor: Patrick Perry. Magazine published 9 times annually. Circ. 500,000. For family readers interested in travel, food, fiction, personalities, human interest and medical topics—emphasis on health topics. Needs photos of people and travel photos; prefers the photo essay over single submission. Prefers all rights, will buy first U.S. rights. Model release required. Send photos for consideration. Provide busi-

ness card to be kept on file for possible future assignments. Pays on publication. Reports in 1 month. SASE. Simultaneous submissions and previously published work OK. Sample copy \$4; free photo guidelines.

B&W: Send 8x10 glossy prints. Pays \$50 minimum/photo or by the hour; pays \$150 minimum for text/

photo package.

Color: Send 35mm or larger transparencies. Pays \$75 minimum; \$300/cover photo.

SATURDAY REVIEW, 214 Massachusetts Ave. NE, Washington DC 20002. Art Director: Brian Noyes. Bimonthly. Circ. 250,000. Emphasizes literature and the arts. Readers are literate and sophisticated. Sample copy \$2.50.

Photo Needs: Uses 20 photos/issue; 80-100% supplied by freelance photographers. Needs "documentary photographs of writer/artist illustrating personality and lifestyle, including at least one representa-

tive environmental portrait." Model release preferred; captions required.

Making Contact & Terms: Query with samples; provide resume, business card, brochure, flyer or tearsheets to be kept on file for possible future assignments. Does not return unsolicited material. Reports in 1 month. Pays \$100-200/color cover photo; \$250-500/job. Pays within 30 days of publication. Credit line given. Buys one-time rights.

Tips: Prefers to see "photographer's ability to cover a human subject and show something of that subject's personality and lifestyle. We do *not* want one posed portrait after another. Variety and perseverance are

the key. Also must be high in technical quality.'

SCIENCE ACTIVITIES, 4000 Albemarle St. NW, Washington DC 20016. (202)362-6445. Managing Editor: Mrs. Dale Saul. Quarterly magazine. Circ. 1,600. Emphasizes classroom activities for science teachers. Reimbursement \$5/photo used. Credit line given on request. Pays on publication. Send photos with ms for consideration. SASE. Reports in 3-4 months. Free sample copy and photo guidelines.

Subject Needs: How-to, "Any photos which illustrate classroom science activities. No photos accepted without ms. Write to editor for information on special theme issues planned." No photos without accompanying ms.

B&W: Uses 5x7 glossy prints.

Color: Can use color prints, but will transfer to b&w. B&w strongly preferred.

Cover: Uses glossy b&w prints.

Accompanying Mss: Description of classroom science activities (such as teaching aids) for grades K through college. Free writer's guidelines.

SCIENCE DIGEST, 888 7th Ave., New York NY 10106. (212)262-7990. Picture Editor: Jodie Boublik. Monthly. Circ. 525,000. Emphasizes science. Readers are laymen age 18 +, college educated. Photo guidelines free with SASE.

Photo Needs: Uses about 60 photos/issue; 50% supplied by freelance photographers. Needs photos of "science: wildlife, archeology, technology, anthropology, astronomy, aerospace, biology, etc." Model

release preferred; captions required.

Making Contact & Terms: Query with samples. SASE. Reports in 1 month. Pays \$75-350/b&w inside photo; \$125-450/color inside photo; \$300/day. Pays on publication. Credit line given. Buys all magazine and periodical rights. Simultaneous submissions and previously published work OK.

Tips: "Propose story ideas that you would like to shoot that would be appropriate for the magazine."

SCIENCE 86, 1101 Vermont Avenue, N.W., 10th Floor, Washington DC 20005. (202)842-9500. Editor-in-Chief: Allen L. Hammond. Picture Editor: Barbara Moir. Readers are educated laymen who are interested in science but may not have a technical background. Published 10 times/year. Circ. 700,000. Free samples copy (mention *Photographer's Market*).

Photo Needs: Uses 30-40 photos/issue supplied by freelance photographers and agencies. Needs include photographs which explain or illustrate articles. Unsolicited photos should be accompanied by captions or ms. "Our subjects include natural and physical sciences, technology, medicine, astronomy, geology

and profiles of scientific figures."

Making Contact & Terms: Send by mail for consideration science-related color transparencies (any size) or prints or clippings. Provide samples to be kept on file for possible future assignments. SASE. Reports in 1 month. Pays on publication \$180/color quarter page. Credit line given. Buys one-time rights. No simultaneous submissions. Previously published work OK if so indicated.

*SCIENCE OF MIND MAGAZINE, 3251 West Sixth St., Los Angeles CA 90020. (213)388-2181. Editor: John S. Niendorf. Photo Editor: Alicia E. Esken. Monthly. Emphasizes science of mind philosophy. Readers include positive thinkers, holistic healing, psychological thinkers. Circ. 75,000. Sample copy and photo guidelines free with SASE.

Photo Needs: Uses 7-10 photos/issue; 4-8 supplied by freelance photographers. Needs scenic nature, sensitive (e.g., baby, baby animals, rays of sun through clouds). Reviews photos with or without accom-

panying ms.

Making Contact & Terms: Send 5x7, 8x10 b&w prints, 35mm transparencies by mail for consideration. SASE. Reports in 2 weeks. Pays \$100/color cover photo, \$25-60/inside b&w photo, \$60-75/inside color photo. Pays on acceptance. Credit line given. Buys one-time rights unless otherwise specified. Simultaneous submissions and previously published work OK.

SCOPE, Box 1209, Minneapolis MN 55440. (612)330-3300. Publication Development Office: Gene Janssen. Monthly magazine. Circ. 310,000. For women of all ages who are interested in everything that touches their home, their careers, their families, their church and community. Needs action photos of family life, children and personal experiences. Buys 50-75 photos annually. Buys first North American serial rights. Model release not required. Send photos or contact sheet for consideration. Pays on acceptance or publication. Reports in 1 month. SASE. Simultaneous submissions and previously published work OK. Guidelines free with SASE.

B&W: Send contact sheet or 8x10 glossy prints. Pays \$20-35/photo.

Cover: Send b&w glossy prints or 35mm or 21/4x21/4 color transparencies. Pays \$40-100/photo.

*SCORE, Canada's Golf Magazine, 287 MacPherson Ave., Toronto, Ontario Canada M4V 1A4. (416)928-2909. Managing Editor: Lisa A. Leighton. Magazine published 8 times/year. Emphasizes golf. "The foundation of the magazine is Canadian golf and golfers, but *Score* features U.S. and international male and female professional golfers, golf personalities and golf travel destinations on a regular basis." Readers are affluent, well-educated, 87% male, 13% female. "Most are members of private or semi-private golf clubs. Majority Canadian, others U.S. and foreign subscribers." Circ. over 170,000 + . Sample copy \$2 (Canadian). Photo guidelines free with SASE or SAE with IRC.

Photo Needs: Uses between 15 and 20 photos/issue; approximately 85% supplied by freelance photographers. Needs "professional-quality, golf-oriented color and b&w material on prominent male and female pro golfers on the US PGA and LPGA tours, as well as the European and other international circults, prominent Canadians, scenics, travel, closeups and full-figure." Model releases (if necessary)

and captions required.

Making Contact & Terms: Query with samples and with list of stock photo subjects. Send 8x10 or 5x7 glossy b&w prints and 35mm or 2½x2½ transparencies by mail for consideration. Provide resume, business card, brochure, flyer or tearsheets to be kept on file for possible future assignments. SASE or SAE with IRC. Reports in 3 weeks. Pays \$75-100/color cover photo, \$30/b&w inside photo, \$50/color inside photo, \$40-65/hour, \$320-520/day, and \$80-2,000/job. Pays on publication. Credit line given.

Buys all rights. Simultaneous submissions OK.

Tips: "When approaching *Score* with visual material, it is best to illustrate photographic versatility with a variety of lenses, exposures, subjects and light conditions. Golf is not a high-speed sport, but invariably presents a spectrum of location puzzles: rapidly changing light conditions, weather, positioning, etc. Capabilities should be demonstrated in query photos. Scenic material follows the same rule. Specific golf hole shots are certainly encouraged for travel features, but wide-angle shots are just as important, to 'place' the golf hole or course, especially if it is located close to notable landmarks or particularly stunning scenery. Approaching *Score* is best done with a clear, concise presentation. A picture is absolutely worth a thousand words, and knowing your market and your particular strengths will prevent a mutual waste of time and effort. Sample copies of the magazine are available and any photographer seeking to work with *Score* is encouraged to investigate it prior to querying."

SCUBA TIMES MAGAZINE, Box 6268, Pensacola FL 32503. (904)478-5288. Editor-in-Chief: Wallace Poole. Managing Editor: J'n Jernigan. Bimonthly. Circ. 75,000. Emphasizes scuba diving for 18-

35 years olds, mostly male. Sample \$3.

Photo Needs: Uses about 25 photos/issue; 15-20 supplied by freelance photographers. Needs "exceptional underwater photos (prefer color slides), tropical travel shots. Reviews dive resorts and destinations. Also reviews nude diving trips, topless beaches and similar 'singles' aquatic activities in our Wet and Wild column. Pays top dollar for articles/photo packages on this type of resort with photos done tastefully of people skin diving or scuba diving in the nude." Photos purchased with or without accompanying ms. Model release preferred; captions required.

Making Contact & Terms: Query with samples. SASE. Reports in 2-3 months. Pays \$100-200/color cover photo; \$25/b&w, \$35/color inside photo; and \$100-300 for text/photo package. Pays after publi-

cation. Credit line given. Buys first world serial rights. Previously published work OK.

Tips: "We require exceptional clarity in photos. Need pictures with divers interacting with marine life. Captions a must!"

SEA, 8490 Sunset Blvd., Los Angeles CA 90069. (213)657-5100. Editor: David Speer. Monthly magazine. Circ. 50,000. Emphasizes "recreational boating in 13 Western states (including Alaska), Mexico

and British Columbia for owners of recreational boats, power and sail." Sample copy and photo guidelines free with SASE.

Photo Needs: Uses about 50 photos/issue; 30 supplied by freelance photographers. Needs "boating-oriented people, activity and scenics shots; shots which include parts or all of a boat are preferred." Special needs include "square or vertical-format shots involving sail or power boats for cover consideration." Photos should have West Coast angle. Model release required; captions preferred.

Making Contact & Terms: Query with samples. SASE. Reports in 1 month. Pays \$200/color cover photo; \$15/b&w or \$50-100/color inside photo. Pays on publication. Credit line given. Buys one-time

rights.

SEEK, 8121 Hamilton Ave., Cincinnati OH 45231. (513)931-4050, Ext. 365. Publisher: Ralph Small. Editor: Leah Ann Crussell. Photo Editor: Mildred Mast. Emphasizes religion/faith. Readers are church people—young and middle-aged adults. Quarterly, in weekly issues; 8 pages per issue; bulletin size. Circ. 60,000.

Photo Needs: Uses about 3 photos/issue; supplied by freelance photographers. Needs photos of people, scenes and objects to illustrate stories and articles on a variety of themes. Must be appropriate to illus-

trate Christian themes. Model release required; captions not required.

Making Contact & Terms: Send by mail for consideration actual 8x10 b&w photos or query with list of stock photo subjects. SASE. "Freelance photographers submit assortments of b&w 8x10 photos that are circulated among all our editors who use photos." Reports in 4 weeks. Pays on acceptance \$15-25/b&w photo. Credit line given. Buys first North American serial rights. Simultaneous submissions and previously published work OK if so indicated. Free sample copy with SASE.

Tips: "Make sure photos have sharp contrast. We like to receive photos of young or middle-aged adults

in a variety of settings."

SELECT HOMES MAGAZINE, (Incorporating 1001 Decorating Ideas), 382 W. Broadway, Vancouver, British Columbia, Canada V5Y 1R2. (604)879-4144. Editor: Pam Miller Withers. 8 times/year. Circ. 160,000. Emphasizes home architecture, renovation, design, decorating, and energy, finance, humor, how-to and maintenance/repairs. Special emphasis on outstanding architecture, good design and attractive decor. Readers are single-family homeowners looking for general information on new products, energy alternatives/techniques and how-to-get-it-done ideas. Sample copy and guidelines \$1, plus self-addressed magazine—size envelope.

Photo Needs: Buys 50-60 photos/issue; all supplied by freelance photographers, both assigned and on spec. Uses 99% color. Query with 8x10 b&w glossy prints or contact sheet. Pays \$50-200 for 35mm, 2\(^14x\)2\(^14\)4 or 4x5 color photos. Reports in 3 weeks. Pays half on acceptance, half on publication. Credit line given. Buys first Canadian serial rights and may reassign rights to photographer after publication.

Simultaneous and previously published submissions OK.

Tips: "We seek 4-color photos of residential interiors and exteriors, any subject dealing with the home or cottage. Best way to break in is to send stock list and publishing credits with samples of work—or query on specific house profile or topic you wish to shoot." Pays top per-day rates for shoots. Before and after photos are important for profiles of houses and other renovation projects."

SELF, 350 Madison Ave., New York NY 10017. (212)880-8800. Editor-in-Chief: Phyllis Starr Wilson. Emphasizes self-improvement and physical and mental well being for women of all ages. Monthly magazine. Circ. 1,091,112.

Photo Needs: Uses up to 200 photos/issue; all supplied by freelancers. Works with photographers on assignment basis only. Provide tearsheets to be kept on file for possible future assignments. Pays \$200 day rate. Needs photos emphasizing health, beauty, medicine and psychology relating to women.

SENIOR GOLF JOURNAL, Box 7164, Myrtle Beach SC 29577. (803)448-1569. Editor: R.E. Swanson. Bimonthly. Emphasizes senior golf. Readers are "golfers over 50 years of age." Sample copy free with SASE.

Photo Needs: Uses about 50 photos/issue; all supplied by freelance photographers. Needs photos of senior golf tournaments, golf resorts. Photos purchased with accompanying ms only. Special needs include

"photos of events on PGA senior tour." Model release and captions preferred.

Making Contact & Terms: Send 3x5 b&w or color prints or 35mm transparencies by mail for consideration. SASE. Reports in 1 month. Pays \$100/b&w or color cover photo; \$25/b&w or color inside photo. Pays on publication. Credit line given. Buys one-time rights. Simultaneous submissions and previously published work OK.

SHAPE, 21100 Erwin St., Woodland Hills CA 91367. (213)884-6800. Editor: Christine MacIntyre. Photo Editor: Sonya Weiss. Monthly. Circ. 525,000. Emphasizes "women's health and fitness." Readers are "women of all ages."

Photo Needs: Uses about 40-50 photos/issue; all (including stock houses) supplied by freelance photographers on assignment, predominantly from the Los Angeles area. Needs "exercise, food, sports, psychological fitness and photo illustrations." Model release required.

Making Contact & Terms: Arrange a personal interview to show portfolio or send samples. SASE. Pays \$25/b&w partial inside photo; \$50/color partial inside photo. Pays on publication. Credit line giv-

en. Buys all rights (negotiable).

SHEET MUSIC MAGAZINE, 223 Katonah Ave., Katonah NY 10536. (914)232-8108. Editor-in-Chief: E. Shanaphy. Photo Editor: Josephine Sblendorio. Emphasizes keyboard music (piano, organ and guitar) for amateur musicians. Monthly. Circ. 262,000.

Photo Needs: Uses about 3 photos/issue. Freelance material used mostly for covers. Needs musical still lifes in 4-color and b&w. Photos accompanying articles usually supplied by writers. Model release re-

quired; captions not required.

Making Contact & Terms: Send by mail for consideration actual 5x7 or 8x10 b&w or color prints; 35mm or 21/4x21/4 color transparencies. SASE. Reports in 2 weeks. Pays on publication \$50/b&w photo; \$200-300/color transparency; \$75-200 for text/photo package. Credit line given. Buys one-time rights. Simultaneous submissions and previously published work OK. Sample copy \$2; photo guidelines for

Tips: "Our freelance material is used mostly for covers. We are interested in musical theme photos in 4color and black and white."

*SHELTERFORCE, 380 Main St., East Orange NJ 07018. (201)678-6778. Editor: Steve Krinsky. Quarterly newspaper. Emphasizes national and international housing issues. Readers include tenants and landlords throughout the world. Sample copy \$1.50.

Photo Needs: Uses about 10 photos/issue; all supplied by freelance photographers. Needs scenic, how-

to, tenants photos. Reviews with or without accompanying ms.

Making Contact & Terms: Send 4x5 b&w prints, b&w contact sheets by mail for consideration. SASE. Reports in 3 weeks. Payment individually negotiated. Pays on publication. Credit line given. Buys all rights. Previously published work OK.

*SHREVEPORT MAGAZINE, Box 20074, Shreveport LA 71120-9982. (318)226-8521. Editor/ Manager: Peter Main. Monthly magazine. "Shreveport is a monthly regional magazine reflecting life on the economic vitality of the Shreveport area and the issues and people of interest to the business community and the Shreveport Chamber of Commerce." Readers are "highly-educated, affluent professionals. They are primarily CEO's and company presidents." Circ. 31,000. Sample copy \$1.75. Photo Needs: Uses about 15-20 photos/issue; all supplied by freelance photographers. Needs photos to accompany business features. Model release and captions required. Query regarding availability and areas of expertise. Needs include color transparencies for cover and some features; b&w (5x7 or 8x10) for other features. SASE. Reports in 1 month. Pays \$125/color cover photo, \$20/b&w inside photo, \$50/ color inside photo, and \$75-150/text/photo package. Pays on publication. Credit line given. Buys first North American serial or first rights in market area. Simultaneous submissions and previously published work OK.

Tips: Prefers to see a "broad range of the photographer's expertise."

*SIGNS OF THE TIMES, 407 Gilbert Ave., Cincinnati OH 45202. (513)421-2050. Editor: Tod Swormstedt. Art Director: Magno Relojo. Monthly plus a 13th "Buyer's Guide." Emphasizes the sign industry. Readers include sign and outdoor companies, graphic designers, architects, sign users. Circ. 17,000. Sample copy free with 8x11 SASE.

Phot Needs: Uses about 100 photos/issue; 2-3 supplied by freelance photographers. Needs sign industry related photos. Reviews with or without accompanying ms. Model release and captions preferred. Making Contact & Terms: Query with samples. SASE. Reports in 2 weeks. Pay varies. Pays on publication. Credit line given. Buys one-time rights. Simultaneous submissions and previously published work OK.

SKI, 380 Madison Ave., New York NY 10017. (212)687-3000. Editor: Dick Needham. Monthly. Circ. 420,000. Emphasizes skiing for skiers.

Photo Needs: All photos supplied by freelance photographers, most assigned. Model release and captions required.

Making Contact & Terms: Send 35mm, 21/4x21/4 or 4x5 transparencies by mail for consideration. SASE. Reports in 1 week. Pays \$700/color cover photo; \$50-250/b&w inside photo, \$75-350/color inside photo; \$150/b&w page, \$250/color page; \$200-600/job; \$500-850 for text/photo package. Pays on acceptance. Credit line given. Buys one-time rights.

Close-up

Pam Withers, Editor, Select Homes

Knowing where place mats and candles need to be on a dining table, being able to work professionally with different kinds of interior lighting—in short, seeing the interior of a home through a designer's eyes—are the skills Pam Withers seeks in freelance photographers.

As editor of Select Homes, Canada's leading homeowner's publication, she says that freelancers who can meet her photographic requirements should contact her now. "We're growing extremely fast, so we're planning much farther ahead, paying better, and trying to develop a reliable list of photographers or agencies that have a lot of photos in our subject area—which means now is the time to break in," she emphasizes.

Select Homes isn't a market strictly for architectural photography. "We deal with decorating more than architecture, and we're also a market for shots of fences, lawns, cottages, brick walls, docks, laundry rooms, and so on. Photographers might note, too, that while we normally seek a photographer after locating a superb house (often found by our writers), we occasionally assign a writer after a photographer presents us with stunning photos from a house shoot we can't turn down," she says.

Canadian photographers do have an edge over American photographers because the part of the magazine which mostly restricts itself to Canadian material—house profiles—is also its primary photo market. "However, we occasionally feature an American home if it's highly unusual, intriguing, interesting and photogenic. We must also know a writer who could collaborate on the article. Generally speaking, we're mostly looking for photographers who live in Canada or travel there frequently or live near the border," she says.

Photographers should write to Withers, letting her know where they live, where they travel, what their back-

ground and specialties are, and what types of photos they have in stock. They should also include 20 to 40 sample slides. "If I like their work, I'll match them with a writer for an assigned shoot; if their stock interests me, I may write them for more information. If they live in the U.S. without quick access to Canada, almost the only way to break in is to impress me with a stock list of house decor/architecture photography, or to present a query on a house we can't turn down," she says.

"For assignments I prefer that photographers use negative film and a camera format larger than 35mm. All photos should be captioned, marked with the photographer's name, address and phone number. Keep in mind that we only publish color. Also, be aware that U.S. stamps don't work in Canada! Photographers outside Canada have to buy International Reply Coupons from their post office to ensure the return of their unsolicited material. Most of all, remember that to be considered for an assignment from us, you must have the 'designer's touch', "Withers emphasizes.

This photo was among more than 1,700 images Miami. Florida, freelancer Lee Wardle made while on assignment in Italy for Ski Racing Magazine. Editor Don Metivier says he used a total of 50 of Wardle's photos in three issues of the magazine. "This action photo of World Cup Champion Pirmin Zurbriggen really represents what we seek for Ski Racing. It's tight, full frame, shows the skier as a person, the bending of the gate and the attack of the skier." he savs.

SKI RACING MAGAZINE, Two Bentley Ave., Poltney VT 05764. (802)287-9090. Editor: Don A. Metivier. News Editor: Hank McKee. Published 20 times/year. Circ. 40,000. Emphasizes ski competition. Readers are "serious skiers, coaches, ski industry, ski press, all interested in photos of skiers in competition." Sample copy free with SASE.

Photo Needs: Uses about 20-25 photos/issue; most supplied by freelance photographers. Needs photos of "skiers in world class or top national competition, action shots, some head and shoulders, some travel shots of ski destinations. There are never enough new skier action photos." Captions required. "If photo

is to be used in an ad, model release is required."

Making Contact & Terms: Send any size b&w glossy prints by mail for consideration; provide resume, business card, brochure, flyer or tearsheets to be kept on file for possible future assignments. SASE. Reports in 2 weeks. Pays \$50/b&w cover photo; \$15-50/b&w inside photo. Pays on publication. Credit line given. Buys one-time rights. Simultaneous submissions OK.

Tips: "Take good pictures and people will buy them especially good action photos that fill the entire

frame."

SKIING MAGAZINE, One Park Ave., New York NY 10016. (212)503-3500. Art Director: Erin Kenney. Published monthly (September through March). Circ. 435,000. Emphasizes skiing for Alpine skiers. Photo guidelines free with SASE.

Photo Needs: Uses 75-120 photos/issue; 75% supplied by freelance photographers. Needs photos of ski

areas, people and competitions. Captions required.

Making Contact & Terms: Query with samples or with list of stock photo subjects; send 8x10 b&w matte or glossy prints, 35mm transparencies or b&w contact sheet by mail for consideration; submit portfolio for review; or provide resume, business card, brochure, flyer or tearsheets to be kept on file for possible future assignments. SASE. Reports in 1 month. Pays \$750/color cover photo; \$25 minimum/ b&w inside photo, \$50 minimum/color inside photo; \$150/b&w page, \$300/color page. Pays on acceptance. Buys one-time rights.

Tips: "Show work specifically suited to Skiing—and be familiar with the magazine before submitting."

SKIN DIVER, 8490 Sunset Blvd., Los Angeles CA 90069. (213)657-5100. Editor/Publisher: Bill Gleason. Executive Editor: Bonnie J. Cardone. Monthly magazine. Circ. 206,198. Emphasizes scuba diving in general, dive travel and equipment. "The majority of our contributors are divers-turned-writers." Photos purchased with accompanying ms only; "particularly interested in adventure stories." Buys 60 photos/year; 85% supplied by freelance photographers. Pays \$50-100/published page. Credit line given. Pays on publication. Buys one-time rights. Send material by mail for consideration. SASE. Free sample copy and photo guidelines.

Subject Needs: Adventure; how-to; human interest; humorous (cartoons); photo essay/photo feature; scenic; sport; spot news; local diving; and travel. All photos must be related to underwater subjects.

Model release required; captions preferred.

B&W: Uses 5x7 and 8x10 glossy prints. **Color:** Uses 35mm and 2¹/₄x2¹/₄ transparencies.

Cover: Uses 35mm color transparencies. Vertical format preferred. Pays \$300.

Accompanying Mss: Free writer's guidelines.

Tips: "Read the magazine; submit only those photos that compare in quality to the ones you see in *Skin Diver*."

THE SMALL BOAT JOURNAL, Box 400, Bennington VT 05201. (802)447-1561. Editor: Tom Baker. Emphasizes good quality small craft, primarily for recreation, regardless of construction material or origin. "Generally we mean boats 30" or less in length, but more importantly 'small' is a state of mind. Traditional boats are covered but of greater interest is the present and future, and the changes boating will undergo." For small boat enthusiasts, boat owners, would-be owners and people in the marine industries. Bimonthly. Circ. 40,000. Free sample copy and photo guidelines with 9x12 SAE and postage. Photo Needs: Buys 30-40 photos/issue. Photos must be related to small boats and boat building. "B&w often purchased with ms, but strong photo essays with full caption information welcome. Color covers should communicate the high excitement inherent in the ownership and use of small boats." No cute or humorous photos; scantily clad females; mundane points of view/framing/composition. Model release and captions required.

Specs: B&w film and contacts with 8x10 unmounted glossies. 21/4x21/4 or larger color transparencies for

cover. 35mm or larger transparencies for interior color.

Making Contact & Terms: Query with samples. Works with photographers on assignment basis only. Provide resume, business card, brochure and tearsheets to be kept on file for possible future assignments. Prefers to see exterior photos with natural light, in a portfolio. Prefers to see tearsheets as samples. SASE. Pays \$10-40/b&w; \$50-150/interior color; \$100 minimum/cover; \$160/day; \$100-500 for text/photo package. Pays on acceptance. Credit line given. Reports in 2-4 weeks. Free sample copy and photo guidelines with 9x12 SAE and postage.

Tips: "We are always eager to see new material. We are assigning in-depth boat text/photo sessions

Tips: "We are always eager to see new material. We are assigning in-depth boat text/photo sessions along all coasts, rivers and lakes. Nautical experience a plus. We're looking for photographers with a somewhat journalistic approach. Action photos of boats particularly sought. Tone should be candid,

fresh."

SMART LIVING MAGAZINE, (formerly *Best Buys Magazine*), 22 East 29th St., New York NY 10016. (212)675-4777. Art Director: Norman Brennes. Monthly. Circ. 100,000. "Consumer-related magazine for upscale New Yorkers." Sample copy \$3.50 with 8 ½x11 envelope (includes postage and handling).

Photo Needs: Uses about 30 photos/issue—type of photos and number supplied by freelancers depends

on issue and article subject matter. Model release required.

Making Contact & Terms: Query with samples or with list of stock photo subjects; will request portfolio for review if interested. Send b&w or color prints by mail for consideration. Provide resume, brochure, tearsheets and samples of work to be kept on file for possible future assignments. "Do not send samples that must be returned. Other materials will be returned." Pays \$200 plus expenses for a color cover photo. Pays on publication. Credit line given. Buys all rights.

Tips: Portfolio should contain "samples of work which show capability and range of talent."

*SNOWMOBILE MAGAZINE, Suite 100, 11812 Wayzata Blvd., Minnetonka MN 55343. (612)545-2662. Editor: C.J. Ramstad. Published 4 times/year. Emphasizes "snowmobiles and snowmobiling, people, industry, places." Readers are 500,000 owners of two or more registered snowmobiles. Sample copy \$2. Photo guidelines free with SASE.

Photo Needs: Uses about 70 photos/issue; 5 or more supplied by freelance photographers. Needs "scenic photography of winter, primarily with snowmobiles as primary subject interest—travel slant is needed—people." Special needs include "scenics, snowmobiling families and family activities, snowmobiles together with other winter activities." Written release preferred.

Making Contact & Terms: Query with samples. SASE. Reports in 1 month. Pays \$250/color cover

photo; \$25 and up/b&w inside photo; \$50 and up/color inside photo. Pays on publication. Credit line negotiable. Buys one-time rights. Simultaneous submissions and previously published work OK.

Tips: "Snowmobiling is a beautiful and scenic sport that most often happens in places and under conditions that make good pictures difficult . . . capture one of these rare moments for us and we'll buy."

SOAP OPERA DIGEST, 254 W. 31st St., New York NY 10001. (212)947-6300. Executive Editor: Meridith Brown. Art Director: Andrea Wagner. Biweekly. Circ. 850,000. Emphasizes daytime and nighttime TV serial drama. Readers are mostly women, all ages.

Photo Needs: Needs photos of people who appear on daytime and nighttime TV programs; special

events in which they appear. Uses color and b&w photos.

Making Contact & Terms: Query with resume of credits to the art director. Do not send unsolicited material. Reports in 1 week. Provide business card and promotional material to be kept on file for possible future assignments. Pays \$25 minimum/b&w photo; \$50 minimum/color photo; \$450-700/photo/text package. Pays on publication. Credit line given. Buys all rights.

Tips: "Have photos of the most popular stars and of good quality."

SOCIETY, Rutgers University, New Brunswick NJ 08903. (201)932-2280. Editor: Irving Louis Horowitz. Bimonthly magazine. Circ. 25,000. For those interested in the understanding and use of the social sciences and new ideas and research findings from sociology, psychology, political science, anthropology and economics. Needs photo essays—"no random submissions." Essays should stress human interaction; photos should be of "people interacting-not a single person." Include an accompanying explanation of photographer's "aesthetic vision." Buys 75-100 photos/annually. Buys all rights. Send photos for consideration. Pays on publication. Reports in 3 months. SASE. Free sample copy and photo guidelines.

Subject Needs: Human interest, photo essay and documentary.

B&W: Send 8x10 glossy prints.

SOLO MAGAZINE, Box 1231, Sisters OR 97759. (503)549-0442. Assistant Editor: Ann Staatz. Quarterly magazine. "Solo's purpose is to encourage, entertain, assist and challenge 25-45 year old single adults to be all God wants them to be. Solo provides practical information and Biblical inspiration that will enable them to grow and live victoriously." Circ. 30,000. Sample copy \$2 plus SASE (large manila envelope).

Photo Needs: Uses about 20-30 photos/issue; 5-10 supplied by freelance photographers. "We especially need photos of people, those in the 25-40 age group." Needs vary from issue to issue, depending on

the subject matter the articles cover.

Making Contact & Terms: Query with samples and list of stock photo subjects. Send b&w prints, 35mm transparencies, or b&w contact sheet by mail for consideration. Provide resume, business card, brochure, flyer or tearsheets to be kept on file for possible future assignments. SASE. Reports in 1 month. Pays \$15-50/b&w inside photo. Pays on publication. Credit line given. Buys one-time rights. Previously published work OK.

Tips: "We often try to find illustrations for specific articles. We like to cultivate a relationship with the photographer so we can tell him/her what we need and he/she can respond by sending specific photos."

SOUTH FLORIDA LIVING, Suite 102, Bldg. 3, 700 W. Hillsboro Blvd., Deerfield Beach FL 33441. (305)428-5602. Managing Editor: Cynthia M. Marusarz. Bimonthly. Circ. 120,000. Emphasizes "the real estate market in Martin, St. Lucie, Indian River, Broward, Palm Beach and Dade counties." Readers are newcomers and home buyers. Free sample copy.

Photo Needs: Uses 5-10 photos/issue, all supplied by freelance photographers. Needs photos of people, architecture, interiors-photojournalistic material. Special needs include scenic photos of the geo-

graphic area covered by the magazine. Model release preferred; captions required.

Making Contact & Terms: Arrange a personal interview to show portfolio. Provide resume to be kept on file for possible future assignments. SASE. Reports in 2 weeks "or when an assignment is available." Pays \$25/b&w inside; negotiates payment for color inside. Pays 1 month after acceptance. Buys all rights. Previously published work OK.

Tips: Prefers to see "people in South Florida, interior shots, architecture, landscaping, waterways and outdoor recreation."

SOUTHERN ANGLER'S & HUNTER'S GUIDE, Box 2188, Hot Springs AR 71914. (501)623-8437. Editor: Don J. Fuelsch. Annual magazine. Circ. 50,000. Emphasizes fishing and hunting, "howto-do-it, when-to-do-it and where-to-do-it in the southern states." Per-photo rates determined by negotiation. Credit line given. Pays on acceptance. Buys all rights. Send photos by mail for consideration. SASE. Simultaneous submissions and previously published work OK. Reports in 30-60 days. Subject Needs: Live shots of fish and game; shots of different techniques in taking fish and game; scenics of southern fishing waters or hunting areas; and tropical fish, aquatic plants and aquarium scenes (for separate publication). No shots of someone holding up a dead fish or dead squirrel, etc. Captions are required.

B&W: Uses 8x10 glossy prints. Color: Uses 21/4x21/4 transparencies.

Cover: Uses color covers only. Requires square format.

SOUTHERN EXPOSURE, Box 531, Durham NC 27702. (919)688-8167. Associate Editor: Marc Miller. Bimonthly. Emphasizes the politics and culture of the South, with special interest in womens' issues, black affairs and labor. Photo guidelines free with SASE.

Photo Needs: Uses 30 photos/issue; most supplied by freelance photographers. Needs news and histori-

cal photos; photo essays. Model release and captions preferred.

Making Contact & Terms: Query with samples; send b&w glossy prints by mail for consideration. SASE. Reports in 3-6 weeks. Pays \$50/b&w cover photo, \$75/color cover photo; \$15/b&w inside photo. Credit line given. Buys all rights "unless the photographer requests otherwise." Simultaneous submissions and previously published work OK.

*SPANISH TODAY, Box 65090, Miami FL 33265-0909. (305)386-5480. Executive Editor: Andres Rivero. Bimonthly magazine. Emphasizes Hispanics/Spanish in the United States. Readers are Hispanic professionals, bilingual and Spanish professors and teachers, general audience. Circ. 10,000. Sample

Photo Needs: 30% of contents are photos, 50% supplied by freelance photographers. Needs travel, scenic, news, education, movies, movie and TV stars." Photos purchased with accompanying ms only.

Model release and captions required.

Making Contact & Terms: Query with list of stock photo subjects. Reports in 4-6 weeks. Payment "open to discussion." Pays on publication. Credit line given. Buys first North American serial rights. Simultaneous submissions OK.

*SPECTRUM STORIES, Box 58367, Lousiville KY 40258. Executive Editor/Publisher: Walter Gammons. Bimonthly. Circ. 15,000. Emphasizes science fiction, fantasy, horror, mystery/suspense stories, articles, interviews/profiles, art and photo portfolios, essays, reviews. Readers well educated, well read, management or professional or student, 18-80. Sample copy \$4 (postpaid); photo guidelines

Photo Needs: Uses about 12-24 photos/issue; 50% supplied by freelance photograhers. Needs "surrealistic, fantastic, experimental photos; story and article illustrations—portraits of famous people, authors, artists, scientists, etc., featured in magazine." Also needs "special photos for illustrations for articles, stories, features-experimental, artistic, advertising for subscribers, etc." Model release required; cap-

tions preferred.

Making Contact & Terms: Query with samples; send 8x10 b&w prints, 35mm, 21/4x21/4, 4x5 or 8x10 transparencies (prefer 21/4x21/4) by mail for consideration or submit portfolio for review. Provide resume, business card, brochure, flyer or tearsheets to be kept on file for possible future assignments. "Send photos with articles, features, etc." SASE. Reports in 1 month. Pays \$100 and up/color cover photo; \$15-25/b&w inside photo, \$25 and up/color inside photo, 1-5¢/word plus extra for photos for text/photo package. Pays on publication. Credit line given. Buys first North American serial and option on first anthology rights.

Tips: "Send photos and/or manuscripts for consideration or to keep on file."

*SPIN, 1965 Broadway, New York NY 10023. (212)496-6100, ext. 336. Editor: Bob Guccione, Jr. Photo Editor: George DuBose. Monthly. Emphasizes music, articles of general interest of ages 18-35.

Readers are 20-25 age group. Circ. 300,000. Estab. 1985. Sample copy \$2.

Photo Needs: Uses 30-50 photos/issue; all supplied by freelance photographers. Needs studio portraits of musicians, celebrities, location portraits of groups, live performance shots, "generally great photos." Reviews photos with or without accompanying ms. Model release required; captions preferred. Making Contact & Terms: Arrange a personal interview to show portfolio; query with list of stock photo subjects. Uses 8x10 glossy b&w prints, 35mm, 21/4x21/4, 4x5 transparencies, b&w contact sheets, b&w negatives. SASE. Reports in 1 month. Pays \$500/b&w or color cover photo, \$50-100/inside b&w photo, \$50-200/inside color photo. Pays on publication. Credit line given. Buys one-time rights. Simultaneous submissions and previously published work OK.

Tips: Prefers to see "good rapport with subjects, good use of lighting and technique. Technique is everything. You must have deep love for music and sensitivity when dealing with people. Don't be aggres-

sive with or intimidated by celebrities."

SPORTS AFIELD, 250 W. 55th St., New York NY 10019. (212)262-5700. Art Director: Gary Gretter. For persons of all ages interested in the out-of-doors (hunting and fishing) and related subjects. Write by registered mail. Credit line given.

Subject Needs: Animal, nature, scenic, travel, sports, photo essay/photo feature, documentary, still

life and wildlife.

Tips: "We are looking for photographers who can portray the beauty and wonder of the outdoor experience."

SPORTS ILLUSTRATED, Time-Life Bldg., New York NY 10020. (212)841-3131. Picture Editor: Barbara Henckel. A newsweekly of sports; emphasizes sports and recreation through news, analysis and profiles for participants and spectators. Circ. 2,250,000. *Everything* is done on assignment; has photographers on staff and on contract. Freelancers may submit portfolio by appointment in person if in the area or by mail; also looking for feature ideas by mail. Reports on portfolios in 2 weeks. SASE. Pays a day rate of \$350 against \$500/page, \$1,000/cover.

Tips: "On first contact with the photographer, we want to see a portfolio only. Portfolios may be varied, not necessarily just sport shots. We like to meet with photographers after the portfolio has been reviewed." The column, Faces in the Crowd, will pay \$25 for b&w head shots of interesting amateur

sports figures of all ages; prints returned on request.

SPORTS PARADE, Box 10010, Ogden UT 84409. Editor: Wayne DeWald. Monthly. Circ. 50,000. Covers all sports. Readers are generally business and family oriented. Sample copy \$1 plus 9x12 envelope. Free guidelines with SASE.

Photo Needs: Uses 10-12 photos/issue; 90% supplied by freelance photographers. Needs photos of

sports personalities. Photos purchased with or without accompanying ms.

Making Contact & Terms: Send photos by mail for consideration. SASE. Provide resume, flyer or tearsheets to be kept on file for possible future assignments. Pays negotiable rate/color cover, \$35/color inside. Pays on acceptance. Credit line given. "We now purchase first rights and nonexclusive reprint rights. This means we retain the right to reprint purchased material in other Meridian publications. Authors and photographers retain the option or the right to resell material to other reprint markets."

Tips: Needs "good action shots."

SPORTSMAN'S HUNTING, 1115 Broadway, New York NY 10010. (212)807-7100. Also publishes Sportmen Bowhunting. Complete Deer Hunting Annual, Hunter's Deer Hunting Annual, Action Hunting, Guns and Hunting. Editor-in-Chief: Lamar Underwood. Magazine published twice/year in early and late fall. Circ. 100,000. Emphasizes hunting for hunters. Free sample copy. Free photographer's guidelines with SASE.

Photo Needs: Uses up to 50 photos/issue; all supplied by freelance photographers. Needs "photos to accompany nostalgic, how-to, where-to and personal experience stories on hunting. Also use photo features with an establishing text." Photos purchased with or without accompanying ms. Model release re-

quired when recognizable face is included; captions required.

Making Contact & Terms: Query with list of stock photo subjects or send by mail for consideration 8x10 b&w glossy prints, any size transparencies or b&w contact sheet. SASE. Reports in 3 weeks. Pays \$500/color cover; \$75/b&w or \$125/color inside. Pays on acceptance. Credit line given. Buys one-time rights.

*SPRINGS MAGAZINE, Box 9166, Colorado Springs CO 80932. (303)636-2001. Editor: Stewart M. Green. Monthly tabloid. "We are a regional magazine for the Pike's Peak region." Readers are mostly residents of Colorado Springs and its suburbs; average 25-50, well-educated, professional. Sam-

ple copy with SASE \$1 postage.

Photo Needs: Uses about 10-25 photos/issue; 1-5 supplied by freelance photographers. Needs animal/wildlife; Colorado and Pike's Peak scenics; Colorado and Southwest travel; Colorado people; adventure sports—hiking, backpacking, rafting, climbing, skiing, etc. Reviews with accompanying ms only. Special needs include human interest profiles; ranching; Colorado history and natural history. Captions required.

Making Contact & Terms: Query with resume of credits, samples and list of stock photo subjects; send 5x7, 8x10 glossy b&w prints, 35mm, 2½x2½ transparencies, b&w contact sheets by mail for consideration; submit portfolio for review. SASE. Reports in 1 month. Pays \$50/color cover photo, \$10-15/b&w inside photo, \$50-300/text/photo package. Pays on publication. Credit line given. Buys one-time

rights. Simultaneous submissions and previously published work OK.

Tips: "I want sharp, well-exposed, well-printed black and white photos. Must be well composed. Well-edited portfolio—We don't like rewriting *unedited* material—show only your best. Photos must be compelling and say something about the story or photostory they accompany. "Send a professional package with typed captions. SASE, a few story ideas. I want to see how a photographer will put together a story from contact sheets and clips. I've been disappointed with most freelance submissions."

*SPUR, 1 West Washington St., Box 85, Middleburg VA 22117. (703)687-6314. Managing Editor: Kerry E. Phelps. Bimonthly magazine. Emphasizes Thoroughbred horses. Readers are "owners, breeders and trainers of Thoroughbreds, jockeys, equine vets, stable hands, and lovers of horses: both sexes, all ages, all income levels, foreign and domestic." Circ. 10,000 + . Sample copy \$3.50. Photo guidelines free with SASE.

Photo Needs: Uses about 45-55 photos/issue; all supplied by freelance photographers. Needs photos of "horses—Thoroughbreds only—and sometimes jockeys in action (racing) or still shots for cover. (All photos accompanying articles by assignment only)." Special needs include "covers—fresh, original

approaches always needed." Captions preferred.

Making Contact & Terms: Query with samples. Send 2½x2½ transparencies by mail for consideration. Provide resume, business card, brochure, flyer or tearsheets to be kept on file for possible future assignments. SASE. Reports in 3 weeks. Pays \$75 and up/color cover photo, \$15/b&w inside photo, and \$35/color inside photo. Pays on publication. Credit line given.

STALLION MAGAZINE, 351 W. 54th St., New York NY 10019. (212)586-4432. Editor: Jerry Douglas. Monthly magazine. Emphasizes male erotica for gay males.

Photo Needs: Uses 75-100 photos/issue; most supplied by freelance photographers. Needs "male eroti-

ca" photography. Model release required.

Making Contact & Terms: Arrange a personal interview to show portfolio; query with resume of credits; send b&w prints and 35mm or 2½x2½ transparencies by mail for consideration. SASE. Reports in 3 months. Pays \$200/color cover photo; \$400 for color/photo package; \$300/b&w package. Pays on publication. Credit line given. Buys one-time or first North American serial rights. Simultaneous submissions OK.

*STAR, 660 White Plains Rd., Tarrytown NY 10591. (914)332-5000. Editor: Ian G. Rae. Photo Editor: Alistair Duncan. Weekly. Emphasizes news, human interest and celebrity stories. Circ. 4,000,000. Sample copy and photo guidelines free with SASE.

Photo Needs: Uses 100-125 photo/issue; 75% supplied by freelance photographers. Reviews photos

with or without accompanying ms. Model release preferred; captions required.

Making Contact & Terms: Query with samples and with list of stock photo subjects, send 8x10 b&w prints, 35mm, 2¹/₄x2¹/₄ transparencies by mail for consideration. SASE. Reports in 2 weeks. Pays on publication. Credit line sometimes given. Simultaneous submissions and previously published work OK.

THE STATE, Box 2169, 417 N. Boylan Ave., Raleigh NC 27602. (919)833-5729. Editor: W.B. Wright. Monthly magazine. Circ. 21,000. Regional publication, privately owned, emphasizing travel, history, nostalgia, folklore, humor, all subjects regional to North Carolina and the South, for residents of, and others interested in, North Carolina.

Subject Needs: Photos on travel, history and personalities in North Carolina. Captions required. **Specs:** Uses 5x7 and 8x10 glossy b&w prints; also glossy color prints. Uses b&w and color cover, vertical preferred.

Accompanying Mss: Photos purchased with or without accompanying ms.

Payment/Terms: Pays \$5-10/b&w print and \$10-50/cover. Credit line given. Pays on acceptance. Making Contact: Send material by mail for consideration. SASE. Reporting time depends on "involvement with other projects at time received." Sample copy \$1.

STEREO REVIEW, 1 Park Ave., New York NY 10016. (212)503-4000. Editor-in-Chief: William Livingstone. Art Director: Sue Llewellyn. Monthly. Circ. 575,000. Emphasizes stereo equipment and classical and popular music. Readers are music enthusiasts.

Photo Needs: Uses 30 photos/issue, supplied by freelance photographers and stock. "We use photos by photographers who do outstanding pictures at concerts; mostly in New York although we will look at work from the West Coast and country music areas." Needs photos of music celebrities performing. Al-

so several products shots per issue, of the highest quality.

Making Contact & Terms: Query with list of stock photo subjects. Uses 35mm slides and b&w contact sheets. SASE. Reports in 1 week. Pays \$100-750/b&w photo; \$200-1,000/color photo. Credit line given. Payment on acceptance. Buys one-time rights. Simultaneous and previously published work OK if indicated.

STERLING'S MAGAZINES, 355 Lexington Ave., New York NY 10017. (212)391-1400, ext. 47. Photo Editor: Roger Glazer. Monthly magazine. Circ. 200,000. For people of all ages interested in TV and movie stars. Needs photos of TV, movie and soap opera stars. Buys "thousands" annually. "Will not return b&w; only color will be returned after publication." SASE. Send contact sheet for consideration.

368 Photographer's Market '86

B&W: Uses 8x10 glossy prints. Pays \$25.

Color: Uses 35mm and 21/4x21/4 transparencies. Pays \$50 minimum.

Cover: See requirements for color. Pays \$50 minimum.

Tips: Only celebrity photos. "We deal with celebrities only—no need for model releases. Familiarize yourself with the types of photos we use in the magazine."

*STING, Alpha Publications, Inc., 1079 De Kalb Pike, Center Square PA 19422. (215)277-6342. Photo Editor: Francis Laping. Bimonthly. Emphasizes humor and satire. Estab. 1984. Sample copy \$2. Photo Needs: Uses 5-10 photos/issue; all supplied by freelance photographers. Needs satire, political, social and humor of any subject. Reviews photos with accompanying ms only. Model release and captions required.

Making Contact & Terms: Query with samples, send 8x10, 5x7 glossy b&w prints by mail for consideration. SASE. Reports in 1 week. Payment depends on photo. Pays on publication. Credit line given.

Buys one-time rights. Simultaneous submissions and previously published work OK.

STOCK CAR RACING MAGAZINE, Box 715, 5 Bullseye Rd., Ipswich MA 01938. (617)356-7030. Editor: Dick Berggren. Monthly magazine. Circ. 180,000. Emphasizes NASCAR GN racing and modified racing. Read by fans, owners and drivers of race cars and those with racing businesses. Photos purchased with or without accompanying ms and on assignment. Buys 50-70 photos/issue. Credit line given. Pays on publication. Buys one-time rights. Send material by mail for consideration. SASE. Reports in 1 week. Free photo guidelines.

Subject Needs: Documentary, head shot, photo essay/photo feature, product shot, personality, crash pictures, special effects/experimental and sport. No photos unrelated to stock car racing. Model release

required unless subject is a racer who has signed a release at the track; captions required.

B&W: Uses 8x10 glossy prints. Pays \$20/photo.

Color: Uses 35mm or 21/4x21/4 transparencies. Pays \$35-250/photo.

Cover: Uses Kodachrome transparencies. Pays \$35-250/photo.

Tips: "Send the pictures. We will buy anything that relates to racing if it's interesting, if we have the first shot at it, and it's well printed and exposed. Eighty percent of our rejections are for technical reasons—poorly focused, badly printed, too much dust, picture cracked, etc. We get far fewer cover submissions than we would like. We look for full bleed cover verticals where we can drop type into the picture and fit our logo too."

STRAIGHT, 8121 Hamilton Ave., Cincinnati OH 45231. (513)931-4050. Editor: Dawn Brettschneider. Readers are ages 13 through 19, mostly Christian; a conservative audience. Weekly. Circ. 100,000.

Photo Needs: Uses about 4 photos/issue; all supplied by freelance photographers. Needs photos of teenagers, ages 13 through 19, involved in various activities such as sports, study, church, part-time jobs, school activities, classroom situations. Outside nature shots, groups of teens having good times together are also needed. "Try to avoid the sullen, apathetic look—vital, fresh, thoughtful, outgoing teens are what we need. Any photographer who submits a set of quality b&w glossies for our consideration, whose subjects are teens in various activities and poses, has a good chance of selling to us. This is a difficult age group to photograph without looking stilted or unnatural. We want to purport a clean, healthy, happy look. No smoking, drinking or immodest clothing. We especially need masculine-looking guys, and minority subjects. Submit photos coinciding with the seasons (i.e., winter scenes in December through February, spring scenes in March through May, etc.) Model release and captions not required, but noting the age of the model is often helpful.

Making Contact & Terms: Send 5x7 or 8x10 b&w photos by mail for consideration. Enclose sufficient packing and postage for return of photos. Reports in 4-6 weeks. Pays on acceptance \$20-25/b&w photo. Credit line given. Buys one-time rights. Simultaneous submissions and previously published work OK.

Sample copy and photo guidelines for SASE.

Tips: "Our publication is almost square in shape. Therefore, 8x10 or 5x7 prints that are cropped closely will not fit our proportions. Any photo should have enough 'margin' around the subject that it may be cropped square. This is a simple point, but absolutely necessary."

STRENGTH AND HEALTH, Box 1707, York PA 17405. (717)767-6481. Editor: Bob Hoffman. Bimonthly magazine. Circ. 100,000. For people interested in Olympic weightlifting and weight training. Needs photos relating to weightlifting, physique, health and sports. Buys all rights, but may reassign to photographer after publication. Model release preferred. Photos purchased with accompanying ms. Credit line given. Pays on publication. Reports in 2 months. SASE. Free sample copy.

B&W: Uses glossy prints. Captions required. Pays \$5-15.

Cover: Uses 21/4x21/4 color transparencies. Captions required. Pays \$100-300.

Tips: Submit seasonal material 4-5 months in advance.

SUCCESS MAGAZINE, 342 Madison Ave., New York NY 10173. (212)503-0700. Contact: Art Director or Picture Editor. Monthly magazine. Circ. 350,000. Emphasizes self-improvement and goal-attainment for men and women. Buys 30 photos/year. Pays ASMP rates. Credit line given. Buys one-time rights or all rights. Query with samples. SASE. Previously published work OK. Reports in 2 weeks. Free sample copy and photo guidelines.

Subject Needs: Sport, human interest, celebrity/personality and still life. "If a photographer is our kind of guy he'll show us a sample case, and if we like it we'll buy or assign him. We'll tell him then what we need. Often it's an abstract shot, but also, at times, it can be an event." Model release preferred; captions

required.

B&W: Uses 8x10 prints. **Color:** Uses transparencies. **Cover:** Uses transparencies.

SURFER MAGAZINE, Box 1028, Dana Point CA 92629. (714)496-5922. Photo Editor: Jeff Divine. Monthly magazine. Circ. 125,000. Emphasizes instruction on and locations for surfing, mainly for student-age males who surf. Needs photos of ocean waves and wave riding. Buys 20-30 photos/issue. Buys first North American serial rights. Query. Credit line given. Pays on publication. Reports in 1 month. SASE. Simultaneous submissions OK. Sample copy \$2.95.

B&W: Send contact sheet, negatives or 8x10 prints. Captions not required, "but helpful." Pays \$10-75,

b&w; \$25-125, color.

Color: Send 35mm or 21/4x21/4 transparencies. Pays \$20-125.

Cover: Send 35mm or 21/4x21/4 color transparencies. Pays \$600 minimum, color.

Tips: "Get experience in the field, swimming and working with water housing. Get experience in the water and in using telephoto from the land. Don't be discouraged; we deal with 165 photographers around the world on a consistent basis. Competition is stiff. Use K64; no Ekta or Fuji films."

SURFING MAGAZINE, Box 3010, San Clemente CA 92672. (714)492-7873. Editor: David Gilovich. Photo Editor: Larry Moore. Monthly. Circ. 85,500. Emphasizes "surfing action and related aspects of beach lifestyle. Travel to new surfing areas covered as well. Average age of readers is 20 with 70% being male. Nearly all drawn to our publication due to high quality action packed photographs.' Free photo guidelines with SASE. Sample copy \$2.50.

Photo Needs: Uses about 80 photos/issue; 50% supplied by freelance photographers. Needs "in-tight front-lit surfing action photos as well as travel related scenics. Beach lifestyle photos always in need." **Making Contact & Terms:** Send by mail for consideration 35mm or 21/4x21/4 transparencies; b&w contact sheet or b&w negatives. SASE. Reports in 2 weeks. Pays \$500/color cover photo; \$20-70/b&w inside photo; \$30-125/color inside photo; \$700/color poster photo. Pays on publication. Credit line given. Buys one-time rights.

Tips: Prefers to see "well-exposed, sharp images showing both the ability to capture peak action as well as beach scenes depicting the surfing lifestyle. Color, composition and proper film usage are important.

Ask for our photo guidelines prior to making any film/camera choices.

SWANK MAGAZINE, 888 7th Ave., New York NY 10106. (212)541-7100. Photo Editor: Bruce Perez. Monthly magazine. Emphasizes nude models for mostly male, single audience earning \$18,000 and up.

Photo Needs: "Small percentage" of photos supplied by freelance photographers. Needs photos of "nude, attractive women or couples." Reviews photos with accompanying ms only. Model release re-

anired

Making Contact & Terms: Query with samples. SASE. Reports in 1 week, Pays \$950-1,400 for photo package. Pays within 30 days of acceptance. Credit line given. Buys first North American serial rights. Tips: Prefers to see "attractive models, demonstrating good quality, color and makeup in a unique and interesting setting."

TAMPA BAY METROMAGAZINE, 2502 Rocky Point Rd., Suite 295, Tampa FL 33607. (813)885-9855. Executive Editor: Ron Stuart. Art Diretor: Sergio Waksnan. Monthly. Circ. 25,000. City magazine for the Tampa Bay area. Readers are "upscale, professional, live in the Tampa Bay area." Sample copy \$1.95.

Photo Needs: Uses about 25 photos/issue; all supplied by freelance photographers. Needs "photojournalism, fashion, food, cover; all are on assignment. Photos purchased with accompanying ms only. Model release and captions required. Pays \$25-250/b&w photo per assignment, \$15-600/color, cover

negotiable

Making Contact & Terms: Arrange a personal interview to show portfolio; query with resume of credits or with samples; or submit portfolio for review. SASE. Reports in 1 month. Pays by the job. Pays on publication. Credit line given. Negotiates rights purchased.

Tips: Prefers to see "an assortment of studio and journalistic work, color and b&w. Compile a thorough portfolio, be prepared to work hard."

*TEEN POWER, Box 632, Glen Ellyn IL 60138. (312)665-6000. Designer: Mardelle Ayers. Weekly magazine. "Illustrates biblical principles and faith in the everyday lives of teens." Readers are young teens, ages 12-16. Free sample copy and photo guidelines with SASE.

Photo Needs: Uses about 2-3 photos/issue; all supplied by freelance photographers. Needs photos of

teens in school, home, and church settings."

Making Contact & Terms: Send b&w prints by mail for consideration. Provide resume, business card, brochure, flyer or tearsheets to be kept on file for possible future assignments. SASE. Reports in 3 weeks. Pays on acceptance. Credit line given. Buys one-time rights.

TEENS TODAY, 6401 The Paseo, Kansas City MO 64131. (816)333-7000, ext. 214. Editorial Accountant: Rosemary Postel. Editor: Gary Sivewright. Weekly magazine. Circ. 60,000. Read by juniorand senior-high-school/age persons. Photos purchased with or without accompanying ms and on assignment. Buys 150 photos/year; 3 photos/issue. Credit line given. Pays on acceptance. Buys one-time rights. Simultaneous submissions and previously published work OK.

Subject Needs: Needs shots of high-school age young people. "Many photographers submit straight-on shots. I'm looking for something that says 'this is different; take a look.' Junior and senior highs (grade 7-12) must be the subjects, although other age groups may be included." Shots of driving, talking, eat-

ing, walking, sports, singles, couples, groups, etc.

B&W: Uses 8x10 glossy prints. Pays \$15-25/photo.

Accompanying Mss: Pays 31/2¢ minimum/word first rights, 3¢/word for second rights. Free writer's

guidelines with SASE.

Making Contact: Send material by mail for consideration. "Send photo submissions to our central distribution center to Rosemary Postel and they will be circulated through other editorial offices." SASE. Reports in 6-8 weeks. Free sample copy; photo guidelines free only with SASE.

Tips: "Make sure your work has good contrast and is dealing with the teen-age group. We buy many

photos and so are always looking for a new good one to go with an article or story.

TENNIS MAGAZINE, 495 Westport Ave., Norwalk CT 06856. (203)847-5811. Art Director: Bobbe Stultz. Monthly magazine. Circ. 500,000. Emphasizes instructional articles and features on tennis for young, affluent tennis players. Freelancers supply 60% of photos. Payment depends on space usage. Credit line given. Pays on acceptance. Buys first world rights or on agreement with publisher. Send material by mail for consideration. SASE. Reports in 2 weeks.

Subject Needs: "We'll look at all photos submitted relating to the game of tennis. We use color action shots of the top athletes in tennis. They are submitted by freelance photographers covering tournaments relating to current and future articles." Also uses studio setups and instructional photography.

B&W: Uses 5x7 glossy prints. Color: Uses 35mm transparencies.

TENNIS WEEK, 6 E. 39th St., 8th Floor, New York NY 10016. (212)696-4884. Publisher: Eugene L. Scott. Editor: David Georgette. Contributing Editors: Richard Quens, Linda Pentz. Readers are "tennis fanatics." Weekly. Circ. 40,000. Sample copy \$1.

Photo Needs: Uses about 16 photos/issue. Needs photos of "off-court color, beach scenes with pros, social scenes with players, etc." Emphasizes originality. No captions required; subject identification re-

quired.

Making Contact & Terms: Send by mail for consideration actual 8x10 or 5x7 b&w photos. SASE. Reports in 2 weeks. Pays on publication \$10-15/b&w photo; \$50 cover. Credit line given. Rights purchased on a work-for-hire basis. No simultaneous submissions.

TEXAS FISHERMAN MAGAZINE, 5314 Bingle Rd., Houston TX 77092. (713)681-4760. Editor: Larry Bozka. Publishes 9/year.Circ. 64,000. Emphasizes all aspects of fresh and saltwater fishing in Texas, plus hunting, boating and camping when timely. Readers: 90% are married, with 47.4% earning over \$35,000 yearly. Sample copy free with SASE.

Photo Needs: Use 25 photos/issue; 75% supplied by freelance photographers. Needs "action photos of fishermen catching fish, close-ups of fish with lures, 'how-to' rigging illustrations, some wildlife." Especially needs photos of Texas coastal fishing (saltwater). Model release optional; captions required. Making Contact & Terms: Query with samples. SASE. Reports in 1 month. Pays \$150/color cover photo; \$15/b&w inside photo. Pays on publication. Credit line given. Buys one-time rights.

Tips: Prefers to see "action shots—no photos of fishermen holding up fish (or stringer shots). Concen-

trate on taking photos that tell something, such as how-to."

TEXAS GARDENER, Box 9005, Waco TX 76710. (817)772-1270. Editor/Publisher: Chris S. Corby. Bimonthly. Circ. 37,000. Emphasizes gardening. Readers are "65% male, home gardeners, 98% Texas

residents." Sample copy \$1.

Photo Needs: Uses 20-30 photos/issue; 90% supplied by freelance photographers. Needs "color photos of gardening activities in Texas." Special needs include "photo essays on specific gardening topics such as 'Weeds in the Garden.' Must be taken in Texas." Model release and captions required.

Making Contact & Terms: Query with samples. SASE. Reports in 3 weeks. Pays \$100-200/color cov-

er photo; \$5-15/b&w inside photo, \$10-200/color inside photo. Pays on publication. Credit line given.

Buys all rights.

Tips: "Provide complete information on photos. For example, if you submit a photo of watermelons growing in a garden, we need to know what variety they are and when and where the picture was taken."

TEXAS HIGHWAYS, 125 11th St., Autsin TX 78701. (512)475-6068. Editor-in-Chief: Frank Lively. Photo Editor: Bill Reaves. Monthly. Circ. 320,000. "Texas Highways interprets scenic, recreational, historical, cultural and ethnic treasures of the state and preserves the best of Texas heritage. Its purpose is to educate and entertain, to encourage recreational travel to and within the state and tell the Texas story to readers around the world." Readers are "35 and over (majority); \$24,000 to \$60,000 per year salary bracket with a college education." Sample copy and photo guidelines free.

Photo Needs: Uses about 60 photos/issue; 50% supplied by freelance photographers. Needs "travel and scenic photos in Texas only." Special needs include "fall, winter, spring, and summer scenic shots and

wildflower shots (Texas only)." Model release preferred; captions required.

Making Contact & Terms: Query with samples. Provide business card and tearsheets to be kept on file for possible future assignments. SASE. Reports in 1 month. Pays \$80 for 1/2 page color inside photo and \$160/full-page color photo, \$300 for front cover photo; \$300-750 for complete photo story. Pays on acceptance. Credit line given. Buys one-time rights. Simultaneous submissions OK.

Tips: "Know our magazine and format. We only take color originals, 35mm Kodachrome or 4x5. No negatives. Don't forget to caption and name names. We publish only photographs of Texas. We accept

only high quality professional level work, no snapshots."

THE TEXAS OBSERVER, 600 W. 7th St., Austin TX 78701, (512)477-0746, Art Director: Alicia Daniel. Biweekly journal. Emphasizes "Texas politics, literature and culture." Readers are young professionals who contribute time and/or money to political campaigns. Circ. 12,000. Sample copy with SASE and 37¢ postage.

Photo Needs: Uses about 6 photos/issue; all supplied by freelance photographers. "We use a wide variety of Texas subjects including wildlife, border scenes, political candidates, organizers, etc." Captions

preferred.

Making Contact & Terms: Arrange a personal interview to show portfolio. Query with samples. Send b&w prints by mail for consideration. SASE. Reports in 2 weeks. Pays \$10/cover photo; \$10/inside photo. Pays on publication. Credit line given. Buys one-time rights. Simultaneous submissions and previously published work OK.

Tips: Prefers to see "documentary-style photos of almost any Texas subject, including jails, rodeos, candidates, etc." Freelancers should "persevere and expect low pay in exchange for freedom."

*3 SCORE AND 10, RD#2, Box 103, Boswell PA 15531. (814)629-9815. Editor: Joseph Kaufman. Monthly. Emphasizes general interest. Readers include people over 70. Estab. 1984. Sample copy

Photo Needs: "We buy one b&w 5x7 photo/month for back cover (without manuscript), preferably

from a photographer over 70."

Making Contact & Terms: Send 5x7 b&w prints by mail for consideration. SASE. Reports in 3 weeks. Pays \$10/b&w back cover. Pays on publication. Credit line given. Buys one-time rights. Simultaneous submissions and previously published work OK.

3-2-1 CONTACT MAGAZINE, c/o Children's Television Workshop, 1 Lincoln Plaza, New York NY 10023. Contact: Photo Editor. Published 10 times/year. Circ. 300,000. "Emphasis is on science for children ages 8 to 12." Readers are "bright kids who may not normally be interested in science but respond to interesting, informative stories with appealing photos." Photo guidelines free with SASE.

Photo Needs: Uses about 15-25 color photos/issue; "most supplied by photo houses." Needs "interesting photos that tell scientific stories. Photos showing kids doing things. Increasing emphasis on computer-related stories and new/high-tech articles. All sorts of natural phenomona." Will review photos "with or without accompanying manuscript, but we will only review material after a photographer has sent for and carefully read our guidelines." Model release and captions preferred.

Making Contact & Terms: Query with resume of credits; provide resume, business card, brochure,

flyer or tearsheets to be kept on file for future assignments. "Never send unsolicited photos to us." Does not return unsolicited material. Reports in 3 weeks. Pays \$300/color cover photo; \$50 minimum/b&w or color inside photo; \$150/b&w page, \$200/color page; job, hourly and text/photo package payment negotiable. "We pay when a magazine issue closes, usually two months before publication." Credit line given. Buys one-time or all rights, depending on the situation, simultaneous submissions and previously published work OK, but "we will not consider simultaneous publication with any magazine we perceive to be a direct competitor."

Tips: "Read guidelines carefully and follow to the letter. Think before you mail. Tailor your query to our

publication. Don't waste your time and ours by sending inappropriate material."

TIDEWATER VIRGINIAN MAGAZINE, Box 327, Norfolk VA 23501. (804)625-4233. Executive Editor: Marilyn Goldman. Circ. 9,000. Emphasizes business for upper management. Freelancers supply 70% of photos. Photos purchased with or without accompanying mss. Credit line given. Pays by assignment or on a per-photo basis, on publication. Buys one-time rights or all rights. Model release required. Send samples of work that can be published immediately. Prefers to see business-type shots (not arty) in a portfolio. SASE. Simultaneous submissions OK. Reports in 3 weeks. Sample copy \$1.95. Subject Needs: Fine art (if it's relevant to a gallery or museum we're writing about); area scenic; photo essay/photo feature (in connection with a local story); travel (for business people); and business, computers, manufacturing and retail sales. Do not send photos not appropriate for a business magazine. Captions required.

B&W: Uses 8x10 and 5x7 glossy prints. Pays \$10-25/print.

Cover: Uses color covers only. Vertical format required. Pays \$200 maximum/photo.

Accompanying Mss: Seeks articles on business—taxes, financial planning, stocks and bonds, etc. Pays \$75-200 for text/photo package.

TIGER BEAT MAGAZINE, 105 Union Ave., Cresskill NJ 07626. (201)569-5055. Editor: Diane Umansky. Monthly magazine. Circ. 500,000. Emphasizes fashion, beauty, how-to, celebrities, for ages 15-19.

Subject Needs: Photos of young stars featured in magazine. Wants on a regular basis everything from candids to portraits, location shots, stills from TV and movies.

Payment/Terms: Pays \$15 minimum/b&w print; \$50-75 minimum/color transparency; and \$75 minimum/cover. Pays on acceptance.

Making Contact: Query with tearsheets along fashion lines or call for appointment. SASE. Reports in 2-3 weeks.

Tips: Prefers to see variety of entertainers popular with young people. "Supply material as sharply focused as possible." Opportunity for photographers just starting out. "Be patient and polite."

*TLC MAGAZINE, 1933 Chestnut St., Philadelphia PA 19103. (215)569-3574. Art Director: James Naughton. Bimonthly magazine. Emphasizes "food, travel, sports, wellness, personalities, etc. (general interest)." Readers are hospital patients. Circ. 250,000. Estab. 1984. Free sample copy and photo guidelines with SASE (mailing weight 6.0 oz.); include sufficient postage.

Photo Needs: Uses about 40 photos/issue; about half supplied by freelance photographers. Model re-

lease and captions required.

Making Contact & Terms: Query with list of stock photo subjects. SASE. Reports in 1 week. Pays \$300/b&w and color page; \$150/b&w color half page; and \$75 b&w and color quarter page. Pays on publication. Credit line given. Buys one-time rights. Previously published work OK.

Tips: "TLC publishes reprints from other sources. Exceptions may be travel or photo essays. If you're an author/photographer combo we want to hear from you. Send tearsheets and a SASE."

TODAY'S CHRISTIAN PARENT, 8121 Hamilton Ave., Cincinnati OH 45231. (513)931-4050. Editor: Mildred Mast. Quarterly magazine. Circ. 30,000. For parents and grandparents. Needs "family scenes: family groups in activities; teenagers and children with parents/grandparents; adult groups; family devotions." Natural appearance, not an artificial, posed, "too-perfect" look. Wants no "way out" photos or shots depicting "freakish family styles." Buys 12-15 annually. Buys first serial rights. Query by mail; send shipments of photos by mail or UPS. SASE. Pays on acceptance. Reports in 4 weeks. Free sample copy and guidelines for 7x10 or larger SASE.

B&W: Send 8x10 glossy prints, clear with sharp contrast. Pays \$15-25/photo depending on use. **Tips:** "This is a magazine used by churches/Christian families, so the themes are often devotional or 'uplifting' in nature." Also, "photos will be circulated to other editors; number or code photos for easy

identification. Send no more than 50 at a time."

*TODAY'S FISHERMEN MAGAZINE, 8161 Center St., La Mesa CA 92041. (619)466-2607. Editor: Ben Massey. Photo Editor: Steve Hire. Monthly. Emphasizes sportfishing: saltwater and freshwa-

ter. Readers include outdoor fishing enthusiasts. Circ. 20,000. Free sample copy with SASE.

Photo Needs: Needs vary: outdoor, fishing oriented; could be travel, scenic, depending on location. Re-

views photos with or without accompanying mss. Captions preferred.

Making Contact & Terms: Send 3½x5 matte b&w or color photos by mail for consideration. SASE. Reports in 1 month. Pays \$50/color cover, \$5/b&w inside photo and \$10/color inside photo. Pays on publication. Credit line given if requested. Rights purchased negotiable; vary with photographer. Simultaneous submissions and previously published work OK.

TORSO INTERNATIONAL, Suite 210, 7715 Sunset Blvd., Los Angeles CA 90046. (213)850-5400. Publisher: Casey Klinger. Monthly magazine. Circ. 354,000. Emphasizes male photo erotica for gay men. Sample copy free with SASE.

Photo Needs: Uses 48-60 photos/issue; all supplied by freelance photographers. Needs photos of nude

males. Model release required; captions optional.

Making Contact & Terms: Arrange a personal interview to show portfolio; send 35mm; 2½4x2¼, 4x5 and 8x10 transparencies by mail for consideration. SASE. Reports immediately. Pays \$250-500/job. Pays on publication. Credit line given. Buys one-time rights.

TOTAL FITNESS, 15115 S. 76th E. Ave., Bixby OK 74104. (918)366-4441. Managing Editor: Anne Thomas. Bimonthly. Circ. 120,000. Emphasizes "exercise, especially 'how to' articles on getting and staying fit and shapely; sports medicine." Readers are "females 28-50 years old." Sample copy and photo guidelines free with SASE (magazine size!).

Photo Needs: Uses about 30-50 photos/issue; 75% supplied by freelance photographers. Needs "cover shots—color transparencies of females engaged in some form of exercise; other photos would be on as-

signment only." Model release required; captions preferred.

Making Contact & Terms: Query with samples. SASE. Reports in 3 weeks. Pays \$200-300/color cover photo; \$10-30/b&w inside photo. Pays on publication. Credit line given. Buys first North American serial rights. Simultaneous submissions OK.

Tips: "We're happy to review samples of your work. However, any photos you submit should "say" something—for instance, we have received whole pages of slides with attractive photos (in terms of using an attractive model) but the photos look contrived, with the subject matter an excuse to take a photo rather than vice versa."

TOWN & COUNTRY, 1700 Broadway, 30th Floor, New York NY 10019. (212)903-5000. Art Director: Melissa Tardiff. Town & Country is a general interest publication for the affluent market. Articles focus on people and cover travel, fashion, beauty, food, health and finance.

Tips: "I am most interested in a photographer's style, journalistic approach and ability to deal with people." Stock photos or submissions are not used.

TRACK AND FIELD NEWS, Box 296, Los Altos CA 94023. (415)948-8417. Feature/Photo Editor: Jon Hendershott. Monthly magazine. Circ. 35,000. Emphasizes national and world-class track and field competition and participants at those levels for athletes, coaches, administrators and fans. Buys 10-15 photos/issue. Credit line given. Captions required. Payment is made bimonthly. Query with samples or send material by mail for consideration. SASE. Reports in 1 week. Free photo guidelines.

Subject Needs: Wants on a regular basis photos of national-class athletes, men and women, preferably in action. "We are always looking for quality pictures of track and field action as well as offbeat and different feature photos. We always prefer to hear from a photographer before he/she covers a specific meet. We also welcome shots from road and cross-country races for both men and women. Any photos may eventually be used to illustrate news stories in T&FN, feature stories in T&FN or may be used in our other publications (books, technical journals, etc.). Any such editorial use will be paid for, regardless of whether or not material is used directly in T&FN. About all we don't want to see are pictures taken with someone's Instamatic or Polaroid. No shots of someone's child or grandparent running. Professional work only."

B&W: Uses 8x10 glossy prints; contact sheet preferred. Pays \$7/photo, inside.

Color: Pays \$45/photo.

Cover: Uses 35mm color transparencies. Pays \$125/photo, color.

Tips: "No photographer is going to get rich via *T&FN*. We can offer a credit line, nominal payment and, in some cases, credentials to major track and field meets to enable on-the-field shooting. But we can offer the chance for competent photographers to shoot major competitions and competitors up close as well as the most highly regarded publication in the track world as a forum to display a photographer's talents."

TRADITION MAGAZINE, 106 Navajo, Council Bluffs IA 51501. (712)366-1136. Editor: Bob Everhart. Monthly magazine. Circ. 2,000. Emphasizes country and folk music. Photos purchased with accompanying ms. Buys 5-6 photos/year. Credit line given. Pays on acceptance. Buys one-time rights. Mail query with samples relevant to country/folk music. SASE. Simultaneous submissions OK. Reports in 1 month. Sample copy, 26¢ postage. **Subject Needs:** Anything relevant to country and folk music only. Travel (relating only to festivals,

Subject Needs: Anything relevant to country and folk music only. Travel (relating only to festivals, etc., music); documentary (relative to old-time country music, folk music, etc.); celebrity/personality (anyone connected with traditional country music—definitely not interested in current Nashville trend).

Model release preferred; captions required.

B&W: Uses 5x7 glossy prints. Pays \$2 minimum/photo.

Cover: Uses b&w prints. Vertical format required. Pays \$5 minimum/photo.

Accompanying Mss: Articles relating to country and folk music. Pays \$2 minimum/ms. Writer's guidelines free with SASE.

Tips: "The magazine sponsors a photo contest with cash prizes for the best photos (b&w) from the annual old-time country music festival held at the Pottawattamie fairgrounds in Avoca, Iowa over Labor Day weekend. Photos must be submitted to *Tradition Magazine* prior to December 1 to be judged for the current year's contest."

TRAILER BOATS MAGAZINE, Poole Publications Inc., Box 2307, 16427 S. Avalon, Gardena CA 90248. (213)323-9040. Editor: Jim Youngs. Monthly magazine. Circ. 85,000. "Only magazine devoted exclusively to legally trailerable boats and related activities" for owners and prospective owners. Photos purchased with or without accompanying ms. Uses 15 photos/issue with ms. Pays per text/photo package or on a per-photo basis. Credit line given. Pays on publication. Buys all rights. Query or send photos or contact sheet by mail for consideration. SASE. Reports in 1 month. Sample copy \$1.25. Subject Needs: Celebrity/personality, documentary, photo essay/photo feature on legally trailerable boats or related activities (i.e. skiing, fishing, cruising, etc.), scenic (with ms), sport, spot news, howto, human interest, humorous (monthly "Over-the-Transom" funny or weird shots in the boating world), travel (with ms) and wildlife. Photos must relate to trailer boat activities. Captions required. Needs funny photos for Over the Transom column. No long list of stock photos or subject matter not related to editorial content.

B&W: Uses 5x7 glossy prints. Pays \$7.50-50/photo. **Color:** Uses transparencies. Pays \$15-100/photo.

Cover: Uses transparencies. Vertical format required. Pays \$150/photo.

Accompanying Mss: Articles related to trailer boat activities. Pays 7-10¢/word and \$7.50-50/photo.

Free writer's guidelines.

Tips: "Shoot with imagination and a variety of angles. Don't be afraid to 'set-up' a photo that looks natural. Think in terms of complete feature stories; photos and manuscripts. It is rare any more that we publish freelance photos only, without accompanying manuscript; with one exception, 'Over the Transom'—a comical, weird or unusual boating shot."

TRAILER LIFE, 29901 Agoura Rd., Agoura CA 91301. Editor: Bill Estes. Monthly magazine. Circ. 315,000. Emphasizes the why, how and how-to of owning, using and maintaining a recreational vehicle for personal vacation or full-time travel. The editors are particularly interested in photos for the cover; an RV must be included. Payment ranges up to \$300. Credit line given. Pays on acceptance. Buys first North American rights. Send material by mail for consideration or query with samples. SASE. Reports in 3 weeks. Send for editorial guidelines.

Subject Needs: Human interest, how-to, travel and personal experience.

B&W: Uses 8x10 glossy prints.

Color: Uses 35mm and 21/4x21/4 transparencies.

Accompanying Mss: Related to recreational vehicles and ancillary activities.

*TRAILS-A-WAY, 1219 Bracy Ave., Greenville MI 48838. (616)754-9179. Publisher: Dave Higbie. Monthly tabloid. Emphasizes camping and recreational vehicle travel. Readers are "middle-aged, midto upper-income with RVs and a strong desire to travel." Circ. 53,000.

Market conditions are constantly changing! If this is 1987 or later, buy the newest edition of *Photographer's Market* at your favorite bookstore or order directly from Writer's Digest Books.

Photo Needs: Uses about 12-15 photos/issue; "maybe half" supplied by freelance photographers.

Needs photos of "travel, camping, RVs, etc." Captions required.

Making Contact & Terms: Query with samples. Send 8x10, 5x7 glossy prints or 35mm, 2¹/₄x2¹/₄ transparencies by mail for consideration. SASE. Reports in 1 month. Pays \$25-35/color cover photo and \$10/b&w inside photo. Pays on publication. Credit line given if requested. Buys one-time rights. Simultaneous submissions and previously published work OK.

TRAVEL & LEISURE, 1120 Avenue of the Americas, New York NY 10036. (212)382-5600. Editor: Pamela Fiori. Art Director: Adrian Taylor. Picture Editor: William H. Black, Jr. Monthly magazine. Circ. 975,000. Emphasizes travel destinations, resorts, dining and entertainment. Credit line given. Pays on publication. Buys first North American serial rights, plus promotional use. Previously published work OK. Free photo guidelines. SASE.

Subject Needs: Nature, still life, scenic, sport and travel. Model release and captions required.

B&W: Uses 8x10 semigloss prints. Pays \$65 minimum/photo.

Color: Uses transparencies. Payment negotiated.

Cover: Uses 35mm, 21/4x21/4, 4x5 and 8x10 transparencies. Vertical format required. Pays \$1,000/pho-

to or payment negotiated.

Tips: Demonstrate prior experience or show published travel-oriented work. Have a sense of "place" in travel photos.

TRAVEL & STUDY ABROAD, 18 Hulst Rd., Box 344, Amherst MA 01002. Editor-in-Chief/Photo Editor: Clay Hubbs. Quarterly. Circ. 15,000. Emphasizes special interest travel. Readers are study abroad program participants and others who travel to learn (not tourists). Sample copy \$2.50 plus 95¢ postage. Free photo guidelines for SASE.

Photo Needs: Uses about 10-12 photos/issue; all supplied by freelance photographers. Needs photos of people in foreign places to accompany travel, study or work abroad stories. Photos seldom purchased without accompanying ms. Special needs: study, travel and work features on all countries outside U.S.

Captions required.

Making Contact & Terms: Query with samples. Does not return unsolicited material. Reports in 1 month. Provide business card and tearsheets to be kept on file for possible future assignments. Pays \$10-25/b&w inside or cover photo. Pays on publication. Credit line given. Buys one-time rights. Simultaneous submissions and/or previously published work OK.

Tips: Prefers to see travel photos of people. B&w only.

TRAVEL/HOLIDAY, Travel Bldg., Floral Park NY 11001. (516)352-9700. Executive Editor: Scott Shane. Photo Researcher: Paul Prince. Monthly magazine. Circ. 816,000. Emphasizes quality photography on travel destinations, both widely known and obscure. For people "with the time and money to actively travel. We want to see travel pieces, mostly destination-oriented." Wants no "posed shots or snapshots." Readers are experienced travelers who want to be shown the unusual parts of the world. Credit line given. Buys 30 photos/issue. Buys first North American serial rights. Send samples for consideration. Pays on acceptance. Reports in 6 weeks. SASE. Write for free photo guidelines.

Subject Needs: Quality photography of all areas of world—scenics, people, customs, arts, amuse-

ments, etc. "We prefer shots which have people in them whenever possible."

B&W: Send 8x10 glossy or semigloss prints. Captions required. Pays \$25.

Color: Send transparencies 35mm and larger. Captions required. Pays \$75/1/4 page, \$100/1/2 page, \$125/3/4 page, \$150/full page, \$200/2-page spread.

Cover: Send color transparencies. Captions required. Pays \$400.

Tips: "We are constantly in need of quality pics to supplement features. Biannual 'photo needs' letters are sent to photographers with whom we have worked. They, in turn, send us a selection of transparencies on the subjects indicated. Photographers who are interested in being placed on this list should send a sample selection of 60-80 transparencies (include SASE) and include a geographical listing of those areas of the world of which they have stock coverage."

*TROPICAL FISH HOBBYIST MAGAZINE, 211 West Sylvania Ave., Neptune City NJ 07753. (201)988-8400. Assitant Editor: John R. Quinn. Monthly magazine. Emphasizes the tropical fish and aquarium hobby. Readers include "a wide variety of hobbyists, from beginners to advanced. The magazine is widely distributed throughout the English-speaking world; and sold through petshops as well." Circ. 55,000. Sample copy available; query for reduced price.

Photo Needs: Uses about 25-35 photos/issue; "most are submitted by authors. On a continuing basis, we need good, clear 35mm slides of tropical and temperate fresh and saltwater fishes. Separations are made and originals returned to photographer." Special needs include "South American freshwater fish-

es, African Cichlids, Invertebrates.

Making Contact & Terms: Query with samples and list of stock photo subjects. SASE. Reports in 3

weeks. Pays \$10/b&w inside photo. Pays on acceptance. Credit line given. Buys all rights, but photographer may sell work again."

Tips: "We require sharp, clear slides of fishes and other aquatic animals that will reproduce well. The more colorful the better. Ours is a rather specialized (underwater) area of photography; study techniques."

TRUE WEST/FRONTIER TIMES, Box 2107, Stillwater OK 74076. (405)743-3370. Editor: John Joerschke. Monthly. Circ. 100,000. Emphasizes "history of the Old West (1830 to about 1910)." Readers are "people who like to read the history of the West." Sample copy free with SASE.

Photo Needs: Uses about 100 or more photos/issue; almost all are supplied by freelance photographers. Needs "mostly Old West historical subjects, some travel, some scenic, (ghost towns, old mining camps, historical sites). We prefer photos with manuscript." Special needs include western wear; cowboys, rodeos, western events.

Making Contact & Terms: Query with samples—b&w only for inside; color for covers. SASE. Reports in 1 month. Pays \$150/color cover photo; \$15-50/b&w inside photo; "minimum of 5¢/word for copy." Pays on acceptance. Credit line given. Buys all rights; covers are one-time rights.

Tips: Prefers to see "transparencies of existing artwork as well as scenics for cover photos. Inside photos need to tell story associated with the Old West. Most of our photos are used to illustrate stories and come with manuscripts; however, we will consider other work, scenics, historical sites, old houses. Even though we are Old West history, we do need current photos, both inside and for covers—so don't hesitate to contact us."

TURF AND SPORT DIGEST, 511-513 Oakland Ave., Baltimore MD 21212. (301)323-0300. Publisher/Editor: Allen L. Mitzel, Jr. Bimonthly magazine. Circ. 35-50,000. Emphasizes Thoroughbred racing coverage, personalities, events and handicapping methods for fans of Thoroughbred horse-racing. Photos purchased with or without accompanying mss. Credit line given. Pays on publication. Buys one-time rights. Send photos by mail for consideration. SASE. Reports in 1 month. Free sample copy. Subject Needs: People, places and events, past and present, in Thoroughbred racing. Emphasis on unusual views and action photos. No mug shots of people. Captions required.

B&W: Uses 8x10 glossy prints or contact sheet. Pays \$15/print.

Cover: Uses 35mm minimum color transparencies. Vertical format required. Pays \$100/color transparency.

*TURN-ONS, TURN-ON LETTERS, OPTIONS, Box 470, Port Chester NY 10573. Production Manager: Warren Tabatch. Monthly magazine. Emphasizes "sexually oriented materials. We emphasize good, clean sexual fun among liberal-minded adults." Readers are mostly male; ages 20-50. Circ. 120,000. Sample copy free with 9x10 SAE and \$1 postage.

Photo Needs: Uses approximately 20-30 photos/issue. Needs a "variety of b&w photos depicting sexual situations in a not-too-graphic manner; also need color transparencies for cover; present in a way suit-

able for newsstand display." Model release required.

Making Contact & Terms: Query with samples and list of stock photo subjects. Send 8x10 glossy b&w prints or 35mm, 21/4x21/4, 4x5 transparencies by mail for consideration. SASE. Reports in 2 weeks. Pays \$250/color cover photo and \$10/b&w inside photo. Pays on publication. Buys one-time rights on covers, second rights OK for b&ws.

Tips: "Please examine copies of our publications before submitting work."

TV GUIDE, Radnor PA 19088. (215)293-8500. Editor, National Section: David Sendler. Art Director: Jerry Alten. Picture Editors: Cynthia Young (Los Angeles), Ileane Rudolph (New York). Emphasizes news, personalities and programs of TV for a general audience. Weekly. Circ. 17,000,000.

Photo Needs: Uses 20-25 photos/issue; many supplied by freelance photographers. Selection "through photo editors in our New York and Los Angeles bureaus. Most work on assignment. Interested in hearing from more photographers."

Making Contact & Terms: Call or write photo editors to arrange personal interview to show portfolio. Buys one-time rights. Credit line given. No simultaneous submissions or previously published work.

*TWINS MAGAZINE, Box 12045, Overland Park KS 66212. (913)722-1090. Editor: Barbara Unell. Bimonthly. Emphasizes parenting twins, triplets, quadruplets, or more. Readers include the parents of multiples. Circ. 25,000. Estab. 1984. Sample copy \$3.50 plus \$1.50 postage and handling. Free photo guidelines with SASE.

Photo Needs: Uses about 10 photos/issue; all supplied by freelance photographers. Needs family related—children, adults, family life. Usually needs to have twins, triplets or more included as well. Reviews photos with or without accompanying ms. Model release and captions required.

Making Contact & Terms: Query with resume of credits and samples; provide resume, business card,

brochure, flyer or tearsheets to be kept on file for possible future assignments. SASE. Reports in 4-6 weeks. Pays \$100 minimum/job. Pays on publication. Credit line given. Buys all rights. Simultaneous submissions OK.

ULTRASPORT, 11 Beacon St., Boston MA 02108. (617)227-1988. Editor: Chris Bergonzi. Bimonthly magazine. Circ. 150,000. Estab. 1984. Emphasizes endurance sports for participatory athletes. Sample copy free with SASE and \$1.22 postage; photo guidelines free with SASE.

Photo Needs: Uses about 50 photos/issue; all supplied by freelance photographers. Needs photos of

"people in sports." Captions optional.

Making Contact & Terms: Query with resume of credits or samples; send 35mm transparencies by mail for consideration. SASE. Reports in 2 weeks. Pays \$500/color cover photo; \$250/color page; \$200-400/job or day rates. Pays on acceptance. Buys variable rights. Previously published submissions OK.

UNCENSORED LETTERS, Box 470, Port Chester NY 10573. Production Manager: Warren Tabatch. Bimonthly magazine. Emphasizes "a variety of sexually oriented topics." Readers are predominantly male, ages 20-60. Circ. 150,000. Sample copy for SASE and \$1 postage; photo guidelines for SASE.

Photo Needs: Uses about 10-20 + photos/issue. Needs "cover photos (full color suitable for newsstand display); b&w 8x10 prints of couples, single women to illustrate editorial. Model release required. **Making Contact & Terms:** Query with samples or list of stock photo subjects; send 8x10 glossy b&w prints or 35mm, 2\(^14x2\)\(^14x2\)\(^14x0\) and 4x5 transparencies by mail for consideration. SASE. Reports in 1 week. Pays \$200-300/color cover photo; \$10-20/b&w inside photo. Pays on publication. Credit line "not usually" given. Buys all rights. Previously published submissions OK.

Tips: "See sample copies to determine our exact needs."

UNITY, Unity Village MO 64065. Editor: Pamela Yearsley. Associate Editor: Shirley Brants. Monthly magazine. Circ. 430,000. Emphasizes spiritual, self-help, poetry and inspirational articles. Photos purchased with or without accompanying ms or on assignment. Uses 2-4 photos/issue. Buys 50 photos/year, 90% from freelancers. Credit line given. Pays on acceptance. Buys first North American serial rights. Send insured material by mail for consideration; no calls in person or by phone. SASE. Reports in 2-4 weeks. Free sample copy and photo guidelines.

Subject Needs: Wants on a regular basis 12 nature scenics for covers and 10-20 b&w scenics. Also human interest, nature, still life and wildlife. No photos with primary emphasis on people; animal photos

used sparingly. Model release required; captions preferred.

B&W: Uses 5x7 or 8x10 semigloss prints. Pays \$15-25/photo.

Cover: Uses 4x5 color transparencies. Vertical format required, occasional horizontal wraparound used. Pays \$100-150/photo.

Accompanying Mss: Pays \$25-200/ms. Rarely buys mss with photos. Free writer's guidelines. **Tips:** "Don't overwhelm us with hundreds of submissions at a time. We look for nature scenics, human interest, some still life and wildlife, some photos of people (although the primary interest of the photo is not on the person or persons). We are looking for photos with a lot of color and contrast."

VEGETARIAN TIMES, Box 570, Oak Park IL 60303. Editor: Paul Obis. Published 12 times annually. Circ. 180,000. Photos purchased mainly with accompanying ms. Buys 180 photos/year. Credit line given. Pays on publication. Rights vary. Send material by mail for consideration. SASE. Simultaneous submissions OK. Reports in 6 weeks. Sample copy \$2.

Subject Needs: Celebrity/personality (if vegetarians), sport, spot news, how-to (cooking and building),

humorous, food to accompany articles. Model release and captions preferred.

B&W: Uses 8x10 glossy prints. Pays \$15 minimum/photo.

Cover: Pays \$150 and up (color slide).

VENTURE, Box 150, Wheaton IL 60189. (312)665-0630. Managing Editor: David R. Leigh. Art Director: Lawrence Libby. Magazine published 7 times annually. Circ. 14,000. Sample copy \$1.50. "We seek to provide entertaining, challenging, Christian reading for boys 12-18." Needs photos of boys in various situations: alone; with other boys; with their families or girlfriends; in school; with animals; involved in sports, hobbies or camping, etc. Buys 1-2 photos/issue. Buys first serial rights. Arrange a personal interview to show portfolio or send photos for consideration. Pays on publication. Reports in 6 weeks. SASE. Simultaneous submissions and previously published work OK. Photo guidelines available (SASE).

B&W: Send 8x10 glossy prints. Pays \$25. **Cover:** Send glossy b&w prints. Pays \$50-75.

Tips: Needs photos for college issues.

"This photo continues to be one of my biggest sellers." savs Peter Morris, a freelance photographer from Lenoir. North Carolina. "I use both Photographer's Market and Writer's Market, and by reading both I get a better idea of what editors are looking for. I simply study the market description and the magazine if possible, and then submit photos I feel are suitable. This photo sold to Unity Magazine, Christian Living Magazine. PTA Magazine, Lutheran Standard and Studio Photography, and is being held by several other publications."

VERMONT LIFE, 61 Elm St., Montpelier VT 05602. (802)828-3241. Contact: Editor. Quarterly magazine. Circ. 130,000. Emphasizes life in Vermont: its people, traditions, way of life, farming, industry, and the physical beauty of the landscape for "Vermonters, ex-Vermonters and would-be Vermonters." Buys 30 photos/issue. Buys first serial rights. Query first. Credit line given. Pays day rate of \$150. Pays on publication. Reports in 3 weeks. SASE. Simultaneous submissions OK. Sample copy \$2.50; free photo guidelines.

Subject Needs: Wants on a regular basis scenic views of Vermont, seasonal (winter, spring, summer, autumn), submitted 6 months prior to the actual season; animal; documentary; human interest; humorous; nature; photo essay/photo feature; still life; travel and wildlife. No photos in poor taste, nature

close-ups, cliches, photos of blood sports or photos of places other than Vermont. Color: Send 35mm or 21/4x21/4 transparencies. Captions required. Pays \$75.

Cover: Send 35mm or 21/4x21/4 color transparencies. Captions required. Pays \$200.

VICTIMOLOGY: AN INTERNATIONAL JOURNAL, 2333 N. Vernon St. Arlington VA 22207. (703)528-8872. Editor: Emilio C. Viano. Quarterly journal. Circ. 2,500. "We are the only magazine specifically focusing on the victim, on the dynamics of victimization." For social scientists; criminologists; criminal justice professionals and practitioners; social workers; volunteer and professional groups engaged in crime prevention and in offering assistance to victims of rape, spouse abuse, child abuse. etc.; victims of accidents, neglect, natural disasters, and occupational and environmental hazards. Needs photos related to those themes. Buys 20-30 photos/annually. Buys all rights, but may reassign to photographer after publication. Submit model release with photo. Query with resume of credits or submit material by mail for consideration. Pays on publication. Reports in 6 weeks. SASE. Simultaneous submissions and previously published work OK. Sample copy \$5; free editorial guidelines.

B&W: Send contact sheet or 8x10 glossy prints. Captions required. Pays \$25-50 depending on subject

matter.

Color: Send 35mm transparencies, contact sheet, or 5x7 or 8x10 glossy prints. "We will look at color photos only if part of an essay with text." Captions required. Pays \$30 minimum. "Collages OK." Cover: Send contact sheet or glossy prints for b&w; contact sheet, glossy prints, or 35mm transparen-

cies for color. Captions required. Pays \$100-150 minimum.

Tips: "Contact us so that we can tell what themes we are going to be covering. Send us pictures around a theme, with captions and, if possible, a commentary—some text, even if not extensive. We will look at any pictures that we might use to break the monotony of straight text, but we would prefer essays with some text. A very good idea would be for a photographer to look for a writer and to send in pictures accompanying text as a package. For instance, an interview with the staff of a Rape Crisis Center or Abused Spouses Center or Crisis Intervention Hotline or victims of a natural or industrial disaster accompanied by photos would be very well received. Other topics: accident prevention, earthquake monitoring, emergency room services, forensic pathologists, etc. A good example of what we are looking for is the work of the Smiths on the victims of mercury poisoning in Japan. We will pay well for good photo essays."

VINTAGE MAGAZINE, Box 2224, New York NY 10163. (212)570-6111. Editor-in-Chief: Philip Seldon. Photo Editor: Philip Seldon. Monthly. Emphasizes "gourmet food and wine for consumers." Readers are "up-scale, heavy wine buyers." Sample copy \$3.

Photo Needs: Uses about 10-15 photos/issue; "few" supplied by freelance photographers. Model re-

lease preferred; captions required.

Making Contact & Terms: Query with list of stock photo subjects. Does not return unsolicited material. Reports in 1 month. Prefers oral inquiries. Pays \$10-100/b&w inside photo; \$25-250/color photo; \$100-500/day. Pays on publication. Credit line given. Buys one-time rights. Previously published work

*VIRTUE MAGAZINE, 548 Sisters Parkway, Box 850, Sisters OR 97759. (503)549-8261. Art Director: Robin Black. Magazine published 10 times/year. Emphasizes Christian growth, family, food, and fashion. Readers are women-mostly married, ages 25-35, Christian, family-oriented. Circ. 90,000. Sample copy \$2.

Photo Needs: Uses about 25-30 photos/issue; 2-3 supplied by freelance photographers. Needs photos of people relating to each other and to their environment, scenics, wildlife, travel; mood shots which

would be difficult for us to set up." Model release preferred.

Making Contact: Query with samples or "send xerox or printed copies to be kept on file." Reports in 1 month. Pays \$100-200/color cover photo, \$25-75/b&w inside photo, and \$50-125/color inside photo. Transparencies only for color photos. Pays on publication. Credit line given. Buys one-time rights. Simultaneous submissions OK.

Tips: Prefers to see "sharp, excellent quality photos with a unique outlook, point-of-view or mood. Send only your best samples. Mediocre work won't get you assignments."

VISTA, Box 2000, Marion IN 46952. (317)674-3301. Contact: Photo Editor. Weekly. Circ. 60,000. Religious magazine for adults. Sample copy and photo guidelines free with SASE.

Photo Needs: Uses about 4-5 photos/issue; 2-3 supplied by freelance photographers. Needs "scenic. adults (singles, couples, families, church groups) photos." Special needs include "family photos, ac-

tion shots, middle-aged adults (35-50 years old) in everyday activities (mood shots)."

Making Contact & Terms: Send 8x10 b&w glossy prints or 35mm transparencies by mail for consideration. SASE. Reports in 2 weeks. Pays \$25/b&w cover photo, \$100/color cover photo (slide); \$15/b&w inside photo; "different rates for reuse." Pays on acceptance. Credit line given. Buys one-time rights. Simultaneous submissions OK.

Tips: "Be sure to read guidelines. We need women in dresses and very little jewelry (if possible)."

WALKING TOURS OF SAN JUAN, First Federal Bldg., Suite 301, 1519 Ponce de Leon Ave., Santurce, Puerto Rico 00909. (809)722-1767. Editor/Publisher: Al Dinhofer. Published 2 times/year: January and July. Circ. 22,000. Emphasizes "historical aspects of San Juan and tourist-related information." Readers are "visitors to Puerto Rico interested in cultural aspects of historical Old San Juan." Sample copy \$2.50 plus postage.

Photo Needs: Uses about 50 photos/issue; 25 supplied by freelance photographers. Needs "unusual or

interesting shots of San Juan; inquire first." Model release and captions required.

Making Contact & Terms: "Tell us in a brief letter what you have." Does not return unsolicited material without SASE. Reports in 1 month. Pays \$100/b&w cover photo; \$125/color cover photo; \$15-30/ b&w inside photo. Pays on acceptance. Credit line given. Buys first North American serial rights. Simultaneous submissions OK.

WASHINGTON, THE Evergreen State Magazine, 1500 Eastlake Ave. E. Seattle WA 98102. (206)328-5000. Picture Editor: Carrie Seglin. Bimonthly magazine. "We're a regional publication covering the entire state of Washington." Readers are "anybody and everybody living in the state, who wants to live in the state, or who is going to visit the state." Circ. 65,000 (projected). Estab. 1984. Sample copy \$3.10; photo guidelines for SASE.

Photo Needs: Uses approximately 50 photos/issue; 35 supplied by freelance photographers. Needs "any and all subjects, provided all subjects are in Washington state. No ringers, please." Model release and captions required. "Captions need not be elaborate; they must, however, identify the subject matter

and provide names of persons.'

Making Contact & Terms: Submit portfolio for review; provide resume, business card, brochure, flyer or tearsheets to be kept on file for possible future assignments. "Preference is to set up an appointment and come in." SASE. Reports in 2 months. Pays \$325/color cover photo, \$250/b&w cover photo; \$125-275/color inside photo, \$50-200/b&w inside photo; \$200/color page, \$125/b&w page. Pays on publication. Credit line given "either individually for single shots or by-lined for multiple." Buys one-time rights or inclusive of use for magazine promotion. Simultaneous and previously published submissions OK, "depending on the subject and where published."

WASHINGTON FISHING HOLES, 114 Avenue C, Snohomish WA 98290. (206)568-4121. Editor: Terry Sheely. Monthly magazine. Circ. 10,500. Emphasizes Washington angling for people interested in the where-to and how-to of Washington fishing. Uses 8-15 photos/issue. Buys first and second North American serial rights. Model release required. Query first. Works with freelance photographers on assignment basis only. Most photos purchased with accompanying ms. Credit line given. Pays on publication. Reports in 4 weeks. SASE. Free sample copy and editorial guidelines.

Subject Needs: "Northwest area, fish species, etc." Actual fishing, fresh catch, rigging tackle, lures

used, etc. Prefers action shots. Wants on a regular basis action/catch shots with map/story articles. "No

'meat shots' or scenics without anglers."

B&W: Send 5x7 glossy prints. Captions required. Pays \$50 for text/photo package. \$10 extra/photo, artwork used.

Color: Send 35mm transparencies. Captions required. Pays \$50 for text/photo package. \$10 extra/photo, artwork used.

Cover: Pays \$50, negotiable. ASA 64 or slower transparencies.

Tips: "Follow our style. Query first." Submit seasonal material 6 months in advance.

WASHINGTON POST MAGAZINE, 1150 15th St., NW, Washington DC 20071. (202)334-7585. Editor: Stephen Petranek. Weekly. Circ. 1,000,000. Emphasizes current events, prominent persons, cultural trends and the arts. Readers are all ages and all interests.

Photo Needs: Uses 30 photos/issue; some are supplied by freelance photographers. Needs photos to accompany articles of regional and national interest on anything from politics to outdoors. Photo essays of controversial and regional interest. Model release required. "We have very few freelance needs."

Making Contact & Terms: Send samples; then call for appointment. Uses 8x10 or larger b&w prints; 35mm, 21/4x21/4, 4x5 or 8x10 slides. Color preferred. SASE. Reports in 2 weeks. Credit line given. Payment on publication.

WATERFOWLER'S WORLD, Box 38306, Germantown TN 38183. (901)754-7484. Editor: Cindy Dixon. Emphasizes duck and goose hunting for the serious duck and goose hunter. Geared towards the experienced waterfowler with emphasis on improvement of skills. Bimonthly, Circ. 35,000, Sample

Photo Needs: Buys 6 freelance photos/issue. Photos must relate to ducks and geese, action shots, dogs and decoys. Will purchase outstanding photos alone but usually buys photos with accompanying ms.

Model release and caption required.

Making Contact & Terms: Send by mail for consideration actual 8x10 b&w glossies and 35mm color transparencies for inside; 35 mm color transparencies for cover. SASE. Reports in 8 weeks. Pays on publication \$25 minimum/color for cover; \$10 b&w. Credit line given. Buys first serial rights.

*WATERSHED, Bag 5000, Fairview, Alberta Canada T0H 1L0. (403)835-2691. Editor: Mark A. Craft. Bimonthly magazine. Emphasizes "living and working in Western Canada, with an underlying concern with alternatives and ecology. Readers are western Canadian, rural and urban. Circ. 15,000-25,000. Sample copy \$2.50. Photo guidelines free with SAE and IRCs.

Photo Needs: Uses 25-30 photos/issue; 75-90% supplied by freelance photographers. Needs photos of 'agriculture, gardening, wildlife, how-to, computers, livestock, food and cookery." Special needs in-

clude "agriculture-all types; western wildlife." Model release and captions preferred.

Making Contact & Terms: Query with resume of credits and list of stock photo subjects, Provide resume, business card, brochure, flyer or tearsheets to be kept on file for possible future assignments. SAE and IRCs. Reports as soon as possible. Pays \$15-30/b&w inside photo and \$20-75/color inside photo. Pays on publication. Credit line given. Buys one-time rights. Previously published work OK.

WATERWAY GUIDE, 850 3rd Ave., New York NY 10022. Editor: Queene Hooper. Annually. Circ. approximately 15,000/edition. "The Waterway Guide publishes 3 East Coast (Southern, Mid-Atlantic, and Northern) editions and Great Lakes edition. It is a boaters cruising guide to each area. Each edition includes advice on navigation, places to anchor, cruising tips, marina and restaurant listings, shore attractions. Each edition is revised each year." Readers are "affluent, mostly middle-age, college educated, own average of 28' boat. (Compiled from a market research report)." Sample copy \$14.95/edition. Photo Needs: Uses one full color cover shot per edition; supplied by freelance photographer. "Each edition's cover shot must depict that particular region's typical pleasure boating experience. We try to express the regionality of each edition within the photo, showing perhaps a typical Waterway Guide reader at anchor or cruising, or a scene that one might experience while cruising that area. Colorful shots preferred. Note: We get too many moody, seascape, sunset/sunrise shots. Don't send yours unless it is truly exceptional." Model release required.

Making Contact & Terms: Provide resume, business card, brochure, flyer or tearsheets to be kept on file for possible future assignments. "Calls will be accepted for further description of photo needs. Since we need photos from all over the East Coast we realize a personal interview is usually impossible." Does not return unsolicited material. Pays approximately \$250/color cover photo. Pays on publication. Credit line given on contents page. Buys rights for one-year use from date of publication. Tips: "Considering the nature of our publication, don't send racing shots, windsurfer or daysailor shots, or aground boat shots. Those people don't use Waterway Guide. Send shots that encourage people to

cruise the area.'

WEIGHT WATCHERS, 360 Lexington Ave., New York NY 10017. (212)370-0644. Editor: Linda Konnor. Art Director: Joy Toltzis Makon. Monthly magazine. Circ. 825,000. For those interested in weight control, proper nutrition, inspiration and self-improvement. Photos purchased on assignment only. Buys approximately 12 photos/issue. Pays \$300/single page; \$500/spread; and \$700/cover. Credit line given. Pays on acceptance. Buys first rights. Portfolio—drop-off policy only.

Subject Needs: All on assignment: food and tabletop, still life, beauty, health and fitness subjects, occa-

sionally fashion, personality portraiture. All photos contingent upon editorial needs.

WEST COAST REVIEW, c/o English Dept., Simon Fraser University, Burnaby, British Columbia, Canada V5A 1S6. (604)291-4287. Editor: Frederick Candelaria. Quarterly. Circ. 500. Emphasizes art photography. "General audience. Institutional subscriptions predominate." Sample copy \$4. **Photo Needs:** Uses about 6 photos/issue; all supplied by freelance photographers. "All good works will

be considered." Model release required.

Making Contact & Terms: Query with samples; send any size b&w glossy prints by mail for consideration. SASE. Reports as soon as possible. Pays \$25-200/photo package. Pays on acceptance. Credit line given in table of contents. Buys one-time rights.

Tips: "Have patience. And subscribe to the Review."

WESTERN HORSEMAN, 3850 N. Nevada Ave., Colorado Springs CO 80933. Editor: Randy Witte. Monthly magazine. Circ. 155,220. For active participants in horse activities, including pleasure riders, ranchers, breeders and riding club members. Buys first rights. Submit material by mail for consideration. "We buy mss and photos as a package. Payment for 1,500 words with b&w photos ranges from \$150-175. Articles and photos must have a strong horse angle, slanted towards the western rider—rodeos, shows, ranching, stable plans, training."

WESTERN OUTDOORS, 3197-E Airport Loop, Costa Mesa CA 92626. Editor-in-Chief: Burt Twilegar. Monthly magazine. Circ. 151,001. Emphasizes hunting, fishing, camping and boating for 11 western states, Alaska and Canada. Needs cover photos of hunting and fishing, camping and boating in the Western states. Buys one-time rights. Query or send photos for consideration. Most photos purchased with accompanying ms. Pays on acceptance for covers. Reports in 6 weeks. SASE. Sample copy \$1.75. Free editorial guidelines; enclose SASE.

B&W: Send 8x10 glossy prints. Captions required. Pays \$100-300 for text/photo package.

Color: Send 35mm Kodachrome II transparencies. Captions required. Pays \$200-300 for text/photo

package.

Tips: "Submissions should be of interest to western fishermen or hunters, and should include a 1,120-1,500 word ms; a Trip Facts Box (where to stay, costs, special information); photos; captions; and a map of the area. Emphasis is on where-to-go. Submit seasonal material 6 months in advance. Make your photos tell the story and don't depend on captions to explain what is pictured. Avoid 'photographic cliches' such as 'dead fish with man,' dead pheasants draped over a shotgun, etc. Get action shots, live fish and game."

WESTERN SPORTSMAN, Box 737, Regina, Saskatchewan, Canada S4P 3A8. (306)352-8384. Editor: Red Wilkinson. Bimonthly magazine. Circ. 28,000. Emphasizes fishing, hunting and outdoors ac-

tivities in Alberta and Saskatchewan. Photos purchased with or without accompanying ms. Buys 50 freelance photos/year. Pays on acceptance. Buys second serial rights or simultaneous rights. Send material by mail for consideration or query with a list of stock photo subjects. SASE. Simultaneous submissions and previously published work OK as long as photographs have not been sold to publications in our coverage area of Alberta and Saskatchewan. Reports in 3 weeks. Sample copy \$3; free photo guidelines with SASE.

Subject Needs: Sport (fishing, hunting, camping); nature; travel; and wildlife. Captions required.

B&W: Uses 8x10 glossy prints. Pays \$20-25/photo.

Color: Uses 35mm and 21/4x21/4 transparencies. Pays \$75-100 photo for inside pages.

Cover: Uses 35mm and 21/4x21/4 transparencies. Vertical format preferred. Pays \$175-200 photo. Accompanying Mss: Fishing, hunting and camping. Pays \$75-325/ms. Free writer's guidelines with SASE.

WESTWAYS, Box 2890, Terminal Annex, Los Angeles CA 90051. Emphasizes Western US and World travel, leisure time activities, people, history, culture and western events.

Making Contact & Terms: Query first with sample of photography enclosed. Pays \$25/b&w photo; \$50/color transparency; \$350/day on assignment; \$300-350 plus \$50 per photo published for text/photo package.

Tips: "We like to get photos with every submitted manuscript. We take some photo essays (with brief text), but it must be unusual and of interest to our readers."

WHERE MAGAZINE, 600 Third Ave., 2nd Floor, New York NY 10016. (212)687-4646. Editor: Michael Kelly Tucker. Monthly magazine emphasizing points of interest, shopping, restaurant, theatre, museums, etc., in New York City (specifically Manhattan). Readers are visitors to New York staying in the city's leading hotels. Circ. 108,000/month. Sample copies are available in hotels.

Photo Needs: Uses 20 photos/issue; 5 supplied by freelance photographers. Needs covers showing New

York scenes. No manuscripts. Model release and captions preferred.

Making Contact & Terms: Arrange a personal interview to show portfolio. Does not return unsolicited material. Payment varies. Pays on publication. Credit line given. Rights purchased vary. Simultaneous submissions and previously published work OK.

*WHOLISTIC LIVING NEWS, (formerly *Holistic Living News*), 3335 Adams Ave., San Diego CA 92116. (619)280-0317. Contact: Managing Editor. Bimonthly newspaper. Emphasizes "the health and fitness area plus environmental and human rights issues." Readers are "health-conscious, environmentally-aware people." Circ. 65,000. Sample copy \$1.50. Photo guidelines free with SASE.

Photo Needs: Uses about 20 photos/issue; most are assigned. Subject needs "depend on the focus of each particular issue. Please query about topic." Model release and captions required.

Making Contact & Terms: Query with resume of credits. SASE. Reports in 1 month. Pays \$50/color cover photo. Pays on acceptance. Credit line given. Simultaneous submissions OK.

WINDSOR THIS MONTH, Box 1029, Station "A", Windsor, Ontario, Canada N9A 6P4. (519)966-7411. Monthly. Circ. 22,000. "Windsor This Month is mailed out in a system of controlled distribution to 19,000 households in the area. The average reader is a university graduate, middle income and active in leisure area."

Photo Needs: Uses 12 photos/issue; all are supplied by freelance photographers. Selects photographers by personal appointment with portfolio. Uses photos to specifically suit editorial content; specific seasonal material such as skiing and other lifestyle subjects. Provide resume and business card to be kept on

file for possible future assignments. Model release and captions required.

Making Contact & Terms: Send material by mail for consideration and arrange personal interview to show portfolio. Uses 8x10 prints and 35mm slides. SASE. Reports in 2 weeks. Pays \$50/b&w cover; \$50/color cover; \$5-10/b&w inside; \$5-10/color inside. Credit line given. Payment on publication. Simultaneous and previously published work OK provided work hasn't appeared in general area.

Thys: "WTM is a city lifestyle magazine; therefore most photos used pertain to the city and subjects about life in Windsor."

WINE TIDINGS, 5165 Sherbrooke St. W., Montreal, Quebec, Canada H4A 1T6. (514)481-5892. Managing Editor: Mrs. J. Rochester. Published 8 times/year. Circ. 27,000. Emphasizes "wine for Canadian wine lovers, 85% male, ages 25 to 65, high education and income levels." Sample copy free with SAE and International Reply Coupons.

Photo Needs: Uses about 15-20 photos/issue; most supplied by freelance photographers. Needs "wine scenes, grapes, vintners, pickers, vineyards, bottles, decanters, wine and food; from all wine producing countries of the world. Many fillers also required." Photos usually purchased with accompanying ms. Captions preferred.

Making Contact & Terms: Send any size b&w and color prints; 35mm or 21/4x21/4 transparencies (for cover) by mail for consideration. SAE and International Reply Coupons. Reports in 5-6 weeks. Pays \$150/color cover photo; \$10-25/b&w inside photo; \$25-100/color used inside. Pays on publication. Credit line given. Buys "all rights for one year from date of publication." Previously published work accepted occasionally.

Tips: "Send sample b&w prints with interesting, informed captions."

WINE WEST, (formerly Redwood Rancher), Box 498, Geyserville CA 95441. (707)433-5349. Editor/Publisher: Mildred Howie. Bimonthly. Emphasizes wine-growing, making, consumption. Readers are wine growers, winemakers (i.e., wineries), wine enthusiasts in the western U.S., Canada, Mexi-

co, Australia, New Zealand, the Orient. Circ. 2,000. Sample copy \$1.50.

Photo Needs: Uses about 15-16 photos/issue; all supplied by freelance photographers. Needs unusual color vineyard or winery shots for cover; 12 b&w historic photos, all from one winery, all shot in one year (about 8 of the 12 will be selected for section called "Vintage"). Photos purchased with or without accompanying ms; ("without ms, only submissions for cover or for 'Vintage' section noted above"). Model release and captions required.

Making Contact & Terms: Query with samples. SASE. Reports in 3 weeks. Pays \$50/color cover photo; \$10/inside b&w photo. Pays on publication. Credit line given. Buys first North American serial

rights. Previously published work OK.

Tips: "Read the publication—several issues—before making an inquiry or submission."

WISCONSIN SPORTSMAN, Box 2266, Oshkosh WI 54903. (414)233-7470. Editor: Tom Petrie. Bimonthly magazine. Circ. 76,000. Emphasizes fishing, hunting and the outdoors of Wisconsin. Photos purchased with or without accompanying ms. Buys 100 photos/year. Pays \$100-800 for text/photo package, and on a per-photo basis; some cases prices are negotiable. Credit line given. Pays on acceptance. Buys first rights. Send material by mail for consideration or query with list of stock photo subjects. SASE. Previously published work OK. Reports in 3 weeks.

Subject Needs: Animal (upper Midwest wildlife); photo essay/photo feature (mood, seasons, upper Midwest regions); scenic (upper Midwest with text); sport (fishing, hunting and vigorous nonteam oriented outdoor activities); how-to; nature; still life (hunting/fishing oriented); and travel. "Good fishing/

hunting action scenes." Captions preferred.

B&W: Uses 8x10 glossy prints. Pays \$25-250/photo.

Color: Uses transparencies. Pays \$50-400/inside photo. Full color photo essays/rates negotiable.

Cover: Uses color transparencies. Vertical format preferred. Pays \$250-300/photo.

Accompanying Mss: How-to oriented toward fishing, hunting and outdoor activities in the upper Midwest; where-to for these activities in Wisconsin; and wildlife biographies. Wisconsin Sportsman frequently buys in combination with its sister publications, Minnesota Sportsman, Michigan Sportsman and Pennsylvania Outdoors.

WISCONSIN TRAILS, Box 5650, Madison WI 53705. (608)231-2444. Photo Editor: Nancy Mead. Bimonthly magazine. Circ. 30,000. For people interested in history, travel, recreation, personalities, the arts, nature and Wisconsin in general. Needs seasonal scenics and photos relating to Wisconsin. Annual Calendar: uses horizontal format; scenic photographs. Pays \$150. Wants no color or b&w snapshots, color negatives, cheesecake, shots of posed people, b&w negatives ("proofs or prints, please") or "photos of things clearly not found in Wisconsin." Buys 200 annually. Buys first serial rights or second serial (reprint) rights. Query with resume of credits, arrange a personal interview to show portfolio, submit portfolio or submit contact sheet or photos for consideration. Provide calling card and flyer to be kept on file for possible future assignments. Pays on publication. Reports in 3 weeks. SASE. Simultaneous submissions OK "only if we are informed in advance." Previously published work OK. Photo guidelines with SASE.

B&W: Send contact sheet or 5x7 or 8x10 glossy prints. "We greatly appreciate caption info." Pays \$15-

20. Most done on assignment.

Color: Send transparencies; "we can use anything, but prefer the larger ones—21/4x21/4 or 4x5." Cap-

tions preferred. Pays \$50-100.

Cover: Send 35mm, 21/4x21/4 or 4x5 color transparencies. Photos "should be strong seasonal scenics or people in action." Uses vertical format; top of photo should lend itself to insertion of logo. Captions preferred. Pays \$100.

Tips: "Because we cover only Wisconsin and because most b&w photos illustrate articles (and are done by freelancers on assignment), it's difficult to break into Wisconsin Trails unless you live or travel in Wisconsin." Also, "be sure you specify how you want materials returned. Include postage for any special handling (insurance, certified, registered, etc.) you request."

WITH, Box 347, Newton KS 67114. (316)283-5100. Editor: Susan E. Janzen. Monthly magazine. Circ. 7,000. Emphasizes "Christian values in lifestyle, vocational decision making, conflict resolution

for US and Canadian high school students." Photos purchased with or without accompanying ms and on assignment. Buys 120 photos/year; 10 photos/issue. Pays \$15/photo and 4¢/word for text/photo packages, or on a per-photo basis. Credit line given. Pays on acceptance. Buys one-time rights. Send material by mail for consideration or submit portfolio and resume for review. SASE. Simultaneous submissions and previously published work OK. Reports in 2 weeks. Sample copy \$1.25; photo guidelines free with SASE.

Subject Needs: Documentary (related to concerns of high school youth "interacting with each other, with family and in school environment"); fine art; head shot; photo essay/photo feature; scenic; special effects & experimental; how-to; human interest; humorous; still life; and travel. Particularly interested in mood/candid shots of youths. Prefers candids over posed model photos. Less literal photos, more symbolism. No religious shots, e.g. crosses, bibles, steeples, etc.

B&W: Uses 8x10 glossy prints. Pays \$15-25/photo. **Cover:** Uses b&w glossy prints. Pays \$15-35/photo.

Accompanying Mss: Issues involving youth—school, peers, family, hobbies, sports, community involvement, sex, dating, drugs, self-identity, values, religion, etc. Pays 4¢/printed word. Writer's guidelines free with SASE.

Tips: "Freelancers are our lifeblood. We're interested in photo essays, but good ones are scarce. Candid shots of youth doing ordinary daily activities and mood shots are what we generally use. Photos dealing with social problems are also often needed. We rely greatly on freelancers, so we're interested in seeing work from a number of photographers. With is one of 2 periodicals published at this office, and we also publish Sunday school curriculum for all ages here, so there are many opportunities for photographers."

*WITTMAN PUB INC., COMPANY—MARYLAND FARMER, VIRGINIA FARMER & GEORGIA FARMER NEWSPAPER, ALABAMA FARMER, Box 3689, Baltimore MD 21214. (301)254-0273. Photo Editor: W.D. Wittman. Monthly tabloid. Emphasizes agriculture. Readers are agri-related. Circ. 60,000. Free sample copy with SASE.

Photo Needs: Uses 50-60 photos/issue; 50% supplied by freelance photographers. Reviews photos with

accompanying ms only. Model release and captions required.

Making Contact & Terms: Provide resume, business card, brochure, flyer or tearsheets to be kept on file for possible future assignments. Pays on publication. Credit line given. Buys one-time rights.

WOMAN'S DAY MAGAZINE, CBS Publications, 1515 Broadway, New York NY 10036. (212)719-6480. Art Director: Brad Pallas. Magazine published 17 times/year. Circ. 8,000,000. Emphasizes homemaking, cooking, family life and personal goal achievement. "We are a service magazine offering ideas that are available to the reader or ones they can adapt. We cater to women of middle America and average families." Uses story-related photographs on assignment basis only. Pays \$400/day against a possible page rate, or on a per-photo basis. Credit line given. Pays on acceptance. Buys one-time rights. Complete woman's service magazine subjects (food, fashion, beauty, decorating, crafts, family relationships, money, health, children, etc.).

WOMAN'S WORLD, 177 N. Dean St., Englewood NJ 07631. (201)569-0006. Editor-in-Chief: Dennis Neeld. Photo Editor: Emily Rose. Weekly. Circ. 1,000,000. Emphasizes women's issues. Readers are women 25-60 nationwide of low to middle income. Sample copies available.

Photo Needs: Uses up to 100 photos/issue; all supplied by freelance photographers. Needs photos of travel, fashion, crafts and celebrity shots. "For our editorial pages we are mainly looking for very informative straightforward photos, of women's careers, travel, people in everyday personal situations—couples arguing, etc., and medicine. Photographers should be sympathetic to the subject, and our straightforward approach to it." Photos purchased with or without accompanying ms. Model release and captions required.

Making Contact & Terms: Query with 8x10 b&w glossy prints or 35mm transparencies or provide basic background and how to contact. Prefers to see tearsheets of published work, or prints or slides of unpublished work, as samples. SASE. Reports in 1 month. Provide resume and tearsheets to be kept on file for possible future assignments. Pays ASMP rates: \$250/day plus expenses; \$300/page for color and fashion. Pays on acceptance. Credit line given. Buys one-time rights.

WOMEN'S CIRCLE HOME COOKING, Box 1952, Brooksville FL 33512. Contact: Editor. Monthly magazine. Circ. 200,000. For "practical, down-to-earth people of all ages who enjoy cooking. Our readers collect and exchange recipes. They are neither food faddists nor gourmets, but practical men and women trying to serve attractive and nutritious meals." Buys 48 photos annually. Freelancers supply 80% of the photos. Credit line given. Pays on acceptance. Buys all rights; will release after publication. Send material. SASE. Reports in 1 month. Free sample copy with 9x12 envelope and 40¢ postage. Subject Needs: Needs photos of food with accompanying recipes. Wants no photos of raw fruit or vegetables, posed shots with "contrived backgrounds" or scenic shots. Needs material for a special Christ-

mas issue. Submit seasonal material 6 months in advance. "Good close-ups of beautifully prepared food are always welcome." Captions and recipes are required.

B&W: Uses 5x7 glossy prints. Pays \$10.

Color: Uses 35mm. Pays \$35.

Cover: Uses 4x5 color transparencies; vertical format required. "We especially like food shots with people. Attractive elderly ladies or children with food are welcome. We prefer shots of prepared dishes rather than raw ingredients." Pays \$50-75.

*WOMEN'S COURT, 4343 Lincoln Centre, Matteson IL 60443. (312)747-7170. Editor: John Hansen. Associate Editor: Lani Jacobsen. Monthly November-July. Emphasizes women's college and high school basketball. Readers include college and high school coaches and players; highly mobile and highly educated. Circ. 16,000. Estab. 1984. Free sample copy with SASE.

Photo Needs: Uses 35-40 photos/issue; almost all supplied by freelance photographers. Needs women's basketball action shots; also posed shots off the court; photos on related subjects shot as needed. Posed cover shots and action. Reviews photos with or without accompanying ms. Model release required; cap-

tions preferred.

Making Contact & Terms: Query with samples, provide resume, business card, brochure, flyer or tearsheets to be kept on file for possible future assignments. SASE. Reports in 2 weeks. Payment individually negotiated. Pays on publication. Credit line given. Rights vary according to agreement and payment made. Simultaneous submissions and previously published work OK.

Tips: "Prefers action photography, keying on individual players, with emphasis on the recognizability of individual players. Contact to arrange photo opportunity in conjunction with a writer's text. Photo as-

signments are generally made after story is assigned."

WOMEN'S SPORTS MAGAZINE AND FITNESS, 310 Town & Country Village, Palo Alto CA 94031. (415)321-5102. Production Manager: Les Belt. Art Director; Dagmar Dolan. Monthly. Circ. 150,000. Emphasizes "health, sports, fitness, with women's emphasis. Personality profiles." Readers are "high school and college students, athletes 18-34 years old." Sample copy \$2.

Photo Needs: Uses about 20 photos/issue; 75% supplied by freelance photographers. Needs "action

shots, portraits." Model release preferred.

Making Contact & Terms: Query with resume of credits; provide resume, business card, brochure, flyer or tearsheets to be kept on file for possible future assignments. SASE. Reports in 3 weeks. Payment varies. Pays on publication. Credit line given. Buys one-time rights.

Tips: "Send intelligent sounding queries."

WOODHEAT: THE WOODSTOVE DIRECTORY, Box 2008, Village West, Laconia NH 03247. (603)528-4285. Editor: Steven Maviclio. Annual magazine. Emphasizes wood heaters and fireplaces. Readers are buyers and owners of wood heaters; energy-minded homeowners. Circ. 175,000. Sample copy \$6 (postage included).

Photo Needs: Uses about 40 photos/issue; 75% supplied by freelance photographers. Needs "installation shots of wood heaters, energy-efficient homes, other energy topics on assignment. We need plenty of 4-color photos; the theme is energy, particularly anything to do with wood heat." Written release and

captions required.

Making Contact & Terms: Query with samples. Send any size glossy prints, 21/4x21/4 transparencies, color contact sheet by mail for consideration. Submit portfolio for review. Provide resume, business card, brochure, flyer or tearsheets to be kept on file for possible future assignments. Payment varies. Rights purchased "varies, depending on photographer and use."

Tips: "Call early to make arrangements. We are always looking for new people with creativity. 'Stock'

type photos welcome, too."

THE WORKBASKET, 4251 Pennsylvania, Kansas City MO 64111. (816)531-5730. Editor: Roma Jean Rice. Monthly except June/July and November/December. Circ. 1,800,000. Emphasizes primarily needlework with some foods, crafts and gardening articles for homemakers. Photos purchased with accompanying ms. Pays on acceptance. Buys all rights. Send material by mail for consideration. SASE. Reports in 1 month.

Subject Needs: Wants on a regular basis gardening photos with ms and craft photos with directions. "No needlework photos. Must have model accompanying directions." Captions required on how-to

photos.

B&W: Uses 8x10 glossy prints. Pays \$10/photo.

Accompanying Mss: Seeks articles on gardening or plants and how-to articles. Pays 7¢/word. Free writer's guidelines with SASE.

WORKBENCH MAGAZINE, 4251 Pennsylvania Ave., Kansas City MO 64111. Editor: Jay W. Hedden. Associate Editor: A. Robert Gould. Bimonthly magazine. Circ. 850,000. Emphasizes do-it-your-

self projects for the woodworker and home maintenance craftsman. Photos are purchased with accompanying ms. Pays \$75-200/published page. Credit line given with ms. Pays on acceptance. Buys all rights, but may reassign to photographer after publication. Ask for writer's guidelines, then send material by mail for consideration. SASE. Reports in 4 weeks. Free sample copy and photo guidelines. Subject Needs: How-to; needs step-by-step shots. "No shots that are not how-to." Model release re-

quired; captions preferred.

B&W: Uses 8x10 glossy prints. Pay is included in purchase price with ms.

Color: Uses 4x5 transparencies and 8x10 glossy prints. Pays \$125 minimum/photo.

Cover: Uses 4x5 color transparencies. Vertical format required. Pays \$150 minimum/photo. Accompanying Mss: Seeks how-to mss. Pays \$75-200/published page. Free writer's guidelines. Tips: Prefers to see "sharp, clear photos; they must be accompanied by story with necessary working drawings. See copy of the magazine."

WORKING MOTHER, 230 Park Ave., New York NY 10169. (212)551-9533. For the working mothers in the U.S. whose problems and concerns are determined by the fact that they have children under 18 living at home. Monthly. Circ. 550,000.

Photo Needs: Uses up to 5 photos/issue from freelancers. "Selection is made on the basis of photographer's portfolio (which I call in from promotional material or through industry sourcebooks and award annuals). Freelance photographers are used exclusively, on specific assignment only. Interested in both studio and location work, for covers, beauty, fashion and illustration. Of particular interest are photographers are used exclusively.

raphers who are adept at working with children."

Making Contact & Terms: Prefer to receive promotional material by mail; drop off portfolios anytime, (must leave minimum 1 day); call first. Use stock photos occasionally. Provide tearsheets, cards, brochures, etc. showing variety of work to be kept on file for possible future assignments. Samples are non-returnable. Reports same or next day if work is assigned. Pays \$250/page; \$250/day. Buys one-time reproduction rights with the right to determine future usages. Any reuse is negotiated, and brings additional compensation. All photos returned.

WORLD COIN NEWS, 700 E. State St., Iola WI 54990. (715)445-2214. Editor: Colin Bruce. Weekly. Circ. 15,000. Emphasizes "foreign (non-US) numismatics—coins, bank notes, medals, tokens, ex-

onumia." Readers are "affluent, average age 45, professional." Sample copy free.

Photo Needs: Uses about 25 photos/issue; 25% supplied by freelance photographers. Needs photos of "coins, medals, tokens, sculptors of coins, banks, landmarks for special issues (12 per year around the country), business. In any given year, WCN runs on the average 12 special issues dealing with major conventions in cities throughout the U.S. and two or three in major cities of the world. We need free-lancers to submit landmark photos along with directories of things to do and see of an editorial nature. We can get canned photos from the tourist agencies; what we're looking for are artistic shots with character. We desire to make contact with freelance photographers in as many countries as possible for future assignments. Therefore, we would appreciate the standard resume, calling card and samples for our files for reference." Model release and captions required.

Making Contact & Terms: Query with samples. Provide resume, business card, brochure, flyer or tearsheets to be kept on file for possible future assignments. SASE. Reports in 1 month. Pays \$5/b&w cover photo; \$5/b&w inside photo; payments negotiable for page rate, per hour, per job, and for text/photo package. Pays on acceptance. Credit line given. Rights negotiable. Simultaneous submissions

and previously published work OK.

Tips: "Contact your local coin dealers and get acquainted with the hobby interests."

WORLD ENCOUNTER, 2900 Queen Lane, Philadelphia PA 19129. (215)438-6360. Editor: James E. Solheim. Quarterly magazine. Circ. 7,000. A world mission publication of the Lutheran churches in North America. Emphasizes world concerns as they relate to Christian activity. Readers have a more than superficial interest in and knowledge of world mission and global concerns. Photos purchased with or without accompanying ms, and on assignment. Buys 25 photos/year. Pays \$20-300/job; \$45-130 for text/photo package; or on a per-photo basis. Credit line given. Pays on publication. Buys all rights; second serial rights; and one-time rights. Query with subject matter consistent with magazine's slant. SASE. Simultaneous submissions and previously published work OK. Reports in 3 weeks. Sample copy \$1.

Subject Needs: Personality (occasionally needs "world-leader" shots, especially from Third World countries); documentary; photo essay/photo feature; scenic; spot news (of Christian concern); human interest (if related to a highlighted theme, i.e., world hunger, refugees, overseas cultures). Needs photos church/religion related. No tourist-type shots that lack social significance. Captions required.

B&W: Uses 8x10 glossy prints; contact sheet and negatives OK. Pays \$25 minimum/photo.

Cover: Uses b&w glossy prints or color transparencies. Vertical format preferred. Pays \$50 minimum/ photo.

Accompanying Mss: Articles relating to world mission endeavors or that help promote global consciousness. Pays \$100-200/ms. Writer's guidelines free with SASE.

Tips: Query to determine specific needs, which change from time to time. "Investigate the overseas involvement of the Lutheran churches."

WORLD TRAVELING, 30943 Club House Lane, Farmington Hills MI 48018. President: Theresa Mitan. Bimonthly magazine. Circ. 60,000. Emphasizes travelers and traveling for the untraveled as well as the experienced. Prefers ms with photo submissions. Freelancers supply 80% of photos. Credit line given. Pays on publication. Buys all rights. Send material by mail for consideration. SASE. Simultaneous submissions OK. Reports in 3 months. Sample copy \$3.

Subject Needs: Scenic and travel of specific places. Captions are required.

Specs: Uses 5x7 glossy b&w prints and 35mm color transparencies and prints. Uses color covers. **Accompanying Mss:** Seeks national and international travel material.

X-IT, Box 102, St. John's, Newfoundland, Canada A1C 5H5. (709)753-8802. Associate Editor: Beth Fiander. Triannual magazine. Emphasizes "all subjects. The magazine is an arts and literature publication. The photo feature in each edition varies and may be compiled of many different areas of interest." Readers are the general public. Circ. 3,000 "and growing." Sample copy \$3.

Photo Needs: Uses approximately 20 photos/issue; 50-60% supplied by freelance photographers. Needs "all types of photos. The magazine is open to all areas. The photo section is displayed in a portfolio manner. There may be photos of different matters within that portfolio." Model release optional;

captions preferred "but may not be used."

Making Contact & Terms: Send 8x10 or 11x14 b&w prints by mail for consideration. SASE. Reports in 1 month. Pays \$30 plus credit/b&w cover photo; \$10/b&w page. Pays on publication. Buys one-time rights. Simultaneous and previously published submissions OK.

Tips: "Read the magazine and get the general feel of it."

YACHT RACING & CRUISING, Box 1700, 23 Leroy Ave., Darien CT 06820. (203)655-2531. Editor: John Burnham. Magazine published 11 times/year. Circ. 50,000. Emphasizes sailboat racing and performance cruising for sailors. Buys 250 photos/year; 20-25 photos/issue. Credit line given. Pays on publication. Buys first North American serial rights or all rights, but may reassign after publication. Send material by mail for consideration. Provide calling card, letter of inquiry and samples to be kept on file for possible future assignments. SASE. Reports in 1 month. Sample copy \$2.50; free photo guidelines.

Subject Needs: Sailboat racing and cruising photos and how-to for improving the boat and sailor. "Include some sort of story or caption with photos." Captions required. Note magazine style carefully.

B&W: Uses 5x7 and 8x10 glossy prints. Pays \$30/photo.

Cover: Uses 35mm and 21/4x21/4 color transparencies. Square and gatefold formats. Pays \$50-200/photo.

Accompanying Mss: Report of race or cruise photographed or technical article on photo subject. Occasionally does photo features with minimal story line. Pays \$100-150/published page. Free writer's guidelines; included on photo guidelines sheet.

Tips: "Instructional or descriptive value important. Magazine is for knowledgeable and performanceoriented sailors. Send examples of work and schedule of events you're planning to shoot."

YACHTING, 5 River Rd., Box 1200, Cos Cob CT 06807. Associate Editor: Deborah Meisels. Monthly magazine. Circ. 150,000. For yachtsmen interested in powerboats and sailboats. Needs action photos of pleasure boating—power and sail. Buys 100 minimum annually. Buys first North American serial rights. Send photos for consideration. Pays on acceptance. Reports in 6 weeks. SASE.

B&W: Send 5x7 or 8x10 glossy prints. Captions required. Pays \$50 minimum.

Color: Send 35mm. Captions required. Pays \$75 minimum.

Cover: Pays \$500 minimum.

YANKEE PUBLISHING, INC., Dublin NH 03444. (603)563-8111. Managing Editor: John Pierce. Editor: Judson D. Hale. Photography Editor: Stephen O. Muskie. Monthly magazine. Circ. 1,000,000. Emphasizes the New England lifestyle of residents of the 6-state region for a national audience. Buys 50-70 photos/issue. Credit line given. Buys one-time rights. Query only. Provide calling card, samples and tearsheets to be kept on file for possible future assignments. SASE. Previously published work OK. Reports in 2-4 weeks. Free sample copy and photo guidelines.

Subject Needs: "Outstanding photos are occasionally used as centerspreads; they should relate to surrounding subject matter in the magazine. Photo essays ('This New England') must have strong and specific New England theme, i.e., town/region, nature, activity or vocation associated with the region, etc. All Yankee photography is done on assignment." No individual abstracts. Captions required.

B&W: Uses 8x10 glossy prints; contact sheet OK. Pays \$50 minimum/photo. **Color:** Uses 35mm, $2^{1/4}$ x2 $^{1/4}$ and 4x5 transparencies. Pays \$150/printed page.

Tips: "Send in story ideas after studying Yankee closely."

YELLOW SILK: Journal of Erotic Arts, Box 6374, Albany CA 94706. Editor: Lily Pond. Quarterly magazine. Circ. 4,500. Emphasizes literature, arts and erotica. Readers are well educated, creative, liberal. Sample copy \$3.

Photo Needs: Uses about 12 photos "by one artist" per issue. "All photos are erotic, none are cheescake or sexist. We define 'erotic' in its widest sense; trees and flowers can be as erotic as humans making

love. They are fine arts." Model release preferred.

Making Contact & Terms: Query with samples; submit prints, transparencies, contact sheets or photocopies by mail for consideration; submit portfolio for review. SASE. Reports in 1 week-2 months. "All payment made in copies; amount to be arranged. (\$1 per shot used)." Pays on publication. Credit line given. Buys one-time rights; "use for promotional and/or other rights arranged."

Tips: "Get to know the publication you are submitting work to and enclose SASE in all correspon-

dence."

YOUR HEALTH & FITNESS, 3500 Western Ave., Highland Park IL 60035. (312)432-2700. Photo Editor: Barbara A. Bennett. Published bimonthly. Health magazine. Sample copy and photo guidelines free with 8x11 SASE.

Photo Needs: Uses vertical 35mm or larger color transparencies of family involved in indoor/outdoor activities (no portraits); b&w photos of adults, primarily health, fitness, safety or nutrition themes. **Making Contact & Terms:** Send prints or transparencies by mail for consideration. SASE. Reports in 2-4 weeks. Buys one-time rights only. Payment negotiable. Pays on publication. Credit line given. Simultaneous and previously published submissions OK.

*YOUR HEALTH & MEDICAL BULLETIN, 2112 S. Congress Ave., West Palm Beach FL 33406. (800)327-7744, (305)439-7744. Editor: Susan Gregg. Photo Editor: Judy Browne. Weekly tabloid. Emphasizes healthy lifestyles: aerobics, sports, eating; celebrity fitness plans, plus medical advances and the latest technology. Readers include consumer audience; males and females from early 20's through 70's. Circ. 60,000. Sample copy 75¢. Call for photo guidelines.

Photo Needs: Uses 40-45 photos/issue; all supplied by freelance photographers. Needs photos depicting nutrition and diet, sports (runners, tennis, hiking, swimming, etc.), food curiosity, celebrity workout, pain and suffering, arthritis and bone disease, skin care and problems. Also any photos illustrating excit-

ing technlogical or scientific breakthroughs. Model release required.

Making Contact & Terms: Provide resume, business card, brochure, flyer or tearsheets to be kept on file for possible future assignments, and call to query interest on a specific subject. SASE. Reports in 2 weeks. Pay depends on photo size and color. Pays on publication. Buys one-time rights. Simultaneous submissions and previously published submissions OK.

Tips: "Pictures and subjects should be interesting; bright and consumer-health oriented."

*THE YOUTH REPORT, Suite 301, 226 W. Pensacola St., Tallahassee FL 32301. (904)681-0019. Editor: William S. Loiry. Monthly. Emphasizes child and youth advocacy. Readers are advocates, parents, young people, professionals, policy-makers and interested citizens. Circ. 10,000 + . Estab. 1985. Sample copy with SASE and 39¢ postage; photo guidelines with SASE and 22¢ postage. Model release required; captions preferred.

Making Contact & Terms: Query with samples. SASE. Reports in 1 month. Payment individually negotiated. Pays on publication. Credit line given. Buys all rights. Simultaneous submissions and previ-

ously published work OK.

Tips: "Inquire about what stories we'll be running in upcoming issues and shoot from there."

Newspapers and Newsletters

News photography, or photojournalism, is one of the most visible and prestigious of all photographic specializations. A single important news picture may be seen by literally millions of people. Such pictures come to define significant moments in history—the crash of the Hindenburg, for example, or the shooting of Lee Harvey Oswald—and can lead to major journalism awards and national recognition for the photographers who take them. From a career standpoint, success in news photography can lead to both financial rewards and inroads into additional markets.

While most of the photographs which appear in newspapers (and in the large national news magazines) are taken on assignment by full-time staff photographers. many are also purchased from freelancers. If a photographer is in the right place at the right time to shoot a newsworthy event as it happens, a newspaper editor isn't going to care who snapped the shutter-he'll just want the film for his paper and not

the competition's.

But how do you get the kinds of pictures newspaper editors are looking for? As any reporter will tell you, news stories must be actively pursued to be captured. For the freelance photographer, this means keeping abreast of local news happenings. knowing when scheduled events that may turn out to be newsworthy will take place. and trying to anticipate what may happen tomorrow. Read the newspapers, listen to the radio, watch television—in other words, take advantage of every source of local information you can get your hands on. Some photographers go so far as to install police scanners in their cars in order to listen in on this most likely source of advance reports on news developments-but please note that police permission to carry such a scanner is required in many areas.

If you do find yourself in the position of being the first or only photographer on the scene as a news event breaks, remain calm, shoot as much film as you have as well as you can under the circumstances, and then rush it immediately to the local newspaper. Explain to the editor what you have. If he's interested, he'll strike a bargain on the spot, or he may wait until the film is processed in the paper's photo lab to see if the pictures are newsworthy. Either way, try to retain resale rights to your photos-if the news is big enough, you may be able to sell the shots to one of the news magazines, or place them with one of the photo agencies which specialize in current

events (see the Stock Photo Agencies section of this book).

A related submarket in this category consists of the many newsletters which cover timely news and information for a specialized readership—often the members of a particular profession. Since most newsletters focus tightly on a specific subject, you'll have to pick and choose among them to find those best suited to your strengths and interests, but bear in mind that newsletter publishing is a growth industry with many new potential markets for your work springing up all the time.

THE AMERICAN SHOTGUNNER, Box 3351, Reno NV 89505. Managing Editor: Sue Bernard. Monthly; 88 pages. Circ: 124,000. Buys 25 annually. Emphasizes hunting techniques, tournament shooting, new products for hunting and gun collecting. For educated sportsmen and affluent gun own-

Subject Needs: Nature; product shot (high-grade modern shotguns or accessories); animal and wildlife (ducks, geese, dogs and hunting subjects); and special effects/experimental. Would also like interesting photos of celebrity hunters afield. Special needs include high-quality studio shots for potential covers. Captions required.

Specs: Uses 8x10 glossy b&w prints and prefers 21/4x21/4 or larger color transparencies. Uses color cov-

ers; originals only.

Payment/Terms: Pays \$10-40/b&w print, \$15-200/color transparency and \$50-200/coyer. Credit line given. Pays on publication, sometimes on acceptance. Buys all rights. Submit model release with photo. Making Contact: Send photos for consideration. SASE. Reports in 2 weeks. Free sample copy, Pro-

390 Photographer's Market '86

vide resume and business card to be kept on file for possible future assignments.

Tips: Photos must be of superior quality. No posed dead game shots. "Most photos are purchased with stories. We need how-to-build-it or how-to-do-it photo narratives. Send only your very best work. We remember quality or the lack of it and associate it to names we have used or reviewed. If we reject your work three times, we probably won't even look at additional submissions."

AMERICAN SPORTS NETWORK, Box 386, Rosemead CA 91770. (818)572-4727. President: Louis Zwick. Publishes four newspapers covering "general collegiate, amateur and professional sports; i.e., football, baseball, basketball, track and field, wrestling, boxing, hockey, powerlifting and bodybuilding, etc." Circ. 50,000-755,000. Sample copy and photo guidelines free with SASE.

Photo Needs: Uses about 10-85 photos/issue in various publications; 90% supplied by freelancers. Needs "sport action, hard-hitting contact, emotion-filled, b&w glossy 8x10s and 4x5 transparencies. Have special bodybuilder annual calendar, collegiate and professional football pre- and postseason edi-

tions." Model release and captions preferred.

Making Contact & Terms: Send 8x10 b&w glossy prints and 4x5 transparencies by mail for consideration; provide resume, business card, brochure, flyer or tearsheets to be kept on file for possible future assignments. SASE. Reports in 1 week. Pays \$1,000/color cover photo; \$250/inside b&w photo; negotiates rates by the job and hour. Pays on publication. Buys first North American serial rights. Simultaneous and previously published submissions OK.

ARIZONA MAGAZINE, *The Arizona Republic*, Box 1950, Phoenix AZ 85001. (602)271-8291. Editor: Paul Schatt. Weekly newspaper magazine. Circ. 425,000. Contemporary nonfiction related somehow to Arizona or of general interest, with related photos. Buys 1-12 photos/issue. Send contact sheet or photos for consideration. Payment upon scheduling for publication. Reports in 2 weeks. SASE. Previously published work OK in certain circumstances. Social security numbers required.

B&W: Send contact sheet or 8x10 glossy prints. Captions required. Pays \$15-30. **Color:** Send 35mm, 2¹/₄x2¹/₄ or 4x5 transparencies. Captions required. Pays \$25-80.

Cover: Send color transparencies. Captions required. Pays \$80.

Tips: "The approach to any subject should be sharply angled. If the photo is story-related then the photographer has a better shot. Talk with us about your ideas and read the magazine. *Anticipate* trends—don't follow them."

ASSOCIATION FOR TRANSPERSONAL PSYCHOLOGY NEWSLETTER, Box 3049, Stanford CA 94305. (415)327-2066. Contact: Staff Editor. Quarterly. Circ. 1,500. Emphasizes "various spiritual paths, therapy, education, books in the field, meditation, experiences and research of a transpersonal nature." Readers are "interested in, or are practicing professionally in psychology, education, research, spiritual disciplines, as well as philosophers. A transpersonal orientation." Sample copy \$3. Photo Needs: Uses about 6 photos/issue; 6 supplied by freelance photographers. Needs scenic, people and nature shots. Photos used with or without accompanying ms. Model release and captions preferred.

Making Contact & Terms: Send by mail for consideration b&w prints, size and finish optional. SASE. Reports in 2 weeks. "We do not purchase photos. We are a nonprofit organization." Simultaneous submissions and/or previously published work OK.

ATV NEWS, Box 1030, Long Beach CA 90801. (213)595-4753. Publisher: Skip Johnson. Editor: John Ulrich. Monthly tabloid. Circ. 88,000. Emphasizes all terrain vehicle views and recreation for ATV racers and recreationists nationwide. Needs photos of ATV racing to accompany written race reports; prefers more than one vehicle to appear in photo. Wants no dated material. Buys 1,000 photos/year. Buys all rights, but may reassign to photographer after publication. Send photos or contact sheet for consideration or call for appointment. "Payment on 15th of the month for issues cover-dated the previous month." Reports in 3 weeks. SASE. Free photo guidelines.

B&W: Send contact sheet, negatives, or prints (5x7 or 8x10, glossy or matte). Captions required. Pays

\$10 minimum.

Color: Send transparencies. Captions required. Pays \$50 minimum.

Cover: Send contact sheet, prints or negatives for b&w; transparencies for color. Captions required. Pay negotiable.

Tips: Prefers sharp action photos utilizing good contrast. Study publication before submitting "to see what it's all about." Primary coverage area is the United States.

*BANJO NEWSLETTER INC., Box 364, Greensboro MD 21639. (301)482-6278. Editor: Hub Nitchie. Monthly. Emphasizes 5-string banjo information. Readers include musicians, teachers. Circ. 8,000.

Photo Needs: Uses 3-8 photos/issue; very few supplied by freelance photographers. Needs musical instruments, cases, well known banjo players, band, PR shots. Model release preferred.

Making Contact & Terms: Query with samples, usually writers provide photos from banjo manufacturers or musicians. Reports in 1 month. Pays \$40-50/color cover photo, \$10-15/b&w inside photo. Pays on publication. Credit line given. Buys one-time rights. Simultaneous submissions and previously published work OK with permission from publisher.

BARTER COMMUNIQUE, Box 2527, Sarasota FL 33578. (813)349-3300. Editor: Robert J. Murley. Quarterly tabloid. Circ. 50,000. Emphasizes bartering—trading goods, products and services; interested in "barter of every kind and description." For radio and TV station owners, cable TV, newspaper and magazine publishers and select travel and advertising agency presidents. Photos purchased with accompanying ms. Buys 3 photos/issue. Pays \$35-50 for text/photo package; or special features on a barter basis up to \$250. Credit line given. Pays on publication. Buys all rights. Query with samples. SASE. Reports in 2 weeks. Free sample copy and photo guidelines.

Subject Needs: Celebrity/personality, documentary, fine art, spot news, how-to, human interest, travel

and barter situations. Model release and captions preferred.

B&W: Uses 5x7 glossy prints. Pays \$35-50 for text/photo package.

Accompanying Mss: Travel, advertising and barter arrangements worldwide. "We like picture and article, maximum 1,000 words." Pays \$35-50 for text/photo package. Free writer's guidelines.

Tips: Oriented towards the owners of magazines, resorts, manufacturers, cruise ships, newspapers, radio and TV stations. "We're very interested in factually correct, documented material on barter experiences."

BASKETBALL WEEKLY, 17820 E. Warren Ave., Detroit MI 48224. (313)881-9554. Managing Editor: Matt Marson. Published 20 times/year. Circ. 40,000. Emphasizes complete national coverage of pro, college and prep basketball. Freelancers supply 50% of the photos. Pays on publication. Buys all rights. Simultaneous submissions OK. Send photos. SASE. Reports in 2 weeks. Free sample copy. Subject Needs: Close facials and good game action. "We don't necessarily want different photos, just good ones which we attempt to play prominently. Since we are not daily, we are very interested in receiving a package of photos which we will buy at an agreed price, then use in our files." No elbows and armpits with a black background.

B&W: Uses 8x10 prints. Pays \$5-10.

Cover: Uses b&w covers only.

THE BLADE TOLEDO MAGAZINE, The Toledo Blade, 541 Superior St., Toledo OH 43660. (419)245-6121. Editor: Sue Stankey. Weekly newspaper magazine. Circ. 210,000. For general audiences. Buys 10-30 photos/year. Buys simultaneous rights. Photos purchased with accompanying ms. Photo work to illustrate a story or form a photo essay is assigned in most cases. Query first with resume of credits. Pays on publication; payment is negotiable for all assignments. Reports in 6 weeks. SASE. Simultaneous submissions and previously published work OK. Free sample copy and photo guidelines. Subject Needs: Local subject matter pertinent to Toledo, northwestern Ohio and southern Michigan. Celebrity/personality, fashion/beauty, fine art, glamour, human interest, photo essay/photo feature, special effects & experimental and sport. No travel or hobby/craft pictures.

B&W: Send 8x10 glossy prints. Captions required.

Color: Send 8x10 glossy prints or transparencies. Captions required. Cover: Send glossy color prints or transparencies. Captions required.

Tips: "Give us a reason for using your photos; show us how they will touch our particular readers." Show them something familiar from an unfamiliar perspective.

BOSTON GLOBE MAGAZINE, Boston Globe, Boston MA 02107, Editor: Ms. Ande Zellman. Weekly tabloid. Circ. 781,500. For general audiences. Buys 150 photos annually. Buys first serial rights. Pays on publication. "All photographs are assigned to accompany specific stories in the magazines." Write for an appointment to show portfolio of work to designer, Ronn Campisi. Query before sending material.

B&W: Uses glossy prints; send contact sheet. Captions required. Payment negotiable. Color: Uses transparencies. Captions required. Query first. Payment negotiable. Cover: Uses color transparencies. Captions required. Query first. Payment negotiable.

BOSTON PHOENIX, 100 Massachusetts Ave., Boston MA 02115. Design Director: Cleo Leontis. Weekly tabloid. Circ. 150,000. Emphasizes "local news, arts and lifestyle." Especially needs freelance photographers on assignment only basis. Buys 20-35 photos/issue. Credit line given. Pays on publication. Buys one-time rights. Query first to arrange personal interview to show portfolio. SASE. Previously published work OK. Reports in 4 weeks.

Subject Needs: "All photos are assigned in any and all categories depending on the needs of special supplements which are published as part of our regular news/arts editions." Model release required.

B&W: Uses 8x10 matte prints. Pays \$40 for first photo; \$25 for each additional photo.

BULLETIN, National/State Leadership Training Institute on Gifted/Talented Children, 316 W. 2nd St., Suite PH-C, Los Angeles CA 90012-3595. (213)489-7470. Editor: Jim Curry. Quarterly newsletter. Circ. 3,500. For administrators, teachers, university personnel, counselors, and parents of gifted and talented children. Needs photos of "gifted and talented children in educational programs designed to challenge their potential. Kindergarten through college. Areas: academic, creativity (the arts), kinesthetic (sports, dance) and psychosocial (leadership). Close-ups and small groups—with teachers, parents or contemporaries." Wants no shots of people lined up or staring at the camera, or "cutesy" or posed shots of children. Prefers candid photos with action. Not copyrighted. Submit model release with photo. Query first with resume of credits. Reports in 1 month. SASE. Free sample copy and photo guidelines.

B&W: Uses 5x7 glossy prints. Captions required.

Tips: "Talk to advocates of gifted children; study our publications—we also publish handbooks of related aspects of gifted education." Activity of subjects must be readily discernible. Subjects "must be unique to gifted/talented children, and must be a positive statement on these children."

BUSINESS INSURANCE, 740 N. Rush, Chicago IL 60611. (312)649-5398. Editor: Kathryn J. McIntyre. Emphasizes commercial insurance for the commercial buyer of property/casualty and group insurance plans. Weekly. Circ. 41,000. Free photo guidelines.

Photo Needs: Uses up to 20 photos/issue, 2 supplied by freelance photographers. Works on assignment. Provide letter of inquiry and samples. Needs "photos of big property losses, i.e., fires, explosions.

Model release required if it's not a news event. Captions required.

Making Contact & Terms: Make query with resume of photo credits to Holly Sequine, graphics editor at (312)649-5277. SASE. Reports in 2 weeks. Pays on publication \$10-20/b&w photo; or pays \$10 minimum/hour, \$100 minimum/job, or lump sum for text/photo package. Credit line given. Buys all rights on a work-for-hire basis. Simultaneous and previously published submissions OK.

THE BUSINESS TIMES, 544 Tolland St., East Hartford CT 06108. (203)289-9341. Managing Editor: Deborah Hallberg. Monthly. Circ. 18,500. Emphasizes business, particularly as it pertains to Connecticut. Readers are business owners and top executives. Sample copy \$1.50 plus postage (prepaid). Photo Needs: Uses about 4-5 photos/issue; all supplied by freelance photographers. "Photos are usually done to accompany an article on a specific business or executive. In the future, we may need photographers stationed in New York City or Fairfield County for articles in that location." Photos purchased with accompanying ms only. Captions preferred.

Making Contact & Terms: Provide resume, business card, brochure, flyer or tearsheets to be kept on file for possible future assignments. SASE. Reports in 1 month. Pays \$100/b&w cover photo; \$30/b&w inside photo. Pays on publication. Credit line given. Buys exclusive rights within the state of Connecti-

cut

CANINE CHRONICLE, Box 115, Montpelier IN 47359. (317)728-2464. Editor: Francis Bir. Emphasizes purebred dogs. Readers are purebred dog breeders and fanciers. Circ. 8,000. Sample copy available.

Photo Needs: Uses about 1 photo/issue; some are supplied by freelance photographers. Needs photos of

purebred dogs or dogs at work. Model release preferred; captions required.

Making Contact & Terms: Send 5x7 or larger b&w glossy prints by mail for consideration. SASE. Reports in 1 month. Pays \$15/b&w inside photo; \$100 maximum for text/photo package. Pays on acceptance. Credit line given. Buys all rights; "may be returned." Previously published submissions OK. "We want sharp, clean b&w glossies of purebred dogs."

CAPPER'S WEEKLY, 616 Jefferson, Topeka KS 66607. (913)295-1108. Editor: Dorothy Harvey. Bimonthly tabloid. Emphasizes human-interest subjects. Readers are "mostly Midwesterners in small towns and on rural routes." Circ. 400,000. Sample copy 55¢.

towns and on rural routes." Circ. 400,000. Sample copy 55¢. **Photo Needs:** Uses about 20-25 photos/issue, "one or two" supplied by freelance photographers. Needs "35mm color slides of human-interest activities, nature (scenic), etc., in bright primary colors."

Model release optional; captions preferred.

Making Contact & Terms: Query with samples; send 35mm transparencies by mail for consideration. SASE. Reporting time varies. Pays \$25/color page/photo. Pays per photo \$10-15 b&w; \$25 color. Pays on acceptance. Credit line given. Buys one-time rights.

Tips: Artists should study publication before submitting photos. "We are not a photography magazine—many beautiful scenes are eliminated because they are too 'artistic' or lacking human interest."

THE CHARLESTON GAZETTE, 1001 Virginia St. E., Charleston WV 25330. (304)348-5120. Graphics Editor: Tim Cochran. Daily newspaper. Circ. 58,000. Prefers a ms with photo submissions. Pays \$4.50-6.50/hour or on a per-photo basis. Credit line given. Pays on publication. Buys one-time

rights. Send material by mail for consideration. SASE. Simultaneous submissions and previously

published work OK. Reports in 1 week. Sample copy 20¢.

Subject Needs: Animal/wildlife, celebrity/personality, documentary, scenic, human interest and humorous. Also uses photo essays, nature and travel photos. "We usually have a West Virginia tie-in, but we're not restricted to that." Captions are required.

B&W: Uses 8x10 prints. Pays \$5-10/photo.

Color: Uses 35mm, 21/4x21/4 and 4x5 transparencies. Pays \$10-20/photo. Cover: Uses color covers only; vertical format used on cover. Pays \$20/photo.

Accompanying Mss: Seeks in-depth documentaries and commentaries.

CHICAGO READER, 11 E. Illinois, Chicago IL 60611. Art Director: Bob McCamant. Weekly tabloid. Circ. 120,000. For young adults in Chicago's lakefront communities interested in things to do in Chicago and feature stories on city life. Buys 10 photos/issue. "We will examine, in person, the portfolios of *local* Chicago photographers for possible inclusion on our assignment list. We rarely accept unassigned photos."

THE CHRISTIAN SCIENCE MONITOR, 1 Norway St., Boston MA 02115. (617)262-2300, ext. 2363/2364. Contact: Photo Division. Daily. Circ. 175,000. Emphasizes international and national news. Readers are the general public; business, government, educators.

Photo Needs: Uses about 20 photos/issue; 5 supplied by freelance photographers. Subject needs vary. **Making Contact & Terms:** Pays \$20-75/b&w cover photo; \$20-75/b&w inside photo (depending on size); \$100/cover photo for pull-out section. Pays on publication. Credit line given. Buys one-time rights. Previously published work OK.

Tips: "Become familiar with *The Christian Science Monitor*—what kinds of photos are used regarding content. Let us know about your upcoming photo trips so we can let you know about specific needs we

might have."

COLORADO SPORTS MONTHLY, Box 3519, Evergreen CO 80439. (303)670-3700. Editor: R. Erdmann. Monthly tabloid. Circ. 35,000. Emphasizes "individual participation sports within Colorado—skiing, running, racquet sports, bicycling, etc. Readers are young, active, fitness conscious." Sample copy free with SASE.

Photo Needs: Uses about 20 photos/issue; 10-15 supplied by freelance photographers. Needs sports

photos in the above subject areas. Model release preferred; captions required.

Making Contact & Terms: Query with samples. Provide resume, business card, brochure, flyer or tearsheets to be kept on file for possible future assignments. SASE. Reports in 1 month. Pays by the job. Pays 30 days after publication. Credit line given. Buys one-time rights. Simultaneous submissions and previously published work OK.

Tips: "Focus on people as they're involved in the sport."

COLUMBUS-DAYTON-CINCINNATI-TOLEDO BUSINESS JOURNALS, 666 High St. Worthington OH 43085. (614)888-6800. Publisher: Paul Parshall. Editor: Wynn Hollingshead. Monthly tabloids. Combined circ. 45,000. Emphasizes business. Readers' average income: \$43,000 + . Sample copy free with SASE and postage.

Photo Needs: Uses about 20 photos/issue. Needs photos covering business, government and high-tech.

Captions required.

Making Contact & Terms: Send b&w prints by mail for consideration. SASE. Reports in 2 weeks. No payment. Credit line given. Buys one-time rights. Simultaneous submissions OK.

COLUMBUS DISPATCH, 34 S. 3rd St., Columbus OH 43216. Editor: Luke Feck. Weekly Sunday supplement. Circ. 340,000. Emphasizes general interest material with an Ohio emphasis. Photos purchased with or without accompanying ms. Credit line given. Pays at the end of the month after publication. Copyrighted. SASE. Simultaneous submissions OK. Reports in 3 weeks.

Subject Needs: Photo essay, scenics (only with accompanying ms) for Sunday travel, arts or feature sections (broadsheet). Rarely use unsolicited material in magazine. Prefer private contract for specific

assignments.

B&W: Uses 8x10 glossy prints. Pay negotiable.

Cover: Uses color transparencies and prints. Pay negotiable.

Accompanying Mss: General interest material with an Ohio angle. Payment negotiable.

CYCLE NEWS, EAST, Box 805, Tucker GA 30085-0805. (404)934-7850. Publisher: Sharon Clayton. Editor: Jack Mangus. Weekly tabloid. Circ. 50,000. Emphasizes motorcycle recreation for motorcycle racers and recreationists east of the Mississippi River. Needs photos of motorcycle racing to accompany written race reports; prefers more than one bike to appear in photo. Wants no dated material.

394 Photographer's Market '86

Buys 1,000 photos/year. Buys all rights, but may reassign to photographer after publication. Send photos or contact sheet for consideration or call for appointment. "Payment on 15th of the month for issues cover-dated the previous month." Reports in 3 weeks. SASE. Free photo guidelines. **B&W:** Send contact sheet, negatives or prints (5x7 or 8x10, glossy or matte). Captions required. Pays

\$5 minimum.

Color: Send transparencies. Captions required. Pays \$25 minimum.

Cover: Send contact sheet, prints or negatives for b&w; transparencies for color. Captions required.

Pays \$10 minimum/b&w; \$25 minimum/color.

Tips: Prefers sharp action photos utilizing good contrast. Study publication before submitting "to see what it's all about." Primary coverage area is east of the Mississippi River, except for events of national importance.

CYCLE NEWS, WEST, Box 498, Long Beach CA 90801. (213)427-7433. Publisher: Sharon Clayton. Editor: John Ulrich. Weekly tabloid. Circ. 50,000. Emphasizes motorcycle news for enthusiasts and covers local races west of the Mississippi River. Needs photos of motorcycle racing to accompany written race reports; prefers more than one bike to appear in photo. Wants no dated material. Buys 1,000 photos/year. Buys all rights, but may reassign to photographer after publication. Send photos or contact sheet for consideration or call for appointment. "Payment on 15th of the month for issues cover-dated the previous month." Reports in 3 weeks. SASE.

B&W: Send contact sheet, negatives (preferred for best reproduction) or prints (5x7 or 8x10, glossy or

matte). Captions required. Pays \$10 minimum.

Color: Send transparencies. Captions required. Pays \$50 minimum.

Cover: Send contact sheet, prints or negatives for b&w; transparencies for color. Captions required. Pay negotiable.

Tips: Prefers sharp action photos utilizing good contrast. Study publication before submitting "to see what it's all about." Primary coverage area is west of the Mississippi River, except for events and news of national and international importance.

CYCLING U.S.A., U.S. Cycling Federation, 1750 E. Boulder St., Colorado Springs CO 80909. Editor: Josh Lehman. Emphasizes 10-speed bicycle racing for active bicycle racers. Circ. 15,000. Sample copy free with SASE.

Photo Needs: Uses about 20 photos/issue; 100% supplied by freelance photographers. Needs action rac-

ing shots, profile shoots or competitors. Model release and captions required.

Making Contact & Terms: Query with samples. Send 5x6 or 8x10 b&w prints by mail for consideration; submit photos on speculation. SASE. Reports in 3 weeks. Pays \$75/b&w cover photo, \$125/color cover photo; \$15-25/b&w inside photo, \$75/color inside photo; 10¢/word. Pays on publication. Credit line given. Buys one-time rights "unless other arrangements have been made."

Tips: "Study European and American bicycle racing publications. Initially, it's a tough sport to shoot,

but if a photographer gets the hang of it, he'll get his stuff published regularly."

DAILY TIMES, Box 370, Rawlins WY 82301. (307)324-3411. Editor-in-Chief: Chuck Bowlus. Dai-

ly. Circ. 5,000. Emphasizes general news.

Photo Needs: Uses about 12-15 photos/issue; 2-3 supplied by freelance photographers. Needs "everything-stress on news photos." Photos purchased with accompanying ms only. Model release pre-

Making Contact & Terms: Query with samples. Provide resume and tearsheets to be kept on file for possible future assignments. "We do not pay for photos." Credit line given.

DETROIT MAGAZINE, The Detroit Free Press, 321 W. Lafayette Blvd., Detroit MI 48231. (313)222-6737. Art Director: Sheila Young Tomkowiak. Weekly tabloid. Circ. 757,000. Emphasizes locally oriented stories for urban and suburban readers in Detroit and Michigan. Works with freelance photographers on assignment only basis. Provide resume, letter of inquiry, samples and tearsheets. Buys 10 photos/year. Not copyrighted.

Subject Needs: Color and b&w photo essays, nature, scenic, sport, documentary, human interest and special effects/experimental. All must be taken in Detroit and environs, or elsewhere in Michigan. No pure calendar art, saccharine scenics or sunsets. We want pictures that tap human emotions; that run the gamut from joy to loneliness; that make a statement about our city, our state, its inhabitants and the

human condition." Captions required.

Specs: Uses color transparencies and 8x10 b&w prints. "We seek only high quality photography." Payment/Terms: Pays up to \$250/color cover; up to \$100/color inside; \$50-150/b&w, depending on use. Negotiable for inside photo essays. Credit line given. Pays after publication. Submit model release with photo "if photo was not taken in a public place."

Making Contact: Arrange a personal interview to show portfolio or send photos for consideration.

SASE. Reports in 2-3 weeks.

DOLLARS & SENSE, 325 Pennsylvania Ave., Washington DC 20003. (202)543-1300. Editor-in-Chief: Tom G. Palmer. 10 times/year. Circ. 140,000. Emphasizes taxpayer-related issues. Readers are people interested in reducing taxes and government spending. Free sample copy with SASE.

Photo Needs: Uses about 3 photos/issue. Needs "pictures that coincide thematically with subject matter

of the articles." Captions optional.

Making Contact & Terms: Query with list of stock photo subjects. SASE. Reports in 3 weeks. Pays \$25-50/b&w cover photo; \$15-30/b&w inside cover photo. Pays on publication. Credit line given. Buys one-time rights. Simultaneous submissions and/or previously published work OK.

ECM NEWSLETTERS, Suite F57, 8520 Sweetwater, Houston TX 77037. (713)591-6015; (800)231-0440. Editor: Deborah Jackson. Monthly. Circ. 1,800,000. Emphasizes real estate. "Newsletters are sent out to homeowners by real estate agents." Sample copy and photo guidelines free with SASE. Photo Needs: Uses about 3-6 photos/issue; 1-3 supplied by freelance photographers. "We use color photos to illustrate various articles—our needs range from pets to home improvement, travel, current events, landmarks, famous persons and food. We feature a recipe in each issue which must be accompanied by a color photo." Model release required; captions optional.

Making Contact & Terms: Query with list of stock photo subjects. Send any size color glossy prints or transparencies by mail for consideration. SASE. Reports in 1 month. Pays \$20/color cover photo; \$20/color inside photo. Pays on acceptance. Buys all rights "but nonexclusive." Simultaneous submissions

and previously published work OK.

Tips: "We look for clear, sharp photos, free of detracting shadows."

EXCHANGE & COMMISSARY NEWS, Box 1500, Westbury NY 11590. (516)334-3030. Senior Editor: Bob Moran. Monthly tabloid. Emphasizes "military retailing: grocery and mass merchandising stores." Readers are buyers and managers.

Photo Needs: Uses about 40-50 photos/issue. Needs "store shots." Captions preferred.

Making Contact & Terms: Send b&w prints; 35mm or 4x5 transparencies; b&w contact sheets by mail for consideration. SASE. Reports in 2 weeks. Payment varies. Pays on acceptance. Credit line given. Buys all rights.

FISHING AND HUNTING NEWS, 511 Eastlake Ave. E., Box C-19000, Seattle WA 98109. (206)624-3845. Managing Editor: Vence Malernee. Weekly tabloid. Circ. 133,000. Buys 300 or more photos/year. Emphasizes how-to material, fishing and hunting locations and new products. For hunters and fishermen.

Subject Needs: Wildlife—fish/game with successful fishermen and hunters. Captions required. Specs: Uses 5x7 or 8x10 glossy b&w prints or negatives for inside photos. Uses color covers and some inside color photos—glossy 5x7 or 8x10 color prints, 35mm, 21/4x21/4 or 4x5 color transparencies.

When submitting 8x10 color prints, negative must also be sent.

Payment & Terms: Pays \$5-15 minimum/b&w print, \$50-100 minimum/cover and \$10-20 editorial color photos. Credit line given. Pays on acceptance. Buys all rights, but may reassign to photographer after publication. Submit model release with photo.

Making Contact: Send samples of work for consideration. SASE. Reports in 2 weeks. Free sample

copy and photo guidelines.

Tips: Looking for fresh, timely approaches to fishing and hunting subjects. Query for details of special issues and topics. "We need newsy photos with a fresh approach. Looking for near-deadline photos from Oregon, California, Utah, Idaho, Wyoming, Montana, Colorado, Texas, Alaska and Washington (sportsmen with fish or game)."

FLORIDA GROWER and Rancher, 723 E. Colonial Dr., Orlando FL 32803. (305)894-6522. Editor: Frank Abrahamson. Monthly. Emphasizes commercial agriculture in Florida. Readers are "professional farmers, growers and ranchers in the state of Florida." Sample copy free with SASE and \$1 postage.

Photo guidelines free with SASE.

Photo Needs: Uses about 20-25 photos/issue; "few, at present" supplied by freelance photographers. Needs photos of "Florida growers and ranchers in action in their day-to-day jobs. Prefer modern farm scenes, action, of specific farm which can be identified." Model release preferred; captions required. Making Contact & Terms: Query with list of stock photo subjects. Provide resume, business card, brochure, flyer or tearsheets to be kept on file for possible future assignments. SASE. Reports in 3 weeks. Pays \$75/color cover photo; \$5-10/b&w inside photo. Pays by the inch plus photo for text/photo package. Pays on publication. Credit line given if required. Buys all rights "but we usually allow resale or use anywhere outside the state of Florida." Simultaneous submissions and previously published work OK.

Tips: "Query first—photography usually tied in with writing assignment."

GAY COMMUNITY NEWS, 5th Floor, 167 Tremont St., Boston MA 02111. (617)426-4469. Managing Editor: Gordon Gottlieb. Design Director: Susan Yousem. Weekly. Circ. 15,000. Emphasizes "gay rights, liberation, feminism. Gay Community News is the primary news source for anyone concerned with what is being done to and by lesbians and gay men everywhere in this country." Sample copy \$1. Photo Needs: Uses 5 photos/issue, all supplied by freelance photographers. Needs "primarily news photos of events of interest to gay people e.g., b&w photos of demonstrations, gay news events, prominent gay people, etc." Model release and captions preferred.

Making Contact & Terms: Arrange a personal interview to show portfolio. SASE. Reports in 1 week. "We can pay only for materials, up to \$5/photo. Our photographers, writers and illustrators are all vol-

unteers." Pays on publication. Credit line given. Buys one-time rights.

GAY NEWS, 254 S. 11st St., Philadelphia PA 19107. (215)625-8501. Weekly tabloid. Circ. 15,000. Assistant to Publisher: Tony Lombardo. Emphasizes news and features of interest to Philadelphia's lesbian and gay community. Readers are gay people who are variously politically involved or socially aspiring. Sample copy 75¢.

Photo Needs: Uses about 5-8 photos/issue. Needs illustrations for features on wide variety of topics that are gay-related. Photos purchased with accompanying ms only. Model release required; captions pre-

ferred.

Making Contact & Terms: Provide resume, business card, brochure, flyer or tearsheets to be kept on file for possible future assignments. SASE. Reports in 3 weeks. Pays \$25/b&w cover photo and \$5/b&w inside photo. Pays on publication. Credit line given. Buys first North American serial rights. Previously published work OK.

GIFTED CHILDREN MONTHLY, Box 115, Sewell NJ 08080. (609)582-0277. Managing Editor: Robert Baum. Monthly. Circ. 45,000. Emphasizes "gifted education; preschool children up to age 14—grade level 9." Readers are "primarily parents; some teachers, schools, libraries." Sample copy free with 9x12 SASE and 56¢ postage.

Photo Needs: Uses about 1-2 photos/issue; none at present supplied by freelance photographers but "would consider both assignments and speculation." Needs photos of children's projects and activities.

Model release required; captions preferred. "Persons must be identified."

Making Contact & Terms: Send b&w glossy prints, contact sheet by mail for consideration. SASE. Reports in 2 weeks or as soon as possible. Rates of pay not available for publication. Pays on publication. Buys one-time rights.

GLOBE, Cedar Square, 2112 S. Congress Ave., West Palm Beach FL 33406. (305)439-7744. Contact: Photo Editor. Weekly tabloid. Circ. 2,000,000. "For everyone in the family. *Globe* readers are the same people you meet on the street, and in supermarket lines—average, hard-working Americans who prefer easily digested tabloid news." Needs human interest photos, celebrity photos, humorous animal photos, anything unusual or offbeat. Buys all photos from freelancers. Buys first serial rights. Send photos or contact sheet for consideration. Pays on acceptance. Reports in 1 week. SASE. Previously published work OK.

B&W: Send contact sheet or 8x10 glossy prints. Captions required. Pays "by arrangement."

Color: Color for covers and inside spreads. Send good quality or any subject shots.

Tips: Advises beginners to look for the unusual, offbeat shots.

GRIT, 208 W. 3rd St., Williamsport PA 17701. Editor: Naomi L. Woolever. Photo Editor: Joanne Decker. Weekly tabloid. Circ. 776,000. Emphasizes "people-oriented material which is helpful, inspiring and uplifting. When presenting articles about places and things, it does so through the experiences of people. Readership is small-town and rural America." Photos purchased with or without accompanying ms. Buys "hundreds" of photos/year. Buys one-time rights, first serial rights or second serial (reprint) rights. Send material by mail for consideration. SASE. Previously published work OK. Pays on acceptance. Reports in 2-3 weeks. Sample copy \$1, photos guidelines free with SASE.

Subject Needs: Needs on a regular basis "photos of all subjects, provided they have up-beat themes that are so good they surprise us. Human interest, sports, animals, celebrities. Get action into shot, implied or otherwise, whenever possible. Make certain pictures are well composed, properly exposed and pin sharp. All color transparencies for the cover are vertical in format. We use 35mm and up." Captions required. "Single b&w photos that stand alone must be accompanied by 50-100 words of meaningful caption information." Model release preferred. "No cheesecake. No pictures that cannot be shown to any member of the family. No pictures that are out of focus or grossly over/or under-exposed. No ribbon-cutting, check-passing, hand-shaking pictures."

B&W: Uses 8x10 glossy prints. "Because we print on newsprint, we need crisp, sharp b&w with white whites, black blacks and all the middle gray tones. Use fill-in flash where needed. We also want good composition." Pays \$35/photo; \$10/photo for second rights. Pays \$25/photo for pix accompanying mss.

Color: Uses transparencies for cover only. "Remember that *Grit* publishes on newsprint and therefore requires sharp, bright, contrasting colors for best reproduction. Avoid sending shots of people whose faces are in shadows; no soft focus." Pays \$100/front cover color.

Accompanying Mss: Pays 12¢/word, first rights; 6¢/word for second or reprint rights. Free writer's

guidelines for SASE.

Tips: "Good major-holiday subjects seldom come to us from freelancers. For example, Easter, 4th of July, Christmas or New Year. Using newsprint paper we need crisp sharp b&w. Avoid shadows on peoples faces—when photo requires action make sure action is in photo.

GROUP, Box 481, Loveland CO 80539. (303)669-3836. Editor: Gary Richardson. Monthly. Circ. 60,000. For high-school-age Christian youth group and adult leaders. Emphasizes activities, concerns and problems of young people. Photos purchased with or without accompanying ms. Buys 10 photos/issue. Pays \$30-200 for text/photo package; pays also on a per-photo basis. Credit line given. Pays on publication. Buys one-time rights. Send material by mail for consideration or call for appointment. SASE. Simultaneous submissions and previously published work OK. Reports in 2 weeks. Sample copy \$1. Photo guidelines free with SASE.

Subject Needs: Sport (young people in all kinds of sports); human interest (young people); adults and adults with young people; humorous; photo essay/photo feature (youth group projects and activities).

B&W: Uses 8x10 prints. Pays \$20-50/photo.

Color: Uses 35mm or 21/4x21/4 color transparencies. Pays \$50-150/photo.

Cover: Uses 35mm or 21/4x21/4 color transparencies. Vertical format required. Pays \$100 minimum/ photo.

Accompanying Mss: Seeks how-to feature articles on activities or projects involving high school students or Christian youth groups. Pays \$75 minimum/ms. Writer's guidelines free with SASE.

Tips: "Make sure photos look contemporary, not dated, and relate to, or are appropriate for, Christian teenagers and adults."

"This photo of the combined New York City and Washington DC Gay Chorus in front of St. Patrick's Cathedral during the June 24, 1984, Gay Pride March was our most successful photo of 1984 and was shot by our long-time freelancer, David Vita," says Michael Kaufman, photo editor for Guardian Newsweekly. "The symbolism of the joined hands holding a teddy bear with flowers gives the viewer a feeling for the demonstrators as people and of what the demonstration is about. The vantage point that Vita chose shows that he's not afraid of the demonstrators."

GUARDIAN NEWSWEEKLY, 33 W. 17th St., New York NY 10011. (212)691-0404. Photo Editor: Michael Kaufman. Weekly newspaper. Emphasizes "progressive politics and national and international news; focuses on Third World and on women's movement, disarmament, labor, economy, environment, grassroots community groups." Readers are "activists, students, labor; we have subscribers around the world." Circ. 30,000. Sample copy for SASE and 90¢ postage.

Photo Needs: Uses 25-35 photos/issue; "at least 50%" supplied by freelance photographers. Needs "news photos—local, international and national. Includes mugs of figures in the news, local rallies,

features; most to accompany stories." Model release optional; captions preferred.

Making Contact & Terms: Prefers query with 2 samples or list of stock photo subjects. Send any size b&w glossy prints by mail for consideration. SASE. Reports in 1 month "or sooner." Pays \$15/b&w inside photo. Pays on publication. Credit line given. Buys one-time rights. Simultaneous and previously published submissions OK.

Tips: Prefers to see "good quality, good sense of political side of subject and human interest aspect" in samples. "We pay low rates, but our photos are often requested by other publications for reprinting and

they will pay photographer too. We feature photos on cover and in centerfold.'

GUN WEEK, Second Amendment Foundation, Box 488, Station C, Buffalo NY 14209. (716)885-6408. Editor: Joseph P. Tartaro. Weekly newspaper. Circ. 30,000. Emphasizes gun-related hobbies—sports, collecting and news. For people interested in firearms. Credit line given. Buys first North American serial rights. Model release required. Send contact sheet or photos for consideration. Pays on publication. Reports in 6 weeks. SASE. Simultaneous submissions OK. Sample copy and editorial guidelines \$1.

Subject Needs: Needs nature, sports, photo essay/photo feature, human interest, product shots, sport news and wildlife on a regular basis. Needs photos of firearms, antique firearms, shooters taking aim at targets, hunters in the field; news photos related to firearms, legislation, competitions and gun shows. Captions required.

B&W: Send contact sheet or 5x7 or 8x10 glossy prints. Pays \$5 minimum/photo and caption.

Color: Send 35mm transparencies. Pays \$10 minimum/photo and caption.

Tips: "Gun Week is based on a newspaper format, and therefore space is limited. We have a lead time of two weeks, making our publication timely. News material is considered on this basis." Send for publication schedule. Submit seasonal material 6 weeks in advance.

GURNEY'S GARDENING NEWS, 2nd and Capitol, Yankton SD 57079. Editor: Pattie Vargas. Emphasizes gardening for a family audience. Bimonthly. Circ. 33,000. Free sample copy and photo guidelines with SASE.

Photo Needs: Uses 60-80 photos/issue; 50-70% supplied by freelance photographers. Needs photos of family gardening and general human interest. Photos purchased with or without accompanying ms.

Model release and captions required.

Making Contact & Terms: Send by mail for consideration 5x7 or 8x10 b&w prints, or b&w contact sheet; or query with samples. SASE. Reports in 2 months. Pays \$10 and up for b&w/inside; \$50-375 for text/photo package. Pays on acceptance. Credit line given. Buys first North American serial rights. Pre-

viously published work OK.

Tips: "Each issue contains several photo essays of 3-10 photographs. Themes should emphasize people and relate to the entire family. Specifically, we need garden material on vegetables, fruit trees, shade trees, shrubbery, flowers, bulbs, etc., or general interest material on family living, family kitchen, country living, food preparation, health, nutrition, crafts, hobbies, saving money, leisure, nostalgia, weather, natural science and humor." Photos should be "b&w, glossy, crisp with good detail and a nice range of tones from black to gray to white. Since we print on newsprint, avoid extremes of black and white." Submit seasonal/holiday material 6 months prior to publication.

*HICALL, Church School Literature Department, 1445 Boonville Ave., Springfield MO 65802. (417)862-2781. Editor: Wm. P. Campbell. Association publication for the general council of the Assemblies of God. 13 weekly, 8-page issues published quarterly. Readers are primarily high school students (but also junior high). Circ. 120,000. Sample copy and photo guidelines free with SASE.

Photo Needs: Uses 2-3 photos/issue; 95% supplied by freelance photographers. Needs photos of teens in various moods (joy, loneliness, prayer, surprise). Some scenics used, also nature close-ups; high

school settings and activities. Reviews photos with or without accompanying ms.

Making Contact & Terms: Query with list of stock photo subjects, send 8x10 glossy b&w prints, 35mm, 21/4x21/4, and 4x5 transparencies by mail for consideration. SASE. Pays \$30/b&w cover photo; \$40/color cover photo; \$25/b&w inside photo; and \$30/color inside photo. Pays on acceptance. Credit line given. Buys one-time rights. Simultaneous submissions and previously published work OK.

THE HONOLULU ADVERTISER, Box 3110, Honolulu HI 96802. (808)525-8000. Editor-in-Chief: George Chaplin. Photo Editor: Allan Miller. Daily newspaper. Circ. 90,000 daily; 100,000 Sunday.

Emphasizes local news, features and sports for general newspaper audiences. Needs human interest, local spot news, sports, general feature and scenic photos. Buys 120/year. Credit line given. Buys all rights, but may reassign to photographer after publication. Send photos for consideration. Provide resume, calling card and brochure to be kept on file for possible future assignments. Pays on publication. Reports in 1 week. SASE. Simultaneous submissions OK.

B&W: Send 8x10 glossy prints. Pays \$20 minimum. **Cover:** Send 8x10 glossy prints. Pays \$25 minimum.

Tips: "Local human interest feature art is what we're looking for in freelance photos that we buy. We're primarily interested in people pictures: people working, playing, etc." Wants no posed or group shots, ribbon cutting, award presentations, other ceremonial "stock" photos and "no cheesecake."

HUNGRY HORSE NEWS, Box 189, Columbia Falls MT 59912. Editor-in-Chief: Brian Kennedy. Weekly. Circ. 7,500. Emphasizes local news; wildlife and scenic areas. Readers are "local residents and many others across the country."

Photo Needs: Uses about 20 photos/issue; 1 supplied by freelance photographers. Needs animal, wildlife and local scenic shots. Photos purchased with or without accompanying ms. Model release optional

and captions required.

Making Contact & Terms: Send by mail for consideration 8x10 color or b&w prints; or submit portfolio for review. Provide resume, business card, flyer and tearsheets to be kept on file for possible future assignments. Payment is negotiable. Pays on publication. Credit line given. Buys one-time rights. Simultaneous submissions and/or previously published work OK.

ILLINOIS ENTERTAINER, Box 356, Mt. Prospect IL 60056. (312)298-9333. Editor: Guy Arnston. Monthly. Circ. 80,000. Emphasizes music and entertainment, including film and leisure activities. **Photo Needs:** Uses about 80 photos/issue; 50 supplied by freelance photographers. Needs "concert photography, band and entertainment, portrait, still life—b&w and color." Special needs include festivals during the summer.

Making Contact & Terms: Query with samples and list of entertainers' photos available. Provide samples to be kept on file for possible future assignments. Does not return unsolicited material. Reports ASAP. Pays \$100/color cover photo and \$20/b&w inside photo. Pays on publication. Credit line given.

Buys one-time rights. Previously published work OK.

Tips: Prefers to see "live concert, portrait, still life, architecture; looking for action or dynamic lighting instead of line 'em up and shoot 'em."

InfoAAU, AAU House, 3400 W. 86th St., Indianapolis IN 46268. (317)872-2900. Editor: Mike Bowyer. Monthly newsletter. Circ. 5,000 est. Emphasizes amateur sports. For members of the Amateur Athletic Union of the United States. Buys one-time rights. Model release required. Send photos for consideration. Pays on publication. Reports in 2-3 weeks. SASE. Free sample copy. "We have national championships across the U.S. Right now I'm looking to make contacts with photographers in all parts of the country. Send resume and tearsheets for possible future assignments."

Subject Needs: Celebrity/personality; head shot; and sport. Must deal with AAU sports: basketball, baton twirling, bobsledding, boxing, diving, gymnastics, handball, horseshoe pitching, judo, karate, luge, powerlifting, physique, swimming, synchronize swimming, taekwondo, volleyball, water polo, weightlifting, wrestling, trampoline and tumbling. Also photos dealing with the AAU Junior Olympics "and all matters pertaining to Olympic development in AAU sports." Captions and identifications re-

quired.

B&W: Send 8½x11 glossy prints. Pays \$5-25. **Color:** Send transparencies. Pays \$10-25.

Tips: Request AAU National Championship and International Competition schedules.

INFOWORLD MAGAZINE, Suite C-200, 1060 Marsh Rd., Menlo Park CA 94025. (415)328-4602. Editor: James E. Fawcette. Circ. 140,000. Weekly magazine emphasizing small computer systems. Readers are owners of personal computers. Sample copy \$1.75.

Photo Needs: Uses about 20 photos/issue; 4-8 supplied by freelance photographers. Model release re-

quired.

Making Contact & Terms: Query with samples. SASE. Does not return unsolicited material. Payment negotiable. Pays on publication. Credit line given.

INSIDE RUNNING, 9514 Bristlebrook, Houston TX 77083. (713)498-3208. Publisher/Editor: Joanne Schmidt. Monthly tabloid. Circ. 25,000. Emphasizes running and jogging. Readers are Texas runners and joggers of all abilities. Sample copy \$1.25.

Photo Needs: Uses about 20 photos/issue; 10 supplied by freelance photographers. Needs photos of "races, especially outside of Houston area; scenic places to run; how-to (accompanying articles by

Chicago freelance photographer Paul Natkin shot this picture of the late Count Basle on the set of "Soundstage." "When I photograph, I always look for salable shots. I'll sometimes carry four cameras loaded with different film to make sure I can get the shots I need," he says. This photo sold to Illinois Entertainer for \$25.

coaches)." Special needs include "top race coverage; running camps (summer); variety of Texas running terrain." Model release optional; captions preferred.

Making Contact & Terms: Query with list of stock photo subjects. Send 5x7 b&w or color glossy prints by mail for consideration. SASE. Reports in 1 month. Pays \$25/b&w cover photo, \$35/color cover photo; \$10/b&w inside photo. Pays on publication. Credit line given. Rights—"negotiable." Simultaneous submissions and previously published work OK.

Tips: Prefers to see "human interest and compostion" in photos. "Look for the unusual. Race photos tend to look the same." Wants "clear photos with people near front; too often photographers are too far away when they shoot and subjects are a dot on the landscape."

INTERNATIONAL LIVING, 824 E. Baltimore St., Baltimore MD 21202. (301)234-0515. Editor: Elizabeth Philip. Monthly. Circ. 40,000. Emphasizes "international lifestyles, travel." Readers are "well-to-do Americans between 30 and 75; many retired, almost all travelers for business and pleasure; many with second homes outside the U.S." Sample copy \$3.50.

Photo Needs: Uses about 6 photos/issue; 50% supplied by freelance photographers. Needs photos of "travel destinations, but no obvious tourists. We like photos which capture the local spirit." Captions

required.

Making Contact & Terms: Query with list of stock photo subjects. Provide resume, business card, brochure, flyer or tearsheets to be kept on file for possible future assignments. SASE. Reports in 1 month. Pays \$10-75 "varies"/b&w inside photo. Pays on acceptance. Credit line given. Buys one-time rights. Previously published work OK.

Tips: "Contact *International Living* if you are planning a trip outside U.S. Send us 'pictures with a story'—no obvious tourists, please. We're interested in slice of life, against readily identifiable back-

grounds."

JAZZ TIMES, 8055 13th St., Silver Spring MD 20910. (301)588-4114. Editor: Mike Joyce. Monthly tabloid. Emphasizes jazz. Readers are jazz fans, record consumers. Circ. 50,000. Sample copy \$1. **Photo Needs:** Uses about 18 photos/issue; all supplied by freelance photographers. Needs performance shots, portrait shots of jazz musicians. Captions preferred.

Making Contact & Terms: Send 5x7 b&w prints by mail for consideration. SASE. "If possible, we keep photos on file till we can use them." Pays \$25/b&w cover photo; \$10/b&w inside photo. Pays \$25/

color photo. Pays on publication. Credit line given. Buys one-time or reprint rights.

Tips: "Send whatever photos you can spare. We keep them on file until we can use them. Name and address should be on back."

JEWISH EXPONENT, 226 S. 16th St., Philadelphia PA 19102. (215)893-5740. Managing Editor: Al Erlick. Weekly newspaper. Circ. 70,000. Emphasizes news of impact to the Jewish community. Buys 15 photos/issue. Photos purchased with or without accompanying mss. Pays \$15-50/hour; \$10-100/job; or on a per photo basis. Credit line given. Pays on publication. Buys one-time rights, all rights, first serial rights or first North American serial rights. Rights are open to agreement. Query with resume of credits or arrange a personal interview. "Telephone or mail inquiries first are essential. Do not send original material on speculation." Provide resume, calling card, letter of inquiry, samples, brochure, flyer and tearsheets. SASE. Model release required, "where the event covered is not in the public domain." Reports in 1 week. Free sample copy.

Subject Needs: Wants on a regular basis news and feature photos of a cultural, heritage, historic, news and human interest nature involving Jews and Jewish issues. Query as to photographic needs for upcom-

ing year. No art photos. Captions are required.

B&W: Uses 8x10 glossy prints. Pays \$10-35/print.

Color: Uses 35mm or 4x5 transparencies. Pays \$10-75/print or transparency.

Cover: Uses b&w and color covers. Pays \$10-75/photo.

Tips: "Photographers should keep in mind the special requirements of high-speed newspaper presses. High contrast photographs probably provide better reproduction under new sprint and ink conditions."

*JEWISH TELEGRAPH. Telegraph House, 11 Park Hill, Bury Old Rd., Prestwich, Manchester, England. Editor: Paul Harris. Weekly newspaper. Circ. 11,500. For a family audience. Needs photos with Jewish interest. Buys simultaneous rights. Submit model release with photo. Send photos for consideration. Pays on publication. Reports in 1 week. SAE and International Reply Coupons. Simultaneous submissions and previously published work OK. Free sample copy and photo guidelines.

B&W: Send 5x7 glossy prints. Captions required. Pays \$5/photo minimum.

LOCUS, The Newspaper of the Science Fiction Field, Box 13305, Oakland CA 94661. Editor: C.N. Brown. Monthly newsletter. Circ. 8,000. Emphasizes science fiction events. Readers are "mostly professionals." Sample copy \$2.50.

Photo Needs: Uses about 80 photos/issue, some in color; 10 supplied by freelance photographers. Needs photos of science fiction conventions and author photos. Photos purchased with accompanying

ms only. Captions required.

Making Contact & Terms: Send 5x7 glossy b&w prints or smaller color by mail for consideration. SASE. Reports in 3 weeks. Pays \$10-25/b&w inside photo; payment for text/photo package varies. Pays on publication. Credit line given. Buys one-time rights.

LONG ISLAND HERITAGE, 132 E. Second St., Mineola NY 11501. (516)747-8282. Monthly. Circ. 18,000. Emphasizes antiques, collectibles, history and art. "Consumers who enjoy reading about

local history, antiques, etc." Sample copy \$1.05. **Photo Needs:** Uses about 50 photos/issue; 10-15 supplied by freelance photographers. "If ms is also enclosed—corresponding pictures of subject matter—art work, antiques or collectibles, historical depic-

tions, oldhouse architecture. If no ms, a strong cutline should be attached so pictures will stand alone."

Making Contact & Terms: Query with resume of credits or with samples; send 5x7, 8x10 b&w glossy

prints or b&w contact sheet. SASE. Reports in 2 weeks. Pays \$50/color cover photo or \$5-7.50/b&w inside photo. Pays on publication. Credit line given. Buys one-time rights. Simultaneous and previously published submissions OK.

Tips: "Provide excellent quality b&w prints showing an unusual antique, collectible or piece or art-work."

LYNCHBURG NEWS & DAILY ADVANCE, Box 10129, Lynchburg VA 24506. (804)237-2941. Executive Editor: W.C. Cline. Chief Photographer: Aubrey Wiley. Daily. Circ. 42,100. Two daily newspapers. Sample copy 75¢.

Photo Needs: Uses about 15 photos/issue; currently none are supplied by freelance photographers. Needs "animals, people features; lifestyles; general and spot news; sports." Photos purchased with ac-

companying ms only.

Making Contact & Terms: Query with samples. SASE. Reports in 2 weeks. Credit line given.

Tips: "Do not give up! Keep trying."

MAINE SPORTSMAN, Box 365, Augusta ME 04330. Editor: Harry Vanderweide. Monthly tabloid. Circ. 21,000. Emphasizes outdoor recreation in Maine. Photos are purchased with accompanying ms. Credit line given. Pays on publication. Not copyrighted. "Read our publication and submit b&w prints that might fit in." SASE. Simultaneous submissions and previously published work OK. Reports in 1-2 weeks.

Photo Needs: Uses 40-50 photos/issue; all supplied by freelance photographers. Needs animal, how-to, human interest, nature, photo essay/photo feature, sport and wildlife. Wants on a regular basis dramatic, single subject b&w cover shots. Does not want photos of dead fish or game. Captions required. Pays \$50/b&w cover photo; \$10/b&w inside photo. Buys one-time rights.

Accompanying Mss: Needs articles about outdoor activities in Maine. Pays \$30-100/ms.

THE MANITOBA TEACHER, 191 Harcourt St., Winnipeg, Manitoba, Canada R3J 3H2. (204)888-7961. Editor: Mrs. Miep van Raalte. Readers are "teachers and others in education in Manitoba." Magazine is issued 4 times/year (October, December, March and June). Circ. 16,300. Free sample copy. Provide resume and samples of work to be kept on file for possible future assignments.

Photo Needs: Uses about 8 photos/issue (including cover material). Interested in classroom and other scenes related to teachers and education in Manitoba. Model release required "depending on type of

photo;" captions required.

Making Contact & Terms: Send by mail for consideration actual 5x7 or 8x10 b&w photos; or submit portfolio by mail for review. SASE. Reports in 1 month. Pays \$5/inside photo. Credit line given upon request. No simultaneous or previously published work.

Tips: Prefers to see photos relevant to teachers in public schools and to education in Manitoba, e.g.,

"classroom experiences, educational events, other scenes dealing with education."

MICHIANA MAGAZINE, 227 W. Colfax, South Bend IN 46626. (219)233-3434. Editor: Bill Sonneborn. Weekly. Circ. 130,000. General interest Sunday magazine section. Sample copy free with SASE. Photo Needs: Uses about 12 photos/issue; 6 supplied by freelance writer-photographers. Needs "scenic and wildlife photos in Indiana and Michigan." Photos purchased with accompanying ms only. Model release preferred; captions required.

Making Contact & Terms: Query with samples. SASE. Reports in 3 weeks. Pays on publication. Credit line given. Buys one-time rights. Simultaneous submissions and previously published work OK.

MICHIGAN, The Magazine of The Detroit News, 615 W. Lafayette, Detroit MI 48231. (313)222-2620. Editor: Lisa K. Velders. Sunday weekly magazine. Circ. 860,000. "We want stories on any subject of interest to the residents of our state. We're looking for the offbeat, the unusual, especially in people or profiles. Please, no changing leaves." Readers are "mix of blue and white-collar; local (Detroit) and regional (statewide).

Photo Needs: Uses 10-20 photos/issue; 5-10 supplied by freelance photographers. "We need ideas more than photos. Local needs for assigned stories are well filled by a competitive freelance market. We need interesting people or places beyond the Detroit area." Prefers photos with mss. Model release and captions required.

Making Contact & Terms: If local, arrange interview; if out-of-state, send samples with SASE. Reports in 1 month. Pays \$350/color cover photo; \$100/b&w and \$150/color page. Pays on publication.

Credit line given. Buys one-time rights.

Tips: Prefers to see "a certain level of technical competence" in a photographer's portfolio or samples. "Find something, or someone, interesting that we don't know about and team up with a good writer. Complete packages, especially from out-of-state, sell well."

MILKWEED CHRONICLE, Hennepin Center for the Arts, Room 508, 528 Hennepin Ave., Minneapolis MN 55403. Send mail to: Box 24303, Minneapolis MN 55424. (612)332-3192. Editor-in-Chief: Emilie Buchwald. Art Director: Randall W. Scholes. Magazine published 3 times/year. Circ. 5,000. Emphasizes "poetry and graphics and the relationship therein." Readers are interested in "poetry, Design and Art and in between." Sample copy \$4; one free to published artists with discount for further issues.

Photo Needs: Uses about 15 photos/issue; all are supplied by freelance photographers. Interested in poetic form, experimental, textural with meaning, varied subjects but always able to refer to the "Life

Mystery." Photos purchased with or without accompanying ms.

Making Contact & Terms: Send by mail for consideration b&w glossy prints or query with samples. SASE. Reports in 3 months—"we are working to speed process though." Provide tearsheets and examples with address to be kept on file for possible future assignments. Pays \$15/b&w cover photo; \$10-25/ b&w inside photo. "On assignment pieces we help pay for processing." Pays on publication. Credit line given. Buys one-time rights. Simultaneous submissions and/or previously published work OK. Tips: Prefers to see a wide range of subjects; quality, diversity and vision. "Look over our themes, and don't be scared by the titles-we are just covering a large area; think what may be a subtext."

THE NATIONAL DAIRY NEWS, Box 951, Madison WI 53701. (608)222-0777. Editor-in-Chief: Jerry Dryer. Weekly. Circ. 4,000. Emphasizes dairy marketing and processing. Readers are dairy plant

personnel, food brokers, imports. Sample copy 50¢ with SASE.

Photo Needs: Uses about 3-6 photos/issue; 1-2 supplied by freelance photographers. Needs photos "to illustrate stories." Model release and captions required. Query with samples or send 8x10 glossy b&w prints by mail for consideration. SASE. Reports in 1 month. Pays \$50/b&w cover photo and inside photo. Pays on publication. Credit line given. Buys one-time rights. Simultaneous submissions OK.

NATIONAL ENQUIRER, Lantana FL 33464. (305)586-1111. Contact: Photo Editor. Weekly tabloid. Circ. 4,512,689. Emphasizes celebrity, investigative and human interest stories. For people of all ages. Needs color and b&w photos: humorous and offbeat animal pictures, unusual action sequences, good human interest shots and celebrity situations. Buys first North American rights. Present model release on acceptance of photo. Query with resume of credits or send photos for consideration. Pays on publication. Returns rejected material; reports on acceptances in 2 weeks. SASE.

B&W: Send contact sheet or any size prints or transparencies. Short captions required. Pays \$50-190. Color: "If it's a color shot of a celebrity, we'll pay \$200 for the first photo," and more if it's in a se-

quence. For a noncelebrity color shot, pay is \$160 for the first photo.

Cover: Pays up to \$1,440.

Tips: "If you have anything amusing or that you think would be of interest to our readers, please send it in. We're happy to take a look. If we can't use your photos, we'll return them to you immediately. If you have any questions, call us.'

NATIONAL NEWS BUREAU, (formerly ElectriCity), 2019 Chancellor St., Philadelphia PA 19103. (215)569-0700. Editor: Andrea Diehl. Weekly syndication packet. Circ. 1,000 member publications. Emphasizes entertainment. Readers are "youth-oriented, 17-45 years old." Sample copy \$1.

Photo Needs: Uses about 20 photos/issue; 15 supplied by freelance photographers. Captions required.

Making Contact & Terms: Arrange a personal interview to show portfolio; query with samples; submit portfolio for review. Send 8x10 b&w prints, b&w contact sheet by mail for consideration. SASE. Reports in 1 week. Pays \$50 minimum/job. Pays on publication. Credit line given. Buys all rights.

NATIONAL VIETNAM VETERANS REVIEW, Box 35812, Fayetteville NC 28303-0812. (919)484-2343. Editor: Chuck Allen. Monthly tabloid. Circ. 30,000-35,000. Emphasizes Indochina, Southeast Asia, primarily the Vietnam War period. Readers are "29-60 years of age, Vietnam era veterans, veterans hospitals, organizations and families." Sample copy and photo guidelines free with SASE.

Photo Needs: Uses about 20-25 ("we need more!") photos/issue; all supplied by freelance photographers. Needs historical, individual, military equipment and action photos. Special needs include strong combat, emotional, unique, good general subject photos that tell the whole story in one shot.

Captions preferred.

Making Contact & Terms: Send 5x7 or 8x10 b&w glossy prints by mail for consideration. SASE. Reports in 1 month. "So far photos have been contributed and photographers paid by subscription. If real good we'll negotiate." Pays on publication. Credit line given. Simultaneous submissions and previously published work OK.

Tips: "You're probably a Nam vet or Vietnam era veteran with a story to tell. Stories with photo get first billing. Good action shot receives cover position. News photos are always in demand, such as Vietnam

marchers in Washington, etc."

Being in the right place at the right time can lead to the publication of your photos worldwide. Quakertown, Pennsylvania, freelance photographer Joseph Edelman shot this accident scene, and the resulting photo has been published by Globe, the National Enquirer and by newspapers throughout Europe and the United States. It has earned Edelman more than \$1,200 in sales so far, and has also produced profits in the legal market.

THE NEVADAN, Box 70, Las Vegas NV 89101. (702)385-4241. Editor: A.D. Hopkins. Sunday supplement tabloid. Circ. 90,000. Emphasizes history, life-styles, arts, personality but buys only history. "All photos must be accompanied by story." Credit line given. Provide business card to be kept on file for possible future assignments. Pays on publication. Buys first or second serial (reprint) rights. Previously published work OK. Send photos or query. SASE. Reports in 3 weeks. Free sample copy. Subject Needs: "There has to be enough for a layout of two pages with supporting text, but pictures can be the main part of the article. History only bought from freelancers. Mostly copies of old photos and photos of present places and living people who were involved in area history. Remember we must have a regional angle, but that includes the entire state of Nevada, southern Utah, northern Arizona and desert counties of California. No celebrity stuff; no color prints, Polaroid or Instamatic photos; and nothing without a regional angle. No photo essays without a supporting story, although stories may be short." Captions are required.

B&W: Uses 5x7 or 8x10 prints. Pays \$10/print plus \$60 for supporting text. Cover: Uses 35mm or larger (uses a lot of 120mm) transparencies. Pays \$15 for color.

Accompanying Mss: "We use a lot of Nevada history: A good deal of it is oral history based on still-living people who participated in early events in Nevada; photos are usually copies of photos they own or photos of those people as they are today, usually both. Stories are sometimes based on diaries of now deceased people, or on historical research done for term papers, etc. Once published a complete description of how to play mumblety-peg and how to score it, which was almost all close-up pictures of a pocket knife. Use how-to-do-its on pioneer lore."

Tips: "Read the writer's guideline. Believe us when we tell you we won't buy photo essays without accompanying mss, and when we tell you we won't buy anything but history. Lack of good accompanying

photos is now the main reason we reject mss.'

NEW ENGLAND ENTERTAINMENT DIGEST, Box 735, Marshfield MA 02050. (617)837-0583. Editor/Publisher: Paul J. Reale. Bimonthly. Circ. 17,000. Emphasizes entertainment. Readers are theatergoers, theater owners, performers, singers, musicians, moviemakers, production companies, film/ video producers, theatrical suppliers, dancers. Free sample with SASE.

Photo Needs: Uses about 23-33 photos/issue. Needs photos of New England entertainment. Photos purchased with accompanying ms only. Department needs: centerfold, featuring a performer or group.

Model release optional; captions required.

Making Contact & Terms: Send by mail for consideration b&w prints. SASE. Reports in 1 month. Pays \$2.50/b&w cover photo. Pays on publication. Credit line given. Buys one-time rights. Simultaneous submissions and previously published work OK.

NEW ENGLAND SENIOR CITIZEN/SENIOR AMERICAN NEWS, 470 Boston Post Rd., Weston MA 02193. Editor: Ira Alterman. Monthly newspaper. Circ. 60,000. For men and women ages 60 and over who are interested in travel, finances, retirement life-styles, special legislation and nostalgia. Photos purchased with or without accompanying ms. Buys 1-3 photos/issue. Credit line given, if requested. Pays on publication. Buys first serial rights. Send material by mail for consideration. SASE. Simultaneous submissions and previously published work OK. Reports in 4-6 months.

Subject Needs: Animal, celebrity/personality, documentary, fashion/beauty, glamour, head shot, howto, human interest, humorous, nature, photo essay/photo feature, scenic, sport, still life, travel and wildlife. Needs anything of interest to people over 60. Model release required; captions preferred.

B&W: Uses 5x7 and 8x10 glossy prints; contact sheet OK. Pays \$5 minimum/photo.

Cover: Uses b&w glossy prints. Vertical or square format preferred. Pays \$20 minimum/photo.

Accompanying Mss: Pays 25¢/inch.

NEW YORK ANTIQUE ALMANAC, Box 335, Lawrence NY 11559. (516)371-3300. Editor: Carol Nadel. Monthly tabloid. Circ. 52,000. Emphasizes antiques, art, investment and nostalgia for collectors and dealers. Buys 55 photos/year. Buys all rights, but may reassign to photographer after publication. Send photos for consideration. Pays on acceptance. Reports in 6 weeks. SASE. Free sample copy and photo guidelines.

Subject Needs: Photo essay/photo feature, spot news, human interest, antiquing travel information and features on antique shop or dealer with unusual collection. Needs photos of "collectors at flea markets and the expressions of the collector or dealer. Photo coverage of antique shows, auctions and flea mar-

kets highly desirable." No unrelated material.

B&W: Send semigloss prints. Captions required. Pays \$5-10.

Tips: Captions must include name and address of the individual in the photo, the price of the item depicted, the location, and a general description of the activity. Includes coverage of art and antiques shows, auctions, fairs, flea markets and major antiques shows in the U.S., Canada and abroad.

THE NEWSDAY MAGAZINE, Newsday, Long Island NY 11747. (516)454-2308. Editor: John Montorio. Managing Editor: Stanley Green. Graphics Director: Miriam Smith. Sunday newspaper supplement. Circ. 600,000. Buys photos with accompanying ms or on assignment. Pays \$75-400/job; payment for text/photo depends on length. Credit line given. Pays on publication. Buys one-time rights. Phone first, then send material by mail for consideration. SASE. Work previously published in another area OK. Reports in 2 weeks.

Subject Needs: No photos without text. Model release preferred; captions required.

B&W: Uses 8x10 glossy or semigloss prints; contact sheet and negatives OK.

Color: Uses transparencies.

Cover: Uses b&w glossy or semigloss prints or negatives; contact sheet OK; or any size color transparency. Square format required. Cover must be part of accompanying story. Pays \$400 maximum/ms. Tips: "Most magazines prefer package of words and photos. If you can write well, half the battle is won. Examine the magazines you intend to submit to in order to see if what is being offered is their style.'

NEWSERVICE, Box 5115, Phoeniz AZ 85010. (602)257-0764. Editor: James D. Parker. Bimonthly. "Newservice is an innovative, alternative magazine on behavior, health, and current events and breaking developments in substance use, consciousness, media, sexuality, technology, health . . . life.' Readers are "general and professional, up-scale, alternative." Circ. 7,000. Sample copy \$2.

Photo Needs: Uses about 10-30 photos/issue; 10-15 supplied by freelance photographers. Photographers "should check with editor regarding future needs; people are important but on a specified basis." Special needs include "substance: interesting, documentary-style shots of illicit substances; people; newsmakers in our areas (alternatives, authorities) preferably on assignment; other as needed.'

Making Contact & Terms: Query with samples. SASE. Reports in 1 month. Pays \$50-150/b&w cover photo; \$5-50/b&w inside photo. Pays on publication. Credit line given. Buys one-time rights. Simulta-

neous and previously published submissions OK.

Tips: Prefers to see "action-oriented (no press release types); studio shots okay for inanimates; fresh and original style. Clear and simple (avoid multiple distracting elements). Abstract okay if it fits with the ms style."

NORTHWEST MAGAZINE/THE OREGONIAN, 1320 SW Broadway, Portland OR 97201. (503)221-8235. Graphics Coordinator: Kevin Murphy. Sunday magazine of daily newspaper. Emphasizes stories and photo essays of Pacific Northwest interest. "Estimated readership of 1,000,000 is affluent, educated, upscale." Sample copy and photo guidelines available.

Photo Needs: Uses about 12-15 photos/issue; 4-6 supplied by freelance photographers. Needs photos "depicting issues and trends (as identified in stories), travel, scenics, interiors, fashion. Will need photographers with interest in home decor, interiors, architecture, fashion." Model release and captions

preferred.

Making Contact & Terms: Arrange a personal interview to show portfolio. Does not return unsolicited material. Reports in 3 weeks. Pays \$350/color inside spread; \$25/b&w inside photo; \$100-200/half day. Pays on acceptance. Credit line given. Buys one-time rights. Previously published work OK "but we want first-time rights in Pacific Northwest."

Tips: Prefers to see "examples of b&w and color, preferably showing range of style (portraits, editorial,

landscape, interiors). Try repeatedly."

NOSTALGIA WORLD, Box 231, North Haven CT 06473. (203)239-4891. Editor: Bonnie Roth. Bimonthly tabloid. Circ. 4,000. "Nostalgia World Magazine, for collectors and fans, covers a broad range of topics dealing with the entertainment industry." Sample copy \$2. Photo guidelines free with SASE. Photo Needs: Uses about 15-20 photos/issue; various number supplied by freelance photographers. Needs "older photos of entertainers, photos of collectibles to tie in with ms." Photos purchased with accompanying ms only. "Always looking for sharp, clear photos of rare, unique collectible items. Query first." Model release and captions required.

Making Contact & Terms: Query with samples. Send 4x5 or larger b&w prints by mail for consideration. SASE. Reports in 2 weeks. Pays \$20/b&w cover photo; \$7/b&w inside photo. Pays on publication. Credit line given. Buys all rights. Simultaneous submissions and previously published work OK. Tips: "We use photos of collector's items-rare collectibles; usually in conjunction with a story.

NUMISMATIC NEWS, 700 E. State St., Iola WI 54990. (715)445-2214. Editor: David C. Harper. Weekly tabloid. Circ. 50,000. Emphasizes news and features on coin collecting. Photos purchased only on assignment. Buys 50-75 photos/year. Pays \$40 minimum/job or on a per-photo basis. Credit line given. Pays on publication. Buys all rights, but may reassign to photographer after publication. Phone or write for consideration. SASE.

Subject Needs: Spot news (must relate to coinage or paper money production or the activities of coin collectors). No photos of individual coins unless the coin is a new issue. Captions required.

B&W: Uses 5x7 prints. Pays \$3-25/photo.

Cover: Uses b&w and color prints. Format varies. Pays \$5 minimum/b&w photo and \$25 minimum/ color photo.

Accompanying Mss: Needs "documented articles relating to issues of coinage, medals, paper money, etc., or designers of same." Pays \$30-100/ms.

Tips: "Devise new techniques for covering coin conventions and depicting the relationship between collectors and their coins.

OBSERVER NEWSPAPERS, 2262 Centre Ave., Bellmore NY 11710. (516)679-9888 or 679-9889. Editor-in-Chief: Jackson B. Pokress. Weekly newspaper. Circ. 50,000. Emphasizes general news with special emphasis on all sports. "We cover all New York metropolitan sports on a daily basis." Readers are teens to senior citizens; serving all areas of Long Island. Photo guidelines with SASE.

Photo Needs: Uses about 25-30 photos/issue; "some" are supplied by freelance photographers. Needs photos on general news, sports and political leaders. Photos purchased with or without accompanying

ms. Model release and captions required.

Making Contact & Terms: Send by mail for consideration 8x10 b&w prints, b&w contact sheet or negatives; arrange a personal interview to show portfolio or query with samples. SASE. Reports in 2 weeks. Provide business card and tearsheets to be kept on file for possible future assignments. Pays \$10/inside b&w photo. Pays on publication. Credit line given. Buys one-time rights or all rights. Simultaneous submissions OK.

Tips: Prefers to see "sampling of work-news, spot news, sports, features and sidebars."

OK MAGAZINE, Sunday Magazine of Tulsa World, Box 1770, Tulsa OK 74102. (918)581-8345. Editor: Terrell Lester. Weekly newspaper magazine. Circ. 240,000. Emphasizes general interest, people, trends, medicine, sports, entertainment, food and interior design. Readers are "mostly adult, middle income." Sample copy available.

Photo Needs: Uses about 10-12 photos/issue; 1-2 supplied by freelance photographers. "We accept unsolicited travel photos as well as photo layouts of regional interest." Model release and captions pre-

ferred.

Making Contact & Terms: Query with samples or list of stock photo subjects; send 8x10 b&w prints, 35mm or 21/4x21/4 b&w transparencies or good color prints by mail for consideration. SASE. Reports in 3 weeks. Pays \$75/color cover photo; \$30/b&w inside photo, \$40/color inside photo. Pays on publication. Credit line given. Previously published work OK. **Tips:** Send "timely photos early enough that we can use them—we work a month, at least, in advance of publication."

OLD CARS NEWSPAPER, 700 E. State St., Iola WI 54990. (715)445-2214. Editor: John Gunnell. Weekly tabloid. Circ. 96,500. "Old Cars is edited to give owners of collector cars (produced prior to 1970) information—both of a news and of a historical nature—about their cars and hobby." Photos used with or without accompanying ms, or on assignment. Use 35 photos/issue. Credit line given. Buys all rights, but may reassign to photographer after publication. Send material by mail for consideration. Provide calling card and samples to be kept on file for future assignments. SASE. Reports in 2 weeks. Sample copy 50¢.

Subject Needs: Documentary, fine art, how-to (restore autos), human interest ("seldom—no 'I did it myself' restoration stories"); humorous, photo essay/photo feature and spot news (of occasional wrecks involving collector cars). Wants on a regular basis photos of old cars along with information. "No pho-

tos of Uncle Joe with the Model A Ford he built in his spare time." Captions preferred.

B&W: Uses 5x7 glossy prints.

Color: Note—color photos will be printed in b&w. Uses 5x7 glossy prints.

Accompanying Mss: Brief news items on car shows, especially national club meets. Occasionally covers "swap meets."

ON TRACK, Unit M, 17165 Newhope St., Fountain Valley CA 92708. (714)966-1131. Editor: Jess Briem. Bimonthly magazine. Emphasizes auto racing. Readers are auto racing enthusiasts. Sample copy \$1.50. Photo guidelines free with SASE.

Photo Needs: Uses about 75 photos/issue; all supplied by freelance photographers. Needs photos of au-

to racing action and drivers. Special needs filled by assignment. Captions preferred.

Making Contact & Terms: Send 5x7 or 8x10 glossy b&w prints with borders; 35mm transparencies by mail for consideration. SASE. Reports in 1 month. Pays \$75/color cover photo; \$10/b&w inside photo. Pays on publication. Credit line given. Buys first North American serial rights. Simultaneous and previously published submissions OK.

PARADE, 750 3rd Ave., New York NY 10017. (212)573-7000. Editor: Walter Anderson. Photo Editor: Brent Petersen. Weekly newspaper magazine. Circ. 22,000,000. Emphasizes news-related features concerning celebrities, education, medicine and lifestyles. For general audiences. Needs photos of personalities and current events. Buys 30 photos/issue. Buys first rights. Query first with resume of credits. Pays on publication. Reports in 2 weeks. SASE. Previously published work OK.

B&W: Pays \$75 minimum/inside photo.

Cover: Uses transparencies. Captions required. Pays \$500-750.

Tips: "We are looking for a good photojournalistic style."

PARENTS' CHOICE, A REVIEW OF CHILDREN'S MEDIA, Box 185, Wabon MA 02168. (617)332-1298. Editor-in-Chief: Diana H. Green. Emphasizes children's media. Readers are parents,

teachers, librarians and professionals who work with parents. Sample copy \$1.50.

Photo Needs: Uses photos occasionally. Needs "photos of parents and children; children's TV, books, movies, etc. and children participating in these media." Column Needs: Parents' Essay, Opinion, Profile use photos of the author and the subject of interview. Model release not required; captions required. Making Contact & Terms: Send sample photos. Arrange personal interview to show portfolio. Provide brochure, flyer and samples to be kept on file for future assignments. SASE. Pays on publication \$20/photo. Credit line given.

PC WEEK, 15 Crawford St., Needham MA 02194. (617)449-6520. Art Director: Albert Rudolph. Weekly tabloid. Emphasizes IBM PC's. Readers are IBM PC users. Estab. 1984. Sample copy availa-

Photo Needs: Uses about 15-30 photos/issue; half supplied by freelance photographers. Needs photos of "business, PC's and users." Model release preferred; captions optional.

Making Contact & Terms: Arrange a personal interview to show portfolio; provide resume, business card, brochure, flyer or tearsheets to be kept on file for possible future assignments. Does not return unsolicited material. Reports in 2 weeks. Payment varies. Pays on publication. Credit line given. Buys one-time rights.

PHOTOFLASH MODELS & PHOTOGRAPHERS NEWSLETTER, Box 7946, Colorado Springs CO 80933. Editor-in-Chief: Ron Marshall. Quarterly. Readers are models, photographers, publishers, picture editors, agents and others involved in the interrelated fields of modeling and photography. Sam-

Photo Needs: "Wanted are crisp, clear high-contrast b&w glossy prints of all types of models—face. figure, fashion, glamour, etc. Photo sets encouraged. Include model releases and complete captions regarding both the model(s) and the photo(s). Don't send 'samples'; send pictures we can use for our cover and to illustrate articles inside. Also needs how-to photos illustrating specific modeling or photographic tricks and techniques." Model release and captions required.

Making Contact & Terms: Send material by mail for consideration. Uses 8x10 b&w prints. SASE. Reports in 3-4 months. For "Showcase" photos, pays with credit line and contributor copies. For photo/ text packages (how-to photo-illustrated "Special Reports"), pays lump sum of approximately \$15-25, depending on quality and completeness of set. Credit line given. Payment on publication. Buys one-

time rights. Simultaneous and previously published work OK.

Tips: "Be professional. Yes, I know that's what everybody else says, too. So perhaps the word needs to be defined. To be professional means to be informed—about your craft, your competition, the marketplace. It means to be mature, responsible. Establish a reputation for producing visually exciting, technically perfect images, on time, within budget, without hassle, and you'll always be in demand."

PHOTOGRAPHER'S MARKET NEWSLETTER, 9933 Alliance Rd., Cincinnati OH 45242. (513)984-0717. Editor: Robin Weinstein. Monthly. Circ. 2,500. Emphasizes the business and marketing aspects of freelance photography. Readers are photographers interested in selling their work. Sample copy \$3.50.

Photo Needs: Uses about 3 photos/issue; all supplied by freelance photographers. Needs previously published photos as examples of marketable work; also needs photo/text packages on any aspect of freelance photography. Photos purchased with accompanying ms only. Model release preferred; cap-

tions required.

Making Contact & Terms: Query with resume of credits; send 8x10 b&w glossy prints by mail for consideration. SASE. Reports in 1 month. Pays \$25 or a one-year subscription/b&w inside photo; \$100 minimum for text/photo package. Pays on publication. Credit line given. Buys one-time rights. Previously published work OK.

Tips: "Captions accompanying previously published photos should tell something about the photographer; how he happened to get the photo or assignment; who bought it and for how much; how and why

the photo was used. Query on article ideas."

THE PRODUCE NEWS, 2185 Lemoine Ave., Fort Lee NJ 07024. (201)592-9100. Editor: Melvina B. Bauer. Weekly tabloid. Circ. 6,000. For people involved with the fresh fruit and vegetable industry: growers, shippers, packagers, brokers, wholesalers and retailers. Needs feature photos of fresh fruit and vegetable shipping, packaging, growing, display, etc. Buys 5-10 annually. Buys feature stories with photos. Send photos for consideration. Pays on publication. Reports in 45 days. SASE. Free sample copy and photo guidelines.

B&W: Send 4x5 or larger glossy prints. Captions required. Pays \$8-15.

RADIO & TELEVISION PROMOTION NEWSLETTER, Drawer 50108, Lighthouse Point FL 33064. (305)426-4881. Publisher: William N. Udell. Monthly newsletter emphasizing radio, TV and cable. Circ. 600. Readers are owners, managers, and program director of stations. Sample copy free with SASE.

Photo Needs: Uses about 6 photos/issue; 1 supplied by freelance photographers. Needs photos of "special, unusual promotional programs of radio and TV stations-different.'

Making Contact & Terms: Send 4x5 or smaller b&w/color prints by mail for consideration, or "call and say you got something." SASE. Reports in 2 weeks. Pays \$5-10/b&w inside. Pays on acceptance. Credit line given "if desired." Buys one-time plus reprint rights. Simultaneous submissions and previously published work OK.

ROLLING STONE, 745 5th Ave., New York NY 10151. Photo editor: Laurie Kratochvil. Associate Photo Editor: Stephanie Allen. Emphasizes all forms of entertainment (music, movies, politics, news

Photo Needs: "All our photographers are freelance." Provide brochure, calling card, flyer, samples and tearsheet to be kept on file for future assignments. Needs famous personalities and rock groups in b&w and color. No editorial repertoire. SASE. Reports immediately. Pays \$150-300/day.

Tips: "Drop off portfolio at front desk any Wednesday between 10 am and noon. Pickup same day between 4 pm and 6 pm or next day. Leave a card with sample of work to keep on file so we'll have it to remember."

SAILBOARD NEWS, Box 159, Fair Haven VT (802)265-8153. Editor: Mark Gabriel. Monthly magazine. Circ. 19,000. Emphasizes boardsailing retailing. Readers are trade and competitors in boardsail-

Close-up

Laurie Kratochvil, Photo Editor, Rolling Stone Magazine

From the beginning, starting with photographer Annie Leibovitz, Rolling Stone has always captured people in a private light, hoping to give its readers a more personal look at very public people. "What you can see everyday on stage or screen isn't what I believe people want from Rolling Stone. Therefore, I always try to work with photographers who can unmask the subject while still keeping him comfortable enough to project a vulnerable side—to 'take' a picture rather than 'make' a picture," says Laurie Kratochvil, photo editor at Rolling Stone

ing Stone.

One particularly successful photographer in this vein is Bonnie Schiffman, who photographed comedian Steve Martin for a November 1984 cover. "She has a great sense of humor, but she's also extremely sensitive. She seems to understand her subject's strong and weak points almost immediately, which is important because you usually have very little time to complete the photos. I am currently working with Deborah Feingold quite a bit and am very excited about the energy she brings to her photos," Kratochvil says. Feingold's portrait of David Letterman appeared on a June 1985 cover.

Rolling Stone, the rocking, reeling tabloid covering the latest in music, entertainment and the arts, relies totally on freelance photographers for its photos, many of which have stirred more than their share of controversy. Kratochvil offers no apologies for them. "However outlandish our covers may be at times, they still represent an image that the subject has already projected to the audience. Take our January 1985 cover photo of Billy Idol. Who else but Billy Idol would ever dream of showing up that way? The point is that we are only trying to capture a recognizable, dynamic, arresting image which works with that particular artist," Kratochvil emphasizes.

Like most larger magazines, Rolling Stone has a portfolio dropoff policy. "I prefer to see 15 to 25 pieces of work (both tearsheets and prints), which the photographer feels best expresses the work he wants to do. Too many varying styles and massive quantities of work only confuse an editor and leave him not wanting to see more.

"A small portfolio can be very effective and memorable. I also like to keep a small photo card from the photographer which I'll refer to when I'm giving assignments," she says. ing. Sample copy free with SASE and 71¢ postage. Photo guidelines free with SASE.

Photo Needs: Uses about 25 photos/issue; 15 supplied by freelance photographers. Photos purchased

with accompanying ms only. Model release optional; captions required.

Making Contact & Terms: Send b&w prints; 35mm, 21/4x21/4, 4x5 or 8x10 transparencies; or b&w contact sheet by mail for consideration. SASE. Reports in 2 weeks. Pays \$35/b&w cover photo, \$70/ color cover photo; \$10/b&w inside photo, \$20/color inside photo; \$100-300 for text/photo package. Pays 30 days after publication. Credit line given. Buys one-time rights. Simultaneous submissions and previously published work OK.

SERVICE REPORTER, Box 745, Wheeling IL 60090. (312)537-6460. Editorial Director: Ed Schwenn. Monthly tabloid. Emphasizes heating, air conditioning, ventilating and refrigeration. Circ.

40,000. Sample copy free with SASE and \$1 postage.

Photo Needs: Uses about 12 photos/issue; no more than one supplied by freelance photographer, others manufacturer-supplied. Needs photos pertaining to the field of heating, air conditioning, ventilating and refrigeration. Special needs include cover photos of interiors and exteriors of plants. Model release and captions required.

Making Contact & Terms: Query with list of stock photo subjects; query on needs of publication. SASE. Reports in 2 weeks. Pays \$50-100/color cover photo; \$10/b&w and \$25/color inside photo. Pays

on publication. Credit line given. Buys one-time rights.

SKYDIVING, Box 189, Deltona FL 32728. (904)736-9779. Editor: Michael Truffer. Readers are "sport parachutists worldwide, dealers and equipment manufacturers." Monthly newspaper. Circ.

7,000. Sample copy \$2; photo guidelines for SASE.

Photo Needs: Uses 12-15 photos/issue; 8-10 supplied by freelance photographers. Selects photos from wire service, photographers who are skydivers and freelancers. Interested in anything related to skydiving-news or any dramatic illustration of an aspect of parachuting. Model release required; captions not required.

Making Contact & Terms: Send by mail for consideration actual 5x7 or 8x10 b&w photos. SASE. Reports in 2 weeks. Pays on publication minimum \$25 for b&w photo. Credit line given. Buys one-time rights. Simultaneous submissions (if so indicated) and previously published (indicate where and when)

work OK.

SOCCER AMERICA, Box 23704, Oakland CA 94623. (415)549-1414. Editor-in-Chief: Lynn Berling. Weekly magazine. Circ. 12,000. Emphasizes soccer news for the knowledgeable soccer fan. "Although we're a small publication, we are growing at a very fast rate. We cover the pros, the international scene, the amateurs, the colleges, women's soccer, etc." Photos purchased with or without accompanying ms or on assignment. Buys 10 photos/issue. Credit line given. Pays on publication. Buys one-time rights. Query with samples. SASE. Previously published work OK, "but we must be informed that it has been previously published." Reports in 1 month. Sample copy and photo guidelines for \$1. Subject Needs: Sport. "We are interested in soccer shots of all types: action, human interest, etc. Our only requirement is that they go with our news format." Captions required.

B&W: Uses 8x10 glossy prints. Pays \$12.50 minimum/photo.

Cover: Uses b&w glossy prints. Pays \$25 minimum/photo.

Accompanying Mss: "We are only rarely interested in how-to's. We are interested in news features that pertain to soccer, particularly anything that involves investigative reporting or in-depth (must be meaty') personality pieces." Pays 50¢/inch to \$100/ms. Free writer's guidelines. SASE required. Tips: "Our minimum rates are low, but if we get quality material on subjects that are useful to us we use a lot of material and we pay better rates. Our editorial format is similar to Sporting News, so newsworthy photos are of particular interest to us. If a soccer news event is coming up in your area, query us.

SOUTH JERSEY LIVING, 1900 Atlantic Ave., Atlantic City NJ 08401. (609)345-1111. Editor: Diane D'Amico. Weekly magazine. Circ. 77,000. Emphasizes "general topics; full spectrum within family readership framework, all with South Jersey angles." Photos purchased with or without accompanying ms. Buys 200 photos/year. Credit line given. Pays on publication. Buys one-time rights. Send material by mail for consideration. SASE. Simultaneous submissions and previously published work OK. Reports in 1 month. Free sample copy and photo guidelines.

Subject Needs: Animal, celebrity/personality, documentary, fashion/beauty, fine art, glamour, head shot, how-to, human interest, humorous, nature, photo essay/photo feature, product shot, scenic, special effects/experimental, sport, still life, travel and wildlife. All must have South Jersey angle. Cap-

tions required.

B&W: Uses 8x10 glossy prints. Pays minimum \$10/photo.

Cover: Uses b&w glossy prints. Vertical format required. Pays minimum \$25/photo.

Accompanying Mss: Seeks mss with strong South Jersey angle. Pays \$75-125. Free writer's guidelines.

THE SOUTHEASTERN LOG, Box 7900, Ketchikan AK 99901. (907)225-3157. Editor: Nikki Murray Jones, Monthly tabloid, Circ. 26,000. Emphasizes general interests of southeast Alaskans, including fishing (commercial and sport), general outdoors, native and contemporary arts, etc. For residents of southeastern Alaska and former residents and relatives living in mainland US. Buys 15 photos/issue. Not copyrighted. Query with resume of credits or send photos for consideration. Pays on publication. Reports in 3 weeks. SASE. Free sample copy and photo guidelines.

Subject Needs: General news and feature photos about southeastern Alaska "that show the character of this island region and its residents." Animal, fine art, head shot, how-to, human interest, humorous, nature, photo essay/photo feature, spot news, travel and wildlife. "Photos used most are those accompanying copy and showing the people, fishing, timber, marine and air transportation 'flavor' of the

southeast.

B&W: Send 5x7 or 8x10 glossy prints. Captions required. Pays \$10.

Cover: Send color slides. Captions required. Shots must be taken within the past 18 months and related

to the copy accepted for the same issue. Pays \$25 and up.

Tips: "We need sharp, uncluttered photos that convey the story in a single glance. The best submission is a package of both story and photos, but photo essays are used if cutlines and visual images contain sufficient information to relate the message."

SOUTHERN MOTORACING, Box 500, Winston-Salem NC 27102. (919)723-5227. Associate Editor: Greer Smith. Editor/Publisher: Hank Schoolfield. Biweekly tabloid. Emphasizes autoracing. Readers are fans of auto racing. Circ. 18,000-19,000. Sample copy 50¢.

Photo Needs: Uses about 10-15 photos/issue; 5-8 supplied by freelance photographers. Needs "news photos on the subject of Southeastern auto racing." Photos purchased with accompanying ms only.

Model release optional; captions required.

Making Contact & Terms: Query with samples; send 5x7 or larger matte or glossy b&w prints; b&w negatives by mail for consideration. SASE. Reports in 1 month. Pays \$25-50/b&w cover photo; \$5-25/ b&w inside photo; \$50-100/page. Pays on publication. Credit line given. Buys first North American serial rights. Simultaneous submissions OK.

"We're looking primarily for news pictures, and staff produces many of them—with about 50% coming from freelancers through long-standing relationships. However, we're receptive to good photos from new sources, and we do use some of those. Good quality professional pictures only, please!"

THE SPORTING NEWS, 1212 N. Lindberg Blvd., St. Louis MO 63132. (314)997-7111. Contact: Ben Henkey. Weekly tabloid. Emphasizes major league and minor league baseball, pro and college football, pro and college basketball, pro hockey and major sporting events in other sports. Readers are 18-80 years old, 75% male, sports fanatics. Circ. 700,000. Sample copy \$1.75. Photo guidelines free with SASE.

Photo Needs: Uses about 25 photos/issue; all supplied by freelance photographers. Needs photos of athletes, posed or in action, involved in all sports covered by the magazine. Captions required.

Making Contact & Terms: Send 8x10 b&w glossy prints, 35mm transparencies by mail for consideration. SASE. Pays \$300/color cover photo; \$50/b&w inside photo; \$350/day for assignments. Pays on publication. Credit line given for covers only. Buys one-time rights on covers; all rights on b&w photos. Tips: "Once accepted, call for tips on upcoming needs."

THE STAR MAGAZINE, The Indianapolis Star, 307 N. Pennsylvania St., Indianapolis IN 46206. Editor: Fred D. Cavinder. Weekly newspaper magazine. Circ. 380,000. For general audiences interested in Indiana, particularly the central part of the state. Needs photos with an Indiana angle. Buys 150 photos/year. Copyrighted. Query first with resume of credits. Photos purchased with accompanying ms: we are interested in photo layouts of interest to Indianians, but they must have some accompanying text." Pays on publication. Reports in 2 weeks. SASE. Simultaneous submissions OK. Free sample

B&W: Send 8x10 glossy, matte or semigloss prints. Captions required. Pays \$5-7.50.

Color: Send transparencies. Captions required. Pays \$7.50-10.

SUBURBIA TODAY, 1 Gannett Dr., White Plains NY 10604. Editor: Meryl Harris. Weekly. Circ. 200,000. Readers are "affluent suburban families and singles." Sample copies available "each week at the newsstand."

Photo Needs: Number and type of photos accepted varies. Photos purchased with accompanying ms on-

ly. Model release and captions required.

Making Contact & Terms: Arrange a personal interview to show portfolio. Provide resume and brochure to be kept on file for possible future assignments. SASE. Reports in 2 weeks. Payment per photo varies; pays \$100-300 for text/photo package. Pays on publication. Credit line given. Buys one-time rights. Simultaneous submissions and previously published work OK, "if we have local exclusivity." Tips: Prefers to see "imagination, enterprise and style; interpretation on difficult assignments."

SUBURBAN NEWS PUBLICATIONS, (formerly *The Booster*), 919 Old W. Henderson Rd., Box 2092, Columbus OH 43220. (614)451-1212. News Editor: Marty Rozenman. Weekly. Includes: Tri-Village News, Northland News, Booster, Upper Arlington News, N.W. Columbus News, Westerville Suburbia News, Worthington Suburbia News, Dublin Suburbia News. Combined Circ: 100,000 + . "We are a weekly, community suburban newspaper."

Photo Needs: Uses about 30 photos/issue. "Features involving people in the community, sports, arts." **Making Contact & Terms:** Does not buy nonlocal, nonassigned photos. Make appointment, provide resume, and portfolio to establish background. Stringer work is available, particularly in sports. Com-

pensation to be established. Credit line given.

SUNDAY WOMAN, 235 E. 45th St., New York NY 10017. (212)682-5600. Editor: Merry Clark. Weekly. "We are a Sunday supplement in a tabloid format—similar to *Parade* and *Family Weekly* with a general newspaper audience but oriented to women." Circ. 4,000,000. Sample copy free with 9x12 SASE.

Photo Needs: Uses about 10 photos/issue; 1-2 supplied by freelance photographers. Need "celebrity

color for covers, b&w of notables." Model release preferred; captions optional.

Making Contact & Terms: Query with samples; "please don't call." SASE. Reports in 1 week. Payment varies—"no price structure." Pays on acceptance. Credit line given. Buys one-time rights. Previously published submissions OK.

SUNSHINE MAGAZINE, 101 N. New River Dr. E., Box 14430, Ft. Lauderdale FL 33302. (305)761-4024. Editor: John Parkyn. "Sunshine is a Sunday newspaper magazine emphasizing articles of interest to readers in the Broward and Palm Beach Counties region of South Florida. Readers are "the 600,000 readers of the Sunday edition of the Fort Lauderdale News & Sun-Sentinel." Sample copy and photo guidelines free with SASE.

Photo Needs: Uses about 12-20 photos/issue; 30% supplied by freelance photographers. Needs "all kinds of photos relevant to the interests of a South Florida readership." Photos purchased with accom-

panying ms or text-block only. Model release and captions preferred.

Making Contact & Terms: Query with samples; provide resume, business card, brochure, flyer or tearsheets to be kept on file for possible future assignments. SASE. Reports in 1 month. "All rates negotiable; the following are as a guide only." Pays \$200-300/color cover photo; \$50/b&w and \$75/color inside photo; \$150/color page; \$250-1,000 for text/photo package. Pays on acceptance. Credit line given. Buys one-time rights. Simultaneous and previously published submissions OK.

Tips: "Study the magazine and our guidelines."

*TEMPO DE VALLE, Suite 630, 2 E St., Santa Rosa CA 95404. (707)528-1364. Editor: Shelley Ocaiva. Photo Editor: Shelley Ocana. Bimonthly newspaper. Emphasizes culture and travel; bilingualism (Spanish, English), Mexico and Latin American countries. Readers include Hispanics and Americans interested in Hispanic culture and travel. Circ. 20,000. Free sample copy with SASE.

Photo Needs: Uses 6 photos/issue; 4 supplied by freelance photographers. Needs scenic and travel/photos of Mexico or cultural events regarding Hispanic interests. Reviews photos with or without accom-

panying ms. Model release and captions preferred.

Making Contact & Terms: Query with samples; send 3x5 b&w prints by mail for consideration. Does not return unsolicited material. Reports in 2 weeks. Pays on publication. Credit line given. Buys one-time rights. Previously published work OK.

TIMES NEWS, 1st & Iron St., Lehighton PA 18235. (215)377-2051. Editor-in-Chief: Robert Parfitt. Daily. Circ. 17,000. Emphasizes local news. Readers are a general middle and low income audience. Sample copy 15¢.

Photo Needs: Uses about 50 photos/issue; 30 are supplied by freelance photographers. Needs "mostly local interest, especially with local people and sometimes news of a firm with local ties." Photos purchased with or without especially with our mithout especially with especially with our mithout especially with our mithout especially with especially with especially with especially with especially especially with especially especially especially especially with especially espec

chased with or without accompanying ms. Captions preferred.

Making Contact & Terms: Send by mail for consideration b&w prints of any size. SASE. Reports in 1 week. Pays \$3.50/b&w cover photo and b&w inside photo. Pays on acceptance. Credit line "not usually" given. Buys one-time rights. Previously published work OK.

THE TIMES-PICAYUNE/THE STATES-ITEM, 3800 Howard Ave., New Orleans LA 70140. (504)586-3560/586-3686. Editor: Charles A. Ferguson. Executive Photo Editor: Jim Pitts. Photo Editor: Robert W. Hart. Daily newspaper. Circ. 280,000. For general audiences. Needs "feature photos with South Louisiana/South Mississippi flavor." Spot news photos should be from the New Orleans area only. Wants no photos of familiar local gimmicks, tricks, scenes or photos lacking people. Send photos for consideration. All work with freelance photographers on assignment only basis. Pays on publication. Reports in 2 weeks. SASE. Simultaneous submissions OK "as long as it's not in the same circulation area."

B&W: Send 8x10 glossy or matte prints. Captions required. Pays \$25-30.

Color: Send transparencies, but rarely uses. Captions required. Pays \$25 minimum.

Tips: "We would like creative, perceptive feature photos. Use a different slant. Submit seasonal material 2 weeks in advance."

*TRIBUNE CHRONICLE, 240 Franklin S.E., Warren OH 44482. (216)841-1600. Executive Editor: Carl A. Basic. Daily. Circ. 42,000. Free sample copy and photo guidelines with SASE.

Photo Needs: Uses about 20 photos/issue; 0-1 are supplied by freelance photographers. Needs "action or aesthetic-preferably local." Photos purchased with or without accompanying ms. Model release optional; captions preferred.

Making Contact & Terms: Send by mail for consideration b&w and color prints. SASE. Reports in 1 month. Provide resume to be kept on file for possible future assignments. Pay negotiated. Pays on publication. Buys one-time rights. Simultaneous submissions and/or previously published work OK.

TRI-STATE TRADER, 27 N. Jefferson St., Box 90, Knightstown IN 46148. (317)345-5133. Editor: Tom Hoepf. News Editor: Elsie Kilmer. Weekly tabloid. Circ. 40,000. Emphasizes learning about antiques and collectibles and where to get them. Buys 10 mss with photos; 3-4 single photos/issue. Photos purchased with or without accompanying ms. Pays \$50 maximum for text/photo package or on a perphoto basis. Credit line given. Pays on publication. Buys one-time rights. Simultaneous submissions and previously published work OK. Send photos by mail for consideration. SASE. Reports in 1 month. Free photo guidelines.

Subject Needs: Fine art (individual antique pieces, not whole collections in one photo); noteworthy old homes (that are being preserved and remodeled); photo essay/photo feature (antique shows, unusual concentrations of shops and the people who run them, noteworthy collections); travel (historic sites only). No shots with too many antiques in a single photograph or subjects that are only tenuously related to antiques and collecting. Captions are required.

B&W: Uses 5x7 glossy prints. Pays \$6 maximum/print.

Accompanying Mss: Seeks well-researched stories about antiques, articles on collectors and their collections, reports on antique shows and shops, and preservation efforts in particular areas.

Tips: "Read the publication, query, give us something to choose from and take dead aim on details."

THE UNITED METHODIST REPORTER, Box 660275, Dallas TX 75266-0275. (214)630-6495. Editor: Rev. Spurgeon M. Dunnam III. Managing Editor: John A. Lovelace. Weekly. Circ. 508,000. Emphasizes "the United Methodist Church, other mainline Protestant denominations and ecumenical activity." Readers are mid-30s to mid-60s in age, above average education, middle to upper middle class. Sample free with SASE.

Photo Needs: Uses about 4-5 photos/issue; 0-2 supplied by freelance photographers. Needs "a picture that tells a story or illustrates an article related to religious themes: hope, despair, seasons of church year,

worship, children, aging, holidays." Captions preferred.

Making Contact & Terms: Send 5x7 or 8x10 b&w glossy prints by mail for consideration. SASE. Reports in 2 weeks. Pays \$10/b&w inside photo. Pays on acceptance. Credit line given. Buys one-time rights. Simultaneous submissions and previously published work OK.

UNIVERCity, 2019 Chancellor St., Philadelphia PA 19103. (215)568-0700. Editor: Andy Edelman. College weekly free tabloid distributed on 33 Philadelphia area campuses. Circ. 82,000. Readers are college students. Sample copy \$1.

Photo Needs: Uses about 20 photos/issue; 15 supplied by freelance photographers. Model release and

captions required. "We use a lot of 'campus cheesecake' coed photos."

Making Contact & Terms: Arrange a personal interview to show portfolio; query with samples; submit portfolio for review. Send 8x10 b&w prints, b&w contact sheet by mail for consideration. SASE. Reports in 1 week. Pays \$50 minimum/job. Pays on publication. Credit line given. Buys all rights. Simultaneous submissions OK.

VELO-NEWS, Box 1257, Brattleboro VT 05301. (802)254-2305. Editor: Barbara George. Published 18 times/year; tabloid. Circ. 15,000. Emphasizes national and international bicycle racing news for competitors, coaches and fans. Photos purchased with or without accompanying ms. Buys 3-10 photos/ issue. Credit line given. Pays on publication. Buys one-time rights. Send samples of work by mail or, "if immediate newsworthy event, contact by phone." Usually works with freelance photographer on assignment only basis. Provide brochure, flyer, letter of inquiry, samples or tearsheets to be kept on file for future assignments. SASE. Simultaneous submissions and previously published work OK. Reports in 2 weeks. Free sample copy.

Subject Needs: Bicycle racing and nationally important bicycle races. Not interested in bicycle touring.

Captions preferred.

B&W: Uses glossy prints. Pays \$15-20/photo.

Cover: Uses glossy prints. Vertical format required. Pays \$45 minimum/photo.

Accompanying Mss: News and features on bicycle racing. Query first. Pays \$10-75/ms.

Tips: "Get photos to us immediately after the event, but be sure it's an event we're interested in."

THE WASHINGTON BLADE, 930 F St. NW, Suite 315, Washington DC 20004. (202)347-2038. Managing Editor: Lisa M. Keen. Weekly tabloid. Circ. 20,000. Emphasizes the gay community. Readers are Gay men and Lesbians; moderate to upper level income; primarily Washington, DC metropolitan area. Sample copy \$1; free photo guidelines with SASE.

Photo Needs: Uses about 6-7 photos/issue; only out-of-town photos are supplied by freelance photographers. Needs "Gay related news, sports, entertainment events, profiles of Gay people in news, sports, entertainment, other fields." Photos purchased with or without accompanying ms. Model release and

captions preferred.

Making Contact & Terms: Query with resume of credits. SASE. Reports in 1 month. Provide resume, business card and tearsheets to be kept on file for possible future assignments. Pays \$25/photo inside. Pays within 45 days of publication. Credit line given. Buys all rights when on assignment, otherwise one-time rights. Simultaneous submissions and/or previously published work OK.

WDS FORUM, 9933 Alliance Rd., Cincinnati OH 45242. (513)984-0717. Editor: Kirk Polking. Monthly newsletter. Circ. 8,500. For students of Writer's Digest School; emphasizes writing techniques and marketing, student and faculty activities and interviews with freelance writers. Photos purchased with accompanying ms. Buys 1-2 photos/issue. Credit line given. Pays on acceptance. Buys one-time rights. Send material by mail for consideration. SASE. Simultaneous submissions and previously published work OK. Reports in 3 weeks. Sample copy 50¢.

Subject Needs: Celebrity/personality of well-known writers. No photos without related text of interest/help to writing students. Model release preferred; captions required.

B&W: Uses 8x10 glossy prints for inside or cover photos. Pays \$10/photo.

Accompanying Mss: Interviews with well-known writers on how they write and market their work; technical problems they overcame; people, places and events that inspired them, etc. 500-1,000 words. Pays \$10-25/ms.

Tips: "Get a free sample if you are interested in working with our publication."

WEEKLY WORLD NEWS, 600 S. East Coast Ave., Lantana FL 33462. (305)586-0201. Editor: Joe West. Photo Editor: Linda McKune. Weekly national tabloid sold in supermarkets. Circ. 1,000,000. Photo Needs: Uses 75-100 photos/issue; 40-50% supplied by freelance photographers. Needs "celebrity candids; human interests including children; the bizarre and the unusual; occult." Model release and captions preferred.

Making Contact & Terms: Query with list of stock photo subjects or send 5x7 or 8x10 b&w glossy prints by mail for consideration. Provide resume, business card, brochure, flyer or tearsheets to be kept on file for possible future assignments. SASE. Pays \$100/b&w cover; \$50-100/b&w inside; minimum \$100 plus mileage by the job. Pays on publication. Buys one-time rights.

WESLEYAN CHRISTIAN ADVOCATE, Box 54455, Atlanta GA 30308. (404)659-0002. Editor: William M. Holt. Weekly tabloid. Emphasizes religion. Readers are members of United Methodist Church. Circ. 31,000. Sample copy \$1.

Photo Needs: Uses about 10 photos/issue; 1 supplied by freelance photographers. Needs religious

themes of a seasonal nature. Captions preferred.

Making Contact & Terms: Query with samples; list of stock photo subjects; send 8x10 b&w prints by mail for consideration. SASE. Reports in 2 weeks. Pays \$15/b&w cover photo. Pays on acceptance. Credit line given. Buys one-time rights. Simultaneous submissions OK.

WESTART, Box 6868, Auburn CA 95604. (916)885-0969. Editor-in-Chief: Martha Garcia. Emphasizes art for practicing artists, artists/craftsmen, students of art and art patrons, collectors and teachers. Circ. 7,500. Free sample copy and photo guidelines.

Photo Needs: Uses 20 photos/issue, 10 by freelance photographers. "We will publish photos if they are in a current exhibition, where the public may view the exhibition. The photos must be b&w. We treat them as an art medium. Therefore, we purchase freelance articles accompanied by photos." Wants mss on exhibitions and artists in the western states. Model release not required; captions required.

Making Contact & Terms: Send by mail for consideration 5x7 or 8x10 b&w prints. SASE. Reports in 2 weeks. Payment is included with total purchase price of ms. Pays \$25 on publication. Buys one-time rights. Simultaneous and previously published submissions OK.

WESTERN FLYER, Box 98786, Tacoma WA 98499. (206)588-1743. Editor: Dane Sclaic. Biweekly tabloid. Circ. 25,000. General aviation newspaper for private pilots, homebuilders, and owner-flown business aviation. Readers are pilots, experimental aircraft builders. Sample copy \$2; photo guidelines

free with SASE (57¢ postage).

Photo Needs: Uses about 25-30 photos/issue; 40-50% supplied by freelance photographers. Needs photos of aircraft, destinations, aviation equipment. Photos purchased with accompanying ms only. Model

release optional; captions required.

Making Contact & Terms: Query with samples; "news photos may be sent unsolicited." Send b&w prints, contact sheets, negatives by mail for consideraton. SASE. Reports in 2 weeks. Pays \$10/b&w inside photo; up to \$3/column inch plus \$10/photo used for text/photo package. Credit line given. Buys one-time rights.

Tips: "Learn something about aviation subjects—we don't need or use pictures of air show teams flying

maneuvers.

THE WESTERN PRODUCER, 2310 Millar Ave., Box 2500, Saskatoon, Saskatchewan, Canada S7K 2C4. (306)665-3500. Editor and Publisher: R.H.D. Phillips. News Editor: Mike Gillgannon. Weekly newspaper. Circ. 140,000. Emphasizes agriculture and rural living, history and fiction; all in western Canada. Photos purchased with or without accompanying ms. Buys 0-10 photos/issue. Pays \$25-150 for text/photo package. Credit line given. Pays on acceptance. Buys one-time rights. Send material by mail for consideration. Usually works with freelance photographers on assignment only basis. SASE. Previously published work OK. Reports in 2 weeks. Free photo guidelines.

Subject Needs: Livestock, documentary, nature, human interest, humorous, photo essay/photo feature, scenic, sport, spot news, travel, rural, agriculture, day-to-day rural life and small communities. No cute

pictures about farming. "We prefer the bull to the girl." Captions required.

B&W: Uses 5x7 glossy prints. Pays \$15 minimum/photo.

Color: Pays \$35 minimum/photo.

Accompanying Mss: Seeks mss on agriculture, rural western Canada, history, fiction and contemporary life in rural western Canada. Pays \$10-150/ms.

Tips: "Don't send negatives. We're a newspaper-prefer to look at what can be used rather than studying a portfolio. We'd be delighted to see a picture (agriculture, rural life, etc.) on every news page."

WISCONSIN, The Milwaukee Journal Magazine, Box 661, Milwaukee WI 53201. (414)224-22341. Editor: Beth Slocum. Weekly magazine. General-interest Sunday magazine focusing on the places and people of Wisconsin or of interest to Wisconsinites. Circ. 530,000. Free sample copy with

Photo Needs: Uses about 12 photos/issue; 1 supplied by freelance photographer. Needs "human-interest, wildlife, travel, adventure, still life and scenic photos, etc." Model release and captions required. Making Contact & Terms: Query with samples. SASE. Reports in 2 months. Pays \$125/color cover photo; \$25-50/b&w inside photo, \$75/color inside photo. Pays on publication. Buys one-time rights, 'preferably first-time rights.'

YACHTSMAN, 2019 Clement Ave., Alameda CA 94501. (415)865-7500. Editor: David Preston. Monthly tabloid. Circ. 25,000. Emphasizes recreational boating for boat owners of northern California. Photos purchased with or without accompanying ms. Buys 5-10 photos/issue. Credit line given. Pays on publication. Buys all rights. Send material by mail for consideration. SASE. Simultaneous submissions or previously published work OK but must be exclusive in Bay Area (nonduplicated). Reports in 1 month. Sample copy \$1.

Subject Needs: Sport; power and sail (boating and recreation in northern California); spot news (about boating); travel (of interest to boaters); and product shots. Model release and captions preferred.

B&W: Uses 8x10 or 5x7 glossy prints or screen directly from negatives. Pays \$5 minimum/photo. Cover: Uses color slides. Vertical (preferred) or horizontal format required. Pays \$75 minimum/photo. Accompanying Mss: Seeks mss about power boats and sailboats, boating personalities, locales, piers, harbors, and flora and fauna in northern California. Pays \$1 minimum/inch. Writer's guidelines free

Tips: Prefers to see action b&w, color slides, water scenes. "We do not use photos as stand-alones; they must illustrate a story. The exception is cover photos, which must have a Bay Area application—power, sail or combination; vertical format with uncluttered upper area especially welcome."

Trade Journals

If you've ever worked in a trade or industry other than photography—and what photographer hasn't-then you're probably aware that there exists another large realm of magazine publishing beyond the consumer market. Trade journals are those magazines—often as large and well produced as any consumer publication read by people employed in a given professional field. There are trade journals for doctors and lawyers, for engineers and scientists, for truckers and farmers-just about any profession, in fact, that you can imagine.

It follows that if you have experience in one or more professions, you're already qualified to become a freelance contributor to one or more of these trade journals. Since the readers of trades are knowledgeable about their work, trade editors are constantly on the lookout for writers and photographers who can cover their sub-

jects knowledgeably.

*THE ABSOLUTE SOUND,2 Glen Ave., Sea Cliff NY 11579. (516)676-2830. Editorial Director: Brian Gallont. Trade quarterly magazine. Emphasize the "high end as audio-component reviews and record reviews. Our audience consists of audiophiles and doctors. Circ. 20,000. Sample copies available free with SASE. Postage required \$1.94.

Photo Needs: Uses 10-20 freelance photos/issue; all supplied by freelancers. Needs photos of "people

of trade shows, in recording industry, artists, audio components." Captions preferred.

Making Contact & Terms: Query with samples; send unsolicited photos by mail for consideration; provide resume, business card, brochure, flyer or tearsheets to be kept on file for possible future assignments. Uses prints:b&w, 4x5, contact sheet: b&w, Negatives: b&w. SASE. Reports in 1 month. Payment on publication. Credit line always given. Buys one-time rights.

ACCESSORIES MAGAZINE, (formerly Fashion Accessories Magazine), 22 S. Smith St., Norwalk CT 06855. (203)853-6015. (212)989-9630. Art Director: Lorrie L. Frost. Monthly. Circ. 25,00. Emphasizes fashion accessories. Readers are "retailers, buyers, manufacturers and fashion forward designers in the accessories business market." Sample copy available.

Photo Needs: Uses about 30-35 photos/issue; all supplied by freelance photographers. Needs "fashion (not catalog type), people profile shots, go to a store and photograph displays, product shots.' Making Contact & Terms: Arrange a personal interview to show portfolio. Query with samples. Pay negotiable. Pays on publication. Credit line given. Buys one-time rights "unless reused by house ad pro-

moting us.'

*ACRE AGE, Box 130, Ontario OR 97914. (503)889-5387. News Editor: Marie A. Ruemenapp. Monthly tabloid. Emphasizes agriculture in eastern Oregon and southern Idaho. Readers are farmers, ranchers, and agri-business people in agriculture in eastern Oregon and southern Idaho. Circ. 42,000. Sample copy \$1.25. Photo guidelines free with SASE.

Photo Needs: Uses about 15 photos/issue; about 1/3 supplied by freelance photographers. Needs photos of "anything to do with agriculture. We like to see manuscripts with pictures." Captions required. Making Contact & Terms: Query with resume of credits and samples. SASE. Reports in 3 weeks. Pays \$35/color cover photo, and \$7.50/b&w inside photo. Pays on publication. Credit line given. Buys first North American serial rights. Simultaneous submissions and previously published work OK "if the other publication does not cover any part of our circulation area."

*ACTIVEWEAR MAGAZINE, Box 5400 T.A., Denver CO 80217. (303)295-0900. Editor: Harvey Cohen. Monthly magazine. Emphasizes "running, exercise, court, ski, cycling and swim apparel, accessories and footwear." Readers are activewear retailers and sporting goods stores. Circ. 15,000. Sam-

ple copy free with SASE.

Photo Needs: Uses about 15 photos/issue; 12 supplied by freelance photographers. "As a national publication, we cover the industry principally via telephone from Denver, or hire freelancers in our network that live in the area of an assignment for stories and photos." Model release and photos preferred. **Making Contact & Terms:** Query with samples. Reports in 1 month. Pays \$100-300/color cover photo, \$50-100/inside photo, \$50-100/color inside photo, and \$50 + /text/photo package. Pays 15-30 days after publication. Credit line given. Buys all rights.

Tips: Prefers to see "good use of color and ability to merchandise clothes" in a photographer's samples. "Accept low-paying assignments initially in order to get published. With good relationship with partic-

ular employers, ask for more after demonstrating ability."

*ADMINISTRATIVE SCIENCE QUARTERLY, Johnson Graduate School of Management, Malott Hall, Cornell University, Ithaca NY 14853-4201. (607)256-5117. Editor: Karl E. Weick. Photo Editor: Linda Pike. Quarterly trade journal. Emphasizes organizational behavior. Readers are business school and university libraries, corporations, students and professionals. Circ. 5,500. Sample copy \$10.

Photo Needs: Uses about 1 photo (covershot)/issue: 50% supplied by freelance photographers. Needs

photos of paintings, etchings, artwork in general. Model release required.

Making Contact & Terms: Query with samples, send b&w or color prints, transparencies, contact sheet or negatives by mail for consideration; provide resume, business card, broohure, flyer or tearsheets to be kept on file for possible future assignments. Reports in 1 month. Payment negotiated. Pays on publication. Credit line given. Buys one-time rights. Simultaneous submissions and previously published work OK.

ADVERTISING TECHNIOUES, 10 E, 39th St., New York NY 10016, (212)889-6500, Art Director: Amy Sussman. Monthly magazine. Circ. 4,500. Emphasizes advertising campaigns for advertising executives.

Accompanying Mss: Photos purchased with an accompanying ms only. Buys 2-3 photos/issue. Must

relate to the advertising field.

Payment/Terms: Pays \$50/b&w photo. Pays on publication.

Making Contact: Query. SASE. Reports in 4 weeks.

AG REVIEW, Farm Resource Center, 16 Grove St., Putnam CT 06260. (203)928-7778. Monthly magazine. Circ. 46,800. For commercial dairy and beef cattle owners and field crop farmers. Needs Northeastern agriculture-oriented photos. No "common" scenic shots. "Always looking for action shots in the field." Buys simultaneous rights. Present model release on acceptance of photo. Send photos for consideration. Pays on publication. Reports in 3 weeks. SASE. Simultaneous submissions OK. B&W: No b&w used.

Color: Color shots considered only for covers. Send 35mm or larger transparencies (2 1/4x21/4 preferred). "Uniqueness is required" for indoor or outdoor agricultural scenes. Captions requested. Pays \$50 mini-

AIPE FACILITIES MANAGEMENT OPERATIONS AND ENGINEERING, 3975 Erie Ave., Cincinnati OH 45208. (513)561-6000. Editor-in-Chief: Eileen T. Fritsch. Bimonthly. Circ. 8,000. Emphasizes technical and problem solving information related to facilities management. Readers are plant engineers (members in U.S. and Canada), many of whom are in charge of America's industrial plant operations or related services. Sample copy and photo guidelines for SASE.

Photo Needs: Uses 10 photos/issue. Subjects must be of interest to our audience; i.e., plant engineers who look to the Journal for technical information and data. Captions required. Also needs photos for

special publications and promotional materials.

Making Contact & Terms: Query with resume of photo credits. SASE. Reports in 2 weeks. Pay is negotiable. Credit line given. Payment on publication. Buys one-time rights.

ALASKA CONSTRUCTION & OIL, 109 W. Mercer St., Seattle WA 98119. (206)285-2050. Editor: Christine Laing. Monthly magazine. Circ. 9,000. Emphasizes news/features on petroleum, construction, timber and mining for management personnel in these industries in Alaska. Photos purchased with accompanying ms, or on assignment. Credit line given. Pays on publication. Buys one-time rights or first serial rights. Send material by mail for consideration. Provide brochure, calling card, letter of inquiry, resume and samples to be kept on file for possible future assignments. SASE. Previously published work OK. Reports in 3-4 weeks. Sample copy \$2.

Subject Needs: Photos illustrating an Alaska project in the construction, petroleum, timber and mining fields. Strictly industrial—no scenic or wildlife. Captions required.

B&W: Uses 5x7 and 8x10 glossy prints. Pays \$15-25/photo.

Cover: Uses 35mm, 21/4x21/4 color transparencies. Pays \$100/photo.

Accompanying Mss: Semitechnical project coverage; i.e., how a construction project is being accomplished. Pays \$75/page (30" per page).

Tips: "Two things are paramount—accuracy and writing to the right audience. Remember, this is a trade magazine, not consumer-oriented."

ALTERNATIVE ENERGY RETAILER, Box 2180, Waterbury CT 06722. (203)755-0158. Editor: John Florian. Monthly. Emphasizes energy products, including solid fuel burning appliances and solar. Readers are retailers of alternative energy products. Circ. 14,000. Sample copy and photo guidelines free with SASE.

Photo Needs: Uses about 10 photos/issue; 5 supplied by freelance photographers. "Most photos accompany mss relating to the story. General shots tend to be of the sun, woodburning, etc." Model release preferred; captions required.

Making Contact & Terms: Query with samples. SASE. Reports in 2 weeks, Pays \$100/color cover photo; \$25 b&w inside photo. Pays on publication. Credit line given. Buys one-time rights.

*AMERICAN AGRICULTURIST, Box 370, Ithaca NY 14851. (607)273-3507. Editor: Gordon Conklin, Photo Editor: Andrew Dellava, Monthly, Emphasizes agriculture in the Northeast-specifically New York, New Jersey and New England. Circ. 72,000. Free photo guidelines with SASE.

Photo Needs: Uses one photo/issue supplied by freelance photographers. Needs photos of farm equipment, general farm scenes, animals. Geographic location: only New York, New Jersey and New England. Reviews photos with or without accompanying ms. Model release required.

Making Contact & Terms: Query with samples and list of stock photo subjects; send 8x10 vertical, glossy color prints, and 35mm transparencies by mail for consideration. SASE. Reports in 3 months. Pays \$100/color cover photo and \$75/inside color photo. Pays on acceptance. Credit line given, Buys one-time rights.

*AMERICAN BEE JOURNAL, 51 S. 2nd St., Hamilton IL 62341. (217)847-3324. Editor: Joe M. Graham. Monthly trade magazine. Emphasizes beekeeping for hobby and professional beekeepers. Sample copy free with SASE.

Photos Needs: Uses about 100 photos/issue; 1-2 supplied by freelance photographers. Needs photos of beekeeping and related topics, beehive products, honey, cooking with honey. Special needs include col-

or photos of seasonal beekeeping scenes. Model release and captions preferred.

Making Contact & Terms: Query with samples; send 5x7 or 8½x11 b&w and color prints by mail for consideration. SASE. Reports in 2 weeks. Pays \$25/b&w or color cover photo; \$5/b&w or color inside photo. Pays on publication. Credit line given. Buys all rights.

AMERICAN BOOKSELLER, Production Dept., Suite 1410, 122 E. 42nd St., New York NY 10168. (212)867-9060. Editor: Ginger Curwen. Photo Editor: Amy G. Bogert. Monthly magazine. Circ. 8,700. "American Bookseller is a journal for and about booksellers. People who own or manage bookstores read the magazine to learn trends in book selling, how to merchandise books, recommendations on stock, and laws affecting booksellers." Photos purchased with or without accompanying ms. Works with freelance photographers on assignment only basis. Provide resume, business card, tearsheets and samples to be kept on file for possible future assignments. Buys 75 photos/year. Pays \$25 minimum/job, \$70 minimum for text/photo package, or on a per-photo basis. Credit line given. Pays on acceptance. Buys one-time rights, but may negotiate for further use. Send material by mail for consideration; arrange personal interview to show portfolio; query with list of stock photo subjects; submit portfolio for review; query with samples. SASE. Previously published work OK. Reports in 2-3 weeks. Sample copy \$3. Subject Needs: Human interest (relating to reading, or buying and selling books); humorous; photo essay/photo feature (coverage of bookselling conventions, original book displays, or unusual methods of book merchandising); and spot news (of events or meetings relating to bookselling-e.g., author luncheons, autograph parties, etc.). Wants on a regular basis "photos of specific bookstores (to accompany a written profile of the place), of specific events (conventions, meetings, publicity events for books and sometimes just general photos of people reading)." Especially needs for next year a "photographer to take shots of the annual convention floor activities and other events."

Special Needs: Photos of people doing things, photos of business operations, and reportage. No photos of libraries, soft focus pictures of book readers, photos of bookstores with no customers. Model release preferred; captions required.

B&W: Uses 5x7 prints. Pays \$25/photo, inside.

Color: No color used inside.

Cover: Uses 35mm color transparencies. Vertical format preferred. Pays \$450/photo.

Accompanying Mss: By assignment. Pay is negotiable. Pays \$40-80 for text/photo package.

THE AMERICAN CHIROPRACTOR, 3401 Lake Ave., Ft. Wayne IN 46805. (219)423-1432. Managing Editor: Laura A. Allen. Emphasizes chiropractic. Readers are professional chiropractors. Circ. 25,000. Sample copy free with SASE.

Photo Needs: Uses 1 photo/issue. Needs photos of "health-related subjects. Dynamic action photos

preferred.'

Making Contact & Terms: Query with samples and list of stock photo subjects. Send unsolicited 4x5 or larger glossy color prints; 4x5 or 8x10 transparencies; and color negatives by mail for consideration. Unsolicited material returned with SASE. Pays \$100-200/color cover photo. Pays on publication. Buys one-time rights. Simultaneous submissions OK.

AMERICAN CITY & COUNTY MAGAZINE, 6255 Barfield Rd., Atlanta GA 30328. (404)256-9800. Editor: Ken Anderberg. Monthly magazine. Emphasizes "activities/projects of local governments." Readers are city and county government officials and department heads; engineers. Circ. 55,000. Sample copy free with SASE and \$1 postage.

Photo Needs: Uses about 20 photos/issue; all supplied by freelance photographers. Needs "pictures of city and county projects, activities-prefer depictive, artsy photos rather than equipment and facility shots." Special needs include "cover photos to illustrate major themes, (editorial calendar with themes listed is available)."

Making Contact & Terms: Query with samples. Send 5x7 or 8x10 glossy b&w prints; 35mm, 21/4x21/4, 4x5 transparencies for consideration. SASE. Reports in 2 weeks. Pays \$300/cover photo; \$25/b&w in-

side photo; \$50-100/color inside photo. Paste-up. Credit line given. Buys all rights.

AMERICAN COIN-OP, 500 N. Dearborn, Chicago IL 60610. (312)337-7700. Editor: Ben Russell. Monthly magazine. Circ. 19,000. Emphasizes the coin laundry business for owners of coin-operated laundry and drycleaning stores. Photos purchased with or without accompanying ms. Buys 60-75 photos/year. Pays on publication. Buys first rights and reprint rights. Send material by mail for consideration, query with list of stock photo subjects, or query with samples. SASE. Previously published work OK if exclusive to the industry. Reports in 1 week. Free sample copy.

Subject Needs: How-to, human interest, humorous, photo essay/photo feature and spot news. "We don't want to see photos that don't relate to our field, out-of-focus or poorly composed pictures, or sim-

ple exterior store photos, unless the design is exceptional." Captions required.

B&W: Uses 5x7 or 8x10 prints. Pays \$6 minimum/photo.

Cover: Uses b&w prints. Vertical format preferred, "but some horizontal can be used." Pays \$6 mini-

mum/photo.

Accompanying Mss: "We seek case studies of exceptional coin laundries that have attractive decor, unusual added services, colorful promotions, or innovative management." Pays 6¢/word. Free writer's

Tips: "Send us some sharp human interest shots that take place in a coin laundry."

AMERICAN DEMOGRAPHICS, Box 68, Ithaca NY 14851. (607)273-6343. Editor: Cheryl Russell. Art Director: Michael Rider. Monthly. Circ. 10,000. Emphasizes "demographics-population trends." Readers are "business decision makers, advertising agencies, market researchers, newspapers, banks, professional demographers and business analysts.

Photo Needs: Uses 10 photos/issue, all supplied by freelance photographers. Needs b&w photos of 'people (crowds, individuals), ethnic groups, neighborhoods; people working, playing, and moving to new locations; regional pictures, cities, single parent families, aging America, baby boom and travel trends. Photographers submit prints or photocopies that they feel fit the style and tone of American Demographics. We may buy the prints outright or may keep a file of photocopies for future use and order a print when the photo is needed. No animals, girlie photos, politicians kissing babies, posed cornball business shots or people sitting at a computer keyboard." Model release required.

Making Contact & Terms: Send by mail for consideration actual 5x7 or 8x10 b&w or photocopies; submit portfolio by mail for review; or call (do not call collect). SASE. Reports in 2 weeks. Pays on publication \$35-100/b&w photo. Credit line given on "Table of Contents" page. Buys one-time rights. Simultaneous and previously published submissions OK. Sample copy \$5.

AMERICAN FIRE JOURNAL, Suite 7, 9072 E. Artesia Blvd., Bellflower CA 90706. (213)866-1664. Managing Editor: Carol Carlsen. Monthly magazine. Circ. 9,000. Emphasizes fire protection and prevention. Buys 5 or more photos/issue. Credit line given. Pays on publication. Buys one-time rights. Query with samples to Brian Strasmann, art director. Provide resume, business card or letter of inquiry. SASE. Reports in 1 month. Free sample copy and photo guidelines.

Subject Needs: Documentary (emergency incidents, showing fire personnel at work); how-to (new

techniques for fire service); and spot news (fire personnel at work). Captions required.

B&W: Uses semigloss prints. Pays \$9/photo. Negotiable.

Cover: Uses 35mm color transparencies. Pays \$30/photo. Covers must be verticals.

Accompanying Mss: Seeks short description of emergency incident and how it was handled by the

angecies involved. Pays \$1.50-2/inch. Free writer's guidelines.

Tips: "Don't be shy! Submit your work. I'm always looking for contributing photographers (especially if they are from outside the L.A. area). I'm looking for good shots of fire scene activity with captions. The action should have a clean composition with little smoke and prominent fire, and show good firefighting techniques, i.e., firefighters in full turnout, etc."

AMERICAN FRUIT GROWER/WESTERN FRUIT GROWER, 37841 Euclid Ave., Willoughby OH 44094. (216)942-2000. Managing Editor: Gary Acuff. Monthly. Emphasizes "all aspects of commercial fruit production, including marketing, production practices, equipment, government regulations, etc. Magazine does NOT cover backyard or hobby orchards or gardens. Tree fruits, grapes, nuts, and small fruits are covered." Readers are commercial fruit growers across the U.S. who make their living by growing fruit. Circ. 55,000. Sample copy free with \$1 SASE.

Photo Needs: Needs "photos showing production practices in *commercial* fruit operations, such as pruning, spraying, irrigating, harvesting, etc; overall shots of commercial orchards, vineyards, groves, etc; fruit closeups; roadside markets or pick-your-own operations. Any photo must be completely labelled as practice shown, and crop/variety. Currently have cover openings for the following themes: "irrigating; spraying; roadside marketing/pick-your-own."

Making Contact & Terms: Query with list of stock photo subjects. Pays \$125/color cover photo; \$50/

color inside photo. Pays on publication. Credit line given. Buys one-time rights.

AMERICAN JEWELRY MANUFACTURER, 825 7th Ave., New York NY 10019. (212)245-7555. Editor: Steffan Aletti. Monthly. Circ. 5,500. Emphasizes "jewelry manufacturing; techniques, processes, machinery." Readers are "jewelry manufacturers and craftsmen." Sample copy and photo guidelines free with SASE.

Photo Needs: Uses about 10-30 photos/issue; "very few" supplied by freelance photographers. Needs

photos of "manufacturing or bench work processes." Model release preferred.

Making Contact & Terms: Query with list of stock photo subjects. Provide resume, business card, brochure, flyer or tearsheets to be kept on file for possible future assignments. SASE. Reports in 2 weeks. Pays \$150/color cover photo; \$15/b&w inside photo; \$25/color inside photo. Pays on publication. Credit line given "if requested." Buys one-time rights. Simultaneous submissions and previously published work OK.

Tips: "Since editor is a professional photographer, we use little freelance material, generally only when

we can't get someone to photograph something.'

AMERICAN OIL & GAS REPORTER, 1069 Parklane, Wichita KS 67218. (316)681-3560. Production Director: Danny Biehler. "A monthly business publication on serving the domestic exploration, drilling and production markets within the oil/gas industry. The editorial pages are designed to concentrate on the domestic independent oilman. Readers are owners, presidents, and other executives." Circ. 18.000. Sample copy free with SASE.

Photo Needs: Uses I color photo for cover per issue; others are welcome. Needs "any photo dealing with the oil & gas industry. We prefer to use only independent oil and gas photos; we discourage anything that would have to do with a major oil company, i.e., Standard, Exxon, Shell, etc. We do have a media file put out each year, usually in the fall; we will consider any photos for next fall's media file, right now there has been no decision on the amount." Written release and captions required.

Making Contact & Terms: Send 35mm transparencies unsolicited photos by mail for consideration. Returns unsolicited material with SASE. Pays \$100/color cover photo; \$20/b&w inside photo; \$20/color inside photo. Pays on publication. Credit line given. Buys one-time rights. Simultaneous submissions OK

Tips: Prefers to see "any picture which depicts a typical or picturesque view of the domestic oil and gas industry."

AMERICAN SALON EIGHTY-FIVE, Suite 1000, 100 Park Ave., New York NY 10017. (212)532-5588. Editor: Louise Cotter. Monthly. Circ. 120,000. Emphasizes all phases of hair styling salon work, including management, operation and hair styling. For stylists and salon owners.

Photo Needs: Rarely purchases from freelancers. Uses photos depicting current hair styles for men and

women. B&w preferred. 8x10. Uses 35mm color transparencies.

Making Contact and Terms: Submit photos by mail. SASE. Pays \$100-150/color transparency. Pays on publication. Credit line given. Buys all rights.

AMERICAN TRUCKER MAGAZINE, Box 6366, San Bernardino CA 92412. (714)889-1167. Editor: Steve Sturgess. Monthly. Emphasizes the "trucking industry—independent owner-operators, small fleet truck companies." Readers are independent truckers or those who work for small fleets. Circ. 47,000. Sample copy free with SASE.

Photo Needs: Uses approximately 25-30 photos/issue; 15-20 supplied by freelancers. Needs "shots of trucks in action, shots that show details of truck and/or truck-trailer combinations and also include driver when possible." Special needs include "photo stories of trucking life in work situations, truck stops,

truck washes, etc." Written release and captions preferred.

Making Contact & Terms: Query with samples. Returns unsolicited material with SASE. Pays \$200/color cover photo; \$50/page, \$20/individual color inside photo. Pays 30 days after publication. Credit line given. Buys First North American rights. Previously published work "if not in another trucking publication" OK.

Tips: "Have a knowledge of the trucking industry."

ANTIQUES DEALER, 1115 Clifton Ave., Clifton NJ 07013. (201)779-1600. Editor: Nancy Adams. Monthly magazine. Circ. 6,500. For professionals in the antiques business. Needs photos of antiques (over 100 years old), heirlooms (50-100 years old) and collectibles (20-50 years old), celebrities/personalities in antiques field and photo essay/photo features on antiques. Buys 3-6 photos/year. Credit line given. Buys all rights. Send photos or contact sheet or query. Pays on publication. Reports in 1 month. B&W: Send 5x7 or 8x10 glossy or semigloss prints. Captions required. Pays \$10.

Cover: Send 8x10 glossy or semigloss b&w prints. Captions required. Pays \$15-25.

Tips: "Usually photos have accompanying mss, but we are looking for freelance cover photos." Always in need of December Christmas-cover ideas; deadline October. Cover "must tie in with antiques—not just Christmas."

APPAREL INDUSTRY MAGAZINE, Suite 300, 180 Allen Rd. South, Atlanta GA 30328. (404)252-8831. Editor: Karen Schaffner. Art Director: Judy Doi. Monthly magazine. Circ. 18,773. Emphasizes management and production techniques for apparel manufacturing executives; coverage includes new equipment, government news, finance, marketing, management, training in the apparel industry. Works with freelance photographers on assignment only basis. Provide resume, brochure and business card to be kept on file for possible future assignments. Buys 3 photos/issue. Pays on publication. SASE. Reports on queries in 4-6 weeks.

Subject Needs: Cover photos depicting themes in magazines; feature photos to illustrate articles.

*APPLIED RADIOLOGY, Brentwood Publishing Corporation, 825 S. Barrington, Los Angeles CA 90049. (213)826-8388. Editor: Esther Grass. Photo Editor: Tom Medsger. Bimonthly. Emphasizes radiology in all aspects. Readers are radiologists and physicians.

Photo Needs: Uses about 2-3 photos/issue; all supplied by freelance photographers. Needs abstracts on the specific fields of radiology; CT scan, mobile units, magnetic resonance imaging for cover photos.

Model release preferred.

Making Contact & Terms: Query with resume of credits or with list of stock photo subjects. Uses 8x10 color prints, 35mm or 21/4x21/4 transparencies. SASE. Reports in 2 weeks. Pays \$400/color cover photo; \$100/color inside photo. Pays on acceptance. Credit line given for cover photos. Buys all rights. "Photographer gets picture back to sell again. BPC reserves the right to use picture again in one of its publications."

ART DIRECTION, 10 E. 39th St., New York NY 10016. (212)889-6500. Monthly magazine. Circ. 12,000. Emphasis is on advertising design for art directors of ad agencies. Buys 5 photos/issue. **Accompanying Mss:** Photos purchased with an accompanying mss only.

Payment/Terms: Pays \$50/b&w photo. Pays on publication.

Making Contact: Works with freelance photographers on assignment only basis. Send query to Amy Sussman. Provide tearsheets to be kept on file for possible future assignments. SASE. Reports in 2 weeks.

*ASSEMBLY ENGINEERING, Hitchcock Bldg., Wheaton IL 60188. (312)462-2215. Editor: Walter J. Maczka. Photo Editor: Norman R. Herlihy. Monthly. Emphasizes design and manufacturing technology where individual parts become useful products (the processes and equipment needed to assemble a finished product. Readers include corporate executives, managers, design engineers, manufacturing engineers, professionals. Circ. 75,000. Sample copy free with SASE.

Photo Needs: Uses about 30-40 photos/issue; few (so far) are supplied by freelance photographers. Needs high-tech photos of assembly systems, robots, conveyors, lasers, machine vision equipment, electronics, printed circuit boards, computers, software, fasteners, welders, etc." Special needs include any general shot where parts (components) become a whole (product)—conceptual in nature. Vertical

format could be a series of shots. Model release required; captions preferred.

Making Contact & Terms: Query with samples or with list of stock photo subjects; send any size b&w or color print, transparencies, color contact sheet or b&w negatives by mail for consideration; submit portfolio for review; provide resume, business card, brochure, flyer or tearsheets to be kept on file for possible future assignments. SASE. Reports in 2 weeks. Pays \$100-500 for text/photo package. Credit line given "only if requested." Buys all rights. Simultaneous submissions and previously published work OK.

THE ATLANTIC SALMON JOURNAL, Suite 1030, 1435 St-Alexandre St., Montreal, Quebec, Canada H3A 2G4. (514)842-8059. Managing Editor: Joanne Eidinger. Quarterly magazine. Circulation 20,000. Readers are dedicated salmon fishermen interested in techniques, management of the species and new places to fish. Free sample copy.

Photo Needs: Good action shots of Atlantic salmon fishing and/or management. All material held on spec unless otherwise stated. Model release preferred; captions and credits required. Prefers 5x7 or 8x10

b&w prints, 35mm or 21/4x21/4 color slides. SAE and International Reply Coupon. Pays \$30-75/photo. b&w and \$50-100/photo, color. Reports in 4-6 weeks. Byline given. Payment upon publication (firsttime rights only, negotiable). Previously published submissions acceptable, but not encouraged.

AUTOMATION IN HOUSING & MANUFACTURED HOME DEALER, Box 120, Carpinteria CA 93013. (805)684-7659. Editor and Publisher: Don Carlson. Monthly. Circ. 26,000. Emphasizes home and apartment construction. Readers are "factory and site builders and dealers of all types of homes, apartments and commercial buildings." Sample copy free with SASE.

Photo Needs: Uses about 40 photos/issue; 10-20% supplied by freelance photographers. Needs in-plant and job site construction photos. Photos purchased with accompanying ms only. Captions required. Making Contact & Terms: "Call to discuss story and photo ideas." Send 35mm or 21/4x21/4 transparencies by mail for consideration. SASE. Reports in 2 weeks. Pays \$300 for text/photo package. Credit line given "if desired." Buys first time reproduction rights.

AVIATION EQUIPMENT MAINTENANCE, 7300 N. Cicero Ave., Lincolnwood IL 60646. (312)674-7300. Editor: Paul Berner. Monthly. Circ. 24,000. Emphasizes "aircraft and ground support equipment maintenance." Readers are "aviation mechanics and maintenance management." Sample copy \$2.50.

Photo Needs: Uses about 50-60 photos/issue. Needs "hands-on maintenance shots depicting any and all maintenance procedures applicable to fixed and rotary wing aircraft." Photos purchased with accom-

panying ms only. Model release and captions required.

Making Contact & Terms: Query with samples. Send 35mm, 21/4x21/4 or 4x5 transparencies by mail for consideration. SASE. Reports in 1 month. Pays \$250-300 for text/photo package. Pays on acceptance. Buys all rights.

BANKING TODAY, (formerly Florida Banker), Box 6847, Orlando FL 32853. (305)896-6511. Vice President and Executive Editor: William P. Seaparke. Magazine published 12 times/year. Circ. 6,500. Emphasizes banking in Florida for bankers. Photos purchased with or without accompanying ms, or on assignment. Credit line given. Pays on publication. Buys all rights. Loans back rights with no difficulty. Works with freelance photographers on assignment only basis. Query; "don't ever send photos or mss without first querying." Provide resume and Social Security number to be kept on file for possible future assignments. Reports in 8-12 weeks.

Subject Needs: Celebrity/personality, documentary, fashion/beauty, fine art, head shot, how-to, human interest (on Florida banking only), humorous, nature, photo essay/photo feature, scenic, special effects/experimental ("yes!"), still life, travel and wildlife. "Anything to do with banking with a story assignment first." Considers new ideas that can be related to banking. Model release and captions re-

B&W: Uses 5x7 glossy prints; contact sheet OK. Pays \$10-100/photo.

Cover: Uses 35mm color transparencies, 21/4x21/4 for covers. Vertical format required. Pays \$50-200/ photo, according to subject matter and whether color or b&w.

Accompanying Mss: Payment negotiable. Writer's guidelines and/or photo guidelines sheet upon request. Sample copy \$2.

Tips: Living in Florida is helpful. "I consider photography an art and seek the best efforts of any photographer. I like to give amateurs an opportunity when I can."

BEVERAGE WORLD, 150 Great Neck Rd., Great Neck NY 11021. (516)829-9210. Managing Editor: Jeanne Lukasick. Monthly. Circ. 30,000. Emphasizes the beverage industry. Readers are "bottlers, wholesalers, distributors of beer, soft drinks, wine and spirits." Sample copy \$3.50.

Photo Needs: Uses 25-50 photos/issue; 10-20 supplied by freelance photographers. Needs photos of people, equipment and products—solicited only. Needs "freelancers in specific regions of the U.S. for

ongoing assignments. Model release and captions required.

Making Contact & Terms: Query with samples. Provide resume, business card, brochure, flyer or tearsheets to be kept on file for possible future assignments. Pays \$300/color cover photo. Pays on acceptance. Rights purchased varies. Simultaneous submissions and previously published work OK, "as long as work is not in any competing publication."

Tips: Prefers to see "interesting angles on people, products. Provide affordable quality."

*BODY FASHIONS/INTIMATE APPAREL, 757 3rd Ave., New York NY 10017. (212)888-4364. Editor and Director: Jill Gerson. Monthly magazine. Circ. 13,500. Emphasizes information about men's and women's hosiery and underwear; women's undergarments, lingerie, sleepwear, robes, and leisurewear. For merchandise managers and buyers of store products and manufacturers and suppliers to the trade.

Accompanying Mss: Photos purchased with accompanying ms only.

Payment & Terms: Pays on publication.

Making Contact: Query. SASE. Reports in 4 weeks.

BRAKE & FRONT END, 11 S. Forge St., Akron OH 44304. (216)535-6117. Editor: Jeffrey S. Davis. Monthly magazine. Circ. 30,000. Emphasizes automotives maintenance and repair. For automobile mechanics and repair shop owners. Needs "color photos for use on covers. Subjects vary with editorial theme, but basically they deal with automotive or truck parts and service." Wants no "overly commercial photos which emphasize brand names" and no mug shots of prominent people. May buy up to 6 covers annually. Credit line given. Buys first North American serial rights. Submit model release with photos. Send contact sheet for consideration. Reports "immediately." Pays on publication. SASE. Simultaneous submissions OK. Sample copy \$1.

B&W: Uses 5x7 glossy prints; send contact sheet. Captions required. Pays \$8.50 minimum.

Cover: Send contact sheet or transparencies. Study magazine, then query. Lead time for cover photos is 3 months before publication date. Pays \$50 minimum.

Tips: Send for editorial schedules; enclose SASE.

BROADCAST TECHNOLOGY, Box 420, Bolton, Ontario LOP 1A0 Canada. (416)857-6076. Bimonthly magazine. Circ. 6,500. Emphasizes broadcast engineering.

Accompanying Mss: Photos purchased with accompanying ms only. Seeks material related to broadcasting/cable TV only, preferably technical aspects.

Payment & Terms: Payment is open. Pays on publication.

Making Contact: Send query to Doug Loney, editor. Reports in 1 month.

BUILDER, Suite 475, 655 15th St., NW, Washington DC 20005. (202)737-0717. Editor: Frank Anton. Managing Editor: Noreen Welle. Monthly. Circ. 185,000. Emphasizes homebuilding. Readers are builders, contractors, architects. Sample copy \$3. Photo guidelines free with SASE.

Photo Needs: Uses about 60 photos/issue; 20 supplied by freelance photographers. Needs photos of ar-

chitecture (interior and exterior). Model release required.

Making Contact & Terms: Query with samples. Send 8x10 b&w glossy prints or 4x5 transparencies by mail for consideration. SASE. Reports in 1 month. Pays \$400-600/job. Pays on publication. Credit line given. Buys one-time rights. Previously published work OK.

BUSINESS ATLANTA, 6255 Barfield Rd., Atlanta GA 30328. (404)256-9800. Managing Editor: Luann Nelson. Monthly. Emphasizes "general magazine-style coverage of business and business-related issues in the metro Atlanta area." Readers are "everybody in Atlanta who can buy a house or office building or Rolls Royce." Circ. 24,600. Sample copy free with SASE and \$1.50 postage.

Photo Needs: Uses about 40 photos/issue; 35-40 supplied by freelance photographers. Needs "good photos mostly of business-related subjects if keyed to local industry." Model release and captions re-

quired.

Making Contact & Terms: Arrange a personal interview to show portfolio. SASE. Reports in 1 month. Pays \$300/color cover photo; \$75/b&w or color inside photo; \$200 minimum/job. Pays on publication. Credit line given. Buys one-time rights.

Tips: "Study the publication for the feel we strive for and don't bring us something either totally off the wall or, at the other extreme, assume that business means boring and bring us something duller than dit-

chwater.'

*BUSINESS FACILITIES, Box 2060, Red Bank NJ 07701. (201)842-7433. Editor: Eric Peterson. Monthly magazine. Emphasizes economic development, commercial and industrial real estate. Readers are top corporate executives, public and private development organizations. Circ. 35,000. Free sample copy.

Photo Needs: Uses about 20-30 photos/issue; 2-3 supplied by freelance photographers. Needs "newsoriented shots; current events; generally illustrative of real estate development. We always need photos

of nationally-known political or business leaders." Captions required.

Making Contact & Terms: Query with list of stock photo subjects. SASE. Reports in 2 weeks. All rates negotiable. Pays on publication. Credit line given sometimes; all times for cover shots. Rights negotiable. Simultaneous submissions and previously published work OK.

Tips: "No telephone queries, please! Put it in writing."

THE BUSINESS OF FUR, 141 W. 28th St., New York NY 10001. (212)279-4250. Publisher: Richard Harrow. Magazine published 7 times/year. Emphasizes the fur and leather industry—"geared to the fur and leather retailer." Circ. 6,950. Sample copy \$3. SASE.

Photo Needs: Uses about 25-40 photos/issue; 50% supplied by freelance photographers. Needs photos

of "people (retailers) for success stories; fashion; visual merchandising shots; window displays; how-to on select subjects." Special needs include "beautiful window displays; fur oddities, interesting advertising techniques." Model release and captions preferred.

Making Contact & Terms: Arrange a personal interview to show portfolio; query with samples or list of stock photo subjects; send 8x10 b&w or color matte prints; 21/4x21/4 transparencies or b&w or color contact sheets by mail for consideration. Provide resume, business card, brochure, flyer or tearsheets to be kept on file for possible future assignments. SASE. Reports "usually within a month." Pays \$300-1,100/job or lump sum for text/photo package. Pays "within a month of acceptance." Credit line given. Buys one-time rights "mostly." Simultaneous and photocopied submissions OK.

*BUSINESS SOFTWARE, 2464 Embarcadero Way, Palo Alto CA 94303. (415)424-0600. Editor: Thom Hogan. Art Director: Bruce Olson. Monthly. Emphasizes software. Readers are entrepreneurs and middle-management. Circ. 50,000. Sample copy \$2.95.

Photo Needs: Uses about 3-4 or more photos/issue; all supplied by freelance photographers. Needs table

top shots, studio shots and location shots. Model release preferred.

Making Contact & Terms: Provide business card, brochure, flyer or tearsheets to be kept on file for possible future assignments. Does not return unsolicited material. Pays \$75-1,000/color cover photo; \$250-300/b&w page; \$400-500/color page. Credit line given. Buys first North American serial rights. Previously published work OK.

BUSINESS VIEW OF SOUTHWEST FLORIDA, Box 1546, Naples FL 33939. (813)263-7525. Publisher: Eleanor Sommer. Monthly magazine. Emphasizes business for professional and business readers. Sample copy \$2.

Photo Needs: Uses about 5-10 photos/issue; 75% supplied by freelance photographers. "Usually needs head shots for profiles, press releases, etc. Almost all would be of local/regional interest (southwest

Florida)." Captions required.

Making Contact & Terms: Query with samples. SASE. Reports in 6 weeks. Payment negotiable depending on the assignment. Pays on publication. Credit line given in masthead. Simultaneous submissions OK.

Tips: Prefers to see "sharp, clear b&w portraits" in samples. "Be local and available."

CALIFORNIA BUILDER & ENGINEER, Box 10070, Palo Alto CA 94303. (415)494-8822. Publisher: David W. Woods. Bimonthly magazine. Circ. 12,500. Emphasizes the heavy construction industry. For public work officials and contractors in California, Hawaii, western Nevada and Arizona. Not copyrighted. Send photos for consideration. Pays on publication. Reports in 2 weeks. SASE. Subject Needs: Head shot (personnel changes), photo essay/photo feature and product shot (construc-

tion equipment on the job).

B&W: Send 4x5 glossy prints. Captions required. Pays \$10-15.

Cover: Cover shots should have an accompanying ms. Color transparencies only. Purchase covers rare-

ly, but will consider. Pays \$15-25/4x5 color or b&w photo.

Tips: Camera on the Job column uses single photos with detailed captions. Photographers "should be familiar with their subject-for example, knowing the difference between a track dozer and a wheel loader, types and model number of equipment, construction techniques, identity of contractor, etc. We are using very little freelance material.'

CANADIAN PHARMACEUTICAL JOURNAL, 1815 Alta Vista Dr., Ottawa, Ontario, Canada K1G 3Y6. (613)523-7877. Editor: Jean-Guy Cyr. Monthly magazine. Circ. 12,500. For pharmacists and health professionals.

Accompanying Mss: Photos purchased with or without accompanying ms.

Payment & Terms: Pays \$50/color transparency. Payment for b&w varies. Pays on publication. Making Contact: Query or send material to the assistant editor, Mary MacDonald. Reports in 3 weeks.

CATECHIST, 2451 E. River Rd., Dayton OH 45439. Editor: Patricia Fischer. Monthly magazine published from July/August through April. Circ. 40,000. Emphasizes religious education for professional and volunteer religious education teachers working in Catholic schools. Buys 4-5/issue. Not copyrighted. Send photos or contact sheet for consideration. Pays on publication. Reports in 2-3 months. SASE. Simultaneous submissions OK. Sample copy \$2.

Subject Needs: Fine art, head shot, human interest (all generations and races), nature, scenic, still life and seasonal material (Christmas, Advent, Lent, Easter). Wants on a regular basis family photos (all ec-

onomic classes and races).

B&W: Send contact sheet or 8x10 glossy, matte, semigloss or silk prints. Pays \$25-35. Cover: Send b&w glossy, matte, semigloss or silk prints. Using 4-color art on covers now. CEE (Contractor's Electrical Equipment), 707 Westchester Ave., White Plains NY 10604. (914)949-8500. Editorial Director: Stuart M. Lewis. Art Director: Gerry Courtade. Monthly tabloid. Emphasizes the electrical construction industry for electrical contractors and electrical consultants/architects. Circ. 104,000. Sample copy \$3.

Photo Needs: Needs "cover photos only-industrial and electrical construction photos." Model release

and captions required.

Making Contact & Terms: Query with list of stock photo subjects; provide resume, business card, brochure, flyer or tearsheets to be kept on file for possible future assignments. SASE. Reports in 2 weeks. "Have not set rates." Pays on publication. Credit line given. Buys one-time rights. Previously published work OK.

CERAMIC SCOPE, 3632 Ashworth N., Seattle WA 98103. (206)632-7222. Editor: Michael Scott. Monthly magazine. Circ. 8,500. Emphasizes business aspects of hobby ceramics for small-business people running "Mama-Papa shops." Needs photos of ceramic shop interiors, "with customers if possible." Also needs photos of shop arrangements and exteriors. Buys 6 photos/issue. Buys all rights. Querry first. Works with freelance photographers on assignment only basis. Provide letter of inquiry and tearsheets to be kept on file for possible future assignments. Pays on acceptance. Reports in 2 weeks. SASE. Sample copy \$1.

B&W: Send glossy 5x7 prints. Captions required. Pays \$5-10.

Color: Send 35mm or 21/4x21/4 negatives. Captions required. Pays \$50 minimum. Cover: Send 35mm or 21/4x21/4 color negatives. Captions required. Pays \$50.

CERAMICS MONTHLY, Box 12448, Columbus OH 43212. (614)488-8236. Contact: Editorial Department. Monthly. Emphasizes "handmade pottery/ceramic art—particularly contemporary American, but also international and historic." Readers are "potters, ceramic artists, teachers, professors of art, collectors of ceramics, craft institutions and libraries." Circ. 40,000. Sample copy \$3. Photo guidelines free with SASE.

Photo Needs: Uses about 100 photos/issue. Needs "museum-quality shots of ceramics (pottery, sculpture, porcelain, stoneware individual objects) shot on plain backgrounds; shots of potters in their studios; photos of ceramic processes." Photos purchased with accompanying ms only "except cover photos which *sometimes* do not have a text." Model release optional; captions required.

Making Contact & Terms: Send 8x10 glossy b&w prints; 35mm (Kodachrome 25 only), 2½x2½, 4x5 or 8x10 transparencies by mail for consideration. SASE. Reports "as time permits." Pays \$50/color cover photo; \$10/b&w or \$20/color inside photo. "News and exhibition coverage excluded from payment." Pays on publication. Buys magazine rights.

Tips: "Team up with a good potter to help with ceramic aesthetic decisions."

CHEMICAL BUSINESS, Suite 1505, 100 Church St., New York NY 10007-2694. (212)732-9820. Managing Editor: J.R. Warren. Monthly magazine. Emphasizes chemicals for 40,000 managers (all levels) in chemical industry—making, research, engineering. Sample copy free with SASE.

Photo Needs: Uses 1-2 photos/issue; none currently supplied by freelance photographers. "Trying now to establish photo feature; several approaches in mind." Special needs include "unusual color shots of chemical plants, products, packages, chemicals." Model release and captions required.

Making Contact & Terms: Query with samples. SASE. Reports in 1 week. "We try for fast response." Pays \$300/b&w cover photo; \$25-75/b&w inside photo. Pays on acceptance. Credit line given in back of book. Buys all rights.

Tips: Prefers to see "ability to obtain dramatic shots of plants and products" in samples. "Make sure you've got clear identification of subject when and where shot; offer choice of the same subject."

THE CHRISTIAN MINISTRY, 407 S. Dearborn St., Chicago IL 60605. (312)427-5380. Editor: A.P. Klausler. Bimonthly magazine. Circ. 12,000. For the professional clergy, primarily liberal Protestant. Seeks religious photos. Buys 2-3/issue. Pays \$15 minimum/b&w print. Pays on publication. Send material by mail for consideration. SASE. Reports in 1 week.

CHRONICLE GUIDANCE PUBLICATIONS, INC., Moravia NY 13118. (315)497-0330. Editorin-Chief: Paul Downes. Photo Editor: Karen Macier. Monthly. Circ. 8,000-10,000. Emphasizes career education and occupational guidance materials (education). "Our main market is with junior high and high school libraries and guidance departments. Materials aimed at students using them to prepare for postsecondary education and deciding on occupational fields."

Photo Needs: Uses about 15-20 photos/issue; 8-10 are supplied by freelance photographers. "We like to show people engaged in actual performance of occupations, without showing sex stereotyping. Males in typical female jobs and vice versa are ideal." Photos purchased with or without accompanying ms.

Model release required; captions preferred.

Making Contact & Terms: Query with samples or submit portfolio for review. Does not return unsolicited material. Reports in 1 month. Provide brochure, tearsheets and literature that shows samples of work to be kept on file for possible future assignments. Pays \$50-100/b&w cover and inside photos. Pays on acceptance. Credit line given. Buys one-time rights. Simultaneous submissions and previously published work OK.

Tips: Prefers to see "b&w glossy photos showing people engaged in work situations—something different that really portrays the overall occupation. Preferably close-up and with tools of the occupation

visible. Action shots—not obviously posed. Sharp detail and color contrasts."

CIM, (formerly CAD/CAM TECHNOLOGY), 1 SME Dr., Dearborn MI 48141. (313)271-1500. Managing Editor: Bob Stauffer. Quarterly magazine. Emphasizes computers in design and manufacturing. Readers are members of the Computer and Automated Systems Association. Circ. 15,000. Free sample copy with SASE.

Photo Needs: Uses about 25-40 photos/issue; number supplied by freelance photographers "depends on need." Needs photos of "computers, computers in workplace and computer images." Special needs in-

clude "specific cover shots, working on ideas with editor and art director."

Making Contact & Terms: Send 5x7 b&w or color prints or transparencies by mail for consideration; provide resume, business card, brochure, flyer or tearsheets to be kept on file for possible future assignments. SASE. Reports in 2 weeks. Pays \$175-300/color cover photo; \$25/b&w inside photo, \$50 color inside photo; maximum \$200/job. Pays monthly. Buys one-time rights or all rights. Simultaneous and previously published submissions OK.

*CIRCUIT RIDER, 201 8th Ave. S, Nashville TN 37202. (615)749-6488. Associate Editor: Bette Prestwood. Magazine published 10 times/year. Emphasizes "United Methodist religion, theology and ministry." Readers are United Methodist clergy. Circ. 41,000. Photo guidelines free with SASE. Photo Needs: Uses about 6-8 photos/issue; "most of them" supplied by freelancers. Needs photos of "clergy (especially women and minorities) involved in tasks of monority—preaching, criminal studying, serving communion, baptism, etc. Some nature shots or other symbolic imagery; some family shots and group shots." Model release and captions preferred.

Making Contact & Terms: Query with list of stock photo subjects. Send 5x7 glossy b&w prints or b&w contact sheet by mail for consideration. Submit portfolio for review. SASE. Reports in 2 weeks. Pays \$65/b&w cover photo and \$30/b&w inside photo. Pays on publication. Credit line given. Buys

one-time rights. Simultaneous submissions and previously published work OK.

Tips: Prefers to see "shots with unusual angels, lighting, special photographic techniques (such as double exposures, etc.) in addition to good clear photos. The publication is specialized. Provide good photos of the subject matter listed. Minority groups especially American Hispanic, Asian, Native American and black."

CITY NEWS SERVICE, Box 86, Willow Springs MO 65793. Photo Editor: Richard Weatherington. Readers are businessmen, travelers and photographers. Semimonthly. Circ. 8,000. Photo guidelines for SASE.

Photo Needs: Uses 10-12 photos/issue; 80% of which are supplied by freelance photographers. Needs travel shots, business photos, artistic shots and nudes. Special needs include candid photos of nudes

(girl-next-door type) for book.

Making Contact & Terms: Send by mail for consideration 8x10 b&w or color prints, or 35mm slides. Provide letter of inquiry and samples (particularly featuring people) to be kept on file for possible future assignments. SASE. Reports in 2-4 weeks. Pays on publication \$15-25/photo; prices double if used on cover. Credit line given. Buys first North American serial rights. Simultaneous submissions and previously published work OK.

Tips: "Send the best samples you have."

*CLASSROOM COMPUTER LEARNING, 19 Davis Dr., Belmont CA 94002. (415)592-7810. Editor: Holly Brady. Art Director: Peter Li, 2451 River Rd., Dayton OH 45439. Monthly. Emphasizes computer in education. Readers are teachers and administrators, grades K-12. Sample copy \$1. Photo Needs: Uses about 7-10 photos/issue; 5 or more supplied by freelance photographers. Photo needs "depends on articles concerned. No general categories. Usually photos used to accompany edit in

a conceptual manner." Model release preferred.

Making Contact & Terms: Arrange a personal interview to show portfolio; query with samples; provide resume, business card, brochure, flyer or tearsheets to be kept on file for possible future assignments. SASE. Reports in 3 weeks. Pays \$600-1,000/color cover photo; \$300-500/b&w inside photo; \$400-800/color inside photo. Pays on acceptance. Credit lines given. Buys one-time rights. Previously published work OK.

*CLAVIER, 200 Northfield Rd., Northfield IL 60093. (312)446-5000. Editor: Barbara Kreader. Magazine published 10 times/year. Circ. 25,000. For piano and organ teachers. Credit line given. Pays on publication. Buys all rights. Send material by mail for consideration. SASE. Reports in 1 month. Sample copy \$2.

Subject Needs: Human interest photos of keyboard instrument students and teachers. Special needs in-

clude synthesizer photos, senior citizens performing.

B&W: Uses glossy prints. Pays \$10-25. Color: Any format. Pays \$50-125/photo.

Tips: "We need sharp, well-defined photographs and we like color. Any children or adults should be engaged in a *piano*-related activity and should have a look of deep involvement rather than a posed portrait look."

*COASTAL PLAINS FARMER, Suite 300, 3000 Highwoods Blvd., Raleigh NC 27625. (919)872-5040. Editor: Sid Reynolds. Monthly magazine. Emphasizes agriculture. Readers are Coastal Plains professional farmers. Circ. 116,000. Sample copy free with SASE and 37¢ postage. Photo guidelines free with SASE.

Photo Needs: Uses about 30 photos/issue; 1-2 by freelance photographers. Needs how-to photos. Spe-

cial needs include "technically accurate photos." Model release and captions required.

Making Contact & Terms: Query with samples. SASE. Reports in 2 weeks. Pays \$100-300/b&w cover photo, \$10-25/b&w inside photo, \$25-150/color inside photo, \$50-150/b&w, and \$150-250/color. Pays on publication. Credit line given "sometimes." Buys first North American serial rights.

COLLEGE UNION MAGAZINE, Box 1500, 825 Old Country Rd., Westbury NY 11590. (516)334-3030. Managing Editor: Catherine Orobona. Emphasizes leisure time aspects of college life for "campus activity and service professionals." Published 6 times a year. Circ. 10,000.

Photo Needs: Uses 5 photos/year. Needs documentary (refurbishing a student union), photo essay/photo feature (operations, vending room, lobby, building, remodeling, lobby theater, ballroom), sport (if related to student leisure time activities), spot news (trends in campus life, related to student centers or unions), how-to (refurbish, decorate, install). Special needs include renovation/refurbishing of student unions. Photos bought with accompanying ms. Column needs: Pinpoint—trends in campus life. Model release and captions preferred.

Making Contact & Terms: Query. "Samples aren't really necessary—send actual photos to be considered. Once we've used them, we keep photographer's name on file." SASE. Reports in 3 weeks. Pays on publication \$5/photo; \$2/column inch for accompanying ms. Credit line given. Buys all rights. No si-

multaneous submissions or previously published work.

Tips: "Pay close attention to our needs and don't send photos of students playing Frisbee—send a photo that tells a story by itself!"

COLLISION, Box M, Franklin MA 02038. Editor: Jay Kruza. Magazine published every 6 weeks. Circ. 20,000. Emphasizes "technical tips and management guidelines" for auto body repairmen and managers in eastern U.S. Needs photos of technical repair procedures, association meetings, etc. Needs especially photo series; Collision Collection Quiz photos—5 or 6 car emblems for ongoing quiz. "A regular column called 'Stars and Cars' features a national personality with his/her car. Prefer 3 + b&w photos with captions as to why person likes this vehicle. If person has worked on it or customized it, photo is worth more." Buys 100 photos/year; 12/issue. Buys all rights, but may reassign to photographer after publication. In created or set-up photos, which are not direct news, requires photocopy of model release with address and phone number of models for verification. Query with resume of credits and representatiional samples (not necessarily on subject) or send contact sheet for consideration. Pays on acceptance. Reports in 3 weeks. SASE. Simultaneous submissions OK. Sample copy \$2; free photo guidelines.

B&W: Send glossy or matte contact sheet or 5x7 prints. Captions required. Pays \$25 for first photo; \$5 for each additional photo in the series; pays \$25-50/photo for "Stars and Cars" column depending on

content. Extra pay for accompanying mss., "even if just facts are supplied."

Tips: "Don't shoot one or two frames; do a sequence or series. It gives us choice, and we'll buy more photos. Often we reject single photo submissions. Capture how the work is done to solve the problem. If you don't know where to look or start, call us for advice or names."

COMMERCIAL CARRIER JOURNAL, Chilton Way, Radnor PA 19089. (215)964-4513. Editor-In-Chief: Gerald F. Standley. Executive Editor: Carl R. Glines. Monthly magazine. Circ. 85,000. Emphasizes truck fleet maintenance operations and management. Photos purchased with or without accompanying ms, or on assignment. Pays on a per-job or per-photo basis. Credit line given. Pays on acceptance. Buys all rights. Send material by mail for consideration. SASE. Reports in 3 weeks.

Subject Needs: Spot news (of truck accidents, Teamster activities, and highway scenes involving

trucks). Model release required; detailed captions required.

B&W: Contact sheet and negatives OK.

Color: Uses prints and 35mm transparencies; contact sheet and negatives preferred.

Cover: Uses color transparencies; color contact sheet and negatives preferred. Uses vertical cover only. Pays \$100 minimum/photo.

Accompanying Mss: Features on truck fleets and news features involving trucking companies.

*COMPRESSED AIR MAGAZINE, 253 E. Washington Ave., Washington NJ 07882-2495. (201)689-4557. Editor: J.M. Parkhill. Monthly. Circ. 149,000. Emphasizes "industrial subjects, technology, energy." Readers hold middle to upper management positions in SIC. Sample copy free. Photo Needs: Uses about 20 photos/issue; "very few" supplied by freelance photographers. Model release and captions preferred.

Making Contact & Terms: Provide resume, business card, brochure, flyer or tearsheets to be kept on file for possible future assignments. Does not return unsolicited material. Previously published work

OK

Tips: "Write for editorial calendar to see subjects that might be needed. We look for high quality color shots, and have increased use of 'symbolic' photos to supplement industrial shots."

COMPUTER DEALER, Box 1952, Dover NJ 07801. (201)361-9060. Art Director: John McLaughlin. Monthly. Emphasizes computers. Readers are retail computer dealers. Circ. 40,000. Sample copy free with SASE.

Photo Needs: Uses about 5-10 photos/issue; all supplied by freelance photographers. Needs still lifes

for covers, and photos of people and showrooms. Model releases required.

Making Contact & Terms: Arrange a personal interview to show portfolio. Pays \$300-500/b&w and \$400-600/color cover photo; \$75-150/b&w and \$200-300/color inside photo. Credit line given. Buys all rights.

Tips: "We look for good, 4-color still lifes and b&w people shots in a portfolio."

COMPUTER DECISIONS, 10 Mulholland Dr., Hasbrouck Heights NJ 07604. (201)393-6015. Art Director: Bonnie Meyer. Biweekly magazine. Circ. 175,000. Emphasizes management procedures, computer operation and equipment. For computer-involved management in industry, finance, academia, etc. Well educated, sophisticated, highly paid. Buys 10-20 photos/issue. Uses color photos for covers and to illustrate articles. Also, location assignments out of town.

Payment & Terms: Fee negotiable. Pays on acceptance.

Making Contact: Query. Works with freelance photographers on assignment only basis. Provide resume and samples to be kept on file for possible future assignments. SASE. Reports in 1 week.

*COMPUTER MERCHANDISING, Suite 222, 15720 Ventura Blvd., Encino CA 91436. (818)995-0436. Associate Editor: Christopher Rauen. Monthly magazine. Emphasizes "Marketing of high technology products: microcomputer hardware, software, peripherals, etc." Readers are retailers, systems integrators, other resellers. Circ. 25,000.

Photo Needs: Uses about 14 photos/issue; all supplied by freelance photographers. Needs photos "for merchandising section, needs profiles of retail stores: exterior and interior photographs of computer re-

tail stores." Model release preferred.

Making Contact & Terms: Provide resume, business card, brochure, flyer or tearsheets to be kept on file for possible future assignments. Pays \$75/job. Pays on acceptance. Credit line given. Buys one-time rights.

COMPUTERWORLD, 375 Cochituate Rd., Box 880, Framingham MA 01701. (617)879-0700. Executive Editor: Rita Shoor. Managing Editor: Bill Laberis. Weekly newspaper. Circ. 116,000. Emphasizes new developments, equipment and services in the computer industry. For management-level computer users, chiefly in the business community, but also in government and education.

Subject Needs: DP-related even if specific subject is primarily impact on people of a DP system. Captions required.

Specs: B&w prints.

Accompanying Mss: Photos purchased with accompanying ms only.

Payment & Terms: Pays \$20-35/b&w print. Pays on publication. Credit line given. Buys one-time

rights

Making Contact: Submit portfolio, query with resume or list of stock photos. SASE. Reports in 3 weeks. Provide resume and brochure to be kept on file for possible future assignments. Sample copy and photo guidelines.

CONTRACTORS GUIDE, 5520 Touhy Ave., Skokie IL 60077. (312)676-4060. Editor: Richard Toland. Monthly magazine. Emphasizes "roofing, siding, insulation, solar construction business, both

manufacturing and contracting." Circ. 28,000. Sample copy free with SASE.

Photo Needs: Uses about 10 photos/issue; 0-1 supplied by freelance photographers. Needs "head shots, group photos, product shots and on-site construction shots." Reviews photos with accompanying ms

only. Model release and captions preferred.

Making Contact & Terms: Provide resume, business card, brochure, flyer or tearsheets to be kept on file for possible future assignment. SASE. Reports in 1 week. Pays negotiable rate for color cover photo; \$25/b&w inside photo, \$30/color inside photo. Pays on publication. Credit line given. Buys all rights.

COOKING FOR PROFIT, Box 267, Fond du Lac WI 54935. (414)923-3700. Editor: Bill Dittruch. Monthly. Emphasizes foodservice operations. Readers are operations managers for foodservice, mainly independent restaurants. Circ. 25,000. Sample copy free with 8½x11 SAE and 40¢ postage.

Photo Needs: Uses about 18 photos/issue; 3 supplied by freelance photographers. "We need photos of particular restaurants on which we are doing profiles, mainly photos of kitchen operations and workers. We need photo sequences demonstrating kitchen techniques—preferably b&w with commentary."

Model release and captions required.

Making Contact & Terms: Provide resume, business card, brochure, flyer or tearsheets to be kept on file for possible future assignments. SASE. Reports in 1 month. Pays \$50-150/job; \$250-300 for text/photo package. Pays on publication. Credit given on index page. Buys one-time rights. Previously published submissions OK.

Tips: "Be positively sure that you know what the editor wants before shooting. Make sure he/she tells

you exactly."

CORPORATE MONTHLY, Box 40168, 105 Chestnut St., Philadelphia PA 19106. (215)629-1611. Editor: Bruce Anthony. Assistant Editor: George Ewing. (Contact: Assistant Editor). Monthly magazine. Emphasizes regional business for upper-middle management of area corporations. Circ. 15,000. Sample copy available.

Photo Needs: Uses about 15-20 photos/issue; all supplied by freelance photographers. "Generally, we need pix to illustrate stories; however, photo essays revelant to our market have been and will be used."

Model release "depends on subject matter;" captions required.

Making Contact & Terms: Arreange a personal interview to show portfolio. SASE. Reports in 2 weeks. Payment negotiated. Pays on publication. Credit line given. Buys one-time rights or first North American serial rights. Simultaneous and previously published submissions OK "if not used within this market. All unsolicited submissions accepted without prior query letter."

Tips: "We are communicators and we want our editorial and art to communicate. We also demand more creativity than is shown by many area photographers. Look at the magazine. Then show me even better

art than we are now using. Request past issues to understand illustrations needed."

CRANBERRIES, Box 249, Cobalt CT 06414. (203)342-4730. Publisher/Editor: Bob Taylor. Monthly. Emphasizes cranberry growing, processing, marketing and research. Readers are "primarily cranberry growers but includes anybody associated with the field." Circ. 650. Sample copy free with SASE. **Photo Needs:** Uses about 10 photos/issue; half supplied by freelance photographers. Needs "portraits of growers, harvesting, manufacturing—anything associated with cranberries." Model release optional; captions required.

Making Contact & Terms: Send 4x5 or 8x10 b&w glossy prints by mail for consideration; "simply query about prospective jobs." SASE. Pays \$15-25/b&w cover photo; \$5-15/b&w inside photo; \$35-100 for text/photo package. Pays on publication. Credit line given. Buys one-time rights. Simultaneous

and previously published submissions OK.

Tips: "Learn about the field."

CROPS AND SOILS MAGAZINE, 677 S. Segoe Rd., Madison WI 53711. Editor: William R. Luellen. Magazine published 9 times annually. Circ. 20,000. Emphasizes practical results of scientific research in agriculture, especially crop and soil science, for "the modern farmer and his advisors: extension personnel, fertilizer and pesticide dealers and salesmen, agribusiness executives, vocational-agriculture teachers and modern, above-average, innovative farmers." Needs "agricultural scenes—livestock; 'portraits' of various crops; good photos showing symptoms of various agricultural diseases, insects and the damage they can cause and all sorts of equipment and machinery—particularly in operation." Buys 6-7 photos/year. Buys one-time rights. Submit model release with photo. Send contact sheet or photos for consideration. Pays on publication. Reports in 1 month. SASE. Previously published work OK. Free sample copy with large SASE. Does not have separate photo requirement guidelines; "read this entry to know our needs and policies."

Cover: Send b&w contact sheet or 8x10 glossy b&w prints. Captions required. Pays \$100.

Tips: Captions should include identification of subject, location and date.

DAIRY GOAT JOURNAL, Box 1808, Scottsdale AZ 85252. (602)991-4628. Photo Editor: Kent Leach. Monthly magazine. Circ. 14,000. For breeders and raisers of dairy goats.

Subject Needs: Relate in some manner to dairy goats, dairy goat dairies, shows, sales, life of people

who raise dairy goats.

Specs: B&w prints and color transparencies.

Accompanying Mss: Photos purchased with accompanying ms only.

Payment & Terms: Pays \$5-15/b&w print, \$15/color transparency and cover. Pays on publication.

Making Contact: Query or send material. SASE. Reports in 4 weeks.

DAIRY HERD MANAGEMENT, Box 67, Minneapolis MN 55440. (612)374-5200. Editor: Sheila Vikla. Monthly magazine. Circ. 100,000. Emphasizes dairy management innovations, techniques and practices for dairymen. Photos purchased with accompanying ms, or on assignment. Pays \$100-250 for text/photo package, or on a per-photo basis. Pays on acceptance. Buys one-time rights. Query with list of stock photo subjects. SASE. Reports in 2 weeks. Free photo guidelines.

Subject Needs: Animal (natural photos of cows in specific dairy settings), how-to and photo essay/photo feature. Wants on a regular basis photos showing new dairy management techniques. No scenics or dead colors. Model release and captions preferred.

B&W: Uses 5x7 glossy prints. Pays \$5-25/photo.

Color: Uses 35mm or 21/4x21/4 transparencies. Pays \$25-100/photo.

Cover: Uses 35mm or 21/4x21/4 color transparencies. Vertical format required. Pays \$50-150/photo. Accompanying Mss: Interesting and practical articles on dairy management innovations, techniques and practices. Pays \$100-150/ms. Writer's guidelines included on photo guidelines sheet.

*DAIRYMEN'S DIGEST, Box 5040, Arlington TX 76011. (817)461-2674. Editor: Phil Porter. Monthly magazine. Circ. 9,500. Emphasizes dairy-related articles for dairy farmers: "solid, family type, patriotic, hardworking Americans." Needs photos of farm scenes, "especially dairy situations." Prefers South or Southwest setting. Buys 6 photos/year. Not copyrighted. Works with freelance photographers on assignment only basis. Send contact sheet or photos for consideration. Pays on acceptance. Reports in 2 weeks. SASE. Simultaneous submissions and previously published work OK. Free sample copy and photo guidelines.

B&W: Uses 5x7 glossy prints; send contact sheet. Pays \$15-30.

Color: Send 8x10 glossy prints or transparencies. Pays \$75 minimum.

Cover: Send glossy prints or color transparencies. Cover photos "must be beautiful or unusual farm or

dairy scenes." Pays \$75 minimum.

Tips: Photos submitted with accompanying ms "should help tell the story or illustrate a point or situation in the story."

DANCE TEACHER NOW, Suite 2, University Mall, 803 Russell Blvd., Davis CA 95616. (916)756-6222. Editor: Susan Wershing. Circ. 5,500. Readers are "professional dance teachers in dance companies, college dance departments, private studios, secondary schools, recreation departments, etc." Sample copy \$2.25.

Photo Needs: By assignment, from your stock of dance photos, or accompanied by an article of a practical nature, only. Uses 10-12 photos/issue, all by freelance photographers. Uses mostly "dance teaching" shots and "talking head" shots. Model release required; identification required, but editor writes

captions.

Making Contact & Terms: Send samples by mail for consideration for assignment. SASE. Reports in 1 month. Pays \$75 minimum/job or \$20/stock photo. Credit line given on page with photo. Buys all rights.

*DAY CARE CENTER, Box 249, Colbalt CT 06414. (203)342-4730. Editor/Publisher: Bob Taylor. Monthly newspaper. Emphasizes features on day care centers and their owners and directors. Readers are primarily owners of private day care centers. Circ. 1,500. Estab. 1985. Free sample copy with SASE.

Photo Needs: Uses 15 photos/issue; 50% supplied by freelance photographers. Needs photos of children in day care centers and child care providers. Captions required.

Making Contact & Terms: Send 4x5, 5x7 or 8x10 b&w glossy prints by mail for consideration; "simply query about prospective jobs." SASE. Reports within 6 weeks. Pays \$30/b&w cover, \$5-30/b&w inside photo, \$50-75/text/photo package. Photo spread pay: 1 page, \$35; 2 pages, \$50; 3 pages, \$75 and 4 pages, \$100. Pays on publication. Credit line given. Buys one-time rights. Simultaneous submissions and previously published work OK.

Tips: "There are day care centers in every community and, therefore, readily available subjects. We use

lots and lots of photos of kids and particularly need photo spreads with a theme."

DEALERSCOPE, 115 2nd Ave., Waltham MA 02154. (617)890-5124. Associate Publisher/Editorial Director: James M. Barry. Monthly magazine. Emphasizes consumer electronics and major appliances for retailers, distributors and manufacturers. Sample copy with SASE and 54¢ postage.

Photo Needs: Uses about 20 photos/issue; 5 supplied by freelance photographers. Needs photos of peo-

ple, products and events.

Making Contact & Terms: Query with resume of credits. SASE, Reports in 2 weeks, Pays \$500/color cover photo; \$50/b&w inside photo, \$75/color inside photo. Pays on acceptance. Credit line given. Buys one-time rights.

THE DEC PROFESSIONAL, 921 Bethlehem Pike, Springhouse PA 19477. (215)542-7008. Editor: Linda DiBiasio. Monthly. Emphasizes Digital Equipment Corporations (DEC) computer and related products and services. Readers are technical, professional computer-users-programmers, engineers, analysts, marketing professionals. Circ. 92,500. Sample copy free with SASE.

Photo Needs: Uses about 6 photos/issue; 95% supplied by freelance photographers. Needs office, com-

puter equipment shots. Also, business-in-progress shots-trade shows, etc.

Making Contact & Terms: Arrange a personal interview to show portfolio; provide resume, business card, brochure, flyer or tearsheets to be kept on file for possible future assignments. Reports in 3 weeks. Pays on publication. Credit line given. Buys first North American serial rights. Simultaneous submissions OK.

DENTAL ECONOMICS, Box 3408, Tulsa OK 74101. Editor: Dick Hale. Monthly magazine. Circ. 100,000. Emphasizes dental practice administration—how to handle staff, patients and bookkeeping and how to handle personal finances for dentists. Photos purchased with or without accompanying ms, or on assignment. Buys 20 photos/year. Pays \$50-150/job, \$75-400 for text/photo package, or on a perphoto basis. Credit line given. Pays in 30 days. Buys all rights, but may reassign to photographer after publication. Send material by mail for consideration. SASE. Reports in 2-4 weeks. Free sample copy: photo guidelines for SASE.

Subject Needs: Celebrity/personality, head shot, how-to, photo essay/photo feature, special effects/ex-

perimental and travel. No consumer-oriented material.

B&W: Uses 8x10 glossy prints. Pays \$5-15/photo.

Color: Uses 35mm or 21/4x21/4 transparencies. Pays \$35-50/photo.

Cover: "No outsiders here. Art/painting."

Accompanying Mss: "We use an occasional 'lifestyle' article, and the rest of the mss relate to the business side of a practice: scheduling, collections, consultation, malpractice, peer review, closed panels, capitation, associates, group practice, office design, etc." Also uses profiles of dentists. Writer's guidelines for SASE.

Tips: "Write and think from the viewpoint of the dentist—not as a consumer or patient. If you know of a dentist with an unusual or very visual hobby, tell us about it. We'll help you write the article to accompany your photos. Query please.'

DESIGN FOR PROFIT, 4175 S. Memorial, Box 45745, Tulsa OK 74145. (918)622-8415. Editor: Ginger Holsted. Photo Editor: Don E. Bryant. Quarterly. Circ. 17,000. Emphasizes floral design. Readers are "florist shop owners, managers, designers, floral service advertisers, (refrigeration, gift accessories)." Sample copy \$5.

Photo Needs: Uses about 35-40 photos/issue; 2 supplied by freelance photographers. Needs photos of "events significant to floral industry (designs for prominent weddings), and how-to (series of shots

describing innovative designs." Model release preferred; captions required.

Making Contact & Terms: Send color prints, 21/4x21/4 transparencies or color negatives by mail for consideration. SASE. Reports in 1 month. Pay "negotiable." Pays on acceptance. Credit line given. Buys all rights. Simultaneous submissions and previously published work OK.

Tips: "Be innovative, suggest new angles for articles that accompany photos, mss are not necessary—

just the idea. Use photos involving Florafax members."

*DIAGNOSIS, 680 Kinderkamack Rd., Oradell NJ 07649. (201)262-3030. Editor: Evelyn Gross. Photo Editor: Susan J. Kuppler. Monthly. Emphasizes medical diagnosis. Readers are physicians. Circ. 84,000. Sample copy \$5.

Photo Needs: Uses about 20 photos/issue; 4-5 supplied by freelance photographers. Needs mostly clinical photos, but some editorial (people). Special needs include photos of disease, photomicrography and

afflicted people. Model release and captions required.

Making Contact & Terms: Submit portfolio for review; provide resume, business card, brochure, flyer or tearsheets to be kept on file for possible future assignments. SASE. Reports in 3 weeks. Pays \$350-700/color cover photo; \$100-350/b&w inside photo; \$175-450/color inside photo; \$250-400/color page;

\$125-400 plus expenses/job. Pays on acceptance. "Our terms and conditions are listed on the purchase order which is issued upon commissioning of job. Credit line given. Buys one-time world rights. Previously published work OK.

Tips: *Examples of photographer's capabilities with lighting, special effects, capturing personalities, composition, reasonable prices, concept. Don't overprice yourself, be aggressive not obnoxious; pho-

tographers are a dime a dozen, good photographers are always in demand."

THE DISPENSING OPTICIAN, Box 10110, 10341 Democracy Ln., Fairfax VA 22030. (703)691-8355. Editor: James H. McCormick. Emphasizes information relevant to dispensing of eye care of opticians. Readers are retail dispensing opticians and contact lens fitters. Monthly. Circ. 10,800. Free sample copy "to photographer who has a story/feature idea of interest to us"; otherwise sample copy costs \$2.

Photo Needs: Uses 7-8 photos/issue. Selects freelancers based on location, specialty and cost (plus willingness to give us negatives without additional cost in 1-2 years when their only real continuing value is historical). Needs photos of "the optician in his shop" and "fitting patients with eyewear." Model re-

lease required (unless straight news photo); captions required.

Making Contact & Terms: Send by mail for consideration actual 5x7 or 8x10 b&w prints; query with resume of photo credits; query with list of stock photo subjects; or send ideas. SASE. Reports in 2 weeks. Pays on acceptance \$10-35/b&w photo; \$60 minimum/color photo; \$150-200 minimum/cover. "Small additional payment made if more than photo description specified by us." No credit line given. Buys first North American serial rights and/or industry rights for photos originated by photographer; all rights for photo work originated by magazine. Simultaneous submissions OK ("but only on an exclusive basis in optical industry"); previously published work rarely accepted.

Tips: "Keep your eyes open for unusually good window displays, promotions or other activities by opti-

cians—not by our dispensing competitors, optometrists or ophthalmologists."

*DISTRIBUTION MAGAZINE, Chilton Way, Radnor PA 19089. (215)964-4388. Editor-in-Chief: Joseph Barks. Monthly magazine. Emphasizes freight transportation (all modes), warehousing, export/import. Readers are managers for manufacturing, wholesale and retail companies responsible for movement of goods inbound and outbound. Circ. 62,000.

Photo Needs: Uses about 12 photos/issue; 1 supplied by freelance photographers. Needs photos of

transportation scenes (trucks, trains, planes, ships, ports, etc.). Written release preferred.

Making Contact & Terms: Query with samples. Send 8x10 color prints, and 35mm transparencies by mail for consideration. SASE. Reports in 3 weeks. Pays \$150-250/color cover photo and \$50-100/color inside photo. Pays on publication. Credit line can be given if requested. Buys one-time rights. Previously published work OK.

Tips: "Let use know if traveling, particularly abroad—we're always in need of shots of foreign ports,

airports (cargo only), trucks, etc.'

DISTRIBUTOR, Box 745, Wheeling IL 60090. (312)537-6460. Executive Editor: Ed Schwenn. Published 6 times/year. Emphasizes heating, air conditioning, ventilating and refrigeration. Readers are wholesalers. Circ. 10,000. Sample copy free with SASE and \$1 postage.

Photo Needs: Uses about 12 photos/issue; 1-2 supplied by freelance photographers. Needs photos pertaining to the field of heating, air conditioning, ventilating and refrigeration. Special needs include cov-

er photos of interior and exteriors of plants. Model release and captions required.

Making Contact & Terms: Query with list of stock photo subjects; "query on needs of publications." SASE. Reports in 2 weeks. Pays \$100-250/color cover photo; \$10/b&w and \$25/color inside photo. Pays on publication. Credit line given. Buys one-time rights. Simultaneous and previously published submissions OK "if not within industry."

DIXIE CONTRACTOR, Box 280, Decatur GA 30031. (404)377-2683. Editor: J. R. Thomas. Twice monthly magazine. Circ. 10,000. Emphasizes news of the construction, engineering and architectural fields. For heavy construction contractors, public officials, architects, engineers, construction equipment manufacturers and dealers. Buys 20 annually. Buys all rights. Present model release on acceptance of photo. Send contact sheet for consideration. Pays on publication. Reports in 2 weeks. SASE. Free sample copy.

Subject Needs: Job story, how-to, human interest, photo essay/photo feature and photos of construction scenes in the Southeastern states: Alabama, Georgia, Florida, South Carolina, and central and eastern

Tennessee. No posed shots.

B&W: Uses 8x10 glossy prints; send contact sheet. Pays \$15-25.

Color: Uses 8x10 matte prints and transparencies; send contact sheet. Pays \$25 minimum.

Cover: Uses color prints and 21/4x21/4 color transparencies. Pays \$25 minimum.

Tips: "We need action photographs of equipment being used: digging trenches, dredging, lifting materi-

al, grading roads, etc. Be sure to include proper identification: name of project, location of construction firm, type of equipment, etc. We also possibly could use pictures of association meetings, contractor conventions, and the like. Ideally, we prefer accompanying ms with photographs. This publication does not cover the western portion of Tennessee."

*DOMESTIC ENGINEERING MAGAZINE, 135 Addison St., Elmhurst IL 60126. Editor: Stephen J. Shafer. Monthly magazine. Circ. 40,000. Emphasizes plumbing, heating, air conditioning and piping; also gives information on management marketing and merchandising. For contractors, executives and entrepreneurs. "For photos without stories, we could use a few very good shots of mechanical construction—piping, industrial air conditioning, etc.," but most photos purchased are with stories. Buys 5 photos/issue. Rights purchased are negotiable. Submit model release with photo. Send contact sheet for consideration. Pays on acceptance. Reports in 2 weeks. SASE. Simultaneous submissions and previously published work OK.

B&W: Uses 5x7 glossy prints; send contact sheet. Captions required. Pays \$10-100.

Color: Uses 8x10 glossy prints or transparencies; send contact sheet. Captions required. Pays \$10-100. **Cover:** Uses glossy b&w prints, glossy color prints or color transparencies; send contact sheet. Captions required. Pays \$50-125.

DR. DOBB'S JOURNAL, 2464 Embarcadero Way, Palo Alto CA 94303. (415)424-0600. Editor: Michael Swaine. Photo Editor: Shelley Doeden. Monthly. Emphasizes computer programming, langagues and software. Readers are computer programmers and engineers. Circ. 33,000. Sample copy \$2.95. **Photo Needs:** Uses about 1 photo/issue; 1 supplied by freelance photographer. Needs photos of computer subjects—technical special effects. Model release preferred.

Making Contact & Terms: Provide resume, business card, brochure, flyer or tearsheets to be kept on file for possible future assignments. Does not return unsolicited material. Pays \$500-800/color cover photo. Credit line given. Buys first North American serial rights. Previously published work OK.

EARNSHAW'S REVIEW, 11 Penn Plaza, 393 7th Ave., New York NY 10001. (212)563-2742. Art Director: Bette Gallucci. Monthly. Emphasizes children's wear. Readers are buyers of children's apparel for specialty and department stores. Circ. 10,000.

Photo Needs: Uses about 30 photos/issue; 4-5 supplied by freelance photographers. Needs photos of "children in various settings (holiday, swimming, springtime, active, back-to-school, birthday parties,

etc.)." Model release required.

Making Contact & Terms: Arrange a personal interview to show portfolio; query with list of stock photo subjects. Pays \$250/color cover photo. Pays on publication. Credit line given. Buys one-time rights. Simultaneous and previously published submissions OK.

Tips: "Do not mail any original work unless specifically requested."

EDUCATION WEEK, Suite 775, 1255 23rd St., Washington DC 20037. (202)466-5190. Editor-in-Chief: Ronald A. Wolk. Photo Editor: Beth Schlenoff. Weekly. Circ. 55,000. Emphasizes elementary and secondary education.

Photo Needs: Uses about 8 photos/issue; all supplied by freelance photographers. Model release pre-

ferred; captions required.

Making Contact & Terms: Query with samples. Provide resume and tearsheets to be kept on file for possible future assignments. Does not return unsolicited material. Reports in 2 weeks. Pays \$50-250 by the job; \$50-300 for text/photo package. Pays on acceptance. Credit line given. Buys all rights. Simultaneous submissions and previously published work OK.

*ELECTRICAL APPARATUS, Barks Publications, Inc., 400 N. Michigan Ave., Chicago IL 60611. (312)321-9440. Editorial Director: Elsie Dickson. Monthly magazine. Circ. 15,000. Emphasizes industrial electrical machinery maintenance and repair for the electrical aftermarket. Photos purchased with accompanying ms, or on assignment. Credit line given. Pays on publication. Buys all rights, but "exceptions to this are occasionally made." Query with resume of credits. SASE. Reports in 3 weeks. Sample copy \$2.50.

Subject Needs: "Assigned materials only. We welcome innovative industrial photography, but most of

our material is staff-prepared." Model release required when requested; captions preferred.

B&W: Contact sheet or contact sheet and negatives OK. Pays \$10-50/photo.

Color: Query. Pays \$25-100.

ELECTRONIC BUYERS' NEWS, 600 Community Dr., Manhasset NY 11030. (516)365-4600. Assistant Purchasing Editor: Elizabeth DiGiose. Weekly newspaper. Emphasizes the electronic component industry. Readers are purchasing management, buyers and specifying engineers. Circ. over 51,000. Sample copy free on request; photo guidelines free with SASE.

Photo Needs: Uses about 10-15 photos/issue; 10% supplied by freelance photographers. Needs "informal candid work setting shots (purchasing people) that are used on the front page of the paper each week. We don't require processing—only the b&w or color slides exposed film.'

Making Contact & Terms: Provide resume, business card, brochure, flyer or tearsheets to be kept on file for possible future assignments. SASE. Reporting time "varies depending on where our subject is located (state)." Pays "after invoice is processed by accounting department." Credit line given.

ELECTRONIC EDUCATION, Suite 220, 1311 Executive Center Dr., Tallahassee FL 32301. (904)878-4178. Senior Editor: Marjorie Blair. Monthly magazine, no issues July and August. Emphasizes computers in education. Readers are educators and school administrators in middle school through college levels. Circ. 70,000. Sample copy and photo guidelines available.

Photo Needs: Uses 10-15 photos/issue; 1/3 supplied by freelance photographers. Needs "high tech type photos depicting applications—particularly in education, especially with people." Model release and

captions preferred.

Making Contact & Terms: Query with list of stock photo subjects. SASE. Reports in 1 month. Pays \$200/color cover photo; \$100/color inside photo; \$200/color page. Pays on publication. Credit line given. Buys all rights.

ELECTRONICS TIMES, 30 Calderwood St., Woolwich, London SE 18 6QH, England. (01)855-

7777. Editor: Mike McLean. Weekly. Sample copy available.

Photo Needs: Uses about 36 photos/issue; 4 supplied by freelance photographers. Needs "industry shots of electronics companies, components, people." Model release preferred; captions required. Making Contact & Terms: Submit portfolio for review. Provide resume, business card, brochure, flyer or tearsheets to be kept on file for possible future assignments. Does not return unsolicited material. Reports in 2 weeks. Pays \$100/job. Pays on publication. Buys all rights. Simultaneous submissions OK. Tips: "Show us some good industry shots relating to electronics."

ELECTRONICS WEEK, 1221 Avenue of the Americas, New York NY 10020. (212)512-2430. Art Director: Fred J. Sklenar. Weekly magazine. Emphasizes electronics business and technology. Circ. 105,000.

Photo Needs: Uses about 35-50 photos/issue; 10% supplied by freelance photographers. Needs "corporate, people, high-tech (electronics), some special effects, creative (to concept) and studio photogra-

phy." Model release required; captions preferred.

Making Contact & Terms: Provide resume, business card, brochure, flyer or tearsheets to be kept on file for possible future assignments. SASE. Reports in 1 month. Pays \$250/b&w cover photo, \$600-1,000 color cover photo; \$75/b&w inside photo, \$150/color inside photo and/or ASMP day rate. Pays on acceptance. Credit line given if requested. Buys all rights but "depends on terms and subject."

*ELECTRONICS WEST, 2250 N. 16th St., Phoenix AZ 85006. (602)253-9086. Photo Editor: Walter Schuch. Monthly. Emphasizes high technology electronics, electronics companies. Circ. 20,000. Sample copy \$2 with \$1.10 postage.

Photo Needs: Uses 10 photos/issue; 1 supplied by freelance photographers. Needs product shots; factory/building shots; people engaged in activity. Reviews photos with or without accompanying ms. Model

release and captions required.

Making Contact & Terms: Query with list of stock photo subjects; send 5x7 b&w glossy prints and 35mm transparencies by mail for consideration. SASE. Reports in 2 months. Pays \$150/color cover photo; \$5/b&w inside photo. Pays on publication. Buys first North American serial rights.

EMERGENCY, The Journal of Emergency Services, 6200 Yarrow Dr., Carlsbad CA 92008. (619)438-2511. Editor: James Daigh. Monthly magazine. Circ. 40,000. Emphasizes emergency medical and rescue services for paramedics, EMTs and emergency room fire fighters, physicians and nurses to keep them informed of latest developments in the emergency medical field. Photos purchased with or without accompanying ms. Buys 80 photos/year; 6-8 photos/issue. Pays minimum of \$100 for text/photo package, or on a per-photo basis. Credit line given. Pays on acceptance. Buys all rights. Send material by mail for consideration, especially action shots of first responders in action; or query with resume and ideas for photos. SASE. Simultaneous submissions and previously published work OK ("if not in our market".) Reports in 2 months. Sample copy and contributor guidelines \$5.

Subject Needs: Documentary, photo essay/photo feature and spot news dealing with emergency medicine. Needs shots to accompany unillustrated articles submitted by physicians; themes forwarded on request. No "shots of accident sites after the fact, backs of the emergency personnel, bloody or gory shots." Captions required. Also needs color transparencies for "Emergency Action," a department

dealing with emergency personnel in action.

B&W: Uses 5x7 or larger glossy prints. Pays \$15-25/photo.

Color: Uses 35mm or larger transparencies or color prints. Pays \$25-50/photo.

Cover: Prefers 35mm; 21/4x21/4 transparencies OK. Vertical format preferred. Pays \$100/photo. Accompanying Mss: Instructional, descriptive or feature articles dealing with emergency medical serv-

ices. Pays \$100-400/ms.

Tips: Wants well-composed photos that say more than "an accident happened here." Looking for more color illustrations for stories. "We're interested in people, and our readers like to see their peers in action.'

EUROPE MAGAZINE, 2100 M St. NW, #707, Washington DC 20037. (202)862-9500. Editor-in-Chief: Webster Martin. Bimonthly magazine. Circ. 50,000. Covers the European Common Market with "in-depth news articles on topics such as economics, trade, US-EC relations, industry, development and East-West relations." Readers are "businessmen, professionals, academic, government officials."

Free sample copy.

Photo Needs: Uses about 30-35 photos/issue, 1-2 of which are supplied by freelance photographers (mostly stock houses). Needs photos of "current news coverage and sectors, such as economics, trade, small business, people, transport, politics, industry, agriculture, fishing, some culture, some travel. Each issue we have an overview article on one of the 10 countries in the Common Market. For this we need a broad spectrum of photos, particularly color, in all sectors. We commission certain photos for specific stories or cover. Otherwise, freelance photos may be chosen from unsolicited submissions if they fit our needs or blend into a specific issue. If a photographer queries and lets us know what he has on hand, we might ask him to submit a selection for a particular story. For example, if he has slides or b&w's on a certain European country, if we run a story on that country, we might ask him to submit slides on particular topics, such as industry, transport or small business." Model release and captions not required; identification necessary.

Making Contact & Terms: Send by mail for consideration actual 5x7 and 8x10 b&w or color photos. 35mm/21/4x21/4 color transparencies; query with resume of photo credits; or query with list of stock photo subjects. SASE. Reports in 3-4 weeks. Pays on publication \$100/b&w photo; \$100/color transparency for inside, \$450 for front cover; per job negotiable. Credit line given. Buys one-time rights. Simulta-

neous and previously published submissions OK.

THE EVENER, Box 7, Cedar Falls IA 50613. (319)277-3599. Managing Editor: Susan Salterberg. Quarterly magazine. Emphasizes "the draft horse, mule and oxen industries—with emphasis on draft horses." Published primarily for draft horse, mule and oxen enthusiasts, as well as for individuals interested in nostalgia, back-to-basics, ecology and rural life." Circ. 9,000. Sample copy for SASE and

\$1.07 postage; photo guidelines for SASE. and 39¢ postage.

Photo Needs: Uses about 60 photos/issue; 25 supplied by freelance photographers usually with accompanying mss. "Draft horse, mule and oxen photos showing beauty and power of these animals are most welcome. Also want human interest shots with owner, driver or farmer working with the animal. Capture the animal and people in creative and engaging angles." Special needs include draft horses captured in action in an attractive, attention-getting manner." Model release and captions preferred.

Making Contact & Terms: Send 5x7 b&w prints (limit—10 prints/submission) or b&w contact sheets by mail for consideration. SASE. Reports in 3 months. Pays \$5-40/color cover photo; \$5-40/b&w inside photo. Pays on acceptance. Credit line given. "Prefer to buy first rights, but will make exceptions." Tips: "Peruse our magazine before sending any materials. Know magazine audience well, and submit only photos that apply to the specific market. We demand a unique mixture of clear photos.'

*EXCAVATING CONTRACTOR, 1495 Maple Way, Troy MI 48084. (313)643-8655. Editor/Publisher: Andrew J. Cummins. Monthly. Circ. 28,500. Emphasizes earthmoving/small business management. Readers are owner/operator excavating contractors. Will send sample copy and photo guidelines. Photo Needs: Uses 20 photos/issue; 2-3 are supplied by freelance photographers. "We'll use a freelance photographer, especially for covers, if it is better than we can obtain elsewhere. Usually receive photos from equipment manufacturers and their hired guns of a very high quality, but if a freelancer submits a quality photo, one that not only features an easily identifiable machine hard at work, but also some nice mountains or water in the background, then we will consider it. Prominent credit line given. Vertical shots are a must." Photos must be of small work sites since readers are small contracting businesses. Captions preferred.

Making Contacts & Terms: Send material by mail for consideration. Uses 5x7 and 8x10 b&w and color prints, 21/4x21/4 slides and contact sheets. SASE. Reports in 2 weeks. Pays \$75/color cover; \$25/color inside; \$25-100 for text/photo package. Credit line given. Payment on publication. Buys all rights on a work-for-hire basis. Simultaneous and previously published work OK, but please tell when and where

work was published.

Tips: "We are using photography more than ever."

The Evener Managing Editor Susan Salterberg chose this photo by Boise, Idaho, freelancer Kenneth C. Poertner because it represents everything she looks for in a photo. "It's a good, clear photo with lots of action. It's the type of crisp shooting not every photographer can do. We paid Ken \$150 for a photo set, which included this shot."

FAMILY PLANNING PERSPECTIVES, 111 Fifth Ave., New York NY 10003. (212)254-5656. Editor: Richard Lincoln. Bimonthly. Circ. 15,000. Emphasizes family planning (population). Readers are family planning professionals, clinicians, demographers and sociologists. Free sample copy with 9x12 SASE.

Photo Needs: Uses about 0-3 photos/issue; 1 is supplied by freelance photographers. Needs photos of women and children of all ages; large and small families; women receiving services in family planning and abortion clinics; certain medical procedures—sterilizations, abortions, Pap smears, blood pressure tests, breast exams—in clinics and hospitals; teenagers (pregnant and nonpregnant); sex education classes; women receiving services from family planning workers in developing countries; family planning and abortion counseling in hospitals and clinics; hospital nurseries, infant intensive-care units; child-birth; and pregnant women and teens. Photos purchased without accompanying ms only. Model release required; captions preferred. "We write captions used in magazine, but prefer to have identifying information with photo."

Making Contact & Terms: Arrange a personal interview to show portfolio. SASE. Reports in 2 weeks. Provide brochure to be kept on file for possible future assignments. Pays \$400/b&w cover photo; \$75-175/b&w inside photo (payment varies with size of photos used). Pays on publication. Credit line given. Buys one-time rights. Previously published work OK.

Tips: Needs photos of "women receiving services in clinics or private MD's offices. Pictures of child-birth, pregnant women and families are readily available from stock agencies."

FARM & POWER EQUIPMENT, 10877 Watson Rd., St. Louis MO 63127. (314)821-7220. Editor: Rick Null. Monthly magazine. Circ. 14,500. Emphasizes farm/power equipment merchandising and management practices for retailers. Photos purchased with accompanying ms. Pays \$50-300 for text/photo package. Credit line given. Pays on acceptance. Buys one-time rights. "Query is absolutely es-

sential." Query by telephone. SASE. Simultaneous submissions and previously published work OK. Reports in 2 weeks. Sample copy 50¢.

Subject Needs: Photos to illustrate articles on farm and power equipment related subjects. Captions re-

quired.

B&W: Uses 8x10 prints; contact sheet and negatives OK. Pay included in total purchase price with ms. **Accompanying Mss:** Articles on dealership sales and parts departments, or service shop management. Pay included in total purchase price with photos. Writer's guidelines must be obtained prior to production and are available by phone.

FARM CHEMICALS, 37841 Euclid Ave., Willoughby OH 44094. (216)942-2000. Editor: Gordon L. Berg. Photo Editor: Charlotte Sine. Emphasizes application and marketing of fertilizers and protective chemicals for crops for those in the farm chemical industry. Monthly magazine. Circ. 32,000. Needs agricultural scenes. Buys 6-7 photos/year. Not copyrighted. Query first with resume of credits. Pays on acceptance. Reports in 3 weeks. SASE. Simultaneous submissions and previously published work OK. Free sample copy and photo guidelines.

B&W: Uses 8x10 glossy prints. Captions required. **Color:** Uses 8x10 glossy prints or transparencies.

FARM INDUSTRY NEWS, Webb Co., 1999 Shepard Rd., St. Paul MN 55116. (612)690-7252. Editor: Joseph Degnan. Photo Editor: Lynn Varpness. Published 10 times/year. Circ. 300,000. Emphasizes "agriculture product news; making farmers better buyers." Readers are "high volume farm operators." Sample copies free with SASE.

Photo Needs: Uses 4 or less photos/issue; freelancers supply "very few, usually cover shots." Needs photos of "large acreage farms, up-to-date farm equipment, livestock, crops, chemical application."

Model release required; captions preferred.

Making Contact & Terms: Query with samples or with list of stock photo subjects; send 2½x2½, 4x5 or 8x10 transparencies by mail for consideration. SASE. Reports in 1 month. Payment per color cover photo negotiated. Pays on publication. Buys first publication rights.

Tips: Uses "many 21/4x21/4 or larger format cover and feature material transparencies of up-to-date large

farm operations, equipment, crops, scenics."

FARM JOURNAL, INC., 230 SW Washington Sq., Philadelphia PA 19105. Associate Editor: Jim Patrico. Monthly magazine. Circ. 1,250,000. Emphasizes the business of agriculture: "Good farmers want to know what their peers are doing and how to make money marketing their products." Photos purchased with or without accompanying ms. Freelancers supply 75% of the photos. Pays by assignment or \$125-350 for text/photo package. Credit line given. Pays on acceptance. Buys one-time rights, but this is negotiable. Model release required. Arrange a personal interview or send photos by mail. Provide calling card and samples to be kept on file for possible future assignments. SASE. Simultaneous submissions OK. Reports in 1 week to 1 month. Free sample copy upon request.

Subject Needs: Nature photos having to do with the basics of raising, harvesting and marketing of all the farm commodities. People-oriented shots are encouraged. Also uses human interest and interview

photos. All photos must relate to agriculture. Captions are required.

B&W: Uses 8x10 or 11x14 glossy or semigloss prints. Pays \$25-100 depending on size used. **Color:** Uses 35mm or 2¹/₄x2¹/₄ transparencies or prints. Pays \$100-200 depending on size used. **Cover:** Uses color transparencies, all sizes.

Tips: "Be original, take time to see with the camera. Be more selective, take more shots to submit. Take as many different angles of subject as possible. Use fill where needed."

*FIRE CHIEF MAGAZINE, 40 East Huron St., Chicago IL 60011. (312)642-9862. Editor: William Randleman. Monthly magazine. Circ. 30,000. Emphasizes administrative problem solving for management in the fire protection field. For municipal, district and county fire chiefs. Needs cover photos of "big fires with fire departments in action and fire chiefs or other officers in action at a fire. Also, photos in connection with feature articles." Buys 12 photos/year. Credit line given. Buys all rights, but may reassign to photographer after publication. Send photos for consideration. Photos purchased with accompanying ms; cover photos purchased separately. Pays 2 weeks after publication. Reports in 1 month. SASE. Free sample copy and photo guidelines.

B&W: Send 5x7 or 8x10 glossy prints. Captions required. Pays \$5 maximum.

Cover: Send 8x10 glossy b&w or color prints or color transparencies. Captions required. Pays \$50 minimum.

FIREHOUSE MAGAZINE, 33 Irving Place, New York NY 10003. (212)475-5400. Editor: John Peige. Art Director: Jon Nelson. Monthly. Circ. 100,000. Emphasizes "firefighting—notable fires, techniques, dramatic fires and rescues, etc." Readers are "paid and volunteer firefighters, 'buffs,'

EMT's." Sample copy \$3; photos guidelines free with SASE.

Photo Needs: Uses about 30 photos/issue; 20 supplied by freelance photographers. Needs photos in the

above subject areas. Model release preferred.

Making Contact & Terms: Send 8x10 matte or glossy b&w or color prints; 35mm, 21/4x21/4, 4x5, 8x10 transparencies or b&w or color negatives with contact sheet by mail for consideration. "Photos must not be more that 30 days old." SASE. Reports in 1 month. Pays \$200/color cover photo; \$15-30/b&w inside photo; \$30-45/color inside photo; \$45/b&w full page and \$75/color full page. Pays on publication. Credit line given. Buys one-time rights. Simultaneous submissions OK "only if withdrawn from other publications."

FLOORING, 7500 Old Oak Blvd., Cleveland OH 44130. (216)243-8100. Editor: Dan Alaimo. Monthly magazine. Emphasizes floor covering and other interior surfacing for floor covering retailers and distributors. Circ. 22,000.

Photo Needs: Uses about 25-30 photos/issue; "a few" supplied by freelance photographers. Needs photos "basically to illustrate various articles—mostly showroom shots." Model release and captions

preferred.

Making Contact & Terms: Query with samples or send 4x5 transparencies for consideration. Provide resume, business card, brochure, flyer or tearsheets to be kept on file for possible future assignments. SASE. Reports in 2 weeks. Pays on acceptance. Buys all rights. Simultaneous submissions OK.

FUNCTIONAL PHOTOGRAPHY, 101 Crossways Park West, Woodbury NY 11797. (516)496-8000. Editor-in-Chief: David A. Silverman. Published every 2 months. Circ. 31,517. Emphasizes scientific photography for scientists, engineers, R&D and medical personnel who use photography to document and communicate their work. Free sample copy; photo guidelines with SASE.

Photo Needs: Uses 20 photos/issue; all are supplied by freelance photographers. "Photography is almost exclusively done by our readers. However, we also have a strong need for photos depicting imagemaking equipment (especially motion picture and TV) in action. Almost all material is accompanied by

ms." Needs photos submitted with ms illustrating documentation.

Making Contact & Terms: Send material by mail for consideration or query with article suggestions. Uses 5x7 and 8x10 b&w and color prints; 35mm, 2½x2½, 4xt5 and 8x10 transparencies. No originals; duplicates only. SASE. Reports in 6-8 weeks. Pays \$100/color cover and \$50-300 for text/photo package. Credit line given. Payment on publication; except when assigned. Buys one-time rights. "We retain all rights to photos specifically shot on assignment for us." Simultaneous and previously published work OK.

GARDEN SUPPLY RETAILER, Box 67, Minneapolis MN 55428. (612)374-5200. Editor: Kay M. Olson. Monthly. Emphasizes "all aspects of retail garden centers—products, displays, customers, employees, power equipment, green goods, holiday goods, service and repair of lawn equipment." Readers are retailers and dealers of garden and lawn supplies. Circ. 40,190. Sample copy free with SASE and 75¢ postage.

Photo Needs: Uses about 10-20 photos/issue; "very few if any" supplied by freelance photographers. Needs "photos depicting business at a retail garden center. Prefer people with products rather than products alone." Special needs include "photographing plants in garden centers located in various areas of

the country (especially outside the upper Midwest)."

Making Contact & Terms: Query with samples; list of stock photo subjects; send 35mm transparencies, b&w contact sheets by mail for consideration; provide resume, business card, brochure, flyer or tearsheets to be kept on file for possible future assignments. SASE. Tries to report in 3 weeks. Pays about \$25/photo, b&w; \$50/photo, color. Pays \$100 for cover photos. Pays on publication. Credit line given only "in certain cases." Buys all rights.

Tips: Prefers to see "photos illustrating retailing in a garden center, or of interest to the magazine's audience. Know the audience of the magazine and photograph what would be of interest to them. Strive for

simplicity in form, using natural, spontaneous shots, people going about daily business."

*GLASS NEWS, (Formerly National Glass Budget), Box 7138, Pittsburgh PA 15213. Manager: Liz Scott. Monthly. Circ. 1,625. Emphasizes glass manufacturing. Readers are "glass manufacturers, suppliers, users." Sample copy for SASE (40¢ postage).

Photo Needs: Uses 2-3 photos/issue. Needs photos of "glass manufacturing details, glass items." **Making Contact & Terms:** Send b&w prints or b&w contact sheet by mail for consideration. SASE. Reports in 1 month or "ASAP." Pays \$25 + /b&w cover photo; \$25 + /b&w inside photo. Pays on acceptance. Credit line given. Buys all rights.

GOLF SHOP OPERATIONS, Box 5350, 495 Westport Ave., Norwalk CT 06856. (203)847-5811. Editor: Nick Romano. Magazine published 6 times photos/year. Circ. 12,500. Emphasizes "methods

that would allow the golf professional to be a better businessman." For golf professionals employed at country clubs and other golf courses. Primarily wants photos of "unusual displays in golf shops along with shots of pros in their shops." Special needs: human-interest shots for a front-of-the-book section. Buys 10 photos/year. Provide business card, brochure, flyer and tearsheets to be kept on file for possible future assignments. Buys all rights, but may reassign to photographer after publication. Prefers photos as part of package with ms, but will consider separate photo submissions. Query. Send contact sheet as part of package with ms, but will consider separate photo submissions. Query. Send contact sheet for consideration. Pays on publication. Reports in 1 month. SASE. Free sample copy and photo guidelines. **B&W**: Send contact sheet. Captions required. Pays \$100-250.

Cover: Send slides or color transparencies. Captions required. Pays \$100-300.

*GRAPHIC, INC., (The Vealer, The Shepherd's Friend, Precious Fibers), Graphicom Inc., Publishers, 125 W. Broadway, Box 384, Monticello IN 47960. (219)583-6212. Editor: Alan K. DuVennsy. Monthly. Emphasizes veal meat, lamb meat, wool, spinning, knitting. Readers include veal growers, sheep raisers, spinners. Circ. 1,600-3,000. Sample copy \$3.

Photo Needs: Uses 4-5 photos/issue; none currently supplied by freelance photographers. Needs the subject animals—spinners, weavers, etc. Reviews photos with or without accompanying ms.

Making Contact & Terms: Send 3x5 glossy b&w prints by mail for consideration; provide resume, business card, brochure, flyer or tearsheets to be kept on file for possible future assignments. SASE. Reports in 2 weeks. Pay individually negotiated. Pays on publication. Credit line given if desired. Buys one-time rights. Simultaneous submissions and previously published work OK.

HARDWARE AGE, Chilton Way, Radnor PA 19089. Editor-in-Chief: Terry Gallagher. Managing Editor: Wendy Ampolsk. Emphasizes retail and wholesale hardware. Readers are "hardware retailers and wholesalers of all types." Monthly. Circ. 71,000. Sample copy \$1; photo guidelines for SASE. Photo Needs: Uses about 20 photos/issue, very few of which are supplied by freelance photographers. Needs clean, well-lighted, well-cropped photos of in-store displays, signs, merchandising ideas, etc.

Looking for "clear, in-focus documentary photography showing what successful retailers have done. Most of our articles are organized along product lines (hardware, housewares, lawn and garden, tools, plumbing, etc.) so that's the logical way to submit material. Not interested in displays from the manufacturer, but rather what the retailer has done himself. People in photos OK, but model release required." Captions not required, "just specs of what store and where."

Making Contact & Terms: Send by mail for consideration actual 5x7 or 8x10 color prints; 35mm, 2¹/₄x2¹/₄ or 4x5 color transparencies; or color contact sheet. SASE. Reports ASAP. Pays on acceptance \$20/color photo; \$10/b&w photo; \$100-200 for text/color photo package. No credit line. Buys first North American serial rights. No simultaneous or previously published submissions.

HIGH VOLUME PRINTING, Box 368, Northbrook IL 60065. (312)564-5940. Editor-in-Chief: Bill Esler. Bimonthly. Circ. 18,000. Emphasizes equipment, systems and supplies; large commercial printers: magazine and book printers. Readers are management and production personnel of high-volume printers and producers of books, magazines, periodicals. Sample copy \$5; free photo guidelines with SASE.

Photo Needs: Uses about 30-35 photos/issue. Model release required; captions preferred.

Making Contact & Terms: Query with samples or with list of stock photo subjects; send b&w and color prints (any size or finish); 35mm, 21/4x21/4, 4x5 or 8x10 slides; b&w or color contact sheet or negatives by mail for consideration. SASE. Reports in 1 month. Pays \$200 maximum/color cover photo; \$50 maximum/b&w or color inside photo and \$200 maximum for text/photo package. Pays on publication. Credit line given. Buys one-time rights with option for future use. Previously published work OK "if previous publication is indicated."

HOSPITAL GIFT SHOP MANAGEMENT, 12849 Magnolia Blvd., North Hollywood CA 91607. (213)980-4184. Editor: Barbara Feiner. Monthly magazine. "*HGSM* concentrates on subjects of interest to managers of hospital gift shops across the United States." Readers are managers and gift shop personnel. Circ. 12,000 + . Sample copy available with \$4 domestic; \$6 foreign postage.

Photo Needs: Uses about 5-15 photos/issue. "A majority" supplied by freelance photographers. Needs "photos of hospital gift shop interiors—on assignment from editor. No unsolicited photos, please. Let us know you're out there. We need to build a pool of photographers from around the country for freelance assignments." Written release and captions required.

Making Contact & Terms: Provide resume, business card, brochure, flyer or tearsheets to be kept on file for possible future assignments. SASE. Reports in 2-3 weeks. Pay varies. Payment made on publi-

cation. Credit line given. Buys one-time rights.

Tips: "Just let us know you're out there and available. We need photographers from all parts of the country."

*HOSPITAL PRACTICE, 575 Lexington Ave., New York NY 10022. (212)421-7320. Editorial Director: David W. Fisher. Design Director: Robert S. Herald. Publishes 18 issues/year. Circ. 190,000. "Hospital Practice is directed to a national audience of physicians and surgeons. Major review articles provide comprehensive information on new developments and problem areas in medicine and clinical research. Authors are nationally recognized experts in their fields." Photos purchased on assignment, "very occasionally, as needed." Pays ASMP rates plus expenses for first reprint rights. Credit lines grouped in space available. Occasionally requires second serial (reprint rights). Arrange personal interview to show portfolio, submit portfolio for review, or query with samples. SASE. Reports in 2 weeks. Photo guidelines provided on assignment.

Subject Needs: Documentary (narrow field, color close-ups of surgical procedures); and photo essay/ photo feature (assignments are made based on ms needs). "Documentary photographers must have experience with medical and/or surgical photography for editorial (not advertising) purposes. May have to travel to location on short notice with appropriate equipment." Model release and captions required if

requested. No studio photos, animals, landscapes, portraits, moods.

B&W: Contact sheet and negatives OK.

Color: Prefers 21/4x21/4 Ektachrome transparencies.

HOSPITALS, Suite 700, 211 E. Chicago Ave., Chicago IL 60611. (312)951-1100. Production Manager: Kathleen O'Leary. Published 2 times/month. Circ. 90,000. Emphasizes hospitals and health care delivery. Readers are hospital managers. Sample copy free with SASE.

Photo Needs: Uses about 20-25 photos/issue; 1-2 supplied by freelance photographers. Needs "hospital

scenes." Model release required.

Making Contact & Terms: Arrange a personal interview to show portfolio. SASE. Reports in 2 weeks. Pays \$500/color cover; \$300-500/job. Pays on acceptance. Credit line given.

*HUMAN ECOLOGY FORUM, 1150 Academic, Cornell University, Ithaca NY 14853. (607)256-3126. Editor: James Titus. Emphasizes serious discussions by College of Human Ecology faculty of the problems individuals and families have with phsycial and social environments. Readers are graduates of the college involved in human services; local and state legislators, college and local libraries. Circ. 5,000. Sample copy \$2.

Photo Needs: Uses about 20 photos/issue; 5 supplied by freelance photographers. Needs candids of individuals, including minorities, in social situations and in families. News photos of social problems and

changing American institutions. Model release required; captions preferred.

Making Contact & Terms: Send 5x7 b&w matte prints and b&w contact sheet by mail for consideration. SASE. Reports in 1 month. Pays \$30-90/b&w inside photo. Pays on publication. Credit line given. Buys one-time rights. Simultaneous submissions and previously published work OK.

INDUSTRIAL ENGINEERING, 25 Technology Park/Atlanta, Norcross GA 30092. (404)449-0460. Editor: Gene Cudworth. Monthly magazine. Circ. 50,000. Emphasizes developments and new products in the industry. For "productivity-minded engineers and managers" with a practical or academic engineering background. Needs photos "related to feature articles in the magazine." Number of photos bought yearly varies tremendously. Submit model release with photo. Query. Works with freelance photographers on assignment only basis. Provide calling card, brochure and flyer to be kept on file for possible future assignments. Photos "must have adequate descriptive material to explain the subject of industrial photos." SASE. Previously published work OK. All rights negotiable. Sample copy \$4.

B&W: Uses 8x10 glossy prints. Captions required. Pays \$5 minimum.

Color: Uses transparencies and good quality prints. Captions required. Pays \$10 minimum. Cover: Uses color transparencies. Query first. Captions required. Pays \$15 minimum.

INDUSTRIAL LAUNDERER, Suite 613, 1730 M St., NW, Washington DC 20036. (202)296-6744. Editor: David Ritchey. Monthly magazine. Circ. 3,000. For decisionmakers in the industrial laundry industry. Publication of the Institute of Industrial Launderers. Needs photo essays on member plants. Copyrighted. Query first with resume of credits. Provide business card, brochure and flyer to be kept on file for possible future assignments. Pays \$10-40/color photo. Submit invoice after publication for payment. SASE. Sample copy \$1.

B&W: Send minimum 3x5 glossies; 4x6 preferred. Pays \$5-20/inside photo. Payment is negotiable. **Tips:** Needs photographers in various regions of the U.S. to take photos for Plant of the Month department. "Ours is a business-oriented magazine—we don't want to see photos of unrelated or nonbusiness-

oriented subjects."

INDUSTRIAL MACHINERY NEWS, 29516 Southfield Rd., Southfield MI 48076. (313)557-0100. Editor/Publisher: M.M. Ecksel. Monthly tabloid. Metalworking plants and machinery. Readers are metalworking plant managers/eningeers and purchasing personnel. Circ. 80,000. Sample available for \$4.

Photo Needs: Uses 2-4 photos/issue. 1-2 supplied by freelance photographers. Needs "action photos of metalworking machinery in use." Photos purchased with accompanying ms only. Written release and

captions required.

Making Contact & Terms: Query with list of stock photo subjects; send b&w prints and b&w contact sheet for consideration. Provide resume, business card, brochure, flyer or tearsheets to be kept on file for possible future assignments. SASE. Reports in 2 weeks. Pays on acceptance or publication. Buys all rights. Previously published work OK.

INDUSTRIAL SAFETY AND HYGIENE NEWS, 201 King of Prussia Rd., Radnor PA 19089 (215)964-4057. Editor: Dave Johnson. Monthly magazine. Circ. 55,000. Emphasizes industrial safety and health for safety and health management personnel in over 36,000 large industrial plants (primarily

manufacturing). Free sample copy.

Photo Needs: Uses 150 photos/issue; 1-2 are supplied by freelance photographers. "Theme assignment made through conversations with editors. Usage depends on the dramatic impact conferred upon otherwise dull subjects; ie., new industrial products, applications of safety and health products in the actual industrial environment." Special needs include photos on fire protection, personal protection items, security devices, other industrial product areas, and health problems.

Making Contact & Terms: Send material by mail for consideration. Uses 5x7 b&w prints, 35mm and 2\(^1/4x2\)\(^1/4\) transparencies and color negatives. Photographer should request editorial schedule and sample of publication. SASE, Reports in 2 weeks. Pays \$50-250/job. Credit line given. Payment on publica-

tion. Buys all rights on a work-for-hire basis. Previously published work OK.

INDUSTRY WEEK, 1111 Chester Ave., Cleveland OH 44114. (216)696-7000. Art Director: Nick Dankovich. Biweekly magazine. Circ. 300,000. Emphasizes current events, and economic and business news. For managers throughout the manufacturing industry. Buys 3-4 photos/issue. Buys all rights or one-time use. Present model release on acceptance of photo. Query first with resume of credits. Credit line given. Pays on acceptance. Reports in 2 weeks. SASE. Simultaneous submissions OK. Sample copy \$2.

Subject Needs: Still life and special effects and experimental. Must be industry-related. No "standard" industrial shots, fashion photos or product shots. Photos dealing with labor, people or human interest re-

lated to industry are "a top interest."

B&W: Uses prints. Pays \$50-350.

Color: Uses 8x10 glossy or matte prints; or 35mm, $2^{1}/4x2^{1}/4$ or 4x5 transparencies. Pays \$50-600. **Cover:** Uses glossy or matte color prints; or 35mm, $2^{1}/4x2^{1}/4$ or 4x5 color transparencies. Pays \$400-600; negotiable.

Tips: "Contact the art director as all freelance buys are on assignment." Wants photographers who are

"able to work well in an interview situation and think editorially (concepts, etc.)."

*INKBLOT, 1506 Bonita, Berkeley CA 94709. Editor: Theo Green. Quarterly. Emphasizes avantegarde and experimental. Circ. 2,000. Sample copy \$3.

Photo Needs: Uses 6 photos/issue; all supplied by freelance photographers. Needs bizarre, experimen-

tal. Reviews photos with or without accompanying ms.

Making Contact & Terms: Send b&w prints by mail for consideration. SASE. Reports in 2-3 months. Pays in copies only. Credit line given. Buys one-time rights. Simultaneous submissions and previously published work OK.

IN-PLANT PRINTER, Box 368, Northbrook IL 60065. (312)564-5940. Editor: Kraig Debus. Bimonthly. Circ. 35,000. Emphasizes "in-plant printing; print and graphic shops housed, supported, and serving larger companies and organizations." Readers are management and production personnel of such shops. Sample copy \$5; free photo guidelines with SASE.

Photo Needs: Uses about 30-35 photos/issue. Needs "working/shop photos, atmosphere, interesting

equipment shots, how-to." Model release required; captions preferred.

Making Contact & Terms: Query with samples or with list of stock photo subjects; send b&w and color (any size or finish) prints; 35mm, 21/4x21/4, 4x5, 8x10 slides, b&w and color contact sheet or b&w and color negatives by mail for consideration. SASE. Reports in 1 month. Pays \$200 maximum/b&w or color cover photo; \$50 maximum/b&w or color inside photo and \$200 maximum for text/photo package. Pays on publication. Credit line given. Buys one-time rights with option for future use. Previously published work OK "if previous publication is indicated."

Tips: "Good photos of a case study—such as a printshop, in our case—can lead us to doing a follow-up

story by phone and paying more for photos."

INSTANT AND SMALL COMMERCIAL PRINTER, Building 11B, 425 Huehl Rd., Northbrook IL 60062. (312)564-5940. Editor-in-Chief: Dan Witte. Bimonthly. Circ. 25,000. Emphasizes the "in-

stant and retail printing industry." Readers are owners, operators, managers of instant and smaller commercial (less than 20 employees) print shops. Sample copy \$3; photo guidelines free with SASE. **Photo Needs:** Uses about 15-20 photos/issue. Needs "working/shop photos, atmosphere, interesting

equipment shots, some how-to." Model release required; captions preferred.

Making Contact & Terms: Query with samples or with list of stock photo subjects or send b&w and color (any size or finish) prints; 35mm, 21/4x21/4, 4x5 or 8x10 slides; b&w and color contact sheet or b&w and color negatives by mail for consideration. SASE. Reports in 1 month. Pays \$300 maximum/b&w and color cover photo; \$50 maximum/b&w and color inside photo and \$200 maximum for text/photo package. Pays on publication. Credit line given. Buys one-time rights with option for future use. Previously published work OK "if previous publication is indicated."

THE INSTRUMENTALIST, 200 Northfield Rd., Northfield IL 60093. (312)446-5000. Managing Editor: Jean Oelrich. Monthly magazine. Circ. 22,500. Emphasizes instrumental music education. Read by school band and orchestra directors. Buys 1-5 photos/issue, mostly color. Credit line given. Pays on publication. Buys all rights. Send material by mail for consideration. SASE. Reports in 2-4 weeks. Sample copy \$2.

Subject Needs: Head shot and human interest. "No photos that do not deal with instrumental music in some way." Especially needs photos for Photo Gallery section.

B&W: Uses 5x7 or 8x10 glossy prints. Pays \$5 minimum/photo.

Cover: Uses color 35mm, 21/4x21/4 transparencies and glossy prints. Vertical format preferred. Pays \$50 minimum/photo.

INSULATION OUTLOOK, Suite 410, 1025 Vermont Ave. NW, Washington DC 20005. (202)783-6277. Managing Editor: Karen Vargo. Monthly. Circ. 6,000. Emphasizes general business and commercial and industrial insulation for personnel in the commercial and industrial insulation industries. Sample copy \$2.

Photo Needs: Prefers photographers in local area. Uses photographers for everything from head shots to covers. Publication features 4-color process on feature material and cover; also provides advertising preparation and production services. Especially needs photos on commercial/industrial insulation pro-

jects.

Making Contact & Terms: Query with resume of photo credits or submit portfolio by mail for review. SASE. Reports in 1 week. Pay is negotiable. Credit line given. Payment on publication. Buys one-time rights. Simultaneous and previously published work OK.

INTERIOR DESIGN, 475 Park Ave. S., New York NY 10016. (212)576-4182. Editor-in-Chief: Stanley Abercrombie. Monthly. Circ. 50,000. Emphasizes interior design including buildings and furnishings for interior designers and architects. Sample copy \$5.

Photo Needs: Uses over 200 photos/issue; most supplied by designers and architects. "Happy to receive color transparencies (must be 4x5) from experienced architectural and interior design photographers.' Photo purchased "must have release from the client and the photographer giving permission to *Interior Design* to publish."

Making Contact & Terms: Send unsolicited photos by mail for consideration. Reports in 1 week. "Usually architectural firms or the subject of the photos will arrange and pay for photos, then provide them gratis to *Interior Design*." Pays on acceptance. Buys one-time rights.

INTERNATIONAL BUSINESS MONTHLY, Box 87339, Houston TX 77287. (713)641-0201. Publisher: T. George Pratt. Monthly magazine. Emphasizes international business for companies engaged in world trade. Circ. 130,000. Sample copy \$2.50 plus postage. Photo guidelines available.

Photo Needs: Uses about 10 photos/issue; all supplied by freelance photographers. Needs photos of "trade shows, exhibitions, travel, international scenics." Photos purchased with accompanying ms on-

ly. Model release and captions required.

Making Contact & Terms: Query with resume of credits; send 4x5 or 8x10 prints by mail for consideration; submit portfolio for review; call to discuss current needs. SASE. Reports in 2 weeks. Pays on publication. Credit line given. Buys all rights. Simultaneous submissions OK.

INTERNATIONAL FAMILY PLANNING PERSPECTIVES, 111 Fifth Ave., New York NY 10003. (212)254-5656. Editor: Richard Lincoln. Quarterly. Circ. 21,000. Emphasizes family planning (population). Readers are family planning professionals, clinicians, demographers and sociologists. Free sample copy with SASE.

Photo Needs: Uses 0-3 photos/issue; 1 is supplied by freelance photographers. Needs photos of Third World women and children of all ages; large and small families; women receiving services in family planning and abortion clinics; certain medical procedures—sterilizations, abortions, Pap smears, blood pressure tests, breast exams—in clinics and hospitals; teenagers (pregnant and nonpregnant); sex educa-

tion classes; women receiving services from family planning workers in developing countries; family planning and abortion counseling in hospitals and clinics; hospital nurseries, infant intensive-care units; childbirth and pregnant women. Photos purchased without accompanying ms only. Model release and captions preferred. "We write captions used in magazine, but prefer to have identifying information with photo."

Making Contact & Terms: Arrange a personal interview to show portfolio. SASE. Reports in 2 weeks. Provide resume and brochure to be kept on file for possible future assignments. Pays \$400/b&w cover photo; \$75-175/b&w inside photo (payment varies with size of photo used). Pays on publication. Credit

line given. Buys one-time rights. Previously published work OK.

JET CARGO NEWS, 5314 Bingle Rd., Houston TX 77092. (713)688-8811. Manager/Editor: Art Eddy. Advertising Sales/Marketing Manager: Regina Priznar. Magazine Director: Don McPherson. Monthly. Circ. 32,000. "The management journal for air marketing." Readers are corporation executives, traffic managers and distribution specialists who utilize the services of or serve domestic and foreign airlines, air freight forwarders, customs brokers and agents, aircraft manufacturers, airports and the air cargo industry in general.

Photo Needs: Averages 24 pages/issue with accompanying mss for feature articles and late-breaking news stories. 5x7 b&w glossy prints preferred. Pays \$10/photo. Captions required for all photos.

*JOB CORPS IN ACTION MAGAZINE, Meridian Publishing, Inc., Box 10010, Ogden UT 84409. Editor: Caroll McKanna Halley. Monthly magazine. "Job Corps matters. There are 107 Job Corps centers throughout the United States; our national editorial material draws from them all." Readers are Job Corps students and staff, Job Corps alumni (20 years), Congress, U.S. Dept. of Labor, Forestry, public libraries, job screening and employment opportunities offices. Estab. 1984. Sample copy \$1 with 9x12 SASE. Photo guidelines free with SASE.

Photo Needs: Uses about 16 photos/issue; "roughly half" supplied by freelance photographers. Needs "only material relating to and including Job Corps Students in Action being trained or on the job." Special needs include "Job Corps community relations activities." Model release and captions preferred;

names of people in photos required.

Making Contact & Terms: Send 5x7 glossy color prints and 35mm (any size) transparencies by mail for consideration. "Query with a sample photo. No resume necessary—you're either a photographer or you're not." SASE. Reports in 1 month or less—usually much less." Pays \$50/color cover photo and \$35/color inside photo. Pays on acceptance. Credit line given. Buys first North American serial rights and reprint rights. Previously published work OK.

Tips: "We now purchase first rights and nonexclusive reprint rights. This means we retain the right to reprint purchased material in other Meridian publications. Authors and photographers retain the option

or the right to resell material to other reprint markets."

JOBBER RETAILER MAGAZINE, 110 N. Miller Rd., Akron OH 44313. (216)867-4401. Editor: Greg Smith. Monthly. Circ. 36,000. Emphasizes "automotive aftermarket." Readers are "wholesalers, manufacturers, retail distributors of replacement parts."

Photo Needs: Uses about 3-20 photos/issue; often needs freelance photographers. Needs automotive feature shots; exterior and interior of auto parts stores." Model release and captions preferred.

Making Contact & Terms: Provide resume, business card, brochure, flyer or tearsheets to be kept on file for possible future assignments. Does not return unsolicited material. Reporting time varies. Pays \$100-500 for text/photo package. Pays on publication. Credit given. Buys various rights—"generally all rights." Simultaneous submissions and previously published work OK.

Tips: "Let us know who and where you are."

THE JOURNAL, 33 Russell St., Toronto, Ontario, Canada M5S 2S1. (416)595-6053. Editor: Anne MacLennan. Production Editor: Terri Arnott. Monthly tabloid. Circ. 21,771. For professionals in the alcohol and drug abuse field: doctors, teachers, social workers, enforcement officials and government officials. Needs photos relating to alcohol and other drug abuse, and smoking. No posed shots. Buys 4-10 photos/issue. Not copyrighted. Submit model release with photo. Send photos or contact sheet for consideration. Pays on publication. Reports "ASAP." Free sample copy and photo guidelines.

B&W: Send 5x7 glossy prints. Captions required. Pays \$20 minimum.

Cover: See requirements for b&w.

Tips: "We are looking for action shots, street scenes, people of all ages and occupations. Model releases are necessary. Shots should not appear to be posed."

*THE JOURNAL OF FAMILY PRACTICE, 25 Van Zant St., E. Norwalk CT 06855. (203)838-4400. Editor: John P. Geyman, M.D. Photo Editor: Jane Ekstrom. Monthly. Circ. 84,000. Emphasizes medicine. Readers are family practitioners. Sample copy and photo guidelines free with SASE.

Photo Needs: Uses 1 photo/issue; all supplied by freelance photographers. Needs nonmedical photos in a horizontal format.

Making Contact & Terms: Send 35mm or 21/4x21/4 transparencies by mail for consideration. SASE. Reports in 6 weeks. Pays \$350/color cover. Pays on publication. Credit line given. Buys one-time rights.

*JOURNAL OF THE NATIONAL MEDICAL ASSOCIATION, 25 Van Zant St., E. Norwalk CT 06855. (203)838-4400. Editor: Calvin C. Sampson, M.D. Photo Editor: Jane Ekstrom. Monthly. Circ. 27,000. Emphasizes medicine. Readers are urban physicians. Sample cover and photo guidelines free with SASE

Photo Needs: Uses 1 photo/issue; supplied by freelance photographers. Needs nonmedical photos in a vertical format.

Making Contact & Terms: Send 35mm or 21/4x21/4 transparencies by mail for consideration. SASE. Reports in 6 weeks. Pays \$350/color cover photo. Pays on publication. Credit line given. Buys one-time rights.

Tips: "We look for imaginative views of familiar scenes and objects-rural/urban, outdoor/indoor, natural/manmade abstracts. Sharp colors and focus are vital. Avoid typical vacation/post card scenics and botanicals better suited to catalogs."

JOURNAL OF PSYCHOACTIVE DRUGS, 409 Clayton St., San Francisco CA 94117. (415)626-2810. Editors: E. Leif Zerkin and Jeffrey H. Novey. Quarterly. Circ. 1,000. Emphasizes "psychoactive substances (both legal and illegal)." Readers are "professionals (primarily health) in the drug abuse field." Sample copy \$10.

Photo Needs: Uses one photo/issue; supplied by freelance photographers. Needs "full-color abstract, surreal or unusually interesting cover photos.'

Making Contact & Terms: Query with samples. Send 4x6 color prints or 35mm or 21/4x21/4 transparencies by mail for consideration. SASE. Reports in 2 weeks. Pays \$50/color cover photo. Pays on publication. Credit line given. Buys one-time rights. Simultaneous submissions and previously published work OK.

LABORATORY MANAGEMENT, 475 Park Ave. S., New York City NY 10016. (212)725-2300. Editor: Kenneth W. Lane. Monthly magazine. Readers are "physicians and scientists who are directors of clinical medical laboratories." Circ. 54,000. Sample copy available with SASE.

Photo Needs: Uses 1 cover photograph/issue; supplied by freelance photographers. Needs "photomicrographs (35mm) of crystals, cells, other biological materials as taken through a microscope (in color). Photographs must be colorful, interesting and sharply defined."

Making Contact & Terms: Query with samples. Send 35mm transparencies by mail for consideration. SASE. Pays \$35/color cover photo. Payment is on publication. Credit line given.

Tips: Photographers "should have some experience in photomicrography."

LAW & ORDER MAGAZINE, 5526 N. Elston Ave., Chicago IL 60630. (312)792-1838. Editor: Bruce Cameron. Monthly. Circ. 25,000. Emphasizes law enforcement. Readers are "police/sheriff administrators and command officers." Sample copy \$2. Photo guidelines free with SASE.

Photo Needs: Needs photos of police performing duties, training, operation of equipment. Model re-

lease preferred; captions required.

Making Contact & Terms: Send 5x7 glossy prints or transparencies by mail for consideration. Provide resume, business card, brochure, flyer or tearsheets to be kept on file for possible future assignments. SASE. Reports in 1 month. Pays \$100/color cover photo; \$10/b&w photo; \$300 maximum for text/photo package. Pays on publication. Credit line given for cover/feature stories only. Buys all rights. Simultaneous submissions and previously published work OK. Tips: "Need action shots."

LAWN CARE INDUSTRY, 7500 Old Oak Blvd., Middleburg Heights OH 44130. (216)243-8100. Editor: Jerry Roche. Monthly. Circ. 14,000. Emphasizes "lawn care professionals: chemical pest/weed control, mowing/maintenance." Sample copy free with SASE.

Photo Needs: Uses 12 photos/issue; 1-2 supplied by freelance photographers. Needs photos of "lawn care professionals in action, features dealing with industry, conferences/symposiums. Captions re-

Making Contact & Terms: Query. Send 5x7 or 8x10 b&w prints or color slides by mail for consideration. SASE. Reports in 2 weeks. Pays by "mutual agreement," usually about \$8/b&w photo; \$25/color photo. Pays on publication. Buys all rights. Simultaneous submissions and previously published work OK "if specified."

LEGAL ECONOMICS, Box 11418, Columbia SC 29211. Managing Editor/Art Director: Delmar L. Roberts. Bimonthly magazine. Circ. 27,000. For practicing attorneys and law students. Needs photos of "some stock subjects such as a group at a conference table; someone being interviewed; scenes showing staffed office-reception areas; *imaginative* photos illustrating such topics as time management, employee relations, automatic typewriters, computers and word processing equipment; record keeping; filing; insurance protection; abstract shots or special effects illustrating almost anything concerning management of a law practice. (We'll exceed our usual rates for exceptional photos of this latter type.)" No snapshots or Polaroid photos. Usually buys all rights, and rarely reassigns to photographer after publication. Submit model release with photo. Send photos for consideration. They are accompanied by an article pertaining to the lapida "if requested." SASE. Simultaneous submissions OK. Sample copy \$3.50 (make check payable to American Bar Association).

B&W: Send 8x10 glossy prints. Pays \$25 minimum. **Color:** Uses 35mm transparencies. Pays \$35 minimum.

Cover: Send 2x3 or $2^{1/4}x2^{1/4}$ color transparencies. Uses vertical format. Allow space at top of photo for insertion of logo. Pays \$75 minimum.

*LICENSING INTERNATIONAL, 490 Rt. 9, Box 420, Englishtown NJ 07726. (201)972-1022. Editor: Donna Abate. Photo Editor: Jack Harris. Bimonthly. Emphasizes licensed products, licensors and licensees, news, etc. Readers include major chain and department store buyers—prospective lincesees.

Circ. 20,000. Estab. 1984. Sample copy available.

Photo Needs: Uses 40 photos/issue; 25% supplied by freelance photographers. Reviews photos with or without accompanying ms. Special needs include cover photos. Model release and captions required. Making Contact & Terms: Provide resume, business card, brochure, flyer or tearsheets to be kept on file for possible future assignments. Reports in 1 month. Pays on publication. Credit line given if requested. Buys one-time rights. Simultaneous submissions and previously published work OK.

LOG HOME AND ALTERNATIVE HOUSING BUILDER, 16 First Ave., Corry PA 16407-1894. (814)664-8624. Managing Editor: Marc Warren. Bimonthly. Circ. 11,000. Emphasizes "log, dome and earth-sheltered housing construction (all other types of alternatives are covered as well)." Readers are builders, dealers, manufacturers, product suppliers and potential builders and dealers for this industry. Free sample copy.

Photo Needs: Uses 10 photos/issue; few supplied by freelance photographers. Needs interiors and exte-

riors of alternative structures. Model release and captions required.

Making Contact & Terms: Query with samples and list of stock photo subjects. Provide resume, business card, brochure, flyer or tearsheets to be kept on file for possible future assignments. Reports within a month. Rates established on individual basis. Pays on publication. Credit given. Buys all rights.

*MACHINE DESIGN, 1111 Chester, Cleveland OH 44114. (216)696-7000. Editor: Ronald Khoz. Photo Editor; Robert Aronson. Bimonthly. Emphasizes technology of interest to mechanical or electrical or electronics engineers. Readers include design engineers. Circ. 170,000. Free sample copy with SASE.

Photo Needs: Uses 40 photos/issue; 0-1 supplied by freelance photographers. "We negotiate photos for cover or lead photo and articles at least 2 months before issue date." Model release and captions required.

Making Contact & Terms: Provide resume, business card, brochure, flyer or tearsheets to be kept on file for possible future assignments. Reports in 2 weeks. Pays \$150-500/color cover photo. Pays on acceptance. Credit line given if requested. Buys one-time rights. No simultaneous submissions or previously published work.

MANUFACTURING ENGINEERING, One SME Dr., Dearborn MI 48121. (313)271-1500. Managing Editor: Robin Bergstrom. Monthly magazine. Emphasizes high technology manufacturing. Readers are "members of the society of manufacturing engineers and paid subscriptions. Circ. 105,000. Sample

copy free with \$2 postage.

Photo Needs: Uses 60-75 photos/issue; 1% supplied by freelance photographers. Needs photos of "manufacturing equipment, tool show shots, high technology, people in business, tooling shots." Special needs include "specific cover shots, working on ideas with editor and art director. Send 5x7 b&w or color prints; or 4x5 transparencies by mail for consideration. Provide resume, business card, brochure, flyer or tearsheets to be kept on file for possible future assignments. SASE. Reports in 1 week. Pays \$175-300/color cover photo; \$25/b&w inside photo; \$50/color inside photo. Pays \$200/day maximum. Payment is made monthly. Buys one-time or all rights. Simultaneous and previously published work OK.

MASS HIGH TECH, 755 Mt. Alburn St., Watertown MA 02172. (617)924-2422 or 924-5100. Managing Editor: Patrick Porter. Biweekly. Circ: 35,000. Emphasizes "high technology industries in east-

ern New England (especially greater Boston)." Readers are "scientists, engineers, managers, financial types who follow technology, programmers, other high-tech professionals." Sample copy and photo guidelines free with SASE.

Photo Needs: Uses about 30-40 photos/issue; "about 1/3" supplied by freelance photographers. Needs "human interest (feature-type) shots associated with East Coast (Massachusetts) high technology,"

Model release preferred; captions required.

Making Contact & Terms: Query with samples or list of stock photo subjects. Send one or two 5x7 b&w glossy prints by mail for consideration. SASE. Reports in 2 weeks to 1 month. Pays \$25 + /b&w inside photo. Pays on publication. Credit line given. Buys one-time or first North American rights. Previously published work OK "if not in our area."

MATERIALS ENGINEERING, Penton Plaza, 1111 Chester Ave., Cleveland OH 44114. (216)696-7000. Monthly. Emphasizes engineering materials (steel, aluminum, plastics, etc.). Readers are engineers who specify materials. Circ. 61,000. Sample copy free with SASE and 60¢ postage.

Photo Needs: Uses about 30-40 photos/issue; 0-2 supplied by freelance photographers. Needs "product and shop shots; creative and artistic shots of products or technical 'concepts' related to feature articles

for lead spreads and covers. Requirements determined issue by issue with art editor.'

Making Contact & Terms: Provide resume, business card, brochure, flyer or tearsheets to be kept on file for possible future assignments. SASE. Reports in 1 month. Pays \$250-700/color cover photo; payment varies for inside photos. Pays on acceptance. Credit line given. Buys one-time rights. Previously published submissions OK "maybe."

Tips: Prefers to see "clever ways to depict 'routine' technical subjects."

MD MAGAZINE, 30 E. 60th St., New York NY 10022. (212)355-5432. Picture Editor: Doris Brautigan. Monthly magazine. Circ. 160,000. Emphasizes the arts, science, medicine, history and travel; written with the readership (physicians) in mind. For medical doctors. Needs a wide variety of photos dealing with history, art, literature, medical history, pharmacology, activities of doctors and sports. Also interested in photo essays. Buys first serial rights. Arrange a personal interview to show portfolio. Single pictures require only captions. Picture stories require explanatory text but not finished ms. Pays on publication. Reports ASAP. SASE. Simultaneous submissions and previously published work OK. B&W: Send 8x10 glossy prints. Captions required.

Color: Send transparencies. Captions required.

Tips: MD also publishes a Spanish edition and automatically pays half the original use fee for reuse.

MEASUREMENTS & CONTROL, 2994 W. Liberty Ave., Pittsbugh PA 15216. (412)343-9666. Managing Editor: Harish Saluja. Bimonthly magazine. Emphasizes "industrial instrumentation, automation, process control, computers." Readers are "engineers—instrument, chemical, design, electrical." Circ. 100,000. Sample copy free with SASE; call for photo guidelines.

Photo Needs: Uses 500 photos; "very few" from freelance photographers. Needs industrial, medical

and technical photos. Model release and captions required.

Making Contact: Send any size b&w or color glossy prints by mail for consideration. SASE. Reports in 2 weeks. Payment varies. Pays on publication. Credit line given.

MEDIA & METHODS, 1511 Walnut St., Philadelphia PA 19102. (215)563-3501. Art Director: Joanna Smith. Publishes 6/issues year. Emphasizes "media, technologies and methods of teaching secondary school students." Readers are secondary school librarians, teachers, administrators. Circ. 40,000. Sample copy free with SASE and \$1.07 postage.

Photo Needs: Uses 10-15 photos/issue; 1-2 supplied by freelance photographers. Needs "photos of stu-

dents and teachers, schools, equipment." Written release and captions preferred.

Making Contact & Terms: Arrange a personal interview to show portfolio. Provide resume, business card, brochure, flyer or tearsheets to be kept on file for possible future assignments. Pays \$100/b&w cover photo; \$200/color cover photo; \$50/b&w inside photo; \$75/color inside photo. Payment is made on publication. Credit line given. Buys First North American serial rights. Simultaneous and previously published work OK.

Tips: "Show a portfolio with imaginative work and a sense of editorial."

MEDICAL ELECTRONICS, 2994 W. Liberty Ave., Pittsburgh PA 15216. (412)343-9666. Managing Editor; Harish Saluja. Bimonthly magazine. Emphasizes "medical instrumentation, equipment, technology and computers." Readers are "doctors, cardiologists, radiologists and medical engineers." Circ. 100,000. Sample copy free with SASE. Call for photo guidelines.

Photo Needs: Uses 500 photos/issue. "Very few" supplied by freelance photographers. Needs "industrial, medical and technical photos." Written release and captions required.

Making Contact & Terms: Send b&w or color prints by mail for consideration. SASE. Payment varies. Payment is made on publication.

MEDICAL TIMES, 80 Shore Rd., Port Washington NY 11050. (516)883-6350. Executive Editor: Susan Carr Jenkins. Monthly. Circ. 100,000. Emphasizes medicine. Readers are "primary care physicians in private practice." Sample copy \$5.

Photo Needs: Uses 6-10 photos/issue; "almost all" supplied by freelance photographers. Needs "medi-

cally oriented photos on assignment only." Model release and captions required.

Making Contact & Terms: Query with samples or list of stock photo subjects. SASE. Reports in 1 month. Pays approximately \$300/color cover; \$50 and up/b&w or color inside. Pays on acceptance. Credit line given. Rights purchased vary with price.

Tips: Prefers to see "photos of interest to physicians or which could be used to illustrate articles on medical subjects. Send in a typed query letter with samples and an indication of the fee expected."

MEDICINE AND COMPUTER, 180 S. Broadway, White Plains NY 10605. (914)681-0040. Art Director: Arline Campbell. Bimonthly. Emphasizes "medicine and the use of computers in the physician's practice." Readers are physicians (primarily computer users). Circ. 47,500. Sample copy \$4.

Photo Needs: Uses about 35 photos/issue; 15 supplied by freelance photographers. Needs "photos of physicians and their practice and the involvement of computers." Special needs include "diversity within a subject that can be limiting. Creativity, yet still communicate a conservativity." Model release and captions preferred.

Making Contact & Terms: Query with samples or list of stock photo subjects; provide resume, business card, brochure, flyer or tearsheets to be kept on file for possible future assignments. Reports in 1 week. Pays \$75-500/job. Pays on acceptance. Buys all rights. Previously published submissions "pos-

sibly" OK.

Tips: Prefers to see "people, action shots. No poses. People communicating with each other. Display talent with a pleasant manner."

METAL BUILDING REVIEW, 1800 Oakton, Des Plaines IL 60018. (312)298-6210. Editor-in-Chief: Gene Adams. Monthly. Circ. 20,200. Emphasizes the metal building industry. Readers are contractors, dealers, erectors, manufacturers. Sample copy free with SASE.

Photo Needs: Uses about 40 photos/issue; 1-3 supplied by freelance photographers. Needs how-to and

building techniques photos. Model release preferred; captions required.

Making Contact & Terms: Arrange a personal interview to show portfolio; query with samples; submit portfolio for review or send prints, slides, contact sheet or negatives by mail for consideration. Provide tearsheets to be kept on file for possible future assignments. SASE. Reports in 3 weeks. Pays \$75-100/color cover photo; \$5-20/b&w inside photo. Pays on acceptance. Credit line given. Buys one-time rights; first North American serial rights and all rights. Simultaneous submissions and previously published work OK.

Tips: Prefers to see "trade magazine assignment work" in a portfolio.

*MICHIGAN BUSINESS MAGAZINE, #302 30161 Southfield, Southfield MI 48076. (313)647-0111. Editor: Ron Garbinski. Monthly independent circulated to senior executives. Emphasizes Michigan business. Readers include top-level executives. Circ. 28,000. Estab. 1984. Free sample copy with SASE; call editor for photo guidelines.

Photo Needs: Uses variable number of photographs; most supplied by freelance photographers. Needs photos of business people, environmental; feature story presentation; mug shots, etc. Reviews photos with accompanying ms only. Special needs include photographers based around Michigan for freelance

work on job basis. Model release preferred; captions required.

Making Contact & Terms: Arrange a personal interview to show portfolio, query with resume of credits and samples. SASE. Reports in 2 weeks. Pay individually negotiated. Pays on publication. Credit line given. Buys all rights.

MICHIGAN FARMER, 3303 W. Saginaw, Lansing MI 48901. Editor: Richard H. Lehnert. Semi-monthly magazine. Circ. 74,000. Emphasizes farming and farmers, for all farmers in Michigan. Wants no material "that is not farm-related or that is obviously not from Michigan." Buys 10-12 cover photos/year. Buys first serial rights. Present model release on acceptance of photo. Query, send photos for consideration. Pays on publication. Reports in 2 weeks. SASE. Simultaneous submissions and previously published work OK. Free sample copy and photo guidelines.

B&W: Send 5x7 or 8x10 glossy prints. Captions required. Pays \$5-10.

Cover: Send color transparencies. Uses vertical format. Allow space at top and bottom of photo for

logos. Captions required. Pays \$60.

Tips: Buys b&w primarily with accompanying ms; buys cover shots with or without ms. "We have annual special issues on chemicals (February), farm buildings (May), grain drying (July) and management (December). These require special cover shots."

THE MILITARY REVIEW, Funston Hall, Fort Leavenworth KS 66027. (913)684-5642. Editor: Col. Frederick W. Timmerman, Jr. Photo Editor: Betty Spiewak. Monthly journal. Circ. 22,000. For military officers, college professors and civilians in the Department of Defense. Needs general military, geographical and topographical photos, and shots of the equipment and personnel of the foreign military. Photos purchased with accompanying ms only. Credit line given. Pays on acceptance. Reports in 2 weeks. SASE. Free sample copy.

B&W: Send 5x7 glossy prints. Captions required.

Cover: Send glossy b&w prints or matte color prints. Captions required.

Tips: All photos must have a direct application to the U.S. or foreign military. "Since our journal is academically oriented, it's difficult to illustrate articles. Action photos are best."

*MINI MAGAZINE, Box 61, 85 Eastern Ave., Gloucester MA 01930. (617)283-3438. Editor: Josh Brackett. Photo Editor: Tania Molinski. Publishes 6 issues/year. Emphasizes computer software and hardware. Readers include IBM System 34/36/38 Decision Makers. Circ. 38,000. Sample copy \$3. Photo Needs: Uses 7-10 photos/issue; currently none supplied by freelance photographers. Needs computer (IBM 34/36/38), office scenes, computer terminals. Reviews photos with or without accompanying ms. Special needs include IBM photos. Model release required; captions preferred.

Making Contact & Terms: Query with samples and list of stock photo subjects. Reports in 2 weeks. Pays \$50-300/job. Pays on publication. Buys all rights. Simultaneous submissions and previously

published work OK.

MISSOURI RURALIST, Suite 600, 2103 Burlington, Columbia MO 65202. (314)474-9557. Editor-in-Chief: Larry S. Harper. Biweekly. Circ. 80,000. Emphasizes agriculture. Readers are rural Missourians. Sample copy \$2.

Photo Needs: Uses about 25 photos/issue; "few" are supplied by freelance photographers. "Photos must be from rural Missouri." Photos purchased with accompanying ms only. Pays \$60/photo and page.

Captions required.

MODERN TIRE DEALER MAGAZINE, 110 N. Miller Rd., Akron OH 44313. (216)867-4401. Editor: Greg Smith. Monthly tabloid, plus January, April and September special emphasis magazines. Circ. 36,000. Emphasizes the operation of retail and wholesale tire business. For independent tire dealers and tire company executives. Buys 15 photos/year.

Subject Needs: Head shot, how-to, photo essay/photo feature, product shot and spot news. Captions re-

quired.

Accompanying Mss: Needs features on successful dealers and businesses with new twists in promotions. Does not use stories without good pictures. Pays \$125-200/ms with photos. Writer's guidelines free on request. Photos are purchased with or without accompanying ms.

Specs: Prefers 35mm 8x10 b&w and color glossy prints and contact sheets but uses 35mm color transparencies. Uses b&w glossy contact sheet or color 35mm transparencies for cover. Vertical format re-

quired.

Payment & Terms: Pays \$5-150/job, \$125-300 for text/photo package or on a per-photo basis. Pays \$5-20/b&w photo. Pays \$10-150/color photo. Pays \$50-300/cover photo. Pays on acceptance. Buys all rights. Previously published work OK.

Making Contact: Send material by mail for consideration. SASE. Reports in 1 month. Free sample

copy and photo guidelines.

Tips: "We are always looking for that different feature with art: unusual merchandising, advertising, operational ideas and store fronts."

MOTORCYCLE DEALER NEWS, Box 19531, Irvine CA 92713. Editors: Fred Clements and Kathy St. Lewis. Monthly magazine. Circ. 15,000. Emphasizes running a successful retail motorcycle business for retail motorcycle dealers. Photos are purchased with accompanying ms. Buys 50 photos/year. Pays \$50-125 for text/photo package or on a per-photo basis. Credit line given usually. Pays on publication. Buys all rights, but may reassign to photographer after publication. Works mostly with freelance photographers on assignment only basis. Provide resume, brochure, calling card, flyer, letter of inquiry, tearsheets, samples, or whatever photographer feels would be the most representative to be kept on file. SASE. Simultaneous submissions (if subject is not motorcycles) and previously published work OK. Reports ASAP. Sample copy and photo guidelines available.

Subject Needs: Wants material related to motorcycle dealerships and marketing techniques only. Does not want consumer-interest pieces. No competition shots. Model release and captions required.

B&W: Uses 5x7 and 8x10 prints. Pays \$10/photo.

Accompanying Mss: Seeks mss on interesting and profitable marketing or promotional techniques for motorcycles and accessories by dealers. Pays \$35-100/ms. Writer's guidelines free on request. Tips: "We are a business publication and not interested in races or most consumer activities."

*NATIONAL BUS TRADER, Rt. 3, Box 349B, Theater Road, Delavan WI 53115-9566. (414)728-2691. Editor: Larry Plachno. Monthly. Circ. 4,500. "The Magazine of Bus Equipment for the United States and Canada—covers mainly integral design buses in the United States and Canada." Readers are bus owners, commercial bus operators, bus manufacturers, bus designers. Sample copy free with SASE and \$1 postage.

Photo Needs: Uses about 30 photos/issue; 22 supplied by freelance photographers. Needs photos of "buses; interior, exterior, under construction, in service." Special needs include "photos for future fea-

ture articles and conventions our own staff does not attend."

Making Contact & Terms: "Query with specific lists of subject matter that can be provided and ask whether accompanying mss are available." SASE. Reports in 1 week. No established rates. Pays on acceptance. Credit line given. Buys rights "depending on our need and photographer." Simultaneous sub-

missions and previously published work OK.

Tips: "We don't need samples, merely a list of what freelancers can provide in the way of photos or ms. Write and let us know what you can offer and do. We rarely use freelance work. We also publish Bus Tours Magazine—a bimonthly which uses many photos but not many from freelancers; The Bus Equipment Guide—infrequent, which uses many photos and The Official Bus Industry Calendar—annual full-color calendar of bus photos."

NATIONAL COIN-OPERATORS REPORTER, (Formerly Coin-Operators Reporter), 717 E. Chelten Ave., Philadelphia PA 19144. (215)843-9795. Editor: Hal Horning. Monthly newspaper. Readers are drycleaners/coin-op owners. Circ. 15,000.

Photo Needs: Uses about 50 photos/issue; "very few" supplied by freelance photographers. Needs "unusual cover type shots; photos of drycleaners or coin-op laundries." Model release optional; cap-

tions preferred.

Making Contact & Terms: Query with list of stock photo subjects; send 5x7 b&w prints by mail for consideration; "query first before shooting." SASE. Reports in 1 week. Pays \$25-50/b&w cover photo. Pays on publication. Credit line given. Buys one-time rights.

Tips: "Query first for description of magazine's needs."

NATIONAL FISHERMAN, 21 Elm St., Camden ME 04843. (207)236-4342. Contact: James W. Fullilove. Monthly magazine. Circ. 58,000. Emphasizes commercial fishing, boat building, marketing of fish, fishing techniques and fishing equipment. For amateur and professional boatbuilders, commercial fishermen, armchair sailors, bureaucrats and politicians. Buys 5-8 photo stories monthly; buys 4-color action cover photo monthly.

Subject Needs: Action shots of commercial fishing, work boats, traditional (nonpleasure) sailing

fishboats. No recreational, caught-a-trout photos.

Payment & Terms: Pays \$10-25/inside b&w print and \$250/color cover transparency. Pays on publication.

Making Contact: Query. Reports in 4 weeks.

Tips: "We seldom use photos unless accompanied by feature stories or short articles—i.e., we don't run a picture for its own sake. Even those accepted for use in photo essays must tell a story—both in themselves and through accompanying cutline information."

NATIONAL GUARD, 1 Massachusetts Ave. NW, Washington DC 20001. (202)789-0031. Editor-in-Chief: Major Reid K. Beveridge. Monthly. Circ. 69,000. Emphasizes news, policies, association activities and feature stories for officers of the Army and Air National Guard. Readers are National Guard of-

ficers. Free sample copy and photo guidelines with SASE.

Photo Needs: "Pictures in military situations which show ability to shoot good quality, dramatic action pictures as this is the type of photography we are most interested in." Uses 40 photos/issue; 6 are supplied by freelance photographers. "Normally, photography accompanies the freelance articles we purchase. Freelance photographers should query first and their photography should be of subjects not available through normal public affairs channels. We are most interested in hiring freelance work in the Midwest, South and West. We never use freelance work in the Washington area because members of our staff take those pictures. Subject matter should be relevant to information of the National Guard officer. Please submit SASE with all material."

NEW METHODS, Box 22605, San Francisco CA 94122. (415)664-3469. Art Director: Larry Rosenberg. Monthly. Circ. 5,000. Emphasizes veterinary personnel, animals. Readers are in the veterinary field. Sample copy \$3.60 and 71¢ postage; photo guidelines free with SASE.

Photo Needs: Uses 12 photos/issue; 2 supplied by freelance photographers. Needs animal, wildlife and

technical photos. Model release and captions required.

Making Contact & Terms: Arrange a personal interview to show portfolio; qyery with resume of credits, samples or list of stock photo subjects; submit portfolio for review; provide resume, business card,

brochure, flyer or tearsheets to be kept on file for possible future assignments. Send 3x5 to 8x10 b&w glossy prints; 35mm, 21/4x21/4 transparencies by mail for consideration. SASE. Reports in 2 months. Contact us for rates of payment." Pays on publication. Credit line given. Buys one-time rights. Simultaneous submissions and previously published work OK.

Tips: Prefers to see "technical photos (human working with animal(s) or animal photos (not cute)" in a

portfolio or samples.

*NEW ORLEANS BUSINESS, 2520 Belle Chaste Hwy., Box 354, Gretna LA 70054. (504)362-4310. Executive Editor: Lan Sluder. Weekly tabloid. Emphasizes "business, industry and the professions in New Orleans and in the state of Louisiana." Readers are executives and professionals making more than \$75,000 a year. Circ. 20,000. Free sample copy and photo guidelines with SASE.

Photo Needs: Uses about 3 photos/issue; 1 supplied by freelance photographers. Needs photos of "various business subjects, especially good color transparencies of subjects of interest to New Orleans busi-

ness people." Model release preferred; captions required.

Making Contact & Terms: Query with samples. SASE. Reports in 2 weeks. Pays \$75/b&w cover photo, \$75-125/color cover photo, \$25/b&w inside photo and \$50/color inside photo. Pays on publication. Credit line given. Buys first rights in Louisiana. Simultaneous submissions and previously published submissions OK.

NON-FOODS MERCHANDISING, 11 West 19th St., New York NY 10011. (212)741-7210. Contact: Editor. Monthly. Circ. 20,000. Emphasizes the products sold by the non-foods sections of convenience stores and supermarkets. Free sample copy and photo guidelines with SASE.

Photo Needs: Uses 75-100 photos/issue; 20% are usually supplied by freelance photographers. Photographers are selected by availability and ability. Captions required.

Making Contact & Terms: Query with resume of photo credits and call with ideas for photos and contacts. SASE. Reports in 2 weeks. Pays \$150-300/day. Payment on acceptance. Buys all rights.

*THE NORTHERN LOGGER & TIMBER PROCESSOR, Box 69, Old Forge NY 13420. Editor: Eric A. Johnson. Managing Editor: George F. Mitchell. Monthly magazine. Circ. 12,500. Emphasizes methods, machinery and manufacturing as related to forestry. For loggers, timberland managers, and processors of primary forest products in the territory from Maine to Minnesota and from Missouri to Virginia. Photos purchased with accompanying ms. Buys 3-4 photos/issue. Credit line given. Pays on publication. Not copyrighted. Query with resume of credits. SASE. Previously published work OK. Reports in 2 weeks. Free sample copy.

Subject Needs: Head shot, how-to, nature, photo essay/photo feature, product shot and wildlife; mostly b&w. Captions required. "The magazine carries illustrated stories on new methods and machinery for forest management, logging, timber processing, sawmilling and manufacture of other products of north-

ern forests.

B&W: Uses 5x7 or 8x10 glossy prints. Pays \$15-20/photo.

Color: Uses 35mm transparencies. Pays \$35-40/photo.

Cover: Uses b&w glossy prints or 35mm color transparencies. Horizontal format preferred. Pays \$35-40/photo.

Accompanying Mss: Pays \$100-250 for text/photo package.

Tips: "Send for a copy of our magazine and look it over before sending in photographs. We're open to new ideas, but naturally are most likely to buy the types of photos that we normally run. An interesting caption can mean as much as a good picture. Often it's an interdependent relationship.'

NURSING MANAGEMENT, Suite 701, 600 S. Federal St., Chicago IL 60605. (312)341-1014. Production Manager: Andrew Miller. Monthly. Circ. 107,000. Emphasizes information on and techniques for nurse management. Readers are managerial level professional nurses.

Photo Needs: Uses 10 photos/issue; all are usually supplied by freelance photographers. Needs hospital

oriented photos. Model release required.

Making Contact & Terms: Query with list of stock photo subjects. SASE. Reports in 1 month. Credit line given. Payment on publication.

OCCUPATIONAL HEALTH & SAFETY, Box 7573, Waco TX 76710. (817)776-5011. Associate Publisher: Darrell Denny. Published 12 times/year. Emphasizes the field of occupational health and safety. Readers are occupational physicians, occupational nurses, industrial hygienists, safety engineers, government and union officials. Circ. 92,000. Free sample copy.

Photo Needs: Uses about 30 photos/issue; 10 or more supplied by freelance photographers. Needs "vary according to editorial content," write for current editorial lineup. Model release and captions pre-

ferred

Making Contact & Terms: Query with sample or list of stock photo subjects; send prints, transparencies and negatives by mail for consideration. SASE. Reports in 1 month. Payment negotiable, usually \$25-100/slide. Pays on acceptance. Credit line given. Buys one-time rights or rights for reuse. Simultaneous and previously published submissions OK "only if not submitted to competing magazines."

OCEANUS, Woods Hole Oceanographic Institution, Woods Hole MA 02543. (617)548-1400. Editor: Paul R. Ryan. Quarterly. Circ. 15,000. Emphasizes "marine science and policy." Readers are "seriously interested in the sea. Nearly half our subscribers are in the education field." Sample copy free with SASE.

Photo Needs: Uses about 60 photos/issue; 25% supplied by freelance photographers. "Three issues per

year are thematic, covering marine subjects." Captions required.

Making Contact & Terms: Query with resume of credits or with list of stock photo subjects; provide resume, business card, brochure, flyer or tearsheets to be kept on file for possible future assignments. Does not return unsolicited material. Reports in 1 month. Payments "to be negotiated based on size of photo used in magazine." Pays on publication. Credit line given. Buys one-time rights.

Tips: "The magazine uses only b&w photos. Color slides can be converted. Send us high contrast b&w photographs with strong narrative element (scientists at work, visible topographic, atmospheric altera-

tions or events)."

OFFICE ADMINISTRATION & AUTOMATION, (formerly Administrative Management), 51 Madison Ave., New York NY 10010. (212)689-4411. Editor: William Olcott. Executive Editor: Walter J. Presnick. Art Director: Aaron Morgan. Monthly magazine. Circ. 54,000. Emphasizes office systems for "managers who have the responsibility of operating the office installation of any business." Buys 10 photos/year. Present model release on acceptance of photo. Works with freelance photographers on assignment only basis. Arrange a personal interview to show portfolio or send photos for consideration. Pays on publication. Reports in 4-6 weeks. SASE. Sample copy \$3.50.

B&W: Uses 8x10 glossy prints; send contact sheet.

Color: Send 4x5 transparencies. Payment is "strictly negotiated."

Cover: See requirements for color. "The editor should be contacted for directions."

Tips: No photos of cluttered offices.

*OFFICIAL COMDEX SHOW DAILY, 300 1st Ave., Needham MA 02194. (617)449-6600. Editorin-Chief: Vic Farmer. Newspaper published 3-4 issues a show, 3 shows a year. Emphasizes COMDEX computer show coverage: Atlanta, Las Vegas and Los Angeles. Readers are show attendees. Photo Needs: Uses about 10 photos/issue; half supplied by freelance photographers. Needs travel, sce-

nic and entertainment photos. Model release and captions required.

Making Contact & Terms: Query with samples. SASE. Reports in 3 weeks. Pays \$25/inside photo. Pays on publication. Credit line "sometimes" given. Buys one-time rights. Simultaneous submissions and previously published work OK.

*OHIO BUSINESS, 425 Hanna Bldg., Cleveland OH 44115. (216)621-1644. Managing Editor: Michael Moore. Monthly magazine. Emphasizes "all types of business within Ohio." Readers are executives and business owners. Circ. 40,000. Sample copy \$2.

Photo Needs: Uses 20-25 photos/issue; 0-3 supplied by freelance photographers. Needs photos of

"people within articles and industrial processes." Captions preferred.

Making Contact & Terms: Provide resume, business card, brochure, flyer or tearsheets to be kept on file for possible future assignments. SASE. Reports in 2 weeks. Pays \$150/color cover photo, \$10 +/ b&w inside photo and \$50 + /color inside photo. Pays on acceptance. Credit line given. Buys one-time rights. Simultaneous submissions and previously published work OK.

Tips: "Read the publication."

THE OHIO FARMER, Suite 330, 1350 W. 5th Ave., Columbus OH 43212. (614)486-9637. Editor: Andrew L. Stevens. Semimonthly magazine. Circ. 100,000. Emphasizes farming in Ohio. Photos purchased with accompanying ms. Pays by 10th of month following publication. Buys 3-6 photos/year. Buys one-time rights. SASE. Reports in 10 days. Sample copy \$1. Free photo guidelines with SASE. B&W: Uses 5x7 prints; contact sheet OK. Pays \$5 minimum.

Cover: Uses slides only. Vertical format only. Pays \$50-100/photo.

Accompanying Mss: Writer's guidelines free with SASE. Pays \$10/column.

THE ONTARIO TECHNOLOGIST, Suite 253, 40 Orchard View Blvd., Toronto, Ontario, Canada M4R 2G1. (416)488-1175. Editor-in-Chief: Ruth M. Klein. Publication of the Ontario Association of Certified Engineering Technicians and Technologists. Bimonthly. Circ. 14,000. Emphasizes engineering technology. Sample copies free with SASE.

Photo Needs: Uses 10-12 photos/issue. Needs how-to photos—"building and installation of equipment; similar technical subjects." Prefers business card and brochure for files. Model release and captions preferred.

Making Contact & Terms: Send 5x7 b&w or color glossy prints for consideration. SASE. Reports in 1 month. Pays \$25/b&w photo; \$50/color photo. Pays on publication. Credit line given. Buys one-time rights. Previously published work OK.

OREGON BUSINESS MAGAZINE, Suite 404, 208 SW Stark, Portland OR 97204. (503)223-0304. Art Director: Richard Jester. Monthly. Circ. 23,000. Emphasizes business features. Readers are business executives. Sample copy free with SASE and 90¢ postage.

Photo Needs: Uses about 15 photos/issue; 5 supplied by freelance photographers. "Usually photos must

tie to a story. Query any ideas." Model release and captions required.

Making Contact & Terms: Query first with idea. Reports in 1 week. Pays \$20/b&w inside photo; \$25/ color inside photo with stories; \$25 minumum/job. Pays on publication. Credit line given. Buys onetime rights. Simultaneous submissions and previously published work OK.

Tips: "Query first, also get hooked up with an Oregon writer. Must tie photos to an Oregon business sto-

ry.

OUTDOOR AMERICA, Suite 1100, 1701 N. Ft. Myer Dr., Arlington VA 22209. (703)528-1818. Editor: Carol Dana. Published quarterly. Circ. 50,000. Emphasizes natural resource conservation and activities for sportsmen. Readers are members of the Izaak Walton League and all members of Congress. Sample copy \$1.50; photo guidelines with SASE.

Photo Needs: Needs outdoor scenes for cover; occasionally buys pictures to accompany articles on con-

servation and outdoor recreation for inside. Captions (identification) required.

Making Contact & Terms: Query with resume of photo credits. Uses 35mm and 21/4x21/4 slides. SASE. Pays \$150/color cover; \$35-50/inside photo. Credit line given. Pays on publication. Buys onetime rights. Simultaneous and previously published work OK.

*OWNER OPERATOR MAGAZINE, Chilton Co., Radnor PA 19089. (215)964-4264. Editor: Leon Witconis. Bimonthly magazine. Circ. 90,000. Emphasizes trucking business articles; selection, maintenance and safety of trucks, and new products and new developments in the industry. For independent truckers, age 18-60; most own and drive 1-3 trucks. Buys 5-6 photos/year. Buys all rights. Submit model release with photo. Submit story outline and plans for photos. Photos purchased with accompanying ms. Pays on publication. Reports in 6 weeks. SASE.

Subject Needs: Occupational photojournalism pieces; documentary; scenic; how-to (maintenance, repairs); human interest and humorous (self-contained photo/caption or with short story); photo essay/ photo feature; product shot (if unique); special effects/experimental (highway shots); and spot news.

B&W: Uses 8x10 semigloss prints. Captions required. Pay negotiable.

Color: Uses 8x10 glossy prints or transparencies. Captions required. Pay negotiable.

Cover: Uses 8x10 glossy prints or 21/4x21/4 transparencies. Prefers long vertical format. Pays \$75-175. Accompanying Mss: "We generally seek photojournalistic articles, such as features on log haulers, livestock haulers, steel haulers, etc. We also lean heavily on articles that help the small businessman, such as taxes, bookkeeping, etc. We would also entertain short news features of on-the-spot news coverage of trucker-sponsored blockades, strikes, human interest and safety."

Tips: "Photos of trucks simply because it's a truck don't sell. There has to be a point to the story or a reason for shooting the photo. Obviously we prefer photos showing trucks with people. Do not call us and ask what you can do. Select a story idea, submit an outline and type of photo coverage you have in

mind."

*P.O.B. (Point of Beginning), Box 810, Wayne MI 48184. (313)729-8400. Art/Production Director: Carol Boivin. Bimonthly magazine. Emphasizes the surveying and mapping profession. Circ. 65,000. Sample copy for 10x13 SASE and \$1.75 postage.

Photo Needs: Uses about 25-30 photos/issue; approximately 10-15 supplied by freelance photographers. Needs "historical and current photos for articles of special interest to our audience." Model re-

lease and captions required.

Making Contact & Terms: Send 5x7 glossy b&w or color prints by mail for consideration. Provide resume, business card, brochure, flyer or tearsheets to be kept on file for possible future assignments. SASE. Reports in 3 weeks. Pays \$5-25/b&w inside photo, \$10-50/color inside photo and \$150-450/text/ photo package. Pays on publication. Credit line given. Buys all rights.

*PACIFIC PURCHASOR, 6090 W. Pico Blvd., Los Angeles CA 90035. (213)653-2198. Editor: Berd Johnson. Photo Editor: Jeanne Vlazny. Association publication for the purchasing managers. Monthly. Emphasizes purchasing and inventory management. Readers include professional buyers for corporations. Circ. 10,000. Sample copy \$1.50.

Photo Needs: Uses 2-3 photos/issue; currently none supplied by freelance photographers. Reviews photos with accompanying ms only. Model release required; captions preferred.

Making Contact & Terms: Query with samples and list of stock photo subjects. SASE. Pays on publication. Credit line given. Buys one-time rights. Previously published work OK.

PACIFIC TRAVEL NEWS, 100 Grant Ave., San Francisco CA 94108. (415)781-8240. Managing Editor: James C. Gebbie. Monthly magazine. Circ. 25,000. Emphasizes information for the travel agent about the membership area of the Pacific Area Travel Association—Hawaii to Pakistan. Approximately 4 feature articles per issue on specific destinations, a destination supplement and a section of brief news items about all Pacific areas.

Subject Needs: Photo essay/photo feature, nature, sport, travel and wildlife, only as related to the Pacific. Prefers nature photos with people involved. "We try to avoid shots that look too obviously set up and commercial. We don't use anything outside the Hawaii-to-Pakistan area." Caption information needed. Specs: Uses 8x10 glossy, matte or semigloss b&w prints and 35mm and 21/4x21/4 color transparencies. Format flexible.

Accompanying Mss: Photos purchased with or without accompanying ms. Seeks destination features describing attractions of an area as well as "nuts and bolts" of traveling there. Most ms are on assign-

Payment & Terms: Pays \$20/b&w print, \$50 minimum/color transparency and \$75-100/cover. Credit line given. Buys one-time rights. Simultaneous submissions (if not to a competing publication) and previously published work OK.

Making Contact: Send material by mail for consideration, query with resume of credits, send portfolio for review or list of Pacific areas covered in work with samples. SASE. Reports in 1 month. Sample copy available.

Tips: Very trade-oriented. Story should be specific, narrow focus on a topic.

THE PACKER, Box 2939, Shawnee Mission, KS 66201. (913)451-2200. Editor: Bill O'Neill. Weekly newspaper. Circ. 16,000. Emphasizes news and features relating to all segments of the fresh fruit and vegetable industry. Covers crop information, transportation news, retailing ideas, warehouse information, market information, personality features, shipping information, etc. For shippers, fruit and vegetable growers, wholesalers, brokers and retailers. Photos purchased with or without accompanying ms. or on assignment. Buys 3-5 photos/issue. Pays \$5-100/job, \$35-150 for text/photo package or on a perphoto basis. Credit line given. Pays on publication. Buys all rights, but may reassign to photographer after publication. Query by phone. Previously published work OK. Reports in 1 week. Free sample copy. Subject Needs: Celebrity/personality (if subject is participating in a produce industry function); human interest (e.g., a produce grower, shipper, truck broker, retailer—or a member of their family—with an unusual hobby); photo essay/photo feature (highlighting important conventions or special sections of the magazine); new product shot; scenic; and spot news (e.g., labor strikes by farm workers, new harvesting machinery, etc.). No large groups of 4 or more staring into the camera. Captions required. Supplements to The Packer using photos include The Grower, which discusses how large growers raise crops, new products, pesticide information, etc.; Produce and Flora Retailing, about merchandising techniques in supermarket produce departments and floral boutiques; Food Service, about the institutional use of produce in serving food; and Produce in Transit, about the transportation of fruits and vegetables.

B&W: Uses 5x7 or 8x10 glossy prints. Pays \$5-25/photo. **Color:** Uses 35mm, 2¹/₄x2¹/₄, 4x5 or 8x10 transparencies. Pays \$35-75/photo.

Cover: Uses b&w glossy prints; or 21/4x21/4, 4x5 or 8x10 color transparencies. Vertical format pre-

ferred. Pays \$40-80/photo.

Accompanying Mss: Copy dealing with fresh fruit and vegetables, from the planting and growing of the product all the way down the distribution line until it reaches the retail shelf. "We have little interest in roadside stands and small growing operations which sell their products locally. We're more interested in large growing-shipping operations.

PARTS PUPS, 2999 Circle 75 Pkwy., Atlanta GA 30339. Editor-in-Chief: Don Kite. Monthly. Circ. 260,000. Also publishes an annual publication; circulation 395,000. Emphasizes "fun and glamorous

women." Readers are automotive repairmen. Free sample copy and photo guidelines.

Photo Needs: Uses about 4 photos/issue; all are supplied by freelance photographers. Needs "glamorcheesecake-attractive females with a wholesome sex appeal. No harsh shadows, sloppy posing or cluttered backgrounds." Photos purchased with or without accompanying ms. Model release required. Making Contact & Terms: Send by mail for consideration contact sheets; 35mm, 21/4x21/4 or 4x5 slides. SASE. Reports in 6-8 weeks. Provide tearsheets to be kept on file for possible future assignments. Pays \$300/color cover photo; \$100/b&w inside photo; \$250/inside color nudes. Pays on acceptance. Credit line given. Buys one-time rights. Simultaneous submissions and previously published

Tips: Prefers to see "good craftsmanship and attention to details."

"Keep submitting, hustle and you'll make it," says Jonesborough, Tennessee. freelancer Tom Raymond. Raymond, who is also a physician, started shooting for newspapers in the 1960s, and now has his own photography studio. His photograph, which appeared on the cover of Pediatric Annals, demonstrates the popularity and the need for sports photographs. The key to shooting sports is being able to catch the peak of the action in clear, crisp focus.

PEDIATRIC ANNALS, 6900 Grove Rd., Thorofare NJ 08086. (609)848-1000. Managing Editor: Donna Carpenter. Monthly journal. Emphasizes "the pediatrics profession." Readers are practicing pediatricians. Circ. 36,000. Sample copy free with SASE.

Photo Needs: Uses 1-4 photos/issue; all supplied by freelance photographers. Needs photos of "children in a variety of moods and situations, some with adults." Written release required; captions preferred. Query with samples. Provide resume, business card, brochure, flyer or tearsheets to be kept on file for possible future assignments. Reports in 6 weeks. Pays \$200/color cover photo; \$25/inside photo; \$50/color inside photo. Payment is on publication. Credit line given. Buys all rights. Simultaneous and previously published work OK.

*PERINATOLOGY NEONATOLOGY, 825 South Barrington, Los Angeles CA 90049. (213)826-8388. Editor: Esther Gross. Photo Editor: Tom Medsger. Bimonthly journal. Emphasizes problems of newborns. Readers include (MD) perinatologists, neonatologists, pediatricians.

Photo Needs: Uses 2-3 photos/issue; all supplied by freelance photographers. Needs photos of the monitoring of newborns, newborns in incubators, with doctors, nurses, etc. Model release and captions required.

Making Contact & Terms: Query with resume of credits, with list of stock photo subjects; provide resume, business card, brochure, flyer or tearsheets to be kept on file for possible future assignments. Uses 35mm transparencies. SASE. Reports in 2 weeks. Pays \$400/color cover photo, \$150/inside color photo. Pays on acceptance. Credit line given for covers only. Buys all rights; photo is returned to artist, but BPC reserves right to use it again in any of its publication.

*PERSONAL COMMUNICATIONS MAGAZINE, 4005 Williamsburg Ct., Fairfax VA 22032. (703)352-1200. Editor: Stuart Crump, Jr. Magazine published 10 times/year. Emphasizes "mobile and portable communications equipment and service, especially car telephones." Readers are "individuals in those industries as well as users of this equipment." Circ. 25,000. Sample copy \$3.

Photo Needs: Uses about 30 photos/issue; "a few" supplied by freelance photographers. Needs photos of "products in use in natural settings-preferably should not look posed. Call and discuss with editor first." Model release preferred; captions required.

Making Contact & Terms: Provide resume, business card, brochure, flyer or tearsheets to be kept on file for possible future assignments. Call first. SASE; reporting time varies. Pays \$200 +/color cover photo, \$25 + /b&w inside photo, \$25 + /color inside photo, \$100 + /b&w page, \$100 + /color page, \$50 + /hour, \$100 + /job, and \$200-400/text/photo package. Pays on acceptance. Credit line given. Buys one-time rights with right to reprint. Simultaneous submissions and previously published work OK "as long as it didn't go to our competitors."

Tips: Prefers to see "anything that can help us assess your ability, creativity and originality. Call us with

a couple of ideas and discuss them. Learn to write a decent article."

PET BUSINESS, 7330 NW 66th St., Miami FL 33166. (305)591-1625. Editor: Robert Behme. Monthly magazine. Circ. 14,500. For pet industry retailers, groomers, breeders, manufacturers, wholesalers and importers. Buys 25 photos/year. Generally works with photographers on assignment basis. Model release required "when it's not a news photo." Submit portfolio or send contact sheet or photos for consideration. Provide resume and tearsheets to be kept on file for possible future assignments. Credit line given. Pays on acceptance. Reports in 3 weeks. SASE. Sample copy \$1; free photo guide-

Subject Needs: Photos of retail stores; and commercial dog, cat, small animal, reptile and fish operations-breeding, shipping and selling. Pays \$15/b&w inside; \$35/color inside; \$20-\$100/hour; \$250

minimum/job; \$150-1,500 for text/photo package.

B&W: Send contact sheet, 5x7 or 8x10 glossy or matte prints or negatives. Captions required; "rough

data, at least."

Color: Send contact sheet or transparencies. Captions required.

*PETROLEUM INDEPENDENT, 1101 16th St. NW, Washington DC 20036. (202)857-4775. Editor: Joe Taylor. Associate Editor: Bruce Wells. Bimonthly magazine. Circ. 14,000. Emphasizes independent petroleum industry. "Don't confuse us with the major oil companies, pipelines, refineries, gas stations. Our readers explore for and produce crude oil and natural gas in the lower-48 states. Our magazine covers energy politics, regulatory problems, the national outlook for independent producers. Subject Needs: Photo essay/photo feature; scenic; and special effects/experimental, all of oil field subjects. Please send your best work.

Color: Uses 35mm or larger transparencies. Pays \$35-100/photo. Cover: Uses 35mm or larger transparencies. Payment negotiable.

Tips: "We want to see creative use of camera—scenic, colorful or high contrast-studio shots. Creative photography to illustrate particular editorial subjects (natural gas decontrol, the oil glut, etc.) is always wanted. We've already got plenty of rig shots—we want carefully set-up shots to bring some art to the oil field."

PETS/SUPPLIES/MARKETING MAGAZINE, 1 E. 1st St., Duluth MN 55802. (218)723-9303. Editor: David D. Kowalski. Monthly magazine. Circ. 14,600. For pet retailers, owners and managers of pet store chains (3 or more stores), managers of pet departments, wholesalers (hardgoods and livestock), and manufacturers of pet goods. Needs pet and pet product merchandising idea photos; good fish photos-tropical fish, saltwater fish, invertebrates; bird photos-parakeets (budgies), cockatoos, cockatiels, parrots; cat photos (preferably purebred); dog photos (preferably purebred); and small animal photos-hamsters, gerbils, guinea pigs, snakes. Buys all rights. Send photos for consideration. Pays on publication only. Reports in 6-8 weeks. Sample copy \$5. Photo guidelines with SASE.

B&W: Send 5x7 glossy prints. Captions required. Pays \$10 minimum.

Color: Send transparencies. Vertical format. Captions required. Pays \$25 minimum. Cover: Send 35mm color transparencies. Captions required. Pays \$100 minimum.

PGA MAGAZINE, 100 Avenue of Champions, Palm Beach Gardens FL 33410. (305)626-3600. Editor/Advertising Director: W.A. Burbaum. Monthly. Circ. 38,000. Emphasizes golf for 14,000 club professionals and apprentices nationwide plus 13,000 amateur golfers. Free sample copy.

Photo Needs: Uses 20 photos/issue; 5 are supplied by freelance photographers. "Prefer local photographers who know our magazine needs." Interested in photos of world's greatest golf courses, major tour-

nament action, golf course scenic, junior golfers. Model release and captions required.

Making Contact & Terms: Send material by mail for consideration, arrange personal interview to show portfolio and submit portfolio for review. Uses mostly color slides, very few color prints. SASE. Reports in 3 weeks. Pays \$200-300/cover, \$50-75/color photo inside. Credit line given. Payment on acceptance. Buys all time rights. Previously published work OK.

Tips: "Know golf and golf course architecture."

THE PHYSICIAN AND SPORTSMEDICINE, 4530 W. 77th St., Minneapolis MN 55435. (612)835-3222. Photo Editor: Marty Duda. Monthly journal. Emphasizes sports medicine. Readers are

85% physicians; 15% athletic trainers, coaches, athletes and general public. Circ. 110,000. Sample copy and photo guidelines available.

Photo Needs: Uses about 25 photos/issue; 20 supplied by freelance photographers. Needs "primarily

generic sports shots-color slides preferred." Model release preferred.

Making Contact & Terms: Query with list of stock photo subjects; provide resume, business card, brochure, flyer or tearsheets to be kept on file for possible future assignments. Does not return unsolicited material. Reports in 1 month. Pays \$250/color cover; \$75/b&w half page, \$100/color half page; \$100/b&w page, \$150/color page; \$45 minimum or negotiates hourly wage; negotiates rate by the job. Pays on publication. Credit line given. Buys one-time rights unless otherwise specified. Simultaneous and previously published submissions OK.

Tips: "Be patient, submit shots that are specific to the subject defined, and submit technically sound

(clear, sharp) photos."

PIPELINE & GAS JOURNAL, Box 1589, Dallas TX 75221. (214)691-3911. Editor-in-Chief/Photo Editor: A. Dean Hale. Monthly. Circ. 28,500. Emphasizes oil and gas pipeline construction and energy transportation (oil, gas and coal slurry) by pipeline. For persons in the energy pipeline industry. Free

sample copy.

Photo Needs: Uses about 40 photos/issue; up to 5 supplied by freelance photographers. Selection based on "knowledge of our industry. Should study sample issues. Location is important—should be close to pipeline construction projects. We would like to see samples of work and want a query with respect to potential assignments. We seldom purchase on speculation." Provide resume, calling card, letter of inquiry and samples to be kept on file for possible future assignments. Uses 35mm or larger b&w or color transparencies; 5x7 or larger prints. No 110 pictures. Send photos with ms. Articles purchased as text/photo package; "generally, construction progress series on a specific pipeline project." Model release required "if subject at all identifiable." Captions required.

Making Contact & Terms: Query with resume of photo credits. "Call or write." SASE. Reports in 2-3 weeks. Pays \$50 minimum text/photo package. Credit line given if requested. Buys on a work-for-hire basis. No simultaneous submissions; no previously published work if "used in our field in a competitive

publication."

PLANT MANAGEMENT & ENGINEERING, Maclean Hunter Building, 777 Bay St., Toronto, Ontario, Canada M5W 1A7. (416)596-5801. Editor: Ron Richardson. Monthly. Emphasizes manufacturing. Readers are plant managers and engineers. Circ. 25,000. Sample copy free with SASE and 67¢ Canadian postage.

Photo Needs: Uses about 6-8 photos/issue; 1-2 supplied by freelance photographers. Needs photos "to illustrate technical subjects featured in a particular issue—many 'concept' or 'theme' shots used on cov-

ers." Model release preferred; captions required.

Making Contact & Terms: Query with samples; provide resume, business card, brochure, flyer or tearsheets to be kept on file for possible future assignments. SASE. Reports in 1 month. Pays \$150-300/color cover photo; \$35-50/b&w and \$50-200/color inside photo; \$100-300/job; \$120-600 for text/photo package. Pays on acceptance. Credit line given. Buys first North American serial rights.

Tips: Prefers to see "industrial experience, variety (i.e., photos in plants) in samples. Read the maga-

zine. Remember we're Canadian.'

*POLICE NET MAGAZINE, Box 225, Tulsa OK 74101. (918)583-0030. Assistant Editor: Rhonda Grannis. Bimonthly magazine. Emphasizes "computers in law enforcement, current topics in law enforcement and criminal justice." Readers are police officers, private security, courts, and corrections. Circ. 10,000. Sample copy \$1 plus SASE.

Photo Needs: Uses about 25 photos/issue; all supplied by freelance photographers. Needs "police in action shots, computers, courts, corrections, people (police) in computers—not just stand-alone. Special needs include "series of photos shows—any police department computer facilities, people—10-15

shots/with cover shots." Model release required; captions preferred.

Making Contact & Terms: Query with samples and list of stock photo subjects. Send any glossy b&w or color prints. SASE. Reports in 1 month. Pays \$25/b&w cover photo, \$25-75/color cover photo, \$10/b&w inside photo, and \$10-20/color inside photo. Pays on publication. Credit line given. Buys all rights. Simultaneous submissions OK.

POLICE PRODUCT NEWS, 6200 Yarrow Dr., Carlsbad CA 92008. (714)438-3286. Editor: James Daigh. Monthly. Circ. 50,000. Emphasizes law enforcement. Readers are "line" or "beat" officers. Sample copy and contributor guidelines \$5.

Photo Needs: Uses about 2-10 photos/issue; half or more are supplied by freelance photographers. "PPN has an ongoing need for both color and b&w photographs of law enforcement officers in action. We also run 1 photo each month depicting officers in unusual or humorous situations." Model release

and captions required. "We like shots primarily in color that can send a message: action, danger, humor,

fatigue, etc.

Making Contact & Terms: Send by mail for consideration b&w prints, color transparencies or prints. SASE. Reports in 3-4 weeks. Pays on acceptance \$10-25/b&w photo; \$25-50/color transparency; \$100-250/cover. Credit line given. Buys all rights. Simultaneous and previously published submissions OK. Tips: "Break-in with a humorous or unusual photo for our '10-9' section."

POLICE TIMES, POLICE COMMAND, 1100 NE 125th St., North Miami FL 33161. (305)891-1700. Editor: Gerald S. Arenberg. Monthly magazine. Circ. 50,000 + . For law enforcement officers at all levels. Needs photos of police officers in action, CB volunteers working with the police and group shots of police department personnel. Wants no photos that promote products or other associations. Buys 30-60 photos/year. Buys all rights, but may reassign to photographer after publication. Send photos for consideration. Pays on acceptance. Reports in 3 weeks. SASE. Simultaneous submissions and previously published work OK. Sample copy \$1; free photo guidelines. Model release and captions preferred. Credit line given if requested; editor's option.

B&W: Send 8x10 glossy prints. Pays \$5-10 upwards.

Cover: Send 8x10 glossy b&w prints. Pays \$25-50 upwards.

Tips: "We are open to new and unknowns in small communities where police are not given publicity."

PRIVATE PRACTICE MAGAZINE, Box 12489, Oklahoma City OK 73157. (405)943-2318. Executive Editor: Brian Sherman. Art Director: Rocky C. Hails. Monthly. Circ. 200,000. Emphasizes private medical practice for 200,000 practicing physicians and medical students from coast to coast. Free

sample copy; photo guidelines for SASE.

Photo Needs: Uses about 20 photos/issue; 30% of which are supplied by freelance photographers. "I select photographers by 3 very simple, practical criteria: 1. Location (in regard to editorial line). 2. Ouality (of the work submitted—this breaks down into actual equipment and material, and what I like to call a photo-illustrator's 'eye'; one who gives me that little extra needed for good editorial). 3. And last, of course, price (this is on everyone's mind and our magazine is no different. We cannot compete with fees on a scale compared to New York or Los Angeles)." Needs include travel, art, some sports, unusual hobbies, cars, medical facilities and equipment, candid interview photos of specific people, tourist attractions—anything that could be directly or indirectly associated with physicians. Model release and captions required. No posed shots.

Making Contact & Terms: Send by mail for consideration actual 5x7 and 8x10 b&w or color prints or any size slides; arrange personal interview to show portfolio; query with list of stock photo subjects; or submit portfolio by mail for review. SASE. Usually reports "within 2-4 weeks. If longer photographer will be contacted directly." Pays on publication \$25/b&w photo; \$40-50/color transparency. Credit line

given. Buys one-time rights. Simultaneous and previously published submissions OK.

Tips: "Welcome more of a doctor with patients or in a work setting or other doctors, general enough to go with a variety of stories."

PRO SOUND NEWS, 220 Westbury Ave., Carle Place NY 11514. (516)334-7880. Editor: Randolph P. Savicky. Monthly tabloid. Emphasizes professional recording and sound. Readers are recording engineers, studio owners, and equipment manufacturers worldwide. Circ. 14,000. Sample copy free with SASE.

Photo Needs: Uses about 12 photos/issue; all supplied by freelance photographers. Needs photos of recording sessions, sound reinforcement installations, permanent installations. Model release and cap-

tions required.

Making Contact & Terms: Query with samples; send 8x10 b&w glossy prints by mail for consideration. SASE. Reports in 2 weeks. Pays by the job or for text/photo package. Pays on publication. Credit line given. Buys one-time rights. Simultaneous and previously published submissions OK.

PROFESSIONAL AGENT, 400 N. Washington St., Alexandria VA 22314. (703)836-9340. Editor/ Publisher: Janice J. Artandi. Monthly. Circ. 40,000. Emphasizes property/casualty insurance. Readers are independent insurance agents. Sample copy free with SASE.

Photo Needs: Uses about 20 photos/issue; 5 supplied by freelancers. Model release required; captions

Making Contact & Terms: Arrange a personal interview to show portfolio; query with list of stock photo subjects; provide resume, business card, brochure, flyer or tearsheets to be kept on file for possible future assignments. Prefers local photographers. Uses minimum 5x7 glossy b&w prints and 35mm and 21/4x21/4 transparencies. SASE. Reporting time varies. Pays \$300/color cover photo. Pays on publication. Credit line given. Buys one-time rights or first North American serial rights, exclusive in the insurance industry.

PROFESSIONAL COMPUTING, Box 250, Hiland Mill, Camdon ME 04843. (207)236-4365. Editor: Bruce A. Taylor. Bimonthly magazine. Circ. 45,000. Estab. 1984. Emphasizes Hewlett-Packard personal computers.

Photo Needs: Uses 10-20 photos/issue; all supplied by freelance photographers. Model release pre-

ferred. Needs "product shots and inventive photos of computers."

Making Contact & Terms: Provide resume, business card, brochure, flyer or tearsheets to be kept on file for possible future assignments. SASE. Reports in 1 month. Pays on acceptance. Payment guidelines on request. Credit line given. Buys one-time rights.

*THE PROFESSIONAL PHOTOGRAPHER, 1090 Executive Way, Des Plaines IL 60018. (312)299-8161. Editor: Alfred DeBat. Art Director: Debbie Todd. Monthly. Emphasizes professional photography in the fields of portrait, commercial/advertising, and industrial. Readers include professional photographers and photographic services and educators. Approximately half the circulation is Professional Photographers of America members. Circ. 30,000 + . Sample copy \$3.25; photo guidelines with SASE.

Photo Needs: Uses 25-30 photos/issue; all supplied by freelance photographers. "We only accept material as illustration that relate directly to photographic articles showing professional studio, location, commercial and portrait techniques. A majority are supplied by Professional Photographers of America members." Reviews photos with accompanying ms only. "We always need commercial/advertising and industrial success stories. How to Sell your photography to major accounts, unusual professional photo assignments." Model release preferred; captions required.

Making Contact & Terms: Query with resume of credits. "We want a story query, or complete ms if writer feels subject fits our magazine. Photos will be part of ms package." Uses 8x10 glossy unmounted b&w/color prints, 35mm, 21/4x21/4, 4x5 and 8x10 transparencies. SASE. Reports in 8 weeks. PPA members submit material unpaid to promote their photo businesses and obtain recognition. Credit line given.

Previously published work OK.

PROFESSIONAL PILOT, West Building, National Airport, Washington DC 20001. (703)684-8270. Editor: John Lowery. Monthly Magazine. Emphasizes "business/corporate aviation (Learjets, King Airs, etc.) and commuter airlines, plus helicopters and the use of such aircraft in military/government operations as well." Readers are business aviation pilots and flight department executives, plus regional

airline pilots and executives. Circ. 40,000. Sample copy \$3.

Photo Needs: Uses 50 photos/issue; 30 supplied by freelance photographers. Needs photos of "business/regional aircraft and their operators in working environment." Captions preferred. Arrange a personal interview to show portfolio; query with resume of credits, samples, and list of stock photo subjects; send 35mm transparencies by mail for consideration; submit portfolio for review. Provide resume, business card, brochure, flyer or tearshets to be kept on file for possible future assignments. Reports in 1 month. Payment negotiable. Pays on acceptance or "when billed." Credit line given. Buys all rights. "We return all unused photos and all rights to them."

Tips: Prefers to see "sharply focused representational work with strong contrasts and saturated color."

PROFESSIONAL SURVEYOR, Suite 410, 918 F Street NW, Washington DC 20004. (202)628-9696 (editorial office). Editor: W. Nick Harrison. Bimonthly. Circ. 52,000. Emphasizes surveying and related engineering professions. Readers are "all licensed surveyors in U.S. and Canada, government engineers." Sample copies free with SASE.

Photo Needs: Uses about 5 photos/issue; "none at present" supplied by freelance photographers. Needs photos of "outdoors, surveying activities, some historical instruments." Photos purchased with accom-

panying ms only. Model release and captions required.

Making Contact & Terms: Provide resume, business card, brochure, flyer or tearsheets to be kept on file for possible future assignments. SASE. Reports in 1 month. "No fixed payment schedule." Pays on

publication. Credit line given. Previously published work OK.

Tips: "Read magazine. Combine pictures with text, set up as photo story. Contact us. Work with us. We might be able to cover costs if something is good. We would like to use freelancers, but at present and for foreseeable future, we would only be able to 'reward' photographers with an appearance in the magazine."

PROGRESSIVE ARCHITECTURE, Box 1361, 600 Summer St., Stamford CT 06904. (203)348-7531. Editor: John Morris Dixon. Monthly magazine. Circ. 74,000. Emphasizes current information on building design and technology for professional architects. Photos purchased with or without accompanying ms, and on assignment. Pays \$350/1-day assignment, \$700/2-day assignment; \$175/half-day assignment or on a per-photo basis. Credit line given. Pays on publication. Buys one-time rights. Send material by mail for consideration. SASE. Reports in 1 month. Sample copy \$7; free photo guidelines. Subject Needs: Architectural and interior design. Captions preferred.

B&W: Uses 8x10 glossy prints. Pays \$25 minimum/photo.

Color: Uses 4x5 transparencies. Pays \$50/photo.

Cover: Uses 4x5 transparencies. Vertical format preferred. Pays \$50/photo.

Accompanying Mss: Interesting architectural or engineering developments/projects. Payment varies.

PSYCHIATRIC ANNALS, 6900 Grove Rd., Thorofare NJ 08086. (609)848-1000. Managing Editor: Donna Carpenter. Monthly journal. Emphasizes psychiatry. Readers are practicing psychiatrists. Circ. 30,000. Sample copy free with SASE.

Photo Needs: Uses 2-3 photos/issue; all supplied by freelance photographers. Needs photos of "adults

and children in a variety of situations." Written release required; captions preferred.

Making Contact & Terms: Query with samples; provide resume, business card, brochure, flyer or tearsheets to be kept on file for possible future assignments. SASE. Reports in 3 weeks. Pays \$250/color cover photo; \$25/b&w inside photo; \$50/color inside photo. Pays on publication. Credit line given. Buys all rights. Simultaneous submissions and previously published work OK.

*QUICK FROZEN FOODS, 7500 Old Oak Blvd., Cleveland OH 44130. (216)243-8100. Editor: John M. Saulnier. Monthly magazine. Circ. 21,000. Emphasizes retailing, marketing, processing, packaging and distribution of frozen foods. For people involved in the frozen food industry: packers, distributors, retailers, brokers, warehousemen, etc. Needs plant exterior shots, step-by-step in-plant processing shots, photos of retail store frozen food cases, head shots of industry executives, product shots, etc. Buys 50-60 photos annually. Buys all rights, but may reassign to photographer after publication. Query first with resume of credits. Pays on acceptance. Reports in 1 month. SASE.

B&W: Uses 5x7 glossy prints. Captions required. Pays \$10 minimum.

Tips: A file of photographers' names is maintained; if an assignment comes up in an area close to a particular photographer, he may be contacted. "When submitting names, inform us if you are capable of writing a story, if needed."

THE RANGEFINDER, Box 1703, 1312 Lincoln Blvd., Santa Monica CA 90406. (213)451-8506. Editor-in-Chief: Arthur Stern. Monthly. Circ. 50,000. Emphasizes topics, developments and products of interest to professional photographers, including freelance and studio photographers. Sample copy \$2.50; free photo guidelines.

Photo Needs: B&w and color photos are "contributed" by freelance photographers. The only purchased photos are with accompanying mss. "We use photos to accompany stories which are of interest to professional photographers. Photos are chosen for quality and degree of interest." Model release re-

quired; captions preferred.

Making Contact & Terms: Send material by mail for consideration or submit portfolio by mail for review. Uses 5x7 and 8x10 b&w and color prints; 35mm, 21/4x21/4, 4x5 and 8x10 color transparencies. SASE. Reports in 3 weeks. Credit line given.

Tips: "The best chance is when photos accompany a ms. There is seldom room in the magazine for pic-

torial alone."

RECORDING ENGINEER PRODUCER, Box 2449, Hollywood CA 90078. (213)467-1111. Editor: Mel Lambert. Bimonthly. Circ. in excess of 20,000. Emphasizes professional audio. Readers are recording and live-sound engineers and producers. Sample copy free with SASE and \$1.50 postage. **Photo Needs:** Uses about 20-30 photos/issue; approximately 25% supplied by freelance photographers.

Needs "technical photos." Captions preferred.

Making Contact & Terms: Provide resume, business card, brochure, flyer or tearsheets to be kept on file for possible future assignments. SASE. Reports in 2 weeks. Pays \$50-100/job; rate varies for text/photo package. Pays on publication. Credit line given. Normally buys one-time rights. Previously published work OK, if stated.

REFEREE MAGAZINE, Box 161, Franksville WI 53126. (414)632-8855. Executive Editor: Barry Mano. Editor: Tom Hammill. Monthly magazine. Circ. 42,000. Emphasizes amateur level games for referees and umpires at the high school and college levels; also some pro. Readers are well educated, mostly 26- to 50-year-old males. Needs photos related to sports officiating/umpiring. No posed shots, shots without an official in them or general sports shots; but would consider "any studio set-up shots which might be related or of special interest to us." Buys 250 photos/year. Buys one-time and all rights (varies). Query with resume of credits or send contact sheet or photos for consideration. Photos purchased with accompanying ms. Credit line given. Pays \$75-175/job; \$175-350 for text/photo package. Pays on acceptance and publication. Reports within 2 weeks. SASE for photo guidelines. Sample copy free on request.

B&W: Send contact sheet, 5x7 or 8x10 glossy prints. Captions preferred. Pays \$15-25/photo.

Color: Send contact sheet, 5x7 glossyprints or 35mm transparencies. Captions preferred. Pays \$25/

Cover: Send color transparencies or 81/2x12 glossy prints. Allow space at top for insertion of logo. Cap-

tions preferred. Pays \$75-100 for cover.

Tips: Prefers photos which bring out the uniqueness of being a sports official. Need photos primarily of officials at the high school level in baseball, football, basketball, soccer and softball in action. Other sports acceptable, but used less frequently. "When at sporting events, take a few shots with the officials in mind, even though you may be on assignment for another reason." Address all queries to Tom Hammill, Editor. "Don't be afraid to give it a try. We're receptive, always looking for new freelance contributors. We are constantly looking for offbeat pix of officials/umpires. Our needs in this area have increased.'

RESIDENT & STAFF PHYSICIAN, 80 Shore Rd., Port Washington NY 11050. (516)883-6350. Editor: Alfred Jay Bollet, M.D. Photo Editor: Anne Mattarella. Monthly. Circ. 100,000. Emphasizes clinical medicine. Readers are interns, residents, and the full-time hospital staff responsible for their training. Sample copy \$5.

Photo Needs: Uses about 10-20 photos/issue; 2-4 supplied by freelance photographers. Needs "medical

and mood shots; doctor-patient interaction." Model release required.

Making Contact & Terms: Query with samples or list of stock photo subjects or send 5x7 b&w glossy prints; 35mm, 21/4x21/4, 4x5, 8x10 transparencies or contact sheet by mail for consideration; provide resume, business card, brochure, flyer or tearsheets to be kept on file for possible future assignments. SASE. Reports in 3 weeks. Pays \$300/color cover photo; b&w and color inside photo payment varies. Pays on acceptance. Credit line given. Buys all rights.

RESORT MANAGEMENT MAGAZINE, 2431 Morena Blvd., San Diego CA 92110. (619)275-3666. Graphic Designer: Barbara Ayers. Published semi-quarterly. Emphasizes resort marketing and management. Readers are "executives of the finest resorts & hotels, convention center resorts and condominium/timeshare resort communities in the U.S. and abroad." Circ. 11,000. Sample copy with SASE and \$5 postage.

Photo Needs: Uses about 10-20 photos/issue; "none at this time" supplied by freelance photographers.

Model release required; captions preferred.

Making Contact & Terms: Query with samples or list of stock photo subjects; send 8x10 b&w or color prints, 35mm, 21/4x21/4, 4x5 or 8x10 transparencies, and b&w and color negatives by mail for consideration. SASE. Pays \$350/color cover photo; \$75/color inside photo; \$75-100 color page; \$50-200/job; \$50-200 for text/photo package. Pays on publication. Credit line given. Buys all rights. Simultaneous and previously published submissions OK.

Tips: "Photos must be dramatic, unusual and should be resort or hotel specific."

*RESOURCE RECYCLING, Box 10540, Portland OR 97210. (503)227-1319. Editor: Judy Roumpf. Bimonthly magazine. Emphasizes "the recycling of waste materials (paper, metals, glass, etc.)" Readers are "recycling company managers, local government officials, waste haulers, environmental group executives." Circ. 3,000. Sample copy free with \$1.50 postage plus 9x12 SASE.

Photo Needs: Uses about 15-20 photos/issue; 6-8 supplied by freelance photographers. Needs "photos of recycling facilities, curbside recycling collections, secondary materials (bundles of newspapers, soft drink containers), etc." Model release and captions preferred.

Making Contact & Terms: Send glossy b&w prints and b&w contact sheet. SASE. Reports in 1 month. Payment "varies by experience and photo quality." Pays on publication. Credit line given. Buys first North American serial rights. Simultaneous submissions OK.

RESTAURANT AND HOTEL DESIGN, 633 3rd Ave., New York NY 10017. (212)986-4800 ext. 355 or 338. Editor-in-Chief: Mary Jean Madigan. Publishes 10 issues/year. Circ. 35,000. Readers are architects, designers, restaurant and hotel executives.

Photo Needs: "We need high quality architectural photographs of restaurant/hotel/lounge and disco in-

teriors and exteriors.'

Making Contact & Terms: Send material by mail for consideration; query with resume of photo credits or arrange personal interview to show portfolio. Prefers to see a variety of interior and exterior shots (location work preferred over studio shots) in a portfolio. Prefers to see any previously published shots preferably architectural 4x5's of restaurant/hotels as samples. Uses 8x10 b&w prints and 4x5 color slides. SASE. Reports in 1 month. Pays per photo. Credit line given. Buys one-time rights.

Tips: "Come in person whenever possible; we like to work with photographers who are willing to do a

lot of creative compositions and work on location."

RESTAURANT HOSPITALITY MAGAZINE, 1111 Chester Ave., Cleveland OH 44114. (216)696-7000. Editor: Stephen Michaelides. Monthly. Circ. 101,000. Emphasizes "restaurant management, hotel foodservice, cooking, interior design." Readers are "restaurant owners, chefs, foodservice chain ex-

ecutives." Photo guidelines free with SASE.

Photo Needs: Uses about 30 photos/issue; half supplied by freelance photographers. Needs "people, restaurant and foodservice interiors, and occasional food photos." Photos purchased with accompanying ms only. "We need photos for a new department: Kitchens at Work. They should be just what the de-

partment's name implies." Model release and captions required.

Making Contact & Terms: Query with list of stock photo credits and samples of work—"published helps." Provide resume, business card, brochure, flyer or tearsheets to be kept on file for possible future assignments. Does not return unsolicited material. Reports in 1 week. Pays \$150-450/job plus normal expenses. Pays on acceptance. Credit line given. Buys exclusive rights. Previously published work OK "if exclusive to foodservice press."

Tips: "Let us know you exist; we can't assign a story if we don't know you. Send resume, business card,

samples, etc. along with query or introductory letter."

*RETAILER & MARKETING NEWS, Box 191105, Dallas TX 75219. (214)651-9959. Editor-in-Chief: Michael J. Anderson. Monthly. Circ. 10,000. Readers are retail dealers and wholesalers in appliances, TV's, furniture, consumer electronics, records, air conditioning, housewares, hardware and all related businesses. Free sample copy.

Photo Needs: Uses 30-40 photos/issue; 5 are supplied by freelance photographers. Needs photos of

products in store displays and people in retail marketing situations. Captions required.

Making Contact & Terms: Send material by mail for consideration. Uses 5x7 and 8x10 b&w and color prints. SASE. Pay is negotiable. Credit line given. Payment on publication. Buys one-time rights. Simultaneous and previously published work OK.

RN MAGAZINE, 680 Kinderkamack Rd., Oradell NJ 07649. (201)262-3030. Editor-in-Chief: James A. Reynolds. Art Director: Tim McKeen. Monthly. Circ. 275,000. Readers are registered nurses. Sample copy \$3.

Photo Needs: Uses approximately 8-12 photos/issue. Photographers are used on assignment basis. "We select the photographers by previous work." Needs photos on clinical how-to and some symbolic theme

photos. Model release and captions required.

Making Contact & Terms: Query with resume of photo credits and submit portfolio by mail for review. SASE. Reports in 2 weeks. Pay is negotiable. Credit line given. Payment on publication. Buys one-time reproduction rights; additional rights are renegotiated. Previously published work OK.

ROBOTICS TODAY, 1 SME Dr., Dearborn MI 48121. (313)271-1500. Managing Editor: Bob Stauffer, Bimonthly magazine. Emphasizes automated manufacturing and robotics. Readers are members of Robotics International and paid subscriptions. Circ. 18,000. Sample copy free with SASE and \$2 post-

Photo Needs: Uses 40-70 photos/issue; number supplied by freelance photographers "depends on need." Needs photos of "automated manufacturing, robots." Special needs include "specific cover

shots, working on ideas with editor and art director."

Making Contact & Terms: Send 5x7 b&w or color prints or 4x5 transparencies by mail for consideration. Provide resume, business card, brochure, flyer or tearsheets to be kept on file for possible future assignments. SASE. Reports in 2 weeks. Pays \$175-300/color cover photo; \$25/b&w inside photo; \$50/ color inside photo. Pays \$200 maximum/job. Payment is made monthly. Buys one-time or all rights. Simultaneous submissions and previously published work OK.

ROOF DESIGN, 7500 Old Oak Blvd., Cleveland OH 44130. (216)243-8100, ext. 451. Editor: Mike Russo. Bimonthly magazine. Emphasizes "commercial roofing." Readers are architects and specifiers. Circ. 20,000. Sample copy free with SASE.

Photo Needs: Uses about 18+ photos/issue; 0-1 supplied by freelance photographers. Needs aerial

photos. Written release required.

Making Contact & Terms: Call to discuss needs. Payment varies; minimum \$600. Payment is made on publication. Credit line given. Buys one-time rights. Previously published work OK.

THE ROOFER MAGAZINE, Box 06253, Ft. Myers FL 33906. (813)275-7663. Editor-in-Chief: Karen S. Parker. Publishes 12 issues/year. Circ. 16,000. Emphasizes roofing. Readers are roofing contractors, manufacturers and distributors. Sample copy \$2.

Photo Needs: Uses about 57 photos/issue; few are supplied by freelance photographers. Needs photos of unusual roofs for "Roofing Concepts" section and photo essays of "the roofs of . . . " (various cit-

ies or resort areas). Model release required; captions preferred.

Making Contact & Terms: Query with samples. Provide resume, brochure and tearsheets to be kept on file for possible future assignments. Does not return unsolicited material. Reports in 1 month. Pays \$25/ color inside photo; \$50-100 for text/photo package. Pays on publication. Buys all rights.

SANITARY MAINTENANCE, 2100 W. Florist, Box 694, Milwaukee WI 53201. (414)228-7701. Managing Editor: Don Mulligan. Monthly magazine. Circ. 13,000 + . Emphasizes everyday encounters of the sanitary supply distributor or contract cleaner.

Subject Needs: Photo essay/photo feature (sanitary supply operations, candid). Captions required.

Specs: Uses glossy b&w prints and color slides preferred.

Accompanying Mss: Photos purchased with accompanying ms only. Query first. Seeks actual on the job type studies. Free writer's guidelines.

Payment & Terms: Pays \$50-150 for text/photo package. Pays on publication. Buys all rights. Previ-

ously published work OK.

Making Contact: Query with samples. SASE. Reports in 1 month. Free sample copy and photo guidelines.

SCIENCE AND CHILDREN, National Science Teachers Association, 1742 Connecticut Ave., NW, Washington DC 20009. (202)328-5800. Editor: Phyllis Marcuccio. Magazine published 8 times annually. Circ. 17,000. Emphasizes science education and science activities for elementary and middle school science teachers, teacher educators, administrators and other school personnel. Needs tightly cropped photos of "children involved with things related to science. Faces must be visible." No "long shots of children gathered around some unseen object, showing their backs." Buys 1-2 annually. Buys all rights. Present model release on acceptance of photo. Send photos for consideration. Credit line given. Pays on acceptance. Reports in 1 month. SASE. Free sample copy.

B&W: Send 8x10 glossy prints. Pays \$20-50.

Color: Send 35mm transparencies. Pays \$100 maximum.

Cover: Send 8x10 glossy b&w prints or 35mm color transparencies. Prefers shots of children. Pays \$100 maximum.

THE SCIENCE TEACHER, National Science Teachers Association, 1742 Connecticut Ave., NW, Washington DC 20009. Managing Editor: Bry Pollack. Magazine published monthly from September through May. Circ. 22,000. For junior and senior high school-level science teachers and administrators. Uses photos each issue. Buys all rights, but flexible. Submit model release with photo. Send contact sheet or photos for consideration. Pays on publication. Reports in 3 months. SASE.

Subject Needs: Needs photos dealing with junior and senior high school students in science classrooms and laboratories, adolescents, natural history, the environment, computers in science/education and

teachers.

B&W: Send contact sheet or 5x7 or larger glossy prints. Captions required. Pays \$35 usually.

Color: Send transparencies. Captions required. Pays \$100 for cover.

Cover: Prefers color slides or 3x5 transparencies. "We try to tie cover photos to an inside article, but occasionally we do carry outstanding nature shots and photos of adolescents, especially face shots." Captions required. Pays \$100 minimum.

Tips: "Submit samples in portfolio. We are very interested in increasing the quality and number of photos used per issue."

*SEAWAY REVIEW, 221 Water St. Boyne City MI 49712. Contact: Publisher. Quarterly magazine. Circ. 15,600. Maritime journal for "the entire Great Lakes maritime community, executives of companies that ship via the Great Lakes, traffic managers, transportation executives, federal and state government officials and manufacturers of maritime equipment." Photos purchased with or without accompanying ms and on assignment. Buys 500 photos/year. Pays approximately \$100 for text/photo package, less on a per-photo basis. Credit line given for covers only. Pays on acceptance. Send material by mail for consideration. Provide samples to be kept on file for possible future assignments. SASE. Previously published work OK. Reports in 3 weeks. Sample copy \$5.

Subject Needs: Photos of Great Lakes shipping and ship views. "We also buy photos for files and for later usage." Special assignments around Great Lakes area. "No photos without ships, ports and car-

gos."

B&W: Uses 5x7 and 8x10 glossy prints; contact sheet OK. Pays \$10-50/photo.

Color: Uses 8x10 glossy prints and 35mm and 21/4x21/4 transparencies; contact sheet OK. Pays \$10-50/

photo.

Cover: Uses glossy color prints, 35mm and 21/4x21/4 transparencies. Horizontal format preferred. Pays \$50-150/photo.

Accompanying Ms: Seeks ms dealing with commercial transportation.

SHUTTLE SPINDLE & DYEPOT, 65 LaSalle Rd., West Hartford CT 06107. (203)233-5124. Editor: Jane Bradley Sitko. Quarterly. Circ. 16,800. Emphasizes weaving and fiber arts. Readers are predominately female weavers and craftspeople, hobbyists and professionals. Sample copy \$4.75; photo guidelines free with SASE.

Photo Needs: Uses about 30-35 color photos and 40-45 b&w photos/issue. Needs photos of weaving, textiles and fabrics. "Writers often use professional photographers to document their works." Special needs include "Fiberscene" which features works shown at galleries; must be handwoven/hand dyed. Model release and captions required.

Making Contact & Terms: Query with samples. SASE. Reports in 6 weeks. Payment varies. Pays on

publication. Credit line given. Buys first North American serial rights.

Tips: "We're looking for freelance photographers."

SIGHTLINES, 45 John St., New York NY 10038. (212)227-5599. Editor-in-Chief: Judith Trojan. Quarterly magazine. Circ. 3,000. Emphasizes the nontheatrical film and video world for librarians in university and public libraries, independent filmmakers, film teachers on the high school and college levels, film programmers in the community, university, religious organizations, film curators in museums and now incorporating *Film Library Quarterly*.

Subject Needs: Photos are used to illustrate articles on films (frame stills or those taken on a production set); filmmakers (head shots or shots of filmmakers at work); film festival or conference reports.

Accompanying Mss: Photos purchased with accompanying ms only.

Payment & Terms: "Photos are usually supplied by the author on the subject of an article. On occasion, we hire a photographer to cover our conferences. Very rarely pay for photos; the most we have paid is \$100." Payment negotiable. Uses 5x7 and 8x10 glossy b&w prints; occasionally use color photos for cover of magazine and interior.

Making Contact: Query. SASE. Reports in 1-2 months.

Tips: "We are now experimenting with a 4-color cover and one 4-color signature inside magazine. Sell cheap. We can't afford high fees."

SINSEMILLA TIPS, 217 2nd St. SW, Box 2046, Corvalis OR 97339. (503)757-2532 or 757-8477. Editor: Thomas Alexander. Quarterly. Circ. 7,000. Emphasizes "cultivation of marijuana in the United States." Readers are marijuana growers. Sample copy \$4.

Photo Needs: Uses about 8-14 photos/issue; half supplied by freelance photographers. Needs "how-to, use of technological aids in cultivation, finished product (dried buds)." Model release required.

Making Contact & Terms: Query with samples. Send b&w or color prints; 4x5 transparencies, b&w or color contact sheets or b&w or color negatives. SASE. Reports in 3 weeks to 1 month or will keep material on file on request. Pays \$25-50/b&w cover photo, \$50-75/color cover photo; \$15-35/b&w inside

photo, \$40-50/color inside photo; \$50-150 for text/photo package. Pays on publication. Credit line given if requested. Buys all rights. Simultaneous submissions and previously published work OK.

Tips: Prefers to see "any marijuana-related photo."

SKIING TRADE NEWS, 1 Park Ave., New York NY 10016. (212)725-3969. Editorial Director: Bill Grout. Tabloid published 7 times/year. Circ. 11,600. Emphasizes news, retailing and service articles for ski retailers. Photos purchased with accompanying ms or caption. Buys 2-6 photos/issue. Credit line given. Pays on publication. Buys one-time rights. Send material by mail for consideration. SASE. Reports in 1 month. Free sample copy.

Subject Needs: Celebrity/personality; photo essay/photo feature ("If it has to do with ski and skiwear retailing"); spot news; and humorous. Photos must be ski related. Model release and captions preferred.

B&W: Uses 5x7 glossy prints. Pays \$25-35/photo.

SMALL FARMER'S JOURNAL, 3890 Stewart, Box 2805, Eugene OR 97402. (503)683-6485. Editor/Publisher: Lynn Miller. Quarterly. Emphasizes "farming with horses, general small scale farming." Readers are "small farmers usually farming between 10 and 100 acres, some using horses, some not." Circ. 26,000. Sample copy \$4.

Photo Needs: Uses about 100 photos/issue; 75% supplied by freelance writers/photographers. Needs "action shots and how-to shots, b&w only. Crops, livestock, horses in use and tools and their uses as

well as farming how-to's." Model release required; captions preferred.

Making Contact & Terms: Query with samples; send up to 8x11 b&w prints by mail for consideration. SASE. Reports in 3 weeks. Pays \$50/b&w cover photo; \$10-35/b&w inside photo. Pays on publication. Buys one-time rights.

*SMALL SYSTEMS WORLD, 950 Lee St., Des Plaines IL 60016. (312)296-0770. Executive Editor: Hellena Smejda. Managing Editor: Jill Pembroke. Monthly. Circ. 46,000. Emphasizes "small business computer management." Readers are "top data processing managers of high-end microcomputers to a high-end microcomputers."

Photo Needs: Uses 1-2 photos/issue; 1 supplied by freelance photographers. Needs "interesting how-

tos, machine shots, conceptual cover shots. Model release and captions preferred.

Making Contact & Terms: Arrange a personal interview to show portfolio. Does not return unsolicited

material. Reports in 2 weeks. Pays on publication. Credit line given. Buys all rights. Tips: Looking for "good technical skills, creative shots."

SOCIAL POLICY, 33 W. 42nd St., New York NY 10036. (212)840-7619. Managing Editor: Audrey Gartner. Quarterly. Emphasizes "social policy issues—how government and societal actions affect people's lives." Readers are academics, policymakers, lay readers. Circ. 3,500. Sample copy \$2.

Photo Needs: Uses about 6 photos/issue; all supplied by freelance photographers. Needs photos of so-

cial consciousness and sensitivity. Model release preferred.

Making Contact & Terms: Arrange a personal interview to show portfolio; query with samples; provide resume, business card, brochure, flyer or tearsheets to be kept on file for possible future assignments. Send 8x10 b&w glossy prints; b&w contact sheets by mail for consideration. SASE. Reports in 2 weeks. Pays \$75/b&w cover photo; \$25/b&w inside photo. Pays on publication. Credit line given. Buys . one-time rights. Simultaneous and previously published submissions OK.

Tips: Prefers to see "editorial content, clarity, sensitivity. Be familiar with social issues. We're always

looking for relevant photos. Contact us."

SOLAR AGE MAGAZINE, Church Hill, Harrisville NH 03450. (603)827-3347. Editor: William D'Alessandro. Photo Editor: Ed Bonoyer. Monthly. Circ. 60,000. Emphasizes renewable energy resources. Readers are solar professionals; designers; installers; architects; inventors; educators; solar business executives; state, local and federal employees in research and development, applications, promotion and information. Photo guidelines with SASE.

Photo Needs: Uses 35 photos/issue; 4 are supplied by freelance photographers. Photographers are selected by examples of their previously published work or by representative examples of their work. Needs photos on alternative energy and renewable energy (examples: woodstoves, hydro-power systems, photovoltaic arrays, collector installations, solar greenhouse, experimental projects, research, passive solar buildings-interiors and exteriors-buildings-commerical, industrial and residentialthat have active solar systems. Model release and captions required.

Making Contact & Terms: Send material by mail for consideration. Uses all sizes of b&w and color prints, color slides and contact sheets. Also uses color cover photos. Payment negotiable. SASE. Re-

ports in 2 weeks. Credit line given. Payment on publication. Buys one-time rights.

*SOONER LPG TIMES, Suite 114-A, 2910 N. Walnut, Oklahoma City OK 73105. (405)525-9386. Bimonthly magazine. Circ. 1,450. For dealers and suppliers of LP-gas and their employees. Pays on acceptance. SASE. Reports in 4 weeks.

SOUTHERN BEVERAGE JOURNAL, Box 561107, Miami FL 33256. (305)233-7230. Editor-in-Chief: Mary McMahon. Monthly. Circ. 17,000. Emphasizes beverage and alcholic products. Readers are licensees, wholesalers and executives in the alcohol beverage industry. Free sample copy. Photo Needs: Uses about 20 photos/issue. Needs photos of "local licensees (usually with a promotion

of some kind)." Captions required. Send b&w and color prints and any size transparency by mail for consideration. SASE. Reports in 1 week. Pays \$10/b&w inside photo. Pays on acceptance. Credit line given "if they ask for it." Buys all rights. Simultaneous submissions and previously published work OK.

SOUTHERN JEWELER MAGAZINE, 75 3rd St. NW., Atlanta GA 30365. (404)881-6442. Editor: Roy Conradi. Monthly. Circ. 8,889. Emphasizes jewelry. Readers are retail jewelry store personnel. Sample copy \$1.50.

Photo Needs: Uses about 70-80 photos/issue; 10 supplied by freelance photographers. Needs photos of "retail jewelry stores (store shots, working on jewelry, close-ups of jewelry)." Photos purchased with accompanying ms only. "Need photo contacts throughout Southeast for feature assignments and cover shots." Captions required.

Making Contact & Terms: Provide resume, business card, brochure, flyer or tearsheets to be kept on file for possible future assignments. SASE. Reports in 3 weeks. Pays \$150/color cover photo; \$15/b&w inside photo; \$100 maximum/hour; \$150 maximum/job. \$100 minimum for text/photo package. Pays on publication. Credit line given. Buys one-time rights.

Tips: "Call the editor. Because of the specialized field it is always best to discuss ideas and projects with

him."

*SOUTHERN MOTOR CARGO, Box 4169, Memphis TN 38104. Monthly magazine. Circ. 51,000. For trucking management and maintenance personnel of private, contract, and for-hire carriers in 16 southern states and Washington DC. Special issues include "ATA Convention," October; "Transportation Graduate Directory," January; "Mid-America Truck Show," February. Specs: Uses b&w prints.

Accompanying Mss: Photos purchased with or without accompanying ms.

Payment & Terms: Pays \$5-10/b&w print. Pays on publication.

Making Contact: Send query to Mike Pennington, SASE, Reports in 6 weeks.

SOUVENIRS & NOVELTIES MAGAZINE, Suite 226, 401 N. Broad St., Philadelphia PA 19108. Editor: Charles Tooley. Magazine, published 7 times annually. Circ. 20,000. Emphasizes new products, buying and selling, and other news of the industry. For managers and owners of resort and amusement park souvenir shops; museum and zoo souvenir shops and hotel gift shops. Buys 10-15 text/photo packages/year. Buys first serial rights or first North American serial rights. Photos purchased with accompanying ms; "the photos should illustrate an important point in the article or give an indication of how the shop looks." Credit line given. Pays on publication. Reports in 2 weeks. SASE. Simultaneous submissions and previously published work OK. Free sample copy.

B&W: Uses 8x10 glossy prints. Pays \$20-40/photo.

Cover: See requirements for b&w. Captions "preferred." Pays \$10.

Tips: Especially interested in articles which describe how a specific manager sells souvenirs to tourists.

SOYBEAN DIGEST, Box 27300, 777 Craig Rd., St. Louis MO 63141. (314)432-1600, Editor; Gregg Hillyer, Monthly magazine, Circ. 195,000, Emphasizes production and marketing of soybeans high acreage soybean growers. Photos purchased with or without accompanying ms and on assignment. Buys 75 photos/year. Pays \$50-350 for text/photo package or on a per-photo basis. Credit line given. Pays on acceptance. Buys all rights, but may reassign after publication. Send material by mail for consideration: query with list of stock photo subjects, resume, card, brochure and samples. SASE. Reports in 3 weeks. Previously published work possibly OK. Sample copy \$2.

Subject Needs: Soybean production and marketing photos of modified equipment. Captions preferred.

No static, posed or outdated material.

B&W: Uses 5x7 or 8x10 prints. Pays \$75-200/photo.

Color: Uses 35mm or 21/4x21/4 transparencies. Pays \$150-300/photo.

Cover: Uses 35mm, 21/4x21/4, 4x5 and 8x10 transparencies. Vertical format preferred. Pays \$200-350/

photo.

Accompanying Mss: Grower techniques for soybean production and marketing. Pays \$100-550/ms. Prefers photos with ms.

SPECIALTY & CUSTOM DEALER, 11 S. Forge St., Akron OH 44304. (216)535-6117. Editor: Jim MacQueen. Monthly. "The magazine is edited for members of the specialty automotive aftermarket. i.e., businesses supplying parts and services for auto racing groups, van converters, street rods, off-road vehicles, etc. The audience is comprised of owners and managers of parts jobber stores selling specialty equipment." Circ. 22,000. Sample copy \$3. Photo guidelines free with SASE.

Photo Needs: Uses about 80 photos/issue. Needs automotive photos—both stores (jobber) and racing. Special needs include "specific national auto racing events." Model release and captions required. Making Contact & Terms: Query with samples; provide resume, business card, brochure, flyer or tearsheets to be kept on file for possible future assignments. SASE. Reports in 2 weeks. Pays \$25-250/ job; \$100-300 for text/photo package. Pays on publication. Credit line given "if requested." Buys onetime rights.

THE SPORTING GOODS DEALER, 1212 N. Lindbergh Blvd., St. Louis MO 63132. (314)997-7111. Editor: Steve Fechter. Monthly magazine. Circ. 27,000. Emphasizes news and merchandising ideas for sporting goods dealers. Photos purchased with or without accompanying ms or on assignment. Buys 20-50 photos/year. Credit line given occasionally. Pays on publication. Buys all rights. Send material by mail for consideration. Simultaneous submissions and previously published work OK if not published in a sporting goods publication. Sample copy \$2 (refunded with first accepted photo). Free photo guidelines.

Subject Needs: Spot news relating to the merchandising of sporting goods. Captions required.

B&W: Uses 5x7 glossy prints. Pays \$3-6/photo.

Color: Uses transparencies, standard sizes.

Accompanying Mss: Seeks mss on the merchandising of sporting goods through trade channels. Pays 2¢/word. Free writer's guidelines.

STONE IN AMERICA, 6902 N. High St., Worthington OH 43085. (614)885-2713. Managing Editor: Bob Moon. Monthly magazine. Circ. 2,600. Journal of the American Monument Association. Reports on the design, manufacture, sales and marketing of memorial stone products in America. Photos purchased with or without accompanying ms. Buys 150 photos/year. Pays on publication. Buys one-time rights. Send material by mail for consideration. SASE. Simultaneous submissions and previously published work OK. Reports in 1 month. Free sample copy and photo guidelines.

Subject Needs: Documentary; fine art (sculpture); photo essay/photo feature (activities surrounding the manufacture, quarrying, setting, sculpture or design of memorial stone products); scenic; how-to; and human interest (industry people with unique backgrounds, skills, etc.). Captions preferred.

B&W: Uses 8x10 or 5x7 glossy prints. Pays \$20 minimum/photo.

Cover: Uses b&w glossy prints and 8x10 transparencies. Vertical format preferred. Negotiates payment

Accompanying Mss: Activities connected with the manufacture, quarrying, setting, sculpture or design of stone memorial products. Pays \$25 minimum/ms. Free writer's guidelines.

STORES, 100 W. 31st St., New York NY 10001. (212)244-8780. Editor: Joan Bergmann. Monthly magazine. Circ. 27,000. Emphasizes retail management and merchandising trends, in apparel and general merchandise. For upper-level management in the retailing business. Photos purchased on assignment. Buys 10-15 photos/issue. Credit line given. Buys all rights. Query with resume. Free sample copy.

Subject Needs: Captions required. Retail store interior and window displays on assigned subjects only.

B&W: Uses 5x7 glossy prints. Pays \$5-10/photo.

STUDIO PHOTOGRAPHY, PTN Publishing Corp., 101 Crossways Park W., Woodbury NY 11797. (516)496-8000. Editor: Mark Zacharia. Monthly magazine. Circ. 65,000. Emphasizes the problems and solutions of the professional photographer. Photos purchased with accompanying ms only. Buys 70 photos/year. Pays \$150-300 for text/photo package. Credit line always given. Pays on publication. Buys one-time rights. Query with SASE first. Reports in 3 weeks. Free sample copy and photo guidelines. Subject Needs: Nude; human interest (children, men, women); still life; portraits; travel, nature, scenics and sports. Model release and captions required.

B&W: Uses 8x10 prints. Pays \$50 minimum/photo.

How sales can snowball is illustrated by Houston. Texas, freelance photographer Craig Hartley, who took this shot of the Space Shuttle Discovery's lift-off for the Houston Post. After this assignment, he wrote a how-to article on the difficulties of shooting the lift-off for Studio Photography. Studio Photography paid him \$300 for the text/ photo package. With his permission they resold the article and art to Functional Photography, a sister publication, for \$150. "Probably the best advice I can offer other photographers is to keep their eyes open for photo-story ideas on their day-to-day jobs. Combining the photographic and writing professions opens many marketplaces that otherwise might be closed."

Color: Uses 8x10 prints; 35mm, medium and large format transparencies.

Cover: Uses b&w and color prints and transparencies. Vertical format required.

Accompanying Mss: Business articles; anything related to photo studio owners. Interested in articles that will enhance the sales or techniques of wedding, portrait, school, commercial and freelance photog-

raphers. Pays \$50 minimum/ms. Free writer's guidelines.

Tips: "Will only accept highest quality copy and photos. All mss typed, proofread and double-spaced before acceptance. Become familiar with the content of our magazine. If you don't write, pair up with someone who can. Transparencies and images should be top-notch—show us something that will really woo us. Explain a newer, easier or less expensive technique for accomplishing tasks in photography.

*SUCCESSFUL FARMING, 1716 Locust St., Des Moines IA 50336. (515)284-2579. Editor: Richard Krumme. Monthly. Emphasizes farming and farm management. Circ. 620,000. Sample copy and

photo guidelines free with SASE.

Photo Needs: Uses about 64 photos/issue; 55 supplied by freelance photographers. Needs photos of farm livestock, farm machinery, buildings, crops (corn, soybeans, wheat, mostly), farming activity, farm people. "We are always looking for good cover shots with unique situations-composition-lighting,

etc., farm management oriented." Model release required.

Making Contact & Terms: Arrange a personal interview to show portfolio; query with samples and list of stock photo subjects; provide resume, business card, brochure, flyer or tearsheets to be kept on file for possible future assignments. Reports in 2 weeks. Pays \$600/color inside photo (one-time use); \$100/color or inside photo (one-time use); \$630/day, plus mileage. Pays on acceptance. Credit line given. Buys all rights on per-day assignments, one-time use on stock photos. No simultaneous submissions or previously published work.

Tips: "We need technically good (lighting, focus, composition) photos. Photographer must remember

that his/her pictures must be reproducable by color separation and printing process.

SUN/COAST ARCHITECT-BUILDER MAGAZINE, McKellar Publications, Inc., Suite 203, 410 West Arden Ave., Glendale CA 91203-1194. (818)241-0250. Monthly. Emphasizes architecture and building industry. Readers are architects, builders, developers, general contractors, specification writers, designers and remodelers in the Pacific, Mountain and Sunbelt states. Circ. 42,000 +.

Photo Needs: Number of photos used per issue varies. "Call to discuss needs before submittal. Editorial material is selected on the basis of the merits of the individual project; graphics to supplement the copy."

Photos must be accompanied by ms. Model release and captions required.

Making Contact & Terms: "Call first to discuss story ideas." SASE. Reporting time varies. "No payments are made." Credit line given. Simultaneous and previously published submissions considered "depending on the story."

*SWIMMING POOL AGE & SPA MERCHANDISER, Communications Channels, Inc., 6255 Barfield Rd., Atlanta GA 30328. Editor: Terri Simmons. Monthly tabloid. Circ, 15,000. Trade publication for the pool, spa and hot tub industry. Buys all rights for industry. Phone queries OK. Needs photos of anything of interest to pool builders, government officials, dealers, educators, distributors—unusual photos of pools, spas, hot tubs or displays and installations of the same. Buys 25 photos/year. Query or send photos or contact sheet for consideration. Pays on publication. Reports in 30 days. SASE.

B&W: Send contact sheet or 5x7 or 8x10 prints. Captions required. Pays \$10.

Color: "Use two or three pool, spa or related four-color separations in each issue. Should be already separated. Will accept separations which have already been used in other nonindustry publications." Pays \$50-100.

Cover: Same as color requirements. Captions required. Pays from \$50-100, but depends on use. Photos

should be vertical.

Tips: Any photos pertaining to the industry which show pools/spas/hot tubs as healthy and enjoyable. Technical pix for 'how-to' articles. Sometimes do photo spreads on various industry groups and issues around the country. 'Interested photographers should advise Terri Simmons on their availability in each area. If you have a client for whom you've shot pix pertaining to pools, spas and hot tubs and they've made separations, call the editor. If not, study your format, query by phone or letter. It is best if you already know the business and can write accurate descriptions in technical terms."

TECHNOLOGY REVIEW, Massachusetts Institute of Technology, Bldg. 10, Room 140, 77 Massachusetts Ave., Cambridge MA 02139. (617)253-8255. Design Director: Nancy Cahners. Published 8 times/year. Circ. 75,000. Emphasizes science and technology for a sophisticated audience. Sample

Photo Needs: Stock photographs. Uses about 20 photos/issue; all supplied by freelance photographers.

Needs technology photos. Model release required; captions preferred.

Making Contact & Terms: Arrange a personal interview to show portfolio; samples or list of stock

468 Photographer's Market '86

photo subjects. Submit portfolio for review; provide resume, business card, brochure, flyer or tearsheets to be kept on file for possible future assignments. SASE. Reports in 1 week. Pays "below ASMP rates." Pays on acceptance. Credit line given. Buys one-time rights. Previously published work OK.

Tips: Prefers to see "excellence; ways of making mundane elegant; intellectual content."

TELECOMMUNICATIONS, 610 Washington St., Dedham MA 02026. (617)326-8220. Executive Editor: Charles White. Monthly. Emphasizes "state-of-the-art voice and data communications equipment and services." Readers are "persons involved in communications management/engineering." Circ. 70,000. Sample copy with SASE and 40¢ postage.

Photo Needs: Uses about 6 photos/issue; varying number supplied by freelance photographers. Needs "applications-oriented photos of communications systems/equipment." Model release and captions re-

quired

Making Contact & Terms: Query with list of stock photo subjects; send b&w and color prints; 35mm transparencies by mail for consideration; provide resume, business card, brochure, flyer or tearsheets to be kept on file for possible future assignments. SASE. Reports in 1 week. Pays \$250/color cover photo; \$25/b&w and \$50/color inside photo. Pays on publication. Credit line given. Buys all rights.

THOROUGHBRED RECORD, Box 4240, Lexington KY 40544. (696)276-5311. Editor: Timothy T. Capps. Managing Editor: David L. Heckerman. Weekly. Circ. 14,000. Emphasizes Thoroughbred racing and breeding. Readers are Thoroughbred owners and breeders. Sample copy \$2.

Photo Needs: Uses about 30 photos/issue; 5% supplied by freelance photographers. Needs photos of "Thoroughbreds racing or on breeding farms and scenic shots. We do several regional issues and need

corresponding cover shots." Captions required.

Making Contact & Terms: Query with samples. SASE. Reports in 1 month. Pays \$150/color cover photo; \$25/b&w inside photo, \$50/color inside photo. Pays on publication. Credit line given. Buys one-time rights. Simultaneous submissions OK, but must be informed of fact.

Tips: Looking for "ability to capture the timeliness of a sporting event; good, strong sense of aesthetics for scenic shots."

TOURIST ATTRACTIONS AND PARKS, Suite 226, 401 N. Broad St., Philadelphia PA 19108. Editor: Charles Tooley. Bimonthly. Circ. 22,000. Emphasizes theme parks, carnivals, concert arenas, amusement parks, zoos and tourist attractions for managers and owners. Needs photos of new developments in amusement parks, such as new systems of promotion, handling crowds or drawing visitors. Buys 5-10 photos/year. Buys first North American serial rights. Send photos for consideration. Credit line given. Pays on publication. Reports in 2 weeks. SASE. Simultaneous submissions and previously published work OK. Free sample copy.

B&W: Send 8x10 glossy prints. Captions required. Pays \$10-15.

Color: Send transparencies. Captions required. Pays \$50. **Cover:** See requirements for b&w and color. Pays \$20-40.

Tips: Wants no nature shots; only professional quality photos of theme parks, attractions or amusement parks.

TOW-AGE, Box M, Franklin MA 02038. Contact: J. Kruza. Magazine published every 6 weeks. Circ. 10,000. For owner/operators of towing service businesses.

Subject Needs: Recovery of trucks, trains, boats, etc. Prefers "how-to" approach in a series of photos. Technical articles on custom built tow trucks and rigs are more desired and receive better payment. **Specs:** Uses b&w prints.

Accompanying Mss: Photos purchased with or without accompanying ms.

Payment & Terms: Pays \$25/first b&w print, \$5 each additional. Pays on acceptance. Making Contact: Query or send material. SASE. Reports in 3 weeks to 1 month.

TOWING & RECOVERY TRADE NEWS, Box M, Franklin MA 02038. Editor: Jay Kruza. Bimonthly magazine. Circ. 15,000 tow truck operators. Needs photos of unusual accidents with tow trucks retrieving and recovering cars and trucks. Avoid gory or gruesome shots depicting burned bodies, numerous casualties, etc. Buys 50 photos/year, 8/issue showing how-to procedure. Buys all or reprint rights. Model release might be required "depending on news value and content." Send photos for consideration. Pays on acceptance. Reports in 5 weeks. SASE. Simultaneous submissions OK. Sample

copy \$2; free photo guidelines. **B&W:** Send glossy or matte contact sheet or 3x5 or 5x7 prints. Captions required. Pays \$25 for first pho-

to, \$5 for each additional photo in the series.

Cover: Send b&w contact sheet or glossy 8x10 b&w prints. Uses vertical format. Allow space at top of photo for insertion of logo. Captions required. Pays \$75 minimum.

Tips: "Most shots are 'grab' shots—a truck hanging off a bridge, recovery of a ferryboat in water, but the photographer should get sequence of recovery photos. Some interviews of owners of a fleet of tow trucks are sought as well as the 'celebrity' whose car became disabled."

*TRADESWOMAN MAGAZINE, Box 40664, San Francisco CA 94140. (415)826-4732. Editors: Sandra Marilyn, Joss Eldredge. Quarterly. Emphasizes women in nontraditional blue collar trades work (carpenters, electricians, etc.). Readers are highly skilled specialized women in crafts jobs with trade unions, and self-employed women such as contractors. Women doing work which is currently considered nontraditional. Circ. 1,500. Sample copy \$1.

Photo Needs: Uses about 10-15 photos/issue; one-third supplied by freelance photographers. Needs "photos of women doing nontraditional work—either job site photos or inshop photos. Occasionally we just use photos of tools." Special needs include cover quality photos—black and white only.

Making Contact & Terms: Send unsolicited photos by mail for consideration. Send high contrast b&w prints; b&w contact sheet. SASE. Reports in 1 month. Payment individually negotiated. Pays on acceptance. Credit line given. Rights negotiable. Simultaneous submissions and previously published work

Tips: "We are looking for pictures of strong women whom we consider pioneers in their fields. Since we are a nonprofit and do not have a lot of money, we often offer write-ups about authors and photographers in addition to small payments."

*TRAINING MAGAZINE, 50 S. 9th St., Minneapolis MN 55402. (612)333-0471. Editor: Jack Gordon. Managing Editor: Chris Lee. Monthly. Emphasizes training of employees by employers. Readers include trainers, managers and other educators of adults. Circ. 50,000. Free sample copy with SASE. Photo Needs: Uses 5 photos/issue; cover supplied by freelance photographers. Needs people at work, e.g., working on a computer terminal, factory, etc., people in or at training or classroom setting. Reviews photos with or without accompanying ms. Captions preferred.

Making Contact & Terms: Query with list of stock photo subjects; provide resume, business card, brochure, flyer or tearsheets to be kept on file for possible future assignments. SASE. Reports in 1 month. Pays on acceptance. Credit line given. Buys one-time rights. Simultaneous submissions OK.

TRAINING: THE MAGAZINE OF HUMAN RESOURCES DEVELOPMENT, 50 S. 9th St.. Minneapolis MN 55402. Contact: Managing Editor. Monthly. Circ. 46,000. Emphasizes training in business and industry, both theory and practice. Readers are training practitioners and directors, personnel directors, sales and marketing managers, government officials, university professors and executives. Sample copy \$3.

Photo Needs: Uses about 10-15 photos/issue; few supplied by freelance photographers. "We accept very few freelance submissions. Most work on assignment only with known professionals. We do keep a contact file for future reference. We use b&w photos or color transparencies only." Photos usually purchased with accompanying ms; "editorial guidelines available with SASE." Model release preferred;

captions required.

Making Contact & Terms: Query with samples or with list of stock photo subjects. SASE, Reports in 1 month. Provide business card, brochure and flyer to be kept on file for possible future assignments. Payment negotiated. Pays on acceptance. Credit line given. Buys all rights. Previously published work OK.

*TREE TRIMMERS LOG, Box 833, Ojai CA 93023. (805)646-3941. Editor: D. Keith. Newsletter published 10 times/year. Emphasizes tree trimming—horticulture. Readers include working tree trimmers, either one-man companies or very small. Tree trimming entrepreneurs. Circ. 400. Sample copy \$1.

Photo Needs: Uses 2 photos/issue; "could be all" supplied by freelance photographers. Needs unusual trees, trees with stories or history, claim to highest, widest, etc., tree trimmers with a slant or idea for work equipment in use (chain saws, etc.). Reviews photos with or without accompanying ms, but with

some caption and facts. Captions required "at least what, who, why, where and when."

Making Contact & Terms: Send unsolicited photos by mail for consideration. Uses any PMT b&w print, b&w contact sheet, b&w negative. SASE. Reports in 2 weeks. Pays \$5/b&w inside photo, \$20-25/text/photo package (250-word story). Pays on acceptance. Credit line given. Buys one-time rights. Simultaneous submissions and previously published work OK.

Tips: Prefers "action photos of trimmers (in the tree, getting ready to ascend). Will also need Arbor Day

photos."

U.S. NAVAL INSTITUTE PROCEEDINGS, U.S. Naval Institute, Annapolis MD 21402. (301)268-6110. Editor-in-Chief: Clayton R. Barrow, Jr. Monthly magazine. Circ. 90,000. Emphasizes matters of current interest in naval, maritime, and military affairs-including strategy, tactics, personnel, shipbuilding and equipment. For officers in the Navy, Marine Corps and Coast Guard; also for enlisted per-

sonnel of the sea services, members of other military services in this country and abroad, and civilians with an interest in naval and maritime affairs. Buys 15 photos/issue. Needs photos of Navy and merchant ships of all nations; military aircraft; personnel of the Navy, Marine Corps and Coast Guard; and maritime environment and situations. No poor quality photos. Buys one-time rights. Query first with resume of credits. Pays \$100/color cover photo. Pays on publication. Reports in 2 weeks on pictorial feature queries; 3 months on other materials. SASE. Free sample copy

B&W: Uses 8x10 glossy prints. Captions required. Pays \$25; pays \$10 for official military photos submitted with articles. Pays \$250-500 for naval/maritime pictorial features. "These features consist of copy, photos and photo captions. The package should be complete, and there should be a query first. In the case of the \$25 shots, we like to maintain files on hand so they can be used with articles as the occa-

sion requires."

VETERINARY ECONOMICS, 690 S. 4th St., Edwardsville KS 66111. (913)422-5010. (800)255-6864. Art Director: Matt Wilhm. Monthly magazine. Emphasizes "animals-domestic mostly; some wildlife. Our magazine is a practice management and finance magazine for veterinarians." Circ. 38,000. Sample copy for SASE and 97¢ postage.

Photo Needs: Uses 1-5 photos/issue, some supplied by freelance photographers. "Mostly domestic animals—cats, dogs, horses, cattle, pigs, etc., in some kind of natural setting; cover photos specifically to cover feature slant (i.e., fees, salaries, investments)." Model release preferred. Some assignments as-

signed for editorial photography.

Making Contact & Terms: Query with list of stock photo subjects: provide flyer or tearsheets to be kept on file for possible future assignments. SASE. Reports in 2 weeks. Pays \$400/color cover; negotiates rate for inside photos; maximum \$400/color page. Pays on acceptance. Credit line given. Buys all rights. Simultaneous and photocopied submissions OK.

VIDEO SYSTEMS, Box 12901, Overland Park KS 66212. (913)888-4664. Publisher: Cameron Bishop. Monthly magazine. Circ. 31,000. Emphasizes techniques for qualified persons engaged in various applications of professional video production who have operating responsibilities and purchasing authority for equipment and software in the video systems field. Needs photos of professional video people using professional video equipment. No posed shots, no setups (i.e., not real pictures). Buys 15-20 photos/year. Buys all rights, but may reassign to photographer after publication. Submit model release with photo. Query with resume of credits. Pays on acceptance. Reports in 1 month. SASE. Previously published work OK. Free sample copy and photo guidelines.

B&W: Uses 8x10 glossy prints. Captions required. Pays \$10-25. Color: Uses 35mm, 21/4x21/4 or 8x10 transparencies. Captions required. Pays \$25-50.

Cover: Uses 35mm, 21/4x21/4 or 8x10 color transparencies. Vertical format. Allow space at top of photo for insertion of logo. Captions required. Pays \$100.

*VIDEOGRAPHY, 475 Park Ave. S., New York NY 10016. (212)725-2300. Editor: Marjorie Costello. Monthly magazine. Circ. 22,000. Emphasizes technology, events and products in the video industry. For video professionals, TV producers, cable TV operators, "AV types," educators and video buffs. Needs photos of TV productions, movie and TV show stills, geographical and mood shots, and photos of people using video equipment. Uses 50 photos/year. Present model release on acceptance of photo. Query with resume of credits. Credit line given. Pays on publication. Reports in 3 weeks. SASE. Sample

B&W: Send any size glossy prints. Captions required. Pays \$5-10.

Color: Send transparencies. Captions required. Pays \$5-10.

Cover: Send any size glossy b&w prints or 21/4x21/4 color transparencies. Captions required. Pays \$10-50.

WALLACES FARMER, Suite 501, 1501 42nd St., West Des Moines IA 50265. (515)224-6000. Managing Editor: Frank Holdmeyer. Circ. 100,000. Emphasizes new ideas in agriculture for Iowans. Photos purchased with or without accompanying ms. Pays on acceptance. Buys one-time rights and all rights. Query with resume of credits and samples. SASE. Simultaneous submissions OK. Reports in 1 month. Subject Needs: Farm-oriented animal/wildlife and scenic. Iowa location only. "We want modern, progressive-appearing photos of agriculture. Try to get people working in photos." Nothing cute or rustic. Captions required.

Cover: Uses 21/4x21/4 or larger color transparencies; vertical format required. Tips: "Shoot Iowa farm scenes with farmer identifable and doing something."

WALLCOVERINGS MAGAZINE, Suite 101, 15 Bank St., Stamford CT 06901. (203)357-0028. Managing Editor/Publisher: Martin A. Johnson. Managing Editor: Peter J. Hisey. Monthly magazine. Circ. 16,000. Monthly trade journal of the flexible wallcoverings and window treatment industries. For

manufacturers, wholesalers and retailers in the wallcovering, wallpaper and window treatment trade. Buys all rights. Submit model release with photo. Send contact sheet or photos for consideration. Pays on publication. SASE. Sample copy \$2.

B&W: Send contact sheet, negatives, or 5x7 or 8x10 glossy prints. Captions required. Payment negotiated on individual basis.

WARD'S AUTO WORLD, 28 W. Adams St., Detroit MI 48226. (313)962-4433. Editor: David C. Smith. Monthly. Circ. 68,000. Emphasizes the automotive industry. Sample copy free with SASE. Photo Needs: Uses about 40 photos/issue; 10-30% supplied by freelance photographers. Subject needs vary. "Most photos are assigned. We are a news magazine—the news dictates what we need." Model release preferred; captions required.

Making Contact & Terms: Arrange a personal interview to show portfolio or query with samples; provide resume, business card, brochure, flyer or tearsheets to be kept on file for possible future assignments. SASE. Reports in 2 weeks. Pays \$150-500/job. Pays on publication. Credit line given. Buys all

rights.

WATER WELL JOURNAL, 500 W. Wilson Bridge Rd., Worthington OH 43085. (614)846-4967. Assistant Editor: Gloria Swanson. Monthly. Circ. 28,000. Deals with construction of water wells and development of ground water resources. Readers are water well drilling contractors, managers, suppliers and scientists. Free sample copy.

Photo Needs: Uses 1-3 freelance photos/issue plus cover photos. Needs photos of installations and how-

to illustrations. Captions required.

Making Contact & Terms: Contact with resume; inquire about rates. "We'll contact."

WEEDS TREES & TURF, 7500 Old Oak Blvd., Cleveland OH 44130. Editor: Bruce Shank. Monthly magazine. Circ. 45,000. Emphasizes professional landscape design, construction and maintenance. "We feature research, innovative and proven management techniques, and material and machinery used in the process." For "turf managers, parks; lawn care businessmen, superintendents of golf courses, airports, schools; landscape architects, landscape contractors and sod farmers." Photos purchased with or without accompanying ms and on assignment. Pays on publication. "Query as to applicability." SASE. Reports in 1 month.

Subject Needs: Turf or tree care in progress.

B&W: Uses 5x7 glossy prints. Pays \$25 minimum/photo.

Color: Uses 8x10 glossy prints and transparencies; contact sheet and negatives OK. Pays \$75-125/pho-

to.

Cover: Uses color 35mm and 21/4x21/4 transparencies. Square format preferred. Pays \$75-125/photo.

WESTERN AND ENGLISH FASHIONS, 2403 Champa St., Denver CO 80205. (303)296-1600. Publisher/Ad. Director: Bob Harper. Editor: Lawrence Bell. Monthly. Circ. 14,000. A trade magazine serving the needs of today's sophisticated retailers of Western and English riding apparel, accessories and square dance fashion. Features editorials, business columns and display advertisements designed to keep retailers abreast of the latest in business and fashion developments. Free sample copy and photo guidelines.

Photo Needs: Uses 30 photos/issue; 5-10 are supplied by freelance photographers. "Most of our photos accompany mss; we do use photo essays about once every 2-3 months. Photographers should query with idea. Photo essays should show Western products or events (rodeo etc.)." Model release preferred; cap-

tions required.

Making Contact & Terms: Query with photo essay idea. "We will respond quickly; if interested we will ask to see sample of photographer's work." SASE. Reports in 2 weeks. Pays \$10-25/inside b&w photo; \$25-50/color cover; \$150 maximum for text/photo package. Pays on publication. Credit line given. Buys one-time rights. Simultaneous and previously published work OK if they were not published by a competitive magazine.

WESTERN FOODSERVICE, Suite 711, 5455 Wilshire Blvd., Los Angeles CA 90036. (213)936-8123. Contact: Editor. Monthly magazine. Circ. 23,000. Emphasizes restaurateurs, legislation and business trends, news and issues affecting commercial and noncommercial foodservice operations in the western states for restaurant owners and operators. Works with freelance photographers on assignment only basis. Provide calling card and letter of inquiry. Buys 6-12 photos/year. Pays \$25-200/job, or on a per-photo basis. Credit line given. Pays on acceptance. Buys all rights, but may reassign after publication. Sample copy \$2.

Subject Needs: Celebrity/personality (restaurant chain executives, independent operators, foodservice operators in unusual situations, i.e., showing off prize car); documentary; head shot (restaurant owners, foodservice school directors, caterers, etc.); spot news; human interest; humorous; and still life (novel

472 Photographer's Market '86

or innovative food service operations. Prefer owner or manager in scene, so the photo makes a statement about the person and place). No "standard stuff-ribbon cuttings, groundbreaking, etc." Wants the unusual or provocative angle. Western-based people and facilities only, including Alaska and Hawaii. **B&W:** Uses 8x10 glossy prints. Pays \$20-50/photo.

Cover: Uses color transparencies. By assignment only.

Accompanying Mss: On assignment. Query. Pays \$50-200/ms.

*WESTERN OUTFITTER, 5314 Bingle Rd., Houston TX 77092. (713)688-8811. Editor/Manager: Anne DeRuyter. Monthly magazine. "Written for retailers of Western and English apparel, Western and English tack and horse supplies." Circ. 17,000. Sample copy free with SASE. **Photo Needs:** Uses about 10-20 photos/issue; 0-10 supplied by freelance photographers. Needs "as-

signed photos illustrating merchandising techniques or showing a retailer and his store when we have an

article on hand. All types of horse photos have potential use.'

Making Contact & Terms: Query with samples. SASE. Reports in 1 month. Pays \$25/b&w inside photo, \$50/color inside photo; more for assigned photos. Pays on publication. Credit line given. Buys one-time rights.

WILSON LIBRARY BULLETIN, 950 University Ave., Bronx NY 10542. (212)588-8400. Editor: Milo Nelson. Monthly magazine. Circ. 28,000. Emphasizes the issues and the practice of librarianship. For professional librarians. Needs photos of library interiors, people reading in all kinds of librariesschool, public, university, community college, etc. No posed shots, dull scenics or dated work. Buys 10-15 photos/year. Buys first serial rights. Send photos for consideration. Provide business card and brochure to be kept on file for possible future assignments. Credit line given. Pays on acceptance or publication. Reports in 1 month. SASE.

B&W: Send 5x7 or 8x10 glossy prints. Pays \$35-50/photo, inside.

Cover: Pays \$300/color cover.

Accompanying mss: Pays \$300 for text/photo package.

WINES & VINES, 1800 Lincoln Ave., San Rafael CA 94901. Contact: Philip E. Hiaring. Monthly magazine. Circ. 5,500. Emphasizes winemaking in the U.S. for everyone concerned with the wine industry, including winemakers, wine merchants, suppliers, consumers, etc. Wants color cover subjects on a regular basis.

Payment & Terms: Pays \$10/b&w print; \$50-100/color cover photo. Pays on publication.

Making Contact: Query or send material by mail for consideration. SASE. Reports in 5 weeks to 3 months. Provide business card to be kept on file for possible future assignments.

THE WISCONSIN RESTAURATEUR, 122 W. Washington Ave., Madison WI 53703. Editor: Jan LaRue. Monthly magazine except that November and December are combined. Circ. 3,600. Trade magazine for the Wisconsin Restaurant Association. Emphasizes the restaurant industry. Readers are "restaurateurs, hospitals, schools, institutions, cafeterias, food service students, chefs, etc." Photos purchased with or without accompanying ms. Buys 12 photos/year. Pays \$15-50 for text/photo package, or on a per-photo basis. Credit line given. Pays on acceptance. Buys one-time rights. Send material by mail for consideration. SASE. Simultaneous submissions and previously published work OK. Reports in 2 weeks. Free sample copy; photo guidelines free with SASE. Provide xerox copies of previously submitted work.

Subject Needs: Animal; celebrity/personality; photo essay/photo feature; product shot; scenic; special effects/experimental; how-to; human interest; humorous; nature; still life; and wildlife. Wants on a regular basis unusual shots of normal restaurant activities or unusual themes. Photos should relate directly to food service industry or be conceived as potential cover shots. No restaurants outside Wisconsin; national trends OK. No nonmember material. Ask for membership list for specific restaurants. Model release required; captions preferred.

B&W: Uses 5x7 glossy prints. Pays \$7.50-15/photo.

Cover: Uses b&w glossy prints. Vertical format required. Pays \$10-25/photo.

Accompanying Mss: As related to the food service industry—how-to; unusual concepts; humorous and "a better way." No cynical or off-color material. Pays \$15-50 for text/photo package. Writer's guidelines free with SASE.

WOOD AND WOOD PRODUCTS, Box 400, Praire View IL 60069. (312)634-2600. Assistant Publisher/Editor: Harry Urban. Monthly magazine. Circ. 40,302. Emphasizes business management and new developments in the furniture, cabinet and woodworking industry. Readers are furniture and cabinet executives. Will send sample copy and writer's guidelines.

Photo Needs: Uses 30 photos/issue; 1-2 supplied by freelance photographers. "We like to develop freelancers we know we can rely on in all areas of the country, so when a story opens up in that photographer's area, we know we can count on him."

Making Contact & Terms: Query with resume of photo credits and list of stock photo subjects. "We need to know your idea, what the photo will show. We seldom buy photos without stories unless the whole story is in the photo." SASE. Reports in 2 weeks if wanted; otherwise possibly longer. Pays \$300 maximum/color photo; payment variable/b&w photo. Credit line given if desired. Payment on publication. Simultaneous and previously published work OK if not to direct competitors.

Tips: "We are particularly interested in photos in the major manufacturing areas of North and South Carolina and California. Knowledge of recent trends in furniture and cabinetry is helpful. Must be adept at in-plant shots. Need to develop relationships with freelance photographers for our cover shots."

WOODENBOAT, Naskeag Rd., Box 78, Brooklin ME 04616. Editor: Jonathan Wilson. Executive Editor: Peter H. Spectre. Managing Editor: Jennifer Buckley. Bimonthly magazine. Circ. 90,000. Emphasizes the building, repair and maintenance of wooden boats. Buys 50-75 photos/issue. Credit line given. Pays on publication. Buys first North American serial rights. Send contact sheet by mail for consideration. Queries with samples, suggestions and indication of photographer's interests relating to wooden boats are imperative. SASE. Previously published work OK. Reports in 6 weeks. Sample copy \$3. Photo guidelines free with SASE.

Subject Needs: How-to and photo essay/photo feature (examples: boat under construction from start to finish or a how-to project related to wooden boat building). No "people shots, mood shots which provide little detail of a boat's construction features, scenic or flashy shots." Provide resume, brochure and tearsheets to be kept on file for possible future assignments. Model release preferred; captions required. "We *strongly* suggest freelancers thoroughly study sample copies of the magazine to become aware of

our highly specialized needs.'

B&W: Uses 8x10 glossy prints; contact sheet OK. Pays \$15-75 minimum/photo.

Color: Uses 35mm transparencies. Pays \$25-125 minimum/photo.

Cover: Uses color transparencies. Square format required. Pays \$250/color photo.

Accompanying Mss: Seeks how-to, technical explanations of wooden boat construction, use, design, repair, restoration or maintenance. Boats under sail needed also. Pays \$6/column inch. Negotiates pay for text/photo package. Writer's guidelines free with SASE.

WOOD 'N' ENERGY, Box 2008, Village West, Laconia NH 03247. (603)528-4285. Editor: Steve Ingersoll. Monthly magazine. Emphasizes "wood heat and energy topics in general for manufacturers, retailers and distributors of wood stoves, fireplaces and other energy centers." Circ. 32,000. Sample copy \$3.

Photo Needs: Uses about 30 photos/issue; 60% supplied by freelance photographers. Needs "shots of energy stores, retail displays, wood heat installations. Assignments available for interviews, conferences and out-of-state stories." Model release required; captions preferred.

Making Contact & Terms: Query with samples or list of stock photo subjects; send b&w or color glossy prints, 21/4x21/4 transparencies; b&w contact sheets by mail for consideration. SASE. Reports in 2 weeks. Payment varies. Pays on acceptance. Credit line given. Buys various rights. Simultaneous and photocopied submissions OK.

Tips: "Call and ask what we need. We're always on the lookout for material."

THE WORK BOAT, Box 2400, Covington LA 70434. (504)893-2930. Managing Editor: Rick Martin. Monthly. Circ. 13,600. Emphasizes news of the work boat industry. Readers are executives of towboat, offshore supply, crew boat and dredging companies; naval architects; leasing companies; equip-

ment companies and shipyards. Sample copy \$3; photo guidelines for SASE.

Photo Needs: Uses about 35 photos/issue; a few of which are supplied by freelance photographers. "Covers are our basic interest. Photos must exhibit excellent color and composition. Subjects include working shots of towboats (river boats), tug boats (harbor and offshore), supply boats, crew boats, dredges and ferries. Only action shots; no static dockside scenes. Pictures should crop 8x11 for full bleed cover. Freelancers are used primarily for covers. Features sometimes require freelance help. We need to develop a file of freelancers along the coasts and rivers." Model release and captions required. No pleasure boats.

Making Contact & Terms: Send by mail for consideration actual 8x10 color prints or 35mm slides. "We will ask for negatives if we buy." Or query with resume of photo credits. Provide resume, calling card, samples (returned) and photo copies of tearsheets to be kept on file for possible future assignments. SASE. Reports in 2 weeks. Pays on acceptance \$50-200/text/photo package. \$50 minimum/cover. Credit line given on cover photos only. Buys one-time rights. Previously published work OK.

WORLD CONSTRUCTION, 875 3rd Ave., New York NY 10022. (212)605-9400. Editorial Director: Ruth W. Stidger. Monthly. Circ. 33,000. Emphasizes construction methods, equipment, management. Readers are contractors, public works officials, worldwide *except* U.S. and Canada. Sample copy free with SASE.

Photo Needs: Uses 30-40 photos/issue; 75% supplied by freelance photographers. Needs "photos illustrating articles." Photos purchased with accompanying ms only. Model release required "unless in public place"; captions preferred.

Making Contact & Terms: Send photos and mss by mail for consideration, "Can work with any format; need color for cover." SASE, if requested. Reports in 2 weeks. Pays \$200 +/color cover photo; \$100-200/b&w or color page. Pays on publication. Credit line on cover photo only. Buys one-time rights. Simultaneous submissions OK "only if submitted to noncompetitors."

WORLD MINING EQUIPMENT, 875 3rd Ave., New York NY 10022. Editorial Director: Ruth W. Stidger. Monthly. Circ. 23,000. Emphasizes mine management, mining equipment and technology. Readers are "mine management worldwide." Sample copy free with SASE.

Photo Needs: Uses about 25-30 photos/issue: 75% supplied by freelance photographers. Needs photos illustrating articles. Photos purchased with accompanying ms only. Model release required "unless in

public place"; captions preferred.

Making Contact & Terms: Send unsolicited photos and mss by mail for consideration; "can work with all formats—need color for cover." SASE "if requested." Reports in 2 weeks. Pays \$200 +/color cover photo; \$100-200 + /b&w and color page. Pays on publication. Credit lines on cover photos only. Buys one-time rights. Simultaneous submissions OK "only if submitted to noncompetitors."

WRITER'S DIGEST, 9933 Alliance Rd., Cincinnati OH 45242. (513)984-0717. Editor: William Brohaugh. Monthly magazine. Circ. 200,000. Emphasizes writing and publishing. For "writers and photojournalists of all description: professionals, beginners, students, moonlighters, bestselling authors, editors, etc. We occasionally feature articles on camera techniques to help the writer or budding photojournalist." Buys 30 photos/year. Buys first North American serial rights, one-time use only. Submit model release with photo. Query with resume of credits or send contact sheet for consideration. Photos purchased 10% on assignment; 90% with accompanying ms. Provide brochure and samples (print samples, not glossy photos) to be kept on file for possible future assignments. "We never run photos without text." Credit line given. Pays on acceptance. Reports in 4 weeks. SASE. Simultaneous submissions OK if editors are advised. Previously published work OK. Sample copy \$2; guidelines free with SASE. Subject Needs: Primarily celebrity/personality ("authors in the news-or small-town writers doing things of interest"); some how-to, human interest and product shots. All must be writer-related. "We most often use photos with profiles of writers; in fact, we won't buy the profile unless we can get usable photos. The story, however, is always our primary consideration, and we won't buy the pictures unless they can be specifically related to an article we have in the works. We sometimes use humorous shots in our Writing Life column."

B&W: Uses 8x10 glossy prints; send contact sheet. "Do not send negatives." Captions required. Pays

Cover: "Freelance work is rarely used on the cover. Assignments are made through design director

Tips: "Shots should not *look* posed, even though they may be. Photos with a sense of place, as well as persona, preferred—with a mixture of tight and middle-distance shots of the subject. Study a few back issues. Avoid the stereotype writer-at-typewriter shots; go for an array of settings. Move the subject around, and give us a choice. We're also interested in articles on how a writer earned extra money with photos, or how a photographer works with writers on projects, etc.'

WRITER'S YEARBOOK, 9933 Alliance Rd., Cincinnati OH 45242. Editor: William Brohaugh. Annually. "We cover writing techniques, sales techniques, business topics and special opportunities for writers." Readers are freelance writers, working full-time or part-time, or trying to get started in writing. Sample copy \$3.95; guidelines free with SASE.

Photo Needs: Uses about 10 photos/issue; some supplied by freelance photographers. "Almost all photos we use depict writers we are discussing in our articles. They should show the writer in familiar surroundings, at work, etc." Photos purchased with accompanying ms only. Model release preferred; captions required.

Making Contact & Terms: Query with article idea. SASE. Reports in 3 weeks. Pays \$25 minimum/ b&w inside photo. Pays on acceptance. Credit line given. Buys first North American serial rights, onetime use only. Previously published work OK.

Tips: "Our needs for Writer's Yearbook are similar to those for Writer's Digest. Check that listing for ad-

ditional details."

Record Companies_

Whether your musical taste runs to Madonna or Perry Como, chances are you've admired the album cover photography adorning your favorite records—and perhaps wondered how you might break into this very glamorous and potentially

very lucrative photographic specialty.

Most of the studio and in-concert photographs of major recording stars used by record companies for album covers and promotion are taken by major photography stars—that is, by well-known photographers who have established reputations for celebrity portraiture. To break into this market, you have little choice but to go it alone at first, mastering in-concert photography, building up a file of high-quality shots, and offering your services to bands and performers in your area. Such local acts are in the same position you are—trying to work their way to the top—and usually need a good photographer to handle their publicity photos. Should an act you shoot for get that recording contract they're after, you may well be in a position to go along for the ride up.

The record companies listed here are interested only in pictures of their own artists—but most will provide you with the names and touring schedules of the acts they represent and are willing to look at any such pictures you can get. Another way to build up credits in this field is to sell your photos to music-oriented magazines (see Consumer Magazines), as well as to any entertainment tabloids in your area. A number of stock photo agencies also specialize in portraits and candids of popular musicians and may also be a good market for your work. Whatever route you take. it's likely to be a long climb to the top-but one that could turn into a long-lasting,

highly satisfying and very profitable career.

*AIRWAVE INTERNATIONAL 6381 Hollywood Blvd., 5th Floor, Hollywood CA 90028. (213)463-9500. President: Terry Brown. Handles dance, pop, and black. Photographers used for portraits, in-concert shots, studio shots and special effects for album covers, inside album shots, publicity, brochures, posters, event/convention coverage and product advertising.

Specs: Uses 8x10 glossy b&w and color prints.

Making Contact: Arrange a personal interview to show portfolio or send unsolicited photos by mail for consideration. SASE. Reports in 1 month.

Payment & Terms: Pays \$100-1,000/b&w photo, \$200-2,000/color photo, \$75/hour. Credit line given. Rights negotiable.

Tips: "We will respond to any material submitted."

APON RECORD COMPANY, INC., Box 3082, Steinway Station, Long Island NY 11103. (212)721-5599. President: Andre M. Poncic. Handles classical, folklore and international. Photographers used for portraits and studio shots for album covers and posters. Buys 50 + assignments/year. Provide brochure and samples to be kept on file for possible future assignments.

Specs: Uses b&w prints and 4x5 transparencies.

Making Contact: Send photos by mail for consideration. Does not return unsolicited material. Reports in 3 months.

Payment & Terms: Payment negotiable. Credit line given. Buys all rights.

*ART ATTACK RECORDS, INC./CARTE BLANCHE RECORDS, Box 31475, Fort Lowell Station, Tucson AZ 85751. (602)881-1212. President: William Cashman. Handles rock, pop, country, and jazz. Photographers used for portraits, in-concert shots, studio shots and special effects for album covers, inside album shots, publicity and brochures. Works with freelance photographers on assignment basis only; "gives 10-15 assignments/year."

Specs: "Depends on particular project."

Making Contact: Arrange a personal interview to show portfolio; provide resume, business card, brochure, flyer or tearsheets to be kept on file for possible future assignments. "We will contact only if interested.

Payment & Terms: Payment "negotiable." Credit line given.

Tips: Prefers to see "a definite and original style—unusual photographic techniques, special effects" in a portfolio. "Send us samples to refer to that we may keep on file."

AZRA RECORDS, Box 411, Maywood CA 90270. (213)560-4223. Contact: David Richards. Handles rock, heavy metal, novelty and seasonal. Photographers used for special effects and "anything unique and unusual" for picture records and shaped picture records. Works with photographers on assignment basis only; "all work is freelance-assigned."

Specs: Uses 8x10 b&w or color glossy prints and 35mm transparencies.

Making Contact & Terms: Query with resume of credits or send "anything unique in photo effects" by mail for consideration. SASE. Reports in 2 weeks.

Payment & Terms: Payment "depends on use of photo, either outright pay or percentages." Credit line given. Buys one-time rights.

BLUE ISLAND ENTERTAINMENT, Box 171265, San Diego CA 92117-0975. President: Bob Gilbert. Handles rock and country. Photographers used for portraits and in-concert shots for inside album shots, publicity, brochures and posters. Buys 50 photos/year.

Specs: Uses 8x10 gloss b&w prints and 35mm transparencies.

Making Contact: Query with resume of credits; provide resume, business card, brochure, flyer, tearsheets or samples to be kept on file for possible future assignments. SASE. Reports in 1 month. Payment & Terms: Pays \$25-100/b&w photo and \$30-150/color photo. Credit line given. Buys all

Tips: "We will not look at portfolio until query/resume has been established. Your resume must sell you before we talk business. Shoot as many artists as possible—use film like it was sand through the hour glass. An artist is only on stage for several hours per show—make use of that time with a lot of photos. Record companies will only pay attention to a photographer who is determined to continue to knock on doors that remain shut. Sell yourself with hard work, good photos and a lot of talking to record companies and various rock (music) publications."

BOLIVIA RECORDS CO., 1219 Kerlin Ave., Brewton AL 36426. (205)867-2228. Contact: Manager. Handles soul, country and pop. Photographers used for portraits, in-concert/studio shots and special effects for album covers, inside album shots, publicity flyers, brochures, posters and event/convention coverage. Buys 400 photos and gives 40 assignments/year. Provide business card, brochure, flyer and samples to be kept on file for possible future assignments.

Specs: Uses 8x10 b&w/color prints.

Making Contact: Query with resume of credits or send indoor or outdoor shots of objects, scenery, people and places by mail for consideration. SASE. Reports in 1-3 weeks.

Payment & Terms: Pays by the photo or by the job. Buys all rights.

BOUOUET-ORCHID ENTERPRISES, Box 18284, Shreveport LA 71138, (318)686-7362. President: Bill Bohannon. Photographers used for live action and studio shots for publicity flyers and brochures. Works with freelance photographers on assignment only basis. Provide brochure and resume to be kept on file for possible future assignments. SASE. Reports in 2 weeks.

Tips: "We are just beginning to use freelance photography in our organization. We are looking for ma-

terial for future reference and future needs."

*BOYD RECORDS, 2609 N.W. 36th St., Oklahoma City OK 73112. (405)942-0462. President: Bobby Boyd. Handles rock and country. Photographers used for portraits and album covers. Buys 12 freelance photos/year.

Specs: Uses 8x10 b&w prints.

Making Contact: Provide resume, business card, brochure, flyer or tearsheets to be kept on file for possible future assignments. Does not return unsolicited material.

Payment & Terms: Credit line given. Buys all rights.

BRENTWOOD RECORDS, INC., Box 1028, Brentwood TN 37027. (615)373-3950. President: Jim Van Hook, Handles gospel, Photographers used for in-concert shots, studio shots and special effects for album covers, inside album shots, publicity, brochures, posters and product advertising. Works with freelance photographers on assignment basis only; gives 10-20 assignments/year.

Specs: Uses color prints and 21/4x21/4 transparencies.

Making Contact: Provide resume, business card, brochure, flyer or tearsheets to be kept on file for possible future assignments. SASE. Reports in 1 month.

Payment & Terms: "Too many factors to print prices." Credit line given "most of the time." Buys all rights and one-time rights, depending on our needs."

Tips: Prefers to see "warmth, inspiration, character; kids and seasonal shots (Christmas especially)."

*BROADWAY/HOLLYWOOD PRODUCTIONS, Box 10051, Beverly Hills CA 90213-3051. (813)761-2646 or (213))596-7666. Producer: Doris Chu. Handles rock, country, pop, musicals, music videos and film. Photographers used for portraits, in-concert shots, studio shots, special effects for album covers, publicity, brochures, posters, event/convention coverage and product advertising. Works with freelance photographers on assignment basis only; gives 2-10 assignments/year.

Specs: Uses various sizes b&w and color prints, 35mm transparencies.

Making Contact: Arrange a personal interview to show portfolio; send unsolicited photos by mail for consideration; provide resume, business card, brochure, flyer or tearsheets to be kept on file for possible future assignments. SASE. Reports in 1 month.

Payment & Terms: Payment arranged individually. Credit line sometimes given. Buys all rights.

Tips: Looks for "good solid techniques, lighting, corporation."

CLAY PIGEON INTERNATIONAL RECORDS, Box 20346, Chicago IL 60620. (312)778-8760. Contact: V. Beleska or Rudy Markus. Handles rock, pop, new wave and avant-garde. Photographers used for portraits, live action and studio shots, and special effects for albums, publicity flyers, brochures, posters, event/convention coverage and product advertising. Buys 100 photos and gives 10 assignments/year. Usually works with freelance photographers on assignment only basis. Provide resume, brochure and/or samples to be kept on file for possible future assignments.

B&W: Uses b&w.

Color: Uses color prints.

Making Contact: Query with resume and credits. Prefers to see a general idea of possibilites in a portfolio. SASE. Reports in 1 month. "We try to return unsolicited material but cannot guarantee it."

Payment & Terms: Negotiates payment per job. "We try to give credit lines." Purchase rights vary. Tips: "Send something for our file so that we can keep you in mind as projects come up. Much of our shooting is in the Midwest but there are exceptions. We want innovative, yet viable work. You have a good chance with the smaller companies like ours, but please remember we have limited time and resources; thus, we can't tie them up interviewing prospective photographers or in screening applicants. Get our attention in a way that takes little time.

*CONTINENTAL RECORDS, Box 79, Joppa MD 21085. (301)679-2262. Handles country, pop, top 10. Photographers used for studio shots, album covers, and brochures. Works with freelance photographers on an assignment basis only.

Specs: Uses 8x10 glossy prints (finished products).

Making Contact: Submit portfolio for review. Does not return unsolicited material.

Payment & Terms: Buys all rights.

Tips: "Send copies of work and prices."

THE COVER STORY, 3836 Austin Ave., Waco TX 76710. (817)752-7227. Art Director: Joan Tankersley. Handles contemporary Christian, country, rock, classical period music. Photographers used for portraits, studio shots, and special effects for album covers, inside album shots, publicity, brochures and product advertising. Works with freelance photographers on assignment basis only; gives 30 assignments/year.

Specs: Uses 16x16 prints and 4x5 transparencies.

Making Contact: Arrange a personal interview to show portfolio. Does not return unsolicited material. Payment & Terms: Pays \$500-1,500/job. "Requires all transparencies from session work. Usually pays by the session, not by the photo." Credit line given. Buys all rights,

Tips: Prefers to see "interesting composition and technical excellence" in a portfolio. "Flexibility is the key. Must be capable of juggling set arrangements, odd shoot hours, etc. Very important that they are people-oriented and display confidence to the client. The possibilities are unlimited! Freelancers should study and acquaint themselves with 'music business' mentality of blending art with commercial viability. Most shoots are becoming more abstract in conception."

CURTISS UNIVERSAL RECORD MASTERS, Box 4740, Nashville TN 37216. (615)865-4740. Manager: Susan D. Neal. Photographers used for live action shots and studio shots for album covers, inside album shots, posters, publicity flyers and product advertising. Buys 5 photos/year; gives 10 assignments/year. Works with freelance photographers on assignment only basis. Provide brochure, flyer and/ or samples to be kept on file for possible future assignments. Negotiates payment. SASE. Reports in 3 weeks. Handles rock, soul, country, blues and rock-a-billy.

B&W: Uses 8x10 and 5x7. Color: Uses 8x10 and 5x7.

Making Contact: Query with resume and credits; send material by mail for consideration; or submit portfolio for review. Prefers to see "everything photographer has to offer" in a portfolio. SASE. Reports in 3 weeks.

Payment & Terms: Negotiates payment per job and per photo. Credit line given. Buys one-time rights.

DANCE-A-THON RECORDS, 1957 Kilburn Dr., Atlanta GA 30324. Mailing address: Station K, Box 13584, Atlanta GA 30324. (404)872-6000. President: Alex Janoulis. Director, Creative Services: Marie Sutton. Handles rock, country, jazz and middle-of-the-road. Photographers used for advertising and album photos. Gives 5 assignments/year. Pays \$75-\$750/job. Credit line given. Buys all rights. Submit portfolio for review. Reports in 4 weeks.

B&W: Uses 8x8 and 8x10 prints. Pays \$75-250.

Color: Uses 8x8 prints and 4x5 transparencies. Pays \$100-350.

Tips: Send portfolio showing only what you are best at doing such as portraits, live action shots, special effects etc. Only 3-4 shots maximum should be submitted. "Know your market-bizarre shots for heavy metal records, tranquil shots for gospel LP's, etc."

DAWN PRODUCTIONS LTD., 2338 Fruitville Pk., Lancaster PA 17601. President: Joey Welz. Freelance photographers supply 50% of photos. Uses photographers for in-concert and special effects for album covers. Submit photos by mail for consideration. Pays percentage of royalty on sales or LP. Rights vary; some photos purchased outright. Always gives photo credits.

DRG RECORDS INC., 157 W. 57th St., New York NY 10019. (212)582-3040. Managing Director: Rick Winter. Handles broadway cast soundtracks, jazz and middle-of-the-road records. Uses photographers for portraits and in-concert shots for album covers and inside album shots. Gives 4 assignments/ year. Pays \$150-500/job or on a per photo basis. Credit line given. Buys one-time rights. Arrange a personal interview to show portfolio. Does not return unsolicited work. Reports in 1 week.

B&W: Uses 11x14 prints. Pays \$50-150/print.

Color: Uses prints; prefers transparencies. Pays \$100-750/photo.

Tips: "Write us giving your interest in the record album printing market as it exists today and what you would do, design-wise, to change it."

E.L.J. RECORDING CO., 1344 Waldron, St. Louis MO 63130. (314)863-3605. President: Edwin L. Johnson. Produces all types of records. Photographers used for musical shots and portraits for record album photos and posters. Freelance photographers supply 20% of photos, gives 8-12 assignments/year. Works with freelance photographers on assignment only basis. Provide samples to be kept on file for possible future assignments. Submit b&w and color samples of all types—scenics, people, etc.—by mail for consideration. SASE. Reports in 3 weeks. Pay and rights purchased by arrangement with each photographer.

Tips: "Send sample and prices."

*EAGLE RECORDS, Box 1027, Hermosa Beach CA 90254. (213)375-8385. A&R Producer: Guthrie Thomas. Handles rock, blues, jazz, folk, classical. Uses photographers for in-concert shots, studio shots for album covers, inside album shots, publicity, brochures, posters. Works with freelance photographers on an assignment basis only.

Specs: Uses b&w prints; sizes vary.

Making Contact: Send unsolicited photos by mail for consideration. "Copies of your best 8x10 b&w work, not necessarily of artists—we don't always use pictures of artists on covers. Please do not phone." Does not return unsolicited material. Reports when material used.

Payment & Terms: Payment negotiated individually. Credit line given.

Tips: "We like to receive at least 5 different photos (8x10, b&w). We do not like to receive photos of just artist's playing in concert! Send us high grade copies on grade 4-6 printing papers b&w only!"

EARTH RECORDS CO., Rt. 3, Box 57, Troy AL 36081. (205)566-7932. President: Eddie Toney. Handles all types of music. Photographers used for studio shots for album covers and product advertising. Works with freelance photographers on assignment basis only. Buys 5 photos/year. Specs: Uses prints.

Making Contact: Arrange a personal interview to show portfolio or submit portfolio for review. SASE.

Reports in 2 weeks.

Payment & Terms: Pays union rates/job. Credit line given. Buys one-time rights.

EPOCH UNIVERSAL PUBLICATIONS/NORTH AMERICAN LITURGY RESOURCES, 10802 N. 23rd Ave., Phoenix AZ 85029. (602)864-1980. Executive Vice President: David Serey. Publishes contemporary liturgical, inspirational records, music books and resource publications. Photographers used for covers and special effects for albums, posters and filler photos in music books. Buys 50-150 photos/year.

Specs: Uses 5x7 b&w/color glossy prints and 35mm, 21/4x21/4 transparencies.

Making Contact: Query with resume of credits or send inspirational shots, people shots, nature scenes. Urgently needs b&w photos of liturgical celebrations with congregation, musicians, celebrants. SASE. Reports in 1 month.

Payment & Terms: Pays \$15-200 for stock pictures, depending on usage and rights. Credit line given.

Buys one-time rights or all rights.

Tips: "Write David Serey, and enclose 4-5 samples for consideration. All work submitted is reviewed carefully. We like to keep photos on file, as filler photo needs pop up frequently and unexpectedly. The photographer who has work sitting in a file ready to use gets the space and the payment."

*FUTURE STEP SIRKLE, Box 2095, Philadelphia PA 19103. (215)844-8422. President: S. Deane Henderson. Handles gospel, rock and roll, R&B, new wave. Uses photographers for standard photos and artist requests.

Specs: Uses 8x10 glossy b&w and color prints.

Making Contact: Send unsolicited photos by mail for consideration; provide resume, business card, brochure, flyer or tearsheets to be kept on file for possible future assignments. Does not return unsolicited material.

Payment & Terms: Credit line given. Buys all rights.

Tips: Prefers to see "group shots of bands. Freelancers have excellent chances to work with our company—a picture says a thousand words."

*GCS RECORDS, Suite 206, 1508 Harlem, Memphis TN 38114. (901)274-2726. Promotion Director: W.H. Blair. Handles R&B, blues, gospel, top forty. Photographers used for studio shots and special effects for inside album shots, publicity, brochures, posters, event/convention coverage and product advertising.

Specs: Gives 40 assignments/year. Buys 100 photos/year. Uses 8x10 b&w and color prints; 4x5 trans-

parencies.

Making Contact: Arrange a personal interview to show portfolio; send unsolicited photos by mail for consideration; provide resume, business card, brochure, flyer or tearsheets to be kept on file for possible future assignment. Does not return unsolicited material. Reports in 1 month.

payment & Terms: Credit line sometimes given. Buys all rights.

*GMT PRODUCTIONS/RECORDS, Box 25141, Honolulu HI 96825. (808)533-3877, ext. 5088. President: Gil M. Tanaka. Handles all types of records. Photographers used for portraits, in-concert/studio shots and special effects for album covers, inside album shots, publicity flyers, brochures, posters, event/convention coverage and product advertising. Buys 10 photos and gives 12 assignments/year. Specs: Uses 8x10 b&w/color glossy prints.

Making Contact: Send samples with specs listed above to be kept on file, query with resume of credits

or submit portfolio for review. SASE. Reports in 3 weeks.

Payment & Terms: Payment negotiable. Credit line given. Buys all rights.

*GRAMAVISION RECORDS, 260 West Broadway, New York NY 10013. (212)226-7057. General Manager: Diana Calthorpe. Handles jazz. Photographers used for portraits, in-concert shots and special effects for album covers, inside album shots, publicity, posters, and event/convention coverage. Works with freelance photographers on assignment basis only; "gives 10 assignments/year."

Making Contact: Arrange a personal interview to show portfolio. Query with resume of credits. Provide resume, business card, brochure, flyer or tearsheets to be kept on file for possible future assign-

ments. Reports in 6 weeks.

Payment & Terms: Payment negotiable.

*GRANDVILLE RECORD CORPORATION, Box 11960, Chicago IL 60640. (312)561-0027. Public Relations/Promotion Head: Ms. Danielle Render. Handles funk, R&B, soul, disco and pop. Photographers used for portraits, in-concert shots, studio shots for album covers, inside album shots, publicity, brochures, posters, event/convention coverage and product advertising. Works on assignment basis only; gives 5-10 assignments/year. Buys 12-15 photos/year.

Specs: Uses 8x10 b&w glossy prints.

Making Contact: Query with resume of credits; provide resume, business card, brochure, flyer, tearsheets or samples to be kept on file for possible future assignments. SASE. Reports in 1 month. Payment & Terms: Pays \$10-15/b&w photo; \$15-20/color photo; \$5 minimum/hour or \$75-100/job.

Credit line given "if requested." Negotiates rights.

Tips: Prefers to see "versatility—more b&w than anything else. Really want to get a sense of his or her identity if they were to say paint the same picture. Basically submit versatile work of musical group shots (all styles) and interpretive. Mail in to us; we will look at all work and possibly try them out on a freelance basis to establish working relationship. There's a good chance of getting in with smaller record companies to begin with, because there are more openings and less competition if the photographer is willing to make some kind of sacrifice."

GREENWORLD RECORDS, 20445 Gramercy Pl., Box 2896, Torrance CA 90509-2896. (213)533-8075. Handles rock (new wave, punk, heavy metal, progressive). Photographers used for in-concert shots, studio shots, and special effects for album covers, inside album shots, posters and product advertising. Buys 10 photos/year.

Specs: Uses any size or finish b&w or color prints.

Making Contact: Arrange a personal interview to show portfolio; send unsolicited photos of "anything interesting that would be appropriate for our use" by mail for consideration. SASE. Reporting time "varies—1 day to 1 month."

Payment & Terms: Payment varies. Credit line given. Rights purchased varies.

Tips: "Record company budgets are being slashed. The prices charged (for photos) must reflect this but still keep quality high."

*HAM-SEM RECORDS, 541 S. Spring St., Los Angeles CA 90013. (213)627-0557. President: William Campbell. Handles R&B and rock. Photographers used for portraits for brochures and product advertising. Buys 3-4 photos/year.

Specs: Uses 8x10 glossy b&w or color prints and 8x10 transparencies.

Making Contact: Provide resume, business card, brochure, flyer or tearsheets to be kept on file for possible future assignments. Reports in 1 month.

Payment & Terms: Payment negotiable. Credit line given if requested.

HARD HAT RECORDS & CASSETTES, 519 N. Halifax Ave., Daytona Beach FL 32018. (904)252-0381. President: Bobby Lee Cude. Handles country, pop, disco, gospel, MOR. Photographers used for portraits, in-concert shots, studio shots, special effects for album covers, publicity and posters. Works with freelance photographers on assignment basis only; gives varied assignments/year.

Specs: Uses 8x10 b&w glossy prints.

Making Contact: Provide resume, business card, brochure, flyer or tearsheets to be kept on file for possible future assignments. SASE. Does not return unsolicited material. Reports in 1 month.

Payment & Terms: Pays on a contract basis. Credit line sometimes given. Buys all rights.

Tips: "Submit credentials as well as work done for other record companies as a sample; also price, terms. Read Billboard/MUSICIAN magazines."

*HEARTLAND RECORDS, 660 Douglas Ave., Altamonte Springs FL 32714. (305)788-2460. General Manager: David Brown. Handles contemporary Christian from rock to easy listening. Uses photographers for portraits, in-concert shots, studio shots, special effects for album covers, inside album shots and publicity.

Making Contact: Send unsolicited photos by mail for consideration; provide resume, business card, brochure, flyer or tearsheets to be kept on file for possible future assignments. Wants "' 'artistic' shots,

similar to those on Windham Hill Records." SASE. Reports in 1 month.

Payment & Terms: Payment negotiated individually. Credit line given. Rights purchased depends on the project.

HOME-BREW RECORDS, Box 617, Hazelwood MO 63044. (314)739-5150. Vice President: Mary Nelson. Handles country. Photographers used for in-concert shots, studio shots and special effects for album covers, inside album shots, publicity, brochures and product advertising. Works with freelance photographers on assignment basis only; gives 2-10 assignments/year.

Specs: 8x10 color matte prints and 8x10 transparencies.

Making Contact: Provide resume, business card, brochure, flyer or tearsheets to be kept on file for possible future assignments. Does not return unsolicited materials. Reports in 1 month.

Payment & Terms: Payment negotiable. Buys all rights.

HOMESTEAD RECORDS, 4926 W. Gunnison, Chicago IL 60630. President: Tom Petreli. Handles all types of records. Photographers used for portraits, in-concert shots, studio shots and special effects for album covers, inside album shots, publicity, brochures, posters and product advertising. Buys 25-40 photos/year.

Specs: Uses 8x10 b&w and color prints and 35mm and 4x5 transparencies.

Making Contact: Send unsolicited photos by mail for consideration. SASE. Reports in 1 month. Payment & Terms: Pays \$50-100/b&w photo; \$125-2,000/color photo; \$50-100/hour or \$400-500/job. Credit line given. Buys all rights.

HULA RECORDS, INC., Box 2135, Honolulu HI 96805. (808)847-4608. President: Donald P. "Flip" McDiarmid III. Handles Hawaiian and traditional. Photographers used for portraits, in-concert shots, studio shots, special effects, and scenics for album covers, inside album shots, publicity, brochures, posters and product advertising. Works with freelance photographers on assignment basis only; gives 12 assignments/year.

Specs: Uses color prints and 35mm transparencies.

Making Contact: Arrange a personal interview to show portfolio; send scenic photos by mail for consideration; submit portfolio for review; provide resume, business card, brochure, flyer or tearsheets to be kept on file for possible future assignments. SASE. Reports in 2 weeks.

Payment & Terms: Pays \$50 minimum/color photo. Credit line given. Buys one-time or all rights.

HYBRID RECORDS, Box 333, Evanston IL 60204. (312)274-9126. Art Director: Mike Rodgers. Handles all types of records. Photographers used for portraits, in-concert shots, studio shots and special effects for album covers, inside album shots, publicity, brochures, posters, event/convention coverage, product advertising and "other forms of creative merchandising." Number of photos bought/year varies.

Specs: Uses 8x10 matte or glossy color prints or 35mm transparencies.

Making Contact: Send "something that shows your best work, by mail for consideration—anything with women, i.e., flashy disco covers, is nice," or submit portfolio for review. SASE. Reports ASAP. Payment & Terms: Payment negotiable. Credit line given. Negotiates rights purchased.

Tips: Prefers to see "energy, flash and uniqueness" in photographer's portfolio. "Give us your best shot

or don't bother."

*J & J MUSICAL ENTERPRISES, Suite 404, 150 Fifth Ave., New York NY 10011. (212)691-5630. General Manager: Jude St. George. Handles progressive. Uses photographers for in-concert shots, studio shots and special effects for inside album shots and publicity. Works with freelance photographers on an assignment basis only.

Specs: Uses 8x10 glossy b&w prints.

Making Contact: Provide resume, business card, brochure, flyer or tearsheets to be kept on file for possible future assignments. Does not return unsolicited material. Reports in 1 month.

Payment & Terms: Payment negotiated individuallly. Credit line given. Buys all rights.

JAY JAY RECORD CO./BONFIRE RECORDS, 35 NE 62nd St., Miami FL 33138. (305)758-0000. President: Walter Jay. Handles jazz, modern and polka. Photographers used for portraits for album covers, publicity, brochures and posters. Works with freelance photographers on assignment basis only. **Specs:** Uses b&w and color glossy prints.

Making Contact: Submit portfolio for review. Does not return unsolicited material. Reports in 1

month.

Payment & Terms: "Photographer must give price." Credit line given.

JEWEL RECORD CORP., Box 1125, Shreveport LA 71163. Album Coordinator: Ms. Donna Lewis. Photographers used for live action shots, studio shots and special effects for album covers and publicity flyers. Freelance photographers supply 1% of photos at present. Uses styles ranging from serene for gospel to graphic for jazz; also produces soul albums and country. "Photographer will be given full credit on album cover." Submit photos by mail for consideration or submit portfolio for review. Prefers to see proofs or prints in a portfolio. Provide resume and samples to be kept on file for possible future assignments. Pays \$45 minimum/photo, b&w; \$50 minimum/photo, color. Buys all rights (reproduction in ads, etc.). SASE. Reports in 30 days.

KENNING PRODUCTIONS, Box 1084, Newark DE 19711. (302)731-5558. President: Kenny Mullins. Handles rock, country, blues, bluegrass and folk. Photographers used for portraits, in-concert shots, studio shots and special effects for album covers, inside album shots, publicity, brochures, posters, event/convention coverage and product advertising. Works with freelance photographers on assignment basis only; gives 25-50 assignments/year.

Specs: Uses 8x10 b&w and color glossy prints and 35mm and 8x10 transparencies.

Making Contact: Provide resume, business card, brochure, flyer or tearsheets to be kept on file for possible future assignments. Does not return unsolicited material. Reports in 1 month-6 weeks.

Payment & Terms: Pays \$50-100/b&w photo; \$75-150/color photo. Credit line given. Buys all rights.

KIDERIAN RECORD PRODUCTS, 4926 W. Gunnison, Chicago IL 60630. (312)399-5535. President: Raymond Peck. Handles rock, classical, country. Photographers used for portraits, in-concert shots, studio shots and special effects for album covers, inside album shots, publicity, brochures, posters and product advertising. Buys 35-45 photos/year.

Specs: Uses b&w or color prints and 35mm or 8x10 transparencies.

Making Contact: Send unsolicited photos by mail for consideration. SASE. Reports in 1 month. Payment & Terms: Pays \$50-100/b&w photo. Credit line given. Buys all rights.

SID KLEINER ENTERPRISES, 3701 25th Ave. SW., Naples FL 33964. Director: Sid Kleiner. Freelance photographers supply 20% of photos. Uses subject matter relating to health, food, mental

health, music, sex, human body, etc. Query with resume of credits or send samples. SASE. Pays \$25/photo. Rights negotiable.

K-TEL INTERNATIONAL, INC., 11311 K-Tel Dr., Minnetonka MN 55343. (612)932-4000. Creative Product Manager: Sherry Morales. Handles "a wide variation of musical selections." Photographers used for portraits, studio shots, special effects, and "imagery" for album covers, posters, product advertising, and P-O-P merchandise. Works with freelance photographers on assignment basis only; gives 1-10 assignments/year.

Specs: Uses 35mm, 21/4x21/4, 4x5 or 8x10 transparencies.

Making Contact: Send b&w and color prints and contact sheets by mail for consideration; provide resume, business card, brochure, flyer or tearsheets to be kept on file for possible future assignments. Does not return unsolicited material. Reporting time "depends on use and timing."

Payment & Terms: "All art is purchased via negotiation." Credit line given "when applicable." Buys

all rights: "other situations can be reached for terms agreed upon."

Tips: Prefers to see "imagery and mood, both in scenery and people in samples. For our soft rock/love theme albums, we could use women in soft focus or ?? Our packages are mainly compilations of musical artists—we therefore are looking for imagery, both in scenery and people: 'mood photos', etc.'

L.R.J. RECORDS, Box 3, 913 S. Main, Belen NM 87002. (505)864-7441. President: Little Richie Johnson. Handles country and bilingual records. Photographers used for record album photos. Credit line given. Send material by mail for consideration.

*LEGEND RECORDS & PROMOTIONS, 1102 Virginia St. S.W., Lenoir NC 28645. (704)758-4170. President: Mike McCoy. Handles rock, old rock, blues, bluegrass, gospel, rockabilly, country/western. Uses photographers for studio shots, posters for music stores, for album covers, publicity, posters, product advertisement and promotion kits. Works with freelance photographers on an assignment basis only; gives 9 assignments/year.

Specs: Uses 8x10 and 5x7 b&w and color prints.

Making Contact: Send unsolicited photos by mail for consideration or submit portfolio for review. Send photos of "work done on album covers of singers, etc." SASE. Reports in 2 weeks.

Payment & Terms: Pays \$27-40/color photo; \$25-35/hour for b&w photos. Credit line given. Buys all rights.

Tips: "Wants to see something new in photography. Be honest. Offer good rates and new ideals."

*LIN'S LINES, Suite 404, 150 Fifth Ave., New York NY 10011. (212)691-5630. President: Linda K. Jacobson. Estab. 1984. Handles all types of records. Uses photographers for portraits, in-concert shots, studio shots for album covers, inside album shots, publicity, brochures, posters and product advertising. Works with freelance photographers on an assignment basis only; gives 6 assignments/year.

Specs: Uses 8x10 prints; 35mm transparencies.

Making Contact: Query with resume of credits; provide resume, business card, brochure, flyer or tearsheets to be kept on file for possible future assignments. "Do not send unsolicited photos." SASE. Reports in 1 month.

Payment & Terms: Credit line given. Rights purchased varies.

Tips: Prefers unusual and exciting photographs. "Send interesting material."

LISA RECORDS, 3530 Kensington Ave., Philadelphia PA 19134. (215)744-6111. Vice President: Claire Mac. Handles rock, soul, country, western and middle-of-the-road records. Photographers used for record album photos and occasionally for advertising and publicity shots for newspapers. Gives 6 assignments/year. Pays by the job. Credit line given. Buys one-time rights. Submit portfolio for review. Looking for portraits, shots of bands and shots of individual entertainers in portfolio. SASE. Reports in 3 weeks.

Specs: Uses 8x10 b&w prints. Color rarely used.

Tips: "Get pictures of different recording acts on tour."

LUCIFER RECORDS, INC., Box 263, Brigantine NJ 08203. (609)266-2623. President: Ron Luciano. Photographers used for portraits, live action shots and studio shots for album covers, publicity flyers, brochures and posters. Freelancers supply 50% of photos. Provide brochure, calling card, flyer, resume and samples. Purchases photos for album covers and record sleeves. Submit portfolio for review. SASE. Reports in 2-6 weeks. Payment negotiable. Buys all rights.

*MONICA LYNCH, Vice President: Monica Lynch. Handles funk, pop, hip-hop. Uses photographers for portraits and studio shots for album covers, publicity, posters. Works with freelance photographers on an assignment basis only; gives 12-15 assignments/year.

Specs: Uses 8x10 b&w prints; 21/4x21/4 color transparencies.

Making Contact: Submit portfolio for review; provide resume, business card, brochure, flyer or tearsheets to be kept on file for possible future assignments. Does not return unsolicited material. Reports in 1 week.

Payment & Terms: Payment negotiated individually. Credit line given. Buys all rights.

Tips: Looks for photographs that capture an individual personality. "Be into our music and have a feel for the funk! Photos are 90% of our jacket artwork."

LEE MAGID, Box 532, Malibu CA 90265. (213)858-7282. President: Lee Magid. Handles jazz, C&W, gospel, rock, blues, pop. Photographers used for portraits, in-concert shots, studio shots, and candid photos for album covers, publicity, brochures, posters and event/convention coverage. Works with freelance photographers on assignment basis only; gives about 10 assignments/year.

Specs: Uses 8x10 b&w or color buff or glossy prints and 21/4x21/4 transparencies.

Making Contact: Send print copies by mail for consideration. SASE. Reports in 2 weeks.

Payment & Terms: Credit line given. Buys all rights.

MARICAO RECORDS/HARD HAT RECORDS, 519 N. Halifax Ave., Daytona Beach FL 32018. (904)252-0381. President: Bobby Lee Cude. Handles country, MOR, pop, disco and gospel. Photographers used for portraits, in-concert shots, studio shots and special effects for album covers, inside album shots, publicity, brochures, posters, event/convention coverage and product advertising. Works with freelance photographers on assignment basis only; gives 12 assignments/year.

Specs: Uses b&w and color photos.

Making Contact: Submit portfolio for review; provide resume, business card, brochure, flyer, tearsheets or samples to be kept on file for possible future assignments. SASE. Reports in 2 weeks. Payment & Terms: Pays "standard fees." Credit line sometimes given. Rights purchased negotiable. Tips: "Submit sample photo with SASE along with introductory letter stating fees, etc. Read Billboard/Musician and Variety."

MASTER-TRAK ENTERPRISES, Box 1345, Crowley LA 70526. (318)783-1601. General Manager: Mark Miller. Handles rock, soul, country & western, Cajun, Zydeco, blues. Photographers used for portraits, studio shots and special effects for album covers and publicity flyers. Buys 20-25 photos/year. Specs: Uses b&w/color prints and 35mm, 21/4x21/4 and 4x5 transparencies.

Making Contact: Send samples with specs listed above by mail for consideration or submit portfolio for

review. Does not return unsolicited material. Reports in 1 month.

Payment & Terms: Payment varies. Credit line given. Buys one-time rights.

*MEADOWLARK VENTURES or CHRIS ROBERTS REPRESENTS, Box 7218, Missoula MT 59807. (406)728-2180. Owner/Art Director: Chris Roberts. Handles rock under the label Metal ARC records. Uses photographers for portraits, in-concert shots, studio shots and special effects for album covers, brochures, posters. Buys 8-15 photos/year.

Specs: Uses 35mm and 4x5 transparencies.

Making Contact: Arrange a personal interview to show portfolio; send unsolicited photos by mail for consideration; submit portfolio for review; provide resume, business card, brochure, flyer or tearsheets to be kept on file for possible future assignments. SASE. Reports in 3 weeks.

Payment & Terms: Pays \$10-50/b&w photos, \$15-250/color photo. Credit line given. Buys one-time rights.

MEAN MOUNTAIN MUSIC, 926 W. Oklahoma Ave., Milwaukee WI 53215. (414)483-6500. Contact: M.J. Muskovitz. Handles rock, blues, R&B, rockabilly. Photographers used for portraits, in-concert shots and studio shots for album covers, publicity, brochures and product advertising. Works with freelance photographers on assignment basis only.

Specs: Buys 5x7 b&w prints and 35mm and 21/4x21/4 transparencies.

Making Contact & Terms: Send photos of "recording artists from the 1940s-1960s (examples: Gene Vincent, Buddy Holly, John Lee Hooker, Beatles, Johnny Burnette, etc.)" by mail for consideration. Does not return unsolicited material. Reports in 1 month.

Payment & Terms: Pays \$5-50/b&w photo. Credit line given. Buys all rights.

Tips: "School not important. Experience and knowledge of past recording artists with samples of past work most important. Since we are in most cases looking for only photos from the 1940s thru the 1960s, the freelancer must have been active during this period of time."

MELODEE RECORDS, Box 1010, Hendersonville TN 37077. (615)451-3920. President: Dee Mullins. Handles country and country crossover. Photographers used for portraits, in-concert shots, studio

shots and special effects for album covers, inside album shots, publicity, brochures and posters. Works with freelance photographers on assignment basis only; gives 10-50 assignments/year.

Specs: Uses 8x10 glossy prints and 35mm and 8x10 transparencies.

Making Contact: "Write for permission to send photos with SASE if material is to be returned." Reports in 1 month.

Payment & Terms: Pays by the job. Credit line given. Buys all rights.

MIRROR RECORDS, INC., KACK KLICK, INC., 645 Titus Ave., House of Guitars Building, Rochester NY 14617. (716)544-3500. Manager: Kim Simmons. Handles rock, blues and popular records. Photographers used for portraits, live and studio shots and special effects for album photos, advertising, publicity, posters, event/convention coverage and brochures. Buys 20 photos and gives 15 assignments/year. Pays per job. Credit line given. Buys all rights. Send material by mail for consideration or submit portfolio for review. Prefers to see photographer's control of light and color and photos with album covers in mind in a portfolio. SASE. Reports in 3 weeks.

B&W: Uses 5x7, 12½x12½ prints. **Color:** Uses prints and transparencies.

MOUNTAIN RAILROAD RECORDS, INC., Box 1681, Madison WI 53701. President: Stephen Powers. Photographers used for portraits, in-concert shots, studio shots, and special effects for album covers, inside album shots, publicity, brochures, posters and product advertising. Works with freelance photographers on assignment basis only; gives 10-20 assignments/year.

Specs: Depends on job.

Making Contact: Query with resume of credits; provide resume, business card, brochure, flyer or tearsheets to be kept on file for possible future assignments. SASE. Reports in 1 month.

Payment & Terms: Negotiates payment. Credit line given. Buys one-time or all rights.

MYSTIC OAK RECORDS, 1727 Elm St., Bethlehem PA 18017. (215)865-1083. Talent Coordinator: Bill Byron. Handles rock and classical, new wave and punk. Photographers used for portraits, in-concert shots, studio shots, and special effects for album covers, inside album shots, publicity, brochures and posters.

Specs: Uses 8x10 b&w or color glossy prints and 35mm transparencies.

Making Contact: Provide resume, business card, brochure, flyer or tearsheets to be kept on file for possible future assignments. Does not return unsolicited material. Reports in 3-6 weeks.

Payment & Terms: Payment varies according to distribution and artist. Credit line given. Rights pur-

chased varies, usually one-time rights.

Tips: "Send resume and examples of previous work used in album content or record promotion. We use freelance photographers (or artists) on most projects because we find we get very creative results. Be extremely creative and do not be afraid of being new and trendsetting. We now also have 2 inhouse photographers, and are looking to add more."

MYSTIC RECORDS/MRG DISTRIBUTING, 6277 Selma Ave., Hollywood CA 90028. (213)462-9005. Art Director: Mark Wheaton. Handles punk, new wave, hard core and metal rock—experimental art music for new label, "Atmosphear". Uses photos for album covers, publicity, posters and house magazine.

Specs: Uses b&w prints.

Making Contact: Describe types of photos available in letter. SASE. Reporting time varies.

Payment & Terms: Credit line given. Rights purchased vary.

NEW WORLD RECORDS INC., Suite 11, 2309 N. 36th St., Milwaukee WI 53210. (414)445-4872. Vice President: Larry K. Miles. Handles R&B and disco. Photographers used for in-concert shots and studio shots for album covers. Works with freelance photographers on assignment basis only; gives 3 assignments/year.

Specs: Uses 8x10 b&w prints.

Making Contact: Provide resume, business card, brochure, flyer or tearsheets to be kept on file for possible future assignments. Does not return unsolicited material. Reports in 1 month.

Payment & Terms: Credit line given. Buys one-time rights.

NUCLEUS RECORDS, Box 111, Sea Bright NJ 07760. President: Robert Bowden. Handles rock, country. Photographers used for portraits, studio shots for publicity, posters and product advertising. Works with freelance photographers on assignment basis only.

Making Contact: Send still photos of people by mail for consideration. SASE. Reports in 3 weeks. Payment & Terms: Pays \$50-75/b&w photo; \$75-100/color photo; \$50 minimum/job. Credit line given. Buys one-time rights.

*ORIGINAL CAST RECORDS; BROADWAY/HOLLYWOOD VIDEO PRODUCTIONS; BROADWAY/HOLLYWOOD FILM PRODUCTIONS, Box 10051, Beverly Hills CA 90213. (818)761-2646. Executive Producer: Ms. Chu. Handles pop & rock, broadway musicals (original casts), C&W, AOR, operettas, etc. Photographers used for portraits, live and studio shots, and special effects for albums, publicity flyers, brochures, posters, event/convention coverage and product advertising. Buys 30 + photos and gives 15 assignments/year. Provide resume and samples to be kept on file for possible future assignments.

B&W: Uses 8x10 glossies.

Color: Uses prints and transparencies.

Making Contact: Arrange a personal interview to show portfolio or query with resume and credits. "Prefer interview with portfolio. Contact by phone and try another day if I am out." Prefers to see "clear, well-composed b&w and color photos. We also use slides for our video production work." Also interested in movie film in a portfolio. SASE. Reports in 1 month.

Payment & Terms: Pays \$1-75 per job, \$1-75 for b&w and minimum \$1 for color. Credit line given.

Buys one-time and all rights depending on need.

Tips: Currently working on film production.

*PALO ALTO/TBA RECORDS, 755 Page Mill Rd., Palo Alto CA 94304. (415)856-4355. Administrative/Production Manager: Jean E. Catino. Handles primarily jazz and urban/black contemporary. Photographers used for portraits, in-concert shots, studio shots and occasional special effects for album covers, inside album shots and publicity. "Gives 25 or so assignments/year; buys 10-15 photos from freelancers/year. Buys stock shots."

Specs: Uses 8x10 glossy prints for publicity; flat for album cover.

Making Contact: Query with resume of credits. Provide resume, business card, brochure, flyer or tearsheets to be kept on file for possible future assignments. Reporting time varies.

Payment & Terms: Prices vary according to use. Credit line given for album covers. Buys one-time use for album covers; all rights for publicity.

PEACEABLE, 3464 Encinal Canyon Rd., Malibu CA 90265. (213)457-4405. Owner: C. Randolph Nauert. Handles rock, classical, ethnic, folk and hymns. Photographers are used for record album photos, advertising illustrations and brochures. Gives 3-5 assignments/year. Pays by the job or hour. Credit line given. Call first. SASE. Reports ASAP.

PETER PAN INDUSTRIES, 145 Komorn St., Newark NJ 07105. (201)344-4214. Art Director: Rob Lavery. Handles all types of records and books. Photographers used for portraits, in-concert shots, studio shots, special effects and product photography for album covers, inside album shots, publicity, brochures, posters, event/convention coverage and product advertising. Works with freelance photographers on assignment basis only.

Specs: Uses b&w and color prints and 35mm, 21/4x21/4, 4x5 and 8x10 transparencies.

Making Contact: Arrange a personal interview to show portfolio. SASE.

Payment & Terms: Pays \$30-35/b&w photo; \$40-45/color photo.

*PRAISE, IND., 7802 Expess ST., Burnaby, British Columbia, Canada (604)421-3444. Manager: Paul Yaroshuk. Handles gospel. Uses photographers for portraits, in-concert shots, studio shots for album covers for brochures. Buys 10 freelance photos/year.

Specs: Uses 8x10 prints.

Making Contact: Send unsolicited photos by mail for consideration. Likes to see modern scenic shots.

THE PRESCRIPTION CO., 70 Murray Ave., Port Washington NY 10050. (516)767-1929. President: David F. Gasman. General Manager: Mitch Vidur. Handles rock, soul and country & western. Photographers used for portraits, in-concert/studio shots and special effects for album covers, inside album shots, publicity flyers, brochures, posters, event/convention coverage and product advertising. Works with freelance photographers on assignment only basis.

Specs: Uses b&w/color prints.

Making Contact: To arrange interview to show portfolio, "send us a flyer or some photos for our files." Does not return unsolicited material. "We want nothing submitted."

Payment & Terms: Payment negotiable. Rights purchased negotiable.

Tips: "Send us a flyer or some photos for our files. We're only a small company with sporadic needs. If interested we will set up an in-person meeting. There is always need for good photography in our business, but like most fields today, competition is growing stiffer. Art and technique are important, of course, but so is a professional demeanor when doing business."

PRIME CUTS RECORDS, 439 Tute Hill, Lyndonville VT 05851. (802)626-3317. President: Bruce James. Handles rock. Photographers used for in-concert shots, studio shots, and special effects for pub-

486 Photographer's Market '86

licity, brochures, posters and product advertising. Gives 10 freelance assignments/year. Buys 4 photos/

Specs: Uses 4x5 color matte prints.

Making Contact: Provide resume, business card, brochure, flyer or tearsheets to be kept on file for possible future assignments. Does not return unsolicited material. Reports in 1 month.

Payment & Terms: Credit line given. Buys all rights.

Tips: Prefers to see "creative, exciting, colorful publicity photos."

PRO/CREATIVES, 25 W. Burda Pl., Spring Valley NY 10977. President: David Rapp. Handles pop and classical. Photographers used for record album photos, men's magazines, sports, advertising illustrations, posters and brochures. Buys all rights. Query with examples, resume of credits and business card. Reports in 1 month. SASE.

RANDALL PRODUCTIONS, Box 11960, Chicago IL 60611. (312)561-0027. President: Mary Freeman. Handles all types except classical music. Photographers used for in-concert shots, studio shots, and video for album covers, brochures, posters, and concert promotion/artist promotion. Works with freelance photographers on assignment basis only; gives 20 assignments/year.

Specs: Uses all sizes of b&w or color glossy prints and 35mm, 21/4x21/4, 4x5 or 8x10 transparencies. Making Contact: Send surrealism, new concept, idealistic, or abstract material by mail for consideration; provide resume, business card, brochure, flyer or tearsheets to be kept on file for possible future assignments. "Call (312)561-0027 to receive application that will be kept on file until assignments arise." SASE if you wish to have material returned. Reports "when needs arise."

Payment & Terms: Pays \$15-25/b&w photo; \$25-40/color photo; \$15-25/hour; \$30-100/day; \$30-150/

job. Buys all rights "but will negotiate."

Tips: "Freelancers have just as much to contribute as any photographer, if not more. Because of the nature of the business, record companies tend to lean towards seeking unknowns, because their styles are usually, in our opinion, more unique."

RECORD COMPANY OF THE SOUTH, 5220 Essen Ln., Baton Rouge LA 70806. (504)766-3233. Art Director: Ed Lakin. Handles rock, R&B and white blues. Photographers used for portraits and special effects for album covers, inside album shots and product advertising. Buys 10 photos and gives 5 assignments/year. Works with freelance photographers on assignment only basis. Provide samples to be kept on file for possible future assignments.

Specs: Uses 8x10 b&w prints and 4x5 transparencies.

Making Contact: Send samples with specs listed above to be kept on file. Does not return unsolicited material. Reports in 2 weeks.

Payment & Terms: Pays \$125-650/b&w photo; \$250-1,000/color photo; \$30-50/hour; \$300-1,000/

job. Credit line given. Rights purchased subject to agreement.

Tips: Prefers to see "Norman Seef photos at Ed Lakin prices. All of our acts are based in the Deep South. We find it more productive to work with photographers based in our area."

REDBUD RECORDS, A Division of CAE, Inc., 611 Empire Mill Road, Bloomington IN 47401. (812)824-2400. General Manager: Rick Heinsohn. Handles folk, jazz and pop. Photographers used for portraits, in-concert shots, studio shots and special effects for album covers and brochures. Works with freelance photographers on assignment basis only; gives 2 assignments/year. Buys 5 photos/year. Making Contact: Provide resume, business card, brochure, flyer or tearsheets to be kept on file for possible future assignments.

Payment & Terms: Payment depends on the job. Credit line given "sometimes." Buys all rights.

REVONAH RECORDS, Box 217, Ferndale NY 12734, (914)292-5965. Contact: Paul Gerry. Handles bluegrass, country and gospel. Photographers used for portraits and studio shots for album covers. Specs: Uses 8x10 glossy b&w and color prints and 21/4x21/4 transparencies.

Making Contact: Arrange a personal interview to show portfolio or send unsolicited photos by mail for consideration; provide resume, business card, brochure, flyer, tearsheets or samples to be kept on file for possible future assignments. SASE. Reports in 1 month.

Payment: Pays \$5-25/b&w photo and color photo. Credit line given. Buys all rights.

Tips: Prefers to see "a little of everything so as to judge the photographer's capability and feeling. Must look at work first—then perhaps a personal meeting."

RIPSAW RECORD CO., Principal Office: #5-J, 320 W. 30 St., New York NY 10001. (212)971-9151; or #1003, 4545 Connecticut Ave. NW, Washington DC 20008. (202)362-2286. President: Jonathan Strong. Handles rockabilly. Photographers used for in-concert shots and studio shots for album covers, publicity, brochures and posters. Buys 0-5 photos/year. Specs: "Depends on need."

Making Contact: Send "material we might use" by mail for consideration. SASE. Reporting time "depends on free time; we try to be considerate and return as promptly as possible."

Payment & Terms: Pays by the job. Credit line given. Buys all rights.

RMS TRIAD PRODUCTIONS, 6267 Potomac Circle, West Bloomfield MI 48033. (313)661-5167 or (313)585-2552. Contact: Bob Szajner. Handles jazz. Photographers used for portraits, in-concert/studio shots and special effects for album covers and publicity flyers. Gives 3 assignments/year. Works with freelance photographers on assignment only basis. Provide samples to be kept on file for possible future assignments.

Specs: Uses 35mm and 21/4x21/4 transparencies.

Making Contact: Query then submit portfolio for review. Does not return unsolicited material. Reports in 3 weeks.

Payment & Terms: Negotiates payment by the job. Buys all rights.

ROB-LEE MUSIC, Box 1338, Merchantville NJ 08109. President: R.L. Russen. Handles rock, middle-of-the-road and rhythm & blues. Photographers used for portraits, live and studio shots and special effects for album covers, publicity flyers, brochures and posters. Buys 36 photos and gives 6 assignments/year. Works with freelance photographers on assignment only basis. Provide resume, calling card, brochure, flyer and/or samples to be kept on file for possible future assignments.

B&W: Uses 8x10 glossies.

Color: Uses 5x7 and 8x10 prints.

Making Contact: Send material by mail for consideration or submit portfolio for review. Prefers to see variety, style, technique and originality in a portfolio. SASE. Reports in 2 weeks.

Payment & Terms: Pays \$50-300/b&w photo; \$100-500/color photo; \$25-100/hr or \$300-1,000/job. Credit line given. Buys all rights.

ROCKWELL RECORDS, Box 1600, Haverhill MA 01831. (617)373-6011. President: Bill Macek. Produces top 40 and rock and roll records. Buys 8-12 photos and gives 8-12 assignments/year. Free-lancers supply 100% of photos. Photographers used for live action shots, studio shots and special effects for album covers, inside album shots, publicity, brochures and posters. Photos used for jacket design and artist shots. Arrange a personal interview; submit b&w and color sample photos by mail for consideration; or submit portfolio for review. Provide brochure, calling card, flyer or resume to be kept on file for possible future assignments. SASE. Local photographers preferred, but will review work of photographers from anywhere. Payment varies.

Subject Needs: Interested in seeing all types of photos. "No restrictions. I may see something in a portfolio I really like and hadn't thought about using."

*ROSE RECORDS COMPANY, INC., 922 Canterbury Rd., NE, Atlanta GA 30324. President: Mario W. Peralta. Handles MOR. Photographers used for in-concert shots, studio shots and special effects for album covers. Works with freelance photographers on assignment basis only.

Specs: Uses 8x10 color prints and 4x5 transparencies.

Making Contact: Send photos of "sexy girls (please, not nudes), beautiful landscapes and unusual and different types of photography" by mail for consideration or submit portfolio for review; provide resume, business card, brochure, flyer, tearsheets or samples to be kept on file for possible future assignments. Does not return unsolicited material. Reports in 1 month.

Payment & Terms: Pays \$100 minimum/color photo. Credit line given. Buys all rights.

SCARAMOUCHE' RECORDS, Drawer 1967, Warner Robins GA 31099. (912)953-2800. Director: Robert R. Kovach. Handles pop, easy listening, rhythm and blues and country records. Photographers used for portraits, live and studio shots and special effects for albums, publicity, advertising and brochures. Buys 12 photos and gives 6 assignments/year. Works with freelance photographers on assignment only basis. Provide samples and tearsheets to be kept on file for possible future assignments. Pays \$25-150/job. Credit line given. Buys one-time rights. Send material by mail for consideration. SASE. Reports in 2 months.

B&W: Uses 8x10 glossy prints.

Color: Uses 8x10 prints and transparencies.

Tips: Advice on how to best break into this firm: "Submit an excellent print, showing originality, with an offer we can't refuse. There is always the need for new people with new ideas."

SHEPERD RECORDS, 2307 N. Washington Ave., Scranton PA 18509. (717)347-7395, 343-3031. Handles pop/rock. Photographers used for portraits, in-concert shots, studio shots and special effects for album covers, publicity and posters. Buys 15-25 photos/year.

Specs: Uses 8x10 b&w or color prints.

488 Photographer's Market '86

Making Contact: Query with resume of credits; send photos by mail for consideration. Does not return unsolicited material. Reports in 1 month.

Payment & Terms: Pays \$25-100/b&w photo; \$50-100/color photo. Credit line given. Buys one-time rights.

*SP COMMUNICATIONS GROUP, INC./DOMINO RECORDS, Duck Creek Station Annex, Box 475184, Garland TX 75047. Vice President, Public Relations: Mr. Steve Lene. Handles adult contemporary, country, black, dance, jazz and international including major motion picture and national network television soundtracks and national television and radio jingles. Uses photographers for portraits, in-concert shots, studio shots, special effects, on location still shots of major feature films and national television and radio productions and commercials for album covers, inside album shots, publicity, brochures, posters, "event/convention coverage and product advertising." Works with freelance photographers on an assignment basis only; "assignments vary according to number of projects we're working with."

Specs: Uses 8x10 glossy b&w or color prints.

Making Contact: Send unsolicited photos by mail for consideration. Needs "event/convention coverage shots; product advertising and marketing shots and tearsheets; sports portraits and sports events/convention coverage shots; and other entertainment personalities shots. Please identify subjects and personalities of photographs submitted." Does not return unsolicited material. Reports in 1 week.

Payment & Terms: Payment negotiated individually. Credit line given. "Usually rights purchased with photos are all rights but we have on occasion purchased the rights with photos as one-time rights. Rights

are negotiable at times, but solely depend upon the nature of the project."

Tips: "All photographs submitted will also be reviewed for possible publication in our upcoming entertainment magazine publication, thus providing a continuous opportunity of national exposure in a national entertainment publication on a regular basis. Follow our company format outlined in Photographer's Market and Photographer's Market Newsletter on material submitted."

*THE SPARROW CORPORATION, 9255 Deering Ave., Chatsworth CA 91311. (818)709-6900. Production Manager: Jackie Schikal. Handles rock, classical, worship, and children's albums. Uses photographers for portraits, studio shots for album covers, inside album shots, publicity, brochures, posters, event/convention coverage, product advertising, cassette inserts and mobiles. Works with freelance photographers on an assignment basis only; gives 10 assignments/year.

Specs: Uses 8x10 color prints; 21/4x21/4 transparencies.

Making Contact: Provide resume, business card, brochure, flyer or tearsheets to be kept on file for possible future assignments. SASE. Reports "if artist calls for feedback or when we decide to use the photos."

Payment & Terms: Pays 300-1,000/job. Credit line given. Buys all rights.

Tips: "Prefer to see people shots, close-up faces, nice graphic design and elements included. Send clean-cut samples with wholesome images. No nude models, etc. Be friendly, but not pushy or overbearing. Freelancers have very good chances. We are moving towards more detailed photo sets and designs that can carry a theme and using elements which can be used separately or together according to need."

SQN ENTERTAINMENT SOFTWARE CORP. (Formerly Sine Qua Non), 1 Charles St., Providence RI 02904. (401)521-2010. Contact: Director of Creative Services. Handles classical and jazz. Photography used as cover images per classical/jazz records, cassettes, compact discs, children's audio/video product lines, shape-up health and fitness audio/video, under-sail video and *Entertainment Software* magazine. Photographers used for album covers. Works with freelance photographers on assignment basis only; gives 100 assignments/year.

Specs: Uses 35mm, 21/4x21/4 and 4x5 transparencies.

Making Contact: Call Creative Department (401)351-3770, or send unsolicited photos by mail for consideration; provide resume, business card, brochure, flyer or tearsheets to be kept on file for possible future assignments. Submissions should consist of "whatever the photographer considers to be most representative of the depth and breadth of his/her capabilities." SASE. Reports in 1 month.

Payment & Terms: All rates are negotiable. Credit line given. Buys exclusive album cover rights.

SONIC WAVE RECORDS, Box 256577, Chicago IL 60625. (312)545-0861. President: Tom Petreli. Handles new wave punk. Photographers used for in-concert shots, studio shots and special effects for album covers, inside album shots, publicity, brochures and posters. Works with freelance photographers on assignment basis only; gives 25-50 assignments/year.

Specs: Uses b&w and color prints and 35mm and 8x10 transparencies.

Making Contact: Provide resume, business card, brochure, flyer or tearsheets to be kept on file for possible future assignments. SASE. Reports in 1 month.

SQN president Bill Comeau, right, is shown with SQN chairman Samuel Attenberg, left, and "Fame" actor Albert Hague. SQN recorded music Hague had composed for the video "What Every Child Should Know."

Close-up

Bill Comeau, President, Sine Qua Non Records

Photographers whose schedules and tastes don't accommodate chasing performers from studio to concert may find Sine Qua Non Records an agreeable alternative. Like most record companies. Sine Qua Non illustrates its album covers with photographs. But because the company specializes in classical recordings, its photographic needs are more unique. "About 90 percent of our covers are 'classical-look' scenes which fit in with classical or European music. The scenes are generally landscapes, and we work with a lot of still life photographic set-ups," says Sine Qua Non's president, Bill Comeau.

The company uses stock agencies to fill many of its photo needs, but will occasionally buy from photographers who have extensive stock lists.

For the set-up shots, however, Sine Qua Non prefers to work with photographers who are local (within commuting distance) to its Providence, Rhode Island, location. "We work with a wide range of topics on set-up shots, and

what we need at any one time is well defined," Comeau says. With the set-up shots, the company's approach is to preproduce the shot, and then to send a photographer and an art director out to do the shooting. With this extensive preplanning, the art director and photographer save time, and the desired results are more easily obtained, Comeau explains.

Although Sine Qua Non doesn't use freelancers exclusively, Comeau says he and his staff are always willing to review freelance submissions. He advises photographers interested in working for the company to first determine whether or not the kinds of work they do match what Sine Qua Non uses.

"We're very open. My art directors usually screen anyone who's willing to send samples. We are just as apt to look at someone's stock as we are to assign photos for a particular need," Comeau says. Sine Qua Non buys exclusive album cover rights, and payment terms are negotiable. Photographers are given a credit line.

Photographers should send samples of their work to Sine Qua Non's creative director, Sue Breschia. "We don't receive a lot of submissions from freelancers, and we're willing to look at new work," she emphasizes.

-Michael Banks

Payment & Terms: Pays \$50-100/b&w photo; \$100-200/color photo; \$25-50/hour; \$125-300/job. Credit line given. Buys all rights.

TEROCK RECORDS, Box 4740, Nashville TN 37216. (615)865-4740. Secretary: S.D. Neal. Handles rock, soul and country records. Uses photographers for in-concert and studio shots for album covers, inside album shots, publicity flyers, brochures, posters and product advertising. Pays per job. "Photographers have to set a price." Credit line given. Send material by mail for consideration. SASE. Reports in 3 weeks.

THIRD STORY RECORDS, INC., 3436 Sansom St., Philadelphia PA 19104. (215)386-5987. Promotion Coordinator: Ellen McCue. Publishing Director: John O. Wicks. Handles rock, country, gospel. Photographers used for portraits and in-concert shots for album covers, publicity and product advertising. Works with freelance photographers on assignment basis only; gives 4-5 assignments/year. **Specs:** Uses 8x10 b&w glossy prints.

Making Contact: Arrange a personal interview to show portfolio; send unsolicited photos by mail for consideration. Submissions should consist of professional quality, promotion shots for printed pack-

ages. Does not return unsolicited material. Reports in 2-3 weeks.

Payment & Terms: Credit line given. Buys all rights.

Tips: Prefers to see "pictures that look professional and make the subject look 'real'" in a portfolio. Photographer should provide "good prices, personality and good shots. I think the recording industry is a great market for photographers. We are a small company, so we don't require their services very often. But, with the video scene growing, everyone wants to 'see.' There are many uses for photography in the record field."

RIK TINORY PRODUCTIONS, Box 311, Cohasset MA 02025. (617)383-9494. Art Director: Claire Babcock. Handles rock, classical, country. Photographers used for portraits, in-concert shots, studio shots, and special effects for album covers, inside album shots, publicity, brochures, posters and event/convention coverage.

Specs: Uses 8x10 b&w prints and 21/4x21/4 transparencies.

Making Contact: Query first. Does not return unsolicited material.

Payment & Terms: Pays "flat fee—we must own negatives." Credit line given. Buys all rights plus negatives.

*TRAIL RECORDS, Box 3860, Kingsport TN 37664. (615)246-8845. President: Tilford Salyer. Handles country, gospel. Uses photographers for portraits, in-concert shots, studio shots for album covers, inside album shots, publicity, posters. Works with freelance photographers on an assignment basis only; gives 100 assignments/year.

Specs: Uses 8x10 glossy b&w prints; 21/4x21/4 or 4x5 transparencies.

Making Contact: Provide resume, business card, brochure, flyer or tearsheets to be kept on file for possible future assignments. Does not return unsolicited material. Reports in 6 weeks.

Payment & Terms: Pays \$250-500/job. Credit line given on album backliner. Buys all rights. **Tips:** "Don't ever forget we only work with square format."

*TROD NOSSEL ARTISTS, 10 George St., Box 57, Wallingford CT 06492. (203)265-0010. Contact: Director of Promotion. Handles rock, soul, contemporary. Photographers used for portraits, inconcert shots, studio shots and special effects for album covers, publicity, posters and product advertising. Works with freelance photographers on assignment basis only; gives 1-10 assignments/year. Specs: Uses 5x8 b&w and color prints and 35mm and 21/4x21/4 transparencies.

Making Contact: Provide resume, business card, brochure, flyer, tearsheets or samples to be kept on file for possible future assignments. Reports in 1-3 weeks.

Payment & Terms: Credit line given. Buys all rights.

Tips: "Submit previous work and short resume-with your goals and purposes well defined."

*TYSCOT RECORDS, 3403 N. Ralston, Indianapolis IN 46218. (317)926-6271. General Manager: Rick Clark. Handles gospel, rhythm and blues and dance music. Uses photographers for portraits, inconcert shots, studio shots and special effects for album covers, inside album shots, publicity and posters. Works with freelance photographers on an assignment basis only; number of assignments/year varies.

Specs: Uses 8x10 prints.

Making Contact: Send unsolicited photos by mail for consideration or submit portfolio for review; provide resume, business card, flyer or tearsheets to be kept on file for possible future assignments. Does not return unsolicited material. Reports in 1 month.

Payment & Terms: Payment negotiated individually. Credit line given.

MIKE VACCARO MUSIC SERVICES/MUSIQUE CIRCLE RECORDS, Box 7991, Long Beach CA 90807. Contact: Mike Vaccaro. Handles classical. Photographers used for portraits, in-concert shots, studio shots, special effects for album covers, publicity, brochures, event/convention coverage and product advertising. Works with freelance photographers on assignment basis only; gives 2-3 assignments/year.

Making Contact: Arrange a personal interview to show portfolio; query with resume of credits; send unsolicited photos by mail for consideration or submit portfolio for review; provide resume, business card, brochure, flyer or tearsheets to be kept on file for possible future assignments. Does not return un-

solicited material. Reports as needed.

Payment & Terms: Payment, credit line and rights purchased are negotiated.

Tips: "Flexibility in many styles and special effects" is advisable.

*VALLEY RECORDS, Box 262, Patton CA 92369. (714)864-7127 or 985-6567. President/Owner: Johnny O. Lopez. Handles rock and country. Photographers used for portraits, in-concert shots, studio shots and special effects for album covers, publicity, posters, event/convention coverage and product advertising. Works with freelance photographers on assignment basis only; "gives 12 assignments/year".

Specs: Uses 3x5 and 8x10 glossy b&w and color prints; 4x5 and 8x10 transparencies.

Making Contact: Send unsolicited photos by mail for consideration. Submit portfolio for review; provide resume, business card, brochure, flyer or tearsheets to be kept on file for possible future assignments. SASE. Reports in 3 weeks.

Payment & Terms: Pays by the job. Credit line to be negotiated.

VOICE BOX RECORDS, 5180-B Park Ave., Memphis TN 38119. (901)761-5074. President: Mark Blackwood. General Manager: Jerry Goin. Handles contemporary Christian music. Photographers used for in-concert shots, studio shots and special effects for album covers, publicity, brochures, posters, event/convention coverage and product advertising. Works with freelance photographers on assignment basis only; gives 10 assignments/year.

Specs: Uses 8x10 b&w or color glossy prints and 35mm transparencies.

Making Contact: Submit portfolio for review; provide resume, business card, brochure, flyer or tearsheets to be kept on file for possible future assignments. SASE. Reports in 3 weeks.

Payment & Terms: "A price is agreed upon depending on the project." Credit line given "for album

covers and major projects." Buys one-time rights.

Tips: Prefers to see "commercial shots suitable for use as publicity shots and album covers as opposed to portraits; casual shots of people as opposed to scenery. Be sure to include with your resume and brochure a listing of work done before, project credits and complete price list. Depending on the project, record companies need different types of photographers so freelance photographers have a very good chance of working with record companies. Our record company and companies like ours are constantly using freelance photographers to take pictures for use in magazine advertisements, press releases, album covers, etc. . . ."

KENT WASHBURN PRODUCTIONS, 10622 Commerce, Tujunga CA 91042. (213)353-8165. Contact: Kent Washburn. Handles R&B, Gospel. Photographers used for portraits, in-concert shots, studio shots, and special effects for album covers, inside album shots, publicity, brochures, posters. Works with freelance photographers on assignment basis only; gives 3 assignments/year.

Specs: Uses 4x5 color glossy prints and 21/4x21/4 transparencies.

Making Contact: Provide resume, business card, brochure, flyer or tearsheets to be kept on file for possible future assignments. SASE; "reply when needed."

Payment & Terms: Pays \$200-1,400/job. Credit line given. Buys all rights.

*MORTON WAX & ASSOC., 200 W 51 St., New York NY 10019. (212)247-2159. Uses photographers for publicity and event/convention coverage. Works with freelance photographers on an assignment basis only.

Specs: Uses 8x10 transparencies.

Making Contact: Provide resume, business card, brochure, flyer or tearsheets to be kept on file for possible future assignments. Does not return unsolicited material.

Payment & Terms: Buys one-time rights.

DAVE WILSON PRODUCTIONS, 3515 Kensington Ave., Philadelphia PA 19134. (215)744-6111. Vice President: Claire Mac. Freelancers supply 50% of photos. Uses special effects, action and studio photos and portrait shots of performers for albums, publicity flyers and posters. Buys 25 photos/year. Submit material by mail for consideration. Provide resume and samples to be kept on file for possible future assignments. Prefers to see samples of b&w glossy—action shots in a portfolio. Payment varies. SASE. Reports in 2 weeks.

Stock Photo Agencies_

Stock photography, in the general business sense, is the selling of large files of existing images for one-time use by many clients in a variety of markets. As practiced by the companies listed in this section, stock photography is a multimillion-dollar industry involving billions of photographs sold and resold many times over to thousands of buyers.

Most freelance photographers sell photos from their own stock files in addition to their assignment work, but after a few years most tend to find that their files have grown so large as to be unmanageable and begin to think about letting a commercial agency handle their stock photos. A typical cutoff point is about 1,000 pictures—and that means 1,000 after editing out everything that's less than perfect. Once you reach the thousand mark, your life is probably too big to keep track of by yourself; also, most agencies want to see an initial submission of at least 1,000 images to choose from.

Although a good number of the giant, old-line stock houses (based mostly in New York City) continue to stock all subjects and styles of photography, most of the newer, smaller, geographically diverse agencies have found it more efficient and practical to *specialize* in some particular area—sports, science, celebrities, or one geographic region, for example. Such agencies offer several advantages to the freelancer in search of a stock agent: first, because they are specialized, it's easier to identify those likely to be most interested in your work; second, since they tend to be newer, they are more receptive to queries from new photographers; and third, because they tend to be smaller, they can offer more personalized service to each photographer they represent.

Most stock photo agents prefer to be queried by mail first. Provide them with a comprehensive list of the stock subjects you have on file; then, if they're interested, you'll be asked to submit from several hundred to about one thousand representative samples of your best work in those subjects the agency needs. If the agency likes what they see, you'll be asked to sign a contract; most agencies prefer to have exclusive representation of your stock file. You'll also be expected to provide the agency with plenty of fresh material as often as possible—stock photography has to be current in terms of both subjects and styles, and it's obvious that the more photos

you have on file, the more sales your work is likely to garner.

The advantages of having your work on file with an agency are that the agency can circulate your pictures among a much greater number of clients than you could yourself, and that it has the marketing expertise to place your photos exactly where they are most needed and will command the highest prices. You're free to go out and shoot new images and to take on all the assignment work you can handle without having to spend long hours filing, retrieving and resubmitting old pictures. And for all this, the agency asks just one thing: 50% of the profits from sales of your photos. That might seem like a lot, but if you play by the rules of the game—if you provide your stock agency with the kinds of photos it needs in the numbers it demands—your 50% could add up to thousands of dollars annually.

AFTERIMAGE, INC. ®, Suite 250, 3807 Wilshire Blvd., Los Angeles CA 90010. (213)467-6033. Interested in all subjects, particularly color photos of model released contemporary people. Sells to advertising and editorial clients. Pays 50% commission. General price range: ASMP rates. Photographers must have a review. Send SASE for submission guidelines.

Tips: "Photographer needs at least 3,000 to 5,000 good quality originals of varied subject matters."

AIR PIXIES, 515 Madison Ave., New York NY 10022. (212)486-9828. President: Ben Kocivar. Has 150,000 photos. Clients include advertising agencies, public relations firms, businesses, book publish-

ers, magazine publishers, encyclopedia publishers, newspapers, post card companies, calendar companies and greeting card companies. Buys photos outright; pays \$50-1,000. Pays 50% commission. General price range \$100-1,000. Offers one-time rights or first rights. Model release and captions required. Photos solicited on assignment only. SASE. Reports in 2 weeks.

Subject Needs: Professional aerial photography, especially of major cities; also science, boats, cars.

B&W: Uses 8x10 prints. **Color:** Uses prints.

Tips: "Our clients are requesting more color prints."

ALASKAPHOTO, 1530 Westlake Ave. N., Seattle WA 98109. (206)282-8116. Owner: Marty Loken. Has 150,000 photos, 40 contracted photographers. Clients include advertising agencies; corporations with business interests in Alaska; AV firms; magazine and book publishers. Does not buy outright; pays 50% commission. Offers one-time rights. Model release preferred; captions required. Query with list of stock photo subjects. SASE. Reports in 1-3 weeks.

Subject Needs: All topics related to Alaska and northwestern Canada (Yukon Territory, British Columbia and Northwest Territories)—flora, fauna, industries, people and their activities, scenics, towns and villages, and historical. No duplicate slides or off-brand films. Minimum number of transparencies ac-

cepted: 2,000.

Color: Uses 35mm, 21/4x21/4, 4x5, 5x7 or 8x10 transparencies.

Tips: "We are no longer actively seeking additional photographers for AlaskaPhoto, but top professional photographers may wish to consider our companion agencies, Aperture PhotoBank and Wildlife PhotoBank, which are stocking photographs from all over the world. Please see their listing for details."

AMERICAN STOCK PHOTOS, 6842 Sunset Blvd., Hollywood CA 90028. (213)469-3908. Contact: Darrel O'Neil or Belle James. Has 2½ million b&w prints and 250,000 color transparencies. Clients include advertising agencies, public relations firms, businesses, AV firms, book publishers, magazine publishers, encyclopedia publishers, newspapers, postcard companies, calendar companies, greeting card companies, and churches and religious organizations. Does not buy outright; pays 40% commission/b&w, 50% commission/color. Offers one-time rights. Model release required; captions preferred. Send material by mail for consideration or "drop it off for review." SASE. Reports on queries in 1 day, on submitted materials in 2 weeks-30 days. Free photo guidelines with SASE; tip sheet distributed "irregularly—about twice a year" free to any photographer for SASE.

Subject Needs: "Everything—animals, scenics, points of interest around the world, people doing anything, festive occasions, sports of all types, camping, hiking. Big requests for snow scenes (Christmas card type) and whatever people do in the snow. We have a few customers that buy shots of young couples

in pleasant surroundings. No stiffly posed or badly lit shots."

B&W: Uses prints; contact sheet OK.

Color: Uses 35mm, 21/4x21/4 and 4x5 transparencies.

Tips: "Be patient on sales. Get releases; look through magazines and see what's popular; try and duplicate the background shots. B&w still a good seller—and not many doing it so market is open and begging for new work."

AMWEST PICTURE AGENCY, 1595 S. University, Denver CO 80210. (303)777-2770. President: Luke Macha. Has 150,000 photos. Clients include advertising agencies, public relations firms, businesses, book publishers, magazine publishers, encyclopedia publishers, postcard companies, calendar companies and poster companies. Does not buy outright; pays 50% commission. Offers one-time rights. Model release and captions required. Arrange a personal interview to show portfolio or send material by mail for consideration. SASE. Reports in 3 weeks. Free photo guidelines; tips sheet distributed periodically to established contributors.

Subject Needs: American West scenics, wildlife, nature, people in professions and recreational activities, scientific photography, recreational and sport activities, food, beverages, dining. In product photography, brands should not be identifiable. No "'arty' prints, 'graphic impressions'; noncommital

landscapes (creeks, stones, a leaf, etc.); fashion."

B&W: Uses 8x10 glossy, dried matte double weight prints.

Color: Uses 35mm or larger transparencies.

ANIMALS ANIMALS ENTERPRISES, 203 W. 81st St., New York NY 10024. (212)580-9595. President: Nancy Henderson. Has 600,000 photos. Clients include advertising agencies, public rela-

The asterisk before a listing indicates that the listing is new in this edition. New markets are often the most receptive to freelance contributions.

494 Photographer's Market '86

tions firms, businesses, AV firms, book publishers, magazine publishers, encyclopedia publishers, newspapers, postcard companies, calendar companies and greeting card companies. Does not buy outright; pays 50% commission. Offers one-time rights; other uses negotiable. Model release required if used for advertising; captions required. Send material by mail for consideration. SASE. Reports in 1-2 weeks. Free photo guidelines with SASE. Tips sheet distributed regularly to established contributors. Subject Needs: "We specialize in wildlife and domestic animals—mammals, birds, fish, reptiles, amphibians, insects, etc."

B&W: Uses 8x10 glossy or matte prints.

Color: Uses 35mm transparencies.

Tips: "First, preedit your material. Second, know your subject. We need captions including Latin names, and they must be correct!"

APERTURE PHOTOBANK INC., 1530 Westlake Ave. N., Seattle WA 98109. (206)282-8116. Contact: Marty Loken or Gloria Grandaw. Has 400,000 photos of all subjects, with emphasis on the U.S. West Coast, western Canada and Alaska. Clients include advertising agencies, corporations, graphic designers, PR firms and publishers. Subject needs include recreation, high tech, travel, industries, wild-life, cities and towns, scenics, transportation—heavy emphasis on "people doing things" and photos that visually define a particular city, region or country (primarily attractions, travel destinations, industries, recreation possibilities). "We deal in color and strongly prefer Kodachrome originals in the 35mm format, and Ektachrome in larger formats. (Please do not send off-brand transparencies; they will not be accepted.)"

Specs: Uses 35mm, 21/4x21/4, 4x5, 5x7 and 8x10 color transparencies.

Payment & Terms: Does not buy outright; pays 50% commission "immediately upon receipt of payment from clients—not 3-6 months later. We follow ASMP rates. One-time use of color ranges from \$175 to \$1,500, generally—the lower figure being for a modest, local editorial usage; the higher figure being for a national consumer magazine ad." Offers one-time rights, first rights, rarely all rights. Model releases required when appropriate; captions always required (on wide edge of slide mounts).

Making Contact: Send submissions by mail, certified or registered, including return postage but not return envelope ("we prefer to use our own shipping materials"). Reports in 3 weeks. "Please submit photos that indicate the range of your photo coverage—both geographic and subject range—with all indication of the total number of photos available in different subject areas. Initial sampler should be fairly small—perhaps 100 photos—to be followed, upon invitation, by far larger submissions." Distributes newsletter, including want list, to photographers under contract.

Tips: "We are a small, responsive agency—an outgrowth of a regional stock photo library, AlaskaPhoto, that we launched in early 1979. We're looking for long-term relationships with top professional photographers, especially in the U.S. and Canada, and stock all imaginable subjects. (We do not stock many abstracts, nudes or fine-art images.) To make submissions, please assemble a portfolio of 100-200 transparencies in vinyl sheets, including an inventory of additional photos that could be submitted. We are selective, and only represent photographers who can place 2,000-10,000 images in our files. We also handle assignments for photographers under contract. Our standard contract is for a three-year period; no demands for exclusivity. Please do not send questionnaires."

ART RESOURCE, 9th Floor, 65 Bleecker St., New York NY 10012. Contact: Ted Feder, President or Warren Ogden. Has 300,000 b&w and color photos. Clients include textbook publishers, encyclopedias, magazines, commercial firms and advertising agencies. Does not buy outright; pays 50% commission. General price range: \$75-120 for b&w; \$135-250 for color. Offers all rights or first North American serial rights. Query with resume of credits, submit portfolio, or call to arrange an appointment. SASE. Free photo guidelines; tips sheet distributed to established contributors.

Subject Needs: Educational material with an emphasis on people and their activity, travel and architecture. Specializes in photos of works of painting, sculpture, architecture, minor arts.

B&W: Uses 8x10 semigloss prints.

Color: Uses 35mm, 21/4x21/4, 4x5 or 8x10 transparencies.

Tips: "We do not like to receive small samples by mail. We prefer an appointment and respond immediately. However, out-of-town photographers are welcome to submit a portfolio or description of work." Also, "we wish to stock *only* serious photographers with some professional background, whose work measures up to professional standards. We always welcome the opportunity to see new work." Prefers to see a "variety of specialties; e.g., travel, out-takes from assignments—be they educational, industrial or commercial."

*ASSOCIATED PICTURE SERVICE, 394 Nash Circle, Mableton GA 30059. Has 25,000 photos. Clients include advertising agencies, AV firms, book publishers, magazine publishers, encyclopedia publishers and calendar companies. Does not buy outright; pays 50% commission. General price range: \$500. Offers one-time rights. Model release required. Query with SASE. Reports in 2 weeks.

Subject Needs: Nature, historical points, city/suburbs, scenics of most major countries. Color: Uses 35mm transparencies.

A-STOCK PHOTO FINDER(ASPF), #30-F, 1030 N. State St., Chicago IL 60610. (312)645-0611. General Manager: Joanne Maenza. Has access to 1 million photos. Clients include primarily advertising agencies, but also public relations firms, businesses, AV firms, book publishers, magazine publishers, encyclopedia publishers, newspapers, postcard companies, calendar companies, greeting card compan-

ies, poster companies and others.

Specs: Uses 35mm, 21/4x21/4, 4x5, 8x10 and 11x14 etc., color transparencies and color contact sheets. Payment & Terms: Pays 50% commission on leases. Commission payments made upon collection from clients. General price range: \$75-2,000. Buys one-time rights or first rights. Copies of model releases required at time of submission; releasability status indicated on each transparency in red ink (R; NR). Cover letter with submission list and short, to-the-point captions required at time of submission. Making Contact: Send samples and list of stock photo subjects. SASE. Complete kits with submission guidelines supplied on request. Tips sheets distributed regularly; also bimonthly newsletter.

Tips: "ASPF is known as 'Chicago's Image Marketplace—where the advertising professional calls for stock photographic art.' ASPF's standards are very high; the company is in pursuit of excellence. Please approach us only if you know you are excellent! This company's management is very strong, marketing-

oriented, and agressive in the marketplace."

BUDDY BASCH FEATURE SYNDICATE, 771 W. End Ave., New York NY 10025. (212)666-2300. Contact: Buddy Basch. Has 40,000 color and b&w photos. Clients include corporations, public relations firms, magazine publishers, newspapers, and wire services. Pays \$10 minimum/photo. Offers one-time rights. Model release and captions required. Query only with resume of credits and SASE. Reports in 7-14 days.

Subject Needs: Travel, entertainment, people, aircraft history; offbeat items considered.

B&W: Uses glossy prints; contact sheet OK.

Color: Uses 35mm and 21/4x21/4 transparencies and glossy prints; contact sheet OK.

Tips: "Have unusual, crisp, storytelling or rare photos to offer. Buying very little at present time."

BERG & ASSOCIATES, Suite 203, 8334 Clairemont Mesa Blvd., San Diego CA 92111. (619)292-8257. Contact: Margaret C. Berg. Has 100,000 photos. Clients include advertising agencies, public relations and AV firms, businesses, textbook/encyclopedia and magazine publishers, newpapers, postcard, calendar and greeting card and pictorial framing art companies.

Subject Needs: Children, including ethnic and handicapped groups—all ages (playing, at school, sports, interacting); careers, business, industry; medical; sports and recreation; underwater; tourism;

agriculture; families doing things together. Also scenics, especially larger than 35mm.

Specs: Uses color transparencies only; 35mm, 21/4x21/4, 4x5, 8x10.

Payment & Terms: Pays 50% commission. Sells one-time rights, first rights or "special rights for spe-

cific time period." Model release and captions preferred.

Making Contact: Photo guidelines free with SASE. Query with list of stock photo subjects; with query list geographical areas covered. Send photos by mail for consideration. SASE. Reports in 3 weeks. Tips sheet distributed periodically only "to those with photos in stock. Don't send photos before studying

guidelines.

Tips: "For 35mm color, send 100 maximum. For larger format, send any amount. Package carefully. If you want photos returned by insured mail, include insurance cost. We note that more and more companies that never used stock photos before, now are looking for them for company brochures, slide/sound shows, etc. Avoid improper exposure, too dark or too light. Remember most printed pages are vertical. For 35mm forget anything but Kodachrome. Also, medium and large format still lives, and fewer people are producing it."

BERNSEN'S INTERNATIONAL PRESS SERVICE, LTD., 50 Fryer Court, San Ramon CA 94583. Contact: Simone Cryns-Lubell. Clients include public relations firms, book, magazine and encyclopedia publishers, newspapers and tabloids.

Subject Needs: "All general interest subjects: people, achievements, new inventions in all fields, bizarre topics for photo feature. All subjects need to be photographed in action/people-oriented. No artis-

tic shots, e.g., art magazine styles.'

Specs: Uses 8x10 b&w glossy prints and 35mm slides.

Payment & Terms: Payment based on size of the assignment. General price range: minimum \$45/pho-

to. Buys all rights. Model release preferred; captions required.

Making Contact: Arrange a personal interview to show portfolio or query with list of stock photo subjects and tearsheets. Solicits photos by assignment only. SASE. Reports in 2 weeks. Photo guidelines free with SASE.

BLACK STAR PUBLISHING CO., INC., 450 Park Ave. S., 4th Floor, New York NY 10016. (212)679-3288. President: Howard Chapnick. Has 2 million b&w and color photos of all subjects. Clients include magazines, advertising agencies, book publishers, encyclopedia publishers, corporations and poster companies. Does not buy outright; pays 50% commission. Offers first North American serial rights; "other rights can be procured on negotiated fees." Model release, if available, should be submitted with photos. Call to arrange an appointment, submit portfolio, or mail material for consideration. Reports in 2-3 weeks. SASE. Free photo guidelines.

B&W: Send 8x10 semigloss prints. Interested in all subjects. "Our tastes and needs are eclectic. We do not know from day to day what our clients will request. Submissions should be made on a trial and error

basis. Our only demand is top quality."
Color: Send 35mm transparencies.

Tips: "We are interested in quality and content, not quantity. Comprehensive story material welco-med."

*CAMERA CLIX, (a Division of Globe Photos Inc.), 275 7th Ave., New York NY 10001. (212)689-1340. Manager: Ray Whelan. Has 2 million photos. Clients include advertising agencies, public relations firms, businesses, AV firms, book publishers, magazine publishers, encyclopedia publishers, postcard companies, calendar companies and greeting card companies. Does not buy outright; pays 50% commission. Offers one-time rights. Model release required; captions preferred. Arrange a personal interview to show portfolio, query with samples, send material by mail for consideration, or submit portfolio for review. SASE. Reports in 3 weeks. Photo guidelines free with SASE. Tips sheet distributed at irregular intervals to any photographer.

Subject Needs: Romantic couples, children, animals, floral designs, girls, babies, scenics, holidays and art reproductions. Color only. "Look at magazines and ads as examples of current market needs."

Color: Uses 35mm, 21/4x21/4 and larger transparencies. "The larger the better." Tips: Interested in calendar or poster-type shots—very sharp with good color.

CAMERIQUE, Stock Photography, Main office: 1701 Skippack Pike, Box 175, Blue Bell PA 19422. (215)272-7649. Representatives in Boston, Los Angeles, Chicago, Detroit and Toronto. Photo Director: Christopher C. Johnson. Has 200,000 photos. Buys photos outright; pays \$10-50/photo. Also pays 35% commission/b&w; 50% commission/color. Model release required on recognizable people for advertising; not required for editorial use. Captions required. Send samples (small cross-section) by mail for consideration. SASE. Reports in 2 weeks. Free photo guidelines. Tips sheet distributed periodically to established contributors.

Subject Needs: General stock photos, all categories. Emphasizes people activities all seasons. Also uses b&w interracial people shots; large format color scenics all over the world. No fashion shots; no celebrities without release or foreign people except calendar and poster types.

B&W: Uses negatives; contact sheet OK.

Color: Uses 35mm or larger transparencies; "35mm accepted if of unusual interest or outstanding quality."

Tips: "Be creative, selective, professional and loyal. Communicate openly and often."

CELEBRITY PHOTOS UNLIMITED, Box 166, Bartow FL 33830. (813)533-6845. President: Ray Floyd. Has 2,500 photos. Clients include public relations firms, book publishers, magazine publishers, newspapers and recording companies.

Subject Needs: "We need all nationally and internationally known celebrities, TV, stage, movies, concert performers, singers. (No politicians unless it is the President of the United States or other countries or Princess Diana or Prince Charles.) We are seeking top quality work—no snapshots."

Specs: Uses 8x10 or 4x5 glossy color prints; 35mm, 21/4x21/4, 4x5 or 8x10 transparencies, b&w or color negatives.

Payment & Terms: Buys photos outright; pays \$5-1,500. Pays 50% commission on b&w and color photos. General price range: \$5-1,500—"depends on client and the person photographed." Buys one-time, first or all rights. Model release and captions optional.

Making Contact: Send photos by mail for consideration. SASE. Reports in 2 weeks. Photo guidelines available. Occasionally distributes tips sheet to "serious inquiries only."

CLICK/Chicago LTD., Suite 503, 213 West Institute Place, Chicago IL 60610. (312)787-7880. Photonet ID PHO 1113. Directors: Connie Ceocaris, ASMP, Don Smetzer, ASMP. President: Barbara Smetzer, ASPP. Vice President: Brian Seed, ASMP. "Click has an extensive general file of both b&w and color pictures (all formats), with an especially large and current collection on Chicago and on international travel. Click is an agent in the USA for the photographs published in the Berlitz travel guides. Over 80 titles are currently in print. A quarterly newsletter is published in order to promote photographers travels and the work in their files. PhotoNet is also used to promote our photographers and their

work. Clients include advertising agencies, major corporations, publishers of textbooks, encyclopedias, AV programs and filmstrips, trade books, magazines, newspapers, calendars, greeting cards. We actively seek assignments and sell stock photos, on an international basis using ASMP guidelines.' Subject Needs: Children, families, couples (with releases), agriculture, industry, new technology, pets, landmarks, national parks, European cities, transportation (planes, trains, trucks, ships), the sea and the seashore, and the midwestern USA.

Payment & Terms: Works on 50% of stock sales and 25% of assignments.

BRUCE COLEMAN, INC., 381 5th Ave., New York NY 10016. (212)683-5227. Telex 429 093. Contact: Stuart L. Craig, Jr. File consists of over 750,000 original color transparencies on all subjects including natural history, sports, people, travel, industrial, medical and scientific. Clients include major advertising agencies, public relations firms, corporations, magazine and book publishers, calendar companies, greeting card companies, AV firms, and jigsaw puzzle publishers. 350 photographers. Subject Needs: "All subjects other than hot news."

Specs: Uses original color transparencies. "If sending 35mm, send only Kodachrome or Fujichrome pr-

fessional transparencies."

Payment & Terms: Does not buy outright; pays 50% commission. Offers one-time rights. Model release preferred; captions required.

Making Contact: Arrange for interview or write for details first. Large SASE. Reports in 4-6 weeks.

Periodic "want list" distributed to contributing photographers.

Tips: "Edit your work very carefully. Include return postage with submission if you wish material returned. Photograph subject matter which interests you and do it better than anyone else. Don't try to copy other photographers because they're probably doing the work better! We don't need second rate copies, but first rate original work. As the field becomes more competitive, there is more concentration on subject matter. Most photographers possess adequate technical skills, but a lack of imagination. Foreign markets are a major source for sales for our photographers."

*COLOUR LIBRARY INTERNATIONAL (USA), LTD., 164 Madison Ave., New York NY 10016. Clients include advertising agencies, public relations firms, businesses, AV firms, book publishers, magazine publishers, encyclopedia publishers, postcard companies, calendar companies and greeting card companies. No commission pay. Offers one-time rights and all rights. Model release and captions required. Photographer should write only. Does not return unsolicited material. "We solicit photos by assignment only.'

Subject Needs: Travel scenes, nature, sports, couples, girls, animals and miscellaneous.

Color: Uses any size color transparency.

COMMUNITY FEATURES, Box 1062, Berkeley CA 94701. Contact: Photo Editor. Most clients are newspapers. Uses 250-280 prints/year. Pays \$15-200 a photo or 50% commission. Offers various rights. Model release preferred; captions preferred. Uses photo stories and captioned photo spreads. Send material by mail for consideration. Previously published work welcome. Work returned only if SASE is enclosed. Reports in 5-6 weeks. Photo guidelines available for \$1. Tip sheets distributed free to photographers who include additional SASE's marked "Tips" with guidelines request.

Subject Needs: Human interest, family, parenting, seniors, education, ethnic communities, travel,

consumer interest, nature, men and women filling nontraditional roles.

B&W: Uses 8x10 glossy prints.

Tips: "Photos must be storytelling shots, unusual content, well exposed and sharp with the full range of greys. Our nationwide newspaper distribution will help talented photographers build a substantial portfolio."

COMPU/PIX/RENTAL (C/P/R), 21822 Sherman Way, Canoga Park CA 91303. (213)888-9270. Photo Librarian: Dixie Thompson. Has 6,000,000 + photo files on computer. Clients include advertising agencies, public relations firms, businesses, AV firms, book publishers, magazine publishers, encyclopedia publishers, newspapers, postcard companies, calendar companies, greeting card companies. Subject Needs: General.

Specs: "We have no specifications in that we do not keep photos, but enter information about each photographer's collection in our PhotoBank (computerized). We refer clients to the photographer and they

work out price and submission between them."

Payment & Terms: "Photographer deals with client and is paid directly. C/P/R receives 25% of photo rental fee." General price range: \$75-2,000. Buys one-time rights; negotiable with photographer. Model release preferred.

Making Contact: Query with stock subject list. SASE. Reports in 2 weeks. Photo guidelines \$1.

COMSTOCK, INC., See Photofile International, page 511.

CYR COLOR PHOTO AGENCY, Box 2148, Norwalk CT 06852. (203)838-8230. Contact: Judith A. Cyr. Has 125,000 transparencies. Clients include advertising agencies, businesses, book publishers, magazine publishers, encyclopedia publishers, calendar companies, greeting card companies, poster companies and record companies. Does not buy outright; pays 50% commission. General price range: \$150 minimum. Offers one-time rights, all rights, first rights or outright purchase; price depending upon rights and usage. Model release and captions preferred. Send material by mail for consideration. SASE. "Include postage for manner of return desired." Reports in 3 weeks. Distributes tips sheet periodically to active contributors; "usually when returning rejects."

Subject Needs: "As a stock agency, we are looking for all types. Photos must be well exposed and

sharp, unless mood shots.'

Color: Uses 35mm to 8x10 transparencies.

Tips: Each submission should be accompanied by an identification sheet listing subject matter, location, etc. for each photo included in the submission.

DESIGN PHOTOGRAPHERS INTERNATIONAL, INC., (DPI), 521 Madison Ave., New York NY 10022. (212)752-3930. President: Alfred W. Forsyth. Has approximately 1 million photos. Clients include advertising agencies, businesses, book publishers, magazine publishers, encyclopedia publishers, poster companies, posteard companies, calendar companies, greeting card companies, designers and printers. Does not buy photos outright; pays 50% commission on sale of existing stock shots. General price range for color: \$135-7,000. Offers one-time rights; "outright purchase could be arranged for a fee." Model release and captions required on most subjects. "Accurate caption information a necessity. We suggest photographers first request printed information, which explains how we work with photographers, then sign our representation contract before we can interview them or look at their work. This saves their time and ours." SASE; "state insurance needed." Reports in 2 weeks-1 month. Free photo guidelines and monthly tips sheet distributed to photographers under contract.

Subject Needs: Human interest; natural history; industry; education; medicine; foreign lands; sports; agriculture; space; science; technology; ecology; energy related; leisure and recreation; transportation; U.S. cities, towns and villages; teenage activities; couples; families and landscapes. "In short, we're interested in everything." Especially needs photography from Pacific Area and Middle East Countries. Avoid brand name products or extreme styles of clothing, etc., that would date photos. "We also have a special natural history division." Ongoing need for pictures of family group activities and teenage activities; attractive all-American type family with boy and girl ages 6-12 years. Also family with teenage

kids. Model releases are needed.

B&W: Uses 8x10 semigloss doubleweight prints; contact sheet OK for editing. **Color:** Uses 35mm or larger original transparencies; "no dupes accepted."

Tips: "Master the fundamentals of exposure, composition and have a very strong graphic orientation. Study the work of top-notch successful photographers like Ken Biggs, Pete Turner or Jay Maisel." In portfolio, prefers to see "60-200 top quality cross-section of photographer's best work, on 20 slide clear plastic 35mm slide holders. Do not send loose slides or yellow boxes. Remember to include instructions for return, insurance needed and return postage to cover insurance and shipping."

DEVANEY STOCK PHOTOS, 122 E. 42nd St., New York NY 10017. (212)767-6900. President: William Hagerty. Has over 1 million photos on file. Does not buy outright. Pays 50% commission on color and 50% on b&w. Buys one-time rights. Model release preferred. Captions required. Query with list of stock photo subjects or send material by mail for consideration. SASE. Reports in 2 weeks. Free

photo guidelines with SASE. Distributes monthly tips sheet free to any photographer.

Subject Needs: High technology; computers; computer chips; video games; modern offices; breaking a tape (winning); tiger-sitting down; industrial sites; close-up of eagle swooping; people; nursing homes; modern tractor trailer shots (dramatic); robot shots; automated production line; set-ups for holidays; exchange of money; teller-lobby shots; women doing housework; stress situations; modern supermarkets, drug, department and sports stores (can be empty); children at Christmas; large meetings (small, too); executives; hard hats; excited crowds; prizefighter on ropes; skylines; street scenes; major landmarks; weather; fires; fireworks; etc.—virtually all subjects. "Releases from individuals and homeowners are most always required if photos are used in advertisements."

B&W: Uses 8x10 glossy prints; contact sheet OK.

Color: Uses all sizes of transparencies.

Tips: "It is most important for a photographer to open a file of at least 1,000 color and b&w of a variety of subjects. We will coach."

LEO DE WYS INC., 1170 Broadway, New York NY 10001. (212)689-5580. Office Manager: Grace Davies. Has 350,000 photos. Clients include advertising agencies, public relations and AV firms, business, book, magazine and encyclopedia publishers, newspapers, calendar and greeting card companies, textile firms, travel agencies and poster companies.

Subject Needs: Sports (368 categories); recreation (222 categories); travel and destination (1,450 categories); and released people pictures.

Specs: Uses 8x10 b&w prints, 35mm, medium format color transparencies.

Payment & Terms: Price depends on quality and quantity. Usually pays 50% commission. General price range: \$75-6,000. Offers to clients "any rights they want to have; pay is accordingly." Model release required; "depends on subject matter," captions preferred.

Making Contact: Query with samples "(about 20 pix) is the best way;" query with list of stock photo subjects or submit portfolio for review. SASE. Reporting time depends; often the same day. Photo

guidelines free with SASE.

Tips: "Photos should show what the photographer is all about. They should show his technical competence-photos that are sharp, well composed, have impact, if color they should show color. Competition is terrific and only those photographers who take their work seriously survive in the top markets."

DRK PHOTO, 743 Wheelock Ave., Hartford WI 53027. (414)673-6496. President: Daniel R. Krasemann. "We handle only the personal best of a select few photographers-not hundreds. This allows us to do a better job aggressively marketing the work of these photographers. We are not one of the biggest in volume of photographers but we are 'large' in quality." Clients include ad agencies; PR and AV firms; businesses; book, magazine, textbook and encyclopedia publishers; newspapers; postcard, calendar and

greeting card companies; and branches of the government.

Subject Needs: "We handle only color material: transparencies. At present we are heavily oriented towards worldwide wildlife, natural history, wilderness places and parks. Subjects also on file are photos of people enjoying nature, leisure time activities, 'mood' photos, and some city life. In addition to high quality wildlife from around the world, we are interested in seeing more photos of suburban life, entertainment, historical places, vacation lands, tourist attractions, people doing things, and all other types of photography from around the world. If you're not sure if we'd be interested, drop us a line. All transparencies on file are stored in polyethylene 'archival' storage sleeves to eliminate the possibility of any deterioration of material due to improper storage."

Specs: Uses 35mm, 21/4x21/4 and 4x5 transparencies.

Payment & Terms: Pays 50% commission on color photos. General price range: \$75-"many thousand." Sells one-time rights; "other rights negotiable between agency/photographer and client." Model

release preferred; captions required. Making Contact: "Photographers should query with a brief letter describing the photo subjects he/she has available. When submitting materials, sufficient return postage should accompany the submission. If more material is requested, DRK Photo will pay postage." SASE. Reports in 2 weeks.

Tips: Prefers to see "virtually any subject, from nature, wildlife and marinelife to outdoor recreation, sports, cities, pollution, children, scenics, travel, people at work, industry, aerials, historical buildings, etc., domestic and foreign. We look for a photographer who can initially supply many hundreds of photos and then continue supplying a stream of fresh material on a regular basis. We are always looking for new and established talent and happy to review portfolios. We are especially interested in seeing more marine photography and African, European and Far East wildlife.

*DYNAMIC GRAPHICS INC., CLIPPER & PRINT MEDIA SERVICE, 6000 N. Forrest Park Dr., Peoria IL 61614. (309)688-8800. Editor-in-Chief: Frank Antal. Photo Editor: Richard Swanson. Has 3-4,000 photos in files. Clients include ad agencies, printers, newspapers, companies, publishers, visual aid departments, TV stations, etc. Buys one-time publishing rights for clients that reuse them as they deem necessary. Model release required. Send tearsheets or folio of 8x10 b&w photos by mail for consideration; supply phone number where photographer may be reached during working hours. SASE. Reports in 2 weeks.

Subject Needs: Generic stock photos (all kinds). "Our needs are somewhat ambiguous and require that a large volume of photos be submitted for consideration. We may send a 'photo needs list' if requested." Specs: Uses 8x10 b&w prints and 4x5 color transparencies only. Captions preferred. Model release re-

quired.

Payment and Terms: Pays \$35-40/b&w photo; \$100-150/color photo. Pays on acceptance. Rights are specified in contract.

EARTH IMAGES, Box 10352, Bainbridge Island WA 98110. (206)842-7793. Director: Terry Domico. Has 60,000 photos and 3 films. Clients include advertising agencies, film makers, book publishers, businesses, magazine publishers, design firms, encyclopedia publishers and calendar companies. Subject Needs: "We specialize in color photography which depicts life on planet Earth. We are looking for natural history, geography including peoples of the world, and documentary photography. Animals, insects, birds, fish, reptiles, science, ecology, scenics, landscapes, underwater, endangered species, foreign studies, especially photojournalism, people working, action recreation-worldwide. Specs: Uses 35mm and larger slides, Kodachrome preferred. Some 16mm and 35mm motion picture

film.

This photo of a queen bee and her workers has appeared in textbooks, magazines and trade books. Last year it earned \$1,800 for the Washington-based stock photo agency Earth Images. It was taken by Earth Images' director Terry Domico.

Payment & Terms: Pays 50% commission on photos. Usual price range: \$100-650. Buys one-time rights. Captions required on slides.

Making Contact: Query with list of credits. Photo submission guidelines free with SASE. Reports in 2 weeks. Newsletter distributed twice/year to photographers represented by Earth Images. Free with SASE. Photographers represented by Earth Images have access to free computer service.

Tips: "We are seeking photographers who have particular talent and interests. We need to see at least 100 best images. We are looking for photographic excellence as this is a very competitive field. We are also interested in well done picture stories and exceptional film footage. Pictures of flowers, tiny ducks centered in the middle of the frame, 'miniature' moose, and fuzzy shots taken at the zoo just don't make it. Our focus is on quality, not quantity."

EASTERN STOCK PHOTOS, 1637 Lake Rd., Youngstown NY 14174. President: Kristen Rogers. Clients include magazine publishers, postcard, calendar and greeting card companies and book/encyclopedia publishers.

Subject Needs: "We tend to specialize in rural settings-agricultural, 'country' types of photos. The photos should be sharp, catchy and graphic—eye-catching. Try to avoid pleasant pastoral scenes—instead zero in on a specific aspect of your general subject. We're also interested in photos of children (not cutesy) and animals (these can be cutesy). Animals should not appear as though caged—they should be as natural as possible. Humorous is always welcome in any subject."

Specs: Uses 35mm color transparencies only.

Payment and Terms: Pays 50% commission on color photos. Usually sell one-time rights. Model release and captions required.

Making Contact: Query with resume of credits, samples or list of stock photo subjects; or send photos by mail for consideration. SASE. Reports in 2 weeks. Photo guidelines free with SASE.

EKM-NEPENTHE, Box 430, Carlton OR 97111. (503)852-7417. Director: Robert V. Eckert. Has 100,000 photos. Clients include advertising agencies, public relations firms, businesses, AV firms, book publishers, magazine publishers, encyclopedia publishers and newspapers. Rarely buys photos outright. Pays 50% commission on photos. General price range: \$75-2,500. Offers one-time rights. Captions preferred. Query with list of stock photo subjects. SASE. Reports in 1 month. Photo guide-

lines free on request.

Subject Needs: Subjects include Folk Art (Americana); architecture; animals; beaches; business; cities; country; demonstrations and celebrations; ecology; education; emotions; agriculture; manufacturing; food, health, medicine and science research; law enforcement; leisure; occupations; nature; art; travel; people (our biggest category); performers; political; prisons; religion; signs; sports and recreation; transportation; weather; historical subjects for our newly formed historical section; also earth sciences, biology, geology for newly developed area, etc. "We prefer b&w and color photos of prisons, education, people interaction, races (ethnic groups), people all ages and occupations (especially nontraditional ones, both male and female). Do not want to see sticky sweet pictures."

B&W: Uses 8x10 glossy, matte and semigloss contact sheets and prints.

Color: Uses any size color transparency.

Tips: "Realizing that stock is a slow business, the photographer must have a long-term perspective toward it. It can be very rewarding if you work hard at it, but it isn't for the person who wants to place his 100 best shots and wait for money to start rolling in. Try to provide unique, technically sound photos. Be object about your work. Study the markets and current trends. Also work on projects that you feel strongly about, even if there is no apparent need (as to make strong images). Photograph a lot, you improve with practice. We are actively seeking new photographers. Edit carefully. We see too much technically and aesthetically bad work. We are not looking to have the most photographers int he world of photo agencies but we would not mind having the best."

ELIOT ELISOFON ARCHIVES, NATIONAL MUSEUM OF AFRICAN ART, Smithsonian Institution, 318 A St. NE, Washington DC 20002. (202)287-3490. Contact: Archivist. Has approximately 100,000 photos. Clients include book and magazine publishers, commercial organizations and scholars. "We accept donations of photographic material in order to maintain our position as the most important repository of Africa-related photographs and films." Offers one-time publication rights on request. Does not return unsolicited material. Reports in 4-6 weeks. Free collection guide.

Subject Needs: "Our archives is only interested in photographic material on Africa. All material donated to us by photographers in the field is kept here for use by teachers, scholars and the general public."

B&W: Uses 8x10 prints; contact sheet OK.

Color: Uses 21/4x21/4 transparencies.

FINE PRESS SYNDICATE, Box 112502, Miami FL 33111. Vice President: R. Allen. Has 19,000 photos and 100+ films. Clients include advertising agencies, public relations firms, businesses, AV firms, book publishers, magazine publishers, postcard companies, calendar companies.

Subject Needs: Nudes; figure work, seminudes.

Specs: Uses color glossy prints; 35mm, 21/4x21/4 transparencies; 16mm film; videocasettes: VHS and

Payment & Terms: Pays 50% commission on color photos and film. Price range "varies according to

use and quality." Buys one-time rights.

Making Contact: Send unsolicited material by mail for consideration or submit portfolio for review.

SASE. Reports in 2 weeks.

Tips: Prefers to see a "good selection of explicit work. Currently have European and Japanese magazine publishers paying high prices for very explicit nudes and 'X-rated' materials. Clients prefer 'American-looking' female subjects."

FIRST FOTO BANK, INC., 304 E. Diamond Ave., Gaithersburg MD 20877. (301)670-0299. Director: Marilyn Davids. Has access to over one million photos. Clients include advertising agencies, public relations firms, businesses, book/encyclopedia and magazine publishers.

Subject Needs: "Our specialty is national and international/travel photography. We need spectacular shots of people, cultures, industry, nature and sports from all over the world. We particularly need model released pictures of people enjoying life (recreation, sports, picnics, etc.)."

Specs: Uses 8x10 b&w glossy or semiglossy prints; 35mm, 2½x2½, 4x5 and 8x10 transparencies. Payment & Terms: Pays 50% commission on b&w and color photos. General price range: b&w, \$50-

175; color, \$150-400 or more. Model release preferred; captions required.

Making Contact: Query with samples or list of stock photo subjects. SASE. Reports in 1 month. Tips sheet distributed "quarterly to photographers whose work I have accepted."

Tips: "Currently we need high-quality, high-tech shots. We look for imaginative, unusual slides with good color situation. *Only sharp, correctly exposed photos*. In addition to industry, we also need excellent photos of people interacting, showing emotion, and working, both here and abroad."

THE FLORIDA IMAGE FILE, 222 2nd St. N., St. Petersburg FL 33701. (813)894-8433. Contact: President. Has 40,000 photos. Clients include ad agencies; PR and AV firms; businesses; book and mag-

azine publishers; postcard, calendar and greeting card companies; and billboards.

Subject Needs: "We are not only specializing in Florida and the Caribbean, but include all of North America, Europe, Russia, Middle East and South America as well. As such, all photos which suggest a theme associated with these geographic areas can be marketed. The best way to shoot for us is to make a list of impressions that remind you of Florida, then go out and shoot it."

Specs: Uses 35mm and 8x10 transparencies, Kodachrome preferred.

Payment & Terms: Pays 50% commission on color photos. General price range: \$100-3,000. Buys one-time rights; "exceptions made for premium." Model release required; captions preferred.

Making Contact: Send unsolicited material by mail for consideration. SASE. Reports in 1 month. Pho-

to guidelines free with SASE.

Tips: "Vacations and leisure are bywords to Florida developers and promoters. The key to Florida and the Caribbean is sunshine and smiling faces. People shooting for us should see the beauty around them as though it was their first time. It often is for many seeing their published work. Keep cars, telephone poles and lines out of frame. Go for happy action, sports, intimate beach shots, wildlife-nature."

FOCUS WEST, 4112 Adams Ave., San Diego CA 92116. (619)280-3595. General Manager: Don Weiner. Has 100,000 photos. Clients include advertising agencies, public relations firms, businesses, book/encyclopedia and magazine publishers and newspapers.

Subject Needs: "We specialize in sports, recreation and leisure activities. We are interested in sports at

any level: high school, college, pro, international."

Specs: Uses 35mm transparencies.

Payment & Terms: Pays 50% commission on color photos. General price range: "We prefer to charge ASMP-level rates." Sells one-time rights. Model release and captions preferred.

Making Contact: Query with samples. SASE. Reports in 2 weeks. Agency guidelines free with SASE.

Tips sheet distributed periodically to photographers on file.

Tips: "We want a general sampling of the subjects the photographer considers as specialties; 60-80 slides are a good amount. We find a need for model-released recreational sports. There is a greater market for jogging, sailing, golf, windsurfing, etc., than some pro sports. My best advice for freelancers is to study the needs of a stock photo agency. There is a big difference between stock photography and editorial photography. The freelancer always envisions a big magazine spread as the end result of his/her work, but doesn't always realize the diverse markets that use stock photos. Work with your agency to determine the most profitable approach to creating stock photos.

FOTO ex-PRESS-ion, Box 681, Station A, Downsview, Ontario, Canada M3M 3A9. (416)736-0119. Director: Milan Kubik. Has 500,000 photos. Clients include ad, PR and AV firms; businesses; book, encyclopedia and magazine publishers; newspapers; postcard, calendar and greeting card companies. Subject Needs: "City views, industry, scenics, wildlife, travel, underwater photography, inspiration, pin-ups, people, animals. All subjects that can be used for promotion and advertising. Worldwide news and features, personalities. Photography from all countries in Eastern Block, i.e. Czechoslovakia, Soviet Union, Poland, etc."

Specs: Uses 8x10 b&w and color glossy prints; 35mm and 21/4x21/4 transparencies; 16mm, 35mm and

videotape film.

Payment & Terms: Sometimes buys photos outright; pays \$25-250/b&w; \$50-500/color. Pays 35% commission on b&w photos; 55% on color photos; 50% on film. Offers one-time rights. Model release required; captions preferred.

Making Contact: Submit portfolio for review. SAE and International Reply Coupons. Reports in 3 weeks. Photo guidelines free with SAE and International Reply Coupons. Tips sheet distributed twice a

year "on approved portfolio."

Tips: "We require photos and film that can fulfill the demand of our clientele. Quality and content therefore is essential. Photographers interested in photojournalistic assignments in Canada, U.S. or in other countries should write directly to Fotopress (News) domestic or international sections."

FOTOBANCO, 720 Milam Bldg., San Antonio TX 78205. (512)226-4626. President: David M. Stevens. Has 50,000 photos. Clients include ad agencies; PR firms businesses book, encyclopedia and magazine publishers, newspapers and calendar companies.

Subject Needs: All subjects.

Specs: Uses 35mm, 21/4x21/4, 4x5 and 8x10 transparencies.

Payment & Terms: Pays 50% commission. Buys one-time rights. Model release preferred; captions preferred, "or required, if necessary to identify photo."

Making Contact: Send samples of 100-200 slides. SASE. Reports in 1 week or immediately. Tips: "FOTOBANCO was located in Mexico City, but we have withdrawn from that market and are now working in San Antonio, Texas."

*FOUR BY FIVE, INC., 485 Madison Ave., New York NY 10022. (212)355-2323. Contact: Production Department. Clients include advertising agencies, corporations and publishers. Model release and captions required. "Write us for a submission form."

Subject Needs: Unique compositions. Artistic animals and pets, yuppies, insights on lifestyles, Ameri-

cana.

FPG INTERNATIONAL, 251 Park Ave. S., New York NY 10010. (212)777-4210. Director of Photography: Hillary Jacobs. A full service agency with emphasis on advertising, calendar, travel and corporate clients. Pays a 50% commission. "We sell various rights as required by the client." Minimum submission requirement per year—500 original color transparencies, exceptions for large format, 100 b&w full-frame glossy prints. Material may be submitted by mail for consideration or a personal interview may be arranged. Photo guidelines and tip sheets provided for affiliated photographers. Model releases required and should be indicated on photograph.

Subject Needs: High-tech industry, model released human interest, foreign and domestic scenics in large formats, still life, animals, architectural interiors/exteriors with property releases and participato-

ry sports.

Tips: "Submit regularly; we're interested in committed, high-caliber photographers only. Be selective—send only first-rate work. Our files are highly competitive."

FRANKLIN PHOTO AGENCY, 85 James Otis Ave., Centerville MA 02632. (603)889-1289. President: Nelson Groffman. Has 25,000 transparencies of scenics, animals, horticultural subjects, dogs, cats, fish, horses and insects. Serves all types of clients. Does not buy outright; pays 50% commission. General price range: \$100-300. Offers first serial rights and second serial rights. Present model release on acceptance of photo. Query first with resume of credits. Reports in 1 month. SASE. Color: Uses 35mm, 21/4x21/4 and 4x5 transparencies.

*f/STOP PICTURES, INC., Box 359, Springfield VT 05156. (802)885-5261. President: John R. Wood. Stock photo agency. Has 100,000 photos. Clients include advertising agencies, public relations firms, businesses, book/encyclopedia publishers, magazine publishers, post card companies, calendar companies, greeting card companies and poster publishers.

Subject Needs: Rural North American including everything from farms to small town life, wildlife and

natural history, people doing things. "We specialize in New England."

Specs: Uses 35mm, 21/4x21/4, 4x5 and 8x10 transparencies.

Payment & Terms: Pays 50% commission. General price range: \$150 and up. Buys one-time rights. Model and caption release required.

Making Contact & Terms: Query with samples; submit portfolio for review. SASE. Reports in 3

weeks. Tips sheet distributed quarterly to photographers with whom they have contract.

Tips: "I want to see photos that show me the photographer knows how to use the camera. This means perfect technical quality (focus, exposure, etc.), as well as interesting subject matter and composition. Increase in request for shots of people using computers and other high-tech equipment. I also get a lot of requests for photos of places, i.e. where people might go on vacation. Increasing business interest in down-home subjects, small-town values and scenics."

*FREELANCE VISUAL PRODUCTIONS, INC., Box 843, Philadelphia PA 19105. (215)342-1492. President: Leonard N. Friedman. Stock photo agency. Has 25,000 photos. Clients include advertising agencies, public relations firms, audiovisual firms, businesses, book/encyclopedia publishers, magazine publishers, post card companies, calendar companies and greeting card companies.

Subject Needs: Original Kodachromes/b&w glossies, people doing things (work; play); all travel destinations; sports, outdoor recreation, industrial (high tech, computers); all cities and towns; nature, wild-

life, landscapes, seascapes; classic shots (one of a kind); still lifes.

Specs: Uses 5x7 and 8x10 glossy b&w prints; 35mm, 21/4x21/4 and 4x5 transparencies; b&w contact

sheets. "We follow the ASMP guidelines."

Payment & Terms: Pays 50% commission on b&w and color. General price range: \$150-1,500/color (less for b&w). Buys one-time rights and will negotiate. Model release required; captions preferred. Making Contact: Query with samples or list of stock photo subjects; send unsolicited photos by mail for consideration. Deals with local freelancers by assignment only. SASE. Reports in 3 weeks. Photo guidelines free with SASE.

Tips: "We need sharp, well exposed work that will show us the photographer has a commercial sense. We have noticed that most of our photographers are the ones who really believe in what they are producing.

It is this type of a labor of love we are selling to our clients."

GAMMA/LIAISON, 150 E. 58th St., New York NY 10155. (212)888-7272. Director: Jennifer Coley. Production Editor: Anne Edmonson. Has 5 million prints. Extensive stock files include hard news (re-

504 Photographer's Market '86

portage), travel features (expedition and adventure), human interest stories, movie stills, personalities/ celebrities, corporate portraits, industrial images. Clients include newspapers and magazines, book publishers, audiovisual producers and encyclopedia publishers.

Specs: Uses b&w negatives or 8x10 glossy prints. Uses 35mm or 21/4x21/4 transparencies.

Payment & Terms: On co-produced material, photographer and agency split expenses and revenues 50/

Making Contact: Submit portfolio with description of past experience and publication credits. Tips: Involves a "rigorous trial period for first 6 months of association with photographer." Prefers previous involvement in publishing industry.

GLOBE PHOTOS, INC., 275 7th Ave., New York NY 10001. (212)689-1340. Editor: Ray Whelan. Has 10 million photos. Clients include advertising agencies, public relations firms, businesses, AV firms, book publishers, magazine publishers, encyclopedia publishers, newspapers, postcard companies, calendar companies, and greeting card companies. Does not buy outright; pays 50% commission. Offers one-time rights. Model release preferred; captions required. Arrange a personal interview to show portfolio; query with samples; send material by mail for consideration; or submit portfolio for review. Prefers to see a representative cross-section of the photographer's work. SASE. Reports in 2 weeks. Photo guidelines free with SASE; tips sheet distributed at irregular intervals to established contributors.

Subject Needs: "Picture stories in color and/or b&w with short captions and text. Single shots or layouts on celebrities. Stock photos on any definable subject. Nude girl layouts in color. Pretty girl covertype color." No straight product shots."

B&W: Uses 8x10 glossy prints; contact sheet OK.

Color: Uses transparencies.

Tips: "Find out what the markets need and produce as much as possible—regularly. There is a general increase in need of stock pictures, particularly photos of people doing things."

*HAVELIN ACTION PHOTO, 21215 Lago Circle, Boca Raton FL 33433. (305)482-1072. Contact: Michael F. Havelin. Has 5,000 b&w and color photos. Clients include advertising agencies, public relation firms, audiovisuals firms, businesses, book/encyclopedia publishers, magazine publishers, newspapers, post card companies and greeting card companies.

Subject Needs: "We specialize in underwater imagery, including salt and fresh water life (vertebrate and invertebrate), divers at work or play, dive sites, wrecks, etc. Also looking for photos of pollution and its effects, animals, insects, spiders, reptiles and amphibians, solar power and alternative energy sources."

Specs: Uses 35mm, 21/4x21/4 and 4x5 transparencies.

Payment & Terms: Pays 50% commission on b&w and color. General price range: "highly variable." Buys one-time rights, but "sometimes negotiable with buyer." Model release required; captions preferred.

Making Contact: Query with list of stock photo subjects. Send unsolicited photos by mail for consideration. SASE. Reports in 1 month. Photo guidelines free with SASE. Tips sheet distributed intermittently; free with SASE.

Tips: "We are always interested in well-exposed, informative images that have impact. Beauty is always a plus. Photo essays or images which tell a story on their own are also useful. A photographer who can research and write can sometimes pull assignment work. Photographers should not give up. Keep shooting and submitting. Don't expect to earn your living at this right away."

GRANT HEILMAN PHOTOGRAPHY, Box 317, Lititz PA 17543. (717)626-0296. Stock photo agency specializing in agriculture, natural science and U.S. scenics. "Our standard is medium format, including original black/white. Our quality is high. We have staff photographers and are not seeking commission people."

HOT SHOTS STOCK SHOTS, INC., 309 Lesmill Rd., Toronto, Ontario, Canada M3B 2V1. (416)441-3281. Submissions: Laurie Clark. "General file that is being constantly added to." Clients include ad agencies; AV firms; businesses; book; encyclopedia and magazine publishers; newspapers; postcard, calendar and greeting card companies.

Subject Needs: Animals, agriculture, scenics, industrial, people, human interest, business, action sports, recreation, beauty, abstract, religious, historic, symbolic.

Specs: Uses 35mm, 21/4x21/4, 4x5, 8x10 transparencies.

Payment & Terms: Pays 50% commission. General price range: \$150-1,500. Buys one-time rights.

Model release and captions required.

Making Contact: Send unsolicited transparencies by mail for consideration. SAE with International Reply Coupons. Reports in 1 week. Photo guidelines free with SAE and International Reply Coupons. Tips sheet distributed to member photographers "when necessary"; or free with SASE. Tips: Prefers to see "creative, colourful, sharp, up-to-date, clean transparencies only (Kodachrome preferred)."

PHOTO BANK, Box 1086, Scottsdale AZ 85252. (602)948-8805; also Idaho Photo Bank, Sun Valley Office, Box 3069, Ketchum ID 83340. (208)726-5731. General Manager: Don Petelle. Has 30,000 photos. Clients include businesses, advertising agencies, AV firms, magazine publishers, calendar companies, greeting card companies, poster companies and interior decorators.

Subject Needs: "We welcome all categories, especially people, lifestyles, business, investments, tots to aged, tots with animals, sports and activities, wildlife, world travel, scenics and food."

Specs: Uses color 35mm and 4x5 transparencies and 8x10 glossy b&w prints.

Payment & Terms: Query in regard to b&w commission; up to 60% commission on color photos. Sells one-time rights or first rights. Model release and captions required.

Making Contact: Query with SASE for a copy of contract agreements and information sheets. Send all

submissions to Arizona address. Reports in 3 weeks.

Tips: "We prefer transparencies, medium or large format, but we accept 35mm. Work should be most attractive in content. Sharp pictures only, no soft focus. Closely edit your work before sending it to us. Send at least 100 of your best photos and include sufficient return postage. We are in need of more action and vivid color in sports, close-ups of animals and wildlife so that you have some emotional feeling upon viewing. All photos should express something. Member of Picture Agency Council of America.'

ILLUSTRATOR'S STOCK PHOTOS, Box 1470, Rockville MD 20850. (301)279-0045. Executive Editor: Jack Schneider. Also has offices in Washington DC (Consolidated Newspictures); and Los Angeles (Photographic Society International, (contact Albert Molduay at (213)392-6537). Has 1,000,000 photos. Clients include advertising agencies, public relations and AV firms, businesses, book/encyclopedia and magazine publishers, newspapers, and postcard, calendar and greeting card

Subject Needs: Political personalities, over the past 30 years; all generic subjects.

Specs: Uses 8x10 b&w prints; 35mm, 21/4x21/4, 4x5 and 8x10 transparencies; and b&w and color con-

tact sheets.

Payment & Terms: Pays 50% commission on b&w and color photos. General price range: \$50 minimum b&w inside editorial use; \$75 minimum color inside editorial use. Offers one-time rights or negotiates. Model release and captions preferred.

Making Contact: Query with resume of credits or list of stock photo subjects. SASE. Reports in 3

weeks. Distributes quarterly tips sheet to "photographerss we represent."

Tips: "Many requests we receive are for photos of lifestyles involving all age groups and sexes. Also environmental issues and, this year, labor and politics.'

THE IMAGE BANK, 633 3rd Ave., New York NY 10017. (212)953-0303. President: Stanley Kanney. Has 3 million color photos. Clients include advertising agencies, public relations firms, major corporations, book publishers, magazine publishers, encyclopedia publishers, newspapers, postcard companies, calendar companies, greeting card companies and government bureaus. Does not buy outright; pays 50% commission. Rights negotiated. Model release and captions required for advertising sales. Send material by mail for consideration, or submit portfolio for review.

Subject Needs: "Our needs cover every subject area. The Image Bank has over 2,000 subject categories-travel, scenics, sports, people, industry, occupations, animals, architecture and abstracts, to name just a few. We now have 30 offices worldwide. We especially need leisure-time photos and images of people doing positive things. The people can be in any age group, but must be attractive. Model re-

leases are necessary.'

Color: "We accept only color transparencies."

Tips: Put together about 300 representative color transparencies and submit to Editing Department, 633 3rd Ave., New York NY 10017. Put all transparencies in clear vinyl pages. "Freelance photographers interested in working with The Image Bank should have a very large file of technically superb color transparencies that are highly applicable to advertising sales. Among other things, this means that closeup pictures of people should be released. The subject matter may vary widely, but should generally be of a positive nature. Although we have heretofore specialized in advertising sales, we are now building a large and superb editorial library. There has been an emphasis on the need for more sophisticated images. Very lucrative stock sales are being made by Image Bank throughout the world in areas where formerly only original assignments were considered." Also handles assignments for photographers under contract.

THE IMAGE BANK/WEST, 8228 Sunset Blvd., Los Angeles CA 90046. (213)656-9003. President: Stan Kanney. Maintains 1,000,000 photos in Los Angeles and 2,800,000 in New York. Serves advertis-

506 Photographer's Market '86

ing agencies; public relations firms; businesses; AV firms; book, magazine and encyclopedia publishers; newspapers; postcard, calendar and greeting card companies; and film/TV.

Specs: Uses 35mm color transparencies; "some larger formats."

Payment/Terms: Pays 50% commission for photos. Model release and captions required. Direct inquiries to The Image Bank in New York c/o Larry Fried, see listing above.

IMAGE FINDERS PHOTO AGENCY, INC., Suite 501, 134 Abbott St., Vancouver, British Columbia, Canada V6B 2K4. (604)688-9818. Contact: Miles Simons. Has 300,000 photos of all subjects. Clients include advertising agencies, public relations firms, businesses, AV firms, book publishers, magazine publishers, encyclopedia publishers, newspapers, postcard companies, calendar companies and greeting card companies. Does not buy outright; pays 50% commission. General price range: \$35-500, more for large ad campaigns. Offers one-time rights, all rights or first rights. For acceptance, model releases and captions must be provided. Send material by registered mail for consideration (do not send in glass mounts); U.S. or other out-of-Canada photographers should contact first before mailing. Reports on queries in 2 weeks; submissions, 2-4 weeks. Photo guidelines free with SAE and International Reply Coupons. (No US stamps-stamps must be Canadian). Distributes semiannual tips sheet to established contributors.

Subject Needs: All subjects that can be used for promotional, advertising, public relations, editorial or decorative items: scenics; people; sports; industrial; commercial; wildlife; city and townscapes; agriculture; primary industry or tourist spots. Especially needs international shots of famous landmarks. Also people of all ages engaged in all kinds of activities, especially leisure and recreational type activities, (U.S.A. and foreign-must be generic.) "We advise photographers to check technical quality with a loop before sending. We especially need photos on Canada, sports and recreation, couples in tropical beach settings, couples, events, families, children and teenagers, primary and secondary industries (especially oil and gas and mining)."

Color: Uses transparencies only.

Tips: "If traveling, take typical shots of scenics, cityscapes, points of interest, industry, agriculture and cultural activities. Try to retain seconds of assignment photography and rights to their further use. We prefer to represent photographers with large and varied stock collections and who are active in shooting stock photos. We are now at a stage of representing more photographers than we would like. Consequently material is being returned to those photographers who have failed to follow through with their initial commitment to shoot stock regularly. There are excellent opportunities for photographers with indepth selections of people, sports and recreation, the work field and world landmarks and Canada. Shoot tight lifestyle pictures of people in all recreation and family activities, work situations and locations (city and country). Remember releases. This is one of our most requested areas. Write us for detailed instructions, suggestions and tips."

IMAGES PRESS SERVICE CORP., 7 E. 17th St., New York NY 10003. (212)675-3707. Managers: Peter Gould and Barbara Rosen. Has 100,000 + photos. Clients include public relations firms, book publishers, magazine publishers and newspapers.

Subject Needs: Current events, celebrities, feature stories, pop music, pin-ups and travel. Specs: Uses b&w prints, 35mm transparencies, b&w contact sheets and b&w negatives.

Payment & Terms: Pays 50% commission on b&w and color photos. General price range: \$50-1,000. Offers one-time rights or first rights. Captions required.

Making Contact: Query with resume of credits or with list of stock photo subjects. SASE. Reports in 2 weeks.

Tips: Prefers to see "material of wide appeal with commercial value to publication market; original material similar to what is being published by magazines sold on newsstands. We are interested in ideas from freelancers that can be marketed and assignments arranged with our clients and subagents."

*INDEX STOCK INTERNATIONAL, 126 Fifth Ave., New York NY 10011. (212)929-4644. Photo Editor: Barbara Bennett. Has 250,000 photos. Clients include advertising agencies, public relations firms, audiovisual firms, businesses, book/encyclopedia publishers, magazine publishers, post card companies, calendar companies, greeting card companies, corporate design firms, in-house agencies, package design firms, and direct mail production houses.

Subject Needs: Agriculture, business, computers, science and research, technology, medical, US transportation, industry, utilities, computer graphics, astronomy, as well as animals, nature, sports, travel, people at work and leisure, and more.

Specs: Uses 35mm, 21/4x21/4, 4x5 and 8x10 transparencies. Strong preference for "Kodachrome." Payment & Terms: Buys photos/films outright; depends on photo. Pays 50% commission on color photos with exceptions of catalog photos. General price range: \$125-5,000. Sell one-time rights plus some limited buy-outs and exclusives. Model release and captions required.

Making Contact: Query with list of stock photo subjects. Responds in 2 weeks. Photo guidelines free. Tips sheet distributed 4-8 times/yearly to photographers contracted to ISI.

INTERNATIONAL STOCK PHOTOGRAPHY, LTD., 113 E. 31st St., New York NY 10016. (212)696-4666. Contact: Donna Macfie or Robert Brow. Has 300,000 photos. Clients include ad agencies, PR and AV firms, businesses, book, magazine and encyclopedia publishers; travel companies, poster, calendar and greeting card companies. Has overseas representation in Toronto, Tokyo, London, Milan, Dusseldorf, Amsterdam and Vienna.

Subject Needs: Domestic and foreign travel, leisure photos of families, couples and adults (model re-

leased); sports, industrials and still life, scenics (large format).

Specs: Uses 8x10 b&w prints; 35mm, 21/4x21/4, 4x5 or 8x10 original transparencies.

Payment & Terms: Pays 50% commission on b&w or color photos. "We generally follow ASMP guidelines." Sells one-time, first or all rights or negotiates rights to clients. Photos from photographers on consignment. Model release preferred; captions required.

Making Contact: Query with samples or list of stock photo subjects or submit portfolio for review. Send unsolicited material by mail for consideration. SASE. Reports in 2-3 weeks. Photo guidelines free

with SASE. Tips sheet distributed "every few months" to member photographers.

Tips: Prefers to see "an overview of what the photographer has to offer for stock—about 200 if 35mm size, in plastic sheets of 20 per page—or less if in larger format. To be put in some order of categories or places." Especially interested in "young and middle-aged couples (released), in active situations, sports, and new technologies. Think about presentation of work, captions, etc. from a buyer's point of

INTERPRESS OF LONDON AND NEW YORK, 400 Madison Ave., New York NY 10017. Editor: Jeffrey Blyth. Has 5,000 photos. Clients include magazine publishers and newspapers. Does not buy outright. Offers one-time rights. Send material by mail for consideration. SASE. Reports in 1 week. Subject Needs: Offbeat news and feature stories of interest to European editors. Captions required. B&W: Uses 8x10 prints.

Color: Uses 35mm transparencies.

JEROBOAM, INC., 122D-27th St., San Francisco CA 94110. (415)863-7975. Contact: Ellen Bunning. Has 50,000 b&w photos, 35,000 color slides. Clients include text and trade books, magazine and encyclopedia publishers. Consignment only; does not buy outright; pays 50% commission. Offers onetime rights. Model release and captions required where appropriate. Call if in the Bay area; if not, query with sample, query with list of stock photo subjects, send material by mail for consideration or submit portfolio for review. "We look at portfolios the first Wednesday of every month." SASE. Reports in 2 weeks.

Subject Needs: "We want people interacting, relating photos, artistic/documentary/photojournalistic images, especially minorities and handicapped. Images must have excellent print quality-contextually interesting and exciting, and artistically stimulating." Need shots of school, family, career and other living situations. Child development, growth and therapy, medical situations. No nature or studio shots.

B&W: Uses 8x10 double weight glossy prints with a 3/4" border.

Color: Uses 35mm transparencies.

Tips: "The Jeroboam photographers have shot professionally a minimum of 5 years, have experienced some success in marketing their talent and care about their craft excellence and their own creative vision. Jeroboam images are clear statements of single moments with graphic or emotional tension. New trends are toward more intimate, action shots."

*JOAN KRAMER AND ASSOCIATES, INC., 5 N. Clover Dr., Great Neck NY 11021. (212)567-5545, President: Joan Kramer, Has 1 million b&w and color photos dealing with travel, cities, personalities, animals, flowers, scenics, sports and couples. Clients include advertising agencies, magazines, recording companies, photo researchers, book publishers, greeting card companies, promotional companies and AV producers. Does not buy outright; pays 50% commission. Offers all rights. Model release required. Query or call to arrange an appointment. SASE. Do not send photos before calling. Subject Needs: "We use any and all subjects! Stock slides must be of professional quality."

B&W: Uses 8x10 glossy prints. Color: Uses any size transparencies.

HAROLD M. LAMBERT STUDIOS, INC., Box 27310, Philadelphia PA 19150. (215)224-1400. Vice President: Raymond W. Lambert. Has 1.5 million b&w photos and 400,000 color transparencies of all subjects. Clients include advertising agencies, publishers and religious organizations. Buys photos outright—"rates depend on subject matter, picture quality and film size"; or pays 50% commission on color. Offers one-time rights. Present model release on acceptance of photo. Submit material by mail for consideration. Reports in 2 weeks. SASE. Free photo guidelines.

Subject Needs: Farm, family, industry, sports, scenics, travel and people activities. No flowers, zoo

shots or nudes.

508 Photographer's Market '86

B&W: Send negatives or contact sheet. Photos should be submitted in blocks of 100.

Color: Send 35mm, 21/4x21/4 or 4x5 transparencies.

Tips: "We return unaccepted material, advise of material held for our file, and supply a contact record print with our photo number." Also, "we have 7 selling offices throughout the U.S. and Canada."

FREDERIC LEWIS, INC., 15 W. 38th St., New York NY 10018. (212)921-2850. President: David Perton. Has 1 million + color and b&w photos of all subjects. Clients include advertising agencies, TV, book, art and magazine publishers, record companies, major corporations and packaging designers. Does not buy outright; pays 40-50% commission. Offers all rights. Present model release on acceptance of photo. Call to arrange an appointment or submit portfolio. Request "want" list. SASE. Photo guidelines free with SASE; tips sheet free on request.

Color: Uses transparencies of all subjects. Especially looking for out-of-the-ordinary treatment of ordi-

nary subjects: people, places, things and events.

B&W: Uses 8x10 glossy prints of all subjects.

Tips: "We will always look at a photographer's work, and will make the attempt to see you."

LIGHTWAVE, Suite 306-114, 1430 Massachusetts Ave., Cambridge MA 02138. (617)566-0364. Contact: Paul Light. Has 20,000 photos. Clients include ad agencies, book publishers, graphic designers and magazines.

Subject Needs: Candid photos of families, people at work, sports, public festivals, political demonstrations, national parks. General documentation of France, Japan, Spain, Mexico and United States.

Specs: Uses 8x10 glossy b&w prints and Kodachrome transparencies.

Making Contact: Mail Kodachromes in slide sheets for consideration. SASE.

Tips: "Photographers should have a photojournalistic or documentary photography background. The quantity of work you put on file is secondary to the quality. Work should be carefully edited before submission. Shoot constantly and watch what is being published. I go out of my way to give my photographers tips on what I am looking for as well as feedback as to why some of their work gets rejected. This is a very competitive field."

MAIN IMAGE PHOTOGRAPHICS, 285 S. Pearl St., Denver CO 80209. (303)698-2936/2937. Contact: Renee C. Arrington. "A full service picture agency offering clients over 20,000 current, original color images of a variety of subjects including the Rockies and the West, Denver cityscapes, people, skiing, and the history of photography." Clients include advertising agencies, public relations and AV firms, book/encyclopedia and magazine publishers and postcard companies. Subject Needs: People, family activities, recreation, sports, science, computer and medical technolo-

Specs: Uses color transparencies.

Payment & Terms: Pays 50% commission. General price range: ASMP guidelines.

Making Contact: Query with resume of credits and samples. SASE. Reports in 3 weeks.

Tips: "We prefer to see at least 100 images. Send transparencies in plastic slide pages with return postage. If you are submitting images including people, please designate with the letters 'MR' when a model release is available. Model releases are almost always required in order to market people images. The more images that you shoot and can send to us, the more chances of making money. We are constantly updating our files and so do not like to keep old transparencies around that are not selling."

MEDICHROME, 271 Madison Ave., New York NY 10016. (212)679-8480. Manager: Anne Darden. Has 100,000 photos. Clients include publications firms, businesses, book/encyclopedia and magazine

publishers, newspapers and pharmaceutical companies.

Subject Needs: Needs "everything that is considered medical or health-related, such as: stock photos of doctors with patients and general photos of that nature to very specific medical shots of diseases and surgical procedures; high-tech shots of the most modern diagnostic equipment; exercise and diet also."

Specs: Uses 8x10 b&w prints and 35mm, 21/4x21/4, 4x5 and 8x10 transparencies.

Payment & Terms: Pays 50% commission on b&w and color photos. General price range: "125 for comp and AV; all magazine and other editorial, such as book, are ASMP prices with few exceptions. All brochures are based on size and print run. Ads are based on exposure and length of campaign." Buys one-time rights or first rights ("if possible and requested"); all rights ("rarely needed-very costly"). Model release preferred; captions required.

Making Contact: Query by "letter or phone call explaining how many photos you have and their subject matter." SASE. Reports in 2 weeks. Distributes tips sheet every 6 months to Medichrome photogra-

phers only.

Tips: Prefers to see "loose prints and slides in 20-up sheets. All printed samples welcome; no carousel, please. Lots of need for medical stock. Very specialized and unusual area of emphasis, very costly/difficult to shoot, therefore buyers are using more stock."

*METRO ASSOCIATED SERVICE, 33 West 34th St., New York NY 10001. (212)947-5100. Research Coordinator: Stephen Tortorici. Camera-ready art service. Has 3,500 photos. Clients include advertising agencies, businesses, printers, over 4,000 daily and weekly newspapers.

Subject Needs: Handles family life, gardening, agriculture, fashion, industry, scenics; "will consider

all legitimate subjects.'

Specs: Uses 8x10 b&w prints; 35mm, 21/4x21/4, 4x5 and 8x10 transparencies. "We pay quickly for all work accepted." Buys one-time repro rights; "our clients can reuse these photos at their own discretion." Model release required. Submit portfolio for review. SASE. Reports in 1 month.

NATIONAL CATHOLIC NEWS SERVICE, 1312 Massachusetts Ave., NW, Washington DC 20005. (202)659-6720. Photo Editor: Bob Strawn. Wire service transmitting news and feature material to Catholic newspapers. Pays \$25/photo also \$50-200/job and \$50-300 for text/photo package. Offers one-time rights. Captions required. Send material by mail for consideration. SASE. Reports in 2 weeks. Photo guidelines free with SASE.

Subject Needs: News or feature material related to the Catholic Church or Catholic people; head shots of Catholic newsmakers; close-up shots of news events, religious activities; timeless feature material (family life, human interest, humor, seasonal). Especially interested in photo depicting modern lifestyles, e.g., women in traditionally male jobs, people coping with the economy, families in conflict,

priests counseling couples, unusual ministries.

B&W: Uses 8x10 glossy prints.

Tips: "Submit 10-20 good quality prints with first letter covering a variety of subjects. Some should have relevance to a religious audience. Knowledge of Catholic experience and issues are helpful. All should have some caption information. We are mainly interested in people. No scenics, no churches, no flowers, no animals. As we buy a great deal of material, chances for frequent sales are very good. We are probably an easier market to crack than most publications. Send a packet of prints every two months. If NC doesn't buy at least one print from each packet (after two or three failures) seek other markets. Send only your best, sell only one-time rights. I see a constant demand for family photos, Catholic weddings, and a special need for photos of teens.'

NATIONAL NEWS BUREAU, 2019 Chancellor St., Philadelphia PA 19103. (215)569-0700. Photo Editor: Andy Edelman. Clients include book/encyclopedia and magazine publishers and newspapers. Distribute/syndicate to 1,100 publications.

Subject Needs: "All feature materials; fashion; celebrity."

Specs: Uses 8x10 b&w and color prints and b&w and color contact sheets.

Payment & Terms: Buys photos outright; pays \$15-250. Buys all rights. Model release and captions re-

Making Contact: Query with samples; send photos by mail for consideration; submit portfolio for review. SASE. Reports in 2 weeks.

Tips: Needs photos of "new talent-particularly undiscovered female models."

OMEGA NEWS GROUP/USA, A.S. Rubel, Inc., Philadelphia PA 19107-5449. (215)985-9200. Managing Editor: A. Stephen Rubel. Stock photo and press agency servicing advertising agencies, public relations firms, businesses, book publishers, magazine publishers, encyclopedia publishers, newspapers, calendar and poster companies.

Subject Needs: "All major news, sports, features, society shots, shots of film sets, national and international personalities and celebrities in the news as well as international conflicts and wars."

Specs: Uses 35mm, 21/1x21/4 or 4x5 transparencies; 8x10 b&w glossy prints. Photos must be stamped with name only on mounts and back of prints; prints may be on single or double weight but unmounted. Payment & Terms: Pays 50% commission. Price depends upon usage (cover, inside photo, etc.). Offers first North American serial rights; other rights can be procured on negotiated fees. Model release and captions required on most subjects.

Making Contact: Submit material by mail for consideration. SASE. Send resume, including experience, present activities and interests, and range of equipment. Supply phone number where photogra-

pher may be reached during working hours. Photo guidelines and tip sheet with SASE.

Tips: Should have experience in news and/or commercial work on location. "We always welcome the opportunity to see new work. We are interested in quality and content, not quantity. Comprehensive story material welcomed.'

OMNI-PHOTO COMMUNICATIONS, INC., 521 Madison Ave., New York NY 10022. (212)751-6530. President: Roberta Guerette. Has 10,000 photos. Clients include advertising agencies, public relations firms, businesses, AV firms, book publishers, magazine publishers, encyclopedia publishers, newspaper, postcard companies, calendar companies, greeting card companies.

Subject Needs: "The file is a general stock file (color and b&w) with an emphasis on human interest."

Specs: Uses 8x10 b&w double weight semiglossy prints and transparencies.

Payment & Terms: Pays 50% commission on b&w and color photos. Price range "very much depends on the usage." Buys one-time rights. Model release and captions preferred.

Making Contact: Query with samples or with list of stock photo subjects. SASE. Reports in 1 month. Tips sheet distributed to signed photographers.

Tips: "I like to see a variety of work with emphasis on the subjects that particularly interest the photographer. Enough variation should be included to show how technique is handled as well as aesthetics."

PANOGRAPHICS, Box 4191, Utica NY 13504. (315)797-9194. Contact: Larry Stepanowicz. Clients include advertising agencies, AV firms, book publishers and magazine publishers.

Subject Needs: Nature, biological, photomicrography, scientific; life in the U.S.—people, places and things; graphic, poster-like images of all types including sports, children, models.

Specs: Uses 35mm, 21/4x21/4 slides.

Payment & Terms: Two year contract, or may duplicate selected material and return originals. Pays 50% commission on b&w and color photos. Offers one-time rights in most cases. Model release and captions preferred.

Making Contact: Query with samples or with list of stock photo subjects. SASE. Reports in 2 weeks. "Will give beginners a chance if work is of outstanding quality."

Tips: "Know your craft. Strive for quality. Build a large collection of photos over time."

PHOTO ASSOCIATES NEWS SERVICE, INC., Box 306, Station A, Flushing NY 11358. (212)619-1700 or (718)961-0909; MCI Mail: 217-8611; Telex: 75-0809 (Photo UD). Managing Editors: Rita Allen and Rick Maiman. Syndicates feature stories and photos.

Subject Needs: Features dealing with education, health, science, entertainment, travel, etc.

First Contact & Terms: "First send us clips (photocopies only) of published work and a list of stories you already have, or ideas you are considering. After reviewing the material, we will respond, usually within a week. If you do not have published work, we are always willing to take a look, but we are looking for talent with the staying power for the long haul. We will handle one-time sales, but prefer opening up a long-term relationship with the photographer." Features and general interest material should be addressed to Rita Allen; entertainment and papparazzi to Rick Maiman; public safety issues to Rick Moran. Takes 35% commission on all sales; reports monthly to staff and stringers.

Tips: "We are very interested in meeting new talent. We prefer photographers who can provide us with written material to accompany their art, but do not rule out anyone with talent. Photographers specializing in public safety issues (police, fire, ambulance, paramedics) are also urged to contact us. An area that is in big demand all the time is celebrity material, interviews. etc. Members of The National Press Photographers Association, American Society of Magazine Photographers and National Writers Union are given priority.'

*PHOTO MEDIA, LTD., 3 Forest Glen Rd., Newpaltz NY 12561. (914)255-8661. Photographer's queries to 3 Forest Glen Rd., New Paltz NY 12561. Contact: Jane Reynolds. Has 50,000 color transparencies only. Clients include advertising agencies, public relations firms, businesses, AV firms, book publishers, magazine publishers, calendar companies and greeting card companies. Does not buy outright; pays 50% commission. Offers one-time worldwide rights. Model release required; identify locations of geographical photos. Query with samples. SASE. Reports in 1 month. Photo guidelines free

Subject Needs: Human interest, faces, couples, medical, crime, mood, special effect, nature, ecology, sports, industry, police, music, dance, personalities, leisure, vacation, retirement, arts, crafts. Wants professional, clean transparencies, with good color saturation or subject matter, technically competent, imaginative and profound in its own way." No fashion or scenic 35mm.

Color: Uses transparencies.

Tips: "Specialize in human interest, nature, medical, scientific or industrial photography and submit only specialized material."

*PHOTO NETWORK, 1541J Parkway Loop, Tustin CA 92680. Owners: Mrs. Cathy Aron and Ms. Gerry McDonald. Stock photo agency. Pays 50% commission. General price range: \$50-750. Works with ad agencies, AV producers-multimedia productions, textbook companies, graphic artists. Model release and captions required. Query with list of stock photo subjects. SASE. Reports in 4 weeks. Subject Needs: Needs shots of "personal" sports such as jogging, exercises, racquetball, tennis, golf, skiing. Also energy uses, industrial shots. waste disposal, families, offices, animals and ethnic groups. B&W: Contact sheet OK.

Color: Uses 35mm, 21/4x21/4 and 8x10 b&w glossies.

PHOTO RESEARCHERS, INC., 60 E. 56th St., New York NY 10022. (212)758-3420. President: Jane Kinne. Computer-controlled agency for hundreds of photographers including the National Audubon Society Collection. Clients include ad agencies and publishers of textbooks, encyclopedias, filmstrips, trade books, magazines, newspapers, calendars, greeting cards, posters, and annual reports in U.S. and foreign markets. Rarely buys outright; works on 50% stock sales and 30% assignments. General price range: \$75-7,500. Submit model release with photo. Query with description of work, type of equipment used and subject matter available; arrange a personal interview to show portfolio; or submit portfolio for review. Reports in 1 month maximum. SASE.

Subject Needs: All aspects of natural history and science; human nature (especially children and young adults 6-18 engaged in everyday activity); industry; "people doing what they do"; and pretty scenics to informational photos, particularly need model released people photos and property photos such as

houses, cars and boats.

B&W: Uses 8x10 matte doubleweight prints.

Color: Uses any size transparencies.

Tips: "When a photographer is accepted, we analyze his portfolio and have consultations to give the photographer direction and leads for making sales of reproduction rights. We seek the photographer who is highly imaginative, or into a specialty, enthusiastic and dedicated to technical accuracy. Have at least 400 photos you deem worthy of reproduction, be adding to your files constantly and fully caption all material."

PHOTOFILE INTERNATIONAL, (now called Comstock, Inc.), 32 E. 31st St., New York NY 10016. (212)889-9700. General Manager: Judy Yoshioka. Has 1,000,000. Clients include advertising agencies, public relations and AV firms, businesses, book/encyclopedia and magazine publishers, newspapers, and postcard, calendar and greeting card companies.

Subject Needs: Write for subject guidelines.

Specs: Uses 35mm (preferred), 21/4x21/4, 4x5 or 8x10 transparencies.

Payment & Terms: Pays 50% commission on color photos. General price range: \$250-15,000. Model

release and captions required.

Making Contact: Lynn Eskanazy, photography coordinator. Query with resume of credits or list of stock photo subjects. SASE. Reports in 3 weeks.

Tips: "We represent very few photographers all of whom are extremely productive. Most of whom

make their living from stock photography."

PHOTOPHILE, 2311 Kettner Blvd., San Diego CA 92101. (714)234-4431. Director: Linda L. Rill. Clients include advertising agencies, book publishers, magazine publishers, encyclopedia publishers and newspapers. Does not buy outright; pays 50% commission. Offers one-time rights or all rights. Captions required. Send material by mail for consideration. SASE.

Subject Needs: People: vocations and activities; sports and action shots; scenics of California, U.S.

and areas of interest around the world. Professional material only.

Color: Uses 35mm, 21/4x21/4 or 4x5 transparencies. Tips: "Specialize."

PHOTOTAKE, 4523 Broadway, New York NY 10040. (212)942-8185. Director: Leila Levy. Stock photo agency; "also 'new wave' photo agency specializing in science and technology in stock and on assignment." Has 10,000 photos. Clients include advertising agencies, businesses, newspapers, public relations and AV firms, book/encylcopedia and magazine publishers, and postcard, calendar and greeting card companies.

Subject Needs: General science and technology photographs, medical, high-tech, computer graphics,

special effects for general purposes, health oriented photographs.

Specs: Uses 8x10 prints; 35mm, 21/4x21/4, 4x5 or 8x10 transparencies; contact sheets or negatives. Payment & Terms: Pays 50% commission on b&w and color photos. Buys one-time or first rights (world rights in English language, etc.). Model release and captions required.

Making Contact: Arrange a personal interview to show portfolio; query with samples or with list of stock photo subjects; or submit portfolio for review. SASE. Reports in 1 month. Photo guidelines "given on the phone only." Tips sheet distributed monthly to "photographers that have contracted with us at

least for a minimum of 40 photographs."

Tips: Prefers to see "at least 80 color photos on general photojournalism or studio photography and at least 5 tearsheets-this, to evaluate photographer for assignment. If photographer has enough in medical, science, general technology photos, send these also for stock consideration." Using more "illustration type of photography—for example 'Life After Death' requiring special effects. Topics we currently see as hot are: general health, computers, news on science. Photographers should always look for new ways of interpreting the words: 'technology' and 'science.' '

PhotoUNIQUE, 1328 Broadway, Penthouse, New York NY 10001. (212)244-5511. President: Ron Basile. Has 400,000 photos. Clients include ad agencies, design firms, calendar companies and some editorial.

Subject Needs: Corporate/industrial, agricultural, travel, scenic, nature, sports, people.

Specs: Uses 35mm, 21/4x21/4 or 4x5 transparencies.

Payment & Terms: Pays 50% commission for color photos. General price range: ASMP prices. Buys one-time rights. Model release required; captions required.

Making Contact: Arrange a personal interview to show portfolio. Deals with all U.S. photographers and some European photographers. Reports in 2 weeks. Tips sheet distributed quarterly to "our photographers only."

Tips: Prefers to see "strong design elements, good graphic ability, strength in corporate photography. We discourage inquiries by celebrity or news photographers. Our clients look to create visual excitement with our material. Material on high-tech areas that pave the way to the future is what we're asked for constantly. Fields such as telecommunications, computers, robots, medical technology are good examples."

PHOTRI INC., Box 971, Alexandria VA 22313. (703)836-4439. President: Jack Novak. Has 400,000 b&w photos and color transparencies of all subjects. Clients include book and encyclopedia publishers, advertising agencies, record companies, calendar companies, and "various media for AV presentations." Seldom buys outright; pays 50% commission. General price range: "\$50-unlimited." Offers all rights. Model release required if available and if photo is to be used for advertising purposes. Call to arrange an appointment or query with resume of credits. Reports in 2-4 weeks. SASE.

Subject Needs: Military, space, science, technology, romantic couples, people doing things, humor picture stories. Special needs include calendar and poster subjects. Has subagents in 10 foreign countries

interested in photos of USA in general.

B&W: Uses 8x10 glossy prints.

Color: Uses all sizes of 35mm and larger transparencies.

Tips: "Respond to current needs with good quality photos. Take other than sciences, i.e., people and situations useful to illustrate processes and professions. Send photos on energy and environmental subjects. Also need any good creative 'computer graphics'."

PICTORIAL PARADE, INC., 130 W. 42nd St., New York NY 10036. (212)840-2026. President: Baer M. Frimer. Has over 1 million photos. Clients include advertising agencies, public relations firms, businesses, AV firms, book publishers, magazine publishers, encyclopedia publishers, newspapers, postcard companies, calendar companies and greeting card companies. Does not buy outright; pays 50% commission. Offers one-time rights. Model release and captions required. Send material by mail for consideration. SASE. Reports "as rapidly as possible, depending upon the amount of material to be reviewed."

Subject Needs: News events all over the world, famous personalities and celebrities, authors, scientific discoveries, stoppers and photo features.

B&W: Uses 8x10 glossy prints; contact sheet and negatives OK.

Color: Uses transparencies.

THE PICTURE CUBE, Suite 300, 89 State St., Boston MA 02109. (617)367-1532. Manager: Sheri Blaney. Has 100,000 photos. Clients include advertising agenices, public relations firms, business, AV firms, book publishers, magazine publishers, encyclopedia publishers, newspapers, postcard companies, calendar companies, greeting card companies and TV.

Subject Needs: U.S. and foreign coverage, contemporary images, agriculture, industry, energy, high technology, religion, family life, multicultural, animals, plants, transportation, work, leisure, travel, ethnicity, communications, people of all ages, psychology and sociology subjects.

Specs: Uses 8x10 or 11x14 b&w prints and 35mm, 21/4x21/4, 4x5 and larger slides.

Payment & Terms: Pays 50% commission. General price range: \$75 minimum/b&w; \$135 minimum/color photo. Buys one-time rights. Model release preferred; captions required.

Making Contact: Arrange a personal interview to show portfolio. SASE. Reports in 1 month. Tips: Serious freelance photographers "must supply a good amount (at least a thousand images per year, of high quality, sales-oriented subject matter) of material, in order to produce steady sales."

PICTURE GROUP, INC., 5 Steeple St., Providence RI 02903. (401)273-5473. Picture Editor: Don Abood. Has 250,000 photos. Clients include advertising agencies, public relations firms, AV firms, book publishers, magazine publishers, encyclopedia publishers and newspapers. "We work on assignment, too."

Subject Needs: "We look for news, news features, celebrities, politicians, etc., of national and international importance. We are interested in photos that deal with issues affecting life in the eighties; our markets are primarily editorial. We are not an outlet for photos of cute animals or typical scenics." **Specs:** Uses 8x10 gloss or glossy dried matte b&w prints; 35mm, 2¹/₄x2¹/₄ slides.

Payment & Terms: Pays 50% commission for stock photos; 60% commission for assigned photos.

General price range: "ASMP rates." Buys one-time rights. Model release preferred; captions required. Making Contact: Query with samples. SASE. Reports in 2 weeks. Photo guidelines free with SASE.

Tips sheet distributed monthly to agency photographers.

Tips: "Just about any subject is of interest to some market, but we are seeing many requests for pictures that deal with the economy, future life, science, technology, the military, Latin America, energy alternatives and the environment. A photographer who wishes to work successfully with us should follow current news and trends.'

PICTURES INTERNATIONAL, Box 14051, Tulsa OK 74159. (918)664-1339. President: James W. Wray II. Has 50,000 photos. Clients include advertising agencies, public relations and AV firms; businesses, book/encyclopedia and magazine publishers, newspapers, postcard, calendar and greeting card companies.

Specs: Uses 8x10 b&w or color glossy prints; 35mm, 21/4x21/4, 4x5, 8x10 transparencies; b&w or color

contact sheets; b&w or color negatives.

Payment & Terms: Pays 50% commission on b&w and color photos. Buys all rights. Model release and

captions required.

Making Contact: Arrange a personal interview to show portfolio; submit portfolio for review. SASE. Reports in 1 month. Photo guidelines free with SASE. Tips sheet distributed "first by mailing list;" free with SASE.

Tips: "Ours is an agency supplying photos to a widely varied market. We will consider all types of photos as long as they are top quality.

PRO/STOCK, 11046 McCormick, North Hollywood CA 91601. (213)877-5694. President: Wayne Hallowell. Photo stock service. Clients: corporations, manufacturers, entertainment.

Needs: Works with 80-95 freelance photographers/year. Uses photographers for brochures, catalogs, posters, AV presentations, newsletters and annual reports. Subject matters covers "all areas." Also works with freelance filmmakers to produce movie titles and training films; "all types dependent on requirement or effects desired by projects."

Specs: Uses 8x10 b&w and color prints; 35mm, 4x5 and 8x10 transparencies.

First Contact & Terms: Arrange a personal interview to show portfolio or submit portfolio for review; provide resume, 2 business cards and samples to be kept on file for possible future assignments. SASE. Reports in 2 weeks. Pays ASMP rates per hour or job. Buys all rights or one-time rights. Model release and captions preferred. Credit line given "sometimes."

R.D.R. PRODUCTIONS, INC., 351 W. 54th St., New York NY 10019. (212)586-4432. President: Al Weiss. Photo Editors: Wendy Raynor and Chuck Musse. Has 700,000 photos. Clients include advertising agencies, public relations firms, book publishers, magazine publishers, newspapers and calendar companies.

Subject Needs: Primarily editorial material: human interest, personalities, glamour and current news features.

Specs: Uses b&w and color glossy prints; 35mm and 21/4x21/4 slides; and b&w negatives. **Payment & Terms:** "Occasionally" buys photos outright; price open. Pays 60% commission for photos. General price range varies from \$35/b&w to \$1,500 for color series. Average for b&w \$75; average for single color \$150. Buys one-time rights. Model release and captions required.

Making Contact: Query with samples or with list of stock photo subjects or send unsolicited material by mail for consideration. SASE. Reports in 3 weeks. Tips sheet distributed "approximately quarterly to

photographers we represent."

RELIGIOUS NEWS SERVICE PHOTOS, 104 W 56th St., New York NY 10019. (212)315-0870. Photo Editor: Jim Owen. Picture library. Maintains 250,000 photos. Serves church-related newspapers (Protestant, Catholic and Jewish).

Specs: Uses 5x7 glossy b&w photos. "Need not be original photos."

Payment & Terms: Pays \$25 minimum/photo. Buys outright. Buys all rights. Captions required. Making Contact: Send material by mail for consideration. Open to solicitations from anywhere. SASE. Reports in 1 week.

*CHRIS ROBERTS REPRESENTS:, Box 7218, Missoula MI 59807. (406)728-2180. Owner: Chris Roberts. Stock photo and artists representation agency. Clients include advertising agencies, public relations firms, audiovisual firms, businesses, book/encyclopedia publishers, magazine publishers, post card companies, calendar companies and greeting card companies.

Subject Needs: Travel, western scenic, advertising, editorial, ethnic and wildlife.

Specs: Uses 21/4x21/4, 35mm and 4x5 transparencies; b&w contact sheets.

Payment & Terms: Pays 50% commission on b&w and color photos. General price range: \$50-1,500.

Buys one-time rights or all rights. Model release preferred; captions required.

Making Contact: Arrange a personal interview to show portfolio; query with resume of credits, samples, or list of stock photo subjects; send unsolicited photos by mail for consideration; submit portfolio for review. Solicits photos by assignment only. Does not return unsolicited material. Reports in 3 weeks.

SEAPHOT LTD/PLANET EARTH PICTURES, 83-84 Long Acre, London WC2 9NG England. 01-240-5037. Managing Director: Gillian Lythgoe. Has 80,000 photos. Clients include advertising agencies, public relations and AV firms, businesses, book/encyclopedia and magazine publishers, and postcard and calendar companies.

Subject Needs: "Marine—surface and underwater photos covering all marine subjects, including water sports, marine natural history, seascapes, ships; natural history—all animals and plants: interrelationships and behavior; lanscapes, natural environments, the people and the animals and plants."

Specs: Uses any size transparencies.

Payment & Terms: Pays 50% commission on color photos. General price range. £30 (1 picture/1 AV showing), to over £1,000 for advertising use. Prices are all negotiated individually according to use. Offers one-time rights. Model release preferred; captions required.

Making Contact: Arrange a personal interview to show portfolio; send photos by mail for consider-

ation. SASE. Reports ASAP. Distributes tips sheet every 6 months to photographers.

Tips: "We like photographers to have received our photographer's booklet that gives details about photos and captions. Trends change rapidly. There is a strong emphasis that photos taken in the wild are preferable to studio pictures."

SHASHINKA PHOTO, Suite 2102, 501 5th Ave., New York NY 10017. Contact: Jane Hatta or A. Matano. Has over 100,000 photos in New York and Tokyo. Clients include AV firms, book publishers, magazine publishers, encyclopedia publishers and newspapers. Does not buy outright; pays 50% commission/35mm transparencies; 60% commission for larger format. Offers one-time rights. Model release and captions required. Send material by mail for consideration with SASE. No reply/return without SASE. Reports immediately.

Subject Needs: "We're strong on East Asian cultures because of our Tokyo office. We're also interested in material for a monthly children's picture book for schools (kindergarten through 3rd grade)." Uses very little b&w. Also needs wildlife, with theme or in sequence; natural, unposed photos of families having meals in their homes; photos of children 4-8 years old for specific shots. Especially needs photos for children's science monthly book on natural and physical sciences. Any series that tells or explains phenomena. Artistic nudes but no pornography.

Color: Prefers 21/4x21/4 and larger transparencies.

Tips: "Poor technical quality turns us off. Every Tom, Dick and Harry with a camera thinks he's a professional photographer, and it's wasting time for us both." Photographer should have professional technique; know lighting and composition.

SHOOTING STAR INTERNATIONAL PHOTO AGENCY, INC., Box 93368, Hollywood CA 90093. (213)876-5555 or 876-8208. President; Yoram Kahana. Clients include book/encyclopedia and magazine publishers, newspapers and "anyone using celebrity and human interest photos."

Subject Needs: "We specialize in celebrity photos and photostories, with emphasis on at-home sessions, portraits, studio and special events. Mostly TV names, also film, music, etc. We also distribute timeless human interest photostories—unusual sports, medical, animals, oddities."

Specs: Uses color only; mostly 35mm, some 21/4x21/4 transparencies.

Payment & Terms: Pays 60% commission on color photos. General price range: "from a few dollars in some Third World countries to thousands of dollars for cover use in U.S.A. or Europe." Captions or text should be provided.

Making Contact: Query with list of stock photo subjects. SASE. Reports ASAP. Information sheet available free with SASE.

Tips: "We can resell your celebrity photos if: a) You are a pro working with celebrities—for example, a fashion photographer in New York who did a fashion shoot with the cast of *Fame* for a woman's magazine, another who did a session with Debbie Allen for a black magazine; b) You shoot a celebrity in an out-of-the-way place (not Los Angeles or New York)—for example, a newspaper photographer in Henry Thomas's (*E.T.*) hometown who did an at-home layout wth him, another who photographed Robert Wagner in Vermont, etc. We specialize in celebrity photography. American TV is seen all over the world—we work with some 30 countries, and we cover TV more thoroughly than any other agency. We have done photo interviews with more than 50 actors and others on *Dallas*, and whole casts of many other popular (and obscure) series. TV names outsell film and music 10 to 1. As for human interest stories—the heartwarming, oddities, Americana subjects—if done well for a U.S. magazine, they are highly resalable overseas."

SHOSTAL ASSOCIATES, INC., 164 Madison Ave., New York, NY 10166. (212)686-8850. Has over 1 million photos. Contact: Joe Barwell. Clients include advertising agencies, public relations firms, businesses, AV firms, book publishers, magazine publishers, encyclopedia publishers, newspapers, calendars, greeting cards, industry, designers, interior decorators, etc. Does not buy outright; pays 50% commission. Offers one-time rights. Model releases and full captions on most subjects required. Arrange for personal interview to show portfolio for review.

Subject Needs: All subjects except news.

Color: Uses color transparencies only 35mm, 21/4x21/4, 4x5 and 8x10.

Tips: "Our markets are very demanding and will only use top quality professional photos. As the original all-color agency we made our reputation on large format originals. Today 35mm contemporary photos are also sought, but they must meet our high standards."

SICKLES PHOTO & REPORTING SERVICE, Box 98, Maplewood NJ 07040. (201)763-6355. Contact: Gus Sickles. Clients include advertising agencies, public relations firms, businesses, AV firms, editors, book publishers, magazine publishers, encyclopedia publishers, newspapers, postcard companies and calendar companies. Primarily still photography assignments, and still photography and reporting assignments; motion picture assignments for footage and videotape assignments. Pays \$50-500/photo assignment; \$200-600/day for photography and reporting assignment plus expenses for processing, phone, mileage and mailing. Offers all rights. Model release and captions required. Query with resume of credits and experience. Photos purchased on assignment only. SASE. Reports "immediate-ly."

Subject Needs: "We cover assignments relating to product applications and services in industry, agri-

culture and commerce, and human interest stories."

Film: Super 8 and 16mm documentary and 1/4" and 1/2" videotape interviews. Gives assignments.

B&W: Need negatives, do not need prints.

Color: Uses transparencies and color negatives; do not need prints.

Tips: "Should have experience in news and/or commercial photography on location, and ability to get story with help of an outline prepared by us. "Videotape capability and aerial photography experience of interest to us." Send resume, including experience, present activities and interests, and tell what cameras and lenses you are working with and your capability of getting stories with pictures. We need contacts with capable photographers and photojournalists and reporters in as many different locations across the U.S.A. and foreign countries as possible. We especially need contacts with photojournalists who can write or report in addition to covering photographic assignments for advertisers, public relations firms, advertising agencies and editors. We cover case history and story assignments. Many of our assignments result in trade paper articles, trade paper ads, publicity releases and sales promotion pieces, brochures, annual reports, etc. Just drop us a line about the type of work you are doing and your experience. We will respond and send a copy of our guidlines and suggestions."

SINGER COMMUNICATIONS, INC., 3164 W. Tyler Ave., Anaheim CA 92801. (714)527-5650. Contact: Nat Carlton. Has 10,000 photos. Also handles educational and theatre films for foreign TV. Clients include advertising agencies, book publishers, magazine publishers, newspapers, postcard companies, calendar companies and greeting card companies worldwide. Does not buy outright; pays 50% commission on photos; 25% on films. Rights offered depend on requirements and availability. "Do not send original transparencies. Send query first." SASE. Reports in 2 weeks. "Will advise of current needs for SASE."

Subject Needs: Interviews with celebrities. "Color transparencies for jacket covers of paperbacks and magazines." Especially needs westerns, mysteries, gothics, historical romance cover art.

Color: Uses 21/4x21/4 and 4x5 transparencies.

Tips: "The international market opens avenues for increased sales of material first sold in the North American area. We need transparencies for paperback jacket covers."

SOUTHERN STOCK PHOTOS, Suite 33, 3601 W. Commercial Blvd., Ft. Lauderdale FL 33309. (305)486-7117. Photo Coordinator: Karin Devendorf. Clients include advertising agencies, public relations firms, businesses, book publishers, magazine publishers, encyclopedia publishers, calendar com-

panies, mural and poster companies. Offers one-time rights or exclusive rights.

Subject Needs: Couples and single people in everyday situations such as dining, picnicking, biking, boating, swimming (pool and beach); jogging, exercising, walking, golf, tennis, romantic, etc. (Couples grouped as ages 25-35, 40-55, seniors); businessmen and women at work; family activities with parents and children together and separately; children playing organized group sports; color scenics and major cities (day and night, skylines) from US and foreign countries; underwater (especially divers); wildlife; boating and sailing, yachts; fishing (all kinds, especially action shots); sports (action shots) and their spectators, especially horse racing, jai-lai, dog tracks; sunsets; airports (interior and exterior); jets in air; industrial, and high-tech photography. "We specialize in Southern lifestyles." No posed, trite

photos. "We especially need exceptional 4x5 chromes of scenics for calendar companies. General scenics will be returned unless they are of exceptional quality."

Specs: Uses color, 35mm, 21/4x21/4, 4x5, 8x10 transparencies, and 8x10 b&w glossy photos. No color prints. Kodachrome on 35mm preferred over Ektachrome.

Payment & Terms: Does not normally buy outright; pays 50% commission. Model releases required and must be marked on the actual slide.

Making Contact: Send SASE for complete submission guidelines first. Reports in 3-4 weeks. Tips: Photos are examined with 8x loupe. "Photographers, please use a loupe before we do. Serious

professionals only."

*SOVFOTO/EASTFOTO, 25 W. 43rd St., New York NY 10036. (212)921-1922. Sales/Research: Victoria Edwards. Has 1,000,000 b&w and color photos of subjects pertaining to all countries of Eastern Europe and the Soviet Union, China, North Korea, Vietnam and Cuba. Clients include foreign and American book publishers, news weeklies, newspapers, governmental agencies and private businesses. Does not buy outright; pays 30% commission. General price range: \$60-750. Rights offered vary. "Photographer must have model releases, if needed, for his protection—we assume that they have been granted and take no further responsibility." Query with resume of credits and describe available material, or submit material by mail for consideration. SASE.

B&W: Send 8x10 glossy prints.

Color: Send 21/4x21/4 or 35mm transparencies.

Tips: "Photos may be of events of current value involving personalities from East Europe and other nations listed above, and not necessarily in their own countries, such as sportsmen, performers, politicians."

TOM STACK & ASSOCIATES, Suite 209-211, 1322 N. Academy Blvd., Colorado Springs CO 80909. (303)570-1000. Contact: Jamie Stack. Has 750,000 photos. Member: Picture Agency Council of America. Clients include advertising agencies, public relations firms, businesses, AV firms, book publishers, magazine publishers, encyclopedia publishers, postcard companies, calendar companies and greeting card companies. Does not buy outright; pays 60% commission. General price range: \$100-200/color; as high as \$1,000. Offers one-time rights, all rights or first rights. Model release and captions preferred. Query with list of stock photo subjects or send at least 200 transparencies for consideration. SASE or mailer for photos. Reports in 2 weeks. Photo guidelines free with SASE. Monthly tips sheet \$20/year; sample issue \$2.

Subject Needs: Wildlife, endangered species, marine-life, landscapes, foreign geography, people and customs, children, sports, abstract, arty and moody shots, plants and flowers, photomicrography, scientific research, current events and political figures, Indians, etc. Especially needs women in "men's" occupations; whales; solar heating; up-to-date transparencies of foreign countries and people; smaller mammals such as weasels, moles, shrews, fisher, marten, etc.; extremely rare endangered wildlife; wildlife behavior photos; current sports; lightning and tornadoes; hurricane damage. Sharp images, dramatic and unusual angles and approach to composition, creative and original photography with impact. Especially needs photos on life science flora and fauna and photomicrography. No run-of-the-mill travel or vacation shots. Special needs include photos of energy-related topics-solar and wind generators, recycling, nuclear power and coal burning plants, waste disposal and landfills, oil and gas drilling, supertankers, electric cars, geo-thermal energy.

B&W: Uses 8x10 glossy prints. Color: Uses 35mm transparencies.

Tips: "Strive to be original, creative and take an unusual approach to the commonplace; do it in a different and fresh way." Have need for "more action and behavorial requests for wildlife. We are large enough to market worldwide and yet small enough to be personable. Don't get lost in the 'New York' crunch-try us. Use Kodachromes and Kodak processing. Competition is too fierce to go with anything less. Shoot quantity. We try harder to keep our photographers happy. We attempt to turn new submissions around within 2 weeks. We take on only the best, and so that we can continue to give more effective service, we have just doubled our office space and hired new personnel to keep our efficiency."

STOCK, BOSTON, INC., 36 Gloucester St., Boston MA 02115. General Manager: Martha Bates. Has 500,000 8x10 b&w prints and color transparencies. Clients include educational publishers, advertisers, and magazines. Subject needs: "As general as possible. Both high-tech and human interestchildren, families, recreation, education, sports, government, science, energy, cities, both domestic and foreign." Does not buy outright; pays 50% commission. General price range: "In accordance with ASMP and PACA guidelines. Minimums for editorial publication: \$90/b&w, \$135/color. Commercial use is higher." Offers one-time rights. Query first with resume of credits. SASE. Reports as soon as possible. Tips sheet distributed intermittently to established contributors.

Tips: Prefers to see "different types, not theme, showing the kind of work they like to do and generally

do.

STOCK IMAGERY, 711 Kalamath, Denver CO 80204. (303)592-1091. Photo Researchers: Karin Leigh Tuck & Garry Adams. Has 60,000 "highly selected images." Clients include ad agencies; PR and AV firms; businesses; book, magazine and encyclopedia publishers; postcard, calendar and greeting card companies; and energy companies.

Subject Needs: "Stock Imagery houses scenes, sunsets and action shots from as far away as Moscow and as close to home as the Rocky Mountains. We stock the primitive, the modern, the industrial, the en-

ergy of the sun, the earth and the people."

Specs: Uses 35mm, 21/4x21/4 and 8x10 transparencies. Seldom buys photos outright. Pays 50% commission on color photos. Buys one-time rights. Model release and captions required.

Making Contact: Submit portfolio for review. Must enclose SASE. Reports in 3 weeks. Tips sheet dis-

tributed quarterly to photographers on file.

Tips: "We would like to see a minimum of 200 images sent in plastic pages with SASE in either 35mm, 21/4x21/4, 4x5 or 8x10 formats. Send us people, sunset, recreation, palaces, or an expression on a face. We are searching for that perfect shot that captures the spirit of event, action or man. Think generic; while shooting take time in creating an image that can sell many times over. When shooting people be careful that clothing will not become dated."

THE STOCK MARKET PHOTO AGENCY, 1181 Broadway, New York NY 10001. (212)684-7878. Director of Photography: Sally Lloyd. Has 400,000 photos. Clients include advertising agencies, public relations firms, businesses, AV firms, book publishers, magazine publishers, calendar companies, designers.

Subject Needs: "We are a general library; nature (scenics, birds, animals, flowers), sports, people,

travel, industry and construction, transportation, food, agriculture."

Specs: Uses 35mm, 21/4x21/4, 4x5 and 8x10 transparencies.

Payment & Terms: Pays 50% commission on color photos. "We follow the 1982 ASMP business prac-

tices guide." Buys one-time rights. Model release preferred; captions required.

Making Contact: Arrange a personal interview to show portfolio (if possible) or submit portfolio for review. SASE. Reports in 2 weeks. Photo guidelines free with SASE. Tips sheet distributed every 3 months to members of TSM.

Tips: "Portfolio preferred; examples of photographer's style and general presentations or range of avail-

able material, preferably 200-300 strong images."

STOCK PILE, INC, 2404 N. Charles St., Baltimore MD 21218. (301)889-4243. Vice President: D.B. Cooper. Has over 22,000 photos "and growing every day." Clients include ad agencies, PR and AV firms, businesses, book and magazine publishers, newspapers, and slide show producers.

Subject Needs: "We are a general agency handling a broad variety of subjects. If it is salable we want to

stock it."

Specs: Uses 8x10 b&w glossy prints and color 35mm or larger transparencies.

Payment & Terms: Pays 50% commission on b&w and color photos. Sells one-time rights. Model release preferred; captions required.

Making Contact: Arrange a personal interview to show portfolio or query with samples. SASE. Re-

ports in 2 weeks. Photo guidelines free with SASE. Tips sheet distributed periodically. **Tips:** "Shoot photos of people. Because we are very new, a freelance photographer joining us now is getting in very close to the ground floor."

THE STOCKHOUSE, INC., 9261 Kirby, Houston TX 77054. (713)796-8400. Director of Sales and Marketing: Ken Krueger. Has 500,000 photos. Clients include publishers, advertising agencies, public relations firms, business, newspapers, calendar companies and decor prints.

Subject Needs: "Every possible category, including farming, transportation, wildlife, people, petroleum industry, construction, fine arts, nature, foreign countries, etc.

Specs: Uses 35mm, 21/4x21/4, 4x5 slides and original color transparencies.

Payment & Terms: Pays 50% commission on photos. General price range: \$75-1,000. Buys one-time rights. Model release preferred; captions required.

Making Contact: Arrange a personal interview to show portfolio or send unsolicited material by mail for consideration. SASE. Reports in 1 month. Photo guidelines free with SASE. Tips sheet distributed

every 6 months to photographers; free with SASE.

Tips: "While the calls we receive vary, we do a large volume of petroleum business (refineries, land and offshore rigs) as well as people shots. We have a great need for young couples and families involved in everyday activities, eating, picnicking, all types of sports activities, as well as good candids of happy children at play. We are rapidly expanding our decor print division and welcome exceptional nature shots, graphics and wildlife shots.'

STOCKPHOTOS INC., 373 Park Avenue South, New York NY 10016. (212)686-1196. Director: Diane Burke. Editor: Craig Jordan. Has 1,000,000 photos. Clients include advertising agencies, corporate publishing, public relations firms, AV companies, book publishers, magazine and newspaper publishers, encyclopedia and textbook publishers, poster and greeting card companies, record cover and tel-

evision companies, and private businesses.

Subject Needs: "We have no limitation on subject matter. Practically every possible picture subject is covered: people, glamour, nudes, industry and science, travel, scenics, sports and nature. Our most popular subjects are people (at work, at play, children, teenagers, women, men, couples, families, and the elderly), and industry (high-tech, computers, office scenes, communications, oil, steel, manufacturing, and transport). We are looking for creative photographers with innovative, dynamic styles and a willingness to take direction."

Specs: Buys photos outright or pays a 50% commission. Accepts original transparencies, all formats, with a special interest in large-format work, and high quality 8x10 prints (with negatives), primarily

aimed at poster and calendar markets.

Payment & Terms: "We generally make sales ranging from \$200-500 up to \$5,000." Offers one-time rights or any rights desired by client. Model releases are necessary; transparencies should be captioned and the photographer's name stamped on the picture's mount or label.

Making Contact: Personal portfolio reviews are welcome, please call for an appointment. Portfolios

and submissions may be sent by mail; please include a return envelope with postage.

Tips: "Portfolios should contain between 150 and 300 original transparencies that are representative of your photographic interests and that are appropriate to our markets. B&w portfolios should have between 30 and 60 prints. Portfolios will be promptly returned with an appraisal of your photographs and their marketability. We are always interested in working with energetic and creative photographers with exciting, colorful transparencies and b&w prints that we can market worldwide through 30 offices.

STRAWBERRY MEDIA, 14/B Via Venezia, 80021 Afragola (NA) Italy. (081)869-3072 or 2072. Director: Michael H. Sedge. Clients include magazine publishers throughout Europe and the United States. Does not buy outright; pays 60% commission. General price range: \$7 to newspapers to \$500 for color in magazine. Offers one-time rights. Often holds photos for up to 3 years, upon agreement with photographer. Model releases and captions required where necessary. Query with samples. Prefers color slides-large amount. SASE; U.S. postage accepted. Reports in 4 days after receipt.

Subject Needs: "Specializes in military subjects, sites in Europe, and sports for young people. We are looking for groups of photos that tell a story. Often our writers will originate an article to fit particular

photos, if there are sale possibilities.

Color: Uses 35mm or larger.

Tips: "We deal a great amount with magazines for the U.S. military stationed overseas. Try to keep this in mind for ideas and activity pictures. Upcoming projects include guidebooks on European cities, how to photograph pictures, and rock music stars. It helps if the photographer is also a writer since we also represent writers and cartoonists-we try to sell complete coverage on a subject."

SYGMA PHOTO NEWS, 225 W. 57th St., New York NY 10019. (212)765-1820. Director: Eliane Laffont. Has several million photos of both international news and domestic news and photos of celebrities. Clients include magazines, newspapers, textbooks, AV firms and most major film companies. Does not buy outright; pays 50% commission. SASE.

B&W: Negatives required. Especially wants photos of international news.

Color: Uses 35mm transparencies. Wants good specialty news, human interest, celebrities.

TANK INCORPORATED, Box 212, Shinjuku, Tokyo 160-91, Japan. (03)239-1431. President: Masayoshi Seki. Has 400,000 slides. Clients include advertising agencies, book publishers, magazine publishers, encyclopedia publishers and newspapers.

Subject Needs: "Women in various situations, families, special effect and abstract, nudes, scenic,

sports, animal, celebrities, flowers, picture stories with texts, humorous photos, etc.

Specs: Uses 8x10 b&w prints and 35mm, 21/4x21/4 and 4x5 slides and b&w contact sheets.

Payment & Terms: Pays 60% commission on b&w and color photos. General price range: \$70-1,000.

Buys one-time rights. Captions required.

Making Contact: Query with samples; with list of stock photo subjects or send unsolicited material by mail for consideration. SASE. Reports in 1 month. Photo guidelines free with International Reply Cou-

TAURUS PHOTOS INC., 118 E. 28th St., New York NY 10016. (212)683-4025. Contact: Ben Michalski. Has 250,000 photos. Clients include advertising agencies, public relations firms, businesses, AV firms, book publishers, magazine publishers, encyclopedia publishers and newspapers. Color: Uses transparencies.

B&W: Uses 8x10 prints.

Tips: "Looking for top-notch photographers. Photographers interested in being represented by Taurus

should submit a portfolio of 100 transparencies and b&w prints tor evaluation along with information about the type of material which they are able to shoot. An evaluation will be returned to you. A self-addressed stamped return envelope is necessary for this step. Beautiful photos of American life, e.g. family, industry, business or naturalist-type photos of nature are particularly welcome."

TEENAGE CORNER, INC., 70-540 Gardenia Ct., Rancho Mirage CA 92770. President: David J. Lavin. Has 10,000 photos and 4,900 films. Clients include advertising agencies, public relations firms and calendar companies. Does not buy outright; pays 5% commission/photos; 10% commission/films. Offers one-time rights. Model release required. Send material by mail for consideration. Photos purchased on assignment only. SASE. Reports in 2 weeks. Free photo guidelines.

Film: Uses 16mm and 35mm films of teenage situations. Gives assignments.

B&W: Uses 8x10 glossy prints; contact sheet OK. Color: Uses 35mm transparencies or 8x10 glossy prints.

This photo, taken by Milwaukee freelance photographer Paul Henning, is one of thousands Third Coast Stock Source, also of Milwaukee, has in its library. It is representative of the type of photo that a hospital might need.

THIRD COAST STOCK SOURCE, Box 92397, Milwaukee WI 53202. (414)765-9442. Research Manager: Regis Lefebure. Has 10,000 photos. Clients include advertising agencies, public relations firms, audiovisual firms, businesses, book/encyclopedia publishers, magazine publishers, newspapers, calendar companies and greeting card companies.

Subject Needs: Needs images specifically relating to the Third Coast region-Ohio, Minnesota, Wisconsin, Illinois, Iowa, Michigan, Indiana-people at work and play, scenics, animals. Also needs photos of other regions of the country.

Specs: Uses 8x10 glossy prints, and 35mm, 21/4x21/4, 4x5 and 8x10 transparencies (Kodachrome preferred).

Photos: Pays 50% commission. General price range: \$200 + . Buys one-time rights. Model release is preferred; captions required.

Making Contact: Arrange a personal interview to show portfolio; query with resume of credits; query with samples; query with list of stock photo subjects; submit portfolio for review. SASE. Reports in 1 month. Photo guidelines free with SASE. Tip sheet distributed 3-4 times/year to "photographers currently working for us.'

Tips: "We are looking for technical expertise; outstanding dramatic and emotional appeal; photos representative of life in this region. We are extremely anxious to look at new work."

THE TRAVEL IMAGE, 1330 Main St., Venice CA 90291 (213)823-3439 or 399-5510. Mailing Address: Box 9550, Marina Del Rey CA 90295. President: Greg Wenger. Has 300,000 photos and growing. Clients include advertising agencies, public relations and AV firms, businesses, book/encyclopedia and magazine publishers, newspapers and wholesale tour operators.

Subject Needs: "Travel photos—popular tourist destinations, pictorial layouts." Specs: Original color; 35mm, 21/4x21/4 and 4x5 transparencies and some b&w prints.

Payment & Terms: Pays 50% commission upon sale. General price range: ASMP rates. Model release,

captions and subject ID required.

Making Contact: Query with samples of at least 100 slides, and list of stock photo subjects. SASE. Reports in 2 weeks. Acceptance of material will require photographer/agency contract signing,

Tips: "Best-sellers are strong in good design and composition. People-oriented subjects, scenics and imaginative use of color. The U.S. has become a travel destination for more countries. Good photos of U.S. vacation spots are in demand. Shoot good color, strong in design. Submit your best material-in volume."

UNIPHOTO PICTURE AGENCY, Box 3678, 1071 Wisconsin Ave. NW, Washington DC 20007. (202)333-0500. Agency Director: William Tucker. Has 250,000 + color transparencies and b&w prints. Clients include advertising agencies, design studios, corporations, associations, encyclopedia and book publishers and magazines. Does not buy outright; pays 50% commission. General price range: new ASMP rates; \$100 minimum/b&w and \$150/color for 1/4 page and less than 5,000 circulation. Offers first serial or one-time rights. Present model release "when sale is confirmed by user." Call to arrange an appointment, submit material by mail for consideration, query with resume of credits, or submit portfolio. Prefers to see dynamic stock photos and corporate location assignments. Reports in 1 week. SASE.

Specs: Send 35mm, 21/4x21/4 or 8x10 color transparencies. Interested in all subjects. Query first for list of specific needs.

Tips: "We are a unique organization that combines traditional stock agency methods with high technology to sell photos. Microslides are a rendering of photo images on a 4x6 piece of film; 675 images are on each one. We are a full-service agency marketing stock photos and actively solicit assignments for our photographers. We sell directly from Washington to all types of clients and through stock photo agencies in other parts of the U.S. We provide 3/4" videotape for 6-minute slide shows, Uniphoto: A World of Photography to our clients. The videotape relates the types of stock photo subjects available and assignment capabilities across the U.S.A. Available upon written request. Uniphoto Picture Agency also uses a computer data system that allows photographers to send in their data on their photo subjects for our data bank. We can then have photographers send their photos directly to clients. We also utilize a computer trafficking program to trace slides that go out to clients. We recently introduced a videodisc (called the Photo Store) with our best slides for our clients—accessed by computer and is an electronic catalog depicting 104,000 images."

VALAN PHOTOS, 490 Dulwich Ave., St. Lambert, Montreal, Quebec, Canada J4P 2Z4. (514)465-2557. Manager: Valerie Wilkinson. Has 150,000 photos. Clients include advertising agencies, public relations firms, businesses, AV firms, book publishers, magazine publishers, encyclopedia publishers, newspapers, postcard companies, calendar companies.

Subject Needs: Canadian scenics, international travel, agriculture, people, wildlife, pets, insects, photomicrography, underwater photography, sport fishing, hunting.

Specs: Uses 35mm or larger transparencies.

Payment & Terms: Will occasionally buy transparencies outright; pays \$5-100. Pays 50% commission on stock transparencies. Price range: \$50-1,500. Sells one-time rights. Model release preferred; captions required.

Making Contact: Query with list of stock photo subjects. SAE and International Reply Coupons. Reports in 1 month. Photo guidelines free with SAE and International Reply Coupons. Tips sheet distributed quarterly to established contributors.

Tips: "We are particularly looking for top quality wildlife photos. Primates, cats, marsupials and other animals found in Asia, Africa, Australia and South America. Query before sending samples. We represent many of Canada's leading wildlife photographers and we are anxious to make contact with international wildlife photographers of similar calibre."

VIEWFINDERS, 181 St. James St., London, Ontario, Canada N6A 1W7. (519)433-7536. Director, Sales: Alec J. Hartill. Has 50,000 35mm slides. Clients include industry, publishing, AV and education. Pays 50% commission. General price range: \$50-300, on commercial sales. Offers one-time rights. Model release and captions required. International Reply Coupons for postage/insurance must be included. No "holiday" snapshots needed.

Subject Needs: People, architecture, market scenes, sculpture, streetscapes, landscapes, waterscapes,

Close-up

Mary Ann Platts Director, Third Coast Stock Source

When stock agencies come to mind, thoughts more often than not turn to the large houses in New York, Chicago and California. And thoughts, too, of how out-of-reach many of them are for photographers who haven't attained elite status.

A new stock agency in Milwaukee, Third Coast Stock Source, may be a welcome alternative. Its standards equal those of the big-name houses, but its subject needs—primarily photos of the Midwest—location and newness are ideal for freelancers who want the best of New York in the Midwest.

"One of our biggest advantages is that a stock agency is something totally new for Milwaukee. And, too, since we're located in the Third Coast region, Midwestern photographers will have a more readily available market for their photos," says Mary Ann Platts, general manager and company founder.

Platts currently has eight photographers under contract and is eagerly seeking more. "I'm canvassing the Midwest for photographers who can give me top-notch material on a regular basis. I won't compromise on quality. There's no room for that in the market. I can't sell mediocre material," she stresses.

The subject matter she needs is "wide open. I need shots of people—Midwesterners—doing just about everything—working, playing, participating in sports, relaxing—the list is endless. I'm also interested in photos which depict subjects ranging from high-tech industry to farming methods. Nor am I limiting myself to photos from the Third Coast region—Wisconsin, Minnesota, lowa, Illinois, Indiana, Ohio and the St. Louis, Missouri, metropolitan area—I want photos depicting life all over the United States," she says.

Photographers under contract with Third Coast receive 50 percent commission on the sale of their photos. She of-

fers one-time rights, and only upon request of the photographer will she sell all rights. Photo prices start out at \$100. "That's rock bottom. After that the sky's the limit," she says.

Photographers interested in working for Third Coast should call or write her. "At that point I try to get an idea of the number and quality of their work. If I feel they have potential I'll ask them to send a minimum of 100 slides. I'll review them, make my comments and return them within two weeks. They should include a SASE.

"Afterward, their first-time submission (original transparencies only, Kodachrome preferred) should include no fewer than 500 images; 2,000 would be better. The more they have the better their chances are of making money," she says.

Platts is optimistic about her business prospects, and the future of stock agencies in general. "Stock agencies will continue to grow because people are becoming more aware of what they can do for them. I especially see rapid growth in the Midwest. This area hasn't been intentionally ignored, it's just gotten lost between the 'heavies' in New York and California. I intend to change that."

resort areas, historic sites, foreign countries and folk arts. Color: Uses 35mm Kodachrome and 4x5 Ektachrome.

Tips: "1. Label your work. 2. Type lists, descriptions. Do not write on slide mounts other than name and copyright notice. 3. Become self-critical! 4. Send examples (60-100 slides) of specialized work in slide view pages with lists in duplicate. 5. Customs declaration must be on packet: "Samples." 6. Be prepared to wait-sales of photos only occur over time."

VISUALWORLD, A Division of American Phoenix Corporation, Box 804, Oak Park IL 60303. (312)366-5084. President: Larry Peterson. Has 20,000 photos of all types with an emphasis on historical and scenic photos. Also emphasizes photos of children, students, Spain, Asia, Europe, biology, agricultural subjects and recreation. Clients include educational publishers, poster and postcard companies and magazine publishers. Does not buy outright. General price range: \$100/b&w single editorial use to \$1,500/color national consumer magazine advertising. Offers first North American serial rights.

WEST STOCK, INC., Suite 600, 157 Yesler Way, Seattle WA 98104. (206)621-1611. President: Tim Heneghan. Project Director: Stephanie Webb. Has 350,000 photos. Clients include ad agencies, businesses, book, magazine and encyclopedia publishers, postcard, calendar and greeting card companies. Subject Needs: "Our files are targeted to meet the photo needs of advertising, corporate communications and publishing. We use our understanding of the capabilities and strengths of our photographers' imagery to satisfy the photo tastes and styles of a diverse, changing photo marketplace."

Specs: Only original transparencies accepted, 35mm and larger.

Payment & Terms: Pays 50% commission on b&w or color photos. General price range: \$100-1,500.

Sells one-time rights. Model release and captions preferred.

Making Contact: Query with list of stock photo subjects. SASE. Reports in 2 weeks. Photo guidelines free with SASE. Tips sheet distributed quarterly to contract photographers.

Tips: Prefers to see "high quality, uncluttered, color transparencies (at least 1,000 available for contract signing), diverse subject matter ranging through leisure activity, travel shots, industrial imagery, as well as scenics. We take a long-term approach to the marketing of the imagery and the services of our organization. The photographer rewards are generally proportional to his/her participation. We need quality photography that is current. We look for photographers who are aware of the latest design trends, advertising styles and editorial requirements, demonstrating that awareness in their work.

*WILDLIFE PHOTOBANK, 1530 Westlake Ave. N., Seattle WA 98109. (206)282-8116. Owners: Marty Loken and Gloria Grandaw. Stock photo agency. Has 100,000 photos. Clients: advertising agencies, magazine publishers, graphic design firms and corporations.

Subject Needs: "We carry photographs of all various forms of wildlife-mammals, birds, amphibians, fish, reptiles, insects-but need tight, graphic, expressive shots of bears, eagles, lions, monkeys, wolves, whales. Top-notch shots.

Specs: Uses b&w 8x10 prints and 35mm, 21/4x21/4 and 4x5 transparencies.

Payment & Terms: Pays 50% commission. Buys one-time rights. Captions required.

Making Contact: Query with list of wildlife subjects. SASE. Reports in 1-3 weeks. Photo guidelines free with SASE.

Tips: "We specialize in the sale of reproduction rights to corporate markets—ad agencies, graphic designers-and have launched an aggressive promotion campaign in that direction. We only need topnotch photos."

WORLDWIDE NEWS SERVICE, Box 4351, Lexington KY 40544. (606)858-4240. Personnel Director: Steve Wilson. Has 20,000 photos in stock; access to 5 million. Clients include magazine publish-

Subject Needs: "Strictly news events, primarily of national/international importance."

Specs: Uses 5x7 b&w and color glossy prints; 35mm, 21/4x21/4 and 4x5 transparencies and occasionally

b&w and color negatives.

Payment & Terms: Buys photos outright; pays \$25 minimum. Pays 65% commission on b&w and color photos. General price range: "\$50 is the usual for b&w and \$75 for color. However, again, it depends upon the client." Buys one-time rights, first rights or all rights. Model release preferred; captions required.

Making Contact: Query wth resume of credits. SASE.

Tips: Prefers to see "news types of photos and photojournalism shots. We do not deal with anything except news and photos of famous people.'

Services & Opportunities

Contests

What is it about contests that attracts so many photographers? In a few cases, it may be the cash or merchandise prizes being offered—although most photo contests offer rewards more along the lines of plaques and ribbons. Perhaps it's simply the chance for a piece of glory, the knowledge that one's work is good enough to

stand up in competition with the best.

Whatever the reason, contests do offer photographers a number of benefits, both tangible and intangible. First, of course, are the aforementioned prizes; these range from the symbolic (ribbons) to the useful (camera gear) to the truly substantial (cash awards in the hundreds, even thousands of dollars). Some contest-winning photographs may earn automatic publication and additional fees for publication rights; some may go on to be exhibited and offered for public sale. Many contests are judged by top professionals in photography and related industries, and the feedback you may receive from these experts can be invaluable in honing and improving your craft. Finally, there's the psychological benefit of learning that your photos are among the very best—not only in your own eyes, but in the eyes and judgment of your professional peers.

For all of this, you should bear in mind that while entering and even winning contests do have their benefits and can be fun, they can never be as worthwhile or career-advancing as marketing your work to paying customers. Also remember to pay close attention to the *rights* assumed by some contest sponsors, especially the dire phrase, "Sponsor assumes all rights to entries." No contest prize can be worth

that high a price.

AMERICAN FILM FESTIVAL, Suite 301, 45 John St., New York NY 10038. (212)227-5599. Festival Director: Marilyn Levin. Sponsor: Educational Film Library Association. Annual festival. Date of show: May/June; deadline: mid-January. Entry fee: varies, depending on length. Entries prescreened to determine finalists which are judged a second time during festival. Accepts 16mm optical track flat prints and 3/4" video cassettes released for nontheatrical distribution in the United States. Awards certificates and trophies. Call or write for entry forms. "Request entry forms early. The American Film Festival is the major 16mm nontheatrical film festival in the United States. Over 1,000 films are judged according to categories such as Art & Culture, Education & Information, Mental Health & Guidance, Contemporary Concerns, Business & Industry, Health & Safety, etc."

ART ANNUAL PHOTOGRAPHY, (now called Photography 86), Box 10300, 410 Sherman Ave., Palo Alto CA 94303. (415)326-6040. Executive Editor: Jean A. Coyne. Sponsor: Communication Arts

magazine. Annual event for still photos held in March in Palo Alto. Entries must consist of photos produced or published between March 22, 1985, and March 21, 1986. Deadline: March 21. Entry fee: \$10/ single entry, \$20/series; not refundable. Work not for sale. "Submission gives CA the right to use the pieces for exhibition and publication purposes." Award of Excellence certificate given and the selections are published in the August issue. Prefers b&w and color photos of any size and "photography that is commissioned for publication, advertising or any other area of the communication arts." Write or call for entry form.

BALTIMORE INTERNATIONAL FILM FESTIVAL-INDEPENDENT FILMMAKERS' COMPETITION, Room 405, 516 N. Charles St., Baltimore MD 21201. (301)685-4170. Contact the Baltimore Film Forum at above address. Annual festival for films held in April in Baltimore. Average attendance: 12,000. Films must have been made within previous 2 years. Deadline: February 1 (entry forms)/ February 10 (films). "There are four judging panels, one for each category and these panels choose the best films from each category and send them to the finals judges. In 1985, \$20 entry fee for films." Work not for sale. Sponsor assumes the right to show the film in the festival. One-time rights. Awards \$1.50/running minute, honorarium and cash. "Cash prize money to at least the top three films in each category. All films screened during the festival receive screening money. A minimum of \$4,000 prize and screening money." Accepts 16mm film. Four categories: animation, documentary, dramatic, experimental. "Education and sponsored films usually do not fare well before the judges." Write or call the Baltimore Film Forum for information/entry forms.

BEVERLY ART CENTER ART FAIR & FESTIVAL, 2153 W. 111th St., Chicago IL 60643. (312)445-3838. Chairman: Pat McGrail. Annual event for still photos held in June in Chicago. Average attendance: 2,000-3,000. "Acceptance is based on quality of artwork only." Deadline: April 26. Maximum number of entries: 5 slides. Jury of three professional artists/critics/professors. "Jury fee is retained if not accepted. Entry fee is refundable. (1985 fees: jury-\$10; entrance: \$17.50.)" Works may be offered for sale. Sponsor assumes "no rights—object is for artists to sell." Awards \$2,000 minimum and ribbons; including \$400 Best of Show and eight \$200 awards of excellence. Accepts photos. Call or write in January.

Tips: "Artists must include own set-ups, chairs, tables, etc. It is an outdoor art fair. Other media: painting, sculpture, graphics, fiber, ceramics, glass, jewelry. No trite subjects; good tonal quality; stress all formal aspects of the aesthetics of photography—good design, composition, imagery, etc. Try to submit professional slides for jurying purposes and work that is of an artistic, not mass-produced commercial nature. Offer a good variety of your work, so as to catch the attention of the sophisticated art fair attendee as well as that of the less sophisticated. Offer variety of prices also."

BIRKENHEAD INTERNATIONAL COLOUR SALON, 29 Fairview Rd., Oxton, Birkenhead, England. Contact: D.G. Cooper. Sponsor: Birkenhead Photographic Association. Annual event for 2x2 or 5x5 cm slides only held in June/July in Birkenhead. Average attendance: over 2,000. Deadline: May. Maximum number of entries: 4 in each of 2 classes. Entry fee: \$4; not refundable. Work not for sale. Sponsor assumes one-time rights. Awards gold, silver and bronze medals (about 15 total); Honorary Mention Certificates to about 10% of accepted slides. Two categories: General Pictorial and Natural History. Looking for named, good modern work including contemporary. For information/entry forms: In U.S., write H&S Mass, 1864 61st St., Brooklyn NY 11204; in Great Britain or Europe, write to A.P. Williams, 5 Howards Ln., Thingwall, Birkenhead, England.

Tips: "Our competition provides a standard for comparison of your best work against currently accepted standards."

*CANADIAN STUDENT FILM FESTIVAL, 1455 Blvd. de Maisonneuve Ouest, Room 109, Montreal, Quebec, Canada H3G 1M8. Director: Daniéle Cauchard. Sponsor: Conservatoire d'Art Cinematographique de Montreal. Annual festival for films held in Montreal. Average attendance: 500-700/day. Deadline: July 14. Entry fee: \$10/entry; not refundable. Awards include "participating certificates, prizes for each category, Prix du Quebec (\$500 cash) and the Norman McLaren (\$1,000 cash)." Accepts 16mm and 35mm film. Four categories: animation, documentary, experimental and fiction. Write for information/entry forms.

THE CREATIVITY AWARDS SHOW, 10 E. 39th St., New York NY 10016. (212)889-6500. Show Director: Dan Barron. Sponsor: Art Direction magazine. Annual show for still photos and films held in September in New York City. Average attendance: 12,000. Entries must consist of advertising photography and TV commercials. Deadline: May. Entry fee: \$7.50/photo; \$15/TV commercial; not refundable. Work not for sale. Sponsor assumes one-time rights. Awards certificates of distinction and reproduction in an annual book. Write or call for information/entry forms.

Use an up-to-date Market Directory

Don't let your Photographer's Market turn old on you.

You may be reluctant to give up this copy of Photographer's Market. After all, you would never discard an old friend.

But resist the urge to hold onto an old <u>Photographer's Market!</u> Like your first camera or your favorite pair of jeans, the time will come when this copy of <u>Photographer's Market</u> will have to be replaced.

In fact, if you're still using this 1986 Photographer's Market when the calendar reads 1987, your old friend isn't your best friend anymore. Many of the buyers listed here have moved or been promoted. Many of the addresses are now incorrect. Rates of pay have certainly changed, and even the buyer's needs are changed from last year.

You can't afford to use an out-of-date book to plan your marketing efforts. But there's an easy way for you to stay current—order the <u>1987 Photographer's Market</u>. All you have to do is complete the attached post card and return it with your payment or charge card information. Best of all, we'll send you the <u>1987 edition</u> at the <u>1986 price—just</u> \$16.95. The <u>1987 Photographer's Market</u> will be published and ready for shipment in October <u>1986</u>.

Make sure you have the most current marketing information—order the new edition of Photographer's Market now.

To order, drop this postpaid card in the mail.

□ YES! I want the most current edition of Photographer's Market. Please send me the 1987 Photographer's Market at the 1986 price—\$16.95. I have included \$2.00 for postage and handling. (Ohio residents add 5½% sales tax.)

□ Payment enclosed (Slip this card and your payment into an envelope.)

□ Charge my: □ Visa □ MasterCard

Account # _____ Exp. Date _____

Signature _____

Name _____

Address _____

City ____ State ____ Zip _____

(This offer expires August 1, 1987, Please allow 30 days for delivery.)

(This offer expires August 1, 1987. Please allow 30 days for delivery.) NOTE: <u>1987 Photographer's Market</u> will be ready for shipment in October 1986.

9933 Alliance Road Cincinnati, Ohio 45242

Make sure you have a current edition of Photographer's

Photographer's
Market has been
the photographer's
bible for many years.
Each edition contains
hundreds of changes to
give you the most current
information to work with.
Make sure your copy
is the latest edition.

Market

Order your 1987 Photographer's Market NOW!

This card
will get you
the 1987 edition...
at 1986 prices!

BUSINESS REPLY MAIL

FIRST CLASS

PERMIT NO. 17

CINCINNATI, OHIO

POSTAGE WILL BE PAID BY ADDRESSEE

Writer's Digest Books

9933 Alliance Road Cincinnati, Ohio 45242-9990 NO POSTAGE NECESSARY IF MAILED IN THE UNITED STATES

DESERTS OF THE WORLD, Desert Botanical Garden, 1201 N. Galvin Pkwy., Phoenix AZ 85008. (602)941-1217. Co-Chairmen: Dottie O'Rourke, Bonnie McCulley. Annual still photography event held in November. Average attendance: 3,000. Deadline: first week of October. Maximum number of entries: 4 b&w prints, 4 color prints and 4 color slides. Prejudged for relation to deserts. Entry fee: \$4/maximum for b&w or color prints; \$3.50/maximum of 4 color slides; nonrefundable. Sponsor assumes one-time rights. Awards 5 tropies; 1st, 2nd and 3rd place ribbons each medium; honorable mention ribbons. B&w and color prints must be mounted (unframed); 8x10-16x20 including mount; color slides may be 2x2 or $2^{1/4}x2^{1/4}$. Photos must be of desert landscapes and desert portraits. Write for entry forms available June to September.

Tips: Read the entry form carefully for instructions regarding desert categories and mounting instruc-

tions.

DOG WRITERS' ASSOCIATION OF AMERICA ANNUAL CONTEST, 133 Chase Ave., Ivyland PA 18974. (215)674-4532. Contest Chairman: Helma N. Weeks. Annual event for still photos/prints of dogs held in October. Average number of entries/submissions: 500. Material must have been published. Deadline: October 1. Maximum number of entries: one per category. Entry fee: \$5, not refundable. Work may be offered for sale; no sponsor commission. Awards: trophies and certificates. Write for information and entry forms.

*ECLIPSE AWARDS, Thoroughbred Racing Associations, 3000 Marcus Ave., Suite 2W4, Lake Success NY 11042. (516)328-2660. Director of Service Bureau: Chris Scherf. Sponsor: Thoroughbred Racing Associations, Daily Racing Form and National Turf Writers Association. Annual event for photographers held in January or early February. Photographer must demonstrate excellence in the coverage of Thoroughbred racing; photo must be published in North American publication between January 1 and December 1. Maximum number of entries: 3. No entry fee. Awards Eclipse trophy, presented at annual Eclipse Awards dinner. Accepts b&w or color; 8x10 or same size as when published; glossy. No entry form; "cover letter including date and name of publication and tearsheet, plus 8x10 glossy must accompany entry."

*8mm FILM FESTIVAL, Box 7571, Ann Arbor MI 48107. (313)769-7787. Directors: Dan Gunning and Mike Frierson. Sponsor: Ann Arbor Film Co-op. Annual festival for films held in February in Ann Arbor. Average attendance: 200/show. Film entries must be shot in 8mm or Super 8mm. Deadline: January 15. Prejudging by screening committee. Entry fee: \$8 for films less than 15 minutes, \$15 for films longer than 15 minutes; not refundable. Work not for sale. Sponsor assumes one-time rights. Awards include over \$2,500 in cash and prizes. Accepts Super 8 or 8mm film. Write for information/entry forms.

EXHIBITION 280: Works on Walls, Huntington Galleries, Park Hills, Huntington WV 25701. (304)529-2701. Sponsor: Huntington Galleries. Annual competition for works on walls: prints, paintings, photos, etc. held in the spring in Huntington. Average number of entrants/submissions: 400. Entrants must live within a 280-mile radius of Huntington, West Virginia. Deadline: end of January. Maximum number of entries: 2. Entries prejudged by three jurors. Entry fee: \$10, nonrefundable. Must accompany entry form. Checks should be made payable to Huntington Galleries. Work may be offered for sale; no sponsor commission. Sponsor assumes "right to photograph and reproduce works for catalog, educational and publicity purposes. A total of \$7,000 in cash and purchase awards will be available for Exhibition 280, of which there will be three Awards of Excellence each in the amount of \$2,000." Write for information/entry forms.

"EXPOSE YOURSELF" FILM FESTIVAL, Biograph Theatre, 2819 M St. NW, Washington DC 20007. (202)333-2696. General Manager: Jeffrey Hyde. Sponsor: Biograph Theatre Group. Film competition held about every year in Washington DC. Average attendance: 600-800. Entrants must be regional residents (DC, MD, VA) and work in 16mm film format. Deadline: 1 week prior to festival; dates vary. Maximum number of entries: "We choose from among the films entered—we do not run every one which is sent in." Sponsor assumes no rights; entertainment and competition only; not necessarily a distribution or sales outlet." Cash prizes: \$50/1st place; \$25/2nd and 3rd place; \$10/honorable mention. All winners receive 10 theater passes; all entrants receive tickets to attend the festival performances. Accepts 16mm film. "Style and subject matter are at filmmaker's discretion; we avoid mere sensationalistic films, and look for those works which show a sense of growth in the medium; wit and taste." Call J. Hyde at (202)338-0707 or write to the theater.

The asterisk before a listing indicates that the listing is new in this edition. New markets are often the most receptive to freelance contributions.

526 Photographer's Market '86

Tips: "Expose Yourself is a competition and an entertainment. Its purpose is to spotlight the works of area filmmakers, and encourage development of their skills while affording them the opportunity to reach an audience they otherwise might not be exposed to. Keep it short. We program 2 hours of screen time and like to run as many films as possible in that time. Ours is a *film* (motion picture) event—still photos are *not* used."

FOCUS (FILMS OF COLLEGE & UNIVERSITY STUDENTS), 1140 Avenue of the Americas, New York NY 10036. (212)575-0270. Director: Sam Katz. Sponsor: Nissan Motor Corp. in USA. Annual event for film: live action/narrative, animation/experimental, documentary, sound achievement, film editing, cinematography and screenwriting. Competition held during the spring semester; awards made in early summer. Average entries: 700. Entries must have been produced by a student at a college, university, art institute or professional film school in the United States. Films must be made on noncommercial basis. Deadline: mid-April. Entries judged by screening committee made up of industry professionals as listed each year in the Official Rules Booklet. Entry fee: \$15/film; films entered in any film-making categories may enter the sound, cinematography and/or Film Editing competition for no additional fee; fee nonrefundable. Films and scripts are returned. Sponsor assumes, two years from date of selection, rights for presentation without payment for noncommercial purposes only. Awards include cash prizes and Nissan automobiles. Schools of first place winners get film stock. Winners also flown to Los Angeles for 5 days. "All winning films screened each year at FOCUS Premiere and Award ceremony attended by Hollywood professionals." Films must be 16mm; silent or with optical sound; color or b&w. Write for information/entry forms.

GALLERY MAGAZINE, 800 2nd Ave., New York NY 10017. Contest Editor: Judy Linden. Monthly event for still photos. Entries must consist of photos of nonprofessional females. Maximum number of entries: 1 entry/model, several photos. No entry fee. Sponsor assumes first exclusive rights. Awards \$1,000 plus cruise for two to monthly (model) winner; \$100 to photographer who submitted photo. \$500 for model (monthly runner-up); free 1-yr subscription to photographer. Annual awards: to model \$25,000 in prizes; \$500 to photographer. Accepts be wo or color photos of any size. "No negatives!" Wants "tastefully erotic females, 18 years old or older." Write for details.

Tips: "All photos must be accompanied by our entry blank, with the model's signature notarized. This is a must. Photos should be sharply focused and in good taste; and whenever possible out-of-doors. Study our Girl Next Door contest layout. If you think you can come up with a similar, but different layout, beautifully photographed, with a beautiful model (an amateur model that has not appeared in other men's magazines!), send it on speculation. The layout has to include some b&w photos of the model in a bikini (for publicity purposes). If the layout is accepted by us, we will pay the photographer \$1,000."

GOLDEN ISLES ARTS FESTIVAL #15, Box 673, Saint Simons Island GA 31522. (912)638-8770. Contact: Registration Chairman, Island Art Center. Sponsor: Glynn Art Association/Island Art Center. Annual competition for still photos/prints; all fine art and craft held the second weekend in October in Saint Simons Island, Georgia. Average attendance: approximately 50,000. Average number of entrants/submissions: 175 from approximately 400-500 submissions. Deadline: August 1. Entries prejudged by Jury Committee by August 15th. Entry fee is \$45 which must accompany each artist's entry for each space; refundable. "We highly encourage all work to be for sale." No sponsor commission; entrants are responsible for paying own sales tax. Offers Best in Show award (open to all categories)—\$300 and ribbon; Photography award—\$50 and ribbon; Honorable Mention award (at discretion of judges in any cateogry)—ribbon. "This is a limited space contest. Upon acceptance by jury, this entitles accepted participants to either a reserved panel, approximately 6x8' wide, or a reserved space approximately 100 square feet, minimun. All types of subject matter are encouraged. This is an outdoor festival, which ranks as one of the tops in the Southeast. Artists and craftmen from many different states vie for acceptance to this festival. Because of the time of year and size of festival, a very large audience attends yearly." Write or call for information/entry forms.

HEMISFILM INTERNATIONAL FESTIVAL, 1 Camino Santa Maria, San Antonio TX 78284. (512)436-3209. Executive Director: Louis Reile. Sponsor: International Fine Arts Center of the Southwest. Annual competition for film held January 30 through February 2 in San Antonio, Texas. Average attendance: 1,000 + . Average number of entrants/submissions: 300-400. "Films must be made or put into distribution two years prior to the festival." Deadline: November 25 of preceding year. "IFACS selects prejudging from its ranks, then hires a panel of judges to sit and award prizes. We list directory of shown films for those interested, who contact filmmakers directly." All prizes will be bronze medallions especially designed for IFACS/Hemisfilm. Accepts 16mm and 35mm film on standard reels, optical sound. "Any film at all, animation, cartoons, features, documentaries, short narrative film, art film, how-to, film from any filmmaker in the world. No prohibitions. Art of film is what we boost." Write for information/entry forms.

*INDEPENDENT FILMMAKERS EXPOSITION, %BACA, 200 Eastern Pkwy., Brooklyn NY 11238. (212)783-4469. Director: Nick Manning. For filmmakers. Purpose is to stimulate creative filmmaking and provide money and exposure for short 16mm films and, beginning in 1982, 34" videotapes. Requirements: Entry in The Expo also means entry into consideration for The Oberhausen Film Festival in Germany. Applicants should be making noncommercial 16mm film or video under 60 minutes. Deadline: January 2. Send for application. "Film should be made up to 1 year prior to entry." Awards/Grants: Presents \$3,000-4,000; amount decided according to length of film.

INTERNATIONAL DIAPORAMA FESTIVAL, Auwegemvaart 79, 2800 Mechelen, Belgium. President: J. Denis. Sponsor Koninklijke Mechelse Fokokring. Competition held every other year for slide sound sequences in Mechelen, Belgium. Average attendance: 3,000. Deadline: February 26. Maximum number of entries: 3. Prejudged by a preselection jury designed by the Koninklijke Mechelse Fotokring. Entry fee: \$7; not refundable. Work not for sale. Awards "the medal of the King, other honourific prizes, and many prizes in materials." Slides mounted in 5x5 plus a sound tape. No limitations on subject matter. "No commercial sequences." Write for information/entry forms.

INTERNATIONAL EXHIBITION OF PHOTOGRAPHY, 1101 W. McKinley Ave., Box 2250, Pomona CA 91769. (213)623-3111. Coordinator: Aileen Robinson. Sponsor: Los Angeles County Fair. Annual exhibition for still photos and slides held in September in Pomona. Average attendance: 1,350,000. Maximum number of entries: 4 in each division. Prejudged by juried selection. Entry fee: 4 color and 4 monochrome prints, \$3.50 each; 4 pictorial slides and 4 nature slides, \$3.50 each; 4 stereo slides, \$2.50; not refundable. Work not for sale. Sponsor assumes all rights unless otherwise requested. Awards PSA medals, ribbons, divisional trophies and participation ribbons. Accepts 16x20 maximum b&w or color photos; stereo, nature and pictorial color slides. No limitations on subject matter. Write for information.

*INTERNATIONAL FILM & TV FESTIVAL OF NEW YORK, 246 W. 38th St., New York NY 10018. (914)238-4481. Annual festival: November. Average attendance: 2,000. Entry fee: varies for different categories. Categories include TV Commercials and Industrial Films, Filmstrips & Slidefilms, Educational & News Films, Filmed Introductions and Lead-in Titles, Multi-Media and Multi-Image Productions, TV Public Service Announcements and Television Programs. Awards include gold, silver and bronze medals.

ROBERT F. KENNEDY JOURNALISM AWARDS, 1031 31st St. NW, Washington DC 20007. (202)628-1300. Contact: Staff Director. For photojournalists. Purpose is to encourage coverage of the problems of the disadvantaged.

Requirements: Applicant may be professional or student. Deadline: January. Entries must have been

published during the previous year. Send for entry blank and rules.

Awards/Grants: To professionals presents \$1,000 prize for photojournalism and one \$2,000 prize for best entry of all categories. Entries judged by professional journalists.

NATIONAL HEADLINER AWARDS, Devins Lane, Pleasantville NJ 08232. (609)645-1234. Chairman: Herb Brown. Sponsor: Press Club of Atlantic City. Annual competition for still photos held in May in Atlantic City, New Jersey. Average attendance: 400. Entries must be published during calendar year 1985 and must be nominated by a newspaper, magazine or news syndicate. Deadline: February 12. Maximum number of entries: unlimited. Entry fee: \$20 per entry; not refundable. Work not for sale. Entries are not returned. Awards Headliner plaque and expense-paid weekend in Atlantic City for awards weekend. All photo entries must be b&w or color for newspapers, and either b&w or color for magazines and syndicates, mounted on 11x14 boards. Entries should contain captions and tearsheets to indicate publication. No sequence or series. Categories include outstanding spot news, outstanding feature and outstanding sports photography. Write for information/entry forms.

NATIONAL ORANGE SHOW, INTERNATIONAL EXHIBITION OF PHOTOGRAPHY, 689 S. E St., San Bernardino CA 92408. (714)797-8292. Chairperson: Lorena Loper. Sponsor: Wind & Sun Council of Camera Clubs. Annual competition for still prints and 35mm nature slides held in San Bernardino. Deadline: early April. Average number of entrants/submissions: 530. Maximum number of entries: 4 in each division. Entry fee for prints: \$4; slides: \$4. Work not for sale. "Right to reproduce for salon catalog is understood unless denied on entry form." Offers Honor Ribbons, Gold and Silver Medals. Entries must not exceed 16x20". B&w or color prints may be on any subject. Slides should be in standard 2x2" mounts. Can be in glass. Subject must be Nature as defined by the Photographic Society of America. For information/entry forms, write: Lorena Loper, 35530 Bella Vista Dr., Yucaipa CA

Tips: Recommends "membership in Photographic Society of America. Members earn 'Star Ratings'

based upon number of acceptances in approved salons. The star rating earned could then be used to advertise their competence in photography."

*NEW YORK STATE FAIR PHOTOGRAPHY EXHIBITION AND SALE, New York State Fair, Syracuse NY 13209. (315)487-7711. Superintendent of Photography Competition: Duane Saurd. Annual event for still photos held in late August-early September in Syracuse. Average attendance: 655,000. Competition is open to amateurs or professionals studying, working or participating in photographic media. Deadline: August 1. Entries are prejudged. Entry fee: \$5 for 1-2 works; not refundable. Sponsor assumes all rights. Presents state fair cash awards amounting to \$1,000; two \$250 Kodak "Best of Show" awards (black & white, and color), and ribbons. Sponsor receives 25% commission on all sales. Accepts 16x20 mounted b&w or color photos; "all types and any subject matter." Send for brochure.

Tips: "We encourage the amateurs as well as the professionals to enter. Photos must be mounted or matted as specified in the brochure. Make sure the presentation is correct."

*NEW YORK STATE YOUTH MEDIA ARTS SHOWS, Bureau of Arts, Music and Humanities Education, The State Education Department, Room 681 EBA, Albany NY 12234. (518)474-5932. Sponsor: New York State Education Department. Annual competition for still photos, film, videotape, creative sound, computer arts and holography, held in 8 regional sites in New York. Average number of entrants/submissions: 600. Entrants must be high school students in New York state. Entries judged at state level by media artist/teachers of summer school. No entry fee. Work not for sale. Sponsor assumes the right to reproduce for educational distribution. Awards scholarships to school. Write for information/entry forms.

NORTH AMERICAN OUTDOOR FILM ACADEMY AWARDS, Box 180, Jefferson City MO 65102. (314)751-4115. Chairman: Joel M. Vance. Sponsor: Outdoor Writers Association of America & North American Wildlife Conference. Annual competition for film held in Washington DC. Average attendance: 1,500. Average number of entrants/submissions: 20-30. For motion pictures or TV programs in two categories: outdoor/conservation and outdoor recreational-promotional. Deadline: February 1. "Films are screened by a panel and top three selected for showing at North American Wildlife Conference, where audience ranks films. There is a \$50 entry fee, to be sent to the chairman. Make checks payable to OWAA. Work may be offered for sale; no sponsor commission. Sponsor assumes no rights. Awards 1st, 2nd and 3rd place plaques and national publicity. Accepts any film or TV program not previously entered (usually previous year production) dealing with outdoor theme. Write for information/entry forms.

Tips: "Screening is done by professional writers/photographers and final audience is composed of people working in conservation/wildlife/forestry/education fields. So don't send anything but highest quality. The contest provides freelancers with national exposure to an audience that buys motion pix on conservation/outdoors subjects."

NORTHWEST FILM & VIDEO FESTIVAL, Northwest Film Study Center, 1219 SW Park Ave., Portland OR 97205. (503)221-1156. Festival Director: Bill Foster. Sponsor: Northwest Film Study Center. Annual competition for film and videotape held in October in Portland, Oregon. Average attendance: 2,000. Average number of entrants/submissions: 150. "Work not previously entered and completed since September 1 by residents of Oregon, Washington, Alaska, Montana, Idaho and British Columbia. Deadline: September 1. Maximum number of entries: 2. No entry fee. Work not for sale. Awards cash to winning entries. Accepts 16mm, 35mm, or Super-8mm film; ½" or ¾" videotape, 35mm slide/tape. Competition open to any subject matter, any length. Write for information/entry forms.

NORTHWEST INTERNATIONAL EXHIBITION OF PHOTOGRAPHY, Box 430, Puyallup WA 98371. (206)845-1771. Superintendent: Floramae D. Raught. Sponsor: Western Washington Fair and approved by Photographic Society of America. Annual event for still photos and slides held in September in Puyallup. Average attendance: 1,000,000. Photographers must make their own prints (except photojournalism and new small pictorial prints section). Deadline: Mid-August. Maximum number of entries: 4 photojournalism prints (maximum 8x10), 4 color prints, 4 b&w prints (maximum 16x20), 4 small prints (maximum 8x10, either b&w and/or color) and 4 slides. Cannot enter both large prints and small prints. Prejudged by panel of 3 judges. Entry fee: \$3/medium—b&w prints, color prints, small prints and slides; not refundable. Work not for sale "but we refer prospective buyers to maker." Sponsor assumes right to use entries in catalog and publicity. Awards gold medal in each medium and ribbons for best in categories (8). Gives special awards for best of animals, children, design, action, humor, human interest, portrait and scenic subjects. Write for information.

Tips: "Mount prints attractively. Prints will be viewed by people who may be interested in buying."

PICTURES OF THE YEAR, Box 838, University of Missouri School of Journalism, Columbia MO 65205. (314)882-4882. Director: Ken Kobre. Sponsor: University of Missouri School of Journalism and the National Press Photographers Association. Annual competition held at the University of Missouri. The competition is conducted to honor staff and freelance photojournalists who work for newspapers and magazines. Competitions are also held in picture editing. Entry fee: \$25 for nonmembers of the National Press Photographers Association. Twenty-five entries maximum/photographer. Accepts b&w and color photos taken or published during the calendar year; 11x14 maximum, must be mounted. Contest deadline: January 15. Rules are subject to revision. Send for rules brochure after Sept. 1. For complete information and instructions, send for brochure.

Tips: Send for the brochure early, prepare early, and if you can find someone who has entered before,

talk to him/her. Make good prints, that are large images not exceeding 11x14.

PRESS PHOTO OF THE YEAR CONTEST, Weesperzÿde 87 1091 EK Amsterdam; The Netherlands. Contact: Executive Director. Sponsor: World Press Photo Holland Foundation. Annual competition for still photos held in February in Amsterdam. Average number of entries: 5,000-5,500 pictures (850 photographers). Only professional photographers are eligible. Deadline: January 31. No entry fee. Work not offered for sale. Buys one-time rights. Awards cash, medals and diplomas. Accepts b&w and color photos and slides. Categories: Spot News, News Features, People, Sports, Arts and Sciences, Happy Events, Nature, Daily Life. Both single pictures and series can be awarded. Write for information/entry forms.

THE PRINT CLUB, 1614 Latimer St., Philadelphia PA 19103. (215)735-6090. Director: Ofelia Garcia. Sponsor: The Print Club. Annual national/international competition of prints and photos juried selections. Entrants must be members of The Print Club; membership is open to all interested. Sponsor assumes right to exhibit if selected and right to reproduce in show catalog if award-winning. Write for complete information.

PRO FOOTBALL HALL OF FAME PHOTO CONTEST, 2121 Harrison Ave. NW, Canton OH 44720. (216)456-8207. Vice President/Public Relations: Donald R. Smith. Sponsor: Canon USA, Inc. Annual event for still photos. Judging will be held in Canton in March for photos of the previous season. Must be professional photographers on assignment to cover NFL preseason, regular-season or postseason games. Deadline: February. Maximum number of entries: 12 b&w photos and 12 color slides. No entry fee. Sponsor assumes the right to use photos for publicity of the contest and Hall of Fame displays. Average attendance each year at the hall is 200,000. All other copyright benefits remain with entering photographer. Awards in each category: first place, \$500 and plaque; second prize, \$250 and plaque; third prize, \$100 and plaque. Also: PHOTOGRAPH OF THE YEAR (from among four category winners): Additional \$500 plus trip to Football's Greatest Weekend in Canton. Accepts b&w prints of any size, mounted on 14x20 boards, or 35mm color slides. Categories: B&w action, b&w feature, color action and color feature. Write or call the Pro Football Hall of Fame for information/entry forms.

Tips: "Follow the rules and regulations instructions that are distributed before each contest, particularly the tips on subject matter and the size specifications for entered material."

PSA YOUNG PHOTOGRAPHERS SHOWCASE, PSA Headquarters, 2005 Walnut St., Philadelphia PA 19103. (215)563-1663. Contact: Chairman. Sponsor: Photographic Society of America. Annual event for still photos held July 1. Average attendance: 200-1,500. Photographers must be 25 or younger. Deadline: July 1. Maximum number of entries: 4. Entries are prejudged by 3 qualified judges. Entry fee: "about \$3; not refundable." Work not for sale. Photos used only to publicize winners. Awards cash prizes, certificates, ribbons and membership in PSA. Accepts 8x10 b&w or color photos on any subject. Contact Chairman at the above address for information.

SANTA CLARA VALLEY INTERNATIONAL, 124 Blossom Glen Way, Los Gatos CA 95030. (408)356-5854. General Chairman: W.B. Heidt. Sponsor: Central Coast Counties Camera Club Council (6C). Competition in even years for still photos: pictorial and nature slides, nature prints, color prints, monochrome prints and photojournalism slides and prints. Closing date April 12. Average attendance: 700. "Slides may be commercially developed; prints must be made by the photographer." Maximum number of entries: 4 in each category. Prejudged by panel of 3 judges. Entry fee: \$4.00/color slides, \$5.00/prints; not refundable. Works returned to maker after exhibition; no provision for sale at exhibition. Sponsor assumes right, with owner's permission, to reproduce works in the sales catalog. No cash prizes. Awards PSA and local medals to tops in each group; honorable mention ribbons to top 10%. Accepts b&w or color photos (maximum 16x20). "Pictorial—any subject. Nature restricted to true wild animal or plant; domestic flowers not considered nature; hand of man shouldn't show in nature slides and prints. Photojournalism photos should depict man and his environment." Write for information/entry forms.

530 Photographer's Market '86

Tips: "Enter the competition as a measure of your photo against some of the top amateur photographers of the world."

SANTA CRUZ VIDEO FESTIVAL, Box 1273, Santa Cruz CA 95061. (408)475-8210. Coordinator: Greg Becker. Sponsor: Open Channel. Annual competition for videotape held in Santa Cruz, California. Average attendance: 500-750. Average number of entrants/submissions: 75-100. "Oriented to independent and access videographers. Write to be put on mailing list. All tapes are cataloged and played by request at the Festival. Judging panel awards prizes. There is a \$10 entry fee, plus return postage and a container to return the tape in." Entry fee not refundable. Work may be offered for sale; 10% sponsor commission. Varying theme from year to year.

Tips: "Keep the works short. Most work could easily be half as long."

SCHOLASTIC PHOTOGRAPHY AWARDS, Scholastic, Inc., 730 Broadway, New York NY 10003. For photographers. Purpose is to provide scholarship grants to college-bound high school seniors.

Requirements: Must be a high school student. Awards granted on regional and national level. Deadline: February. Write for application and information between October and January; *specify photography*. **Awards/Grants:** Presents one \$4,000 scholarship; one \$2,000 scholarship; one \$1,000 scholarship; and one \$500 scholarship.

THE SEVENTH HIROSHIMA INTERNATIONAL AMATEUR FILM AND VIDEO FESTIVAL, % Chugoku Broadcasting Co., 21-3, Motomachi, Naka-ku, Hiroshima, Japan 730. (082)223-1111. Contact: Takeshi Hayashi. Sponsor: The Hiroshima International Amateur Film and Video Festival Working Committee, Chugoku Broadcasting Co., National Federation of UNESCO Association in Japan, The Chugoku Movie Association. Biannual event for film and video held in July in four cities: Hiroshima, Tokyo, Osaka and Nagasaki. Average attendance: 150-200. Entrants must be amateur. Deadline: January 31. Maximum number of entries: 1. Entry fee: none. Awards include: Grand prize (statuette, citation, travel coupon 500,000 yen), Prime Minister's prize, Foreign Minister's prize, etc. "Subject matter of films and videos would be any that manifests' efforts towards peace and reverence to life,' be it a tribute to humanity or relation between nature and man. Entrants are free to choose any style of works (records, documentary dramas, animation, art, etc.)." Write to obtain entry form.

TEN BEST OF THE WEST, Box 4034, Long Beach CA 90804. Executive Secretary: George Cushman. Annual competition in its 30th year for film and videotape held in October in the Western United States or Canada. Average attendance: 200. Average number of entrants/submissions: 60 + . Entrants must reside west of the Missouri River, or in one of the 3 western Provinces of Canada. Deadline: August 18. Entry fee: \$5/1 or 2 entries; none refused. Work may be offered for sale after the festival; no sponsor commission. Awards certificates. Accepts a limit of 30 minutes screening time/entry. Any subject is eligible. Write for information/entry forms.

THREE RIVERS ARTS FESTIVAL, #5 Gateway Center, Pittsburgh PA 15222. (412)261-7040. Executive Director: John Brice. Sponsor: Carnegie Institute. Annual competition for still photos/prints, film and videotape held in June in Pittsburgh. Average attendance: 500,000. Average number of entrants/submissions: 1,600/4,000 in all categories. Entrants must be 18 and over and must live, work or study in the following states: Pennsylvania, Ohio, West Virginia, Virginia, Maryland, Washington DC, New York, Delaware and New Jersey. Deadline: March 31. Maximum number of entries: 3. Entry fee: \$15 for Juried Visual Arts: up to 3 matted photos may be submitted. All works must be for sale; 25% sponsor commission. Sponsor assumes one-time publication rights. Offers cash awards: \$750-Festival Exhibition Award; \$500-Festival Award; \$250-Juror's Discretionary Award; \$300-Leonard Schugar Award. Accepted photos are *not* restricted in style, content, color vs b&w, etc. All photos entered are juried; no prescreening. Please send name, address and two first-class stamps for information/entry forms.

TRAVEL PHOTOGRAPHY CONTEST, c/o Maupintour, Inc., Box 807, 1515 St. Andrews Dr., Lawrence KS 66044. (800)255-4266/(913)843-1211. Marketing Director: Paul Kerstetter. Sponsor: Maupintour, Inc. Annual and monthly contest for still photos and slides. Entries must consist of travel photography, preferably taken in a locale visited on a Maupintour holiday. Sponsor assumes all rights except by other arrangement. Awards monthly cash prizes of \$100, \$75 and \$50 and optional honorable mention, \$50; annual prizes of \$1,000, \$750 and \$500 in credit on Maupintours. Accepts b&w and color prints, 4x6-8x10, mounted on cardboard; color 35mm or 21/4x21/4 transparencies, mounted in cardboard. Write for information/entry forms.

Tips: "We particularly like photos of people (both natives and travelers enjoying themselves). We prefer

freelancers to contact us directly rather than through the contest." (Contact: Mrs. Kerry Mueller at above address).

*U.S. INDUSTRIAL FILM FESTIVAL, 841 N. Addison Ave., Elmhurst IL 60126. (312)834-7773. Chairman: J.W. Anderson. Executive Director: Patricia Meyer. Sponsor: The United States Festivals Association. Annual festival for film and video with awards presentation in May in Chicago, Illinois. Average attendance: 200. Open to work produced in previous 12 months only. Entry deadline: March 1. Entry fee varies by the type of entry; not refundable. Sponsor assumes no rights, "except one-time showing." Work not for sale. Awards include plaques and certificates. Accepts 16mm and 35mm film-strips; 3/4 video, video discs, 35mm slides and 16mm films. Write or call for information/entry forms.

U.S. TELEVISION & RADIO COMMERCIALS FESTIVAL, 841 N. Addison Ave., Elmhurst IL 60126. (312)834-7773. Chairman: J.W. Anderson. Executive Director: Patricia Meyer. Sponsor: The United States Festivals Association. Annual festival for film, ³/₄ video tape and radio commercials (reel to reel 7½" ips) with award presentation in January in Chicago, Illinois. Average attendance: 200. Open worldwide to work produced in previous 12 months only. Entry deadline: October 1. Entries prejudged by subcommittee panel. Entry fee varies by the type of entry; not refundable. Awards include "MO-BIUS" statuettes and certificates. Accepts 16mm film and ³/₄ video and reel to reel audio casettes. Entries limited to TV and radio commercials. Assumes right to screen at awards, presentations and to retain winners for educational and publicity opportunies. Entrant has option to limit our use. Call or write for information/entry forms.

Tips: "Make sure work is professional, creative and contemporary."

UNDERWATER PHOTOGRAPHIC COMPETITION, Suite 38, 3922 Emerald, Torrance CA 90503. (213)367-7635. Competition Chairman: Lance Bennett. Sponsor: Underwater Photographic Society of Los Angeles. Annual competition for still photos held in October in Los Angeles. Average attendance: 50 for judging. Average number of entrants/submissions: 125/800. Maximum number of entries: 4/category. Entry fee: \$7.50/category. Work may be offered for sale; no sponsor commission. Sponsor assumes right to use entries for publicity only. Awards: \$50 First Place and \$100 Best of Show (prints and slides). Size limits: minimum 8x10, maximum 16x20. Entries must be taken underwater. Write for information/entry forms.

WESTERN HERITAGE AWARDS, 1700 NE 63rd St., Oklahoma City OK 73111. (405)478-2250. Public Relations Director: A.J. Ace Tytgat. Sponsor: National Cowboy Hall of Fame. Annual competiton for film and videotape held the 4th week of April in Oklahoma City. Average attendance: 600. Average number of entrants/submissions: 200. Entries must be Western in subject. Deadline: January 31. No entry fee. Work not for sale. Requires promotional rights. Awards "The Wrangler, a replica of a C.M. Russell bronze statue." Prefers "productions which authentically capture the spirit and history of the West." Write for information/entry forms.

CAPTAIN DONALD T. WRIGHT MARITIME JOURNALISM AWARDS, Department of Mass Communications, Southern Illinois University, Edwardsville IL 62026. (618)692-2230. Chairman: John A. Regnell. Sponsor: Southern Illinois University. Annual competition for still photos and film stories. Average attendance: 200-300. Deadline: September 1 each year. No limit on entries. Prejudged by faculty committee. No entry fee. Works may be offered for sale; no commission. Awards plaque. Accepts "educational, documentary, informational type photos/film having to do with the maritime industry (principally in the Mississippi and Ohio valleys)." Write for information/entry forms.

YOUNG PEOPLE'S FILM & VIDEO FESTIVAL, Northwest Film Study Center, 1219 SW Park Ave., Portland OR 97205. (503)221-1156. Attention: Festival Director. Sponsor: Northwest Film Study Center. Annual competition for film and videotape held April or May in Portland, Oregon. Average attendance: 350. Average number of entrants/submissions; 80-100. Competition open to any young film or video maker living in Oregon, Washington, Idaho, Montana or Alaska entering in one of five grade categories: K-3, 4-6, 7-9, 10-12 and college/university. Deadline: 3 weeks before festival date. "All entries are viewed by a jury which select winning entries in each category." No entry fee. Work not for sale. Assume right to broadcast winning works a maximum of two times on PBS and to preserve duplicates of work for educational, broadcast and publicity purposes. Awards certificates. Accepts 16mm or Super-8 film and VHS, Beta or 3/4" cassette. "Open to any style or subject matter with suggested running time of ten minutes or less." Write for information/entry forms.

Workshops_

As you expand and sharpen your knowledge of freelance photo marketing, don't neglect your study of photography itself—remember that no amount of marketing know-how is going to sell poor or even so-so pictures; the competition in the

photography marketplace is just too great.

The workshops and seminars listed in this section, as well as many more photography classes and programs offered by schools and colleges across the country, are the very best opportunities you can find to practice and learn the kinds of professional photography techniques that will enable you to compete at the highest levels of the business. You can choose among courses in studio lighting, portraiture, printmaking, nature photography, video, the zone system, landscapes—whatever area of photography you need or want to learn more about. Many workshops are now also offering instruction in the business and marketing aspects of photography.

Check with the directors of those workshops which interest you for further in-

formation about their curricula and schedules.

AMPRO PHOTO WORKSHOPS, 636 E. Broadway, Vancouver, British Columbia, Canada V5T 1X6. (604)876-5501. President: Ralph Baker. Offers 12 different courses throughout the year in dark-room and camera techniques including studio lighting and portraiture, a working seminar where students can shoot. Class size depends on course, from 6-15. Length of sessions varies from 3-7 weeks. Cost ranges from \$60-125. "Creative Images is a course designed to help the photographer plan photos that are more effective." Write or phone for latest brochure. Private tutoring available. Darkroom facilities for b&w and color, mat cutting, mounting and studio rentals available. Now an approved educational institute.

ANDERSON RANCH ARTS CENTER, Box 5598, Snowmass Village Co 81615. (303)923-3181. Director: Bradley Miller. Offers workshops in photography, clay, wood, printing and painting. Photography: one week sessions for advanced and beginning photographers. Past faculty includes: Ernst Haas, Eliot Porter, Art Kane, Dick Darrance, Al Satterwhite, Cherie Hiser, Peter de Lory. Call or write for summer brochure. Housing available. Tuition: \$200-300.

*APPALACHIAN PHOTOGRAPHIC WORKSHIPS, INC., 2432 Charlotte St., Asheville NC 28801. (704)258-9498. Director: Tim Barnwell. Offers basic to advanced programs in landscape and wildlife photography, studio and outdoor portraiture, glamour photography, lighting, darkroom technique, b&w and color printing and the zone system. Weekend and master classes, and evening lectures are also offered. Workshops last up to four days and run year-round; registration deadlines vary. Guest instructors include Ernst Haas, Nancy Brown, George Tice, Carson Graves, John Sexton, Fred Bodin, Ken Taylor, Sonja Bullaty and Angelo Lomeo, Robert Farber, Cole Weston, Tim Olive, Eugene Richards and Dean Conger. Costs: \$45-365. Free catalogue upon request.

HOWARD BOND WEEKEND WORKSHOPS, 1095 Harold Circle, Ann Arbor MI 48103. (313)665-6597. Owner: Howard Bond. Offers two types of 2-day weekend workshops: Refinements in B&W Negative Making and Refinements in B&W Printing, each costing \$95. "The negative workshops clarify the Zone System and how to do the necessary calibration tests. About ½ of the time is spent on other topics relevant to exposing and developing negatives. The printing workshops are intended for people who already know how to make b&w prints. Primary emphasis is on strengthening a student's concept of the full scale fine print through critical examination and discussion of many prints by master photographers. Methods of achieving such prints are explained and demonstrated, often with student negatives. Particular attention is given to clarifying the situations in which various techniques are appropriate." Spring and fall only. Class size: 11. Also offers 3-day b&w field workshops in early summer at Lake Superior Provincial Park, Ontario. "These run Friday-Sunday, with an optional introduction to the zone system. Both workshops stress practice in applying the zone system with several instructors available for individual help. Indoor sessions are in the evenings and as dictated by weather." Cost is \$100. Write to apply.

Close-up

Tim Barnwell, Director, Appalachian Photographic Workshops

Appalachian Photographic Workshops There are various ways to learn photography-self-study, an apprenticeship with a well-known professional, or a formal university program. But one of the fastest and easiest ways is by enrolling in a photographic workshop. Workshops offer many of the advantages of apprenticeships or degreed programs without a great investment in time, and are often better than self-study because they offer a chance to share one's work with other people and to have it critiqued by experts. Even the experienced professional or advanced amateur can benefit from a workshop, since no photographer is an expert in all fields.

Tim Barnwell had been to some of the better-known workshops in Maine and California and while he found their quality excellent, they were located in very out-of-the-way places. Students frequently spent more for transportation than for tuition. He wanted to offer a more accessible workshop, and he reasoned that his hometown-Asheville, North Carolina-would be a perfect location since it was within a few hour's drive of nearly half the country's population, was close to wilderness areas such as the Great Smoky Mountain National Park, and local costs for lodging and transportation were low. Tim started Appalachian Photographic Workshops in 1980. With two friends he rented a building and started holding classes.

The idea was good and the classes were successful, but Barnwell admits it took longer than he thought to get things going. Running his own business was a lot different than working for someone else. "But finally," he says, "we've combined market research, business techniques, and a solid core of instruction to come up with a workshop that's as good as any in the country." His "master class" instructors include such well-known names as Cole Weston, Robert Farber and Carson Graves. Barnwell teaches along with others,

such as Assistant Director Nick Lanier and Asheville pro LaMont DeBruhl. "We try to offer courses to students with different interests, from art and fashion to photojournalism," Barnwell says.

Workshops are held year-round and combine classroom lecture with demonstrations, critiques and field trips. Classes for beginning to advanced local photographers are held one night a week in four-to-eight week sessions. Weekend classes generally cater to photographers from the southeastern states.

Master classes, such as Weston's. involve a day of introduction and portfolio review, two days of hands-on nature photography in the Blue Ridge and Smoky mountains, a third day of intensive darkroom instruction and a fourthday return to the mountains for classes in fine art, nature and nude photogra-

Barnwell had a wide variety of photographic experience before starting Appalachian Photographic Workshops, including a four-year stint as chief photographer of Mountain Living Magazine, and advertising studio work shooting "batteries, toilet seats, and deodorant cans." He tries to reserve some time for his own projects, one of which is a book project recording the traditional Appalachian methods of farming. "There hasn't been much time for that lately," he says. "but I do it to keep myself fresh. One of the things I really enjoy the most, though, is instruction."

Barnwell projects a continued expansion of his workshops. Is he getting rich? Not in dollars, but in terms of job satisfaction and accomplishment he's getting a lot. To Tim Barnwell, it has all

been worth it.

CATSKILL CENTER FOR PHOTOGRAPHY, 59 A Tinker St., Woodstock NY 12498. (914)679-9957. Director: Colleen Kenyon. Coordinator of *Woodstock Photography Workshops* summer program: Kathleen Kenyon. Summer weekend workshops are designed to be "varied, intensive experiences instructed by nationally known guest artists who will also present evening slide lectures." Average cost: \$60. The year-round educational program consists of slide lectures, short workshops, and a series of 8-week classes averaging \$60 in cost. CCFP also houses 4 exhibition galleries, a darkroom and finishing room, and a bookshop/library area. Call or write for detailed schedule.

CREATIVE COLOR WORKSHOPS, 30 Niantic River Rd., Waterford CT 06385. (203)442-3383. Contact: Robin Perry. Offers a program designed for the professional or advanced amateur photographer interested in increasing his earning power. Includes the creative processes and techniques used by successful illustrators on high revenue assignments; Creative Color Workshops; Creative Video Camera Techniques Workshops. Also includes how to prepare a portfolio, pricing, what rights to sell, the photographer as writer, choosing a camera system, video camera techniques, processing color films, meters and metering techniques, fine tuning with filters, etc. Sessions limited to 10 photographers. Sessions last for 3 full working days. Cost is \$350; does not include meals and accommodations. Write for brochure or call. SASE.

Tips: Acceptance is on a first come, first served basis.

CUMBERLAND VALLEY PHOTOGRAPHIC WORKSHOPS, 3726 Central Ave., Nashville TN 37205. (615)269-6494. Director: John Netherton. "The major concerns are visual awareness and artistic quality. Technique is the foundation on which these concerns are based. It is a support, not a dominating factor, and will be emphasized only in so far as a means to this end: an aesthetically valid photograph." Offers workshops throughout the year including Wildlife in the Everglades, Scenics and Macro in the Smoky Mountains, China, B&W Rural in Middle Tennessee, Coastal Photography at Ocracoke NC, Nocturnal, Basic Photo Classes, Fashion, Landscapes, Large Format, Studio and Location Lighting, Portrait, Photographing People. Workshops last from 1 to 12 days. Class size 10 to 15. Costs \$40 to \$3,500. Write or call for brochure.

CUMMINGTON COMMUNITY OF THE ARTS, Cummington MA 01026. (413)634-2172. Director: Carol Morgan. Offers programs for writers, painters, visual artists, musicians, filmmakers and photographers. Exists "primarily to stimulate individual artistic growth and development while providing an atmosphere for communication and interdisciplinary cooperation among its residents." Occupancy during summer about 20 adults and 10 children; about 15 artists during nonsummer months. Year-round residencies. Minimum one-month stay, with two- and three-week stays possible on a space-available basis from November-March. Cost is \$250-300. Cost for July and August is \$500/month. Cost is \$500 during nonsummer months. Includes private room, work space and meals. Work assignments add up to about 10 hours/week. Write to apply.

Tips: "Application deadline for September, October and November sessions is June 15; for December, January and February, September 15; for March, April and May, January 1; for June July and August, March 15." A limited number of scholarships and loans are available to economically disadvantaged artists. April, May and October offer optional work-programs, in which a resident pays only \$100 for

room and board in exchange for 22 hours a week for the community.

THE DOUGLIS VISUAL WORKSHOPS, 212 S. Chester Rd., Swarthmore PA 19081. (215)544-7977. Director: Phil Douglis. "This workshop is not just in photography, but rather in visual thinking, particularly for word-oriented people such as editors of organizational publications. We also stress picture usage, particularly in employee publications, annual reports." Offers 30 workshops, year-round, entitled *Communicating with Pictures*, in 18 cities coast to coast. Class size: 20 maximum for 2½-day workshop. Cost is \$595. Includes breaks and two luncheons. Write to director to apply.

THE FOTO-TEK DARKROOM, 428 E. 1st Ave., Denver CO 80203. (303)777-9382. Manager: Jim Johnson. Offers different courses and workshops in photography, including basic and intermediate photography, and the zone system. Occasionally offers special workshops. Class size limited to 20. Length of sessions is 6 weeks. Cost is \$75. Includes tuition only; lab time and materials extra. Write to apply.

EGONE WORKSHOP, 14 Embassy Rd., Brighton MA 02135. (617)254-0354. Owner/Teacher: Egon Egone. Offers programs in darkroom techniques, portrait photography, outdoor portrait photography, travel photography and photography of the nude. Programs offered year round. Class size: 4-8. Programs last for 4-9 weeks. Cost is \$60-90. Includes chemicals and use of darkroom and sitting room. Write or phone to apply. SASE.

FILM IN THE CITIES/LIGHTWORKS, 2388 University Ave., St. Paul MN 55114. (612)646-6104. Director: James Dozier. Offers programs in b&w darkroom techniques, lighting, camera basics,

zone system, still photography, motion picture studies, intermediate and advanced photography and concentrated summer workshops with leading photographers. Length of sessions vary from 1 4-hour session to 4 or more sessions; concentrated summer workshops are 6 days long, meeting each day with assignments and critique sessions. College credit available. Costs range from \$55-125 for short classes, \$245-270 for 6-day workshops. Class fees include use of darkroom where appropriate, chemicals, other equipment, instruction, demonstration materials; workshop fees include instruction, private and class consultation with workshop leader, darkroom use and chemicals, breakfast, use of library, and field trips. Emphasis is always on personal growth in both ideas and skills. Write or call to apply. "We have no special forms. A letter telling about yourself and your interests is enough. Specify 'Still Photography' or 'Motion Picture' or both, to be sure you get the proper and full information." SASE.

FRIENDS OF PHOTOGRAPHY, Box 500, Carmel CA 93921. (408)624-6330. Workshop Coordinator: Claire V.C. Peeps. The Friends of Photography Workshop Program covers general interests in photography as well as related specialized fields such as history, criticism and the teaching of photography. Workshops at The Friends consist of a combination of lectures, discussions, print critiques, technical discussions and field sessions. Instructors and specific content of workshops varies each year. Workshops last 3-6 days, cost varies from \$95-375. Write for workshop information.

THE GILLETTE WORKSHOP OF PHOTOGRAPHY, 498 N. McPherson St., Ft. Bragg CA 95437. (707)964-2306. Director: J. Stephen Gillette. Offers specialized training in photography of people and figure photography. Programs last one week—"eight in the morning till one, giving time to vacation on the beautiful Mendocino coast." Includes models, film, paper, chemicals, lights, camera room and darkroom—"all you need is your camera"—35mm or 120. Workshops include "Negative Retouching," "Copy Restoration"—including air brush, "How to Operate a Mini Lab." All private instruction—no groups or classroom work—"learn by doing". Call or write for brochure, price and dates available.

INTERNATIONAL CENTER OF PHOTOGRAPHY, 1130 5th Ave. at 94th St., New York NY 10128. (212)860-1776. Contact: Education Department. Offers programs in b&w photography, nonsilver printing processes, color photography, still life, photographing people, large format, studio, color printing, editorial concepts in photography, zone system, the freelance photographer, etc. Also offers advanced weekend workshops and 1- or 2-day weekend seminars for advanced professional photographers in a variety of technical and aesthetic subjects. There are 1,000-1,200 students at the center/semester. Class sizes range from 12 students in a darkroom course to 18 in seminars and 80 in lectures. The fall semester runs from October-December with registration beginning in September. The winter semester begins in February and runs through April with registration beginning in January. A late spring session (April-June) and an intensive summer session (July-August) offer a more limited selection of courses. Sessions last from 2 full weekends to 10 weeks. An interview with portfolio is required for all courses except introductory b&w photography weekend seminars and lecture series. ICP also offers a full-time studies program in both "photojournalism" and documentary photography and general studies in photography, which combines classroom study with independent study. Full-time programs are available for intermediate/advanced level students. In addition ICP in conjunction with New York University offers a Master of Arts Degree in Photography. The Master of Arts program combines the rich assortment of studies available through NYU and the highly specialized approach of the International Center of Photography. Write for the ICP Education Program Brochure for specific schedule of dates, times, costs, etc.

Tips: "It is recommended that wherever possible prospective students visit the Center. Where this is not possible, applicants can mail examples of their work to us along with a short statement of photographic background and interests. Work can be either prints or slides, and should have enclosed: (1) name of the course applied for, (2) a short statement of involvement with photography and reasons for wanting to take the course, (3) instructions for returning or holding the portfolio, and return postage in case of prints being returned. There are no restrictions in size, finish, etc."

THE MacDOWELL COLONY, Peterborough NH 03458. (603)924-3886. President Director: Christopher Barnes. Offers studio space to writers, composers, painters, sculptors, printmakers, photographers and filmmakers competitively, based on talent. Serves 31 artists in the summer; 20-25 in other seasons for stays of up to 2 months. Suggested fee is \$15/day—"more if possible, less if necessary." Room, board and studio provided. To apply write to Admissions Coordinator, The MacDowell Colony, Inc., 100 High St., Peterborough NH 03458. File applications at least 6 months in advance.

THE MAINE PHOTOGRAPHIC WORKSHOP, Rockport ME 04856. (207)236-8581. Director: David H. Lyman. "Each summer the world's greatest photographers gather here to share their work, exchange ideas, explore new areas of vision, to teach and to learn. There are over 100 one- and two—week

workshops and programs to help improve the craft and vision of working professionals, serious artists and beginning amateurs." Workshops cover a wide variety of subjects each summer, including fine art photography, photojournalism, studio and advertising photography, portraiture, fashion and commercial photography, special processes and techniques—such as dye transfer, platinum printing, the view camera, Zone System—and fine silver printing. Basic and intermediate workshops for amateurs cover craft and photographic perception. Summer master classes taught by such well-known photographers as: Ernst Haas, Pete Turner, Eliot Porter, Cole Weston. Arnold Newman, Mike O'Neill, Jay Maisel, Jean Pagliuso, Dick Durrance, George Tice, Lilo Raymond and Eugene Richards. Costs: \$250-700. plus lab fees. Class size 7-20. All advanced workshops by portfolio only. One weekend conference is held each summer, each dealing with the photographic market. Costs for the three days each of the threeday conferences is \$175. Summer workshops for film directors, cameramen, cinematographers and technicians in Rockport, Maine each June. Costs \$700. Three-month and two-year resident programs begin each fall and spring, leading to associate degrees in photography and certificates in commercial photography, photojournalism and fine art. Costs: \$4,800 per term includes housing, meals, tuition and b&w lab fees. Student housing, financial aid and college credit available for all programs. Facilities include over 50 enlargers in 17 darkrooms, 5 color labs, library, print collection, 2 galleries, sound studio, commercial studio, theater, classrooms, extensive equipment and a supply store on the premises. Resident staff of seven full-time photographic instructors. Complete catalogue available by writing the Workshop.

Tips: "We are now offering 6 programs overseas for serious photographers who wish to travel. Programs this year include France, Italy, England and the Caribbean—all led by some of the world's leading

photographers."

*MILWAUKEE CENTER FOR PHOTOGRAPHY, 207 E. Buffalo St., Milwaukee WI 53202. (414)273-1699. Contact: Director. Not-for-profit tax exempt institution offering an Associate Degree (3 years) in photography. Also offers day and evening and summer workshops in basic, intermediate, advanced, view camera, color photography; history of photography; zone system. Has 25 full-time students, 130 day and evening workshop students, and 80 summer students. Fall and spring workshop sessions last 14 weeks; summer workshops last 3 weeks. Cost for a full-time degree is \$1,200/semester plus \$75 lab fees. Evening workshops cost \$160; summer workshops, \$160. Fee includes chemicals. Portfolio of 10-15 prints required for advanced classes only. Call or write for catalog.

*JOHN SHAW & LARRY WEST NATURE PHOTOGRAPHY WORKSHOPS, (formerly Nature Photography Workshops,) Photography Associates, 8737 E. DE Ave., Richland MI 49083. Contact: Larry West or John Shaw. Offers 5 week-long sessions in Houghton Lake, Michigan, covering all aspects of nature photography. Subjects covered include: how to photograph various types of plants and animals; close-up photography; flash; equipment selection; bird photography; scenic photography; finding and identifying subjects; carrying equipment; using filters, long lenses and tripods; photography on trips and assignments; care of equipment in the field; stalking subjects; and marketing photos. Also offers Fall Color Workshop and Africa/Kenya Safari. Costs: \$290 per person, or \$425 including meals and lodging. Each workshop is limited to 20 students. Cost for the Africa/Kenya safari is approximately \$3,195. Write for workshop information.

NORTHERN KENTUCKY UNIVERSITY SUMMER PHOTO WORKSHOP, Highland Heights KY 41076. (606)292-5423. Associate Professor of Art: Barry Andersen. Offers programs provided by a series of visiting photographers. Offers 1 course in "Applied Photography." Sessions limited to 15-20 fine art photographers. Sessions last 2 or 3 weeks. Cost is \$150-300/session. Write to apply.

BOYD NORTON WILDERNESS PHOTOGRAPHY WORKSHOPS, Box 2605, Evergreen CO 80439. (303)674-3009. Director: Boyd Norton. Offers "intensive programs designed to aid in creative self-expression in nature photography. Strong emphasis is placed on critique of work during the several days of the workshop. We deal strongly with principles of composition, creative use of lenses and psychological elements of creativity." Has several programs in different locales: Kachemak Bay, Alaska (6 days); Shepp Ranch on Salmon River, Idaho (6 days); Snowy Range, Wyoming (7 days); St. Thomas and St. John, Virgin Islands (8 days). Also offers workshops in Maine, California, Colorado, Arizona, Utah and Ontario. "In Colorado we offer two advanced editorial workshops for aspiring pros and free-lancers featuring the editor and picture editor of *Audubon* magazine. Some of our workshops also feature David Cavagnaro and Mary Ellen Schultz, both well-known and well-published photographers from California." In Alaska, holds 2 workshops in June; 2 workshops in Idaho in May; and in Wyoming—2 workshops in July, 2 in September; in Virgin Islands, 2 workshops in March. Class size is 10 in Alaska, 15 in Idaho, 10 in Virgin Islands and 16 in Wyoming. Cost is \$1,500 in Alaska. Includes all meals, lodging, boat trip and Ektachrome processing. Cost is \$895 in Idaho. Includes all meals, lodging, air charter and Ektachrome processing. Cost is \$495 in Wyoming. Includes all meals, lodging and Ektachrome

processing. Cost is \$895 in Virgin Islands. Includes all meals, lodging (on 451 sailing boats) and scuba diving instruction. Housing is in comfortable cabins at the edge of wilderness. Uses semiautomated Ektachrome processing on-site for critique of work. Send for brochure. "Because of increasing popularity, we urge very early inquiry and reservations."

OWENS VALLEY PHOTOGRAPHY WORKSHOPS, Box 114, Somis CA 93066. (805)987-7912. Instructors: Bruce Barnbaum, Ray McSavaney and John Sexton. Offers programs in zone system; filters, color and b&w; Polaroid demonstrations; outdoor field sessions; indoor lectures, presentations and critiques; and informal discussions on both technical and philosophical subjects. Spring, summer and fall. Class size: 20-25. Programs last 1 week. Cost is approximately \$300. Includes instruction only. "We help coordinate housing for all workshops." Write for brochure.

KAZIK PAZOVSKI SCHOOL AND WORKSHOP OF PHOTOGRAPHY, 2340 Laredo Ave., Cincinnati OH 45206. (513)281-0030. Director: Kazik Pazovski. Offers year-round programs in all phases of b&w photography. New offerings include portraiture in the studio and on location. Class size: 5-10. One course lasts approximately 3 months, 20-25 sessions. Cost is \$75/course for continuing students, \$85 for all others. Includes all studio and darkroom equipment and chemicals. Write or call the school. "All students are required to take a Photo-Quiz. Generally students with less than high school education may find even the beginners course too difficult to master. Basic knowledge of mathematics and chemistry is desired."

*PETERS VALLEY CRAFTSMEN, Star Route, Layton NJ 07851. (201)948-5200. Offers special summer workshops for all skill levels in specific techniques. Classes include field trips into the rural area of the beautiful Delaware River Valley National Park area, the figure in photography and darkroom classes. Sessions last from 1-7 days. Write for free brochure.

PROJECT ARTS CENTER, 141 Huron Ave., Cambridge MA 02138. (617)491-0187. Photo Director: Charles Leavitt. Offers programs in beginning and intermediate, b&w, color portrait, darkroom techniques, studio lighting, nonsilver and advanced photography. Classes can be taken for college credit. Class size limited to 12. Length of class is 5 or 8 weeks, 3 hours/week, in 4 sessions: fall, winter, spring and summer. Cost is \$10 plus \$30 lab fee. Includes 3 hours of instruction/week. Darkroom rental available. Also offers one and two day workshops taught by locally acclaimed photographers. Write or call to apply. SASE.

SOUTHEASTERN CENTER FOR THE PHOTOGRAPHIC ARTS, INC., (SCPA), Suite 310, 470 E. Paces Ferry Rd., Atlanta GA 30363. (404)231-5323. Director: Neil Chaput de Saintonge. Professional career program, 18 months duration, both day and night classes. Offers workshops and classes on portraiture, fashion, darkroom, nature, figure, macro, photojournalism, audiovisuals, lighting and view camera. In addition conducts nature workshops with trips of 3 days-3 weeks to Florida, Appalachia, Vermont, Georgia, the Okeefenokee Swamp and other locations. SCPA sponsors the annual Fall Photography Festival in September and Nature Festival in the spring; and operates the SCPA Gallery with monthly shows. Write or call for additional information.

ORVIL STOKES WORKSHOPS, 317 E. Winter Ave., Danville IL 61832. (217)442-3075. Workshop Leader: Orvil Stokes. Instructors: Dale Goff, Mike DeLoriea. Processing Supervisor: Ron Tuttle. "Lectures and field trips to improve your photographic seeing, composing and exposing with the Color and B&W Roll Film Zone System of Orvil Stokes. Students will complete several assigned projects using their own E-6 type films. The workshop staff will develop these films daily using Unicolor Rapid E-6 chemicals. The students will mount their own slides during the evening sessions. The fall color workshop will be during the week of September 21-26, 1986 in the photoscenic Arkansas Valley of Chafee County, Colorado. The summer workshop will be held June 8-13, 1986." Early registration is recommended. For information and enrollment application send an SASE to Orvil Stokes Workshop, above address.

SUMMER WORKSHOPS IN PHOTOGRAPHY AT COLORADO MOUNTAIN COLLEGE, Colorado Mountain College, Box 2208, Breckenridge CO 80424. (303)453-6757. Director of Photography Programs: Andrea Jennison. Summer visiting artists' program offers 3-day and 1-week intensive workshops ranging from introductory level to advanced b&w, color, nonsilver, mixed media, photojournalism, photomarketing, nature/wildlife, magazine photography and commercial photography. Class size: 8-15. Tuition range: \$35-70 (in-state) and \$125-250 (out of state); tuition subject to change. Some upper division and graduate credit opportunities provided. Lab fees: \$15-35. Inexpensive condominium and dormitory housing available during summer. A 2-year degree program in photography is also part of regular CMC year-round curriculum.

538 Photographer's Market '86

VISUAL STUDIES WORKSHOPS,31 Prince St., Rochester NY 14607. (716)442-8676. Offers programs in basic, intermediate and advanced photography; printmaking; offset printing; video; museum studies; and multimedia. "We have expanded both our regular and summer workshop offerings, providing fall through spring semester students with a broad range of guest lectures and visiting artists, in addition to the regular faculty." Combines classes with work experience in research center, gallery, print shop, monthly newspaper "Afterimage" or book service. Length of sessions vary from 1-2 weeks (summer) to 9 months (September-May). Cost varies; write for information. SASE. Portfolio necessary for admission.

YOUR MIND'S EYE PHOTOGRAPHY SCHOOL, 109 N. Pennsylvania Ave., Falls Church VA 22046. (703)534-4610. Director: Dale Hueppchen. "We're a full-time, year-round school. Classes run continuously throughout the year." Classes offered include: beginning photography, basic photography and darkroom, color photography and color darkroom, intermediate photography and darkroom, photographic lighting, color printing from slides (cibachrome), advanced photography and darkroom, color printing from negatives and portfolio development seminars. Maximum of 10 students per class. Private instruction is also available. Classes are 5-7 weeks, depending on the class. Classes meet once weekly for 3 hours. Cost is \$35-275, including use of darkrooms and chemicals. Paper is included in color printing classes. No housing available. Write or phone for course catalog.

ZONE VI WORKSHOP, c/o Fred Picker, Director, Putney VT 05346. (802)257-5161. Administrator: Lil Farber. "The Zone VI workshops are for the serious individual who wants to improve his technical and visual skills and probe the emotional and intellectual underpinnings of the medium. Long experience or a high degree of skill are not required. Strong motivation is the only requisite." Offers 2 7-day workshops covering negative exposure and development; (Zone System) printing theory and practice; equipment use and comparison; filters and tone control; field trips; and critiques. Summers only. Class size: 70; 8 instructors. Cost is \$795 for everything—room, all meals, linen service, lab fee, chemicals; \$475 for tuition and lab fees only; and \$445 for room and board only for family members not attending. Write or call for brochure. "The program is usually filled by May."

Appendix

The Business of Freelancing

The photographer who intends to turn a profit at his craft has little choice but to adopt professional business practices in order to keep track of his submissions, income and expenses; accurately estimate his taxes; maintain clear and accurate communication with his clients; protect himself and his work; and promote his services. This Appendix will serve to introduce you to the basics of these practices.

Promotional Materials

The freelance photographer—particularly the photographer who works primarily through the mail with distant buyers—needs to establish a professional *identity* in order to distinguish himself from other contributors and to convey a businesslike image to prospective clients. As a basic requirement, you'll need business cards and stationery which include your name, address and phone number; your photographic services or specialities; and, if possible, a distinctive symbol or logo which will serve to "highlight" your name and help buyers remember you.

If you're not comfortable with trying to design such materials yourself, any quick-print shop will be able to assist you in producing a businesslike yet individual design for both your cards and letterhead. You might also consider working with another freelancer—a freelance graphic designer—to design promotional materials. Often a barter—an exchange of your photographic services for his design serv-

ices-can be agreed upon.

Even the most distinguished stationery, however, cannot convey to a potential buyer the quality and impact of your best photography. For this purpose—once your business has grown to the point where you're ready to invest more in it—you'll want to consider producing a promotional *mailer*—a brochure or flyer which gives the customer a graphic idea of what you can do. Again, it's best to work with a professional printer who will be able to reconcile your desire with your budget. While a color mailer can easily run into a couple thousand dollars, a simple black-and-white flyer—two or three of your best photos on one side, printed information about your services on the other—can be produced for two or three hundred dollars. Another alternative is the color post card featuring a single "stopper" shot; many photographers can produce such cards in their own darkrooms.

Photographers who sell stock material through the mail should also put together a stock list—that is, a typed or typeset listing of the major subject areas covered in their files. Depending on your specialities and the extent of your stock inventory, you can even put together different lists for different types of clients. A copy of

the list should be mailed with every query and submission.

Of course, none of these promotional materials will generate any business unless you use them effectively and regularly. Based on the needs listed by buyers in this book, make periodic—monthly or quarterly—mailings to potential clients using your stationery, business card and mailer to remind editors and art directors who you are and what you have to offer.

The Portfolio

For all in-person and some mail sales promotions, you'll need to put together a portfolio of your work—that is, a leather-bound "book" whose pages contain your best and most representative images. (Such portfolio books are available at most art supply shops.) Virtually all photo buyers in the advertising industry, and many in the editorial and other markets, select the photographers they want to work with based almost entirely on the quality of the photographers' portfolios, so putting yours together is a task requiring the utmost care. While most photographers' portfolios always include a few of their favorite or best-known shots, the bulk of the portfolio should be geared to the needs of the particular client you'll be showing it to. This requires some research on your part to determine which of your photos are most likely to match the client's needs, and extremely careful editing of your work to ensure that only the very best images are presented. Most buyers also want to see *tearsheets* in a portfolio—that is, actual examples of work the photographer has done for other clients. Tearsheets as well as b&w and color prints should be inserted into the portfolio's transparent pages, grouped together logically according to subject and style.

If a client indicates a preference for viewing portfolios in transparency form, this obviously calls for a different format. While slides may be inserted into a book-style portfolio, they will not be very effective unless there is some means for the buyer to project them. Many photographers create a slide portfolio by using a slide *carousel* which the client can use with his own carousel-type projector; check with each client ahead of time to see if he has such a machine. If not, it may be wise to carry a small *light box* with you when you make sales calls. But whatever format your portfolio takes, *edit* your work so that only the very best images are included, and *slant* the

portfolio to the photographic requirements of each potential buyer.

Business Forms

While you're visiting the printer to see about letterhead and cards, ask about standard business forms he might have available which could be adapted for your photography business. At the very least, you'll need a simple *invoice* form to be enclosed with all submissions of work. The invoice details the contents of the submission and describes the terms and conditions under which the photos are being offered—the rights available, the payment expected, and when payment is to be made.

Photographers whose work includes assignments, particularly in the advertising market, will require more sophisticated forms to cover such additional factors as price estimates, billing for support services such as model fees and props, custom lab work and advances. Your printer may also be able to help with these; if not, a full range of professional business forms may be found in *Professional Business Practices in Photography*, published by the American Society of Magazine Photographers at 205 Lexington Avenue, New York NY 10016.

Model Releases

Perhaps the most important single business form for the freelance photographer is the *model release*. When signed by the person(s) the photographer is shooting, the model release gives the photographer the right to use, sell and publish the person's picture for whatever purpose desired. This does not mean that you can use the photo to insult or embarrass the subject—the right of the individual to be protected from such abuses will always outweigh the photographer's right to publish—but a signed release will enable you to market the photo without fear of legal reprisals—and with confidence that buyers will appreciate your efforts.

While the law generally holds that model releases are not required with photos used for editorial purposes—that is, to educate or inform the public in such media as newspapers, books and magazines—releases are always required with photographs used for advertising or trade purposes—to sell something, in other words. This is especially important for the photographer who places his work with a stock

agency, because neither he nor the agency can know in advance to what purposes—

editorial or advertising—the images might eventually be applied.

If you're photographing children, remember that a release must also be signed by the child's parent or legal guardian. For trade purposes, a *property release* may also be needed—for example, if you were to photograph a house for an aluminum siding ad, you'd need a release from the building's owner.

The sample model release forms below will protect you and your clients in most cases; detailed release forms are also included in the ASMP's *Professional Business*

Sample Model Polesco

Practices in Photography.

	Campio Model Moledo
	alue received, I,, do hereby give pher), and parties designated by the photographer, in-
cluding clients, licensees, pu	rchasers, agencies, and periodicals, the irrevocable
	fictional name) and photograph for sale to and repro-
duction in any medium for pu	rposes of advertising, trade, display, exhibition or edi-
	lease and fully understand its contents.
	nan 18 (21) years of age.
1471	
	Signed:
Address:	Address:
Date:	
rendamentona to sousparts.	
	Guardian's Consent
I am the parent or legal gu	ardian of the above-named minor and hereby approve
	the photograph's use subject to the terms mentioned
above.	
H 프레크스트웨어 (INSTERNATION IN LINES HELD HELD HELD HELD HELD HELD HELD HELD	gal right to issue such consent.
Witness:	Signed:
Address:	Address:
Date:	
Dato.	

Copyright

Photographers and other creative artists are guaranteed full ownership and control of their work under the Copyright Act of 1978. There are, however, certain rules which must be adhered to.

First, the copyright notice, ©, followed by the photographer's name and the year of first publication, must appear with the published photo. (If a photo has not been published, the last two numbers of the year may be left blank.) Every photo submitted should have this copyright notice affixed to it—on the backs of prints or transparency mounts—so that buyers know you are aware of your rights and intend to protect them. Any stationery or office supply store will be able to supply you with a rubber stamp for this purpose.

Also, when submitting work, you can request of the buyer that your copyright notice appear adjacent to any photo published. This is not strictly necessary—the publisher's copyright will protect your work within the body of the text—but more and more photographers are demanding this as a means of further protecting their rights.

Absolute copyright protection may be obtained by *registering* your copyright with the Copyright Office of the Library of Congress (Washington DC 20559). Done individually, this can be a time-consuming and expensive process, but there are ways to protect large groups of images with a single registration. Photos may be registered either before or after publication; contact the Register of Copyrights at the address above for more information.

The copyright is the most fundamental of the photographer's rights, and one that should not be given up easily or cheaply. The concept of selling *limited* rights—and the relationship between rights and rates—are discussed next.

Rights

Even when a photographer gives a buyer the right to publish or otherwise use a photograph, he does not have to—and generally should not—give up his copyright. There is a host of usage rights the photographer can sell without sacrificing his abil-

ity to keep and resell the image.

As long as the photographer sells only limited rights to a photo, he can market the photo over and over again—and thus continue to earn more money. The simplest of these limited rights is *one-time rights*—the buyer is allowed to use the photo just once, after which both the photo and all remaining rights revert to the photographer. Selling one-time rights is also known as *leasing*, because the buyer only has use of the photo for a limited time.

While in theory you could sell one-time rights to a photo any number of times without limitations or regard for how the buyer wishes to use the photo, in fact most buyers will want more than simple one-time usage. For example, *Time* magazine wouldn't be satisfied with one-time rights because there's no guarantee the photo wouldn't show up in *Newsweek*. In other words, most buyers will want some degree of *exclusivity* in their use of a given image. Thus most magazine editors will require *first North American serial rights*, so that their publication will be the first on the continent to publish the picture. The picture editor of a newsweekly might also want to place a time restriction on further use of the photo: first North American serial rights for *30 days*, so that the picture can't appear in a rival magazine for another month.

The most commonly sold rights include:

First rights. The buyer pays for the privilege of being the first to publish the pho-

to-but may still use it only once unless further rights are negotiated.

Serial rights. "Serial," like "periodical," is another euphemism for a newspaper or magazine. Most magazines will want to make sure that the same picture isn't also sold to a competitor.

Second (reprint) rights. The buyer purchases one-time use of the photo after it has already appeared elsewhere. Or, the buyer retains the right to use the photo a se-

cond time, as in an anthology.

Exclusive rights. Like serial rights, exclusive rights guarantee the buyer's exclusive right to use the photo in his particular market or for a particular product. For example, a paper product publisher may want exclusive greeting card rights so that the same picture doesn't show up on another card.

All rights. Even if no transfer of copyright occurs—this requires a formal signed agreement—a buyer may still acquire the right to use the photo without limitation and without further payment to the photographer. Since this is virtually as bad as

losing your copyright, it should be avoided.

As a general rule of thumb, the more rights a buyer demands, the more he should be willing to pay. Editorial rates are generally lower than advertising rates because editorial buyers are getting some form of one-time usage and know the photographer will be able to sell the photo again elsewhere. On the other hand, most advertising buyers will make assignments on what is known as a work-for-hire basis; that is, while on assignment the photographer is working as an employee of the agency and must give up all rights, including the negatives and copyright, to the photos produced. The fees paid in the advertising market are—or should be—correspondingly high.

Unless you're being paid extremely well for all rights, it's clearly to your advantage to sell only limited rights. Once all rights have been relinquished, a photograph's future resale value has been lost. Be aware of your rights and of the relation-

ship of rights to rates.

Recordkeeping

Accurate and comprehensive records of all your photography business transactions are critically important for at least two reasons. The role of recordkeeping in

taxes will be discussed shortly; the more immediate necessity of good bookkeeping

is for the very good reason of making a profit.

Photographers, who tend to be creative sorts, may not be familiar with the techniques of accurate recordkeeping, and may even wonder how records can affect profitability. The photographer who sells a magazine cover for \$300 may believe that he just turned a \$300 profit, but without an accurate log of the expenses incurred in producing the photo, he really has no idea how much money he actually gained from the transaction, and may even have lost money without realizing it.

Fortunately, creating an expense-and-income ledger system isn't all that difficult. Calendar-style ledger books may be found at the local office supply store and enable you to keep track of all incoming and outgoing cash on a daily basis. It's also important to keep receipts for all expenditures and copies of cancelled checks for payment received; these can be filed in envelopes by the month. (See Taxes)

Your ledger book is also a good place to keep track of where your photo submissions are at any given time. Write down the contents of each submission package and to whom it was sent on the appropriate page, then make a note when the photos are returned and when payment is made. As an alternative, you can create a file for each of your potential and paying clients, and record submissions, payments and re-

turns there.

In order to keep track of your submissions, you'll also need to create a coding system for your inventory of photos. Instead of having to write "color slide of sunset taken at Half Moon Bay on August 3, 1979," you'll be able to jot something like C-11-879. Every photographer creates his own code, and you'll probably have to experiment and refine your own system before it works perfectly. The photo's code should appear both on the photo itself and in an index card file which also lists all pertinent information about the photo—when and where taken, technical data, perhaps a brief caption. Then, when you submit the photo to a client, write the photo's code number in your ledger book or client file so that you know where any given photo is at any given time.

Taxes

As much time and money as your records save throughout the course of a business year, their value is even greater at tax time. And as painful as paying taxes might be, with accurate records you'll at least be able to face the IRS confident that your books are in order.

The photographer in business to make a profit—whether or not he actually makes one in any given year—has significant tax advantages over the photographic hobbyist. As a small businessperson (or a large one, for that matter), the tax laws are so written as to enable you to deduct from your income many of your photography

business expenses.

Of course, in order to take full advantage of these tax benefits, you must establish in the eyes of the IRS that you actually are engaged in a business for profit. This can be accomplished by taking the following steps. One, use the types of professional stationery and business cards detailed earlier in this Appendix. Second, open a separate bank account for your photography-related income and expenses. Three, file your tax returns using Schedule C, "Profit (Or Loss) From Business or Profession." And four, maintain those accurate and detailed records of expenditures and payments year-round.

The importance of that last step will become apparent when it comes time to fill out your tax form. You'll know exactly how much money you made or lost in your photography business that year, and you'll have a comprehensive record—and re-

ceipts to match-of your deductible business expenses.

What is a deductible business expense? Ever-changing tax laws make this a difficult question to answer, and it's recommended for the photographer-businessperson to get professional tax and accounting advice. Obviously, the strictly business-related costs of film and processing, stationery and postage, as well as professional

publications (like this one) may be safely deducted, but there are additional, more complicated areas of business expenses which may also offer substantial tax benefits. These are:

Depreciation. Certain types of photographic equipment—particularly those requiring a large cash outlay such as cameras and enlargers-may be depreciated over a number of years. That is, the law allows you to deduct a certain percentage of the cost during each of three to five years, so that you can recover such large costs for new equipment in a fairly short period. Such purchases also qualify for an immediate investment tax credit, generally 6-10% deductible directly from any tax you may owe. The law also allows you to deduct up to \$5,000 of capital expenditures in the same year the expense incurred—but you give up the investment tax credit. Because the percentages and time periods vary with the type and cost of the equipment, it's wise to consult with a tax professional before spending the money.

Office at Home. This is a tricky area which requires extreme caution on the part of the photographer-businessperson. Generally, even if you maintain a separate office or business address, it is still possible to deduct at least some of the costs incurred in outfitting and maintaining an office or work area within the home. For example, if you use a den or spare bedroom exclusively for business purposes, you're entitled to deduct a percentage, based on the square footage of the work space as a proportion of the total building, of the costs of rent, utilities, renovation, etc.

Travel and Entertainment. This is another grey area, mainly because the distinction between personal and business travel and entertainment is often very slight. Although you'll be keeping all receipts for transportation, lodging and meals paid for while on a photography job, the IRS will also require that you explain the purpose of such expenditures. A bill for your dinner with a client at Chez Bon is worthless to the IRS unless you can tell them what sort of business was conducted or discussed over the wine and pheasant. Keep track of these matters as you go-not when you're sitting in the IRS office months later.

While you're keeping track of your own tax information, remember that the photo buyers you deal with also have tax problems in working with freeance contributors. Whenever you submit photos to a buyer, be sure to include your Social Security number in the cover letter. This enables the buyer to pay for use of the photos with-

out having to deduct federal insurance taxes.

Editor's Note: At the same time Photographer's Market went to press, U.S. legislators were discussing major tax reforms. These reforms may be enacted in 1986 and could modify the tax laws pertaining to your freelance photography business. Keep abreast of these potential developments.

Insurance

The best and most creative photographer, with the most carefully organized files and the most profitable business operation, is still subject to catastrophic loss if not adequately protected against fire, theft and other types of damage.

Photographers may well have more to lose than many businesspeople, if only because of the extensive and expensive equipment required to practice photography professionally. Even more potentially damaging would be the loss of your file of images—original transparencies and negatives for which no price can be accurately fixed. Insurance settlements could not ever replace a career's creative output, but they would certainly be preferable to nothing.

More mundane assets such as office furniture, books and other supplies also represent an investment worth protecting. To determine the total value of your photography business and the amount and type of insurance needed to protect it, shop around among companies specializing in small business policies. Once you're covered, periodically review your assets and policy so that you're sure to keep your cov-

erage equivalent to your worth.

Glossary

Acceptance (payment on). The buyer pays for certain rights to publish a picture at the time he accepts it, prior to its publication.

Agent. A person who calls upon potential buyers to present and sell existing work or obtain assignments for his client. A commission is usually charged. Such a person may also be called a *photographer's rep*.

Animation. The technique of simulating continuous movement by photographing a series of single drawings or inanimate objects, each member of the series showing the moving part in a slightly different position from the preceding member.

Answer print. The intermediary motion picture print between work print and release print that contains the sound and all necessary corrections such as editing, density changes, and color changes. Synonymous with approval print, sample print and check print.

Archival processing. A printing technique, included as part of the actual processing, intended to preserve the quality of prints or negatives by meeting stated levels of freedom from contaminants that can cause image fading and staining.

Assignment. A definite OK to take photos for a specific client with mutual understanding as to the provisions and terms involved.

Audiovisual. Materials such as filmstrips, motion pictures and overhead transparencies which use audio backup for visual material.

Available light. The term usually implies an indoor or night-time light condition of low intensity, where no light is added by the photographer. It is also called existing light.

Back light. Illumination from a source behind the subject as seen from the position of the camera.

Bimonthly. Every two months.

Biweekly. Every two weeks.

Bleed. In a mounted photograph it refers to an image that extends to the boundaries of the board.

Bleed page. A page on which one or more illustrations run off the margins at the top, bottom, and side, or into the gutter.

Blowup. An enlargement printed from a negative.

Blurb. Written material appearing on a magazine's cover describing its contents.

Bounce light. Light that is directed away from the subject toward a reflective surface.

Bracket. To make a number of different exposures of the same subject in the same lighting conditions.

Camera angles. Various positions of the camera in relation to the subject, giving different effects or viewpoints.

Caption. The words printed with a photo (usually directly beneath it) describing the scene or action. Synonymous with *cutline*.

Cheesecake. A slang term to describe glamour photographs of women.

Cibachrome. A direct process that yields fade-resistant color prints directly from color slides.

Commission. The fee (usually a percentage of the total price received for a picture) charged by a photo agency or agent for finding a buyer and attending to the details of billing, collecting, etc.

Composition. The visual arrangement of all elements in a photograph.

Contact print. A print made by passing light through the negative while it is lying directly on the paper.

Contrast. The comparison of tonal values in a negative or print. A contrasty negative or print has few middle tones.

Copyright. The exclusive legal right to reproduce, publish and sell the matter and form of a literary or artistic work.

Credit line. The byline of a photographer or organization that appears below or beside published photos.

Crop. To omit unnecessary parts of an image when making a print or copy negative in order to focus attention on the important part of the image.

Cutline. See Caption.

Custom lab. Professionally equipped and staffed lab that specializes in developing and processing negatives and prints to order.

Dry mounting. A method of mounting prints on cardboard or similar materials by means of heat, pressure and tissue impregnated with shellac.

Enlargement. A print that is larger than the negative. Also called blow-up.

Fast. A term used to describe films of high sensitivity or lenses of large apertures.
 Fast glass. Slang for a high-speed lens. The smaller the f-stop, the faster the lens.
 Fee-plus basis. An arrangement whereby a photographer is given a certain fee for an assignment—plus reimbursement for travel costs, model fees, props and other related expenses incurred in filling the assignment.

Film speed. The relative sensitivity of the film to light. Rates usually in ISO numbers. First rights. The photographer gives the purchaser the right to reproduce the work for the first time. The photographer agrees not to permit any prior publication of the work elsewhere for a specified amount of time.

Fisheye lens. An extreme wide-angle lens, having an angle of coverage of about 180 degrees, and typically producing distorted, circular photographs.

Flat. A term used to describe a low contrast negative or print.

Flat lighting. Lighting the subject in such a way as to produce a minimum of shadows and contrast in the subject.

Format. The size, shape and other traits giving identity to a periodical. Frontlighting. Light falling on the subject from in front of the subject.

Gaffer. In motion pictures, the person who is responsible for positioning and operating lighting equipment, including generators and electrical cables.

Glossy. A smooth and shiny surface on photographic paper.

Grip. A member of a motion picture camera crew who is responsible for transporting, setting up, operating, and removing support equipment for the camera and related activities.

Hard. A term used to describe an image that is high in contrast.

Highlights. The brightest areas on a print and the darkest areas in a negative.

Holography. Recording on a photographic material the interference pattern between a direct coherent light beam and one reflected or transmitted by the subject. The resulting hologram gives the appearance of three dimensions, and, within limits, changing the viewpoint from which a hologram is observed shows the subject as seen from different angles.

- Internegative. An intermediate image used to convert a color transparency to a black-and-white print.
- IRC. Abbreviation for International Reply Coupon. IRCs are used instead of stamps when submitting material to foreign buyers.
- Jury. A group of persons who make judgments of photographic quality, as in some competitions.
- **Leasing.** A term used in reference to the repeated selling of one-time rights to a photo; also known as *renting*.
- Lens. One or more pieces of optical glass, plastic, or other material, designed to collect and focus light rays to form a sharp image on the film or paper.
- Logo. The distinctive nameplate of a publication which appears on its cover.
- **Long lens.** A lens whose focal length is longer than the diagonal measurement of the film. Generally used to describe telephoto lenses.
- Macro lens. A special type of lens used for photographing subjects at close ranges.
- Matte. A textured, dull, nonglossy surface on a photographic paper.
- Media. The vehicle used to reproduce photos, i.e., printed material such as magazines, books, posters, billboards, flyers, annual reports, or TV commercials.
- **Model release.** Written permission to use a person's photo in publications or for display.
- Monograph. A book consisting solely of one photographer's work.
- Mug shot. Slang for a portrait, especially one made on a mass-production basis, as for a passport, license or press release.
- Negative. Any photographic image in which the subject tones have been reversed.

 Usually, it refers to film.
- Offset. A printing process using flat plates. The plate is treated to accept ink in image areas and to reject it in nonimage areas. The inking is transferred to a rubber roller and then to the paper.
- One-time rights. The photographer sells the right to use a photo one time only in any medium. The rights transfer back to the photographer on his request after the photo's use.
- Page rate. An arrangement in which a photographer is paid at a standard rate per page. A page consists of both illustrations and text.
- Photoflood. A photographic light source.
- Point-of-purchase display. A display device or structure located in or at the retail outlet, which advertises the product and is intended to increase sales of the product. Abbreviated P-O-P.
- **Polarized light.** Waves of light which vibrate uniformly in, or parallel to, a particular plane.
- Polarizer. A filter or screen which transmits polarized light.
- **Portfolio.** A group of photographs assembled to demonstrate a photographer's talent and abilities, often presented to buyers.
- Positive. An image in which the tones are similar to those of the subject. A print made from a negative.
- Print. An image, usually positive, on photographic paper.
- Publication (payment on). The buyer does not pay for rights to publish a photo until
- it is actually published, as opposed to payment on acceptance.

 Query. A letter of inquiry to an editor or potential buyer soliciting his interest in a
- possible photo assignment or photos that the photographer may already have.

 Reflector. Any surface used to reflect light.
- Resume. A short written account of one's career, qualifications, and accomplishments.
- Royalty. A percentage payment made to a photographer/filmmaker for each copy of his work sold.
- SASE. Abbreviation for self-addressed stamped envelope. Most buyers require SASE if a photographer wishes unused photos returned to him, especially unsolicited materials.

Second serial (reprint) rights. The photographer (or the owner of the photo rights) sells the right to reprint an already published photograph.

Semigloss. A paper surface with a texture between glossy and matte, but closer to

Semimonthly. Twice a month.

Serial rights. The photographer sells the right to use a photo in a periodical. Rights usually transfer back to the photographer on his request after the photo's use.

Shadows. The darkest areas on a print and the lightest areas on a negative.

Silk. A textured surface on photographic paper.

Simultaneous submissions. Submission of the same photo or group of photos to more than one potential buyer at the same time.

Slidefilm. A series of transparencies on a strip of 35mm film viewed by projection one at a time. Synonymous with filmstrip.

Soft. Used to describe a print or negative which is low in contrast. Also used to describe an image which is not sharp.

Solarization. The reversal of photographic image tones, caused by extreme overexposure of the photosensitive material.

Speculation. The photographer takes photos on his own with no assurance that the buyer will either purchase them or reimburse his expenses in any way, as opposed to taking photos on assignment.

Spotting. The process of bleaching or painting out spots or defects from a negative or print.

Stock photo agency. A business that maintains a large collection of photos which it makes available to a variety of clients such as advertising agencies, calendar firms, and periodicals. Agencies usually retain 40-60 percent of the sales price they collect, and remit the balance to the photographers whose photos they've sold.

Stock photos. General subject photos, kept on file by a photographer or a photo agency, which can be sold any number of times on a one-time publication basis.
 Stringer. A freelancer who works part-time for a newspaper, handling spot news and

assignments in his area.

Table-top. Still-life photography; also the use of miniature props or models constructed to simulate reality.

Tabloid. A newspaper that is about half the page size of an ordinary newspaper, and which contains news in condensed form and many photos.

Tearsheet. An actual sample of a published work from a publication.

Thin. Denotes a negative of low density.

Tonal scale. The range of grays (densities) in a photographic image.

Trade journal. A publication devoted strictly to the interests of readers involved in a specific trade or profession, such as doctors, writers, or druggists, and generally available only by subscription.

Transparency. A color film with positive image, also referred to as a slide.

Tripod. A three-legged stand or support to which a camera can be attached. They are usually adjustable in height and provide a means of tilting the camera.

Tungsten light. Artifical illumination as opposed to daylight.

Videotape. Magnetic recording material that accepts sound and picture signals for later use, as on a delayed broadcast.

Warm tones. The shades of red and orange (brown) in a black-and-white image. Washed out. Denotes a pale, overall gray print lacking highlights.

Weight. Refers to the thickness of photographic paper.

Zone system. A system of exposure which allows the photographer to previsualize the print, based on a gray scale containing nine zones. Many workshops offer classes in zone system.

Zoom lens. A type of lens with a range of various focal lengths.

Index

Δ

A.D. Book Co. 112 A.F.B. Manufacturing & Sales Corp. 183 A.N.R. Advertising Agency 70 A.V. Media Craftsman, Inc. 80 AAA Michigan Living 196 Aboard 238 Abrams Associates Inc., Sol 70 Abramson Associates 36 ABS Multi-Image 43 Absolute Sound, The 252 Accent 252 Accent on Living 252 Access to the Arts, Inc. 165 Accessories Magazine 416 Acre Age 416 Activewear Magazine 416 Adams & Adams Films 103 Adamson Public Relations & Promotions 41 Addison-Wesley Publishing Company 112 Adirondack Life 252 Adler, Schwartz Inc. 70 Administrative Science Quarterly 417 Ads Inc. 109 Adsociates, Inc. 96 Advance Advertising & Public Relations 41 Advanced Communications Group 107 Advertising Council, Inc., The 142 Advertising Techniques 417 Advertising to Women, Inc. 81 Aero Publishers, Inc. 112 Aerobics & Fitness. The Journal of the Aero-

196
Aetna Life & Casualty 33
Africa Report 253
AFTA—The Alternative Magazine 253
Afterimage Photograph Gallery, The 165
Afterimage, Inc. 492
AG Review 417
Aglow Publications 112
Ahrend Associates, Inc. 81
Aim Magazine 253

bics and Fitness Association of America

AIPE Facilities Management Operations and Engineering 417 Air Force Magazine 197 Air Line Pilot 197 Air Pixies 492 Airwave International 475 Alamo Ad Center, Inc. 103 Alaska Construction & Oil 417 Alaska Nature Press 113 Alaska Northwest Publishing Company 113 Alaska Outdoors Magazine 253 Alaskaphoto 493 Alchemy Books 113 Alcoholism/The National Magazine 252 Alden Public Relations Inc., J.S. 81 Alfa-Laval, Inc. 143 Alico News 238 Alive! 254 Alive Now! Magazine 254 Allegro Film Productions, Inc. 37 Alliance Pictures Corp. 92 Allied Advertising Agency, Inc. 58 Allright Auto Parks, Inc. 143 Aloha, The Magazine of Hawaii 254 Alpine Publications, Inc. 113 Alternative Energy Retailer 417 Alternative Sources of Energy Magazine Altschiller, Reitzfeld, Solin 81 American Advertising 43 American Agriculturist 418 American Animal Hospital Association 143 American Atheist 197

American Bee Journal 418

American Chiropractor, The 418
American City & County Magazine 418

American Cage-Bird Magazine 255

American Coin-Op 419

American Demographics 419

American Film Festival 523

American Fire Journal 419

American Birds 198

American Craft 198

American Bookseller 418

American Forests Magazine 198

American Fruit Grower/Western Fruit Grower 419

American Fund for Alternatives to Animal Research 143

American Health Care Association Journal 198

American Hockey & Arena (see American Hockey Magazine 199)

American Hockey Magazine 199

American Hunter 199

American Jewelry Manufacturer 420

American Libraries 199 American Motorcyclist 199

American Museum of Natural History Library, Photographic Collection 143

American National Red Cross 144 American Nurseryman 239

American Oil & Gas Reporter 420

American Postcard Company Inc., The 183

American Salon Eighty-Five 420 American Shotgunner, The 389

American Snotgumer, The 369

American Society for the Prevention of Cru-

elty to Animals 144 American Society of Artists, Inc. 165

American Sports Network 390 American Stock Photos 493 American Survival Guide 255

American Survival Guide 2 American Traveler 200

American Trucker Magazine 420 American Video Laboratory 108

Amphoto, American Photographic Book

Publishing Co. 113 Ampro Photo Workshops 532

Amyid Communication Services, Inc. 17

Amwest Picture Agency 493

An Gael 200

Anchor News 200

Anderson Co., Inc., Merrill 33

Anderson Gallery 165

Anderson Ranch Arts Center 532

Andover Gallery 165 Angus Journal 200 Animal Kingdom 255

Animals Animals Enterprises 493

Animation Arts Associates 98 Ann Arbor Observer 254

Ansel Adams Gallery, The 166

Antiques Dealer 421

Antiquing Houston 255

APA Monitor-American Psychological 201

Aperture 201

Aperture Photobank Inc. 494

Apon Record Company, Inc. 475

Appalachia 201

Appalachian Photographic Workshops, Inc.

Appalachian Trailway News 201 Appaloosa Racing Record 256 Apparel Industry Magazine 421 Applied Cardiology 239 Applied Radiology 421 Archery World (MN) 256 Archery World (WI) 256

Architectural Digest 256

Architectural Metals 201
ARCsoft Publishers 114

Ardrey Inc. 71

Argonaut Press 183

Argus Communications 103, 114, 183

Arizona Magazine 390

Arizona Theatre Company 144

Armory Art Gallery 166 Arnold & Company 58

Arnold Harwell McClain & Associates, Inc. 104

Arpel Graphics 183

Art & Cinema 256

Art Annual Photography (see Photography 86 528)

Art Attack Records, Inc/Carte Blanche Records 475

Art Direction 421

Art Directors Book Co. 114

Art in San Diego 186 Art Resource 494

Art Source 186

Ascherman Gallery/Cleveland Photographic Workshop 166

Ash at Work 202

Assembly Engineering 421

Assets 257

Associated Book Publishers 115

Associated Film Production Services 96

Associated Picture Service 494

Association for Retarded Citizens of the

United States 144

Association for Transpersonal Psychology Newsletter 390

(*) And Books 114

A-Stock Photo Finder (ASPF) 495

ATA Magazine 202

Atlantic City Magazine 257

Atlantic Monthly, The 257

Atlantic Salmon Journal, The 421

Attage, Online Data Access, Database Monthly 257

ATV News 390

Audubon Magazine 257

Augsburg Publishing House 115

Aurelio & Friends, Inc. 37

Austin Homes & Garden 260

Auto Trim News 202

Autobuff Magazine 260

Automation in Housing & Manufactured Home Dealer 422

Automotive Group News 239

Aviation Equipment Maintenance 422

Avon Books 116 Azra Records 476

Aztex Corporation 116

B

Baby Talk 260 Bachner Productions, Inc. 81

Back to Godhead 202 Bafetti Communications 17 Baker Book House 116 Baker Street Productions Ltd. 144 Ballantine/Delrey/Fawcett Books 116 Baltimore International Film Festival-Independent Filmmakers' Competition 524 Baltimore Museum of Art, The 166 Balton Productions, Chris 81 Banjo Newsletter, Inc. 390 Banking Today 422 Bantam Books 116 Barickman Advertising, Inc. 66 Barkus Company, Inc., Ted 98 Barney & Patrick Advertising 14 Baron Advertising, Inc. 93 Barsky & Associates Advertising 61 Bartczak Associates Inc., Gene 76 Barter Communique 391 Basch Feature Syndicate, Buddy 495 Basketball Weekly 391 Bassin' Magazine 260 Batten, Barton, Durstine & Osborn, Inc. 63 Battenberg, Fillhardt & Wright, Inc. 17 Bauerlein, Inc. 55 Bay City Public Relations and Advertising 29 BBDO/West 26 BC Outdoors 261 BC Space 166 Bean Publishing, Ltd., Carolyn 186 Bear Advertising 26 Beautiful British Columbia Magazine 261 Beauty Digest Magazine 261 Beautyway 186 Beckerman Group, The 71 Bedell Inc. 16 Bend of the River Magazine 262 Bender & Associates, Lawrence 145 Benjamin Associates, Herbert S. 55 Berg & Associates 495 Berkey K+L Gallery of Photographic Art Berkshire Museum, The 167 Berkshire Public Theatre, The 145 Berman Gallery, Mona 167 Bernard Picture Co. 187 Bernsen's International Press Service, Ltd. Bernstein Associates, Inc., Ronald 46 Berol USA 145 Besser Museum, Jesse 167 Best Wishes 262 Betzger Productions, Inc. 46 Beverage World 422 Beverly Art Center Art Fair & Festival 524 Bhaktivedanta Book Trust 116 Bicycle Guide 262 Bicycling 262 Bikecentennial 145 Bikereport 202 Billiards Digest 263 Bing Advertising, Ralph 18

Biology Digest 263 Bird Talk 263 Bird Watcher's Digest 263 Birkenhead International Colour Salon 524 Bishop Communications, Don 98 Bittersweet 264 Black America Magazine 264 Black & Musen, Inc. 58 Black Hills Creative Arts Center 167 Black Star Publishing Co., Inc. 496 Blackhawk Films, Inc. 53 Blackwood, Martin, and Associates 16 Blade Magazine, The 264 Blade Toledo Magazine, The 391 Blair & Ketchum's Country Journal 264 Blate Associates, Samuel R. 56 Bloomsbury Review, The 265 Blue Island Entertainment 476 Bluegrass Unlimited 266 Blumenthal/Herman Advertising 98 B'nai B'rith International Jewish Monthly, The 266 Board of Jewish Education, Inc. 82 Boat Pennsylvania 266 Boating 267 Bob's Videomania Magazine 267 Body Fashions/Intimate Apparel 422 Body Politic, The 239 Boeberitz Design, Bob 91 Bolivia Records Co. 476 Bond Weekend Workshops, Howard 532 Book Publishers of Texas 117 Booke and Company 18 Bop 267 Borden & Associates, Robert E. 46 Bosco Multimedia, Don 76 Boston Globe Magazine 391 **Boston Phoenix 391** Boston Publishing Company, Inc. 117 Bosustow Video 26 Bouquet-Orchid Enterprises 476 Bow & Arrow 267 Bower and Associates, Michael 18 Bowhunter 268 **Bowlers Journal 268 Bowling Magazine 203** Boyd Records 476 Boy's Life 268 Bozell & Jacobs Advertising & Public Relations 104 Bradham-Hamilton Advertising 101 Bragaw Public Relations Services 43 Brake & Front End 423 Brand Public R3g391 Boston Phoenix 391 Boston Publishing Company, Inc. 117 Bosustow Video 26 Bouquet-Orchid Enterprises 476 Bow & Arrow 267 Bower and Associates, Michael 18 Bowhunter 268 **Bowlers Journal 268** Bowling Magazine 203

552 Photographer's Market '86

Boyd Records 476 Boy's Life 268 Bozell & Jacobs Advertising & Public Relations 104 Bradham-Hamilton Advertising 101 Bragaw Public Relations Services 43 Brake & Front End 423 **Brand Public Relations 93** Bray Studios Inc. 33 Brea Civic Cultural Center Gallery 167 Bread 268 Breed & Show, The Magazine for Champions 269 Brentwood Records, Inc. 476 Bridge Publications, Inc. 117 Brigade Leader 269 **Bright Light Productions 93** Brine Co., W.H. 145 British Heritage 269 Broadcast Technology 423 Broadway/Hollywood Productions 477 Brody Video, Inc. 98 Brooks Associates, Anita Helen 82 **Brooks Baum Productions 108** Brotherhood of Maintenance of Way Employes Journal 203 Brown Advertising Agency, E.H. 46 Brown Co. Publishers, William C. 117 Broyles Allebaugh & Davis, Inc. 31 Brumfield-Gallagher 102 Bryson Productions, Bill 99 Bucket/Herbs & Spices 239 **Bucknell University 148** Builder 423 Bulletin 392 Bulletin of the Atomic Scientists 203 Bulletin of the Philadelphia Herpetological Society 203 Bullfrog Films 98 Bulloch & Haggard Advertising Inc. 31 Buntin Advertising, Inc. 102 Burrell Advertising Inc. 46 Buser & Associates, Joe 104 **Business Atlanta 423 Business Facilities 423 Business Insurance 392** Business of Fur. The 423 Business Publications Inc. 117 **Business Software 424** Business Times, The 392 Business View of Southwest Florida 424 Butwin & Associates Advertising, Inc. 63

C

C.E.P.A. (Center for Exploratory & Perceptual Art) 168
Cabscott Broadcast Productions, Inc. 71
Caldwell-Vann Riper 51
California Builder & Engineer 424
California Magazine 269
California Redwood Association 148
California State Employee, The 204

Callaloo 269 Camera Clix 496 Camerique 496 Cameron Advertising, Walter F. 76 Campbell Soup Company 148 Campus Life 270 Campus Voice 270 Canadian Fiction Magazine 270 Canadian Pharmaceutical Journal 424 Canadian Student Film Festival 524 Canine Chronicle 392 Canoe 270 Canon Photo Gallery 167 Canton Art Institute, The 167 Cantor Advertising 18 Cape Rock, The 271 Capper's Weekly 392 Car Collector 271 Car Craft 271 Car Review Magazine 272 Carden & Cherry Advertising Agency 102 Carmichael-Lynch, Inc. 64 Carolina Biological Supply Company 148 Carolina Cooperator 240 Carolina Quarterly 272 Carter Advertising, Inc. 55 Cat Fancy 272 Catalog Shopper Magazine 272 Catechist 424 Caterpillar World 240 Catholic Forester 204 Catholic Near East Magazine 273 Cats Magazine 273 Catskill Center for Photography 168, 534 Catzel, Thomas and Associates, Inc. 27 Cavalier 273 CEA Advisor 204 **CEE 425** Celebrity Photos Unlimited 496 Centerscope 240 Central Mass Media Inc./Worcester Magazine 274 Ceramic Scope 425 Ceramics Monthly 425 CIF Communications 38 Cessna Owner Magazine 204 C/F Communications 38 Changing Men 274 Changing Times Magazine 274 Charleston Gazette, The 392 Charlotte Magazine 274 Charnas, Inc. 33 Chemical Business 425 Chenoweth Films, R.B. 18 Cheri Publications 275 Chesapeake Bay Magazine, The 275 Chess Life 203 Chessie News 240 Chiat/Day (Los Angeles) 27 Chiat/Day (San Francisco) 29 Chicago 275 Chicago Reader 393

Chickadee Magazine 275

Child and Family Services of New Hampshire 149

Child Life 275

Childhood Education 204 China Painter 205

Chosen People, The 205 Christ Hospital 149

Christian Artist, The 205

Christian Business Magazine 276

Christian Century, The 276

Christian Computing Magazine 276

Christian Herald 277 Christian Home 277

Christian Ministry, The 425

Christian Science Monitor, The 393

Christian Single 277

Christian Talent Source Directory/Christian Bus. Services Source Book 277

Chronicle Guidance Publications, Inc. 425

Church & State 205 Church Herald, The 277

CIM 426

Cimarron Productions 31

Cincinnati Bar Association Report 205

Cincinnati Magazine 278 Cine/Design Films 31

Cine-Mark 47

Cinetudes Film Productions, Ltd. 82

Circle K Magazine 278 Circuit Rider 426 City News Service 426

City of Los Angeles Photography Centers

Civil Engineering-ASCE 205

Clark Goward Fitts 58

Classroom Computer Learning 426 Clavier 427

Clay Pigeon International Records 477 Clearvue, Inc. 47

Clearwaters 206

Cleland, Ward, Smith & Associates 92

Click/Chicago Ltd. 496 Clymer's of Bucks County 149

Coaching Review 206 Coast Magazine 278 Coastal Plains Farmer 427

Coin-Operators Reporter (see National

Coin-Operators Reporter 449) Coins Magazine 278

Coldwell Gallery, Perry 168

Cole Publishing Company, M.M. 118

Colee & Co. 38

Coleman, Inc., Bruce 497 College Union Magazine 427

Collision 427

Colman Communications Corp. 149

Colonial Homes Magazine 279 Colorado Sports Monthly 393

Colorado Springs Convention & Visitors Bureau 149

Colorfax Laboratories 168

Colour Library International (USA), Ltd. 497

Columbia Magazine 279

Columbus Dispatch 393

Columbus Homes & Lifestyles 279

Columbus Monthly 279

Columbus-Dayton-Cincinnati-Toledo Business Journals 393

Commercial Carrier Journal 427

Commonwealth, The Magazine of Virginia

Communication Northwest Inc. 109

Communication World 206

Communigraphics Inc. 76

Community and Government Affairs 150

Community Features 497 Competitive Edge, The 75

Compressed Air Magazine 428

Compro Productions 41

Compu/Pix/Rental 497 Computer Dealer 428

Computer Decisions 428

Computer Merchandising 428

Computerworld 428 Comstock, Inc. 497

Concordia Publishing House 118

Conklin, Labs & Bebee 76 Connecticut Magazine 280

Conservative Digest 280 Contact (CA) Magazine 280

Contact (MN) Magazine 241 Contemporary Art Workshop 169

Continental Records 477

Contractors Guide 428 Cook Publishing Co., David C. 118

Cooking for Profit 429 Corbett Advertising, Inc. 93

Cornerstone 280

Corporate Communications, Inc. 61

Corporate Monthly 429 Cortani Brown Rigoli 18

Corvette Fever Magazine 281 Country Magazine 281

Covenant Companion, The 281

Cover Story, The 477

Craftsman Book Company 118

Cranberries 429

Cranium Productions 27 Creative Color Workshops 534

Creative Computing 281

Creative Crafts & Miniatures 281

Creative House Advertising, Inc. 61

Creative Photography Gallery 169 Creative Productions, Inc. 71

Creative Resources, Inc. 38 Creativity Awards Show, The 524

Credithriftalk 241

Creem 282

Crib Sheet, The 282

Crops and Soils Magazine 429

Crosscurrents 282

Crossing Press, The 118

Crowe Advertising Agency, John 44

Cruising World Magazine 282

Crusader 283 CSC News 241

554 Photographer's Market '86

Cuffari & Co., Inc. 71 Cumberland Valley Photographic Workshops 534 Cummington Community of the Arts 534 Cundall/Whitehead/Advertising, Inc. 19 Cunningham & Walsh 29 Cunningham & Walsh Inc. 82 Curcio, Inc., Andrew 58 Current Affairs 33 Current Consumer Lifestudies 283 Current Health 2 284 Currents 206 Curtiss Universal Record Masters 477 Cushman and Associates, Inc., Aaron D. 66 Custom Studios 150 Cycle News, East 393 Cycle News, West 394 Cycling U.S.A. 394 Cyr Color Photo Agency 498

D

Da Silva & Other Filmmakers, Raul 82 Daily Times 394 Daily Word 284 Dairy Goat Journal 430 Dairy Herd Management 430 Dairymen's Digest 430 Dance Gallery, The 150 Dance Magazine 284 Dance Teacher Now 430 Dance-A-Thon Records 478 D'Arcy-MacManus & Masius, Inc. 41 Darino Films 82 Darkroom and Creative Camera Techniques 284 Darkroom Photography Magazine 284 Darkroom, The (see The Foto-Tek Darkroom Dash 285 Davidson Advertising Co. 69 Davies & Rourke Advertising 43 Davis-Blue Artwork Inc. 187 Dawn Productions Ltd. 478 Day Care Center 430 Dayco Corporation 150 Dayton Ballet 150 De Palma & Hogan Advertising 77 De Wys Inc., Leo 498 Dealerscope 431 DEC* Professional, The 431 Deer and Deer Hunting 285 Defenders 207 Dekalb Literary Arts Journal, The 207 Delaware Today 285 Dell Inc., George 151 Delmar Publishers, Inc. 119 Delta Design Group, Inc. 119 Delta Scene 285 Denmar Engineering & Control Systems, Inc. 151 **Dental Economics 431** Dental Hygiene 207

Departures 241 DePauw Alumnus, Charter House 208 Derby 285 Desert Magazine 241 Deserts of the World 525 Design for Profit 431 Design Photographers International, Inc. 498 Detroit Magazine 394 Devaney Stock Photos 498 Diabetes Forecast 208 Diagnosis 431 Dickens Company 187 Didik TV Productions 77 Diegnan & Associates 72 Dimensional Design 19 Disciple, The 286 Discoveries 286 Discovery 242 **Discovery Productions 83** Dispensing Optician, The 432 Distribution Magazine 432 Distributor 432 Diver Magazine 286 Diver, The 286 Dix & Eaton Inc. 99 Dixie Contractor 432 Documentary Films 19 Dog Fancy 287 Dog Writers' Association of America Annual Contest 525 Dollars & Sense 395 Dolls-The Collector's Magazine 287 Dolphin Log, The 208 Domestic Engineering Magazine 433 Doner & Co., W.B. 62 Donning Co.,/Publishers, Inc., The 119 Donohue Associates, Inc., Jody 83 Dorchester Publishing Co., Inc. 119 Dorsey Advertising Agency/General Business Magazine 104 Dort and Co., Dallas C. 62 Doubleday and Company, Inc. 119 Douglis Visual Workshops, The 534 Down East Magazine 288 DPR Company 96 Dr. Dobb's Journal 433 Dramatika 288 Draw Magazine 288 DRG Records Inc. 478 DRK Photo 499 Druck Productions, Mark 83 Ducks Unlimited 208 Duke Unlimited 55 **Dulaney Advertising & Public Relations 54** Dunedin Fine Arts & Cultural Center 169 Dwight Advertising, Hugh 97 Dykeman Associates, Inc. 104 Dynacom Communications International Dynamic Graphics Inc., Clipper & Print Media Service 499 Dynamic Years 209

E

E.L.J. Recording Co. 478 Eagle 288 Eagle Records 478 Earnshaw's Review 433 Earth Images 499 Farth Records Co. 478 Earthtone 288 Earthwise Poetry Journal 289 Eastern Stock Photos 500 Eastview Editions Inc. 120 Eaton/Shoen Gallery 169 Ebel Advertising Agency 53 Ebony 289 Ebony Jr! 289 Eclipse Awards 525 **ECM Newsletters 395** Edelman, Inc., Daniel J. 36 Edison, The 242 **Education Week 433** Educational Dealer Group 38 **Educational Dimensions Group 34** Educational Images Ltd. 77 Edwards & Company 70 Egone Workshop 534 Ehrig & Associates 109 8mm Film Festival 525 Eisner & Associates, Inc. 56 EKM-Nepenthe 500 El Paso Magazine 209 Elbert Advertising Agency, Inc. 59 Electric Company Magazine, The 290 Electrical Apparatus 433 ELECTRICity (see National News Bureau 403) Electron, The 290 Electronic Buyers' News 433 Electronic Education 434 **Electronics Times 434** Electronics Week 434 **Electronics West 434** Elisofon Archives, National Museum of African Art, Eliot 501 Elms Productions, Inc., Charles 107 Elysium Growth Press 290 EMC Publishing 120 **Emergency 434** En-Lightning Productions, Inc. 19 Ensign, The 209 Enterprise 242 **Environment 290 Environment News Digest 209** Epoch Universal Publications/North American Liturgy Resources 478 Equinox Magazine 290 Equivalents Gallery 169 Erie & Chautauqua Magazine 291 Esprit 242 Estey-Hoover, Inc. 19 Etherton Gallery 169 Europe for Travelers! 291

Europe Magazine 435

Evangelical Beacon, The 291 Evangelizing Today's Child 292 Evans & Bartholomew, Inc. 31 Evans/Salt Lake 107 Evans/Weinberg Advertising 27 Evanston Art Center 170 Evener, The 435 Event 292 Everett, Brandt & Bernauer, Inc. 66 **Excavating Contractor 435** Exceptional Parent, The 292 Exchange & Commissary News 395 Exhibition 280: Works on Walls 525 Expanding Images 20 Expecting Magazine 292 Explorer, The 242 "Expose Yourself" Film Festival 525

Faber Shervey Advertising 64 Faces: The Magazine about People 292 Facets 209 Fact Magazine 293 Fahlgren & Ferriss, Inc. 93 Fahlgren, Swink and Nucifora 41 Falcon Press Publishing Co., Inc. 120 Falk Associates, Richard 83 Family Affairs 293 Family Computing 293 Family Festivals 293 Family Magazine 293 Family Pet 243, 294 Family Planning Perspectives 436 Fandango Intercontinental Network 83 Farm & Power Equipment 436 Farm & Ranch Living 294 Farm Chemicals 437 Farm Industry News 437 Farm Journal, Inc. 437 Farm Woman News 294 Farmstead Magazine 294 Farnam Companies, Inc. 15 Feeley Enterprises 47 Fessel, Siegfriedt & Moeller Advertising 54 Fighting Woman News 295 Film in the Cities/Lightworks 534 Film | 59 Fine Dining Magazine 295 Fine Press Syndicate 501 Finescale Modeler 295 Fire Chief Magazine 437 Firehouse Magazine 437 First Foto Bank, Inc. 501 First Hand Magazine, Manscape 296 First Marketing Group, Inc. 105 Fisherman, The 296 Fishing and Hunting News 395 Fishing World 296 Fixophotos 188 Flashcards, Inc. 188 Fletcher/Mayo/Associates, Inc. 42

Flooring 438 Flora and Fauna Publications 120 Florida Banker (see Banking Today 422) Florida Grower and Rancher 395 Florida Image File, The 502 Florida Production Center 38 Florida Singles 296 Florida Wildlife 210 Fly Fisherman 296 Flyfisher 210 Focal Point Gallery 170 Focal Press 120 Focus (Films of College & University Students) 526 Focus Gallery 170 Focus on the Family 243 Focus West 502 Focus: New York 297 Food & Wine 297 Foote, Cone & Belding Communications, For Men Only 297 For Parents 297 Ford Times 243 Foreign Service Journal 210 Forth Worth Magazine 210 Fortune 297 Forum 298 Fotheringham & Associates 107 Foto ex-PRESS-ion 502 Fotobanco 502 Foto-Tek Darkroom, The 170, 534 Four by Five, Inc. 503 4-H Leader, The National Magazine for 4-H Fox, Sweeney & True 32 FPG International 503 France Today Magazine 298 Franklin Advertising 59 Franklin Mint Almanac 243 Franklin Photo Agency 503 Frazier Irby Snyder, Inc. 17 Freedom Greetings 188 Freelance Visual Productions, Inc. 503 Freeway 298 French & Partners, Inc., Paul 42 Frets Magazine 298 Friedentag Photographics 32 Friends Magazine 244 Friends of Photography, The 170, 535 Front Page Detective 298 Fruition 244 F/Stop Pictures, Inc. 503 Fuller Fine Art, Jeffrey 170 Fun in the Sun 299 Functional Photography 438 Fun/West 299 Fur-Fish-Game 299 Furman Advertising Co., Inc., The 77 Fusion Magazine 211 Future Magazine 211 Future Step Sirkle 479

Futurific Magazine 299

G

G & S Publications 299 Galeriia 170 Gallery Imago 171 Gallery Magazine 300, 526 Gallery 614 171 Gambling Times Magazine 300 Game & Fish Publications 300 Gamma/Liaison 503 Gamut 300 Gang & Associates Inc., Stu 64 Garden 300 Garden Design 301 Garden Gourmet 301 Garden Supply Retailer 438 Garden Way Publishing 121 Gardens for All News 211 Garner & Associates, Inc. 92 Gary Plastic Packaging Corp. 151 Gay Community News 396 Gav News 396 Gaynor Falcone & Associates 84 GCS Records 479 Geer Public Relations, Abbot 78 Generation 244, 301 Genesis 301 Gent 302 Geomatrix Associates, Inc. 34 Geomundo 302 Georgia-Pacific Corp. 151 Gerding Productions, Inc. 93 Gibson, C.R. 188 Gifted Children Monthly 396 Gilbert, Whitney & Johns, Inc. 72 Gillette Workshop of Photography, The 535 Glasheen Advertising, Inc., Pete 84 Glass News 438 Glencoe Publishing Co. 121 Globe 396 Globe Photos, Inc. 504 GMT Productions/Records 479 Godine, Publisher, David R. 121 Gold Prospector Magazine 211 Golden Isles Arts Festival 526 Golden Turtle Press 188 Golden West Books 121 Golden Years Magazine 302 Goldsholl Associates 44 Golf Course Management 212 Golf Digest 302 Golf Journal 303 Golf Shop Operations 438 Good Housekeeping 303 Goodman & Associates 105 Go-Video, Inc. 15 Grace Brethren Home Missions Council, Inc., The 151 Gramavision Records 479 Grand Rapids Calendar Co. 188 Grand Rapids Magazine 303 Grandville Record Corporation 479

Graphic Artisan Ltd., The 189

Graphic Arts Center Publishing Company 121 Graphic Experience Inc., The 84 Graphic Expertise Inc., The 84 Graphic Image Publications 189 Graphic, Inc. 439 Graphic Media Inc., 84 Graphic Workshop Inc. 72 Grass Roots Productions 20 Gray Gallery, Inc., Lenore 171 Gray's Sporting Journal 303 Great Lakes Fisherman 304 Greater Portland 304 Greenworld Records 480 Greneadier Magazine, The 304 Grey Advertising 64 Greyhound Review, The 212 Griffin Media Design Inc. 51 Griswold Inc. 94 Grit 396 Group 397 Group Two Advertising, Inc./Florida 39 Groves & Associates, Inc. 52 Guardian Newsweekly 398 Gulf Coast Golfer 304 Gulfshore Life 304 Gumpertz, Bentley, Fried 27 sestiment i primitival. nedinali a veni Pinostali. Gun Week 398 Gun World 305 Gurney's Gardening News 398 Guymark Studios 34

H

H.P. Books 122 H.W.H. Creative Productions, Inc. 189 Hadassah Magazine 305 Halsted Gallery, The 171 Ham-Sem Records 480 Handley & Miller, Inc. 52 Happy Wanderer, The 305 Hard Hat Records & Cassettes 480 Hardware Age 439 Harper & Associates, Inc. 152 Harrowsmith 305 Harvey for Loving People 306 Hastings, Doyle & Co., Inc. 109 Havelin Action Photo 504 Hayden Book Company 122 Hayes Publishing Co., Inc. 94 Haynes Advertising 42 HBM/Creamer (IL) 47 HBM/Creamer (MA) 59 HCM 28, 84 Health Magazine 306 Health Science 123 Healthplex Magazine 244 Healy, Dixcy and Forbes Advertising Agency Heaping Teaspoon Animation 29 Heartland Records 480 Heath and Co., D.C. 123

Heilman Photography, Grant 504 Hemisfilm International Festival 526 Hemisphere Publishing Corporation 123 Hepworth Advertising Co. 105 Herb Quarterly. The 306 Hesselbart & Mitten, Inc. 94 HFAV Audiovisual, Inc. 72 HiCall 398 Hideaways Guide 306 High School Sports 308 High Times 307 High Volume Printing 439 Hill & Knowlton 39 Hill and Knowlton, Inc. (IL) 47 Hill and Knowlton, Inc. (TX) 105 Himark Enterprises, Inc. 152 His Magazine 307 Historic Preservation 212 Hobie Hotline 212 Hodes Advertising, Bernard (CA) 20 Hodes Advertising, Bernard (IL) 47 Hodes Advertising, Inc., Bernard (MA) 59 Hoefer-Amidei Associates, Public Relations Hoffman York and Compton, Inc. 110 Holistic Living News (see Wholistic Living News 382) Hollywood Associates, Inc., The 20 Holt, Rinehart and Winston 123 Home 307 Home & Away Magazine 213 Home Shop Machinist, The 307 Home-Brew Records 480 Homemaker. The 307 Homestead Records 480 Honolulu Advertiser, The 398 Hoof Beats 213 Horizon Press Publishers Ltd. 124 Horse and Rider 308 Horse & Rider Magazine 308 Horse Digest, The 308 Horse Illustrated 308 Horseman, The Magazine of Western Riding 308 Horseplay 309 Horticulture 309 Hospital Gift Shop Management 439 Hospital Practice 440 Hospitals 440 Hot Bike/Street Chopper 309 Hot Rod Magazine 309 Hot Shots Stock Shots, Inc. 504 Hottman Edwards Advertising 56 Houck & Harrison Advertising 108 Houlgate Enterprises, Deke 20 House Beautiful 310 House of Collectibles, Inc., The 124 Hudson County Division of Cultural and Heritage Affairs 152 Hudson Valley Magazine 310 Hula Records, Inc. 480 Human Ecology Forum 440 Hungness Publishing, Carl 124

Hungry Horse News 399 Hustler Magazine/Chic Magazine 310 Hybrid Records 481

ı

I C Communications, Inc. 21 Idaho Department of Parks & Recreation 152 Ideals Magazine 310 Illinois Entertainer 399 Illinois Magazine 310 Illuminati 124 Illuminator, The 245 Illustrator's Stock Photos 505 Image Bank, The 505 Image Bank/West, The 505 Image Finders Photo Agency, Inc. 506 Image Innovations, Inc. 72 Image Magazine 310 Image Media, Inc. 64 Images 171 Images Press Service Corp. 506 Imahara & Keep Advertising & Public Relations 21 Imprimatur, Ltd. 171 Imprint 213 In Touch 311 In-Plant Printer 441 Independent Filmmakers Exposition 527 Index Stock International 506 Indian Life Magazine 311 Indianapolis 500 Yearbook 311 Indianapolis Magazine 311 Indianer Multi Media 39 Industrial Engineering 440 Industrial Fabrics Association International 152 Industrial Launderer 440 Industrial Machinery News 440 Industrial Safety and Hygiene News 441 Industry Week 441 InfoAAU 399 Information Counselors, Inc. 34 Infoworld 399 Inkblot 441 Inland 245 Innovative Design & Graphics 153 Inside Detective 312 Inside Running 399 Insight 312 Instant and Small Commercial Printer 441 Instant Printer (see Instant and Small Commercial Printer 441) Instructor Magazine 312 Instrumentalist, The 442 Insulation Outlook 442 Interand Corporation 47 Intercontinental Greetings, Ltd. 189 Interior Design 442 International Business Monthly 442 International Center of Photography 171, 535

International Christian News 213 International Diaporama Festival 527 International Exhibition of Photography 527 International Family Planning Perspectives International Film & TV Festival of New York 527 International Gymnast 312 International Living 400 International Media Services Inc. 73 International Reading Association 124 International Research & Evaluation (IRE) 153 International Stock Photography, Ltd. 507 International Wildlife 312 Interpress of London and New York 507 Interracial Books for Children Bulletin 213 Interstate 313 lowan Magazine, The 313 Iris Photographics 171 Islands 313 It Will Stand 313 Itinary Magazine, The 313

J

444

J&J Musical Enterprises 481 Jackson/Ridey & Company, Inc. 94 Jacoby/Storm Productions, Inc. 34 Janapa Photography Gallery Ltd. 172 January Productions 73 Jay Jay Record Co./Bonfire Records 481 Jazz Times 401 Jazziz Magazine 314 Jeb Gallery, Inc. 172 Jenkins & Associates, T.S. 62 Jeroboam, Inc. 507 Jerryend Communications Inc. 99 Jet Cargo News 443 Jewel Record Corp. 481 Jewish Exponent 401 Jewish Telegraph 401 Job Corps in Action Magazine 443 Jobber Retailer Magazine 443 Jock Magazine 314 Johnson Advertising, George 67 Johnson Advertising, Inc. Elving 44 Johnston Advertising, Inc., Jim 84 Joli Greeting Card Co. 190 Jon-R Associates 85 Jordan Associates Advertising & Communications 96 Jordan/Case & McGrath 85 Journal of Family Practice, The 443 Journal of Freshwater, The 214 Journal of Physical Education, Recreation & Dance 214 Journal of Psychoactive Drugs 444 Journal of School Health 214 Journal of Soil and Water Conservation 214 Journal of the National Medical Association

Journal of the Senses 214 Journal, The 443 Junior Riders 314

K

Kahn Group, Al 153 Kansas 314 Kaplan Co., Inc., Arthur 190 Karr Productions, Paul S. 15 Karr Productions, Paul S. (Utah Division) Keepin' Track of Vettes 315 Keller Crescent Company 52 Kelso Associates Ltd. (see Bob Boeberitz Design 91) Ken-Del Productions, Inc. 35 Kennedy Journalism Awards, Robert F. 527 Kennedy-Lee, Inc. 99 Kenning Productions 481 Kesslinger & Associates, J.M. 73 Ketchum Advertising, Inc. 30 Keyboard 315 Kiderian Record Products 481 Kite Lines 315 Kiwanis Magazine 215 Klayman Publishing, Leon 190 Kleiner Enterprises, Sid 481 Kondos Art Galleries, Peter J. 172 Kowal & Wicks, Raymond 59 Kramer and Associates, Inc., Joan 507 Krantz Company Publishers, The 125 Kroloff, Marshall & Associates, Ltd. 36 Krueger Direct Marketing 21 K-Tel International, Inc. 482

L

L.R.J. Records 482 La Crosse Area Convention & Visitor Bureau La Grave Klipfel Clarkson Advertising, Inc. Laboratory Management 444 Lacma Physician 215 Lakeland Boating 315 Lakewood Books, Inc. 125 Lambert Studios, Inc., Harold M. 507 Landmark General Corp. 190 Landscape Architecture 215 Lane Pictures, Inc., Don 85 Lang, Fisher & Stashower 94 Laughing Man Magazine, The 316 Launey, Hackmann & Harris 85 Laurentian University Museum & Arts Centre 172 Law & Order Magazine 444 Lawn Care Industry 444 Lawrence, Detrick 59 Lay Leadership Institute, Inc. 125

Leadership 246 Lebhar-Friedman 125 Lefthander Magazine 215 Lefton Company Inc., Al Paul 85 Legal Economics 445 Legend Records & Promotions 482 Lehr Photographis, Inc., Janet 172 Leon Company, Inc., S.R. 78 Let's Go 316 Let's Live 316 Letters 316 Levine Associates, Inc., William V. 85 Levine, Huntley, Schmidt & Beaver 86 Lewis Advertising, Inc. 92 Lewis Advertising, Inc., J.H. 15 Lewis, Inc., Frederic 508 Liberty Magazine 317 Licensing International 445 Life 317 Lifetime Cutlery Corporation 154 Light 172 Light and Life 317 Light Impressions Corporation 125 Lightbooks 125 Lights and Shadows 317 Lightwave 508 Lilith 317 Lin's Lines 482 Lion, The 215 Lisa Records 482 Little House Press, Inc., The 126 Little, Brown & Co. 126 Live! 318 Live Steam Magazine 318 Livres Commoner's Books 126 Llewellyn Publications 126 Locus 401 Lodestar Productions 21 Log Home and Alternative Housing Builder Long Beach Symphony Association 154 Long Island Heritage 401 Longan Gallery 172 Lookout, The (OH) 318 Lookout, The (NY) 246 Los Angeles Magazine 318 Los Angeles Reader 318 Lost Colony, The 154 Lott Advertising Agency 21 Lottery & Gaming Review 319 Louisville Magazine 319 Lowe & Hall Advertising, Inc. 102 Lowe Runkle Co. 96 Lucifer Records, Inc. 482 Luedke and Associates, Walter P. 44 Lutheran Forum 319 Lutheran Journal, The 320 Lutheran Standard, The 216, 320 Lutheran, The 319 Lutheran, The 319 Lynch, Monica 482 Lynchburg News & Daily Advance 402 Lyons, Inc. 35

M

M.F.I. 21. MacDowell Colony, The 535 Mace Advertising Agency, Inc. 44 Machine Design 445 MacIntosh Communications, Inc., Rob 154 MacKenzie & Associates, Malcolm L. 36 Macmillan Pub. Inc./School Division 127 Madden & Goodwin 102 Magazine for Christian Youth!, The 216 Magazine of Utah, The 320 Magid, Lee 483 Main Image Photographics 508 Maine Line Company 190 Maine Photographic Workshop, The 535 Maine Sportsman 402 Mainstream-Animal Protection Institute of America 216 Mainzer, Inc., Alfred 191 Maler, Inc., Roger 73 Mandabach & Simms 48 Mandabach & Simms/Ohio, Inc. 95 Mandate 320 Manitoba Teacher, The 402 Mansfield Co., Lloyd 78 Manufacturing Engineering 445 Map International 217 Mari Galleries of Westchester, Ltd. 172 Marian Helpers Bulletin 320 Maricao Records/Hard Hat Records 483 Maris, West & Baker Advertising 66 Maritz Communications Co. 67 Mark Advertising Agency, Inc. 95 Mark I Inc. 191 Marketaide, Inc. 53 Marketing Support, Inc. 48 Marlborough Gallery, Inc. 173 Marriage and Family Living Magazine 321 Marsden 86 Marshfilm, Inc. 53 Marsteller Inc. 32 Marsteller, Inc. (See HCM 84) Marstrat, Inc. 48 Martin-Williams Advertising Inc. 65 Marzola and Associates, Ed 22 Mass High Tech 445 Master-Trak Enterprises 483 Materials Engineering 446 Mattingly Baker 173 Mature Years 217 Maverick Publications 127 Maxfilms, Inc. 28 Mayo Alumnus, The 217 Mayo Associates, Fletcher 67 McAndrew Advertising Co. 78 McCaffrey and McCall, Inc. 86 McCalls Magazine 320 McCann-Erickson 54 McCann-Erickson Worldwide, Inc. 105 McCheyne, Inc., MacKenzie 36 McDougall, Littell 127 McKinney/Great Lakes 95

McKinney/New England 60 McManus Company, The 34 MD Magazine 446 Meadowbrook Inc. 127 Meadowlark Ventures 483 Mealer & Emerson 22 Mean Mountain Music 483 Measurements & Control 446 Media & Methods 446 Media Department 45 Media Exchange, The Inc. 108 Media Materials, Inc. 57 Mediaworks 75 Medical Electronics 446 Medical Multimedia Corp. 86 Medical Times 447 Medichrome 508 Medicine and Computer 447 Mekler/Ansell Associates, Inc. 86 Melodee Records 483 Mendocino Review 321 Menlo College 154 Meriwether Inc., Arthur 45 Merrill Publishing Company, Charles E. 127 Meta-4 Productions, Inc. 28 Metal Building Review 447 Metro Associated Service 509 Michiana Magazine 402 Michigan 402 Michigan Business Magazine 447 Michigan Farmer 447 Michigan Natural Resources Magazine 321 Michigan Out-of-Doors 321 Michigan Sportsman 321 Midtown Y Photography Gallery 173 Midwest Art Publishers 191 Midwest Motorist, The 322 Milady Publishing Corporation 128 Milepost, The 322 Military Review, The 448 Milkweed Chronicle 403 Mill Gallery, The 173 Miller Assoc. Inc., Howard 100 Miller Communications, Inc. 60 Milliken Publishing Company 67 Milwaukee Center for Photography 536 MINI Magazine 448 Mining Equipment International (see World Mining Equipment 474) Minnesota Dance Theatre and School, Inc. 154 Minnesota Opera, The 155 Minnesota Sportsman 322 Minot Art Gallery 173 Mintz/Public Relations Advertising, Bennett Mirror Records, Inc., Kack Klick, Inc. 484 Mississippi State University Alumnus 217 Missouri Life 322 Missouri Ruralist 448 Modern Curriculum Press 128

Modern Drummer Magazine 322

Modern Liturgy 323

Modern Maturity 218 Modern Percussionist 323 Modern Photography 323 Modern Tire Dealer Magazine 448 Moment Magazine 323 Momentum 218 Monks Associates, Inc., Arthur 60 Moody Press 128 Morgan & Morgan, Inc. 128 Morgan Horse, The 218 Morris Communications Corp. (MOR/COM) Morrison Associates, Ruth 87 Moss & Company, Inc. 87 Mother Earth News. The 323 Motivation Media, Inc. 45 Motor Boating & Sailing Magazine 323 Motorcycle Dealer News 448 Motorcyclist 324 Motorhome 324 Motorland Magazine 246 Mott Media 128 Mountain Railroad Records, Inc. 484 Moving Targets, Inc. 22 MRC Films 87 MSD AGVET 155 Muir, Cornelius Moore, Inc. 87 Muller, Jordan, Weiss, Inc. 87 Multi-Image Resources 105 Multivision International Inc. 48 Multnomah Press 130 Munk & Company, Burt 45 Murray & Associates, Stanley H. 35 Muscle Mag International 324 Muscular Development Magazine 246 Museum of New Mexico 174 Music City News 324 Music Educators Journal 218 Music Sales Corp. 130 Muskegon Museum of Art 174 Muzzle Blasts 218 Mystic Oak Records 484 Mystic Records/MRG Distributing 484

N.Y. Habitat 325 Naiad Press, Inc., The 130 National Association for Creative Children & Adults, The 155 National Association of Evangelicals 155 National Association of Legal Secretaries National Bus Trader 449 National Catholic News Service 509 National Coin-Operators Reporter 449 National Dairy News, The 403 National Enquirer 403 National Fisherman 449 National 4H News (see 4-H Leader-the National Magazine for 4-H 211) National Fund for Medical Education 156

and an interior Publishing for

Index 561 National Future Farmer, The 219 National Geographic 325 National Geographic Society 130 National Geographic Traveler 325 National Geographic World 325 National Glass Budget (see Glass News 438) National Guard 449 National Headliner Awards 527 National Hot Dog & Sausage Council 156 National News Bureau 403, 509 National Notary, The 219 National Orange Show, International Exhibition of Photography 527 National Parks Magazine 326 National Rural Letter Carrier, The 219 National Scene Magazine 326 National Teaching Aids, Inc. 78 National Utility Contractor 220 National Vietnam Veterans Review 403 National Wildlife 326 Nationwide Advertising Inc. 95 Natural History Magazine 327 Nature Conservancy News, The 220 Nature Friend Magazine 327 Nature Photography Workshops (see John Shaw and Larry West Nature Photography Workshops 536)

Nature Trails Press 131 Naturescapes, Inc. 191 Nautica Magazine 327 ND Rec Magazine 220 Neikrug Photographica Ltd. 174 Nelson Associates, Dallas 103 Nelson-Hall Publishers 131 Network 220 Neuman, Inc., Susan 39 Nevada Magazine 327 Nevadan, The 404 New Age Journal 327 New Alaskan 328 New Body Magazine 246

New Breed 328 New Catholic World 328 New Cleveland Woman Journal 328 New Driver 328 New England Entertainment Digest 404 New England Monthly 328

New England Senior Citizen/Senior American News 405 New England Skier's Guide 329 New Frontier Magazine 329 New Guard 220 New Hampshire Profiles 330 New Methods 449 New Mexico Magazine 330 New Orleans Business 450

New Orleans Museum of Art 174 New Orleans Review 330 New Realities 330 New Times 331 New World Outlook 245 New World Records Inc. 484 New York Alive 331

New York Antique Almanac 405 New York State Fair Photography Exhibition and Sale 528 New York State Youth Media Arts Shows 528 Newbury House Publishers Inc. 131 News Circle/Mideast Business Exchange 331 Newsday Magazine, The 405 Newservice 405 Nexus 174 Night Life Magazine 331 Nightheat Magazine 331 Nikon House 174 Nit & Wit. Chicago's Arts Magazine 332 Nitech Research Group 131 NJFA Review 221 NI ADA Cornerstone 221 Non-Foods Merchandising 450 Normandale Gallery 174 North American Hunter 221 North American Outdoor Film Academy Awards 528 Northeast Outdoors 332 Northern Kentucky University Summer Photo Workshop 536 Northern Logger & Timber Processor, The Northlich, Stolley, Inc. 95 Northwest Film & Video Festival 528 Northwest International Exhibition of Photography 528 Northwest Magazine/The Oregonian 406 Northwoods Press 131 Norton Wilderness Photography Workshops. Boyd 536 Nostalgia World 406 Nuclear Times 332 Nucleus Records 484 Nugget 332 Numismatic News 406 Nursing Management 450 **Nutshell News 333** NW Ayer, Inc. 28 NY Talk 331

0

O.M.A.R. Inc. 48
Oakland Convention & Visitors Bureau 156
Observer Newspapers 406
OCAW Reporter 221
OCAW Union News (see OCAW Reporter 221)
Occupational Health & Safety 450
Ocean Realm 333
Oceans 333
Oceans 451
Odyssey 333
Off Duty America 333
Office Administration & Automation 451
Official Comdex Show Daily 451
Offshore 334

Ogilvy & Mather, Inc. 87 Ohio Ballet 156 Ohio Business 451 Ohio Farmer, The 451 Ohio Fisherman 335 Ohio Magazine 335 Ohio Renaissance Review 335 OK Magazine 406 Oklahoma Living Magazine 335 Oklahoma Today 222 Old Cars Newspaper 407 Old West 335 Omega News Group/USA 509 Omni Communications 52 Omni-Photo Communications, Inc. 509 On Cable 336 On the Line 336 On Track 407 101 Productions 132 1001 Home Ideas 336 Ontario Out of Doors 336 Ontario Technologist, The 451 Open Space Gallery 175 Open Wheel Magazine 337 Opera News 222 **Optasonics Productions 73** Optica-A Centre for Contemporary Art 175 Orange Coast Magazine 337 Oregon Business Magazine 452 Organic Gardening 337 Organization Management 74 Original Cast Records; Broadway/Hollywood Video Productions: Broadway/ Hollywood Film Productions 485 Original New England Guide, The 337 Orlando Gallery 175 Ortho Books 132 Other Side. The 338 Ottawa Magazine 338 Our Family 338 **Ouroboros Communications 30** Outdoor America 452 Outdoor Canada 339 Outdoor Empire Publishing, Inc. 132 Outdoor Life Magazine 339 Outside 340 Overseas! 340 Owens Valley Photography Workshops 537 **OWL 340** Owner Operator Magazine 452 Ozark Magazine 247

P

P.M. Craftsman 157 PO.B 452 Pacific Boating Almanac 341 Pacific Coast Productions 22 Pacific Discovery 222 Pacific Productions 43 Pacific Purchasor 452 Pacific Travel News 453 Packer, The 453 Padre Productions 132

Pages 247

Paint Horse Journal 341 Paladin Press 133

Palm Beach Life 341

Palm Springs Convention and Visitors Bureau 156

Palo Alto/TBA Records 485 Pan Industries, Peter 485 Panographics 510

Pantheon Books 133 Papercraft Corp. 191

Parade 407

Paramount Cards, Inc. 191

Parents' Choice, A Review of Children's Media 407

Parents Magazine 341 Park Place Group, Inc. 87

Parker Advertising Company, The 95

Parts Pups 453 Passages North 222

Passenger Train Journal 341 Passport Magazine 342

Paton & Associates 67

Pazovski School and Workshop of Photog-

raphy, Kazik 537 PC Week 407 PC World 342 Peaceable 485

Peanut Butter Publishing 133

Pediatric Annals 454

Pelican Publishing Co., Inc. 133

Pelland Advertising and Photography, Peter (see Pelland Advertising Associates, Inc. 60)

Pelland Advertising Associates, Inc. 60

Pemberton & Oakes 192 Pennsylvania 342

Pennsylvania Angler 223

Pennsylvania Game News 342 Pennsylvania Heritage 223

Pennsylvania Lawyer, The 223 Pennsylvania Outdoors 342

Pennsylvania Review, The 343 Pennsylvania Sportsman, The 343

Penrose Productions 23 Pentecostal Evangel 223

Pentecostal Messenger, The 224

Penthouse 343

Peregrine Smith Books (see Gibbs M. Smith, Inc./Peregrine Smith Books 135)

Perinatology Neonatology 454

Personal Communications Magazine 454

Personal Computing 343

Perspective 247 Pet Business 455

Peters Valley Craftsmen 537 Petersen's Hunting Magazine 343 Petersen's Photographic Magazine 343

Petroleum Independent 455

Pets/Supplies/Marketing Magazine 455

PGA Magazine 455 PGA of America 156

Phi Delta Kappan 224

Phoebe 344

Phoenix Home/Garden 344

Phoenix Magazine 344

Photo Associates News Service, Inc. 510

Photo Bank 505

Photo Communication Services, Inc. 62

Photo Communique 344

Photo Gallery at Portland School of Art, The

Photo Life 345

Photo Marketing Magazine 224

Photo Media, Ltd. 510 Photo Metro 345

Photo Metro 345

Photo Network 510

Photo Researchers, Inc. 510

Photo/Chronicles, Ltd. 192

PhotoCom Productions 23

Photofile International (see Comstock, Inc. 497)

Photoflash Models & Photographers Newsletter 407

Photographer's Market 345

Photographer's Market Newsletter 408 Photographic Investments Gallery 175

Photographics Unlimited Gallery175
Photography at Oregon Gallery 175

Photography 86 528

Photography Gallery, The 175

Photophile 511 Phototake 511

Photounique 511 Photoworks, Inc. 175 Photri, Inc. 512

Physician and Sportsmedicine, The 455 Pickups & Mini-Trucks Magazine 345

Pickups & Mini-Trucks Magazii Pictorial Parade, Inc. 512 Picture Cube, The 512

Picture Group, Inc. 512 Pictures International 513 Pictures of the Year 529 Pilot's Log. The 247

Pinne Garvin Herbers & Hock, Inc. 30

Pipeline & Gas Journal 456 Pittsburgh Magazine 346

Plane & Pilot, Homebuilt Aircraft 346

Planning 224

Plant Management & Engineering 456

Pleasure Boating 346 Pocket Books 133

Podiatry Management 346 Poetry Magazine 346

Pointer Productions (see Ouroboros Communications 30)

Police Net Magazine 456 Police Product News 456

Police Times 225

Police Times, Police Command 457

Pomeroy Company, The 23 Pop International Corp. 74 Popular Cars Magazine 346

Popular Computing 347 Popular Photography 347 Popular Photography Gallery 176 Popular Science 347 Posey School of Dance, Inc. 157 Positive Photographics Gallery 176 Practical Real Estate Lawyer, The 225 Praise Ind. 485 Praxis Creative Public Relations 23 Praying 347 Presbyterian Record, The 225 Presbyterian Survey 347 Prescription Co., The 485 Present Tense 348 Press Photo of the Year Contest 529 Primalux Video 88 Primavera 348 Prime Cuts Records 485 Prime Time Sports & Fitness 348 Princeton Alumni Weekly 225 Principal Magazine 225 Print Club, The 176, 529 Private Practice Magazine 457 Pro Bass Magazine (see Bassin' Magazine Pro Football Hall of Fame Photo Contest 529 Pro Sound News 457 Pro/Creatives 78, 486 Pro/Stock 513 Probe 226 Problems of Communism 348 Produce News, The 408 Producers International Corporation 52 Product Centre-S.W. Inc., The Texas Postcard Co. 192 Professional Agent 457 Professional Computing 458 Professional Photographer, The 458 Professional Pilot 458 Professional Surveyor 458 Progressive Architecture 458 Progressive, The 349 Project Art Center 176 Project Arts Center 537 Prometheus Books 134 Pruitt, Humphress, Powers & Munroe Advertising Agency, Inc. 39 PSA Young Photographers Showcase 529 Psychiatric Annals 459 Psychic Guide 349 Psychic Observer, The 226 Public Communications, Inc. 50 Pulpdent Corporation 157 Pulse Communications 50 Purdom & Co., Paul 23 PVA-EPVA 192

Q

Quadria Art, Inc. 192 Quarasan Group, Inc., The 157 Quarson Associates 157 Quarter Horse Journal, The 349 Queens College 158 Quest 247 Quick Frozen Foods 459 Quill, The 226

R

R.D.R. Productions. Inc. 513 Racing Pigeon Pictorial 349 Racquetball Illustrated 350 Radio & Television Promotion Newsletter Radio-Electronics 350 Rain 350 Ralston & Associates, Inc., Joanne 16 Randall Productions 486 Random House 88 Rangefinder, The 350, 459 Banger Rick 350 Rapp & Collins 88 Rase Productions, Inc., Bill 24 Razor's Edge-Hair News, The 351 Real Estate Today 226 Reco International Corp. 159 Record Company of the South 486 Recording Engineer Producer 459 Recreation World Services Inc. 159 Recreational Equipment, Inc. 159 Redbud Records 486 Reeves Journal 351 Referee Magazine 459 Reflections 176 Regal's Books, Inc. 134 Regents Publishing Company, Inc. 134 Reid Co., The Russ 24 Reilly & Associates, E.M. 67 Religious News Service Photos 513 Relix Magazine 352 Repertory Dance Theatre 159 Resident & Staff Physician 460 Resort Management Magazine 460 Resource Publications, Inc. 134 Resource Recycling 460 Restaurant and Hotel Design 460 Restaurant Design (see Restaurant and Hotel Design 460) Restaurant Hospitality Magazine 460 Retailer & Marketing News 461 Retired Officer Magazine, The 227 Review of Optometry 351 Revonah Records 486 RFM Associates, Inc. 74 Richard-Lewis Corp. 78 Richardson Myers & Donofrio 100 Richter Productions, Inc. 88 Rider College Student Center Gallery 176 Rinhart Galleries, Inc. 176

Ripsaw Record Co. 486

River Runner Magazine 352

RMS Triad Productions 487

RN Magazine 461 Roanoker, The 352 Rob-Lee Music 487 Roberts Represents, Chris 513 Robinsons Inc. 39 Robotics Today 461 Rochester Telephone Tieline 248 Rochester Women Magazine 352 Rockshots, Inc. 193 Rockwell Records 487 Rodale Press Inc. 134 Rodale's New Shelter 352 Rodeo News 353 Rodeo News, Inc. 227 Roffman Associates, Richard H. 88 Rogers & Cowan, Inc. 24 Rogers, Weiss/Cole & Weber 28 Rolling Stone 408 Ronan, Howard, Associates, Inc. 79 Roof Design 461 Roofer Magazine. The 461 Roommate 248 Rose and Co., John M. 103 Rose Records Company, Inc. 487 Roseburg Woodsman 248 Ross/Gaffney, Inc. 89 Rotarian, The 227 Rothholz Associates, Inc., Peter 89 Rowing USA 227 **RSVP Marketing 159** Rubin Associates, Inc., Bruce 40 Rudder Finn & Rotman, Inc. 50 Ruhr Advertising, Inc., Chuck 65 Runner, The 353 Runner's World 353 Running Times 353 Russell-Manning Productions 65 Ryan/Ryan Southwick Advertising & Public

S

Sackbut Press 193

Sackett Executive Consultants, Richard 55 Sacramento Magazine 354 Sadlier, Inc., William H. 135 SAF-The Center for Commercial Floriculture (see The Society of American Florists 160) Sage Advertising 68 Sail 354 Sailboard News 408 Sailing 354 Sailors's Gazette 354 Saint Vincent College 160 Salome: A Literary Dance Magazine 356 Salt Water Sportsman 356 Sam Advanced Management Journal 228 San Francisco Opera Center 159 San Jose State University 160 Sander Allen Advertising, Inc. 50

Relations 97

Sander Gallery Inc. 176 Sanders, Wingo, Galvin & Morton Advertisina 105 Sanitary Maintenance 462 Santa Clara Valley International 529 Santa Cruz Video Festival 530 Sarkett & Associates 50 Sarver & Witzerman Advertising 24 Satellite Dealer 356 Saturday Evening Post Society, The 356 Saturday Review 357 Save the Children 35 Savings Institutions 228 Sawyer Camera & Instrument Co. 24 Saxton Communications Group, Ltd. 89 Scafa-Tornabene Pbg. Co. 193 Scaramouché Records 487 Schecterson Associates, Inc., Jack 89 Schneier Fine Arts, Donna 176 Scholady Publishing Group, Inc., The 135 Scholarly Publishing Group, Inc., The 160 Scholastic Photography Awards 530 Schweig Studio/Gallery, Martin 176 Schweinfurth Memorial Art Center 177 Science Activities 357 Science and Children 228, 462 Science Digest 357 Science 85 357 Science of Mind Magazine 357 Science Teacher, The 462 Scope 358 Score 358 Scott Enterprises, Liz 100 Scouting Magazine 228 Screenscope, Inc. 37 Scuba Times Magazine 358 Sea 358 Sea Cliff Photograph Co. 177 Sea Frontiers 228 Seaphot Ltd/Planet Earth Pictures 514 Seaway Review 462 Secretary, The 229 Security Management 229 Seek 359 Select Homes Magazine 359 Self 359 Senior Golf Journal 359 Sentinel, The 248 Sergeants 229 Service Reporter 410 Seventh Hiroshima International Amateur Film and Video Festival, The 530 Sewanee News. The 229 Shable Sawyer & Pitluk 106 Shape 359 Shashinka Photo 514 Shaw and Larry West Nature Photography Workshops, John 536 Shecter & Levin Advertising/Public Relations 57 Sheet Music Magazine 360 Shelterforce 360

Sheperd Records 487

566 Photographer's Market '86

Shooting Star International Photo Agency. Inc. 514 Shorey and Walter, Inc. 102 Short Shepler Fogleman Advertising (see SSF Advertising 92) Shostal Associates, Inc. 515 Show Biz, The 95 Shreveport Magazine 360 Shuttle Spindle & Dyepot 462 Sickles Photo & Reporting Service 515 Sierra 230 Sight & Sound, Inc. 69 Sightlines 463 Signpost Magazine 230 Signs of the Times 360 Silver Image Gallery, The 177 Simon & Schuster 135 Simsemilla Tips 463 Sine Qua Non (see SQN Entertainment Software Corp. 488) Singer Communications, Inc. 515 Single Parent, The 231 Sioux City Art Center 177 Ski 360 Ski Racing Magazine 362 Skiing Magazine 362 Skiing Trade News 463 Skin Diver 363 Skydivina 410 Skylite 249 Small Boat Journal, The 363 Small Farmer's Journal 463 Small Systems World 463 Small World (see Volkswagen's World 250) Smart Living Magazine 363 Smith & Yehle, Inc. 68 Smith McNeal Advertising 42 Smith, Inc./Peregrine Smith Books, Gibbs M. 135 Smith, J. Greg 69 Snapdragon 232 Snowmobile Magazine 363 Soap Opera Digest 364 Soccer America 410 Social Policy 464 Society 364 Society for Visual Education, Inc. 50 Society of American Florists, The 160 Soho Repertory Theatre 160 Sol Del Rio 177 Solar Age Magazine 464 Solo Magazine 364 Sonic Wave Records 488 Sooner LPG Times 464 Sormani Calendars 193 South Florida Living 364 South Jersey Living 410 South-Western Publishing Company 136 Southeastern Center for the Photographic Arts. Inc. 537 Southeastern Log, The 411 Southern Angler's & Hunter's Guide 364 Southern Beverage Journal 464

Southern Exposure 365 Southern Jeweler Magazine 464 Southern Light 177 Southern Motor Cargo 464 Southern Motoracing 411 Southern Stock Photos 515 Southside Hospital 160 Souveniers & Novelties Magazine 465 Sovfoto/Eastfoto 516 Soybean Digest 465 SP Communications Group, Inc./Domino Records 488 Spanish Today 365 Sparrow Corporation, The 488 Specialty & Custom Dealer 465 Spectrum Stories 365 Spencer Productions, Inc. 89 Sperry New Holland News 249 Spin 365 Spiritus Gallery, Inc., Susan 178 Spiro & Associates 100 Spooner & Company 74 Sporting Goods Dealer, The 465 Sporting News, The 411 Sports Afield 366 Sports Illustrated 366 Sports Parade 366 Sportsman's Hunting 366 Spray Dust Magazine 232 Springs Magazine 366 Spur 367 SQN Entertainment Software Corp. 488 SSF Advertising 92 St. Lawrence 227 St. Louis Magazine 354 St. Louis Weekly 355 Stack & Associates, Tom 516 Stallion Magazine 367 Standard Educational Corp. 136 Star 367 Star Advertising Agency 106 Star Magazine, The 411 Starr/Ross Corporate Communications, Inc. 40 State Historical Society of Wisconsin 160 State, The 367 Steck-Vaughn Company 136 Stein & Day/Publishers 137 Stephan Advertising Agency, Inc. 54 Stereo Review 367 Sterling's Magazines 367 Stern Associates, Lee Edward 90 Stern-Walters/Earle Ludgin 29 Sting 368 Stock Car Racing Magazine 368 Stock Imagery 517 Stock Market Photo Agency, The 517 Stock Pile, Inc. 517 Stock, Boston, Inc. 516 Stockhouse, Inc., The 517 Stockphotos Inc. 517 Stokes & Associates, J. 24

Stokes Workshops, Orvil 537

Stolz Advertising Co. 68 Stone & Adler, Inc. 51 Stone in America 465 Stone Wall Press 137 Stores 466 Straight 368 Strawberry Media 518 Strength and Health 368 Student Lawyer 232 Studio 8 Photo & Film Studio 79 Studio Photography 466 Suburban News Publications 412 Suburbia Today 411 Success Magazine 369 Successful Farming 467 Sudler & Hennessey Inc. 90 Summer Workshops in Photography at Colorado Mountain College 537 Sun/Coast Architect-Builder Magazine 467 Sunday Woman 412 Sunprint Cafe & Gallery 179 Sunshine Magazine 412 Surfer Magazine 369 Surfing Magazine 369 Survival Guide (see American Survival Guide 255) Swain Productions, Inc., Hack 40 Swank Magazine 369 Swanson, Rollheiser, Holland 69 Swimming Pool Age & SPA Merchandiser 467 Sybron Quarterly Magazine 249 Sygma Photo News 518 Symmes Systems 137 Symphony on the Sound, Inc. 161

T

T-Shirt Gallery Ltd. 161 T.M. Gallery 179 T.N.T. Designs, Inc. 193 Tab Books, Inc. 137 Talco Productions 90 Talent Clearinghouse 161 Tampa Bay MetroMagazine 369 Tank Incorporated 518 Tansky Advertising Co., Ron 24 Taurus Photos Inc. 518 **Technical Educational Consultants 79 Technology Review 467** Teen Power 370 Teen Times 232 Teenage Corner, Inc. 519 Teens Today 370 Tel-Air Interests, Inc. 40 Tele-Press Associates, Inc. 90 Telecommunications 468 Telefilm Ltd. Inc. 40 Telex Communications, Inc. 65 Tempo de Valle 412 Ten Best of the West 530 Tennant Company, Don 51

Tennessee Banker, The 232 Tennis Magazine 370 Tennis Week 370 Terock Records 490 Terrain Gallery 179 Texas Fisherman Magazine 370 Texas Gardner 371 Texas Highways 371 Texas Observer, The 371 Texas Pacific Film Video, Inc. 106 Textile Rental Magazine 233 Third Story Records, Inc. 490 Thompson and Associates, Ray 57 Thompson Recruitment Advertising 57 Thompson USA, J. Walter 37, 42 Thompson/Matelan & Hawbaker, Inc. 101 Thorndike Press 137 Thoroughbred Record 468 Three (3) Score and 10 371 Three Rivers Arts Festival 530 Three-2-1 Contact Magazine 371 Tidepool Gallery 179 Tidewater Virginian Magazine 372 Tiffen Manufacturing 79 Tiger Beat Magazine 372 Tilton Films, Inc., Roger 25 Time-Life Books Inc. 138 Times News 412 Times-Picayune/The States-Item, The 412 Tinory Productions, Rik 490 TLC Magazine 372 Toastmaster, The 233 Today's Christian Parent 372 Today's Fishermen Magazine 372 Today's Insurance Woman 233 Tongass Historical Museum 179 Topics 249 Torso International 373 Torso/Jock Magazines 233 Total Fitness 373 Touch 233 Touchstone Gallery 179 Tourist Attractions and Parks 468 Tow-Age 468 Towing & Recovery Trade News 468 Town & Country 373 Track and Field News 373 Tradewinds 249 Tradewoman Magazine 469 Tradition Magazine 374 Trail Records 490 Trailblazer Magazine 250 Trailer Boats Magazine 374 Trailer Life 374 Trails-A-Way 374 Training Magazine 469 Training: The Magazine of Human Resources Development 469 Translight Media Associates, Inc. 45 Transtar Productions, Inc. 32 Travel & Leisure 375 Travel & Study Abroad 375 Travel Image, The 520

568 Photographer's Market '86

Travel Photography Contest 530 Travel/Holiday 375 Travis/Walz & Associates 54 Treasure Craft/Pottery Craft 161 Tree Trimmers Log 469 Tribune Chronicle 413 Tricolor, Inc. 36 Tri-State Trader 413 Tritronics Inc. (TTI) 25 Trod Nossel Artists 490 Troll Associates 75, 138 Tropical Fish Hobbyist Magazine 375 True West/Frontier Times 376 Tucker Wayne & Co. 42 **Tulchin Studios 90** Turf and Sport Digest 376 Turkey Call 234 Turn-Ons, Turn-On Letters, Uncensored Letters, Options 376 Turner, Inc., Douglas 75 TV Guide 376 Twins Magazine 376 Tyndale House Publishers 138 Tyscot Records 490

U

Ultrasport 377 Uncensored Letters 377 **Undercover Graphics 30 Underwater Photographic Competition 531** Uniphoto Picture Agency 520 United Auto Workers (UAW) 161 United Cerebral Palsy Associations, Inc. 161 United Evangelical Action 234 United Methodist Reporter, The 413 U.S. Industrial Film Festival 531 U.S. Naval Institute Proceedings 469 United States Student Association 162 U.S. Television & Radio Commercials Festival 531 Unity 377 Univelt, Inc. 138 **UNIVERCITY 413** Universal Training Systems Co. 46 University of New Haven 162 Unspeakable Visions of the Individual, The 193 Upitn, Corp. 37 Urdang, Bertha 179 **USC Davidson Conference Center 27** UTU News 234

V

Vaccaro Music Services/Musique Circle Records, Mike 491 Valan Photos 520 Valley Records 491 Van Brunt and Company, Advertising Marketing, Inc. 90

Van Der Linde Co. Advertising, Victor 75 Van Enck Design Limited, Walter 162 Van Leer & Associates International, G.W. 51 Van Sant, Dugdale & Company, Inc. 57 Vanguard Associates, Inc. 66 Vegetarian Times 377 Velo-News 413 Vend-O-Books/Vend-O-Press 138 Venet Advertising 90 Venture 377 Vermont Life 378 Veterinary Economics 470 Victimology, Inc. 139 Victimology: An International Journal 378 Videography 470 Video Imagery 25 Video International Publishers Inc. 68 Video Resources 25 Video Systems 470 Video Vision 30 Video Workshop 56 Video/Visuals, Inc. 61 Viewfinders 520 Vintage Magazine 379 Vinton Productions, Will 97 Vinyard & Lee & Partners, Inc. 68 Virginia Wildlife 234 Virtue Magazine 379 Vision Gallery, Inc. 180 Vista 379 Visual Horizons 79 Visual Studies Workshop Gallery 180 Visual Studies Workshops 538 Visualworld 522 Vital Christianity 235 Vocational Education Productions 25 Voice Box Records 491 Volcano Art Center 180 Volk Company, The John 51

W

Wadsworth Publishing Company 139 Walker & Company 140 Walking Tours of San Juan 379 Wallaces Farmer 470 Wallack & Wallack Advertising Inc. 80 Wallcoverings Magazine 470 War Cry, The 235 Ward's Auto World 471 Ward-Nasse Gallery 180 Waring & LaRosa, Inc. 91 Warner Bicking & Fenwick 91 Warner Educational Productions 26 Warner Press, Inc. 194 Washburn Productions, Kent 491 Washington Blade, The 414 Washington Fishing Holes 380 Washington Post Magazine 380 Washington, The 379

Volkswagen's World 250

Vomack Advertising, Co. 79

Washington Wildlife Magazine 235 Waste Age Magazine 235 Water Skier, The 236 Water Well Journal 471 Waterfowler's World 380 Watershed 380 Waterway Guide 381 Wax & Assoc., Morton 491 Wax & Associates, Morton Dennis 91 WDS Forum 414 Wedge Public Cultural Center for the Arts 180 Weeds Trees & Turf 471 Weekly World News 414 Weight Watchers 381 Wesleyan Christian Advocate 414 West Coast Projections, Inc. 26 West Coast Review 381 West Jersey Health System 162 West Stock, Inc. 522 West Wind Productions, Inc. 32 Westart 414 Wester Photographic, Rick 180 Western and English Fashions 471 Western Flyer 414 Western Foodservice 471 Western Heritage Awards 531 Western Horseman 381 Western Outdoors 381 Western Outfitter 472 Western Producer, The 415 Western Sportsman 381 Western Wood Products Association 162 Weston Woods Studios 35 Westways 382 Wettstein/Bolchalk Advertising & PR 16 Where Magazine 382 Whitaker House 140 Wholistic Living News 382 Wilderness 163, 236 Wilderness Studio, Inc. 194 Wildlife Photobank 522 Wiley & Sons, Inc., John 140 Willett Associates, Inc., Roslyn 91 Wilshire Book Co. 140 Wilson Library Bulletin 472 Wilson Productions, Dave 491 Winard Advertising Agency, Inc. 61 Windsor This Month 382 Windsor Total Video 91 Wine Tidings 382 Wine West 383 Wines and Vines 472 Winterkorn and Lillas 80 Wire Journal 236 Wisconsin 415 Wisconsin Restaurateur, The 472 Wisconsin Sportsman 383 Wisconsin Trails 194, 383 Wisconsin Trails Books 140 With 383 Wittman Pub. Inc. Company-Maryland

Farmer, Virginia Farmer, & Georgia

Farmer Newspaper, Alabama Farmer 384 Witkin Gallery Inc., The 180 Wolf, Inc., Daniel 181 Wolff Associates 80 Womack/Claypoole/Advertising 106 Woman's Day Magazine 384 Woman's World 384 Women's Art Registry of MN. (WARM) 181 Women's Circle Home Cooking 385 Women's Court 384 Women's Sports Magazine and Fitness 385 Wood 'N' Energy 473 Wood and Wood Products 472 Woodenboat 473 Woodheat: The Woodstove Directory 385 Woodmen of the World 236 Woodstock Gallery and Design Center, The 181 Words 236 Work Boat, The 473 Workbasket, The 385 Workbench Magazine 385 Working Mother 386 World Coin News 386 World Construction 473 World Encounter 386 World Mining Equipment 474 World Traveling 387 World Wildlife Fund-US 163 Worldwide News Service 522 Wren Associates, Inc. 75 Wright Maritime Journalism Awards, Captain Donald T. 531 Writer's Digest Books 141, 474 Writer's Yearbook 474 Wustum Museum of Fine Arts, Charles A. Wyoming Rural Electric News 237 Wyse Advertising 96

X-It 387 Xerox Education Publications 163

Yaba World 237
Yacht Racing & Cruising 387
Yachting 387
Yachtsman 415
Yankee Publishing, Inc. 387
Yellow Silk 388
Yoga Journal 237
Young & Rubicam/Zemp Inc. 40
Young Children 237
Young People's Film & Video Festival 531
Your Health & Fitness 388
Your Health & Medical Bulletin 388
Your Mind's Eye Photography School 538
Youth Report, The 388

570 Photographer's Market '86

Zachry Associates, Inc. 106 Zelman Studios, Ltd. 80

Zhivago Advertising 26 Zondervan Publishing House 141 Zone VI Workshop 538

Other Writer's Digest Books of Interest

British Journal of Photography Annual—This outstanding yearbook contains more than 150 color and black and white photos, articles on techniques and current trends, and a section filled with chemical formulae for mixing processing solutions. 93/4x101/4, 222 pages, \$18.95 (paper)

Developing the Creative Edge in Photography, by Bert Eifer—How to turn average pictures into stunning photographs using Eifer's creative techniques. 8x8, 233 pages, 45 color, 34 b&w illus., \$16.95 (paper)

How to Create and Sell Photo Products, by Mike and Carol Werner—Over 30 sets of instructions for making and selling products featuring your photos, including clocks, greeting cards, calendars, lamp shades, and more. 357 pages, 100 b&w photos, \$14.95 (paper)

How to Create Super Slide Shows, by E. Burt Close—Whether for family and friends or for profit, here's how to put on a show that will turn yawns into applause, 233 pages, \$10.95 (paper)

How You Can Make \$25,000 a Year With Your Camera (No Matter Where You Live), by Larry Cribb—scores of profitable jobs for freelance photographers available right in your own community, with details on how to find and get the job, equipment, what to charge. 194 pages, \$9.95 (paper)

Photographer's Computer Handbook, by B. Nadine Orabona—Specific procedures for completely computerizing your freelance or stock photography business. 187 pages, \$14.95 (paper)

Sell & Re-Sell Your Photos, by Rohn Engh—Takes you step by step through the process of selling your photos by mail, using the right techniques for each market. Plus advice on taxes, record-keeping, marketing and sales tips. 323 pages, 40 b&w photos, \$14.95

Starting—and Succeeding in—Your Own Photography Business, by Jeanne Thwaites—A no-nonsense guide for starting your own photography studio, including how to choose a location, select equipment, advertise, manage finances and more. 343 pages, 55 b&w illus. \$18.95

Wildlife & Nature Photographer's Field Guide, by Michael Freeman—A compact guide filled with striking photos, practical tips, and photography instruction. 224 pages, 90 color photos, \$14.95

Use this coupon to order your copies!

YES! I'm interested in your photography book	cs. Please send me		
(1086) British Journal of Photograp	phy Annual 1985,	\$18.95*	
(1204) Developing the Creative Ed	ge in Photography	, \$16.95	
(1382) How to Create and Sell Pho	oto Products, \$14.9	95	
(1384) How to Create Super Slide			
(1423) How You Can Make \$25,00		ur Camera \$9.95	
(1811) Photographer's Computer H		ar Camera, 47.75	
(2059) Sell & Re-Sell Your Photos			
보다 어떤 트로스 내용 내용 보고 있는데 그들은 것이 불어보고 있다면 하는데 이번 이번 때문에 가장 하는데		to anombry Dusiness \$19.05	
(2080) Starting—and Succeeding in			
(2456) Wildlife & Nature Photogra	apher's Field Guide	2, \$14.95	
*current edition			
Add \$2.00 postage and handling for one book,	, 50¢ for each addi	tional book. Ohio resident	s add sales tax.
Allow 30 days for delivery.			
☐ Check or money order enclosed	I	Please charge my: Visa	☐ MasterCard
Account #		Exp. Date	
Signature			
Name			
Address			
City	State	Zip	
□Please send me your current catalog of Write			1854
Send to: Writer's Digest Books Cre	edit card orders cal	II TOLL-FREE	

9933 Alliance Road 1-800-543-4644
Cincinnati, Ohio 45242 (In Ohio call direct 513-984-0717)
(PRICES SUBJECT TO CHANGE WITHOUT NOTICE)

Other Writer's Digest

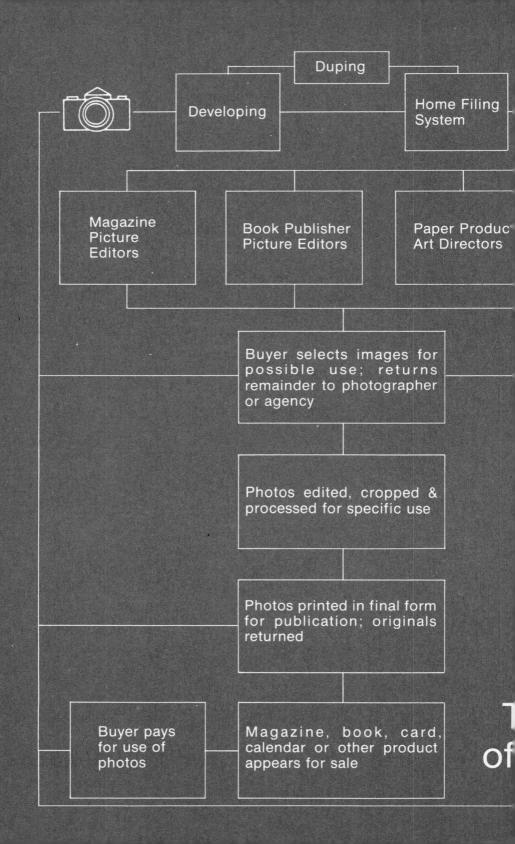